D1334834

THE PELICAN HISTORY OF ART
Founding Editor: Nikolaus Pevsner
Joint Editors: Peter Lasko and Judy Nairn

S. J. Freedberg
PAINTING IN ITALY: 1500-1600

S. J. Freedberg was educated at Harvard University, where he received his doctorate in the history of art in 1940. He is Arthur Kingsley Porter Professor of Fine Arts at Harvard, where he has also served as chairman of the University Museums Council and as chairman of his department. He is the author of monographs on Parmigianino and Andrea del Sarto, and of a general work on painting of the High Renaissance in Rome and Florence. His publications have received the Faculty Prize of the Harvard University Press and the Morey Prize of the College Art Association. He is a Fellow of the American Academy of Arts and Sciences. For service with the British forces in the Second World War he holds honorary membership of the Order of the British Empire. For work in connexion with the rescue of Italian art following the floods of 1966 he has the rank of Grand Officer in the Order of the Star of Solidarity of the Italian Republic. More recently, he was named Grand Officer in the Order of Merit of the Italian Republic.

Penguin Books

S. J. Freedberg

PAINTING IN ITALY
1500 TO 1600

Penguin Books Ltd, Harmondsworth, Middlesex, England
Penguin Books, 40 West 23rd Street, New York, New York 10010, U.S.A.
Penguin Books Australia Ltd, Ringwood, Victoria, Australia
Penguin Books Canada Limited, 2801 John Street, Markham, Ontario, Canada L3R 1B4
Penguin Books (N.Z.) Ltd, 182–190 Wairau Road, Auckland 10, New Zealand

First published 1971
First (revised) integrated edition 1975
Reprinted with revisions 1979
Second edition 1983

Library of Congress catalog card number: 75-15156

ISBN 0 14 0560.35 1 (U.K. hardback)
ISBN 0 14 0561.35 8 (U.K. and U.S.A. paperback)

Printed in the United States of America by
Kingsport Press, Inc., Kingsport, Tennessee
Set in Monophoto Ehrhardt

Designed by Gerald Cinamon and Paul McAlinden

For Catherine,
Will, Kate, Nathaniel, and Sydney Jr,
and in memory of Nonna

CONTENTS

PREFACE

Like the authors of other books in this series, I have had to make some difficult decisions of selection, organization, and method. While the extent of my discussion of a given topic may usually be taken as an index of the importance it assumes in my perspective of Italian painting of the Cinquecento, this is a measure I have had to apply flexibly. The relative unfamiliarity of some matters, the difficulty of access to information about them, or just their complexity, has often influenced the length of what I wrote. I hope that this has not upset too much the relation between significance and scale that I intended, and that those who read the book in its entirety will find its final balance just. The main factors that determined the size of parts within this balance were those of human and aesthetic quality, but the structure within which this balance works results from what I recognize of the historical processes of becoming, change, and interaction in styles of painting throughout Italy in this time. The historian who seeks to chart such processes risks making categories that may seem too strict, and patterns that may seem too arbitrary. I have tried to diminish this risk by making generalization cohabit, as much as I could, with the specific actuality of works of art.

There are evident – and self-imposed – limits to my approach to the material of this book. My choice may be taken to be a matter not just of principle but of economy, considering that the most pressing business of the historian of art is to deal with that which is essential and peculiar to art: its visual matter as it becomes, both in its own right and as an instrument, an agency of meaning. But I am aware that sometimes it may be insufficient, or even erroneous, to depend on evidence of this kind alone, and I do not mean to minimize, by the choice that I have made, the usefulness of methods different from my own.

Dr Bernice Davidson was the first reader of the complete manuscript, and on this occasion, as in the past, gave me invaluable help with issues of style as well as sense. Dr John Shearman also undertook to read the manuscript, and offered numerous corrections which I have accepted gratefully – of factual matter; he was kind enough to refrain from commenting on points that were matters of interpretation or opinion. Finally, I wish to record that the generosity of the American Council of Learned Societies helped substantially to complete the writing of this book.

Cambridge, Massachusetts
2 November 1969

For the second edition I have been able to provide some corrections and a considerable number of refinements of the factual information in the book. In particular, datings for some pictures have been improved, with consequent alterations in the presentation or interpretation of the material. The bibliography includes new publications to the end of 1981, and certain older items which on reconsideration have seemed to be of major value have been added.

Cambridge, Massachusetts
1 January 1982

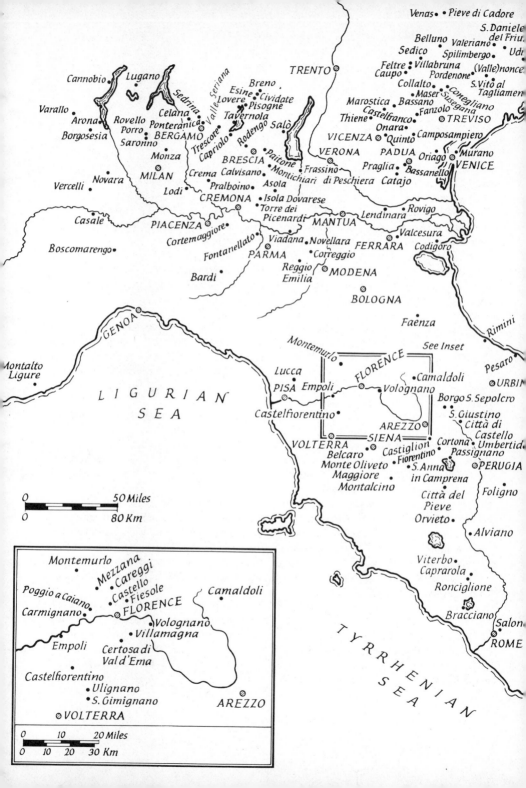

ividale

PAINTING IN ITALY

1500 TO 1600

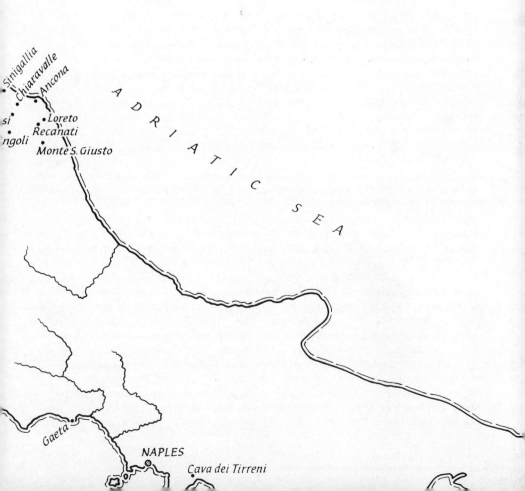

CENTRAL ITALY 1500-1520[1]

The artistic events that most powerfully determined the history of sixteenth-century painting took place in the century's first two decades in Florence and Rome, in the time which, implicitly recognizing the stature of its achievement, we have come to call the High Renaissance. The most extraordinary intersection of genius art history has known occurred then and gave form to a style which, again eliciting a term that is a value judgement, we call 'classic' or 'classical' – meaning, in its original usage, 'of the highest class'. The inventors of this classical style developed it and demonstrated it with an authority that compelled their contemporaries to reshape their art, and for the artists of succeeding generations of the sixteenth century this style remained an inescapable precondition with which they had to deal. In Central Italy the painters who chose – or whose lot it was – to work with the inheritance of the High Renaissance masters made their relation to them clear, and dependence on them is apparent even when the later artists may be of pronounced individuality. Even the artistic actions that may have been meant as a dissent from classicism were conditioned by it in essential ways; usually the dissenter was, in time, reclaimed. This does not mean that innovation of important kind was precluded by the weight of classical authority: it does mean that what was new within the sixteenth century after the High Renaissance was either a consequence drawn from it or had to be reconciled in some way with its tradition. The innovations in Central Italian painting through the century's course were many and significant and they resulted in a diversity of styles, but all are marked by their descent from the ideal created in its first two decades. The

relationship persisted even as the interval of distance from the early Cinquecento grew and reference to its classical example became indirect, compounding references made earlier; and it persisted through circumstances of political and Church history that were not sympathetic to a classical cultural style. The classical heritage of the High Renaissance created a common denominator among the varieties of painting that arose in sixteenth-century Central Italy. That classicism is their shared term of reference, and its vicissitudes compose the historical thread that links them.

With less emphasis this applies elsewhere in Italy through the sixteenth century's extent. In Venice the first years of the Cinquecento had seen the invention of a style which in more essential principles resembled that of the contemporary Florentines. The Venetian variant of High Renaissance classicism endured longer than its counterpart in Central Italy and assumed, in the territories relevant to Venice, a comparable authority. Though the Venetian style had been more flexible from the beginning than that of Central Italy, and was by no means so intellectually defined, the Venetian conception of a classicism was also central not only to its High Renaissance style but to developments that followed. Intermittently in the early Cinquecento, but later with more constant pressure, Central Italian style intruded upon Venice, and the issue of the differences between them became crucial – at first that between their variants of classical style, then that of the changes both schools came to make in them. In North Italy outside Venice, often less culturally advanced, there were centres where painting remained, well into the sixteenth century, mainly what it had come to be in the preceding time, a mimetic instrument. But as Venetian influence penetrated to these centres, then (together with it and at times displacing it) that of Central Italy, the history of North Italian painting became not just one

of native modes but a dialogue between them and classicism. The diversity of Cinquecento styles throughout Italy, vastly multiplied beyond that within the Central Italian school, is thus also bound, though more loosely, by the consequences of the classicism of the High Renaissance.

The principles of High Renaissance classical style had been precociously conceived by Leonardo da Vinci more than two decades before the new century began. He was alone in his exploration of a new style until the early nineties, when the younger Michelangelo – as personally precocious as Leonardo, but by an accident of generation not so historically advanced – independently conceived some similar ideas. A third Florentine, Baccio della Porta (later to be known as Fra Bartolommeo), formulated a more elementary conception of a Cinquecento classicism in the last moments of the old century. It was very shortly after 1500 that the parallel event occurred in Venice, in the art of Giorgione, and in Umbria in the painting of the youthful Raphael. The routes by which these artists came to their resembling principles were diverse; when we examine their histories individually we shall try to ascertain how each was moved to his invention. Before the middle of the first decade of the new century their actions were no longer personal and separate probings but had become a current, of a height and force that derived from the genius of its makers, and which had the power to alter the direction of contemporary art.

The Venetian development initiated by Giorgione remained distinct, but the other innovators, Florentine by origin save for Raphael, converged in Florence, and they were joined there by the young Umbrian in 1504. The conjunction of great genius in Florence was brief, dissolving finally in 1508 with the departure of Raphael for Rome and Leonardo's definitive departure for Milan; Michelangelo had already gone to Rome in 1506. The pre-

sence of the younger innovators determined where the capital of art was to be, but furthermore they found in Rome a climate of extraordinary cultural aspiration and large opportunity, evoked by Pope Julius II, which made new stimuli to creativity, expanding its scale and accelerating its pace. In Julius's Rome and then throughout most of the succeeding reign of Leo X de' Medici, the two great artists worked towards, and often on, the highest reaches of expression that art knows, developing the resources and powers of their classical principles of style; at times forcing them and, finally, perhaps exceeding them. What they achieved is of such a stature – of the mind as well as aesthetically – that all else in their context is diminished by comparison. Painters who in other circumstances would be pre-eminent in rank seem to recede: in Rome this is the case with Baldassare Peruzzi and Sebastiano Veneziano, and in Florence with Fra Bartolommeo and the younger aspirant to the place of Florentine *caposcuola*, Sarto.

There were no more than twenty years between the time when the new classical style became recognizable in Florence as an including current and the emergence of another style, the evident issue of the High Renaissance yet no less evidently distinguishable from it, and which would displace it. Events of political, and in particular religious, history that were certainly most unsettling for contemporary Italian culture have been called on – in a somewhat over-simple view of the relation in cultural history between cause and effect – to account mostly for the displacement in Central Italy of High Renaissance classical style. The same logic would require that conditions oppositely propitious to classical cultural style should have existed when the High Renaissance began and have accompanied most of its course, but this is hardly true. The classical style in painting emerged in Florence in a time at which the political and social actualities were in disaccord

with it: the latter years of the fifteenth century were a time of commotion more violent than the state had known since the mid Trecento, and the first years of the sixteenth century were less disturbed but by no means serene. The classical style was a consequence not of what we commonly refer to as historical reality but of a historical order of another kind, made up of ideas. It was the realization of an ambition the early Renaissance had been unable to attain: to reconcile what its culture had newly discovered and valued of the material world with its inheritance of Christianity. The conflict made a dichotomy of cultures within Florence, which could be regarded (perhaps more than some apparently 'objective' cause) as the source from which the worst of Florentine political commotion came. We may in part interpret Cinquecento classicism as a solution, in terms of art that do not touch political reality, and are not essentially touched by it, to the Quattrocento's cultural dilemma.

In Florence not only the beginning but the whole course of the new classical style was in a context of events and social circumstances that did not make a climate sympathetic to it. Under its penultimate republican government, of the Gonfaloniere Soderini, Florentine political and moral stature shrank, as did the Florentine economy. In 1512 the Medici were able to reimpose their rule, and when in the following year Leo X became Pope, Florence became a political dependency of Rome; it is clear that in the second decade of the Cinquecento the sociological climate of Florence was largely mediocre. Much art in Florence at the time reflects this social stature, and the absence of a sense of aspiration qualifies the accomplishment even of Fra Bartolommeo and Sarto. The effects of the milieu upon their style (though not upon their lesser Florentine contemporaries) are qualitative, much more than of kind; they still remain protagonists in the development of the principles of classical style.

Rome came to provide a differently propitious atmosphere for the development of classicism, but this was only well after its Florentine invention. Pope Julius II invited the creators of a style that had been clearly formed to practise in Rome, and through efforts for which Julius himself seems ultimately to be responsible, made circumstances of patronage and, more essentially important, a cultural climate favourable to their continuing development. Julius gathered as much as he could of the best literary reputations into Rome just as he did the best artistic ones, not necessarily concerning himself in either case with their allegiances of style. The creative stature of the so-called humanists did not resemble Michelangelo's or Raphael's, but they too were involved – for reasons that are perhaps more obvious than the artists', if without their grand measure of success – with the realization of a classical ideal of style. Not just underlying the cultural milieu but in a sense including it, so that it was infused by its tenor and its kind, was Julius's concept of the action of the Papacy in Italian and European politics, and inseparable from it, his concept of the role of Papal Rome. In both there was a discernible analogy to Rome of the ancient Empire, and by it Julian Rome reassumed much more of its ancient sense of grandeur. The cultural atmosphere was charged with the effects of Julius's aspiration, which not only stimulated creativity but indicated the direction it should take. The modern artists reached out towards the art of antique Rome as they had not in the early Renaissance, and as they had no comparable inclination or opportunity to do in Florence; in Julian Rome the symbols of antiquity took on powerful new relevance. What could be discerned of classicism in the art of old Rome – and often this might be appearance more than substance – came to serve more cogently than at any time before as a guide for the proponents of the modern classical style, affirming the out-

ward resemblance between the two but also strengthening their relationship of principle.

The impetus of development that Julian culture gave to Roman classical style survived him: it was part of the legacy of achievement that Julius left to Leo X. For a short while in the early years of Leo's reign the Papacy stood at a climax of both temporal and cultural authority, and this time was one of climax in the development of the Roman High Renaissance classical style. But Leo was unable to maintain the situation Julius's efforts had made: he came to dissipate his financial and political inheritance, and while opulently promoting culture Leo's action in the wider world was such as eventually to deprive culture in Rome of the conditions of environment that permitted aspiration to a classical style. In Leo's reign the favouring environment began to be removed as surely as, in Julius's time, it had been assured. However, this process did not have an effect on art until after Leo's death; Clement VII, the next Medici Pope, was to induce more drastic ruin. Meanwhile, sharing in the benefits of Leo's opulence, Roman artists manipulated their material, much more tractable than that of politics, to explore still farther (or, more often, to refine) the classical principles of which they won the substance earlier.

A verbal précis of these principles is possible, but almost unavoidably gives an effect of cliché. The rules we might select as defining High Renaissance classicism may sound, especially to modern ears, like noble platitudes, and because they are reduced to rules what they define seems less to be the classical style than the academicism that derived from it. Even more than in the case of other styles the tenets of High Renaissance classicism lose meaning when they are abstracted from the actuality of art, for it is this style's almost overriding principle that principle and actuality should fuse. Their interaction is a living one, by which idea is given substance in the particular event of art,

while its substance is informed, conversely, by idea. It is a living relation in another, equally important sense: while principle remains consistent in its essence it is not unchanging but itself a vital, thus developing, idea; it is responsive, too, to the substance of art in which it is required to exist. Abstraction in a scheme of words will not convey this life of principle. We shall identify it as it works, finding it as we experience the paintings, singly and as they follow one another to make the history of High Renaissance painting style.

LEONARDO

Leonardo's invention of the idea of style that was to shape so much of the history of the Cinquecento occurred more than two decades before the century began. However, it is not only as a matter of chronology that an account of this invention and its earlier results belongs in the history of the fifteenth-century style. Much in Leonardo's art requires to be seen as a fulfilment of identifiably fifteenth-century ideas, and some of his most salient innovations have their reverse, retrospective face. Even in the later years of his career, into the sixteenth century, qualities persist in Leonardo's style that indicate its origin in the century before and mark him off, subtly but distinctly, from younger colleagues in the modern style. None of this discounts the novelty or the prodigious historical significance of his invention. It is caution that the view that we shall take of it, in a perspective with a sixteenth-century station point, should be complemented by a view taken from the Quattrocento side.

The Cinquecento was a quarter of a century away when, close to 1475, Leonardo demonstrated the idea of what we recognize to be the core of the High Renaissance classical style. Born in 1452, Leonardo was then past twenty years of age and had not yet left the employ of Verrocchio, who had been his teacher. His

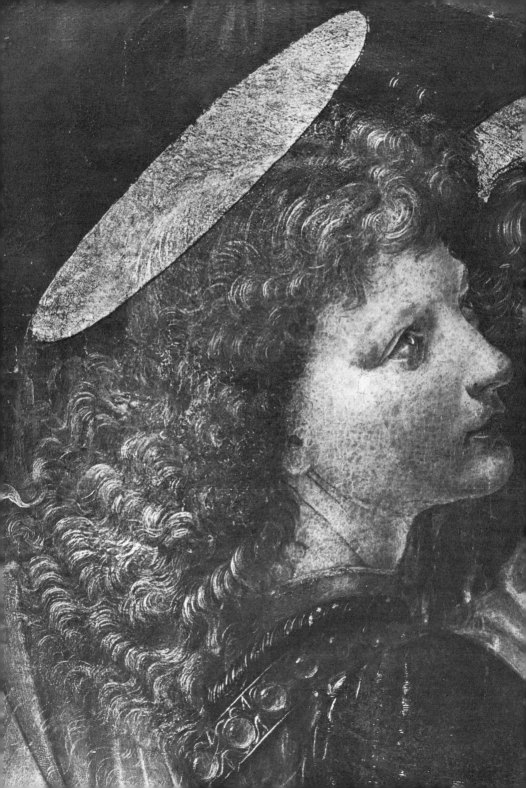

demonstration is within a painting otherwise mainly by Verrocchio, *The Baptism of Christ* (Florence, Uffizi), in the head of one of two angels attendant on Christ [1].[2] The difference between this detail and the context into which Leonardo painted it is the symptom of a difference of much greater magnitude, between the idea Leonardo's image represents and the whole context of contemporary art. In that setting his idea is an innovation almost as drastic as Masaccio's had been fifty years before. Leonardo's angel reconciles what his contemporaries and predecessors of the early Renaissance had normally dealt with as opposites in their depictions of a human image: physical description and expression of a state of spirit or mind. This purpose has required Leonardo's reshaping of the ordinary experience of nature – which he knew better than any of his early Renaissance contemporaries how to record and paint – so that appearance is reformed into a manifest idea of harmony, while the expression that inhabits the appearance is remade according to the same intention and with equal stress. The image that results is visibly distinct from normal expectations, and aesthetically and ethically far superior to them. Yet, surpassing reality, it commands us to feel it to be plausible as no image in art was before. A wonderfully subtle knowledge of the look of nature has been subsumed into the harmony of form, and a sense of actual vitality inspires the harmony of mind. These infuse each other: the harmony itself becomes not a condition but a living power. Spirit and substance, equally asserted in the image, concord within this vital harmony, interact, and become synthetic: this was the first event in the history of classicism in the Christian world that resembles, in its essence, the classicism of the antique Golden Age.

Half a decade later Leonardo had the opportunity to demonstrate this new – in a longer perspective, re-created – principle of art in an extended form. His vehicle was an *Adoration of the Magi* (Florence, Uffizi) [2], commissioned in 1481 for the monastery of S. Donato a Scopeto near Florence. Leonardo did not complete the work, leaving it as an underpainting, but carried far enough to indicate clearly what his ideas were. He has applied the concept of ideal revision of appearance that he laid down in the angel of the *Baptism* to the wide cast of characters the Adoration theme permits: he has shaped the actors' heads into perfected types, condensing his experience of humanity and selecting qualities from it that have to do not only with appearances but with spiritual disposition and moral values. His generalizings are insistent, yet Leonardo observes – or invents – shading differences of individuality, so that there is interplay among his actors in quality of appearance and tonality of feeling. This reforming process is applied also to the bodies of the actors, most apparently in the Virgin, whose whole figure has been shaped in curves of smoothed melodious effect into which no disharmonious accident of nature has been permitted to intrude. The pattern of her shaping and her posture – an incipient contrapposto – unfold farther, with change of stress but not of essence, the sense of a living harmony that Leonardo has illustrated in the Virgin's head. Less insistently, he extends this mode of shape and pose to the surrounding male forms. Their kinds and powers of feeling are differentiated by a character of bodily action consonant with the expression of their heads; but as Leonardo describes it even the utmost power of emotion takes on a harmonious shape.

The principle of an arbitrarily formed and living harmony extends beyond the single

1. Leonardo da Vinci:
Angel, from Verrocchio's Baptism of Christ.
Florence, Uffizi

figures to their relation in a composition. Two strong geometric shapes, of almost schematic obviousness, form a framework on which the figures are arranged: a semicircle, partly laid back into space, locks into a triangle mainly drawn on the picture surface. Within its arbitrary clarity each of these shapes engenders an effect of movement and of its simultaneous control; and each shape plays with complementary and magnifying effect upon the other. Obviously ideal as it is, the scheme of design is instinct with energy that derives from its shapes alone; however, this scheme functions not just as an abstract geometry but in terms of the figures it contains, which literally inhabit it, taking energy from it and simultaneously giving it their own. There are no inert relationships, and balances are made within the geometric

2. Leonardo da Vinci:
Adoration of the Magi, 1481. *Florence, Uffizi*

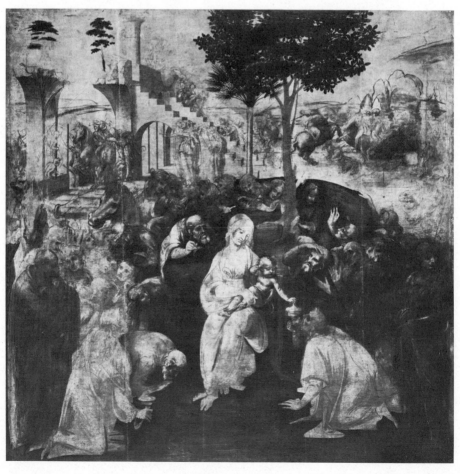

scheme not just of shape or apparent mass but of energies. Literal symmetry is not useful or even relevant to such a concept of relating forms. They begin in the *Adoration* to act in the reciprocal responses of a contrapposto.

Much in the *Adoration* still shows that it is a beginning. Yet the bases of the new principles of style that Leonardo has conceived are generally legible in it even when they may not yet be surely formed or enough articulated. His idea of a functioning of space is of this kind: not yet certainly defined, it still holds the symptom of a principle that would be vital to the subsequent history of the classical style. Leonardo had, obviously, learned perspective science thoroughly; he became one of its theorists and acknowledged masters. Yet, since he was concerned to make an ideal reforming of reality rather than to imitate it, and to capture the effect of life, not to fix it, Albertian perspective was at best incidental to Leonardo's purposes. The structure of the *Adoration* rests on an inversion of the Albertian rule. Leonardo's space begins not as Alberti had prescribed with a perspective grid, which then is populated with the figures, but oppositely, with the figures: their volume gives shape to the surrounding space. A history of the evolution of the classical style that would not be only formal in its kind could be composed with the fulfilment of this beginning in the *Adoration* as a central thread.

The style Leonardo conceived for the *Adoration* is 'ideal' (in the commonly accepted meaning for art criticism of the word); and it is so because it is the most 'ideated' picture up to its time in the history of art. Later in his career, when Leonardo formed the habit of recording his ideas in words, he came to define most of the conceptions on which his invention of a new artistic style was based. His definitions may be in his scientific notes as well as in his observations on the art of painting. In Leonardo's view, knowledge was a unity and art the preferred instrument for its communication,

and scientific principles might often be principles of painting, too.

Painting, for Leonardo, is 'the sole means of reproducing all the known works of nature' which it does with 'subtle and philosophic speculation' (*Trattato*, I, 4v); '. . . the mind of the painter must transmute itself into the very mind of nature and be the interpreter between it and art, commenting with art the causes of its demonstrations as they are determined by its laws . . .' (*Trattato*, I, 24v). None of these words counsels imitation but, instead, the depiction of that truth which intellect may find behind the façade of visible experience. In a scientific context Leonardo defines this prescription more precisely: 'This is the true rule how observers of natural effects must proceed: while nature begins with reasons and ends in experience, we must follow the opposite [path], beginning with experience and with that investigating the reasons' (Cod. E 55r). The programme is the same as that by which, in painting, Leonardo seeks the typical and general that underlie the evidence of surface observation. In painting it is not sufficient to describe the physical phenomena alone: 'A good painter has two chief objects to paint, man and the intention of his soul. The former is easy, but the latter hard, because he has to represent it by the attitudes and movements of the limbs' (*Trattato*, I, 60v); a 'figure is not praiseworthy if there does not appear in it the action that expresses the feeling of its spirit' (Cod. A 109v). It is through substance that spiritual life must be communicated; and this life must be expressed in a concordant vital motion of the body: 'The painted movement appropriate to the mental state of the figure should be shown with great liveliness . . . if this is not done, such a figure will be called twice dead, for it is dead because the figure is an imitation, and dead again when it does not display motion, either of the mind or body' (*Trattato*, III, 110). And, with arbitrary licence: 'Where natural vitality

is lacking, create an artificial one' (Cod. Atl. 147r). The action of the body, or its cause, 'energy, originates in the movement of the spirit . . .' and then inspires the physical form; 'running down through the limbs of conscious animals, it expands their muscles . . .' (Cod. Arundel 151r and v). This inspiration is pervasive in the form: in an untranslatable phrase it is 'tutta in tutto, e tutta per tutto' in the body where it is caused (Cod. Atl. 302v). In the same definition energy is described as incorporeal and weight corporeal, and immediately redefined as spiritual and material. The contrast is of the two realms that Leonardo unifies, in their interaction, in his painting. To this interaction of spiritual and physical being harmonious form must be given, since painting depends 'on the harmonious proportion of the parts [that] pleases the senses' (*Trattato*, 1, 11). And this harmony, since it encloses vital forms, must live in itself as music lives harmoniously, in movement: 'Music is not to be called anything other than the sister of painting . . . rhythm circumscribes the proportionality of the members of which harmony is composed not otherwise than the circumferential line surrounds the members of which human beauty is generated' (*Trattato*, 1, 16-16v).

There is not, in Leonardo's writings, any central summarizing definition of his art; the work of art itself is his manifest definition. Yet each separate verbal definition of a principle proceeds from an identifiable common conceptual core: to see, within the indissoluble unity of being, a functional equilibrium between substance and spirit, and between immediate experience and general law. Leonardo had no collective name by which to call this new doctrine of style; it was Vasari who described it, two generations later, as the beginning of that 'third manner which we wish to call the modern' (IV, 11). It was not only modern: we have remarked already that there is a deep resemblance between the principles of Leonar-

do's art and those which govern ancient classic style. However, Leonardo's 'modern' classicism is neither imitation of the ancient style nor purposely recreative of it; it is in no sense a neo-classicism. It was conceived within a preexistent and contemporary Christian culture that had acquired some of the attitudes of classicism, partly by imitation, but partly also self-generated. Not just the *Adoration* but even the later, entirely developed painting of the High Renaissance betrays that its classicism was born out of, and lives within, a Christian context.

There were phenomena of style in the early Renaissance that had distinguishable elements of classicism; there is a line of descent that we can trace, beginning in Masaccio and ending among Leonardo's contemporaries in Florence and Umbria (Perugino conspicuously but also Ghirlandaio); Piero della Francesca may be said to represent its peak. This early Renaissance classicism bears to the style of Leonardo and the classicism of the High Renaissance a relation which (in terms of analogy) is like that of early classical Greek art to the style of the Greek Golden Age. Leonardo's classicism may similarly be considered as a maturing of what was potential in his antecedent line. None of these antecedents, however, handled even the single elements of classical style as he does, much less combined them in a comparable whole. Moreover, the style Leonardo formulated does not relate just to the fifteenth century's classicizing strain: it was the result of Leonardo's confrontation with all the possibilities available to art in Florence at the end of the third quarter of the fifteenth century, and these were various and complex, for the most part quite apart from classicism. This diversity - in some respects, quite visible divergence - in sense and style within contemporary art was the raw material on which Leonardo's power of invention worked, and which summoned that invention into being. After more

than half a century's development of the propositions that had been novel to the early Renaissance, the painters of Florence found themselves involved in a conflict between these ideas and the survival - vigorous, though often in much altered form - of conceptions that were medieval or traditionally Christian in origin. Much too summarily, it may be said that the opposition was between a view which took the first function of art to be that of rationally and objectively describing physical reality and one that held it to be the expression of spiritual - non-rational and subjective - values.[3] The problem was not just one of art; in different terms it had come to be primary among the concerns of contemporary Florentine philosophers. More than they invented a solution to the problem they recast an old one, neo-Platonism, for contemporary use. Leonardo also recognized the problem as it matured in Florence in the years in which he was being educated. The solution he felt it required, however, was of a different kind from the essentially reactionary one the neo-Platonists professed. Leonardo's object was to effect a genuine reconciliation between the values of material and spiritual experience, not a concession of one to the other. To do this it was necessary to revise the conceptions contemporary painters held of both reality and spiritual value, to devise a single principle that contained and controlled both, and to find the means for their concordance. The relation that he sought between them was equal, functional, and synthetic; the means of that relation were to be a rationality of ideas and form, and its governing mode, harmony. We have already seen, in the *Adoration*, the working elements of the solution Leonardo found.

Leonardo's accomplishment of this solution in 1481 was so precocious an event, not only in the artistic but in the general intellectual history of Florence, that it evaded the intelligence of his contemporaries. When he left the city for Milan, late this same year or very early in the next, the unfinished manifesto of the *Adoration* was left behind to bemuse the Florentines. But it was not comprehended until, some two decades later, the more ordinary processes of history caught up with it.

In Milan, where Leonardo remained, in his first long stay, for almost twenty years, his continuing development of his invention of style was still more isolated. His first painting done in Milan, the *Virgin of the Rocks* (Paris, Louvre, commissioned 1483),[4] is a more evolved demonstration of the main ideas the *Adoration* contained, but at the same time it supplies evidence with which we can adjust the effect that the unfinished state of that picture makes. It is in a descriptive skin like that of the *Virgin of the Rocks*, finely worked and rich with passages of detail, that the ideas of the *Adoration* ought to have been clothed. The precise sensibility to seen things is related to the realism of the Quattrocento, but exceeds it, for Leonardo has observed not only the object he describes but its effect of interaction with surrounding atmosphere. What was evident already in the novel use of chiaroscuro in the *Adoration* is affirmed here: that light has been raised to a role in description equal to that of drawing (which, in Leonardo's more developed sfumato, light would quite displace); still more important, it has become a major factor in the making of the whole pictorial scheme. In the *Virgin of the Rocks* chiaroscuro has begun to dominate colour and absorb it, substituting for the analytic effects of quattrocentesque colour a visual continuity, and thus a harmony - which, conversely, takes life from the play of light and dark. The details that are so finely described not only by their drawing but by light no longer stand discrete like products of a Quattrocento realism but are knit into this continuity. In any case, the illusionist details have been incorporated, in the figures, into larger forms that are still more evidently the

results of a reforming will than in the *Adoration*: fuller and more rounding in shape, making an effect of heavier, more deliberated harmony. And in the landscape background from which the picture takes its name the geological details are similarly parts within a whole construction which, though plausible at first sight, does not reproduce reality: it is instead a rearrangement of reality, based – according to Leonardo's own dictum – on observation that probes through natural appearances to find their causes and laws. Knowing exactly not only the outward forms of nature but its laws, Leonardo could re-create, according to his own requirements of expression and design, an image of nature that is at the same time believable and arbitrary; the principle is ultimately the same one that permits him to remake his images of humanity.

A decade's maturing of the new principles lies behind the *Last Supper* (Milan, S. Maria delle Grazie, *c.* 1495–8, now partly ruined),[5] and its instantly visible result is the great increase in the extent and power of Leonardo's reshaping of the evidence of nature. The Apostles, as well as Christ, have been given an extraordinary moral and dramatic stature. Their features and the reactions that their faces show to Christ's pronouncement of His imminent betrayal are boldly cast into moulds of typicality, and their bodies and gestures are generalized in strong, ample curves: their effect is magnified progressively as the figures knit together into groups and the groups into *crescendi* of formal and emotional powers that converge on Christ. These are beings who have been aggrandized in substance and idea beyond the personalities in earlier art. Their setting also remakes nature arbitrarily. The disposition to manipulate the sense of Albertian perspective that Leonardo showed much earlier in the *Adoration* is now absolute: the first effect of thorough plausibility the setting of the *Supper* makes bears proof less than the figures do. Constructed with the usual perspective means,

the space is uninhabitable beyond the nearest plane in which the figures are; the devices of perspective have been more essentially applied to the use of serving and supporting what the figures mean and do. What is contained within this frame belongs so evidently to a region of superior existence that the spectator cannot but realize that the picture world, for all its seeming palpable existence, is not meant for him to share as any realist illusion. The strip of tablecloth across the front plane of the picture makes a boundary between our world and the idea.

As the *Last Supper* is related in extent and drama to the early *Adoration*, so is the *Madonna and Child with St Anne*, oppositely intimate, related to the *Virgin of the Rocks*. Still in Milan, Leonardo began to occupy himself with the St Anne theme, which he seems to have considered a vehicle particularly suited in its possibilities of content as well as form to his ideas of style – not only to their exposition but to the process of their continuing refinement. He made three distinct essays on the theme, but rather than as separate works they should be thought of as stages of development of one idea. The first, done in Milan, was carried to the point of a complete cartoon (London, National Gallery, *c.* 1499) [3], but not translated into paint.[6] The second, also a cartoon (now lost, though imitations in paint tell us, quite inadequately, something about how it looked), was the work with which Leonardo reintroduced himself to Florence in 1501, after his return the year before. Vasari tells us (IV, 38) of the astonishment and admiration with which this cartoon was received when Leonardo showed it to the Florentines in SS. Annunziata. He was working at the subject much less for the patron than for his private ends, and he did not turn this cartoon into a picture. Instead, he conceived another, more perfected version of the theme which he began, only about 1505, to set down in paint (Paris, Louvre).

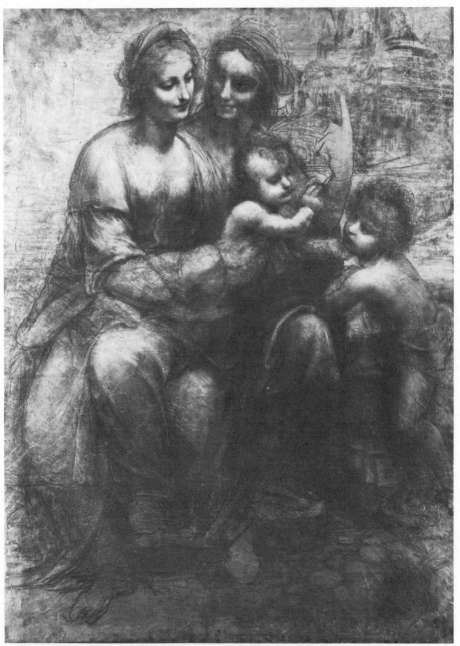

3. Leonardo da Vinci: Virgin, Child, and St Anne, *c.* 1499. *London, National Gallery*

Though we can reconstruct the design of the cartoon of 1501 we cannot presume its effect as an aesthetic object. The chronologically just previous cartoon from Milan must serve in this respect for both. In its concentrated compass it exhibits an effect of unity of form and overt geometry of structure that far exceeds that made by the *Last Supper* and which, as an ideal integer, is altogether of another order from that he had conceived a decade and a half before in the *Virgin of the Rocks*. The shapes in the cartoon are suavely full, slow in rhythmic movement, and artfully interwoven in a new measure, and the relations of proportion among them instantly convey the sense of harmony. In a degree of difference that almost constitutes a new effect, the qualities of form convey a sensuous pleasure to the eye and mind of the beholder. Throughout the cartoon Leonardo demonstrates what he had implied, but not known quite so fully how to say before: that his harmony is now meant not only to impose upon the mind but to enchant the senses so that the work of art shall, literally, be lovely. Leonardo himself would speak (*Trattato*, 1, 5) of 'bellezze che . . . innamorino'. Among his works this is the first where not some portions of a picture but its entirety compels the immediate sensation in the spectator of the beautiful. It is an effect more profoundly revolutionary than may at first appear: in joining to the intellectual ideality of form the conception of a sensuous content to be derived from it Leonardo has achieved what is in effect a re-creation of the sense of beauty as classical antiquity understood and felt it. This re-creation was achieved, as far as we know, with no more specific reference to antique models than we can document for Leonardo in the past. The quality of beauty emerges in the cartoon from its finer harmony of form, but it arises still more from the sense, more pervasive here than in any of Leonardo's prior works, that this harmony is of subtly mobile relations: a new

dimension of aesthetic effect has been assumed in the cartoon by what Leonardo himself might have described as a musicality. Not only the bodily forms and draperies but the heads also indicate this same development of a subtle, exquisitely movemented harmony of rounding form. The heads are of a perfection that recalls Praxitelean models which, despite the similitude of their original loveliness that he re-creates, Leonardo cannot have known. The faces wear that veiled radiance we first saw in the angel of the *Baptism*, but it is raised here to a far higher power – stronger, but also more tender, and more vibrantly differentiated in its content of expression. The emanation that is here of love, in the spirit of the persons and in their loveliness of form, makes a relation between the image and the spectator that is an ennoblement and a seduction.

Between the version of the *St Anne* cartoon, about two years later, that Florence saw and the beginning of the Louvre painting Leonardo was occupied with a project of much grander scale than the *Anne* theme, offered him in October 1503, when he was commissioned to paint the *Battle of Anghiari* (won by the Florentines against the Milanese in 1441) for the great Salone of the Palazzo Vecchio. A cartoon was finished by the end of 1504 and painting of the central – and climactic – portion of the history, the *Battle for the Standard*, was begun in June 1505. Using an experimental medium, Leonardo saw his work decay almost as soon as he laid it on the wall, and he abandoned it. The partly executed *Battle for the Standard* was soon lost; the cartoon apparently survived until the eighteenth century. Copies of varying dependability and Leonardo's own preparatory drawings help form an idea of what he planned [4].[7] Apparently the whole painting would have included, in addition to the climax of the *Battle for the Standard* in the centre, episodes subsidiary to it, converging from either side. The basic idea of design was that of a confluence of

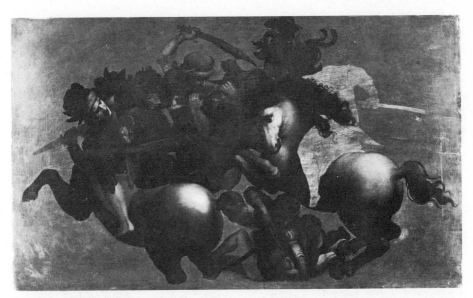

4. Leonardo da Vinci:
The Battle of Anghiari (copy). *Florence, Uffizi*

energies upon the picture's centre, where they were interwoven as if in a knot. Leonardo has given due regard to the historical account of the actual battle of Anghiari; however, at the same time he has taken this theme in terms of its typical and essential meaning as no earlier painting of a battle scene had done: as a meeting in a climactic moment, which becomes a fusion, of opposing physical forces and spiritual wills. More than a historical report, Leonardo's *Battle* becomes the vehicle of an idea. The copies of the central portion show, despite the dissimilarity of theme, a close relation with the idea of form that Leonardo had employed for the first two *St Anne* cartoons and a development of it; and beneath the quite opposing modes the essence of expression is the same. Unlike the earlier cartoons, where movement is generated by aesthetic means, the *Standard* group depicts violent and impassioned action, which moves and turns into the space: its whole form seems to expand into a dimension resembling a sphere. This central group accumulates the contending energies of the entire battlefield and knots them in a charged, unitary, compact rotation of forces and forms which, at this moment of intensest conflict, are equal and indissoluble. The accomplishment in the *Battle of Anghiari*, four years after the opening of the new century, is an event of great significance in the history of the classical style that Leonardo had invented. It marks what we shall recognize, as we proceed, to be almost a complete realization of the possibilities of a central idea of classical style: Leonardo has conceived an absolutely compelling unity within which both form and idea work with virtually maximum complexity and at maximum intensity. It is possible to regard the history of classical style for a decade to come as a conquest of the position that Leonardo had already attained here.

Contemporaneously, Leonardo was at work on what would be his definitive formulation in another genre, antithetic to that represented by the grand endeavour of the *Battle*: the portrait – the female portrait, specifically: of Madonna Lisa, wife of Francesco del Giocondo, otherwise *Mona Lisa* (Paris, Louvre, 1503-6). Leonardo does not allow that even the specific and real person who is his sitter is a fact of nature that he may not alter: he has worked upon her appearance and expression with subtle pressures that re-shape them, gently but ineluctably, towards his artistic ends. The result is a synthesis of rare perfection between art and actuality: an image in which a breathing instant and a composure for all time are held in suspension. Sfumato, here developed for the first time in Leonardo's œuvre to the status of a primary pictorial means, supplies a unitary visual stuff in which the matter which makes up the image has been bound. The sfumato is more than a way of seeing forms or relating them to one another; it is also the carrier of an attitude towards content. The sfumato works to melt and soften, yet we may still perceive how subtly, – sharply, even, underneath the filming light – the existence of particulars is felt. An almost poignant sense of individual phenomena, coming from his roots in the Quattrocento, persists in Leonardo, and it is particularly evident in some details of form, and above all in the fineness with which Leonardo describes textures, not just of substances but of the very air; and it is also evident in *Mona Lisa*'s personality. But all these are perfectly contained within the discipline of Leonardo's whole idea, and their complementary play within and against it is, finally, further matter Leonardo has suspended in the harmony he has achieved.

The third, painted, version of the *St Anne* theme was Leonardo's last important exercise in painting [5]. Begun late in this stay in Florence, much of its execution – never quite completed – post-dated Leonardo's definitive return, early in 1508, to Milan. The Paris painting is the concluding episode of its series and (except for one mysterious later work) exhausts the possibilities Leonardo was able to develop from his own long-previous invention of a classical style. Leonardo applies to this *St Anne* the breadth of form and variety of articulation in space that he had evolved for the *Anghiari*, but transposes their effects of expression into an appropriately different key. He makes a quality of movement in the forms that is unsurpassably melodious: a visible *cantilena* that ranges from full sweeping arcs to finest ornament, and in which all the rhythms are continuous or interwoven. The figures that compose the major rhythms are at the same time richly differentiated and inescapably interlocked into a larger form that is a containing integer. Its shape compounds the oval design of the first *St Anne* cartoon with the pyramidal design Leonardo worked out for the second. The effect of balance and stability, containing and controlling movement, is as sure as in the cartoons, but it is both more complex in artifice and deceptively more natural-seeming.

The setting for the figures has been worked dependently around them, an obbligato to the figured theme. Landscape space has no independent rationale, no measurable distance, and no perspective shape. Not only its forms but the content that emanates from it are ancillary to the figure group. But while the landscape is accessory to the figures, it is seen also as a matrix out of which they grow. The light and the content of colour the light carries are described as if, in natural truth, they belong to the landscape. Its muted colours, made just sufficiently more explicit, become those of the figures' draperies, making a pervasive coloristic

5. Leonardo da Vinci:
Virgin, Child, and St Anne.
Paris, Louvre

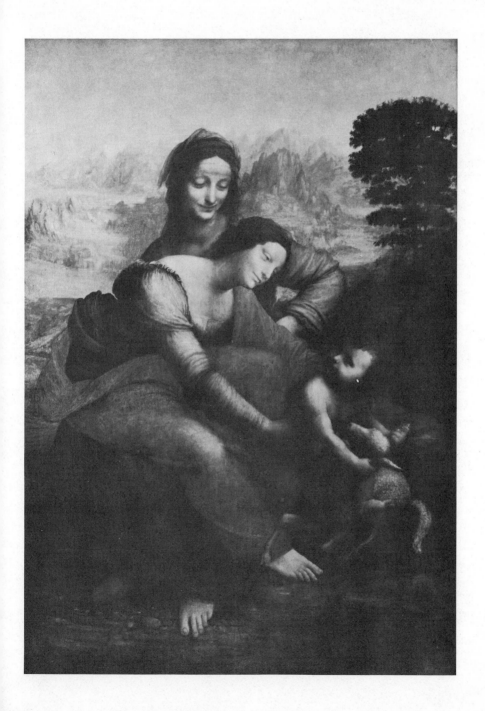

texture. This texture of colour is inextricable from the atmosphere in which it is suspended, vibrant with subtly nuanced energies of light. Colour, and the forms that half-absorb, half-emanate it, is seen as if in a living aether, muted by it but growing out of it as well. A union of setting and its contents, indeed of the whole pictorial experience of vision, is determined in the *St Anne* by this ultimate development in it of the Leonardesque sfumato – in the wholly finished passages within the painting, more sophisticated even than in the *Mona Lisa*. But where in the *Mona Lisa* the sfumato light had virtually consumed colour, in the *St Anne* colour re-emerges, renascent from the light, to claim a role again within the tissue that is woven, in Leonardo's art, into a harmony. In this tissue of a vital harmony which the *St Anne* painting makes Leonardo has projected a meaning that was, for him, partly the consequence of his science, partly the fruit of the intuition he had come to hold of the nature of the world. The *St Anne* is (in Leonardo's own language) the finally effective act of 'transmutation of the mind of the painter into the very mind of nature' and the 'commentary in art of nature's demonstrations as they are determined by its laws' (*Trattato*, 1, 24v): it has acquired the virtue of a symbol of his understanding of the process and mode of functioning of nature. The close-meshed, endlessly interwoven, vitally acting and reacting harmony of this picture is the visible pattern of Leonardo's comprehension of his world: not just of the earth that he inhabits but of the universe whose laws the earth reflects in small. This image of persons and an earthly landscape is an image also of the mode of being and the mode of movement of the spheres: it is Leonardo's realization in art of his vision of the cosmos.

In one sense, the generalization that this symbol holds is vaster and higher than any that the subsequent history of classical art will attain. But in another, the matter upon which it has been made contains the limitation of Leonardo's possibilities of any different avenue of development of classical style than this one, in its own way ultimate, that he has achieved. This is an ultimate of classical thought, but it is not the only one; if Leonardo's were the only possible conception of a classicism, all other artists of the High Renaissance would have been condemned, from this time on, to uncreative recapitulation of his accomplishment. It is his very preoccupation with the world as an experience and interpretation of nature, an experience as much that of the scientist as of the humanist, that closed to Leonardo the further possible directions of development, more exclusively (in the literal sense) humanist, which the younger generation would explore. This naturalism, transformed long since beyond its origins in the Quattrocento, still relates Leonardo to the period out of which his art had come. He retains, within his prodigious capacity for inducing generalizations, the sense of the specific identity of each phenomenon of experience that is acute in the *Mona Lisa*, and of which the evidence is still ample in the last *St Anne*, and this identity is too precious a datum for him to surrender wholly. The synthesis that his painting attempts, and in fact achieves, is of an almost defeating complexity. It has, so to speak, no limits either in the cosmic or in the infinitesimal sense.

It is not only physical data to which he responded thus; it is the data of human emotion also. For Leonardo, emotion is – in his own terms of intellectual redefinition – the apt response to specified situations. There are spheres of comprehension of peculiarly human idea and aspiration – of exalted, wholly internally generated, states of spirit and of mind – that he did not invade: Michelangelo's way of a transcendent thought about humanity is closed to him. So also, in this very private com-

munion with experience that is Leonardo's way of making art, is he closed off from the realm of public rhetoric, with its burden of grand and surpassing emotions, that was to be the basis for Raphael's highest acts of classical style. There is a touch still, within Leonardo's poetic transformation of the art of fifteenth-century Florence, of some of its familiar attitudes of mind. The style he invented would develop, still within his lifetime, into regions into which Leonardo, at last bound by generation and by place, could not move.

In Milan until 1513, Leonardo's attention was engaged in seemingly more multiple directions than ever, and especially in the pursuit of his scientific researches. He may have become less involved with painting (though he drew, of course, incessantly, his science being of phenomena he could explore by visual or graphic means). No major new work of painting was begun in these Milanese years, nor did he finish wholly any old one.[8] Late in 1513 Leonardo went to Rome, invited by Pope Leo X; but no evidence exists of the two small paintings which, according to Vasari (IV, 47), he painted during three years there. One work invented in this late time survives, the half-length *St John the Baptist* (Paris, Louvre), obscured now so that its idea, but not much else, is comprehensible. Despite the ferment of activity in art around him, Leonardo seems to have stood quite apart from the contemporary Roman scene: he worked by now, more than ever, in a private realm. In January 1517 another honorific invitation, from the new French King, François I, brought Leonardo to live near François' court, at Amboise; he died there two years later, in May 1519. The end of Leonardo's career, like its beginning, was isolated, completing the image that comes to mind of an intersection with his contemporary history like a comet's, on an eccentric orbit and only briefly coincident with it, but of extraordinary brightness.

MICHELANGELO

Born in 1475, Michelangelo was Leonardo's junior by the rough measure of a generation. The angel Leonardo painted in Verrocchio's *Baptism* is datable about the time of Michelangelo's birth, and the unfinished *Adoration* from Michelangelo's fifth year. When Michelangelo was receiving his formative education in art, first in painting with Domenico Ghirlandaio, then in sculpture under the guidance of Bertoldo di Giovanni, Leonardo was in Milan. In Florence in the 1490s only Michelangelo was competent to gather Leonardo's entire meaning, in the *Adoration* or in the other sparse evidence of new style he left behind; but Leonardo's precedents were not, in any way that we can document, instrumental in Michelangelo's creation of a comparable new classicism. The process by which Michelangelo formed his classical style was unlike Leonardo's: where Leonardo's invention was made wholly in response to the situation of contemporary art and with its data, Michelangelo's was generated out of reference to the past. In both artists, of course, the act of invention was the consequence of discontent with what their environments offered them of style, which in Florence in the interval between the seventies and nineties had become still more divergent and diffuse. Within this contemporary complexity, Michelangelo was disposed from the beginning towards a retrospective and at the same time classicizing attitude towards style. In Ghirlandaio's workshop he was exposed to an end-product, however paled and prosified, of the Florentine tradition that began in Masaccio – the origin of early classicism in Tuscan painting. In his study of the frescoes of the Carmine, obligatory for all apprentices of the time, Michelangelo found the source of this tradition and, temperamentally akin to Masaccio, regenerated it for his own art.

On his transfer to Bertoldo's school of sculpture, Michelangelo grew to know, by study of antique works, the ancient sources that had contributed to the forming of Masaccio's classicism.[9] And Michelangelo brought to his study of antique sculpture some literary knowledge of antiquity also, acquired in his frequentation of the humanists of the Palazzo Medici when, in the early nineties, he lived there as a privileged Medici protégé. Other young painters in the later eighties and the early nineties had an education with much the same classical components; only on Michelangelo, however, did it have a profoundly classical effect. In his first sculptured works he showed that his response to antique models was as if to the classic essence that they might contain, remaking it out of the intimations offered to him by an ancient copy or a ruin. His evolution of his classical style was a process in which he illuminated the meaning of the classicism in those imperfect ancient works he knew, while that illumination reciprocally helped him further to create his own.

Much in Michelangelo's early education in the arts was classicizing, but it was by no means all such, no more than were the other artistic aspects of his upbringing. He was early exposed in the Medici circle to the mixed, but eventually Christian, doctrine of neo-Platonism, with effect sufficient for his thinking later almost always to bear its impress. To the spiritual incitement of neo-Platonism there was added the impact – to that depth which Michelangelo's own confession bears witness – of the preaching of Savonarola, whose beginnings in Florence coincide with the time of Michelangelo's early art. In the field of Quattrocento artistic accomplishment that was most relevant to Michelangelo, sculpture, the most demanding precedent was that of Donatello, whose range of expression had embraced the extremes possible to the early Renaissance mentality. It seems that Michelangelo's comprehension of classical example was promoted – in an only apparent paradox – by the unclassical aspects of his education and contemporary cultural environment. It was from his intense spiritual being, initially Christian in its form and orientation, that there emerged his perception that antique art was spiritually inhabited: that it was not, as for some of his contemporaries, merely a repository of recipes for naturalism, or, as it was for others, a dictionary of quotations.

We can identify nothing certainly of Michelangelo's painting that might have belonged to his earliest years. Until the *Holy Family* for Angelo Doni [6], begun at the earliest in 1503, we know only sculpture by him and some drawings, the latter few in number. To grasp how he conceived the style of which the Doni Tondo is already rather an advanced expression we must look to some of the preceding work in sculpture and at least summarily assess the ideas that are at work in them. They contain no such striking look of novelty as is in Leonardo's early works: the retrospective route by which Michelangelo evolved the bases for his style moderates its effect of inventiveness. None the less, the invention is there from the discernible beginning, as unmistakable as it had been in Leonardo and resembling it in essence. The *Madonna of the Steps* (Florence, Casa Buonarroti, *c.* 1495)[10] makes an almost reactionary reference to precedents in Donatello, and at the same time, in heavy dignity of form and clarity of order, depends on Masaccio: the dignity of one model has been used to correct the intensity of the other. A powerful but generalized and restrained spiritual content has been synthesized effectively with a massive gravity of form. The concord between form and content is in their mutual grave power, and a device for binding them together has been found in the rhythmic mode of the design: a slow-weaving, rounding continuity, inspired with a controlled force. Details of description, for all their fineness, are subsumed within the generalization of design. The nascent but already explicit

character of classicism in this relief shows little that may be specifically dependent upon ancient art, but the sense of a relation with the antique style is so strong as to have suggested the possibility of Michelangelo's knowledge of antique stelae (perhaps indirectly, in a gem). In any case it is clear that the process of reciprocal illumination between Michelangelo and antique art had already begun.

The fuller emergence of a classical style in Michelangelo depended on the completion of this illumination. What could be learned of antique art in Florence did not suffice for this; it required the experience of Rome. Michelangelo went there in mid 1496, and within the next year made the life-size *Bacchus* (Florence, Bargello): a reconstitution of an ancient classical style which is, in the same instant, the absolute constitution of a modern classicism. Because it is a creation as much as it is a recreation, its classicism is not interchangeable with that of antiquity. Within its mould of antique form and subject matter the *Bacchus* makes a unity between things which, in the course of Christian culture, had become polarities: human substance and its content of the spirit. The spiritual presence of the *Bacchus* is felt not only in his countenance and gesture but in his flesh, which spirit seems to pervade and infuse. It makes a unity, but not the effect of an indissoluble essence we perceive in authentic ancient classic art. For all the beauty and idea of worth attached to the physical – even sensual – being of the *Bacchus*, it is still a vessel for a separable spirit, which we know here by a subtlety of psychic state – a controlled febrility – that exists in no ancient prototype. This reconstitution of a classical unity is not only different from the classicism of antiquity in the fact that it is a reconstitution; its difference will continue to be marked by the self-conscious effort needed to sustain the artifice it is and the aspiration of modern classical culture it represents.

The same conviction of spiritual presence finds easier habitation within traditionally Christian themes, as in Michelangelo's *Pietà* (Rome, St Peter's, 1498-9), which is no less sincerely Christian than the works of the Savonarolan Botticelli. The feeling Michelangelo depicts is no less profound than Botticelli's might be, but it is contained by an ennobling dignity. As in Leonardo's actors in the *Last Supper*, which is contemporary, in Michelangelo's Virgin there is the sense of a dimension of humanity grander than our own, and this is not only of a psychic but of a consonant physical presence. The sculpture is inevitably less complex than Leonardo's fresco, but it reveals in almost all essential aspects that Michelangelo has attained a stage in the formation of a classical style comparable to Leonardo's, drawing almost abreast of the older man's development of more than two decades.

Nevertheless, when on his return to Florence in May 1501 Michelangelo encountered the living and contemporary fact of Leonardo's art, he found it an important guide, less towards wholly new ideas than towards a new stage in the evolution of conceptions that Michelangelo had already entertained. He was prepared, now, as well as willing to profit from Leonardo's demonstrations, but with an essential reservation: Michelangelo could not accept – or, more exactly, could not but reject – the ideal of humanity formed by Leonardo's temperament and the tenor of expression that went with it. The attention that Michelangelo directed to Leonardo's style was to the core in it of formal structure. Probably as soon as he had seen Leonardo's *St Anne* cartoon of 1501, Michelangelo paraphrased it, with much vigour but no trace of Leonardo's grace, in a drawing (Oxford, Ashmolean) that is concerned mainly with the working of form into a compact interwoven unity. About 1504, the chief work in painting that Michelangelo was to execute in this Florentine phase, the tondo *Holy Family* for Angelo

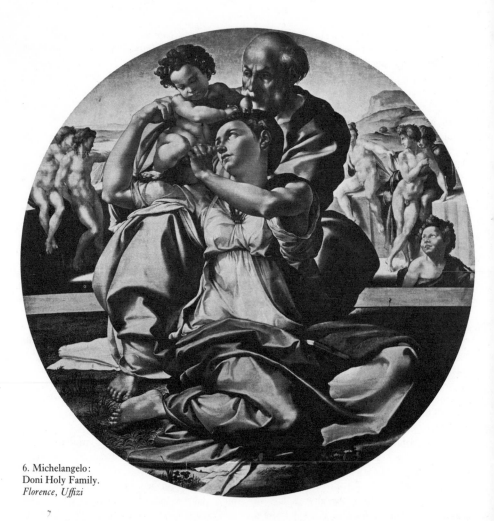

6. Michelangelo:
Doni Holy Family.
Florence, Uffizi

Doni (Florence, Uffizi) [6], is, in all but its exact subject matter, still visibly related to Leonardo's cartoon, and the nature of the relation is at once of dependence and of rivalry. Michelangelo seems to have set himself the task of bettering Leonardo's solution to the problem of classical structure – in Leonardo's own terms first, but also in a transposition of them into the preference that Michelangelo had by now conceived, even when he might be painting, for the terms of sculpture. The cartoon of 1501 affords the basis of design of the Doni painting: in particular Leonardo's device is re-used here of including one main form not only in the silhouette but within the spatial embrace of the form behind. Michelangelo had already probably adapted it from Leonardo, but in more rudimentary fashion, for the design of his sculptured *Bruges Madonna*. As in Leonardo's model, Michelangelo imposes a

continuous contour on his painted group, and further reinforces its effect by reference to the containing shape of the round frame. Then, in a way that seems more consciously aggressive than in a work of actual sculpture, he defines the plastic existence of the painted group and its parts by intensest modelling and deep excavation; he then joins these parts into a connected sequence as if they were interdependent pieces of a single mass of stone. In this sculptural language he creates an absolutely compact, deeply differentiated unity, of a force of impact far beyond that of Leonardo's model. Also exploiting a precedent in that cartoon with his sculptor's sense, Michelangelo has developed the former's mode of moving form in space into an assertive spatial contrapposto, which will reappear constantly in his succeeding works.

The structure of the Doni Tondo reveals a development, on a basis afforded by Leonardo but exceeding it, of a principle of classical style: it is a progress in the exposition of controlled energy internally articulating a unity of form. The classicism of the picture is, however, almost confined to this character of structure: it was not created with a pervasive classicism of state of mind. It is a statement only relatively meant that the expression of the subject matter, unlike that of the Roman *Pietà* or the *Bruges Madonna*, verges on the conventional. In this, the tondo seems almost to recall Michelangelo's first master, Ghirlandaio; also recollective of that first training is a hard clarity of technique and a tendency to precise description of detail. Colour, too, is based on Ghirlandaiesque precedent, but with stresses of clarity and intensity that in places make it as assertive as the plastic form to which it adheres. The ideal realized in the design of the tondo is not matched, then, either in the spiritual content of the actors or in their more specific elements of form. But these disparities cannot impede the sheer force, of idea and form, that Michel-

angelo has found for his design: its content, a concentrated unity of vital power, holds more and higher expressive meaning than the persons in it.[11]

The relation of Michelangelo to Leonardo, of dependence and rivalry at once, that is implicit in the Doni Tondo became overt late in 1504 and in 1505. Just as Leonardo was completing his cartoon for the *Battle of Anghiari*, Michelangelo received the commission, in August 1504, for a companion piece to decorate the great Salone of the Palazzo Vecchio: its subject, the surprise attack in 1364 of Pisans on Florentine troops bathing in the Arno near the town of Cascina, which the Florentines turned into a victory.[12] The direct confrontation with Leonardo compelled Michelangelo to study what the former had done and perhaps to make some kind of accommodation to it. The formative influence of Leonardo's battle piece on Michelangelo's is unmistakable, but the distinction between them emerges still more strongly. Michelangelo's scene betrays a persistent link with Quattrocento modes of thought, and on this account with Quattrocentesque elements of style (as in Signorelli). Unlike Leonardo, for Michelangelo the subject 'battle' held no ideal or essential sense; what he found in it was a pretext for an exercise in dealing with anatomy in action. Painting or not, he confronted this narrative with a sculptor's mind and in sculptor's terms. His conception of the *Cascina* in this most anthropocentric sense implies a kind of ideality, but one narrower than Leonardo's and also less synthetic. Instead of a meeting, as in the *Anghiari*, between artist and subject there has been a constraint of the subject to the artist's interests and will. Michelangelo confronts us with a set of virtuoso demonstrations of a sculptor's supreme formal knowledge, and it is his pride that is the most pervasive and convincing content of the picture. We feel the assertiveness of Michelangelo's genius, which wills not only to com-

pete with Leonardo but to demonstrate its superiority over every analogue in the past, including those in Michelangelo's own art. For the brief while it survived, the cartoon displaced the Brancacci Chapel as the Florentine academy of art. Its matter, in effect, consists of what we call 'academies', in which Michelangelo's preoccupation, as in the immediately precedent Doni Tondo, is primarily with problems of form. No force of gesticulation or any urgency of facial expression the lost original may have held could have been more eloquent than the artifices of posture in the cartoon, or equalled them in interest. The alarm of the arriving enemy is pretext more than true motivation for the actions of the naked or half-clothed soldiery; they are moved by the artist, not by their situation. In spite of a development of classicizing structure in the figures, there is a disparity between the bodily forms and their humanly expressive content which, by Leonardo's paradigm, is not wholly classical. Indeed, in his emphasis on formalism and virtuosity in the *Cascina* cartoon Michelangelo anticipates the mentality of post-classical art.

Michelangelo's *Cascina* project went even less far than Leonardo's *Battle*. Michelangelo's work on the cartoon was interrupted in the spring of 1505 by his summons to Rome to undertake the design of the tomb Julius II thought to erect for himself in St Peter's. When that Roman project was set aside, Michelangelo returned to Florence in the spring and summer of 1506 and then completed the central section, the *Bathers*, of the cartoon, but he may never have begun its transfer to the wall. The cartoon had of necessity been involved in some ways, even with the extreme sculptor's bias it displays, with painter's problems. We have sparse evidence of the design Michelangelo conceived for the tomb in 1505/6 (the first in a sequence that was to extend over more than thirty years), but enough to tell us that it marked his entire rededication to the sculptor's

special problems. This is relevant to the history of Michelangelo's painting: the conception and the making of the ceiling of the Sistine Chapel in the Vatican, which followed on the first design for the tomb and which Michelangelo was compelled to undertake instead of it, was affected essentially by his thinking for the tomb design. There, he had quite put aside the picture-maker's cast of mind that made him think, however inadequately, in terms of groups of forms and the (Leonardesque) requirement to link them by rhythmic devices into a unity. The design of the tomb reverts instead to the basic unit of the classicizing sculptor's thought, the single figure, and in consequence requires a different concept of attaining unity. The sculptor's unity that Michelangelo evolved is more abstract than Leonardo's in both the form and the content with which it works. Formally, this unity is achieved in the association of figure forms with forms of architecture. In this relationship the block of stone from which the figure grows is conceivable as a living outgrowth from the geometrical substance of the architecture, but conversely and at the same time the architecture is a reduction to geometry of the figured forms. In content the unity is not illustrative, as in painting, but thematic, and this unity of theme is articulated not in concerted action but in diversified human symbols. The tomb design also makes it clear that Michelangelo has put aside the expansiveness of action of anatomy in space of the *Cascina* – so unproblematic to assert in painting – and instead now faces, as a sculptor, the limits upon spatial action implied by the block: this limit now tends to acquire, in a way quite distinct from the sculptural habit of the fifteenth century, the authority of an ideal geometric value. This is a reinforcement of a classical character of form in sculptor's terms, of the basic figure unit, and it is within the ideal limits of the single sculptural form, rather than in a wider composition,

that Michelangelo expresses his most cogent will towards unity.

These elements of an explicitly sculptural variant of classical aesthetic carry over into Michelangelo's invention, in 1508, of the ceiling of the Sistine Chapel; however, the relation to the ceiling of the tomb design is still more exact. That design was not abandoned with the suspended project for the tomb: it became the basis from which Michelangelo evolved his design for his vast fresco,[13] transposing the major elements from one to the other, as if the scheme intended for the tomb should be unfolded flat upon the ceiling space. On that space, Michelangelo has made the semblance of a closed monumental structure richly populated by sculptured-seeming forms, as the tomb was meant to be. An architecture projected in paint (in a perspective internally 'correct' but not illusionistic to the spectator) holds Prophets, Sibyls, and nude male forms (the *Ignudi*) placed in it as if they should be single sculptured figures, inserted in a niche or set up on an architectural base. In the topmost, central, panels of the ceiling nine scenes illustrating Genesis are painted flat upon the ceiling plane, envisioned, and also framed, as reliefs might be on the surface of an actual monument. Even the colouring that Michelangelo employs grows out of his initial sculptural conception. The dominant tone is that of the fictive stone of the framework of architecture and of the nude figures that inhabit it, whose flesh is muted towards ancient marble. Where the figures are clothed, as are the Seers, their colours – though they become, as painting proceeds, increasingly fluid and harmonious – seem often like the varied patinas of old bronze: the draperies evoke the memory of metal.

The whole scheme retains the sculptor's mode of thinking in terms of single figure units, and the manner of relating them is exactly that which Michelangelo had evolved for the tomb. As there, unity depends first on the formal interdependence of the figures with the architecture, then on the progressive interlocking of units of architectural form, and finally – here more visibly than in what we can deduce of the first tomb design – on repeated balancing concordances among all the forms. With this sculptor's aesthetic Michelangelo achieves a unity as compelling as any in the art of his contemporaries, and more extensive.

The commission for the Sistine Ceiling was given Michelangelo most likely in March 1508, and the work of its design began probably in May. The conception he first entertained for it,[14] based on subject matter that would have been suggested by the Pope, was nothing like so elaborate as the one put into execution. The first scheme consisted of twelve figured spandrels with Apostles in them, and only abstract patterning elsewhere on the vault. Michelangelo much later explained, in a letter of 1523,[15] that he found this insufficient – too 'poor', apparently in both theme and form – and was then given permission to 'make what I wanted, whatever would please me'. What pleased him, we observed, was to create a painted substitute for the abandoned tomb. However, we do not know to what degree the new subject matter, with its necessary effect upon his ideas of design, was Michelangelo's own invention, and how much the result of consultation with authorities available in person or in print.

It has long since been pointed out that the theme of the ceiling is, in general, a complement to the pre-existent decoration of the walls below, and that it illustrates the history of man *ante legem*, in prelude to the history *sub lege* and *sub gratia* that Pope Sixtus's artists had depicted almost thirty years before. In its middle range of panels the ceiling tells a summary history of Genesis: the creation of the world and man; man's first sin and fall and its echo in a second fall. The core of meaning of this story is in the central panels, where man is

made who then makes sin, and so requires re-
demption by the Christ. Around this history,
in the prophetic thrones, are those who foretell
man's redemption by the Son of Man, alternat-
ing Prophets of the Old Testament and Sibyls
of classical antiquity; the Sibyls appear in a
Christian context and are taken in the sense of
their meaning for Christian dogma. Below
these Seers are the Ancestors of Christ, in
whose line is the long generation of his coming,
and in the four pendentives there are Old
Testament narratives which refer prophetically
to Christ's mission of salvation and to his sacri-
fice of Crucifixion. The main elements of sub-
ject matter in the ceiling, with their intrinsic
literary content of tragedy and prophecy, are
deeply moving in their common theme, in
which they make a perfectly apparent general
sense. With surpassing power to convince, the
Sistine Ceiling basically means what it instant-
ly and evidently says.[16]

However, in a more specific dogmatic or
theological sense, it is not always quite clear
what the various thematic motifs mean, or
how they relate precisely to each other. The
Prophets and Sibyls are certainly connected
with the scenes of Genesis they adjoin by
literary allusions, sometimes overt but more
often abstruse or, to us, evasive. It may be
more important that the literary justifications
that exist for the Seers have been absorbed in
and in some cases obscured by the expressive
and aesthetic meaning Michelangelo has con-
ceived for them. For the secondary figures who
attend the Seers – the caryatid putti on their
thrones, the bronze-coloured men in the spaces
between them, and the great Ignudi above –
precise literary explanation seems still less ac-
cessible. Yet they appear to hold a general sense
that is decipherable, which enriches the overt
meaning of the central theme and makes it dog-
matically more profound. Their presence adds
to the history of man *ante legem* and the pro-
phecy of his redemption by Christianity a

commentary on the moral situation of man in
that pre-Christian time. There is a spiritual
hierarchy in these figures and the Seers whom
they accompany. The bronze-coloured nudes,
dark and darkly imprisoned in the spandrels
next to the Prophets' thrones, are the anti-
thesis of the Seers. They suggest the idea of
barbarian peoples of pre-Christian times, in-
accessible to the prophecy of Christ's coming:
captives of an ancient ignorance, they have no
sense of the history that surrounds them. The
Ignudi [9] suggest another place in the scale of
awareness, between the absolute illumination
of the Seers and the dark ignorance of the
figures in the spandrels: they would be the
creatures of the ancient pagan world, who are
half-conscious of the meaning of the history
they attend and the prophecy they oversee. The
bronze-coloured nudes are almost animal in
nature, moving in contortions like those of
caged beasts; oppositely the attitudes and ex-
pressions of the Seers are precise and purpose-
ful, dictated by an ultimate explicitness of state
of spirit and of mind. Between the two, the
Ignudi are possessed by moods and express
themselves in posturings that are neither wholly
rational and inspired nor merely physical and
animal. They are beings in whom the mind and
soul have not yet assumed, as in the Christian
habit of belief, a separable identity from the
flesh. As for the caryatid putti: if we continue
to assume that things basically mean, in the
ceiling, what they evidently say, it may be that
they stand in fact for *Innocenti*. They would
represent a state of man that precedes Know-
ledge, and they may allude as well to the
children whom Herod sacrificed as later he
would be an instrument of the sacrifice of
Christ, which the ceiling as a whole foretells.

The role I discern in the Ignudi would ex-
plain the conjunction in them of pagan beauty
and Christian disquiet of personality, and
would justify the presence of these figures, so
much more precisely recollective of the ancient

classic world than the Sibyls, in the Christian context. The history of pre-Christian man becomes, by their presence and that of the bronze-coloured nudes, enriched by a symbolic and anonymous population of antiquity. The nudes are not participants or spectators but concurrent presences in the pre-Christian history, either blind to its meaning or half-knowing of it; but at the same time its meaning is resonant through and differentiated in them. The conception – not only in the nudes but in the Seers – of a division of humanity into strata that are different in their proportion of spiritual to physical content, and in their articulation of a distinguishable and rational soul within the body, is the profoundest demonstration (and the first one formulated in terms of visible ideas) of the nature of man as classicism within Christianity conceived it.

The sources of this thinking are of course generally neo-Platonic, but there is no definition we know in neo-Platonic writing of a proposition quite like this. In the figures of the ceiling it is demonstrated that the human physical being untouched by Grace is animal in nature and behaviour; it is in proportion as the creature has knowledge – here foreknowledge – of Christ that the soul is a distinguishable essence and no longer confounded with the tissues of the body. In beings like the Seers who know Christ, or in Adam who is made by God directly, the soul is inspired and distinguishable from the mortal flesh; but that flesh is infused by the soul, directed by it, and expressive of its force and splendour. It is this last conception that the classical style within Christianity intended as its ideal. In the ceiling this conception is exactly articulated for the first time, in the context of a history, and in the guise of a process that history reveals.

The iconography and the general design of the ceiling were worked out by the end of 1508, and by January of the new year Michelangelo began the labour of execution. Almost four

years later, in early October 1512, the vast enterprise was done. Evidence exists for the painting's intervening history which, though much of it is in Michelangelo's own words, has never altogether satisfactorily been sorted out. The best deduction we can make (taking account of the longer interruptions of work that we are sure about) is that after some initial difficulties with the new technique, the execution proceeded at the rate of about three months per ceiling bay (including the lunettes on the adjacent walls, executed more or less contemporaneously with the bays above). Painting began at the eastern end of the chapel, in this case towards the entrance rather than the altar, and seems to have been carried towards the altar in a sequence that approximately, but by no means inflexibly, follows in the order of the bays. At the end of August 1510 Michelangelo finished a major section of the work and uncovered it: by our reckoning it is most likely to have been somewhat more than half the ceiling's extent, up to its fifth bay. A second section of the finished work was uncovered before 14 August 1511, presumably (since there had been an interruption in the work) no more than two or three bays farther on. From midsummer 1512 Michelangelo refers to an imminent completion, which he announced finally early in October.[17]

When at the beginning of 1509 Michelangelo turned to the execution[18] of what he had conceived for the decoration of the ceiling, his first effort was in the large panel of the second bay from the entrance end of the chapel, with the depiction of the *Flood*: the evidence of style confirms the statement the biographer Condivi made to this effect. Confronted with a large field and a dramatic narrative that required many actors, Michelangelo turned for inspiration to his own precedent in the *Cascina* cartoon and tried, as he had there, to deal with his theme at least partly in painter's terms, with somewhat more success. The design is spread

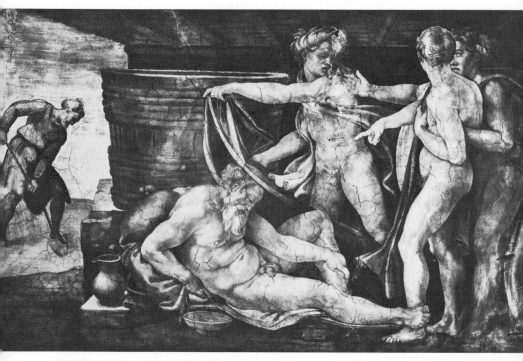

7. Michelangelo: Drunkenness of Noah.
Sistine Ceiling, 1508–12, *Vatican*

across the picture field and into space, and there is a visible concern to bind its parts by continuities of rhythm. Yet the sculptor's will is not diminishable by much: the primitive, nude actors are projected in paint as similes of sculptured forms, intensely tactile. Despite the measure of pictorial intention in it, the *Flood* is in a limbo between a painter's and a sculptor's aesthetic. In the second history to be painted, the *Sacrifice of Noah* (in the third bay from the entrance, in one of the smaller fields reduced by the presence around it of Ignudi), Michelangelo is still preoccupied with the painter's problems that have been forced on him, but in a narrower and less alien range. He has carefully 'composed' his figures, making them into a rhyth-

mically ordered oval pattern of design. But at the same time he has dealt with the design sculpturally, condensing forms into a unit and sealing off the rearward space. The effect of structure which results tends towards that of classical relief – the apposite solution to the confrontation of a sculptor with the demands of pictorial art. Indicated in the *Sacrifice*, the terms of this solution are explicit in the third in order of execution of the histories, the *Drunkenness of Noah* in the easternmost bay [7]. In this fresco Michelangelo reduces the pictorial effect of space to a near minimum, enlarges the scale of the figures within the frame, and distributes them along a narrow plane adhering to the surface. They are connected with

more fluency than in the *Sacrifice*, but now not at all into depth but only in a lateral sequence. In a wholly overt way the conception is an analogue of classical relief. Michelangelo is no longer concerned with the making of an image as a painter would, but in the *Drunkenness of Noah* he has, finally, found entire confidence and ease in the use of a fresco painter's technique.

It was with this quota of experience that Michelangelo began the first Ignudi and the first Seers of the ceiling. In them there was not at any time a conflict between sculptural and pictorial aesthetic: they were initially conceived, as we observed, as if they might be sculpture, as solid figure elements upon an architectural support. The order of evolution of these figures is yet more apparent than that of the histories. Having done the *Drunkenness of Noah*, Michelangelo must have continued in the first bay, painting (in obvious descending sequence on the vault) its Ignudi and its pendant Seers, the Delphic Sibyl and the Prophet Joel; the *Zachariah* of the spandrel preceding the first bay seems also to have been done within this time. All these figures are contained in form and movement, disposed more or less rigidly in an axial and frontal or in a profile scheme. The effect of an analogy with sculpture is most marked in the *Delfica* and *Joel*, even as the former in particular recalls the formal logic of the Florentine tondo. Joel is informed by a higher energy of spirit than the Delfica, expressing a contrast of principle that will persist throughout the ceiling between the male force of the Prophets and a lesser spiritual vigour in the Sibyls. More not only than the Delfica but than his companion Zachariah, Joel makes the spectator know that Michelangelo will henceforth speak about a new dimension of humanity. Joel's controlled energy and scale of form convey that they are the reciprocal of a state of mind: he makes the impression of a being magnified in body and spirit far above the normal status of humanity.

Above Joel, a first pair of Ignudi are in quiet, literally corresponding poses in plane against the wall; above Delfica the matching pair[19] move only gently forward from it. All four seem possessed by a veiled melancholy, as if their function might have been like that of a chorus, of commentary on the scene they frame. But in the second set of Ignudi, around the *Sacrifice* in the third bay, this idea has been set aside. These nudes are not bound to the theme and mood of the history that they adjoin but only to the idea the Ignudi collectively express. Each pair echoes the postures of his pair of predecessors on the same side of the earlier bay, but with a major difference in degree of liberty and energy, especially of movement of the figure in its space. Their feeling, quite unrelated to the scene above, is similarly much more varied and assertive. Below them on one side is the Sibyl Erithrea, freer and more elaborate in movement than the Seers of the first bay and grander in dimension than the male Joel, but not so inspired. Opposite her, Isaiah, equally on grander scale, embodies Michelangelo's new idea of a stature of humanity, and does so with a subtlety that complements the Prophet Joel's controlled force. Isaiah shows a spiritual power not instantly expressed but in the process of unfolding, between meditation and inspiration. To say this, Michelangelo finds a new reach of articulateness, more exactly commanding painterly and draughtsman's skills than in any previous episode on the ceiling. He makes Isaiah's body echo and reinforce in every part the state of spirit revealed on his face, so that the whole person tells us of his slow-awakening might. If we contrast Isaiah and Erithrea with their surmounting Ignudi, it becomes clear that these two classes of being belong to distinct orders of emotion and idea. The feelings of the Ignudi are those of a category of humanity lower than that of the illumined Seers: what the Nudes express is tinged with the animal or the irrational, and their

energies are in some way finally bound, slave-like, by the duty they perform of holding up the great bronze-coloured medallions swung between them.

The increase of energy, freedom, and variety that is visible in each successive step that we can trace in the painting of the first three bays is accelerated in the two that follow. The fifth bay, a long one, exactly in the middle of the ceiling, seems to have been decorated earlier than the fourth. Its narrative panel, the *Creation of Eve*, is more painterly in technique and at the same time structurally even less pictorial than the latest preceding narrative, the *Drunkenness of Noah*: here the ordering of form is absolutely in a mode of classical relief. The figures are expanded to the largest scale within the frame the subject will permit; massively modelled and set out laterally on the foremost plane, they wholly prevail over any sense of space. To the interpretation of the subject Michelangelo has brought not only the new reach of power he had found for the *Isaiah* but the subtlety of articulation he had devised there. The result is a re-creation of the biblical event so poignant psychologically and so physically explicit that the spectator is compelled to experience it almost empathically. The Ignudi near this scene are no less articulate, conceived in a new range of freedom and diversity of posture and on a larger scale than the Nudes before. The Seers of the fifth bay, Ezekiel and Cumea, share, though less evidently, in this increase of expressive energy and scale. It is in the larger picture area in the preceding bay, with the *Temptation and Expulsion*, that we are made decisively to feel the effects of a change in scale: it is in this scene that the splendour of physique, the power of movement, and the resonance of feeling in the actors take on the character of the heroic. The figures have not merely grown in size: their expression comes from the accretion in them of both force and

depth of meaning. The magnifying of the human form is in response to the growth in dimension of Michelangelo's ideas of its content.

In the *Temptation and Expulsion* the figures act in a setting as summary as that in the *Creation of Eve*. That panel had referred back to the precedent of Jacopo della Quercia, and the *Expulsion* of this bay recalls Masaccio: Michelangelo's description of environment is not much less abstract than either. However, in the fourth bay Michelangelo arrives at an important difference in his exposition of the idea of relief-like design. Now that his command of the painter's techniques is absolute, and he has come to understand their value and resources fully, he arrives at a definitive solution to the problem that the narrative panels of the ceiling posed of conflict between the painter's and the sculptor's language. He creates a painter's atmosphere around his figures, and describes their modelling with painterly chiaroscuro, but as Michelangelo applies them to his forms these painter's means increase their effect of plasticity. The figures become more visually credible and more tactile-seeming substances until they convey, as much as their accompanying Ignudi and the Seers, the sense of presences in the full round. Sculpturally plastic form, set within a summary pictorial ambience, has been described with the fullest powers of a painter's hand.

The *Creation of Adam*, in the sixth bay [8], affirms this solution still more explicitly, emphasizing through the expert painter's means that it is still more essentially sculpturally conceived. Two great plastic units make up the design, of a simplicity exactly proper to Michelangelo's idea of the theme: the confrontation in a high bare world of the first man and his Maker. For the moment Michelangelo's and God's roles merge: God acts the classical sculptor. He has just shaped the first image of

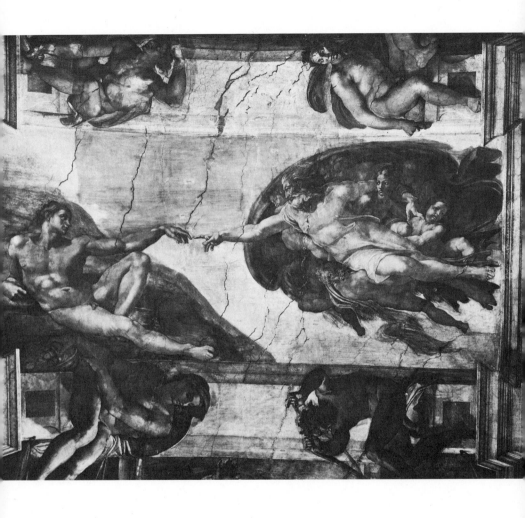

8. Michelangelo: Creation of Adam. *Sistine Ceiling*

a man, giving him such beauty of physical being as should belong to the ideal ancestor from whom we imperfectly descend. He hovers above His creature in the act of endowing it with its content of life and soul. The vital spark flows from the outstretched hand of God into the matter He has shaped, and in response this matter begins to live, to move physically and to feel. The body of Adam shows precisely how and to what degree it is, at this instant, infused by vitality: each part of the anatomy articulates how much it contains of energy and how much is still inert flesh. The Adam illustrates the essence of the classical idea of interpenetration of the physical and spiritual being, but he also illustrates the non-classical origin of this re-creative synthesis: the flesh and spirit are conceived of as initially separate elements, and it is the spirit, divine in source, which controls and moves the flesh. At the same time the splendour of the flesh and its worth of beauty are as much the work of God as its inner radiance of soul: the beauty of divine creation is in the archetypal substance of the first man as well as in his spirit. What Michelangelo thought God meant by the idea of man and what, thus, humanity was meant to be was this Adam before the deformation of experience: by God's will and grace, a hero, the mortal counterpart of God.

The *Creation of Adam* inaugurates a new stage in the execution of the ceiling, begun probably in February 1511 after a hiatus of some four or five months. Its idea and form are by a measurable stage of still grander effect than the *Temptation and Expulsion*, and its figure scale conforms, roughly, to that in the succeeding scenes. But the other figures in the decoration of the last few bays are on a grander scale still, in a marked acceleration of the process – till now relatively gradual – of growth in their external and internal stature. The Ignudi and, even more, the Seers expand in scope and power of idea. In the large panel of the *Crea-*

tion of the Sun and Moon (in the eighth bay, probably next after the *Adam* in time of execution) God is depicted as creating with a terrible dynamic energy, hurtling through the heavens like a celestial body. In the smaller panel that precedes this one, most often referred to as the *Separation of the Earth and the Waters*, God's movement is altogether contrasting, a slow-gliding majesty. His image takes a shape, extremely simplified and generalized, which even more suggests the merging of God's human form with that of a celestial sphere. As Michelangelo ponders the first episodes of Genesis, his conception of God's nature and action becomes higher and more remote, apart from incident, narration, and materiality. In the last panel of the ceiling [9] the first act of Genesis is represented in an image that reduces meaning to an essence, reaching as if above and through the first bald sentence of the Bible to a vision of a hardly apprehensible God, seemingly newly self-formed from the surrounding chaos. He turns in chaos – a cosmic simile suggests itself, unknown to Michelangelo, of a solar body in its process of formation – seeking to shape the dark reaches where there is as yet no form and no direction. The idea of this image, so exalted and so nearly abstract, is given us in a corresponding language, so general as to border on abstraction.

The last two sets of Ignudi also seem, by comparison with their predecessors, to have been generated in a higher range of Michelangelo's invention – still applied, however, to the theme they are required to illustrate. Their emotions are more intense but no less irrational than before; the Nudes are still enslaved by their bodily existence. Proceeding from the idea of physical splendour devised for the created Adam, their bodies elaborate that con-

9. Michelangelo:
Separation of Light and Darkness, and Ignudi.
Sistine Ceiling

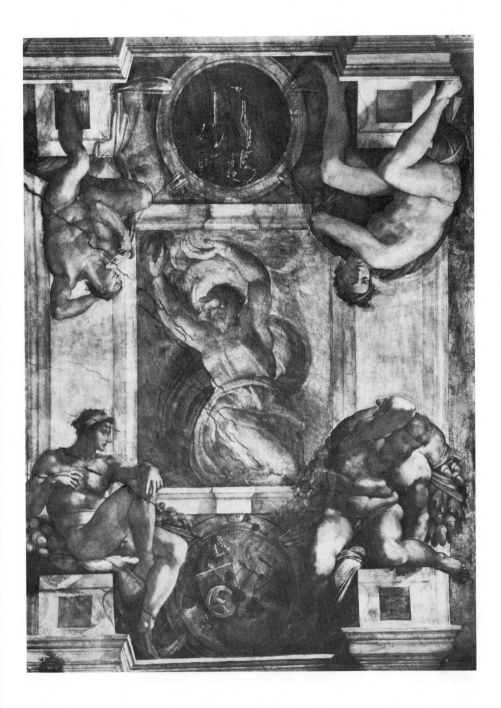

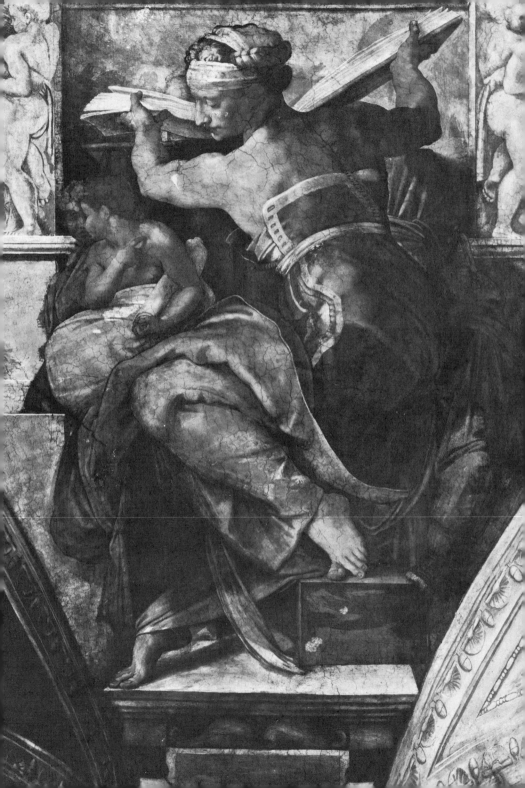

ception or surpass it. The last Ignudi have forms more powerful than Adam's, or both more powerful and fine, and in them Michelangelo has at last won his long private war with the *Laocoön* (which he had known since it was unearthed in 1506) and surpassed the envied model of the Belvedere Torso. But we are impressed in most of the last Ignudi by the sense that in their archetypal beauty or their archetypal strength they no longer seem possible or credible images of human being. In some way they share the extreme ideality with which Michelangelo has conceived the image of God above their heads. The proportion of ideal invention and of plausible description in them has been decisively weighted towards the former. This shift, by which the image is removed yet farther than before from natural appearances towards an idea invented in the artist's mind, marks a clear change from the conception of a classical ideality that Michelangelo had demonstrated in the ceiling's middle range, there a kind of median.

The change may be more marked among the later Seers. In them new energies and depths of thought are released in forms of consonant, and overwhelming, scale. In the *Daniel* of the seventh bay an impassioned intelligence works like an electricity, inspiring swift and subtle action in his gigantic shape. On the same scale, his counterpart, the ancient *Persica*, contrasts a slow-moving, heavy power to his. The Seers around the last bay may be touched with a still higher ideality: each approaches closer still to the effect of archetype. Each, within its higher ideality, conveys an idea differentiated from the others in its kind. The *Libica* [10], superbly poised, seems above all else a demonstration of the idea of a formal beauty, as if this idea should have assumed a sense that could be separately

10. Michelangelo: Libyan Sibyl.
Sistine Ceiling

identified within the larger idealizing process of classical style. In the concern in the *Libica* for formal beauty as a primary ambition and in her complex elegance she is an art-historical as well as a religious prophetess, foretelling the aesthetic of the post-classical Maniera. *Jonah*, at the western end of the vault, differently seems to foretell a baroque. The most terribly inspired figure on the ceiling, he moves with a vehemence that strains the concept of classical constraint. To his left, *Jeremiah*, Prophet of Lamentations, is as grandiose, but opposite in his expression [11]. The power of feeling in this Prophet, as great as the expansive passion of the *Jonah*, is turned in on itself: Jeremiah's great, compact, gathered form expresses the dimension of his thought and its concentration. Every other Seer has been given some pretext of action or of illustrative incident, but Jeremiah has no 'motive' beyond that of his thought. This slow-breathing, meditating monolith embodies, more than any allegory, the concept of thought itself, in that dimension of it Michelangelo himself has now attained: Jeremiah is the image of Michelangelo's Idea. In ways that are different in their form and in intent of content, these last three prophetic figures express aspects of the same conception that dictates the image of God in the final bay. Like Him, all three Seers are no longer idealized representations but, instead, representations of ideas; and Michelangelo's evolution in the ceiling may be summarized in this inversion of a phrase. In the process of this inversion he has moved towards an ideality so high that it now stands at the limits of a classical style.

In the pendentives at the western end of the ceiling Michelangelo finally trespassed those limits. What had occurred between the first and last bays of the vault was all encompassable within a definition of classicism, but what has happened between the first and last pendentives shows, beyond their development, a

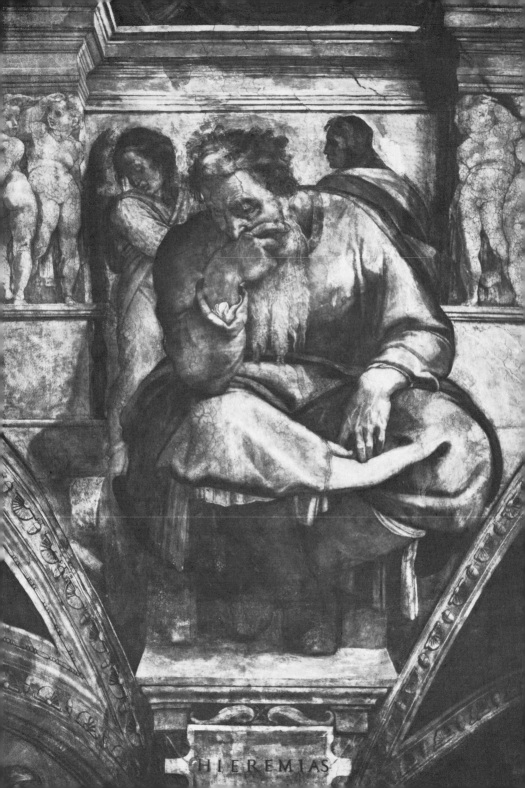

HIEREMIAS

11 (*opposite*). Michelangelo: Prophet Jeremiah.
Sistine Ceiling

12 (*below*). Michelangelo: Brazen Serpent.
Sistine Ceiling

cleavage in conception of artistic style. In the *Hanging of Haman* the single forms of which it is composed are still classical, but the manner of composing them is not. There are, in the *Haman*, a violation of the rationale of space, a blunt yet restless order of design, and a dark violence of mood that can no longer be called structurally or expressively classical. Even more than the *Haman*, the pendentive of the *Brazen Serpent* [12] is conceived with a vio-

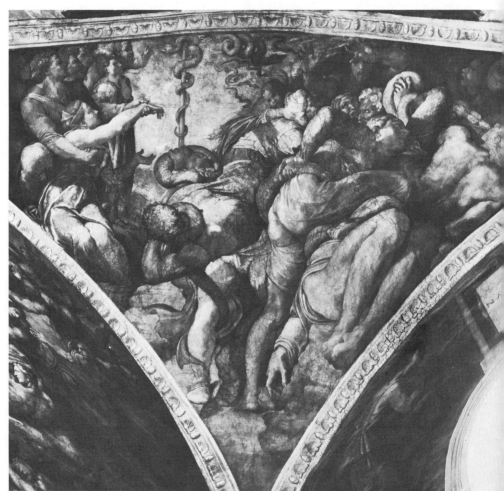

lence of emotion and an abstractness and illogic of form that remove it from recognizable classical principles of style. In both pendentives, moved perhaps in part by the drama of their subject, but more by a climactic surge of his own expressive intensity, Michelangelo's force and ideality acquire, for the moment only, an apocalyptic nature. In this momentary breach of the confines of classicism the pendentives take on, prematurely, the character of post-classical phenomena of style, Mannerizing in the *Haman*, and in the *Brazen Serpent* simultaneously Mannerizing and Baroque. No development in any other artist is comparable to this one of Michelangelo in the Ceiling. In four years he accomplished an evolution that embraced, in summary and essential terms, the possibilities of the High Renaissance classical style from a relatively elementary to an apparently final stage, and also tested its impossibilities. The ceiling may be not only the highest but the swiftest flight of spirit ever undertaken by an artist.

Until he was summoned, more than twenty years later, to confront the problem of design of the *Last Judgement* on the altar wall of the Sistine Chapel, Michelangelo did no major work in painting. He returned to the profession he considered properly his, sculpture, and continued to give major example to his contemporaries in this field, first in Rome till 1516, then in Florence until 1534, when he returned for good to Rome. But the ceiling still remained the most extensive and in some ways the most overwhelmingly impressive of his accomplishments, and it worked with inevitable and increasing effect, as time went on, upon the progress of contemporary painting.

RAPHAEL

Born in 1483, Raphael was eight years younger than Michelangelo, and his difference in age from Leonardo measured three decades. Of the three great innovative geniuses of the High Renaissance style in Central Italy, Raphael carried the least accumulation of Quattrocento baggage with him into the new century; he was seventeen when it arrived. He was the son of a modest painter of Urbino, Giovanni Santi, who died when Raphael was eleven, but nevertheless gave him the first rudiments of art. According to Vasari (IV, 317), the young Raphael received his more substantial education under Perugino in Perugia, and this is likely to have been in the years following close after Giovanni Santi's death. In December 1500 the first document we possess for Raphael, a contract for an altarpiece (of which only fragments now remain) for Città di Castello, identifies him as *magister*, an independent painter.[20] He had assimilated Perugino's teaching to the point where, as Vasari saw it, Raphael's beginning mode and Perugino's could not be distinguished. The relation is in fact unusually close, but even the first works by Raphael reveal, beneath the resemblance to Perugino, a basically distinct idea of style. Raphael's entire artistic background, not just his training under Perugino, had been in the strongest continuing tradition of classicism in the fifteenth century, of which Piero della Francesca had been the mediator. In Perugino's hands the austere early classicism of Piero had become a style of détente, seeking easier naturalness and harmony in quiet, which too often verged upon inertia. Raphael's first identifiable instinct was to instil this style with a new aliveness, akin in gentleness to Perugino's détente mood but thoroughly pervasive. The working of this pulse of animation through the forms of Perugino's vitiated Quattrocento classicism creates a change of essence much more sensible than any surface alteration in the Peruginesque vocabulary of form: that this essential change is into a mature, Cinquecento, classical style is

suggested in the evidence that tells what the first documented altarpiece, painted in 1501, looked like (*Crowning of S. Nicola di Tolentino*; fragments in the Naples and Brescia Museums); it is clearer in the *Crucifixion* altarpiece (London, National Gallery, 1503) and entirely explicit in the *Marriage of the Virgin* (Milan, Brera, 1504).[21] They increasingly show a harmony that pertains to a cohesive whole – not, as in the Peruginesque style, a harmony of added parts. It is still a harmony of quiet, but with the sense of a movement in it as its forms relate to one another in cadenced continuity. A gentle pressure mollifies the shapes that the design contains, smoothing and rounding off the accidents of nature, making ideal images. The result is akin in principle, though hardly in precise effects, to Leonardo's and Michelangelo's propositions of a Cinquecento classical style. Raphael's invention seems more easily achieved than theirs, almost as if it might have been a natural effect of an evolutionary process by which classicism might move from an early phase into a maturity.

In the autumn of 1504, when Raphael transferred his residence to Florence, he thus possessed the bases of the modern style in which Leonardo and Michelangelo already worked, but by comparison what he had formulated seemed provincially simple and naïve. With the profound and intelligent receptivity he would exhibit in later years as well, Raphael set himself to learn from them, but from Leonardo mainly, more willing than Michelangelo to admit Leonardo's leadership in the new style. Raphael's four years of residence in Florence may be considered, with not much exaggeration, as a time devoted chiefly to acquiring what Leonardo had to teach. But to this process, which so easily could have become corrosive, Raphael brought a quality that was the positive residue in him of his provincial education – a corollary to his simplicity: clarity

of intelligence and feeling. His work in Florence is based upon a simplification and reduction of Leonardo's style, but this process is also a clarifying of it; he does not follow Leonardo into his torturing complexity of ambitions. Raphael's development in these years thus was a restating of the principles of Cinquecento classical style in terms of greater clarity than those of Leonardo and of easier intellectual and emotional accessibility. This restatement, unlike Leonardo's style (and in this degree unlike Michelangelo's also), carried nothing over from the Quattrocento except its heritage of classicism: Raphael's Florentine style is uncomplicated by the older artists' reminiscences. It assumes the historical significance not only of a redefinition but of the first definition of High Renaissance classical style in terms that are unequivocally of the Cinquecento.

The succession of Raphael's pictures through his Florentine years illustrates his absorption and, at the same time, creative exploitation of Leonardo's art. A series of Madonna paintings in particular, among the most popular of Raphael's works, has become a classroom paradigm for Raphael's developing command of classical style.[22] The *Madonna del Prato* (Vienna, Kunsthistorisches Museum, dated 1505) depends on Leonardo's *St Anne* theme, but over-simplifies its logic; the *Madonna del Cardellino* (Florence, Uffizi, late 1505-1506), which succeeds it, shows a fuller understanding of Leonardo's – and, in this case, perhaps also Michelangelo's – models of classical style; the so-called *Belle Jardinière* (Paris, Louvre, dated 1507) [13] must rely on Leonardo's third painted version of the *St Anne*, and like it fulfils a preceding evolution. In the *Belle Jardinière* Raphael has translated the intensity of temper and extremely involved artifice of the Louvre *St Anne* into a lighter ornamental grace, delicate and just in measure. But the knowledge and control of the formal means of

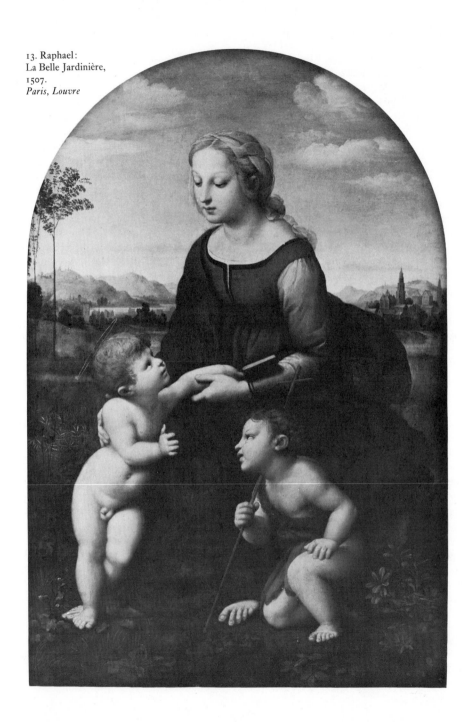

13. Raphael:
La Belle Jardinière,
1507.
Paris, Louvre

classical style that he now displays are comparable to those in the Leonardo models from which Raphael has learned. Having won this much, Raphael for a while followed Leonardo farther, into his corrosive emotional preserve, as if he should have found it vital to explore beyond the kinds of feeling native to him from his Umbrian character and at need surpass them. A few works of 1507 (e.g. the *Bridgewater House Madonna*, Edinburgh, National Gallery, Ellesmere Loan; *Holy Family of the Casa Canigiani*, Munich, Pinakothek), highly animated, shadowed and complex, are nearly imitative conjunctions between Raphael and Leonardo's mature style. A similar will to expression of increased intensity, but also on a grander scale, turned Raphael to the dramatic model of the *Anghiari*, and even more towards Michelangelo's companion *Cascina* cartoon: the latter especially was guide to Raphael in his sole large-scale essay in Florence in dramatic narrative, the *Entombment* for Atalanta Baglioni (Rome, Borghese, 1507). Raphael grasped Michelangelo's example adequately, but exaggerated its defects: the *Entombment* has still more of the character of an academy in it than the cartoon. The aspiration to new force of feeling and new power of effect in form are more important than his actual result. The *Entombment* marks the opening of an avenue of development that Raphael was later most effectively to explore. His last work on a major scale in Florence, in a more accustomed vein, an altar for the Dei Family, now called the *Madonna del Baldacchino* (Florence, Pitti, 1508), also prepares what he would later do in grander form in Rome. He has conceived a relation in this altar between figure composition and the setting of architecture that makes a resonance between them and confers upon the figures the architectural effect of an aggrandizement of scale.[23]

Later in 1508 Raphael went on to Rome, already recognized, at twenty-five, as a painter

of sufficient eminence to be called on to direct the major enterprise of decoration, other than the Sistine Ceiling, that Pope Julius had undertaken in the Vatican: the frescoing of the suite of state rooms, the so-called Stanze. The scale and character of the opportunity presented to Raphael, the impact of antique Rome, and the stimulus of the contemporary, Julian environment acted upon Raphael in a way for which his own just-previous invention in the *Baldacchino* altar is a metaphor. What he would come to create in the Stanza della Segnatura, his first Roman enterprise, is more than a logical development from what he had achieved in Florence: it is the result of a dramatic magnification, in the new setting, of Raphael's personality.

The programme given to Raphael to illustrate in the Stanza della Segnatura was itself of a kind to stimulate a classicizing character of artistic thought in him. It is certain – as it is not for Michelangelo, working in the Sistine Chapel near by at the same time – that Raphael did not command a literary culture sufficient to enable him to invent his programme. Its author or authors are not known; however, their idea is almost as remarkable a landmark in the history of classicism within Christianity as the form Raphael conceived to describe it. The programme grew out of the functions this Stanza had: its regular one that of a library; its more formal one that of a meeting place for the Papal tribunal of the Segnatura (seal), usually presided over by the Pope in his capacity of chief officer of the canon and the civil law.[24] The theme of law could be taken in the context of this room as a province of its normal function of a library, for it was the habit of the time to arrange libraries by 'faculties' like those in the contemporary university. For the walls of the Segnatura, then, four 'faculties' were selected for illustration as having most pertinence to the thinking of the Papal court and the most generalizable significance. Obviously, in this

room, these included Law, and, no less obviously, Theology, but also the two faculties that displayed the 'humanist' aspects of contemporary Roman thought, Philosophy and the Poetic Arts. To illustrate Theology, the programme gave Raphael the theme of an imaginary council of the great defenders of the dogmas of the Roman Church, supervised by a heavenly senate of saints and prophets and presided over by the Trinity [14]. The fresco is traditionally titled *Disputa*, and its disputation (not dispute) concerns the doctrine of transubstantiation, a matter of great general importance for Catholic theology which was at the same time highly topical, as well as a particular concern of Pope Julius. The opposite wall, given to the illustration of Philosophy (the *School of Athens*), is an ideal assembly of the great philosophers of the ancient world, led jointly by Plato and Aristotle [15]. In the juxtaposition of Christianity with pre-Christianity, one seeking revelation and the other possessed of it, there is an analogue – but in humanistic terms that are more respectful of the illumination of the Ancients – to the scheme of the Sistine Chapel. The wall to the right of the *School of Athens* personifies the arts in a gathering of classical authors and modern humanists and poets, presided over by Apollo and his Muses.[25] Finally, on the wall across the room the Law is represented. On the lower portion of this wall, to either side of a separating window, are the historical foundations of civil and canon law, in the latter of which Pope Julius acts the part of the giver of the Decretals, Gregory IX; and on the upper portion of the wall is the representation of the three Virtues Prudence, Temperance, and Fortitude, which complement the Virtue of Justice.

Each illustration is an ideal generalization in the situation invented for it and in the cast of characters who act it out, but it is a still higher generalization at which the programme aims. It intends to describe not only the dignity of each 'faculty' but their ideal community. Theology and Philosophy lie across from one another, contrasted not as irreconcilable opposites, but as the classicizing humanists saw them, as complementary avenues to truth, one by faith and spiritual revelation, the other by reason and observation. Poetry and Art, which men create by inspiration, contrast with but also complement the Law, which man administers by deliberation and by precedent. The different disciplines and seemingly opposite ways in which men work within them are matched and balanced to form together a unity of intellectual endeavour. Reason and faith, discipline and inspiration, become four walls of one temple of the human mind. On the ceiling, personifications of each 'faculty', accompanied by smaller illustrative episodes, are interlocked in theme in a way that demonstrates still more closely that a unity is meant.

Raphael apparently began painting on the ceiling late in the winter of 1508, displacing the Sienese, Il Sodoma, who had been engaged earlier for the painting of this room and had started it, setting the ceiling's system of compartmentation.[26] The painting of the ceiling occupied Raphael until some time in 1509. In the course of working on it Raphael acquired, from the stimulus of his first extensive contact with antique art, the capacity to make the human form actively, entirely articulate, as had rarely been required of him before. No less important, this time was an interval in which Rome, Julian as well as ancient, could work its aggrandizing effect on Raphael, so that when he began painting on the walls he was prepared to feel and to conceive on an appropriately Roman scale.

The disputation pictured in the first of the wall frescoes is about the Eucharist, which Raphael has set out on an altar in the centre of the vast arched picture field as its true protagonist, and as if the scene should half symbolize, half represent, an enactment of a Mass

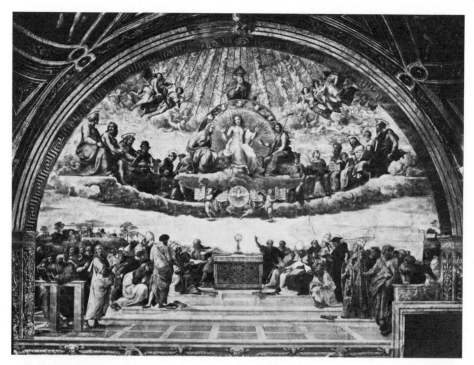

14. Raphael: Disputa, *c.* 1509.
Vatican, Stanza della Segnatura

[14]. The whole design focuses on the Eucharist, and depends in form and sense on relations to it. Echoing the shape of the wall, the disputants and their holy witnesses have been disposed in simple, grandly sweeping semicircles that enclose the altar. Their close-packed forms create the semblance of an architecture which, in an inspired interaction between form and meaning, is the apse of a church. This shape has a clarity, harmony, and spaciousness, as well as a sense of scale, like that of an actual architecture, but it also has the flexibility of the living forms out of which it has been made. As in a real architecture, the solids of the composition not only shape but give aesthetic personality to the space that they enclose. There is no longer, in this pictorial structure, the contrast

usual in earlier Renaissance painting between solids and a measured void; instead there is a unity in which space acts as complement to and in concert with the solid forms. This was the first time such a pictorial idea had been expressed on large scale; it is a middle term in the evolution of a classical mode of relation between substances and space in which Leonardo's *Adoration* stands at one end and, as we shall see, Raphael's Tapestry Cartoons at the other.

The figures that populate this structure have grown beyond Raphael's former scale, magnified along with the structure and the grandeur of the idea they and it express. Full forms, recollecting the antique, convey a decorum – even more, a stately grace – that may reflect

but more likely ennobles the ideal of behaviour of the classicizing Roman court. The figures act as if in complement to one another, making differentiated consonance; yet each figure seems to have been welded into an association with its group: the group makes a formal and expressive chord of which the resonance is much more than the result of an addition of its parts. Each group is then distinguished from yet ineluctably related to the next to make a richly charged, finally inclusive harmony of whole design. This manipulation of a harmony exceeds in both extent and quality what Raphael or any of his predecessors in the High Renaissance style had done before.

The fresco celebrating the arts, *Parnassus*, was most probably executed within 1510. Its theme combines with the effect of longer residence in Rome to stimulate Raphael to a more evident relationship with ancient classicism. The scene evokes into visible life an antique world a neo-Latin poet might have conceived, lyrically warm and populated by beings who, as Raphael has shaped them, are less reconstructions after antique art than regenerations of the ancient classic figure style. They are arranged in a design of which the armature is a rhythmic continuity of particular melodiousness, exactly consonant with the sense of the given theme. The movement of design has a variety – an alternation of rich arabesque and yielding pause – more developed than in the *Disputa*. The next fresco, the *School of Athens* [15], executed probably from late 1510 to mid 1511, also summons up an antique world, but in a different mood from the *Parnassus*, not sensuously warm but crystalline, in an atmosphere of high clear thought. A Bramantesque architecture, lucid, grand, and simple, makes a stage and sets the tenor of the action on it. Contrasting in form and idea with the fictive church architecture of the *Disputa* opposite, this man-made architecture symbolizes the structure of intellect and reason the philoso-

phers have built. Within this structure, on the various levels of its deep foreground space, Raphael distributes his figures in an order that absorbs the experience of both the *Parnassus* and the *Disputa*: this design has more variety than one and yet more grandiose stability than the other. The harmony of the image has been immeasurably enriched. Its figures are in part not different in scale or in expressive value from the classicizing actors of the *Parnassus*, but the more prominent of them have again been magnified in both of these dimensions, answering in size and breadth of action to a grander and more vital state of mind. They move in and occupy space with powerful assertiveness, and as they do they charge it – far more evidently than had been the case in the *Disputa* – with the emanation of their energies. As groups of figures and, finally, the whole figure design enclose space, shaping it, acting in and on it, and filling the air that it contains with energies, space altogether ceases to be conceivable as void and becomes nearly palpable, a kind of plastically responsive aether. Interacting thus, space and substance become parts of an experiential unity. The *School of Athens* also employs a traditional perspective space, and its working and that of the space formed by the figures have been fused, but it is the latter that represents the classical development.[27]

The thought that is so essentially concerned with the relation between substances and space – or, less abstractly put, between the human figure and its environment – is a painter's mode of thought, different in profound ways from the aesthetic contemporaneously projected on the Sistine Ceiling by Michelangelo. Yet the *School of Athens* contains the first certainly identifiable indices of the action of the Sistine Ceiling upon Raphael, obviously in terms of figure style – not just in motifs or effects of form, but in an ambition to a comparable spiritual scale; as the comparison provoked by Raphael's own imitation reveals, the ambition

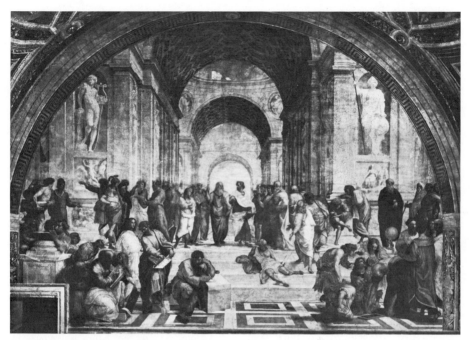

15. Raphael: The School of Athens, *c.* 1510–11.
Vatican, Stanza della Segnatura

was not realized. But what Raphael's images of men may lack in force or stature by contrast with Michelangelo's they compensate for by their diversity. Like Leonardo before him, the mature Raphael continues to believe in the function of art as comment on the multiform experience of the world. Where Michelangelo's art is the expression of a lonely psyche and his creatures in the Sistine Chapel are images of man in an essential isolation, the *School of Athens* – and the frescoes of the Segnatura room in general – speak of the community of men: they are representations of the greatness man may attain and promote in social concourse. More overtly than in Michelangelo, Raphael's tableaux convey an ethic along with their aesthetic sense, implying identity between beauty and human good.

On the last wall of this Stanza to be executed (late 1511), Raphael maintains a Michelangelesque dimension to depict the three allegorical figures who represent the Virtues of Law; however, below them in the two histories of the giving of the canon and the civil law he purposely descends from this high level towards naturalism. Both these scenes intend an effect close to illusionism, enough asserted in the one still clearly legible, the *Canon Law*, so that the reference in it to a past historical event is almost submerged in its look of actuality, made with perspective, lighting, and actors who are portraits of real members of the Papal court.[28]

From the moment of his arrival in Rome Raphael's main function was that of a decorator, and during the three years of his work on

the Stanza della Segnatura he was more nearly exclusively so occupied than he would permit himself to be at any later time in his career. He had not as yet evolved the shop system which soon after was to enable him to diversify his efforts in proportion as, by means of assistants, he multiplied his hands. The few easel works contemporary with the Stanza della Segnatura were wholly his own doing: they include the *Madonna di Casa Alba* (Washington, National Gallery, c. 1509) and the large-scale altarpiece called the *Madonna di Foligno* (Rome, Vatican Museum), probably executed during 1511.

Later in 1511 or early in 1512 Raphael proceeded to the decoration of the Stanza adjoining the Segnatura on the east, since called, after the main fresco he painted there, the Stanza d'Eliodoro; this decoration was complete by mid 1514. The programme given Raphael was in a significant respect unlike that for the Segnatura, where his subject matter was not actions or events but situations symbolizing an idea – a kind of theme that was intrinsically suited to the mentality and forms of an idealizing classical style. In the Stanza d'Eliodoro he was asked instead to illustrate historical narratives, all of which conveyed how in various times and circumstances divine intervention had secured the safety of a threatened Church. When the decoration was conceived in the second half of 1511, the Papacy was in politically uncomfortable straits, and the programme appears simultaneously to intend prayer, affirmation, and prophecy.[29] It is characteristic for the state of mind that Julius could inspire that, in the actual frescoes, it is the sense of affirmation that Raphael has caused to emerge most strongly – a temper surely reinforced as the situation of the Papacy very rapidly improved. Raphael has far exceeded the nominal requirement that he paint efficient narratives: he has taken the given subject as occasion for a content of dramatic triumph. The potential for this had of course to be in the programme, but to

exploit it was a matter purely of artistic choice. The dramatic animation that pervades the Stanza d'Eliodoro is a meeting of potential in the subject matter with Raphael's inclination and potential of development. The inclination may have been stimulated by Raphael's deepening awareness of the dramatic value of Michelangelo's contemporary painting, even though that was expressed in such concentrated, sculpturesque terms. In the Stanza d'Eliodoro, on the wide dimensions of his picture-maker's stage, Raphael proceeded to create his counterpart of Michelangelo's grand pathos, but in terms of history made near and present to us rather than, as in Michelangelo, heroically remote.

The four frescoes in the Stanza d'Eliodoro (the *Mass of Bolsena*, early 1512; the *Expulsion of Heliodorus*, second half of 1512; the *Repulse of Attila*, in progress in 1513; and the *Liberation of Peter*, of 1513 or early 1514) in general explore a region of classical style different from that attained in the Segnatura and which, in intensification of expressive content and elaboration of form, must be considered a development beyond it. The level of dramatic life Raphael seeks here requires that, before it, he should have found the sparkling and pervasive animation he instilled in the *School of Athens*. But there, and in the other tableaux of the Segnatura, this animation was infused into an ideal content, and a form consonant with it, that were basically stable; in the dramatic scenes of the new room it is the idea of activity that comes first, while the concept of stability and the mechanisms that insure it follow. The will to achieve a final and embracing harmony is no different than in the Segnatura, but to achieve it in these circumstances needs more complex means. In the Eliodoro frescoes the devices used to control and counterbalance action tend in themselves to be conceived of active elements, even in the architecture; in each of these scenes, harmony is achieved by

the manipulation of substances and forces more highly charged than in the Segnatura. The temper of harmony so made is, of necessity, not the same as that of the frescoes of the earlier Stanza. It is rich with energies and resiliences that the Segnatura does not know: it is of a more complex, and also of a more distinct articulateness, and it is instilled with higher power.

Almost as much as in the Segnatura room there is, among the frescoes of the Stanza d'Eliodoro, a development from one to the other of the articulateness and diversity with which Raphael explores their shared proposition of a dramatic style. This is despite the fact of the contemporaneous invention, probably still within 1511, of the elementary ideas of

design for all four frescoes. As the time for the actual painting of each wall approached, the initial design for it was recast to suit the new resource that intervening experience in the fresco just before had brought to Raphael. This is not different, though it is less obvious in degree, from what we have observed occurring in the Stanza della Segnatura, where the elementary designs of the whole were also probably set down at inception. In the new room each fresco is conceived with a different power and kind of dramatic urgency, and in each Raphael invents new devices to express this urgency and, at the same time, discipline it into harmony.

The first fresco to be executed, the *Mass of Bolsena* [16],[30] is still visibly related to the mode

16. Raphael: Mass of Bolsena, early 1512.
Vatican, Stanza d'Eliodoro

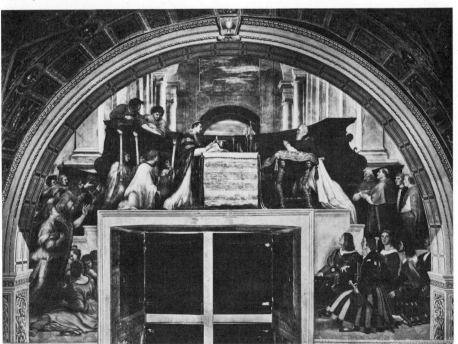

of the preceding Stanza, but in it Raphael has incorporated the new problems presented by a development of the classical style into a dramatic mode, and has worked out the basic elements of their solution. In the left half of the fresco he has described the past historical event at Bolsena, and on the right, taking what might have been either a requirement of the patron or the sanction of tradition, he has represented Pope Julius and some members of his court as if they were part actors and part spectators of the past event. The past history is made to seem dramatically active, but at the same time its actors are distanced from us by idealization; while the contemporary persons, whom he describes with a strong effect of physical and psychological actuality, are made contrastingly still. It is as if past and present should exchange the measure of activity we ordinarily associate with each, and even as they contrast thus be somewhat reconciled. The mobile forms on the left find not only contrast but equally a complement and counterpoise in the passive ones on the right. The principle of contrapposto, which earlier had been mainly used to make complementary contrasts within the unity of single human forms, has now been applied to the conception of the whole design, and it is a vastly bolder and more generalizing application of the idea. In the *Mass of Bolsena* the element of design that contains this grand-scale counterpoise is the architecture: its forms share the higher energy that inspires the composition. Lighting has a new degree of complication and more contrast, adding its vibration to the sense of drama, while the colour takes on darker and more masculine strength. All these animating powers of form, concerted with the drama of the content, are resolved in a harmony – a synthesis of equal and interpenetrated forces of expansive energy and of authoritative control – that is as certain as that in the *School of Athens* but more intensely charged.

Between the *Mass of Bolsena* and the succeeding *Expulsion of Heliodorus* there is a sharp distinction in the levels of dramatic urgency Raphael has chosen to express. In the *Expulsion* [17] the impulse to power of dramatic content is so strong that for the first time in Raphael's painting the effect of force dominates that of grace. The mode he finds for the *Expulsion* is of drastic, swiftly consummated action. Most of the wider stage this picture field affords is given to the action: the required group of Papal figurants is set well to one side. The scene is the Temple of Jerusalem, deep within which the priest Onias prays for deliverance from the Roman Heliodorus who has come to despoil the Temple's treasury. At the left, spectators recoil in wonder, while militant angels, answering Onias's prayer, fall on Heliodorus at the right and drive him to the ground. The arrangement of the elements of the drama is of a sophistication without precedent in the history of painting: on the fulcrum of Onias's small, distant person two grand groups are set in contrast and counterpoise quite near to us, of the spectators and the miracle they watch. To understand the drama we must move, as an almost vertiginous perspective recession takes us, deep into the Temple to Onias: the space defined by the perspective architecture, almost more than other elements of feeling and of form, has been made dynamic: no longer just a sounding board for the figures, the architecture becomes an agent of the drama with them.

The *Repulse of Attila* on the opposite large wall [18] must already have been in execution at the time Pope Julius died in January 1513. His successor, Leo X, appears in it twice: once in his original role of Cardinal in the Papal suite, and again (in consequence of his election to the Papacy in March) in the place Julius was meant initially to fill. For the first time so far in the Stanze Raphael's tendency to depend on helpers in the painting of these large works –

17. Raphael: Expulsion of Heliodorus, second half of 1512. *Vatican, Stanza d'Eliodoro*

18 (*below*). Raphael: Repulse of Attila, in progress in 1513. *Vatican, Stanza d'Eliodoro*

19 (*opposite*). Raphael: Liberation of St Peter, 1513/14. *Vatican, Stanza d'Eliodoro*

already partly visible in the *Expulsion* – has increased to the point of a diminishing effect.[31] The articulation of the idea of design is none the less altogether clear, and it is a probe towards means of expression in dramatic form that exceed those found for the *Expulsion*. The subject is like a magnifying of the climax of the preceding fresco. An army charges at the Pope, but breaks against his rampart-like solidity and simultaneously is turned back by the counter-action from the heavens, like an aerial attack, of St Peter and St Paul. The setting is an unassertive landscape; there is no frame of architecture or any features in the landscape to help control the forces acting in it. The chief of these forces, the Hunnish charge, is so strongly conceived that it cannot be expressed within

the scheme of roughly equal part and counter-part used in the *Mass of Bolsena* or the *Expulsion*. It moves beyond the principle of centralized design which until now had governed Raphael's compositional thought, and instead posits the idea that a design may be conceived to begin with as an asymmetrical relation of dynamic parts, on which a machinery to make equilibrium is only subsequently imposed. The equilibrium is none the less definitive: this system of design in the *Attila* is a significant new invention, extending the boundaries of classical style but not violating them.

It was not caution about further probing in this same direction but a concern to investigate a quite opposite machinery of dramatic expression that determined the mode of the

Liberation of St Peter [19]. The theme here is relatively simple, and Raphael not only accepts this simplicity but magnifies it into an agency of prime dramatic force. Contrary to the *Attila*, the order – established *ab initio* by the austere, heavy prison architecture – affirms centrality and symmetry with strongest emphasis. The sparse figures in this setting move less than the story would permit, almost consonant in stillness with the architecture. The time is night, and the angel who bends to free the sleeping Peter emits an aureole of brilliant light. Contrasting with the dark, the stillness, and the severity of setting, the light alone makes an equivalent in dramatic value of the narrative and formal action that the preceding frescoes so elaborately set forth. Though not quite so

obviously as in the *Attila*, this mode of expression is also an invention for the classical style. Where in the *Attila* it is the idea of activity that is given new development and an incipient new form of expression, in the *Liberation* it is the contrary expressive potential of a static system and extreme restraint that has been stressed. The modes of both the *Attila* and the *Liberation* offer possibilities of yet further development, but in the very fact of the divergence of the avenues of exploration they offer there is the material of a creative conflict. And in the will to test these new propositions towards a level of yet higher expressive power, inevitable in the dynamism of Raphael's development, there is the risk of violation of classical principle, so far secure.[32]

20. Raphael: Galatea, *c.* 1513. *Rome, Villa Farnesina*

The span in which the Stanza d'Eliodoro was made completes the maturing in Raphael of the classical style that began with the painting of the Stanza della Segnatura. The fluency and assurance of his accomplishment of the Eliodoro years, and the effect it makes not of an unproblematic but of an unlaboured art, inevitably wedding suavity to grandeur, do not occur in the same measure earlier or afterwards in his career. The virtues of this phase are in two other fresco works outside the Eliodoro room, in the *Galatea* in the Villa Farnesina and the *Sibyls* of the Chigi Chapel in S. Maria della Pace (both *c.* 1513).[33] The *Galatea* [20], as classical in subject matter as parts of the Segnatura decoration earlier had been, displays a growth in power of its content beyond the level of the Segnatura and a grander and more various repertory of form: the scene conveys a sense of the physical splendour of the antique world such as only Michelangelo hitherto had known how to represent. Its design is the lucid elaboration of a contrapposto, poised finally in an equilibrium which seems almost miraculously to assure that this instant of a golden time must be enduring. The *Sibyls* of S. Maria della Pace, not over-religious in their tone, were painted for the same patron, the Sienese banker Agostino Chigi. They also refer to the style of the Segnatura and exceed it, in this case reconsidering the *Three Virtues of the Law*, but finding a variety of movement and a charged grace that bring them closer to the stature of their counterparts in Michelangelo, and nearer to the temper of the Eliodoro room.

Probably in 1513, about contemporary with the *Galatea*, Raphael conceived a Christian analogue of style for it in an altar painting for the church of S. Sisto in Piacenza,[34] the *Sistine Madonna* (Dresden, Gallery) [21]. With a sense for the drama of relation between the audience and the picture that was in the previous great altar, the *Madonna di Foligno*, Raphael has

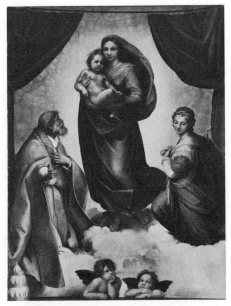

21. Raphael: Sistine Madonna, 1513(?). *Dresden, Gallery*

devised means to convey that the ideal, utterly invented image he has painted is an illusion, seen in the heavens as if through a window in the wall. The design of the altar is based on principles like those in the *Galatea* fresco, but they have been much moderated in kind and effect. Appropriately, there is a differently grave content and contained form in the religious subject matter. More even than the *Galatea*, the Virgin of this altar resolves the action of a moment into an eternal poise, so that gravity and time seem to be suspended in the heavens with her. The *Madonna dell' Impannata* (Florence, Pitti, *c.* 1513)[35] is somewhat different from the almost hieratic *Sistine Madonna* in the mode of relation to the spectator which it achieves. More a private than a formal public image of devotion, it intends an idea of domestic nearness. It is less ideal than

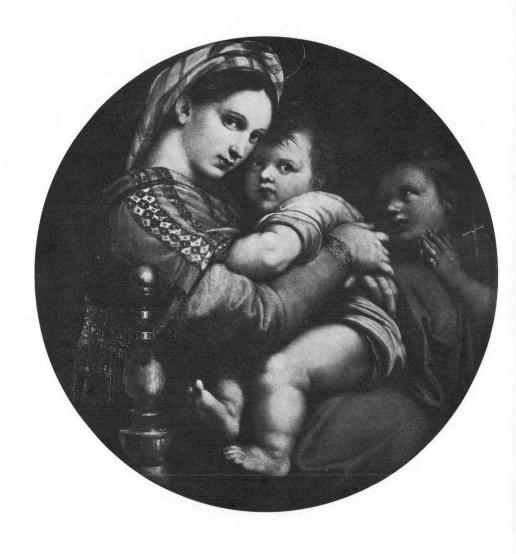

22. Raphael: Madonna della Sedia, 1514–15. *Florence, Pitti*

the *Sistina*, described more tangibly in a situation, as well as a design, that strongly convey the effect of mobility and life. The temper of design – some of its motifs, too – is close to the contemporary Chigi *Sibyls*. Yet another vein we have observed in Raphael's monumental style, that of the austere Eliodoro *Liberation*, appears in a large altar painting of this time, the *St Cecilia* (Bologna, Pinacoteca, c. 1514), almost as famous as the *Sistina*. In a setting that consists of landscape only, the design of the *St Cecilia* altar makes an effect like an architecture: the figures seem an analogue for the dense columnar substance of an antique temple, discrete from the surrounding landscape yet suffused by its light and air. This pictorial structure stands in relation to the *Sistine Madonna* like a demonstration of a higher value placed on pure geometry. The *Madonna dell'Impannata* has a similar subsequent critique, the *Madonna della Sedia* (1514–15) [22], of which the pattern deduced from the picture's tondo form is a phenomenally legible *gestalt*. However, this is meant still less than in the *St Cecilia* altar to work only as a formal and abstract idea. The geometry of design, with its instant clarity and force, serves to convey, with unprecedented efficiency, the sensuous presence and the beauty of the forms of which it is the armature; and it illustrates their human meaning as, also more efficiently than ever in Raphael's art before, form and content coincide. The *Madonna della Sedia* is the consummation in brief of the wisdom of art Raphael had gained to date, and at the same time it is the affirmation of a new clarity of purpose. It is the threshold of the next phase of his development of style.[36]

The beginning of what was to be the last half-decade of Raphael's life marked a new expansion of his professional career. His role as a decorator was heavily increased, in the Vatican especially, and commissions for easel

paintings multiplied beyond the possibility of fulfilling them. More and more Raphael found it necessary to pass on the execution of his ideas to assistants in his enlarged shop. In April 1514 he had taken on a whole new sphere of activity beyond his role of painter and decorator when he was named architect of St Peter's in succession to Bramante; in August 1515 he added the responsibility (originally consequent upon his functions at St Peter's) of the superintendency of antique monuments of Rome. In this connexion, he came to occupy himself in a 'discrittione, et pittura di Roma antiqua'.[37] After 1514 Raphael was a figure of larger scope and scale than before: he had become the great *régisseur* of arts in Rome, of a stature in Pope Leo's court like that of his ministers. The contrast between Raphael and Michelangelo of a public versus a private personality became still more overt. Michelangelo's departure from Rome in 1516 was not a retreat, but it left Raphael in almost undisputed domination there.

The character of Raphael's new role was surely one among the motives of change in his art that became manifest towards 1515, so marked as to convince us that it represents the beginning of a new stage in the development of Raphael's style. The change is almost as pronounced as that which, eight years before, appeared in his initial work in Rome. It is expressed almost simultaneously in two major enterprises with which this late phase began: the first two frescoes in the decoration of a further Stanza, called the Stanza dell'Incendio (adjoining the Stanza della Segnatura on the side opposite the Stanza d'Eliodoro), and a set of cartoons for tapestries illustrating the Acts of the Apostles Peter and Paul, to be woven for the lower walls of the Sistine Chapel (the surviving original tapestries are in the Vatican Museum; the seven surviving cartoons out of ten are in the Victoria and Albert Museum,

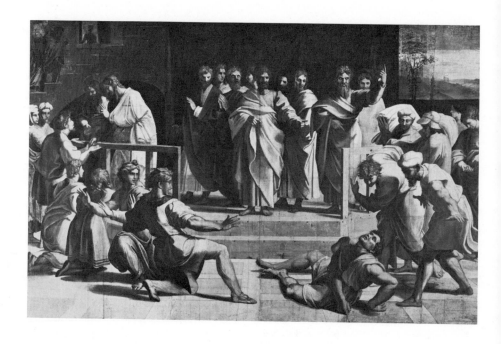

23 (*above*). Raphael: Death of Ananias (tapestry cartoon), 1515. *London, Victoria and Albert Museum*

24 (*opposite*). Raphael: Paul at Lystra (tapestry cartoon), 1515. *London, Victoria and Albert Museum*

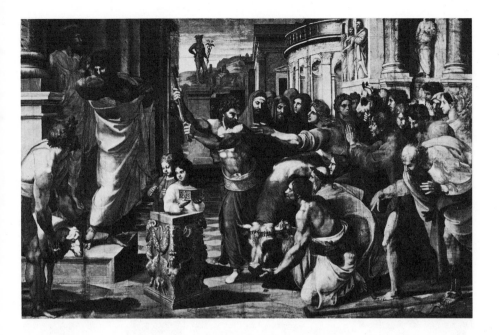

London [23 and 24]). The Stanza dell'Incendio may have been undertaken slightly earlier than the Tapestry Cartoons. A letter from Raphael in July 1514 states he had begun 'un altra stantia per S. Sta. a dipignere'.[38] Documents indicate with considerable probability that the making of the cartoons was mainly during 1515; they are more than ordinarily homogeneous in style. In the Stanza, the main fresco, the *Fire in the Borgo* [25], may be earlier in initial invention than the *Battle of Ostia* on the adjoining wall, and prior to the Tapestry Cartoons in this respect as well, but its actual painting seems mostly subsequent to the cartoons. The invention of the *Battle*, however, is clearly concurrent with that of the cartoons. Most of the cartoons display Raphael's own hand in their execution, and at the very apex of its power; in the Stanza dell'Incendio he had a considerable share in the execution of the *Fire*, but did not participate again in actual

painting in this room, nor indeed in any of his later decorations. The *Fire* marks the shift in Raphael's career as a decorator to an entirely cerebral role.[39]

The évidence, internal and external, of the close relation in time between the beginning phase of the *Incendio* and the Tapestry Cartoons is ample, yet the results in each significantly diverge. In part, the divergence is the consequence of obvious external causes: of unlike picture-shapes given into the designer's hand and of differences in quality of given theme. But these were then taken as matter with which to exploit a further, much more important difference: between alternative ways, found by Raphael in the preceding Stanza, to articulate what was essentially a common ambition that he entertained for both new projects. The ambition was not just to increase the efficacy of dramatic expression found for the Eliodoro room, but to change its tenor,

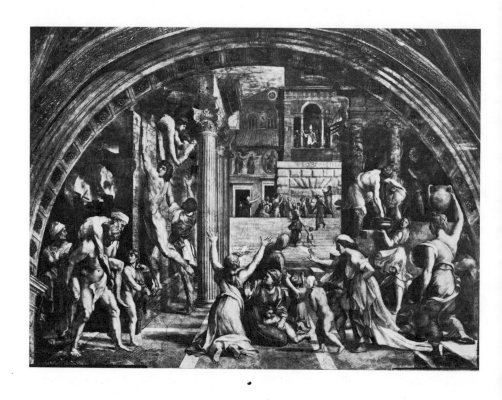

25. Raphael: Fire in the Borgo, *c.* 1515. *Vatican, Stanza dell'Incendio*

making its communication at the same time more arbitrary – more styled and rhetorical – and more acute. In the Tapestry Cartoons the mode Raphael chose to accomplish this is based on that which he had conceived for the *Liberation of St Peter* in the Stanza d'Eliodoro – the basis of the *St Cecilia* altar also, and in a looser sense even of the *Sistine Madonna*; in the *Fire* and the *Battle* his springboard is the different mode of the *Attila* fresco and of its antecedent, the *Expulsion*. In the cartoons Raphael finds, by comparison with the precedents to which they relate, a concentration, severity, and monumental force of statement that not only exceed prior quantity but, in their new dimension, take on meaning of a higher kind. The action he performs upon the preceding mode is like a distilling of the essence of its classicism, moving from its threshold to a still higher plane: the classicism Raphael propounds in the cartoons seems, by a long reach, to be more nearly absolute.[40]

The cartoons of course presented a different formal problem to begin with from that posed by the walls of the Stanze. They were somewhat less in size than the Stanze lunettes and regular in shape; no less important, they were meant for translation into a medium rather unsuited to description of extensive space. These considerations helped determine that the matter which the rectangular frames of the cartoons contain consist in the main of figures, large in proportion to the whole. But it is a matter of aesthetic choice that space in the cartoons should become, in the degree that it is, incidental, no more than a by-product of the ordering of substance. Perspective, though still a convenience, is not aesthetically relevant. An idea conceived at the beginning of the High Renaissance by Leonardo and pressed farther by Raphael in his first Stanza has here been completely evolved. Michelangelo, approaching pictorial problems inversely, from a sculptor's point of view, had already come to the

same end. The pictorial substance of the cartoons thus tends to approximate classical relief: it suggests the effects of the Sistine Ceiling below which the woven tapestries were to be hung, and the relation – not just in this respect – is surely pertinent. This relief-like matter is organized in designs of extreme geometric clarity, of which the generalizing character is stressed. The whole cartoon becomes a lucid integer of massive form, legible to the spectator with exceptional force and immediacy.

As is necessary to a classical style, this character of form is one with a development in the character of content. The nature of design in the cartoons is both the cause and consequence of Raphael's conception of dramatic meaning in them. Emotions among the protagonists seem to take on the stature not just of the typical but of archetypes: the visible signs of states of spirit acquire the effect of symbols. Form and the dramatic narrative converge in their conception and functioning: much more explicitly than in the Stanze, the points of emphasis in the design and the strong points of dramatic content have been made to coincide. The cartoons make drama of another order than that of the scenes of the Stanza d'Eliodoro and of a differently impressive eloquence; Raphael has here fused the devices of a high rhetorical style with those of drama. And as always in Raphael's classicism, ethical and aesthetic values are indissoluble from each other, and meant to be. The austere nobility of the protagonists in the cartoons makes them, to the cultural disposition of this time, ultimate exemplars of a humanity inhabited by the powers of Christian spirit, but of a supreme classical discipline in their expression.

We know from historical hindsight that this is the ultimate level of classicism in pictorial form that the High Renaissance had it in its nature and power to achieve: Raphael has ascended here to the plateau Michelangelo

attained four years before. But at that same time Michelangelo had also tested ideas of form and expression that strained the limits of classicism and, indeed, exceeded them, and in Raphael's career the *Incendio* frescoes are a parallel phenomenon, though far from so extreme or daring in their reach as Michelangelo's divergences from classical style had been. The *Incendio* frescoes move, beyond their own antecedents within Raphael's style, in an opposite direction from the purifying and restrictiveness of the cartoons. In the *Fire* and the *Battle of Ostia* Raphael magnifies what had been in the *Expulsion* and *Attila* an effect of complex activity; he makes both form and illustration seem more multiple and diverse and, at the same time, strikingly emphatic. What is an economical - and a noble - rhetoric in the cartoons becomes, in the *Fire* and the *Battle*, a gesticulative, almost operatic speech, in places a rhetoric *faussée*. What Raphael wished when he conceived these frescoes may have been more than the language of a classical style can be asked to bear. His will in them to urgent, active meaning is intense but unaccompanied by any lessening of will to classicizing discipline: the powers of animation and control, which in the drama of the Stanza d'Eliodoro were made to fuse, work now as if in contest with each other. Emphases, disruptive of the sense of unity, enforce discipline of form and impose stiffness upon feeling. It is as if the seams between components of the whole synthetic structure of images in classical style should become apparent, as they had not been before; the classical image begins, as it were, to fracture under the pressures of Raphael's urgencies. The *Fire* and the *Battle* (or what we can discern in the latter despite its unevenness of execution - by the young Giulio, mainly) are, however, not yet unclassical. What has happened in them may be described as a faulting of their classical style, by analogy with the cracking and shifting under pressure of a

geological or architectural structure, by which its look may be much altered and its security impaired, though the structure is not changed in basic character and function or destroyed.

The direction is the opposite of that in the cartoons but, as in them, Raphael probes in his designs for the first two *Incendio* frescoes towards a new dimension and, in some respects, a new kind of expression for his classical style: these are the more daring, open-ended probes. The temper of experiment in them persists in the third fresco of the Stanza dell'Incendio, the *Coronation of Charlemagne*, not invented until 1516.[41] The least dramatically potential subject in the room, Raphael in compensation made it the most daring manipulation of a design in space since the inception of the classical style. The fresco on the fourth wall, the *Oath of Leo* (early 1517), is debased in execution and, it also seems, in Penni's working up - perhaps more accurately, down - of the idea we presume Raphael conceived for it. In any case, it is a retreat from a posture - perhaps untenable with this subject matter - of experiment and a linking with the mode of the Tapestry Cartoons, accepting a stilled architectonic scheme.

Both modes, the austere and exalted classicism of the cartoons and the stressful, complicating classicism of the *Incendio*'s experimental style, have a continuing place in the painting of Raphael's last five years. Theme and function tend to determine which one shall be used, but they are not mutually exclusive. The works of 1515 are more highly characterized in their identity of style than those that follow; they are climactic probings of their distinct directions. In general, a mode resembling that of the Tapestry Cartoons persists in Raphael's later architectural decorations, but in them the resemblance is more often outward than essential. These decorations engage Raphael intellectually and aesthetically; however - perhaps only accidentally - their themes, antique or

Christian, do not demand strong emotional commitment. In comparison to the cartoons, in which there is such compelling feeling, the later decorative works seem grand but only partially inhabited persistences of the cartoons' *summum* of classical style. The easel paintings seem to summon more intensity from Raphael, even when they are in the devotional genre. Their variations of mode range widely, from near-approximation of the finest moments of the cartoons to straining, complicated mechanisms like that in the *Fire in the Borgo*; and the last altarpiece on a grand scale, the *Transfiguration* [30], forcibly conjoins episodes of both modes within one frame. In Raphael's own exercises in his more complex mode the sense of stress we have remarked is usually perceptible enough, and it may result in the effect I termed a faulting of the character of classicism. In the hands of his assistants, to whom Raphael in these years had to entrust most of his ideas for execution, these stresses may take on still more divisive effect, more damaging to the unity that must pertain to an image in an authentically classical style: this is the case when Giulio Romano intervenes. Or on the other hand, as when Giovanni Francesco Penni is Raphael's executant, the master's measure of emphasis may not be matched, weakness and incoherence being substituted instead. That result no less compromises the classicism of style that Raphael's own late painted statements convince us was still integral in him despite the strains his creativity put upon it.

Of the five decorative schemes that Raphael designed either concurrently with the Tapestry Cartoons and Stanza dell'Incendio or later, three are on ancient pagan themes, but he did not require this justification to give all his later decorations, whether their subjects were Christian or antique, a strong cast of ancient classic style – in instances assertively archaeological as it had not been in Raphael's art before. The tendency was almost inevitable, given his assimilation to the highest Roman cultural milieu, but beyond this it proceeded from the antiquarian functions he had taken on in consequence of his new role as architect. That role of itself, however, may have influenced how he conceived his later decoration. Regardless of their kind of subject matter, the later schemes share two important formal ideas, which seem to reflect a sense for the relation between decoration and the architecture that comes from deeper understanding of the latter. One of these ideas is to deduce, with an exceptional new directness of reference, the geometric mode of the decorative scheme from the geometry of the given architecture: the late schemes have a hitherto unknown measure of lucidity not only in their larger form but in their rigorously consequential subdivision. This effect is of a more abstract logic; the second idea, as if in counterbalance, promotes naturalism, deducing motives or, on occasion, whole systems of illusion from the actual architecture.

The first in time of these commandingly efficient conjunctions between geometry and illusion was in Raphael's design for the mosaic dome of the chapel for Raphael's already familiar patron, Agostino Chigi, in S. Maria del Popolo, designed in 1515 (dated by the executant, Luigi de Pace, 1516).[42] Perhaps because it is contemporary in invention with the Tapestry Cartoons, the Chigi dome is the most stringently classical of the late decorative schemes in its effects both of form and of content. A scanned geometrical perfection, the form that the illusion takes affirms its separateness: it portrays an ideally distinct world, a heaven we may contemplate but not enter. Its classicism is the antithesis of the deduction, baroque in tendency, that Correggio would not long after make from it. Though Christian in essential subject, the Chigi dome has an antique accent even in the handling of its theme; Raphael's

next decoration, in the apartment of Cardinal Bibbiena in the Vatican (first half of 1516), created an entirely antique-humanist environment for a dignitary of the Church. Two spaces, a smallish loggia, the Loggetta, and an adjoining bathing room, the Stufetta, are completely painted in a re-creation of the antique grotesque style: this is the first complete decoration *alla grottesca* since antiquity. It is the immediate forerunner of the greater Logge, and by way of this more public, influential offspring is the ancestor of the important tradition of grotesque decoration in the sixteenth century. The architecture of the Loggetta may have been of Raphael's design, or he may only have re-modelled it; in any case there could not be a more eloquent example of consonance in geometric sense between the architecture and the painting of grotesquerie upon it. And strictly observing the archaeological intention, it is with material and devices imitated from antique painting that restrained play with illusionism has been made.[43] A decoration of the first half of the succeeding year, the Sala dei Palafrenieri (or dei Chiaroscuri) in the Vatican (now replaced by an only roughly analogous scheme, of the mid century and later), used some of the same elements as the Loggetta, but with a deliberately different stress upon illusionist effect.

From late in 1517 to the end of 1518 Raphael's best assistants – Giulio, Penni, and Giovanni da Udine in particular – laboured at the execution of their master's ideas for the grandest of his late decorative enterprises, the Loggia di Psiche in the (then) suburban villa of Agostino Chigi, known now as the Farnesina [26]. The decoration depicts – on the vault only of the large garden loggia – the episodes of the history of Psyche that took place in the heavens; it is possible it also may have been intended that at some time tapestries (more probably than paintings) should illustrate the earthly episodes of Psyche's story on the walls.[44] Making the closest possible deduction of his scheme

out of the given architecture, Raphael has used paint to transform the loggia's vault into an arbour, open through its foliate architecture to the illusion of a sky. To hide the interior from the imaginary sun he has stretched two fictive *tende* across the arbour's roof; these show, in non-perspective view, as if they were on tapestries, the crowning scenes of Psyche's story, her reception into Olympus and her marriage. In the spandrels below, framed in foliage, we see preceding episodes enacted by figures in a perspective that makes plausible, though not insistent, continuity with the viewer's space; we accept that these scenes take place in a heaven just beyond the arbour, impinging on it. The lesser spaces between the spandrels seem genuinely to open upwards: foreshortened *amoretti*, birds and mythic beasts fly in a reach that seemingly extends high into the sky. The scheme achieves illusion, and defines it in both visual and structural terms with entire plausibility. But when it is accurately observed, the structure is made up of massive and planar elements (in the by now accustomed mode that suggests classical relief) much more than of perspective devices and of space; what Raphael has projected as illusion is still, in the fully classical sense, a discrete, ideal realm, appropriate to its Olympian nature. On this Olympus it was meant to re-create a splendour of existence like that Raphael had so eloquently embodied in his *Galatea* in the adjoining room, but with still more august and archaeologically more evocative presences. The heavier hands of his executants have not realized Raphael's ambition well enough, but more than their execution alloys his idea, that idea lifts what they have done towards it.

26. Raphael:
Three Graces, 1517–18.
*Rome, Villa Farnesina,
Loggia di Psiche*

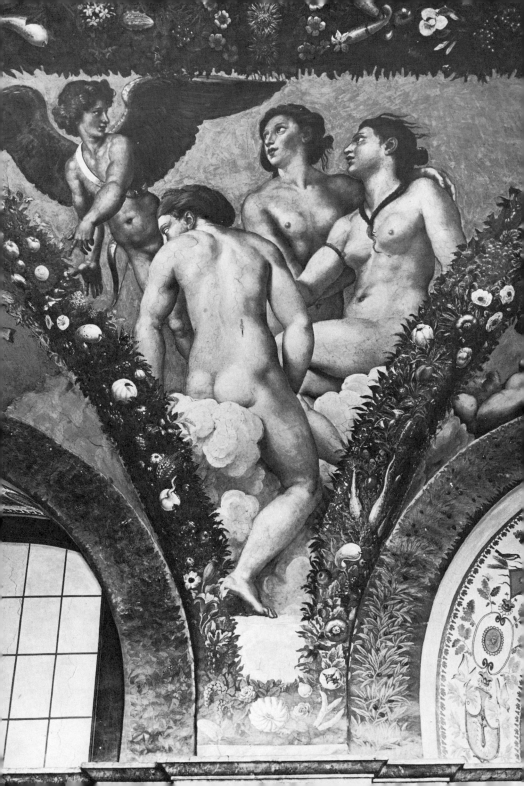

27. Raphael:
Bay from the Logge, 1518-19. *Vatican*

Not only these executants but further rein- forcements were required for the last major work of decoration executed by the shop in Raphael's lifetime, the Logge (on the main storey of the Vatican apartments overlooking the Cortile di S. Damaso; 1518-first half of 1519). The loggia of thirteen vaulted bays, built on Bramante's design but under Raph- ael's supervision, is decorated in a style that combines grotesquerie *all'antica*, illustrations of Bible themes (in all but the last bay, from the Old Testament), and minor devices of illusion [27]. To the vocabulary of grotesquerie that the shop had developed earlier Giovanni da Udine, Raphael's deputy in this field, has now added stucco work, re-inventing a tech- nique lost since antiquity. The decoration evidently depends on the mode conceived for

the Loggetta of Cardinal Bibbiena two years before, but also remarkably develops it. The grotesques are not so visibly imitative of their ancient sources, and they are of a richer texture of design, disciplined yet ingeniously various. Their logic is no less apparent than their fantasy, and one important function that they serve is to continue, with progressively finer differentiation, the process of articulation that begins in the body of the architecture. Here, the close-textured grotesque ornament does not merely conform to the actual structure but adheres to it: the decorative surface has been made to be like a living skin upon the body of the architecture, mobile and porous, giving respiration to the underlying form.

The elaboration of the grotesquerie would have been the responsibility of Giovanni da Udine, but it must be assumed that Giovanni acted here, as in the Loggetta, as Raphael's instrument. The Bible illustrations (recently carefully restored) were also given into the charge of an assistant, who, Vasari tells us (IV, 362), was Giulio Romano, and he in turn had help not only in execution but possibly in the development of Raphael's designs from his associates: from Penni and, in time, from at least the best among the new recruits, Perino del Vaga and Polidoro. Raphael supplied exact designs for the earliest in order among the scenes, but then seems to have allowed increasing liberty to his helpers to elaborate *invenzioni* he would have given them; the effect of originality the later illustrations have is not always Raphaelesque.[45] The content of the decoration is of course in part that of its biblical subject matter, but the context *all'antica* into which it has been set is so rich that the Christian meaning takes on an overcast from it. Religious meaning, as such, carries no great weight in the ensemble: the first sense of the whole is that which emerges from its decorative form. And this conveys the idea of reason made evident in order and enriched with fan-

tasy and learning; and it bespeaks opulence and suave delight. It is the expression of a sophistication difficult to surpass, the product of a late stage in the evolution of a classical style.[46] Before Raphael died he had gone farther, but in a direction unlike this, turning his attention to the problem of the last and largest state room in the suite of Stanze, the Sala di Costantino. But there the action of his pupils on what Raphael left moved into a different sphere of style, and the posthumous result was not his.

The decorative works remained Raphael's most demanding occupation in the later years, asking more than any of his other genres from his remarkable intelligence of form even if they got nothing, or almost nothing, from his painter's hand. It was an opposite pole of his activity, his portraiture – private in purpose and in scale and the least problematically demanding – that contrarily involved him in most cases to the point of entire personal execution. On this account, the portraits may serve as a gauge to estimate the intervention of his hand, less frequent and more difficult to judge, in the later easel paintings of religious themes. The portraits serve also as an indicator of his ideas on an issue which in all the later figurative works becomes increasingly acute: the sharper evocation of reality. The desire to achieve it in the easel paintings by descriptive means is like the motive which, in the decorations, led Raphael towards illusionism; but no more than it does Raphael's descriptive realizing trespass beyond classical values of style.

Five, perhaps six among the not much larger number of late portraits that survive seem substantially autograph. The earliest of them is the famous *Baldassare Castiglione* (Paris, Louvre, second half of 1515),[47] the most lucid of Raphael's portraits in the state of mind that it depicts as well as in character of form, comparable in this respect with the Tapestry Cartoons. The portrait image requires, more

than a historical narration does, a sense of the actuality its subject has, and to achieve it Raphael has employed, among other means, an almost illusive effect of light, unusual for him in its sheer optical sensibility, and so alive it vibrates. It has been suggested that a Venetian influence (as from the Romanized Venetian Sebastiano del Piombo) may account for this, but the more accurate explanation may be a renewed acquaintance with the great exemplar of portraiture in the High Renaissance classical style, the *Mona Lisa*. We recall that Leonardo was in Rome from 1513 well into 1516, quite possibly with the *Gioconda* in his baggage. The *Castiglione* is a reshaping, into the vocabulary and with the resources of the highest classical style, of this great precedent from the style's first phase.

Two further members of the humanist circle of which Raphael had become a part, Andrea Navagero and Agostino Beazzano, are the subjects of a double portrait (not so certainly from Raphael's own hand; Rome, Doria, first half of 1516), unusual in Rome in this respect alone;[48] it is more marked than the *Castiglione* by an intention to make its sitters appear physically and psychologically near. Slightly later, a still more complicated portrait subject, of three figures, *Leo X with the Cardinals Giulio de' Medici and Luigi Rossi* (Florence, Pitti, second half of 1517 to 1518) [28], presses this ambition to a danger point. Descriptive detail is insistent and sought out by forcing contrasts in the light; the effect of plastically realized presence is emphatic, almost harsh. These forms have been captured as if they were still-life: to animate them and to press the point of their connexion with us as if in reality they are assembled in a design that makes movement, built on a diagonal perspective that trespasses the picture space. The measure of actuality to which this portrait aspires is not easily reconcilable with a classical aesthetic, and to maintain the sense of clas-

sicism Raphael has had to force its means of discipline. The result – taut, urgent, and in stress – has the character of what I earlier described as faulted classicism.

That the manner of the *Leo X* posed a dilemma must have been quickly realized. Raphael did not surrender the essential ambition for his portraiture that he entertained there, but he turned instead to a less literal means for achieving it. His latest portrait, again a double one, of himself with a friend (called *Raphael and his Fencing Master*, Paris, Louvre, 1518–19) abjures the *Leo*'s labouring of descriptive detail and moderates its forcing and immobilizing light, but it makes the action of diagonal perspective much more energetic: this image fluently attains its object of conveying that the persons in it are illusions, again of discretely idealized beings such as the *Castiglione* had been, but of more immediate vitality. The latest portrait reaffirms values that belong to classical style and implies a new course on which they could evolve, similar in principle to that of contemporary Venice. Raphael did not live to give it consequence.[49]

Of more complex kind, the later altars and devotional pictures are more indicative than the portraits of the range of problems Raphael chose to deal with in his last half-decade as well as of the powers with which he addressed them. As in his decorator's role, in the late easel works it is Raphael's ideas that signify, but in a good number of these paintings eloquence, or even an added dimension of meaning, has been given the ideas because, at least in some degree, Raphael has set them down himself – perhaps only once entirely; otherwise the large share in execution that he left to his helpers makes these works, in terms of artistic personality if not of their ideas, uneven compounds. The picture that seems wholly Raphael's is a relatively small devotional one, the *Madonna della Tenda* (Munich, Pinakothek), as luminous and subtle in its quality of

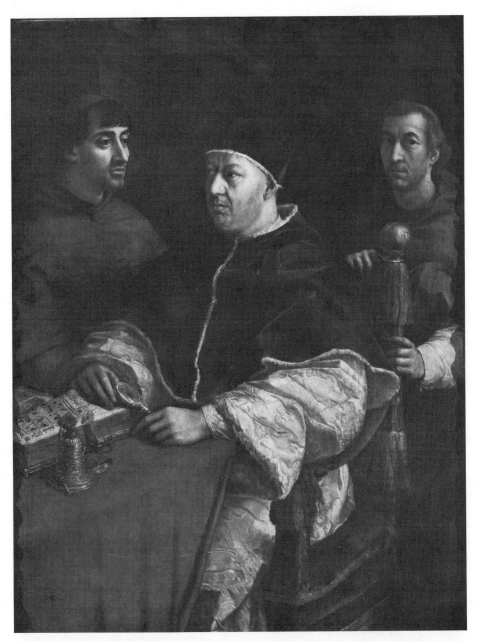

28. Raphael: Leo X with the Cardinals Giulio de' Medici and Luigi Rossi, 1517-18. *Florence, Pitti*

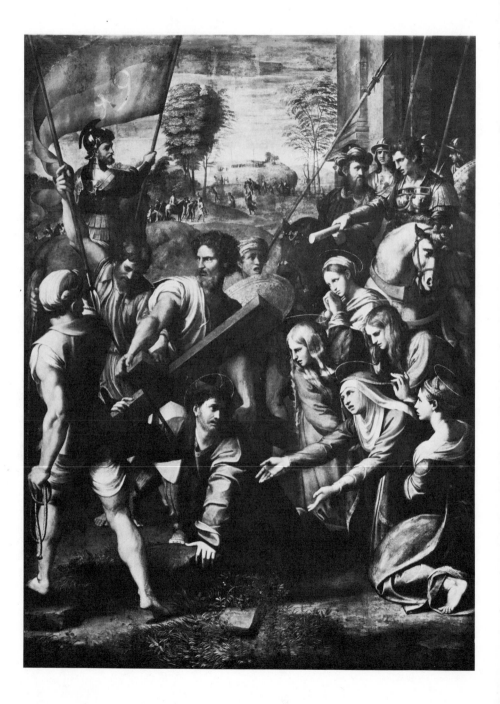

surface as the *Castiglione* or the *Madonna della Sedia*, but much more opulent. The *Madonna della Tenda* is, indeed, an updating of the *Sedia* in terms of Raphael's since-revised ambitions, seeking a physical and psychological situation that is of higher stress and more insistent as presence and communication.

The force that inhabits this ambition and the efficacy of the aesthetic devices Raphael invents to achieve it are such that they cannot be too much diminished even when much of the actual execution is an assistant's. The full-scale altarpiece called the *Spasimo di Sicilia* (*Christ fallen beneath the Cross*, Madrid, Prado, *c.* 1516) [29] was painted with the considerable aid of Penni, whose intervention helps to give the work its look of a *machine*; but this surface impression is deceptive. The design is of remarkable efficiency, generating strong powers, ordering them precisely to the needs of the dramatic action, and finally tying form and meaning together, in the head of the fallen Christ (of Raphael's own execution), as if in a charged knot. For a large devotional work destined for the Queen of France (but now called after her husband), *The Holy Family of Francis I* (Paris, Louvre, dated 1518), Raphael employed the more sophisticated helping hand of Giulio Romano. The design Raphael invented for this painting is distinct in its ornamental effect from the *Spasimo*, but it is actually more involved, stressing complexities of shape; the theme, too, is conceived with what might be called an ornamental complication of psychology. On this matter given him by Raphael the extensive parts of its surface that are Giulio's grow so organically that epidermis and idea cannot be separated. Even qualities we recognize to be the results of a temperament distinct from Raphael's seem to have developed by extension or extrapolation

29. Raphael: Lo Spasimo di Sicilia, *c.* 1516. *Madrid, Prado*

out of Raphael's own current ideas. A companion work intended for the King himself, a *St Michael* (the patron saint of French kings; Paris, Louvre, also dated 1518), partakes of the character of both devotional and dramatic subject, and the mode Raphael has devised for it resolves the force of design of the *Spasimo* into the ornamental order of the *Holy Family* for the Queen. The *Michael* recreates a height of classicism that compares with the best among Raphael's inventions in the Tapestry Cartoons. Like them, this seems also to be in essential parts from Raphael's own hand.[50] It is informative for the direction in which Raphael had been aiming since about 1515 that he has used his hand to elaborate the picture's grandeur of substance with an overcast of fineness, almost precious, and made the tenor of its drama a little more self-consciously theatrical.[51]

All the problems that the late works of Raphael present are visible in their acutest form in his great altarpiece of the *Transfiguration* (Rome, Vatican Museum) [30], also meant for a French destination, the cathedral of Narbonne. The painting was ordered by Cardinal Giulio de' Medici late in 1516 or early in 1517, at the same time as a competing altar, a *Resurrection of Lazarus* (now London, National Gallery) [44], from Raphael's rival on the Roman scene, Sebastiano del Piombo – rival not just on the basis of his own considerable merits but because he was taken to be the deputy of the absent Michelangelo. Raphael's picture was the later to be started, after mid 1518. It was still in his studio, probably not quite finished, at the time of his death, when it was exposed at the head of his bier. That the entire responsibility for the design of the *Transfiguration* is Raphael's has never been in doubt, and recent cleaning has revealed that he had by far the major part in execution.[52] The picture is at once the most commanding and the most difficult of the later Raphael's conceptions,

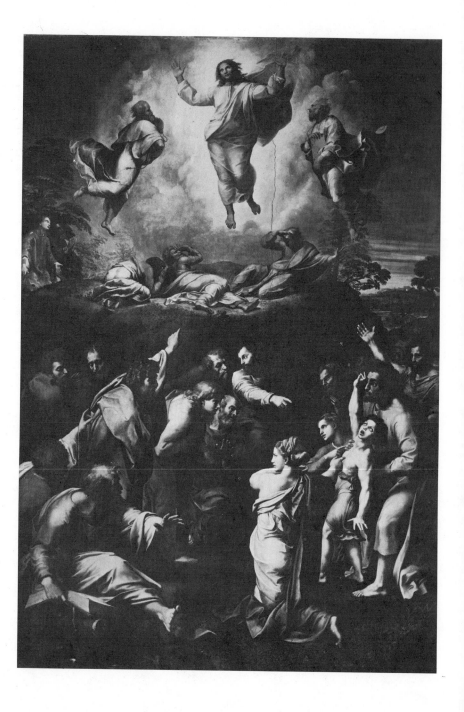

with strong elements in it that work counter to a sense of unity. These exist not only in the design that Raphael chose to organize his subject matter but, even prior to design, in the subject matter itself. It could well have been Raphael's own thought to compound the scene of the Transfiguration with the story of the Possessed Boy that is described just following in the Bible text (Mark ix: 14 ff.; Matthew xvii: 14 ff.), painting in the picture's lower zone what the text in fact says was happening on the plain while Christ was on the mountain: not yet the healing of the boy but the impotence of Christ's Apostles to perform the healing in His absence. It may be that, considering Sebastiano's richly elaborated *Lazarus* that was his competition, Raphael found the Transfiguration subject in itself too limiting and sought the added episode so he might have the opportunity for complex drama and strong sensation.[52a] Not only this, but he took the themes he thus combined as matter to build an effect of grand contrast between events of quite diverse kind depicted not only as if they took place at the same time but in the confine of a single picture space.

In this space the miraculous event of the Transfiguration is relatively removed from us, while the earthly scene of the possessed youth is made on the contrary intensely near. The figures of the lower scene are painted in a searching and contrasting light and sharply drawn to force their look of actuality; their emotions are urgent, pointed, and diverse, and the pattern that their actions make is in accord. Above, the Transfiguration has a seeming calm of content and an almost abstract purity of form that make essential contrast to the scene below; but the calm is in fact a suspension of great forces in a moment of absolute equilibrium. The two zones are made to connect by quite obvious formal means, yet their confrontation is no less

30. Raphael: Transfiguration, 1517–20.
Rome, Vatican Museum

apparent. It is as if Raphael had willed to make one whole new construct from the two possibilities of dramatic style he had explored in recent years: one the exalted, purely disciplined mode of the Tapestry Cartoons, the other the more active and complicating mode of the Incendio frescoes. What Raphael has conceived in the *Transfiguration* no longer works as a genuinely synthetic image but as one in which disparates have been forced to coexist: this forced unity has been made by an overriding utmost power of dramatic idea, supported by brilliantly contrived devices of form. No work could demonstrate more clearly Raphael's continuing assertion of basic classical principles and, at the same time, the strain and alteration of such principles by new intentions. The *Transfiguration* shows, with almost schematic explicitness, the fault that has opened in the structure of classical style.

We can only unprofitably speculate how Raphael would himself have resolved the problem of the next step beyond the style of the *Transfiguration.* The decision was made not by him but by his heirs, and Raphael's personal decision need not necessarily have been the same as theirs. Our last certain evidence for Raphael's dramatic style is the *Transfiguration.* What occurs in it is no necessary index of the destiny of style of all the aspects of Raphael's wide artistic practice. As we have seen, an unfaulted classicism coexists, in the contemporary late decorations, with this dramatic faulted one; and in the portraits there is, for reasons inherent in the genre, no such grave stress laid on classical effects as there has been here. However, in the late phase it is only in the dramatic style, as of the *Transfiguration*, that Raphael confronts not a part only but the whole range of problems with which his art could be involved, of urgency and variety of human expressiveness and of complexity of form. As the non-dramatic works are not, this is the whole test of what the classical style had

come to be in Raphael; it is the significant representative symptom of his latest art. The *Transfiguration* is pregnant with post-classical style, but it remains itself the last and extremest statement of Raphael's classical ambition.

THE SCHOOL IN FLORENCE

Fra Bartolommeo

Baccio della Porta, Fra Bartolommeo, the protagonist of High Renaissance painting style in Florence in the decade after Leonardo's departure, had come initially to a Cinquecento classicism by way of Leonardo's example. It was sought early in Baccio's career, in Leonardo's own early and relatively tentative essays in the new style that he had left in Florence after a long-previous departure, in 1482. Baccio, born in 1472, had been a pupil of Cosimo Rosselli and then became in some way a dependent or auxiliary of the Ghirlandaio shop:[53] it is a manner partly like Rosselli's but more like Ghirlandaio's orderly and meticulous realism that Baccio shows in his *Annunciation* of 1497 in Volterra Cathedral. But probably earlier than this, in paintings of less noticeable destination, Baccio had begun to investigate alternative ways among contemporary styles, first (as in a tondo *Holy Family* of the Borghese Gallery, *c.* 1495?) taking some of the very hesitant, conditioned Leonardism of Lorenzo di Credi into his style, then searching Leonardo's own example. In Baccio's *Madonna and Child with St John* (New York, Metropolitan Museum) Leonardo's *Benois Madonna*, no more recent but less baffling than his great unfinished *Adoration*, is the disruptive and adulterating agent of the picture's basis of Ghirlandaiesque style. Baccio quite rapidly converted his interest in Leonardo's art into an adequate comprehension of it: imitating neither Leonardo's exact vocabulary nor his complexities, Baccio applied what he had come

to understand of Leonardesque principle to the style in which he had been educated. As Baccio took it, Leonardesque principle served to temper Late Quattrocento realism and infuse it with spiritual life, and to compel its static order into a connected harmony. Baccio formulated this basis for a Cinquecento classical style in his (the upper) part of a *Last Judgement* fresco for S. Maria Nuova (Florence, Museo di S. Marco, 1499-1500), evidently far less disconnective from Quattrocento style than Leonardo's own inventions of long-prior date had been but of a distinct novelty none the less – not more bound to a Late Quattrocento context than the work of Raphael about the same time after his beginning.

In 1500, overtaken by a Savonarolan inspiration, Baccio joined the Dominican order, becoming Fra Bartolommeo. For three or four years afterwards he did not paint. What he had given shape to in the *Last Judgement* had been before Leonardo's return to Florence; when in 1503 or 1504 the Frate began to paint again, it was with knowledge of a different body of Leonardesque material from the works, more than two decades old, he had known before. The effects of Leonardo's more recent vocabulary began to penetrate Bartolommeo's style, but even now not wholly altering those qualities in it that recall the Quattrocento (*Vision of St Bernard*, Florence, Accademia, 1504-7; *Noli Me Tangere*, Paris, Louvre, *c.* 1506). It seems relevant that during a visit of some months to Venice (April–November 1508, engaged by the Dominican establishment there) it was the old Bellini's art, more than Giorgione's, that seems to have commanded Bartolommeo's attention. The evidence of his looking at Bellini is in two at least of the three important altar paintings he produced in Florence during 1509, in which Venetian and Leonardesque modes of light work somewhat in contest. That they could not quite be reconciled must quickly have become

clear, the one revealing itself in colour, the other consuming and neutralizing it; the native mode prevailed. The most Bellini-struck of these three altars, the *Madonna with Six Saints* (Florence, S. Marco), is also in other respects the most retrospective in its style (perhaps from the intervention in its execution of the Frate's partner, Albertinelli). There are traces of Bellini in the *God the Father with the Magdalene and St Catherine of Siena* (Lucca, Pinacoteca, dated), but they have been incorporated into a vocabulary which makes an effect never earlier apparent in Bartolommeo's art, of a modernity without a residue of archaism in it. The basis of structure of this altar relates, by iconographic as well as formal necessity, to the Quattrocento tradition (and so, almost inescapably, do all the altar paintings of the High Renaissance); on this basis, to which Bartolommeo was more bound than the greater modern inventors, he finally, in 1509, imposed the suavities and sophistications of their modern style. In all three altar works of 1509, but most of all in the one that seems to be the most advanced, the *Madonna with St Stephen and St John the Baptist* (Lucca, Cathedral, dated), there are indications that, beyond his earlier concern with Leonardo, Bartolommeo has carefully considered the most recent (and in that moment most Leonardesque) Florentine accomplishments of Raphael; a major instrument in the entire modernizing of Bartolommeo's style may have been the influential, even though unfinished, *Madonna del Baldacchino.*[54]

It was thus only in the year following Leonardo's final abandoning of Florence and Raphael's departure for Rome that Bartolommeo, become *caposcuola* by default, came to possess a style that was a valid surrogate for theirs. Far more limited than they in spiritual as well as intellectual resource, it may have been fortunate for the Frate that the main patronage in Florence – the one in any case to which his vocation should have best disposed

him – was for devotional altarpieces rather than for more flexible or dramatically complicating forms. He applied his late-won modernity to altar painting, making a Cinquecento classicism of structure for his works in this grand genre which, though deduced to begin with from Raphael's *Madonna del Baldacchino*, clarified and transcended that example. The more profound intelligence and the more pregnant meaning in these altarpieces is in their structure; not altogether from the limitations of iconography, what illustrates human meaning in them tends towards the conventional, and their harmony may verge on blandness. But the way in which their formal structure is manipulated endows them with expressive sense and rhetorical value; it is by the working in these altars of the elements of form that the spectator may be moved to feel nobility and a high pathos. The human population of the picture are less actors than acted upon by the aesthetic structure: grandeur of form may be a substitute – or stand – for a dimension of content that the figures lack.

The great altarpieces of this mature style work (almost like Leonardo's *St Anne* pictures or Raphael's Florentine Madonnas) *en série*, consequent exploitations of a connected structural and expressive idea. In the idea of structure there is a core of a geometry as obvious and as strict as in an altar of the Ghirlandaio school, but the kind of geometry is that of the modern classical style. In 1511 the *Marriage of St Catherine* (Paris, Louvre, dated) sets the structural theme (which the latest of the altars of 1509, in Lucca Cathedral, initially adumbrated), an ordering of forms upon the picture surface and into its space that in the whole approximates a sphere [31]. A setting of architecture supports and stabilizes this order and lends it monumental scale, but the architecture is not primary or even necessary to the construction. In an advanced classical sense (like that Raphael realized in his

figure groups in the contemporary Stanza), this plastic form, so ideally clear and whole, is built of the idealized human substance that inhabits and animates it. The unfinished *St Anne* altar (Florence, Museo di S. Marco, commissioned by the Signoria in 1510, designed and underpainted *c.* 1512, but never delivered) amplifies the scheme of the *St Catherine* altar; a second *Marriage of St Catherine* (Florence, Accademia, dated 1512, formerly in the Pitti) [32] amplifies and complicates the geometric structure, and adds to the expressive powers contained in the form a forcing of chiaroscuro, a deduction drawn out

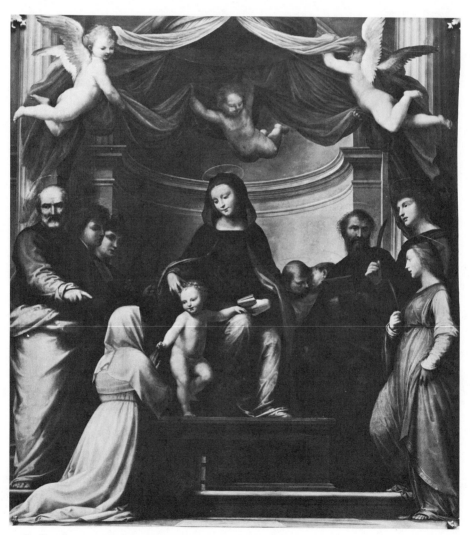

31. Fra Bartolommeo: Marriage of St Catherine, 1511. *Paris, Louvre*

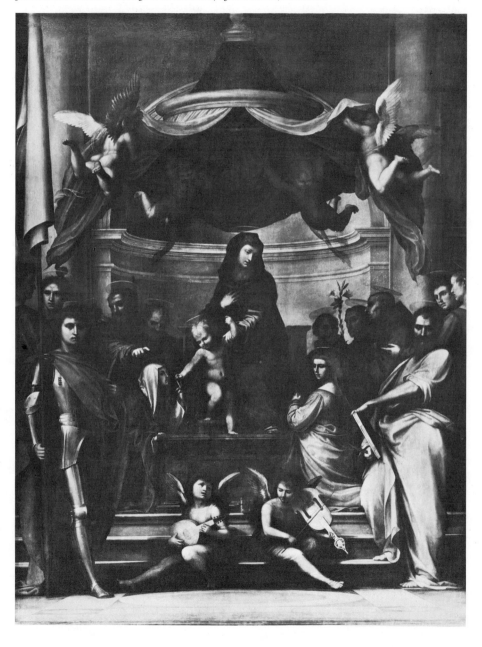

to a near-extreme from the art of Leonardo and a conversion of it to a rhetorical end. Here, and almost equally in the shortly precedent *Virgin in Glory* (Besançon Cathedral, 1511-12),[55] Bartolommeo realizes the measure of dramatic pathos that can be made without the overt illustration of dramatic action, using only the resources that reside in form.

What the Frate had attained in this series of monumental altar paintings was, in terms of the development of the formal vocabulary of the classical style and the powers in that vocabulary of expression, not much less than Raphael's accomplishment of the same time in Rome. For a multitude of reasons, the Frate's field of action was very differently restricted; these joined to factors in the painter's temperament to make a whole region of expression, depending on the illustration of dramatic action, difficult of access for him. In 1514 Bartolommeo visited Rome, concerned to see what, in the time since Michelangelo and Raphael had gone there, art had accomplished. The experience was instructive but also (Vasari, IV, 187) quite discouraging; Roman standards pointed up the comparative limitation of the Frate's art. Returned to Florence, he attempted to infuse his altar style with the movement and variety in illustration of a Roman mode: his *Madonna della Misericordia* (Lucca, Pinacoteca, dated 1515) pretends to the repertory of a Raphaelesque dramatic fresco, and a large *St Mark Evangelist* (Florence, Pitti, *c.* 1514) paraphrases the Sistine Michelangelo. However, the deficiency of passion that was in the actors of Bartolommeo's pre-Roman works persists, made only more apparent by the borrowing of Roman forms to illustrate it. It is a more considered rethinking of the Roman experience that produced, in 1516, Bartolommeo's last great altar, the *Salvator Mundi* (Florence, Pitti, dated). First conceived, as the drawings for it indicate, as a dramatically movemented image, the actual

design stills movement, ordering its elements into a willed simplicity as clear as the Frate's deliberation can achieve and impressively ponderous. Almost contemporaneously with Raphael, Bartolommeo for a moment in this altar makes an analogue to the austere dignity of the style of the Tapestry Cartoons – far from equally inspired, however: comparable in form and in intention of expression but of no comparable power.

Where he could make form eloquent, in paintings of large scale, the Frate's capacity – or will – to describe emotion in his actors was conversely lacking, but in paintings of small scale (e.g. his *Annunciation* altar, Paris, Louvre, dated 1515) he could articulate, and with extraordinary subtlety, emotions that were intimate and fine; and his later drawings, altogether private objects, are rich in expansive feeling inspired by their themes as well as in energies of form. Little of this was carried over into the larger works, or into the conventional devotional pictures for household use that the Frate's atelier multiplied for him in later years. The power and the sensibility that may be in his first conceptions do not sufficiently survive his translation of them into paint, and the final image too often has his mark of blandness and a grandeur that is slightly vacant.

In many of the works that issued from Bartolommeo's shop, including parts of some that we have discussed, the translation of idea into paint is doubly vitiated, since it is made by less able hands and by insufficiently understanding minds. Closest to the Frate, occasionally able to function for him almost in the role of *alter ego*, was Mariotto Albertinelli (1474-1515), Baccio's schoolmate in Rosselli's shop, through much of his career joined with Baccio in some form of association, and from 1509 to 1512 formally his partner. However, Albertinelli was by no means a mere adjunct to the Frate's personality; even during the times when he acted as assistant, collaborator,

or deputy for Bartolommeo he did not leave off working independently. The 'independent' pictures most often conform to the models of style laid down by Bartolommeo, but Albertinelli's following seems as if at a sensible chronological distance, of more backward accent than the Frate's. The Quattrocento element in their shared background, persistent for so long in Bartolommeo, was, even with Bartolommeo's modern example, harder for Albertinelli to put by. Albertinelli was thus an artist of uncertain consistency and direction. By 1500-1, when he completed the lower half of Bartolommeo's *Last Judgement* for S. Maria Nuova, most likely using the Frate's designs, it was in a style essentially quattrocentesque. In 1503 Albertinelli's *Visitation* (Florence, Uffizi, dated) seems also likely to be from a design Bartolommeo would have supplied; and though the painting is quattrocentesque in surface – in some ways specifically Peruginesque – it responds with intelligence and power to essential principles of Bartolommeo's modern style, joining forms into a large, moving harmony. Yet two or three years later the fresco *Crucifixion* at the Certosa di Val d'Ema[56] is ponderous, intense, and discoordinate, almost heedless of the incipient ideas of classical style. However, as Bartolommeo's example of a classicism grew more evident and firm, Mariotto shaped himself more wholly on it. Dated 1510, but probably the product of at least two preceding years as well, Albertinelli's monumental *Annunciation* (Florence, Accademia) [33][57] assembles bits and pieces from Bartolommeo (and, perhaps, a notion from a drawing by Raphael)[58] to make a somewhat inchoate masterwork, the first counterpart in Florence – earlier than in Bartolommeo's own œuvre – of the contemporary tendency in Rome to make an image convey a monumental pathos. Also before Bartolommeo, Mariotto in the *Annunciation* makes dramatic value out of forced chiaroscuro. Apparently inventive as

33. Mariotto Albertinelli: Annunciation, 1510. *Florence, Accademia*

Mariotto seems to be in this work, his subsequent independent pictures on a larger scale use only what is obvious or superficial of Bartolommeo's past demonstrations of principles of classicism. Probably in 1510, a *Madonna Enthroned with Saints* (Florence, Accademia) refers to Bartolommeo's altarpieces of the year before, but with more retardataire effect; in 1514 another *Madonna Enthroned* (Volognano, S. Michele, dated)[59] simplistically transcribes the Frate's models of about 1511 and 1512.

There is not only a difference in principle – or the absence of it – between the style of these works and the Frate's. There is a marked distinction in the tenor of Albertinelli's personality: ingratiating, but also flaccid, softer in his touch and more inclined to play with colour.

On occasion, in pictures on a smaller scale (e.g. *Madonna and Child with St John*, Harewood House, Yorks., signed and dated 1509) he indulged tendencies of sentiment that verged on eccentricity. Still, his art as a whole achieved a sense nearer to Bartolommeo's than the lesser members of the shop attained. The chief among them, Fra Paolino (of Pistoia, *c.* 1490-1547), came to imitate the outward face of Bartolommeo's style rather literally, but with a glassy lifelessness (e.g. *Pietà*, Florence, Museo di S. Marco, 1519). The substantial matter of Paolino's art – a stock of Bartolommesque types and compositions and timid similes of Bartolommeo's content – were only little affected by the changing fashions of the years in which he practised after Bartolommeo's death.[60]

Fra Bartolommeo was without doubt the most important model to the painters of the Florentine school who came to work in the High Renaissance style. Leonardo and Michelangelo had said determining, but too revolutionary things too soon for their contemporaries to comprehend. Raphael had helped significantly to make the new doctrine of style accessible, and despite his departure from Florence had, for a while afterwards, a strong effect upon the painters of the city. Bartolommeo's slower emergence to command of the new style was, however, more in keeping with the process of acclimatization to it among his contemporaries and juniors. In an accent more native than Raphael's and with much less intimidating skill, Bartolommeo remade Leonardo's language into a practicable speech for lesser Florentines. Hardly a painter in the city working during the second decade, or many who worked longer into the century, escaped his shaping influence. Like Raphael, but with more enduring effect locally, the Frate made his model the efficient surrogate of Leonardo's. But Bartolommeo's authority as *caposcuola* was relatively quickly challenged by a painter half a generation younger whose style Bartolommeo, in the normal pattern of this time, helped in part to form: Andrea del Sarto, of a richer and subtler talent than Bartolommeo, and even more representative of tendencies and traditions special to the art of Florence.

Andrea del Sarto

Born in 1486, Andrea had his first training (according to Vasari's testimony) with Piero di Cosimo, then, within the first decade of the new century, probably as late as 1505, with Raffaellino del Garbo (Carli).[61] The teaching of both masters, when Andrea had it, was of late Quattrocento style, but it may have been a temperamental matter more than one of time of birth and training that disposed Andrea, within his subsequent high development of classical ideas of style, to a way of seeing and a tone of content that remain sensibly like those of the Quattrocento. About 1507-8 (*Holy Family with St Peter Martyr*, Bari, Pinacoteca), on a basis that seems mostly to have been learned from Raffaellino, Andrea imposed the results of study, since he had gained his independence, of advanced currents of contemporary style. His chief source is Raphael, but Andrea insists more than Raphael himself on the Leonardism to which the latter was so much indebted at the time. Fra Bartolommeo's models, at this point not yet quite maturely formed, seem less relevant. Andrea's new inclination coincides in time with that of a friend, a little older, with whom he had entered into occupancy of a common studio, Francesco Franciabigio, though Franciabigio's tendency was more exclusively towards Raphael. Despite elements of style that they then shared, Andrea's penetration into the classical sense of his models was far deeper. However, his command of new resources was limited; it was sufficient to achieve a fair consistency of classicizing effect in small images (e.g. *Madonna*, Rome, Galleria Nazionale, *c.* 1508), but not in

a work of large extent. In 1509, when Andrea undertook his first major effort of fresco decoration, the *History of St Philip Benizzi* (finished 1510) in the atrium of SS. Annunziata, his relation to the new classicism seems equivocal, obscured by a more apparent connexion with the Quattrocento precedents of Ghirlandaio; but where he could deal again with more concentrated matter, as in the panel *Noli me Tangere* (Florence, Uffizi, *c.* 1510), his communication of an essential tone of classicism is explicit: the scene is suave and grave and at the same time vibrant with contained emotion.

During the following year, Andrea achieved a dramatic expansion of his apparatus of new style. His paintings of 1511 and also the year after may still show indices of immaturity, but they no longer make the effect of persistent but strong affiliation with the Quattrocento: they mark Andrea's determining commitment to modernity. Fra Bartolommeo's model, now, is Andrea's principal guide, largely displacing Raphael; Bartolommeo's vocabulary – his canon of appearance and behaviour and, conspicuously, his drapery style – are the basis of a thorough remodelling of Andrea's manner. But within Bartolommeo's art Andrea sees yet more of Leonardo than he had in Raphael's before. He does not revert to Leonardesque example but infuses Bartolommeo's style with a complexity and animation like Leonardo's and with an almost comparable mobility of light. By contrast with the transposition that Andrea made of Fra Bartolommeo's style, Bartolommeo more than ever seems conventional and bland. Incorporating the Frate's accomplishment, Andrea draws abreast of his development of a Cinquecento classicism, and in some ways overtakes it.

The fresco *Procession of the Magi* (often called an *Adoration*; 1511), again in the forecourt of SS. Annunziata, is the dramatic demonstration of this new stage in Andrea's style; it also marks his achievement of the stature that henceforth will be his. The classical sense of the *Procession* is not only in its breadth and suavity of forms or their cadenced stateliness of movement, or even in the fine deliberation with which Andrea has made weighty balance in an asymmetrical design. His penetration into classical principle has gone farther; for the first time he conveys that the whole image has been thought of and projected as a unity, simultaneously working all its aspects – plane, mass, space, and coloured light – into a harmony. As important, there is no longer a distinction between thinking of the picture as a representation and the purpose in it of creating an aesthetic order: these values also have been wholly fused. In the *Annunciation* from S. Gallo (Florence, Pitti, *c.* 1512) and the small altarpiece of *The Marriage of St Catherine* (Dresden, Gallery, 1512–13) [34]

34. Andrea del Sarto:
Marriage of St Catherine, 1512–13. *Dresden, Gallery*

Andrea's reference to Bartolommeo's precedents (in the former case, more precisely, to Albertinelli) and his vivifying transformation of them continue. In the *Marriage* his intensifying of the life of form is accompanied by an extraordinary brilliance and assertiveness of colour, quite contradictory of Bartolommeo's habit; this had also appeared shortly earlier in a painting by Andrea probably precedent to the *Procession* fresco, the *Tobias* altar (Vienna, Kunsthistorisches Museum) of 1511. More than in the *Tobias* altar, the energy of colour in the *Marriage* exceeds classical measure; the tenor of emotion in the picture, which seems set in almost as high a key, comes close to doing the same. The *Marriage* seems a momentary extreme, assimilating classical principles of form with deep intelligence but then testing the limits of expression they might be expected to contain. More maturely, and with a deeper sense of what is apposite to a classical style of expression, the *Holy Family with St Catherine* (Leningrad, Hermitage, 1513) converts energy of colour into subtlest manipulation of light, and no less subtly manipulates complex emotion. In both respects Andrea recalls Leonardo, not just in kind but almost in quality. For Fra Bartolommeo, the classical vocabulary had its chief use as an instrument for generalization; in Andrea the principles that make generalization are quite clear, but they are inhabited – not just suffused – by an acute sense for individual phenomena: things are seen with a special sensibility, and there is an equal sensibility to what is individual or private in emotion. Again there is an analogue to Leonardo, but in Andrea there is no comparable pressure of the facts towards ideality. The classicism that he has achieved by now has a most sophisticated aesthetic apparatus and generally conforms to the style's prescriptions for expressive tone; but more than the classicism of his predecessors it is bound to nature and the ordinary expectations of experience.

The great work that signals Andrea's entire achievement of artistic maturity, the fresco *Birth of the Virgin* in SS. Annunziata, begun late in 1513 and dated 1514 [35], is profoundly marked by this naturalizing disposition. The painting does not imitate the famous Ghirlandaio fresco of the theme, but within an absolutely accomplished classical framework it perpetuates a strong quota of the same kind of meaning. Andrea's fresco, too, is reportage, opulent, mundane, and remarkable for its effect of actuality; and it is less aristocratic. Appearance and deportment in the actors is suave and handsome, but not ennobled, and their composition on the picture stage evades formality, carefully pretending to be casual. It is apparent that the painter would convey that this pictured world is alive in the manner of our own and, in effect, accessible to us. For all the masking of deliberation this requires, the evidence of its working in a high development of classical ideas is amply and pervasively apparent. Extending the conception he had used in the adjoining fresco, the *Procession*, Andrea makes a far more eloquent, more gravely balanced slow grace in the design. And colour, seeming at first sight ingratiatingly offhand, proves no less than the arrangement of substance to be calculated on classicizing principles: Florentine *disegno* has been applied with as precise control to colour as to form. More than Bartolommeo's art in 1514, Andrea's achievement in the *Birth of the Virgin* is comparable to Raphael's contemporary work in Rome; the Frate comes nowhere so near Raphael in suavity in the classical idiom, or in variety and vitality of form and idea.[62]

In 1515 Andrea returned to work at another fresco decoration on which he had made a tentative beginning earlier, in 1509-10: the painting in grisaille of a history of St John the Baptist in the small cloister of the Florentine Confraternity of the Scalzo. Andrea was to work on its scenes at irregular intervals through

35. Andrea del Sarto: Birth of the Virgin, 1513-14. *Florence, SS. Annunziata*

36. Andrea del Sarto: Madonna of the Harpies, 1517. *Florence, Uffizi*

most of his career. He had apparently fixed the system for the decorative scheme himself: rectangular fields set on a *basamento*, framed by painted pilasters and capped by painted atticae.[63] The system suggests that each scene in it is an enactment set out on a stage, and even without colour they make remarkably efficient similes of actuality. The scene painted in 1515, the *Preaching of the Baptist*, again recalls a precedent by Ghirlandaio, and the sense of a relation is affirmed by Andrea's inclination towards more than is usual for classicism of descriptive truth; but again a different structural geometry and unity of painterly effect show, as much as in the *Birth of the Virgin*, the profound and essential change of the tradition that Andrea has wrought. By now, he has come close to a mastery of the resources of classical painting style that, already surpassing Bartolommeo's, moved higher still, towards Raphael's; and, as with the recent Raphael, Andrea's development was one not only of sophistication but of strength. In a fresco painted for the Scalzo in 1517, the *Arrest of the Baptist*, there is a stringency of order and sharpness of dramatic sense that almost bear comparison with the Roman Tapestry Cartoons. The *Madonna of the Harpies* (Florence, Uffizi, dated 1517) [36] demonstrates a more extraordinary command of classical *disegno*: a logic that is evident and absolute is subtly and complexly differentiated. In the former respect it resembles Raphael's *Sistine Madonna*, in the latter exceeds it. The complexity is not an abstract manipulation of geometry but a function of the way in which Andrea perceives colour, light, and form: as many qualities in this picture are induced from actuality as are inspired in it by acts of ordering artistic will. Andrea's image, thus transcending nature less than Raphael's, is nearer to the spectator as a descriptive – even in a precise way, an optical – experience, and its quality of human presence corresponds. The vibrance of line and colour that so plausibly evokes the actors interprets their spiritual dispositions also: subtly live and intimate, inviting shared communication but not aspiring even to Bartolommeo's rhetoric, much less to any Roman heroic stature. Comparable in formal and expressive kind, Andrea's *Disputation on the Trinity* (Florence, Pitti, *c.* 1518) may be still more concerned for subtleties of eye and hand.

The climactic work of this first high phase of Andrea's art is a *Caritas* (Paris, Louvre, dated 1518), painted in France, where he had gone in François I's service for a period in 1518–19. In this picture Andrea's realization of his classical constructive powers converges with his finest exposition of his painterly and psychological sensibilities. It seems likely that the result, almost more Leonardo-like in principle as well as in effect than any of Andrea's earlier paintings, should have followed on his again seeing the pictures that Leonardo, recently deceased, had left in France. In Andrea, the infusion in this extreme degree of complication into classical principle threatens compromise of it: the *Caritas* has qualities of form and emotion that suggest some that Andrea's ex-assistant, Jacopo Pontormo, had explored in Andrea's absence (or perhaps just before it) in his initial ventures beyond the confines of classicism. But differently in essence from Pontormo's Mannerism, what is in the *Caritas* is, in a genuinely classical sense, the most complex differentiation of a harmonious unity, not a disruption of it. But in the measure of complexity and the fineness of the equilibrium made from it, this is a precarious *summum*, and it is a developmental end. Having reached this end in the *Caritas*, Andrea confronted a crisis as well as a climax of his classical painting style. After his return to Florence he was to probe in a context that included an emerging Mannerism towards a reformulation of his style, but not with the means of the younger Mannerists nor towards their ends.

Franciabigio

The painter in whose company Andrea had started his independent career, Francesco Franciabigio (1482/3-1525), slightly older than Andrea, may in the beginning have given him some stimulus towards the modern style. For a time, not just in the few years that they shared a shop but even briefly afterwards, the interests of the two *compagni* were much alike and their styles occasionally similar. Relatively quickly, however, the difference between Andrea's genius and Francesco's much more limited gifts began to show. Adventurous to start with in his approach to the models in Florence of the new classical style, Franciabigio's capacity to penetrate their sense soon faltered, constrained, probably, less by his intelligence than by defects of sensibility and a temperament that, unlike Andrea's, could not sublimate a strong inheritance from the Quattrocento into Cinquecento terms.

What Francesco's initial training as a painter may have been is not clear, but he was for a while (until about 1506) in Albertinelli's shop, more likely as an assistant than as a pupil. It was from Albertinelli that he took his first impulse towards a modern style (*Madonna with the Infant St John*, Perugia, Count Ranieri, *c.* 1506); but afterwards, like his companion Sarto, he moved towards the model of a classicism afforded by the current, Leonardo-inclined Raphael (*Holy Family*, Florence, Accademia, *c.* 1507). During 1509, as a *Madonna* (Rome, Galleria Nazionale, dated; long taken to be by Andrea) attests, Andrea's particular vocabulary began to impose upon Francesco, and until about 1511 he worked in a mode that resembles, in a rather simplistic version, Andrea's style of his Benizzi phase (*Adoration of the Shepherds*, Florence, Museo di S. Marco, dated 1510).

In 1511 or early 1512 it seems, entirely on internal evidence, that Francesco must have visited Rome, and once more the chief object of his study was the recent Raphael. It may have been just after his return from this journey that he painted the nearly-imitative Raphaelesque *Madonna del Pozzo* (Florence, Accademia) and the *Holy Family* (Vienna, Kunsthistorisches Museum), a little more independently conceived: both works are of an almost glassy slickness, more quattrocentesque than modern in their handling, and exaggerate the movement of the Roman Raphael into disequilibrium.[64] There are traces in the fresco *Marriage of the Virgin* that Francesco painted in the forecourt of the Annunziata in 1513, close by Andrea's *Birth of the Virgin* but mostly earlier,[65] of this presumed Roman study: they appear not only in specific motifs but in a will to stimulate the scene to action. Francesco makes his composition move, but neither wholly nor coherently: classical contrivances of form observed in Raphael (more, now, than in the recent Sarto) make connexions but no synthesis of the design. The quota of pre-classical prevention and inherently unclassical disposition in Francesco makes the essence of the modern style ungraspable by him. His hybrid art evidently cannot have a classical personality, but its effortful strength of character is not unwelcome in the context of Bartolommeo's blandness and Andrea's suavity.

The insufficiency the *Marriage* shows in contrast with Andrea's *Birth of the Virgin* was somewhat repaired by subsequently borrowing from its vocabulary, adapting its fullnesses of form and more than Francesco had been able to digest from Raphael of the idea of connected movement. His *Last Supper* (Florence, Convento della Calza, dated 1514) makes a frieze of forms that nearly approximate a classical effect [37]. Its figures have an un-suave, rather awkward power, and they are moved by an obvious dramatic sincerity, a little naïve. Despite their deficiency of classical sophistication, Francesco's actors convey a dramatic force

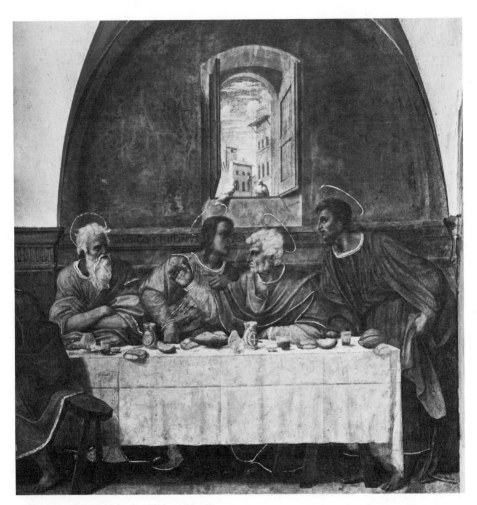

37. Francesco Franciabigio: Last Supper (detail),
1514. *Florence, Convento della Calza*

which, exceptionally for Florentine painting of the time, is comparable to that in the dramatic works of contemporary Rome. Once formed, this was the vein of style in which Franciabigio was to work for the rest of the decade. His *St Job* altar (Florence, Uffizi, dated 1516) attains a singular pathetic power, stark, gloomy, and quite unbeautiful; it is more fluent than Fran-

cesco's earlier paintings only in the actions of his hand, not in the workings of his mind. In 1518–19, while Sarto was away in France, Francesco took his place in the cloister of the Scalzo, executing two scenes from the beginning of the Baptist's history. There, mistaking emphasis for eloquence, Francesco exaggerated his dramatic manner of the Calza *Last Supper*,

making the most ponderous actors to be seen in Florentine painting of the time. It would require another experience of contemporary Rome, which we assume occurred within the next year or so, to give Franciabigio's style a renewed impetus of classicism and a renewed consistency.[66]

Piero di Cosimo

Franciabigio's history is an indication of the uncertainty of purpose with which painters of less than the first rank faced the demonstrations given them of the modern style, and of the incomplete accommodation they might make with the classical principles that it contained. And Franciabigio, as an exact contemporary of Raphael, belonged by generation among the moderns; painters who were older and whose personalities had been more wholly formed within a Quattrocento style were still less tractable. Some among them, continuing to work for some time into the new century, were impervious to change: Lorenzo di Credi (d. 1537), who perhaps till about 1520 ran an active and successful shop, or Raffaellino del Garbo (Carli, 1466-1524). A still older master, Piero di Cosimo (1462-1521), of different stature, responded to the novelties of Cinquecento style with flexibility and interest, but for more than a decade turned them mostly to his idiosyncratic and conspicuously unclassical ends. But when, about 1515, he finally converted himself into a follower of Fra Bartolommeo, it was at heavy cost to his own personality. The manner of the latest of Piero's paintings lacks conviction, and gives the sense that he has come to it from tired acquiescence in the reigning fashion.

Though it took more than a decade, the course of change in Piero was quicker than might have been expected in an artist half of whose career had already been accomplished in the Quattrocento. The first agent of the change was Leonardo, of whose long-past

precedent in the *Adoration* Piero began to take cognizance, however tardily and incompletely, in his *Madonna and Saints* for the Hospital of the Innocenti (*in situ*, c. 1503?). By 1505-6 not only Leonardo but what had been propagated of his style into Fra Bartolommeo considerably reformed Piero's art: his *Immaculate Conception* (Florence, Uffizi), still singular in quality of seeing and of fantasy, resisting idealization, is nevertheless structurally in an elementary classical style. In a way that seems almost paradoxical, but is in fact a distorting mirror of a process that occurred in Leonardo, singularity grows in Piero quite concurrently with his acquisition of elements of classical style. His *Madonna with Angels* (Venice, Cini Collection, c. 1507) [38] is certainly Leonardo-inspired, but its musical design is interrupted by eccentric cadences, and the smiling presences that it contains are not harmonious and sfumato but, contrarily, too sharply searched by line and light, curious and poignant in appearance and psychology. His tondo *Adoration of the Child* (Rome, Borghese, c. 1510-12) is even more extraordinary: here Piero has transformed what he had gathered of modernity into a delicate, nostalgic archaism. About 1513 this progressive union between what is special in Piero and his acquisitions from the classical vocabulary attained a climax in the fairy-tale *Liberation of Andromeda* (Florence, Uffizi).[66a] However, Piero's acquiescence in the Bartolommesque idiom of classical style that by then had unqualified first place in Florence was soon complete. His *Prometheus* panels (Munich and Strasbourg, c. 1515) have the inescapable enchantment of any of Piero's narratives, but no more than a residue of quattrocentesque habits marks their style off from Bartolommeo's; in the contemporary *Immaculate Conception* (Fiesole, S. Francesco) the effect of style is about the same, but weakened by the intervention of assistants. Of the merits that had earlier been peculiar to Piero little remains in these late concessions to

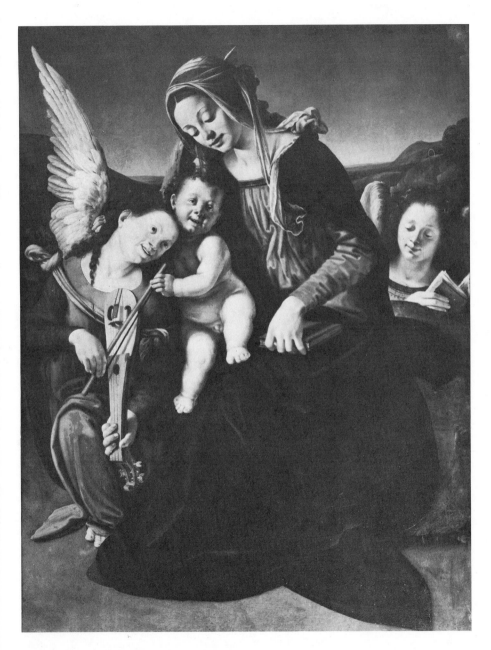

38. Piero di Cosimo: Madonna with Angels, *c.* 1507. *Venice, Cini Collection*

Bartolommeo's mode save for a soft and un-sure private pathos (as in the *Holy Family with the Infant St John*, Venice, Cini Collection, *c.* 1515?), the relic of an individuality of sensa-tion that had been so wonderfully complex.

Lesser Florentines

Francesco Granacci (1469/70–1543) was of a generation between Piero's and Fra Bartolom-meo's, and by the time the new century began his new style had matured in a Quattrocento mould, determined in his case mainly by his working as an assistant to Domenico Ghir-landaio. With much quality of hand, but little individuality, his accommodation to the modern style as it acquired precedence in Florence was gradual, unquestioning, and on the whole pedestrian in its results. Until about 1505–6, he worked undisturbed in the style in which he had been formed, a technically fine, tonally pale, and expressively pallid derivation of Ghirlandaio's. Then, he turned his attention to the art of his modern colleagues, and in succession reacted to the models of Michel-angelo (an old friend of their joint time in Ghirlandaio's shop) and Leonardo briefly, and more lastingly of Fra Bartolommeo. His bor-rowing from them was enough to give a super-ficial cast of novelty to his native style and to instil in him the elementary principles that distinguished Cinquecento classicism from the classical tradition of the Quattrocento. By about 1512 his style seems to belong within the High Renaissance, but as if at a very early rather than a contemporary stage (e.g. *Madonna with St Jerome of Villamagna and St Donnino*, S. Donnino di Villamagna, *c.* 1511). His com-mand of principle seems never to have become much advanced; however, by about 1515 he had acquired – from Fra Bartolommeo chiefly, but also from past Florentine works of Raphael – enough suavity in shapes and modelling chiaroscuro effectively to give his work a modern aspect (*Madonna with St Francis and St Zenobius*, Florence, Accademia, *c.* 1515–16). Yet even now the Ghirlandaiesque foundation of Granacci's art is sensible, and it is evident how his 'modern' style is an old one not much more than minimally transformed.

In 1517–18, Michelangelo provided Gra-nacci with a design for the centre panel of a high altar he had been commissioned to paint for the convent of S. Apollonia. The panel done from Michelangelo's design is lost, but side panels with figures of standing saints from Granacci's own design survive (Munich, Pina-kothek). In such close proximity to Michel-angelo, paraphrasing a drapery style his model must have supplied, it is still clear that Granacci's pliable goodwill towards classical style does not make up for his limited compre-hension. The predella stories of this altarpiece (Florence, Accademia and Berenson Collec-tion), however, hold a quite different sense: in their *maniera piccola*, where the ambitions of classical design and expression do not per-tain, Granacci works with almost exaggerated liberty, loose in handling, giving the design of figures an attenuated, unsubstantial grace, and ordering narrative with cursive speed. The result resembles the deduction that young Jacopo Pontormo had shortly before made from Sarto's small-scale style. But it less than that suggests an incipient Mannerism; rather, like the larger and more cautious narratives from the Joseph story Granacci contributed to a decoration for Pier Francesco Borgherini at the same time (Florence, Uffizi), they seem translations of late Quattrocento small-scale modes into contemporary speech. That their modernism was no more than apparent seems confirmed by a work commissioned to Granacci in 1521, an altar of the *Madonna with Four Saints* (Montemurlo, Pieve), which is man-nered only in its preciosity of handling: in structure and in content it is uninspiredly traditional.[67]

Vasari characterized Granacci as an artist who disliked effort: that he gave some exercise to his hand but little to his mind is quite apparent from his works. His close contemporary and fellow-student in the Ghirlandaio shop, Giuliano Bugiardini (1475–1554), on the contrary engaged himself with much seriousness in the problems of his art and tried, with an apparent effort of the spirit and the intellect, to make the modern classical style his own. We do not know early Ghirlandaiesque works he may have done; when we can first identify him, after 1505, he had already reoriented his art in the new direction, taking counsel from Albertinelli and, shortly afterwards, from Raphael. Some time before 1512 he recognized the ascendancy that Fra Bartolommeo had assumed in Florence and had absorbed much of the appearance of his style (*Madonna del Latte*, Florence, Uffizi, *c.* 1512–15). Even at this point, however, it was only an incomplete and awkward simile that he could make of this example; from the beginning of the long course of his approach towards classical style there had been a conflict between its principles and Bugiardini's personality, and it was not resolvable. His seriousness of expression and assertiveness of form are accompanied by an overwhelming naïveté, and sometimes a naïve pretentiousness. No less deeply rooted in him is an absolute lack of sense for aesthetic relations; the concept of a harmony of form and of the kind of beauty that proceeds from it was inaccessible to Bugiardini. Impermeable to the meaning of proportion, he constantly committed *gaffes* of scale and shape that are awkward contradictions of any intended classicizing form. His craftsmanship was adequate: it is the *gestalt* of the new style that he could not adequately learn. Yet his ambition to work in the current fashionable and authoritative mode was a force more powerful than his aesthetic disability. By sheer effortful application he was able to absorb the elementary and external elements of classical style, and even something of its more essential laws.

In the later teens Bugiardini developed some independence from the Frate's manner, creating a more plastically emphatic style which, harsh and disarticulate as it may be, entertains ambitions like those of the classical style's recent advanced, austere phase. The *Madonna with the Infant St John* (Florence, Uffizi, dated 1520), emphasizing clarity, and of a stiff dignity in its expressive tone, suggests contemporary Rome almost more than current Florence. Despite his limitations, Bugiardini achieved a tardy contemporaneity in his style, but then he tended very quickly to rigidify in it. He had a long subsequent career in which, as new styles developed around him, he seemed again not only a limited but an old-fashioned artist.

If such was the course of two painters whose origins had been in the Ghirlandaio shop, a not dissimilar history might be expected from a third, actually Domenico Ghirlandaio's son. Ridolfo Ghirlandaio (1483–1561) was educated more by his uncle than his father, who died when Ridolfo was eleven. On this most conservative basis other influences were imposed: first Piero di Cosimo's and the early, still preclassical Fra Bartolommeo's; then the most modern ones of Leonardo – only superficially – and, with peculiar effectiveness, Raphael's. From 1507–8 for two or three succeeding years Ridolfo – Raphael's exact contemporary and, according to report (Vasari, IV, 321), his friend – overlaid the Ghirlandaiesque foundations of his art with a luminous veneer of Raphaelism, not merely imitated but much felt, and understood just sufficiently to give his forms a modicum of flexibility and grace (e.g. altar wings with Angels, Florence, Accademia, *c.* 1508). In portraiture the best approximation of the Florentine Raphael so far was Ridolfo's (*Lady with a Rabbit*, Yale Art Gallery, *c.* 1508; *Girl with a Unicorn*, Rome, Borghese, *c.* 1508–9).

By the time Fra Bartolommeo's example took primacy in Florence Ridolfo was equipped to follow it: his conversion to that mode seems to have occurred towards 1512. His borrowing from Bartolommeo's vocabulary was much less imitative than his Raphaelism had been, however; his disposition – not only inherited but, it would seem, cultivated – towards literal description is more sharply relieved in a context of Bartolommesque style. But beneath this insistent carry-over of a backward taste Ridolfo may have absorbed as much, perhaps a little more, of the structure and expression of a classical style than Granacci or Bugiardini. For all the ineradicable traces in them of Ridolfo's heritage, his *Translation of the Body of St Zenobius* (Florence, Accademia, *c.* 1517) or his *Madonna with Saints* (Pistoia, Museum, *c.* 1518) at least modestly approximate, by this late date, the character of works in modern classical style. This was the mid-point of a career that was busy, but hardly could be called creative. Its later half was still to be active, but creatively to yield even less.[68]

Pontormo

The authority that Fra Bartolommeo's style exercised in Florence in the second decade was such as to impose not only on Andrea del Sarto, who would challenge it, but on the early Jacopo Pontormo (1494-1557), who towards the end of the decade was to set himself at variance with its essential principles. But until, in 1518, Pontormo articulated his dissent in a large-scale painting, the main sense of his accomplishment was that of a contribution to the history of the classical painting style. Pontormo's serious apprenticeship had been, probably *c.* 1508-10, with Albertinelli, and it seems to have been followed by a time with Piero di Cosimo. In both cases, conspicuously the former, Pontormo's training was an education at second-hand in Bartolommesque style.

Towards 1512, about his eighteenth year, Jacopo was taken as an assistant by Andrea del Sarto, though only briefly: this would have been at once a reinforcement and an adulteration of his prior education. It was in a style mainly founded on Fra Bartolommeo, but with Sartesque elements, that Jacopo's independent work began. A fresco altarpiece, once in the church of S. Ruffillo (now installed in the chapel of the Company of St Luke in SS. Annunziata; 1514), is his first work on a major scale that survives in legible condition; a fresco *Faith and Charity* on the outer façade of the Annunziata, a little earlier, can now only indistinctly be made out. Bartolommesque in motifs and in almost every formal element of style, the altar painting has been instilled with an energy more pointed than Bartolommeo's, excited and irritant in effect, different from the Frate's harmony. The temper of the forms and quality of expression in the actors resembles what had been in Sarto's painting of the year before, when, as in his *Marriage of St Catherine* (Dresden), he remade Bartolommeo's model, giving it a higher concentration and expressive energy; but the means Jacopo employs to the same end are much less well controlled. Andrea's altar represents a moment that precedes his full maturing of the sense of classical style; following Andrea's, Pontormo's painting is by a degree less comprehending of classical ambitions. It should not be taken as a first step by Jacopo towards a post-classical style but as evidence of an aesthetic that is not yet classical.

The very temperamental factor that made Jacopo respond so strongly to Sarto's vivifying of the Frate's example was shortly to enliven, more than in Sarto's contemporary art, a classicism better learned. The stage that follows on the S. Ruffillo altar represents the brief but important moment of Jacopo's maturing in the classical style. Its monument is the fresco *Visitation* (1515-16) he added to the *Life of the Virgin* in the Annunziata forecourt, to which

Sarto and Franciabigio had only shortly earlier contributed. In the *Visitation* [39] a basis of style still obviously Bartolommesque has been given a fluency and movement studied from Andrea's *Birth of the Virgin*; adapting Andrea's mature means, Jacopo has learned how to discharge into exactly manipulable, classically articulated form the energies that had been compressed in the Ruffillo altar. It is apparent in this *Visitation* that Jacopo's energies surpass

39. Pontormo: Visitation, 1515-16.
Florence, SS. Annunziata

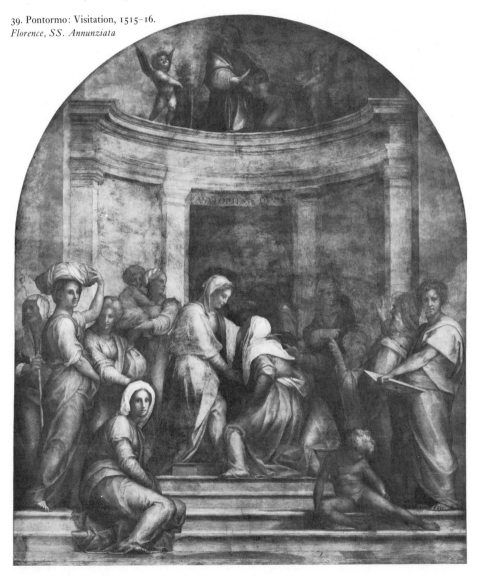

Andrea's in their power (though not as yet in subtlety); channelling this power into the classical means he has acquired, Jacopo has made the first demonstration of dramatic rhetoric in Florence which in quality as well as kind approximates the recent art of Rome. Still more than the *Visitation*, a fresco *St Veronica* (Florence, S. Maria Novella, Cappella del Papa, 1515) speaks with an accent of grandeur and declamatory force like that of Rome, but with simpler and more instantly compelling emotional effect. With these two works Pontormo carried the postulates of classical style he learned from Andrea and the Frate to a kind of fulfilment different from theirs, but equally important to the history of the style in Florence. From this fulfilment Jacopo was to proceed, soon afterwards, to its undoing.

Pontormo was to have a companion of importance comparable to his own in this latter process, Il Rosso. We have no knowledge in Rosso's case of a phase of classical conviction like Jacopo's, or of any evolution that precedes it; his known œuvre belongs to the history of post-classical style, where we shall treat it. Jacopo's seeking and conquest of a classical discipline make a distinction between him and Rosso in that later history: Jacopo's unclassical innovations were to be made with keen awareness of the classical ideas from which they diverged. His inventions were to be generated, much more intimately than Rosso's, from the very tissues of the classical style. The Mannerism of Jacopo's creation is thus, more than Rosso's, integrated into the history of style of Florentine painting.

One artist of foreign origin, Alonso Berruguete (1486/90–1561), had a part in the creation of a style in Florence that deviated from classicism. In his case, his role in Florence ended by mid 1518; in that year he returned to his native Spain, where he was to establish himself as the country's leading sculptor and the most remarkable personality of Spanish

sixteenth-century art preceding Greco. By the time he left Florence he had achieved a painting style (*Madonna with St John*, Florence, Palazzo Vecchio, Loeser Collection, *c.* 1518) that subjected the formulae of classicism to tensile and deforming pressures; it would be the threshold for his evolution, in Spain, of a Mannerist style of sculpture. He came to such a post-classical solution, however, without earlier assimilation of a classicism; temperament or foreignness, or both, almost disjoined him even from the superficial sense of classical style. He did not work with anything like the intellectual awareness of Pontormo or with so articulate an expressive personality as Rosso; though comparably powerful, Berruguete was at this stage of his career an artist of simpler intentions and means. His works were few, and none of them was of the scale or complexity of Pontormo's or Rosso's; thus his contribution to the formation of what came to be Florentine Mannerism should not be over-estimated.[69]

PAINTERS IN ROME

In the first years of the sixteenth century, as earlier, Rome had no significant indigenous school. Pinturicchio, who had been the chief imported painter of the latest fifteenth century, left a fashion that retained pre-eminence in Rome until Raphael's coming. Painters formed by working as Pinturicchio's assistants when he was in Rome, or by association with him elsewhere, made continuity of style between Pinturicchio's own renewed Roman visits (1505-6 and 1508-9). Among the painters thus disposed there came to be an accentuation of certain of the antique-minded interests residence in Rome had stimulated in Pinturicchio: decoration with antique grotesquerie,[70] façade painting simulating ancient sculptural decorative schemes, and in general, where subject matter might allow it, an increase of the trappings that identify antiquity. Occasionally

these were studied with a virtually archaeological concern, as by Jacopo Ripanda, a painter of Bolognese origin and Pinturicchiesque style, or another Bolognese of related interests, Amico Aspertini, resident in Rome for a while between 1500 and 1503.

Painting in Rome might have persisted longer in this vein of Pinturicchiesque style with a heightened accent of archaeology if Julius II – not till the fourth or fifth year of his reign – had not decided otherwise. His decision to abandon the apartments decorated and lived in by the (to him) intolerable Alexander Borgia and undertake instead the decoration of the Stanze required a gathering of painters to Rome. Two of those Julius summoned, Perugino and Signorelli, were old hands who had served his uncle, Sixtus IV, in his great scheme for the Sistine Chapel walls a quarter of a century before. Among the younger artists were the Venetian Lotto, the Milanese Bramantino, and the Sienese Sodoma and Peruzzi, the latter two already at the time in Rome. What these painters did has either been destroyed or (in the cases of Perugino and the two Sienese) remains as stuff of minimal significance, engulfed in the profundity of historical and aesthetic meaning of Raphael's action in the Stanze when he took over the responsibility of painting there. Of the painters other than Raphael whom Julius called to decorate the Stanze, none brought a Cinquecento classicism with him. The older painters were entirely intractable, and though the younger ones proved to be adaptable to what Raphael's (and, in less degree, Michelangelo's) example could instruct them in of modern classical style, none was capable of its independent generation.

Peruzzi

Baldassare Peruzzi (1481–1536) was the chief pre-Raphaelite painter in Rome who remained after Raphael's advent and throughout his life-time. In his painting not just the accent but some transmuted substance of his pre-classical style was to persist. He was to prove himself an artist of great gifts, in architecture as well as painting. The place he came to occupy in the history of the High Renaissance in Rome, though obviously much below Michelangelo's and Raphael's, was the most considerable after theirs, a fact obscured to us by the loss of a significant amount of his work in painting, in façade decoration, and in ephemeral scenery for the theatre. He was to be challenged in this eminence in Rome only by the more powerful but less variously creative Sebastiano.

Peruzzi had come to Rome from his native Siena about 1503, and about 1504 was important among the painters working in Pinturicchio's manner at frescoing the apse wall and semi-dome of the church of S. Onofrio on the Janiculum. Contact with his colleague from Siena, Sodoma, in Rome in 1508–9, then did something (but not significantly) to enlarge the reference of Peruzzi's style towards modernity; that occurred only after Raphael displaced Sodoma in the decoration of the first Stanza. Probably in 1509 Peruzzi was employed in the adjoining Stanza, the Stanza d'Eliodoro, on the decoration of its ceiling; only the figured borders of the vault survive from his work there.[71] This adjacency to Raphael was decisive for Peruzzi, even though it must at this time have been to little more than Raphael's ceiling in the Segnatura, the first instalment of his efforts there. Meanwhile, Peruzzi had been studying a parallel classicism of architectural style in the earlier Roman pieces of Bramante, and before 1510 he had achieved a major work of architecture of his own design, the villa for Agostino Chigi now called the Farnesina. Within the year, Peruzzi was at work on its external decoration in grisaille (obliterated now) and on the painting of the ceiling of the large ground-floor salon named, from the slightly later contribution

made by Raphael, the *Sala di Galatea*. The ceiling is an illustration, in terms of figurations taken from antique mythology, of the horoscope of Agostino Chigi – not only a purely secular undertaking but the largest enterprise of painting of any kind in contemporary Rome outside the Vatican. A fictitious painted architecture on the ceiling, still reminiscent of Pinturicchio, contains a population that, in its classicist details, shows Peruzzi as the most expert among Roman students of archaeology. But unlike his Pinturicchiesque colleagues of similar bent, Peruzzi's study has given him some sense of the aesthetic of the ancient models. However, it is Raphael's example that seems to have been more motive to Peruzzi's incipient acquisition of a classicism of style. What has thus been acquired has not, at this point, displaced what is pre-classical and quattrocentesque in Peruzzi's disposition but coexists with it. There are new-found classical purities of form in the figures, but there is as much of sharp-edged contour, quattrocentesque in effect, and of high-keyed light that facets forms or makes them glisten. His idea of grace, still pointed and a little precious, is not yet Raphael's. The ceiling shows the mentality, ultimately Tuscan and quattrocentesque, with which Peruzzi has approached Raphael's modern style: he interprets whatever intellectual or aesthetic data the new style may give with an astringent, complicating intelligence and wit. The decoration of a second, small room in the Farnesina, the Sala del Fregio (*c.* 1511), with Ovidian mythologies contains no less distinct evidence of Peruzzi's individuality. The vocabulary here is much more reminiscent than in the ceiling of the immediate past style of Raphael, accepting more of his canon of proportion, his ideal of grace, and his fluidity of movement. Yet the mood is of pointed excitant sensation, and form is tensely live, articulate with a sharpness that the movement of the draughtsman's brush and quality of light convey.

A *Holy Family* (London, Pouncey Collection, *c.* 1513-14) indicates Peruzzi's growing assimilation of Raphaelesque ideas of style, but also his insistence on his separate personality, more abstracting and sharp-edged.[72] A chapel for the Ponzetti family in S. Maria della Pace, dated 1516 [40], contains as full an accommodation to Raphaelesque classicism as any contemporary in Rome had made, yet it is still explicit in its indices of Peruzzi's difference. It has his draughtsman's acerbity, his astringent and precise grace, and his reluctance to concede to Roman *gravitas*. Peruzzi may be an archaeologist, but he is no rhetorician; he has the quick elegance of a Tuscan temper of an earlier time.

In his early paintings in the Farnesina (and in the later Cappella Ponzetti as well) there was a major element – perhaps more conspicuous to Peruzzi's contemporaries than to us – of illusionism, which in the Farnesina decorations referred, like the subject matter there, to antique precedents. A whole important genre in Peruzzi's art, now lost to us, explored this special interest in the years following 1512. Numerous paintings of house fronts that Vasari (e.g. IV, 594, 596) describes for us joined antique themes and devices of illusion to make a pretence of grand ancient sculptural façades.[73] About 1516 Peruzzi returned to the Farnesina to paint an elaboration of these antique-illusionist ideas in the grand salon of the Villa's *piano nobile*, the Sala delle Prospettive (or delle Colonne). Absorbing the actual articulation of the room, Peruzzi has created a fictitious painted architecture in it, on a grand scale, that suggests to the viewer that he is inside a structure like a temple; perspective devices open the wall of this illusory building on all sides to views of landscape towards the city and the

40. Baldassare Peruzzi: Madonna, Saints, and Donor (fresco altarpiece), 1516. Rome, *S. Maria della Pace, Cappella Ponzetti*

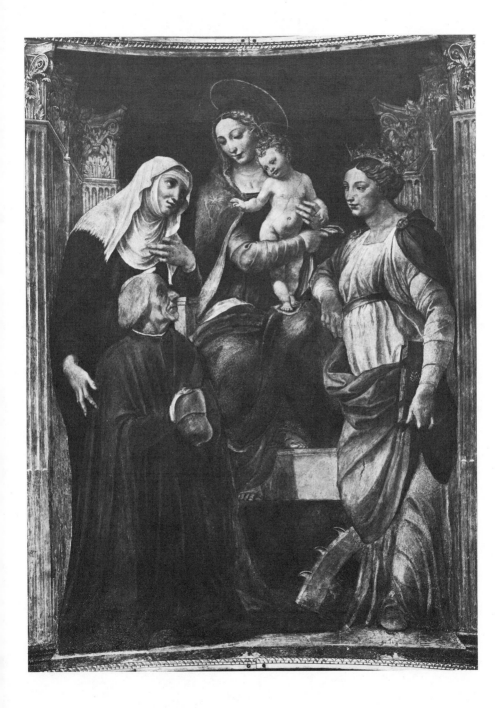

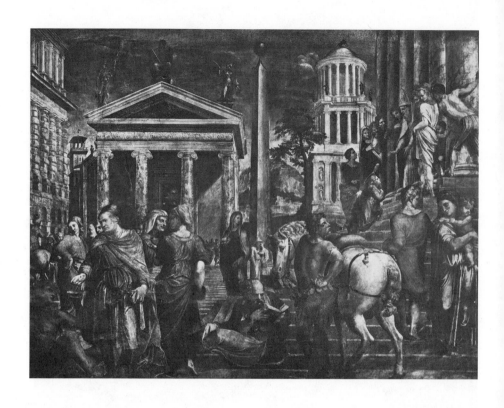

41. Baldassare Peruzzi: Presentation of the Virgin, *c.* 1520. *Rome, S. Maria della Pace*

countryside that we might see in reality. As in his house façades, this architectural fiction is the frame for a population of antique beings, almost startling in their effect of presence. A frieze above the colonnade, very freely painted in a technique that suggests the influence of antique 'impressionism', illustrates narratives after the *Metamorphoses*. The style of the frieze relates to that in the Sala del Fregio of some five years before, but is by contrast not only freer in technique but quite libertarian in its regard for classical conventions. Anatomy is flexible, making fluent patternings that may deviate considerably from a formal norm. Design seems also to be rhythmically propelled, determined mainly by the unfolding of the narrative in an arabesque along the frieze. There is no effect of decorum, much less of any formal rhetoric. Seen in the context of the contemporary elevation of art in Rome to the Grand Manner, this is an antidote to it, a personal and informal evocation of antique poetry. Peruzzi's idiosyncrasies of temperament and aesthetic bent, still in part persistent from his pre-Raphael time, emerge more in this mature work than in any other since Raphael intervened between him and his origins. A poetic wit, flickering and fantastic in interpretation of the subject matter and in the very touch that gives it form, enlivens Peruzzi's disciplined and ornamental scheme of painted architecture; but even that scheme of architecture, though made by processes of reason, is in a deeper sense a witticism and a fantasy.

Peruzzi's last important work in painting in these years is also, but in a tangential aspect only, an illusionistic witticism: his half-life-size fresco of the *Presentation of the Virgin* in S. Maria della Pace (*c.* 1520) [41] is surrounded by a stucco frame to give it the appearance of a large easel picture hung upon the wall – an early instance of the conceit, later to be so important, of the *quadro riportato*. Treating a narrative subject on a large scale, Peruzzi turns

with renewed attention to Raphael's example: the *Fire in the Borgo* has especially been an object of Peruzzi's study. He has adapted Raphael's kind and complexity of pictorial construction, but not equalled its discipline; Peruzzi's scene seems not only busy but, in comparison with Raphael's, somewhat incoherent. And his figures seem to be moved less by needs determined by the narrative than by a will to stress the possibilities in them to make ornament. The tendency to elegant and pointed forms that Peruzzi's paintings had displayed before he quite achieved a classicism has been reasserted; now it is imposed upon a figure style related to the recent Raphael, and warps the forms with straining and elaborate calligraphy. The complicated setting and stage management of the *Presentation*, and still more these figures whose behaviour is so much aesthetically motivated, are elements that can appear in Mannerism: this picture may come nearer than any other of its moment to the deductions that younger painters, after Raphael's death, were to draw from Raphael's style. Peruzzi himself, however, had no intention in his closely subsequent career of drawing a conclusion so radical as theirs.

Sebastiano

Very shortly after his completion of the ceiling frescoes of the Sala di Galatea in the Farnesina, Peruzzi's work was followed by the painting of the room's lunettes, illustrating the mythology of the creatures of the upper air, by Sebastiano Veneziano (del Piombo, *c.* 1485–1547). Sebastiano had arrived in Rome from Venice in mid 1511, already the possessor of a considerably developed High Renaissance classical style, acquired (as we shall see in its Venetian context) as a result of the independent evolution of this style in the first decade of the century in his native city. It was nevertheless inescapable that Rome should demand a new orientation of

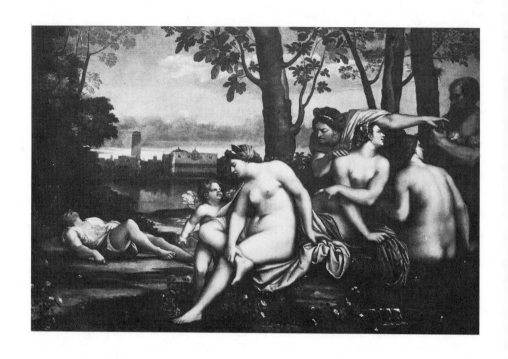

42. Sebastiano: Death of Adonis, *c.* 1512–13. *Florence, Uffizi*

Sebastiano, as of any foreigner who came to practise there. His fresco lunettes in the Farnesina, perhaps executed still within 1511, make clear what difference from Sebastiano's just-past Venetian style was intended, carefully articulating anatomy, accentuating sculptural effects, and probing action and foreshortening: this is an evident attempt to master a Roman and in part a specifically Michelangelesque mode. On the lower wall of the same room, a giant *Polyphemus* (*c.* 1512; companion to the *Galatea* Raphael was to paint in an adjoining bay) is more openly dependent on Michelangelo. At the same time the Venetian component of its style is more explicit, in sensuous effects of surface and in a slower temper, ultimately Giorgionesque. The fusion that Sebastiano managed to effect between Venetian ideas and what he very rapidly acquired in Rome makes a sensible effect even in what may be his earliest Roman easel picture, an *Adoration of the Shepherds* (Cambridge, Fitzwilliam Museum, 1511-12), though Venice still seems dominant in it; by *c.* 1512-13 he had achieved a working dialectic of Roman and Venetian classical styles. The remarkable work in which this occurs is the *Death of Adonis* (Florence, Uffizi) [42]. When it was painted the values of *Giorgionismo* were not dimmed in the painter's mind, while the virtues of the Roman style had come to be intellectually comprehended and profoundly felt. While still in Venice, Sebastiano had shown qualities of mind and temper that aligned him with a Roman classical aesthetic – his gravitation towards Rome was as if predestined – and among them had been a magnifying of the scale of form and the effects of pathos in the human figure. Following the entire revelation to him of the Sistine Ceiling, Sebastiano in the *Adonis* enlarged the proportion of his figures into an almost bulking massiveness, ponderous and sensuously splendid: idealizations, but of sensuous existence. Their slow magniloquence is a compound

made out of what has been borrowed from Michelangelo and what initially was Sebastiano's own. The content the scene conveys is equally a compound, between Roman values of dramatic feeling and a Venetian luxury. Even texture and colour have been made to work in dialectic: texture in the figures subdued to achieve a compromise between flesh and statuary, and colour muted in them into tones of greyish marble or of paled bronze.

It was to be expected that longer residence in Rome should turn Sebastiano more towards a Roman style, while his Venetian qualities should diminish in comparison, or be translated into some equivalent in Roman speech. His Romanizing must have been accelerated by a partisan dedication to the example of Michelangelo (not, however, that he disdained to learn from Raphael, where that was useful to him) which culminated, probably in 1515, in Michelangelo's selecting the Venetian as a kind of deputy for him in painting. His function was to contest Raphael's first place in that art in Rome, on Michelangelo's behalf more than Sebastiano's own; to achieve this purpose Michelangelo was to supply Sebastiano with ideas – obviously in the form of drawings of some kind. The intimate arrangement that may have been intended was quickly undermined by Michelangelo's return to Florence in the autumn of 1516, and though the relationship continued for years to come – long after Raphael's death, and until Sebastiano alienated Michelangelo by interfering in the preparations for the *Last Judgement* – its exact artistic consequences and the manner of its working are not clear.[74] In general, however, it appears that whatever Michelangelo supplied to Sebastiano was taken by him in a way quite different from that in which Raphael's assistants took the *disegno* of their master: the data Sebastiano received from Michelangelo became matter for a distinct and deeply personal meditation. This is the case even in an instance, from the earliest

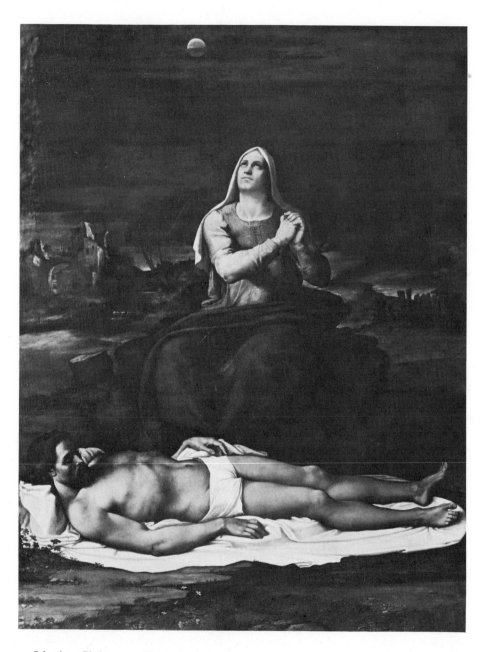

43. Sebastiano: Pietà, *c.* 1515. *Viterbo, Museum*

time of their association, in which it is quite sure that the essential invention was Michelangelo's: that of the great *Pietà* (Viterbo, Museum, *c.* 1515) [43]. For this Michelangelo conceived a design for the two sole actors that is a development into the terms of contemporary classicism of his youthful version of the theme. An idea of high tragic power is expressed with extreme simplicity in a structure of severe geometric rigour; there is close analogy – perhaps even some influence, as Sebastiano interprets Michelangelo's idea for us – to the mode of Raphael's contemporary Tapestry Cartoons. The conception is emphatically a sculptor's, of a figure group that is massive and aggressively substantial, meant to be set in an aesthetically neutral space. But despite the action on him of Rome and Michelangelo, Sebastiano is not only still residually Venetian but above all a painter, and he has given the sculptor's theme a context of landscape, moonlit, tragic, and romantical, that vibrates with *Giorgionismo*, and of which both the emotional and visual tonality suffuses and surrounds the austere figures; colour has been dimmed or chilled by the extraordinary light, but makes a dully glowing radiance within the dark. Sebastiano's particular personality emerges in other respects: in an effect of looming and ponderous grandeur he generates out of the master's forms, and in his admixture of slowed, almost dreaming temper into the tragedy. As it appears they meant this work to do, Michelangelo and Sebastiano made an effective challenge in it to the highest classical accomplishment to date of Raphael.

The version of the same theme that Sebastiano painted in 1516 (Leningrad, Hermitage, dated) owes no specific element of significance to Michelangelo. This is Sebastiano's own conception, quite unlike that in the Viterbo *Pietà*, pictorial in essential kind, and as much as in Raphael invented as a populated composition working in a space. The richness of conception is opposed to the restrictive structure of the Viterbo picture; and the Leningrad design, too, has an analogue in the contemporary Raphael, in his dramatically active vein, as in the fresco of the *Battle of Ostia* or in the *Spasimo di Sicilia* (most likely of this same year, 1516 [29]).[74a] In Sebastiano's picture the impulses of emotion that invest the narrative move the composition with a blunter and more forthright force than in Raphael, less concerned than his altar paintings to make a counterpoint of ornament for feeling. Sebastiano has lent his figures a consonant character of shapes, tending to a rectangular geometry, so insistent that its effect of generalization may exceed descriptive sense. This generalizing makes the grandeur of the figures seem a little vacant, but cannot reduce the expressive pathos in the faces and the gestures of the actors, touched with that slow gravity which is particularly Sebastiano's.

Late in 1516, Sebastiano's rivalry with Raphael was put to an explicit test when Cardinal Giulio de' Medici commissioned both artists to paint altars that were supposed to become companion pieces in the cathedral of Narbonne. Raphael's picture was his *Transfiguration* [30], Sebastiano's *The Raising of Lazarus* (London, National Gallery) [44]. Begun before Raphael actually set to work on his *Transfiguration*, Sebastiano's *Lazarus* also was completed first, early in 1519. The advice of the absent Michelangelo had been used, as Vasari reports (v, 570), 'in alcune parti' (for Lazarus and his immediate attendants in particular), but nothing indicates that the invention and the design in general were not Sebastiano's: despite what may have been absorbed in it of Michelangelo, the work is essentially and pervasively the creation of a painter's intelligence. More than the Leningrad *Pietà*, the *Lazarus* affirms resemblance to the most recent art of Raphael, as for example in the *Spasimo*.[75]

Even more, however, there is likeness – not in any specific fact but in whole character of

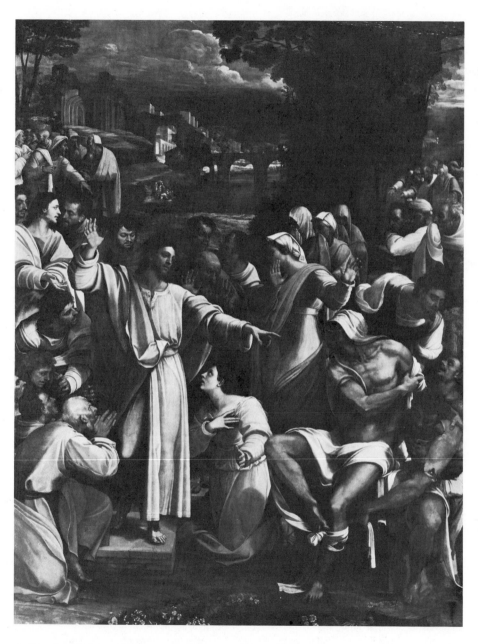

44. Sebastiano: Raising of Lazarus, 1517-19. *London, National Gallery*

style – between the *Lazarus* and the Raphael in competition with which it was painted, a likeness generated not by Sebastiano's knowledge of the *Transfiguration* (the competing pictures were carefully kept secret) but by a similarity of projects, and still more by the like situations of their painters in the development of classical style. Given this development, and the taste of a Roman audience educated by it, it is understandable that both artists should make virtuoso demonstrations of grandeur and complexity in both the content and the form of their pictures; each would seek impressive effects of drama and articulate them with maximum richness. The temper of Sebastiano's drama is different from Raphael's inspired conjunction between passionate commotion and sublimity; this is of majestic gravity and slow-unfolding power. In both pictures the major motifs of design work in powerful asymmetric thrusts, and in each design the simple underlying scheme has been elaborated with matter more various than the theme might call for, meaning to enrich the content as much as the form. The effort towards such complexity, accustomed in Raphael, is new to Sebastiano in the *Lazarus*; the Giorgionesque temper that underlay his assimilated Romanism had not disposed him to so much intense and precise intellectual exercise. But he has even handled colour in this ambitious, intellectualizing temper, assuming a new arbitrariness in hue and calculation in the plotting of sequences and combinations. The hues retain a Venice-like luminosity that enchants the eye; however, they no longer transcribe but aesthetically transmute sensuous experience.

This ambitious, richly orchestrated image is distinct from Sebastiano's preceding works in its high development of classical rhetoric, which Sebastiano has made beautifully articulate of his special sense of grandeur and of what is finally a Roman *gravitas*. The dramatic and the formal language of this picture are of a kind that – as was intended – may well bear comparison with the contemporary Raphael. Sebastiano lacks Raphael's sublimity and force, but in the *Lazarus* he displays a magnitude of idea and a complexity that truly rival the *Transfiguration*. Unlike the *Transfiguration*, the classicism of the *Lazarus*, for all its high internal charge, shows no imminently faulting strain. Sebastiano's creative pressure was not, like Raphael's, of an urgency that tested the essential sense of classical style.

In 1520 or early 1521 Sebastiano had the opportunity to add a postscript – probably, as far as Raphael was concerned, a post-mortem – to their debate of the preceding years. Having seen Raphael's *Transfiguration*, Sebastiano painted a fresco version of the same theme into the semi-dome of the Borgherini Chapel in S. Pietro in Montorio in Rome, where he had been sporadically at work (as the evidence of letters indicates, with slight results) since 1516; for the main element in this chapel, a *Flagellation of Christ* on the wall beneath his *Transfiguration* (the *Flagellation* executed only in 1521-4), Sebastiano had Michelangelo's design. Sebastiano's *Transfiguration* is an almost literal critique of the relevant, upper, portion of the Raphael: no less remarkable as a conception of the theme, and not less compelling in its power of dramatic articulation. Yet here, too, where precise comparison with Raphael was sought, it is clear that Sebastiano's reach is not into Raphael's exalted region of idea and form, or of idea as form. Straining the machinery of classical style less, it could for longer be a viable vehicle for Sebastiano; his evolution beyond a recognizable classical style was relatively slow. As we examine Sebastiano's career through the next two decades we shall see how more of the appearance of the classical style remained in his art than in that of any other painter in the Roman school. Nevertheless, his style in time would be transformed, less in semblance than in essence, until in the end its

more profound relation came to be with Mannerism.

In a less ambitious field, portraiture, Sebastiano challenged Raphael during his lifetime with much success. Having known in Venice the portrait style created by Giorgione and early exploited by the young Titian, Sebastiano took the elements of this style with him to Rome. Even with his growing inclination towards Roman gravity, Sebastiano's portraits were more visibly persistent than his other works in their fidelity to Venetian style, particularly in chiaroscuro opulence and in the warmth of communication of their human content. Sebastiano's *Giorgionismo* is less adulterated in these pictures of small compass, where the subject is a single personality: its quality pervades the *Young Violinist* (Paris, Baron G. de Rothschild, *c.* 1515) and the *Young Man* (Budapest, Museum), probably a brief moment later, and it is most apparent even in a portrait of *c.* 1517, the *Cardinal Antonio Ciocchi del Monte Sansovino* (Dublin, National Gallery).[76] After Raphael's death, Sebastiano's portrait art was to assume a primacy in Rome that was beyond challenge, equivalent in this genre to the contemporary Titian's portraiture in Venice, and even so late as this more faithful to the temper of Giorgione than he.

The main business of painting in Rome in the second decade of the century, and certainly all that was of significant creative dimension, was done in the ateliers of the three great resident painters, Raphael, Peruzzi, and Sebastiano. Michelangelo, who interrupted his career as a painter after 1512, may not be counted in this group unless – viewing his relationship to Michelangelo much too dependently – Sebastiano is taken as his deputy. Sebastiano seems to have painted, as Michelangelo did, with no more than merely mechanical assistance. Peruzzi seems not to have kept a continuing group

of helpers in his *bottega*, but evidently employed assistants in his larger decorative schemes, such as the Sala delle Prospettive and the house façades; these assistants have not been identified.[77] Raphael's assistants, however, became major factors in the extent of his accomplishment as the decade progressed and his enterprises grew more widespread and diverse. Marshalled in a single atelier, his helpers came to constitute a school (within what can be only loosely called the 'school' of Rome) that is not much less in number than the Florentine painters of comparable artistic rank. But so marshalled, the degree of creative individuality they expressed was in general relatively less, and what was expressed of it was perforce in the vocabulary conceived by Raphael. In some instances – such as that of Giovanni Francesco Penni (Il Fattore; b. *c.* 1488), the earliest and most submissive among Raphael's assistants – the difference of his art from Raphael's was mainly negative, a vitiation of its formal and affective life; in the case of the young Giulio Romano (b. 1499?), who came to displace Penni as Raphael's most important aide, the differences became a matter of creative alteration of the master's style. Giovanni da Udine (1487–1564), having found a special province within Raphael's shop, re-inventing antique processes for stucco modelling and brilliantly developing the mode of grotesquerie, made a long subsequent career not only in Rome but in Florence and North Italy out of this valuable capital. In the decoration Giulio and Giovanni jointly supervised in the Logge in 1518–19 a kind of subdivision of the Raphael shop came into being, apparently more closely supervised by these assistants than by Raphael himself. The young men of Giulio's generation, almost as precocious as he, who were recruited into the atelier in the Logge, Perino del Vaga (b. 1500/1) and Polidoro da Caravaggio (b. *c.* 1500), were not bound like the older assistants, or like

Giulio himself, by a long discipline under Raphael's authority, and even as they learned the current repertory of classical style they were ready to make change and innovation in it.[78]

SIENA

At the beginning of the sixteenth century native talent in Siena had petrified so much that foreign painters, Umbrian in preference to Florentine, were invited to carry on Siena's more important artistic business. Chief among them was Pinturicchio, who from 1502 onwards worked more in Siena than elsewhere, dying there in 1513. Vasari says (VI, 380) that when Giovanni Bazzi, Il Sodoma, arrived in Siena from Lombardy – not much before 1502 – he had no competition for a while: if the statement was meant to refer only to the native Sienese, it was correct. The only likely native competition, Baldassare Peruzzi (four years Sodoma's junior), had gone to Rome about the time of Sodoma's arrival. Beccafumi, younger still, had not then begun to paint. The native painters in the field were such inflexible survivals of archaic Quattrocento stripe as Benvenuto di Giovanni (d. c. 1518) or his son Girolamo (1470–c. 1524); the wooden Matteo Balducci (mentioned from 1509 to 1555), at one time Pinturicchio's assistant; and Bernardino Fungai (c. 1460–1516), no less wooden, whose art is a still more obvious compost of Sienese archaism and denatured Umbrian example. Giacomo Pacchiarotti (1477–c. 1540) was no more modern, but at least possessed some measure of vitality. Even Pacchiarotti, who lived long into the sixteenth century, seems not to have acquired more than an occasional and superficial coloration of sixteenth-century style.

Sodoma (1477–1549) was born in the Piedmontese centre of Vercelli and had his first education in that school, with the archaic Martino Spanzotti, but in some fashion came to be exposed to the work of Leonardo in Milan, with an effect strong enough to give him the most superficial markings of a Leonardo follower, but no sense whatever of Leonardesque principle. Soon after his arrival in Siena he was commissioned to work at frescoes in S. Anna in Camprena, the Olivetan monastery near Pienza (1503–4); the satisfaction he gave an undemanding taste there led to his engagement at Monte Oliveto Maggiore, where he completed a cycle of the history of St Benedict on which Signorelli had made a beginning in 1497. In the course of these two fresco cycles Sodoma sloughed off some of his initial Lombard heaviness, gaining fluency, and took on much of the locally popular Umbrian vocabulary, from Pinturicchio in particular. When he went to Rome in 1508 to work for Agostino Chigi he was thus in step with the fashion there, also determined mainly by Pinturicchio. Borrowed from Chigi by Julius II for the campaign of new decoration in the Vatican that was then beginning, Sodoma was assigned the ceiling of the Stanza della Segnatura. Basing the compartmentation of the ceiling on Pinturicchiesque ideas, and painting its lesser ornamental parts, Sodoma left a substantial precondition for Raphael when the latter came, shortly later, to displace him. The length of Sodoma's exposure to Raphael in Rome on this trip is uncertain, but it had some maturing effect upon his style – not so much, however, as the attention Sodoma about 1510 began to devote to current Florentine art. A major altar painting of the *Crucifixion* (Siena, Pinacoteca, c. 1510) is based in composition on the altar in the Florentine Annunziata that Filippino Lippi began and Perugino finished, but in figure style conveys some indication of response to more modern examples. By about 1513 the Florentine model of Fra Bartolommeo had taken a clear hold on Sodoma. Fusing with his past Roman (as well

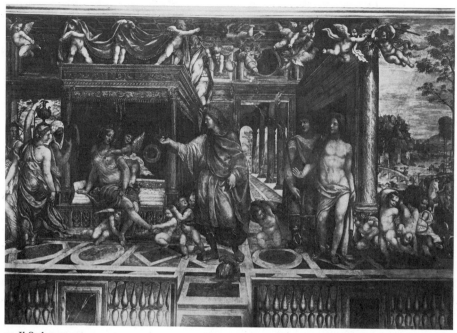

45. Il Sodoma:
Marriage of Alexander and Roxane, 1516-17.
Rome, Villa Farnesina

as Florentine) experience of Raphael, and with a re-thinking of his primitive acquaintance with the work of Leonardo, the result was the assimilation of Sodoma more or less effectively into the modern classical style. His *Madonna Enthroned* (Turin, Gallery) shows no more persistences from an older style than the contemporary work of many of the Florentines of comparable artistic rank.

It was with such an adequate but quite imperfect basis of High Renaissance style that Sodoma returned to Rome, almost certainly in 1516, to decorate Agostino Chigi's bedroom in the Villa Farnesina (working beside his compatriot Peruzzi, then in the adjoining Sala delle Prospettive). In his decoration Sodoma's attention to Peruzzi's current work is less apparent

than the interest he has displayed in Raphael. But his study of the recent Raphael has yielded, in Sodoma's *Marriage of Alexander and Roxane* (1516-17) [45],[79] a vocabulary that only parodies the paintings he had known long before, in the initial stages of the Stanza della Segnatura; and even now Sodoma could not comprehend that classical principle required a meaningful coordination of design. In his *Alexander and the Family of Darius*, from early 1518(?), longer knowledge of Raphael's art (including the loggia his atelier had just painted in the same building) has brought Sodoma's style to a threshold of classicism that he would not much exceed. It is based on the appearances that could be deduced from Raphael's style, but softens and sweetens them so that they carry,

even now, a faint overcast not only of Leonardo but of Pinturicchio; it borrows Raphaelesque canons of form with a deficient sense for the harmony and logic that reside in them, and Raphaelesque devices of composition with an elementary understanding, but no more, of their purposes and mode of function. Returned from Rome in 1518 to work (along with the younger Beccafumi and the contemporary Pacchia) in the Oratory of S. Bernardino in Siena, Sodoma contributed three frescoes to the history of the Virgin there. As if liberated from the competition and constraints of Rome, his fluency increased, but so did the accent of provincialism in his style: these pictures are busy in form, and of *popolano* garrulousness of illustration.

Sodoma's companion in this decoration, Domenico Beccafumi (Il Mecherino; *c.* 1486–1551), was at this point evidently much the more provincial in the sense that his style referred to habits of form and temper special to the locality, rather than to a fashion borrowed from Florence or Rome. Yet he had also had a term of experience in Rome, which the best evidence situates about 1511, and had followed it, probably closely, with study in Florence. As had been the case in Sodoma's earlier career, Beccafumi's Florentine experience was the more influential. The distance interposed by historical environment as well as personality between Beccafumi and the classicism Michelangelo and Raphael were making about 1511 in Rome was not bridgeable, and even what his compatriot Peruzzi had assimilated of it could not have been wholly sympathetic. Florentine example in the modern style was less uncongenial: more domestic and susceptible to personal reinterpretation. More than any Roman element, then, the traces of Fra Bartolommeo, Albertinelli, and perhaps Sarto appear in the first works we know by Beccafumi, but they have been remarkably transformed, put to the uses of a gender of expression that has not in any essen-

tial way been touched by the ideals of classical style. A three-part altar painting of the *Trinity and Saints* (Siena, Pinacoteca, 1513; from the Cappella del Manto in the Spedale della Scala) reinterprets sources that are mainly Florentine in a deforming and eccentric vein, as if a spirit inherited from the most Renaissance-resistant personalities of the Sienese late Quattrocento should have infused them. Fresco paintings in the chapel (*Meeting at the Golden Gate*, much damaged; a *Resurrection of Lazarus*, destroyed; 1514) less strongly deform what is Florentine in their vocabulary, but Beccafumi makes a spidery and insubstantial delicacy in their forms and manipulates chiaroscuro and colour in them until their working seems mysterious and romantic. The vocabulary of an altar painting of *c.* 1514–15, a *Stigmatization of St Catherine* (Siena, Pinacoteca), is more obviously studied from the school of Fra Bartolommeo, and though it still resembles that of the frescoes it shows more concern for an approximate conformity with classical correctness. Beccafumi has disciplined his sensibility so that it is not conspicuously eccentric, but it still makes a fragile elegance that is disparate from any classical canon, and his pointing subtlety in the handling of line and light recall the temper of the Sienese Gothic past.

It is likely to have been Sodoma's example, after he had formed his fair approximation of a High Renaissance style about 1513, that diminished Beccafumi's tendency to effects that resemble Gothicizing archaisms. The *St Paul* altar (Siena, Opera del Duomo, *c.* 1515) substitutes a cursive draughtsmanship for Beccafumi's previous pointed one; shapes and forms take on a more modern-seeming, rounding effect, and the lighting (which, it is by now apparent, is an intensely present factor in each of Beccafumi's paintings) is richer and deeper in its modulation. This picture is more coherent in design and far more finely articulate than the contemporary Sodoma, but the tempera-

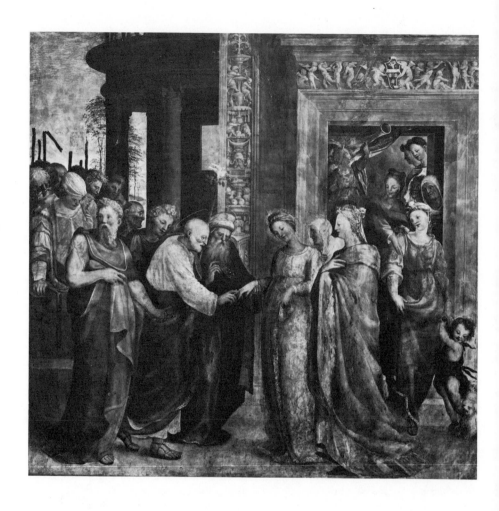

46. Domenico Beccafumi: Marriage of the Virgin, 1517-18. *Siena, Oratorio di S. Bernardino*

ment that inhabits it keeps it farther from coincidence with the ideas of classical style – even though Sodoma's intelligence of classicism is more nearly mechanical. In the frescoes of the Oratory of S. Bernardino, where the two artists came together, Beccafumi's two frescoes, the *Marriage* and the *Death of the Virgin* (1517–18), derive from the basis of style established in the *St Paul*, but in this larger compass, where narrative and drama are required, Beccafumi has made expression still more singular. In the *Marriage of the Virgin* [46] he has warped and attenuated forms and feelings in a way that surrenders modernity to a reminiscence of Pinturicchio; in the *Death of the Virgin* (surely influenced, as the *Marriage* is not, by the returned Sodoma) a more classicizing substance is dissolved in the illustration of eccentricities of appearance and states of mind.

In 1519 Beccafumi went again to Rome, and the consequences of that visit were to initiate an important alteration in his art, relating it for a brief but critical moment much more intimately to classicism. But until then, Beccafumi's style was one in which principles of classicism had not ever been decisive, wholly understood, or even unequivocally wanted. A temperament allied to the most idiosyncratic aspect of the Sienese late Quattrocento tradition had intersected with what it saw of the classical fashion that held primacy in Rome and Florence (but was not meaningful artistic currency in Siena, nor ever would be); in the intersection the pre-classical element remained dominant, deforming classical principle and form where it was not heedless of them altogether. The result is related in some ways to what occurs in the early, experimental phase of Mannerism, in which expressive pressures may disrupt classical principles. However, this is not, like true Cinquecento Mannerism, a style that has moved beyond the boundaries of High Renaissance classicism, but one that has, at this point, only insufficiently penetrated into it. In historical balance this is a pre-classical, not a post-classical event, attached almost more to the Quattrocento past than to the Cinquecento present.

In time, the painters in Siena and the close neighbourhood who were contemporaries of Sodoma or younger came under his influence to some degree. In no case, however, was his example strong enough to make close followers. As earlier, despite Sodoma's assumption of a modestly durable local leadership, the Sienese of lesser rank continued to refer elsewhere for artistic direction: no longer now to Umbria, as in the final years of the last century, but to Florence or Rome. Girolamo del Pacchia (1477–*c*. 1540), seeming to lack any personal inspiration, compensated for it by a long career of borrowing, first from Perugino, then from the Florentine school of Bartolommeo and Sarto, then from Sodoma. Beneath his many outward changes an ineradicable residue of Quattrocento style persists. Andrea del Brescianino (Piccinelli; notices 1505–25), perhaps Pacchia's pupil, had a more consistent style but no more talent. His manner before 1520 turned Sodoma's model back into the most archaic, petrifying local language, or conversely gave that local mode a gloss of Sodoma. Andrea then turned towards the Florentines, and, enlivening his unchanging basis just a little, replaced its Sodomesque cast with a pallor borrowed from the posthumous descent of Fra Bartolommeo. He must actually have practised for a time in Florence.[80] Vincenzo Tamagni of S. Gimignano (1492–*c*. 1530) while still a boy was an assistant of Sodoma at Monte Oliveto, and then of Raphael in Rome (*c*. 1512–*c*. 1516). His later career was mostly in the Sienese provinces, in particular in his native S. Gimignano. He did to Raphael's example much the same thing that Andrea del Brescianino did to Sodoma's and Fra Bartolommeo's.

VENICE 1500-1520

There is a Venetian counterpart to the phenomenon we have examined in Central Italian painting, of a 'High Renaissance', but its complexion is identifiably different, and even more its chronological extent. So far the literature of art history has approached the High Renaissance of Venice in a mostly fragmentary way, so that we have as yet no view of the processes that informed Venetian painting of the earlier part of the sixteenth century which is comparable to that we have for Central Italy. The analogues of style and manner of development with those of Central Italy are unexplained, and partly in consequence of this the distinction of Venetian painting of the High Renaissance is not accurately enough observed either. The effort of a more historical understanding is worth making, not only for the intrinsic interest of the Venetian material but because, beyond the immediate boundaries of the city, Venetian painting had great importance for the shaping of the vocabulary of much North Italian art, in the schools of Brescia, Bergamo, and Ferrara in particular.

It is a cliché in older studies to assert that the splendid flowering of art in Venice in the Cinquecento coincides with the perceptible beginning of the city's political and economic decline. The cliché is a very limited truth, and in the earlier years of the sixteenth century especially Venice was still, as it had been for at least two centuries, the richest, most powerful, and most populous Italian city. By 1500, furthermore, Venice had entirely assimilated the culture of the early Renaissance, which had come late, a generation after its inception in Florence. In the latter half of the fifteenth century Venetian painting had developed *pari* *passu* with the art of Central Italy – inspired by it initially, and continually responsive to its innovations as they were diffused into the north, but maintaining nevertheless a pronounced local identity. What earlier had been a stress of coloristic splendour, part Byzantine, part Gothic, was transposed in Venetian painting of the early Renaissance into an emphasis on the sensuous beauties, visual and tactile, that were to be observed in nature. The intellectual systems of Central Italian art were incorporated into much Venetian practice, but they were rarely as apparent as the outward guise Venetian painters gave them of sensuous experience.

A conjunction of external factors encouraged this character in Venetian painting, the Venetian economy obviously included.[1] Opulence was a visible fact of the Venetian environment, and a factor in Venetian taste as it was to no comparable degree in any other European city. No other state had such good reason to invent and try to enforce, however unsuccessfully, a sumptuary code. More important, the demonstration of the richness of material existence took place in Venice in a unique urban setting, in which nature combined with the work of man to enhance the fascination of the sensuous world. The atmosphere of this sea-borne city heightens the existence of seen things. Colour is deepened in the damp-saturated air and sharpened by the sea-reflected light, which also may make complicating interactions among colours. The air has an apparent texture which it lends to surfaces perceived through it; and this atmosphere accentuates the sensuous skin of substance. The whole visual phenomenon arrests the eye yet more because it is in movement, unceasingly borrowing animation from the sea. The changes of light and colour with the time of day are, further, those of the sea, more various and extreme than usual experience, and so also are the changes brought by the seasons.

The apparatus of reason has small part in our perception of the Venetian environment, and the non-rational nature of response to the life of light, colour, and textured substance is increased by the context of the topographical accidents in which it manifests itself. The modern traveller still knows the maze-like illogic of the city and the swift changes of sensation that are offered by its variety of direction, of size and shape of space, of brilliances and darkness, of silence and sound. And he knows, together with the kaleidoscopic visual enchantment of this man-made, sea-borne world, the sense of an estrangement from the land, and the need to return to it. Much in the temper of Venetian painting of the Cinquecento plays on these dualities, and on the last especially. Like the painters of Rome, the major Venetian painters of the sixteenth century were rarely natives of the city, and one aspect of their art is a dialogue between their urban vision and their roots upon the landscape of the *terra ferma*, which they see with the nostalgia and with the quality of sight induced by their Venetian milieu.[2]

Giorgione

The first steps in the invention in Venice of a distinguishable sixteenth-century style in painting belong to Giorgio da Castelfranco (1476/8-1510). From the middle of the sixteenth century Venetian partisans of Titian's greatness had tried to diminish Giorgione's stature in order to increase Titian's, quite unnecessarily. Vasari, detached from this local and partisan conflict, saw the circumstances clearly, and assigned Giorgione a role in Venice like that he gave Leonardo in the school of Florence.[3] This was a right, if approximate, historical judgement, even though it was based by Vasari on a knowledge of Giorgione that was highly inexact. Vasari's situation in this last respect, however, was not so different from that of modern critics. There is almost no problem in art history in which the evidence that constitutes an artistic personality has been read in such divergent ways, or, indeed, in which the question of what to take as evidence has been so much disputed.

There is the utmost paucity of archival information on Giorgione's work: not more than seven documents survive from his lifetime or immediately after which mention him in connexion with paintings,[4] but of these paintings only one ruined fragment, from the frescoes of the Fondaco dei Tedeschi, is surely identifiable and extant. One further painting, the *Laura* in Vienna, carries a contemporary inscription that defines it as Giorgione's, and the inscription is circumstantial enough to convince. A literary source of which the compilation dates, in respect to its information on Giorgione, from a decade and a half after Giorgione's death until 1543, the *Notizie* of Marcantonio Michiel, supplies fourteen attributions, but only two of them, the so-called *Three Philosophers* or *Three Magi* (now in Vienna) and the *Tempesta* (now in the Academy in Venice), may positively be identified with extant works. For five others among Michiel's attributions there are only doubtful associations that may be made with pictures that survive, and (save for a copy of one presumed original) the rest of Michiel's 'Giorgiones' have vanished without trace. Literary sources of the middle years of the sixteenth century add some twenty items to the Giorgione catalogue, but again most of these cannot now be identified. One new attribution in Vasari's edition of 1568, of Giorgione's self-portrait now in Brunswick, has only lately been reasonably substantiated; another made in an inventory of 1569, of the portrait of an old lady (*Col Tempo*; Venice, Accademia) has received much more restricted credence. The literature of the later sixteenth century supplies no

further attributions we are able to confirm, and that of the seventeenth century proliferates conjecture and unsubstantiated fancy.

With data such as this to work with it is not surprising that there is such diversity of opinion on the subject of Giorgione's œuvre. In its treatment of the problem, the criticism of the nineteenth and twentieth centuries has ranged to the very extremes of the inclusive and exclusive positions that may be taken by the practitioners of connoisseurship.[5] The state of the Giorgione catalogue, even now, is an indictment of the art historian's methods of dealing with problems of attribution, or perhaps more exactly, of our practice of these methods. From each diverse conception of what Giorgione did the critic makes a different artistic personality, with a different role in the development of Venetian art.

In all this attributive diversity there are at most six extant works that are usually taken for Giorgione without dispute. Only three of these are from the small group attested by the sixteenth-century sources: the ruined fragment from the Fondaco (in effect a documented work),[6] the *Tempesta*, and the *Three Magi*. The *Castelfranco Madonna* is not mentioned until 1648, in Ridolfi's *Maraviglie*, while the two remaining 'standard' works, the *Judith* of the Hermitage and the *Portrait of a Youth* in Berlin, are discoveries of late-nineteenth-century scholarship. All these have, indeed, such general evidence of a common hand and personality as to forestall argument, but beyond this dispute begins. The 'Giorgione' who is offered here may be as subject to dispute as any other, but it may have some measure of the consistency within itself and reasonable relation to the context of contemporary events that we expect of a satisfactory account of history.

Among the small group of pictures that are accepted without question as Giorgione's, the *Castelfranco Madonna* (Castelfranco, Duomo)

[47] is the most commanding work, and the one most generally taken as characteristic of his style. There is some external ground for assigning it to the year 1505,[7] at the midpoint of Giorgione's brief career. The date is also that of the great altar in S. Zaccaria [66] by Giovanni Bellini, the master who stands for the highest accomplishment in Venice of the early Renaissance, and comparison of the two works illumines the profound novelty Giorgione had by this time brought into Venetian painting. Giorgione's altar is inescapably involved with the precedents of Bellini's accomplishments; and conversely, Bellini's altar reflects an ambition new within his own history, and which resembles that of Giorgione. Despite the relations, the two contemporary works stand in distinguishable realms of style. Bellini's picture is, probably, his most surpassing demonstration of the resources of his painting which achieve illusion. All the powers of observation and all the techniques of description that early Renaissance painting in Venice had developed are projected in Bellini's altar in their superlative degree. But this demonstration of the sensuous apparatus of art is accompanied by an equal development of the intellectual machinery, particularly of perspective, which imposed order on the data of illusion and gave the record of existence the effect of harmony. As with the mature style of Perugino, Bellini's art has come, a little later, to express a compound of realism and reason that at once extends and moderates the propositions of early Renaissance style as they had been made, for Perugino by Piero della Francesca, and for Bellini by Mantegna.[8]

In the Giorgione altar there are elements that assert existence, and convince of it, more than in the Bellini; and even more, there are elements that assert a principle of order. Both the existence and the order are, however, differently conceived. For example, in the Giorgione

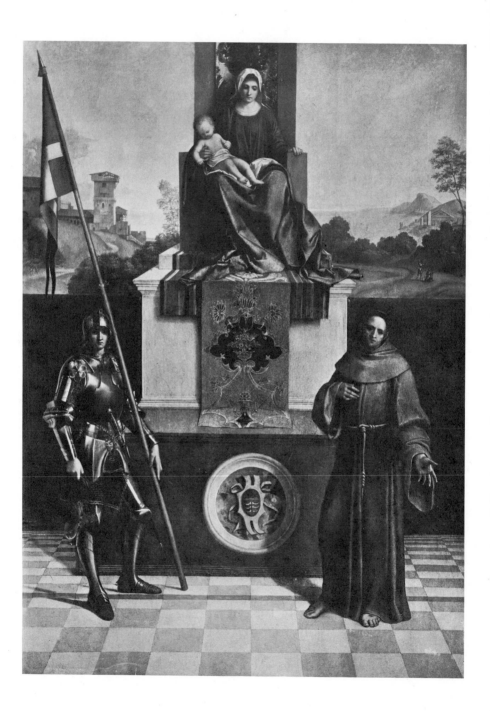

47. Giorgione: Madonna
with St Francis and St Liberale, 1505(?).
Castelfranco, Duomo

the shapes and stance of figures imply a heaviness of presence that is more than in Bellini, and their clothing has a texture that conveys physical and optical effects like those of reality. Not only garments but all the visible surfaces that Giorgione records are textured thus, given depth by the play on them of light in a dense atmosphere. In this atmosphere, the light infuses colour with a deep luminosity more resonant than in Bellini's altar. The sensuous factors of existence, as they may be translated through the eye, have become more compelling in Giorgione; yet the existence he describes is not, as Bellini's still is, a counterpart of their contemporaries' accustomed reality. For Bellini, the achievement of a counterpart of nature remains primary among his goals. In Giorgione, primacy is assigned not to the imitative function of art but to the factors which are inventions of the mind, or to conceptualized feeling.

The imitative truth of parts of the Giorgione altar may resemble Bellini's, but the facts are related by a different principle. This is evident in the single figures, where Giorgione has connected parts he may have described precisely into an arbitrary smoothed pattern to make a purified and artificial whole. An element of abstractness emerges from these figure shapes, but this is not so pronounced as the quality of abstractness in the whole design. Not only its framework but its visible surface consists largely in a play of geometric shapes. Unlike what is in Bellini's altar, this geometry is not an outgrowth of the measuring and describing functions of perspective order:[9] on the contrary, it is as if the rectilinear geometry of perspective should have been detached, as an aesthetic abstraction, from its descriptive function.

What is abstracting in this play of forms accords with what is, as a described situation, evidently unreal. What actual logic can explain the elevation of the Madonna, or the improbable architecture of her altar-throne, or the setting of the whole construction in the landscape? And the remove from reality is not only in this invented situation but also in the psychological circumstances of the actors in it – though 'actors' may be the wrong word for them. In posture, gesture, and expression of face they bespeak withdrawal, as if their spirit were preoccupied with a remembered dream.

From one aspect, then, Giorgione's picture affirms a sensuous existence more compelling than in Bellini, but this existence is at the same time reformed towards an abstracting purity – of shapes, of whole pictorial structure, of situation, of human types, and of their states of mind. The sensuous element and the abstracting element are each more pronounced in their distinct character than in the inventions of the young Raphael of the same time, but the proposition by which art is made is essentially the same. There is a similar concert between the sense of existence and the ordering of it in a slow-breathing harmony. Giorgione's *Castelfranco Madonna* is the analogue of the accomplishment of Raphael at the same date, and it no less represents a decisive forming of an identifiable Cinquecento classicism in painting style.

The achievement at this date is similar, but in Giorgione's case we cannot trace so clearly as for Raphael the route by which it was arrived at, nor are the motives or the sources of Giorgione's style as clear. The earliest generally accepted evidence we have of Giorgione's painting is in a small picture, the *Trial of Moses* (Florence, Uffizi), of which the likely date is 1500-1.[10] It is already a work of marked individuality, though inconsistent in vocabulary and tentative in its novelties of form. Among its loosely set-out figures, the *Trial* shows some which, for their fine cursive shaping and grace

of attitude, approximate the earliest ideas of Raphael, but other figures have a papery archaism that seems still in a line of descent from Mantegna; and there are exotic overtones among the figures also, suggesting North European sources, as in Bosch. The quality of psychological removal that we noted in the *Castelfranco Madonna* is, in these figures, accompanied by a strain of the bizarre. At least as much as the actors, however, it is the setting that creates the emotional tonality of the picture. The landscape not only dominates the painting quantitatively; it is endowed with a personality which, like that of the figures, is compounded of lyricism and fantastical invention.

Giorgione's origins are not decisively established in the old sources, but it is generally held that he was a pupil of Giovanni Bellini.[11] The resemblance of style in the *Trial* to Giovanni's painting is closer than to any other of the Venetian masters of that generation, but it is still not specific in the ways that would clearly indicate Giorgione's study with Bellini. What connexion there is, furthermore, is not with Bellini's contemporary art, towards 1500, but with his manner of a decade or fifteen years before. One might point out the so-called *Earthly Paradise* (Uffizi, c. 1485-90) for its analogous relation of figures and their setting, for the conspicuous modal function that the landscape has, and for the likenesses of figural conception. The factors in the *Trial* that recall Bellini link it with the Venetian tradition, though not with contemporary Venetian practice. What is novel in Giorgione's picture suggests relation rather with a non-Venetian contemporary environment, and a hypothesis of Roberto Longhi[12] indicates that this environment may have been Emilian. Comparisons of paintings by Francia, but more especially by Costa, that just antedate the time in which we locate the *Trial* seem to support this hypothesis:[13] in them we may find convincing

resemblances to the landscape style of the *Trial* (and of its companion picture, *The Judgement of Solomon*), and apparent precedents for Giorgione's cursive shaping of some of his figures, and for their somewhat languid grace. Where others of Giorgione's figures seem, instead, to be related to a more archaic mode than that of Francia and Costa, the relation seems still to remain Emilian, to the art of Ercole Roberti.

We may suppose, then, that Giorgione's earlier artistic education took place in Bellini's environment at least, and probably in his studio, in the early or mid 1490s, and that this foundation in Venetian tradition was succeeded by experience of Emilian art, and of Bologna in particular. The latter experience (likely, but still hypothetical) would have been of particular significance in Giorgione's first inclinations towards classical qualities of style. In the art of Francia and Costa of the later nineties Giorgione would have been exposed to one of the conspicuous reflections of the style of Perugino, and to the general phenomenon, disseminated throughout (and in this case beyond) Central Italy, of the most developed form of Quattrocento classicism.[14] In this way Giorgione would share partly in the same background out of which Raphael created his variety of a new, Cinquecento, classical style; and this (presumed) factor in Giorgione's early experience could have oriented him in a similar inventive direction, which a Venetian education alone might not have stimulated. But Giorgione's action towards a new style, as the *Trial* indicates it, was less decisive than that of the earliest Raphael, and conspicuously less consistent. The *Trial* is much more explicitly the document of a process of transition from a Quattrocento to a Cinquecento style.

By 1503 or 1504, the likely date of Giorgione's so-called *Tempesta* (Venice, Accademia) [48], the signs of a transitional situation have disappeared, except for a mode of drawing that in places is still thin and hesitant, occasionally

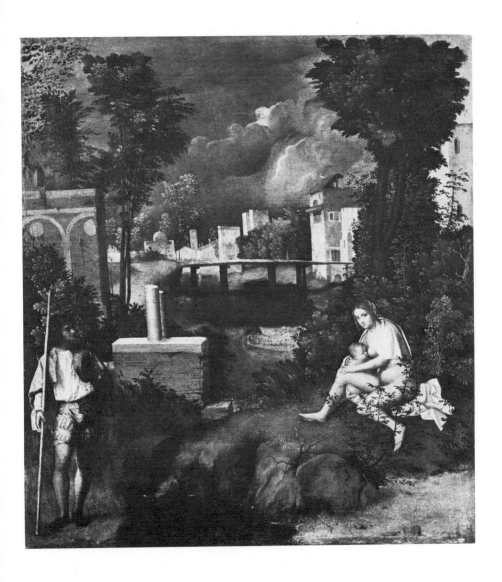

48. Giorgione: La Tempesta, 1503/4(?). *Venice, Accademia*

angular, as if the hand were lagging in the following of the inventing mind. Here, quite unlike the *Trial*, all the forms are composed in a system of responsive balances and woven into a connected unity of structure. There is no trace in the larger scheme of the design of quattrocentesque additive mentality or of the rectilinear aesthetic that derives from fifteenth-century perspective. As a design of forms, this works by principles like those of Leonardo's art, even more than the contemporary Raphael's. But unlike their designs, that of the *Tempesta* is built from forms of landscape, and in the structure of the picture the human actors are quite incidental. They loom larger than their physical scale in the picture's communication of its content, but in this too the landscape seems the real protagonist. There is no reference here to antecedents outside the Venetian tradition: this depends on the Bellini, on Antonello, and on what both had assimilated from Flemish art; and Giorgione has invested the environment with a power of communication no earlier painting had foreseen. The magnifying of the role of landscape does not arise mainly from considerations which have to do with landscape thought of as a 'literary' subject, or as an illustrative setting,[15] though these considerations are certainly present. More than these, the landscape is thought of as a state of nature that, chiefly by its visible qualities of light and colours, evokes emotion. There may be no earlier comment on man's environment which, so much as the *Tempesta*, infuses sheerly optical experience with the vibrance of the seer's feeling.

We have seen that the composition of the *Tempesta*, like that of the *Castelfranco Madonna*, is a manipulation of shapes and substances towards an artificial end. This same component of subjectivity is in Giorgione's record of light and colour in that his emotion participates in his description of his seeing. He does not give

us, in the *Tempesta*, the literal account of sight that, essentially, Bellini does, but he mingles fact and affect. And consistent with Giorgione's developing attitude towards the other factors of pictorial experience, his description of optical sensation is incipiently generalized, and his vision of particular effects is governed by a sense of their relation in a unity. This synthetic mode of communicating his experience of light and colour is the particular Venetian component in Giorgione's evolution of a Cinquecento classical style. It is the necessary consequence of the subjective factor in the new style operating on the distinguishing property of the old one which was Giorgione's inheritance. He was the first to effect this profound and liberating translation of Venetian vision, and his action was historically decisive for the future of Venetian Cinquecento art. He created for Venetian painting – and it is evident in the *Tempesta* – a system of pictorial unity based on the orchestration of optical effects, which is unknown in this degree to Central Italian painting. Giorgione conjoins this unity to structures of design that are akin in principle to those of Central Italian classicism, and because he – and the Venetian painters who succeed him in his course – has this particular optical resource, a machinery of design that depends on ordering of substances is never so crucial for them. The complicated intellectualizing that makes Central Italian formal order only rarely operates in Venice, because the native resource of Venetian classicism, its manipulation of light and colour, remains less a function of the intellect than of the senses, and of sensibility.

Giorgione is the inventor of this distinguishing optical factor in Venetian classical style, but his mode of working in it responds to a quality of mind and temperament which is not like that of his successors. The quota of subjectivity in his translation of visual experience, and of sensuous data in general, is higher than theirs, and

this is made explicit in the pictures that mark his attainment of a matured style. The *Judith* (Leningrad, Hermitage), very probably of 1504-5, falls like the *Castelfranco Madonna* close to the midpoint of Giorgione's brief career, and like it is a clear statement of Giorgione's developed principles of style [49].[16] In

49. Giorgione: Judith, 1504-5(?).
Leningrad, Hermitage

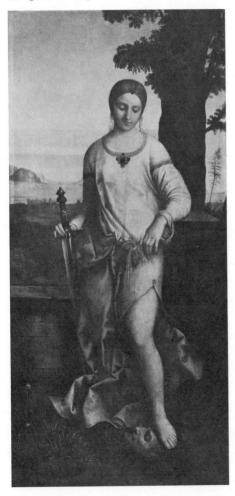

the larger forms of the *Judith* the richness of optical sensation that was in the *Tempesta* is diminished. The atmosphere and texture seem less dense, and they less suggest sensuous emotional associations. A purer and more generalized surface, both of drapery and landscape forms, and a greater clarity of colour offer a more abstracting transcription of the optical experience, as if the perception were strained through a veil. More explicitly than in the *Tempesta*, the optical element in the *Judith* is not a record of sense-data, but of purified sensation: what Giorgione offers is the ideality of sensory perceptions. The sum of the effect of colours, lights, and textures that the painting emanates – its 'tonality' – is similarly not a record of a natural effect, but a pictorial idea.

This way of approaching optical data is also Giorgione's way, at this stage, of treating data that substances afford. Even more evidently than his Florentine contemporaries, Giorgione deals arbitrarily with shapes, making geometric similes of Judith's body, and an implausible ovoid perfection of her head. The contour that describes the figure moves in a sustained *largo*, in a cadence slower and purer even than any in Leonardo, and this transmutes, in the lower passages of drapery especially, into ornamental convolution.[17] The forms of the setting also tend towards geometry, and certainly towards a simplicity greater than in the *Tempesta*. In these abstracting shapes Giorgione only denotes the substances they enclose. These forms barely weigh, and the effect derives not only from their purity but from the fact that Giorgione, disposed primarily to optical apprehension, sees surfaces, not substance. Judith's presence is not that of a sensuous reality, but of an ideal surrogate for it. So, then, is her – or Giorgione's – mood that of a removal from reality: of the sensuous existence remembered but no longer present to the touch; of the seen thing recalled, but as if veiled; of the action

stilled in time that does not move. This is the *sogno* of Giorgione: he has placed the locus of the classical compromise between idea and actuality in the most private region of any of his contemporaries. The energy and the complex resources of style that closer reference to nature give to Raphael, or even to the old Leonardo, are not evident in Giorgione's variant of classicism. A cogent demonstration of this difference is in a comparison of the *Castelfranco Madonna* and the *Ansidei Madonna* of Raphael, which is about contemporary.

Giorgione's definition of his style differs, then, in two principal respects from the Florentines: in its measure of remove from reality, and in the quota in it of effects depending upon optical experience. Both differences are of degree, but the second is in part also a difference of kind. Leonardo had evolved the most conspicuous optical sensibility, and had demonstrated how to manipulate its data into a major component of the pictorial harmony. Leonardo's optics were, however, based mainly on the function of light in respect to forms and substances, diminishing the role of light *as* colour; while Giorgione's opticality is purer, seeing light primarily as colour, and only secondarily as defining forms. Despite this difference and its consequences for Giorgione's formulation of his mature style, he is at the same time concerned, as he defines that style, with its constructive aspects, like those in Central Italian classicism. We have noticed an artificial order, making harmony and unity, in the *Tempesta*, and observed the deliberate geometry of design in the *Castelfranco Madonna*; the *Judith* is equally disciplined in structure and seems even more to attain a quality of monumental form. In the major works that follow, Giorgione is concerned less with the development of the explicitly optical factor in his style than with problems of formal order, and while the end of his research is the same orchestrated harmony his Central Italian contemporaries seek, his

means of finding it are distinct, less intellectually dogmatic. He finds increasingly monumental effects of structure, but this is not only the consequence of a formal search. Once he has defined the basis of his style, as in the *Castelfranco Madonna* and the *Judith*, his temper changes, and the dimension of what he wants to say in his art grows. The association of ideal and dream persists, but the dream seems more intense, more present and compelling; it becomes the projection of a masculine power of imagination that is different from the lyric tenderness in the preceding works. And the persons who exemplify the dream assume a larger dimension and a nearer, more sensuously described presence.

The *Three Magi* (Vienna, Kunsthistorisches Museum, *c*. 1506)[18] may be the initial evidence of the alteration of Giorgione's style as he enters on the second lustrum of his short career. The *Magi* remain *sognosi*, psychologically separate from one another as they are from us, but they are persons of a larger internal scale and more positive – more literal – existence[19] than those of the Castelfranco altar, and without their touch of languor. Form and colour in them take on a higher sharpness and intensity, and as a group they make a close-gathered and impressive presence. As before, the setting remains a larger quantity in the picture than the figures, and their equivalent in determining the picture's mood, but the forms of landscape are now also on a larger scale, more assertive, and as decisively articulated as the figures. The figure and landscape elements both form part of a very evident whole formal order of design which is not less obvious than that in the *Castelfranco Madonna* or the *Judith* because it is less geometrically schematic. Large forms of setting, of movemented shape, are built into a clear and stable structure, in which one feels the power of its constituent parts; and the effect of a matching between powers and disciplines is, for the first time in Giorgione's

art, comparable to that in the most advanced structural inventions of the same date in Central Italian classicism. Yet there is an important difference of the specific means Giorgione uses which have produced this classical result. It is a Venetian circumstance that his structure begins with the landscape and is deduced from it, so that the central feature is a space, not a substance. He may arbitrarily arrange larger forms of landscape, but the precise forms of flora and geology are too many and complicated to subdue, and they impose their variety on the large design. In any case, to make too evident an architecture out of landscape is contrary to the impulse that takes the Venetian to it; so that while Giorgione seeks to make pictorial structure he seeks also to preserve in it the real landscape's quality of complex accidental life. With its deliberation, his structure at the same time designs to convey at least the surface look of accident, which he reinforces in this picture by a daring – and novel – asymmetry in the placing of his figures. Yet this asymmetry, too, as much as it implies the look of naturalness, is part of the controlled apparatus of design, in a system of responsive balances.[20]

From this evident concern in the *Three Magi* with the development of classical pictorial structure Giorgione proceeded to explore a problem even more peculiar to classicism, the complex yet harmonious manipulation of the figure. The fresco decoration of the waterside façade of the Fondaco dei Tedeschi (the depot and exchange of the German colony in Venice; 1508) was Giorgione's most ambitious and extensive work, and like most such exterior decorations it is lost. A ruinous fragment has survived, a standing female nude – perhaps a Venus – but a series of engravings document the look of other figures, and a print made in the seventeenth century[21] provides (along with various written accounts) an idea of the lost ensemble. Mainly, the paintings were of single figures posed in various attitudes in fictive

niches.[22] Evidently, the given architectural fields suggested the appropriateness of this solution, and thus may have posed to Giorgione, more urgently than otherwise might have been the case, the problem of manipulation of the human form. The architectural datum accounted also for the size of the figures, larger than life, but not for their internal scale. Beyond any of Giorgione's own precedents, these figures convey gravity and density, and the effect of monumental presence. The extant fragment shows us that their power of form was accompanied by a new magnitude of power of colour, vibrant and even hot in tone. Not only substantial but optical experience is apprehended by Giorgione more intensely and powerfully than before, and the tonality of the emotion has changed correspondingly. His temper now contains the quality of slow-burning passion.

Some of these powerful presences (like the extant *Venus*) stood immobile in their painted niches, and remarkably convey the whole effect of ponderation and ideal shape of authentically classic ancient statuary. Others, however, are made to move in spatially complicated contrapposti, in a repertory of postures that is the effective analogue of what Michelangelo began to do in the year following in the Ignudi of the Sistine Ceiling. This concern with the stature and the powers of humanity, and its expression through the devices of classical form, is remarkable in its coincidence with the contemporary Central Italian style, all the more so because it appears in a development that had such different origins.[23] But however the means and matter of style in the Fondaco frescoes may be altered, it retains its constant of essential Giorgionesque state of mind. The power of idea and presence is immanent in the Fondaco figures, but they still look and function in the state of spirit that relates to the world of dream – abstractly pure of form, and reticent and slow in the temper of their action.

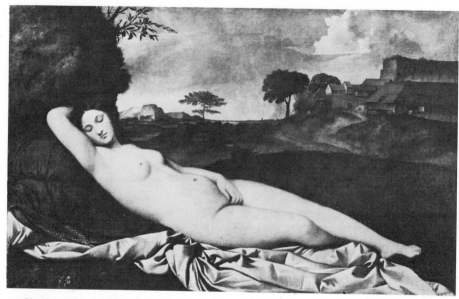

50. Giorgione: Sleeping Venus, 1507-8.
Dresden, Gallery

The *Sleeping Venus* (Dresden, Gallery, 1507-8)[24] [50] is the same kind of magnified yet abstracted presence as the figures of the Fondaco. Even in the context of landscape and drapery that another hand, that of the young Titian, provided for the Venus after Giorgione's death[25] we recognize her extreme, arbitrary purity of form. The idea of sensuous being is intensely, largely conveyed by this figure, but not its facts. These are muted, and absorbed into the affect of the form's musical geometry. The shape of being is the visual demonstration of a state of being in which idealized existence is suspended in immutable slow-breathing harmony. All the sensuality has been distilled off from this sensuous presence, and all incitement; Venus denotes not the act of love but the recollection of it. The perfect embodiment of Giorgione's dream, she dreams his dream herself.

This meaning in the *Venus* – ultimately it is a meditation on the idea of the beauty and harmony of sensuous existence – is expressed in a temper peculiar to Giorgione and in his particular vocabulary, but as with the figures of the Fondaco it is inescapable that we observe how essentially this work relates to the contemporary conceptions of Central Italian classicism. The analogue, here still less expected than in the case of the Fondaco figures, is again with Michelangelo. On a different plane of involvement with actuality, of formal complexity and complexity of idea, the *Venus* is the counterpart of the *Adam* in the *Creation of Man* in the Sistine.

Two portraits document the remarkable growth and change of Giorgione's style from the midpoint of his career to its last phase. The earlier, the *Portrait of a Youth* (Berlin, c. 1504-5), is still in the temper, and works with the

means of style, of the Castelfranco altar; the latter, the *Self-Portrait as David* (Brunswick, Gallery, 1508-10),[26] is big not in scale but in conception and effect of form, communicating the intensity and the power of the artist himself. His career was cut short at the end of a decade, and legend has it – with strange appropriateness – that he died (in the early autumn of 1510) of plague caught by him from his mistress. His idea took the form and quality of dream, but there was vast strength in his statement of it, and he possessed the force of thought that made for an enlargement of idea and a development of forms within his art no less dynamic than in the same stage of evolution of a classical style in Central Italy. He founded a classical style for Venice and left his creation to Titian to complete.[27]

The Earliest Titian

We have observed that from the middle of the sixteenth century Titian's polemic admirers, and probably Titian himself, felt it necessary to add to his vast glory, aiding the work of time that, by then, had outmoded the accomplishment of Giorgione and obscured his role in forming the young Titian's art. The nature of Titian's relationship with Giorgione is fairly clear, however, and there is no doubt that essential elements of Titian's style derive from the older master. That Giorgione was older is not provable, and it is contrary to assertions Titian made about his own age in later years, but the best interpretation of the evidence indicates that Titian was a decade, or even slightly more than that, Giorgione's junior.[28] Titian was much the more precocious personality, but even the extreme suppositions we can make for juvenile works by him do not antedate 1506, when Giorgione's invention of a new style was already sufficiently affirmed. These putative first efforts of the young Titian are, in any case, still attached to the style of his teacher, Giovanni Bellini, more than to the novelties of Giorgione. By 1507 or 1508, however, Titian had simultaneously developed his own individuality and assimilated essential facets of Giorgione's precedent; and his subsequent development to 1510 brought Titian increasingly towards dependence on Giorgione's example. For a few years following Giorgione's death, Titian's relationship to him was that of a disciple, as if he meant consciously to supply the absence of the master. Such is the kinship of intention and effect that some works by Titian of these years, and even of a few years before, have been taken to be by Giorgione. This succession of events does not diminish Titian's own creative power, and the differences of his personality from Giorgione's are almost always – at least to this viewer's eye – strongly marked. But he owes to Giorgione a precedent for the new mode of painterly vision, though this may not be vital, for it is likely that Titian would have come to this out of his own resources. More important, he found in Giorgione a demonstration of the principle of subjective liberty in respect to experience of nature; and perhaps most important he learned the apparatus of classical form and the ideal of classical discipline from the older painter.

The earliest certain works by Titian, of 1507-8, have evidently been formed from a conception of expression and vision that derives from the experience of Giorgione. The two cassone panels with the *Birth of Adonis* and the *Legend of Polydorus* (Padua) and the *Orpheus and Eurydice* (Bergamo) depend on Giorgione's imagery, and on his demonstration of an integral communication made by human actors and their landscape setting. They derive another unity from Giorgione, of the whole pictorial texture that results from his demonstration of what we have called his optical mode. Yet these pictures are specifically unlike Giorgione: they are less cautious in small forms and less deliberated in their larger design, and

the optical element in them is also less controlled. On the contrary, Titian's visual responses are set down in a way that intensifies their energy and brilliance. The *Lucretia* at Hampton Court, of about 1509, shows the latter quality on a larger scale, in luminous drapery and in the textured radiance of the nude female figure. Here the liberty to generalize and reshape form largely and cursively is after Giorgione's example, but Titian's purpose in its use diverges markedly from Giorgione's. Titian shapes the nude to give new stress to its physicality and to its sensuality; his subjective liberty of representing is not used, like Giorgione's, to abstract from sensuous existence but to affirm it. Titian, too, deals with the idea, not just with the objective record of appearance, but that idea is of the magnified intensity of sensuous experience – of physical being and its vitality, revealed to the powers of sight.

Among all the juvenilia of Titian the *St George* (Venice, Cini Collection, also *c*. 1509; the surviving third of a lost altarpiece) [51] may demonstrate this most remarkably. The image of the Saint is generated from the precedents of Giorgione, and evokes a mood related to his; but this is differently immediate and vital. The armour of the Saint is taken as occasion for a turbulence of light, which saturates surrounding colour and infuses the contrasting darks. The brush records the brilliance of light and the texturing vibration that it makes on surfaces with a rough energy of hand. Beyond what it reveals of physical being, light is in itself sensuous experience for Titian, and he sees it as alive and yet more complexly charged with energy than the bodily factors of existence are. This light, and the colour it creates, is more than record of a visual fact. It begins in the seeing of reality, but that seeing is then charged with the energies, the passion, and the poetic power to enlarge experience that is in the artist. Part of the subjective component in this mode of vision is in the manual action by which

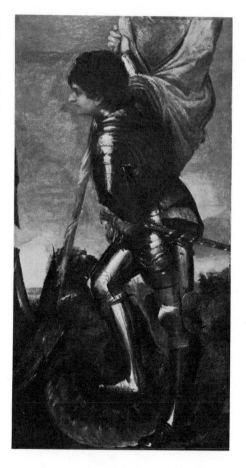

51. Titian: St George, *c*. 1509.
Venice, Cini Collection

it is set down, and this is, more than in Giorgione, revolutionary in its liberty.

This is the poetic enlargement of a sensuous experience, and a partial transmutation of it in an ideal sense, but the root in that experience and tie to it are evident as never in Giorgione; and they are an indication of Titian's earliest artistic origins. Where (as I see it) Giorgione detached himself from an early education in Bellini's shop, and found his threshold for a new style in an intellectualizing late Quattrocento classicism in Emilia, Titian's threshold was, directly, his Bellinesque education, primarily concerned with the depiction of physical and visual reality. The *Allendale Nativity* (Washington, National Gallery, 1506?) is, I believe, a step yet farther back in Titian's history towards his beginnings in Bellini's style.[29] In the *Allendale Nativity*, only symptoms distinguish its manner of painting from Bellini's, but these show the peculiar intensity of visual response that we find in Titian later. Perhaps still more significant, the structure of the picture seeks on the one hand a liberty, and on the other a cohesiveness, that belong to the mentality of Cinquecento style.[30] There is no unchallengeable bridge of works we can adduce to make transition from the Allendale picture to the certain Titians of 1507-8,[31] but we might hypothesize the nature and the motives of this change.

Experience of aspects of Giorgione's art – the subjective component in seeing and the mobile elements in structure particularly – serves to stimulate a very vital temper bound hitherto, by Bellini's schooling, to observed reality. It is not the classicism of the entity of Giorgione's style that the earliest Titian wants or understands, but more those elements which will liberate him from quattrocentesque literal, essentially objective, depiction: from forms copied in their immobility and contained in static order. Titian's capacity to see reality intensely is developed by his Bellinesque training,

but it is innately a function of his extraordinary vitality, which will inform his whole long career. Taking authority from Giorgione's infusion of the arbitrary and subjective into his depicted world, Titian charges Bellinesque reality with his own vitality, magnifying sensuous presence, setting it in movement, making vibrance in the light and air, and inventing graphic signs of new flexibility to communicate these things. By sheer force of animation discharged on his Bellinesque inheritance he breaks up its old order, and embarks on a new style which at the beginning is more revolutionary in temper, yet more directly an outgrowth of the Venetian precedent, than Giorgione's.

At the beginning, Titian was not yet willing to exchange an old discipline for a new one: we have observed that his initial stimulus from Giorgione was not from Giorgione's whole classicism of style. Once his new liberty and its means had been affirmed, however, Titian turned more integrally to the example of Giorgione, and the remaining years of the first decade show his increasing assimilation of the structural principles, and even of the modes of content, that characterize the classicism of Giorgione. It seems that they were brought together, or at least nearly into conjunction, when Titian was assigned the decoration of the minor, side, façade of the Fondaco dei Tedeschi, probably in the same year as Giorgione, in 1508.[32] The similarity of his assigned task, and the presence of Giorgione's models for it, must have encouraged Titian in his study of Giorgione, and Titian's frescoes imitated important aspects of Giorgione's in this most classically ambitious moment so far of his career. Like Giorgione, Titian aspires to a new monumentality and power of form, and he approximates Giorgione's amplitude of figure and his manipulation of it into movement; but neither shape nor movement find Giorgione's harmony. What Titian evokes with what he

borrows of Giorgione's means is a grander physicality but not yet a classical ideal of form.[33]

In the *Christ and the Adulteress* (Glasgow, *c.* 1509) [52][34] Titian's new command of larger form is evident, but his intention for it is conspicuously unlike Giorgione's. No earlier work so powerfully asserts sheer physical existence, for the substance of the figures is described with almost exaggerated fullness, and they are made to move with heavy urgency, almost lunging towards one another. And, in addition, Titian has developed a remarkable technique for recording their surfaces of drapery and flesh, more controlled than his handling in his previous works and more literally illusionistic. The garments show strong fields of colour, saturated with intense light, and the

effect of counterfeit of actuality is conveyed with unprecedented force. In a sense this is a reaffirming of a quattrocentesque strain, but the very force of the illusion transcends normal expectation and experience of reality. And there is a dualism in the working of this light-saturated colour: even while apprehending what it objectively describes, the eye and mind perceive it also as a separate, non-descriptive power, as an abstract and subjective aesthetic effect. Titian's purposes are not yet synthetically resolved. What is in the effortful and vital physicality of the *Adulteress*, and in its strain of painterly illusionism, explores conceptions on the basis of which a baroque style might be made; but the simultaneous value of abstraction in the colour tends more towards

52. Titian: The Adulteress brought before Christ, *c.* 1509. *Glasgow, Art Gallery*

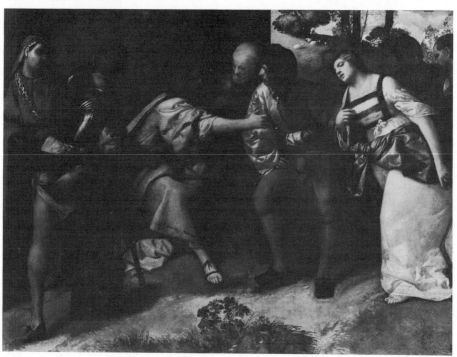

the ideality of a classical style. The character of structure in the picture tends the same way.[35] The figures move too urgently to accept the disciplines of contrapposto, but they are connected in a formally deliberated cursive rhythm, and set out in a scheme of mobile reciprocal balances that accords with the compositional innovations of the classical style. No precedent survives for such an extended classicizing order as this that we can give certainly to Giorgione, but there is a close analogy to the design of Sebastiano del Piombo's *Judgement of Solomon* (Kingston Lacy, Bankes Collection, *c*. 1508 [54], probably antecedent to the *Adulteress*), in the invention of which Giorgione may have been involved.[36] But since the classical order of larger design follows out of that of the single figures, Titian's accomplishment in the *Adulteress* evolves out of a discipline he had learned, especially through the frescoes on the Fondaco, from Giorgione's classical style.

An ancient confusion exists about the authorship of the *Christ carrying the Cross* (Venice, S. Rocco), which Vasari gives in different places to Giorgione and to Titian. It seems to us to indicate a moment of Titian's evolution just following the *Adulteress*, in which he moves more deliberately and still more imitatively into the orbit of Giorgione's style. Muting his aggressive energy, Titian seeks more discipline as he matures, and accepts Giorgione's authority for the means by which it may be achieved.[37] In the *Portacroce* Titian comes close to Giorgione's purity of form and approximates the tone of feeling he evolved towards 1508.[37a] The assimilation of Giorgione is to the point of giving good grounds for confusion, but Titian's personal accent, of a specificity unlike Giorgione's in description and in mood, is still there. In his contemporary adaptations of Giorgione's portrait style, where Titian seems less convinced that Giorgione's extreme ideality is applicable, this specificity is yet more evident. In Titian's portraits around the time

of the *Portacroce*, such as the *Portrait of a Man* (ex-Goldmann Collection, now Washington, D.C., Kress Collection, *c*. 1509-10), or the so-called *Ariosto* (London, National Gallery, *c*. 1510-11), the dependence on Giorgione's mode does not obscure the personality of the author.

The *Portacroce*, of 1509 or 1510, dates from within Giorgione's lifetime, and it is evidence of a still learning, literal, dependence on that master. The *Pastorale* (Paris, Louvre) [53] represents to us another, more advanced stage of Titian's relationship to Giorgione:[38] it is no longer imitation, but a demonstration of creation in Giorgione's style, according to his most advanced precept and in a stature that resembles his. The painting should be, by my calculation, of late 1510 or 1511, just following Giorgione's death, and it is as if Titian were determined in it to deny Giorgione's mortality, perpetuating the life of his idea. In every respect of the working of the hand and eye in it the *Pastorale* is Titian's, and so is the repertory of forms and their precise morphology;[39] but the idea and emotion – more truly the idea *is* an emotion – are one with Giorgione. The theme recalls the essence of the early *Tempesta* (apart from any possible overlay of identifiable literary meaning, either in that picture or in this), but it has been articulated with a resonance and depth like those of Giorgione's latest years. Not only Titian's own maturing but a willed consonance in him with the departed master's thought has finally produced in Titian a classical restraint upon his powers of asserting presence, and imposed continence – even Giorgionesque indirection – on his expressive mode. As much as in the latest Giorgione, passion is slowed and muted; not quite as much, sensuous being is generalized and aggrandized towards the realm of idea. In this latter respect, there is a recognizable persistence of the temper with which Titian earlier confronted sensuous experience. It is evident not only in the nudes but

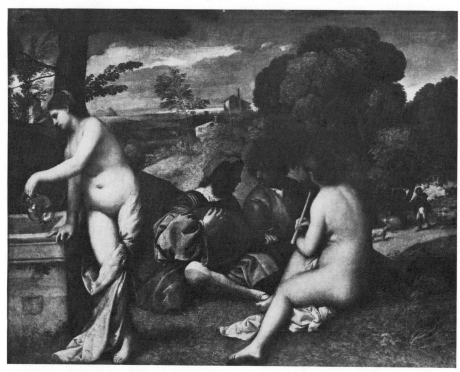

53. Titian: Pastorale, 1510/11(?).
Paris, Louvre

still more in the clothed males, where Titian cannot resist the exercise of the brilliant illusionistic technique developed for the *Adulteress*; and he sees the landscape with a sparkling particularity. The *Pastorale* extends Giorgione's world, but as if it had been not only absorbed but re-invented by the young Titian, and even through the subduing disciplines of Giorgionesque classicism it radiates an effect of vitality distinct from Giorgione's slow, abstracting power. In one aspect the *Pastorale* differs from any precedent certainly by Giorgione that is known to us. Because shapes are less carefully proportioned into regularity by Titian than by Giorgione, they tend to be more rhythmically mobile (apart from any element of described action). In Titian's earlier pictures, as in the *Adulteress*, this mobility had been often impulsive, and sometimes awkward. In the *Pastorale*, in the restrained temper assimilated from Giorgione, Titian's mobility of forms becomes a fluency not only in the shapes of figures but in the elements of setting. The whole pictorial design becomes a beautifully cursive, elaborated arabesque, of a complex and sustained development beyond any analogue of composition by Giorgione. The design makes equilibrium with an assortment of interacting means of which the flexibility and variety exceed Giorgione's, and avoid the sense of arbitrariness and abstractness of structure that, according to the surviving evidence, was his. By

contrast with the sophistication and the ease of classical order that Titian evokes in the *Pastorale*, Giorgione seems still to be bound by some of the stringency of the older sense of order of the Quattrocento. Founded deeply in Giorgione, giving him a momentary posthumous existence, the *Pastorale* moves towards a new reach of possibilities of Venetian classical style. The pictorial devices Titian finds out in it are already those with which he will create the masterworks of a decade later.[40]

The Venetian Sebastiano

In the spring of 1511 Sebastiano Luciani left Venice to continue his career in Rome. We have already met him in his Roman guise, and witnessed the important role he played in the history of classical style in Rome. His rapid and successful assimilation to the Roman scene indicates a prior disposition in him towards the formalism and intellectuality that characterized their classicism, but which was less conspicuous in the Venetian variant of the style. What he brought to Rome was in fact an offshoot of the last stage of Giorgione's evolution, in which we have seen the emergence of formal values very like those of contemporary Central Italian art; and it was a temperamental matter in Sebastiano that even in his response in Venice to Giorgione's example it was this formal aspect that particularly concerned him. Sebastiano was approximately Titian's contemporary (born, according to Vasari, in 1485).[41] Vasari indicates that his first education had also been with Bellini, and that later he was in some way in relation with Giorgione – Vasari's phrase 'si acconciò con Giorgione' (v, 565) is ambiguous, and does not specify their connexion. Vasari describes Sebastiano, like Titian, as Giorgione's 'creato'. The two were thus similar in education, but they were quite unlike in temperament. In place of Titian's rebellious vitality, impatient of example, Sebastiano was

more cautious and conservative. He was as sensuous in disposition as Titian, but at the same time more disposed to abstracting intellectual deliberation, and in this latter sense he is closer to Giorgione.

Where we identify Sebastiano's Venetian work with complete certainty, only towards 1508–9, Vasari's account of his education seems correct. More speculative attributions to preceding years can be made, and these show a Bellinesque style already touched by Giorgione. The earliest among them may be a small *Madonna in a Landscape* (Leningrad, Hermitage), for which a date *c.* 1506 seems appropriate. An attribution to Giorgione is often hazarded for it in the literature, but the Giorgionesque elements are minor. There is an identifiable reflection of Giorgione's physiognomic type, but the other qualities that suggest Giorgione may be derived indirectly, from the example of Bellini's response to Giorgione at this time. In general, the Leningrad *Madonna* resembles the mode Bellini evolved towards 1505.[42] The *Madonna Reading* (Oxford, Ashmolean, *c.* 1507), more widely assigned to Giorgione than the Leningrad picture, seems by the same hand making a more convinced but still not complete concession to Giorgione's style. The equivocation between Bellini and the newer mode is very like that in the paintings of the *Allendale Nativity* group, which I assign to Titian, and place *c.* 1506, and his example as well as that of Giorgione may be operative here.[43] Both the Leningrad and the Oxford paintings require association with a *Madonna with St Catherine and St John Baptist* (Venice, Accademia) that is more firmly assignable to Sebastiano.[44] Its vocabulary appears more conservative than those of the two Madonna pictures, but this need not indicate that it precedes them, for typology and handling are closer here to Sebastiano's certain, later, work. The style seems less a direct extension from Bellini's than a dialectic made between Bellini and Gior-

gione; and the deliberate technique and careful structure seem an affirmation of a clearer, more personally mature point of view than is demonstrated in the Oxford or the Leningrad Madonnas. This Academy painting may represent a formulation, *c.* 1507-8, of a basis for Sebastiano's subsequent development of style.

We are still on unproved ground with the next work I choose to call Sebastiano's, the *Judgement of Solomon* (Kingston Lacy, Bankes Collection) [54], for which not only tradition but a body of opinion in the modern literature claims Giorgione's authorship. Of monumental dimension and ambitiousness, the *Judgement* is a major landmark in the history of the first decade of sixteenth-century Venetian painting, which nothing in the hypothetical earlier career of Sebastiano would seem to have foreshadowed. Furthermore, documentary evidence exists that may be interpreted to connect the painting with Giorgione's name. Yet the whole Morellian vocabulary of the *Judgement* is explicit in its declaration of Sebastiano's hand, and from comparison with sure works by him of immediately later date, the *Judgement* falls with fair certainty into the year 1508. This is the year of Giorgione's decoration of the Fondaco (and probably of Titian's), and the precedent of the Fondaco, even in the process of its painting, may be sufficient to explain the generation by Sebastiano of his monumental work.[45] Resembling the Fondaco, the *Judgement* shows figures of large proportion in active postures, set in architecture, but unlike the Fondaco, where (from our evidence) there was no extensive single picture field, the figures in the *Judgement* are combined into an extensive composition, and the architecture develops a deep space. This is the first instance in Venetian painting of the exploration of the proposi-

54. Attributed to Giorgione: Judgement of Solomon, *c.* 1508. *Kingston Lacy, Bankes Collection*

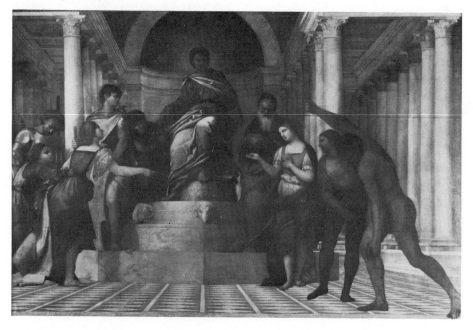

tion of a grand equilibrium made from a multiplicity of interwoven, mobile human forms, and the first to test the uses of a classicizing architecture to support it.[46] There is still, in the design of the figures, a residue of additive mentality, and the sense of identity of each is only partly overcome by reciprocal relations made in posture and by connexions of directed cursive rhythm; also, the architecture betrays its origin in its perspective grid, evoking a quattrocentesque antecedent in Bellini. Sebastiano responds to Giorgione's demonstration of mobility of balanced form, but with deliberation and with a disposition that relies still (as it had more evidently in the Accademia *Madonna*) on Bellini's additive aesthetic. The colour is tempered by Bellinesque tradition, translating Giorgione's warmth and luminosity towards smoother brilliance, and attaching colours more separately to their containing forms. But despite its residues from a preceding style, the *Judgement* is in sum a remarkably advanced construction, fulfilling in principle and in extent requirements of classical design that only the great triumvirate from Florence was, in 1508, prepared to meet. There is a legitimate analogy in the *Judgement* with Raphael's *Madonna del Baldacchino*, and a forecast of the propositions Raphael was to develop in the Segnatura; and the forecast of Sebastiano's own subsequent ease of assimilation to the Roman style and to the formal interests of Roman art is here too. The measure of accomplishment is such, indeed, that it does not reappear in Sebastiano's work until he comes to Rome. The remaining Venetian pictures are essentially less radical than the *Judgement*. There is a disparity between the formal ambition of this painting and the paintings by Sebastiano that closely succeed it, and a disparity also between the intellectual advancement of the idea and the relative conservatism of the means by which it has been realized. This could be explained, we must remind ourselves, by the possibility of Giorgione's invention.

The organ wings of S. Bartolommeo a Rialto (1508-9)[47] are also not wholly consistent in their style. The inner figures, St Sinibald and St Louis of Toulouse, are more Giorgionesque in handling than the figures of the *Judgement*, but in posture they are more Bellini-like. Their setting is inspired by the Fondaco, but it has been interpreted according to the vein of illusionism that is in Bellini, as in the S. Zaccaria altar. There is a different whole effect of modernity in the outer wings, with St Bartholomew and St Sebastian, which may afford the best substitute we possess for the figures that Giorgione made for the large fields on the Fondaco. These Saints take the temper of slow, heavy movement of the Fondaco forms, as well as their amplitude, and approach the power which, we deduce, the Fondaco figures had of existence in an ambience of strong coloured light. Framed within an imposing architecture, they make an effect of eloquence that foretells the rhetoric of the developed Roman classical style. Sebastiano is exploiting Giorgione's capital, but the specific accent he gives to it seems, in the light of his subsequent history, his own.

The last major work of Sebastiano's Venetian years, the altar of S. Giovanni Crisostomo in Venice, painted between March 1510 and spring 1511,[48] is less explicitly dependent on Giorgione, and it is no longer recollective of Sebastiano's Bellinesque origins. More clearly than in the organ wings, specific traits (and types) emerge here that we identify in the Sebastiano of the Roman years. Conspicuous among them is the enlargement upon Giorgione's late example of classical figure canon, and its exaggeration into ponderosity. In Rome, this element brought down from Venice was to find renewed encouragement in Michelangelo. Developing the principle of design of the *Judgement*, the scheme of the Crisostomo altar is

more complex, combining profile and frontal dispositions of the figures, asymmetry and centrality in the setting, and landscape and architecture into unity and balance. More formally complex than the *Judgement*, this design manipulates geometry with the abstractness we have recognized in Giorgione, but the sense of a dominantly rectilinear order still persists from Sebastiano's earlier inheritance. This last residue of an older art was to go, while the intellectual command of devices to make classical composition which Sebastiano prepares here was to make him, in Rome, the sole painter fit to challenge Raphael's pre-eminence in this field.[49]

Titian: The Post-Giorgionesque Decade

The breadth of form and of conception that are in the *Pastorale*, and which indicate emergence to maturity, are also in the three frescoes Titian contributed to the decoration of the Scuola del Santo in Padua (1511), and their handling is still more confident – this, too, an indication of maturity. But in an important sense the Padua frescoes regress from the accomplishment of the *Pastorale*. These barely face the problem of a complex pictorial order that, in the *Pastorale*, Titian had so brilliantly solved. There is some comprehensive geometric structure, but the necessity to make narrative seems to recall Titian to the only tradition for it that he knew, the *teleri* of the late Quattrocento. The composition of two of the Scuola frescoes shows an accent like theirs, somewhat additive, or even merely accumulative. The discipline they do have recollects, still more than Sebastiano's barely earlier Crisostomo altar, the older mode of order of Bellini. The third fresco, the *Jealous Husband*, refers backward in a very different way, to Titian's own early departure from Bellini, and to his research towards an energy of action that verges in impulsiveness and force on a baroque. In all three frescoes Titian looks

beyond the recent episode of close dependence on Giorgione and links their style and ambition rather to the *Adulteress*. In particular, the prescription he had come to there for effects of colour that are at once illusionistic and poetic is repeated here – with astonishing brilliance for the fresco medium; and it is as if this colourism, and the *tours de force* of description that accompany it, were sufficient to Titian's purposes, without more complicated demonstrations of his machinery of art. The *St Mark* altar (Venice, S. Maria della Salute, *c.* 1511)[50] is closely related in style to the main fresco at the Santo, the *Miracle of the Newborn Child*, but even more than there its order recalls the perspective-deduced aesthetic of the Quattrocento. Yet it has visibly been brought up to date: simple but efficient devices relate forms towards unity in pattern and make connexions in their disposition in the space, and the very density of form suggests its unity. Decisively unlike the Quattrocento precedents (and more than in a partial model, Giorgione's Castelfranco altar)[51] the conception of the picture begins with the substances it represents, not with the projection of their space. There is another bridge between two tastes – in effect Bellini's and Giorgione's – in the descriptive mode. Titian's force and degree of literalness in his description of the figures is like that in the Santo frescoes, and, as there, there is a visible concession to Giorgione's precedent of regularizing form. But there is no wish thereby to reshape appearance into ideality, as there had been in the moment of the *Pastorale*. Appearance is reformed, just adequately, towards classical proportion, but mainly to increase its sensuous attractiveness, which is further magnified by effects of texture and by the sheer magnetism Titian makes with coloured light. His devices are at a measurably different level of development, disciplined and subject to exact control, but Titian's basic intentions for his art are not different from those of his first

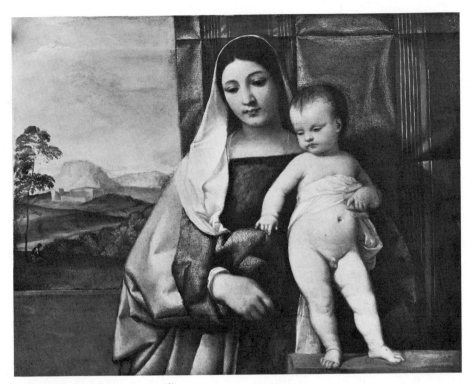

55. Titian: Gypsy Madonna, *c.* 1511(?).
Vienna, Kunsthistorisches Museum

years. In the *Gypsy Madonna* (Vienna, Kunsthistorisches Museum) [55], which must be virtually identical in date with the *St Mark* altar, the effect of sensuous existence Titian makes by his command of optical device is of an extreme virtuosity. No picture before this attains a comparable sense of presences existing palpably within an atmosphere, reflecting coloured light but also absorbing it to saturation point, so that each pore of flesh or drapery makes texture. The proposition is not new in Titian, but its sophisticated, utterly authoritative execution is: to a new degree the optical illusion of existence is so powerfully intense that it transcends the existence it describes, and assumes the status of idea – of sheerly pictorial,

aesthetic fact, more than it is the counterfeit of a fact of nature. This vibrant presence is affirmed, in the *Gypsy Madonna*, of figures which, more evidently than in the *St Mark* altar, depend in physical canon on the example of the late Giorgione, of harmonious fullness and slow gravity of form.[52] A corresponding effect of charged, grave harmony is in the mood of persons and setting that the picture illustrates. With the difference that results from Titian's greater sensuousness, this mood – like that of the *Pastorale* – deliberately perpetuates the temper of Giorgione.

It is less likely that Titian is, now, referring back directly to Giorgione than that he is recalling his own translation of Giorgione in the

Pastorale. This appears to be the case in the *Noli me Tangere* (London, National Gallery, 1511-12), where the motif of posture in the Christ and the principle of composition are deduced from the earlier picture.[53] Despite the difference of subject, the tenor of communication continues the poetic Giorgionismo of the *Pastorale*, but the poetic temper is a little sharper, less immersed in the atmosphere of dream. This is occasioned by more than the requirements of subject: in general, in the *Noli me Tangere* there is the evidence of the working of a more precise sensibility, articulated by a finer, still more virtuoso touch. The elements of awkwardness or of aggressive stress that had been frequent in Titian's juvenilia (and of which there is a trace even in the *Pastorale*) are gone. Forms assume a more fluent grace, and the cursive action of the brush is so swift and exact as to suggest a sleight-of-hand. This is a further revision away from Giorgionesque example, but the affiliation is still eminently visible.

It may be less so in the small *Madonna with St Roch and St Francis* (Madrid, Prado, *c.* 1511),[54] for despite the variant in it of a Giorgionesque mood the main meaning of the picture is its painterly experience of vision, as it was accessible only to Titian and demonstrable only by him at this time. As the forms of the *Noli me Tangere* are the projections of a more refined sensibility, so are the behaviour of light and colour here and the subtlety and brilliance of their transcription. It is this latter aspect of the picture, not its Giorgionism, that is significant for the next few years to come in Titian's career. The subject matter of the *Three Ages of Man* (Edinburgh, National Gallery, Ellesmere Loan, *c.* 1512-13) still commands affiliation with Giorgione, or rather with Titian's personal precedent of a Giorgionism in the *Pastorale*; but it is true in substance that the few pictures we discussed previously, and would date 1511 and early 1512, represent a

brief and only partial renewal of dependence on Giorgione. What succeeds these is a series of works that reasserts Titian's distinction in vision and temperament from the older master. He seems almost to turn back across the intervening episodes of Giorgionismo to link up with his own accomplishment as it had been towards 1508 or 1509, about the time of the *Adulteress*.

Refinement of form and fluency of composition distinguish the *Madonna with St John the Baptist and a Donor* (Edinburgh, National Gallery, Ellesmere Loan, *c.* 1512) from similar themes by Titian of a few years earlier, but there is no doubt of the continuity of idea and essential concerns between them; and this is true also of the *Holy Family with a Shepherd* (London, National Gallery, *c.* 1512-13). Conspicuous among the continuities is a concern to exploit the brilliance of colours and reflected lights on draperies. In these pictures Titian reasserts a former tendency to descriptive literalism in the rendering of drapery and carries it much farther than before, apparently to give himself the opportunity to make virtuoso illusion, but even more to make a maximum of complex brilliance of reflected light. The look of literalness and the broken patterning of drapery intrude a note of archaism into conceptions that are otherwise advanced, and reinforce the link – almost always somewhere evident in young Titian – with the style of Bellini.[55] In this respect these works seem somewhat regressive, and they are aberrant in Titian's evolution of these years, but only in the degree to which Titian has permitted himself for a brief while to confuse the aim of expression made by optical devices with the objective facts of optical experience.

The tendency persists in the *Madonna with Two Saints and a Donor* (Genoa, Eredi Magnani, ex-Balbi Collection, *c.* 1514-15), where the Madonna serves almost as a lay figure on which to arrange a cascade of complicated

drapery. The brilliance of her display is still more heightened by relief against a contrasting dark hanging behind the Madonna, recalling an earlier device of Titian's, as in the *Gypsy Madonna*. The archaistic accent of the drapery pattern is less than in the Ellesmere or the London pictures, but the emphasis on literal illusion remains very strong. This element of literalness is not quite reconciled with the grand artificiality of the Madonna's pose, or with the generous impulse of movement Titian instils into the composition, or the large clarity of balance among its forms. The *Madonna with St Ulfus and St Bridget* (Madrid, Prado, *c.* 1515) displays the same compulsion to make demonstration of illusionism with the draperies, but with an important change, which stems from the intention which had re-emerged in the *Balbi Madonna* and which is concerned with the inventive rather than the imitative means of art. Realizing that fine complexities of description cannot be reconciled with large effects of human presence and pictorial idea, Titian diminishes the former in the drapery style of the *Ulfus Madonna*, reducing the angular facetings that had given an accent of

archaism. His patterning of drapery becomes again, much as it had been at an earlier time, more cursive, and this impulse of cursive patterning pervades the composition. The grand dimension of the Madonna of the Balbi picture is given now to all the figures, and they are drawn together to make a dense pictorial substance, interwoven by large movements of continuous rhythm. The sense of breadth and unity of form are new in Titian's career in the degree in which he achieves them here. By the time of the *Sacra Conversazione* in Dresden (Gallery, *c.* 1515–16) it is evident that he is close to a new stage of maturity in the evolution of a classical style in his Venetian terms. Effects of sheer illusion are still more diminished to become, in a deepened chiaroscuro, more evidently the poetic effects of the painter's art; and these are in a context of pictorial order that is concentrated and monumental, scanned by large rhythms, and of fluent ease.

The so-called *Sacred and Profane Love* (Rome, Borghese, *c.* 1515)[56] is Titian's splendid exposition of a maturity entirely achieved [56]. What marks it off against the just preceding pictures is the evidence in it of entire clarity

56. Titian: Sacred and Profane Love, *c.* 1515.
Rome, Borghese

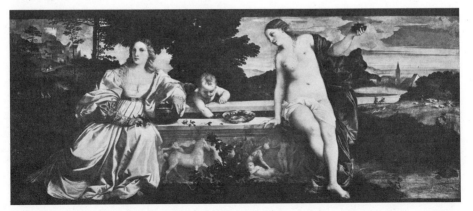

and consistency of purpose, and certainty in the selection of artistic means. After a decade of search in multiple and sometimes contradictory directions, Titian has settled for the basic proposition of classical style that had been expounded by Giorgione, but with precise self-knowledge of the differences of personality and vision – and, not least, of hand – with which he could interpret it. The *Sacred and Profane Love* is more visibly related than any prior term in Titian's art to his own restatement of Giorgione in the *Pastorale*, of which the ideas have been clarified and refined. A more overtly classical logic of composition is charged with more precisely articulated devices that enliven it. These are devices not only of structure but of descriptive mode, the result of Titian's development since the *Pastorale* of more sharply analytic vision and of discipline of his recording hand. The whole surface of the *Sacred and Profane Love* is an alternation of fine suavity and sparkle. No wholly convincing explanation of the picture's subject matter has been offered,[57] but surely its essential sense derives from the juxtaposition (more exactly the complementary relation) of the nude and clothed figures. Titian has exploited in the relation its classicizing value of mutually responsive part and counterpart, using not only the form and meaning of the figures to this end but all the elements of setting. The clothed and unclothed figures make two competing yet related radiances.

The picture is a remarkable accomplishment of inventive and of ordering powers, of high artifice in its manipulation of structural as well as visual material, and the effect of art is supported further by the poetic theme. Yet the picture skirts the edge of prose. The mark of Titian's pre-Giorgionesque disposition remains, as does that of the search for effects of illusionistic vision in the pictures of more recent years. He is willing to reorder sensuous experience, and he transforms his actors in a measure by cosmetic devices, but he will not remove them into Giorgione's distant region of idea, as he had in part done before. Titian's ideality is a genuine concession to Giorgione's example of a classical aesthetic, but only a limited concession to his ethic. By contrast with the still recent memory of Giorgione, this diminishes Titian's stature at this moment, for his newly matured classical vocabulary shows a disparity between its level of significance of form and the human significance that inhabits it.

The *Madonna of the Cherries* (Vienna, Kunsthistorisches Museum, 1515–16) is a formal manipulation of a less complicated kind than the *Sacred and Profane Love* but no less accomplished, and with its formal beauties it shows, still more than the Borghese painting, the touch of prose in what it illustrates, in the prettiness of types and their conventional emotion; it contrasts again with the temper of Titian's own earlier Giorgionism, in the *Gypsy Madonna*. The almost sleek perfection of the *Tribute Money* (Dresden, Gallery, *c.* 1516) with its psychologically precise but pallid tenor of emotion demands a similar contrast with Titian's Giorgionism in the S. Rocco *Portacroce*. In the moment of maturing of his classical vocabulary Titian reaffirms within it that his interest is in psychologically accessible and sensuously apprehensible reality. A limitation now, it is the source of a power in Titian by which he will imminently overtake the accomplishment of Giorgione.

A series of half-length female figures with various pretexts of subject come from the chronological vicinity of the *Sacred and Profane Love*, and they still more explicitly confirm the limits at this time of Titian's ideality. The different subject matters of the *Vanity* (Munich, Pinakothek, *c.* 1515), the *Flora* (Florence, Uffizi, *c.* 1515–16), and the so-called *Laura Dianti* (Paris, Louvre, *c.* 1515–16) overlay a common content: the female face and form that Titian has improved cosmetically to illustrate an obvious and accessible beauty. His

revisions do not cancel the strong sense of presence of the model, so that these images verge on portraiture, in format as well as in psychological effect.[58]

In his actual portraiture, the bond that holds Titian to reality serves him to clear advantage. His portraits done within Giorgione's lifetime, even while accommodating themselves to Giorgione's late formula, had already revealed Titian's closer adherence to the psychological and physical identity of his sitters. If the *Knight of Malta* (Florence, Uffizi, *c.* 1511) is in fact Titian's, as I believe, it is a maximum concession to the late Giorgione's mood, not unexpected in the neighbourhood of the *Pastorale*. But even here the sense of physical presence and of psychological acuity are distant from Giorgione. In the *Concert* (Florence, Pitti, *c.* 1512), the theme that unifies the three portrayed figures is related to Giorgione, but also to Titian's *Pastorale*,[59] but unlike either the circumstance is real and specifiable, and the persons more exactly so. The pointed, brisk descriptive mode resembles Titian's manner in the *Noli me Tangere*. As in his religious paintings, the element of Giorgionism in Titian's portraits rapidly diminishes. The *Portrait of an Older Man* (Copenhagen, Statens Museum, *c.* 1513) is still touched by a distant recollection of Giorgione's mood, but ambience is more precise than in the *Concert*, and description is as literal.[60] By the time of the *Youth* in the Frick Collection (New York, *c.* 1515) the Giorgionesque mood is the most pallid of polite concessions, and the portrait relies mostly on Titian's exact command, achieved towards 1515, of optical veracity. The *Young Man* formerly at Temple Newsam (now in the Irwin Collection, London, *c.* 1516–18) is the more positive expression of the growing individuality of Titian's portrait art. There is no residue of *Schwärmerei*, but clarity and restrained force of characterization, and the conviction of an am-

bience made less by precise description than by suggestive optical device. There is the incipient revelation here of the effect of magnitude that Titian will instil into his portraits of the next decade.

Despite their evidence of new mastery and maturity in the repertory of the classical style, the works that may be grouped around the *Sacred and Profane Love* have an excess of reticence, which might more accurately be called a want of something more in them than formal and technical inspiration. The emotional dimension behind Titian's genius required more to stimulate it than these restricted themes, in which his energy was dispersed into effects of sophistication or of virtuosity. This character in them was reinforced by the fact that these pictures, and most of the others of the years since 1511, had been conceived as household objects, made for a private audience, who were presumably the descent of that group of refined connoisseurs who had been the chief patronage of Giorgione. An opportunity of different extent and ambitiousness, addressed to a public audience, came to Titian some time in 1516, when he was given the commission for the giant apsidal altar of S. Maria dei Frari, depicting the Assumption of the Virgin [57]; this was the first challenge that was adequate to the whole range of artistic resource Titian had by now acquired. The picture was in all likelihood designed in 1516[61] but its time of execution is indefinite, and it was set up only in March 1518.

The *Assunta* grandly exploits the possibilities of its large scale, but that is only part of the expansion of creative force which occurs in all its dimensions, not just that of size. Its temper differs sharply from that in the pictures of the last half-decade, overleaping them to summon up again the passion and the force of statement that had been Titian's in his earliest years, before his partial subjugation to Giorgione. The subject is taken as occasion for high drama,

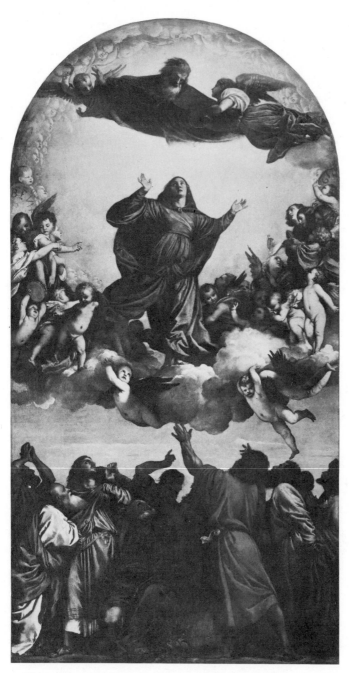

57. Titian: Assumption, set up in 1518. *Venice, S. Maria dei Frari*

conspicuously unlike the precedents for it in Venice.[62] The Virgin ascends with outflung gesture, draperies wind-blown, carried on clouds populated by a turmoil of young angels. Above, God the Father descends to meet her in a gliding turn; below, the Apostles comment on the miracle with urgent movement and gesticulation. Titian conceives the theme as an actual, physically present happening, enacted by intensely vital, emphatically real beings. Not only size but the internal scale of the figures is magnified to affirm their presence. The main forms are powerfully hewn by strong chiaroscuro light, and emphasized by bold red colour: Titian's repertory of optical devices is used here chiefly to assert the power and authenticity of substantial presences. The scene convinces by the sheer emphasis of re-creation in it of the look and energy of life, and the emphasis is doubled, not diminished, by the arbitrary scale. The architectural setting of the picture has been taken, furthermore, as a pretext for a situation that will read to the spectator as an illusion. Set high on the axis of the apse of the church, the altarpiece seems a window[63] through which we look towards the heavens to perceive the actual event of the Assumption. Devices of perspective and foreshortening are exactly adequately employed to convince us that what we see occurs in a space that extends from our own, and is connected with it.[64]

Titian's emphasis on actuality and illusion is a further demonstration of the link his art has to its origins in a Bellinesque education, but nothing could show more pressingly than the *Assunta* how the conception of reality has changed. This reality is no mere mime of physical existence but an arbitrary aggrandizement of it, and the world it reproduces is not still but passionately vital. Like Bellini, Titian in the *Assunta* makes an *Existenzbild*, but this existence is dynamic. As such, there is further affirmation in this picture of the character we found in Titian's first assertion of his individu-

ality, and which implies a tendency like that of a baroque style. But what is ultimately the Giorgionesque component in Titian's formation, his classicism, exactly disciplines the vastly energized reality that he depicts. The meaning of the reality – itself ideally magnified – is dominated by and subsumed within the meaning made by lucid, ideal, arbitrary order, and its energies have been patterned into a charged harmony. Like the great dramatic works of classical style in contemporary Rome, the *Assunta* suspends passion in an arrested life, but does not diminish it.

Raphael's *Transfiguration* [30], similar in theme and even in aspects of its structure, is a creation of almost the same years. The contrast between it and the *Assunta* implies the divergent histories in the next decades of the Venetian and Central Italian schools. More complex, rigorous, and abstracting in its intellectuality – not only in design but in the very mode of apprehension of experience – the *Transfiguration* points a way that leads beyond the sphere of classical style, towards the still greater intellectual abstraction and complexity of Mannerism. The *Assunta* points to the possibility of baroque; but it is Titian's option to realize it, and he does not. Instead, he finds the contact of his art with reality a resource for the development and continuous replenishment of the propositions of classical style; he affirms the necessary bond in classicism between artifice and nature. By his practice and example he gives a span of life to classical style in Venice that goes far beyond its durability in Central Italian art.

No closely subsequent commission of a religious painting offered Titian the opportunities or the demands of the *Assunta*. Three major altarpieces came from him in the neighbourhood of 1520, and while each is a demonstration of Titian's matured mastery, none is so inclusive as the *Assunta* of his whole range of artistic resource. Each one, indeed, appears to

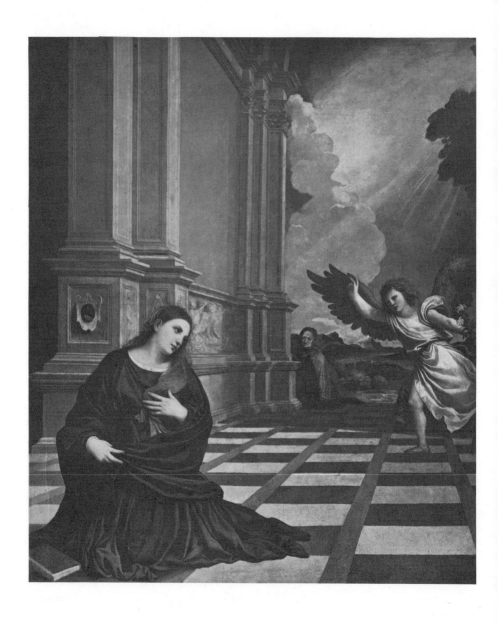

58. Titian: Annunciation, *c.* 1520. *Treviso, Duomo, Cappella Malchiòstro*

stress a different facet of the possibilities he had set out in the Frari altar, and to explore it more particularly than there. The *Annunciation* [58], the altar of the Malchiostro Chapel in the cathedral of Treviso, is probably contemporary with the fresco decoration there by Pordenone.[65] In the altar Titian probes in the direction of illusionism with extreme boldness. He turns the accustomed lateral arrangement of this theme into a penetration of perspective depth, and its normal balance into a compensated asymmetry.[66] *In situ*, the effect of a dynamic continuity from the viewer's space is absolute, but it is not baroque; the space we penetrate and what inhabits it give too explicit evidence of ideal order. The Gozzi Altar at Ancona (Museo Civico, dated 1520) searches in a different sense, making a major factor of what had been a secondary one in the *Assunta*. The Ancona painting is a mobile and equilibrated order, but this is not its main point. Unlike the *Assunta*, and unlike the Treviso altar also, it is made out of manipulations of effects of light, not of substances or measurings of space. The whole apprehension of experience and the means of painting it reassert the optical predisposition within Titian's art, somewhat obscured recently by his classicizing search for form. The reassertion is not merely retrospective: it is an exploring of a new degree of visual sensibility and, more important, of the ways in which the classical end of mobile harmony can be attained by manipulations less of form than of coloured light. This direction is explicitly opposed to that of Central Italian classicism, yet the Ancona altar offers a provable instance of Titian's response to the dissemination in prints of Central Italian examples, for he has based his Madonna in placing (and somewhat in pose) on Raphael's *Madonna di Foligno*.[67]

There is a more remarkable evidence in the Averoldo Altar (Brescia, Ss. Nazzaro e Celso, dated 1522 but begun in 1520) [59] of the intrusion of Central Italian influence into Titian's art, this time through another reproductive medium, that of casts. The resurrected Christ who is the central figure of the altarpiece is an adaptation of the *Laocoön*, and the St Sebastian at the altar's lower right is closely imitated from Michelangelo's *Struggling Slave* (now in the Louvre). This concern with the Roman statues is not one of motif only: it goes far deeper, finding in them provocation to compete with extreme examples (one a cause, the other a consequence) of the Roman plastic-anatomical style. In the *Assunta* there had already been a strong – indeed almost a dominating – component of formalism (in the same sense as the word may be applied to Central Italian classicism, of making a pictorial order mainly out of plastically affirmed human substance). Now the experience of two examples of isolated Roman statuary stirs Titian to a paraphrase of their effect in paint, and he equals their plasticity but gives it his Venetian surface, sensuously actual. Partly to intensify the plastic emphasis of the main figures, but also to reduce it, they appear in a light that is still (as the subject permits) that of the first dawn. The 'Roman' figures are thus embedded in a context that deliberately develops, even more than in the Ancona altar, the range and complexities of optical experience in depicting not only figure surfaces but also atmospheric space. This is a brilliant reconciliation of extremes. And it works; but it seems somewhat strained, giving an effect otherwise exceptional in Titian of intellectual manipulation. This first serious confrontation with the statuary essence of the classical style of Central Italy urgently poses a problem of antithesis between plasticity and opticality that is not quite soluble by Titian's present means, and it provokes a moment's crisis of which the aesthetic result resembles that of the Raphael *Transfiguration*. However, this is not a crisis between classicism and unclassicism, but between two varieties of classical style, one native and the other foreign to

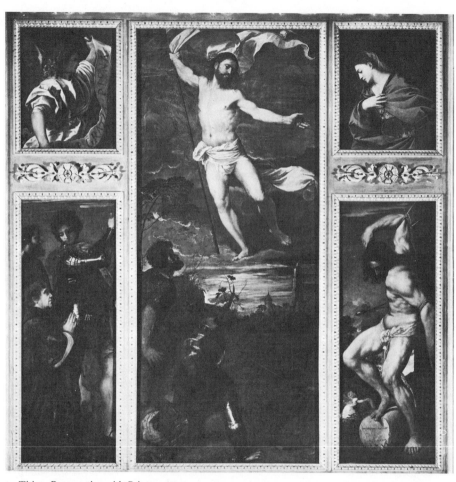

59. Titian: Resurrection with Saints
(Averoldo Altar), 1520-2. *Brescia, Ss. Nazzaro e Celso*

Titian's ambience. The problem, with its consequence of crisis, was to persist for a while, then diminish, only to recur with redoubled pertinence two decades later, and it was to be a *Leitmotiv* in the history of the sixteenth-century Venetian school.[68]

Titian's exposure to Central Italian example in the Gozzi and Averoldo altars was by the indirect means of reproductions; but there were two instances at least, not long preceding these, when his contact with examples of Central Italian classicism must have been immediate. In November 1519 he travelled (in the company of Dosso Dossi) from Ferrara, where he was temporarily in residence, to Mantua,[69] and almost certainly encountered the (right) half of Michelangelo's mutilated *Cascina* cartoon, which had emigrated to Mantua from

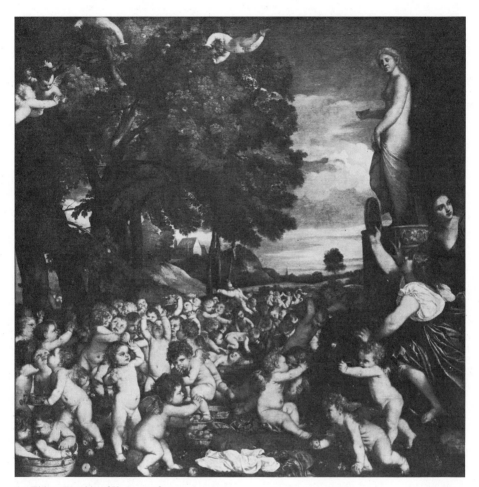

60. Titian: Worship of Venus, 1518–19.
Madrid, Prado

Florence probably a little earlier. It is not only the effect of the cast of the *Bound Slave* but the after-trauma of this experience that seems evident in the altarpiece for Brescia; and the cartoon also left its clear mark on the *Andrians*, which Titian was to paint a few years afterwards for Alfonso of Ferrara.

It was the delivery of the first of this set of pictures for Alfonso's *camerino*, the *Worship of*

Venus (Madrid, Prado) [60], that had brought Titian to Ferrara in 1519, and in that picture there is the indication of another contact with a Florentine example, quite unlike Michelangelo's. In 1517 Alfonso had asked Raphael, without success, for a picture for his *camerino* (he did elicit a design, for a *Triumph of Bacchus*), and he had ordered a painting from Fra Bartolommeo: a drawing by him for a *Worship of*

Venus – a singular theme for the Frate – survives in the Uffizi. There is no doubt that it came into Titian's hands when, after Fra Bartolommeo's death late in 1517, Titian was chosen to replace him in the commission.[70] The Frate's drawing is in his freest late vein, broad in form and deep in chiaroscuro, and full of energy of action. In almost all respects Bartolommeo's expression of his developed Florentine classical style accords with Titian's style of the moment – of course, Titian's sympathy with Bartolommeo's drawing is more than he would have demonstrated had the Frate's model been a painting. In his picture Titian adapts Bartolommeo's main motifs for the figures, and his temper of interpretation of the theme seems inspired by the Frate.[71] Beyond this, Titian diverges from the Florentine exemplar into pure Venetian. He insists upon a major place for landscape in his composition and an exploration in depth of the landscape space; and this insistence is not separable from the inspiration that has caused him to shift the Florentine design into diagonal asymmetry, turning Bartolommeo's structure into profile and displacing its main axis to the side.[72] The structural results resemble those in the near-contemporary *Annunciation* for Treviso, making a higher energy of form and intensified illusion. Here, however, where the physical context of the picture does not suggest illusionistic stress, and there are no rigid forms of architecture in the painted space to measure the progression into depth, the relation between space and picture surface is quite different. The shapes and colours of the landscape describe depth, but they are manipulated at the same time into a pattern that relates to the design on the picture surface, muting the recession, compensating the asymmetry of composition, and – almost most important – suggesting an effect of interwoven continuity of visual texture. Part of the intention of the asymmetric structure is to avoid the look of artifice, and

convey the sense of a more casual and thus more actual existence. This intention is realized, but on the basis of the most sophisticated contrivances to make classical unity in equilibrium that Titian had so far achieved.

Like the *Sacred and Profane Love* a few years earlier, the *Worship of Venus* celebrates a beautified sensuous existence, but the fluency and fullness with which Titian makes his statement here exalt its meaning towards a higher ideality. The sense of beauty of existence has become lyric, but vibrant and immediate in its poetry, not distant, as the lyricism of Giorgione had been. This immediacy is an index not only of Titian's response but of that of Venetian art in general to the literary matter of antiquity. It was no impediment to the translation of antique myths into the warmest actuality that the programme for Titian's contribution to Alfonso's *camerino*[73] was as archaeological as any that might be devised in contemporary Rome. *The Worship of Venus* was intended to re-create a picture described in detail by Philostratus the Elder in his *Imagines* as existing in a house near Naples, and the second work supplied by Titian for the *camerino*, the *Bacchus and Ariadne* (London, National Gallery, 1520-3) [61],[74] follows, quite literally, a text in Catullus (*Carm.* LXIV). The last of Titian's set, the *People of Andros* (Madrid, Prado, *c.* 1523-5) [62], was based on another description in the *Imagines* which Titian illustrated (as in the *Worship* also) with exceptional fidelity. There is not only a literary but a visual antiquarianism that Titian exercises in these paintings, making more quotations from antique statuary than he ever had occasion to before,[75] and there is a reinforced attention to what he had been able to learn of the classicism of the Central Italian school. The *Bacchus and Ariadne*, like the Averoldo Altar just before it, gives prominent place to types based on the *Laöcoon*, as well as Michelangelo's *Bound Slave*; beyond this, the variety of action in the figures

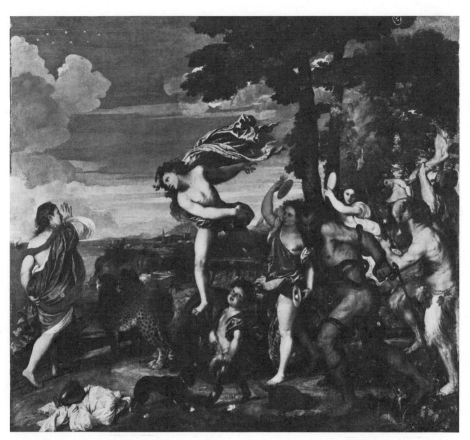

61. Titian: Bacchus and Ariadne, 1520-3.
London, National Gallery

and their carefully related postures seem a likely consequence of Titian's experience in Mantua of the fragment there of Michelangelo's *Cascina* cartoon. In the *Andrians*, Titian's response to the cartoon is still more sure: one figure motif in it is specific in its derivation and others seem more generally to have been Cascina-inspired. More than in the *Bacchus*, the very mode of complex figure composition in the *Andrians* results from Titian's comprehension of the Michelangelo example.

Though the commission for the Averoldo Altar and the *Bacchus* were both received in 1520, and the painting of the *Bacchus* was at least tentatively begun late in that year, the main work on it followed the completion of the altarpiece for Brescia. The relationships of motif between the two works, in particular of the *Laöcoon* and the *Bound Slave*, are less significant in themselves than as an index of the continuity into the *Bacchus* of the basic stylistic concern these works of statuary had inspired in the Averoldo Altar: the reconciliation of opticality with plastic form. In the *Bacchus* each of

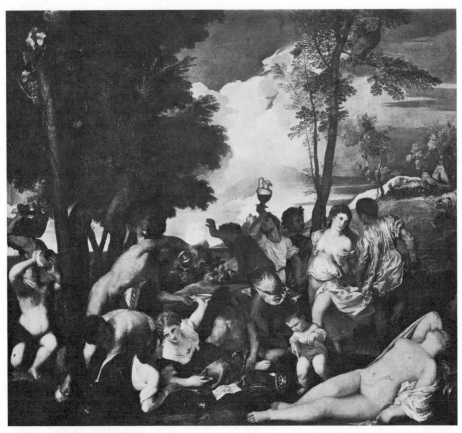

62. Titian: The People of Andros, *c.* 1523-5.
Madrid, Prado

these aspects is less separately assertive than they had been in the Averoldo picture: their reconciliation is in an easier and more fluent synthesis, masterful in its meshing and adjustment between visual and formal matter. The character of the whole figure composition is consequent upon this quality in its parts; it is structured and deliberate in its articulation in a degree that has no precedent in Venetian art. Even in the order that extends beyond the figures into the landscape setting there is evidence of a formalist concern: the whole design recalls the legible geometries to which we are accustomed in Central Italian classical art.[76] But Titian still does, in this structural scheme, what the classical Roman or Florentine would rarely do: he makes a major motive of the balance of the coloured light of space against near substances.[77] Substance and its energies articulate a harmony just as they do in the classical style of Central Italy, but differently; light and colour work pervasively and integrally within the scheme of design, and its ultimately perfect equilibrium - in which the Bacchus is

literally suspended as he leaps – results as much from them.

Titian's references to the antique and his interest in Michelangelo are not indices of his submission to a presumable higher authority; on the contrary, they are exploitations of these sources for their usefulness in adding new dimensions to his own classical style. The classical citations are translated in the *Bacchus* into the utmost sensuous immediacy, and in the *Andrians* the sleeping nymph (the so-called Ariadne) and the putto near her are still more conspicuous examples. In the *Andrians* the figure scheme is more obviously Michelangelo-inspired than that of the *Bacchus*, surely extrapolated from the complex orderings of the *Cascina* cartoon, but this too has been recast into Titian's idiom, far more relaxed and flexible, and quite without the *Cascina*'s effect of a self-conscious formalism. Instead, Titian gives his figure composition an easy mobility, much more true to life. At the same time he makes a pattern of relation among his figures that is at once more explicit and more subtle than in Michelangelo's example, and he makes a more sophisticated calculation of the equilibrium of the whole design. Titian learns a mode of order from the classical example of the early Michelangelo, but he articulates it with the resources of a later and more developed classical style. Still more than in the *Bacchus*, the order of the figures in the *Andrians* is a translation into contemporary Venetian of Central Italian precedent, and as there (and as had been the case as well with the very specific example of Fra Bartolommeo's design for the *Worship*) the figure order is embedded in a context of Venetian landscape, which plays a part in the whole form and content of the picture equal to that of the figures, and is inextricably intermingled with them. Optical sensations of coloured light and air, more mobile and complex than in the *Bacchus*, emerge from the landscape, infiltrating and suffusing the figures and encompassing

their substance in the flux of illumined atmosphere. The formal structure of design is merged, more subtly than in the *Bacchus*, with a continuum of optical texture, and the mobile equilibrium that Titian makes of shapes and substances is suspended in another, that of the shimmering light. This is a new plateau in the development of what had begun for Venetian painting a decade and a half before, in Giorgione's *Tempesta*.

It is not only what Titian illustrates of forms, appearances, and actions that evokes so much of warmth and actuality in his re-evocation, in the *Andrians*, of a vanished world. The vibrance that is in our seeing lends its quality to the actors, and we know their presences and read their meaning through the coloration of an enjewelled light. Our experience of their existence and their meaning is poetic, but the principal devices that communicate it – besides, obviously, those of explicit illustration – remain sensuous. This antiquity that we apprehend sensuously and intuitively is a re-creation distinct from that of the Roman classicists: it is – not only for this iconographically appropriate case but more generally in Titian and in Venice – Dionysian rather than Apollonian.

The pictures for the Este *camerino* realize the potential that Titian gave evidence of in the *Assunta*, of the extension of a classical style of painting into a new reach of development. In these pictures (and in the religious works contemporary with them) Titian had his first serious encounter with major problems that the Central Italian variety of classicism posed, and that are at variance with his native terms, but this experience made no enduring crisis. He subjugated it to his own ends and absorbed it into a remarkable development of his peculiarly Venetian sensuous apparatus of picture-making: there is less dialectic than exploitation in his contact with Central Italian ideas. In the same years that these pictures find avenues of classical expression unlike those the Central

Italians had evolved, and give Venetian classicism means that would extend its life, the classical style of Central Italy passed through a crisis it did not survive. No precise contemporary circumstance of history, political or economic, or any explicit cultural events can be convincingly argued as accounting for this difference in Venetian art. A major cause may lie, however, in a factor that is more general and less time-bound – the historical process of accumulation of experience that creates the temper of existence in a place. Another cause seems to reside, oppositely, in the specific problems that the evolution of a style of art confronts, but in the temper this historical accumulation makes. No more poignant contrast of attitudes towards experience and its translation into art can be found than that between Titian's pictures from the *camerino* and Pontormo's contemporary *Vertumnus and Pomona* [72], or Giulio Romano's commentaries on the classic world.

Palma Vecchio: His Earlier Career

No artist of the early sixteenth century in Venice other than the trio we have so far discussed – and the old Bellini – can pretend to genius, but among the others Palma's talent is the most conspicuous. His personality has some marked individuality, and he was not only responsive to invention but capable of it. It may be his most conspicuous distinction that in sheer painterly capacity, manipulating brush and colour, he not infrequently approaches Titian. Palma was not Venetian by origin, but the chief member of a colony of Bergamasque craftsmen who came to Venice to learn and practise there, and whose commissions came in part from their native province – their situation was precisely the reverse of Lotto's in the second and third decades. The presence of this group in Venice (of whom the second most conspicuous member was Andrea Previtali) was a testimony of the cultural as well as the political dependence of Bergamo on Venice, which had been confirmed by actual annexation long ago, in 1430.

Palma was born Jacopo Nigreti in Serina near Bergamo about 1480. His first documented notice in Venice is only in 1510, but he was doubtless resident there earlier. We have no knowledge of his initial training, which he may as well have received in Venice as in Bergamo. In any case, his earliest traceable production derives wholly from a Venetian style, that of Carpaccio: Palma's signed *Madonna* (Berlin-Dahlem, *c.* 1506?)[78] depends on a precedent of Carpaccio's in manner and in motif. This wholly quattrocentesque style seems not to have persisted long. By *c.* 1508-10, as in his *Madonna with St Anthony, St Jerome, and a Donatrix* (Rome, Borghese), Palma's interests are decidedly more 'modern'. The later Bellini has become Palma's primary exemplar, but there is also evidence of a response to Giorgione's mode in figures and in landscape and a reflection of the early Titian's mobile handling of colour. Palma's accommodation to the new style accelerated rapidly thereafter, and by *c.* 1512 he was effectively a convert to it.[79] His model was, however, less Giorgione than Titian's most recent reinterpretation of Giorgione's repertory.

A group of smaller works of *c.* 1512-14 that are mythological or secular in theme,[80] and derive in imagery and mood from Titian's Giorgionesque examples, attained a wholly adequate effect of contemporaneity. Palma's eye and hand are working in these towards a range of colour and a brilliance of illumination that suggest Titian's and essentially depend on him, though Palma does not yet aspire to a comparable liberty. This he achieved only by degrees, and in consequence of continued consultation of Titian's example. But by 1514-15 Palma had created his own equivalent for Titian's brilliant luministic mode, and freed

himself almost entirely from the residues of Bellinesque descriptive vocabulary. Basing himself mainly on precedents supplied by Titian in the years 1512-14, but still referring often to Bellini's compositional prototypes, Palma developed what would become an almost specialized genre for him: *Sacre Conversazioni* of horizontal format, in which the figures are disposed before an extensive landscape.[81] Like Titian's art of the middle years of this decade, the interest of Palma's *Sacre Conversazioni* of this time is mainly sensuous. His figures are the products of his own variant on the proposition of a cosmetic beauty that Titian conceived in these years, and Palma's variant is still more overtly physical in its appeal. The expressiveness of his actors is more limited – more conventional and literally illustrational – than Titian's. He exploits colour now no less

boldly than Titian does, but with less subtlety. His high-keyed contrasts are occasionally divisive and his surfaces sometimes harshly bright, so that despite its modern vocabulary his painting style may recollect the effects of the Quattrocento, provincial and Bergamasque rather than Venetian.

The more developed of the *Sacre Conversazioni* (such as the *Holy Family with the Magdalen and the Infant Baptist*, Florence, Uffizi, *c.* 1516-17)[82] make agreeable variations on a compositional formula, derived at the beginning from Titian, in which an easy balance is created among asymmetrically and diagonally disposed forms. The larger the composition, the more concession Palma makes towards symmetry, but he does not compromise the effect in his designs of fluidity and ease. In this respect, his large *Conversazione* in Vienna

63. Palma Vecchio: Sacra Conversazione, *c.* 1517.
Vienna, Kunsthistorisches Museum

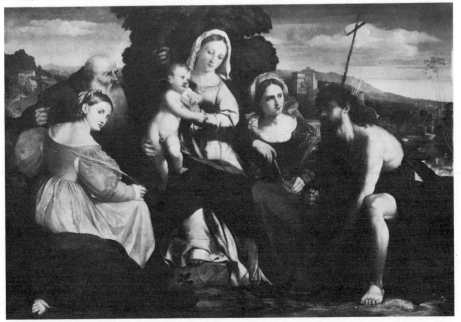

(Kunsthistorisches Museum, *c.* 1517) [63] is a landmark in the evolution of the genre, for traditional and current conceptions of pictorial order are combined in it with a high skill. Beyond this, the sense of integration Palma achieves in this composition between the holy figures and their landscape setting is immediate, as it had not been in any Titian *Sacra Conversazione* so far. Palma develops for his religious subjects, more than Titian does, the Giorgionesque principle that landscape setting be a major and intrinsic part of the tonality of content.

Palma's pictures after about 1518 are wholly Venetian in their technique, but about 1518-20 an extraneous element intrudes into his style, initially only modifying the Titianesque basis of Palma's art, but then penetrating it deeply: it consists of a concern with the purity of shapes, an insistence on effects of plastic clarity, and an intensification of physical and psychological responsiveness - in a word, with characteristics that pertain to the Central Italian repertory of classical style. The evidence of this appears in the *Madonna with St Roch and St Mary Magdalene* (Munich, Pinakothek) and in the *Holy Family with St Catherine* (Dresden); and in the latter at least the source of contamination is identifiable, in prints after Raphael distributed from Marcantonio's *bottega*. A narrative picture that should approximate 1520 in its date, the *Flagellation of Christ* (Rovigo, Pinacoteca), makes still more thorough concession to the style of Central Italy than the *Sacre Conversazioni*: its symmetrical composition of clear plastic forms is based - by what precise means of transmission we cannot say - on Michelangelo's designs for the painting of the *Flagellation* by the ex-Venetian Sebastiano. Like Titian at the same time, Palma is involved with the evidence by then at hand of the foreign ideas of Central Italian art. With more tendency to imitation than Titian, but less power of assimilation, Palma's responses

result in a considerable concession and compromise: they are not, like Titian's, a synthetic resolution of the confrontation between the doctrine of plastic form and that of colour.

There is yet a further expression of Palma's concern - now more overt and more extreme than Titian's - with the problems posed by an aesthetic that has its origin in Central Italy. About 1520, perhaps in 1521, Palma's *Sacra Conversazione* (Lugano, Thyssen Collection) attempts to define form not only plastically but with aggressive power, and to display this form in dramatically impelled movement, creating a formal as well as psychological pathos exceptional for the theme. No direct Central Italian model accounts for this dense and movemented -and still highly coloured - plastic style, but a style formed in part on Central Italy, that of Pordenone (as in his frescoes of 1520 in Treviso), seems to have suggested a parallel route for Palma to explore.[83]

Palma's emergence to high merit as a portraitist - a genre in which he stood for a brief while second only to Titian - would seem not to have preceded the last years of the decade by much, and his portraits of that time evince the effects of his efforts to attain a plastic style. As with Palma's religious paintings, the formulae on which his portrait style is based derive initially from Titian, and so does the approach to the record of appearance and state of mind of the sitter. In the concentrated format of the portraits the individual traits of Palma's style may be yet more apparent than in the religious paintings - as in the *glissando* of smooth shapes and surfaces, and the hard, sometimes abstract-seeming, brilliances of colour.

Palma came to specialize in a genre Titian had explored earlier, which lies on the verge of portraiture as it is usually conceived. This is the representation of the half-length female of conspicuous handsomeness, whom Titian had endowed (as in his *Flora* or his *Vanitas*) with some allegorical attribute, but whose chief

meaning was her sensuous beauty. Confirming this, Palma minimizes the allegory, and concentrates frankly on the fact of sensuous appeal. The subjects seem models rather than paying patronesses, but it is also possible that these pictures represent certain of the great courtesans of contemporary Venice.[84] The two finest of them, from the same model, probably painted *c.* 1518, in Vienna (Kunsthistorisches Museum) and in the Thyssen Collection (Lugano; the

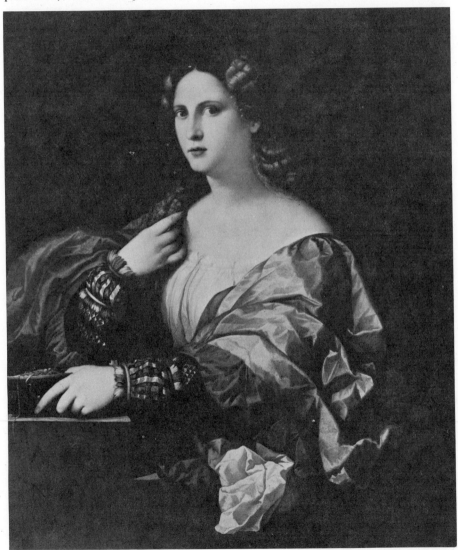

64. Palma Vecchio: La Bella, *c.* 1518. *Lugano, Thyssen Collection*

latter the so-called 'La Bella' [64])[85] convey a luminous, enamelled sensuality, and their psychological communication of an invitation could not be more explicit. There had come to be a market in Venice for an art of which the burden was an overt sensuality; Palma's belles descend – literally – from Titian's invention of a type of female beauty and they are the consequence, but also the converse, of Giorgione's earlier conception of a poetry of womanhood.

'Giorgionismo' and its Variations in the Second Decade

Our account of Palma's early career indicates how, in his case, Titian quickly displaced Giorgione as a model. What happened so rapidly for Palma took more time for painters of less progressive disposition. In the later years of Giorgione's lifetime, and afterwards through the second decade, there was a current of painting in Venice and in its cultural dependencies that was formed out of Giorgione's example; it continued through the 1520s. But the painters we describe as Giorgionisti seem often to have seen Giorgione's models in the light of Titian's translation of his style. However, much or most of the profound new formal and optical sense not only of Titian's painting but even of Giorgione's escaped the efforts of these imitators. What drew them to Giorgione was mainly his kind of thematic matter and the tenor of his interpretation of it. The select group of noble humanists who patronized him and helped to create his mental climate had set a fashion for his themes and for his tenor. In the sphere of patronage they had imitators who made up a clientele for the imitators of their painter.

Like most conceptions of art that are concerned primarily with a literary burden, or which are no longer part of the main developmental stream, Giorgionismo in the time that followed Giorgione's death was an affair for masters of secondary or even lesser rank, and still more a matter for provincials. Even in these masters, their Giorgionism did not necessarily pervade their whole art at any given time: its appearance in their production seems more often to be occasional, determined by considerations of subject matter. There are such episodes of Giorgionismo in the early Palma, as we have seen, and in Cariani and Previtali among the Veneto-Bergamasques; in the Veneto-Brescian Savoldo; in the Veronese Torbido and in Girolamo da Treviso; the Paduan Giulio Campagnola was a translator of Giorgione's themes mainly into graphic art. There were many more practitioners of the mode, who include the unidentifiable authors of a host of painted idylls and romanticizing portraits, almost none of them without an element of charm. But what is in Titian or in the Ferrarese Dosso after their first profound immersion in Giorgione's art is not imitative or derivative, and should not fall under the rubric of Giorgionismo.

One singularly well-travelled provincial, Lorenzo Luzzo (Morto) da Feltre,[86] gives interesting and not untypical evidence of the consequences of exposure to Giorgione's art – an exposure that in Morto's case seems to have included personal association with the master: Vasari informs us that he worked on the Fondaco dei Tedeschi, painting the ornamental matter to accompany Giorgione's frescoes. He had earlier achieved a reputation as a specialist in decoration in the grotesque style, having learned this genre in Rome (as an assistant of Pinturicchio) in the last years of the fifteenth century, and had practised it in Florence. In 1511, at Feltre, Morto signed and dated an altar of the *Madonna with St Stephen and St Liberale* (now Berlin-Dahlem). Its style is more advanced than anything on the contemporary Venetian scene except for Titian and Sebastiano. Apparently, Morto's experience of art in Florence in the formative years there of the classical style helped him to assimilate the

means and the intentions of Giorgione's classicism, for this painting reflects the density of form and something of the tenor of emotion of Giorgione's later art. Its colour does not have the depth or the intensity of Giorgione's, but it exploits the freedom of choice that Giorgione introduced and Titian elaborated on; the example of that other collaborator in the Fondaco is surely operative here. An altarpiece which is likely to be of somewhat later date, the *Madonna with St Vitus and St Modestus* (from Caupo near Feltre; now Feltre, Museum) has a power of chiaroscuro that reflects Giorgione's. However, its structure is more sparse and rigid than that of the altarpiece of 1511, and a dated fresco of 1522, *Christ Appearing to St Anthony Abbot and St Lucy* (Feltre, Ognissanti), is altogether conventional in its design. As the example of Giorgione recedes in time, and Morto's provincial isolation grows, his art seems to regress from the adventurous position to which, a decade earlier, Giorgione had stimulated him.

Our conception of Morto requires to be based on the large works that are safely attributable to him, but even in these his style is so suggestive of rapport with Giorgione that it seems necessary that he should have worked, in pictures of lesser scale and different theme, in a vein of more literal *Giorgionismo*. This assumption is supported by the attribution to him of a *Portrait of a Young Man* in shepherd's guise (Padua, Museum);[87] and we can at this stage of our research only speculate what others among the anonymous or unattributed Giorgionesque pictures may be his.

Our evidence for Morto's Giorgionism is incomplete, but by no means so frustrating as the evidence we have to assess the work of Domenico Mancini.[88] As with Morto, the problem lies in the connexion between paintings of religious themes and works that are in the vein of subject we consider more characteristic for *Giorgionismo*. Mancini's only signed religious picture is a *Madonna Enthroned* with an angel

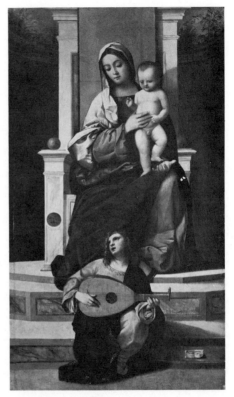

65. Domenico Mancini: *Madonna Enthroned*, 1511. *Lendinara, Duomo*

lutanist, the surviving panel of what was originally a triptych (Lendinara near Rovigo, Duomo), dated 1511 [65]. Its composition is conventional and its motifs are borrowed (from the S. Zaccaria altar of Bellini, from Palma, and from Dürer), but there are symptoms in its form and stronger evidence in its colour of the mark of the latest manner of the young Titian,[89] and there is a tendency to communicate emotion in a way that resembles both Titian and Giorgione towards 1508-10. The same admixture of responses is in a *Madonna with St John the Baptist and St Peter* (Florence, Count Gamba). However, in a painting of half a

decade or so later in Mancini's career, a *Sacra Conversazione* with a donor (Paris, Louvre),[90] there is almost no residue of Bellini's style. The laying on of colour is as bold as the contemporary Titian's, and yet more *pastoso*. Intensely sensuous yet languorous, the Louvre picture is at once highly individual and thoroughly eclectic, just as Mancini's preceding works had been – a personal exploitation of the recent innovations made by others in contemporary Venetian art. A portrait signed 'Domenicus' and dated 1512 (London, Duke of Grafton; versions in Leningrad and elsewhere) is usually, and probably correctly, thought to be Mancini's.[91] In design, setting, and quality of expression, and in some of its effects of handling, it seems a convergence of the latest ideas of Giorgione, Sebastiano, and the young Titian. Among other pictures of secular and more obviously Giorgionesque themes there are two more signed works, and on the basis of these Berenson[92] has attributed others of the kind to Mancini, which however still do not make, in the Morellian sense, an entirely consistent group.[93] Yet the personality they reveal is related to that of the author of the Louvre picture – both assertive and derivative, and tending still more towards a vulgarizing into illustrative sensuousness of Giorgione's mode.

We have suggested that *Giorgionismo* may often be a thematic matter more than one of a formal style. If this definition is accepted, Domenico Capriolo (1494-1528)[94] may be considered to have been, at least in his earlier career, an adherent of *Giorgionismo*. But Capriolo moved from Venice, settling in Treviso before 1518 to practise his art there. His case came rather to resemble that of Morto da Feltre; as Capriolo's signed *Adoration of the Shepherds* (Treviso, Museo Civico, 1518) demonstrates, provincial residence quickly diminished his tendency towards novelty. His *Giorgionismo* became little more than a recollection of its external signs.

Persistence and Accommodation of the Quattrocentesque Tradition

The advent of a new style in early-sixteenth-century Venice did not transform the entire artistic practice of the city. In Venice and its dependencies, even more than in Florence, there was a conservative patronage as well as an enlightened one, and it made a sufficient market for the production of painters who stood untouched, or almost so, by the rapid pace of innovation. For this market Carpaccio painted until his death in 1526, virtually impervious to new doctrine, and Cima, not much less rigid in his quattrocentism, fulfilled important Venetian commissions until the late years of the second decade. Giovanni Bellini's always remarkable flexibility carried him in the direction of the new manner, but his large production continued to represent, in its essentials, the Quattrocento's view of art. His artistic magnitude on the early-sixteenth-century Venetian scene adjusts backward, in the direction of tradition, our conception of the whole historical situation in these years. These painters we have named were only the major representatives of a persistent taste: it must not be forgotten that their production was multiplied a hundredfold by that of pupils and lesser imitative masters, and by the output of an extensive Venetian *artigianato* of picture-making, more allied to industry than to fine art.[95]

We have discussed Bellini's S. Zaccaria altar of 1505 earlier [66], indicating some of the significant differences that distinguish it from Giorgione's contemporary Castelfranco altarpiece, and also some of the ambitions the two pictures share. In the years that remained of his career, until his death in 1516, Bellini did not radically change the fundamental proposition he arrived at in the Zaccaria altar. He never

66. Giovanni Bellini: Madonna with Saints, 1505. *Venice, S. Zaccaria*

quite achieved the profound transition from analytic to synthetic apprehension of pictorial form which most basically marks the new mentality of art. His structures remain additive; for all the clarity and serenity they increasingly attained, they stay bound to the logic of a perspective style, and not only the large design but its lesser forms are built from the accumulation of perceptions of their parts. Bellini never quite accepted the virtue of the cursive shape to bind and unify. His latest pictures soften contours and give them easier mobility, but Bellini's essential mode of shaping form continued to depend upon his habit of apprehending it, distinct static piece by piece. The gestalt of form was at root unalterable. The aesthetically abstracting unity that Giorgione invents and imposes on the work of art was inaccessible to Bellini, and much less the young Titian's seizing on the unity between energy and form.

Yet, while Bellini's apprehension of form remained traditionally bound, he moved in his last decade towards a development of vision and a region of emotional expression that exceed his past. What he achieves in these respects does not coincide with the inventions of the modern style, but is related to them in intention and in kind. Contemporary with the great *pala* for S. Zaccaria, his small altar with a *Madonna with Two Saints and a Donor* (Cornbury Park, Watney Collection, signed and dated 1505) demonstrates a way of responding to the experience of light that verges on essential difference from that in the larger painting. There, a fine manipulation makes light serve to reveal itself and substance equally, and to make an atmosphere which is both a fact of nature and a mood. In the smaller altar the equivalence among objectives is upset: it is the sense of light in its self-revelation that is dominant – a golden suffusion on the figures, contrasting with a cool luminousness of sky. What is described is physical existence no less trenchant than in the Zaccaria

altar, but its meaning recedes behind that of Bellini's magnifying, into poetic reach, of the sense of beauty of the light. This is akin to Titian's earliest intensifying of illuminated colour in the *Allendale Nativity*, but it exceeds Titian's first essays. It is not, however, what Giorgione had already done, for a reason that lies in Bellini's habit of analytic apprehension. Even with its poetic value, the light remains a separable element of the picture's total sense. It works on and around what it reveals, unfused with it. Bellini's visual experience does not, here, create what we have described in Giorgione as the texture of an optical unity.

It is possible to assume that Bellini was stimulated to such an exercise of poetic vision as is in the Watney altarpiece by his encounters with what Giorgione had already done, but what is in that picture is a logical extension of Bellini's own past history of experiment and new discovery. By half a decade later, however, his study of the new mode and his willingness to learn from it were quite apparent. In the *Madonna* of 1510 (Milan, Brera) no draughtsmanly device assists in making form. Contours are sfumato, melding with a palpable surrounding atmosphere, and substances – both of figure and of landscape – exist in textured interaction with the glowing light. The mode of vision and description approximate Giorgione's and the young Titian's in essential kind, but still the ineradicable habit of the Quattrocento mind, even one so flexible, does not permit the act of unitary fusion. Not imitativeness, but the will that had always been his to explore the possibilities of new ways of art makes the old Bellini continue to adapt the demonstrations of Titian especially, and convert them to his own ends. He moved still closer to the mode of structure, as well as the visual mode, of the new style in his *St Jerome* altar of 1513 (Venice, S. Giovanni Crisostomo). His last major work, however, the great *Feast of the Gods* (Washington, National Gallery, signed and dated 1514) [67], remains

67. Giovanni Bellini: Feast of the Gods, 1514. *Washington, National Gallery*

the index of the limit of Bellini's power to change and to renew himself. Its time-bound beauty is more poignant from the contrasts made within the picture by Titian's alterations and completion of it.

In the *Feast of the Gods*, and in more concentrated form in the very late *Drunkenness of Noah* (Besançon, Museum) [68], the other factor of Bellini's unceasing development emerges, of subtlety and poignance of emotion. In these pictures[96] the emotion is not like that in the late altars and Madonna themes, where the state of mind Bellini represents remains the harmony of the late-fifteenth-century détente: like Perugino's, and therefore (if our idea of Giorgione's origins is right) not far from the earlier Giorgione's. The *Feast* explores a wide range of physiognomic expression, unassertive yet profoundly compelling, and precise in its descriptive indices as no other Venetian picture

to this time. The *Drunkenness of Noah* makes a yet more extraordinary communication, probing differences of psychology with an old man's subtle knowingness and a truth of record that seems absolute. This mode of feeling, and of knowing and describing it, are contrary to the rhetoric of the modern style; this is, instead, the ultimate expression of the fifteenth-century power of observing and specifying psychological reality. Yet the result is, more poignantly than it had ever been before in Bellini's painting, poetic commentary on real experience. The great survivor of the Quattrocento's tradition affirms at the end of his life that the essential burden of his art is not less but only differently poetic than that of the new moderns. There is something more than just thematically Dionysiac in the *Drunkenness of Noah*. Its tenor and profundity of emotion strangely anticipate what Titian would do half a century later in

68. Giovanni Bellini: Drunkenness of Noah.
Besançon, Museum

his own great age, in his *Flaying of Marsyas* [228].

Bellini's personal production constituted only a part of the output that passed in Venice and its dependencies under his name. Skilled hands employed in his shop continued to reproduce Bellini's models for a seemingly undiminished market, and to give him assistance in his larger works. In the last years of Bellini's shop three assistants remained to perform these functions: Girolamo da Santacroce (inherited by Giovanni from his brother's shop), Vittore Belliniano (apparently the master's favourite), and Rocco Marconi. Of these only Marconi (notices 1504 to 1529)[97] exhibited a significant measure of individuality, and in addition to his reproduction of Bellini's models he seems to have been allowed some independent practice. After the dissolution of Bellini's shop in 1516 Marconi moved into the shop of Palma. He quickly assimilated Palma's style and in time became an adequate imitator of the advanced Venetian mode of the twenties.

Among those who had been Bellini's pupils earlier, Andrea Previtali (*c.* 1470?-1528), of Bergamasque origin, seems to have practised in Venice for a short time only. It is not certain when he returned permanently to Bergamo; our first clear external indication is not until 1512.[98] Half a decade earlier than this his Bellinism had begun to yield to Lombard influences: witness the change from his *Madonna*, signed and dated 1502, in Padua (Museo Civico), and the altar with the *Madonna, St Sebastian and St Bernardino*, dated 1506, in Bergamo (Galleria Carrara). Previtali was subsequently reconverted to Venice, but indirectly and through an eccentric agency whereby he became – as far as his temperament and limited talents permitted – a follower of Lorenzo Lotto after he took residence in Bergamo.

Marco Basaiti (*c.* 1470-after 1530) had been Alvise Vivarini's pupil, but that tradition was too rigid even for an artist of conservative temper to pursue very far into the new century. Basaiti turned towards the model of Bellini, though at first still with the strong accent of Alvise's style, and thence to the manner of Carpaccio. It was only tardily, after 1520, that he achieved a thin, limping, partial comprehension of the more modern mode, in which his chief exemplar seems to have been Catena, and to a lesser degree Palma.

Benedetto Diana (Rusconi; *c.* 1460-1525) was still more firmly embedded in the Quattrocento than Basaiti: his first notice dates from 1482, and his earliest surviving painting, a *Sacra Conversazione* (Venice, Ca d'Oro), from 1486. He may have been a pupil of Lazzaro Bastiani, whose own style depends mostly from Gentile Bellini's; Diana was thus a follower of the Bellini tradition, but of its more cautious branch. Despite his age and background, Diana's attempts to change his style inventively were vigorous, and they are of remarkable effect. Eccentric in his sense of form from the beginning, and singular in his tendencies of colour, he suggests affinity with the late Quattrocento Milanese rather than with his native school. No dates specify the order of his production after 1500, and our information does not permit an attempt at a chronology. We can only speculate that the Bellinism of a major altarpiece, a *Sacra Conversazione* (Venice, Accademia), indicates a date not much later than 1515, but it is a Bellinism interpreted in the temper of late gothic mannerism (curiously suggesting Bramantino). A huge *Assunta* (Crema, S. Maria della Croce, signed) has a startlingly eccentric character, and evokes another awkward terminology: late gothic baroque. There is an opposite strain in Diana's art, however, rather later; and it is more conventional. Its best symptom is the *Madonna with St Anne and St Louis of Toulouse* (Venice, Accademia), a design of grave, broad forms, architecturally disciplined, described in a silvery blue colour of great luminosity. The pic-

ture has the accent of its author's generation, but its substance is that of a Cinquecento style.

Perhaps the most apt accommodation between tradition and modernity in early-sixteenth-century Venice was Vincenzo Catena's. Born probably towards 1480, he had been a pupil in Bellini's shop, and his identifiable early works are, as late as *c.* 1510, stiff but accomplished derivations of his master's style. However, as early as 1506 Catena is recorded as a 'colleague' of Giorgione – more exactly it is Giorgione who is described as Catena's colleague;[99] and some form of association must in fact have existed between them. Catena, a man of considerable wealth, was no mere craftsman. It seems that he, like Giorgione, was privileged to frequent the same humanist society that provided Giorgione's patronage. It is documented that he was acquainted with Bembo and with Marcantonio Michiel. What the exact nature of his connexion with Giorgione was is not clear, for Catena's art shows

no significant response to his colleague's innovations until years afterwards. Through the earlier teens Catena only slowly modified the precedents of Bellinesque design and handling on which his first works had been based, softening shapes somewhat and finding a more flexible light. He assimilated some of the mood of Giorgionism, though not much else in it. It seems to be not much before the end of the decade that his style acquired the aspect of a tardy transition between the older way and the new. Catena's sole dated work, *St Christine adoring the Resurrected Christ* (Venice, S. Maria Mater Domini, 1520), indicates his position at this time. His old associate's model determines the mood of this picture, but Palma's influence is also visible, and there is evidence of reference to Titian. In works of lesser scale, the personal interpretation that Catena put on this compound of influences is more accessible. Mostly, what he produces is an archaized revision of Giorgione, as if reintegrating him into the

69. Vincenzo Catena: Warrior adoring the Infant Christ.
London, National Gallery

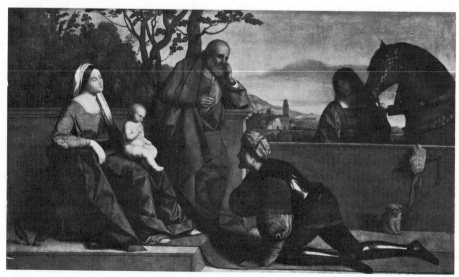

descent of Bellini. Pictures of the period around 1520 and soon afterwards – the *Rest on the Flight* and the *Adoration of the Shepherds* (Florence, Contini Collection),[100] or the serene *Warrior adoring the Infant Christ* (London, National Gallery) [69] – are the simplest deduction from Giorgione's mode, but they are also the most nearly faithful perpetuation of it that exists as late as this, within the third decade. Somewhat paradoxically, it is Catena's own persistent Bellinism that now promotes his affiliation with Giorgione. His Bellinesque geometry, a little softened, takes on a quality that resembles Giorgione's structural abstractness, and the détente mood that had been in

Bellini's art translates with no great effort into an analogue of Giorgione's poetic dream.

By the middle 1520s *Giorgionismo* had begun to be an archaism, even to a painter of such inherently archaic disposition as Catena. Late in his career he attempted to assimilate Titian's and Palma's technique, but with small evidence of adaptability, and without effect on his conservative habits of design. The tonally gloomy *Holy Family with St John the Baptist* (formerly London, Winterbottom Collection) and the *Noli me Tangere* (Milan, Brera; much damaged) evince Catena's tardy knowledge that Giorgione's innovation, which he recognized so late, had been displaced in Venice by another.[101]

CENTRAL ITALY 1520-1535

POST-CLASSICAL EXPERIMENT
AND THE FIRST MANIERA

What was accomplished in the art of painting, in Rome especially, in the course of the evolution of the Central Italian classical style during the first two decades of the century attained a hitherto unparalleled character of authority. There had never previously been so rich and commanding a concentration of achievement, or one so consistent in its principles of style. Far more than in contemporary Venice it imposed itself upon the painters of the rising generation, and interposed itself between them and the experience of nature. The accomplishment of Raphael and Michelangelo required to be taken as example before the experience nature could afford. But it was in the nature of the situation (and not only a matter of accidents of personality) that no painter who followed on Raphael's and Michelangelo's classicism could deal with the whole matter of their styles as they did. The response of younger painters was to aspects of their classicism, not to its essential, vastly synthesizing, whole. What was least easily transmitted of the classical synthesis was its character of content; it was its formal language – its immediately visible data – that was more accessible to imitation or paraphrase. Even with the formal language, however, the responses of the younger painters were of necessity to parts, because they lacked the motives of content that had shaped that language in its whole. The vast resources held in synthesis within the classical style became a treasury from which the painters could select, and then elaborate, refine, or alter what they had selected to suit purposes that were extrac-

ted from the classical style, but no longer classical in essence. Furthermore, the dynamics of development of the classical masters themselves had, even within the second decade, already unsettled the consistency of the style they had created, leading in directions that could go beyond it. While basically accepting – at least in Rome – the ideal authority of the classical style, the newer generation tended to respond to the implications in the evolution of the masters that led elsewhere.

The extent and the authority of classical example in Rome forestalled the possibility of overt challenge. But even in Rome authority could be felt not only as example but as constraint, and in the years immediately following the death of Raphael there was an acceleration of the temper of experiment that had marked Raphael's own late career, probing in directions that in Raphael implied unclassical effects, and which the younger generation now made explicit. Despite the result of stylistic novelty, the lineage by which it evolved from classicism remains clear. In Florence, where classical example was less powerful and pure and its authority less, there was overt challenge to it, and this was reinforced by the sense in Florence of continuing connexion with a major tradition of Quattrocento art that Rome did not possess. In Florence the formal rhetoric of classical style was subjected earlier than in Rome to experiments that transformed it. No less than their Roman contemporaries, Pontormo and Rosso worked from their inheritance of classical accomplishment, but they worked on it in a different temper and with more radical effects. They subjected the classical vocabulary to pressures of expression that often were not to be deduced from classicism, and indeed were contrary to it. They inverted the accepted sense of classical form or warped it to their new ends, and made new inventions of aesthetic devices or borrowed them from sources that were geographically or chronolo-

gically outside the sphere of reference of classicism. The term 'anti-classicism' has been used to describe the efforts of the Florentines, and for some of their experiments it has a measure of validity.[1] Among the Romans there is no comparable rebellious tendency – though Giulio Romano's covert acts of subversion of his master's style might well be taken in this light. Yet the actions of the Florentines were not just anti-classical; simultaneously much of their experimenting, like that of the Romans, was with deductions affirmatively drawn from the premises of classical style.

In both Rome and Florence the first half of the second decade was devoted to experiment – in Rome often of an unclassical kind, in Florence generally more extreme. In both places the experiments established the salient propositions of a new expression, distinct in temper and in means from the antecedent classicism. But in this time the very diversity of experiment – and, as well, another factor that should not be overlooked, the relative immaturity of the experimenters – did not make a consistency that could, as yet, be generalized under the rubric of a new historical style. However, there was a discernible community in the directions of experiment. Having explored their salient – and, in Florence, radical – new positions, the innovators then receded from them to effect a partial reconciliation with the doctrines of classicism, or more accurately, some form of dialectic with it. In that action, which occurred in both Rome and Florence just following the middle of the third decade, the new style attained its first clear formulation, and a maturity; and the maturing of the personalities of the innovators and their style was in effect coincident. This action gave historical sense to the new direction of art. In Rome it clarified and affirmed the relation of the new tendencies to their antecedents, and in Florence it reintegrated what had been at times eccentric novelty into tradition, and made it

again consecutive upon it. At the same time, the matured new style of this moment was the style that would shape the art of the next generation of painters to mature. What was formed after a decade or less of experiment was in essential respects of the same nature as the subsequent development in Central Italian painting that we universally describe as the 'Maniera', and the basis of the aesthetic it conceived.

In the older historical sources, less preoccupied than we are with the problems of a terminology for historical styles, the term 'Maniera', in its sense of a generalization for a historical style, was in the main applied only to the production of the mid century and after.[2] The preceding phase was treated loosely as an aftermath of the classical High Renaissance (which also, in those writers, had no specified nomenclature). More recently, recognizing essential distinctions between the style of the third decade of the century and the first two on one hand, and on the other essential likenesses between the style formed in the third decade and the Maniera, the community of style that contains both the latter has received (initially in German and then in English usage) the broad appellation 'Mannerism', baptizing the whole style by synecdoche. By an extension that is pragmatically legitimate, but which results – like all broadenings of a term's inclusiveness – in a dilution of specific sense, the appellation 'Mannerism' has come to include not only the defined and matured style of the first postclassical generation but the experimental (and in part anti-classical) phase before it, and with equal (but no more) sense, the late phase, after *c.* 1570, of dissolution or adulteration of Maniera proper. Each of the phases in this whole extent of Mannerism requires its own more precise subdefinition (and will receive it in the appropriate places in this book), but the including community of style the use of the generic term implies is there.[3]

The motives that precipitated the first post-classical researches can be accounted for in circumstances that are intrinsic to the history of art and to the personalities of its makers. At the same time, wider cultural circumstances promoted the experiments. Among these circumstances was the very increase of cultural sophistication that the classical period produced. This sophistication was a corrosive agent to the integrity and authority of institutions and beliefs. External forces – religious challenge and unrest, the unsettling of Papal authority and of the security of government elsewhere, war and major alterations of economy – worked strongly counter to the cultural aspiration to a true classicism, more patently exposing the degree to which, as a cultural style, it was a splendid and illusory artifice. The post-classical climate – sophisticated, unsettled, and compelled to introspection – helped to shape the experiments from which the thesis of the Mannerist style came. Perhaps because the classical style had made an autonomy of art, and an authority more sure and enduring than that of the institutions that surrounded it – or perhaps only because art is more easily ordered than reality – the new style, when it had accomplished its dialectic with classicism, found purpose, direction, and security before those institutions did. In Rome, the most disastrous historical event of its Christian history, the sack of the city in May 1527, interrupted the pursuit of the new-found manner there for half a decade, but promoted its diffusion elsewhere. The diaspora of artists that followed on the ruin of Rome transferred (in some cases only temporarily) their process of development elsewhere, with conspicuous effect on the wider Italian scene. In Florence, the siege of 1529-30 had no discernible enduring effect on developments in art, except that by an accident that seems to have resulted from the siege the last great exponent there of a classical art, Andrea del Sarto, died. His death, however, was in effect posthumous to the demise of the style he espoused. More than in Rome artists in Florence had perpetuated a conservative and local variety of classical style during the third decade, side by side with the utterly diverse experiments of Pontormo and the example Rosso had left behind. In quantity of production the conservatives outmatched the innovators. Yet as the decade advanced, the persistences of the older style became increasingly adulterated, yielding to the fashion the new Mannerism represented, if not to its essential character of style. By the middle years of the fourth decade the newer style largely dominated Florence, and the younger generation that would make the high Maniera was emerging towards its own imminent maturity within its atmosphere. At the same time the Roman school had been re-established and the dominant agents in art there, from whose example the Roman Maniera of the mid century would come, included some of those whose example had made the first Maniera, before the Sack.

FLORENCE: I

Michelangelo and Florentine Mannerism

An older view of Mannerism (thinking, then, of the art of the mid century rather than the phase we are discussing now) conceived of it as the style of the imitators of Michelangelo. That view is no longer valid, even for the Maniera proper, but it reminds us of the role of Michelangelo in relation to the whole style as we now chronologically define it. He was the greatest living power in art, and contemporary style took significant aspects of example from him. From about 1518 to 1534 he was mostly resident in Florence, and his example was most powerfully felt there. In Rome, where his authority had earlier been shared with Raphael, it was the latter's example that, in the absence of Michelangelo, was in general more influen-

tial in the first phase of the Mannerist style; yet the accumulation in Rome of Michelangelo's past achievements remained as a continuing and inescapable influence upon the rising style there. But Florence in the third decade knew different aspects of their Michelangelo, at once more primitive and more advanced than what he left in Rome. For the Florentines of the twenties, Michelangelo's example consisted on one hand of the early works – not only the sculpture but the remnants of the Cascina cartoon and the painting of the Doni Tondo – and on the other hand of the emerging forms of the sculpture for the Medici Chapel; and towards the last years of his stay there were the statues for the penultimate version of the tomb of Julius II. A Florentine post-classical mentality could read the early cartoon or the Doni Tondo as lessons in an analytic formalism, and as demonstrations of mechanical and intellectual *disegno*. The Medicean statues carried other meanings relevant to Mannerism: nowhere previously had art – not only in Florence – known such charged and subtle exposition of the power of aesthetic artifice, or such intense projection of abstract ideas. The style of Michelangelo in the Cappella Medici nevertheless remained within the limits of a synthetic classicism, though at its highest, extreme verge. It was Michelangelo's example that induced the end of the more radical Florentine experiments and set the classical term for the dialectic from which the first maturity of Florentine Mannerist style emerged; but at the same time these same radicals were able to extract from it a potential of Mannerist ideas.

Not only the younger generation but Michelangelo himself made this deduction in certain of the statues from the last years of his time in Florence. The *Victory* surely, and perhaps the *Medici Madonna*, conform more nearly to the vocabulary of Mannerism than to that of the antecedent classical style. It is conceivable that the younger generation may, here, have had a reverse influence on their exemplar. Michelangelo himself did only one painting in this time, a *Leda* (1529–30), and then between 1531 and 1533 made two cartoons, a *Venus and Cupid* and a *Noli me Tangere* [70], which were given to Pontormo to be executed.[4] None of the originals survives, but close contemporary copies indicate their style. More than Michelangelo's most recent statues, the pictures not only require to be assimilated into Mannerism but beyond this are prototypes of the Maniera. The *Leda* and the *Venus* are self-quotations, as literal as any quotation from the master that his epigoni were allowed. The quotations make the principle that the same form is interchangeable among diverse themes: meaning now need not internally determine form but is attached to it by illustrative adjuncts – form is essential; its content may be incidental. In the *Venus* (though not in the *Leda*) and even in the religious painting, the *Noli me Tangere*, the values of communication in the theme are chilled, and given in the terms of fine-poised artifice, concordant with the stress on artificiality – and primacy – of form. Michelangelo's work of the previous decades had made some contribution to early Mannerism, but these were explicit precedents in Florence for Maniera. A major episode in Michelangelo's career as a draughtsman had exemplary value for an aspect of Maniera in Rome also: these were the highly finished demonstration drawings Michelangelo produced in 1532–3 for his Roman friend Tommaso Cavalieri (and one or two further sheets in similar vein), like the paintings of the early 1530s in their style. Even when he drew or painted Michelangelo's example remained essentially sculptural, and in Florence the force of this example on painters came to displace to a great extent the mode that had its origin in the style of Leonardo, and its culmination in the painterly exercises of Andrea del Sarto. It was Michelangelesque classicism, far more

70. After Michelangelo, *c.* 1531–3: Noli me Tangere. *Florence, Casa Buonarroti*

than Andrea's, that had a continuing validity as a term of reference for the Florentine Mannerist style.[5]

Pontormo

We tend to speak of the formative time of Mannerism as if it were a wide artistic current, but this is what it only gradually came to be. At the beginning, the first affirmations in Florence of a new style which we recognize in retrospect as the initial steps of Mannerism were the actions of two men, Jacopo Pontormo and Giovanni Battista di Jacopo, called Il Rosso. Until the latest years of the second decade these young painters had been bound in different degrees to the precepts of the prevailing style. Pontormo's assimilation of the classical style had been much more profound than Rosso's, and it may be on this account that his subsequent alteration of it was more searching and historically consequential. In both his art and Rosso's the same year, 1518, marked the emergence of a decisive novelty of style. In Pontormo's art this landmark is his altarpiece for S. Michele Visdomini, dated 1518 (*in situ*) [71].[6] It is most unlikely that this picture, which has the effect of a revolutionary act, was generated out of any consciously formulated motive of anti-classicism; it is not a negative motive that gives new shape to its style. Not less than the first steps of Mannerist research in Rome, Pontormo's painting takes off from propositions of which at least the implication was contained in the developments of classical style, but he subjects them to pressures and to changes that negate their origin. There is a dual reference, in almost each important facet of the altar's style, to classical antecedent and to the alterations worked on it. The motive force for change begins in an expressive will that has a character of contradiction in it, at the same time irrationally intense and excessively refined. For this kind of feeling,

the reasonable rhetoric of Fra Bartolommeo is a constraint, and Sarto's manipulations of emotion are too discreet.

Jacopo's references to Fra Bartolommeo's schema of design make it even more apparent that this design is, by contrast, unstable and nervously complex. It is a structure of kinetic fragments, held together in a precarious equilibrium. In this kinetic scheme there is no longer the classical effect of an equation between energy and substance: the former is the dominating value, not only in the structure but in the figures that inhabit it. It is their psychic energy that is asserted, while their physicality is attenuated or masked; concordantly, so is their ambience of space. The result violates the normal visual experience of nature, and for the first time since the dominance of classical style an image projected on a major scale at first sight projects an effect of implausibility.

What is sacrificed of physical convincingness is the price, and in part also the means, of making a conviction of another kind, of spiritual states. Not only what is described of the emotions of the actors, as they look at us, each other, or the high altar to their right in the church (contemplating the mystery of the sacrifice of the adult Christ), but the whole temper of design as such communicates excitement to the spectator; the closing up towards us of forms in space gives this communication an impinging nearness. Emotion in the altar transcends the boundaries imposed by classicism on the actors and on the discrete pictorial realm in which they were supposed to act. In a decisively different degree than in pictures made on classical principles, this one is created in an immediate communion of the artist with the image, and in turn makes intensely imminent communication with us; and our immediacy of involvement, and its urgency, are required to be like those of the artist.

The Visdomini altar established a threshold for research into multiple new possibilities of

style beyond the limits of classicism, into which Pontormo was quick to probe. In a smaller picture of 1518, on a narrative theme (less bound therefore to iconographic precedent for design than an altarpiece), *Joseph in Egypt* (London, National Gallery), Pontormo makes complexities and dislocations in its spatial order that subvert the whole perspective logic of the Renaissance, and he warps forms with eccentric pressures that create effects like those of caricature. Seeking other ways than those of classicism, he has consulted precedents outside classical example, in contemporary North European prints, and in the – by then – archaic early Renaissance, in Ghiberti's Porta del Paradiso. In expression as in form he seeks what is complex and specified – or, even more, singular – opposite to the generalization that is usual to classical style, and the primary effects of feeling and form in the *Joseph* panel are in this vein. But at the same time there is another motive within this picture (more clearly than in the Visdomini altarpiece) which is vital to the whole complexion that Pontormo's new style bears. The temper of expression and its descriptive means are eccentric and intense, but they are also subtle and fine-spun: intensity is not separable from a sensibility that verges upon preciousness. Even as Pontormo charges feeling and warps form, he does so with extreme refinement. In places in this picture a formal symptom of his sensibility is a spidery skein of pointed shapes, like those in the Visdomini altar, but more often it is an accentuation – new to Jacopo – of complex gracility of curving line, inventing rather than describing patterns of anatomy and drapery. In the moment that Jacopo affirmed a new liberty of non-rational expression, he also sought a new and equally assertive conception of the work of art as ornament. There is a tension between these two ambitions: the impulse to eccentric expressiveness and to a kind of beauty that proceeds from grace are not easily reconcilable. Pontormo

raises the problem here, and it was to be a central issue not only for his art but for the history of early Mannerism in general. Its solution was essential to the attainment of the maturity of the style.

A shortly successive larger work by Jacopo, the *St John Evangelist and St Michael* (Empoli, Collegiata, 1519), is much occupied with the development of a new gracility, swift-tempered and sharp-etched. Unlike the grace of classical style, the grace of these figures is not an ornament of substance. Swift, slender arabesques override substance and attenuate it. As shapes are turned to ornament, so also – and this is again a new step for Pontormo in his process of invention – is the colour of these figures. Jacopo finds hues for them that are neither descriptive nor, as in classical style, emergent from the seen form but invented visual sensations, which call attention to themselves for their value of ornament.

In 1520 and 1521 Pontormo shared, with Sarto and Franciabigio, the commission for a decoration which, had it been carried through completely at the time, would have become the Florentine rival of the great interior decorations of the Roman school. This project, the painting of the grand salon at the Medici villa of Poggio a Cajano, was interrupted by the death of the patron, Pope Leo X.[7] What was actually accomplished, a single fresco by each of the three painters, remains a major index of the situation of contemporary Florentine art, in which Jacopo's lunette (identified by Vasari, VI, 265, as *Vertumnus and Pomona*) emerges both historically and aesthetically as by far the most important [72]. This painting was conceived in great travail, and almost certainly after an experience in Rome devoted mainly to the study of the Sistine Ceiling – Pontormo's first entrapment by Michelangelo's art, from which at this point he was still able to liberate himself.[8] An important aspect of this liberation was in Jacopo's relation to the given theme.[9] A first

72. Pontormo: Vertumnus and Pomona, 1520-1.
Poggio a Cajano, Villa ex-Reale

design, formed in a Michelangelesque exag-
geration of heroic classical style, was sup-
planted by an interpretation of the subject
matter utterly without rhetoric and almost even
without explicit character of narrative; this
divorce from rhetoric and exposition is con-
trary to the principles of classical style. The
actual subject matter has become near-genre –
villani resting on a summer day – and it is
described in a way that is thematically and
visually full of incidents of naturalism. Pontor-
mo reaches, thus, in one direction that lies
outside the idealizing bounds of classicism. But
Jacopo's observation of nature is not only more
immediate than that of a classically-minded
artist; it is different in its kind. No objective
distance interposes itself between him and the
thing he sees. His relation to the subject he
experiences is probing and intense to the degree
where he assimilates himself to it, as if he
should inhabit it. While he perceives, he infuses
the object of perception, not just with a physical

empathy, or with poignant sympathy for the
emotions of the actors, but also with a charged
response to the purely aesthetic character of
each seen shape. What Jacopo in the end sets
down is in one sense acutest observation of
nature, but it is also nature simultaneously trans-
formed by subjective pressures into art. In an
opposite direction from his probing into nature,
his liberty in the transformation of it departs
from the synthesis of classical style. Each form
in the *Vertumnus and Pomona* is thus translated
into a subtlest image of Jacopo's sensibility to
it. These forms then are set out in an order that
extends this sensibility into a pattern of rela-
tions traced out as if with the very nerve-ends,
suspending sensations of mobile and accented
shape within an equilibrium of supreme fine-
ness.

The temper of idyll that Jacopo achieved in
the *Vertumnus and Pomona* is a function of his
identification with the object he creates – in this
case with the essential sense, beyond that of the

73. Pontormo:
Road to Calvary, 1523–4.
Certosa di Val d'Ema

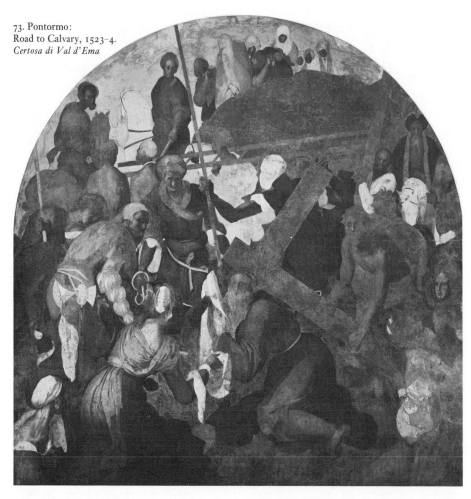

narrative, which suits the subject in the context of this special country place. A very different theme and context for it are in the five frescoes of *Christ's Passion* which Jacopo painted in 1523–4 in the cloister of the Certosa di Val d'Ema near Florence (to which he had retired for refuge from the plague that beset the city in these years).[10] The same power of identification and extreme sensibility that had been at Poggio respond now, in this silent monastery, to the human poignance and the spiritual mys-

tery of the Passion, and its effects cannot but be very different. Jacopo's sense of involvement with Christ's history is such that in the *Road to Calvary* [73] he puts himself into the role of a major actor in it, helping the fallen Christ to lift his cross;[11] as far as we know it was without precedent for the artist to become actor, as distinguished from a painted spectator, in a religious narrative. Jacopo not only specifies this measure of his own involvement; he compels the same immediate commitment from the

spectator. He compresses the matter of the narrative towards us and seals off its rearward extension into space. In the *Road to Calvary* and the *Christ before Pilate* half-figures in the foremost plane appear to rise from our space into the painting, stressing the idea of our connexion with it.[12] Compelled to close confrontation and involvement, the spectator is engaged not only by the psychological and dramatic action but by the affect of each shape and of the whole design: of yearning attenuated forms, eccentrically vital silhouettes, and complex interlacings made among them.

The precedents of Dürer's prints, already earlier consulted by Pontormo, served to guide him at the Certosa towards the farthest remove from classicism that he ventured in these years. Aberrant from the taste and the tradition of Pontormo's native art, these frescoes mark the limit of his experimental search for new freedoms and new means; their disjunction from the continuous history of a 'bella maniera' (whether of the High Renaissance or of the later Mannerism) was sharply characterized by Vasari. Yet, even the concessions Jacopo has made to what is foreign to his tradition do not obscure his preoccupation with the value of art as ornament. As they once looked, the Certosa frescoes made much less disruptive patterns than their ruined state offers now. The expressive pressures that warp shapes in them convey, in these shapes, not only an emotion but an aesthetic equivalent for it: an eccentric beauty – complex, difficult, and of extreme refinement. In form, as well as in their tenor of action and expression, the figures possess a bizarre elegance, which is extended by their mode of rhythmical relation into an effect of the entire design. The large oil painting, the *Supper at Emmaus* [74],[13] done for the Certosa in 1525 after the completion of the fresco series, is conceived in a vein that is in all essentials like them, and its relatively sound state of preservation permits us to assess the comparable ornamental

value they possessed. Still probing towards extremes, however, Pontormo in the *Supper* seeks an even more highly charged divergence of artistic aims, between still more refined ornamental artifice and elements of realism the theme suggests to him, so sharply characterized that, extracted from their context, they antici-

74. Pontormo:
Supper at Emmaus, 1525. *Florence, Uffizi*

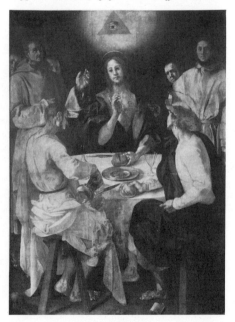

pate the mode of Caravaggio or the early Velázquez.

This was the style in which Pontormo conceived his first piece in the decoration of the Capponi Chapel in S. Felicita, which was to be his principal concern of the years 1525-8. The frescoed *God the Father with the Four Patriarchs*, once in the vault of the chapel, has been lost, but a developed study for it (Florence, Uffizi) more resembles the *Supper* of the same year than it does the following portions of the

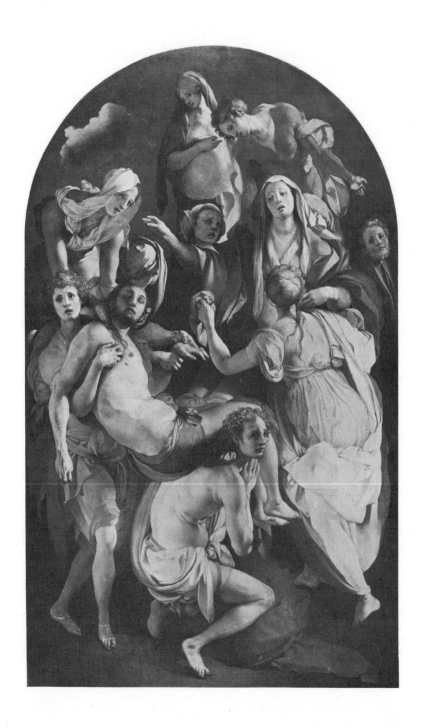

chapel. But as Jacopo proceeded to invent the tondo panels of the Evangelists[14] for the lower vault and then, probably in 1526, the altar of the *Deposition* [75], an illumination of the highest clarity informed the purpose of his art and transfigured his style. The *Deposition* marks the emergence to maturity of Pontormo's powers and his artistic personality. It is a plateau he has attained after his often extreme and aberrant researches, and it is in part the consequence he has derived from them; but it is more important that the style of the *Deposition* rejoins the yield of Jacopo's experiments with their antecedents in the history of classical style. The stimulus to this transforming act must have been, at first, from contact with Michelangelo – renewed after Jacopo's isolation at the Certosa – in this time when Michelangelo's first images for the Cappella Medici were taking shape. His example inspires a sculpture-like clarity of form and surfaces that had not been in Pontormo's style before; and extrapolating from this sculptural example with his draughtsman's hand, Jacopo now finds an equal lucidity of shaping and defining line. The character of his emotion, too, acquires a new clarity. There has been no loss in intensity of feeling, but Jacopo has observed, probably in the main from Michelangelo, that feeling is not less poignant communication when it is disciplined. There is no search, as in the Certosa, for disjunctive eccentricities of expression, nor are emotions pointedly assertive, as they were there. In the *Deposition* there is a tight emotional consistency, which the actors differentiate within its unitary texture as if according to the precepts of the classical style. The power of feeling that was in the Certosa *Passion* is heightened by this concentration, and the sympathy elicited is more complete, because it is without distraction. A principle of expression

75. Pontormo: Deposition
(Christ's Departure for the Tomb), *c*. 1526–8.
Florence, S. Felicita

has been re-won from classicism, but the kind of emotion grows entirely from Pontormo's new research. Feeling in the *Deposition* reaches towards a pitch of anguish, most finely and precisely felt, which attains a new dimension of the idea of the capacity for feeling, and the beauty in feeling, of human personality. The most private, sharp-etched poignance of suffering is made exquisite, and informed with the spiritual quality of grace.[15]

Both the emotion and the vocabulary of form that communicate it are confluent results of a new climate of Pontormo's art in which he has come to understand that no matter what the intensity or complexity of emotions or forms, they can be reconciled with the consequences of the ideal of beauty that classicism had evolved. Except for moments in the few preceding years of extreme experiment he had not been altogether alienated from this ideal, and we observed his increasing concern with the value of the work of art as ornament. In the *Deposition* the processes that shape form re-admit principles of classicism: harmonious relations among the large parts of form, their definition by full-rounded continuities of outline and modelling, and a cursive connexion among shapes that binds them in melodic unity. These principles begin with observations made in Michelangelo, though Pontormo has developed them in his more elaborate vocabulary of painting.

There is thus, in both the form and content of the *Deposition*, a recall of the first *bella maniera*, that of the High Renaissance, and its style is related not only to the classicism of the current Michelangelo but to the past art of Raphael and Leonardo. But, obviously, this is no literal recollection but a dialectic made between that maniera and Pontormo's own unclassical researches: in the dialectic he achieves the new Maniera of Mannerism.

The strands of truth in this painting are inextricably woven into those of fantasy. So

indissoluble is the single fabric that results, and so compelling the transmutation of experience in it, that it commands the immediate involvement of the spectator. In the form Pontormo has given the design this involvement is made complete. It moves in a counter-clockwise interlacing like a visual polyphony, unfolding the narrative and commenting on its emotions as it proceeds. Simultaneously, the forms communicate their beauty of artifice and express the anguish of the beings whom they describe – and transform: the effect of form and the quality of emotion partake absolutely of each other. There is no end to the movement of this circular polyphony and no release from it except by the spectator's act of will. We are drawn to repeated readings of the image, each time with a new refinement and awareness of its complexity and at a mounting pitch of response to the unnameable union of precious beauty and of anguish that it contains. Again, Jacopo has asserted himself among the actors (in a self-portrait at the right rear of the group). His presence is a symbol of what he wishes of the spectator – an assimilation as entire as his own with the existence he has created in the work of art.

The *Deposition*, emotionally motivated by its subject, is different in explicit tenor from the paintings of the same phase whose style is deduced from it. The *Annunciation* in fresco on the side wall of the Capponi Chapel (*c.* 1527-8) is an essay in lyric ornamentalism, emotionally oblique. The angel in it prefigures, and surpasses, the most artificial graces that the high Maniera would conceive: the pattern that his movement makes is a suspended music. The same complex ornamental grace is in the *Visitation* (Carmignano, Pieve, *c.* 1528), but there it is ennobled by a grandeur of large form that recollects, even more directly than the *Deposition*, the aspirations of the classical style. Emotion in the *Visitation* also makes an analogue to

classicism in its complexity and strength, but like the form it is removed and crystalline, experienced not in a climate of reality or even of classicizing ideality, but as if in a stratosphere. Despite its grandeur, the whole apparition floats, suspended in a distilled harmony.

One of the characteristics of the paintings of this brief span, 1526-8, that most relates them to the principles of classicism is Pontormo's will in them to harmony; but his attainment of the sense of harmony is over matter that is less tractable, and more volatile, than the classicism of the High Renaissance had chosen to control. It would seem beyond the possibilities of human discipline to sustain for very long a fusing and surpassing of complexities in the measure and at the level Pontormo achieved in 1526-8. From *c.* 1529 there is an alteration in the temper of Pontormo's art, at least momentarily: he no longer seeks such strict intensity of feeling and concomitant acuity of form, and the tautness of complex ornamental order that made the formal harmony of the *Deposition* and the *Visitation* is relaxed. He recedes from the ambitions which, in those works, resemble the purities and disciplines of classicism and re-admits aspects of the antecedent and unclassical phases of his own style. It is as if a further elaboration of a dialectic process had occurred, between the style of S. Felicita and what preceded it in Jacopo's own art. The *St Anne* altar (Paris, Louvre, *c.* 1529) recalls something of the mode of the *Supper at Emmaus*, or even of the Visdomini altarpiece of a decade past, and infuses this into the vocabulary that had been found at S. Felicita. The frescoed *Crucifixion* from Boldrone (Florence, Forte di Belvedere), of about the same time, compromises the new vocabulary with an element of the primitivism of design and feeling that were in the *Pietà* of the Certosa frescoes. The *Pygmalion and Galatea* (Florence, Palazzo Vecchio, *c.* 1529-30; largely executed by the

young Bronzino)[16] and the contemporary *Martyrdom of the Theban Legion* (Florence, Pitti)[17] revive some part of Jacopo's earlier emotional eccentricities, and even more conspicuously his eccentricities in drawing of anatomy. The relaxation of the high disciplines of the classicizing moment and the loosening of Jacopo's requirement in it of a stringently consistent harmony are not just a concession to the difficulty with which they were achieved. As in his first rupture with classicism, Pontormo's present diminution of it is a release from constraint and an opening to different resources of artistic style.

It is in this new dialectic that Pontormo formed the basis for what was to be his subsequent enduring style. However, this evolution is not merely an internal one: as its previous stage had begun with a profound concession to the style of Michelangelo, so its present stage continued to consider Michelangelo and compound the demonstrations of his art into Pontormo's own. The nature of the relationship of Jacopo to Michelangelo is extraordinary. It is not possible to recall another case in which an individuality so special and intense as Jacopo is so obsessed – possessed even – by another's art. Singular as it was, the results of the relationship seem to have been largely positive. It was not only an example of a magnitude of creative possibility that Jacopo derived from it. It appears that the conflict in Jacopo between submission and assertion of his own identity was for him the source of a creative tension; and in the end it came to be his own identity that this creative tension spurred.

Between 1531 and 1533 Pontormo acted as Michelangelo's executant for two paintings the older master had prepared only in cartoon: the first a *Noli me Tangere*, the second a *Venus and Cupid*. Versions after the cartoons by other artists survive, but not Pontormo's own.[18] This was the extreme conjunction between Michel-

angelo and Jacopo, and the experience seems to have come close to disorienting him. In 1532 Jacopo made designs towards the completion of the decoration of the grand salon at Poggio a Cajano. When Clement VII died in 1534 the project was dropped, and they were never executed. The sole design of Jacopo's to survive is for a *Game of Calcio*, played by gigantic nudes. The drawing extends the style of the Pitti *Martyrdom* into a more overt and more literal Michelangelism, and there is an equal dependence on Michelangelo's motifs and style in the drawings that preserve for us some part of the ideas used in Pontormo's destroyed paintings for the Medicean villa at Careggi (1535-6). But even where Jacopo's submission to the art of Michelangelo seems most clear, it is his translation of the borrowing that is meaningful, more than the borrowing itself. In a measure decisively beyond Michelangelo's examples, Pontormo's images of this time, in the first half of the fourth decade, stress the value of ornament that may be deduced from forms, and in order to achieve it may take radical liberties in representation. Jacopo seeks a *grazia* much more extreme than Michelangelo's, and more pervasive; he extracts this element from Michelangelo's still classically synthetic style and elevates it to the status of an aesthetic absolute – or, conversely, makes it the instrument of an absolute aestheticism. Further, the *grazia* Pontormo now seeks is of a temper still more distinct than that of the S. Felicita phase from the *grazia* of classical style. It is not more precious or precise than in the *Deposition* or the *Visitation*, for that would verge on the impossible, but it is a more wilfully eccentric grace, skirting dissonance and risking the bizarre. It is infused with the pervasive savour of the warpings of appearance that Pontormo takes licence to himself to make: the spectral beings of the Certosa years are now rephrased in a melodic mode. Through a draughtsman's

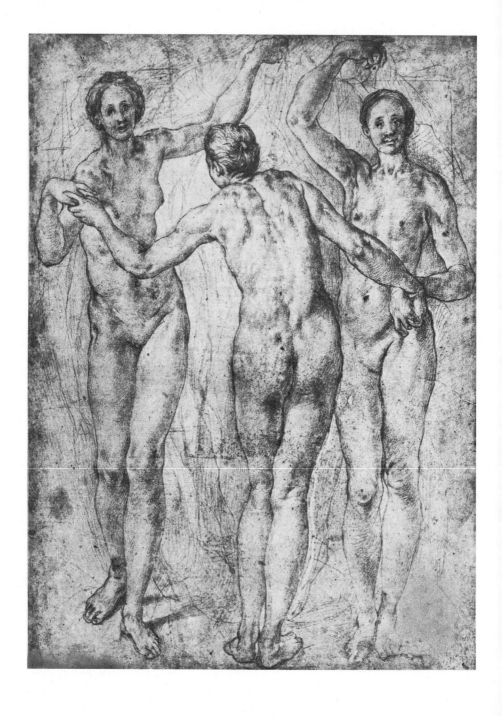

76. Pontormo: Three Graces.
Florence, Uffizi

means derived from Michelangelo's statuary, the human form appears as malleable as ectoplasm, and as disquieting, and its reformation is felt in the same moment as a deforming. The beauty that Pontormo seeks is more than ever the product of a sensibility for which sensation is not only complex but ambivalent. What he finds with this sensibility is still more perilous now than it had been before: this special beauty shows the subtle torment and the difficulty with which it has been sought and felt. The drawing study for a *Three Graces* (Uffizi) [76], contemporary with the paintings for Careggi, is the surpassing exposition of this character in Pontormo's matured art, gathering willed ambivalences into an evanescent moment of pure lyric poise. Difficulty is not overcome, but demonstrated through a consummate skill.

Between this style that Pontormo evolved by the middle 1530s – preciously ornamental, difficult, and complex – and that of the subsequent Florentine Maniera, there seems to be only one distinction to be made that represents a basic principle, and its source may lie more in Jacopo's personality than in a wider issue of historical style. This is the poignance with which he experiences human presence, even as he may be most concerned to transform that presence into ornament. It is this quality and kind of feeling, along with the pressures and complexities that it occasions in his management of form, that are disjoined from his style by the painters of the Maniera. They would accept Pontormo's general principles of form, but not his immediate involvement with a human content or the special consequences for form that content had. With aesthetic devices much like Jacopo's they would make meaning partially like his, but it would be meaning generated more from form than from his inextricable union between form and humanity.

Pontormo's responsiveness to the psychological presences he encountered was such that it is evident in his studies from the model, where it may have no relation to the purpose of the study for the finished work. When Pontormo confronts the sitter for a portrait his psychological responsiveness becomes the means for introducing a dimension of meaning that portraiture had, in general, not previously known. No portraiture of the classical style seems so subtly indicative of private states of mind, opened to – indeed, asking for – a sympathetic communication. The common denominator of expression that is in Pontormo's portraits through the middle of the fourth decade suggests that, more than usually in portraiture, their mode of feeling synthesizes the sitters' states of mind with Pontormo's own. In the specific kind of communication they make, as well as in formal character, the portraits are parallel in their development to the other aspects of Pontormo's style. The young *Alessandro de' Medici*, for example (Lucca, Pinacoteca, *c.* 1525), partakes of the active patterning of form (and colour also) and of the febrility of feeling of the *Supper at Emmaus*,[19] while the *Halberdier* (New York, Stillman Collection, 1528–9) [77], like the S. Felicita paintings with which it is contemporary,[20] attains an utmost controlled rhythmic elegance; the complex psychological communication in it is accompanied by a quality of poise. Like Jacopo's religious paintings of this time, this elegant and subtle image is a prototype of the Maniera. The control of expression that, in the *Halberdier*, we identify as poise develops in a later portrait of *Alessandro de' Medici* (Philadelphia Museum, Johnson Collection, *c.* 1534–5) into a crystalline containment which resembles more exactly the psychological tone of a Maniera portrait; the conception of the second *Alessandro* virtually converges with the conceptions of the portrait with which Bronzino began his career in that field.

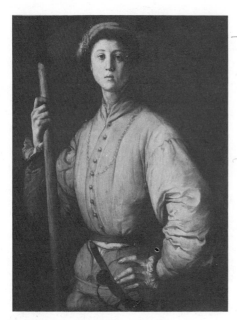

77. Pontormo: Halberdier, 1528-9.
New York, Chauncey Stillman Collection

Rosso

More radically than Pontormo, his nearly exact contemporary Il Rosso (1495-1540) challenged the values that the period of ascendancy of classical style had published in Florence. Rosso seems to have been allied by temperament with a sub-current in Florentine art, introverted and extravagant, that continued through the time of classicism from the period that preceded it, of which the chief representatives had been Piero di Cosimo and Filippino. According to Vasari, Rosso in his formative years could find no master in Florence with whom he was content to stay. Even as a youth he seems to have been temperamentally indisposed to accept curbs on his individuality, and it is understandable that he should be at odds with the disciplines exemplified in classical style. Yet this style was dominant in the visual culture in

which Rosso was brought up, and it was unavoidable that his first artistic vocabulary should be formed by it, in a fusion – not so different from Pontormo's – of the modes of Sarto and Fra Bartolommeo.[21] What Rosso was disposed to learn, however, was not much more than a vocabulary. From the first works by him that we can certainly identify his syntax only superficially conforms to that of his exemplars, and it is obvious almost at once that what he means to say is incompatible with them. His first large-scale work, the fresco *Assunta* in the atrium of SS. Annunziata (1516-17), adjoins the effectively classical *Visitation* by Pontormo, finished just about when Rosso's fresco was begun. The *Assunta* makes obvious references to the same authorities that served Pontormo: to Bartolommeo's grand and rhetorical mode of composition, and to Sarto's drapery style. But Rosso has given his large design the character of an abstracting scheme while filling it at the same time with forms that possess an erratic turbulence. His descriptions of his actors verge on caricature. Colour tends towards violent and unexpected hues, in imminently dissonant combinations. The image is not as yet divorced from classicism, but what is aesthetically and psychologically positive in it runs counter to the disciplines of classical style. Rosso may have had no specifiable master, but the source of the direction he has taken here is clear enough: he is extrapolating from the phase of Sarto's style about 1513 that just succeeded their one sure moment of association, when Sarto himself had not yet secured his own commitment to a matured classicism, and suggested, as we have remarked of Rosso too, affiliation with the strain in contemporary Florentine art that persisted from the latest Quattrocento.

Rosso's overt break with classical example came, like Pontormo's, in a work of 1518, an altarpiece for S. Maria Nuova (Florence, Uffizi) [78]. As in the Visdomini altar of Pontormo, the revolutionary act takes place upon

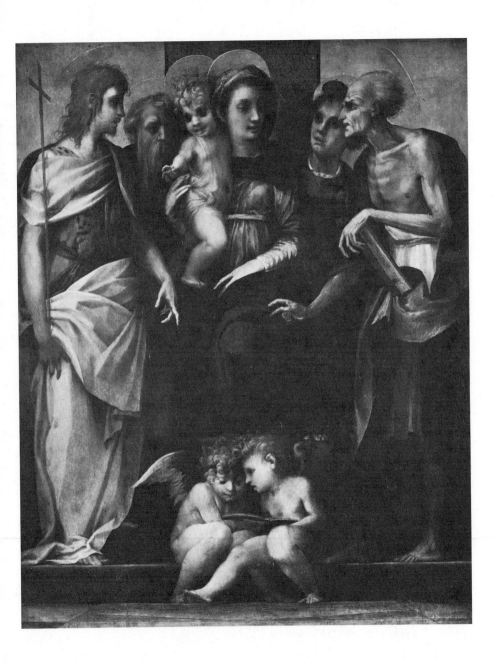

78. Il Rosso: Madonna with Saints, 1518. *Florence, Uffizi*

the given matter of the current classical style: the composition of the S. Maria Nuova altar is based on Fra Bartolommeo, and its colourism and its tendency of feeling are deduced from Sarto. But an eccentric expressiveness has infused this matter and transformed it. The figures have the look of apparitions, caricatured and substanceless, with a probing angularity of shape that evokes the memory of an archaic style.[22] These shapes are less articulated into facets of prismatic colour than they are overridden by them, and the colour – assertive and now wilfully dissonant – consumes and replaces effects of plastic form. It finds a singular quality of beauty, poignant and bizarre, that partly redeems and partly reinforces the state of mind the actors illustrate. The operation Rosso performs upon the substratum of classical style in this work is more drastic than in the contemporary altar of Pontormo, and the spirit that provokes the change appears to be distinct from his. Rosso's is not just a transforming inspiration but a corrosive will as well, which is identifiably antagonistic to the values of the style of classicism. There is a sardonic element in Rosso's creativity, which he makes evident not only in the interpretation of his theme but in the overt references he takes care to make to the classical images he controverts.

Three years later than the S. Maria Nuova altar, in the *Madonna with St John the Baptist and St Bartholomew* (Villamagna, Pieve, dated 1521), the reference to classical precedent – in this case, most likely, to Andrea's *Madonna of the Harpies* [36] – attains the status of perversion. This image is overtly anti-classical in its way of generation and anti-classical in each effect, yet the 'anti' character is not primary either to Rosso's motive of creation or to his achieved work of art. This is, now, the affirmation of a positive creative will, seeking to construct a way of art that is not against another way but for its own. Because Rosso had less

discipline, both of education and personality, than Pontormo, more facile daring, and no less of inventive genius, his liberation from the authority of classical style was easier and quicker to achieve than Jacopo's. By 1521 Rosso had found the complete matter of a new style, wholly internally consistent, while Pontormo was still attempting to resolve a much more complex relation between the old and the new. The lunette at Poggio makes no such clear or drastic statement of a novelty as does Rosso's *Deposition* (Volterra, Museum, 1521) [79],[23] though in it Rosso seems indebted to Pontormo for virtues of aesthetic and expressive discipline that he did not earlier possess. Rosso's drawing has assumed a brittle clarity, articulating with distinctness hard-edged, pointing shapes and planes, set into movement but then petrified. Light that is cool, studied, and intense defines each form sharply, and with equal sharpness fragments its surface into planes. The figures seem to have no substance; they exist only by the response of their geometry of surface to the light. The light makes paradox: by it our perception of the picture becomes an intense optical experience, but the experience is not of a visual reality but of an apparition. In it, beings of a disquieting spidery elegance and singular emotions are transfixed as they act in an abstracted world – the persons of the drama seem possessed automata. The tragedy has been described with an admixture in it of evasive irony, as if there were some ambivalence in Rosso towards the human and religious meaning that the theme traditionally bears. Yet thereby it becomes all the more evident how very personally the content of the image is conceived, and how the private individuality of the painter is involved in it, regardless of the measure of orthodoxy – or otherwise – of his

79. Il Rosso: Deposition, 1521.
Volterra, Museum

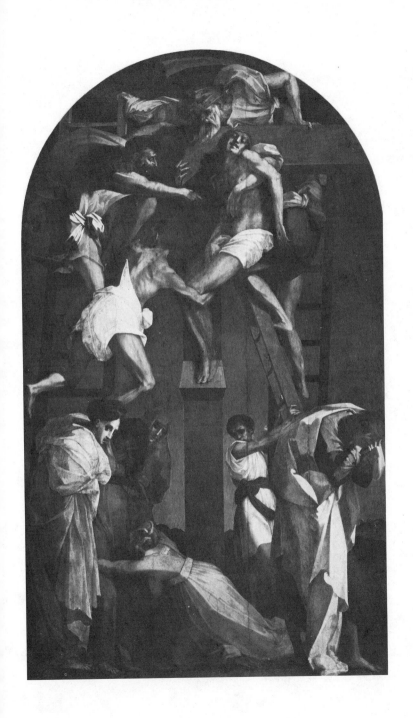

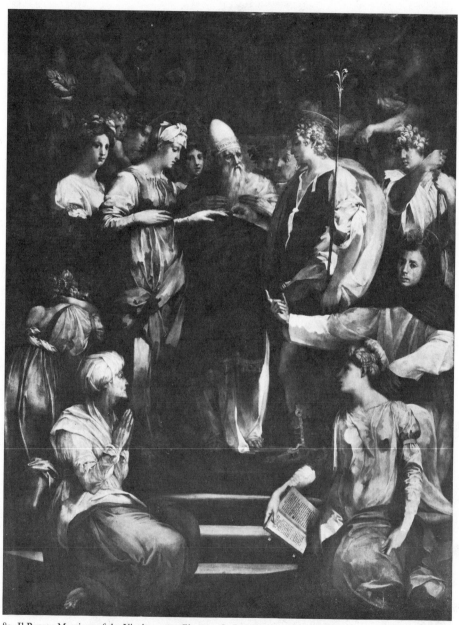

80. Il Rosso: Marriage of the Virgin, 1523. *Florence, S. Lorenzo*

belief. Suspending the matter of his vision in a thin stratum on the surface of the picture, impinging on the psyche of the spectator even more than it does upon his space, Rosso commands an involvement from the viewer that is like his own. The *Deposition* has the aspect of an apparition and the force of a hallucination, and it attains meaning in a new style that is radically distinct in kind but not less in its dimension than what classicism had achieved.

More than Pontormo's, Rosso's individuality is too complex and his sensibility too multiform to permit a linear development of his art. By comparison with the *Deposition*, and still more with the Villamagna altarpiece, the *Pala Dei* (Florence, Pitti, 1522)[24] recedes from the salient novelty of the Volterran paintings. The tone of travesty of the classical style that appeared in Rosso's earlier *conversazioni* is quite absent here, and the open reference to Bartolommeo's altars is sympathetically meant. After Rosso's definitive conquest of a new style, the *Pala Dei* seems to represent a willed compromise with the inheritance against which he had rebelled.[25]

There is less overt evidence of a concession made to classicism in the *Marriage of the Virgin* (Florence, S. Lorenzo, 1523) and more overt expression of Rosso's individuality, which here seems perceptibly more mature – more sophisticated and controlled [80]. Yet the relationship between the picture and the precedents of classicism is deeper and more significant than in the *Pala Dei*. Rosso has found more complex resources of expression, and increasingly subtle and exact means with which to articulate them (it is likely, again, that he has looked with profit at Pontormo), and it is no longer necessary for him to speak in terms of exalted self-assertion or protest. More important than his admission of a classicizing structure in the *Pala Dei*, in the *Marriage of the Virgin* he concedes the virtue of the classical ideal of *grazia*. And he accepts the concomitant ideal of ornamental

value in the work of art: that which proceeds not only from grace of form but from a discipline of modulating colour. In the aspect of this new turn of style that involves *disegno*, Rosso's classical reference is not backward, as in the *Pala Dei*, but contemporary, to Michelangelo, and it is this reference that makes the most decisive alteration of vocabulary in the *Marriage of the Virgin*; his style earlier had been almost purely in the local dialect.[26] Obviously, these concessions, significant as they are for a reorientation in the *Marriage of the Virgin* of Rosso's style, are no surrender, but they are matter which has been fused at an essential level into the substance of his preceding highly personal new conquests. The result cannot, by any legitimate extension of the term, now be described as 'anti-classical'. What Rosso achieved in the *Marriage of the Virgin* is not so profoundly assimilative of theses given by the classical style as Pontormo came to be at S. Felicita, and thus may not justify the appellation 'dialectic', but in process and result it is akin to what Pontormo was to do in 1526. This style, too, is a foundation of the Florentine Maniera, and relates to it in temper and in form not less intimately than the style of S. Felicita. As the Maniera of Bronzino may be considered to derive from Pontormo's by restrictive processes, so the Vasarian Maniera might be thought of as a reduction made from this. Among the many facets of a new aesthetic that Rosso finds in the *Marriage of the Virgin*, one is of particular importance to the origins of Maniera: a definition more explicit than Pontormo had given up to this time of the new style's alteration of the classical ideal of grace – intensely precious and, as Rosso feels it with his pointed sensibility, so fine-spun that it is brittle and so exquisite that its sweetness is exasperated, taking on a savour of acidity.

For Rosso's searching, restless individuality the will to novelty takes precedence over any

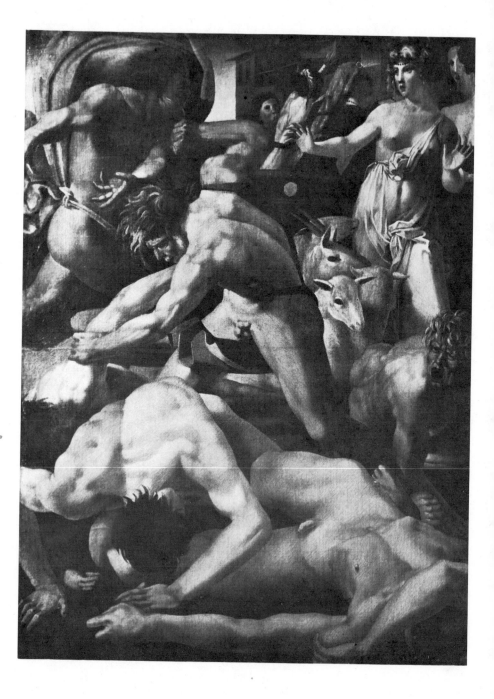

concern with consistency. In the *Moses and the Daughters of Jethro* (Florence, Uffizi, late 1523–early 1524) [81] Rosso relegates the mannered grace and the subtly distilled sensuality of the *Marriage of the Virgin* to the feminine and minor components of the picture, and exploits the subject's possibilities of violence instead. The interpretation of the theme must have been stimulated by a precedent with which, as theme, it has no compelling relation, the *Cascina* cartoon of Michelangelo. Rosso's conversion of his picture into a commentary on the Michelangelo is gratuitous, and it is an indication of his growing sense of a necessity for consultation with the master's art. But Rosso's reference is only in part direct; at the same time, the *Moses* is indebted to Pontormo, in a more specifiable way than his earlier pictures may have been: he has studied the design (Hamburg, Kunsthalle), itself inspired by the cartoon, which Pontormo made in 1522 or 1523 for a *Victory of the Theban Legion* for the Camaldoli,[27] and it is from this that the postures of Rosso's figures have mostly been compiled. But in contrast to Pontormo, Rosso's interpretation of the common source is more radically unclassical. He makes substanceless and faceted patterns of the anatomies and makes their violence of action virtually abstract, arresting it in a staccato, interlocked design.[28] The illustrative meaning of the actions and expression is quite sharp, but it is so stylized that it becomes the symbol to the intellect of the drama of the figures instead of the description of its human facts. The force of expression does not come from the congealed humanity but from the artist's transmutation of emotion into affects made by the manipulation of the picture's forms. These are consonant in their own tenor of abstractness with

81. Il Rosso:
Moses and the Daughters of Jethro, 1523–4.
Florence, Uffizi

the states of mind the figures show: the distinction lies in the power, and thus the primacy, which the communication made by form assumes. By his partial suppression, and indeed partial disassociation, of the picture's content of humanity, Rosso has set forth a principle that belongs to the repertory of the subsequent Maniera, and to which Pontormo would never entirely accede. The deduction Rosso has made from the *Cascina* cartoon is exactly in the sense in which its style could serve towards shaping the aesthetic of Maniera: of a demonstration made to post-classical art, by a classicism not yet wholly synthesized, of a primacy and intrinsic virtue that reside in form.

In 1524, when the recent election of a second Medicean Pope, Clement VII, promised renewal of grand patronage in Rome, Rosso[29] went there. He was to stay until the Sack in 1527. The Michelangelism that had taken increasing hold upon him in the last year or so in Florence was only a prelude to the effect on Rosso of the master's work in Rome. In the frescoes of the *Creation of Eve* and the *Expulsion* (Rome, S. Maria della Pace, Cappella Cesi, dated 1524) the consequence of exposure to the Sistine Ceiling has been almost altogether overwhelming, disorienting Rosso for the moment while he dealt with the trauma of his first experience of Rome. But more profoundly, the Cesi frescoes also represent a reorientation of Rosso's art in which he tries, as much as his personality and prior history permit, to come to terms with the authority of classical style, which confronted him in Rome as it did not in Florence. Not only Michelangelo's example has been taken into account but Sebastiano del Piombo's, and, equally important, the ideal of *grazia* that originates eventually in Raphael. The style of these frescoes is extravagant, but it is not an aberration: however incongruously, it reflects a preoccupation growing currently in Rome with synthesizing the art of Michelangelo and Raphael – extending, in fact, an

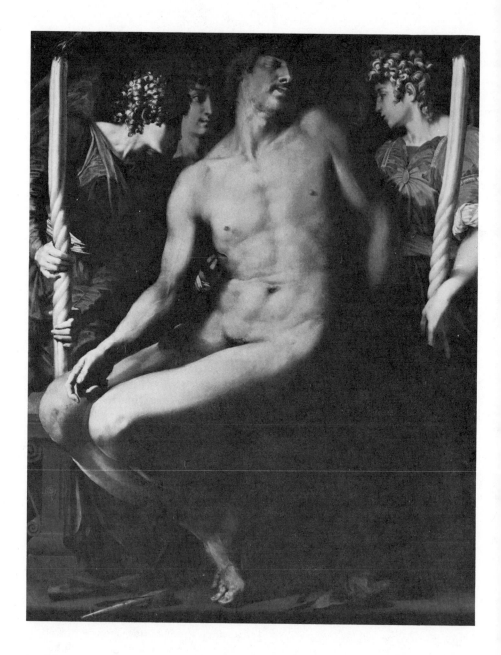

82. Il Rosso: Dead Christ supported by Angels, *c.* 1525–6. *Boston, Museum of Fine Arts*

aspect of Raphael's own concern in his last years. In the *Dead Christ supported by Angels* (Boston, Museum of Fine Arts, *c.* 1525–6) [82] Rosso achieved effectively what he had sought too abruptly and exaggeratedly in the frescoes. The *Dead Christ* is a fusion of the grand sculpturesque canon of Michelangelo and the deliberated ornamental grace that grows from Raphael's style; but these are fused in turn into Rosso's reasserted individuality, tempered by Roman experience but not basically altered in kind or diminished in its special and eccentric sensibility. There is a reconciliation, much more explicit than it had been in the Florentine *Pala Dei* or the *Marriage of the Virgin*, with the models of classical style and with some part of their ideas. The *bella maniera* of the classical masters has been studied with intelligence and some respect, but then has been extrapolated and exploited by Rosso to suit purposes that remain those, essentially, of his pre-Roman style: the Grand Manner has served Rosso in this work to create Maniera. Save for the special intonation of meaning which Rosso's psyche gives it, the *Dead Christ* is comparable to the most signal precedent for the Maniera in the contemporary Roman school, in the art of Parmigianino.[30]

The change that Roman experience has made in the *Dead Christ* is especially apparent in the way in which the pointed gracility of its closest resembling Florentine antecedent, the *Marriage of the Virgin*, has been tempered and made more deliberate, while a new and dominating role among effects of form is taken (in the body of the Christ) by full shapes and large, cursive rhythms. These relate to the classical vocabulary, but they are given an exaggerated grace, and in detail are exasperatedly refined. The elements that refer to classicism, and in particular the way in which Rosso's Christ insists on its relation to Michelangelesque precedents, serve to intensify the differences of Rosso's translation: in the design of form, in the affects it communicates, and in what it illustrates.[31] Even more in its psychological content than in its form, Rosso's image perverts the classicism of his exemplars, equivocating with brilliant irony – or effrontery, perhaps – between deference and outrage. The equivocation is not only between the authority of past artistic style and Rosso's individuality, but also seems to be between that individuality and the beliefs required by the Catholic religion. The theme that Rosso's picture illustrates is a vital dogma of the Church, one that especially in these years was the subject of defence against heretical assault. The palpable body of Christ, neither dead nor alive but eternal, is exposed to us on the altar, around which the angels are the acolytes; this is a demonstration of the Eucharistic miracle of Christ's real presence. But the presence here asserted to the senses is described with a sensuality that contradicts a value more essentially Christian than the specific dogma, and the sensuality is confounded with an aestheticism that seems more important than the picture's meaning of religiosity. The ambivalence in content of the theme is all the more remarkable when we recall that the picture was painted for the bishop of a major see, Leonardo Tornabuoni of Borgo San Sepolcro. The *Dead Christ* may reflect more than Rosso's private state of mind: it may be the most immediate evidence we possess of religiously as well as morally cynical attitudes within élite circles of contemporary Rome.[32]

The society from which Rosso could extract the matter for such an image suffered, in May 1527, in the Sack of Rome, a fate that must have seemed to some contemporaries as merited as that of Sodom. Rosso, gravely maltreated in the Sack, fled northward and settled for the next few years in the Aretine, in Arezzo and its neighbourhood. When he left behind the ruin of the ambience that had fostered his Romanized Maniera, he left something of the style as well. Perhaps the consequence of his

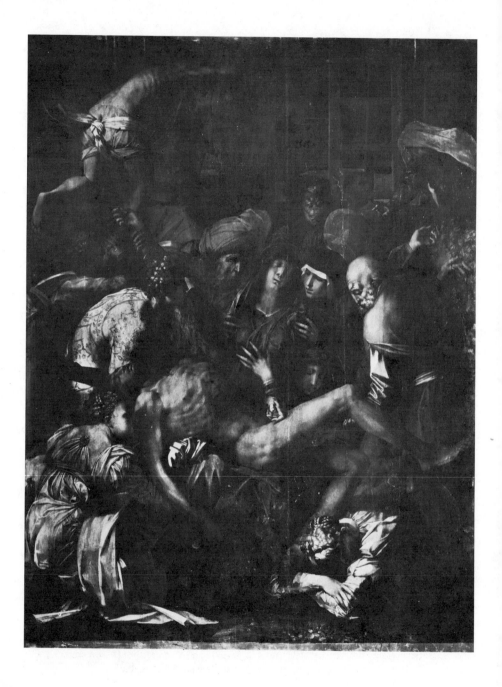

83. Il Rosso: Pietà, 1527-8.
Borgo S. Sepolcro, Orfanelle

experiences in the Sack combined with the given subject of the *Pietà* which Rosso painted late in 1527 and 1528 for the Orfanelle of Borgo S. Sepolcro [83] to give his interpretation of it a high-pitched passion, expressed in a vocabulary of etched and pointing forms that recalls the earlier Volterra *Descent*. What persists of Rosso's Roman manner has been altered towards the different tenor of this theme and used to make glittering passages of ornament, of a metallic brilliance. The expressive temper of the picture could not be strained to a higher pitch or complicated more, yet it is as if congealed at this point of extreme intensity. Its passion has been stylized utterly, and suspended in an equal stylization, surpassingly artificial, of form.[33]

The second large work that Rosso did during these few provincial years, a *Resurrection* (Città di Castello, Duomo, commissioned 1528 but not completed until early 1530),[34] is in a less exalted temper, but it is hauntingly oblique in mood, and of subtle, shadowed preciosity of form. The *Resurrection* has something of the introversion of a work conceived in provincial isolation by a temperament isolation did not suit. Rosso was rescued from it in the autumn of 1530 by a call to work in France for François I. Stopping in Venice on his way, Rosso made a drawing for his host, Pietro Aretino, of *Mars disrobing before Venus*.[35] The theme of the drawing, together with the identity of its recipient and his context of sophisticated culture, stimulated a recollection of the manner Rosso had used in his designs for mythological engravings in Rome, but he has infused this with the brittle brilliance of his re-won *Toscanità*, and with a higher stylization, elegant as well as precious, of the theme and form. The drawing attains the precise style that Rosso was to em-

ploy at Fontainebleau, and which would be the initial component of the French Maniera, that first and most important consequence of the dissemination of the Romano-Florentine Maniera beyond the boundaries of Italy.

The last decade of Rosso's career (he died in 1540) belongs to the history of art in France.[36] In Italy Rosso's historical place is difficult to assess. His genius was as extraordinary as Pontormo's, and the intrinsic value of his works is hardly less. His relation to the evolution of Italian Mannerism is parallel to Pontormo's, and his part in it more radical. The temperament that bred Rosso's radicalism, however, also made his art so personal and extreme that, despite the power of its invention and ideas, it lay towards the periphery of the main historical development. In Italy Rosso was not, as he was in France, the master of a significant school. In France there was no historical framework to which Rosso's art referred; it was his art that created it for the subsequent French sixteenth century.[37]

ROME, THE EXPERIMENTAL PHASE
OF MANNERISM

The School of Raphael

In Rome Raphael had come before his death to shape not only the dominating style of art but the economy of artistic practice. When he died, his school and shop (not quite interchangeable terms) continued for a while to control the Roman scene, working in collaborative enterprises like those in which the members of the school were formed, and according to directions of style they had found there. Two of the most important projects of the immediate post-Raphael years, the decoration of the Loggia of the Villa Madama (begun late 1520) and that of the Sala dei Pontefici in the Vatican (1521, and substantially completed then), are in effect

extensions of the ideas Raphael had conceived for the Vatican Logge and apartment of Cardinal Bibbiena. Giovanni da Udine, who had been Raphael's principal agent for the non-figurative matter of those schemes, was almost certainly responsible for the framework of design in the new ones, which sets the tenor of the effect they make as a whole. His collaborators – in the Villa Madama, Giulio Romano and Peruzzi; in the Sala dei Pontefici, Perino del Vaga – assert their individualities, and some elements of forceful novelty of style, in the figurative inserts they paint within Giovanni's schemes, but these make no controlling impress on the sum, which continues a major and, as it would prove, long-enduring strain of Raphaelesque decorative style.

A third major collaborative enterprise, the decoration of the Sala di Costantino (the largest of the suite of state rooms in the Vatican which Raphael had begun to paint in 1508), has a different relation to Raphael's legacy of classical style. Recent reconsideration of the older evidence, and some new evidence,[38] has made it explicit that Raphael himself must have been responsible for the invention of the basic idea of the decorative scheme (what Vasari (v, 528) called the 'partimento'), and that within the scheme he may have specified, in some detail, the design he intended for one major part, the depiction of the Battle of Constantine. The claim his garzoni made to Pope Leo just after Raphael's death, and which Sebastiano del Piombo (who for a moment hoped to succeed to Raphael's commission) reported, that 'costoro aveano e' disegni de mano de Rafaello',[39] must have been substantially correct, at least for the portions of the room the garzoni were prepared to execute first.[40] In one sense, therefore, our consideration of the Sala di Costantino belongs within that of Raphael's own art, not that of his school, in that its general scheme and some part of its actual form are accountable to him. Yet what was actually painted in the Sala was not begun until after Raphael had died, though within three months later. Half or more of the decoration was finished by the end of 1521; interrupted after Leo's death (during the brief reign of the puritan Adrian VI), work was taken up again after Clement VII's accession and finished wholly within 1524.[41] The development beyond the point at which Raphael had left his incomplete designs, and, equally important, their specific articulation in paint, thus fell to Giulio Romano, who also, after Raphael's death, had inherited the direction of his shop.[42]

From the evidence that survives of Raphael's own intentions for this room we can make only very insufficient generalizations about the character of what he would have wished done in it. The conception of division of the walls – simulated tapestries for the narrative scenes, framed by architectural thrones with figures of seated Popes and Virtues attendant on them – seems a legitimate extension of preoccupations that were recent in Raphael's art, and a characteristically apt solution to the problem of the given space. The system in general conforms to his late concern with devices of illusionism, and the design for the main fresco, the Battle of Constantine, extends the movemented and complex style he evolved for large fields of dramatic narrative in the Stanza dell'Incendio, which he had decorated not long previously. The archaeological accent of the Battle is also an extension of a growing interest of Raphael's, as in the Sala di Psiche and the Logge, though here it is apparent in a new way: it is not only illustrative of antiquarian details or suggestive of the imitation of antique statuary but structurally based in its entirety on the style of antique sarcophagi of comparable themes.

Had Raphael lived to complete his designs for the scheme and to supervise its execution – he would, in all likelihood, have been little more involved directly in the latter than he had

been in the other late decorations he conceived –the Sala di Costantino might have had a different character. The difference might have been one only of degree, but precisely of such degree as would have forestalled the crucial and profound change of style that Giulio effected here.[43] Giulio's articulation of Raphael's ideas had compromised their classical substance even when Raphael was there to watch; each gesture Raphael made that strained the synthesis of classicism was interpreted by Giulio in such a way as to accentuate the strain. Now free from Raphael's control, Giulio's own aesthetic emerged with new decisiveness, assuming an authority that supplanted Raphael's – not only in Giulio's inventions for those parts of the decoration for which Raphael left no certain indications, but in the transformation of what Raphael did leave. What Giulio achieved in the Sala di Costantino is the first statement on a grand scale of Mannerism in Rome. Yet it is in the nature of the history of the Roman classical style – so different in its consistency and accomplishment from that of Florence – that even in Giulio's decisive alteration of it there should be a confession of profound bondage to it also. Much more visibly than in the new style in Florence, each of Giulio's innovations has been made upon the basis of a property or a principle of Raphaelesque classicism. The relation to the classical style of these innovations – of extension of a classical principle or of a contradiction of it – can clearly be discerned. Giulio's Mannerism is of an ineradicably classicistic cast, and this is in far more than its obvious preoccupation with an illustrative archaeology. By comparison with what happens in the art of Giulio, the Florentine invention of a new style seems libertarian. The mode that he creates seems to be deduced by acts of almost schematic deliberation, as precise as they are daring, from the antecedent style. Because of this strictness of relation, Giulio's Mannerism contains, more

poignantly than the Mannerism of Florence, the sense of contrast and of ambivalence between classical and unclassical values.

Of matter in the basic decorative idea out of which classical practice (even that of the latest Raphael we know) would make complements, Giulio in this room makes stressed contrasts. By acts of emphasis and insistence already familiar in Giulio's earlier interventions into Raphael's ideas – but now much more assertive – Giulio exaggerates the separateness of parts, and sets them in contest with each other and with the unity of the whole. As he makes stress and contrasts he makes, in inevitable quantitative consequence, complexity also. Some of these complexities are only formal, but others are of a larger kind, of aesthetic concept or of illustrative idea. Among these is a complication of spatial levels so ambiguously interrelated and so multiplied as to leave no fixed plane of reference the spectator can grasp; and an exceptional diversity of figure-scales works with a similar effect. The actual medium, the fresco paint, almost nowhere admits to being only that. It simulates tapestry or architecture, and within the fictive tapestries pretends to the effects of sculpture; and at the same time that one art counterfeits another it pretends to make the most convincing counterfeit of actuality.

The levels of experience we are presented with are not only multiple but disparate, and they shift. The whole visual and intellectual situation is beyond ambivalence: it is a calculated multivalence, and its meanings are disjunctions or emphatic contrasts. It is as if the synthesis of classical style had been thrown into a centrifuge and its separated elements recombined, but into an opposite totality of which complexity and antithesis have become the motive principles. The effect of the whole room is of a vast organized commotion, which assaults the spectator and commands his involvement in it.

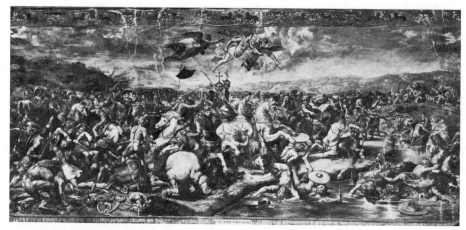

84. Giulio Romano: Battle of Constantine, 1521. *Vatican, Sala di Costantino*

85. Giulio Romano: Allocutio (Vision of Constantine), 1521. *Vatican, Sala di Costantino*

Within the compositions of the large narrative scenes, even in the *Battle of Constantine* (the *Battle at the Milvian Bridge* [84]), for which Raphael seems certainly to have left designs, Giulio's articulation is by principles that invert the sense of classicism. In the *Battle* and the *Allocutio* or *Vision of Constantine* [85], the two narrative frescoes painted wholly within 1521, the clear references to preceding works by Raphael serve to illustrate only more explicitly how Giulio has transformed what he inherited. In the structure of both frescoes an accumulation of movemented plastic forms is crowded in a rigid outline of no rationalizable geometry. This shape is as if clamped upon the forms, imprisoning their dense substance and their energies. Beyond the confines of this shape the contents of the frame are only loosely organized, dispersed in a contrasting openness. The figure style also contravenes its antecedents within classicism. The figures of the *Allocutio* and *Battle* are beyond all precedent in the sheer insistence in them of their plastic definition: their forms are as if excavated by the brush, not merely modelled, and their surfaces are polished to a brilliant hardness, in which precise and minute passages of detail are as if incised. The conviction of a substantial presence is more than had ever been conveyed in paint. But the human substance is observed as a still life rather than as an inhabited organism; and the recording of the observation is of disjunctive, not of organically related parts. The figures are deprived of the evidences of an inner energy and they are powerless to act (as they seem to do in Raphael) of their own will.

That the figures are deprived of their vitality as human agents is a sufficient index of Giulio's difference in a central point of principle from the classical style. He has evolved a new controlling principle to take its place, which is fundamental to the formation of what would become Maniera. He supplants the human vitality that has been lost by an intensely affirmed life of art; and in Giulio's case, at the beginning, the affirmation attains a force approaching violence. His images communicate a drastic power, not of illustrated human energy but of emphases imposed upon the forms and of the contrast of these emphases with one another.

The energy of art the forms convey is in the power in them of antithesis. One of the most eloquent of these, and the most encompassing in its meaning and effects, is the contrast between the urgency of existence in the images and the insistence in them on archaeological re-creation. There is a profound contradiction in this intention to assert on the one hand a present reality more pressing, and on the other an archaeological past more pervasive and exact, than were in Raphael's style. Even as Giulio protests to us that he has revived the ancient world more truthfully than Raphael, he demonstrates that the dream of its re-creation is a fallacy. But the still profounder contradiction that Giulio makes with his display of outward trappings of a classicism is in the assertion – to himself in part, as well as to his audience – that the classical style to which he had just put an end is not yet dead. It was a kind of truth, more valid for Giulio and the Roman school in general than for the Florentines: though the creative life of Raphaelesque classicism was ended, it had shaped the nature and ambitions, even in Giulio's inversions, of the succeeding style.

An altar by Giulio, the *Stoning of St Stephen* (Genoa, S. Stefano), which seems to be contemporary in design with the first campaign of decoration in the Sala di Costantino,[44] indicates the same processes of transformation of Raphaelesque precedents. In this case, however, where Giulio's main precedent is Raphael's *Transfiguration*, it seems differently evident how far Raphael had gone towards giving Giulio the style he here achieves, and

indicated the directions towards it. The dramatic theme of the *St Stephen* altar accentuates its resemblance in style to the first frescoes of the Sala di Costantino (to the *Allocutio* in particular); and one of the elements of likeness among these works conceived so soon after Raphael's death is the overstatement in the assertion of their novelty. The tone is appropriate to the first moments of entire independence of a personality like Giulio and to the way in which he would propose the terms of what is in effect a revolutionary experiment – a palace revolution, but no less unsettling on that account.

The two remaining narratives that Giulio designed for the Sala di Costantino, the *Baptism of Constantine* and the *Donation of Constantine* (both mainly painted in the campaign of 1524), are ceremonial rather than dramatic in theme, and the styles in which they are presented are not so charged as in the two earlier military scenes. The *Baptism* was entrusted to Francesco Penni for most of its execution, and while aping Giulio's new language, Penni has softened and diluted it until the impression in detail of the fresco, and even its manner of relating forms, are not to be distinguished much in style from the shop work of Raphael's own last years. But the underlying novelty of spatial scheme that Giulio proposed remains, exploring a new complexity of architecturally determined form, and relating this with pressing immediacy to the spectator. The *Donation* (in the execution of which Giulio's own hand is largely evident) also relaxes from the aggressive inventiveness of the earlier frescoes and recedes towards compromise with Raphael's style, but not to the extent that Penni has admitted in the *Baptism*. As in the *Baptism*, a principal novelty of style in the *Donation* is the manipulation of an architectural space, which however takes its starting point from the *Fire in the Borgo* (on the figure repertory of which Giulio has also drawn). Giulio's space extends the idea of its precedent,

creating an exaggeratedly swift, uninterrupted penetration into distance, of which the effect is at once intensified and contained by a stringent rectilinearity in the architecture: even as the energy of space is affirmed, it is contrasted against the forms that shape it. (This may be the first explicit instance of the device that German art historians describe as the Mannerist *Raumflucht*).[45] The figure composition conforms basically to the structure laid down for the space, departing from it only to make discreet ornamental variation. The figures lack drama in this ceremonial scene, but a content of drama is in it none the less, supplied by the forms invented for the setting.

In the actors of the *Donation* Giulio seems concerned to express a quality of refinement and considerable ornamental elegance; these are absent from the military narratives of 1521 and, indeed, might have been thought inappropriate in them. The varieties of cursive patterning that, for the most part, make the effects of ornament evoke the Raphaelesque vocabulary for expressing *grazia*, but only in a significantly altered way. The *grazia* these figures have is congealed, an ornament imposed on an arrested statuary form. It is not a function of a Raphaelesque synthesis but a quality isolated and abstracted from it as a formal value and as an index of a state of mind. But in this altered form the ideal of *grazia* is a continuing major factor in Giulio's art, to be expressed whenever the thematic circumstances would allow. It is primary in the two major devotional pictures of the latter moments of Giulio's post-Raphaelesque Roman years, the *Madonna della Gatta* (Naples, *c.* 1523) and the altar of the *Holy Family with St Mark and St James* (Rome, S. Maria dell'Anima, *c.* 1524) [86]. The Madonna of the Naples picture is precious and ornate beyond the precedents of Raphael, or of Giulio's Raphaelesque *Madonna della Perla*, and of a shadowed sensuality. This exposition of a complex sensibility resembles that of the contem-

86. Giulio Romano: Holy Family with St Mark and St James, *c*. 1524. *Rome, S. Maria dell'Anima*

porary Florentines, but the sensibility is of a different kind, not so private, and reflecting the more mundane sophistication of the Roman society in which it was formed; and there is a temper of morbidity in it. But Giulio's transmutation of the classical ideal of *grazia* is not unlike Rosso's in his *Marriage of the Virgin* of the same time; like Rosso, Giulio achieves subtlety, difficulty, and extreme refinement all at once, and makes it explicit that these are the effects of high artifice.

The temper of artificiality is still more evident in the altar of S. Maria dell'Anima, where the Madonna is a confluence of paradoxes – most conspicuously between Christian convention and antique archaeology, and between sensuality and stone. Conflicts are congealed within her brittle elegance. The saints are not so precious, but they are more abstracting in form, and almost altogether vacant of any emotion that might be supposed to motivate them. The structure of the altarpiece is a brilliantly inventive set of contradictions, generating a multitude of affects, which are either irrelevant to an expression of religiosity or subvert it. The religious subject matter has been taken by Giulio as if it had no ethical content but only the value of a convention, which he may take as the occasion for an aesthetic construction inhabited by an aestheticized humanity.

The Anima altar seems symptomatic of an attitude towards the significance of religion that must have been held by a considerable fraction of the Roman élite of this time. It is not an attitude so extreme as in Rosso's *Dead Christ* of the year or so following – Giulio's picture need not be interpreted as a document of perverting scepticism but only as a demonstration of indifference towards the values that Christian religion is traditionally supposed to represent. For Giulio the values of aesthetics, and of an aestheticized society, have assumed their place.[46]

In October 1524 Giulio, acceding finally to the repeated requests of the Marchese Federigo Gonzaga, left Rome for Mantua, where he was to assume a role which, despite the smallness of the place, would be as significant as that he played in Rome, and grander in the scale of his eventual accomplishment. What remained of his Roman *bottega* and its various unfulfilled commissions fell, by a combination of default and seniority, to Francesco Penni. Even before Giulio's departure, however, there was one collaborative enterprise in the execution of which Penni played a leading part. This was an altar for the nuns of Monteluce near Perugia (Rome, Vatican Museum), for which the commission had been given to Raphael as long ago as 1503, and reconfirmed in 1516. The altar represented a compound subject, the Assumption and Coronation of the Virgin – iconographically unusual, but with a precedent in Raphael's own early œuvre – and its design was based on drawings left behind by Raphael.[47] Both the precise articulation and the execution of the Raphael ideas were shared out between Giulio and Penni, but the execution seems for the most part the Fattore's, and the lower half of the panel is expressly his. For this part of the picture Raphael's notion had contained a strong element of drama, related to the lower part of the *Transfiguration*. On this dramatic matter Penni has performed an operation that resembles Giulio's controverting of the evidences of energy, but there is a basic difference: for Penni the figure has no energy to begin with. As he formally imitated the outward aspect and the obvious mechanics of Raphael's style, so he now follows Giulio's. Penni's vacancy of meaning is compounded by his chill, licked lifelessness of surface and his mindless labouring of detail.

The most ambitious project that Penni undertook after Giulio's departure was the supply of designs for a set of tapestries of the

life of Christ, commissioned by Clement VII in October 1524 for the decoration of the Sala del Concistoro in the Vatican (Rome, Vatican Museum).[48] For this extensive series Penni exploited, with adequate appropriateness, a whole treasury of sources in the œuvre of Raphael, and at the same time – curiously, in Giulio's absence – he is also more literal and more successful in his approximation of Giulio's style. However, there is no motive in Penni to effect a consistency of style, even one imitated from Giulio: he can distinguish even less than before between accident and principle. Where his style resembles Giulio's new Mannerism it is in accidentals, but the resemblance is enough to give his work, in general, the flavour of post-Raphaelesque modernity.

We do not know the reasons that induced Penni to leave Rome in 1526 – perhaps he had contracted, too deeply to change it, the habit of dependence – but in that year he went to Mantua, seeking to renew the former partnership with Giulio. Giulio apparently found the prospect unwelcome. Vasari says that Penni was 'poco accarezzato' by his ex-associate, and soon departed. He travelled to Lombardy, returned to Rome, and then (before the Sack) moved to Naples. No work from the time following the visit to Mantua survives. He died in Naples, aged about forty, in 1528 or shortly thereafter.

Perino del Vaga

Perino del Vaga (born Piero Buonaccorsi in Florence *c.* 1500–1) had been recruited into the Raphael *bottega* in the master's last years, as an executant in the decoration of the Logge, and he had learned the Raphael style in the beginning from Giulio's – and Penni's – transcriptions of it more than directly from Raphael. Yet Perino's art evolved in a relation to the style of Raphael that was less critical (in both senses

of the word) than Giulio's, and more consequential to the later development of Roman painting. Perino's first education had been Florentine, in the conservative atelier of Ridolfo Ghirlandaio.[49] It was only towards 1516 or 1517 that he made his way to Rome, in the company of a painter called Vaga, from whom he took the name by which he was subsequently known. Some time in 1518 he joined the executants working in the Logge, and a significant share in the painting of the later bays came to be assigned to him. It is doubtful whether he was permitted to invent his own compositions, but he certainly developed the initial ideas that were given him, and his way of articulating the designs quickly took on a character special to Perino among the artists of the Logge, assuming to a degree that has no counterpart so far among them a dominating quality of movement. He reflects a measure of Raphael's (or Giulio's) narrative and dramatic sense, but he is much more concerned to make the scenes he paints vehicles of an assertive grace. The same attitude appears in what seems Perino's first independent work in Rome, a fresco *Pietà* (S. Stefano del Cacco, *c.* 1519),[50] derivative in its chief motif from the obvious Michelangelo, but more dependent upon Raphaelesque style. The subject matter does not much affect a preference, perhaps even at this point a principle, that sees the major function of the work of art as the communication of fine effects, psychological as well as aesthetic: the first role of art is, above all, ornamental.

The S. Stefano fresco is an immature work, but it indicates the transformation Perino was to work upon the Raphaelesque classical style. Rather than a deduction from it, it is (like much of what is in Giulio's art) an extrapolation, in which Perino isolates an aspect of the classical synthesis, its ornamentalism, to become a dominant of style. Perino had left Florence just before the first subversions of

classicism there, but in Rome, close to the same moment as Pontormo and Rosso in Florence, he indicated a main direction of post-classical development. It is one which, as Perino came to extend it, was to have yet more historical effect. However, the formal basis of this novelty, its fluidity of pattern, was by no means Perino's sole invention within the Roman school. Contemporaneously, Giulio and Penni in their narrative scenes in the Logge, and Peruzzi in the Sala delle Prospettive even before, had evolved a comparable mode, but one distinct from Perino's in that their motive was to increase efficiency of narrative as well as the effect of ornament, not just the latter. The meaningful content of Perino's frescoes in the Logge is their gracile form.

This style that Perino evolved with such precocious rapidity in the Logge is explicitly identifiable in its premises with the style we recognize in a later form as that of the Maniera, and, as Perino himself developed what he propounded in the Logge, his results were to become a major one among the Maniera's models. More than other varieties of post-classical style, his model was more nearly imitable – more nearly possible to 'far di practica': aesthetically engaging, intellectually facile, and emotionally unproblematical. Unlike Giulio's powerful inversion of the meaning of the classical style, Perino's art seems an easy transmutation of it, taking its decorative capital only, elaborating it, and converting its humanity into ornament.

The basis of Perino's mature style was thus established as early as 1519, and with it a proposition of what was to become the Roman Maniera, but Perino's assimilation into Raphael's school involved him at the same time with wider problems of new possibilities for art that Raphael's example and inheritance had generated. Until the time shortly following the Sack, when Perino left Rome for Genoa, he participated in experiments of style almost as

diverse as Giulio's (though never so radical or profound) and not less inventive than those of his other chief contemporaries in the line of descent from Raphael, Polidoro and Parmigianino. We recall that in 1521 Perino was engaged with Giovanni da Udine in the decoration of the Sala dei Pontefici in the Vatican. Most of the figured insertions are Perino's contribution, painted with a vibrancy of touch and a controlled draughtsmanship that fulfilled the promise of his latest paintings in the Logge. His main group is in the centre of the ceiling of the Sala, in a simulated oculus above which four angel-nikes seem to hover in an open sky [87]. The effect is brilliantly illusionistic, referring to a major interest of the later Raphael, but exceeding Raphael's self-imposed classical limits in audacity and in apparent verity. The first impact of an optical conviction remains even when, in the moment that instantly succeeds, we see that the angels are creatures of unlikely artifice, and that their anatomies and draperies are the matter of a purely ornamental patterning of form. The evolution of this pattern, involved and gracile, is more important to the painter than the point of plausibility. He has created a calligraphy on a grand scale that has an independent virtue. It is inescapable by now to the Romanized Perino that, as with his colleagues in the school, his vocabulary should be classicistic, and that this idea of beauty should depend – even in this Mannerist transformation – on forms derived from the antique and from Raphael. However, it is not a motive in his Roman education but a sensibility of Florentine origin which impels this transformation to be into a draughtsman's grace.[51]

Like Giulio's experiments, Perino's used as their point of departure precedents afforded by products of the classical style; but Perino's way of dealing with them was more sympathetic. His reference was more dependent and his developments from them less radical in their

87. Perino del Vaga: Oculus, 1521. *Vatican, Sala dei Pontefici*

effect. His frescoes of the main salon of the Palazzo Baldassini (c. 1522)[52] are based on ideas found in recent classical schemes of decoration, conspicuous among them the Sala delle Prospettive of Peruzzi and Raphael's Sala dei Palafrenieri. However, it is not unlikely that the temper in which Perino has interpreted these sources has been influenced by the first episodes of painting in the Sala di Costantino. The principal element of Perino's scheme, life-size ancient philosophers who sit or stand, singly or in pairs, in fictitious architectural enframements on the wall, develops the illusionism of its source in the Sala dei Palafrenieri with an assertiveness of plastic substance and an energy that compare with the Papal groups of the Sala di Costantino. Perino's philosophers suggest, still more than Giulio's groups, a questing towards resources like those of a baroque style. Yet their power of movement is expressed in patterns of great rhythmic elegance;[53] and in the scenes of ancient histories in Perino's frieze his calligraphic patterning exceeds any precedent. Far beyond the mode he had found in the late scenes of the Logge, he makes these narratives dense and complicated, elaborating the design in charged convolutions that invade the whole picture field, and refining shapes and attitudes of figures towards an artificial grace.[54]

Rome was beset by plague in 1522, and Perino returned to Florence, hoping to take refuge in his native city. His stay was relatively brief (he was again in Rome in 1524), but excited considerable interest in the Florentine artistic community. Vasari reports (v, 603-4) the curiosity of the Florentines to discover the 'differenza [che] fusse fra gli artifici di Roma e quelli di Firenze nella practica', and their concern to see the 'maniera di Roma'. As Vasari construed it when he wrote, this response[55] indicates that there was an awareness not only of the distinction between the Florentine and Roman styles, but of the recent novelty to which the Roman manner had attained. The

demonstrations Perino made in Florence of his 'maniera di Roma' are most self-conscious in their Romanism, and lean with a heavy classicistic emphasis on the style of Raphael and his treasury of motifs, and on Giulio also.[56] It is frequently assumed that these works must have affected the course of the post-classical development in Florence, but no sure evidence survives for this. What is certain is that, on the contrary, Perino learned from the Florentines, and incorporated not only motifs but essential factors of their advanced contemporary style into his Roman art. The indication of this is in his frescoes of the *Life of the Virgin* in the Pucci Chapel in the Trinità dei Monti, Perino's major work of the few years after his return to Rome. The dating of the beginning of the decoration is a matter of much critical dissent,[57] but the evidence of style in the paintings of the vault as well as in the two lunettes below that are by Perino suggests that not only the latter but the vaults also are not earlier than 1523 in their design. The lunettes explicitly confess a Florentine experience: the smaller one, with *Faith and Charity*, depends on Perino having re-seen Pontormo's early fresco on the façade of SS. Annunziata; the large lunette of the altar wall, a *Visitation* [88], borrows liberally from Pontormo's *Visitation* in the atrium of that church. The references to non-Roman models in the frescoes of the vault are more oblique, but in figure style and manipulation of perspective space they contain elements that have no antecedents in Perino but which do exist in Rosso (as in his *Marriage of the Virgin* of 1523), and perhaps more identifiably in the work of the Sienese Beccafumi. The vault frescoes[58] have an accent like that of the new Tuscan Mannerism, more febrile and eccentric than the Maniera that evolved in Rome.

This foreign flavour is less in the lunettes. Despite the explicitness of borrowings from Florence, the larger structure of the *Visitation* depends (as before in the frescoes of the Palazzo

88. Perino del Vaga:
Apostles; Visitation, after 1523(?).
Rome, SS. Trinità dei Monti, Cappella Pucci

Baldassini) on precedents in Raphael and Peruzzi. Perino has not wholly resolved his diverse sources into a consistency of style. Nevertheless, the entire fresco exhibits an extraordinary energy: it drives the figures to extravagantly fluid posturings, and strains the perspective of the setting to create recession into depth of space. A visual (as well as iconographic) prelude to the *Visitation* is on the outer arch face of the chapel, on which two gigantic Prophets recline – the most brilliant illusionist exercise in post-Raphaelesque Rome.

What is important in these figures, even beyond the wit with which Perino develops their classical antecedents, is the nature of their relation to them. Their sources lie in Michelangelo's Sistine Ceiling and in Raphael's Chigi Chapel in S. Maria della Pace; this is obvious, and so meant to be. But it is also obvious that Perino's figures mean to fuse the styles of their sources, and do so not by an additive compounding, but by means of an aesthetic energy so compelling that it can synthesize a grandeur and expressiveness which stem from Michelangelo with a Raphael-derived grace. Power and *grazia* are fused to that degree where each quality partakes of the other, yet essentially it is the grace that subsumes the power. The amalgam has a refinement of temper and an artificial elegance of form that is not in either of its sources; it is infused with a different, Mannerist, sensibility.

There is no certainty for the date we think appropriate to the Prophets of the Pucci Chapel, but they seem to be of 1525 or 1526, later than Perino's *Visitation*. They show a command of the complex possibilities that Perino's past experiments had explored, and a consistency of style finally deduced from them, that indicate an attainment of maturity. Perino has accomplished a process of self-definition, but it is at the same time a definition of a style in a larger sense, of the new Maniera that the advanced artists of the Roman community of these years were seeking. His reconciliation of the two great classical exemplars and his transformation of them into the mentality and vocabulary of a post-classical Maniera resembles what Rosso did in Rome about 1525, and even more resembles the contemporary Roman accomplishment of Francesco Parmigianino.

These three painters were in close contact in the years between 1524 and 1527, and visual documentation exists to attest the interchange among them of ideas. The evidence that survives indicates that it was the youngest of the three, Parmigianino, who came very soon after

his introduction to the Roman scene to be a principal giver. Perino's vocabulary, already much like the Parmesan's, grew more like his in consequence of the latter's commandingly facile, single-minded demonstrations of a new Maniera, which were multiplied ceaselessly by this most compulsive of all sixteenth-century draughtsmen. By late 1527, in his designs for engravings by Caraglio of the *Loves of the Gods*,[59] Perino had adopted Parmigianino's elegantly unreal figure canon, purifying and attenuating his own, and had further stylized his own caprice of ornament according to Francesco's model. And, as important, Perino took from Parmigianino his clarification of a principle of structure which Perino's own Raphaelesque inheritance, with its concern for plasticity of substances and space, had hitherto completely obscured: the principle of the dominating role of surface pattern in a design. Another influence was joined to Parmigianino's in these prints: Giulio Romano's.[60] From Giulio Perino took the character, so specifically Roman, of an archaeologizing crystalline statuary into which the actors in these prints have been transformed. On the eve of Perino's departure for Genoa, the Maniera he was to practise had assumed its distinctive accent.[61]

Parmigianino

When Francesco Mazzola of Parma arrived in Rome in mid 1524 he was already the master of a style that accorded in essentials with the Maniera that was evolving there. He had been as precocious as Perino in his statement of the principles of the style: by 1521, when he was eighteen years of age, he had painted a large altar for S. Maria at Bardi, a *Marriage of St Catherine* [89] in which the exposition of an identifiable Maniera is both narrower and more explicit than that in Perino's initial efforts in the Logge. On a basis taken in the classical moment of Correggio's style Parmigianino has imposed

the conception that the function of art is to convey exquisite and excitant sensation, to achieve which he may take the liberty of re-shaping appearance as artificially as he may require, and of translating – or diminishing – the content of his given subject into consonant expressive terms. In the Bardi altarpiece meaning resides in the energy of complex grace that the forms achieve, and the content of the actors is in accord with this aesthetic end and no more than this end will allow. Though Parmigianino is not yet even in possession of a consistent vocabulary, his essential conception of a style is remarkably clear, all the more so from its single-mindedness, and the result of that con-

89. Parmigianino: Marriage of St Catherine, c. 1521. Bardi, S. Maria

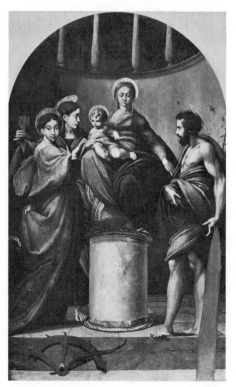

ception is to reshape the precedent given him in Parma by Correggio's classical style into a post-classical Maniera. The process by which he arrived so quickly at this end is not clear, though, as in Perino's case, it is ultimately determining that there was a disposition to extrapolate, from the classical example each confronted, those elements which made orna-ment and grace. Given this common disposi-tion, it is not so surprising that the styles of the two young artists should resemble each other as they do (even, occasionally, in details of vocabulary); for despite his different geogra-phical origin Parmigianino had, always by in-direction and at a considerable remove, an education in styles of art that was roughly analogous to Perino's. Francesco's earliest known mode, preceding that of the Bardi altar, had been shaped by diffusions from the art of Umbria[62] and after 1520 his absolute exemplar was Correggio, newly settled in Parma after his return from Rome with a style profoundly affected by Raphael and Michelangelo; Correg-gio thus stood to Parmigianino as a substitute for the direct formative experience which Perino had enjoyed of Roman style.[63]

Francesco's assimilation of Correggio's classicism and his transformation of it into Mannerism must have been almost simultane-ous. Correggio himself was not content to rest within the limits prescribed by Roman and classical experience, and as he sought reaches of expression that verged towards a baroque style Parmigianino followed him in this direc-tion, comprehending at least his formal objec-tives more clearly than any other painter of the region. Parmigianino's absorption from Cor-reggio (and from Pordenone also) of ideas of an art that affirms itself in illusion was not allowed to conflict with the development of the orna-mental function of art that he had already con-ceived. For the few brief years while Francesco continued to reside in Parma he was able to effect a fusion between themes of illusion

inspired by Correggio and his own accentuated grace. He tended to translate Correggio's models of illusionism into more decorative and abstract intellectual conceits, but the vitality of illusion that he thus diminished was replaced by a vitality of graphic language. We have observed that his results resemble the exactly contemporary experiments in which the new *grazia* and effects of illusionism were conjoined by Perino in Rome, but Francesco's results are more dominated by their character of ornament, and they are more explicit in their temper of Maniera. A chief example of this phase of Francesco's work is his decoration, with the legend of Diana and Actaeon, of the *salotto* in the Rocca of the Counts San Vitale at Fontanellato (1523). In the framework of an illusionistic arbour based on Correggio's precedent in the convent of S. Paolo, Francesco developed a conceit of illusion as ingenious as any of Correggio's, but combined it with patterns of charged fluidity woven on the figures. An atmosphere of refined sensuality, lighter, more precious, and more private than Correggio's, emerges from the decoration of this room; it falls in temper between Perino's Roman decorations and Pontormo's at Poggio a Cajano.

For Francesco, the direct experience of Rome was the catalyst for his complete maturing of a post-classical Maniera. His contact there with his contemporaries[64] gave him the knowledge, both comforting and challenging, that they were embarked on a course resembling his own. Still more important, coming to know the classical art of Raphael and Michelangelo directly, rather than through the medium of Correggio, served to clarify the sense of the Maniera that was deduced from it; and in the direct experience of the great classical exemplars lay the revelation of the vast resources and high ambition possible to art. The accent of Francesco's preceding education in Correggio's style was not displaced wholly.

Motifs remembered from Correggio persist, as well as a measure of his kind of optical sensibility and the technique that records it, and there is a continuing temper, like Correggio's, of vibrant sensuousness. But Parmigianino's main allegiance shifted, seeking an assimilation of the styles of Raphael and Michelangelo and a compounding of them (as a programme, when we include the residue of Correggio, this is not unlike the prescriptions of an early-seventeenth-century eclecticism). Francesco's drawings document his study of the classical masters, and there is more evidence of his reference to them than to younger colleagues. But no less than in his earlier relation to Correggio, each reference was a matter to be transformed – or rather, in this artist of such explicit stylistic will, exploited to the ends of that will. He painted relatively few works while he was in Rome, but he drew ceaselessly, and the fluency and single-mindedness of style in his drawing helped his contemporaries to give their Maniera clearer shape.

The latest of Francesco's Roman paintings, a large altar of the *Vision of St Jerome* (London, National Gallery, 1526-7) [90],[65] summarizes the results of Francesco's Roman experiences. It marks not only the development to maturity of Francesco's personal maniera but a maturing of Maniera style. The dimension of its actors and their expansiveness of form and movement are inspired from the art of Michelangelo, but as in Perino's efforts of the moment and in Rosso's this Michelangelesque power is infused into a dominating grace. In Parmigianino's case the *grazia* is not the consequence of his Roman studies of the art of Raphael; however, his own ideal of grace has been tempered by Raphael's models and given a new breadth and masculine authority. From both classical exemplars Parmigianino has acquired a larger conception of the ambitions of his art, seeking grandeur of appearance and nobility in the demonstration of his theme, and inspiring the artificial beauty

derives from the intensity and quick, mannered, fineness with which aesthetic sensation is experienced, and the emotion that has been allowed the actors is of a concordant kind. Though they are projected in a new magnitude they are still an aestheticized humanity. The ultimate meaning of the altarpiece is its power of aesthetic artifice, of which it is the most commanding statement of these years in Rome. The articulation of principles of style so clear, in a vocabulary so consistent and precise, defines Maniera with an authority unlike that of any work in Rome before. As Parmigianino continued in his post-Roman years to expound this vocabulary formed in Rome, it was to become the most widely disseminated and the most influential basis for Maniera in the art of others.

The historical place of the *Vision of St Jerome* is like that of Pontormo's *Deposition* of S. Felicita, of exactly the same time, and there is far more, in form conspicuously, that makes them similar than makes them different. Pontormo deals with a far more complicated problem, involving the distillation of the most poignant human feeling within artifice of form; Parmigianino excludes from his humanity to begin with all emotion that is not consonant with artifice. But in its distillation, Pontormo's feeling is a sensibility as subtly precise as Francesco's, and even anguish in Pontormo has become exquisite. Pontormo's initially different relation to emotion in his actors makes his *Deposition* a picture of profoundly Christian content, and Francesco's altar seems by contrast to have no specifiable Christian sentiment. Like Giulio's painting of two or three years earlier in S. Maria dell'Anima, the *Vision of St Jerome* seems to demonstrate an attitude in Pope Clement's Rome towards belief that is virtually indifferent to the accustomed values of a Christian devotion, willing to take the symbols of religion and its dogma only aesthetically and as matter to be exploited towards

90. Parmigianino: Vision of St Jerome, 1526–7.
London, National Gallery

that his *grazia* makes with an energy that resembles passion. His art is now as eloquent as it is elegant. Yet the passion is not an emotion about the subject matter of the picture so much as it is an emotion about art. Its excitement

aesthetic aims in art. Yet, though there is no overt religiosity in Francesco's altar, there is a high and intense spirituality in its very aestheticism, and this is in effect a private substitute for the devotion that the Roman Church of Clement's time could not command from individuals of Francesco's sophisticated and questing stripe. The spirituality of such individuals might choose uninstitutionalized ways to express itself, and in this time of scepticism the making of aesthetic experience in art became an important one among these ways.

Polidoro da Caravaggio

Time has dealt more drastically with the accomplishment of Polidoro da Caravaggio than with that of any other major artist of this period, but it is clear that his achievement was the most considerable in quantity of the years in Rome between the death of Raphael and the Sack, and that in quality it rivalled Giulio's, Parmigianino's, and Perino's. Polidoro was not more intellectually inventive than Perino, but emotionally he was of an altogether different constitution. He was involved in the human feelings that art could generate with an immediacy unlike Perino's and he felt them with a different power. Where Perino's considerable energies were devoted chiefly to the achievement of aesthetic effects, Polidoro's, wider in their scope as well as more intense, found outlet in ideas and feelings ranging from impassioned grandeur to the privately bizarre. We must use the appellation 'romantic' with much caution for a sixteenth-century artist, but in Polidoro's case it makes a partial sense and helps to suggest the atmosphere his art attains. Among the Roman inventors of the Mannerist style, he most nearly suggests analogy with the Florentines, Rosso and Pontormo, in his involvement with the humanly expressive factors of artistic style and in the singularity and intensity with

which he seeks them out. However, the eventual direction of Polidoro's development was the inverse of that of the Florentine Mannerists. They emerged in time from unclassical beginnings to a temper and vocabulary like those of the Maniera. Polidoro, in the years before the Sack, evolved the most fluent of post-Raphaelesque *maniere*, but afterwards, in the ensuing decade and a half of his career in Naples and Messina, turned to a style that was increasingly divorced from his former classicistic vein. The cause of the change was not only his removal from a classical environment; it was temperamental.

Born about 1500 (his name implies in the town that was to be the birthplace of Michelangelo da Caravaggio), Polidoro may have had no prior training in art when he was employed to begin with as a plasterer in Raphael's Logge. By the later stages of that enterprise, however, he was entrusted with the painting of the narrative frescoes in at least one bay, where he may be identified as the possessor of a mode formed basically, like that of his colleague Perino, on the model of their foreman and contemporary, Giulio. His difference from Perino results from what is at this point an almost uncontrolled surcharge of energy that he imposes on the matter given him; his art is as yet almost unstyled, at least in the sense of the developed artifice of design that Perino already demonstrated. Of provincial origin and less artistic education than Perino, Polidoro required more exposure to the art of Rome in general, and to that of his contemporaries in the Logge school in particular, before he acquired the disciplines of the classicizing style.[66] The earliest among Polidoro's surviving paintings that postdate his employment in the Raphael shop are the remnants of a badly damaged decoration of the Cappella della Passione in S. Maria della Pietà in the Vatican (probably 1522), more highly personal than his scenes in the Logge but still not in an entirely consistent mode. About 1523,

and probably until Giulio Romano left Rome, Polidoro seems to have renewed his former connexion with his old foreman, painting for him in the grisaille *basamenti* of the Sala di Costantino and in the fresco ceiling (now detached and installed in the Palazzo Zuccaro) of the main salon in the Villa Lante, of which Giulio was the architect and the supervisor of the decoration. By this time, however, despite evidence of a continuing dependence upon Giulio, Polidoro's Lante frescoes give brilliant evidence of the emergence of a formed personality.[67]

Earlier than this, Polidoro must have made his first partly independent essay in the genre of decoration for which, after 1524, he was to achieve a special fame, the painting with monochrome ancient histories of whole palace façades. Before 1522 he painted the façade of a house near S. Silvestro al Quirinale, in company with his associate Maturino and in collaboration with Pellegrino da Modena, who had been an older but inconsequential col-

league in the Logge corps; Pellegrino returned to his native city in that year. Their precedent and inspiration, as Vasari reports (V, 142) quite correctly, were Peruzzi's façade decorations of the previous decade. When Polidoro attained his own full independence and maturity, he enlarged what Peruzzi had done into a wholly new dimension of development. The visual recreations that Polidoro made of Roman histories, unfolded in vast panoramic friezes across the façades of the dozen Roman palaces he painted between 1524 and 1527, must have been among the grandest splendours added to the city in the brief but fertile span of Clement's reign before the Sack. Most of them endured into the following century, but as exterior decoration they were necessarily ephemeral. Of all Polidoro's façades only one, the relatively early decoration of the Palazzo Ricci (*c.* 1524–5), exists in a state that can convey some sense of its original effect [91], though even this is a remaking of a nearly vanished work. The other decorations (among which the chief were those

91. Polidoro da Caravaggio: Façade, detail (restored), *c.* 1524–5. *Rome, Palazzo Ricci*

of the Gaddi and Milesi Palaces, both *c.* 1527) are no longer visible, but the designs are largely preserved in prints and drawings, including some of Polidoro's own studies.

From what survives, as on the Palazzo Ricci, and from other evidence, we can adequately assess the character of Polidoro's decorations, but we can only partly take the measure of the great accomplishment they represent. He created his façades with an extraordinary apparatus of learned reference to the visual as well as the literary survivals of antique Rome, simulating on the modern architecture the effects of encrustation with antique niche-statues and reliefs. The density of his designs, as well as their rich archaeological matter, is paraphrased from antique relief sculpture, but their vitality exceeds that of the ancient models. Polidoro's response to his themes is inspired by a power and excitement that take the outward form of teeming copiousness and variety. He infuses the ancient matter with an energy that revivifies his archaeology and makes it actual: Polidoro's recreations of an antique world become the opposite of Giulio's petrifactions of it. Polidoro's actors are arranged in postures that show the utmost deliberation of effects of *grazia*, but they move with a compelling power and uncoil, spring-like, a plastic force which is discharged into the swift flow of composition in a frieze.

The fusion between power and grace, and the self-conscious stress of *grazia*, are in the contemporary vein of Perino and Parmigianino, and Polidoro's emancipation from Giulio's example of an archaeological style must be indebted to the former, and perhaps to both. Yet Polidoro's innate energy was more masculine in kind than theirs, and his will to make refined aesthetic ornament was less. More than his colleagues in the new Maniera, he remained engaged with the emotions his themes generate. In the compound that results in his façades of narrative with formal powers their style is

related, more than Perino's or Parmigianino's, to an essential principle of classicism, and still more recognizably than theirs appears to have grown by extension from the Raphaelesque style.

For all the difference that there came to be between Polidoro's mode and Giulio's, it must not be forgotten that Giulio's example was the most influential of the factors that first formed Polidoro's art and shaped his interests. In addition to the vein of archaeology in Giulio, it was in his painting that Polidoro found the first source of landscape style on which he made an extraordinary development. Giulio's landscape style had been inspired at least partly by experience of ancient Roman painting in the genre; still more studious than Giulio of antique examples and more direct in his emotional responsiveness to them, Polidoro conceived a translation of antique models into a modern style that is one of the most remarkable innovations in landscape art. About 1525, in the chapel of Fra Marino Fetti in S. Silvestro al Quirinale, Polidoro painted laterals that illustrate the lives of the Magdalene [92] and St Catherine of Siena. Both scenes approach the character of pure landscape, in which the narrative figures are reduced to the scale – though not at all to the meaning – of what later would be called *staffage*. This idea, new to modern Rome, and the forms of topography and of architecture are eventually inspired by ancient painting, and so is the technique – in oil on the wall, it suggested the effects of antique 'impressionism'. Yet the antique references are only raw material for Polidoro. His landscapes convey a highly personal and a radically transforming response to nature as well as to its mode of record in antique art. He conceives forms of landscape with profound sensuousness and feels them as if they were vitally inhabited, infusing them with a barely suppressed turbulence; and he describes his vision of this invented world with a vibrating touch, now rough, now exquisitely

92. Polidoro da Caravaggio: Noli me Tangere, c. 1525.
Rome, S. Silvestro al Quirinale

fine, that manifests an extreme optical sensibility.

The mode of landscape painting that Polidoro evolved in S. Silvestro was too revolutionary to have quick influence on what, in Central Italy especially, was not an advanced genre, and the elements in these landscapes that evoke ideas of 'romanticism' and 'impressionism' more truly anticipate the seventeenth century than they do the landscapes, only little touched by Polidoro's precedent, of the later-sixteenth-century Maniera. Yet the paintings in S. Silvestro reveal, more than Polidoro's

grand public frescoes do, the private temper of the man. He confessed this still more openly in his drawings. Like Parmigianino, Polidoro was a compulsive draughtsman, and used drawing not only as an instrument towards making other works of art but as a sufficient end. Polidoro's drawings show a power of inventive fantasy – and also a concern with the experience of reality – that exceeds Parmigianino's, and the emotions Polidoro conveys in them are of a different force and range. What he communicates lies well outside the limits of the aestheticism of Maniera, and it does not conform to the

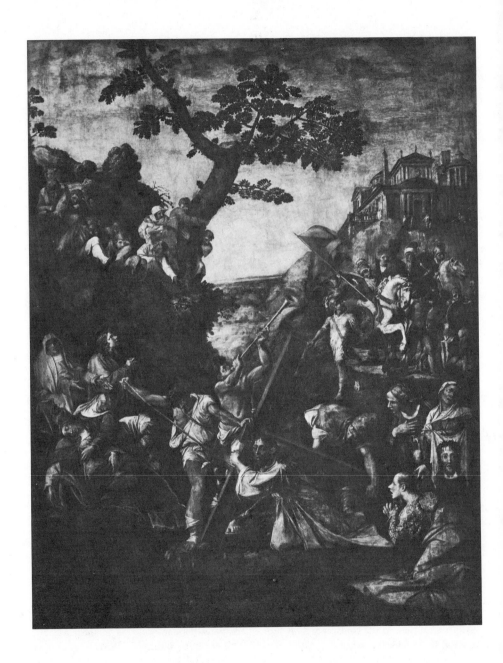

93. Polidoro da Caravaggio: Road to Calvary, before 1534. *Naples, Capodimonte*

conventions he inherited from the classical style. The element of turbulence and romanticism in Polidoro's painted landscapes is intenser and more poignant in his drawings, and forms as well as feelings are more eccentric. The accent of personality is different, but the realm of feeling in which Polidoro's drawings work is less that of his colleagues Parmigianino and Perino, who stand towards the Maniera, than it is like Giulio in his private moods, or like the Florentine Pontormo.

It was this deeper and more private side of Polidoro's temper, unquiet and unclassical, Mannerist but not of the Maniera, that emerged when, after the Sack, he left Rome to practise in the south of Italy, where the authority and the inhibition of the classical tradition and its classicist continuation were no longer operative on him. He went first to Naples, where he was recorded in October 1528,[68] worked there briefly, mainly in his speciality of façade painting (we have no more than verbal record), and settled finally in Messina. An altar of the *Road to Calvary*, once in Messina (Naples, Capodimonte, before 1534) [93], quotes Raphael's Sicilian *Spasimo* [29] and remembers a motif from Michelangelo, but has no residue of classicism in its style. What had been incipiently eccentric in Polidoro's art in Rome emerged now as a deforming fantasy, verging on effects of caricature. A conscious exploration into anticlassicism is supported by devices of form and expression borrowed from the Flemish and Germanic works that made so large a part of the artistic culture of the Sicilies. A group of small sketch-like paintings of religious themes (Naples, Capodimonte), of later date, is less bizarre only from the fact that they do not show the borrowings of the *Road to Calvary* from the northern style, but they are as if Polidoro had deliberately forsworn in them all he once knew of classical beauty and grace. They have a dark, rude power of form and a daemonic violence of feeling, and their expression seems an artistic-

ally isolated, solitary monologue. They are not anti-classical but something more drastic and detached than this – they are anti-style. We have observed that the *percorso* of Polidoro is the inverse of that of the contemporaries in Florence whom he temperamentally resembles. Moving on an inverse parabola from theirs, in Polidoro's post-Roman career he explored an inward region of strangeness and violence that Rosso at his most extreme would only skirt. It is not unexpected that his later art, at once so remarkable in merit and so singular in kind, should have had small influence on subsequent painting in South Italy. He died in Messina, murdered, in 1543.[69]

Sebastiano

In the changeful history of the Roman school the art of Sebastiano del Piombo represents the strongest line of continuity. We know him already as a foremost master of the classical style, a contemporary of Raphael's and on occasion an effective rival. When after Raphael's death the younger generation of painters in Rome – the pupils or followers of Raphael mainly – made their explorations into a new style, Sebastiano felt no similar compulsion to make change. For Sebastiano, a span of style was measured not by Raphael but by Michelangelo, whose absence from Rome left his models there unalterable. Furthermore, though Sebastiano's intelligence was deep it was also ponderous, and his habits of working came to be, by his own confession, at least sporadic, even lethargic. Throughout the first half of the second decade he was mainly occupied in carrying towards slow completion a work he had begun long before, the Borgherini Chapel in S. Pietro in Montorio, finished only in 1524. Neither its style nor that of the two major devotional pictures he painted in these years, the *Visitation* (Paris, Louvre, dated 1521) and a *Holy Family* (Prague, Národní Galerie, c. 1522-3),[69a] is dis-

tinguishable except in details from the grand classicism he had achieved in the previous five years. However, even in this high style there had been symptoms of a disposition that could compromise the essence of its classicism: a tendency to over-generalize appearances and pictorial structures so that they verged on an effect of geometrical abstraction; and there was a parallel tendency in dealing with emotion. It may have seemed a natural developmental logic that a higher purity of classical expression lay in reaching towards a higher measure still of generalizing. Left without the challenge of the living Raphael's example, with its ceaseless expansion of complexities, and in default of first-hand knowledge of Michelangelo's most recent and no less complex art, Sebastiano moved into a realm of generalization that must be assessed as lying beyond the limits of a High Renaissance classical style. In 1525, when the *Flagellation* in S. Pietro in Montorio had barely been finished, he painted a partial and altered repetition of it for Viterbo (Viterbo, Museo Civico), in which the geometry of forms and the regularity of composition are wholly dominating effects, only a little conditioned by a few bravura passages of forced realism. Content is as generalized as the form. By contrast with its precedent, the Viterbo *Flagellation* seems emotionally and intellectually removed into a more distant and abstracting realm. A *Holy Family with the Salvator Mundi* (Burgos Cathedral, *c.* 1526–7) is still more rigidly conceived in its design and yet more arbitrary in its purity of forms, and in mood it combines a slightly hollow grandeur with a preciousness that recalls Giulio Romano's temper of a preceding moment.

Sebastiano's portraits of this time, just before the Sack, show a similar magnitude of abstracting form, but his transcription of the sitter's personality gives them a less distant human meaning. His portrait of Anton Francesco degli Albizzi (Houston, Museum of Fine Arts), finished in 1525 and sent to Florence, had an immediate effect on the conventions of advanced portrait painting there. His *Clement VII* (Naples, Capodimonte), painted in 1526, may be Sebastiano's finest exercise in portraiture [94]. The figure partakes of an almost unreal geometry, inflated in scale and shape in a way that suggests, by the action of the form alone, the idea of an expanding grandeur. With minimal detail, the surfaces equivocate between abstracting planes of colour and sensations of an optical reality. The face is a remarkable characterization, shadowed and subtle, full of ambivalence, withdrawn in a poised hauteur.

In these works that precede the Sack Sebastiano holds to the conventions and to the outward prescriptions of his own former high classical style, still more than Giulio held to those he inherited from Raphael. But there has been in Sebastiano, differently but no less than in Giulio, the crucial loss of a classical essential, the synthesis of artifice with the complexities and energies of nature. The prime sense of this art is in its purities of form, and its condiment is a knowing equivocation between art and reality. Its emotions are those of a veiled distance, decorous to a point beyond discretion, suspended and distilled. Its grave *Romanità* and its deliberation are, even in exaggeration, in the temper of classicism, but it is a classicism with a vacant core: the hollow, shadowed grandeur of the *Clement* portrait is the most eloquent symbol of a situation of history as well as art. This vacated classicism is thus, by definition, classicistic only – an after life of classical style of another kind than the aestheticizing elaborations of that style in *grazia* by the painters of the post-Raphaelesque Maniera.

94. Sebastiano: Clement VII, 1526.
Naples, Capodimonte

Though Sebastiano's classicistic style lacks the apparatus of gracility, and chooses to restrict rather than elaborate, it has much in common with contemporary Mannerism. It is no less artificial in its form and content, differently but not less highly stylized, and as pointedly self-conscious in the psychological and aesthetic effects that it attains. This may not seem sufficient to include this style as yet as one of the aspects of the new Mannerism, but that is where it finds its closest kin. After 1530, however, continued exposure to a Roman environment in which the demonstrations of Maniera tendencies were dominant resulted in accommodations of Sebastiano's style to Maniera, and his affiliation with Mannerism became explicit. More precisely, as we shall see, it was not a complete conversion, though it did affect his largest and most publicly important works and all his portraiture.

Sebastiano carried into the atmosphere of the developing Maniera a core of resistance which seems to have solidified in consequence of a conversion of another kind, which he experienced as an effect of living through the Sack. A letter he wrote to Michelangelo in 1531 communicates Sebastiano's sense of a profound disorientation, fearful and withdrawn,[70] of which the positive result was an affirmation of religious sentiment of deep pathos and directness, not unlike what Michelangelo was to come to only later (after his association with the doctrines of the Italian Reform) in its concentration on the image and the sufferings of Christ. In the context of the *mores* and the taste of the evolving Maniera in contemporary Rome, this overt and pathetic Christianity was exceptional, and it had no antecedent in the sophistications of the Roman classical style. Yet it must have responded to another current of religion in the Roman scene, which was even at this time generating the Italian Reform, and which would produce the Counter-Reformation. Thus while on one hand Sebastiano's few

paintings and his portraiture conformed in much to the elegances and aestheticism of Maniera, an at least equal strain of his production in the thirties was of paintings that were not just conventional images of devotion but of a feeling, almost simplistic, piety, quite counter to the tendency of Maniera art. This aspect of Sebastiano's temper is a perceptible undertone within his public work: the actors of his late large altarpiece, the *Birth of the Virgin* (Rome, S. Maria del Popolo, Cappella Chigi),[71] have a heavy, yet altogether mannered grace of attitude and of expression, but their context makes a tenor of dark melancholy for them – a vast, dark, underpopulated, geometrically abstract space. The *Christ in Limbo* (Madrid, Prado, *c*. 1532) [95][70a] develops from the central motif which Michelangelo had supplied long before for the *Flagellation* of S. Pietro in Montorio, and the development is with the accent of Maniera that appears in Michelangelo's own most recent and contemporary style, as in the *Victory*, as well as that of Parmigianino's translations of Michelangelism. Yet the *Christ in Limbo* communicates, still more than its flavour of Maniera, a melancholic religiosity.

The first evidence of this state of mind came shortly following the Sack: it is in a *Cristo Portacroce* (Madrid, Prado, *c*. 1528-30) which Sebastiano painted after a renewed experience of his native Venice, where he had taken refuge for a time in 1528, and perhaps into 1529 – when he returned (alone so soon among the major painters) to Rome. The Prado *Portacroce* shows clearly the consequence of contact with the art of Titian; not only in its momentary reassertion of Venetian technique, but also in its inspiration by the *Portacroce* of S. Rocco. But Sebastiano's action on this model is exactly indicative of an altered, and unclassical, involvement with the theme: he turns his actors normal to the picture plane, compelling confrontation with them from the spectator, and this confrontation is with a presence of morbid-

95. Sebastiano: Christ in Limbo, *c.* 1532. *Madrid, Prado*

96. Sebastiano: Pietà (from Ubeda), 1537-9. *Seville, Casa di Pilatos*

ly pathetic power. At least two further paintings of the *Portacroce* theme are authentically by Sebastiano. One, in Leningrad (Hermitage, datable 1537?), infuses its pathos into the lineaments of Maniera, and the result is a reciprocal contamination – a bitter-sweet high-style *bondieuserie*. Another (Budapest, Andrássy Collection), probably later still, is mannered in proportion; its content is an anguish utterly inward but immediately given us to see and feel. The *Pietà* of Ubeda (Seville, Casa di Pilatos) [96], commissioned in 1533 'a guisa di quella [Madonna] della febre' of Michelangelo by Ferrante Gonzaga, was not painted until 1537-9.[72] It is the most advanced exposition of Sebastiano's creed for a religious art. Partaking of the nature of Mannerism in abstractness of description and of formal language, it abjures all Maniera grace, presenting an image of extreme simplicity and legibility, in which hieratic distance and affective poignance are combined. In the tenor of both form and content the picture anticipates the rigour of the Counter-Reformation, still a while to come, and its insistence upon immediate and explicit communication; and as in the Counter-Reformation's doctrine for art, this gives religious meaning primacy far above aesthetic value.

Here, by an act that is partly innovation and partly a backward reference to his own classical and classicistic past, Sebastiano has given explicit form to a mode which, within the orbit of Maniera, is a reverse face of Maniera style: not an anti-Maniera, but an inverse counterpart to its dominating aspect, which we may more accurately baptize Counter-Maniera. This mode was created at a time that marks the full conversion of a second generation to the Maniera style in Rome; so that even as the Maniera came to dominance this counterpart appeared. Supported by the reformed and ascetic style that Michelangelo would evolve later, Sebastiano's precedent was to be a major formative example for the Counter-Maniera which, as the

Counter-Reformation grew, would have wide scope, and eventually contest the primacy of style in Rome. But Sebastiano himself took no further part in this development. Apparently he ceased to paint after 1539; he died in 1547.

FLORENCE: 2

The Persistence and Alteration of Classical Style

The factors of authoritative example and of organization of the economy of art that gave post-Raphaelesque developments of style in Rome considerable consistency were not operative to the same extent in contemporary Florence, nor did Florentine art in general derive from its own recent history of classical accomplishment an equally compelling impetus towards stylistic change. In the 1520s, in the Florentine atmosphere of laissez-faire, there was room for painters who continued to depend on classicism as well as for the protestants against it. Painters who had been formed by Fra Bartolommeo, or by even more conservative models, persisted and found takers for their art. More important, the Frate's successor as the *caposcuola* in Florence, Andrea del Sarto, maintained this rank and held to the practice of a classical style, working for some years with an integrity of purpose and an efficiency of output that were as if he did not recognize that dissent could and did exist. Nevertheless, around him his own school came to be corroded by the growing influence of Rosso and Pontormo, and eventually the creative impulse of his own classicism failed. Within half a decade after Andrea's death in 1530 the classical style in Florence was dead of inanition or had been subverted to the doctrines of Mannerism. The younger generation that emerged in Florence in the course of the early 1530s were to be the foremost practitioners, in Florence and in Rome also, of the Maniera: Bronzino, Vasari, Salviati, and Jacopino del Conte.

Andrea del Sarto

Unlike his contemporary in the Roman school, Sebastiano, Andrea del Sarto made no essential concession to Mannerist style. Yet he had been involved with the earliest history of Mannerism in Florence: his own works of a phase before he had attained his maturity in classical style verged on an unclassical expression, which his young associates of that moment, Pontormo and Rosso, had taken as example. Even in his first great works in classical style this tendency was sublimated rather than suppressed: the psychological and painterly complexities of these pictures is its residue. When after his return from France late in 1519 Andrea found the first Mannerist works, probably done in his absence, his response was twofold. On one hand, he was disposed to follow Rosso and Pontormo – as they had earlier followed him – into new regions of expressive urgency; but on the other he was, by now, firmly set within the formal disciplines of classical style. A *Pietà* of *c.* 1520 (Vienna, Kunsthistorisches Museum) illustrates the result: its theme has been exploited to permit the strongest communication of emotion in all Andrea's art, but this has been compelled into a strictly classicizing structure of design. In 1521 Andrea was put into a quasi-collaborative association with Pontormo in the fresco decoration of the grand salon at Poggio a Cajano (where Franciabigio also was engaged). The large space and the expansive theme of Andrea's piece, a *Tribute to Caesar*,[73] encouraged a temper of experiment, and Pontormo's presence may have accelerated it. Andrea evolved a design for his fresco which, like Pontormo's, exceeds the limits of past classical conventions; but the directions in which the two painters reach are opposite. While Jacopo's painting seeks, beneath its references to reality, a realm of introverted and abstract sensation, Andrea's effort is to give more forceful outlet to the energies that he perceives in

nature. The power of movement that Andrea liberates in his design and the strength of his description of appearances invite comparison with the means by which, in the north of Italy at this time, a new avenue of development, of baroque cast, was opened for the classical style. But Andrea's experiment is too restrained, and his allegiance to classical principles of balance and control too deeply felt, to make the element of innovation in his Poggio fresco one that had historical consequence.

It had none for Andrea. The energies he devoted for the short time *c.* 1520-1 to probing in directions that might go beyond the classical conventions he himself had helped to set were converted instead into a reinforcement of them. In the fresco *Madonna di Porta Pinti* (lost, but known to us through copies), probably of the same year as the Poggio decoration, Andrea made his option for the classical style absolute, resolving the complexities that had been in his painting before 1520 in a grand simplicity of form and in a new decisiveness of content. He moves in this work on to that high plateau of classical expression in which (as in the Tapestry Cartoons of Raphael) its principles are reformed in clearer, more pregnant, and higher terms. From this moment, for the next half-dozen years, Andrea's art was a succession of masterworks of high classical style. Almost every picture of these years is a surpassing exposition of a rationality of form, supporting a measured communication of a content. The human communication is usually reticent; Andrea's temperament and his Florentine culture dispose him still less now than earlier to the rhetoric of Roman style. The formal values also have the character of understatement, for they are a substructure that Andrea chooses to reveal to us only through a descriptive surface of continuing, and indeed developing, naturalism. Even now, Andrea regards the overt purpose of the work of art as mimesis, and not only what he describes but the temper in which he chooses

to describe it retain the look of nature. Nevertheless, his work is as conscious in its art as the painting of the contemporary Mannerists: his pictures are as highly styled, but with no visible effect of stylization. Both the surface and the structure of these masterworks hold commanding power, the one ordering and summarizing the most finely perceived visual truth, the other demonstrating an intelligence of form of subtle and unchallengeable strength.

A remarkable indication of the level and consistency with which Andrea worked in these years is in his completion of the grisaille frescoes of the Chiostro dello Scalzo, where between 1521 and 1526 he added six narratives of the Baptist's life and two smaller paintings of Virtues to the scenes he had painted up to 1517. Among these the *Visitation* [97], painted in 1524, may represent a qualitative climax. Even in its present damaged state and in its mono-

97. Andrea del Sarto: Visitation, 1524.
Florence, Chiostro dello Scalzo

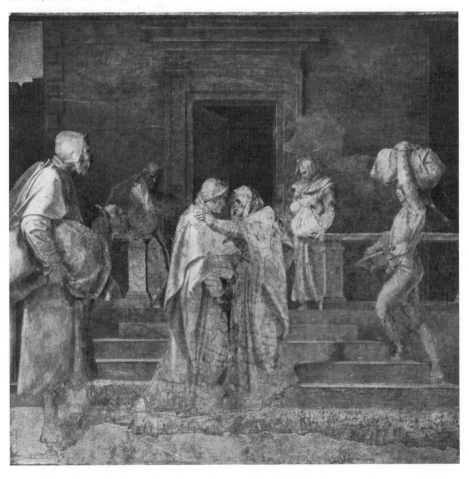

chrome technique it communicates an effect of seen truth. A cast of characters just lightly touched by a reshaping hand, and in a contemporary setting, is described in a vibrant, transient light, which suffuses the whole stage with its energy. But underneath this naturalness there is an absolutely disciplined design, of an exalting clarity, which orders both the surface and the picture space according to the schema of a quincunx. The logic is exact, but it is not inflexible; and the sense of the pictorial pattern coincides exactly with that of the narration. Andrea here attains an ambition like one of Raphael's concerns in his highest phase of classical style, to extend the reach of art in directions both of rationality and actuality: in the *Visitation*, reason wears the very countenance of nature. The *Madonna del Sacco* of 1525 (Florence, SS. Annunziata) [98] is of the same kind, and may be on a more extraordinary plane. It approximates, more daringly than the *Visitation*, the look of casual occurrence and its effect of life, and does so in a more flexible and subtle structure, of which the functioning here

integrates Andrea's colour. From two large, vitalizing, asymmetric shapes Andrea makes one impeccable equilibrium, and binds them in a strong, slow, curving rhythm that transforms their underlying geometry into music.

The fresco *Last Supper* (Florence, Cenacolo di S. Salvi, 1526-7)[74] is Andrea's most extensive single painting. In the same vein of naturalism and dramatic understatement that is in the Scalzo frescoes, this shows not only their intelligence in the ordering of structure but the same intelligence in the ordering of colour in it. The effect of colour intensifies the effect of descriptive naturalism, but so inextricably are the powers of illusion and the powers of a rationally invented order joined in the *Last Supper* that each makes a reciprocal reinforcement for the other. The fresco stands at the highest level of the aesthetic possibilities of a classical development, and commands its apparatus faultlessly. But there is a missing factor that makes this unlike the Grand Manner of the past Raphael style in Rome, and – despite the incidental touches of a Michelangelism in

98. Andrea del Sarto: Madonna del Sacco, 1525.
Florence, SS. Annunziata

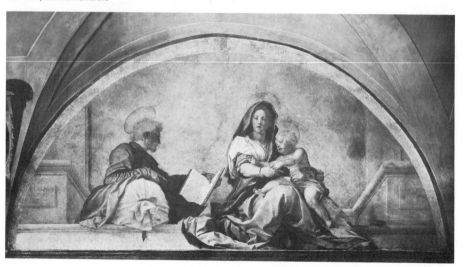

its figure style – unlike the accomplishment, past or present, of Michelangelo. On this large scale the powers of form are not sufficient, as they are in Andrea's smaller frescoes, to infuse and supplement the reticence of emotion in the theme. Andrea's tie to ordinary nature is not only in the look of his world but in the temper with which it – and he – respond to spiritual events, and the last, exalted, reach of classical expression is therefore barred to him.

What we may consider in the *Last Supper* to be a primary dependence of the work of art on its machinery of form is in fact a symptom of a tendency that was to increase in Andrea's last large works. Structure and design of colour remain explicitly classical in such later altars as the *Assunta* of the Passerini family (Florence, Pitti, no. 225, 1527–9), the *Vallombrosa* altar (Florence, Uffizi, 1528), and the *Madonna with Saints* of 1528 (destroyed; formerly in Berlin); but emotion in them is now not so much a measured reticence as it is pallid. The form, too, has become more obvious and somewhat inert, as if there had been a general decline of inspiration; yet their assertion of effects of form is the chief sense these works retain. There is a character in them that verges on, and in instances makes, the impression of formulae of classical style insufficiently inhabited by force of mind or by emotional conviction: of a classicism grown only classicistic.

It would seem that towards the end of his career Andrea had played out the combinations and permutations of the kind of classical style possible to his personality, and that his inspiration to create authentically in that style lapsed. Attached to it by twenty years of practice, and attached within it more than most to nature, Andrea could not accept stimuli that might revitalize his classical style from contemporary Mannerism. One or two smaller works of 1527 and 1528, for example the Borgherini *Holy Family* (New York, Metropolitan Museum) and the so-called Barberini *Holy Family* (Rome, Galleria Nazionale), do incorporate devices that resemble those of Mannerism, but what is in them of this kind is limited and temporary. Confronted on one hand by his exhaustion of creative power in classical style, and on the other by the impossibility of progressive compromise with Mannerism, Andrea fell back on those resources that precede his schooling in a historical style: his tenderness and warmth of feeling for the world he could perceive immediately about him, and the sensibility of eye and hand that were his surpassing means of record of them. The blandness of the late large altars is redeemed in places by the gentle vibrance of physical and psychological response that Andrea has in them to human presences, and this is the major burden of the smaller works of his last years – the *Madonna* (Florence, Pitti, no. 476, *c.* 1529), a *Self-portrait* (Edinburgh, National Gallery, *c.* 1528), his portrait of his stepdaughter Maria (Florence, Uffizi, *c.* 1529), the fragmentary portrait of his wife Lucrezia (Berlin–Dahlem, *c.* 1528), and the single figures that compose the polyptych altarpiece in Pisa (Duomo, 1529–30), of which two are again portraits of his womenfolk.

When Andrea died in 1530, still only in his middle forties, he had already seen the gradual vitiation all around him of the classical style, and his own late lapse was the index not just of the exhaustion of his capacity to create in it but of the exhaustion of the potential of the style to inspire creation. In terms that did not have to do with the classical aesthetic by which his whole mature existence as an artist had been shaped, he still possessed an inexhaustible resource, which, no less than the new style of the Mannerists, depended on a private sensibility. But even now, when the attitudes and modes of the rising Mannerism had infiltrated most of Andrea's environment, the world of his sensibility remained, opposite to theirs, that to which his earliest seeing had been formed, of nature.

Franciabigio

Franciabigio lived only four years into the third decade. When he died (in January 1525) there was already much dissent from classical style, but as yet no formed mode that threatened to displace it. The authority of classical practice that Andrea (and the works of the late Fra Bartolommeo) did not monopolize fell to Franciabigio, and his art was faithful to the tenets of that style – as he, with his curious combination of striving and limitations conceived it – to the end. In 1521 Franciabigio was elected to share the fresco decoration of the walls at Poggio a Cajano with Sarto, and contributed a *Triumph of Cicero*.[75] He had always been inclined, more than Andrea, to effects of drama and rhetorical stress, and this theme permitted him to achieve them. The landscape is old-fashioned and discursive, but the figure style is of a force not unlike that in Andrea's companion piece, though not comparably fluent. There is a Roman accent in the forms and in the temper of their actions that is not just a consequence of the subject: it is certain that the heavily dramatic mode reflects study of the recent art of Rome. Franciabigio's transcription is provincial, but he has managed to do again, in wholly contemporary terms, what he had once done before: make the nearest equivalent in Florence for the Grand Manner of the classical school of Rome. Andrea's aspiration for his Poggio fresco seems to have resembled this, but he had neither Francesco's rhetoric nor his Romanizing cast of style.

Their shared ambition of this moment towards a forceful and monumental mode is in Andrea's *Madonna Pinti* and in a *Madonna with St John* that Franciabigio painted, perhaps towards 1522 (Vaduz, Liechtenstein Collection), and it inspires a similar impressiveness of form in Francesco's *Portrait of a Young Man* (Berlin-Dahlem, signed and dated 1522). However, this high vein of style did not endure. A

detached fresco of a *Noli me Tangere* (Florence, Horne Collection, *c.* 1523-4) displays an awkward power in the posture of the Christ, but this does not redeem the conventional and literal-minded painting of the rest. The best known of Franciabigio's late works, *David and Bathsheba* (Dresden, dated 1523), takes the theme as the occasion for precise description and engaging illustration, not for drama. Franciabigio has been thoroughly reintegrated, after his Romanizing excursion, into a persistent and conservative Florentine tradition. The *David and Bathsheba* was painted as part of a set of pictures, commissioned by Giovanni Maria Benentendi, in which Pontormo also shared, but Franciabigio's painting is the affirmation of what Pontormo at that time negates.

Puligo

Born in 1492, Domenico Puligo belonged to the generation of Pontormo and Rosso more than that of Sarto. His first training had been ultra-conservative, with Ridolfo Ghirlandaio, but he then adopted Fra Bartolommeo's model, and later Sarto's.[76] Schooled in the formulae of Florentine classicism, Puligo tended to adhere to them. But his disposition was more timid than it was truly conservative. He had habits of style rather than convictions about them, and he was temperamentally malleable – impressionable and, in emotion, disposed to an excessive morbid sentimentality. He came to imitate Sarto's technique and exaggerate his expression, both in the sense of morbidity; then, exceeding both himself and Sarto, he responded to the examples Rosso and Pontormo offered, compounding some of their tendencies – but in a feminine translation – into his own.

In works on a larger scale, such as his *Vision of St Bernard* (Baltimore, Walters Gallery, *c.* 1523), Puligo was capable of accomplishment of considerable dignity, despite the softness of his feeling and his form. A major altar of his

latest phase (Florence, S. Maria Maddalena dei Pazzi, 1525-6) is still based closely in design on Sarto and Fra Bartolommeo, and it is painted with more skill and grace than any work of the moment in Florence outside of Mannerism, save for Sarto's own.

Puligo had a wide practice in portraiture, in which he gradually exchanged Sarto's precedents for recipes he deduced from his Mannerist contempororaries.[77] But Puligo was by practice and disposition a painter of works on a relatively smaller scale, a kind of sophisticated *madonnero*, specializing in Madonna groups and in single female heads that illustrate Magdalenes, Lucrezias, and Cleopatras. Their chief interest is in the tenor of their content: beginning like the Mannerists with Sarto's model of expression, Puligo intensifies its immediacy of communication. His likeness to the Mannerists in this essential respect made Puligo respond to their example in others, but wanting intelligence of form, his response to their stimulus was mainly in painterly terms, operating upon the Sartesque technique he had acquired with an effect like that which he imposed on Sarto's mode of feeling. He complicates surfaces with sfumato, dissolving form and seeking strangeness of tonality – silvered, bronzed, and blued; the affect of form is exactly consonant with the morbidity of emotion that he seeks.

A series of his latest smaller pictures, from *c.* 1524 until his death in 1527 (e.g. the Madonna pictures in Florence, Pitti, no. 145, *c.* 1524-5; in Rome, Borghese, no. 432, *c.* 1526; and in the Columbus, Ohio, Museum, *c.* 1527), shows his movement towards a position that, while resembling Mannerism in some ways, is more properly a corrosion of the classical style. By the time Puligo died in 1527 he was only an ambiguous convert to the rising manner, making an equivocation, more than a compromise, between his sympathy with the novelties of his contemporaries and his corruptible fidelity to Sarto. Puligo's position must have had considerable attraction for his contemporaries, even in its latest, morbid aspect. The evidence for it is not only in the quantity – and, therefore, market – of the works he produced in his brief career, but in the school works and imitations that exist. In so far as quantity is a valid measure of the state of art, it was this compromise that was the most accepted currency of taste in Florence in the middle of the third decade.

Lesser Florentines

Giovanni Antonio Sogliani was born, like Puligo, in 1492, and like him began to leave some mark on the Florentine scene only in the third decade. His schooling had been, if anything, still more conservative than Puligo's. Vasari reports that he was an assistant of the old Lorenzo di Credi for twenty-four years – surely an exaggeration, but an indication of a personality with small inclination to invention or to new ideas. Despite his community in generation with Puligo, and with Rosso and Pontormo, and despite a busy practice till his death in 1544, he made no more than superficial concession to the processes of stylistic change around him. Just on this account, his art is a symptom of the importance of what may be called an after-life, more than a persistence, of the Florentine classical style – an after-life which extends, in his work, into the time of complete dominance of the Maniera.

Sogliani's earliest recognizable works, from around 1515, are basically in Credi's style, and hardly of the Cinquecento. When he achieved his independence, probably only towards 1520, Sogliani chose to follow Bartolommeo's manner, and for at least a transitory moment to accept some part of Sarto's style. Sogliani's *Martyrdom of St Acasio* (Florence, S. Lorenzo), his best work, done in 1521, shows these elements in combination. However, its chief character derives from a geometry borrowed

from Fra Bartolommeo which has the superficial look of classical structure but no part of its vital principle. Sogliani took the most obvious aspect of classical style to use as an uninhabited formula. The *Acasio* altar is already an only classicistic *calque* of Fra Bartolommeo but the *St Brigitta* altarpiece (Florence, Museo di S. Marco, 1522) is a complete petrifaction of Bartolommeo's style. Congealed so quickly into this dried shell of a classicism, Sogliani continued to fabricate quasi-icons of this general kind for a ready market that seems to have consisted mainly of provincial and monastic customers. He was much employed by Pisa, for the Duomo, where he provided pictures on occasion from 1528 until 1541. On at least two occasions he served for Pisa by default of better masters: for Sarto, whose design for an altar originally in the church of S. Agnese (but now in the Duomo) he completed between 1539 and 1541, in a craftsmanly but inert style; and for Perino del Vaga, whose drawing (now at Zürich, Kunsthaus) for a side altar in the Duomo he translated back, in 1536-8, into his own, by then archaic, mode. In Sogliani's paintings of the later thirties, as in the Pisan altar that adapts Perino, or in a quite imposing *Allegory of the Immaculate Conception* (Florence, Academy), he borrowed some of the stylizations Mannerism had by then made fashionable, but these are as much a surface matter as his classicism. Sogliani is a case history of the artist for whom style is not a matter of aesthetic principle but one of compromise between habit and the artistic fashion that happens to prevail.

It is more obvious that the members of an older generation than Sogliani's who continued to practise in the third decade of the century should persist in the conventions of the classical style. We have seen earlier the slow accommodation of Giuliano Bugiardini's striving but small talent to these conventions; once he had acquired them in the measure of which

he was capable, he was not disposed to accept change, and he was temperamentally unable to comprehend it in the terms proposed by Mannerism. Bugiardini had been much longer than Sogliani in acquiring his classicism, but, unlike Sogliani's, Bugiardini's classicism contained at least in part a command of principles and a conviction in them. Bugiardini's later works generate an ill-articulated strength and, occasionally, an effect of large rhetoric that attest the persistence in him, throughout the third decade, of a limited but convinced classical style.

In 1526-30 Bugiardini painted in Bologna, where his mode found some who were sympathetic to it at the same time that others were patronizing the advanced Maniera of Parmigianino. In 1531, returned to Florence, Bugiardini finally completed a *Rape of Dina*, for which Fra Bartolommeo had left designs, translating it into a laboured prose. A whole decade of intermittent travail in the thirties produced the *Martyrdom of St Catherine* (Florence, S. Maria Novella), for which Michelangelo's generosity supplied drawings and ideas; there is no comparable instance in Florentine painting of a gap between authentically grand inspiration and the petrification of it in its visible form. There are some successful efforts by Bugiardini from his latest years, of which the most impressive is the altar of the *Madonna with the Magdalene and St John the Baptist* (New York, Metropolitan Museum, *c.* 1540). A style that even now extends the mode of Fra Bartolommeo is touched a little, finally, by a fluency and breadth that Michelangelo's example has inspired, and by the ornamental working of line and polish of high-keyed surface of contemporary Mannerism. But there is no concession to Maniera, only an exploitation of an element of its vocabulary within Bugiardini's essentially archaic mode.

For all its limitations, Bugiardini's persistent working in the way of classicism was creative.

Another artist of his approximate generation, Ridolfo Ghirlandaio, who had earlier achieved a partial and tardy approximation of classical form on Bartolommeo's example, turned this quickly after 1520 into vacant formula, while content in his painting was reduced to nullity. Ridolfo lived until 1561, and in his continuing practice till the 1540s he responded slightly, but in superficial facts alone, to the gradual change of artistic fashion. But eventually his art lost even its inherited core, its efficiency of descriptive realism, and then the tradition of the Ghirlandaios of the Quattrocento which had stubbornly persisted in Ridolfo's painting through the years of classicism vanished in entire inanition. As Ridolfo aged, he yielded the direction of his shop to his youthful collaborator, Michele di Ridolfo (Tosini). A member of the younger generation, born in 1503, Michele's work – whether in collaboration with Ridolfo or independently conceived – remained faithful to the older man's prescriptions until about 1540. Then, in the face of the general ascendancy of Mannerism in Florence, Michele underwent a conversion, eventually complete, to his own contemporaries' modern style.

There is another variety of artistic production in Florence and its neighbourhood in the years that accompany the decline of classicism and the rise of Mannerist style. This production lies on the borderline between art and artisanship, and it would be incorrect to deal with it as if it offered a problem that was relevant to the large issue of the development of historical styles, such as classicism and Mannerism are. Style is a property of these works only in the limited sense of the stamp given them by their – the word is stretched here – creating personality. Often, indeed, the processes by which these works come into being are hardly purposeful enough to achieve style even of this kind. They are given individuality less by any shaping force of will than by the marks that betray ineptitude – of mind, eye, or hand – and which, measured by the standards of a higher contemporary art, acquire the effect of eccentricities – sometimes interesting, sometimes merely ugly. A group of such Florentines has recently been recalled from oblivion,[78] with the useful by-product of clarifying the attribution of a number of pictures that had previously been assigned to more important masters. One among these, baptized 'The Master of the Kress Landscapes', appears to derive from the same atmosphere of contrariness and dissent that produced Rosso, and his beginnings may relate to the first ferment of Mannerism; but he descended quickly from this level towards an only private mannerism that is at best a poetically bizarre distortion of Bartolommesque style.[79]

The art of Francesco Ubertini, Il Bacchiacca (1494-1577), was more than that of these quasi-artisans, yet its kind of relation to the historical styles is akin to theirs. His initial status was that of a craftsman-painter, and his temperament and talents were never quite to be detached from his beginnings. Vasari always makes his awareness of this character of *artigianato* in Bacchiacca evident, and it appears even in his most developed art. Bacchiacca emerged in the late years of the second decade as a painter of small panels trained in the archaic classical style of Perugino, but with an inclination towards piquant and unclassical aberrations in both form and colour. By 1523 (when he participated, with Franciabigio and Pontormo as companions, in the decoration of the *camera* of Giovanni Benintendi) he had been enough exposed to Rosso and Pontormo to take stimulus from them for his own eccentricity, and he invented a manner in which forms and feeling are made pointed, brittle, and disarticulate. The means by which he arrived at this mode are only partly like those of his Mannerist contemporaries. Bacchiacca's effects, fanciful and disjunctive, rather recollect those

that can be found in the cassone panels of the later Quattrocento. His devices are unintellectual and in part naïve, and they are small, as befits the scale in which it was his chosen speciality to work. This is a highly personal manner, but there is almost nothing in it that resembles Pontormo's or Rosso's profound reforming of a whole aesthetic order. Nevertheless, the generic climate of Bacchiacca's art is, in naïve terms, like that of Mannerism.

Once thus established in the early thirties, this style persisted with no significant change in its level of sophistication, and with only minor alterations, throughout the rest of Bacchiacca's long career; he responded only in discreet measure to the outward elegances of the Maniera as it matured. He emerged occasionally from his specialized, near-craftsman's genre to paint awkward portraits. Late in life (1549-53) he provided designs for two sets of tapestries, one of genre subjects of the Seasons and another of grotesques (both Florence, Uffizi). But essentially he remained a specialist painter of small works - crowded, talkative, and diverting, and more nearly illustration than high art.

SIENA

The rise to leadership of the Roman school in the first two decades of the sixteenth century had caused two at least of the chief Sienese painters of that time, Peruzzi and Sodoma, to attach themselves to it, the former wholly, the latter partly. Beccafumi, the third major Sienese, had remained more attached to Florentine example. But in all three painters - even in Peruzzi, whose entire career of those years was in Rome - there were strains that were resistant to the disciplines of classicism to which they were exposed in both 'foreign' schools. In Sodoma these strains were more conspicuous than in Peruzzi, and in Beccafumi they were dominant. Explicitly a creature of

the Sienese locale, as the other two for different reasons were not, Beccafumi remained essentially attached to a Sienese tradition that was but ill-assorted, even now, with the rational and naturalistic elements of Renaissance style. We saw of Beccafumi that his career before 1520 contained a phase of naïve Mannerism, the consequence of a conjunction between a mentality still embedded in an incompletely rationalized - almost late-medieval - Sienese Quattrocentism and an imperfect experience of the new classicism; there is no strict analogue for this in contemporary Florentine art. This phase was succeeded by an assimilation of classical disciplines, reinforced by a new study, on the spot (probably in 1519), of recent art in Rome. Earlier restive and frequently resistant to the pressure of Florentine classical example, Beccafumi's experience in Rome of almost all Raphael's accomplishment was finally convincing, and the temper of irrationality and of a naïve Mannerism that had persisted in varying measure in his paintings of the latter half of the second decade was put aside. His chief productions after his return from Rome, designs for the first scenes in the inlaid pavement with biblical histories in Siena Cathedral (1519-24; the remaining designs would occupy him intermittently for the rest of his career), are in a developed, Romanizing classical style which would have been entirely acceptable in Rome at the time of their invention.

This was a tardy conversion, however complete it may have seemed, and it proved to be a momentary one. Before 1524, in a major altarpiece of the *Nativity* in S. Martino at Siena [99], non-rational inclinations that had been present in Beccafumi's art from the beginning re-emerged; but they emerged now through the substance of a wholly comprehended classicism. Where his earlier mannerizing qualities

99. Domenico Beccafumi: Nativity, before 1524.
Siena, S. Martino

were forms of late medieval survival, this is now Mannerism in a different and historically more consequential sense: no longer naïve or merely personal mannerism, but a post-classical style that has been integrated into the mainstream of the historical process of Central Italian art. Thereby Beccafumi's situation comes, but only now, to resemble that of his Roman and Florentine colleagues in the new style. His earlier art could be described as a precursor of the historical style of Mannerism; but now he joins the group who had been authentically its inventors.

In great part, of course, the qualities that transmute the classicism Beccafumi had acquired into a Mannerism in the *Nativity* of S. Martino are endogenous, but the stimulus to give them rein again and the specific form they take seem to require a renewed return of interest in contemporary Florentine art. There had earlier been resemblances – so far not objectively explained – in temperament and formal habits between Beccafumi and the younger Rosso, but the *Nativity* suggests that Beccafumi has taken his precise course in it from a study of Rosso's art. There is, in the *Nativity*, a fine pointing brittleness of forms, a precious and abstracted character of emotion, and a vibrantly complex chiaroscuro like those in Rosso's recent work. The specific quality of light is different, more optical and fluid than in Rosso, and less dependent on a linear accompaniment; yet it seems significant that this character of light had been no more than a minor factor in Beccafumi's art before, and only now – after the study of Rosso's example that we presume – becomes a major instrument for him.

Beccafumi takes an effective place within the new Mannerist style, then, only towards 1524 – a little later than the Florentines, and in a mode that is allied to theirs. But unlike the Florentines, his progress of invention in the style is not, as their tradition and intellectuality

determined for them, involved with the problems of *disegno*. Structure is, for Beccafumi, subservient to more pressing interests, and his compositions tend to be accumulative or heraldic, or occasionally merely conventional. The source of his creation is a visionary sense of theme and narrative, bizarre and mystical, that belongs authentically to a tradition special to the Sienese. Transposed by Beccafumi into modern terms, this spirit has some resemblance to Rosso's, with the important difference that there is no grain of scepticism in it. What Beccafumi paints is visionary also in another meaning than that of spiritual imagination, in that he describes what he imagines as an experience of light – no light of nature, but a spiritual illumination made apparent to the eye, which veils matter and transforms colour into radiance. As with his Mannerist contemporaries, Beccafumi's most radical experiments occur in the years that followed his conversion to the new style. Two versions of the *Fall of the Rebel Angels* (Siena, Pinacoteca, *c.* 1525, and in the Carmine, *c.* 1527-8) describe a mystic's vision of the theme in patterns of an archaic heraldry and in a mingled light of heaven and of hellfire. An altar of the *Marriage of St Catherine* (Siena, Chigi-Saracini Collection, perhaps of 1528) is based literally (as Rosso's *Dei* altar had been) on Bartolommesque compositions, but both the setting and the actors in it are consumed by an incandescence in which the figures become spirit-presences, radiating an abstract serenity.

In 1524 Beccafumi had received a commission for a fresco decoration on a theme of ancient history, the story of Scipio, for a ceiling in the Palazzo Bindi-Sergardi. His decorative scheme reflects his Roman experiences, of his compatriot Peruzzi's works as well as Raphael's. Executed mostly in the later years of the decade, the secular theme called forth another vein than that which inspired his religious pictures: a fluid and artificial elegance, almost calligraphic, which in temper and effect resembles the Mani-

100. Domenico Beccafumi: Christ in Limbo, *c.* 1535. *Siena, Pinacoteca*

era. However, the tenor of description and narration is not less transformingly fantastic than in the religious paintings of this experimental time.

After 1530 there is a distinct change in Beccafumi's art. While he sacrificed none of the essential Mannerist devices he had found, he moderated their use, and the controlling factor of his style is no longer fantasy but serious-mindedness and precise discipline. His descriptive mode became more literal and careful, and his manner became graver, more learned in a literary sense, and more intellectual in use of form, approximating the mentality of the Romans and the Florentines. His frescoes of episodes from ancient history in the Sala del Concistoro of the Palazzo Pubblico in Siena, commissioned in 1529 but executed mostly towards 1535, illustrate this consolidation of Beccafumi's style, as does the handsome and precisely calculated *Christ in Limbo* (Siena, Pinacoteca, *c.* 1535) [100]. In their disciplined and complex grace, their controlled yet evident artificiality, and their care to reconcile this artifice with descriptive accuracy of detail, these works are close to the character of the Maniera that the generation of Salviati and Vasari would achieve, anticipating it by almost a decade. Yet it is doubtful whether they exercised any shaping influence on these younger men.

Beccafumi's style retained the complex and precise character acquired in this time, but he was not temperamentally disposed to hold its tone of gravity for long or to restrain his fantasy. A trip to Genoa, perhaps in 1536 (on the invitation of the Principe Doria), brought him into contact with the sophistications and extravagances of the style Perino del Vaga had developed in the Palazzo Doria, and these seem to have been a stimulus towards the highly-mannered artifice of Beccafumi's panels for the apse of Pisa Cathedral (1536-8). These brilliantly precise manipulations of Maniera forms are infused, as their Genoese inspiration was

not, with a renascent power of narrative imagination, which in the *Punishment of Dathan* [101] reaches an almost daemonic level. Another voyage, this time to Rome, in 1541, seems to have had no traceable effect, though in the course of it Beccafumi was exposed to Michelangelo's *Last Judgement* and to new examples of the formed Maniera. Indeed, after his return he seems to have receded from his own concern with the ambitions of Maniera.[80] An altarpiece of the *Birth of the Virgin* (Siena, Pinacoteca, *c.* 1543), depicted most exceptionally as a night-lit interior, has evident elements of Maniera artificiality in it – by now ineradicable – but these ornamental elements are no longer the very substance of the painting but literally only ornamental, woven upon an exposition of the theme that is tender and almost sentimental. The night lighting is much less a Mannerist *concetto* than an instrument with which Beccafumi remarkably evokes and varies mood. An *Annunciation* (Sarteano, Ss. Martino e Vittoria, 1545-6) is still more singular in its effects of light, making colour even more affective, translucent and flame-like. The figures make a serpentine calligraphy, finely indicative of a Maniera taste, but here – more nearly in equal proportions than in the *Birth of the Virgin* – their elegance of form and a poetry of narrative sentiment, delicate and poignant, are absolutely fused. As in the contemporary Pontormo, the elements of Maniera form are made to carry an inescapable content of emotions, as they did not always do in Beccafumi's preceding phase. In a *Coronation of the Virgin* (Siena, S. Spirito; of uncertain date within the 1540s) the qualities of Maniera are very much diminished and its classicistic accent specfically is quite gone; only the thin fineness of handling and surfaces insists on a connexion with the

101. Domenico Beccafumi:
Punishment of Dathan, 1537-8.
Pisa, Duomo

modern style. The subject is treated in a temper of devotion that recalls the early Beccafumi, but more quietly. The effect is archaistic, and purely native Sienese. It looks backward, but it is at the same time an anticipation of an artistic current that was shortly to be widespread – simplistic and assertive of the authority of belief – the incipient Counter-Reformation's *arte sacra*.

Sodoma had been earlier and more effectively Romanized than Beccafumi. The style he had matured in Rome, however, was an imposition of Raphaelism on Sodoma's provincial origins – Sienese, distantly Lombard, and tangentially Florentine – rather than a true assimilation of it. After 1520, when Sodoma's practice became almost wholly Sienese, his acquired Romanism waned, and the personal and provincial bases of his art emerged more strongly. His works of the twenties are still related to his Romanizing style, but with only wavering consistency; they refer increasingly to local and to Tuscan models, and their qualities of resemblance to classicism diminish. A major work of 1525, a double-sided standard painted for the Sienese Company of St Sebastian (Florence, Pitti), shows both the persistence of a classicism in Sodoma and his re-provincialization, and the same admixture can be found among the frescoes he painted in 1526 for the Chapel of St Catherine in the church of S. Domenico. Until about 1530 Sodoma's pictures show diverse tendencies in style, which reflect his response to influences that seem to depend more on accidents of contact than on a principle of choice – e.g. Pinturicchio, the early Sarto, and the recent Michelangelo. But his diversity of manners does not exclude the emergence at the same time of an increasingly apparent strain of personal expression, in which there is a marked sharpening of emotional content and a complication of effects of form. Rhythmic patterns become more precise, complex, and mobile, contrasts of chiaroscuro become more charged,

and psychological sensation is both more inward and acute. His feelings and his devices of form come into focus, and Sodoma's style in the thirties rises on occasion (as in his *Ordination of S. Alfonso*, Siena, S. Spirito, 1530) to a febrility and poignance like those in contemporary Florentine Mannerism. His quality of feeling and his vocabulary of form resemble somewhat those in Beccafumi's pictures of the previous decade, and seem in part due to his example.

Despite an extended stay in Florence, in 1528, Sodoma seems to have responded little to contemporary events there;[81] his stimulus to a new direction lay rather in the local, Sienese, example. Sodoma's conversion to Mannerism was never more than tentative, yet during the thirties he acquired more of the outward indices of the style – still, it would appear, mostly from Beccafumi: a tendency to elongated forms and an inspiration to an elegance which, as Sodoma expressed it, remains provincial. In pictures done for the cathedral of Pisa in the early 1540s, following in Beccafumi's footsteps and working beside Sogliani, Sodoma pretends to Michelangelesque and Mannerist modernity, but petrifies the novelties he would adopt. A *Sacra Conversazione* (Pisa, Museo Nazionale di S. Matteo, 1542) [102] is less pretentious and more effectively contemporary – introspective, precious, and equivocal, tardily translating Leonardo into a hesitant Maniera. This is the character that his latest works, such as the *Lucrezia* (Turin, Gallery), maintain: they belong to the Maniera which in the fifth decade had become universal currency, but with the reservations that Sodoma's aberrant personality and his long history of prior practice caused him to retain.

In his character of a painter, Peruzzi's later years are no more than an appendage to the remarkable and creative career of his maturity in Rome. His interest, and apparently his opportunities also, turned increasingly towards

102. Il Sodoma: Sacra Conversazione, 1542. *Pisa, Museo Nazionale di S. Matteo*

architecture, and his practice in painting became quite secondary. Save for an episode in Bologna (late 1521 to 1523) he remained an adoptive Roman until the Sack, and even after he resettled in Siena he returned twice to work in Rome, once briefly in 1530-1, and then in 1535, dying there in January 1536. Yet, as a painter, it was his native school that in the end reclaimed him. This reconversion took a decade and a half to accomplish. The project that called Peruzzi to Bologna, the design – never executed – for an architectural remodelling and a painted decoration for the façade of S. Petronio, survives in an important drawing (London, British Museum); its painting style would have been related to the charged late classicism of the *Visitation* of S. Maria della Pace. This is also the manner of a monochrome painting of an *Adoration* (London, National Gallery) done in Bologna as a cartoon to be executed by Girolamo da Treviso. It may have been only after his return to Rome from Bologna that Peruzzi finished his painting of the figured inserts in the loggia of the Villa Madama, where, almost certainly, he had begun to work before he left in 1521. His work in the east vault of the Madama loggia is the last sure evidence that we have of Peruzzi's painting from his residence in Rome before the Sack. Having earlier anticipated some of the qualities of post-Raphaelesque Maniera, these small frescoes now make these more precise, in a polishing of figure surface and an added artifice of posture; but these may be less personal developments than a reflection from Giulio Romano's dominating style.

There is a long hiatus in Peruzzi's later career in Siena until a major work in painting can again be credited to him.[82] Having completed the building of the Castello at Belcaro, Peruzzi was entrusted with the decoration of its chapel (dated 1535), salon, and garden loggia. He was much assisted in this work, and much of what is left, in the loggia particularly, is heavily restored. But his responsibility for the designs is certain, and his own execution is evident in much: in the *Judgement of Paris* in the salon and in the frescoed altar painting of the chapel and the small narrative scenes of martyrdoms (equivalent to predella panels) on either side. Their style represents the most sophisticated possible reversion to the local and eccentric artistic dialect of the Sienese school. The strangenesses of form that were the currency of Sienese late Quattrocento painting – stilted, disarticulate, and elaborately unreal – are resurrected, and converge with the fantasy of modern Mannerism. The vocabulary in which the two are joined is precious in the extreme, calculating in its affectation of archaism and naïveté, and most calculating of all in its assumption that this pretence of fairy-tale primitivism is a proper region for artistic fantasy to explore. At the end of Peruzzi's career he emerged – though on an altogether different plane of sophistication – into a style that is more like his earliest identifiable beginnings, at S. Onofrio in Rome, than all that his invention and experience had produced in the years between.

This is archaistic in Peruzzi, which is very different from the real archaism of all except his major contemporaries in the Sienese school of this time. Some of the painters – Pacchiarotti, Pacchia, and Vincenzo Tamagni among them – who had been the conservatives of an earlier moment survived to practise almost without change into the third and even fourth decades, and thereby give a sallow complexion to the collective face of Sienese painting in this time. The hold of tradition on the generality of Sienese art is illustrated by a painter of the generation which, elsewhere, tends to mature into the full style of Maniera: Bartolommeo Neroni, called Il Riccio (fl. after 1530, d. 1571), who in his long and busy career achieved a slow alteration of his modes, from Sodoma's all the way to one that was a partial accommodation

with Maniera, but stamped each into the patterns of an archaism.[82a]

THE DISSEMINATION OF ROMAN MANNERISM

The rapid spread of the version of the Mannerist style that was generated in Rome, and the primacy that it acquired in Italy, were in part the result of the historical accident of the Sack, which forced protagonists of the Roman development to transfer their practice elsewhere. Other factors also promoted the spread of Roman style, among them the continuing activity as a publisher of contemporary prints of Baviera, the entrepreneur who before had served Raphael in this capacity. Almost as rapidly as the new Maniera came into being, prints from designs by its leading masters made its appearance known to a wider audience. It was nevertheless the Sack that precipitated the diffusion of the style from Rome, and the years 1527 and 1528 saw a veritable diaspora of Roman Mannerism.

Giulio

However, the first major step in the diffusion of this style did not wait upon the Sack. Late in 1524 Giulio Romano had moved to Mantua, where he was to have two decades of remarkable achievement before his death in 1546. His arrival drastically changed what had been a situation of provincial backwardness since Mantegna died in 1506, existing on a thin diet of the late works of the resident Lorenzo Costa, the minor Leonbruno, and on assorted imports. But the ambitions of the young ruler of Mantua, the Marchese Federigo Gonzaga, were vast – consonant with his importation of a personality as important as Giulio to fulfil them – and he gave Giulio both opportunity and authority that were in scale. Giulio was Federigo's architect as well as decorator, an absolute *régisseur* of all artistic activity in Mantua. He carried to his Mantuan practice the shop system that Raphael had developed and which he had inherited, but in Mantua there was no diffusion of Giulio's authority into his executants' hands. They were virtually automatic agents in the demonstration of his style and the exposition of his ideas.

The character and the abundance of ideas in Giulio's Mantuan accomplishment make it one of the most distinctive as well as forceful expressions of the Mannerist style. Of the Palazzo del Te, Giulio's earliest and most important work of architecture and decoration in Mantua (the painting done mainly between 1527 and 1530, with adjuncts until 1534), Vasari later remarked that there were 'certe stanze piene di tanti varii fantasie, che vi si abbaglia l'intelletto'; and in fact the fertility and power of inventive intellect that Giulio displays in his decorative schemes is without precedent save in the career of Raphael himself. But Giulio's ideas are not presented to the spectator like Raphael's, as serenely compelling revelations, but as assertions of a startling eruptive force. They are made by processes of intellect, but this intellect seeks effects that trespass reason: 'si abbaglia l'intelletto'. It is not only that the utmost ingenuity of mind is used to manipulate the elements of fantasy but, still more 'abbagliante', at times within the decorations of the Te an anticlimax of unreason is achieved by pushing logic mercilessly to its limits. The conclusion of reason in absurdity is fully conscious. Throughout the decoration there is a strain (in both senses of the word) of wilful, even sadistic, humour – an acid ferment within the grandeur and the opulence, which questions the sense of splendour even as it is extravagantly made. The temper of the decoration in the Te is the evidence in extreme degree of the kind of post-classical personality in which individuality is developed to the point of eccentricity, in which sophistication is so great

that it requires stimuli beyond the range of normalcy (either in their force or subtlety), and in which mondanity is cynical even of its own values. The prime emotions by which Giulio is moved are too complex for us to examine here, but their main channel of expression – curiously oblique for feelings so profound, in which the will to destroy cohabits with a daemoniacal creative urge – is wit. This decoration is the first, and here utterly inspired, demonstration of the *concettismo* that was to be one among the hallmarks of literary as well as later pictorial Mannerism.

Yet the link with Raphael in kind, both thematic and aesthetic, if not in temper of idea, remains perceptible. The principal room in the suite of which Giulio conceived the decora-

tion,[83] the Sala di Psiche (1528–30), by its very theme required reference to the Farnesina, but it is in the nature of Giulio's habit of response to Raphael's authority that he should at once acknowledge and transform it. In this large, square, vaulted room Giulio creates a whole consistency of illusionistic structure [103]: Raphael's classically idealizing exercises in illusion are replaced as precedents for Giulio by the stringency and daring of Mantegna's model in the Mantuan Camera degli Sposi and by the newest inventions in illusionism of Correggio in near-by Parma. The *Wedding Feast of Cupid and Psyche* extends into a landscape setting across two walls of Giulio's room, and a third wall is divided by two scenes from the history of Mars and Venus. The painted struc-

103. Giulio Romano: Sala di Psiche, 1528–30.
Mantua, Palazzo del Te

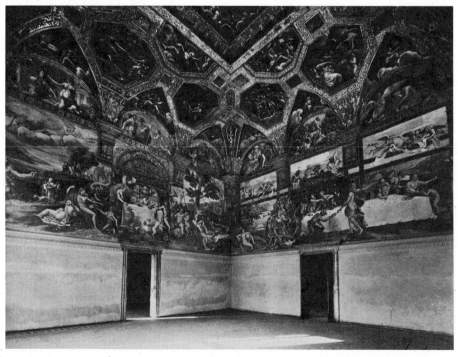

ture of the lower walls is made to intersect with a superstructure of lunettes, severies, and a geometrically patterned ceiling in which each division is an oculus through which we see, with inexorable exactness of foreshortening at three successive levels of ascent into the heavens, an incident in Psyche's history. The perspective structure culminates in a view absolutely *sotto-in-su* of Psyche's cloud-borne marriage which is at once an astonishment and an absurdity. The architectural enframements, heavy and severe in shape, are disposed in a system that compels them into movement, and they are filled with massive forms none of which is at rest; the whole assertive, dense accumulation is charged with the powers of masses and energies in contest with each other.

The force that is generated is tremendous, but it belongs to the aesthetic structure more than to the actors who inhabit it. They are an artificial race, more even than before in Giulio a resurrected statuary that his sole will manipulates. The illusion has no baroque element in it, as its Correggesque parallel does: it does not project the semblance of reality but confirms a fantasy, abstracted yet a further plane beyond the illusion of an ideal sphere that Raphael had made.

A later and still more remarkable room in the Palazzo del Te, the Sala dei Giganti (1532–4), carries a conceit of Mannerist illusion to an extreme that nothing in the century would surpass [104]. The theme represents the destruction of the Giants by the Gods: Jupiter, sur-

104. Giulio Romano: Sala dei Giganti (detail), 1532–4. *Mantua, Palazzo del Te*

rounded by his excited court, hurls thunderbolts from a painted heaven on the ceiling to bring the habitations of the giants down upon them in crashing ruin. The room is built into the shape of a beehive, so that there are no divisions of the space but only one continuity of sensation by which the spectator is surrounded and in which he is enclosed. He is a captive audience upon whom this illusion of catastrophe and terror is imposed in most aggressive terms, with the certainty that he must share it. The contest of powers that is in the structure of the Psyche room has been resolved in a collapse. Yet even this thematic and aesthetic statement, which implies a content of philosophy, is only sceptically made. Every device of illusion that could make an empathy of terror is employed, but the terror is a thrill, the nightmare fairy tale and the tragedy is enacted by monstrous buffoons. Despite the tumult of the subject, meaning is reticent of humanity, and the true sense of this work is in its wit and artifice.[84]

While the other rooms of Giulio's invention in the Te are less astonishing conceits than these two, they abound in brilliant incidents of illustration, and they develop the vocabulary of decorative devices which Giulio had brought with him from the Raphaelesque school into what amounts to a new mode. In Giulio's hands this vocabulary becomes more than an ornamental adjunct of design: it takes on the mass, the opulence, and the visible intelligence of structure that, in Raphael's time, had been reserved to figurative art. What had been incident assumes, in the Te, a self-sufficient aesthetic authority that may rival or even dominate the illustrative matter of a room.

In 1529, while still deeply engaged in the main campaign of decoration in the Palazzo del Te, Giulio received a commission for a religious work, a fresco *Assunta* for the apse of the cathedral of Verona, but only for the supply of the design, which was put into paint by Fran-

cesco Torbido. The theme of illusion is more explicit than in the contemporary Sala di Psiche, and more explicitly confesses Giulio's indebtedness to Correggio. It is not just the fault of the executant that the Veronese *Assunta* seems a forced and classicistic vulgarization of its inspired Parmesan source. Another religious commission, in 1531, was of a less ambitious kind: the fresco decoration and provision of an altarpiece (a *Nativity with St Longinus and St John Evangelist*, now Paris, Louvre) for the chapel in S. Andrea of Isabella Boschetta, Federigo Gonzaga's mistress. The altar painting indicates a small but important change in Giulio's style. While still more forced in contrasts of illumination than his Roman altarpiece for S. Maria dell'Anima, and more charged in eccentricity of types, there is an intrusion of a mode of drawing that attempts fluidity and cursive grace. In part, this is renascent Raphaelism, caught from the *St Cecilia* altar in Bologna, but more significantly it is a response to the artist (recently returned to Parma after four years in Bologna) whom some regarded as the transmigrated Raphael: Parmigianino. By response to the Maniera Parmigianino had evolved, Giulio's Mannerism begins to entertain an ambition of a kind it did not have before, which was at variance with his earlier aesthetic, and which would never cohabit quite successfully with it. This borrowed *grazia* is the symptom of an incipient conversion of Giulio to an overt Maniera.[85]

It was in Giulio's subsequent great decorative enterprise that this conversion was accomplished, in so far as it was possible to the premises of style that Giulio brought to it. From 1536 to 1539 Giulio was engaged in a major remodelling and decoration of the Appartamento di Troia of the Mantuan Palazzo Ducale (assisted, as at the Te, by his *équipe*). A suite of rooms of assorted sizes, each of them displays a variation upon Giulio's developed style of ornament, which in its force, its sense

of scale, and its character of geometric conse-
quentiality seems to be a growth out of the
architecture, not an imposition on it – the
evident creation of a painter who was also an
architect. The main rooms contain large figured
decorations also: in the Gabinetto dei Cesari
Giulio made a pictorial elaboration as well as
an ornamental setting for a set of portraits of
the twelve emperors supplied by Titian.[86]
Giulio's panels, illustrating a history from the
life of each emperor, have been lost or dis-
persed, but those that survive (three smaller
panels at Hampton Court, and a larger *Triumph
of Titus* in the Louvre) [105] show the measure
of Giulio's accommodation in 1536-7 to the
diffusion in Emilia of the Parmigianinesque
Maniera. His figure style accepts the new taste
for attenuation, but incompletely, for there is a
persistent heaviness in the proportions of the
figures; nevertheless, the action and drapery of
each form and their patterning into a whole
design is in rhythms of elaborate gracility. Save
for the persistence of his ineradicable plastic
strength and the force with which he conceives
human content, Giulio, in the middle thirties,
yields to the Maniera; but the saving clauses
are essential to the definition, even in this
moment, of his style. This is the character also
of the fresco decoration of the chief room of the
apartment (1538-9), which illustrates the his-
tory of Troy in a compound, not always
aesthetically functional, of violence and man-
nered grace. The ceiling painting has an extent
and liberty of illusionist conception that in its

105. Giulio Romano: Triumph of Titus, 1536-7.
Paris, Louvre

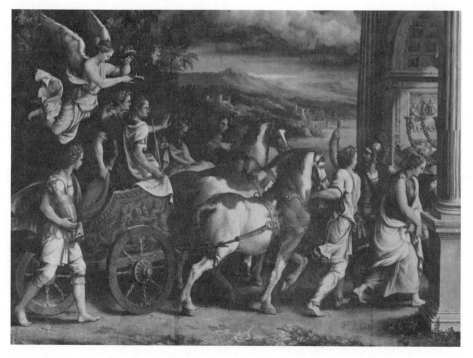

mechanics presages the Baroque, but no more than before describes a visual reality.[87]

Giulio's accomplishment in Mantua was extraordinary in extent and quality, but its effects on contemporary and subsequent art in North Italy were less important than the accomplishment itself. A central point of Giulio's art, his Roman involvement with plasticity and energy, had a profound and it would seem regenerative effect on the ageing Titian, and this is of major significance; lesser painters throughout Emilia responded too to facets of Giulio's style, but he had no widespread school. His style – and his temperament – were too idiosyncratic and too difficult of digestion to command an extensive following. Rather than a diffusion of his style out from Mantua into its Emilian context the reverse occurred, and the Parmigianinesque Maniera that had concurrently established itself in Emilia imposed itself on him.

Perino

Giulio had a stature of personality which, almost more than any other of the first Mannerist generation, bears comparison with the great men of the time of the classical style. Perino was a mind and spirit on a lesser scale, who finds his level with the generation that follows his own rather than with the generation that precedes. It is in part on this account that, unlike Giulio's, Perino's intelligent but facile art had wide historical consequences. In Genoa, where he practised following the Sack, from 1528 to 1536-7, he formed a long-enduring local school; but historically it is more important that after this absence he returned to Rome to work there for a full decade until his death in 1547. Incipiently in possession of a formed Maniera when he left, the style he brought back was the richest and most various fulfilment that Maniera had so far achieved –

exceeding even Parmigianino's, from whom Perino had acquired much in the beginning. In Pauline Rome Perino became a principal formative example for the next generation, who converged upon the city as Perino's generation had before the Sack, and who were to be the painters of the high Maniera style.

The manner with which Perino had left Rome was not yet wholly affirmed; it was the time in Genoa that brought his style to fruition. He was invited to work there in a situation that was not so unlike Giulio's in Mantua: he was in entire charge of the remodelling and decoration of the Palazzo del Principe, the chief residence of Andrea Doria. The burning of the palace in 1527 was the pretext for new work. Perino supervised the necessary architectural alterations, and probably in 1529 was able to begin his painting. His first decoration, the ceiling of a large salon with the *Quos Ego* from the history of Aeneas (in the east wing of the palace), has been destroyed, but its design is preserved in a drawing in the Louvre. The painting of the salon in the west wing which was its counterpart seems to have waited until between 1531 and 1533, and in the interval Perino may have painted in the vaulted entrance, often called the *atrio*, of the palace.[88] The decorative scheme here relies closely on Perino's Raphaelesque antecedents, fusing recollections of the Farnesina, the Stufetta of Cardinal Bibbiena, and the Logge. The main figured panels in the vault, illustrating antique triumphs, are akin in theme and mode of composition to the Roman façade designs of Polidoro. But the most important factor in their style is a consequence that Perino has now more fully drawn from Parmigianino: a swiftness, flexibility, and pervasiveness of mobile rhythm beyond what he had used before, of superb grace and lightness in its temper.

The major decoration that survives in the Palazzo del Principe is of the west salon, of

106. Perino del Vaga:
Fall of the Giants, 1531/3(?).
Genoa, Palazzo del Principe (Doria)

which the theme – like Giulio's nearly contemporary work at Mantua – is the *Fall of the Giants* [106]. We have no certainty of a priority in time of either room before the other, nor any knowledge of a contact between the painters,[89] but the radical differences in their treatment of the common theme indicate that there was none. Giulio's Raphaelesque ancestry is obscured entirely in his Sala dei Giganti and has undergone (in his longer time of residence away from Rome) a deep contamination by Mantuan and Parmesan illusionism. Perino's bond to Raphael remains absolutely clear. As in the Farnesina, Perino's ceiling with its vast central panel of the *Fall* is on a horizontal plane, entirely without intention of illusion: a grandiose *quadro riportato*. Its stucco enframement, with figured panels and grotesques, is in the manner of the Logge. Below, an ornamented architecture of spandrels, severies, and

lunettes is a re-synthesis of various precedents in Raphael's school, but it is also a development on them, for the stucco figure decoration here assumes a scale and a plasticity not used earlier in Rome (though it begins – apparently independently – to do so at this same time at Mantua and, under Rosso's guidance, at Fontainebleau).[90] The effect of the decorative whole is in the vein of elegantly restrained opulence that Perino had exemplified, together with Giovanni da Udine, in his Roman Sala dei Pontefici, with the same accent of a neoclassicism: discreet, orderly, and cool – the temperamental opposite of Giulio's decorations. The classicistic character of the *Fall* itself is equally apparent. In the upper zone, where Jupiter is surrounded by his court, the population of the Farnesina reappears, but smoothed and chastened – they are the visible ancestors of the mythologies of Ingres – and of

107. Perino del Vaga: Pala Basadonne, 1534. *Washington, National Gallery*

more artificial poise. Below, the Giants, lean and fine-muscled, are fallen into rigid, pointing attitudes, as if in some improbable ballet. The patterns each form makes and the linear movement that defines them are instinct with energy, but an exquisite calculation then congeals them. Repetitions, progressions, and precise intersections link each form in a design that is complicated in its movement, yet immobilized. The atmosphere that this aesthetic mechanism creates is of a cold tension, as in an electrically charged stratosphere: it is a brilliant compromise between the descriptive immediacy and the mythological distance of the pictured event.[91]

The decoration for Andrea Doria was not Perino's only occupation in his time in Genoa. He had commissions for religious works as well, altarpieces or panels of Madonna themes of which the most impressive is the *Pala Basadonne* (or *Bacciadonne*, from S. Maria della Consolazione; ex-Cook Collection, now Washington, National Gallery; dated 1534) [107]. Like Perino's other altar paintings, this one is more traditional in structure than his contemporary mythologies – more dependent on Raphaelesque tradition, and in expression quieter and more reserved. Yet in detail it is articulated in a way that pertains explicitly to the Maniera, complicating the calligraphy of drapery, pointing and refining postures, and making feeling subtle to the point of evanescence. Colour is eccentrically powerful, glowing with acidulous intensity out of dark. In this effect of light and colour Perino's painting verges closely on the mode of Giulio Romano, whose influence is clear: not from the Mantuan altar for S. Andrea that this painting seems to resemble, but from the earlier *Martyrdom of St Stephen*, then (and still) in Genoa.[92]

Perino's presence back in Rome is documented only in April 1539, but other evidence shows that he was certainly there before the end of 1537. It is symbolic for a major function he would have in the Roman school, then still in process of its reconstitution, that the earliest action we know of after his return was an intervention in the affairs of the rising generation: it appears that he supplied the design that was the basis for Jacopino del Conte's fresco of the *Preaching of the Baptist*, painted in 1538 in a principal milieu of the rising high Maniera, S. Giovanni Decollato.[93] Perino's own first major work after 1538 was a commission to complete the decoration, begun by Giulio Romano and Penni, but interrupted by the Sack, of the Cappella Massimi (now destroyed) in SS. Trinità; Perino's contribution was the painting on the walls of frescoes of the life of Christ, set in an elaborate system of enframement. We have several of Perino's designs for this lost decoration, and one major fresco (*The Resurrection of Lazarus*, now London, Victoria and Albert Museum) is extant, from which we can assess a change in Perino's manner consequent upon his return to Rome. The decorative system no longer has the neo-classic quality of those in the Palazzo del Principe but is more plastic, more internally diversified and more precise in temper of articulation, and depends more on a repertory derived from architecture. The figure style is denser, heavier, and more movemented. In this Roman climate, Perino takes renewed inspiration for his achieved Maniera from the late Raphaelesque (and Michelangelesque) tradition that had formed his art before the Sack, and which he, in his own earlier independent Roman works, attempted to perpetuate. The presence in Rome of Michelangelo, and the vastly impressive accomplishment in 1541 of the Sistine *Last Judgement*,[94] must have accelerated this alteration in the temper of Perino's Maniera. It appears in the panel paintings of Madonnas of these years as well.

Perino became the principal decorator for the Pauline court, but time and circumstances interfered with the completion of his main

commissions. Yet it is his controlling mind that absolutely dictates the form and character of the decoration, begun in 1545 (two years before Perino's death), of the great Pauline apartment in the Castel S. Angelo: the vast Sala del Consiglio and the smaller adjoining Sale of Psyche and of Perseus.[95] In the Sala del Consiglio Perino describes the history of Alexander the Great [108]. On the vaulted ceiling the painted scenes are set out in planes of strict rectangular geometry, but this is plastically elaborated and ornate. On the walls a system of painted architecture, only intellectually illusionistic, supports – more properly is overladen by – a dense accumulation of figures which simulate (again by intellectual device, but not optically) niche statuary and compositions in relief. The figure style has made obeisance to the most recent example of Michelangelo in muscular exaggeration, scale, and ponderousness, but translates what was Michelangelesque into the artificial language of Maniera. The sense as subject matter of the room requires seeking: it almost vanishes beneath the surcharge of formal energies and complications. The human figure is converted, more pervasively and wholly than it had ever been before in Perino, to the ends of ornament. Of the whole matter of design, he makes an encrusted opulence, abstracting and remote despite its power.

This is the culmination of a Maniera decorative style in the forming of which Perino had been one of the chief agents since the early years of post-Raphaelism (and, regardless of his accent of Michelangelism, it is on this tradition, in Giulio Romano and Raphael himself, that Perino's Sala del Consiglio depends). He came to the conclusion of his art with a work of which the character is wholly that of the high

Maniera. More than any other artist Perino illustrates – and created – the historical continuity in which the high Maniera style was formed.[96]

Parmigianino

After Parmigianino left Rome following the Sack, he settled in Bologna for four productive years. He then returned to Parma, where he worked, though under circumstances of increasing difficulty, nearly until the time he died, at the age of thirty-seven, in 1540. In Rome, his personal development and his experiences of Roman stimuli had coalesced into the matured statement of Maniera he had made in the *Vision of St Jerome*, and it was from this threshold that he advanced during his Bolognese and later Parmesan years. He did not take the result of his Roman achievement of a new style as adequate, requiring only more refinement and elaboration: the passion and the energy of research that had inspired his art in Rome did not decrease. After the *Vision of St Jerome* he explored the further possibilities that his achieved position opened up, and pressed these with such daring and consequentiality that, by the middle of the fourth decade, he had reached the extreme limits of what is essential to Maniera style. The mere elaboration was a function he would leave to others. But when he reached this developmental end he was not content with repetition, and in the few years that remained to him he effected a major reorientation of his style. What he had sought until about 1535 had been the ultimate – indeed the barely probable – extreme of *grazia*, the terminal experience of exquisite aesthetic sensation. Afterwards his art sought for a different value, which he communicated in a new gravity of form and content. It was a different commitment from the one to which he had applied himself before, but that commitment had been no less profound.

108. Perino del Vaga: Story of Alexander (detail), 1545–7. *Rome, Castel S. Angelo, Sala del Consiglio*

When he left Rome, Parmigianino's technique began to reassert its Correggesque and North Italian origins, no longer in any derivative way but in a characterization as subtle as Correggio's, and often more assertively brilliant, of effects of optical sensation. In Parmigianino's paintings of his Bolognese phase his colour assumes a new intensity, strong and often dissonantal, and more suggestive than in his Roman works of the quality of atmosphere and textures. A surface property of his style – but not his handling of shapes and forms – thereby assumes a character that distinguishes it from the Maniera of Central Italy. Beneath this surface, Francesco's formal vocabulary developed the dominance in it of the role of mobile shapes, so that he now made pictures in

109. Parmigianino:
Madonna with St Margaret, 1528-9.
Bologna, Pinacoteca

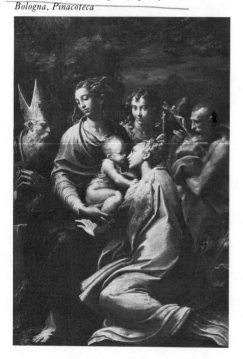

the temper that he earlier expressed only in his drawings. The *Madonna with St Margaret* (Bologna, Pinacoteca, 1528-9) [109] bespeaks passion discharged in a fluency and febrility of feeling that have been refined into an ultimate grace. An air of grandeur recollected from the classical style persists, as it did in the *Vision of St Jerome*, but the temper of the Bolognese work is freer, and it is more poignant. In two later paintings of the Bolognese time, the *Madonna della Rosa* (Dresden, Gallery, 1528-30) and the *Madonna with St Zachariah* (Florence, Uffizi, *c.* 1530), there is a still more probing refinement of sensation, in draughtsmanship, in complexities of colour threaded, tapestry-like, into the drawing of the form, and in psychological expression. It was after his return to his native Parma that Francesco found the conclusion of his search for the exquisite, in the *Madonna dal Collo Lungo* (Florence, Uffizi, *c.* 1535) [110]. No sixteenth-century work of art goes farther than this in its arbitrary reformation of humanity into images of artificial grace, grand yet precious, and of an improbable and quasi-abstract beauty. As it proved, in the terms of reference within which the sixteenth century functioned it was not possible to press beyond this limit without compromising sense and quality. Vasari himself remarked (1550 ed., 852) that 'he who would imitate him would make no more than an exaggeration of his style'.

It was mostly after 1535 that Parmigianino executed (only in part, but the larger part himself) the fresco decoration of the east vault of the church of the Steccata in Parma. Here he combined into an original scheme motifs and ideas he had observed long before in Raphael's school in Rome. The sense of a relationship between Francesco's art and the precedents of classical style is affirmed anew: the major figures of the decoration have a gravity like that of antique images or of those of Raphael's highest style. The mood evident in the whole

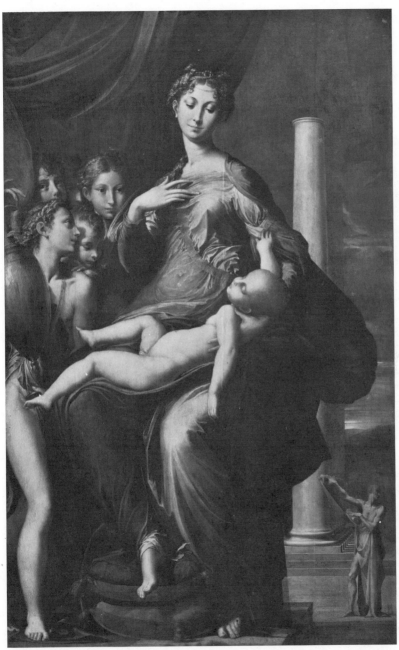

110. Parmigianino: Madonna dal Collo Lungo, *c.* 1535. *Florence, Uffizi*

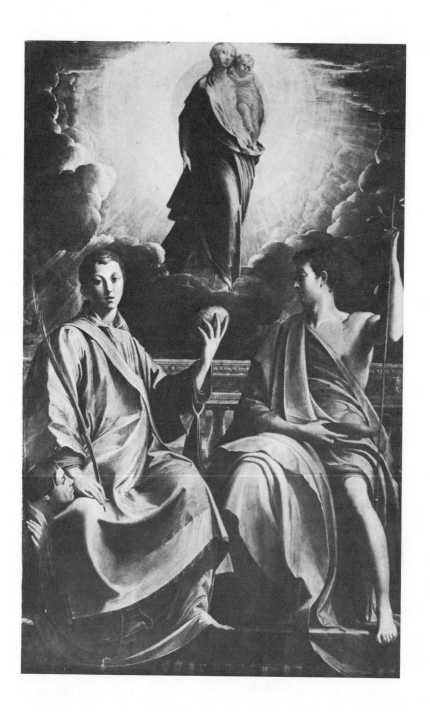

decoration is distinct from that of Francesco's recent works, seeking dignity and seriousness in place of febrility of sensation. This new gravity of form and content is the dominant of the last painting of Francesco's that survives, the altar of the *Madonna with St Stephen and St John the Baptist* (Dresden, Gallery, 1538–40) [111]: it is severe and hieratic in its structure, reserved and grave in its expression, yet distanced by extreme refinement towards abstraction. Vasari has recorded for us a change in Parmigianino's personality that occurred in his last years. No longer content with the credo of private aestheticism that seems to have been his sole spiritual resource, he sought other surrogates for the experience of religion. For a while during his later Parmesan years he found it in alchemy, to which (in the manner of his time) he certainly gave a sense of Christian allegory, but in the end he seems to have had an entire reconversion to religious faith. The austere religiosity of the Dresden picture seems an anticipation of the imminent Counter-Reformation.[97]

The influence that Francesco's style exercised was vast and extended far beyond the limits of the Roman and Emilian centres in which he worked. It was generated not only by his paintings but still more by his drawings and by the products of his activity in the graphic arts. While in Bologna he not only continued his sporadic practice of the art of etching (he was, apparently, the first Italian to employ this graphic technique) but also directed an atelier in which chiaroscuro prints were made from his designs by printmakers of much merit, chief among them Antonio da Trento. In Bologna, the predominance of an imported Raphaelism of a conservative and provincial kind yielded only gradually to his example, but by the 1540s his *St Margaret* painting had at

least partly displaced Raphael's *St Cecilia* altar in its formative effect on younger artists. In Parma, the exemplary value of Francesco's style replaced Correggio's. At first, through Schiavone's agency, his mode infiltrated Venice, where it became a major factor in the history of Venetian style in the 1540s. We have seen the effect of Francesco's manner on Giulio Romano's style in Mantua; it was of more consequence that it affected, and eventually mainly shaped, the painting of Giulio's Bolognese assistant Primaticcio, who succeeded Rosso in the direction of the School of Fontainebleau, and had no less effect on Primaticcio's successor, the Modenese Niccolò dell'-Abbate. Not only the North Italians of the younger generation but the Central Italians also were not exempt from seduction by Francesco's art: experience in both Rome and Bologna confirmed an inclination to his model of Maniera, already felt through graphic works, in Salviati and Vasari. In the decade following Francesco's death it was his currency of art that had come to have the widest circulation. His formula for a Maniera was enchanting, and, at least superficially, imitable; the quality of his poetic imagination and his subtlety of hand were not.

Romanist Example in Umbria and the Marches

When Giulio left Rome, so did Raffaellino dal Colle (*c.* 1490–1566), who had been Giulio's most faithful executant in the Sala di Costantino and had helped in other works of Giulio's post-Raphaelesque shop. Raffaellino joined Giulio briefly at the beginning of his stay in Mantua, but the principal places of his post-Roman practice were to be in Umbria, at Borgo S. Sepolcro, Città di Castello, and in the Marches at Pesaro. In these places he was an adequate representative of Giulio's style for a full decade. But as was the case with Giulio also, Raffaellino yielded in time to the influence

111. Parmigianino: Madonna with
St Stephen and St John the Baptist, 1538–40.
Dresden, Gallery

exerted on him by his local context. Working mainly in Umbria after about 1533,[98] and near its Tuscan border, Raffaellino exchanged a good part of his Giulian style for Vasari's version of a newer Maniera when, in the course of time, that style assumed a regional dominance.

At Pesaro, where he had first been active between 1530 and 1532, Raffaellino was – as he had been in Rome – part of a decorative *équipe*, working now under the direction of Girolamo Genga, the Urbinate architect and painter who himself had earlier been Romanized in Giulio's mode.[99] In 1524 Genga had been called to Pesaro to work as architect and decorator for Duke Francesco Maria della Rovere in his Villa Imperiale. Throughout most of Genga's remaining career (he died in Urbino in 1551) the invention and supervision of this decoration was to be a principal concern. The experience of Raphael's and Giulio's inventions is the basis of what Genga conceived for the Villa Imperiale, but he had a narrower, even obsessive, concern with the role of illusion – not unexpected in a painter who, in these years, was mainly an architect. An extraordinary series of illusionist conceits dictates the decorative scheme of the Villa Imperiale, making fanciful elaboration of large spaces or giving startling perspective extent to quite small ones. This is a genuine development upon the decorative concepts learned from Rome, making the devices of illusion radically more assertive, and in instances extending it to include, as if beyond the walls, the presence and invading atmosphere of landscape. The ideas are thematically and structurally brilliant, but there is an element of stiffness in their articulation. The thinking is related to the caprices and conceits of Mannerism, but the mode of speech retains the accent of Genga's older generation as well as his provincialisms; it lacks *maniera*. At the same time, the mentality at work here requires

to be compared with Giulio's in his contemporary inventions in the Palazzo del Te. Its results are among the major ones produced by the ferment of new decorative ideas in post-classical painting.

Genga himself appears to have worked in part at least on the gigantic painted *tenda* in the main salon of the villa, the Sala del Giuramento, depicting *Francesco Maria of Urbino receiving the Oath of Fealty*. The *tenda* (reflecting those in the Farnesina) is unveiled by putti who stand on a heavy structure of perspective architecture (the vaults of the Raphael Logge vastly magnified), below which more putti lift draperies which reveal, through framing pilasters, a grand continuity of romantic landscape. Even drastic repainting does not obscure the scale and novelty of the idea. The execution is primarily by others, and in the other rooms of the villa it is wholly by imported helpers. In 1530, when the building was ready for painting, Genga made a rather remarkable convocation of artists to this provincial place, who served him, apparently with much freedom, in the painting of his ingenious ideas. In addition to Raffaellino, who was the main executant of the Camera dei Semibusti (again a freely developed compound of sources in the Farnesina and the Logge), the young Bronzino painted, between 1530 and 1532, in the same room. In this contact Raffaellino seems to have served in some small measure as an early agent of transmission of a Roman cast of style to Bronzino. In the Sala dei Cariatidi a lyrically conceived arbour, supported by caryatid-dryads, and completely open to a vast circumferential landscape, was painted by the brothers Dossi: it is a room in which the tempers of Correggio and Giulio Romano might have been fused. Some smaller rooms, like the Cabinet of Hercules, are a learned illusionistic extension of the models of antique decorative style; their execution seems largely Raffaellino's. His style at Pesaro seems

to have been a major influence upon that assumed by Francesco Menzocchi da Forlì (1502–74), who had begun as a pupil of Genga and was his earliest helper in the Villa Imperiale. The Sala della Calunnia, in which Raffaellino painted the eponymous fresco (probably in his later time in Pesaro, about 1540), is otherwise of Menzocchi's execution. The conception of the space, still Genga's, has its origin in a long-remembered Roman source, again in the Farnesina but by Peruzzi, his Sala delle Prospettive. Now, finally, the figures that inhabit Genga's conceit have acquired the accent of the new contemporary style: in Raffaellino from Vasari, and in Menzocchi perhaps from an experience of Francesco Salviati's art in Venice, in 1539. Genga's villa was no centre for the formation of Maniera, but it was a major outpost in the provinces of Roman-inspired Mannerist thought.

POST-CLASSICAL INNOVATORS IN NORTH ITALY

In northern Italy there was no general movement that corresponded to the post-classical developments in Central Italy, but a few artists – in no sense a group; on the contrary, salient individualities – did accomplish in the third decade acts which, as much as those of their Florentine and Roman contemporaries, worked creative changes upon classical painting style. These artists – Correggio, Pordenone, Lotto, and Dosso – cannot be gathered easily under the rubric of a geographically determined school, though the focus of their activity in the crucial time of their inventions was in North Italy; nor does any generalization exist that can characterize inclusively the nature of the art that they conceived. What they accomplished is as diverse as their individualities, yet much more than they are diverse from one another all appear to stand distinct from the environment of style in which their inventions were made.

Despite the differences among these artists, we can find certain factors in common in the circumstances out of which their inventions came. All had an initial bias towards an optical mode of painting – in three of them from some essential training in the school of Venice, but in Correggio less objectively explained; and each one also had, in a second stage of his career, an experience of Central Italian art. For reasons that the biographies of each explain, none had a firm attraction to the principles of a particular northern school, Venetian or other. None felt the constraints upon response to foreign stimuli, or on freedom of invention, that integration into an authoritative tradition makes. They were to an uncommon degree free agents, not only temperamentally, but in respect to their relation to their contexts of northern visual culture.

As a proper Venetian could not do, these artists became deeply involved with the results of their experience of Central Italy, considering the propositions of an art of which the bias, differently from their own so far, was plastic and structural. They used their liberty to effect a confrontation, on the middle terrain of North Italy, between the two great divergent schools and modes of Cinquecento classical painting. In the very elements of the confrontation there was matter to provoke a ferment; furthermore, the styles that were brought together were both in an advanced stage of development, probing towards the limits of a classical expression. Based within a mode like that of Venice, but without Venetian restraints, engaged by the novel and dynamically impelling example of Central Italy, but without schooling in its discipline, these painters moved quickly towards a region of post-classical experiment.

In the course pursued by each of them, and in some of the means they used, there are elements that resemble those that we discerned in the experimental phase of Central Italian Mannerism. But the North Italian or Venetian factor in the compounds these men make gives what they do a measurably different nature. In their varieties of style each retains an immediacy of response to sensuous – not only optical – experience, and to physical presence and its energies, that is opposite to the Mannerist translation of experience by intellect and artifice. Emotion may be as intense and irrational as in the first Mannerism's anti-classic strain, or it may be febrile as in the incipient Maniera, but it is illustrated by these northerners in a palpable humanity.

There are aspects of this way beyond the confines of a classicism that imply, more than

they do a Mannerist style, a style of baroque; but among these painters only Correggio makes a consistency that in some works strongly adumbrates, but yet is not, baroque. This is occasional, and the occasions come within a brief time-span of Correggio's career, when he works in a more inspired but actually not much less hybrid style than do the others. They unsettle the propositions of classicism, share in qualities and ambitions of contemporary Mannerism, and find devices like those of baroque style, and all this is the fermenting intersection made by great creative artists from the resources laid before them by their time and place. It does not endure in this complexity and level of creative force beyond the crucial third decade. In these painters, as in their Central Italian counterparts who were the innovators of the Mannerist style, there is then a détente of experiment, and indications of concession: to the persistently available example of the classical style, or to the increasingly pervasive models of the new Mannerism.

Correggio

The most profound of these innovators, and the subtlest spirit among them, was Antonio Allegri, Il Correggio. His origins and the chief places of his practice were provincial, yet he transcended them utterly to achieve a suavity and complexity of artistic utterance which alone in the whole extent of the northern Italy of his time may be compared to that of the Venetian Titian. His place of birth, from which he takes his name, was the seat of a minuscule provincial court, not far east of Parma, the town where he was to spend the most important years of his mature career. The time of his birth is uncertain: between 1489 and 1494, with the strong likelihood that it was towards the later year.[1] His birthplace had no role we can discern in his artistic education, which it is now clear

must have taken place in Mantua at a time when, even if Mantegna might no longer have been still alive, his direct school held the dominating place. There is no documented work by Correggio before late 1514, but approximately a dozen pictures survive that attest his activity during at least the three preceding years, from about 1511. The earliest of these are in a style of which the strongest evident component is its connexion, in motifs as well as in manner, with a Mantegnesque inheritance; but they are softer, touched with a sfumato that is not native to the older style. Correggio's inclination in this sense is not only personal, even in the beginning; it reflects the savour of détente that is in Costa (the successor of Mantegna as the Mantuan *caposcuola*) and which was a widespread tendency in the contemporary Emilian school. Certain among these early works, dating from 1513-14, indicate a second aspect of Correggio's education: an experience that is almost – but not quite – provable of the Milanese work of Leonardo, and a likely contact with the earliest work in Bergamo of Lorenzo Lotto. Correggio's ties to his first Mantegnesque vocabulary are, however, so profound that he does not loose them wholly even in response to Leonardo; yet the change that this response creates is crucial and was to be a major factor in the evolution of Correggio's style to come. A small panel of the *Marriage of St Catherine* (Washington, National Gallery, Kress Collection, formerly in the Frizzoni Collection) is thus Mantegnesque in details of vocabulary, but is conceived in a sfumato that is not only pervasive, but so subtly described as to approach Leonardo's own quality of vision and touch.[2] It is much more than a technique that Correggio has comprehended: he has fused this Leonardesque optical consistency with a consonance of vibrant, shadowed mood – what can only be described as a sfumato of emotion; this is a quality that

Correggio was to retain in his art long after its specific precedent in Leonardo has been forgotten. This image moves not with the facile languor of a détente style but with the life of an internally responsive unity: this is the legible beginning of a Cinquecento style. The Leonardesque essence is infused into the conservative substance Correggio inherited and instigates the process of its transformation.

It is doubtful whether in this earliest time Correggio also knew the new art of contemporary Venice. Yet in his *Adoration of the Child* (Milan, Brera), close in time to the Washington *St Catherine*, he conceived a landscape setting (for figures that are largely still of Mantegnesque accent) that is as subjective – as romantic, indeed – a response to the visual and emotional matter that resides in landscape as anything in Giorgione or the young Titian, and more freely mobile. Even if the notion of a landscape handled in this active and emotive style should have derived from Venice,[3] the mode of vision in it is that which Correggio deduced from Leonardo. Nor is the colour, of landscape or of figures, that of the contemporary Venetians; it is a colorism still related to the 'local colour' systems of the Quattrocento, but in which hues are given new translucence and intensity by immersion in a Leonardesque light.

The young Correggio does not confess his influences readily, but there is the likelihood that another one, which would in time be no less significant than Leonardo's, conditioned the formation of Correggio's style within 1514. In August of that year he received a commission from the Franciscan monastery at Correggio for his first large-scale altarpiece, the *Madonna of St Francis* (Dresden, Gallery) – also his first documented work; it was delivered in the spring of 1515 [112]. There are persistences in it of Mantegnesque style (as there would continue to be in some degree for a further year or two) and a reflection of Costa's gracile affectation, and there is a Leonardesque accent more overt than in preceding works. But in addition there is a new rounding fullness that Correggio has given to most of the sfumato forms and a rhythmical coordination, resembling a contrapposto, of their attitudes, so that (despite the episodes of archaizing drapery) the figure style now approximates that of a modern classicism. And the larger structure, supported by a monumental architecture, gathers the figures into a geometric order of responsive movements, and thus makes an adequately accomplished classical scheme – an analogue as close as any in Emilia at the moment to the style that Raphael had achieved in Central Italy half a decade before. Raphael's influence is very likely relevant to this emergence in Correggio of an approximation of classical style: the *St Francis* altar may reflect Correggio's experience of Raphael's *Sistine Madonna*, probably in North Italy, at Piacenza, by 1514.[4]

The *Four Saints* altar (New York, Metropolitan Museum, *c.* 1515) more openly confesses an experience of Raphael, derived from another recent import into northern Italy, the *St Cecilia* altar in Bologna. More than the *St Francis* altar, the *Four Saints* conforms to Raphaelesque prescriptions of design and of classicizing amplitude of canon for the human form. The picture is conceived with a sophistication which, more than in the *St Francis* altar, attests Correggio's maturing command of his artistic resources. Yet the same maturing marks the liberation of his own individuality, which as it emerges in the *Four Saints* shows a tendency, at once subtle and insistent, towards eccentric and refined emotion and effects of rhythm and chiaroscuro that support it. The exposure to Raphael's classical example was not sufficient to effect an essential classical conversion, and the earlier memory of Leonardo serves not as classical example but as a stimulus towards shadowed sentiment. Correggio's provincial

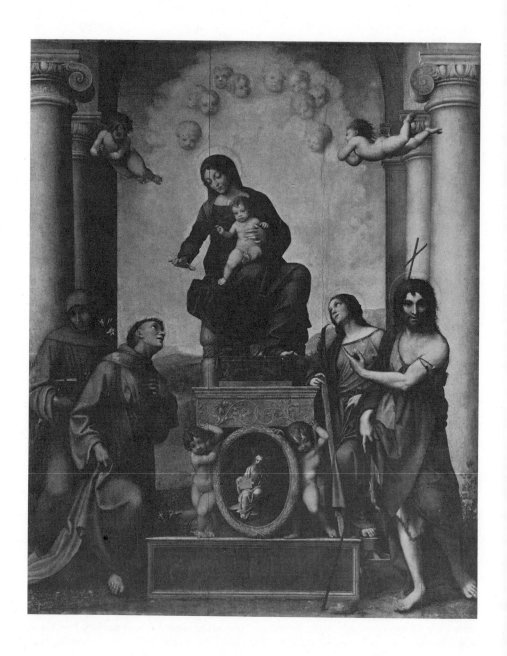

112. Correggio: Madonna of St Francis, 1514–15. *Dresden, Gallery*

context reinforces this unclassical direction: the attitudes he reveals in it are not unlike those of the ageing Costa, and the eccentricities of form as well as emotion which Correggio in the next year or so increasingly displays suggest those of such Emilians painting at this time as Aspertini and Mazzolino. More than Correggio, their styles are attached to a tradition of the latest Quattrocento, and their measure of exposure to classical example – or their concern with it – is less, but the phenomenon their style represents is related to Correggio's in this brief but important phase. The phenomenon has been given uncomfortable names: proto-Mannerism or naïve Mannerism,[5] signifying a mode of which the expressive intentions and the liberties of form may resemble those of the imminent Mannerism of the twenties, but which, unlike true Mannerism, does not presuppose the formative example of the classical style. It is in such an emotionally charged and descriptively libertarian mode that Correggio painted his *Adoration of the Magi* (Milan, Brera, *c.* 1516), and the *Hellbrunn Madonna* (Vienna, Kunsthistorisches Museum) of the same time. In the *Adoration* Correggio's actors communicate an inspired tenderness, which they express in convoluted rhythmic patterns that warp appearance, and in colours that glow out of chiaroscuro with an effect of phosphorescence.[6] To a moment slightly later, but almost as extreme, belongs the famous *Zingarella* (Naples, Capodimonte, *c.* 1516-17; damaged), as lyric a conjunction between figures and landscape as any in Giorgione, but more emotionally inward and evanescent.[7]

Within 1517, and yet more evidently in works that follow into the next year, Correggio receded rapidly from this eccentrically expressive mode, and while he retains what he had gained in it of deepened and more complex sensibility he communicates it in successively more moderated terms. Correggio had previously achieved the elements of a classical style

in the *St Francis* altar, and evidence in the paintings of 1517-18 suggests that more mature rumination on Raphael's *Sistina* began to have significant effect. A picture like the *Madonna di Albinea*, painted in 1517 (the original lost; copies in Parma, Gallery, and in Rome, Capitoline Museum), retains the warping attitudes of the preceding phase but partially incorporates them into rounding classicizing forms; the *Holy Family with St Jerome* (Hampton Court) much more consistently approximates classical example; and the *Rest on the Flight* (Florence, Uffizi, *c.* 1518) finally assimilates not only the essentials but also the sophistications of an advanced classical style. The guide to this end has been, almost surely, Raphael: typology, figure canon, drapery style, and deportment of Correggio's actors resemble Raphael's as he had demonstrated them in his exports to North Italy. But the example has been interpreted in Correggio's private temper, which even as it accepts the classical prescription for form and its refinements of feeling, communicates within them a differently impulsive energy and more intimate, excitable emotion. Correggio's instinct of response to experience is, differently from Raphael's, in that region where emotion and motion intersect, one reciprocally signifying the other. In the *Rest on the Flight* it impels the figures into an asymmetrical mobility of composition which is yet, with classicizing effect, resolved in balance; it generates a vibrant interplay of coloured light and textural sfumato; and it gives the whole image a quality, not ordinary to classicism, of nearness – of optical experience, of sensuous presence, and of psychological communication. We cannot trace a sure Venetian component in the formation of this – now effectively mature – style of Correggio, while the influence of Central Italy is clear; yet the closer analogue to Correggio's accomplishment in 1518 lies in Venice, in the art of Titian, rather than in Rome.

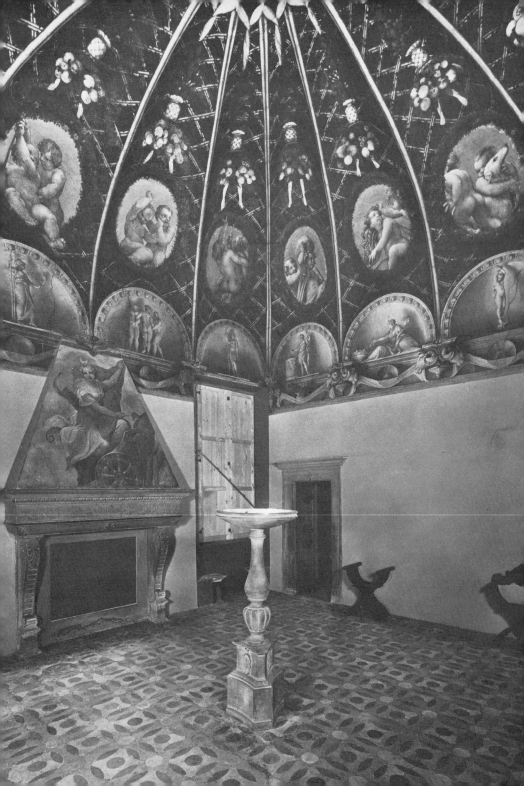

This is not an abnormally delayed emergence of a matured style. Correggio at this time may have been no more than twenty-four. If he in fact belongs exactly to the generation which made the first post-classical researches in Florence, his tempo of development is not so different from theirs, nor is its course. But differently from them, Correggio's environment in North Italy could supply only meagre information of the nature and accomplishments of the classical style. Like the Mannerists, Correggio was to move beyond classicism, but he first required to know more fully what it was. It is a virtual certainty that Correggio sought this knowledge at its source, in Rome. The evidence of documents in no way attests it, but permits time for a trip by Correggio to Rome in the period between March 1518 and January of the next year. His works that follow are sufficient attestation that the Roman visit did occur.[8]

In 1519, after the presumed time of this voyage, Correggio settled in Parma (where he was to spend the greater part of the next decade), and probably between February and September of that year painted the *camino* and the vaulted ceiling of a room in the convent of S. Paolo, commissioned by its abbess, Giovanna Piacenza, to illustrate a programme of sophisticated humanist complexity [113].[9] The assigned literary symbolism is, however, utterly incorporated within meanings that are addressed essentially not to the reading but to the seeing eye. Correggio summons into figured life a simple integer of space, by means of, and with an effect like, those he must have observed in the most advanced contemporary classical style in Rome. An inheritance from Mantegnesque illusion[10] is tempered in a fictive pergola that substitutes the vault, accepting the

control of the pre-existent architecture: Raphael's conceptions in the Cappella Chigi of S. Maria del Popolo, in the Psyche ceiling of the Farnesina (and perhaps in the earlier bays of the Logge) are Correggio's models, less in overt motifs than in their classical aesthetic for illusionism and in their demonstration of a way to create opulent yet lucid harmony. It is not only the larger scheme that takes on the character of Roman classicizing form. The figures in it find a plastic power and richness of articulation that derives from Raphael's example, and in a measure from the impact of the Sistine Ceiling. There is even an alteration of Correggio's previous types and canon in the figures which requires the precedent of the Roman Raphael. Correggio's *Camera* is the entirely up-to-date counterpart of the Roman works whose study shaped its style. But it retains, as the private accent in its classical style, the effects of Correggio's prior optical disposition, his responsiveness to sensuous excitement, and his pulse of mobility – elements which, expressed at a higher level of intensity, or in the context of thematic matter more emotionally charged, could alter the complexion of the classicism which they here subserve.

As it had been once before, this new – and now authoritative – command of classicism was on one hand an acceptance of a discipline, and on the other a threshold for a liberation of Correggio's personal resource. In his immediately subsequent commission, for frescoes in the Parmesan church of S. Giovanni Evangelista, Correggio was given a theme, a purpose, and a scale of operation of another order than in the *Camera*. Invention was galvanized by opportunity, and the result was an event in the history of Cinquecento style equal in consequence to those that occurred in Florence, Rome, and Venice in these same crucial years. From late 1520 to early 1521, Correggio painted the *Vision of St John on Patmos* in the

113. Correggio:
Camera di S. Paolo, 1519.
Parma, Convento di S. Paolo

dome of S. Giovanni [114], attended by four patron saints of Parma and Doctors of the Church in the pendentives; in the spring and summer of 1522 he painted a *Coronation of the Virgin* in the apse (destroyed when the apse was lengthened, and replaced by a copy).[11] With far more dramatic effect than in the small *Camera* the memory of Mantegnesque illusionism and the experience of Raphael's recent essays coalesced in this setting, the daring and perspective realism of the one expanding the controlled ideality of the other. Correggio's experience of the Sistine Ceiling is also much in his mind – so much that the dome and its pendentives are permeated by quotations from it[12] – but the inspiration of Michelangelo serves for figure motifs and magnitude of human drama, not illusion; Michelangelo's limits on illusion are not what an ambition founded in Mantegna would accept.

As the apse and dome of the S. Giovanni decoration once were, almost adjacent to each other, they made a close sequence of illusions, populating and expanding the climactic architectural features of the church. The spectator entering the church was first commanded by the sweeping panorama of the *Coronation* in the apse; as he came nearer down the nave the pendentives of the cupola compelled his eye; then St John's vision was progressively revealed to him in the dome itself. Beneath the dome, where the spectator was arrested by the conjunction of effects of architecture and of painting, the Revelation in it became complete: a vision given the effect, in terms both of spirit and of sight, of an illumination. Bursting within the dome as from a suddenly opened heaven, light expresses an energy of optical sensation and effect of verity in it that far exceed anything of its kind so far in the history of painting. The

light conveys its vibrance to the figures it reveals, shaped to a new power of presence on Michelangelo's and Raphael's examples. Linked in movement, the Apostles are the inspired chorus for the Christ who hovers over them, a helix arrested at the nearest instant of His visionary descent.[13]

The painted revelation probes strongly and surprisingly into space like a Mantegnesque illusion of the Quattrocento and uses its devices of foreshortening, but without reference to a perspective scheme. This is not an illusion of static form but of a mobility, and of the energy that convinces us that forms are alive. Differently from Raphael's recent illusionisms, the more urgent verity that Correggio intends, and its overriding energy, demand to be projected as a unity in which restraints of architectural geometry may not intervene. Correggio has conceived a mode of illusion that exacts a concentrated, instant act of credence, of which the apparatus is not the measuring intelligence, as for Mantegna's illusionisms, nor the intellect that discerns form, as for Raphael's, but the intense convincingness of its sensuous and spiritual life.

The descriptive means and yet more the optical devices Correggio employs to achieve this measure of illusion affirm a factor of reality in the image that exceeds the normal usages of classical style; but it is not his main purpose thereby to attain a more objective truth. On the contrary, the increased verity is the means to a subjective end: the credibility of form is intended as an agency of communication. As in the most recent art of Raphael, but still more like the first inventions of the Mannerists of Central Italy, Correggio seeks for a way of communication more immediate than classical style had allowed, and of a more urgent tenor of emotion. It is his private passion that inspires substance in the *Vision* and infuses its light. This subjective energy is Correggio's essential communication, inhabiting what he represents

114. Correggio:
Vision of St John on Patmos, 1520–1.
Parma, S. Giovanni Evangelista

of appearance and illustrates as subject matter. From the moment of his entrance into the church the spectator is involved with the artist in a transaction, in which he is required physically to move, as the painted image seems to do, and required to respond to its living sense until he stands finally transfixed, a surrogate for the Evangelist, beneath St John's vision.

There are elements in Correggio's decoration – in the apse as well as in the dome – which, as they exceed the previous repertory of classical style, imply a baroque direction: as the heightened sensuous and optical veracity, the energy of form and feeling, and the dynamic unity of design are expressed in concert here, they may be assessed as potential, and even partly realized, factors of a baroque style. It does not discount the meaning of invention in this that in the end it is more evident how much attached the S. Giovanni decoration still is to classical ideas. Correggio's conception of the human form remains based on the canons of appearance and behaviour of the Roman school, and the figures act together with a contrapuntal grace like that in Raphael's mature designs. The energy of forms is manipulated into a grandiose equilibrium, no matter how highly it is charged, and there is a counterpoise between the powers of substance and of light. The illusion takes the place of the given architecture, but does so with an equivalent form which adheres to the architecture and accepts, even rigorously, the definition that it makes of shape and limits. In the dome the mark of classicizing ideality and measure in effects of form and the classical tonality of grandeur in expression are no less evident than Correggio's novelties. But in the next year the *Coronation of the Virgin* was already more committed to the exploration of the novelties, at the expense of classical restraints. A clear reference to Raphael's *Disputa* is only a point of departure for Correggio's design of the

Coronation. The actors in the *Coronation* are impelled to movement of unprecedented breadth, the main ones pressing forward towards and over the architectural limits of their space, the others (by exaggerated contrasts of scale) expanding its dimension upward and to the rear. More explicitly than in the *Vision*, the *Coronation* fresco probes and amplifies the repertory of devices by which the painted image can make contact – physical, optical, and psychological – with the spectator and thereby claim his involvement in communication.

Correggio himself was immediately involved in the consequences of his inventions at S. Giovanni. His founding there of an aesthetic that to a new degree compounded communication with illusion was decisive for the subsequent direction his work took, and in the course of 1522 and 1523 infiltrated his easel paintings also. Some, like the *Madonna adoring the Child* (Florence, Uffizi, *c.* 1522) or the *Marriage of St Catherine* (Paris, Louvre, *c.* 1523), remain relatively conservative, but increasingly the tenor of expression and the manipulation of form in easel works incorporates the aesthetic made for S. Giovanni. The *Madonna del Latte* (Budapest, Museum, *c.* 1523) seems classical in the breadth and geometrical cohesion of its forms, but these are pressed on to an inclined axis to make mobility in space, and painted with an energy of drapery rhythm and chiaroscuro that projects excitement. On a more private scale, the small *Madonna della Cesta* (London, National Gallery, 1523-4) [115] is freer and still more explicit in the means it uses to communicate its activity of form and content. Madonna and Child are placed extremely near to us, in sloping postures that (without the justification for them of a decorator's illusionism) approximate foreshortening. Their shapes are composed

115. Correggio: Madonna della Cesta, 1523-4. *London, National Gallery*

into a concavity that magnetically demands invasion by the viewer's eye. The energy of these figures vibrates in the space that closely adjoins ours, or seems even to intersect with it. Behind them, an opening on a deep diagonal into the background extends the effect of a spatial continuity from the viewer's world into the painting. Upon this whole mobile structure, Correggio's brush moves to give its surface the appearance of an inspired acceleration. The patterns of drapery modulate from swift, taut grace into sparkling brilliance. The light, differentiating tender, quicksilver colours, breaks to a vibrating climax on the central forms. This concert of subtlety and brilliance is much more than virtuoso play of visual effects: it is the legible response to the human presence Correggio describes. He feels this presence in its living unity of psyche and of substance, and so passionately responds to its loveliness that the image takes on, as in loving, an overcast of sensuality. The patterns of this picture are manipulated into a charged equilibrium that is a requisite of classicism, but neither its form nor its content in the end makes a classically finite self-sufficiency. It is not only that its physical presences are near to us, or that its energies of form and content demand sharing, but that what is in this easel picture – now even more than in the illusionist situation of the images at S. Giovanni – insists that there is no boundary between its world and ours. It is, still like the classical image, an exaltation of our world, but unlike the classical picture it is an episode and not an entity: what happens in it begins this side of the picture surface and outside the limits of the frame.

The propositions that emerge so clearly in the *Madonna della Cesta* are explored with a differently dramatic consequence in the *Pietà* (Parma, Gallery, *c.* 1524) [116], one of the two laterals painted by Correggio for the Cappella del Bono in S. Giovanni Evangelista. The theme stirs Correggio to an empathy that has no precedent for its degree or for the means by which it is expressed. As in Pontormo's *Deposition* for S. Felicita [75], a few years later, emotion is exquisite anguish, but in Correggio's picture it is not comparably distilled into effects of aesthetic artifice. Correggio's calculation is of course not less than Pontormo's, but its intention in Correggio is to subserve a communication that is, in terms of swiftness and urgency of feeling, far more immediate. The scene is brought intensely near to us, its actors given almost palpable existence in a misted atmosphere of early morning light. Passion moves the figures violently or has just moved them. The cramped dead Christ, the Virgin's crumpling, and the anguished action of the others are merged into one sweeping rhythm – swift, knotted, of tormented grace, and of the shape and impact of a breaking wave. The conception begins in a precise sense with an act of empathy, by which the painter has identified himself not only with the acutest psychological response of the actors but with its permeation of their physical being. The communication the spectator is required to share is of Correggio's empathetic re-creation of these whole human presences in an environment not separable from our own. The light in the picture projects that in the spectator's space (in the chapel the light appeared to take, as is usual, the direction of the real light from the window). At the left of the picture the second Mary, intersected by the picture frame, comes on the scene from the same direction as the spectator and as if from his space, a consort or an *alter ego* of the viewer in the first moment of his apprehension. More essentially than in the *Cesta*, the limiting and separating function of the frame has been diminished in the *Pietà*, and the pictured world made continuous with that of the spectator. Though the patterns of this picture, more powerfully asymmetrical, are again manipulated to create an equilibrium, their energies, like the effects of light and space and like the

116. Correggio: Pietà, *c.* 1524.
Parma, Gallery

picture's content, trespass the pictorial bound-
aries. But a major residue of classicism does
remain: in the appearance of the actors, still
visibly related to the classical canons of ideali-
zation, and in their tenor of expression which,
for all its acute poignancy, is the ennobled pathos
that classicism could achieve. This pathos is
compounded into grace, and appearance in-
tends not just illusion, but in equal measure a
transcending beauty, and even the light that
makes presence almost palpable is modulated
like music. More than at S. Giovanni, the
whole apparatus of a baroque style is in the

Pietà, but it serves an ethos of nobility still
bound to that of the classical style.

If Titian's contemporary treatment of a like
subject in his *Entombment* (Paris, Louvre) is to
be taken as evidence of a continuing classical
style in the north of Italy at this moment, then
Correggio's *Pietà*, despite what is still classiciz-
ing in it, belongs under another rubric than the
Titian – just as, in Central Italy, the products of
the new Mannerism do, while also manifesting
ties to classicism. It is as if Correggio had taken
a way that led outside the province of classicism
in a direction much divergent from that on

which Mannerism had embarked, and which in some respects appears the opposite, but on his different route had gone as far. The conception of an art in which illusion of existence is a primary communicative means is polar to the basis of the Mannerist style in abstracting artifice. Yet Correggio's style in the *Pietà* and – to make the qualitative level of comparison in a Mannerist work equal – Pontormo's in the *Deposition* at S. Felicita show some essential motives and some results that are alike beneath the visible, and not to be discounted, difference of relation to observed nature. Both have imposed on classical inheritance a kind and energy of feeling that exceeds classical restraints and which demands a mobility of form that overrides classical prescriptions of constructed order. The mobility of forms, like the energy of emotion, results in a pictorial structure that is no longer self-contained but open to the participation of the viewer and dependent on it. Both Correggio's and Pontormo's images have become terms in a relation with the spectator differently immediate from that of images in classical style. And in both, the main burden of the transaction between the images and the spectator is a communication of non-rational meaning. To articulate his communication, Pontormo uses a language that departs from the classical norm of ideality towards abstractness, and Correggio uses a language that diverges towards illusion, but the end the different means propose is much the same.

The similarities are still not such that the style of Correggio's *Pietà* can meaningfully be called by the same name we use for Pontormo's picture. A designation does exist which has been used for this style: proto-Baroque, begotten from the valid likenesses of major aspects of Correggio's aesthetic to the Baroque of the seventeenth century, which in effect depends significantly on Correggio, via the Carracci, for its origins. Like any term that depends upon historical anticipation, this one is uncomfort-

able, and it is falsifying in the way in which its use tends to diminish the actuality in its own context of time of Correggio's style, and still more in its implied discounting of Correggio's continuing profound relation to classicism. Nor does this term have, for Correggio, the same extent of validity that the term Mannerism has for the contemporary inventors of the new style in Central Italy. The point of innovation of new device to which Correggio probes in the *Pietà* is an extreme. Its baroque-like characteristics reappear in the same degree and with the same effect of a historical anticipation only once again, in Correggio's grandest creation, the dome of Parma Cathedral. Elsewhere in Correggio's art after the moment of the *Pietà* the elements of classicism stand more in balance with tendencies of a baroque, or come to dominate them; and there are episodes in which the impulses that in the *Pietà* result in effects resembling a baroque are transformed by variant expressive pressures into close analogues of the effects of Mannerism. 'Proto-Baroque' is, then, no portmanteau designation to encompass all Correggio's mature accomplishment. It may stand for some of his acts of significant invention, but not for his entire style.

It makes an analogue with Mannerism, not of character of style but of the chronology of the process of invention in it, that in Correggio's style too the extreme of experiment in new directions was reached in less than half a decade after its beginning. The year 1524, the likely time of painting of the del Bono *Pietà*, is also the probable moment of conception of the frescoes of the cathedral dome, Correggio's most daring act of innovation. Dedicated to the absolute achievement of the means of illusion, and to the purposes of communication illusion signified for him, the Duomo frescoes concentrated all Correggio's resources towards that single end in the five years which its vast extent required for execution, between 1525 and 1530.

But the easel pictures of the time that followed on the *Pietà* brought forth a great variety of response from Correggio, none of it completely of the kind he conceived in that work. In the *St Sebastian* altar (Dresden, Gallery, begun *c.* 1524 and delivered before 1526) the emotion that inspired the *Pietà*, welding its effects of form into an overwhelming tragic consistency, turns in a context of celebrant joy into febrility. Pointed and ecstatic, this kind of emotional intensity complicates form and is disruptive of its unity, so that the altarpiece acquires a temper comparable to one that occurs in

Mannerism, as, for example, in Pontormo's earlier altar for S. Michele Visdomini. The pendant lateral to the *Pietà* in the del Bono chapel, the *Martyrdom of St Placidus and St Flavia* (Parma, Gallery) [117], painted *c.* 1526, reveals more explicitly the affinity between Correggio's genre of emotion and that of the inventors of Mannerism. The motive impulse of the *Martyrdom* is an exploration of the possibility of art to express feeling in a degree that was to exceed that even of the *Pietà*, achieving a still higher poignance. A wholly baroque style would solicit, in this theme of

117. Correggio:
Martyrdom of St Placidus and St Flavia, *c.* 1526.
Parma, Gallery

martyrdom, a more literal naturalism and the stress of violence. But Correggio's bonds to the ideality of classicism bar this route, and the direction he finds beyond the *Pietà* is to sharpen and refine its character of sensation, transmuting its authentic pathos into exquisite feeling. The consequence in the *Martyrdom* is a fineness of sensation so extreme that it verges on or passes into artifice. The same refinement of sensation responds not only to nuance but to variety of feeling of a seeming ultimate complexity, exploiting ambivalence and paradox. Pain and ecstasy are confounded into one another, as are violence and grace; the martyrdom is as welcome to the two saints as a gift of love, and has its overtones of sensuality. Vibrating life, marbled death, and the very moment when one is translated into the other are mingled in one visual and emotional skein. To give to this tenor of emotion – as subtle as anything we find in Mannerism, though by comparison emotion in the Mannerists appears austere – its consonance in form, each element is drawn with tensile grace. Postures take on a character of rhythmic artificiality, and the whole design is manipulated into ornament as elaborate as any in Maniera. Even the colour, for all its infusion by Correggio's light, is altered to a cooler tone and a higher key, in this too approximating Mannerism.[14]

In yet another vein during these years Correggio's inclination is neither assertively like a baroque nor like Mannerism, but closer to the modes of classicism. This is the effect made by his first important essay in an easel painting on a mythological theme, the *Education of Cupid* (London, National Gallery, *c.* 1523). The theme solicits Correggio's instinct sensuality and permits that its expression be overt rather than an undertone of meaning. Nowhere previously – not even in Titian – is there such a demonstration of the way in which an optical technique can convey the effects and the emotive associations of the sense of touch. Yet these are contained in forms of classicizing beauty, idealizing sensuality. The same amalgamation of erotic emanation and idealized shape is in the pendant of the *Education*, the so-called *Jupiter and Antiope* (Paris, Louvre, *c.* 1524–5) [118], but responsive as he is to theme, Correggio here exploits what it implies of action and more pointed sensuality. By foreshortening, the figures shape out a concavity of explicitly erotic implication: sinuous oblique arabesques quicken the sleeping figure of Antiope, and a rotating impulse spurs the action into continuity and makes us know how the satyr's movement must conclude.[15] The ideality and grandeur of the forms exalts the tone of the enactment but cannot obscure the novelty of means by which the spectator is psychologically compelled to participate in it, not only by spatial and optical device but by a remarkable new conception of his sharing in a continuity of narrative theme.

Three great altar paintings – known familiarly as the *Giorno*, *Notte*, and *Madonna della Scodella* – crown Correggio's production of the later twenties concurrent with his execution of his vast project in the dome of the cathedral. Not only are they concurrent with the Duomo frescoes, but they appear to intersect in time of execution with each other.[16] The density of this accomplishment gives the effect of a magnified energy of creation in Correggio, and the works specify that the creation is, apart from any question of extent, truly magnified in its internal scale. The time of straining search for new ends and means of art is passed, and its results permit the extension of Correggio's powers to their highest level. He works in the altar paintings with an effect of ease that is the very exposition of Castiglione's *sprezzatura*, and with a breadth of idea and form that conveys nobility. The similitude to high classical

118. Correggio: Jupiter and Antiope, *c.* 1524–5.
Paris, Louvre

119. Correggio: 'Il Giorno', 1526–8. *Parma, Gallery*

temper in these qualities is reinforced by a lessening of the veristic tendency that had been a part of Correggio's experimental concern with illusion; that too is mastered matter now and does not require stress. Conversely, there is an increase in the ideality of human appearance and emotion. So that, while these altars work so freely with the accomplished repertory of new – if the term can serve – proto-Baroque device, their effect is produced in dialectical relationship with a strong tonality of classicism. The final ripening of Correggio's style thus resembles, in this dialectic process, the exactly contemporary maturing of style by the protagonists of Mannerism.

The likely first in sequence of these altars is the *Madonna of St Jerome* ('*Il Giorno*', Parma Gallery, 1526–8) [119].[17] It contains the devices to make mobility and communication that had been developed in preceding works, among them foreshortening of figures, space-creating exaggerations of their differences of scale, a concave grouping, and strong impulses of diagonal movement that energize the surface and the space. But these are now fused into an imposing density of forms and function in a monumental balance of design. Expression is more probingly refined than ever, but tenderly nuanced: we feel its vibration as the modulating of a unity of ideal mood, not as an ecstatic pathos. In the *Adoration of the Shepherds* ('*La Notte*', Dresden, Gallery, *c.* 1527–30) [120][18] Correggio uses a close counterpart of the composition of the *Giorno*, but builds it round a remarkable theme of nocturnal light, not natural in origin but miraculously emanating from the new-born Child. This is a demonstration in extreme degree of Correggio's development of optical resource, which now serves, beyond the purpose of illusion, that of revealing with the poignance of the unexpected the beauty of the beings it describes. Of unparalleled richness and subtlety, the light is also an expressive agent, not only magnifying

120. Correggio: 'La Notte', *c.* 1527–30. *Dresden, Gallery*

drama by its contrasts but lending its subtlest vibration to the expression of a countenance or the gesture of a hand. In the *Notte* a device of illusion, a kind of umbrella of foreshortened angels that seems to extend its cover to include the spectator, is carried over from Correggio's contemporary repertory in the Duomo, and so is the towering figure of the shepherd on the left. The same reverberations from the dome appear in the *Return of the Holy Family from Egypt* ('*Madonna della Scodella*', Parma, Gallery, *c.* 1526–30),[19] which is probably antecedent to the *Notte* in conception and in most of its execution. In the *Scodella* altar the reverberation is not only of the motifs of the dome but also of its special mode, emphatic and impetuous, commanding that we partake in its tone of exultation.

In November 1530 the last payment to Correggio for his work on the cathedral dome was

made – only half the project that Correggio had been commissioned for eight full years before; that commission intended that Correggio decorate the apse as well, as he had done in S. Giovanni.[20] His reason for abandoning the rest of the scheme is nowhere documented, but it may be surmised that what he did paint had provoked discomfort in his patrons on two grounds, one aesthetic and the other moral – objections that were ingeniously combined at an early date in a canon's epigram that called the dome a 'stew of frogs'.[21] It must have been difficult for the canons and burghers of the Duomo to find themselves the owners of the most drastically revolutionary act of art made so far in the Cinquecento. It would carry its status of unmatched revolutionary invention into the next century.

Commissioned in November 1522, the designs for the dome were probably made only late in 1523 or early in 1524; painting was certainly not begun before spring of that year. In September 1526 half the work was paid for, but it is uncertain what this sum defines, for the whole includes not just the dome proper, with its representation of the *Assumption of the Virgin* [121 and 122], but four patron saints in the pendentives, a frieze in the spaces between them, and allegorical figures in the soffits. All this was complete, as we observed, before November 1530. The work at S. Giovanni, which won Correggio this new commission, was of course the threshold from which he approached it, but in the interval until he made the dome designs his thinking had developed in the ways that we have seen in the *Madonna della Cesta* and the del Bono *Pietà*. It is in the time and in the temper of inspiration which those works exemplify that Correggio confronted the theme of his new decoration and the vast space on which he was to paint it. Still more than at S. Giovanni, Correggio's conception of his new theme, the *Assunta*, is a *gestalt* in the full round: an enactment, unfolded on

the surface of the hemisphere the architectural space provides, of a scene that in an easel painting would be projected on a flat field.[22] The Apostles are distributed around the drum of the dome, standing vertiginously on its cornice in front of a fictive balustrade, in postures of impassioned action. Angels, as if suddenly materialized, swarm on the balustrade's top edge. Above them is a space of light-struck moving clouds, then the miracle itself, portrayed in a mingling of foreshortened human and angelic forms and clouds into a shape like that of a funnel, suspended in the heavens and rotating slowly. Within this cone the figures rise upwards, level upon level, fading as they recede towards the light of a central opening into an infinite sky. Towards the forward and lower part of this rotating form, where it will take the eye of the spectator as he approaches from the nave, there is a concentration of the heavenly host, among whom the Virgin is borne upward by a jubilation of angels. The perspective of these figures, like that of the whole form within which they are gathered, is not strictly central but inclined slightly towards the oncoming spectator.

All the effects that at S. Giovanni predicated the involvement of the spectator have been astonishingly magnified, and not just from the difference of extent. In the pendentives below the drum the four patron saints of Parma are given the appearance of entire projection forward from the surface of the wall, carried on clouds borne by angels that float within the spectator's space. Grand form and power of action command belief in the presence they assert. Above them the lower cornice of the drum, a hexagonal shape, carries no such capacity to define a boundary as the heavy circular cornice of S. Giovanni, but in any case it is made explicit how strongly Correggio intends that the boundary be crossed. The giant Apostles, standing where the ribs of the drum should be, translate the architectural statics of

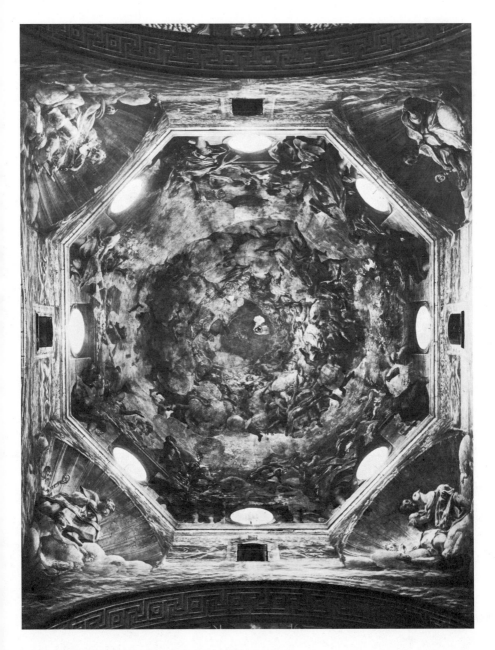

121. Correggio: Assumption, *c.* 1524–30. *Parma, Duomo*

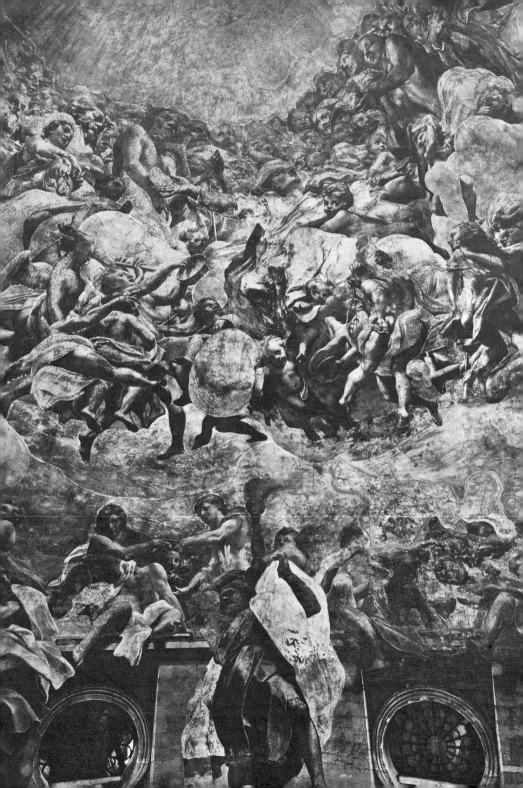

the drum into the dynamics of their human action, which almost as much as in the patron saints is defined as taking place before the wall and in our space. Still higher, the illusion of the heavenly figures projected in foreshortening conveys the sense of an energy in them that derives not so much from their physical action as from the energy of light that falls on them and infuses the surrounding air. There is no real effort in their flight; theirs is a floating in a divinely generated turbulence to which Correggio has given the look of an event of nature. Its effect of an ascent towards an infinity is absolute. Differently from the *Vision* at S. Giovanni, this scheme accepts no classicizing spatial constraints from the form of the architecture on which it is painted. It far more urgently commands connexion with the viewer's space below, and extends its penetration upward without a sense of limit.

The illusion surmounts the spectator, but he is as if absorbed into it, the object of psychological and aesthetic processes that create in him a state of levitation. His experience becomes utterly unlike that which he would have in confronting the same theme in an easel painting: it is as if the pictured event should surround him – not his earthbound body but his spirit, levitated from the earth by Correggio's devices of art.[23] The image recreates the miracle as material presence and inspired action, but projects presence into a sphere where substance seems to loose itself from weight and where light is an exalting energy. What is materialized into illusion is not denied – not even the accent of their sensuality in the angels or the nude Eve – but it prepares and is subsumed into a different end. What we perceive is the very process of a transforming ascent towards spirituality: an *ascensio* without benefit of neo-Platonism. The response of the spectator (who, by Correggio's action on him, is also a participant) is of the swiftest assimilation into spiritual ecstasy. In the dome, as in the dogma that defines the event that it depicts, physical being is vehicle and agent of a spiritual mystery.

The entire apparatus as well as an essential religious point of view of Seicento Baroque style is here, and the dependence of ceiling painting of the seventeenth century on this precedent was to be profound. Yet when the seventeenth-century derivations or elaborations on the cathedral dome are compared with it, none makes so high an effect of liberation of material illusion into spirit. For all the innovations that foretell the Baroque and for all the kinships with it in the concept of expression, the reach and tenor of Correggio's thought belongs still to the ideality of Cinquecento classical style.

The repertory of the Duomo frescoes is so wide that it is almost inevitable that the easel works that follow should recall its motifs or remind us of the quality of expression of some of its details. Yet when such elements appear apart from the context they have in the dome, their meaning becomes different. And more important, there is a discernible alteration in the expression that Correggio gives his work after the Duomo, or even during its latest stages. It is apparent in the difference between the *St George* altar (Dresden, Gallery, c. 1530–2)[24] and the three great altarpieces previous to it. In the *St George* altar, the design is, at least in basic elements, more traditional, even retrospective, as if it might have been conceived as an *aggiornamento* of Correggio's first altarpiece of 1514–15. Returned after the completion of the dome to his native town (where he was to reside until his death in 1534), Correggio might well have been stimulated by the contemplation of his early work to such an exercise. Accepting the framework of the earlier classical design, he has fused into it the devices and sophistications of the intervening years. But the tone of sophistication is different from that in the preceding works. It illustrates not only subtlety of feeling in the actors but a fine-edged artificiality in

122. Correggio: Assumption (detail). *Parma, Duomo*

them, evident in physiognomy, in gesture, and in quality of attitude. These latter factors become, obviously, elements of form, and their precise, overdriven grace is reinforced by a new sharpness of articulation of linear rhythms in the design, and by a polishing of surfaces. A smaller devotional image which may be of the same time, the *Ecce Homo* (London, National Gallery),[25] applies a like mode of sensation to a tragic theme with a result that prophesies the world of Carlo Dolci. Here Correggio has set himself the proposition that pathos be compatible with grace, but in this degree of each they cannot be reconciled. The consequence is a mode of feeling in which the contrast of the two emotions generates a third, of the unresolved tension between them; but in the main the effect is that feeling itself has become artful. This recollects the emotional mode of the *Placidus and Flavia* of some years before, or more exactly extrapolates from it, and like that picture this one too conveys an accent of Maniera.

Correggio's chief commissions in his last years were for secular themes, among them four illustrations of the Loves of Jupiter for Federigo Gonzaga of Mantua: the *Ganymede*, the *Jupiter and Io* (both Vienna, Kunsthistorisches Museum, *c.* 1530), the *Danaë* (Rome, Borghese, *c.* 1531) [123], and the *Leda* (Berlin-

123. Correggio: Danaë, *c.* 1531.
Rome, Borghese

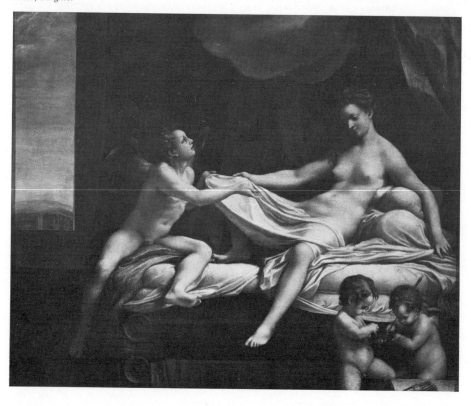

Dahlem, *c.* 1532-3).[26] Emotion in these consists of an extreme sophistication of erotic sensuality – the counterpart of Correggio's compassion in religious themes and, as we observed, a frequent undertone in their expression. The response to sensuality is now at an unexampled level of complex subtlety, at once explicit and oblique, prurient and lyrical, impassioned and exquisitely tender, and the pictures are at the same time overt illustration and high art. The mingled skein of feeling and the extreme refinement with which feeling is expressed makes these works kin to the mentality of the Maniera, and this sense is reinforced by certain elements of form. The grace with which shapes and postures are described hovers close to preciosity, and the emanation made by light on flesh is tempered to a silvered opalescence, distilling sensual effects.

Theme affects the specific expressive tenor of Correggio's other late secular paintings. In the pendant allegories of *Virtue* and *Vice* (Paris, Louvre, *c.* 1532-3), the former is a gracile rhythmical elaboration of design very like a product of Maniera. The latter, almost as fluent, lays stress on refined carnality. A further painting, the so-called *Capture of Christ* (known only in copies, e.g. Rome, Capitoline), converts an obscure passage in the Gospel of St Mark to the ends of a perverse erotic theme, as if some equivocal illogic should permit that the mentality of the *Danaë* and the *Ecce Homo* be combined.

These works of the brief time between the completion of the dome and Correggio's death mark a recession of the creative energies that had carried him so far in his inventions towards a baroque style; and as passion yields to high refinement, the direction the late works take finds increased affinity to the recently affirmed style of Maniera.[27] In the context of contemporary art in which Correggio existed this is the association we are required to make, but in the context of Correggio's own past history, in which there is so much that resembles a baroque, this last phase of his career should perhaps be thought of as Correggio's personal rococo. With all the immediacy of relation to his own time and its aesthetic and expressive problems that his art displays, he was also the prophet of the styles of two centuries to come.

Pordenone

Giovanni Antonio de Sacchis, called Il Pordenone (1483/4-1539), was an artist whose genius was far less than Correggio's, but his power of invention was almost comparable and the motives that inspired it were similar. The influence of Pordenone's inventions was not as enduring as Correggio's, but within the span of Pordenone's own activity it was vast, and geographically more widespread. Pordenone's inventions were clamorous in their novelty and more obvious in their effect. Of a provincial origin much more isolated and retardataire than Correggio's, in the Friuli, north-east of Venice, the climate of his earliest artistic education was not one to impose a discipline of form or of expressive manners. Even after close experience of Venice and a knowledge of the classical style of Rome, Pordenone's conception of the function of art for long remained provincial and popular, not only daring vulgarity but at times evidently willing it.

Pordenone's first works, which we can trace back to 1500, belong entirely to the local tradition in the Friuli of late Quattrocento style.[28] By the last years of the first decade, however, he had gravitated towards the orbit of near-by Venice, and by 1511 a dated altarpiece from Collalto (Venice, Accademia) approximates the recent models of Venetian painting, though still with an archaic cast. Thus re-oriented, Pordenone's assimilation of the contemporary Venetian style proceeded rapidly. In his Vallenoncello altar of 1513-14 (Vallenoncello, church) the quotations from Venetian models are quite

up-to-date and his technique has assumed the surface aspect of Venetian opticality, and in the *Madonna della Misericordia* (Pordenone, Duomo, commissioned 1515) technique and motifs thoroughly resemble those of the current Venetian mode. Yet it is apparent, as Pordenone grew towards mastery of the new style, that he was not quite sympathetically disposed to the classical principles that reside in it: the inclination in Pordenone's provincial beginnings towards a rude, even disruptive plastic force and towards a rough directness of communication remains. His conversion to Venetian modernism was superficially effective, but it was incomplete. No sooner was it accomplished than Pordenone was exposed to a very different kind of experience offered by the art of Central Italy, and there he found matter to exploit that was more congenial to him.

The first evidence of direct contact of Pordenone with Central Italy is in an altarpiece at Susegana of which the date must be just subsequent to that of the *Madonna della Misericordia*. There is only one provable index of this contact in the altar, and it is with an early work of Raphael, at that time in Perugia. Other indices suggest, but do not prove, more extensive contacts at this moment to the south.[29] By 1516 or, at latest, 1518 Pordenone's acquaintance with the art of Rome is certain. Some time in this span he painted a frescoed altar in the church of Alviano (south of Orvieto towards Rome) for Pentesilea Baglione, the Perugian wife of Bartolommeo d'Alviano, recently deceased, who until his death had been a condottiere of Venice and lord of the town of Pordenone. The Roman contact seems to have had a galvanic effect on Pordenone. In the Alviano fresco Pordenone compounds Raphael's example into Michelangelo's, and both are seen through a filter provided by Sebastiano del Piombo's style – the ground for Pordenone's sympathy with the expatriate Sebastiano, also inclined towards an art that is plastic and

pathetic despite a Venetian education, is obvious. When Pordenone encountered the art of these Roman exemplars it stood at an apex of the classical development, but it was not a classical response they stimulated in him. He took those aspects of their art that would come to strain the style of classicism: in particular its pressure towards a higher energy of form, its grandiose impressiveness, and its dramatic force. He chose not to observe its formal logic or its discipline. Uncongenial to the manners of a metropolitan style, and restive even before this beneath the constraints that the classicism of Venice had imposed on him, Pordenone – until now more tangent to the classical style than of it – found in his experience of Roman art a springboard for a post-classicism. At Alviano Pordenone's forms grew suddenly towards the exaggeration of dimension, the turbulence of composition, and the impetuosity of action and emotion that were to characterize his art of the twenties. A strong element of illusionism also appeared for the first time at Alviano among the components of Pordenone's style. Illusionism had been in his experience of North Italian Quattrocento art since his early years, but it required the demonstrations of contemporary Rome to show how it could become a major adjunct of a liberated power of expression.

It was in the Cappella Malchiostro in the Duomo of Treviso (dated 1520) that Pordenone's new style came to its fruition.[30] The fresco decoration here consists of three major elements: a dome with God the Father borne by angels (destroyed in the Second World War) [124], complementary to Titian's painting of the *Annunciation* (done about contemporaneously) on the altar wall below [58]; an *Augustus and the Sibyl* in the semi-dome between; and on the left wall an *Adoration of the Kings*. The presence of Pordenone and Titian in this single context is the symptom of a competition between them which, now that both were publicly

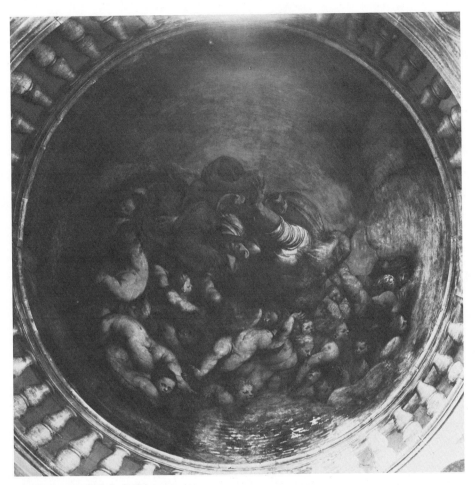

124. Pordenone: God the Father, 1520.
Destroyed, formerly Treviso, Duomo

established, was to be recurrent and at times overtly hostile, but in the course of which the rivals would not hesitate to borrow from each other – an exchange in which, as we shall see, Titian may have been the larger debtor. If Titian's altar was in the chapel before Pordenone started work, it put the proposition of illusionism on which the fresco scheme is based; but Pordenone certainly did not need the stimulus. Vaunting the results of his Roman studies, Pordenone proceeded to show just how much more novel, dramatic, and – in a Roman sense – stylish an effect he could achieve than Titian had two years before in his first great public work, the Frari *Assunta* [57]. To outdo the *Assunta* Pordenone makes reference to it, and in referring to it exploits what had been Titian's invention as a base for his

own. The *Augustus and the Sibyl* in the semi-dome exaggerates the dramatic gesticulation of Titian's *Assunta* Apostles into a sweeping rhetoric, and inflates their grandeur into swollen majesty; all this at the foremost plane of the curved wall, so that the figures intrude on the spectator's space. Their effect of presence is supported, and their tone of grandiosity increased, by a looming architectural perspective – ostentatiously Roman – just behind them. The movement and illusionism of this fresco is, however, only a prelude and transition to the invention Pordenone made in the dome. Bust-length Apostles in roundels in the pendentives lean out at us as if through casements; above them a painted balustrade defines the drum, and in the dome itself a massive God the Father descends towards us, almost hurtling: he is barely held within the space of sky the dome is made to represent by the efforts of the dense swarm of boy-angels who support him. The idea is a critique of Titian's God in the *Assunta*, and it refers to Michelangelo's God in the Sistine *Creation of Adam* and perhaps to the God in the oculus of Raphael's Chigi Chapel in S. Maria del Popolo, but these sources are exploited towards a sensationally novel end. The dome is antecedent by a brief moment only – a few months at most – to Correggio's in S. Giovanni Evangelista in Parma, and there is no good likelihood that any connexion can exist between them; yet Pordenone's image and Correggio's resemble each other remarkably in devices and effects. Pordenone, however, is almost not at all constrained by discipline or measure that derive from classicism; far more than Correggio, he asserts the intrusion of the weighty forms upon the spectator's space and makes a clamorous affirmation of their life and presence by their movement. There is a baroqueness in the Pordenone that results not only from the aggressiveness in it of illusion but from its hyperbole; but the very hyperbole that exaggerates presence diminishes our con-

viction of its reality. And unlike Correggio, who supports his illusion by an optical descriptive mode, Pordenone – now that he is much Romanized – projects his forms primarily as plastic elements, and only secondarily qualifies them with visual effects that persist from his Venetian past. The form that Pordenone asserts with such emphasis is still bound in part to the ideality of classical style, as he had seen it in Rome – to its remaking of appearance in intellectually determined, plastically emphatic shapes, to its preference for large and cursive patternings of form, and to its tone of declamatory rhetoric. Pordenone's novelty is drastic, but for different reasons (though not much less) than Correggio's dome it is still visibly affiliated with the antecedent classical style.

Pordenone must have gone directly from Treviso to take up a new commission in the cathedral of Cremona, given him in August 1520, to complete a decoration of the nave with frescoes of Christ's Passion. Girolamo Romanino of Brescia, who had been working on the series till that moment, was discharged to make way for him. By October 1521 Pordenone had painted the three scenes that remained to be done in the nave arcade, a *Mocking of Christ*, a *Road to Calvary*, and a *Nailing to the Cross*, and had executed a vast *Crucifixion* [125] on the inner west façade. In 1522 he added a *Pietà* on the inner façade (below the *Crucifixion* to the right [126]), and apparently within the same year painted an altarpiece for the Cappella Schizzi. At Cremona, Pordenone's novelty of style is yet more radical than at Treviso. The absence in the new commission of a space that offered special provocation to illusionism, as the dome at Treviso had done, was no impediment to Pordenone's impetus in this direction. Powerfully developing the idea of his predecessors in the nave decoration, he took each flat oblong field of the arcade as the raw material of a shallow stage; on this he set his actors in a stage perspective, very near to us, in dense,

intermingled, and excited action. There is almost no room left to indicate the setting; where it is suggested, it does not open space but seems to thrust perspective forward. Pordenone invents motifs that will make his actors force the frontal limit of their stage, and in climactic places obtrude across it into our very space. The painted drama uses the form of actual theatrical spectacle, and probably took inspiration from it, but the will to urge the scene upon the spectator exceeds theatrical convention. The existence that Pordenone asserts is powerful and intrusive, both in physical being and emotionally, and the types he chooses to convey it have a deliberate vulgarity. The artist makes gross stress of passion in them, anguished and

gesticulative; he illustrates violence, and where he can compounds its effect with a violent effect of form. These means that utterly abandon objectivity and restraint intend more than their affirmation of dramatic presence: they intend the whole involvement of the spectator in what is affirmed.

The *Crucifixion* fresco is conceived in the same vein, seen as if through a painted proscenium [125]. Great forms press towards us in the nearest foreground, but behind them composition has been opened somewhat, and its heavy shapes set out in the near depth of a dramatically lighted landscape. Here, on this more ample picture field, the projective elements of illusion are secondary, and they serve

125. Pordenone: Crucifixion, 1520–1.
Cremona, Duomo

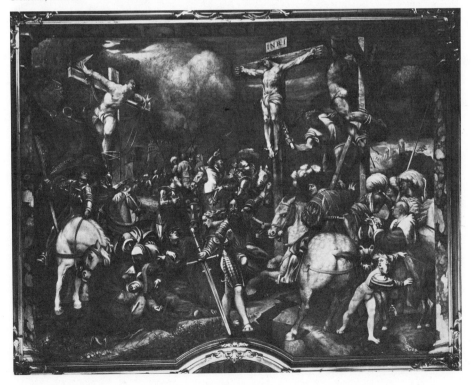

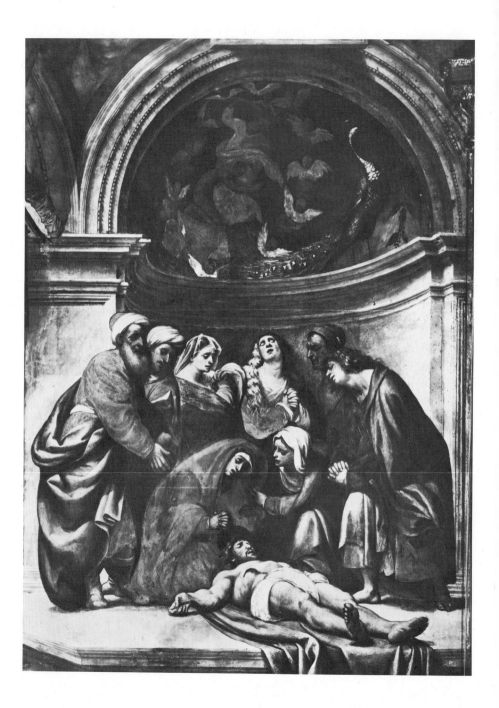

the main intention of engaging the spectator into the midst of the action on the deeper stage. The composition is formed – in an extraordinary invention – on the ground plan of a circle, partly open to the front, of which the diameter is diagonal to the picture plane. Led into the circle by the nearest figures, the great forms that shape it then give the effect of a rotating movement that encloses us in its embrace. The painting ceases to be spectacle and becomes an event in which the viewer is required to participate, sharing its violence and tragedy. The *Crucifixion* makes an effect that singularly anticipates the mood and even aspects of the form of the modern *Guernica*. The *Pietà* below conveys a different ambition, exaggerating the projective illusionism of the frescoes of the nave arcade [126]. In the *Pietà*, Pordenone builds – in paint – not only the architecture of a chapel into the wall, but also a platform out from it on which the mourners stand, while in front of them Christ lies exposed in drastic foreshortening. The whole scene takes place within the spectator's space, an event re-created in its physical being in the church. The illusion adds the power of conviction of its massive forms to that of its perspective device. It has the sheer shock value of the most radical invention of illusion so far in the history of art.[31]

The Cremona frescoes are not only prime acts of radical invention but inventions that are violent and even vulgar in the effects they seek and in the tenor of expression they are meant to serve. The vulgarity and violence are not just natural functions of the temperament Pordenone has now fully matured: they are aspects of it which he has stressed deliberately for the purpose of making communication with a popular and provincial audience that his own origins had equipped him to understand. In this intention of a popular religious communi-

cation there may be an analogy with the kind of popular revivalism that, in the same years, seems to have inspired the decoration in Lombard North Italy of the *Sacri Monti*, bastions of faith against the incursions of Transalpine Protestantism. Pordenone's tenor of emotion is unlike the contemporary Correggio's (still more so his *popolano* accent), but the function of their pictures and the means by which they fulfil it are in principle the same: intense subjective participation of the spectator is compelled by devices that create physical illusion. But in Pordenone's case it is at once more and less of an illusion of reality than Correggio's that he conveys; we have remarked some of the distinctions already at Treviso. At Cremona, however, other differences emerge still more strongly to adulterate the effect of reality. Colour, though now faded, could never have been a major component even of the descriptive apparatus of these frescoes; the optical mode that Pordenone had learned from Venice survives in not much more than the drama it can make with chiaroscuro and the roughness with which he manipulates his brush. His hyperbole of form exaggerates a Roman model, now more than before that of Michelangelo, and the *Brazen Serpent* of the Sistine [12] is example to him in design and licence for his own still more unclassical excess. The element of artifice within his forms is overt, and in the *Crucifixion* in particular it is extreme. There is not only a rhetoric of posture but a shaping of it into sweeping arbitrary rhythms, compounding – again in a hyperbole of Michelangelo – great power and arbitrary grace: the baroqueness is touched with a *maniera*.

Pordenone's most radical inventions appeared in the frescoes of Treviso and Cremona at the brief moment, just following 1520, that was so widely a time of eruptive experiment in Italy. He would not again make an invention which would be new in essential principle, but

126. Pordenone: Pietà, 1522.
Cremona, Duomo

he would press those he had made in a variety of directions, and in some ways draw conclusions more extreme. In 1523-4, at Spilimbergo, Pordenone painted a set of organ shutters for the Duomo, depicting the *Fall of Simon Magus* and the *Conversion of St Paul* on the inside, and on the outside the *Assumption of the Virgin*. The perspective situation of the shutters gave him pretext for more exercise in illusionism: the *Assunta* (again competing with the precedent of Titian) is a gesticulative drama seen in a *sotto-in-su* as extreme as the view of the spectator will allow.

Conceptions that appear at Spilimbergo, Cremona, and Treviso are conjoined in a major work by Pordenone at the end of the decade, probably in 1529-30: the decoration of the Pallavicini Chapel in the Franciscan church at Cortemaggiore (between Piacenza and Cremona). In the sense that this scheme elaborates on earlier inventions and, even more important, relates them in a structured unity, it is a new dimension of Pordenone's art. It may be, in this case, that Correggio's cathedral dome gave guidance to Pordenone – each painter by now surely knew and understood the intentions of the other; but the example is not necessary. Mingling actual and painted architecture, Pordenone here articulates the entire surface of this small chapel and densely populates its walls and ceiling with figures in concerted action, celebrating the Immaculate Conception in the altarpiece (removed from the chapel, and now in Naples, Capodimonte). The forms of the fictitious architecture relate with a muscular-seeming vigour to each other, but their energy is far surpassed by that of the figures. They override the limits of the architecture not only by illusionist projections but by their acting out the common theme. In the dome, a God the Father borne by angels dares what the antecedent at Treviso did not, descending from the ceiling towards the altar and into our space, while the angels spill across the boundary of the dome on to the top of the altar-picture's frame. The space of the chapel is as if inhabited by these energetic presences who communicate with each other at the same time that they communicate with us; the spectator who ventures into this charged enclosure becomes inescapably a participant in the celebration it depicts. Pordenone has accomplished in three actual dimensions what he intended in the painted spatial structure of the Cremona *Crucifixion*. In Correggio's Duomo frescoes the viewer participates in what surmounts him as if in a spiritualized ascent; here the event descends upon the viewer and physically surrounds him.[32]

With all the force of psychological and physical conviction that the Cortemaggiore chapel thus achieves there is at the same time strong evidence in it of increased refinement of its forms. The tendency which at Cremona had emerged as ponderous and artificial *grazia* is now tempered and made fine. It works both to make description more precise and the effect of artifice more trenchant; within its power Pordenone's style now incorporates a quality that almost resembles elegance.

Finally, the provincial has made a real concession to the civilizing manners of the metropolis. Earlier, Pordenone had worked in the Venetian orbit, but not on the Venetian scene itself; but in 1527 he had in effect become a resident of Venice, and though he was to be absent from the city at repeated intervals to work elsewhere, he was from then on (for the eleven years until his death) subject to the canons of taste of the Venetian school, by which his art came to be perceptibly conditioned. Powerfully expressive as he still might be, and even at times deliberately seeking of effects that in Venice would be taken as sensational, he was never forgetful of the requirement of high style in his adopted metropolitan milieu. Contemporary Venice in this important sense changed Pordenone; but the counter-influence of his

presence on the Venetian scene was more important still. By civilizing his art, Pordenone had made it acceptable in Venice, but its substance, based on inventions far more daring than any that the classicizing style of Venice had conceived, was stimulation – provocation, indeed – for Titian in particular. Earlier and more urgently than any other agency, Pordenone's art supplied the matter that would instigate a crisis in Venetian style. He was the prime exponent in the city of an art based on the energies of form, and the agent-provocateur of the proposition, Central Italian and Michelangelesque in origin, that this represented.

Pordenone's first intrusion into Venice was as Titian's unsuccessful rival in a competition (in which Lotto took part also) for the *St Peter Martyr* altar of the church of Ss. Giovanni e Paolo. His subsequent successes were considerable, however, even in further competition against Titian – not necessarily for identical commissions, but for level of attainment and for public notice of it. Our estimate of Pordenone's role in Venice in the fourth decade is obscured by the grave losses of his major fresco works, but no other painter was so much in the public eye at this time as Pordenone – not even Titian, whom he replaced for a brief moment as the sanctioned painter of the Serenissima. In his contest for attention Pordenone's practice as a decorator gave him an advantage. In 1528-9 he did a major fresco decoration in the choir and semi-dome of S. Rocco, now mostly destroyed, which fragments (including a *Christ at Bethesda*, now queerly hung with two saints, on panel, Martin and Christopher, from another place in the church) and studies tell us was a demonstration, somewhat tempered, of Pordenone's illusionism. Even in a tempered vein it was the most radical example of its kind that Venice, conservative especially in its traditions of decorative painting, had so far seen. In 1532-5 Pordenone frescoed a series of Bible illustrations in the cloister of S. Stefano (now detached). These too are ruined, damaged and faded to near-invisibility. In their time their novelty and force of impact was such that Titian, after Pordenone's death, was to exploit them closely for his S. Spirito designs.

Pordenone did secular external fresco decorations in Venice, also vanished now.' For one, the façade of the Palazzo Martino d'Anna (now Volpi di Misurata; *c.* 1535), we at least have Pordenone's rough plan in drawing (London, Victoria and Albert), re-using themes of illusion from his earlier repertory. A finished drawing for one figure (*Time*; Chatsworth Settlement) indicates the refinement of form with which, now, old themes were restated. Elsewhere, the moderating influence of Venice is still more apparent. Fractions of a ceiling for the Scuola di S. Francesco (*c.* 1535), dismantled, survive in London and Budapest; in this Pordenone has compromised his illusionism with the restrictions of a traditional compartmented and divisive geometric scheme. Extensive work that Pordenone executed in the Palazzo Ducale between 1535 and 1538, which won him the official favour that Titian till then had held, has perished without trace, lost in the fire of 1577. It is to a major work done not in Venice but, once again, in the Emilia, that we must turn for extant evidence of Pordenone's style as a *frescante* in the fourth decade, at the Madonna di Campagna in Piacenza, where at intervals between 1530 and 1535 (the commission had been given him in 1529) Pordenone painted three chapels and the dome. In the chapels (the earliest dedicated to St Catherine, the others to the history of the Virgin and the birth of Christ) it is the relative moderation Pordenone's style has acquired that is its most marked new characteristic: this manner has partaken liberally of Titian's. Forms are as magnified as ever, but they are finely articulated and are shaped and moved with suavity; and while the mode of action is rhetorical, it is not impulsive. Plastic power is still heavily affirmed, but within the

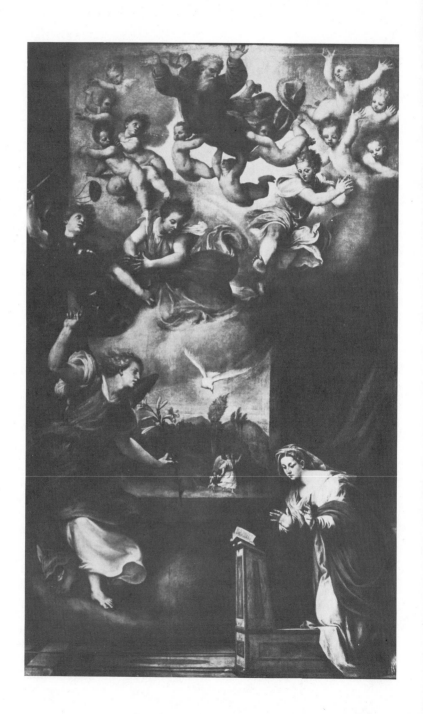

context of a moderated chiaroscuro taken from the repertory of Titian's style. Illusionist device persists, but not in the sense of an apparatus that intends projection; it creates positive but controlled spatial settings in the wall. The tenor of the whole is of an energetic and emphatic style, but one that has made a working compromise with the authority of classicism. The dome (latest in the decoration: *c*. 1535) is also relatively conservative in its conception, rejecting Pordenone's own past radical illusionist ideas and refusing challenge from the near-by examples of both Correggio and Giulio. The sections of the segmented dome contain separate Old Testament histories enacted by figures, rich in Roman reminiscence, which attain a grandiose pathetic power.

Pordenone's residence in Venice was a major factor in the alteration of his later art, but it was not the only one. His stay in Venice was interrupted often, not only to work in the Emilia and in his native province of Friuli; he also had new contacts with the art of Rome. His presence (and that of his family) is recorded there in 1531. About 1533 he was briefly in contact with the outpost of the Roman Maniera that Perino del Vaga had established at the Palazzo del Principe in Genoa, and during his voyages to Piacenza he would have seen Giulio's Mannerist work in Mantua and Parmigianino's in Parma. The Central Italian element in Pordenone's style was supported by these contacts, making counterweight to his assimilations from the art of Venice. But more precisely, this later Romanist experience was of its contemporary Mannerist variety, and the accent of the new style is perceptible in Pordenone's work from 1535. It is most conspicuous in the *St Mark* altar, executed for the Duomo of his native town in 1535, but it is of more historical effect that it appears also in altar paintings done for

127. Pordenone: Annunciation, 1537.
Murano, S. Maria degli Angeli

Venice, for S. Giovanni Elemosinario (*c*. 1535–6) and for S. Maria degli Angeli at Murano (1537), where he painted an *Annunciation* [127] to replace a picture done by Titian, but which the patrons had refused to accept because they found the price too high. Pordenone's *Annunciation* is in effect a translation of Titian's scheme into a vocabulary which blends a Venetian mode with that of the Maniera. These altar works by Pordenone are among the earliest symptoms of this compromise in Venice, and may be the most explicit. With not less pronounced effect than the earlier and different demonstrations he had made in Venice, they combined with them to become one of the major factors to provoke change in Venetian style.

Pordenone's *percorso* may be one of the most complex of its time in Italy. Quattrocentesque provincialism and a minimal Venetian classicism preceded his contact with the energies of Roman classical style, which he exploited to make a radical eruption into novelty. In some ways identifiably anti-classical, his style in the third decade partakes of elements of a baroque and at the same time contains an aspect that resembles Mannerism. This style was extended and refined, and in Venice in the 1530s it was tempered to accommodation with contemporary Venetian classicism. Still responsive, however, to Rome and to the current doctrine Rome exported, Pordenone made a further accommodation, with the contemporary style of Maniera. Surely the variety of his career would not have been possible to an artist bound by entire loyalty to a native school. The last accommodation may have been too alien to Pordenone's gifts. His latest work descends in quality, and for the first time in his long history conveys a lack of expressive conviction. He could not reconcile Maniera with his accustomed brand of passion. As Pordenone vanished from the Venetian scene, Tintoretto emerged upon it: it was he who was to resolve the problem Pordenone's later style had proposed.

Lotto

Like Pordenone, Lorenzo Lotto was involved inextricably with Venice, but his career and the character of his art are still more than Pordenone's attached to provincial places rather than the metropolis. This is despite the fact that Lotto was almost certainly a native Venetian, born there towards 1480.[33] He acquired from his Venetian education a mode of seeing that it was possible to learn only in that school, from the example of Antonello and Giovanni Bellini in particular; this remained an essential and ineradicable bias of his art. But beyond this there was no accord between the metropolitan ambience in which he learned and Lotto's temperament, introverted, pietistic, and unstable, and as the years went on they became more divergent from each other. From the beginning of his career Lotto's more important works were undertaken for the provinces; then, the more his practice and actual residence became provincial, the more his difference from the culture of his native place increased. Even his provincial practice, however, in general brought him only insufficient indications of success. His private destiny in the end was as pathetic and withdrawn as the personality he came to project in his art.

The earliest works by Lotto that we know (the first dated work is of 1503) were already painted not for Venice but for a provincial market. From 1503 to 1506 at least he worked at Treviso, and then briefly in the Marches. His first pictures for Treviso indicate a basic affiliation with Bellini's school, but show characteristics that indicate that this may not have been the sole or even the main place of his initial education.[34] The evidences of difference from the norms of contemporary Bellinesque style became rapidly more pronounced as Lotto matured, and by 1508, when he signed and dated a major altarpiece for S. Domenico at Recanati (now Recanati, Pinacoteca Comu-

nale), they were acutely marked. The first of them is a tendency to accentuate irregularities of form in the appearances he describes, making restless angularities of shape and sharp saliences of detail. There is a pronounced sympathy with the art of Dürer and with the residual Germanisms of Jacopo de' Barberi, not only formal but illustrative: types have an unbeautiful, even caricatural, specificity, and their emotions an introspective pathos. Light is consonant in its functions of describing presence and conveying an emotional temper: it makes passages of sharp brilliance or, alternatively, extremely refined distinctions of the surfaces of form.

The Recanati altar demonstrates that a mode of lighting learned in the beginning from Bellini and from northern sources has become an almost morbid hyperphotosensitivity in Lotto. In full possession of the most advanced apparatus for describing nature that Bellini had developed, and cognizant of the rationality by which such a painted nature could be ordered, Lotto's interests required that he alter the purpose of the one and diminish the function of the other. He extrapolates the techniques of realism, and in particular its technique of light, to record the response of a special sensibility, acute and nervous, to visual experience. With the same technique he illustrates an emotional sensibility which in the Recanati altar takes the form of a pathetic piety. Lotto's departure from Bellinesque style was towards an art that, like Giorgione's, has a major new component of subjectivity; but that is the only basis the art of the two contemporaries shares. The opposite of Giorgione's translation of Bellini's style into a higher classicism, Lotto's might be taken as an anti-classicism *avant la lettre*, diverging from Bellini not into modernity but towards archaism, evoking a non-rational quattrocentesque religiosity and the eccentricities of provincial Quattrocento form. In the light of contemporary developments in his native

Venice this style is against the grain, evolved despite the knowledge Lotto demonstrably had of the new mode Giorgione had affirmed.

In 1508 it was appropriate for a painter resident not in Venice but in provincial milieux to mature into a style of this kind, in which what is new is converted to reactionary ends. But as the classical style grew into its own maturity and spread, it was no longer possible to avoid a confrontation with it, and – given Lotto's artistic stature and his relative youth – a coming to terms with it of some kind. The next phase of Lotto's career was to be devoted to his making this accommodation and to his own eventual approximation, after more than a decade, of a classical style. The accommodation was not easy: it required the undoing, necessarily difficult and slow, of the contrary position he had taken and the alteration of a temper he had already maturely affirmed. An impulse of the first importance towards change came in 1509. In that year Lotto was in Rome among the corps of painters working in the Stanze of the Vatican: his name is twice recorded there in that year, and it is likely that he remained in Rome at least into 1511. Where his exposure to a developing classical style had left off in Venice it began again in Rome. That he knew at least the *Disputa* among the Raphael frescoes is attested by a fresco of *St Vincent Ferrer in Glory* painted *c.* 1512 at Recanati, in the same church of S. Domenico in which he had left the polyptych done in 1508 before his Roman stay. The style of the fresco is entirely different, reformed on Raphael's example. But this adopted classicism is not consistent or profound, and a stimulus of subject matter was enough to recall the tenor of eccentric pathos which he had found before. The *Entombment* (Jesi, Pinacoteca Comunale, dated 1512) is partly based in motifs upon Raphael's painting of the theme, at that time in Perugia, and the mode of representing form – generalized, rounding, and sfumato – is based on knowledge of Raphael's more recent style. Yet Lotto's language in his picture is more essentially un-Raphaelesque: he uses a vocabulary of description and emotion that seems designed to make the most direct communication between a painter whose religiosity is untouched by classicism and an audience that is also distant from contemporary Rome. The types are popular, and their feelings are violent and sentimental both at once. Lotto's learned classicism yields willingly to deforming pressures, and the *Entombment* suggests, even more than his pre-Roman works, an affinity with Germanic art. As in other contemporaries from the north of Italy – Aspertini, or Correggio a few years later – the compound of a partial classical experience and an expressive will irrelevant to classical style results in a phenomenon like a proto-Mannerism.

To his exposure in Rome (and in Umbria also) to classicizing styles Lotto must have added knowledge of the art of Florence, where, probably in 1512, he seems to have encountered the mature accomplishment of Fra Bartolommeo in particular.[35] By late 1512 or early 1513, however, Lotto had left Central Italy for good, not to return to the Veneto but to settle in the Venetian dependency of Bergamo, where he was to enjoy the one relatively long period of stability and success in his career. His residence in Bergamo made yet another contribution to his classical experience, not in Bergamo itself but in near-by Milan, where he would have found the art of Leonardo, but this was an example he could and did take ambiguously. Lotto's first great altar painting done in Bergamo, for S. Stefano al Fortino (now Bergamo, S. Bartolommeo; commissioned in 1513 and dated 1516), shows, at once, the cumulative weight of past encounters with the demonstrations of the classical style and Lotto's continuing differences from it. Before a setting of grand, Bramantesque architecture[36] a large assembly of figures is arranged according to a scheme, and by a geometrical principle, that

are like Fra Bartolommeo's. The general effect approximates the logic and the monumental mode of classicism, but this is not reconciled with the effect of the particulars. The emotions of the actors and their manner of deportment are still only incompletely styled, and they do not act in concert. Grace of feeling is interpreted in the provincial tone of sweetened sentiment, and grace of movement and of pattern in design is given as an uncoordinated, complicating ornament. Colour, luminous and brilliant, equivocates between its ornamental and descriptive functions. There is a compound in Lotto, now more apparent than it had ever been, of unstylish, primitive sincerity and sophistication of response.

Five years later the civilizing process was as complete as it would become. 1521 saw the completion of two major altar paintings for Bergamo, similar in scale, in structure, and in theme, for S. Bernardino and for S. Spirito [128]. In them Lotto's actors have lost most of their archaistic accent of appearance and behaviour: in proportion and deportment they approximate the rhetoric and deliberation of classical examples. The compositions have a gravity and logic like those of classicism and a comparable richness of coordinated movement. Almost as important in these paintings is the evidence of Lotto's liberation from his long-persistent quattrocentesque habits of technique. Just as he now conceives structure as a working unity, so can he now see the objects that he paints in their working relations – almost as a unity – of visual effects; finally, Lotto's seeing and his technique for recording it have been made nearly consonant with the modern mode. The modernity of structure may be self-generated, but it may also be in part the result of longer meditation on the memory of Fra Bartolommeo. However, the relative modernity of vision must have been achieved through knowledge of recent art that was either Venetian or Venice-inspired. Romanino's

models in near-by Brescia may have been influential, as well as Palma's works exported to the area of Bergamo; and though no document proves Lotto's direct experience of Venice during this time, it is likely that he had it.[37] It is by contact with models of achieved Venetian classical style and not through some private evolution that Lotto has translated his Venetian quattrocentesque mode of seeing towards a modern opticality.

The basic elements of a developed classical style in its Venetian variant, as advanced as any of the date save only Titian's, are present in the two Bergamo altar paintings of 1521, and it is remarkable that a painter who for so long had been opposed to classicism or inaccessible to it should achieve this much. Yet within the classicism of these images the evidence persists of what Lotto's earlier temperament had been, adjusted towards the tenor of the new style but not radically changed. Emotion retains a flavour of its former popular and pietistic tone and in episodes tends towards febrility; in the S. Spirito altar especially (probably the later of the two) emotional excitement makes an agitating overcast of pattern on the forms. In the S. Spirito altar the colour (which in the S. Bernardino painting is relatively constrained) takes on a consonant activity: high-keyed hues assert themselves in local fields, contesting the optical effect of unity and making unexpected and even slightly dissonant relations with each other. In both altars there is the persistent sense of Lotto's ancient way of seeing, now given more sophisticated form, in which his hypersensitivity to light works to transform his subtlest response to optical truth into effects of magic radiance.

Even as Lotto completes the process, begun a dozen years before, of assimilating the elements of contemporary classicism, his art contains the signs of what had for so long made him dissent from it. His classical moment is no more than that, and its occurrence did not pre-

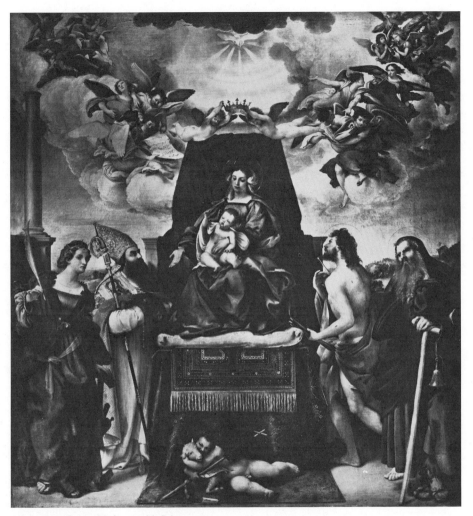

128. Lorenzo Lotto: Madonna with Saints, 1521.
Bergamo, S. Spirito

clude a mode of expression, quite concurrent, that continued from his former vein. The classical moment had enduring effects in two major respects, breadth and fluency of figure style and an opticality of modern Venetian cast, and these are consistent factors in Lotto's work from the beginning of the third decade. But he rapidly divorced them from classicizing contexts, using them to illustrate unclassical responses to human sentiment and to visual sensation. Lotto's unclassicism of the third decade shows two distinguishable strains, neither really new for him: they were already evident in one compound within the S. Stefano

altar of 1516. Now these strains may again co-exist within one picture, but they more often manifest themselves singly in separate pictures very close in time, communicating opposite aspects of what is, ultimately, the same intense non-rational emotion. One strain tends to an expressive turbulence in which the roughness and immediacy of forms and feelings are dominant and in which types and manner of deportment are *popolano*, unstylized and un-idealized as they had been long before in Lotto's art and as they were in the contemporary Pordenone. In 1521 the diptych for Domenico and Elisabetta Rota Tassi (*Christ taking Leave of His Mother*, Berlin; *Nativity* by night light, Venice, Accademia) represents this powerful, rude strain. Again as in Pordenone of the identical moment, but without a comparable illusionist excuse, Lotto's scenes suggest they may be re-creations of the types and temper of some actual popular religious drama. The other strain, no less irrationally inspired, seeks to translate pathos into an extreme of grace, conveying the rapture of religious feeling by an artificial beauty given to appearances and forms. A *Madonna with St Sebastian and St Roch* (Florence, Contini Collection, *c.* 1521–2) exemplifies this style. The figures are in states that approach ecstasy, strongly moved in body as well as in mind. Their response is as exquisite as it is intense, and types, attitude, dress, and gesture all convey an extreme of refinement. The quality of relationship among the actors is given not only illustratively but by a rhythmic patterning that winds them in an arabesque. More than in the S. Spirito altar, the colour takes on an effect of artifice, high-keyed and luminous, and it is as acute as the emotion. Intensifying sharpness and purity, the colour diminishes in warmth, turning towards the silvered tones of the Lombard tradition rather than the sensuousness of the Venetian mode, and by this too an effect of artificiality is suggested.

This style is a deduction made from the classical moment achieved in 1521, extending the conceptions Lotto had won there of unity of form, and more particularly of grace of form and of aesthetically styled behaviour. Putting these to the service of a mode of feeling that exceeded classical restraints, and – characteristically for a provincial – exaggerating the grace of the social as well as the formal manner of classicism, Lotto has extrapolated a classical *bella maniera* into what, at least in this painting, may be called Mannerism. Among the works of the painters in North Italy whom we have discussed so far, this is the nearest analogue in form and sense to contemporary innovations made in Central Italy, and within North Italy it has some kinship with the contemporary early works of Parmigianino. But there is an element in Lotto's art, even in this refined strain, that resists its easy assimilation into Mannerism. His insistence – still, in him a persistence of old-fashioned habit – on verity of appearances attaches him, more than the early Mannerists, to described reality. The Mannerizing character of pictures in this vein is most pronounced in the earlier 1520s: examples exist in the bust-length *St Catherine* (Washington, National Gallery, Kress Collection, dated 1522) and the *Marriage of St Catherine* with a donor (Bergamo, Accademia Carrara, dated 1523).[38] As his classical moment receded, Lotto's native temper and that of his Bergamasque milieu coincided to reinforce his other, popular and pietistic strain. The *Adoration of the Child* (Washington, National Gallery, Kress Collection, dated 1523) is in this rougher mode, and a *Marriage of St Catherine* (Rome, Galleria Nazionale, dated 1524) is an image of inspired vulgarity, as clamorous as a Pordenone and almost as insistent in communication. Lotto was by this time certainly influenced by Pordenone's example. Like Pordenone, Lotto was concerned with the communication of religious emotion to a provincial,

even unlettered audience; but when Lotto undertook this ancient task of Christian art, he did so with less self-conscious emphasis upon the art than Pordenone: Lotto preserved a different directness and sincerity of belief.

In 1524 Lotto frescoed the oratory of the Suardi family at Trescore in the subalpine countryside not far from Bergamo [129]. His themes here juxtapose a simple system of illusionism, an archaic religious heraldry, and the utmost narrative simplicity. Christ is presented as the vine of life, but as if this were not a symbol but a literal fact: the tendrils of the vine grow from his fingers, rise to circle and enframe Saints of the Church, and then give pretext to convert the ceiling of the oratory into an illusionistic arbour. To either side of Christ's standing figure and beyond him a city view opens the chapel wall to space, and in it Lotto represents the successive episodes (in continuous narrative) of St Barbara's martyr-

dom. The narrative mentality is as diffuse as that of a fifteenth-century predella painting, and enriched still further with prose incident and realist detail, but the illustration of the brutalities of martyrdom anticipates the Counter-Reformation martyrologies of the late sixteenth century. The deliberately *popolano* nature of the imagery, making symbol literal and narrative explicit to an extreme degree, is unmistakable. Art serves the purposes of popular instruction, yet in Lotto even the willing subordination of art to such an end does not exclude its effects. He infuses a sparkling energy of action into his figures and describes their existence with subtlety and brilliance in inventive variations of real-seeming light. The quality of his seeing is in itself lyric, touching the prose and the brutality of the narrative with transforming effect. On a larger scale and with a more conventional theme, the *Life of the Virgin*, the fresco decoration of S. Michele al

129. Lorenzo Lotto: Trescore,
Oratory of the Suardi Family (detail), 1524

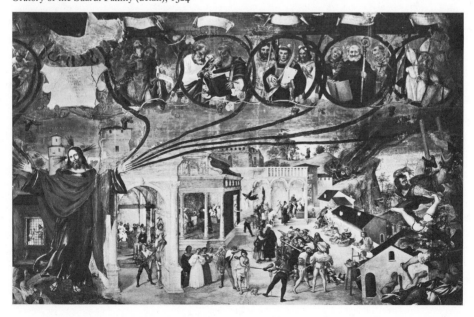

Pozzo Bianco in Bergamo (1525) is in a comparable popular and simplistic vein, restraining even more effects by which art might assert itself at the expense of illustrative verity. These frescoes are the closest Lotto comes to Lombard prose,[39] and they may indicate another mode, distinct from the two we described earlier: almost abjuring style, and taking mimesis as the painter's primary end.[40]

By January 1526 Lotto had returned to Venice, and though he revisited Bergamo briefly in that year and continued for a while to supply works for clients in the Bergamasque vicinity, his long tie to the region was now broken. He was to be no more successful at home in Venice than he had been a quarter of a century before, though he tried to adapt his style to the expectations of the Venetian public. The commissions he received for work in Venice were in fact quite few; again he found his market outside, sending pictures from Venice, or travelling to paint in provincial towns. His residence in Venice was interrupted constantly by visits elsewhere, some of them of long duration: in 1532 at Treviso, in 1535 at Jesi, in 1538 at Ancona, and in 1545 at Treviso again. In 1549 he left his native city finally, a tragic, disappointed opposite to his contemporary Titian, and retreated to the Marches.

The change in Lotto's artistic context from Bergamo to the metropolis brought him more emphatically into contact with the optical and painterly example of Venetian style – Titian's most assertively, but that of the other 'modern' painters of the school as well. The character of these painters' styles was, in general, classicizing, and the temper of expression they conveyed and the taste they represented were those of an urban culture. However, Lotto's reaction to these factors in his Venetian context was not immediate, and – as his recent history would lead us to expect – it was not consistent. A large *Assunta* painted in 1527 for export back to the neighbourhood of Bergamo (Celana, S.

Maria Assunta, dated) consults the Frari work of Titian, but transcribes it into peasant, even more than *popolano*, drama. More than Titian's model, that of Pordenone in the cathedral at Spilimbergo has worked on Lotto here. A polyptych of typical Bergamasque form for Ss. Vincenzo e Alessandro at Ponteranica near Bergamo, dated 1527 (?), is devotional rather than dramatic in its subject, but again is mostly in the popular and provincial vein. Gradually, however, the sense of his Venetian milieu infiltrated Lotto's art. His handling of light and texture became more Titianesque, his mode of feeling more controlled, and the actors he employs to illustrate it more refined. Exposed to example that was mostly classicizing, and to metropolitan manners, Lotto re-created a position which resembles that in his own art about 1521, when (as in the S. Spirito altar [128] rather than in that for S. Bernardino) he worked with a basis of style like that of classicism but gave it a refinement which, in terms both of form and feeling, verged towards a Maniera. A *Holy Family with St Catherine* (Vienna, Kunsthistorisches Museum, 1527–9) is in the revised Venetian variant of this prior mode. In it Lotto's febrility has been beautifully restrained and the rhythmic instinct that makes ornament has been disciplined: for the first time Lotto achieves the effect of a cultured elegance. Colour keeps its special Lottesque intensity, but it is controlled within an ambience of atmosphere; in this, not only Titian's art but that of the Veneto-Lombard quasi-compatriots of Lotto in Venice, Palma and Savoldo, have had effect on him. The Mannerizing aspect of Lotto's art has been moderated by the Venetian milieu but still, in this milieu at this moment, it seems salient. The *Annunciation* done for S. Maria sopra Mercanti at Recanati [130] about the same time as the Vienna *Holy Family* is no less elegantly subtle in its quality of ornament and in the fineness with which it conveys feeling.

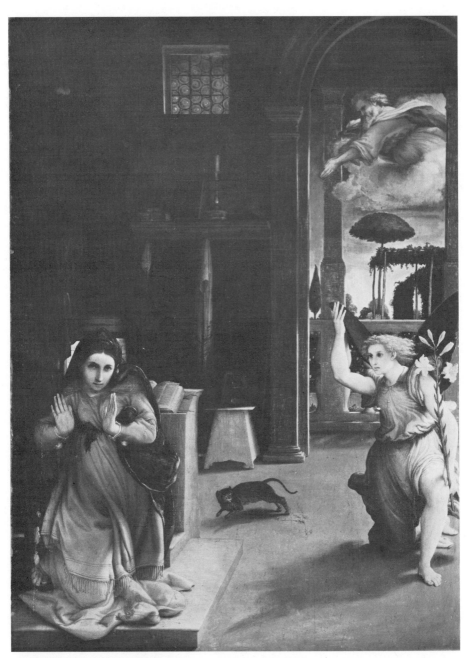

130. Lorenzo Lotto: Annunciation. *Recanati, S. Maria sopra Mercanti*

Yet the subject and perhaps the provincial destination of this picture evoke a different context for these qualities. Lotto adapts an idea of design from Titian, a character of setting from the archaic Carpaccio, and from Pordenone a way of making illusion and communication coincide; and then he mingles effects of perspective and optical reality with those of ornamental artifice. But his way of describing the interior in which the scene is set and of which he means the apparent reality to relate to our own is such that it becomes, beyond its prose truth, the record of a poetically transforming response to the experience of light.

A major altar commissioned for an explicitly Venetian destination, *St Nicholas of Bari in Glory* (Venice, Carmine, dated 1529), is more conventionalized and more consistently idealized to conform to the reigning standards set by Titian for Venetian art. But the most touching evidence of Lotto's willingness to adjust his style and taste to Venice are in his few pictures of this time on allegorical or mythological themes. The *Triumph of Chastity* (Rome, Palazzo Rospigliosi-Pallavicini, *c.* 1530) is in effect the index of his own possession of that virtue: the Venus in it is utterly a-sensuous, a crystalline abstracting of the nude into a still life. Later and more committed efforts to adapt to a Venetian morality, as in the *Toilet of Venus* (Milan, private collection, *c.* 1535?), are pathetically engaging in the hopeless disconnexion Lotto shows from his erotic theme.

Lotto's real accommodation to contemporary Venice could be only in technical aspects, in the learning from Venetian example of a more self-knowing, polished control of effects of drawing and of light. But in more essential respects his accommodation could not but be effortful and frustrating to a temperament that had long since differently matured. It was perhaps fortunate that his commissions continued to come mainly from the provinces, where his accustomed language could be heard with sympathy instead of apathy or offence. His *Crucifixion* altar for S. Maria in Telusiano at Monte S. Giusto in the Marches, dated 1531, erupts from the restraints of Venice into complicated and gesticulative religious drama in which the force and pathos of communication that Lotto seeks are like those of the earlier provincial Pordenone, before his accommodation to the art of Venice.[41] In the *St Lucy* altar for Jesi (Jesi, Biblioteca Comunale, dated 1532) [131] Lotto reasserts another aspect of his popular style: the very simplistic narrative he had found long since at Trescore. Now, however, his technique of description has the surpassing articulateness that he developed only in the recent Venetian years. The illustrations of St Lucy's story take on a quality of fairy tale, at once naïvely real yet poetically distant, as Lotto finds pretexts of lighting for each of them that infuse their atmosphere – literal and figurative – with warmth and vibrance.

About 1535 a new character appeared in Lotto's style, of which the legible symptoms are in the *Recognition of the Holy Child* (Paris, Louvre).[42] Designed mostly in a mode that still depends upon the ornamentalism of his recent relatively sophisticated Venetian style, the forms these rhythms describe are heavy now, and the rhythm slowed, while the design tends towards symmetry. There are not only accents of realistic description but major episodes of it, in the manner of Savoldo. Shortly later, in the *Madonna of the Rosary* (Cingoli near Macerata, S. Domenico, 1539), the tendency to heavy form and literal description is much more pronounced, and the visual excitements made by light have been diminished. Lotto seems to have abjured the refinements of sensation that proceed from the effects of art and from the display of private sensibility. He seeks a grave, direct, unornamented style, as if in the interest of a simple, even ponderous religious sincerity. The last (but even so only the second) altar

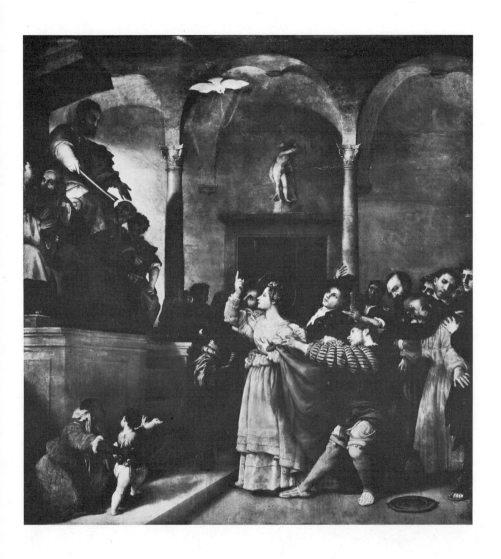

131. Lorenzo Lotto: St Lucy Altar, 1532. *Jesi, Biblioteca Comunale*

132. Lorenzo Lotto: Presentation in the Temple. *Loreto, Palazzo Apostolico*

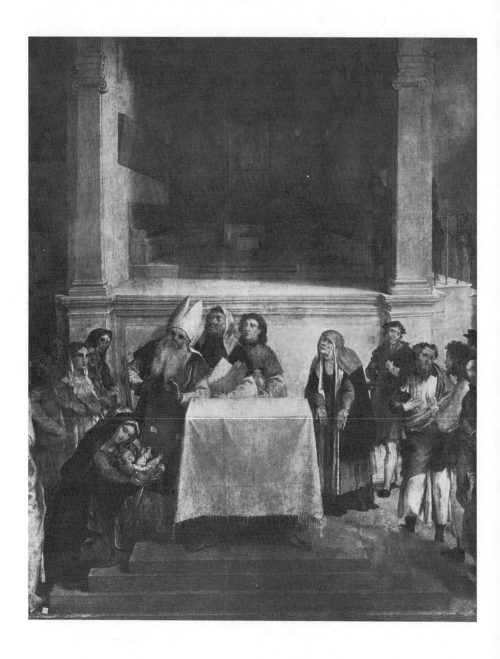

painting Lotto was commissioned to do for Venice, St Anthony distributing Alms (Venice, Ss. Giovanni e Paolo, 1542), attempts, for its Venetian public, a more enlivened and self-conscious mode; but in the same year a Madonna in Glory with Saints for S. Girolamo at Sedrina near Bergamo (dated) shows an almost primitive simplicity of form and directness of expression. The latest altars are for the most part in this vein, almost iconic.[43] Among the smaller devotional paintings of these years there are some of a tragic roughness, scorning beauty, like the Pietà (Milan, Brera, 1545), and others, like the Christ in Glory (Vienna, Kunsthistorisches Museum, 1543), in which the vibrance that the artist can still make with his brush has no effect of art, but of religious emotion only.

In 1552 Lotto went to live and work in the Santa Casa of Loreto, and in 1554 became an oblate there. He left two major pictures in Loreto before his death (probably before the end of 1556): a Fall of Lucifer (Loreto, Palazzo Apostolico), a spare, dark, dream-like vision, and a Presentation in the Temple (ibid.), unfinished, or the product of a failing hand [132]. In this the ellipses of the brush tell of the sacrifice of art and the sincerity of pathos. The residue that is still here of once great gifts of hand and eye are, without the least remainder of the sense of self, in the service of the spirit: the picture seems like the old man's private utterance of prayer.

Lotto's capacities were particularly suited to the practice of portraiture. The fineness with which he responded to the data of appearance disposed him to record the look of individuals more trenchantly than any of his North Italian or Venetian contemporaries. His emotional sensibility, matching his visual response in complexity and fineness, equally found its use in portraits; the effect of individuality of psychological characterization also is more acute in Lotto than in any of his northern contem-

poraries. In his earliest portrait, Bishop de' Rossi (Naples, Capodimonte, 1505), or in the Young Man (Vienna, Kunsthistorisches Museum, c. 1508), their difference from their context of Venetian style is already apparent in the way in which the sharpness of the light and line focuses the expression of the sitter. To a portraitist disposed to such a specificity a classical approach to portrait art would not seem sympathetic, and its influence on Lotto in the period from his Roman visit to the end of the second decade was not salutary. He dealt with it best by evading it, as in the rather simple visual and psychological realism of the Double Portrait of the Brothers Della Torre (London, National Gallery, 1515). When, at the turn into the next decade, Lotto acquired 'manner', it most appropriately appeared in the portraits of his Bergamasque patrons. Manner gives a context of different decorative elaboration to the so-called Lucina Brembate (Bergamo, Accademia Carrara, 1521–3), but it does not much alter the acuity of Lotto's description of appearance or of state of mind. But despite the acquisition of manner, the portraits of the early twenties could on occasion be invaded by the same surcharge of feeling that appeared in the contemporary religious pictures: an example is the Wedding Portrait, dated 1523 (Madrid, Prado), in which not only the countenances but the very patterning expresses sentimentality to a degree that could have been thought tolerable only by provincial patrons.

His return to Venice eliminated most of the provincial cast from Lotto's portraiture. His response to his sitters' psychological individuality did not then diminish in the least, but it is controlled and communicated through a formal mode that has a Venetian effect of breadth and fluency. His best portraits of the later 1520s and the 1530s achieve not only high expressiveness but elegance. In a few works about 1527 and 1528 Lotto uses an exceptional horizontal format (Andrea Odoni, Hampton

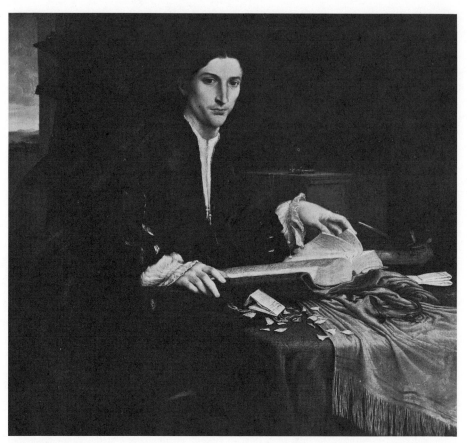

133. Lorenzo Lotto:
Young Man in his Study, *c.* 1528. *Venice, Accademia*

Court, 1527; *Young Man in his Study*, Venice, Accademia, *c.* 1528 [133]) which gives him an opportunity to develop ornamental patterns like those in the *sacre conversazioni* of the same time. In the *Man holding a Golden Claw* (Vienna, Kunsthistorisches Museum, *c.* 1527) Lotto adopts the very modern Venetian format of the three-quarter length, and takes on a protective tonality of Titianesque chiaroscuro and colour. The sitter's grace of action is impeccable, but what he is doing tends to strain

a classical conception of behaviour: his movement, gesture, and quality of gaze compel an immediate and penetrating communication with the spectator. The Venetian mode of the picture moderates but does not obscure the sense of an analogy in human meaning between it and the portraiture of Pontormo in Florence at this same moment closer than that which might be made with the contemporary Titian.

The quality that suggests Maniera in the portraits is even shorter-lived than in the reli-

gious paintings. The *Man with Rose Petals*[44] (Rome, Borghese, *c.* 1530) accepts the basic conventions of modern Venetian portrait form; but it requires only a few pregnant indices – the quality of the sitter's fixed and melancholy gaze, the inclination of his head, the *memento mori* on which he rests his hand – to make a tenor of expression quite divorced from the conventions. It is Lotto's characterization of an unmitigated seriousness of spirit in his sitters, rather than symbolic accessories or devices of design, that gives them their communicative power. A few portraits of the later years (for example, the pendant *Febo da Brescia* and his wife *Laura da Pola*, Milan, Brera, 1543-4) have a social elegance that suggests, again, analogy with the contemporary Central Italian Maniera but does not have its mask-like reticence. More of the later portraits (for example the *Old Man with Gloves*, Milan, Brera, 1547; *G. G. Stuer and his Son*, Philadelphia, Museum, 1544) have a pressing psychological immediacy and an increasing realist accent in description. One of the last portraits we possess, a *Monk as St Peter Martyr* (Cambridge, Mass., Fogg Art Museum, *c.* 1548-9), half-portrait, half-icon, is a powerful affirmation of a simple and intense presence; it is not only by an accident of subject matter that we feel here, as in the last religious paintings, that art has become the servant of belief.

In a sense, Lotto's whole style from the twenties onwards may be read as a visual chapter in the history of the Italian Reform, and, like the Reform, what he ended with is the incipient mentality of the Counter-Reformation. Still more than the Reformers, Lotto dissociated himself from the secularity of the culture of his time, and drew strength instead from the strata in it that were archaistic and popular, and in which the continuity of old beliefs lay. But he made no school of painting around him as the Reformers made schools of religious thought. His faith resembles theirs,

but in the context of art in which Lotto worked it was more nearly a private and isolated thing. Eventually this isolated faith consumed him, and in the end he surrendered his art to it as he had already surrendered himself.

Dosso

Born Giovanni Luteri, the son of a *fattore* of the Este court, probably towards 1490,[45] Dosso would have been a contemporary of the Venetian Titian and close in age to Correggio among the Emilians. Our earliest knowledge of his activity as an artist is (as with Correggio) in the earliest years of the second decade, and it is also in Mantua.[46] By 1514 Dosso was employed in Ferrara, the main centre of his practice for his entire life. A determining immersion in the modern Venetian style must have been contemporary at least with Giorgione's later lifetime, and have lasted close to his first documented presence in Mantua, in 1512. The works we can identify that precede 1515[47] show only a residue of quattrocentesque literalness that is rapidly sloughed off, and a mood like Giorgione's abstracting lyricism; and from the beginning, landscape that is as subjectively interpreted as Giorgione's is a major element in Dosso's art. More than any native Venetian save the young Titian, Dosso accepted the new role Giorgione had conceived for light and the technique to describe it.

But Dosso's response was not only to Giorgione directly but also, and it seems more specifically, to the young Titian's libertarian interpretation of Giorgione. In his early pictures Dosso's abstractness is not only in the mood, but in the mode of representing form, and in this he is more extreme than Giorgione and dependent rather on the example of free, loose, rounding shape of the beginning Titian. It was from Titian, too, more than from Giorgione, that Dosso took courage to accentuate intensity of colour. And it is even more evident

than in Titian's pictures of the first decade that Dosso's early works do not respond to the principles of order that belong to Giorgione's classicism of style. Dosso's learning in Venice had been of the visual and thematic aspects of that modern style, but not of the intellectual aspects of its aesthetic. He took its liberty but not its discipline, either of modes of representation or of structure. Despite his foundations in Giorgionismo, Dosso thus in effect bypassed classicism, and in the milieu in which he worked, at once archaizing and sophisticated, he used the liberties acquired from the Venetian mode to make an art of poetically expressive eccentricity. There may have been stimulation to a temperament inherently so disposed from a similar vein that is so strong in the Ferrarese tradition of Quattrocento, and example in the work of local contemporaries of minor rank like Aspertini and Mazzolino, whose mode equivocates between a tardy quattrocentesque style and naïve Mannerism. The *Bacchanale* which Dosso painted about 1515 for the *camerino* of Alfonso d'Este (London, National Gallery),[48] compared with its companion pictures by the old Bellini (*The Feast of the Gods*, Washington, National Gallery, 1514) and by Titian (*Venus Worship*, 1518), gives the exact relation of Dosso's style of that time to modernity.

Shortly after 1515 Dosso began to paint cabinet pictures, at first of religious subjects, then of secular themes also, which were intimate in terms of size and in the response they evoked from the spectator. From the beginning these small pictures show an aberrant, almost caricatural manner of description – a willed, sophisticated primitivism – and a romantic mood supported usually by landscape; in these pictures an arbitrary use of colour, luminous and intense, was a main agent of pictorial effect. In these small works, where public and conventional expectations were not operative, Dosso's liberty could be exercised with minimal

restraint. He quickly cast off the last traces of the old-fashioned tightness that had been in his style and developed a remarkable *sprezzatura* handling, more daring even than the juvenile Titian's had once been. Exactly as the term implies, this *sprezzatura* is designedly careless in its drawing of forms, and the disproportions made in shapes and their rough summarizing make effects of piquancy and intimacy. Affecting naïveté, Dosso makes appearances that are engaging and approachable in a way impossible to images of classicizing canon. His colour erupts in the same mode of *sprezzatura*, unheeding of expected natural effects and seeking brilliances, depths, and intensities in a range that exceeds the young Titian's – from whom, in the beginning, the colour mode had been derived. Distinct from Titian, who may exalt into an effect of poetry the colour that his eye perceives, Dosso's colour is a poetry conceived to begin with in the mind's eye, and its end is not an experience of nature but of paint. His colour may observe a harmony of some kind, of dominating hue or of intensities, and it tends to unity of rich textural effects, but its temper is less of harmony than of excitant coruscation. The conception of a Mannerist style should not be stretched to include this phenomenon of a post-classical development by a painter who, at this point in his career, had not adequately assimilated classicism, yet the combination in it of unnatural and subjective stress, its libertarian means, and its private aestheticism may justify association by analogy with early Mannerism. Small paintings in this strain, beginning towards 1516 (*Holy Family with Shepherds*, Cleveland, Museum; *Madonna with Angel, Donor, and a Bishop Saint*, formerly Budapest, Therey Collection), reach quick fulfilment in such works as the *Holy Family* (Florence, Uffizi) of *c.* 1518 and in secular *poesie* like the *Idyll* (New York, Metropolitan Museum) and the *Argonauts* (Washington, National Gallery) of *c.* 1518-20. They continue into the early

1520s in a vein that becomes ever more free and brilliant: so the pendant *St Lucrezia and St Paola* (Washington, National Gallery, Kress Collection; Edinburgh, National Gallery) and the *Madonna* (Rome, Borghese). In the *Deposition* (London, National Gallery, *c.* 1521-2) [134] the force of sheer aesthetic effect is conjoined with a moving sense of a religious pathos.

134. Dosso: Deposition, *c.* 1521-2.
London, National Gallery

In the latter picture there is already the indication of Dosso's experience of contemporary Roman art,[49] which was to come increasingly to count in the development of his style. He had visited Florence in 1517, but there is no discernible index of an effect made by that visit upon his art. The consequences of a Roman visit were, however, profound. It is probable that it occurred in 1520.[50] Dosso's younger brother Battista had long since been resident in Rome, working in some connexion with the Raphael shop since 1517, and he was more or less a convert to the Raphaelesque style. In Dosso's own works of the early twenties and the following years his response to the Raphaelesque milieu, to Michelangelo's example, and to the art of Sebastiano del Piombo is obviously attested by repeated quotations of motifs taken from their Roman works. But the deeper import of the Roman style for Dosso was in his acquisition from it of a sense for effects seen in classical style that had not been impressed on him by contemporary Venetian art: of controlled and monumental structures of design, of assertive density of figure style, and of gravity and grandeur in idea and emotion. These elements appear after Dosso's Roman visit in a series of altar paintings where the public nature of the works makes ordered rhetoric appropriate. In the earliest of these altars, a *Madonna in Glory with St Sebastian, St John Baptist, and St Jerome* (Modena Cathedral, dated 1522), Roman influence is less decisive of the whole effect than Dosso's private strain of emotional and formal eccentricity, but the influence is present none the less, in particular in adaptations of Michelangelesque motifs of pose and in a quotation from the *Laocoön*. A recognizable classicizing character emerges increasingly in Dosso's subsequent *Madonna with the two St Johns* (from Codigoro; now Florence, Pitti, *c.* 1523–5) and the *Madonna with St George and St Michael* (Modena, Galleria Estense, best dated *c.* 1525).

The *St John Evangelist and St Bartholomew with Donors* (Rome, Galleria Nazionale, once inscribed 1527) is in great part a paraphrase of motifs recalled from the art of Rome.

The altar paintings approximate elements of a classicism, but these do not displace the special and a-normative stresses Dosso had conceived for colour or reduce the – for want of a better word – romanticizing play between his figures and their settings of landscape; and while the tone of classicism gives the emotion a rhetorical style and power, it only tempers its great inward warmth. Parallel in time to the major altar paintings there are pictures on a large scale of mythological themes such as the *Melissa* (Rome, Borghese, *c.* 1523) [135] or the *Apollo* (*ibid.*, *c.* 1525) in which the classicizing grandeur of form, powerful and evident as it becomes, is less telling than the sensuous opulence that the colour and chiaroscuro make, or than the romantic eloquence which Dosso evokes in the feeling of his subjects. Dosso's classicizing was a tardy imposition on a personality already formed in different terms, seeking sensation that was special to the point of eccentricity, of which the communication had to be extremely personal – an interchange between his private and sophisticated fantasy and that of his court audience. The classical influence on him was not enough to make full counterweight against this strain, and even as he paints the works of classicizing cast which we have discussed, he makes excursions into a style which is unclassical in essence. This style extends the eccentricities of Dosso's small-scale mode, magnifying them in dimension and effect; but these eccentricities are now applied to precedents of form seen in Rome in the art of Michelangelo and in Sebastiano, and known perhaps as well from Pordenone's work in Mantua. The result is a mode of anatomical hyperbole, disharmoniously powerful, and fantastic in appearance and expressive effect. It appears in symptom in the comic-pathetic

135. Dosso: Melissa, *c.* 1523. *Rome, Borghese*

136. Dosso: Allegory of Music.
Florence, Museo Horne

Allegory of Painting (Vienna, Kunsthistoriches Museum, *c.* 1522?),[51] and it is fully manifest in the radical distortions, compounding the lyric and the grotesque, of the *Allegory of Music* [136], perhaps datable in the mid-decade. Other works, in which the same arbitrary attitude towards large forms is further combined with accented realism of detail, may be grouped into the later 1520s.[52] Unclassical in essence, all these works bear a strong stress of their cast of Romanism, and this compels our thinking of them as analogies of aspects of the current Central Italian Mannerist style.

Of the painters discussed in this chapter, Dosso was the most susceptible to the influence of Rome – as Romanism, however, not as classicism. About 1530[53] he was involved directly with an outpost of exported Romanism, the

Villa Imperiale in Pesaro. Accompanied by his brother Battista, who had some time past returned from Rome, Dosso worked (under Genga's supervision) on the decoration of the Sala delle Cariatidi in the villa.[54] For this room Dosso, following Genga's dictate for themes of illusion, conceived an invention in which ideas derived from Central Italy, North Italy, and Venice intersect. He displaced the ceiling with a fictive pergola and the walls by a painted loggia with seemingly live caryatids, behind whom a continuous panorama of deep landscape opens up. A classicist and concettistic wit supplies the mechanism of Dosso's scheme, but its deeper content is one of romantic fantasy.

What Dosso encountered of Romanism at Pesaro was no doubt an impetus in the direction which his art took immediately after, but the Giulian disciples he encountered at the villa had no effect on him comparable to that of Giulio himself. By 1530 the extent and impressiveness of Giulio's Roman demonstrations in Mantua were of a measure far exceeding those of the beginning 'school' at Pesaro. With the court at Mantua that of Ferrara had continuous relations; and the most decisive experience for Dosso's art in the fourth decade was of the Mantuan Giulio.[55] In 1531-2 Dosso was engaged, again with his brother, on an extensive fresco decoration for Bishop Clezio in the Castel Buonconsiglio at Trento (where Romanino of Brescia was called to work at the same time); Dosso's paintings there show an alteration from their former style that is markedly towards the style of Giulio. In the Buonconsiglio frescoes and in the major easel works that closely succeed them the libertarian attitudes towards form and expression that had characterized so much of Dosso's art before are chastened: drawing becomes firm and sharp and contests the assertiveness of colour; surfaces take on a harder brilliance; fantasy and free invention yield to a new desire for classicist correctness. This is the incipient temper of the altar of the *Coronation of the Virgin with Church Fathers* (actually a *Disputation on the Immaculate Conception*, Dresden, Gallery, dated 1532) and it is more evident in the large *Holy Family* (Rome, Capitoline Museum) of about the same time. It is explicit in the *Christ among the Doctors* of 1534 (for the cathedral of Faenza, lost, but preserved in a copy), of which Vasari remarked on the 'nuova maniera'. These works represent what is in effect a conversion of Dosso to the outward aspects of the post-classical Emilian style of Giulio, and the manner would serve for all of Dosso's self-consciously more 'important' works until his death. He conforms to the exported Romanist mode more than he had, earlier, to what he knew of Rome itself. But the conformity is in the spirit of concession to authority; it subordinates Dosso's earlier mode of feeling but does not engage it, or any new replacement for that old intensity, in the service of the newer style. Giulian Mannerism is taken as a source from which to make a manner based on classicist conventions, but not as the vehicle for a personally creative style. And as he had done earlier, Dosso continued to work parallel to this public style in a more private vein, more moderated than before and less frequent, but by no means quite suppressed: among its remarkable examples are the darkly luminous *Madonna with the Cock* (Hampton Court, *c.* 1535) and, from the last moments of his career, the satiric portrait group called *La Stregoneria* (Florence, Uffizi, *c.* 1540).

Despite the personal episodes that continued to distinguish Dosso's painting of the fourth decade, his art, even more than is in general the case, receded then from its creative, innovative level of the 1520s. It may not only have been the need of productive economy that caused Dosso to concede a continuously more important role to his brother Battista; as Dosso's public manner became increasingly classicist, conventional, and impersonal, it mattered less

whether his ideas were presented by his private hand. We have observed that Battista, who was several years Dosso's junior (born perhaps *c.* 1497), had been for some time in relation with the Raphael shop in Rome,[56] and was thus, far more than Dosso, disposed to classicist conventions. We have an even less sure knowledge of Battista's early activity than we have of Dosso's, but the small pictures by Battista which we may assign still to the 1520s are effectively enough Romanized to indicate that some effort has been required to adjust them to the models of his older brother's style. Like Dosso, Battista painted cabinet pictures in abundance; and it may be that in the thirties most of the more usual subjects for small pictures (such as the *Holy Family with St John*, Rome, Borghese) were painted by Battista. In 1533–4 Battista was entrusted with the execution of his first work on a large scale, an *Adoration of the Magi* (Modena, Galleria Estense), but as Dosso's deputy and probably to his design; and after

that the works on a major scale that issued from the brothers' shop were painted either with Battista's substantial collaboration or by him mainly. His quality of hand, compared with Dosso's, was undistinguished, but even so it was more than his quality of mind. What there was of classicist vacancy in the late designs that Dosso conceived (e.g. *Madonna Enthroned and Saints*, Rovigo, Pinacoteca, *c.* 1537; *St Michael*, Dresden, Gallery, documented 1540) is increased by Battista's inability to apprehend forms in a large-scale unity.

After Dosso's death in 1542 his atelier continued under Battista's nominal direction, devaluing further the currency of the Dossesque public style of the fourth decade and completing absolutely the conversion of the style into Romanism. Of the artists who were the creators of decisive novelty in North Italy in the third decade, Dosso was the most idiosyncratic, and perhaps on this account his innovation was the least historically enduring.

Compared with the experiments of the advanced painters of the North Italian centres whom we have discussed, and yet more in comparison with the ferment of style in contemporary Central Italy, the course of painting in Venice in the third and fourth decades seems relatively peaceful. Throughout the 1520s Titian continued to exploit the development he had made of classical style in the Este *Bacchanales* but did not significantly exceed it, and during most of the next decade there is a relaxation in his art even more pronounced than that we have observed to be generally the sequel of the truly innovative twenties. In the later thirties Titian's development began to show renewed activity and symptoms of a change of style; the stimulant appears to have been in factors which at that time came to sharpen the meaning for Venetian art of the problems presented to it by an aesthetic that originated in Central Italy. The same factors began to modify the larger course of the Venetian development; however, the full sense and effects of this change did not appear until the following decade. Pordenone's work in Venice in the thirties had been, as we have seen, a major one among the stimuli there towards novelty: in the present context we should stress how, despite the moderating influence of Venice upon him, he was the most active force for change in the city in the fourth decade. We observed that Lotto's presence was far less relevant to Venetian painting of the time. Palma's latest works, still within the twenties, made an interesting but only momentary deviation in Venetian classical style, and his fellow members of the Lombard colony in Venice, Cariani and Savoldo, continued to work into the thirties in styles that were the result

more of the conservative Lombard than the modern Venetian components of their art. Two other painters who emerged to prominence in the Venetian school in these decades, Bonifazio de' Pitati and Paris Bordone, though also foreigners by origin, were more modern, though by no means conspicuously inventive or consistent in direction of development. Nevertheless, they contributed to the shaping of the change in Venetian style that was to mature towards 1540, and they afterwards partook in its consequences.

As we must tell it in a condensed space, the history of this time in Venetian painting will seem more active than in fact it was, obscuring the easy expenditure throughout most of these two decades of resources in Titian's treasury amassed to the benefit of all Venice. The relative peace of art that Venetian painters enjoyed in these years was like the relative exemption the city enjoyed – purchased with its still great power – from the ravages that had made turmoil in most of the rest of Italy in the 1520s and from their aftermath.

Titian

The *Madonna of the Pesaro Family* (Venice, Frari) [137] is the counterpart in religious painting of Titian's accomplishment in the Este *Bacchanales*, and its time of creation was about coextensive with them. It was commissioned in 1519 and finally set up only in 1526, but its likely time of design is towards the earlier date and its most concentrated moment of execution probably about 1522.[1] Differently accessible to inspection from Titian's prior grandiose apsidal altar in the same church, the *Assunta*, the first effect the Pesaro altar makes is that of the absolute efficiency, so great it needs no show of virtuosity, that Titian's technique for describing nature has attained. He evokes the persons, the setting of architecture, and their ambient atmosphere into a new order

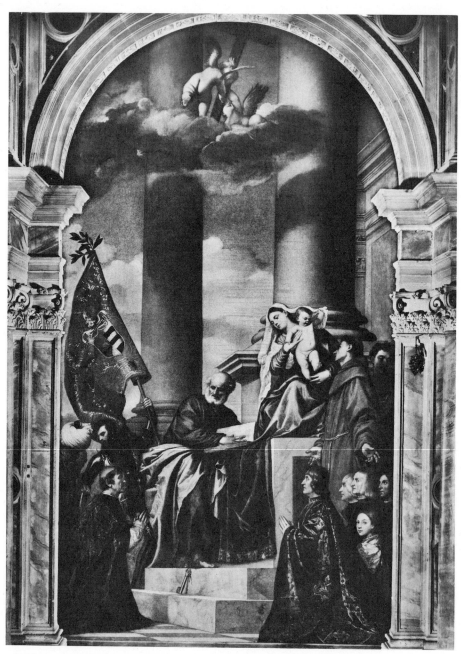

137. Titian: Madonna of the Pesaro Family, set up in 1526. *Venice, S. Maria dei Frari*

of credibility. Naturalism is so obvious a factor of the Venetian classical style that we tend to overlook its role, and it requires a demonstration like this one to recall the function and the magnitude of such descriptive power, though in this degree it is Titian's alone. What persists in Titian of the Bellinesque ambition to make *Existenzbilder* seems to have been reawakened by the task of painting a large-scale devotional altar, and the temper of the later altars of Bellini – their still monumentality – influences Titian's thinking in this task, chastening the expansive energies that his other pictures of this time called forth. Yet, while this tradition seems much present to his mind, it is remade in modern terms – the old monumental form given higher grandeur and more resonance, and the actors endowed with the evidence of their vitality. Taking the structure given by tradition to this iconographic type as a starting point, Titian turns it on its vertical axis, and then

displaces the axis towards the right; he thereby creates a scheme which, while it retains every element of geometric order from the older structure, translates them into shapes that induce movement.[2] From frontal, additive, and still, the old structure becomes diagonal (simultaneously on the picture surface and in space), active, and consecutive in the relation of its parts. The figures can retain the dignity of movement that the theme requires since a higher energy than that which they physically illustrate is infused in them by design. As the figures act, with a contained rhetoric, their movements counterbalance one another and are stabilized against the grand architecture. Similarly, the action of colour is restrained, powerful where it emerges from the unifying chiaroscuro, but disciplined carefully to support the working of design.

About 1525, the *Entombment* (Paris, Louvre) [138] shows another, still higher aspect of the

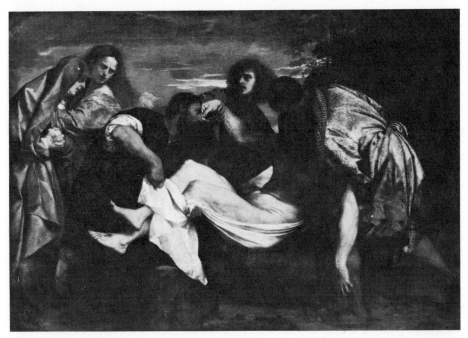

138. Titian: Entombment, *c.* 1525. *Paris, Louvre*

same intentions that informed the *Pesaro Madonna*. With a sophistication of visual sensibility like that which he had come to in the two later Este *Bacchanales*, and with a control of hand that seems even to exceed what was in them, Titian makes absolute synthesis in the *Entombment* between optical verity and effects of art. He describes existences in light with the truth of an illusion, yet the illusion is not only of the seen thing, but of the seen thing manipulated to make strengths, mutings, and consonances that are not truth but invention. It is also invention that shapes the movement of the actors, giving them a styled grace and deliberating their connexion in a rhythmic accord. They are set close to us, and the strength of colour in them intensifies their sense of nearness; but even as this closeness presses the effect of verity, there is no desire to give the image the relation to us of an actual illusion. The painting's contents, its colours especially, verge towards the picture plane or adhere to it, emphasizing the explicitly pictorial identity of the work: the principle is identical with one we have observed in examples of the highest classical painting style of Central Italy, but it functions still more patently when the primary pictorial matter is colour. As Titian finds a new reach of his powers of description he accompanies it with a development of means that at the same time reaffirm the ideal and synthetic value of the work of art.

Titian's concern for classical restraint in these two pictures is not only aesthetic: it proceeds from a classical ethos in conception of their subject matter. But where the given theme is more openly dramatic, Titian may respond in kind. Also, he may deal with subjects in which a major stimulus may be to his new accretion of descriptive power – no inert naturalism, but a result of the energy with which he sees nature and which he finds in it; where subject summons this response primarily, Titian may make it a primary effect. A higher energy may thus be generated in his art from nature as well as by emotions induced by a theme, but it may be a response to explicitly aesthetic problems also. About 1523, perhaps following on the Este *Bacchus and Ariadne*, Titian painted a *St Christopher* fresco (Venice, Palazzo Ducale; about twice life-size) in which the *Laocoön* and Michelangelo's *Bound Slave* were again (as in the *Bacchus* picture and the Averoldo Altar) a challenge and a source,[3] provoking more overtly than before a demonstration of the energies the painter can extract from plastic form. Titian exceeds his models, moving the gigantic figure of the Saint with an impetuosity that recalls the pictures of his earliest years, and intensifying the sense of activity of substance by the vibrance of description he makes with his painter's brush. The aesthetic problem in the *St Christopher* was joined some time later to a theme of authentically dramatic action. At an undetermined date after 1525 but before 1528 a competition was held for an altar painting of the *Death of St Peter Martyr* in Ss. Giovanni e Paolo: Titian won the contest, and in 1528-30 executed the painting (now lost, and replaced by a copy [139]).[4] Titian's rivals were Palma and Pordenone. Palma was no challenge, but Pordenone was, and in terms that presented to Titian the same problem of a plastic style that he had faced recurrently since his indirect encounter with the *Laocoön* and Michelangelo. In addition, Pordenone was the exponent of the extreme dramatic manner in contemporary art. Apparently thinking of Venetian taste, Pordenone moderated his accustomed violence in his design;[5] but apparently thinking of his competitor, Titian conceived the most radical invention he could make, exceeding Pordenone's precedents in dramatic force, in urgency of action, and in

139. Titian:
Death of St Peter Martyr, 1528-30 (copy).
Venice, Ss. Giovanni e Paolo

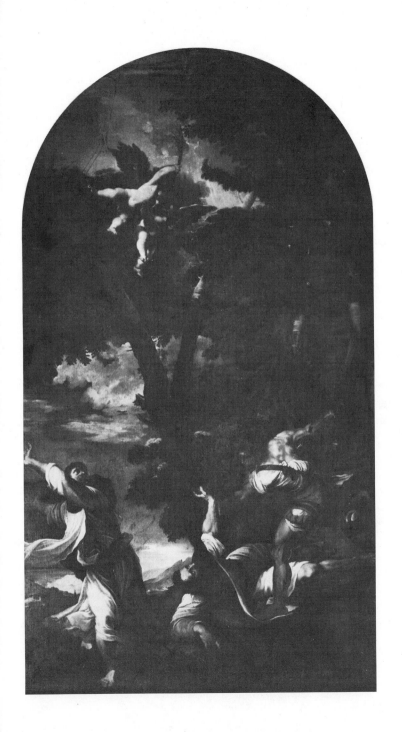

assertion of an energy of forms expanding in their space. Articulate in form and in expression as Pordenone could not be, and far surpassing him in his descriptive means, in this picture Titian generated a vastly higher and more trenchant power. The design in which the figures act conveys the sense of an explosion: behind the figures tree-trunks act almost anthropomorphically to extend and elaborate this effect. The violence of emotion, the intensity of action, and the expansiveness of pattern are in a degree which, at least as much as in Pordenone's or Correggio's extreme inventions, suggests the temper of a baroque style. Yet, more evidently than in them, the end effect pertains to classicism. The mode of feeling of the figures is refined towards typology, and their actions have the structured grace of classical dramatic repertory;[6] their ordering is in a scheme of counterpoise. In the setting, the explosive impetus of design is tempered as it rises, then muted, then diffused into a lyrical and tragic light. Rather than a foretaste of a baroque style, the *St Peter* altar is a counterpart, in Venetian terms, of that magnitude of classical dramatic mode which Raphael had reached a decade and a half before in his Stanza d'Eliodoro.

By 1530 Titian's position in respect to the resources of the classical style was one of absolute command: he could work any possibility that they contained or any permutation of them at will and with total mastery. There are two remarkable demonstrations of about this date, in smaller-scale devotional pictures, in which he exploits this fluency to give an effect of life so facile and apparently so casual that it seems that recognizable classical conventions have no part in them: these are the *Vierge au Lapin* (Paris, Louvre, probably done for Federigo Gonzaga of Mantua) and the *Marriage of St Catherine* (London, National Gallery). In them Titian evokes schemes of compositional asymmetry which he had invented earlier and

(as if in compensation for his Romanist and plastic preoccupation in the *Peter Martyr* altar) a purely optical painting mode; he recalls the mood and setting of his former *Giorgionismo*. All these, however, are developed with his present measure of sophistication. The air of accident in these images is the surface of a brilliant and finely deliberated manipulation of design in structure and in colour: these might be demonstrations of a classicist's conception of the virtue of *sprezzatura*. They extend into a new degree of freedom the principle (earlier substantially demonstrated in the *Andrians*) of a charged harmony and a unity of pictorial texture made from shapes and colours set in movement.[7]

These pictures in one sense that is peculiarly Venetian, and the *St Peter Martyr* altar in another that is less explicitly native, mark the extreme points so far in Titian's extension of the possibilities of the classical painting style. For him, as for the painters who had participated in a more revolutionary way in the ferment of the 1520s, the new decade initiated a phase of détente. For a time the temper of Titian's art became contrastingly conservative, not just declining further new experiment but seeming to seek reaffirmation of old principles, or of the virtues of a safer, less experimental classicism. Between 1534 and 1538 he executed a major large-scale commission, the *Presentation of the Virgin*, for the Scuola della Carità (Venice, Accademia)[8] and chose to interpret it in the quattrocentesque tradition of Venetian *teleri*, only unassertively modernizing the rectilinear perspective order of those archaic examples, and enlarging – with his by now unsurpassable technique – their emphasis on descriptive naturalism. About the middle years of the decade, he painted a monumental altar of the *Madonna in Glory with Six Saints* for S. Niccolò dei Frari (Rome, Vatican)[9] in which he emphasized, again with almost rectilinear effect, clarity of structure and heavy dignity of form.

A large-scale mythology, the so-called *Pardo Venus* (Paris, Louvre), was probably in substance an invention of the later 1530s, though significantly reworked later; it is full of motifs and ideas that have been recollected from an earlier and more Giorgionesque time, ordered in an obvious and uncomplicated classicizing scheme.

The summation of this major vein in Titian's art in the fourth decade is the *Venus of Urbino* (Florence, Uffizi) [140] – the painting of a 'donna nuda'[10] to which the patron, Guidobaldo, Duke of Camerino (only later of Urbino), referred in a letter to Titian of 1538 – poised with wonderful effrontery on the border between portraiture and mythology, and between erotic illustration and high art. The mode of design in this painting is a sophisti-

cated archaism, resurrecting not only Titian's own compositional schemes of his phase closest to Giorgione but obviously also Giorgione himself (and even recalling the perspective-based designs of Bellini). The patent reference to Giorgione underlines how Titian has transposed the distanced dream of Giorgione's *Venus* into a present prose. In its mondanity Titian's treatment of the subject is completely modern;[11] at the same time it reasserts the oldest strain in Titian's art, the realist substratum that is in his pictures of the second decade, which persisted there as an inheritance from Bellini. What there is of ideal beauty in the *Venus of Urbino* is not more than the cosmeticizing process that had been applied to the women of the *Sacred and Profane Love*, or to the subjects of the half-length allegories of that time. The last had been

140. Titian: Venus of Urbino, *c.* 1538.
Florence, Uffizi

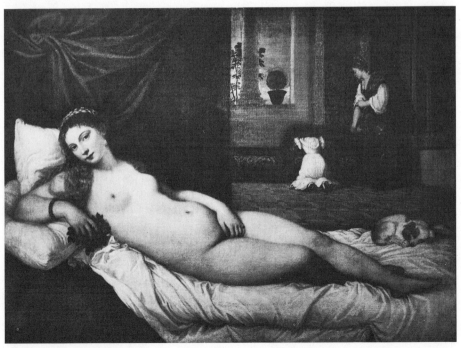

more covert advertisements than the *Venus* for the same conspicuous product of the opulent Venetian economy: negotiable female beauty. But what is not in the earlier thematic analogues is the painting of this image with Titian's present powers of eye and hand. The mastery of touch that summons the figure to existence and evokes its vibrance – muted for the moment – of sensuality is the hand's recording of a power of generalizing of sensuous experience that resides in the mind. This is what, despite the atmosphere of illustration in the *Venus*, conveys its counterweight, an authentic sense of ideality.

The *Venus of Urbino* is the end product, chronologically a kind of postscript, of the strain that had been dominant in Titian's pictures of the fourth decade. Before it was painted his course had again begun to change, re-attaching itself to the mode exemplified at the end of the twenties by the *Peter Martyr* altar and to the problems contained in it. As Pordenone's stimulus seems then to have been a factor, so, with his continuing activity in Venice, is it even more explicit that, a decade later, this is again the case. Also, the Romanist propaganda of Giulio in Mantua had come to have an increasingly important effect, signifying to the painters of northern Italy what was authoritative as well as new. In the later 1530s Titian was repeatedly in touch with Mantua, and there are records of his certain visits there in 1536 and 1540 and of a probable visit made in 1538.[12] These were the immediate stimuli for Titian to revitalize his style, but in addition he could not but be cognizant of the general course of events in Rome and Florence and of the affirmation there by the middle thirties of an art unlike his own of that moment.

In 1537 these combined factors worked on Titian to effect a major change, and in that year and the next he did a group of works that demonstrate a convinced re-immersion in the problems that at this time signified 'modernity'

– as marked in this as the previous paintings were oppositely conservative. The whole group has been lost, so its import for this moment in Titian's history tends often to be underestimated; but all are recorded in prints or painted copies, and their character can be assessed. The first was an *Annunciation* for S. Maria degli Angeli at Murano: it was this picture that was replaced by Pordenone's painting of the subject when the monks refused to pay Titian's price.[13] Interpreting the theme as a pretext for an ennobled drama, Titian set its protagonists on a monumental and near-illusionistic architectural stage, moving them powerfully, and populated the upper scene with swirling angels. In the engraving that records the painting it is the effects of energy of structure and of plastic form that seem to dominate, but the original contained a further agency of drama that was natively Titian's, raised in this present context to a new force – what a description from the pen of Aretino tells us was a 'lume folgorante'.

In the life-size *Battle of Cadore* once in the Palazzo Ducale [141][14] Titian's response to the potentiality for drama is at a still higher pitch, and he has exploited every available resource, in his own repertory or in others', that would help him realize it. Pordenone, the arch-antagonist, is at once an irritant for Titian and a main source for borrowings.[15] Roman prints derived from the battle scenes of the later Raphael and Giulio served Titian also,[16] but the direct example of Giulio's works in Mantua is the most decisive stimulus – less from any analogues in the subject matter than from the whole tenor of style, complex and violent, in the main rooms of the Palazzo del Te, most importantly the Sala dei Giganti. Titian tempers Giulio's precedent to his own purposes and gives fluency to what he takes from Pordenone, creating on challenge the most swiftly impelled image of an ordered turmoil art so far had conceived. The energy of forms

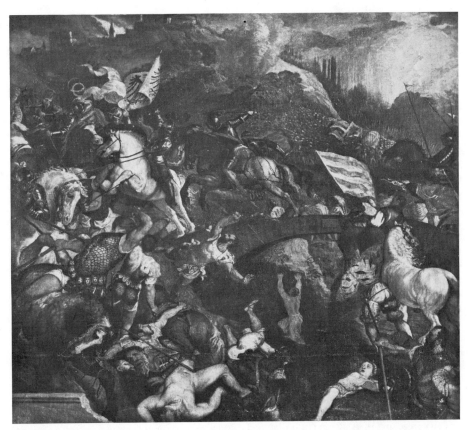

141. Titian: Battle of Cadore, 1537–8 (reduced copy).
Florence, Uffizi

that act in space seems even to exceed what was in Titian's sources, not only in the single figures but in the whole development in depth of the design. Yet this activity in space depends less than in Pordenone or Giulio (and less also than in Titian's own earlier *Peter Martyr* altar) on assertions of plasticity of form. On the contrary, plastic emphases are lessened by the action on them of a very varied chiaroscuro, and they seem to have been expressed less by means of modelling than by translation into equivalent energies of colour. The devices of illusion that Titian has taken with seeming

literalness from Giulio and Pordenone assert themselves much less than in the works of those painters as simulations of sheer plastic facts. This is even less than in Titian's career before a simply imitated response to the Central Italian doctrine of a plastic style, and more truly a dialectic made between it and his Venetian principles of light and colour. The visual and the illustrative energies of the *Battle of Cadore* match, but all the passionate commotion in it still is resolved into a unified pictorial texture, in principle what Titian had conceived in the *Andrians*; here, however, the

vibrance the unity contains is at a vastly heightened pitch.

The third element in this group of lost works is in the most literal sense Romanist: a set of half-length portraits of the Caesars painted to be inset into Giulio's decoration of the Gabinetto dei Cesari in the Mantuan Palazzo Ducale.[17] Antique models – busts and coins – were obviously consulted by Titian for the portraits, but this necessary archaeology made only part of their effect of a *Romanità*. Apparently from sympathy with their Giulian setting and its author's style, Titian paraphrased Giulio's taste for an exaggerated physical presence, in both amplitude and plastic strength. This suits the power implied in the subjects, but even the tone of Titian's treatment suggests the impact on him of Giulio, for he has described the Emperors with an accent like Giulio's of caricatural realism and with a suspect touch of Giulio's mock-heroics. More than the companion pictures of 1537-8, the Emperor portraits constitute a concession to the mounting pressures on Venetian classicism of intruding Central Italian style. The group of works of which they form part contains, more than at any time in Titian's career, the evidence of his confronting problems which could force on him a far-reaching re-evaluation of his ideas of art. What began in the last years of the fourth decade continued for a while into the next, and then generated what for the moment had the look of a profound crisis. It was for the rest of Venetian painting, but not, as we shall see, for Titian; as usual he came to dominate and exploit what influenced him.

There is no significant distinction in the course of Titian's portrait style from that of his more complex works of these two decades. With the necessary limits and restraints that are occasioned by the genre, the portraits generally reflect the wider attitudes that Titian adopted in these years. Portraiture is not a field in which Titian makes basic inventions of style, though

it is one in which he applies inventions conceived elsewhere to achieve solutions that have particular effectiveness. By 1520 he came to demonstrate in portraits like the *Tommaso Mosti* (Florence, Pitti) or the *Man with a Glove* (Paris, Louvre) a breadth of touch and an amplitude of presence that are the evidences of his maturing of a classical style. It is in the portraits of this time that he finds the justness of compositional *mis-en-page* that will distinguish his best portraiture henceforth. This quality of design, so intelligently considering the relation of the elements of the image to the picture frame, is the counterpart in more restrained and concentrated form – and thus more simply and strikingly apparent – of the larger manipulations of classical pictorial order that Titian had achieved. In the middle 1520s, as his sense of magnitude of form and his power of descriptive touch expand, they appear in the splendid *Federigo Gonzaga* (Madrid, Prado), at once expansively assertive and aristocratically controlled. The unidentified sitter of the *Man with a Falcon* (Omaha, Joslyn Art Museum) is larger still in its effect of form, but not so grand; the mood of the subject and the warmth of painterly effect that is consonant with it evoke the aura of Giorgione. In both these portraits their power comes from their effects of art, not from any probing illustration of the character of the subject. Titian stands at least at arm's length from these sitters of high station, seeing them ideally and almost typologically in state of mind and, to the degree that recognizable description will permit, in appearance also. Their countenances are ennobled quasi-fictions, and the psychological energy they must have held in actuality is masked, replaced by energies, almost as eloquent, of aesthetic device. In 1533 the countenance of *Cardinal Ippolito de' Medici* (in Hungarian costume in remembrance of his recent Papal mission to Vienna; Florence, Pitti) lends itself well to psychological evasion: his face is commanding

and sharp-featured, but it is still a mask. In the earlier portraits there had been much painterly exploitation of the texture and colour of costume; in the *Ippolito* his exotic dress supplies Titian with the material for an exercise in beautifully controlled opulence. A portrait of a yet more striking personality, *Isabella d'Este* (Vienna, Kunsthistorisches Museum, c. 1534), is a costume piece by first intent, so authorized by the terms of the commission, requiring that this portrait be a copy of an older work by Francia, copied itself from an older portrait still. But a different humanity, warm and accessible in an opposite degree to that in Titian's paintings of grandees, is in the two portraits he painted in the middle thirties of the courtesan who was to pose, in 1538, as the *Venus of Urbino*. In a portrait of about 1534 (Vienna, Kunsthistorisches Museum) she is in a sumptuous fur-trimmed dress, and wears it only loosely gathered round her, so that she takes the typical sixteenth-century courtesan's pose, one breast exposed. Here her lovely face is still a girl's, with a frank and gentle radiance that Titian has communicated with sympathy. About two years later, in the portrait called *La Bella* (Florence, Pitti), her beauty - and her personal style, as Titian sees it for us - are evidently more mature [142]. Her attitude is formal and her dress as proper as a duchess's and no less superb. Titian takes its restrained splendour as pictorial matter to rival the enchantment to the eye, if not to the spirit, of his subject's face.

In 1536 Titian began, and in 1538 finished, a portrait of *Francesco Maria della Rovere of Urbino* [143], and in the latter year painted a portrait of his Duchess, *Eleanora Gonzaga*, as a pendant to it (both Florence, Uffizi). The first intention for the Duke's picture was for a standing portrait at full length,[18] which was abbreviated to three-quarters; the Duchess's portrait, though in seated pose and on a smaller internal scale, was given a format that approx-

142. Titian: 'La Bella', c. 1536. *Florence, Pitti*

143. Titian: Francesco Maria della Rovere, 1536-8. *Florence, Uffizi*

imately matched the Duke's. Both are state portraits in a sense that Titian had not defined before, in which the sitters are made to convey a sense of station that is more than an expression of their personal aristocracy. They are easy in pose, yet seem austere, giving the effect that dignity of carriage is native to them. A curiously simple aesthetic means supports this effect: an unusually wide format, within which breadth of shapes and measured rectilinear elements are stressed. At this extent the neutral screen of light of the preceding portraits does not suffice for background; setting and some accessories must be specified. In the portrait of the Duchess, painted in the same year as the *Venus*, the classicist rectilinearity of composition is the same, and the descriptive mode similar. In the Duke's portrait the subject solicits an appropriately unlike response to his military emanation of command and power. Against background forms that make a planar and rectilinear control, his figure, darkly lucent, is set in a diagonal pose that is simple but of great implicit force: he rests, but the shapes that make his armoured form and the controlled force of light on it create a vast quota of contained energy. In the moment in which we have observed the intersection among Titian's larger subjects between a conservative classicism and a regenerated energy of style, a similar coincidence appears in these companion portraits, justified in them by the difference of the given matter in each.

In the form it finally took in 1538, the Duke's portrait assumed something of the character of the Emperor series from Mantua, completed also in this year. More likely near this time than earlier, Titian, apparently in Mantua, did Giulio Romano's portrait (London, private collection)[19] in a mode that shows an accretion beyond the *Rovere* of sheer plastic force, achieved less by movement of the figure than by strength of modelling itself, of which the clarity and insistence surely reflect Giulio's artistic style. Again, the tenor of expression responds to the subject, but for the first time in a male form since his earliest years Titian's response is not in general terms but in terms of acute individuality. The relationship between the two artists explains this only partly, and a larger factor must be taken into account: the new force with which Titian apprehends experience is not directed only to its plastic and substantial facts but also to its emotionally expressive content. In portraiture the ennobled generalization is now not enough, and Titian's portraits will rarely again revert to the handsome but evasive conventions of the previous years. Not only the lesser sitters but the great lords are recorded from this time on with the effect of their individuality. *Alfonso d'Avalos in Armour* (Paris, Comtesse de Béhague, 1538) is the ultimate aristocratic general, but his face is described with trenchant specificity of form and the sharpest focus of expression. Its force combines a consonance of descriptive and aesthetic means: the plastic energy of the head is one with the energy of the sitter's look, and the armoured torso magnifies a similar power of effect into the whole dimension of the portrait. More essentially than the *Rovere*, the *d'Avalos* conveys a cast of Mantuan Romanism like that which Titian took on for the *Emperors*. In plastic strength of form and in its severe continence, and in its demonstration of aristocratic attitude, the *d'Avalos* suggests likeness to – and chronologically anticipates – the portraits of the high Maniera, and is as close as Titian in this phase of his career was to come to them.

Palma Vecchio: His Later Works

By the beginning of the third decade Palma had not only absorbed all that was pertinent to his ambitions of Titian's recent developments of style, but had responded more readily than Titian to ideas that had their origin in Central

144. Palma Vecchio:
St Barbara altar (detail),
c. 1522–3.
Venice, S. Maria Formosa

Italy. The Thyssen *Sacra Conversazione*, which we have dated *c.* 1521, seems to have marked Palma's maximum overt concession to foreign style. In the paintings of this favourite theme that come shortly after, the un-Venetian element is less strong, by no means rejected but assimilated as a reinforcing virtue into the Titianesque basis of Palma's style. The *Adoration of the Shepherds* (with a female donor; Paris, Louvre, *c.* 1522) is such a case, clear in geometric structure and asserting grand scale and plasticity of form, yet brilliant in its painterly descriptive mode. In the *St Barbara* altar for S. Maria Formosa (Venice, *in situ, c.* 1522–3) [144] an old-fashioned compartmented form, in which each compartment holds a single full-scale figure, permits Palma to make an imposing demonstration of his concern to join largeness of substance with opulent visual effect. The result recalls the ponderous and splendid pictures that Sebastiano del Piombo had left in Venice before his departure more than a decade before. Despite his capacity for response to contemporary developments there is a disposition in Palma, especially when he works on a public scale, to seek simpler and thus more conservative-seeming solutions for artistic problems than Titian. When he painted his large altarpiece of the *Madonna with St George and St Lucy* for S. Stefano in Vicenza (*in situ, c.* 1523) he chose an essentially conventional scheme and gave it a character of modernity by manipulations of its surface rather than by substantive adjustments of design. However, the effects of surface are significant: as if in compensation for the conservative basis of the design, Palma not only makes on it a brilliant colouristic display but also gives it an extraordinary vigour, new for him, of rhythmic energy.

About 1523 Palma must again have focused his attention upon non-Venetian artistic happenings. Palma was, it must be remembered, not a native but an emigrated Bergamasque,

with no exclusive loyalty to Titian's lead. In 1523 Lotto – the opposite of Palma, a Venetian emigrated to Bergamo – was for a while in Venice, but given Palma's repeated contacts with his own province it is not necessary to assume that only this visit was the cause of a visible infiltration of Lotto's quasi-Maniera of this time – emotionally active and permeated by linear energy – into Palma's art. A conspicuous evidence of the relation is in the *Madonna with St Catherine and St John the Baptist* (Hampton Court, *c.* 1523), in which Lotto's influence gives new pathos to Palma's actors and lends more visual as well as emotional urgency to the chiaroscuro mode that Palma had acquired from the most recent Titians. Palma consults not only Lotto but, apparently, the novelties of the recent Dosso and – once more – the now-increasing repertory of Central Italian prints. The *Bathing Nymphs* (Vienna, Kunsthistorisches Museum) seems a consequence of the working of these stimuli on Palma, introducing qualities that in their cumulative effect almost disjoin him for the moment from the mainstream of contemporary Venetian art. Linear excitements made from liberties of description in the nude (and in the shapes of landscape, too), an ornamentalism in design, and the transposition of Venetian colour into a high, silvered key give this work an affinity with the temper and the forms of a Maniera, making a singular anticipation of an alteration in Venetian style that would not recur to this degree for almost twenty years. Probably close to this same time, responding to a similar complex of stimuli (and perhaps to Pordenone also), Palma invented the kernel of the huge *telero*, a maritime *Miracle of St Mark* (Venice, Scuola Grande di S. Marco),[20] in which the violent and foreshortened male nudes who are its most conspicuous feature seem a foretaste of some academicized and acrobatic demonstration of advanced Maniera; theme of course in part generates this forced handling of form. In the *Venus and Amor* (Cambridge, Fitzwilliam Museum, *c.* 1523-4)

145. Palma Vecchio: Venus and Amor, *c.* 1523-4. *Cambridge, Fitzwilliam Museum*

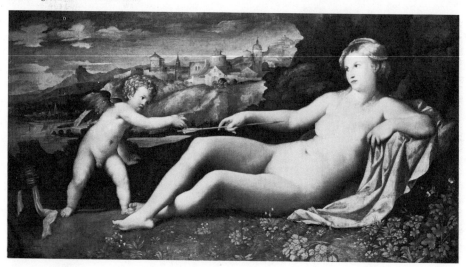

[145] Palma finds his just mean for the reconciliation of Lottesque and Central Italian with Venetian ideas. The nude Venus conforms in general to the explicitly sensual canon of female beauty that Titian was the first to illustrate, but Palma has attenuated her proportions and given each part of her anatomy a refinement of shape which in her extremities becomes an *affilatura*. A precisely articulate effect of ornamental grace, defined by contour, conditions Venus's emanation of sensuality. No less important as a deviation from accustomed Titianesque effect is that this precise linear contour encloses a purity of modelling, almost statue-like, of the nude form. Texture is chastened and colour cooled towards marble, not to the degree that denies sensuous effect, but to that which makes equivocation between life and statuary; the light reflected on the polished surface is an opalescence. The figure is defined with grace, yet, statue-like, seems more fixed than poised in it; so is the Amor. The picture conveys the sense of an aesthetic that is less classical than neo-classic.[21]

The moment that produces this accommodation between Palma's Venetian classicism and a temper of Maniera which in Central Italy was itself barely incipient is brief, and seems not to extend beyond 1525. Though the stimuli behind it may be foreign, the actual generation of the mode of this moment is personal to Palma within Venice, and its precise definition is markedly his own. He applies it during this time to the second of his specialized genres, the portraits of Venetian *bellezze* (so outwardly at variance in theme with his other speciality of *Sacre Conversazioni*), which from the imposition on them of this style that is so self-conscious of effects of art cease to be, as they often had mostly been before, opulent advertisements. Instead, they incorporate sophisticated effects of artifice into the description – fine-spun patterings of drapery and silhouette and complex modellings with brilliant light on

polished surfaces of form. The sense of stylization equals in interest, or may dominate, the subject that Palma illustrates.[22]

Palma seems not to have been able to maintain this precise, complicating style. A marked change, mostly for the worse, occurs in the painting of his last few years. It cannot be explained by the role that his assistants take in execution of at least his larger pictures of this time: the change is more essential, a matter of conception of design and of descriptive function, not of accidents of hand. About 1525 or 1526, in the *Holy Family with the Magdalene and Baptist* (Venice, Accademia; completed after Palma's death in 1528 by Titian) Palma – reacting, apparently, to Titian's demonstrations in the Pesaro altar – paraphrases Titian's style more faithfully than at any time before, and with an added private power; but this is not a lasting reconversion. The *Holy Family with Donors* (Naples, Capodimonte), probably of later date, is in a heavier, more laboured style, much less like Titian; and the *Adoration of the Kings* (Milan, Brera, commissioned in 1525, executed largely by assistants) is quite disconnected from contemporary Titianesque style. The *Adoration* reasserts old values, some of them pre-classical like those we should expect to find in the last perpetuators of the tradition of Bellini. Structure is simplistic; form is massive but inert; description is literal and laboured. Palma's *Visitation* (Vienna, Kunsthistorisches Museum, after 1525) is conceived in the same ponderous and simple prose. The last portraits[23] show that this vacating of classical style in Palma's latest art was a pervading fact. They are inert in form and in expression, glassily abstracting in the flesh, and laboured with the specificity of the Quattrocento in costume. There is a kind of melancholic attraction in them, but their character – and lack of it – does not result from any positive conception of artistic problems but from some private reason, unrelated to larger historical processes.

The Veneto-Lombard Colony

The relatively conservative complexion which painting in Venice bears in these decades is strengthened by the members of the Lombard colony, part Brescian, part Bergamasque, among whom Palma was the chief until his death in 1528; Cariani, Savoldo, and the Licinio and d'Asola families were next in prominence. Only Palma came to be effectively de-provincialized, becoming a participant in advanced developments on the contemporary Venetian scene: the rest retained a strong measure of provincial taste and conservative disposition.

For Giovanni Busi, Il Cariani, our information of his time and place of birth is inexact: between 1480 and 1490, probably in the Bergamasco but conceivably in Venice; in any case his signature describes him only as a Bergamasque. The first record of his residence in Venice is of 1509, but between 1518 and 1524 he was at work in Bergamo and was probably there again in the last two or three years of the decade. Otherwise he lived in Venice, where he is last mentioned late in 1547. Thus, much more than Palma, Cariani kept contact with his native place. Naturally this contact influenced him, but temperamentally he was much more disposed to Lombard and provincial standards than to Venice.

It is clear from the beginning of his career that there is a powerful attachment to the aesthetic of the Quattrocento in Cariani's art. His earliest dated work that survives is of 1519,[24] when he was in Bergamo, but undated paintings exist which may be assigned to the few previous years. These are in a style that is predominantly quattrocentesque, employing a vocabulary related generically to the late Bellini or the earliest, still Carpaccesque Palma. The concession to modernity in these paintings is literally superficial, consisting in the enlivening of surface with a textured light, described however with a conservative technique. Evidence in Cariani's landscape style and in his themes shows willing interest in Giorgione and the early Titian, but his personal *gestalt* of form – heavy, angular, and disjointed – cannot be reconciled with theirs. In Bergamo a signed and dated *Resurrection with Two Donors* (Milan, Gerli Collection, 1520) develops the force and variety of Cariani's use of light, and as its movement is accelerated, so is that of form; but the effect does not thereby seem more modern. His handling has an archaic hardness, and the assertive presences and actions are almost without unity. It was Lotto's example in Bergamo that eventually impressed Cariani with some more adequate sense of the elements of Cinquecento style. Cariani's *Pala di S. Gottardo* (Milan, Brera, *c.* 1523), conditioned by the model of the great Lotto *pale* of 1521, comes close to demonstrating a unity of vision and connective relation among forms. Yet these are secondary pictorial effects; what engages him more is an ambition stubbornly persistent from the Lombard tradition: the re-creation in paint of unfancy, popular reality. It is not surprising to find, in another painting that appears to date from these Bergamasque years, the *Road to Calvary* (Milan, Ambrosiana), that there is a Germanic cast, not only resembling what we may find at this time in the Brescian Romanino or in Pordenone, but more specifically imitative of the illustration of detail and emotions in transalpine art.

Painted probably after his return to Venice, the *Madonna Cucitrice* (Rome, Galleria Nazionale, *c.* 1525-8) [146] is descriptively precise and awkwardly powerful in form and in effects of colour, but it shows more inclination than before to Palma's canons of Venetian style. A *Finding of the True Cross* (Bergamo, Accademia), which dates from *c.* 1530 (perhaps painted in Bergamo rather than exported there from Venice), despite its clamorous accumulation of types, shapes, colours, and details, is

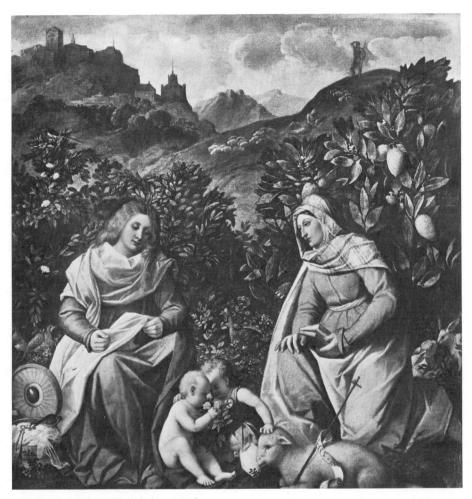

146. Cariani: 'Madonna Cucitrice', *c.* 1525–8.
Rome, Galleria Nazionale

painted in an expert prose reduction of Palmesque technique.[25] Even in his first Venetian phase Cariani had been attracted on occasion to Giorgionesque themes, though he saw them mainly in Palma's transcriptions, and it is his *reprise* of these in the latter half of the third decade that impelled Cariani towards an entire assimilation of Cinquecento style. His paintings in this vein are not a private and reactionary aberration but part of a discernible current in contemporary Venetian taste. In the *Lovers in a Landscape* (Rome, Palazzo Venezia) Cariani recollects the warmth of feeling and fluency of form of past idylls by the early Palma; in the *Concert* (Bergamo, Accademia), probably of the early 1530s, he recalls the young Titian's world

and presents it in a mastered Titianesque technique and with a cinquecentesque grace and unity of form. The religious paintings of the early thirties (e.g. *Madonna with St Jerome and St Francis*, Bergamo, Frizzoni-Salis Collection, signed) retain more of Cariani's idiosyncratic, still occasionally awkward and impulsive accent, but this is no less visibly incorporated than in the secular paintings into the parlance of the Titian style.

Towards 1540, as if in further demonstration of the modernity he tardily achieved, Cariani even shifted from *Tizianismo* to respond (e.g. *Sacra Conversazione with a Youthful Donor*, London, National Gallery), as an advanced painter might do, to the novelties of style exhibited in Venice by Lotto and Pordenone. Cariani's work is interesting and often even admirable in this latter phase of his career, but the sense of vigour in his art and, perhaps obviously, its force of individuality diminished as he became less salient from his context and was incorporated into the mainstream of Venetian style.

Girolamo Savoldo, born between 1480 and 1485 in Brescia, was more resistant to the pressures of Venetian modernism. He was already a mature artist when he took up permanent residence in Venice, probably not long before 1520,[26] the possessor of a highly accomplished but non-Venetian style. We presume his first artistic education to have been in Brescia, Milan-oriented, and even more immersed than Bergamo in the Lombard preoccupation with literal reality. Our first documented knowledge of Savoldo is, however, not in North Italy but in Florence, where in 1508 he matriculated in the painters' guild. The degree to which his style was formed there, rather than in North Italy, is doubtful. His earliest surviving work (*Elijah in the Desert*, Washington, National Gallery, Kress Collection) seems not to predate 1510 or 1512, and internal evidence indicates that it is based more on North Italian than on

Florentine contacts.[27] A painting similar in theme but apparently of later date, *St Anthony and St Paul as Hermits* (Venice Accademia, *c.* 1515),[28] is more visibly related to the contemporary North Italian style, or, still more specifically, to modes dispersed from Venice into the provinces, like Cima's. A *Madonna with St Francis and St Jerome* (Turin, Museo Civico), which may precede 1520, adopts a Venetian formula of composition, dependent on the late Bellini.

These works, preceding Savoldo's likely time of settling in Venice and following soon upon it, are clearly products of a temperament already formed. Longer and deeper experience of Venetian art would come to make important differences in Savoldo's style, without, however, effecting an essential change in his attitude towards art. That had been generated from Savoldo's Lombard roots, conceiving the first function of art to be the reproduction of an ordinary reality; and in this respect Savoldo's early paintings represent the fulfilment of his previous tradition. To a simplistic and popular descriptive mode he added a refinement of light-searched detail that approximates the effects of a Flemish style, and must be learned in part from it. The human image takes on the character of still life, but one to be described not just in detail but with a generalizing and including power of whole plastic form. These large plastic elements are structurally simple, and they are combined in designs in which an additive mentality like that of the late Quattrocento détente style remains dominant. Seen outwardly as still life, and inwardly with reticent emotion, Savoldo's persons do not conform to a principle of modern classicism, and cannot achieve the mobile coexistences we expect of Cinquecento style. Yet in these cautious structures and in this atmosphere of emotional reserve there is a factor that intensely charges both: the same light that in one aspect of its functioning finds out detail in another

suffuses surfaces with arbitrary strength, re-flecting brilliances of colour that exceed our expectation of visual truth. These brilliances, lucent and commanding, make an effect of illusion still stronger than that of the underly-ing form, but they transcend illusion, exalting it beyond verity into an effect of art. The power of this surcharged colour to transmute descrip-tion into poetic meaning is the more compelling from the very contrast of its eloquence with the mutism in design and emotion.

As he worked in Venice in the twenties, Savoldo modified his manner. Like Cariani, he responded on occasion to the themes and temper of Giorgionismo (e.g. *Shepherd with a Flute*, Florence, Contini Collection, *c.* 1525); Giorgione's reticence of mood and form would have been sympathetic to his own. The exam-ples of Titian and of Palma inclined Savoldo towards more flexible delineation of form and deepening of chiaroscuro. It was Lotto, how-ever, who after his return to Venice especially attracted Savoldo: Lotto, standing himself be-tween Lombardy and Venice, seems to have served as a bridge into the contemporary Vene-tian style, towards which Savoldo moved in the latter years of the third decade, for a while almost converging with it. In 1527, the dated *Adoration of the Child with Donors* (Hampton Court) is recognizably a Venetian painting in the main, in which Savoldo's still-persistent alien accent emerges as an appearance of con-servatism. Three portraits of this time employ a format Savoldo had observed in Lotto, a horizontal half-length, and learn from him in compositional device and sophistication of colour handling as well. The earliest of these, the *Flautist* (Florence, Contini Collection, *c.* 1527), is subdued in tonality as well as temper, combining Lotto with Giorgione; the later two, a *Lady as St Margaret* (Rome, Capitoline) and the wrongly-titled *Gaston de Foix* (Paris, Louvre),[29] both of *c.* 1530, are freer, taking example not only from the art of Lotto but also

from the energy of form and colour of the recent Titian. They prove to be, in hindsight, the most assimilated to Venetian style and the most metropolitan in their temper of any of Savoldo's works; and as such they are a forcing of his disposition. Probably contemporaneous with them, a very large-scale altar of the *Madonna in Glory with Four Saints* (Milan, Brera, towards 1530) is most conservative: heavy in form almost to inertness, sombrely powerful in colour, and insisting on veristic presence. The distinction from the contem-porary portraits is not occasioned only by the different genre: a portrait that seems shortly to post-date 1530, a *Lady in the Guise of Justice* (Milan, Pesenti Collection), diminishes the Titianesque effect of fluency, reasserting Savoldo's sense of the human image as still life. The surface of the figure takes on, as in Savoldo's pictures of a past time, a quality of near-opacity, reflecting far more than it absorbs of light. But Savoldo's light now works, though not with Titian's fluency, with the active and complex chiaroscuro of Titian's style, so that the colour shifts in light almost prismatically from muted shimmerings to sharp brilliance.

Savoldo's religious paintings of the thirties are still more evidently marked by reassertion of his native tendencies. He incorporated a new activity of light and colour learned from Titianesque style into his own, but he rejected almost altogether the activity that in Titian's style is infused into the pictured actors. In Savoldo's *Tobias and the Angel* (Rome, Borghese, early 1530s) and in the *Transfigura-tion* (Florence, Uffizi, towards 1535) he creates powerful effects of life, but wholly in terms of illumined paint: his means are an exaggeratedly abundant drapery, strong in colour and brightly lit, disposed around plastically large but inert forms. Neither the design of forms – not even of the foldings of the drapery – nor the ordering of colour evinces the working of a synthesizing mind. Beneath the new complexity the essential

experience is what it had been long before: of dense substances in additive relation and of colour of compelling force, perceived primarily in local fields. In the *Pietà* (formerly Berlin, *c.* 1535; destroyed 1945), Savoldo multiplies the pretexts that permit an illusionist display of colour and accompanies it with an almost

Flemish labouring of descriptive detail. More high craft than art, perhaps a picture of this kind was motivated by a wish to make the kind of communication that a popular and provincial Lombard audience would best understand.

The effect in Savoldo's paintings of the early thirties of dominant, indeed almost exclusive,

147. Girolamo Savoldo: Magdalene.
London, National Gallery

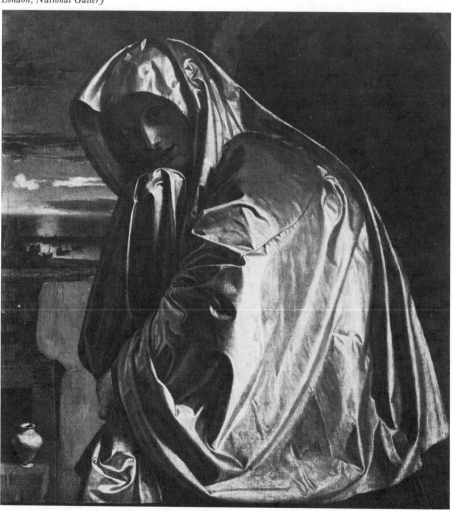

concern with painterly display recedes some-what in the latter half of the decade – the end of his career; we know no works that certainly post-date 1540. In the later pictures the splendour of paint becomes part of a more generally expressive context. The actors take on warmth and grander stature, and setting

and its actors an effect of grandeur and more vital being. The same enhanced dimension is in Savoldo's best-known and most seemingly virtuoso theme, the *Magdalene* by night light [147],[31] whose shining moonlit mantle is much more than a luministic *tour de force*: it reflects, as from a counter-moon, not only an effect of

148. Girolamo Savoldo: Adoration of the Shepherds, *c.* 1537. *Turin, Museo Civico*

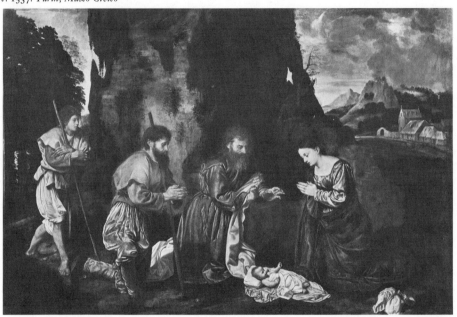

evokes mood; the temper of expression is still reticent, but it is gentle and profound, and on occasion it recalls the lyric accent of Giorgione. The nocturnal image of *St Matthew* (New York, Metropolitan Museum, *c.* 1535)[30] is remarkable not only for the virtuosity of light which it displays but also for the way in which the light is the vehicle of an emotion. As the picture is conceived thus simultaneously as a visual experience and as an experience of human feeling, it finds a new degree of unity,

lunar light but a quality of emotion which we associate with it. The most feeling of the late works is an *Adoration of the Shepherds* (Turin, Museo Civico, *c.* 1537) [148] in which the figures move with slow, almost arrested cadence in a crepuscular landscape, shining in it. The painterly effects in this work have been achieved with the subtlest control Savoldo has exhibited so far, and with deep care for their relation in a unity. The picture has an accent – perhaps more noticeable than in any of

Savoldo's previous paintings – that derives from consultation with the art of Flanders, seeking a northern truth of type along with luminous perfection of detail. At the same time it refers to an ancient precedent of Titian's, the *Allendale Nativity*. Inconceivable outside Venice, the *Adoration* still does not belong entirely to it; and despite its high refinement, its modernity is in essence an updating of an attitude towards art that belongs to the past.

The last work which we can place in Savoldo's career is a replica (done almost certainly in 1540 for S. Giobbe in Venice; *in situ*) of a *Nativity* of which the earlier version had been painted for Brescia four or five years before. Even the replica, however, shows the profounder feeling and control of means that characterize Savoldo's latest style. His practice as a painter must virtually have ceased not much after this. We last hear of him in Venice 'troppo maturo dei suoi anni in la vita' at the end of 1548.[32]

If we may think of it as a Lombard trait in Savoldo and in Cariani that they were concerned with realism, then Bernardino Licinio's Veneto-Lombard art must be differently defined: it is by comparison banal prose. Licinio was born *c.* 1489 of a Bergamasque family resident in Venice and Murano, and is recorded as a painter in Venice as early as 1511. His first training seems to have been Bellinesque, and his earliest identifiable works (e.g. a *Holy Family with the Magdalene*, ex-Wyndham Collection) show contact also, not unexpectedly, with his compatriots Palma and Cariani. He was readier than Cariani to slough off the obvious traits of affiliation with an older style, and adopted the outward indices of modernity, which he observed, chiefly, in the models of Palma. But his capacity did not take him underneath the formulae he borrowed: he confronts them in the spirit of a craftsman with a pattern-book. He used the minor talent that he had to

make himself a willing but restricted imitator of current styles.

Mainly employed as a portraitist, Licinio came to follow the successive portrait modes in which Titian worked, at first at a cautious distance but then more closely in time. His Giorgionesque portraits, based on Titian's of the teens and twenties, are a decade late (*Young Man with a Skull*, Oxford, Ashmolean, *c.* 1525; *Stefano Nani*, London, National Gallery, dated 1528), but his *Ottaviano Grimani* (Vienna, Kunsthistorisches Museum, dated 1541) refers to precedents in Titian of only a short time before. Licinio seems to have been (more in his earlier career than later) the principal Venetian painter of group portraits (e.g. *Family Group*, Hampton Court, dated 1524; the *Artist and his Pupils*, Alnwick Castle), a speciality for which his inability to relate forms – not to speak of feelings – evidently did not suit him well. In time his portraits acquired some effect of consistency in style – hard-surfaced and meticulously described, they can produce both strong presence and a considerable decorative effect.

Though Licinio's chief practice was in portraiture, he was frequently commissioned for religious pictures throughout his career. In these, where it is more imperative to have some talent for design, he proved himself unable to compose except by a simple-minded process of addition, or by imitation. He is not attached to reality in the religious pictures to the degree that portraiture requires, and he exaggerates a tendency, often present even in the portraits, to over-generalization of form, so that his actors seem to be of ponderous vacancy; they make the same effect in feeling, too. In the thirties Licinio found it useful – in his religious paintings only – to compound Palmesque example with that offered by the work of Pordenone,[33] and he made contact also with the contemporary school of Bergamo. A major altarpiece, a *Madonna Enthroned with Saints* (Venice,

Frari, 1535, executed with a diligence exceptional in Licinio's religious paintings), reflects both Pordenone and the Bergamasque Moretto more than the contemporary Venetian school. Licinio continued to work into the forties (our last record of him is in 1549), but no change of importance overtakes his later works.[34]

Two Brescians, Giovanni da Asola and his son Bernardino, acquired a minor prominence in Venice in the third decade. Giovanni died in Venice in 1531, and though we have no documented evidence of the later work of Bernardino, it seems that he continued to be active in Venice in the thirties. Giovanni first appeared in Venice in 1512, perhaps at the same time as his compatriot Romanino and in his company. Unlike Romanino, Giovanni stayed, but as was usual for the Lombard colony part of his Venetian production was for export home. He is also known to have worked for Padua. He was not only a provincial but a painter of indifferent gifts. Evidently willing to assimilate himself to Venetian example, he could not grasp much more than its most obvious effects. An *Adoration of the Magi* painted in 1518 for his native town (Asola, Duomo) has effortfully acquired some elements of style from Titian, but with only limited effect upon the archaizing Lombard substance. In 1526 he was commissioned (together with his son) to paint a set of organ shutters for S. Michele in Murano (now Venice, Museo Correr); two are of his execution and two by Bernardino. In Giovanni's shutters (showing donors kneeling before enthroned patron saints) he has achieved, by now, a simplistic imitation of a Titianesque style. The Lombard accent still persists, in metallic hard-edged surfaces and stressed details. In an *Adoration of the Shepherds* (Padua, Museo Civico), also commissioned in 1526, he is more fluent, but the results of his Venetian accommodation remain – though at a far lower level – not unlike his

countryman Savoldo's, whom he must have taken partly as a guide.

Bernardino seems to have made a more energetic effort to acquire a cast of Venetian modernity, but at least in his earlier career he appears to have remained in closer contact than his father with his native school. His contributions to the organ shutters for Murano, an *Assunta* and a *Fall of the Rebel Angels*, react to Titian's demonstrations of a dramatically active style, but then freeze forms almost to rigidity. Cartaceous surfaces and laboured detail, as well as a repertory of *popolano* types, reveal the influence on Bernardino of Moretto's works. That Bernardino may indeed have been educated at home rather than in Venice with his father is indicated by a *Last Supper* (Venice, Querini-Stampalia, perhaps earlier in date than the Murano shutters), which depends explicitly on Moretto's painting of the same time in S. Giovanni Evangelista in Brescia. However, in the fourth decade Bernardino came to closer terms with Venetian example. *Sacre Conversazioni* that we can identify by him in those years are efficient, if pedestrian, approximations of the recent Titian style.

Francesco Vecellio

The degree to which the significant history of art depends on a few creative individuals in any place, even in a major centre, is nowhere more apparent than in Venice in the third and fourth decades. Titian first, Palma briefly, and then Pordenone are so saliently the active agents of Venetian art at this time that in comparison their contemporaries seem almost inert, and their slowness to respond is a disenchantment. Titian's brother, Francesco Vecellio, is conspicuous for the small profit his relationship with Titian brought him. A few years Titian's senior (born probably in the mid or later 1480s),[35] his beginning as a painter was set back

by service as a soldier. We know no work of his before the first years of the second decade. His principal activity was in the twenties and thirties, mostly in his native region of Cadore rather than in Venice proper. After the mid thirties, when his father died and Francesco took over the management of the family's affairs, he exercised his profession more sporadically. Almost as enduring as his brother, he died in 1560.

From the first he seems to have been content to accept the role of a follower of his brother to which his closeness of relationship and distance in talent had condemned him. On occasion the working connexion between Francesco and Titian seems to have been close,[36] and Francesco may even at times have performed the functions of a shop assistant. A *Madonna of Humility with Saints* (Munich, Pinakothek), mostly from Francesco's hand, seems to be an invention made by Titian in the earlier twenties and shows a limited contribution by him to the execution. Perhaps within the shop, but more likely painting independently, Francesco used the central motif of that picture in repetitions of smaller format and with varying accessories (e.g. Verona, Museo; San Diego, Gallery). These are not inadequate in their paraphrase of Titian's style, but the style is that which Francesco had adopted from his brother's paintings of the first and second decades; he could not follow Titian's developing complexities. In general, Francesco's practice was a separate one, which with the good sense of his limitations he confined in great part to the area around his native town. In the twenties and early thirties he was the busiest supplier of altarpieces for the churches in the Bellunese. In these, his profound difference from his brother becomes drastically apparent as he exploits what he recalls of Titian's older motifs and technique – but with varying fidelity – to form images that are provincially retardataire. In the early 1520s, as in the enthroned Madonna that

survives from a polyptych for Sedico (Sedico, church), or in the pastiche from Titian's early *Allendale Nativity* once at Belluno (now Houston, Museum, Kress Collection), he makes a fair approximation of Titianesque effects. But in 1524, when he signed and dated an altar for S. Vito da Cadore, his handling as well as his small structural sense have been substantially revised towards archaizing standards, and this is in general the vein in which he served his provincial custom for the next ten or fifteen years. At times his performance, retardataire as it may be, is tolerable but at others it becomes so careless and mechanical that it seems that Francesco must deliberately have correlated quality with contract price, or made it relative to the advantage he could take of country audiences.

There is no sure indication of a refurbishing of Francesco's mode until the 1540s. Then, the polyptych of Candide (Candide, church) or that at Venas, both datable to the middle forties, adjust Francesco's manner more nearly into accord with Titian's present mode, softening handling and somewhat refining form, and accepting elements of grace and movement in the figure style. In the later forties Francesco undertook a large-scale work in Venice proper, the organ shutters of S. Salvatore;[37] for these he plunders his brother's repertory, and exerting all the talent he commands, makes images of laboured grandiosity. Imitating Titian's recent plastic and dramatic style, he exaggerates it into wooden stiffness; yet these works are imposing, not just in consequence of scale alone. For once, Francesco shows the ambitions of an artist rather than an artisan. In a still later *Annunciation* done for Venice (for S. Nicola di Bari; now Venice, Accademia) Francesco again makes a *pastiche* of his brother's compositions, but with a smoothed handling that makes concession to the camp, by then established in the city, of Venetian Romanists. Susceptible to provincial taste when

he worked for it, Francesco was also responsive to fashions as they changed in the metropolis, but he was impervious to style.[38]

Bonifazio and Bordone: Their Earlier Careers

Two new names emerge to noticeable prominence in Venice in this time, those of Bonifazio de' Pitati and Paris Bordone. Both were to make contributions of some value to the next phase of Venetian style, after 1540, but even before this their art consisted of much more than an imitation of examples set for them by the prime masters. They worked with facility in a fully modern vocabulary, but beyond this they were involved, each in a different way, with the problems in contemporary Venetian art that were the motives in it of experiment and change. In this respect they were progressive painters, and well before 1540 elements in their art suggest some that were to appear in the style of the fifth decade – more recognizably, in instances, than in the painting of the masters of first rank. However, their action in this sense was not consistent; and both painters also chose, it seems in a positively motivated way, to work with ideas that are oppositely conservative.

Bonifazio was by more than a decade the older painter, born c. 1487 in Verona; yet we have no information of him until 1528, when a document reveals his presence in Venice. But he must have been in the city for some years before, and the best assumption we can make about his long anonymity is that it was spent in the shop of another painter. From the appearance that the earliest certain works by Bonifazio (of c. 1528 or shortly after) present, the shop must have been Palma's. Such paintings as the *Sacra Conversazione* in a landscape (Boston, Fenway Court, c. 1528–30) or the somewhat more developed *Sacra Conversazione* in London (National Gallery, c. 1530–1) seem almost to be a posthumous extension of Palma's

most fluent and attractive – and most Titianesque – mode. It may be that Bonifazio actually inherited Palma's shop and patronage, and in this practical sense, as well as by long training, was disposed to extend his style. Works by Bonifazio in the early thirties are related not only to Palma's Titianesque mode but to other distinguishable modes in which the later Palma practised. An altar for a presumably conservative clientele, the Tailors' Guild, of the *Madonna Enthroned with St Omobono and St Barbara* (Venice, Accademia, from the Palazzo Reale, signed and dated 1533) resembles the archaizing and naturalistic religious narratives of Palma about 1525; in addition, this *conversazione* recalls the simplicity of Bellinesque design, almost immobilizing form, and includes elements of almost literal descriptive detail. Dated in the same year, a *Judgement of Solomon* (Venice, Accademia, from the Palazzo Camerlenghi) [149][39] is oppositely modern and suggests an analogy with a strain in Palma's art that, as early as c. 1520, had given certain of his paintings a character of Romanism and then, by 1523, an effect of Maniera. Bonifazio's *Judgement* is thus also an extension of a mode in Palma, and Bonifazio depends as Palma did in this mode on prints from Central Italy for inspiration. There are episodes of plastic emphasis of form and rhetoric of posture that are strongly Romanist; further, there is an element of attenuating grace of shape and attitude and a long-lined fluency in composition that convey an accent like that of Maniera. A setting of grand architecture opens on the left, with explicit Venetian effect, to a landscape space, but this is a backdrop on a stage for acting out a rhetorically styled and imposing drama. This is a new mode in Venetian art, different from the dramatic ventures of Titian or Pordenone, and its inspiration comes in part from Central Italy. More Romanist in amplitude and plastic working of its forms, and more suggestive of a temper of Maniera in deliberated grace, is

149. Bonifazio de' Pitati:
Judgement of Solomon, 1533.
Venice, Accademia

Bonifazio's large *Sacra Conversazione* (Paris, Louvre, *c.* 1535); these qualities too are extrapolated from aspects of the later Palma, but Bonifazio seems now to have reinforced his Romanism by observing Pordenone, and to have found a spur towards a refined rhythmic taste in Lotto's recent ornamentalism.

These are the tendencies in which Bonifazio stands with the advanced currents in Venetian painting of the thirties. But he had another interest beside this concern with an art of high style, which is evident even within the pictures in which he achieves it; and at this point in Bonifazio's career the two are not reconcilable. It is not only a matter of accommodation to conservative patrons' taste but his own disposition that prizes narrative and descriptive efficiency to that point where Bonifazio may often make effects of style second to effects of legibility and imitative truth. The results make such works as his *Adoration of the Kings*

(Venice, Accademia, also from the Palazzo Camerlenghi decoration, *c.* 1536) seem conservative in structure and literal in their way of seeing, and despite its manipulative brilliance this is also the effect of his *Sacra Conversazione* of *c.* 1537-8 (Florence, Pitti). In the large *Christ at Emmaus* from the Palazzo Camerlenghi (Milan, Brera, *c.* 1536-8), the descriptive interest is so much pressed that it results in what is virtually a picture of domestic genre. Coeval with the earliest works of Jacopo Bassano (who may recently have been Bonifazio's student), this seems even more than they a translation into a modern technique of the realism of the quattrocentesque *teleri*. But it also resembles an aspect of the contemporary Lotto, and is parallel to the interests of the recent Lombard school. In one sense an archaistic revival, in another the *Emmaus* is a foreign-seeming but novel incident in the current Venetian school. It was not until the

forties that Bonifazio evolved some general consistency of style out of these various and sometimes contradictory tendencies in his art.

Bordone was Trevisan by origin, born there in 1500. We hear of him in Venice for the first time in 1518, when he is described as a painter, but most of his youth seems to have been spent in Venice, and he received his education as a painter there. He was for a while a pupil of Titian, but an unhappy one; Vasari seems to have heard directly from Paris, in his old age, accounts of Titian's disagreeable behaviour towards him. Paris seems to have been nearly as precocious as his master: at the age of eighteen he received a first commission, which Titian promptly took away. We can identify paintings by Paris as early as the close vicinity of 1520[40] (e.g. *Holy Family*, Florence, Berenson Collection; *Sacra Conversazione with Donor*, Glasgow; *Holy Family with St Catherine*, Leningrad, Hermitage) which are remarkably skilled paraphrases of the antecedent Titian style. Paris's handling is harder than Titian's and more linear, and tends towards disjunctive emphases of form; then, however, he infuses forms with a physical (and also psychological) activity that propels them into a mobile connexion. His energy suggests the Titians of the early teens, and the specific cast of brilliant, hard-wrought surface that these pictures have suggests also that those early works by Titian were more sympathetic objects for Bordone's study than the more recent ones. He seems to seek a style more overt in feeling and more positive in the existences it depicts than the high classical example of the current Titian.

Not only because he was thus disposed but because he was Trevisan by origin, with commissions as well as connexions there, it was easy for young Paris to gravitate from Titian's example towards that of Pordenone. He compromises the Titianesque basis of style with Pordenone's largeness of form and his kind of assertive movement in a *Holy Family with St*

Ambrose and a Donor (Milan, Brera, *c.* 1523), and in the *Marriage of St Catherine* (Genoa, Rosetti D'Oria Collection, *c.* 1524-5) the imitation of Pordenone's plastic strength and even of his inchoate dynamics has gone farther. A further element that is un-Titianesque appears in the latter work: a colder and more metallic handling of colour and texture, and, through its means, a heightened stress on effects of existential verity; in this the influence of Lombard style is apparent. This handling is rigidifying in effect, potentially contrary to the life and movement of existence that Paris otherwise depicts. It is known that he was working in the Lombard region in the middle of the third decade: though mostly resident in Venice, Paris was often inclined to find custom elsewhere. As Vasari (VII, 464) reports, he was temperamentally unwilling to 'corteggiare'. In 1525-6 in the Lombard town of Crema Paris painted an altarpiece of the *Madonna with St Christopher and St George* for the church of S. Agostino (now Lovere, Galleria Tadini) in which, beyond his still quite evident debt to Titian and Pordenone, he shows the effects of exposure in this neighbourhood to Lotto's and Moretto's modes. Lombard qualities have been incorporated in the Crema altar, as in the earlier *Marriage of St Catherine*, as a means of sharpening the emphasis and energy, as well as truth, of form, but in a second altar done for Crema (close to the preceding one in time), a *Pentecost* (Milan, Brera), there is a striking change. Paris has made a large concession not only to Moretto's style but also to the veristic creed and the conservatism of Lombard style in general. In the *Pentecost* Paris freezes form in order to present it to us with the clarity of still life, in sharp detail and with the high-keyed brilliance of a Brescian lighting, then locks it in a static composition resurrected from the Quattrocento. He accepts the immobility that results from this extreme of Lombard mode; his normal energy is channelled wholly into

150. Paris Bordone: Fisherman delivering the Ring, *c.* 1534–5. *Venice, Accademia*

affirming substances defined by intense light. The precise mode of the *Pentecost* is a passing episode for Paris, but its consequences are of prime importance: all his subsequent art was to be conditioned by it. Even the *Sacre Conversazioni*, earlier so fluent, that date from the beginning of the following decade (e.g. *Madonna with St Francis and St Jerome*, Los Angeles, County Museum) show the effects of this more rigid style.[41]

Probably in 1534-5[42] a major Venetian commission for the Scuola di S. Marco, a *telero* of the *Fisherman delivering the Marriage Ring of Venice to the Doge* (Venice, Accademia) [150], stimulated Paris on the one hand to re-align himself with Venetian taste, and on the other to express his personal powers of invention in their highest degree so far. In this painting he re-admits much of the chiaroscuro and textural effects of Titianesque style, and straining his Lombard-inspired brilliances of surface through these he makes a shimmering variety of colours and lights. Paris may have known Titian's *Presentation of the Virgin* in its first stages, for the lateral arrangement of his composition is like Titian's, but beyond this the two designs are very different. Both *teleri* refer to Quattrocento precedents, Bordone's more literally than Titian's, yet Bordone's translation of the precedents does not result, like Titian's, in a conservatively classical design but in a pictorial scheme of significant novelty. This is the first example in Venetian painting on a large scale in which a perspective setting of architecture (recalled from the settings of the old *teleri*) is used to make a complex, asymmetrically inclined, and strongly energized progression into depth of space.[43] The architecturally defined space is not, as in Quattrocento or high classical example, either a descriptive incident of the picture or a sounding-board for the figures in it: it becomes a main agent among the *telero*'s expressive effects – a major actor – made so by the energy of perspective movement that describes it and by the movement implied in the forms of painted architecture themselves. The style of the setting – or, more precisely, and again like an actor, its personality – counts in the expression of the whole work as it had not in comparable degree before. The rectilinear aesthetic that is induced by emphasis upon perspective structure is evident in Bordone's ordering of his human actors, as if he were concerned to control and counterbalance the novel energy of background that he has made for them. Yet in the placing of his figures on the main perspective line, as they recede into depth, Paris makes another invention for Venetian art: a setting out of figures in diverse planes of space in such a way that, despite their differences in scale and depth, they are linked together in a continuity of rhythmic pattern.

Paris may have taken inspiration for this type of architectural and perspective setting from stage designs: Peruzzi's were accessible, and there may have been influence from Peruzzi's heir and propagandist, Serlio, whose work, however, had not yet been published.[44] But Bordone's way of using this material is wholly personal, and is an invention that was to help to shape the style of the next decade. In this invention for manipulating pictorial space and the figures in it Paris lays one foundation for the new style of which, almost exactly contemporaneously, Bonifazio laid another, in his *Judgement of Solomon*, where he demonstrated the ordering of design on the picture surface as a fluid lateral arabesque. Tintoretto was to fuse these ideas in his style, and for this he is in Paris's and Bonifazio's debt.

We have no accurate chronology for Paris's painting of the later 1530s. Recent criticism puts in this period works done in the region of Belluno, the style of which we can account for only by assuming Paris's deliberate rejection of all pretence to modernity out of consideration for his patrons' provincial taste. Most probably

in 1538,[45] however, he undertook a voyage to France, and was resident there for a time, at Fontainebleau. There, in the company of Rosso and Primaticcio, he was exposed in full measure to novelties of style to which his interests and native temper sympathetically disposed him. In this farthest but extremely advanced outpost of Central Italian Mannerism Paris acquired ideas that so far had not been in his experience (but to which Bonifazio, through the medium of prints, had already willingly exposed himself): of classicist purity of modelled form, of rhythmic *grazia*, and of expressive artifice. After his return from France Bordone's art took on a new character, an often difficult compound of Venice, Lombardy, and Central Italy – a parallel to the most advanced situation which in the same years matured on the Venetian scene, but of which, in Bordone, the elements were never quite synthetically fused.[46]

NORTH ITALY 1500-1550

The developments in Italian painting of the sixteenth century that are significant to a history of style were made for the most part in the three great capitals of art, Rome, Florence, and Venice. When they occurred elsewhere, in provincial places, it was in outposts colonized by painters from the capitals or – as in the case of the innovators working in North Italy whom we have discussed earlier – they were the consequence of the direct impact of the art of the capitals upon a few provincials of extraordinary personal dimension. The general tendency of provincial art is conservative, in a degree dependent on the factors of cultural and geographical isolation and, usually, of size. It is exceptional that this tendency should be broken from within by the action of an artist or creative patron; most often in the Cinquecento novelties of style came to provincial centres as imports. But the less the measure of sophistication in a provincial centre, the less the concern of artists in it with 'style', in the precise sense in which the inventors of the new art of the Cinquecento had come to separate style from mimetic function. Having learned by prior importation in the fifteenth century how to fulfil that function, the provincial painter and his patron were both essentially satisfied with it; for them the first purposes of art were reproduction of reality and narrative illustration, the latter often trenchantly expressive. Their 'style' was not the sophisticated intellectual and aesthetic apparatus, meant neither to describe nor illustrate, that had been evolved in the capitals, but a less commanding, less abstracting thing: a set of functional conventions established as a local currency of art, to which a painter's individuality could give

personal and specific shape. At the most elementary and provincial level it is not style, in the Cinquecento sense, but an attitude towards reality that determines the character of the work of art.

We shall not be dealing with centres where the function of art is elementary to this degree, and we shall find sufficient places of a contrary kind, where Cinquecento style makes relatively easy inroads, assisted usually by local artists who had come to know its innovations in the capitals. But a resistance of mimetic purpose to the ideas of Cinquecento style is a frequent and at times powerful factor in the major centres of provincial painting, and the provincial state of mind may seem remarkably intractable. Even in such places, as the new stylism of the Cinquecento came in time to be more widely visible, its authority – of fashion if not always essentially of style – tended to wear the local habit out. In each provincial centre, however, the intruding style was not adopted out of hand but made to coexist in an accommodation, sometimes awkward, with the traditions and the local temper of the place. There is thus both dependence on the styles that emanate from the capitals and a continuity of local character in each school.

The examples of Cinquecento style that serve to guide a school need not come from a single metropolitan source. A circumstance of location or political relationship may bring the art of a provincial centre in North Italy mainly into the orbit of Venetian style, or conversely into a sphere of influence that may belong to Central Italy, or there may be a confluence upon the place in varying proportions of the two. Moreover, one provincial place may react to the style of another. The interactions are not always mainly geographically determined, nor politically; a host of cultural and personal accidents may make effects that do not correspond to simple expectation. Processes of cultural interchange may be more important in

determining the complexion of art in the provincial centres than in the capitals, and their operation in the provinces can be complex: style in some of these centres is formed out of a multiple intersection. It is the roughest generalization, which does not take enough account of this complex intersection, to assert that in the Veneto style receives its main impulses from Venice, and that this is the case also in the Venetian tributary cities of Veneto-Lombardy, while Emilia responds more to Central Italy. Milan and Piedmont constitute a separable artistic milieu, the former colonized by Leonardo and thus disposed to Central Italian influence. Yet despite this, the Milanese, and Piedmont also, hold perhaps most stubbornly among the Cinquecento North Italian schools to their provincial identity.

THE VENETO

The main centres in the region just west of Venice – Padua, Vicenza, and Verona – present a picture of relative artistic deprivation in the sixteenth century, contrasting with the higher status they enjoyed before. In Treviso and in Udine, to the north and east, the situation was no better. The nearness of these cities to the Venetian metropolis seems to have worked on them only rarely with positive effect, and in the earlier years of the century especially their art was marked by its conservatism: their relation to contemporary events in Venice seems less than that of the more distant schools in the Veneto-Lombard region.

In Padua the main events of note during the earlier Cinquecento consist of imports into the city. In the first years of the second decade Titian had been there and left a powerful example of his modern style in the Santo, and in 1513 the Brescian Romanino had left work in Padua that was of almost comparable interest. Even these, however, were not enough to stimulate a general conversion of the old-fashioned Paduan native painters to the new style. Girolamo del Santo (active *c.* 1511-1550), the most prominent member of the generation following that of Giulio Campagnola, is typical in his conservatism as well as in his mediocrity. In 1521, in a dated altar of the *Enthroned Madonna* (Padua, Museo Civico), he gives very minor evidence of his awareness of the sixteenth-century style, and even his later paintings, such as his fresco *Assunta* in the Scuola del Carmine or his *Histories of St Anthony of Padua* (Santuario del Noce di Camposampiero, *c.* 1535), make no more than a limited concession to the example of the new Venetian mode. The sole Paduan painter of measurable talent, who, unattached to the Quattrocento by generation, alone came fairly soon to be an efficient representative of Cinquecento style was Domenico Campagnola (1500-64). He was a prodigy who had been schooled in his youth by the native Giulio Campagnola (from whom he took his name), but he must then have studied in Venice. Like Giulio, Domenico practised as an engraver and the first work we know by him is in this medium: a set of sheets dated 1517, some of them evidently influenced by Roman models, but in a violently *agitato* style. Other engravings by him are closely dependent on Titian, and Domenico used his graphic talent also to make skilled approximations of the Titian drawing style. As a painter Domenico's beginnings (fresco *Saints*, Padua, S. Croce) still show the stiffness of his first master's quattrocentesque mode, but by *c.* 1525, the date of his *Meeting of Joachim and Anna* (Padua, Scuola del Carmine), he had achieved a lively, even florid imitation of Titian's manner in his Santo frescoes. In 1531 Domenico painted four ceiling tondi of half-length prophets for S. Maria de' Servi in Padua (now Venice, Accademia) in which he mingled Titian's style with an influence from Pordenone, then recently arrived in Venice. In the middle thirties Domenico's *St Anthony resusci-*

tating a Drowned Girl (Padua, Scuola del Santo) almost brilliantly imitates Titian's recent painterly technique, but in a dense and disarticulate composition that is Campagnola's equivalent of Pordenone's example.[1] The *Madonna with the Protectors of Padua* (Padua, Museo Civico, *c.* 1545) [151] is more controlled, and it is stylish almost with the effect of mannered grace. To his recent amalgam of Titian and Pordenone, Campagnola has added a quota of the brilliant drapery effects observed in imports in Padua from the Brescian school.

In general, however, the forties see an academicizing of Campagnola's style, of Pordenonesque and also Romanist cast (*Resurrection* fresco, Praglia, Badia, 1545–50), which continues in the fifties. The *Presentation of the Baptist's Head* on the outer wings of the organ shutters of S. Giovanni in Verdara (now Padua, Palazzo Salvatico; 1552) are excellent reflections of the exactly contemporary development

of a Romanist influence in the art of Venice proper; the inner scenes reflect, with equal skill, another current Venetian fashion, the painterly Maniera of Schiavone. Domenico's last large work, *Christ Enthroned with the Podestà Cavalli* (Padua, S. Giustina), painted in 1562, two years before his death, assimilates a third advanced Venetian mode, that of Veronese. No one could have been more in step with contemporary art in Venice in these later years of his career than Campagnola, but it became evident that his contemporaneity was a doubtful virtue, signifying a surrender of his individuality to fashion.

Vicenza in the first half of the century cannot claim the distinction of a painter even of the stature of Campagnola. The first two decades were still dominated by the gloomily impressive figure of the *caposcuola* of the late Quattrocento, Bartolommeo Montagna, who worked until 1523, and then left his son, Benedetto (an

151. Domenico Campagnola:
Madonna with the Protectors of Padua, *c.* 1545.
Padua, Museo Civico

engraver more than he was a painter), to protract his style. Signed works by Benedetto, always faithful in kind but not in quality to his father's Quattrocento model, are traceable as late as 1541. Giovanni Speranza (1480-1536) was equally stubborn in his archaism, and so was Francesco Verla, for whom we know of dated works from 1512 to 1520. Occasional residence by painters from elsewhere in the Veneto did not much ameliorate the situation in Vicenza.[2] One Vicentine of the late Quattrocento generation, Giovanni Buonconsiglio (Il Marescalco), had in effect removed himself from the local school to become (c. 1495) a member of the foreign colony in Venice. He carried his native style with him and practised it with only minor alteration there until the middle of the fourth decade. A late work by him, probably of c. 1530, a *Madonna Enthroned with St John the Baptist and St Stephen* (Wroclaw (Breslau), Museum; on loan from Berlin) at most reforms his Montagnesque and Bellinesque style into one resembling that of the conservative Catena.

In the Friulian region the striking personality of Pordenone imposed itself upon the local traditions in which he himself had first been brought up. Very quickly after he brought the first results of his experience of Rome back into his native province the strongly archaic complexion of painting there began to change. His own early model, Pellegrino da S. Daniele (otherwise known as Martino da Udine, 1467-1547), until then had been the powerful and often eccentric continuator of a Quattrocento style formed not only locally but by contact with the tradition of Ferrara. About 1520, however, Pellegrino underwent a conversion, remarkably complete, to a mode based on Pordenone's. Pellegrino's temperamental force as well as his eccentricities had once been sympathetic to Pordenone; now, conversely, it seems not to have been hard for Pellegrino to reflect that which in Pordenone was sympathetic

to him. Before 1522, Pellegrino's frescoes in the church of S. Antonio in his native town, S. Daniele del Friuli, very reasonably approximate the appearance of Pordenone's recent style; by 1525-8 his triptych altarpiece for S. Maria dei Battuti at Cividale is closer still to Pordenone's models in this genre. Pellegrino's conversion carried his pupils and assistants with him: an instance of the speed with which the shift occurred is in the sole work that survives by the short-lived Luca Monverde (c. 1500-25/6), a *Madonna Enthroned with Saints* (Udine, S. Maria delle Grazie), which is dated 1522. Sebastiano Florigerio (c. 1500-43), who was trained in Pellegrino's shop, may have worked with Pordenone also. As with Pellegrino there is some residue of old-fashioned descriptive literalness in Florigerio, but his most ambitious works (*St George* altar, Udine, S. Giorgio, 1529-30; *Madonna and St Anne Enthroned with St Roch and St Sebastian*, Venice, Accademia, c. 1530-5) competently use the formulae that he deduced from the surface aspects of Pordenone's style - of which, however, the inventive essence was no more accessible to Florigerio than to Pordenone's less facile imitators. Francesco Pagani da Milano (fl. 1502-47) was one of these. He had worked earlier in the Bergamasco, and appeared in the Friulian and Trevisan region in the later years of the second decade possessing a formed, rather backward Bergamasque style. On his arrival, he could make no more than an uneasy compromise between it and the rising fashion for a repertory like Pordenone's.

Pordenone's domination was considerable, but it was not exclusive. Francesco Beccaruzzi (c. 1492-1562) began his long independent career in the neighbourhood of his native Conegliano and in Treviso in a manner much dependent on Pordenone, and in the 1540s began to shift his interest towards Titian. A signed and dated *Stigmatization of St Francis* (Venice, Accademia, 1545, from Conegliano)

exemplifies the compound which his later style became. Beccaruzzi grew to become the most adequate imitator in his region of the portrait style of Titian, giving the Venetian models of the genre a stiff provincial dignity. A painter who seems actually to have been Pordenone's pupil, Pomponio Amalteo (1505-88), was despite this less observant of Pordenone's example. Amalteo's early independent works (e.g. *St Sebastian* altar, S. Vito al Tagliamento, Duomo, dated 1533) diminished Pordenone's model towards an academic coolness – a personal inclination, but one that must have taken some support from Pordenone's tendency about 1530 towards Romanism. As he matured, Amalteo's style increasingly took on a specifically Romanist character, not just extending what he had found in Pordenone but liberating himself from Pordenone's models to consult the style of classicistic Mannerism directly, apparently in Emilia. In the course of a very long career (extending well into the second half of the century; his last dated painting is of 1578), in which he worked extensively in the Friuli and in Treviso, he became the main exponent in the region of this effectively non-Venetian style.

Marcello Fogolino (fl. *c.* 1510-48) was from the Friuli, but since he worked mostly elsewhere he came to reflect the Pordenone fashion only incompletely. In Vicenza, the chief locus of his earlier career, he was a dutiful follower of the local taste for the retardataire mode of Montagna. But returned to work in the Friuli, apparently in 1520 or 1521, Fogolino was subject at once to the effect of Pordenone's style, and his quick conversion of his retardataire manner to a modern one would be surprising if this were, as we have seen, not so much the general case in the Friuli at the time. Marcello's *Madonna and Six Saints* (Berlin, Museum, from Vicenza) and his *St Francis between St John the Baptist and the Prophet Daniel* (Pordenone, Duomo, recorded before 1523) mark the contrast between his past Vicentine style and the manner he adopted after his return. Banished from the Venetian territory in 1527 for complicity in a murder, Fogolino settled at Trento. There, with further flexibility, he soon assimilated the manner that Romanino and the Dossi had exemplified in their decoration of the Castel Buonconsiglio, on which Fogolino also was engaged; Romanino in particular was influential on him. He had a considerable practice as a *frescante* after this, exploiting what he had learned of modern decorators' style in the painting of palaces and villas in the Tridentine region (Castello Malpaga, Villa Salvotti, Palazzo Sardagna). Our last record of him is in Trento, in 1548.

Girolamo di Tommaso da Treviso, called the Younger[3] (*c.* 1497-1544), had an even more restless career, which removed him farther from his native scene. His career illustrates, in three main phases, the role that place as well as time had in determining his artistic style. Maturing towards 1520, his earliest works (including an *Isaac blessing Jacob*, Rouen; a *Sleeping Venus*, Rome, Borghese; a *Ceres*, Berlin, Museum; a *Noli me Tangere*, Bologna, S. Giovanni in Monte)[4] show the imposition of influences from Titian and, to a lesser extent, from Pordenone upon a stiff and in part still quattrocentesque vocabulary. Called to Bologna in 1524 to work (as a sculptor) on the portals of S. Petronio, Girolamo in 1525 painted frescoes, in grisaille, in the Chapel of St Anthony of Padua in the church, and in them immediately and entirely adopted a classicistic, Raphael-derived mode, then popular among Bolognese contemporaries such as Bagnacavallo. Still in Bologna, but at a somewhat later date, a *Presentation of the Virgin* for S. Salvatore (*in situ*) inclines strongly to the example of Peruzzi. From 1527 Girolamo was on the move again, working in Genoa and, in 1530, at the Castel Buonconsiglio at Trento; in 1531 he was employed in Venice. In 1533, returned to the

Bolognese region, he left a major dated fresco in the Chiesa della Commenda at Faenza. Despite his presence recently in Trento and Venice, and its effect of a slight re-infusion of Pordenone into his style, his conversion to the classicist style of Bologna holds. However, as he remained in the neighbourhood of Bologna, Girolamo fell under the sway of the newer fashion that had been begun there by the Mannerist Parmigianino, and by the middle and later thirties, as in his *Adoration of the Shepherds* (Oxford, Ashmolean), he was a fluent practitioner of that most advanced Emilian style. Girolamo's career as a painter ends, as far as our knowledge of it is concerned, in 1538, when he left Italy to take service as a military engineer in England for Henry VIII. Involved thus in Henry's siege of Boulogne in 1544, he was killed there.[5]

Though Verona was an old tributary of the Serenissima, the main axis of its artistic interest in the sixteenth century was not towards Venice. Until 1529, the old Liberale da Verona continued to work in the city, persisting in an essentially archaic style that had long since been generated out of Mantuan more than Venetian sources and which in his latest years was faintly touched by an Emilian Raphaelism. His pupil Niccolò Giolfino held to this latter manner with hardly any meaningful alteration, and at a very inferior level, until 1555. Liberale's influence and its conservative effect were also felt by the most important native painter of the first half of the century in Verona, Giovanni Francesco Caroto (1480-1555/8). He first formed a style that was dependent not only on Liberale but on explicitly Mantuan and Mantegnesque models. Then, in the second decade, he was resident for some years in the Milanese. His earlier works were deeply attracted to the traditions of late Quattrocento style, and his old-fashioned inclination towards hard, stiff form and precise description - reinforced by his sojourn in Lombardy - was too strong for

any subsequent influence to eradicate. When in the middle twenties Caroto began to take some cognizance of the Raphaelesque mode that by then was visible in near-by Emilia, it could exact no more than limited concessions from him (*Madonna and St Anne in Glory with Four Saints*, Verona, S. Fermo, 1528). His measure of modernity consisted of an admixture of motifs from Raphaelesque prints, remembered Leonardisms, and a touch of the Mantuan Giulio Romano's smoky chiaroscuro (*Holy Family with St John*, Verona, Museo Civico, 1531). Under constant pressure of Emilian example in particular, the classicistic accent of his style increased, but at no sacrifice of his literalness of touch and way of seeing. In this, his sympathy was with the realist strain that persists also in the Lombard school, to which he looked, more willingly than towards Emilia, in his later work. His last important altarpiece, *St Ursula and her Companions* (Verona, S. Giorgio in Braida, 1545), remains, in the context of its different moment in art history, what his early works had been: the most conservative solution possible in its time and place to a painter of some gifts.

The career of Paolo Morando (Il Cavazzola, 1486-1522) is within its brief limits at least equally a testimony to the conservative disposition of the native Veronese. In 1517 his series of the *Passion of Christ* (Verona, Museo del Castelvecchio) is dramatically eloquent, but in a vocabulary that is fixed in its attachment to the Quattrocento: all that identifies the time of painting of these works is that light is manipulated in them with a chiaroscuro range unlike that of the older century - but only in order to intensify effects of realism. Morando's grand-scale altar representing the *Madonna in Glory with Saints* (Verona, Castelvecchio, 1522) is absolute in its rigidity, and harshly forceful yet inert in its realism; it is a demonstration at a late date of the propositions that belong to a past style.

Verona sent its most gifted painter, Boni-fazio, to Venice: it was an uneven bargain that Venice should export Francesco Torbido to work in Verona. Torbido (Il Moro, *c.* 1482/3–1562?) was born in Venice, but apparently of Veronese family; he settled in Verona at the latest in 1510. He seems to have completed, perhaps with the aged Liberale da Verona, an artistic education that began in Venice, and which Vasari – in general accurate in his information about Torbido – states had been in the studio of Giorgione. The first works by Torbido that we can identify are in fact para-phrases of Giorgione, loosely handled portraits (*Young Man with a Rose*, Munich, Pinakothek, dated 1516; *Youth with a Flute*, Padua, Museum) which imitate the mode and setting that are the overt apparatus of Giorgionismo. An altarpiece, the *Madonna and St Anne with Other Saints* (Verona, S. Zeno), of which the likely date is towards 1520, is also related to Venetian style – the old Bellini's and the recent Titian's, more than to Giorgione – but less explicitly, for it has a cast, partly realist and partly archaizing, that adjusts it towards Veronese example. It was Torbido, much more experimental than Caroto, who first among the Veronese reacted to the infiltration of Raphael-ism into Emilia; Torbido's action in this sense may well have influenced Caroto. In Torbido's altar of *The Trinity, the Madonna, and Saints* (Verona, S. Fermo, 1523) a smooth-surfaced, plastically assertive style, Venetian only in its chiaroscuro, marks his decisive turn towards Romanism. An eccentric energy, which had appeared in the S. Zeno altar also, bestirs the hard forms of this altar, giving it a precocious look like that of the classicist Maniera. Not long afterwards the mounting propaganda made in near-by Mantua by Giulio Romano for just this style quite captured Torbido. In 1534 he served as deputy for Giulio in Verona, execut-ing the designs which Giulio had prepared for the fresco *Assunta* in the apse of the Duomo.

Subsequently, Torbido was the principal agent for the popularization in Verona of this brand of Mannerist style. A decade of residence in Venice, between 1546 and 1557, only moderated Torbido's adopted Romanism, restoring in part some Venetian, and specifically Titianesque, sensibility for the effects of colour and of softened surface. He worked in Verona until 1560, but increasingly, in his later years, handed over the execution of his larger works to his painter son-in-law, Battista Angelo del Moro.

VENETO-LOMBARDY

It is as an artistic more than a political de-nominator that the term 'Veneto-Lombardy' is meant. The centres to which it may be applied literally, both politically and artistically, are Brescia and Bergamo, which were the farthest outposts towards Milan of the Venetian dominion. Despite this dominion the affinity of art in the later fifteenth century in both towns had been rather with Milan, and their artistic traditions were definably Lombard – not in any significant degree Venetian. In the sixteenth century, however, the connexion with Venice made its artistic effects strongly felt and Vene-tian style became an opposite pole of attraction to the Lombard tradition of the locality. The artists of Brescia – thanks to the accident that two of them, Romanino and Moretto, possessed great talent – dealt with this duality effectively, and in such a way that the school not only retained its independence but increased it, finding a stature it did not possess before. Bergamo, though much nearer to Milan, on the other hand virtually surrendered its identity as a centre of art to Venice. Except for the long practice there of the Venetian Lotto, and that of the Venetian-trained, then Lotto-influenced Andrea Previtali,[6] art was supplied to Bergamo by painters of Bergamasque origin who took residence in Venice.[7] Cremona in the later fifteenth century had been mostly involved, in

the person of its *caposcuola*, Boccaccio Boccaccino, with precepts of style that originated in Venice; yet Cremona was not politically in the power of Venice but a dependency of Milan. It was, however, on the borders of Emilia, and already in the fifteenth century Cremonese painting had been responsive to Emilian influences, generated chiefly in Ferrara and Bologna. In the course of the sixteenth century Venetian influence on Cremonese art tended to decline and the effect of the Milanese relation to increase, but more important than either was the sympathy among the Cremonese to the infiltration into near-by Emilia of Central Italian ideas. The last major centre of art in Lombardy was Lombard only by an eccentricity of boundary and owed no artistic or political loyalty either to Milan or Venice: Mantua, in the easternmost salient of the province, had long been part of the artistic culture of Emilia. We have seen how, when the rule of art in Mantua passed to Giulio Romano, it became the prime outpost in the north of Central Italian style.

In Brescia the earliest years of the sixteenth century were dominated by the presence of the old Vincenzo Foppa, who in his earlier and middle years had been the most important painter in the region of Milan, working at Pavia and Milan chiefly (and in Genoa also). In 1490, at the age of sixty, he returned to Brescia, which had been his place of birth, to live and work, subsidized (while the city could afford it) to set the standards of artistic instruction for the young. His own art had grown turgid in his later years but was still an authoritative example of the tenets of the Lombard late Quattrocento style: of strong and simply ordered forms, almost wholly unconcerned with grace, and seeking a realistic immediacy of appearance and emotions. Foppa revealed his images in a silvered light (which in these latest years tended to emerge from a deepening shadow) that seems a peculiarly Lombard kind

of seeing, and which one would like to think of as the equivalent in art of a fact of nature that exists there. The art of Foppa was a factor present to the Brescian painters who would mature into a sixteenth-century style, but it was not (as past literature on the subject tends to make it be) a major one in their formation; furthermore, the Lombard values that he represented were visible in a way more sympathetic to the younger painters in more recent artists in Milan (as in Bramantino), with which Brescia was obviously in continuous relation.[8]

The history of Cinquecento style in Brescia begins with Girolamo Romanino (born in Brescia between 1484 and 1487) towards the end of the first decade. In 1510, a dated *Pietà* (Venice, Accademia) is in a style that equivocates between the Quattrocento and modernity, and, more important, between the Lombard mode that then dominated Brescia and elements of style acquired from Venice. The Lombard factors relate less specifically to Foppa than to his follower, Civerchio, and may reflect the recent Bramantino in Milan. There is an affinity of style with the school of Boccaccino in Cremona, so strong that it is likely that Romanino took some example from it. The Cremonese component already includes, in Boccaccino's art, a reference to the Bellinesque Venetian style. However, what is in the *Pietà* requires that its artist should have known Venice at first hand, and not just the painting of Bellini[9] but Giorgione's and perhaps the youthful Titian's. Painted in Brescia (for the church of S. Lorenzo), the *Pietà* was formed by a sequence of experiences that took Romanino from his native place to Venice and back again. By 1513 at the latest Romanino had returned at least to the neighbourhood of Venice:[10] in Padua in that year he was commissioned to execute a monumental altar, a *Madonna Enthroned with Saints* for the church of S. Giustina (Padua, Museo Civico) [152]. Titian had recently finished his frescoes for the Santo, and

152. Girolamo Romanino: Madonna Enthroned with Saints (S. Giustina altar), 1513. *Padua, Museo Civico*

exposure to this example added decisively to the consequences of Romanino's earlier Venetian study. Romanino's altar adopts the larger dimension of Titian's forms and his power of light-infused colour and combines them in a monumental structure. The temper Romanino achieves is strong and ennobled, authentically partaking of the Cinquecento classical style. Yet every element of Venetianism or of modernity contains a compromise. The lighting, of a perfectly including consistency, is high-keyed but not a chiaroscuro; the colour, rich and luminous, is still local colour, which makes unity by sequence of relations rather than by synthesis; and the grand forms work similarly, hardly moved. The picture is in essence an *Existenzbild* in which the new features serve to revise into a dialect of modern Venetian a conception of art that is still realistic, particular, and reticent in structure in ways that are identifiably related to the tradition of a Lombard style. That Romanino was deeply occupied with the opposite, Lombard pole of his experience is evident in the *Last Supper* (Padua, Museo Civico) which he had already executed in Padua in the same year,[11] in which the Titianesque references are far less obvious than the dependence of the whole on Leonardo's mural in Milan, as well as on Bramantino, and of the descriptive technique on a popular verism that is Lombard and still quattrocentesque. Once more in Brescia there are, in the interval between 1513 and 1516, instances in Romanino's art of re-affirmation of his roots within his Lombard context,[12] but it is the development of what he had acquired from Titian that rapidly assumed the upper hand. Because it resembles his Paduan altarpiece in type, Romanino's altar for the church of S. Francesco (Brescia, *in situ, c.* 1516-18) shows the swift change occasioned in the few intervening years: in forms that are more pliable, gathered into a design that is more dense; in a deepened chiaroscuro from which lights emerge

in radiant contrast; and in the sumptuous and textured colour which, almost as much as Titian's own, simultaneously achieves illusion and an effect of beauty of pure visual sensation that transcends it. In monumental value and in fullness of design, and in woven animation that the life of light and colour in it make, this work belongs in good measure to the contemporary domain of classical style;[13] yet it does not wholly accord with the canons set by metropolitan accomplishment for that style. The substructure of design is mechanically ordered according to a taste recalling Quattrocento modes: its skin of light and colour moves, but the form beneath remains relatively inert. The degree of reformation of appearance is less than in high classical style, and within the largeness of the forms there is the pressing sense of a veristic purpose and of reference to ordinary types. This can no longer be described as an *Existenzbild* in the Quattrocento sense, though it retains a comparable realist ambition, nor can we dismiss as quattrocentesque what differs in this picture from Venetian classical style: these differing qualities, though generated in late Quattrocento art, are not here as the residues of an outworn style but as continuing vital values of the Lombard point of view. They are qualities that must in some degree conflict with contrary values in the metropolitan ideas of classicism, of which it thus could not have been Romanino's ambition to assimilate the entire sense.

Romanino's four frescoes in the series of *Christ's Passion* in the nave arcade of the cathedral of Cremona (1519-20) [153] are the exact testimony of what his art intended to accomplish as he attained a full command of what from then on were to be the resources of his style. His whole apparatus of light and colour, at once descriptive and poetic, is manipulated with extraordinary brilliance for the fresco medium, and it is combined with a fluency of drawing with the brush that attains

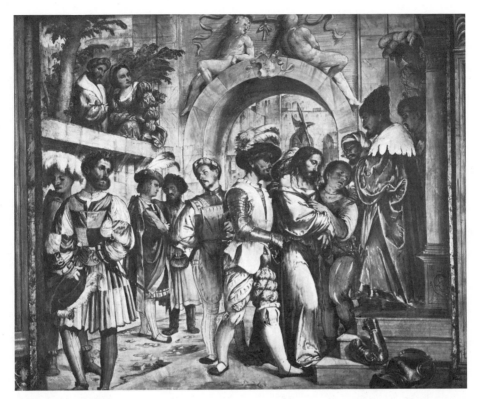

153. Girolamo Romanino:
Christ before Caiaphas, 1519-20. *Cremona, Duomo*

an almost electrical effect. Compositions are varied and full of incident, only unobtrusively ordering a complexity that resembles life. In almost every respect of these frescoes that seems new there is the visible effect on Romanino of the work of his immediate predecessor (1517) in the Duomo decoration, the native Cremonese Altobello Melone. At an earlier time Romanino's model helped to form Altobello's style; now the latter's achieved mastery made a return of influence on Romanino. Of a more eccentric and impetuous temperament than Romanino, Altobello was sympathetic to the expressive – as it were

Late Gothic – strains in Emilian Quattrocento style, and to the stimulus of North European prints. Their compositional energy and graphic means – the exotic costumes, too – affected Altobello's frescoes, and through them the adjoining works of Romanino. But these facets of Altobello's style entered Romanino's as matter not to be imitated but to be turned to his more sophisticated ends, in which there is no longer the sense of a connexion with an older style that is residual in Altobello. Romanino's frescoes are more Venice-like and modern, and at the same time more authentically Lombard. Their fullness and variety of

forms and of design and the richness with which light and colour work in them are qualities like those in Venetian classical painting style. But among these qualities, only the light and colour rise beyond their functions of description to make effects of ideality. Otherwise, the dominating sense of each artistic means is its descriptive one, and it is in accord with this that in his relation to the given themes Romanino's first purpose is that of an illustrator. He re-creates a complex visible reality for the event (and with it all the legible indices of emotion fitting to its actors) and gives this the effect of a thing described rather than (as it is to begin with) imagined and invented: his scenes acquire a value more like that of an objective truth than an image made, according to classical proposition, from a synthesis between invention and reality. It grows out of this that Romanino's figures, even when they are shown in action, seem resistant to mobility, for he sees their action as an objective fact more than as something to be subjectively participated in. He responds less to the vitality in the human substances that he depicts than to the life of light and colour that their surfaces reflect.

Late in 1520 Romanino was unwillingly displaced in his commission at Cremona by Pordenone, and returned to Brescia to work on a joint undertaking with his younger but more strong-minded compatriot Moretto: the decoration of the Cappella del Sacramento in S. Giovanni Evangelista (1521-4).[14] Moretto was a much less adulterated Lombard than his collaborator, whom he challenged with the efficacy of his more native veristic and illusionistic style. The harder brilliance of Moretto's lighting and his tighter, more precise technique appear in Romanino's paintings in the Cappella del Sacramento, and in this sense especially the younger artist from this moment was increasingly to lead the older. Romanino's paintings in the chapel also show an impact on him of the frescoes his successor did in the

Duomo at Cremona. Pordenone's example, combined with Moretto's, leads Romanino to a lessening even of his former measure of ideality.

Romanino was just enough detached by earlier experience from his native tradition and locality to be responsive to the sense of foreign styles as they came into his vicinity. Partly out of such response, Romanino made probes in his painting in the 1520s that were neither logically sequential nor consistent. Titian's art reclaimed some of Romanino's allegiance when the great *Resurrection* altar was imported into Brescia after 1522. Romanino made his own luminous reflection of it – part paraphrase, part parody – in a painting, shortly later, of the same theme (Capriolo, church, *c.* 1525); and it is a more specifically Titianesque mode that dominates the *Nativity* polyptych (London, National Gallery) of 1525. Yet in the same year Pordenone's models almost inverted Romanino's style in the organ shutters that he sent to Asola (*Augustus and the Sibyl*; *Sacrifice of Isaac*, Asola, Duomo). Beside these foreign powers there was the continuing influence of Moretto's insistent example of the virtue of a native style. At the end of the decade Romanino was still inconsistent in his resolution of these influences that converged on him. His *Nativity* (Brescia, Pinacoteca, 1525-30) has an optical luxury like Titian's and a vigour of expression that seems indebted for its largeness of effect, but not for its nobility, to Pordenone. The *St Anthony* altar (Salò Cathedral, 1529) more closely recalls Pordenone by its bulking, generalized form. On the other hand, the *Marriage of St Catherine* (Calvisano, church, *c.* 1530) is excessively particular, evidently imitating Moretto's verism and attempting to exceed it.

In 1531 and 1532 Romanino had the opportunity to return to work on a major scale as a *frescante*. In those years he was engaged at Trento in the decoration for Bishop Bernardo Clezio of the Castel Buonconsiglio, working

concurrently with the brothers Dossi (and with the lesser Marcello Fogolino). Romanino's extensive work in the Clesian palace resurrects the brilliant fluency of touch which he had shown earlier in fresco at Cremona and now, finally – the result of study in particular of Pordenone – his fluency does not merely work in the description that the brush makes of the forms but infuses them essentially. What Romanino shares with Dosso (who just at this moment was tending towards a Giulian Romanism) is not more than the liberty inspired by the secular subjects of the decoration; he is untouched by the new classicistic accent of his collaborator. In the refectory of the abbey of Rodengo near Brescia, in 1533-4, Romanino's frescoes of the *Supper in the House of Simon* and the *Supper at Emmaus* (now Brescia, Pinacoteca) are in a still larger and more fluent style than that which he had achieved at Trento. At Rodengo his art finds, again from impetus derived from Pordenone, a scale of

form and emotion like that at which the recent Pordenone had arrived, and makes compelling union between aggrandized actors and the passions by which they are inspired. Here, Romanino has come late but wholly to the high eminence of an expanded classical style that, in the early thirties, only Titian, Pordenone, and in a sense Correggio, had attained. But when in 1534 or shortly earlier Romanino painted a fresco series of the life of Christ in S. Maria della Neve in the country town of Pisogne near Brescia [154], and *c.* 1535 a series of Old and New Testament scenes for another country church, at Breno, the grand classical manner of Rodengo was displaced by one resembling the earlier, inchoate, *popolano* Pordenone. In these country frescoes the Lombard primacy of illustration reasserts itself, and popular verism, in a way that is modern in touch but archaizing – Germanic and Gothical – in substance is turned to the account of expressive caricature. This is a native disposition in Romanino, but its

154. Girolamo Romanino: Crucifixion, *c.* 1534.
Pisogne, S. Maria della Neve

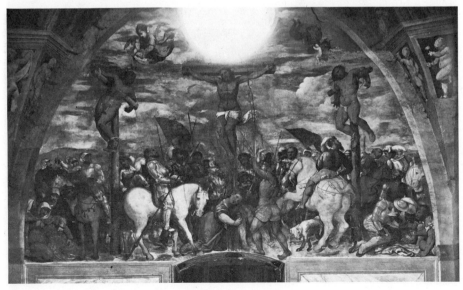

155. Girolamo Romanino: Christ Preaching, 1558. *Modena, S. Pietro*

emergence must have been in some part promoted by the nature of his audience. It must have been still more in the spirit of accommodation to a country place that, probably shortly after 1535, Romanino painted a *Last Supper* for the parish church of Montichiari in a literal, hard-surfaced vein that is based upon Moretto and outdoes him. However, for a city patron, the church of S. Domenico in Brescia, Romanino painted in a different mode. His *Coronation of the Virgin* (now Brescia, Pinacoteca, *c.* 1535) is Moretto-like in detail and in accent only; in every other respect it is conceived according to a conservatively classicizing formula. Romanino's moment of assimilation to a style like that of the contemporary Titian and Pordenone was not more than that; after the early thirties classicism worked on him in the sense of its conventions or, on occasion, not at all. It is the continuity of a view of art that precedes classicism, rather than the classicizing formulae they still observe, that is significant in Romanino's late organ shutters with the *Life of the Virgin* (Brescia, Duomo Nuovo, 1535-41).

Romanino lived through the sixth decade (he died between 1559 and 1561), and in his latest years, probably in the main through the action on him of his son-in-law and collaborator, Lattanzio Gambara, he became susceptible to the influence of the Romanizing styles that by then were firmly established in Cremona and neighbouring Emilia. The effect on his religious works of the fifth and sixth decades was not salutary. His late secular decorations, undertaken with Lattanzio (as in the Palazzo Lechi, 1550-5, or the Palazzo Averoldi), were less constrained, illuminating realism with provincial humour, and even with a touch of elegance. The last known work by Romanino, *Christ Preaching* (Modena, S. Pietro, 1558) is a surprising re-ascent to high creative power [155]. There is an Emilian accent in it, as of something that the latest Dosso could have invented

but did not. It is conceived as an ennobled rhetoric of action, set in a landscape inspired with high dramatic power by its light. It stands again, as Romanino had for a moment a quarter of a century before, on a plane and in a region of style like that of the contemporary Titian, in a new reach but one that belongs still to classicism.

The same diversity of artistic experience that Romanino had was also accessible to Alessandro Buonvicino, called Moretto, but Moretto was unlike Romanino in that his certitudes were unassailable. By comparison Moretto's temper has an almost ferrous consistency, exceptional in an artist of high gifts in this complex time. Born probably in 1498, and thus younger than Romanino by more than a decade, Moretto's education also included an exposure to the style of Venice, but late in the second decade. However, even more than Romanino, Moretto seems to have been attached to the Brescian tradition inherited from Foppa and Milan, and after a Venetian moment (e.g. *Cristo Portacroce with a Donor*, Bergamo, Accademia Carrara, dated(?) 1518) he sought to re-integrate his style with it.[15] Obviously, Romanino's model was present to Moretto and influential on him, but he chose to take it more in its Lombard than its Venetian sense. In 1521, when Moretto – precociously mature, and rewarded early with local eminence – was selected to join Romanino in the painting of the Cappella del Sacramento (until 1524), he decisively reacted against the Venetian style and, as we have seen, thereby exercised a counter-influence on Romanino. In his paintings (on the eastern wall of the chapel) Moretto converted the sophistication of descriptive means that he had found recently in Titian as well as in Romanino to realist purposes that were far more exact, linked in their ambition of mimetic truth to Quattrocento style. To reinforce this he seems to have consulted his compatriot Savoldo, and, like

Savoldo, the precedents of Flemish art. What Moretto achieved of the capacity to make a nearly tangible duplicate in paint of un-idealized reality exceeds at least the precedents in Italy. Though linked in kind and purpose to an older style, in the context of the early twenties this mimetic power had the meaning not of an archaism but of an invention, invading a new reach of the possibilities of art: this is the primary sense of Moretto's *Last Supper* in the Cappella del Sacramento. This verism was, however, not Moretto's sole preoccupation at this time: he was also engaged with a quite contrary problem, that of calculated style, and it would appear that part of his dissympathy for Venetian art was that it did not have enough of it. In the *Elijah in the Desert* and the *Fall of Manna* in the Cappella del Sacramento Moretto has superimposed on his probing after realist detail an element opposite to it and to Venetian taste: a Romanist stylization with rhetorical postures and laboured plastic forms. It is apparent also, though not so obviously forced, in Moretto's smaller paintings in the chapel, of half-length Prophets. The example of Pordenone at Cremona may be related to this tendency, but it does not decide it; it is more important that Moretto has consulted Raphaelesque prints with more diligence and literalness than any North Italian contemporary.

This classicistic cast is so strong in the *Coronation of the Virgin with Four Saints* (Brescia, Ss. Nazzaro e Celso, *c.* 1525) that it outweighs the references in motif to the recently imported Titian in the same church. But this reassertion within Brescia of Venetian style regenerated at least part of Moretto's former interest in it, and his *Assunta* in the Duomo Vecchio at Brescia, finished in November 1526, recalls the range of chiaroscuro and the variety of texture of Venetian painting, and in motifs and design refers to the Titian in the Frari that Moretto must have known at first hand, very probably in the year of its unveiling, 1518. The

result makes a strong analogy to the style of Savoldo, whose example of compromise between Lombardy and Venice may have been operative too.[16] For the remaining years of this decade and until the beginning of the next there was some deference in Moretto to Venetian elements of style, not only as he remembered them from Titian but as he saw them persist in the art of Romanino. A quietened but rich chiaroscuro and deeper colour – less insistently localized, moderating the earlier acerbity of Moretto's surfaces and details – distinguish the three major works of these years: the *St Anthony* altar (Brescia, Pinacoteca, *c.* 1526–30), the *St Margaret* altar (Brescia, S. Francesco, 1530), and the *St Giustina with a Donor* (Vienna, Kunsthistorisches Museum, *c.* 1530) [156]. All have an impressive gravity of form and a stilled strength of feeling in the actors. Almost immobile in structure, they yet are not inert, but seem to constrain a deep power of which part comes from the extraordinary efficacy of Moretto's re-creation of existence in them. In this vein Moretto makes a reticent assimilation of his style to a restrictive classicism, but the state of mind that underlay these works did not persist. He was concerned with meditated style, but not with the expression that should accompany it in an authentic classicism: a colder stylization, classicistic more than classical, like that which he had found sympathetic earlier in Roman prints, is nearer to his disposition and artistic needs. In 1530-1, in his *Massacre of the Innocents* (Brescia, S. Giovanni Evangelista), Moretto recalled the classicistic Romanism he had chosen for earlier paintings in the Cappella del Sacramento in this same church. The Romanism was for this occasion only, but the classicistic will persists. It appears

156. Moretto: S. Giustina with a Donor,
c. 1530.
Vienna, Kunsthistorisches Museum

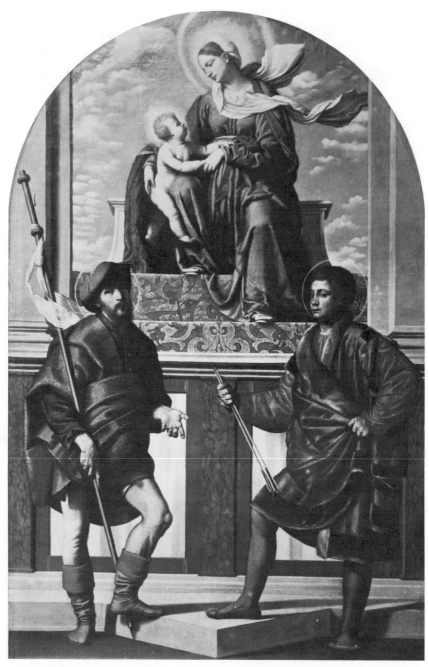

157: Moretto: Madonna with St Roch and St Sebastian, *c.* 1535. *Pralboino, church*

in the *Madonna with St Roch and St Sebastian* (Pralboino, church, *c.* 1535) [157], where he transforms the grave architectonic structure of the preceding altars into chaste geometry, thins forms towards pallid elegance, and makes emotion poised and mute. Light and the colours it describes take on a high-keyed, silvered clarity. This style, beautifully calculated here in each of its effects, is the basis for a major strain in Moretto's subsequent career. However, the exquisite balance between artifice and imitation that distinguishes this work, making it akin to Bronzino, is not maintained; Moretto's veristic impulses are too often too commanding. In the later *Madonna with St Nicholas of Bari* (Brescia, Pinacoteca, 1539) they are again Moretto's chief concern.

In this design that derives from Titian's *Pesaro Altar*, Moretto seems to have renewed his experience of Venice and, now, of its more recent art. This, combined with the influence of Pordenone's omnipresent Lombard and Emilian works, pressed Moretto in the forties into imitation of the scale and power he could not but recognize in him as well as Titian. In Moretto this ambition proved perverse, impossible to reconcile with his commitment to descriptive minutiae. It yielded (as in the *Madonna in Glory*, Brescia, S. Giovanni Evangelista, *c.* 1540, or the *Madonna Enthroned* for S. Andrea in Bergamo, *c.* 1540–5) more ponderousness than monumental strength, and the effect of an only turgid energy. Moretto's best works of this decade are those in which his native capacities and the given theme coincide to invite his treatment of it as a modern version of an *Existenzbild*: for example, the *Five Female Saints* of the later forties in the Brescian church of S. Clemente.

The last half-dozen years of Moretto's career present a double-faced phenomenon. On the one hand they contain works that in authenticity and depth of feeling are the crown of his entire art, and in which his power to evoke –

not just support – emotion through his use of light and colour is at its summit. In these works each effect is the masterly result of an unfailing hand. The *Madonna di Paitone* (Paitone, Chiesa del Pellegrinario), the silvered and russet *Ecce Homo* (Brescia, Pinacoteca) [158], and his last work, a *Pietà* (New York, Metropolitan Museum, painted in 1554, the year of his death), are of this kind. But contemporaneously Moretto produced a group of altarpieces in which the classicist mode that first had been applied to the altarpiece for Pralboino more than a decade before is turned into mechanical rigidity. Feeling, structure, and colour are now not just crystallized but congealed. Though these altarpieces are still veristic in detail, the effect of the whole is of unliving stiffness: it is as if reality should have been petrified to make

158. Moretto: Ecce Homo.
Brescia, Pinacoteca

an icon. These works do not assume this character of the iconic and the seeming primitive by any accident of execution: it is in their conception and represents a conscious choice. In the *St Ursula* altar (Brescia, S. Clemente, towards 1550) it might be explained as a deliberate archaism (imitative of the style and iconography of an altar by Antonio Vivarini then in Brescia; now in the church of S. Angelo). But there is no such pretext to explain the puppet-like fixity of the *Madonna with Five Saints*, the high altar of S. Clemente (1548). In part its style seems a response to the spreading example in North Italy of the Maniera, but in terms that are not cordial to it – those of Moretto's native aesthetic of immobility and verism. The result is spare and dry but not elegant, structurally and descriptively simplistic, and immediately legible to the most unsophisticated spectator. Where the Maniera finally touched Moretto it could not make a conversion, but was itself inverted to make a style that has basic properties like those we shall identify in the Counter-Maniera, which in Central Italy had its more creative birth at the same time.

For about a decade that was crucial to the formation of his style, Callisto Piazza (*c.* 1500–*c.* 1562), the most able of a family of painters at Lodi in the Milanese, worked in Brescia and its environs. Trained first at Lodi in a harsh and retardataire style, he appeared in Brescia shortly after 1520. In quick successive stages, which we can follow in his earliest pictures (the first surviving one is dated 1524), he shunted off his archaism and became, by 1526 or 1527, expert in the paraphrase of the contemporary style of Romanino (e.g. *Deposition*, Esine, Valcamonica, 1527) to a degree that has caused critical confusions. Like Romanino himself, Callisto was responsive to Moretto's purer Lombard art. Before the end of the decade Callisto had achieved a working compromise of

Romanino's and Moretto's styles, like Romanino in his types and repertory but tending towards Moretto's quality of light and stiffening of forms, though not towards his degree of verism. The classicist strain that engaged Moretto in the twenties only for a while was more enduringly present in Callisto, and it is conspicuous in the style of his work towards 1530. In his altar of a *Madonna and Four Saints* for Cividate (S. Maria Assunta, 1529) the classicist inclination has been reinforced by influences from Emilia (relayed to Callisto probably via Cremona). The consequence is a cool, hard style, not inelegant and touched with an accent of Maniera.

After 1530 Callisto worked for the most part at Lodi, collaborating frequently with his brothers Cesare and Scipione, on whom he imposed his style. The chill he had exaggerated from Moretto soon diminished in Callisto's Lodi works; now, nearer to the orbit of Cremona and to Pordenone's sporadic centre of activity at Piacenza, Callisto's style took on more resemblance both to Pordenone and the Cremonese, becoming darker and more dramatic (the *Passion of Christ*, Lodi, Incoronata, 1534–8), though still almost invariably dry. His competence and reputation won him custom in Milan: it was there that he practised mostly during the fifth and sixth decades. In these later years his style was not always consistent. It could include quite literal revivals of the mode he had learned from Romanino long before, or references to the more recent painting of Moretto; more generally, however, Callisto's later style tended increasingly to reflect a cast, diffused from Emilia into Lombardy, of Maniera. What he reflected of Maniera is unfortunately its classicist and academic aspects, and never its inventive or fantastic substance. At the middle of the century, Callisto's art was mostly gloomy and labouring, but this character was not much

discordant with the general temper of contemporary painting in this part of Lombardy.

Cremona gives the most pregnant example in North Italy of the process of formation of artistic styles by intersection. Its geography invites confluence upon it of influences not only from Milan and Brescia but from Emilia; Cremona serves, we have already noticed, as a point of relay of Emilian style to Lombardy. Because of the diversity of pressures working in Cremona, its character as a local school came to be, in the crucial third decade especially, less unified than is the case of other Lombard centres.

The *caposcuola* who dominated the first decade of Cinquecento painting in Cremona (and whose formative influence was much more significant and continuous than the old Foppa's in Brescia) was himself an excellent example of the making of a style by intersection of influences, but upon a personality of much consistency and strength. Boccaccio Boccaccino (before 1465–1525) was the son of a Cremonese resident in Ferrara. His early schooling was entirely Ferrarese, and his activity almost wholly so till about 1505. Ercole Roberti's style as well as Costa's had been most important to him; then, shortly after the beginning of the new century, experience of Venice caused a major infusion of Bellinism in his art. At Cremona after 1505, he came to show a special sympathy with northern graphic art and painting, and it was probably his lead that disposed the younger Cremonese in the same way. In 1506 Boccaccio set an important model for the younger artists in a vast apse fresco of *Christ the Redeemer and Four Saints* in the Duomo, and from 1514 to 1518 made major contributions to a fresco series of the lives of Christ and of the Virgin. Boccaccio's style remained unequivocally quattrocentesque in both the recognizable and somewhat diverse aspects it presents. One, reserved for devotional pictures (e.g. *Marriage of St Catherine*, Venice, Accademia, c. 1516–18), is a strong and quiet compound of virtues that are, still, more Ferrarese than Venetian; the other mode (as in the histories in the Duomo), though generated from the same sources, is more active. The Duomo frescoes have sweeping, sharp-angled draperies and enlivening eccentricities of form inspired by German prints, and a lighting that is no less sharp and movemented. Boccaccio may have been in Rome late in his career, but too late to turn him towards a Cinquecento style; in any case, it was his example of the approximate decade 1505–15 that helped to form the younger Cremonese.

In Altobello Melone (fl. c. 1508–35)[17] the Emilian and quattrocentesque elements of Boccaccio's style left so strong a trace that it is perceptible even after he had been in some close association with the Brescian Romanino, probably about 1510. The exact nature of their connexion is not clear, though Michiel reported that Altobello was Romanino's pupil. The first substantial work by Altobello, a *Pietà* (Milan, Brera, c. 1512?), resembles Romanino's painting of the same subject, dated 1510, so closely in its composition as to suggest dependence on it, but they are more disparate than related in other features. Altobello's lighting and his hard-shelled lucidity of form are still at this point more like Boccaccio's, and rather than moderating this by reference to Venetian style Altobello's inclination was towards Milan and Bramantino. It was only a few years afterwards that Altobello came obviously closer to Romanino: more accurately, for a short while the styles of the two almost converged, the result not only of Altobello's coming to accept Venetian elements from Romanino but of Romanino's momentary turning, himself, towards Bramantino. A work like Altobello's triptych of a *Madonna and Two Saints* (the Madonna formerly Port Washington, Long Island, Rabi-

159. Altobello Melone: Massacre of the Innocents, 1517. *Cremona, Duomo*

nowitz Collection, the Saints in Brescia, Butoni and Lechi Collections, *c.* 1515), long wrongly attributed to Romanino, marks the point in time at which the Brescian and the Cremonese seem to intersect.

In December 1516 Altobello was commissioned at Cremona (following on Giovanni Francesco Bembo) to continue the fresco series begun by Boccaccio. Early in the next year Altobello executed a *Flight into Egypt* and a *Massacre of the Innocents* [159], following prescriptions from his patrons that were specific in their narrative demands and accepting a requirement that his paintings be more 'beautiful' than the frescoes Boccaccio had done before. The Venetian aspect of Romanino's example has now taken more effective hold on Altobello, and the cast of his style in these two frescoes is, with dramatic suddenness, quite modern. The range and brilliance of Altobello's light equals Romanino's, and the malleability of his forms is greater. At the same time Altobello retains the tendency, inherited from Boccaccio, to break up surfaces into lucent planes. He insists, also as Boccaccio did, on the force and action of his line: Altobello, like Boccaccio, takes graphic stimuli from northern prints and translates them into excitant and incisive drawing with the brush. Line combines with light and colour to make a prismatic sparkling. Much more than Romanino at this date, Altobello is seized with an impulse of pervasive energy – surprisingly, after his interest in Bramantino – that moves his designs in propulsive rhythms, conjoining power of ornament and expressive sense. As we have seen, when in 1519 Romanino undertook his frescoes in the Duomo, these remarkable works had influence on him.[18] Altobello's set of illustrations in the Duomo of the *Life of Christ*, begun in March 1517, recede quickly from this inventive and qualitative peak. Perhaps he had gone farther than his notoriously difficult patrons were prepared to tolerate in

the direction of the new 'bellezza' they had demanded in the contract. In any case the Passion series grows step by step more wary and conservative, adjusting backwards towards the precedents of painting style and narrative distinctness found in Boccaccio, and taking illustrative adjuncts and compositional ideas from Dürer's prints. Altobello's panel of *Christ on the Road to Emmaus* (London, National Gallery, *c.* 1518) is in the same vein of renascent conservatism. In a differently diligent technique from that of the later Duomo frescoes, the panel makes the effect of a displaced, tardy, Bellinesque style.

About 1520 Altobello's triptych from Torre dei Picenardi (Washington, National Gallery, Kress Collection and Oxford, Ashmolean), though exactly traditional in structure, reasserts elements that re-establish his connexion with Romanino and, at the same time, re-create the level of personal distinction to which he had risen earlier. A subtly worked calligraphy, made of threads of light, instils power in the quiet forms, and a shimmering illumination suffuses colours. The persons in the triptych resemble Romanino's, but they have been made more piquant, given a deliberately unbeautiful Germanic cast. As Altobello moved farther into the 1520s his renewal of his old connexion with Romanino became increasingly overt, clearly accepting the lead of the Brescian master's contemporary style. Indeed, Altobello came at times to exceed Romanino in his Venetian effects (e.g. *Salome*, formerly Berlin, Museum, *c.* 1525–30; destroyed), but even then insists on his own eccentric, brilliant draughtsmanship and on his tendency – probably encouraged not only by Germanizing inclinations but by Pordenone – towards eccentrically expressive forms. It was only towards the end of his career that Altobello turned away from Romanino, answering (as he had also at an earlier time) to Emilian pressures in Cremona. His *Annunciation* (Isola Dovarese, church) is of

about 1535; it has the identifiable accent not only of Emilian Raphaelism but of Emilian Maniera.

One of the pressures at Cremona towards Central Italian style came from Giovanni Francesco Bembo (whose activity is documented from 1515 to 1543). He was the son of an inconsequential painter at Cremona, and it was Boccaccio who was his real teacher. When Boccaccio made his late trip to Central Italy Bembo is supposed to have accompanied him to Florence and to Rome. It was probably in 1514 that this event occurred: we noted that it was essentially unprofitable for Boccaccio, but it served instantly to deviate his pupil's sympathies towards Central Italian art. Bembo seems to have begun his career as an independent artist only after his return to Cremona, when late in 1515 he painted two frescoes, a *Presentation in the Temple* and an *Adoration of the Kings*, for the Duomo series; the latter is inscribed 'Bembus incipiens'. The substance of the style of both frescoes depends on Boccaccio, with accents that suggest exposure to Bologna and Milan, but the *Adoration* especially shows the overlay of motifs and ideas of form studied from the Florentine Leonardo and from Raphael. The conjunction of these with the basis in the frescoes that derives from Boccaccio makes an incomplete modernity, somewhat eccentric in effect. But the eccentricity is not only the result of an uncertain compound of the archaic and the modern style; it is there on purpose, the expression of the same caricatural and transalpine sympathy that is in Altobello. By 1524, when we can next date a major work by Bembo, an altar of the *Madonna with Three Saints and a Donor* (Cremona, S. Pietro), he was equipped to make a fluent paraphrase upon his memory of Raphael's *Madonna del Baldacchino* and Fra Bartolommeo's altars. Residues of caricatural realism and of graphic restlessness persist, and Romanino's influence has

immersed the forms in a chiaroscuro more Venetian than Florentine, but the whole is sufficiently in concord with modern classical style. The next identifiable moment of Bembo's career, represented by the fragmentary *Madonna with St Stephen* (Cremona, Museo Civico, towards 1530),[19] is a deviation, in the current climate of Cremona, from near-classicism towards a more active, broader style, in which eccentricities of form are more pronounced. The motive agents of the change appear to be Pordenone and the Bolognese Aspertini. Moreover, Bembo's susceptibility to influence did not stop here: in the course of the succeeding decade he found another guise of style in models of Emilian art, which by that time also had other followers in Cremona. Bembo's *St Lawrence* altar (Budapest, Museum, *c.* 1535) is a classicist piece touched but not permeated by Maniera, but his *Madonna with St John the Baptist and a Bishop Saint* (Cremona, Museum, *c.* 1540) is a fusion, characteristic of the situation in this area of North Italian painting at the time, of Mantuan, Bolognese, and Parmesan elements of Mannerist style.

Altobello's gravitation towards Mannerism in his later years was a concession made to an accelerating change of fashion; Bembo's was a willing accommodation. But a third painter of this generation in Cremona, Camillo Boccaccino (*c.* 1504-1546), Boccaccio's son, had a differently active role in his relation with the newer style. Of a different creative stature altogether from his local contemporaries, Camillo was intelligently responsive to the most advanced currents of invention that he encountered - not at Cremona, but in Emilia. He found the examples of Correggio, Pordenone, and Parmigianino, and in time that of Giulio Romano, and creatively transformed them. Almost from the beginning, there was an inclination in his style towards a temper which resembled that of Mannerism, and no more

than a decade from the time of his first independent work he made an identifiably personal, indeed idiosyncratic, contribution to the repertory of that style. Though first trained by his father, Camillo is reported by old sources, with almost certain truth, to have been in Parma between 1522 and 1524 and connected with Correggio. His education put him thus in quicker contact than his young compatriots with an Emilian centre in which major, stimulating inventions were just being made, not only by Correggio but (in a vein that was, in hindsight, even more congenial to Camillo) by Francesco Parmigianino. But this Parmesan experience was not the only foreign one to which Camillo was exposed. In 1525 in Venice he had seen Titian's paintings; he certainly knew the work in Brescia of Romanino and perhaps that of Dosso and Garofalo in Ferrara. In 1527[19a] Camillo painted an exceedingly accomplished altar of the *Madonna Enthroned with Saints* for the church of S. Maria del Cistello in Cremona (now Prague, Gallery; the earliest work by him that is preserved) in which his experiences are not eclectically assembled but fused under high creative pressure. Compared with its legible sources, the picture is almost as advanced in style as the most progressive among them, not yet identifiably post-classical but manipulating its material in a way that tests complexity of form and sophistication of expression at an extreme limit, verging towards Mannerism. There is no evidence of Pordenone's impact in this altarpiece of 1527, but in the area of Cremona it was inevitable that a young painter of Camillo's active temperament should respond to it. It was still more so at Piacenza, where Camillo painted his next dated work, organ shutters with the prophets Isaiah and David (Piacenza, S. Vincenzo, 1530). These adapt the largeness of form and vigour of spatial action of Pordenone, but in almost equal measure they depend

on the figure canons and the cursive drawing of Parmigianino – to whose models, by now, increasing authority had begun to accrue. Not only synthesizing these modes of form but fusing the optical techniques which he learned from painting of Venetian origin and from Correggio into them, Camillo here evolved a style at once explicitly North Italian and no less explicitly Mannerist: except for Parmigianino's, the earliest such phenomenon in North Italy. But the force of Pordenone's example was more immediate to Camillo than Francesco's, and for a while pulled Camillo more towards his model in the *Madonna in Glory with Four Saints* for S. Bartolommeo at Cremona (Milan, Brera, 1532), making the image more Venetian in aspect and less acute in its effect of stylization, diminishing its overt relation to Maniera.

In the middle of the decade, however, Camillo made his commitment to the Mannerist aesthetic complete and irrevocable. In 1535 he was commissioned to undertake the decoration of the Cremonese abbey church of S. Sigismondo, which in consequence of his efforts and those of his successors in the task was to become one of the prime ensembles of Mannerist style in North · Italy. Camillo's work there consisted of the painting of the semi-dome and laterals in the apse. In the semi-dome, the *Eternal in Glory with the Evangelists* is dated 1537; on the side walls are the *Raising of Lazarus* [160] and *Christ and the Adulteress* [161], of successive date. (Payments for Camillo's work continue until 1539.) The fresco in the semi-dome indicates that Camillo has turned away from Pordenone to renew his old allegiance to Parma – to both Correggio and Parmigianino. Both Correggio's Parmesan domes and his apsidal scheme at S. Giovanni Evangelista supply the basis of Camillo's design, a cloud-borne illusion at once propelled towards the spectator and ascending into far celestial space, brilliant with silhouetted con-

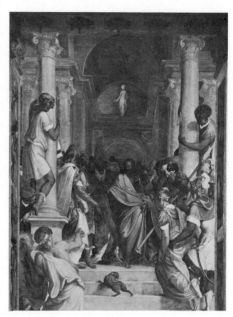

160. Camillo Boccaccino:
Raising of Lazarus, 1537/9.
Cremona, S. Sigismondo

161. Camillo Boccaccino:
Christ and the Adulteress, 1537/9.
Cremona, S. Sigismondo

trasts of sharp lights and darks. But the precise vocabulary of form is not Correggio's but deduced from Parmigianino, describing shapes in impelled, arbitrary rhythms that make unexpected transformations of appearances and a temper of excitant grace. The lateral frescoes on the lower wall reveal that Camillo has studied the contemporary art not only of Parma and Bologna but of Giulian Mantua, and the effect on him is evident in a pronounced lessening of the optical – Correggesque and Venetian – element of his painting mode and in a Romanist hardening of surface. Giulian motifs, in particular his illusionist devices and his archaeological repertory, have also left their obvious mark. But it is more important that the laterals are still more permeated than the painting in the semi-dome had been by the art of Parmigianino. Beyond Francesco's figure style and

calligraphy Camillo seems to have assimilated – almost too impulsively – his extreme of Maniera aesthetic. Less classicist and less fine in control than Parmigianino, Camillo makes the 'augumento nella maniera' – the exaggeration of the Parmesan's inventions – that Vasari (1550 ed., 852) describes as a consequence of imitating him. There is an element of parody in the result which, however, is not the consequence of imitation but of assertion of Camillo's private difference from Francesco. Camillo infuses into the adopted Parmesan Maniera factors resuscitated from identifiable Cremonese components in his past: the sweeping, faceted aberrations of shape, the prismatic colourings, the tendency towards caricature, and the illustrative inclination that Camillo's father initiated at Cremona, and in which Camillo himself must at first have been trained.

The accent that the Maniera of these lateral frescoes carries – pointed and excitable, and as extravagant in stylization as in expression, wilfully skirting the bizarre – is not quite like any other manifestation of this moment. It is as if in these provincial circumstances, less cognizant of classicism and less constrained by it, Camillo should have re-created some of the radical aspirations of Mannerism's first experimental phase. Nevertheless, in their demonstration of the qualities not just of a generically Mannerist style but of Maniera, Camillo's laterals – the *Adulteress* in particular – are almost as explicit as the contemporary work of the greater and more innovative Parmesan.[20]

It is uncertain whether the single late panel picture which we can assign certainly to Camillo, the *Madonna with St Michael and the Beato Ansedoni* (Cremona, Museum), coincides in time with the S. Sigismondo frescoes or is later.[21] Its style is close to that of the laterals, profoundly Parmesan but accented with a Romanism due to Giulio Romano. No documents exist for works by Camillo between 1541 and his death in 1546, but what he accomplished at Cremona before the end of the fourth decade was of such moment as to determine the main course of painting of its Cinquecento school from that time on, not only reinforcing the increasing accumulation of outside pressures towards the modern Mannerist style from Emilia, but embodying it in high examples present in Cremona itself.

It could be said of Camillo, the last member of one of the two artistic dynasties of the Cremona school, that he captured the other, represented by the Campi family, for his cause. The sons of Camillo's close contemporary Giulio Campi, who were to dominate the Cremonese scene in the second half of the century, were more Camillo's followers than their father's; and before them Giulio Campi himself had fallen under the influence of Camillo's powerful example. Son of the painter

Galeazzo Campi, Giulio was born some time in the earlier years of the first decade, became Camillo's rival for the place of *caposcuola* at Cremona, and outlived him to make a long and busy but not always distinguished career until 1572. Beyond the obvious fact of an initial education with his quattrocentist father, no dependable account exists of the training he received. An altarpiece of the *Madonna with Ss. Nazzaro e Celso* (Cremona, S. Abbondio, dated 1527), dark-shadowed and conservative, seems in the main dependent upon Brescian and perhaps Venetian sources. By 1530, however, Giulio inclined towards Emilia: in his *Madonna in Glory with St Catherine, St Francis, and a Donor* (Milan, Brera, dated) Raphael's *Sistine Madonna* at Piacenza, the Bolognese work of Parmigianino, and that of Correggio (and perhaps Anselmi) at Parma itself have served to give a styled and even slightly mannered look to Giulio's forms, though not to diminish much his tendency to murky light and inert colour. His eclecticism, unlike Camillo's, was genuine; called upon in 1537 to depict the life of St Agatha in the Cremonese church dedicated to her, Giulio found the accumulated precedents for narrative fresco in Cremona inescapable, and ineffectually compounded Pordenone (mainly) with Romanino to make his scenes. Evidence of their contemporaneity consists not of essential facts of style but of inserted incidents of mannered attitude and stereotypes found in Parmesan and Roman prints. Despite these touches, the frescoes remain essentially conservative. Not even an increased deference to Pordenone makes Giulio's high altar for S. Sigismondo (1540) more genuinely animate: it is an effortful but rigidified machine.

It is the drastic example of what Camillo had accomplished in S. Sigismondo that served finally to stir Giulio to modernize his style. About 1542 Giulio undertook the next major portion of this decoration, the painting of the transept of the church. His frescoes of the *Four*

Doctors, surmounted by Bible stories, are in a mannered style that is a tempered version of Camillo's: more discernibly eclectic, with references to Pordenone, to Parmigianino, to Giulio Romano – and to Michelangelo – that are not entirely assimilated, but are infused with Mannerist-pattern-making energy. In 1557-9, again in S. Sigismondo, and again provoked by Camillo's precedent, Giulio made his most interesting near-invention, a fresco in the nave vault of a *Pentecost*, seen drastically *sotto-in-su*, of which the surprising foreshortened shapes make silhouettes almost as brilliant as Camillo's. Giulio's sources are entirely obvious, however; they are compounded from Correggio's Apostles in the Parma Duomo and Giulio Romano's *Wedding of Psyche* in the Te. Giulio does not function at this level of near-inspiration except in the competitive context of S. Sigismondo. Elsewhere, he is content to demonstrate his recently acquired Maniera modernity in a more reposeful way. His fresco series of the lives of Christ and of the Virgin in S. Margherita (1547) is based in large part on a classicist variant of Maniera that he observed mainly in the later Giulio Romano (with generous adulterations from Bolognese and Parmesan example), which he makes more academic and inert. It is essentially such a style that he employs in most of his subsequent works, as in the half-dozen or more altar paintings, both devotional and narrative, which he dispersed through the Duomo of Cremona in the later 1560s. Maniera – like the styles he practised earlier – had never had much more meaning to him than one of formula, and increasingly his later paintings petrified the formula, becoming hard and chill. But within the formulae and concomitant upon the hardening is an increasing descriptive literalness and a concern, anciently Cremonese and Lombard, to illustrate the temper as well as the appearance of the commonplace. This is the mark of a new turn, and one of positive historical significance, in

the course of the Maniera style, but it seems to come from Giulio's sons, not him, and a discussion of its import belongs to our account of them.

A painter who was still more durable than Giulio, Bernardino Gatti (Il Sojaro, *c.* 1495-1575), more specifically illustrates the role of the Emilian style in Cremona. Sojaro was only uncertainly of Cremonese birth, but it is known that he began his career as an independent artist there. In the course of the 1520s, however, he must have been in Parma, intensively studying the production of Correggio. Sojaro's first major surviving painting, a fresco of the *Resurrection* in the Cremona Duomo (1529), pendant to the *Pietà* of 1522 by Pordenone, is inevitably influenced in its particular mode of illusionism by its neighbour, but is more wholly formed by Parmesan experience. His subsequent work in Pavia (1531) and at Piacenza (1543, again in the immediate vicinity of works by Pordenone) allows no doubt of the continuing primacy for Sojaro of Correggio's example. His interpretation of Correggio's style was unfortunately graceless and pedestrian, and it was subject to the ponderousness and literalness that the Lombard disposition shows when it is least inspired. Sojaro's most accomplished work, the large fresco *Multiplication of the Loaves and Fishes* (Cremona, S. Pietro, 1552), recalls Correggesque style only in its outward guise, which is a mask for its essential Lombard stuff of realist detail and illustration. There is as yet no accent in Sojaro of Maniera, but his next work shows the compromise that he felt forced to make with the primacy that had been established all around him of Mannerist style: his fresco in the centre field of the nave vault of S. Sigismondo, the *Ascension of Christ* (1553), reworks Correggio's forms into a grossly heavy Romanism based in part on Pordenone but more on Mantua. A pretentious rhetoric dictates the posturing of figures but does not move them.

From 1560 to 1572 Sojaro was mainly employed in Parma and there demonstrated, in his dome of the church of the Steccata (1560-6), how his acquired Romanist emphases could make even a direct plagiarism from Correggio quite dull. His last work, an altar of the *Assunta* for the Duomo in Cremona (1573), petrifies a style that, until then, had been no worse than wooden. Yet here, as with the hardened Maniera of the late Giulio Campi, we are dealing with a phenomenon that is not merely negative but reflects a new tendency of artistic thought, of which we shall examine the meaning in a later context.

MILAN AND PIEDMONT

There is a disparity between the nature of Milan in the earlier sixteenth century as a metropolis in terms of size and – even under the successive French and Spanish dominations – as a locus, if not as an agent, of political power and its role as a metropolis of art. Even in the Quattrocento, when Milan was a major independent force, no great school of art had arisen there. Nevertheless, in the later years of the fifteenth century there had been enough accumulation of patronage and practice in Milan to dominate the modes of near-by towns and influence the western Lombard territory. Artists working in Milan, but not necessarily of Milanese origin, led in the formation of what seems to be definable as a Lombard taste, of which we have already seen symptoms that persist into the Cinquecento. But this taste emanating from a capital was still provincial in that its main constituent was mimesis, bound to an idea of art that (both historically and in terms of development of artistic thought) preceded the aesthetic factors of artistic style. It was thus at variance with the essence, so conspicuously styled, of the new art that spread from sixteenth-century Venice towards Lombardy, and it was equally at variance with the

demonstrations of the bases of a Cinquecento style that Leonardo made, still within the Quattrocento, in Milan itself.

The effect of Leonardo's example during his two visits (1482-99; 1506/7-13) was inevitably major, yet it was significantly incomplete. He attracted the majority of the Milanese painters of the earlier sixteenth century to his model in degrees that ranged from intelligent selection from it to mindless following. He worked profoundly on the strongest native personality of the Milan school, Bramantino, yet left the surface vocabulary of his style virtually untouched. Bramantino was the Milanese who most nearly came to penetrate the sense of Leonardo's Cinquecento classicism; conversely, Leonardo's closest overt imitators were the ones who tended least to understand what the principles of his art meant. In between, a personality like Luini combined, not always wisely, the main possibilities, Leonardesque and Lombard, which the situation in Milan offered. There is frequent conflict in the history of Milanese art in the first decades of the century between the outward look of styles and their substance. In the course of time the problem tended to evaporate as mannered Romanism, mostly in its Emilian and Lombard-Emilian forms, infiltrated Milan, displacing both Leonardo's and Bramantino's examples, but not the native inclination of the place towards verism.

The real sense of Leonardo's style, difficult enough for the Milanese to assess within the sixteenth century, was almost inaccessible to them on his first visit. Some older leaders of Milan's native Quattrocento school were not touched by it at either time. Foppa and Civerchio evaded Leonardo's art by removing themselves from Milan, the former to work in Brescia and the latter in Brescia and in Crema, while Bergognone's later practice (lasting until 1522) was confined mostly to the smaller towns outside Milan. However, other painters of the

older generation fell in time under Leonardo's influence. Ambrogio de Predis (Preda; c. 1455 - after 1508) was the first of the Milanese to be brought into relationship with Leonardo, attached to him by contract in 1483 as a collaborator in the execution of the altar for the Confraternity of the Conception, the *Virgin of the Rocks*. He had earlier been mentioned as a portraitist and as a court painter for Ludovico Sforza, and later is documented as a miniaturist. He had a miniaturist's manual skill, and used it to emulate the draughtsmanly and luministic finenesses of Leonardo's art, but for a realistic purpose that was no more than a lopsided fraction of what was in the style of the Florentine. The inaccessibility to Ambrogio of more than this in Leonardo's meaning is demonstrated in his extensive intervention in the London version of the *Virgin of the Rocks*.[22] Bernardino de' Conti (fl. 1490–c. 1522) belongs more inextricably to the Quattrocento style. Only tentative touches of Leonardism qualify his rigid portrait style about 1500; later, when he imitated Leonardo more, at least in superficial aspects, he imposed them on a basis that was still archaizing. Andrea Solario (1450–c. 1520) was an artist of quite different merit as well as more complicated background. He appears to have been trained by a sculptor brother, Cristoforo, and was already a mature artist when, in 1490, he accompanied Cristoforo to Venice. There the art of Bellini and still more of the Flemish-oriented Antonello made a profound impression on Andrea. His earliest dated painting, of 1495, a *Holy Family with St Jerome* (Milan, Brera), is from Murano; in it Lombard realism is sophisticated by Venetian and Flemish references and penetrated by a Venetian sense of structure. In 1507-9 he worked in France, as decorator in the Château de Gaillon, where again he would have been exposed more directly to North European style. His structural sense persisted through the ac-

cumulation of realist experience, and when, again in Milan, Andrea began in the late years of the first decade to reshape his style on Leonardo's, he was equipped to understand it not just in its apparent sense of consummate description but in its working of design. Comprehending principle, it was unnecessary for him to produce mere literal imitation; in his *Vierge au Coussin Vert* (Paris, Louvre, 1510-15), for example, Solario achieved a style that adapted Leonardesque forms and means but incorporated them into a firm and subtle handling that was his own. Solario was not so close in outward aspects to Leonardo's manner as was Giovanni Antonio Boltraffio (1467-1516), who became Leonardo's friend as well as follower. However, an essential difference in temperament, as well as the results of his pre-Leonardesque training, inoculated Boltraffio against exact dependence upon Leonardo. The converse of Leonardo's complications and sfumati of both form and thought, Boltraffio's disposition was to clarity and simple statement. Despite his occasional closeness of approximation to a Leonardesque style (as most of all in his *Madonna*, Milan, Poldi-Pezzoli), Boltraffio's more accustomed affiliation was with an older mode. The kind of classicism he achieved is rarely Leonardo's; more often it is of the more passive and constrained sort – like Foppa's or the earlier Bramantino's – that belongs to the late Quattrocento style. His time of nearest relationship to Leonardo was in fact in the last years of the fifteenth century and in the first half-decade of the next, and in the last ten years of practice that remained to him he turned by degrees more nearly towards the native and non-Leonardesque aspect of the Milanese style.[23]

None of these artists was so literally imitative of Leonardo as painters less rooted by age in the Quattrocento could become. Marco d'Oggiono (c. 1477–c. 1530?) took over Leo-

nardo's types, his chiaroscuro, and in many cases his inventions of motif more obviously than the older artists, but this apparatus merely cloaks the archaism of the form beneath, and hardly modifies the painter's pedestrian care for realism. Giampetrino (notices 1508 to 1521)[24] was a more exact exploiter of Leonardo's repertory, not quite so harsh as Marco. What both do to their model is instructive of the stubbornness in them of traits that are native to their school. Leonardo's modes of drawing and chiaroscuro are denatured to become descriptive tools, affirming a glossy verity, essentially inert, and his complex and precarious emotion slides off – as so easily it might in imitators' hands – into illustration. There are other imitators in Milan not less convinced than Marco and Giampetrino, but more retardataire, such as the curious Francesco Neapolitano or the anonymous Master of the Pala Sforzesca. Two names, one of them a near-myth as an artist, the other apparently altogether so, are also attached to Leonardo's school. The former is Francesco Melzi (1492–1570?), a young Milanese nobleman who was a companion of Leonardo from about 1507 till his death, and apparently more dilettante than serious practitioner;[25] the latter Salai (Il Salaino), a handsome but disagreeable domestic of Leonardo whom he seems to have taught a little of the painter's trade.

In the context of response to Leonardo of the kind we have described so far, Cesare da Sesto (1477-1523) is projected to significant stature. He had no major talent but he possessed, to a degree uncharacteristically Milanese, a sensibility and intelligence that permitted him to penetrate beneath the skin of Leonardo's style. Furthermore, alone among these Leonardeschi, Cesare's exposure to the modern world of art extended far outside Milan. We have no information about his teachers, and no work that predates the second decade, but it seems almost certain that we can identify him first in Rome in the neighbourhood of 1505, as a collaborator of Peruzzi. He seems to have remained in Central Italy at least until 1510 (but possibly until c. 1512), and his Roman associations must have included, beyond Peruzzi, the Lombard-Sienese Sodoma, still discernibly Leonardesque; he must also have known the early Roman works of Raphael. It is virtually certain that Cesare saw Florentine painting of the first decade, too, as well as the earlier leavings there of Leonardo. On his return to Milan he was able to effect a form of fusion of the more recent, and especially Raphaelesque, developments of Central Italian style and the dominating model in Milan of Leonardo. In his full-length *Salome* (best version in Vienna, Kunsthistorisches Museum, c. 1512) Cesare's tenor of expression, his specific types, and his theme are based on Leonardo, and, equally important, most of his manner of working up the picture surface. But the canon of the human form and its articulation are derived from Raphael, as Cesare could have seen them in the early stages of the Segnatura. In the figures of the *Baptism*, of the same period (once in the Milan Mint; now Milan, Gallarati-Scotti Collection), Cesare's alteration of Leonardesque types towards a smoother, slightly vapid grace is in recollection of the Raphaelesque style.[26] His working with motifs from both sources takes on an almost programmatic sense: a *Holy Family* (Elton Hall, Carysfort Collection), interweaving the *Virgin of the Rocks* with the *Madonna di Foligno*, indicates the deliberateness as well as the skill with which Cesare applied himself to the union of Leonardesque and Raphaelesque ideas. However, Cesare's intention and his effects were not always so classical as those of his identifiable sources. His sensibility exposed him to the fascinations and the risks that paraphrase of Leonardo's subtleties involved, and the states of mind that he depicts

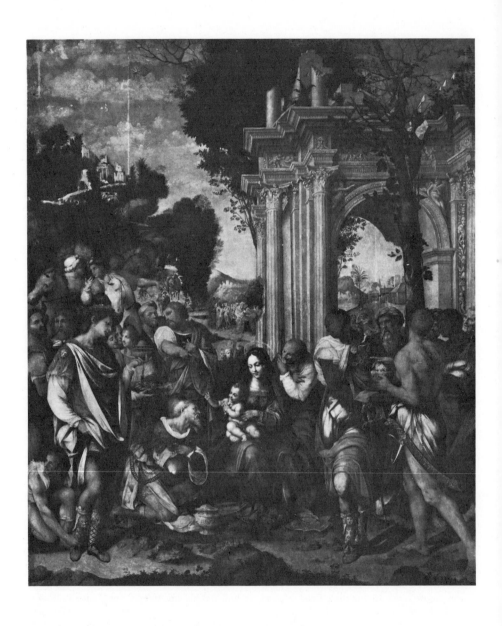

162. Cesare da Sesto: Adoration of the Kings. *Naples, Capodimonte*

- and his forms, on occasion, too - may be of a slippery obliqueness, with accents of expression or description that may turn Leonardo's precedents towards caricature.

Cesare's stay in Milan was brief. In 1514, accompanied by an assistant, Aliprando, he departed from Milan (as Leonardo had the year before) and travelled southward, almost certainly again through Rome (and probably through Florence and Siena also), to settle for a period of about six years in Naples and Messina. The works he left there were major factors in the tardy conversion to a sixteenth-century style of those local schools. His most important picture of this southern stay, an *Adoration of the Kings*, painted for Messina (Naples, Capodimonte) [162], perpetuates the synthesis he conceived earlier, but in far more complex and sophisticated terms. The old Leonardesque repertory is given subtler exposition, and it is accompanied now by the results of study of the very recent Raphael. Raphael's *Spasimo di Sicilia* [29], in Palermo shortly after it was painted (but also engraved in 1517), is a particular source not only for enriching motifs but for more substantial structural elaborations. There is also an indication, but not proof, in the *Adoration* of Cesare's recent renewed contact with the Romanized Sienese Peruzzi and Sodoma. A consequence of this most developed kind of interaction between a Leonardesque past and contemporary Raphaelism is a style that resembles the current Sodoma in principle and considerably in aspect. It is as sufficient an approximation of contemporary classicism as Sodoma's: more consistent but less forceful, tending to a refinement more extreme than his and towards more mannered grace. This style is not now specifically Milanese but a more general phenomenon, which Cesare has conveyed throughout the length of the peninsula.

Cesare did not maintain this standard. Returning to Milan about 1520, he left one more major work there in the year he died, a polyptych of the *Madonna in Glory* with attendant single figures of saints, for the church of S. Rocco (Milan, Castello Sforzesco, 1523). Another trip through Rome for Cesare, increasingly assiduous in his regard for Raphael, finally weighed him down with the baggage of motifs which, in this last work - inhibited in part by its archaic Lombard form - he could no longer synthetically recombine. But in the course of his career he had achieved a historical function of modest consequence by his eclecticism, as the agent of transmission of elements of Raphaelism to the north, and of Leonardism to the south of Italy.[27]

Bartolommeo Suardi, Il Bramantino, born in Milan *c.* 1465, was of an age to have a formed style by the time Leonardo's work became a meaningful example in Milan. Substantially educated by the older Bramante, from whom he took his name, Bramantino belonged on this account in the line of descent from Piero della Francesca, carried by Bramante from Urbino; this represented a tradition - the structured but immobile realism of the Quattrocento - that was fundamentally distinct from Leonardo's thought. In Milan, in Bramante's hands, this tradition had been altered by a new infusion of expressive force and by a sharper focus in description. Acquiring these new elements of style from his master, Bramantino employed them yet more energetically in his earliest works. In the *Nativity* (Milan, Ambrosiana) of the early 1490s he does not just incisively describe but manipulates appearances into excitant silhouetted patterns. In his *Ecce Homo* (Lugano, Thyssen Collection, *c.* 1495), adapted frankly from a model of Bramante's, Bramantino finds, with more authentically Milanese tendency, a more trenchant verism - not self-sufficient, but the means by which he could transmit an intense expressiveness. The Bramantesque rigour of structure in the *Ecce Homo* is more pronounced than in the earlier *Nativity*, and in the

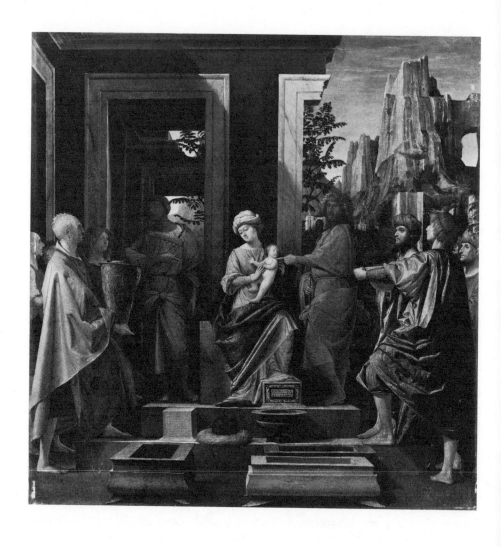

163. Bramantino: Adoration of the Magi, 1500–5. *London, National Gallery*

Adoration of the Magi (London, National Gallery, 1500-5) [163] it has become the picture's dominating effect, seeking architectonic and geometric logic of a purity beyond Bramante's. Still sharp in its rendering of form, and more acute in its sensibility to light, the *Adoration* seems not only a development on Bramante's style but a re-creation of its sources in Piero. But the stringency of logic of form in the *Adoration* and the arbitrariness with which Bramantino pursues it are not just the end product of an old idea but the symptoms of a kind of thinking that belongs to sixteenth-century style. Only a few details in the *Adoration* reveal that Bramantino had studied Leonardo; neither the rigidity of design nor the probing technique resemble his, and the effect of the structure still is more akin to that of a quattrocentesque classicism. Yet the elevation of aesthetic principle in this structure to the status of a commanding, indeed virtually absolute idea is what Bramantino could have grasped in Leonardo's first work on a grand scale in Milan, the *Last Supper*. The presence of the Leonardesque principle in Bramantino's painting is more important than the few confessed Leonardesque details. It remains that the new principle has been imposed upon an order that is deduced from a rectilinear perspective logic. This coexistence between a new aesthetic principle and an older system of design will persist, determining, beneath the subsequent changes in Bramantino's vocabulary, the peculiar relation of his style to Cinquecento classicism.

The likely painting in which the significant change in this vocabulary occurred is a fragmentary fresco *Pietà* (from S. Sepolcro, now Milan, Ambrosiana, *c.* 1505?), in which the sharpness of description of the earlier works appears only in details, while the larger forms become generalized geometric volumes; Bramantino now imposes on his figure style as well the principle of primacy of aesthetic idea. Projected against a recognizably cinquecentesque architecture like the contemporary Bramante's, the figure composition is itself simply architectonic, its rectilinearity and symmetry only a little relaxed. The fresco nowhere quotes directly from Leonardo, yet the change of form in it from precise angularity to rounded generalization comes in all likelihood from him. Before 1508, Bramantino designed tapestries of the Months for Gian Giacomo Trivulzio (Milan, Castello Sforzesco, woven by 1509). The themes require a rich variety of *dramatis personae*, setting, and illustrative incident, but the way in which this matter is presented shows (even through the disfigurement by the weavers) a style that essentially resembles that achieved in the *Pietà*.

Bramantino was among the group of artists summoned to Rome to work in the first campaign of decoration of the Stanze in the Vatican. His presence there is documented in December 1508, and by December 1509 he was again in Milan; no work by him survives from this Roman year. Bramantino could not have learned much that was significant for his progress from his pre-Raphaelite associates in Rome, but a stop in Florence would have served to acquaint him with the fact that Leonardo's Milanese inventions could have other kinds of consequence than the limited ones Bramantino had so far drawn. After his return to Milan, Bramantino was prepared to accept more of what Leonardo had demonstrated – mostly, however, still in the *Last Supper*. The broad cursive rhythms that move form, not just enclose it, the amplitude of shape and the dignity of mood that appear in Bramantino's best works of the second decade are further deductions he has made from Leonardo's style; nevertheless, the use he puts them to remains his own. The *Madonna* fresco once in the Palazzo della Ragione (Milan, Brera, *c.* 1510-12) has an almost ponderous dignity, which he has enlivened by a warmth of colour and by a

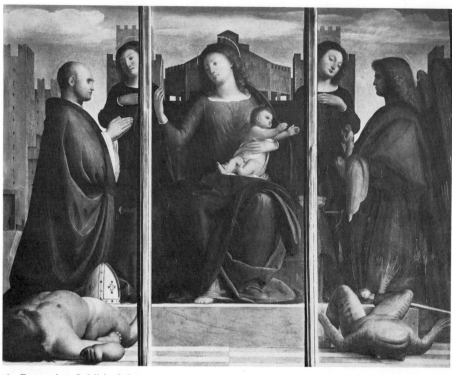

164. Bramantino: St Michael altar.
Milan, Ambrosiana

corresponding warmth of emotion rare in the mature Bramantino. The *Holy Family* of *c.* 1515 (Milan, Brera) is a more abstracting and emotionally distanced image; a little later, the *St Michael* altar (Milan, Ambrosiana) is still more removed [164]. The impulse, Leonardesque in origin, that briefly summoned Bramantino's forms to near-mobility recedes beneath a will to make geometry as rigorous and pure as in an architecture, and as abstracting as the requirements of representation will permit. As if to symbolize his point and make it still more clear, Bramantino's backgrounds, looming silhouettes of an imagined and unpeopled architecture, constructed with a rule and square, take increasing prominence in his designs. Against

such settings the effect of a consonant geometry in the figures is doubled: they seem as generalized in feeling as in form, quiet in an ideal symmetry of total stillness. The extreme ideality – more properly, near-abstractness – of description and design exaggerates the principles of Cinquecento classicism, denaturing them in a double sense.

The evocation of a still and removed world is in Bramantino's ordering even of the tragic drama of the *Crucifixion* (Milan, Brera, *c.* 1520) [165], impressive in the grandeur of its forms, but a little vacant. It is the vacancy that displaces grandeur in the succeeding years, but because Bramantino never quite wholly moved in the domain of Cinquecento classicism, it is

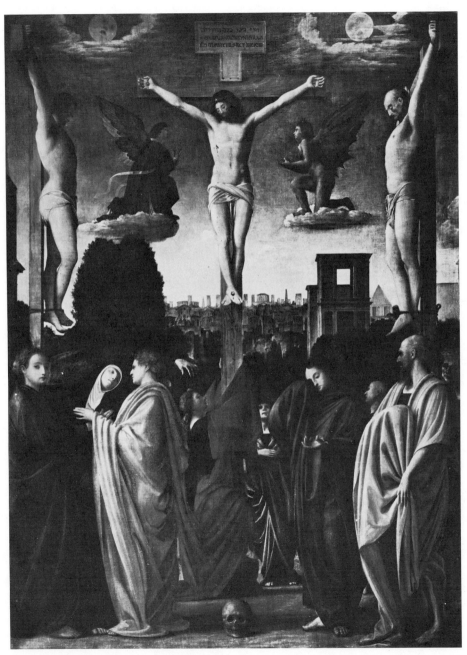

165. Bramantino: Crucifixion, *c*. 1520. *Milan, Brera*

not exact – though it is suggestive – to speak of his work of the third decade as exhibiting the traits of a vacated classical style. Nevertheless, what until then had been a beautifully deliberate geometry turns gradually in the pictures of his last decade (he died in 1530) into deadened pattern, made as if by routine, and his figures acquire the look of mournful, structureless automata (e.g. *Pietà* from S. Barnaba; now Milan, Werner Collection; *Pietà* and *Pentecost*, Mezzana, church). There is a private pathos in these later works, but it is so inward and so weak that it barely reaches to the viewer. This kind of abstraction from a classicizing style was not dictated, like that of contemporary Mannerism, by creative principle but by a negation of it that could have no future consequence.

What Bramantino represented in Milan was not so much tradition native to the place as an acclimatized one, imported there from Central Italy, by long detour, before the time of Leonardo. A more truly native Milanese tradition had its representative in the early sixteenth century in Bernardino Luini (*c.* 1480?-1532), and it was he who gave it viable existence alongside Leonardo's newer foreign style, taking as much from Leonardo as his roots in his tradition enabled him to comprehend – which was superficially considerable, but in essence almost nothing. Much more Leonardesque in outward aspect than Bramantino, Luini in principle approached Leonardo less: in Luini's tradition there was no such link with Leonardo – i.e. between successive phases in the development of classicism – as there was in Bramantino's. Luini made a willing and facile compromise at no real cost, by which he at the same time satisfied conservative Lombard taste and the wish in that same taste to be adequately of the modern fashion nonetheless.

If a *Madonna with St Augustine and St Margaret* (Paris, Musée Jacquemart-André) signed 'Bernardino Milanese' and dated 1507 is in fact by Luini (as current critical opinion

thinks), it is an index of the solidity of Luini's training in a veristic, rigid Quattrocento style.[28] The attribution seems convincing, perhaps less on Morellian grounds than on those of the temperament and formal habits that the work reveals, which reappear almost unchanged beneath Luini's later Leonardesque disguise: a heaviness of forms, a mechanical simplicity of structure, and a stressed but superficial psychological content. We have no trustworthy knowledge of the steps that intervene between this style, already wholly formed, and Luini's transformation towards modernity. About 1512, his fresco *Madonna Enthroned* in the abbey of Chiaravalle is no less wholly in the style by which we universally recognize him. Leonardo's models of a quarter of a century before and the current propaganda of the Leonardeschi are the primary agents of this transformation, but Bramantino's influence is present too. Expression and typology are agreeably simplified from Leonardo, and though form is still ponderous, it is at least remade in part according to a cursive scheme. But this is a *sauter en avant pour mieux reculer*: finding the old Foppesque vein again beneath his modicum of borrowed modern apparatus, Luini's *Pietà* of *c.* 1515 (Houston, Museum, Kress Collection) is a compilation of inertias, of stiff, vacant shapes that carry a Leonardesque glaze. As Luini sees it, the first function of the picture is to illustrate, and what he concedes to Leonardo's lesson is no more than a cleaning up and polishing of appearances and psychological expression. It is not altogether a merit that Luini, unlike his less urban Lombard colleagues, makes out of this middle-class rather than *popolano* illustration. The grander version of this theme in S. Giorgio al Palazzo (1516) is even more archaic, with the specificity and garrulousness of narrative that we expect only in the naïvest religious art. It is more accumulated than composed; and as in sign painting, the only role design has is to make the matter

legible. The fresco decoration once in the Cappella di S. Giuseppe in the church of S. Maria della Pace (detached and reassembled in the Brera; 1518-20) is more coherent both in structure and in devices of narration, and here the attractions that Luini can possess may be discerned. He has the virtues of the popular illustrator: able to make narration clear and garnish it with engaging incident, he prettifies reality but does not remove it from the common sphere; his art entertains, and it is utterly accessible. He is a Milanese Benozzo Gozzoli. Occasionally his simplicity of spirit coincides with the content of a story, as in the *Dream of Joseph* in this series [166], and then simplicity is transmuted into an almost poetic purity. This is what occurs in the two fresco series painted in the town and country houses of the Robia family (1520-5), the former with mythological

166. Bernardino Luini:
Dream of Joseph, 1518-20.
Milan, Brera

subjects entirely, the latter with religious themes as well (now Milan, Brera; Berlin, Museum; Washington, National Gallery; and elsewhere). In his treatment of the mythologies especially, Luini's naïveté becomes – by accident, not by design – a virtue, endowing them with a freshness like that of a fairy tale, and with a fairy-tale quality of not being realistically plausible. Colour in the frescoes, silvery and pale, recalling the tonality of Foppa, increases the sense in them of a removed world. It verges on the improbable that within the third decade of the sixteenth century Luini should still conceive the ancient myths in the same spirit as the Quattrocento did.

There is no further genuine development in Luini's art. In the early twenties an occasional Leonardesque Madonna (e.g. the *Madonna del Roseto*, Milan, Brera, or the *Madonna with St John*, Paris, Edouard de Rothschild Collection, or a *Salome*, Boston, Museum of Fine Arts) is worked with finer subtlety of touch and feeling than before, and on occasion he may even verge on elegance; his style acquires a higher surface polish. In general, however, this polish is applied to works in which components that are previous to classicism become yet more apparent than before. His most important later fresco scheme, with scenes from the lives of the Virgin and Christ (Saronno, S. Maria dei Miracoli, 1525), is ordered by pure Quattrocento principles, and its overt illustrative purpose is as great as, and its verism greater than, in his works from the previous decade. In 1529 his fresco *Crucifixion* in S. Maria degli Angeli at Lugano is almost primitive illustration, part realism and part heraldry. The most sought-after *frescante* in the Milanese, he spent his latest years in decorations in the city, at Lugano, and at Saronno again. His popularity was no accident but the product of a perfect accord between the artist and his public; the counterpart of that public still exists, and so does Luini's popularity.

Among the early-sixteenth-century Milanese there is still evidence of the sympathy their Quattrocento predecessors had shown for northern European art, but there is nothing in Milan that compares with the kind of real affiliation with transalpine style that the Piedmontese (and the painters of the Genoese region also) displayed in the fifteenth century, nor the instances of its almost unmodified persistence in the sixteenth. Defendente Ferrari (born at Chiavasso near Turin c. 1490), active in the area of Turin and at Ivrea, was the most important master working in this vein; dated works that range from 1511 to 1535 show, in his beginnings, a style that is more readily exchangeable with that of contemporary France or Flanders than with Cinquecento Italy. Late in the third decade and in the early fourth he modified his manner somewhat, touched by the effect of spreading Milanese example; but what he achieved then is still no more modern in essence nor less Gothical. Gaudenzio Ferrari (not a relative) was even more a *montagnard* by birth (born at Valduggia, between Novara and Varallo, c. 1475/80, died in 1546 in Milan), and his first works have a strong accent of the same transalpine inclination.[29] But Gaudenzio was less provincially isolated than Defendente, and he early and decisively turned his attention towards the busy prospect of activity in the Milan school. In 1511 his ancona in the Collegiata di S. Maria at Arona has the graphic insistence and some of the eccentricities of Gothicizing form that mark the older Piedmontese mode, but it is also deeply penetrated by the art of Leonardo. The best analogue of style for the Arona altar is in the contemporary Bramantino, who may have been, more directly than Leonardo himself, Gaudenzio's model. Stretching his perspective farther than Milan, Gaudenzio has also closely studied a work by Perugino (an *Adoration of the Child*, at that time in the Certosa of Pavia) and has based the central panel of his altar on it. Gaudenzio's

studies partly extricate him from his peculiar Quattrocento origins, and partly align him with a classicizing (and eventually Central Italian) artistic culture, though not with its most modern aspect. His previous background and a temperament conditioned in it are not amenable to Bramantino's or Perugino's geometric immobility, their emotional remoteness, or their moderation of effects of realism; nor is their kind of art the best adapted to communication with an almost transalpine and Gothically-minded public. When in 1513 Gaudenzio depicted Christ's Passion in a fresco series in the mountain sanctuary town of Varallo (Varallo, S. Maria delle Grazie), the classicist and Milanese elements of his manner in the Arona altar receded, while those of the local dialect re-emerged, with all their implication of connexion with North European late Gothic style. A pointing and at times turbulent graphic mode is used to make popular communication, emotionally surcharged, gesticulative, and realist in detail. The relation to Germanic style of Gaudenzio's ancona at Novara (Novara, Basilica di S. Gaudenzio, 1514-16) is as pronounced, but at least the Germanicisms are contemporary. However, even as Gaudenzio continues to exhibit this overt sympathy with transalpine art, he once again takes up the Leonardesque propositions of form he had learned earlier. In this altar, or more completely in the *Madonna* in the Brera of c. 1516, he approximates the formal repertory of a classicizing style.

After 1517 Gaudenzio began to work intensively at the Sacro Monte at Varallo,[30] the earliest and most remarkable example of the shrines in North Italy that were designed to be stimulants to faith among the Italians who were most exposed to the disturbances across the Alps. Addressed to the least sophisticated level of the population, in the region least penetrated by the Renaissance, the contents of the Sacro Monte were not conceived of as works

of art in the developed sixteenth-century sense. Art in them was wholly a means and not at all an end; its sole use was to recreate the utmost that it could of a reality. At the Sacro Monte the various chapels that illustrate the history of Christ [167][31] are identical in kind and purpose to what waxworks, or the dioramas of a natural history museum, are today. Their main com-

167. Gaudenzio Ferrari:
Crucifixion, shortly after 1520. *Varallo, Sacro Monte*

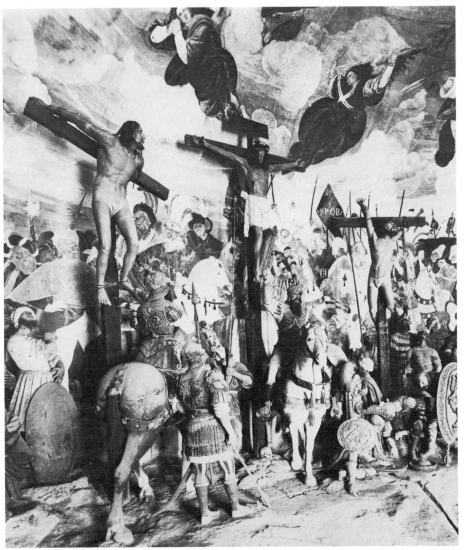

ponents are life-size statues made of polychrome terracotta, set as if on the full depth of a stage (which, however, has no clear delimitation from the spectator); where the sculpture stops against the wall, painting takes up and uses its devices to continue the illusion of the staged event into a farther depth. The elementary idea is not Gaudenzio's; it had precedents in art of Late Gothic realist tendency elsewhere in Italy, and particularly in the north; furthermore, it must follow from a stipulation of Gaudenzio's patrons. However, the development of the idea to the degree it finds at the Sacro Monte is Gaudenzio's responsibility, and this development is so extreme that it takes on the effect of radical invention. Art summons the historical event to physically present reality, and the spectator for whom the image was intended was not meant to see the art but only this reality, responding to it as to a truth of his own place and time. As far as it is in the power of art to do so, it denies all virtues in itself that are not those of an *ars meccanica*, reposing meaning solely in an act of imitation. This is true of the conception of these images in general, and of the sculptural portions of the dioramas in particular, which are not only of Gaudenzio's design but in some instances even finished by his hand. But the painted extensions of the scenes assume a different character: as the image recedes from the spectator it ceases, when the painted wall is reached, to be clumsy but inescapably present reality and turns into expressive transformation. In the painting, the realist elements count less than the caricatural and exotic imaginings of type and costume; but, more important, both are embedded in exciting patternings of form, and the same excitement works through colour, making sharply salient, fantastic radiances in it. There is some analogy in Gaudenzio's images at the Sacro Monte to Pordenone's at Cremona, but while the latter are popular in their intended religious effect, they are far from invad-

ing the domain of folk art, as the chapels at Varallo do. There is more likeness in the temper, sometimes turbulent, that their styles share, but the difference between them persists, made by Pordenone's profound and telling contacts with Cinquecento classical style.

The context of the Sacro Monte impelled Gaudenzio's painting there towards what may be described as a translation of late Gothic provincial ideas into a modern vocabulary, learned mostly from Milan. Relieved from this context, Gaudenzio turned – as if seeking to redress a deviation – more decisively than before towards cultivation of the modern aspects of his style, chastening and controlling the eccentric energies he had given rein to on the Sacro Monte. The first result of this new direction was Gaudenzio's altar, the *Madonna degli Aranci* (Vercelli, S. Cristoforo, 1529) [168], with classical elements in it that clearly refer to Leonardesque Milan. If only for the moment, the style of this painting makes an analogue, closer than on the Sacro Monte, with the contemporary Pordenone – who, too, had now become more controlled. In 1529–32 Gaudenzio was once more engaged on an extensive fresco work, depicting a *Crucifixion* and stories from the lives of the Virgin and the Magdalene, in the same church as the *Madonna degli Aranci*. The frescoes are more pointed and realistically illustrative than the altar but have little in them of the violent, fantastic temper of the Sacro Monte. A large canvas of the *Crucifixion* (Turin, Galleria Sabauda, *c.* 1535, from Casale) shows that Gaudenzio's expressiveness, called forth once more by the theme, is not diminished but in fact controlled, and by an ethos formed by modern classicism. Recollecting episodes from the Sacro Monte and some of the pointed and expressive patterning that served as an emotive agent there, the *Crucifixion* superficially resembles its antecedent, but the essential tone of feeling – grave and deliberately styled – and the gravity of form

168. Gaudenzio Ferrari: Madonna degli Aranci, 1529. *Vercelli, S. Cristoforo*

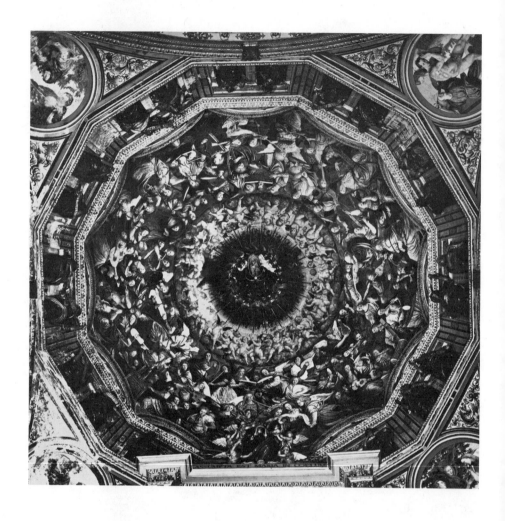

169. Gaudenzio Ferrari: Assumption, 1534/*c.* 1537. *Saronno, S. Maria dei Miracoli*

are in Gaudenzio's newer vein. In 1534, two years after Luini's death had left a project for the decoration of the dome at Saronno in suspense,[31a] Gaudenzio was commissioned to paint an *Assunta* for it, which he completed about 1537 [169]. Tiers of angels, in an inspired variety of postures, make musical celebration of the miracle as the Virgin is borne upward through them. The painting has a power of illusion that derives from the energy of its close-packed plastic forms, and a visual excitement that is made by sharp-etched rhythms and by high-keyed colour. This is now, in a more instantly apparent way than in Gaudenzio's preceding works, the product of a thoroughly contemporary sophistication. It is, moreover, original in conception and in means; one looks in vain in it for evidence of contact with the precedents of Correggio or Pordenone.

Some time between 1535 and 1539 Gaudenzio confirmed his growth beyond the limits of a Piedmontese provincial culture by taking up permanent residence in Milan. But the effects upon his art were hardly salutary, for he sacrificed the imaginative and expressive liberty of one provincial style to the much more pedestrian realist and illustrative mode that characterized another. His *Road to Calvary* (Cannobio, Sanctuary, *c.* 1540) lies at the beginning of this process: the heavily pretentious, stiffened *Martyrdom of St Catherine* (Milan, Brera) completes it, and takes the further step (which in the 1540s was the mark of full modernity in Milan) of Romanism. It is as a *frescante*, in a medium where the dark and glossy realism to which the Leonardesque tradition had degenerated in these years could not so readily penetrate, that Gaudenzio maintained his merit in his latest years. Fragments of a late fresco decoration with the *Life of the Virgin* for S. Maria della Pace, finished (after Gaudenzio's death in 1546?) by pupils, survive in the Brera: they are open and luminous, and of an easy grandeur in their forms. There is

no touch of Mannerism in this latest style of Gaudenzio, any more than there had been in his preceding works. His history does not, as the literature on occasion claims, have to do with Mannerism, but is that of the difficult reconciliation of an artist more of the late Gothic than of the Renaissance with the modern style, of his command of it, and of his growth in style and stature beyond the limits of his provincial origins.

Gaudenzio had a considerable influence among the Piedmontese, and later in Milan as well. Among contemporaries from the Vercelli, school who had an education like his own, Gaudenzio had a marked effect on Eusebio Ferrari (again no relative; fl. 1508–32/3), and on Gerolamo Giovenone (fl. 1513–*c.* 52), who perpetuated a moderated and fatigued version of Gaudenzio's manner until the mid century.[32] The most able follower to be formed by Gaudenzio's example, Bernardino Lanino (*c.* 1512–1582), belonged to the next generation. Lanino distributed competent and softened paraphrases on Gaudenzio's mature style throughout eastern Piedmont and Milan until late in the fifth decade (e.g. *Madonna Enthroned with Saints*, Borgosesia, Ss. Pietro e Paolo, 1539). Like the later Gaudenzio, Lanino after 1550 made concessions to the impress on Milan of Romanism, but without gross change – even in the works that he manufactured so prolifically throughout the sixties and seventies (*Adoration of the Child*, Vercelli, S. Paolo, 1565) – of his Gaudenzian style.

EMILIA

We have already discussed the painters of Emilian origin whose genius elevates them to significance in the general prospect of art history in sixteenth-century Italy. In Parma, Correggio and Parmigianino – the latter in Bologna also – assume this status, as does Dosso in Ferrara. Our account here of painting

in these main Emilian centres is thus confined to personalities of a lesser order who, however, are not all by any means mere dependents of the greater men. There are frequent interchanges among these centres, in patterns that are not always determined by vicinity, and in which Mantua, Lombard by boundary but Emilian by cultural affiliation, figures as a vital factor in the Emilian constellation. Geography does affect the sympathy with which Ferrara on one side regards Venetian painting, Parma on the other Veneto-Lombardy, and Bologna Central Italy. In the course of time the expanding authority of Central Italian style came increasingly to count above the others, because of pressures not only from the south but from Romanism's northern outpost in Mantua. We have had repeated occasion to remark how then, in turn, Emilia was a place of relay for the influence of Central Italy into Lombardy.

In Ferrara, the history of painting in the sixteenth century opens with an undistinguished peace. The best painters of its Quattrocento school, Roberti and Costa among them, had emigrated elsewhere, attracted particularly to the larger opportunities of Bologna; Boccaccio Boccaccino, whose earlier career had been Ferrarese, departed for Cremona. The painters of any visible stature in Ferrara in the first decade of the new century were few. Domenico Panetti (c. 1460-before 1513) continued, in still lower key, the example of a languid détente classicism given by Lorenzo Costa. Niccolò Pisano, as his name implies of Tuscan origin (fl. 1484-1538), appeared in Ferrara in 1500, by then middle-aged, and worked in a vein of the utmost conservatism, accommodating a style based on Ghirlandaio to the local taste. Giovanni Battista Benvenuti, called L'Ortolano (fl. before 1488-c. 1525), at first was not much less attached to quattrocentesque principles, derived in his case mostly from Roberti and Boccaccino, but then compounded with more recent Bolognese (and perhaps Venetian) ideas.

Throughout the first decade and well into the second his works display a realism and a depth of feeling, both equally shadowed, that have considerable strength but are no less archaizing on that account. Subsequently, as the new styles of Dosso and Garofalo rose to dominance in Ferrara, L'Ortolano modified his whole vocabulary towards theirs, towards Garofalo's especially, but it was not in his power to change his old-fashioned way of seeing.

Beside Dosso, Garofalo (Benvenuto Tisi, 1481-1559) was a much less significant exponent of modernity in Ferrara. Yet, earlier and more explicitly than Dosso, and more ably than Battista Dosso, Garofalo became the agent in Ferrara of Romanist style, so prolific in it that his production colours the general complexion of art in the city with his classicist cast. He took on this role a decade before Dosso, amenable to Garofalo's influence as well as to the more decisive one of Giulio Romano, made his similar option. It is likely that at the beginning of his career Garofalo, like Dosso, had contacts with Venice, but with no comparable effect upon his style. Garofalo had apparently been a pupil of Panetti, and his earliest works, still within the first decade, are in a manner which resembles that which Panetti had derived from Costa. But some among them (e.g. *Adoration of the Child*, Ferrara, Pinacoteca, c. 1508-9) reveal Garofalo's close acquaintance with the early *Allendale Nativity* of Titian (at that time in Ferrara?), and others (*Madonna with Saints and Donors*, Valcesura, church, c. 1510) have affinities with the earliest Giorgione.[33] Evidence of Venetian interest persists until early in the second decade. But in 1512 the dated *Neptune and Pallas* (Dresden, Gallery) [170] indicates the strongest inclination towards a classicizing style of a Romanist rather than a Venetian kind; the picture is, indeed, the

170. Garofalo: Neptune and Pallas, 1512. *Dresden, Gallery*

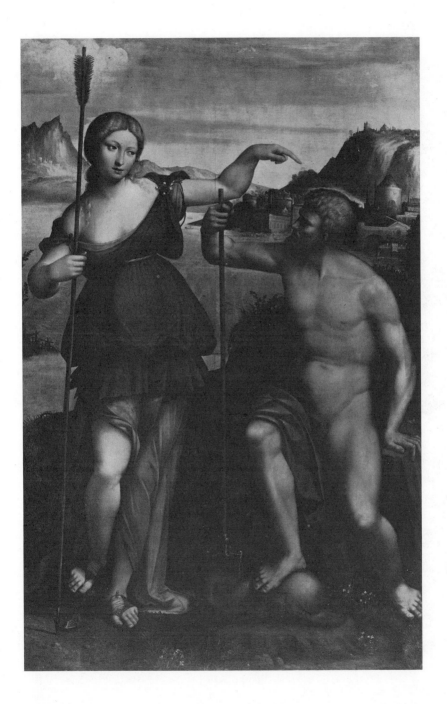

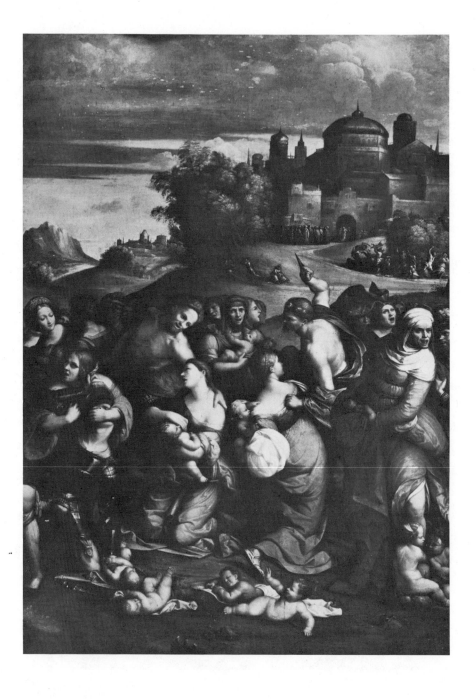

closest approximation by a painter of North Italy at this date to the current Roman language of the classical style. Late in 1514 a major altarpiece, the so-called *Madonna delle Nuvole* (Ferrara, Pinacoteca), is, from its subject matter, less overtly classicist, but is based upon ideas that seem almost certainly to have been acquired as late as 1512 in Rome. Garofalo seems to have been absent from Ferrara in 1515 and 1516, and it is usually assumed that his experience of Rome dates from that time. However, the language of the Segnatura and the *Madonna di Foligno* is already in these works of 1512 and 1514, and the trip of 1515-16 is more likely to have been a second visit. By the time of Garofalo's return to Ferrara he was, more than any other painter outside Raphael's closest Roman circle, or even outside Rome, a Raphael imitator. The *Madonna del Baldacchino* (from S. Guglielmo, Ferrara, now London, National Gallery, 1517) is not only taken from the Florentine altarpiece by Raphael but updated towards conformity with Raphael's contemporary style. The closeness of Garofalo's paraphrase of Raphael's vocabulary is remarkable, but his capacity to imitate Raphael's syntax is much less. There is still the insistent residue in him of the mentality of the late Quattrocento classicism – eventually a Peruginesque style – in which he was first formed, which gives his description and his mode of painting a laboured, over-smooth preciseness and his ordering of form a cautious rigidity. An elaborate Raphaelesque apparatus appears in the *Massacre of the Innocents* altar (from S. Francesco, Ferrara, now Pinacoteca, 1519) [171], and here the subject matter stimulates Garofalo to transcend as much as he is able his tendency towards stiffness in articulation. The design is based upon a thoroughly considered

171. Garofalo: Massacre of the Innocents, 1519. *Ferrara, Pinacoteca*

and developed classical scheme of counterpoise of mobile elements, somewhat too obvious in pattern and diminished by a too-polished execution, but accurately reflecting the advanced Raphael. Raphael, however, was not Garofalo's only model: Titian's recent Ferrarese activity in the Este *camerino* had revived Garofalo's early interest, resulting in enriched chiaroscuro effects and in an intenser colorism; Dosso's colorism also had begun to influence Garofalo.[34] It is thus a somewhat softened and more flexible mode that appears in Garofalo's paintings of the twenties, indicating that he had reached a compromise between his learned Raphaelism and qualities that he abstracted from Titian's and from Dosso's styles. But the temperament that makes the compromise is not only far more conservative than its exemplars, it is spiritually somewhat timid: Garofalo can appropriate appearances from the greater masters, but not their complexities or energies. Large altarpieces of the twenties (the *Madonna del Pilastro*, Ferrara, Pinacoteca, 1523; *Madonna Enthroned with Saints*, Ferrara, Duomo, 1524) exactly accomplish what is required to suit public taste, recasting traditional formulae of iconography into the outward aspect of a newer, more fashionable style.

Garofalo had been the first exponent in Ferrara of a simplistic version of the style of Raphael; when late in the third decade the symptoms of the Raphaelesque Maniera filtered northward into near-by Bologna, and Giulio Romano's Mantuan translation of Raphaelism matured, Garofalo responded to what he would have regarded as the newer face of the style to which he was already dedicated. Dosso's own conversion after 1530 to a classicistic mode would have been further encouragement to Garofalo to bring his Raphaelism up to date. During 1532 he painted on the one hand so conservative – and accomplished – a paraphrase of the *Madonna di Foligno* as his

Madonna in Glory (Rome, Capitoline), and on the other the *Madonna Enthroned* (Modena, Galleria Estense), which was clearly influenced by Parmigianino in the attenuation and the attitudinizing of its figure style. Given Garofalo's disposition, however, it was the classicistic rather than the Maniera aspects of post-Raphaelesque style that were sympathetic to him. His *Raising of Lazarus* (Ferrara, Pinacoteca, 1534) nicely balances the basic elements of his updated style: attenuated canon, stressed fineness of attitude, and classicistic stiffness; the preciseness of detail and polished execution that had before been discordant with a Raphaelesque classicism now conform to post-Raphaelesque practice.

Garofalo's art had always been more classicistic than truly classical, disjoined from the Raphael he had tried to imitate, but now he had fallen into true accord with a primary mode that post-Raphaelesque style had assumed. His disposition was much more towards Giulio's rendering of Raphaelism than towards Parmigianino's, and Giulio increasingly and more specifically affected the repertory, the structure, and the temper of expression of Garofalo's style. The *Blessing of St John the Baptist* (Bologna, S. Salvatore, 1542), architectonically disposed yet finely patterned, reveals Giulio's impression also upon Garofalo's handling of light and colour; it has the contrasting sharpnesses of chiaroscuro and the intense translucent colour, more glassy than metallic, of Giulio's style. Repeated contact in these years with Battista Dosso (and earlier with Dosso himself) made for vacillation in Garofalo's later style, and occasionally his paintings took on a cast resembling theirs in quality of surface and in colour. His latest dated work, however, an *Annunciation* (Milan, Brera, 1550), is in a purer, though somewhat pedestrian, transcription of contemporary high Maniera. He apparently was prepared, even at that date, to test yet another way to adjust his art in the direction

indicated by changing fashion. In 1550, however, Garofalo went completely blind, suffering a recurrence of a malady that had struck him briefly two decades before, and which now was permanent.

His had been a long career, in which he had been much more imitative than inventive: timid in his classical aspects, and more meticulous than precious in those that suggest affinity with Maniera. Nevertheless, his ambitious works maintained, almost continuously, a standard of distinguished competence, while in smaller pictures, where the measure of his talents and the scale of his effort could more nearly coincide, he often achieved results of exceptional attractiveness. In those smaller works his meticulousness of mind and hand were not a limitation but an asset, with which he worked on occasion to make a jewel-like effect.

The histories of the Ferrarese and Bolognese schools of painting intersect even more than is usual in the person of the first of the Ferrara-born artists who belongs entirely to the new century, Girolamo da Carpi. Born in 1501, the son of a minor painter of the city, he was (according to an old document, now no longer traceable) in 1520 in Garofalo's shop. By the middle twenties at the latest, however, he had taken up residence in Bologna, and he worked mainly there for about ten years. An initial Raphaelesque inclination acquired from Garofalo was accentuated in Bologna, and more quickly than in Garofalo or Dosso it was at once compounded and significantly altered by the influence of Giulio Romano. By 1530 or 1531 Girolamo was as expert in the transcription of Giulio's style as an exact pupil (cf. the *Adoration of the Magi*, Bologna, S. Martino),[35] and in 1532-4 his *Marriage of St Catherine* (Bologna, S. Salvatore) [172] penetrated not only Giulio's classicistic style but that difficult aspect of his mentality, at once brutal and *maniéré*, that he embodied in the *St Longinus*

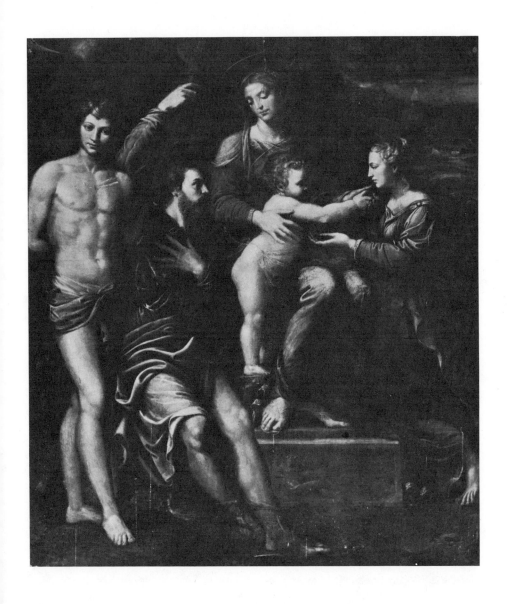

172. Girolamo da Carpi: Marriage of St Catherine, 1532-4. *Bologna, S. Salvatore*

altarpiece of 1531. After this, however, working mostly in Ferrara until 1549, Girolamo adopted a much less expressively erratic style, and one more in conformity with the modes of the two Dossi and Garofalo. On at least three occasions in the later 1530s and early 1540s Girolamo worked in collaborative projects of decoration for the Este *delizie* with Battista Dosso and, once, with Garofalo, and he was involved (apparently with some regularity) in the practice of the Dossi's shop. Girolamo's work is distinguished from that of his close colleagues in Ferrara by his more distinctly Giulian manner, smoother and more classicistically correct than that of the later Dossi, but more energetic than Garofalo's and more recognizably *au courant* (*Pentecost*, Rovigo, S. Francesco, 1537–40; *Opportunity* and *Patience*, Dresden, Gallery, 1541). In 1549 Girolamo went to Rome, where he worked for Julius III in the capacity of an architect, on the construction of the Vatican Belvedere. He returned to Ferrara in 1554 and died there two years later.[36]

Ferrara and Bologna had two curiously related phenomena who are eccentric to the main course of artistic development in each city, as they are eccentric in the personality their art displays. The Ferrarese was Ludovico Mazzolino (*c.* 1480–*c.* 1528), who, however, worked in Bologna also in his later years; the Bolognese, Amico Aspertini (1474/5–1552). Both had been formed in the late Quattrocento tradition of their connected schools: that of Costa and Francia, and more particularly of Ercole Roberti, of whom it seems likely that both may have been pupils. Unlike the majority of their contemporaries, whose development took off from the classicizing aspect of the late Quattrocento style, Mazzolino and Aspertini attached themselves to the residues in it of the anti-rational, anti-general, and expressively idiosyncratic – qualities that may be described, for want of a more fit term, as Gothical. They were thus in a sense anti-classicists – certainly not by any intellectually articulated programme but mainly by accident of temperament – but at least until the neighbourhood of 1520, the classicism they worked counter to was not that of the Cinquecento style but of its distinct antecedent of the later Quattrocento; quattrocentesque classicism persisted in Emilia for about as long as that. While the earlier activity of Aspertini, and most of Mazzolino's, was contemporary with the classical style of the High Renaissance in Central Italy and Venice, it was not related to it. But then, from the middle of the second decade, their action against quattrocentesque classicism is contemporary with the early symptoms in Central Italy of dissent from the classicism of the Cinquecento: by being backward enough, they fell into a specious relationship to what was most advanced in current art.

It has become the art-historical habit to refer to this activity of the two painters as a 'proto-Mannerism'. This may be useful in that this term points up a valid element of continuity between pre-classical and (Cinquecento) post-classical style; but it would be more useful still to eliminate the idea of a relationship to the Mannerism of the Cinquecento and stress instead the more important fact that in the first and second decades the art of Mazzolino and Aspertini is no anticipation of events to come but a postscript to the style of the preceding century.[37] Even in the third decade Mazzolino responded only superficially to an acquaintance he had made by then with modern classical style. Aspertini's case is more complex. With experience of High Renaissance classicism gained in Rome in the later teens and early twenties, his later style was in some ways assimilated into the contemporary currents of post-classicism, but not entirely: his idiosyncrasy remained more visible than the qualities of style in him that resemble those of Mannerism.

In his earlier career in Ferrara, Mazzolino did extensive work as a *frescante*, but his decorations have been lost and we now know him for the quite different genre – a Ferrarese speciality – in which he was principally engaged after 1510: the production of cabinet pictures of devotional subjects. The earliest pictures of this kind that survive (*Madonna with St Anthony Abbot and the Magdalene*, Berlin, Museum, 1509; *Adoration of the Magi*, formerly Rome, Chigi Collection, 1512) are not much distinguished from the norms of the contemporary Bolognese and Ferrarese style. About 1515, however, Mazzolino's figures acquire a more singular appearance, tending towards energetic and complex shape and to incidents of caricature, and his compositional patterns seek a busy complication. North European prints seem to have been part of Mazzolino's stimulus towards this changed style, but the remaining stimulus is native, a recollection of the narrative excitement of the older art of Ercole Roberti. The mentality of a naïve story-teller dictates the character of such mature small pictures as the *Massacre of the Innocents* (Rome, Doria, c. 1515-20), multiplying incident, describing feeling by the use of caricature, and making a diffuse excitement in the almost inchoate pattern. As in Dosso's cabinet paintings of the same time, effects of primitivism generate appeal; but in Mazzolino's case, unlike Dosso's, the primitivism seems to be an instinct, not a willed phenomenon. The fineness of Mazzolino's execution, almost invariable, seems his sole element of sophistication. After 1520 Mazzolino's vocabulary often reflects Dosso's style (as in the *Madonna with St Anthony Abbot*, Chantilly, Musée Condé, 1525), and he may borrow some of Garofalo's Raphaelism (*Circumcision*, Vienna, Kunsthistorisches Museum, 1526). The evidences of the impression on Mazzolino of these more modern painters in Ferrara (and of the Bolo-gnese whom he had worked among in the mid twenties) is enough to make clear that he was, at this late date, trying genuinely to change his art in the direction that these models showed. But fixed as he essentially was in a pre-classical mode, the change was not in his power to effect.

The first information we have about Aspertini's career concerns what was to be a *Leitmotif* in it: a Roman voyage. He was in Rome, exposed to the then reigning school of Pinturicchio, between 1500 and 1503. In Bologna again in 1504, the pictures Aspertini painted shortly after his return are assimilable to the mode of Pinturicchio as much as to the local school – not a difficult adjustment, since both were so much dependent on an eventual common source in Perugino. Aspertini's *Adoration of the Child* (Bologna, Pinacoteca, c. 1504) and his two frescoes in the Oratory of St Cecilia (1505/6) are more in accordance with our expectation of this widespread style than otherwise, indicative of some eccentricity only in a preference for irregularities of form and in a stress of illustrative and emotional details. Between 1507 and 1509 Aspertini was again in Central Italy, but this time in Tuscany, at Lucca, working on a fresco history of S. Frediano in the church dedicated to that saint. The indices of Florentine experience appear beside the preceding Roman ones. They are conspicuously not those of the rising classical painters in Florence at the time; it was Filippino Lippi and Piero di Cosimo (Masaccio also), the first especially, who attracted Aspertini most. It may be the example of the late Filippino more than any other that encouraged the emergence in these frescoes of more of Aspertini's tendency towards singularities of expression and form.

The quota of eccentricity in the Lucca frescoes, or in the altarpiece for S. Frediano (now Lucca, Pinacoteca, probably contemporary),[38] is evident but not excessive, and in this Tuscan context consorts well with the extension into

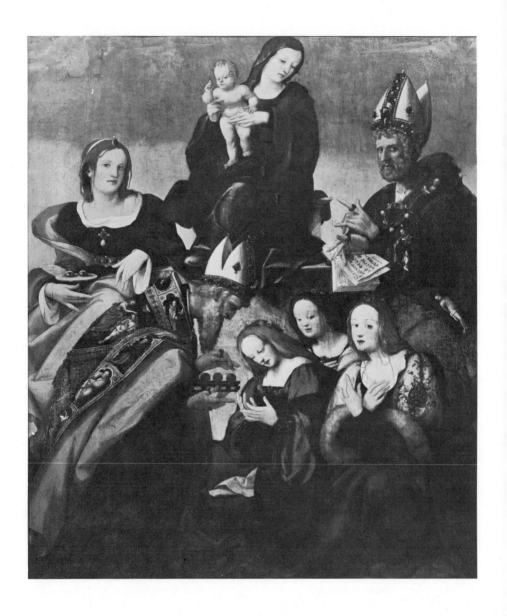

173. Amico Aspertini: Madonna Enthroned. *Bologna, S. Martino*

the sixteenth century of what had been a major strain of late Quattrocento Florentine art. But after this the specialness and the intensity of what Aspertini wishes to communicate increase sharply. His altar of the *Madonna Enthroned* (Bologna, S. Martino) [173] may be of *c.* 1515; it is the extremest tissue of expressive idiosyncrasies in Italian painting of its moment. Intensity of feeling finds its outlet in a sweeping, charged calligraphy; the same feeling, using line as its main instrument, works on shapes until they are malleable, and slightly but visibly deforms them. Aberrations of appearance are conjoined with singular psychological communication, and both with an eccentric energy of form. The effect of this style is no longer mainly quattrocentesque (as that of the Lucchese frescoes had still been), for it has fluency and breadth that exceed Quattrocento example and a unity of formal and expressive texture that is new. Yet there is no surely identifiable reference in it to modern classical painting, while there are references to the Quattrocento and to contemporary North European art.[39] It may be that contact with contemporary art in Florence (rather than with Roman art), made in the interval between the painting of the S. Martino altar and the last years of the decade,[40] accounts for what we can perceive, beneath more quattrocentesque and Germanic references, to be an alteration in a classicizing sense of Aspertini's style. In 1519, a *Pietà with Saints* (Bologna, S. Petronio) shows forms that have taken on – characteristically, in exaggeration – the fullness we associate with classical style, and the rhythms that shape draperies and attitudes are powerfully cursive. Composition has a more deliberated order, and the quality of resonance that is in classical form and classical expression of emotion is also here. Yet what has been assimilated has been turned to ends no less unclassical than before: the visible substance of the work of art and something in the tone of

expression have been altered, but not its essential stuff, which in the *Pietà* is a rough agonized violence. Calmer and less germanicized, a painting of the exceptional theme of the *Adult Christ seated between Mary and Joseph* (Florence, Longhi Collection; probably not much later than the *Pietà*) is less unconvincing in the resemblance to classicizing form that it affects, but the emotion it communicates remains difficult and strange.

Our understanding of Aspertini's chronology from this point onward is deficient, made difficult by the apparent lacunae of survival among his panel paintings and, still more, by the virtually entire disappearance of his extensive work as a decorator of façades in fresco – a field in which he was the most prolific artist in Bologna. In the 1520s one dated picture exists, a *Disputation of St Augustine* (Hannover, Kestner Museum) of 1523; on a small scale and not much different in style from the Longhi altarpiece, it does not provide a pole of reference strong enough to attract the remaining panels that must be chronologically accounted for. In the early years of the next decade Aspertini was again in Rome, probably for two extended visits, one between 1532 and early 1534 and a second between 1535 and 1540.[41] He then had direct access to the mass of accomplishment of High Renaissance and subsequent post-classical Roman art, but the antiquarian sketch-books he compiled hold no clue to his response either to the painting of the recent past or to contemporary painting. However, the finest among Aspertini's panels that seem *prima facie* in a later style than those we have discussed suggest a relation to the sketch-book that is best assigned to his last Roman stay. The *Adoration of the Magi* (Florence, Uffizi) is elaborately antiquarian, and propulsive feeling and an element of preciousness interact in it, making an oblique analogy to the ex-Roman Polidoro. In a *Holy Family with St Helena* (Holkham Hall, Earl of Leicester), shapes that parody a classicizing

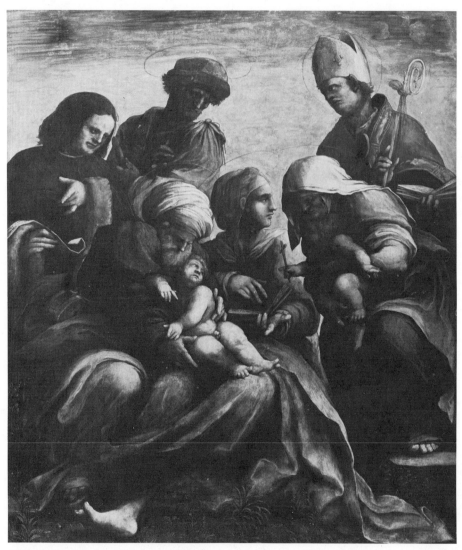

174. Amico Aspertini: Holy Family with Saints.
Paris, Saint-Nicolas-aux-Champs

grandeur are tormented into eccentricity with a fine, nervous, and deforming line. An altar of the *Holy Family with Saints* (Paris, Saint-Nicolas-aux-Champs) is the completest articulation that we possess of Aspertini's mature style [174]. In it, broad forms, of bizarre shape and cast of countenance, are compelled into a passionate communion by the action of a

sweeping, knotting rhythm. An effect of complex excitement is accentuated by the handling of light, which makes a broken coruscation. The work has an extraordinary, mostly irrational, power, suggesting to the spectator the image of what he would expect from a demented Michelangelo.

These later works, the Paris *Holy Family* especially, refer enough to an exposure to High Renaissance classicism – no matter how much it then is contravened – to require that they be identified as post-classical in the Cinquecento sense, and their relation to post-classical Mannerism, at least to its initial and unclearly defined experimental aspects, is more than that of Aspertini's early works. Yet it is still not satisfactory to associate this later style of Aspertini unequivocally with Mannerism: the *maniera* within Mannerism clearly has almost no part in it. And even now, this mode insistently recalls the forms and temper of the late Quattrocento style with which Aspertini had, in an earlier time, displayed a strong affinity and of which Filippino was the chief exemplar: the continuity we perceive from this late Quattrocento strain disjoins Aspertini's later art from modern Mannerism.

When Vasari (v, 179–80) describes some of Aspertini's façade decorations he comments on the extravagant capriciousness – and in one case on the *pazzie* – of Aspertini's inventions. If Vasari's accounts of Aspertini's personal behaviour can be believed (and they are adequately circumstantial), he was even more eccentric in his person than he let be manifest in his art: his kind of manically-inspired individuality would stand inevitably separate from his context of artistic culture and from easy categorizing under generalizations of historical style.[42]

We are told that Aspertini spoke harshly of his Bolognese colleagues, who were given 'ad imitare non altri che Raffaello'. Aspertini's view of art was provably counter to that of his colleagues, who in the course of the third decade were pleased to turn most of painting in Bologna into a posthumous extension of the Raphael school, and keep it that way until their Raphaelism was displaced by Maniera. The Raphaelism of these Bolognese was natural enough: emerging from the climate of late Quattrocento classicism established by Francia and Costa, they found it congenial to turn from this to the modern classicism that Raphael represented – not in its full extent or in its depth of meaning but in the overt terms they could perceive especially in the model of his art present in Bologna since *c*. 1514, the *St Cecilia*. What they could not learn of the surface look of the Raphael style from this they could acquire from the prints of another famous Bolognese and Francia pupil like themselves, Marcantonio Raimondi. Aspertini's anti-Raphaelism, as he so fractiously practised it alongside them, was an obvious aberration, and probably – partly rightly – an archaism in their eyes, and when Parmigianino came to work in Bologna briefly after 1527, all that was not clearly Raphaelesque in his Maniera must have been no less unsympathetic. The Raphael cult of the representative Bolognese, of which the *St Cecilia* was the literal and figurative altar, took most long-term visitors in the twenties, like Girolamo da Treviso, in thrall as well. Those who did not yield to Raphael directly went in bond to his disciple in near-by Mantua, Giulio, as Girolamo da Carpi did when he was in Bologna at the beginning of the next decade.

The Raphaelesque dedication of the Bolognese was obviously in no way wrong in principle; what was to be deplored in it was the superficiality of their imitation and, worse still, the small talents they brought to it. Bartolommeo Ramenghi, called Bagnacavallo (1484–1542), was the most prominent among them, making repetitive compromises in his earlier years between Francia's late style and the

vocabulary he could gather from the *St Cecilia*. Neither unsusceptible to fashion nor manually inept, in the thirties (*Holy Family and Saints*, Bologna, Pinacoteca) he adjusted his style to take account of newer notions he had acquired from Giulio, Dosso Dossi, and from Parmigianino. Innocenzo Francucci da Imola (1490/4–1547/50) was not only Francia's pupil but (according to Vasari, v, 185) had also studied in Florence with Albertinelli. He was thus more fully informed about the modern classical style than Ramenghi, and could approximate its formulae more closely. But it was only in the terms of formula that Francucci could respond to the newer classicism, and his pictures are remarkable for the blandness and rigidity they achieve, by which Francucci almost reconverts the Raphaelesque (and Bartolommesque) style into one of which the principles are like Francia's. Francucci also, in the thirties, slightly felt the impact of Giulio Romano. The third noticeable representative of this group, Biagio Pupini (dalle Lame, notices from 1511 to 1551), was still less able as a painter, and by the accident of the loss of most of his extensive production in Bologna is the least well known; our chief present information on him is as a draughtsman. He was also Francia's pupil, and on occasion a collaborator both of Ramenghi and of Girolamo da Carpi. His external Raphaelism is derived from Ferrarese as well as Bolognese examples, but the admixture in his hands (e.g. *St Ursula* altar, Bologna, S. Giacomo Maggiore) is not to good effect. The production in Bologna of these Raphaelesques is a phenomenon which is only quantitatively important. Their imitations of Raphaelesque style reduced it to classicistic formula, but this could be simply grasped and then in turn re-imitated, so that painters in more provincial places could still follow, without pain, this admired fashion. At the critical geographical point for diffusion of artistic influence farther northward, the Bolognese Raphaelesques were the earliest

agents in North Italy of a classicist propaganda. It was fortunate for North Italian art that they were soon supplanted in this role by less imitative but more authentic offshoots of the Raphaelesque style, Giulio and Parmigianino.

Francesco Primaticcio (1504–70), whom the older sources describe as a pupil of both Ramenghi and Francucci, did not wait for the Mantuan and Parmesan pressures on Bologna to have their full effect but took employment in Mantua among Giulio's large corps of assistants in the decoration of the Palazzo del Te. He cannot be distinguished as a painter there, but Vasari (v, 539) identifies him as the executant of the Sala degli Stucchi (*c.* 1530). In 1532 he departed for Fontainebleau, to become in time the principal ornament of that great French Maniera school. Primaticcio already belongs to the first element of the generation that in Italy was to include the practitioners of the high Maniera; Niccolò dell'Abbate (*c.* 1509–1571) belongs exactly to the generation of Vasari and Salviati. Like Primaticcio, he was to conclude his career in France, but not until he had worked (mostly as a fresco decorator) until just past the mid century in the neighbourhood of his native town of Modena and then in Bologna. His earliest Modenese works, frescoes once in the so-called *Beccherie* (fragments now in Modena, Galleria Estense, 1537), are related to Dossesque models, some of which were accessible in Modena (an Este dependency), rather than to the still predominantly Raphaelesque examples of Bologna; the influence of Correggio's style is apparent also. There is no perceptible novelty in these works, but in the *Aeneid* illustrations painted about 1540 for the Rocca di Scandiano (detached, partly preserved in Modena, Galleria Estense) the Dossesque and Correggesque foundations of Niccolò's art are infiltrated by the Maniera of Parmigianino. An altar painted in 1547 for the church of Ss. Pietro e Paolo in Modena (formerly Dresden, Gallery, destroyed in the

Second World War), depicting the martyrdom of the two saints, is somewhat more conservative (and explicitly dependent in a major motif on Correggio), but it is the proof of Niccolò's capacity to handle the developed modern apparatus of a grand dramatic style. The success that attended this public piece resulted in Niccolò's migration to the larger sphere of action that Bologna offered, and there, from 1547 until his departure for France early in 1552, he was engaged in several decorative projects, almost all of them, like his earlier work at Scandiano, on secular themes. The two most important among them were in the Palazzo Torfanini (now in the Pinacoteca) – illustrations of ancient history and of the *Orlando Furioso* – and in the Palazzo Poggi (now the University), where he depicted romantic landscapes, battle scenes, and, most notably, musical parties of aristocratic contemporaries [175], of genre-like intimacy and arresting charm. The Bologna into which Niccolò had come was no longer the enclave of retardataire Raphaelism it had been; it was now effectively a centre of the new Maniera, proselytized by Vasari, Salviati, and the effect – finally fully recognized in

Bologna – of Parmigianino's art. In this climate Niccolò's last Italian works became what they previously had not quite been: explicit examples of Maniera style. But the last edge to his new sophistication, and his highest accomplishment in this style, were yet to come, after Primaticcio's tutelage at Fontainebleau. The last two, and the finest, decades of his career belong to the history of the school in France.[43]

In Parma, the condition of painting in the earlier sixteenth century, before the advent of the young Correggio, had been as low as it was possible to be. Of the native painters who actually practised in the city only Alessandro Araldi (*c.* 1460–1528), a dependent of the contemporary Bolognese, attained even the level of artistic mediocrity. The brothers Mazzola, the uncles of Parmigianino and presumably his first teachers, were archaizing craftsmen at their best.[44] When on occasion painting of some merit was required in the city, it was necessary to commission foreigners, such as Francia and Francesco Zaganelli. However, there was youthful talent ready to manifest itself in Parma, requiring direction, and this is what Correggio's presence decisively gave it. With

175. Niccolò dell'Abbate:
Musical Party, before 1552. *Bologna, Palazzo Poggi*

remarkable swiftness Correggio converted the younger elements of the Parma school to his new style, and in the case of Francesco Parmigianino endowed a young painter of a creativity almost equal to his own with a vocabulary of complete modernity. For the whole of the third decade Correggio's formative effect upon Parmesan painting was almost absolute; but even in this time there were symptoms of the attraction that Parmigianino's painting was subsequently to have for his colleagues. When after Correggio's departure Parmigianino returned to the city in 1531, his influence increased, at first combining with Correggio's and then by degrees displacing it, until Parma became, in consequence of Francesco, one of the earliest and most consistent centres of Maniera. But this Parmesan Maniera school that Francesco formed did not, as a school, become a major factor in disseminating the style elsewhere in North Italy: it was the action and the models of Parmigianino himself – left not only in Parma but in Bologna, and before that in Rome, and the wide effect of his graphic work – that accomplished this. The influence towards Maniera that came to emanate from Parma was Francesco's personally, much more than that of the collective local school.

The career of Michelangelo Anselmi (c. 1492–1554/6) may typify the situation of Parmesan painters in the period from the 1520s to the mid century, though his artistic origins are exceptional for that school. Though of Parmesan family, he was born not in Parma but in Tuscany, in Lucca or Siena, and a late tradition has it that his initial training was in the shop of Sodoma. He did not come to his ancestral city until some time between 1516 and 1520, but once there he settled permanently. We have no certain knowledge of any work that precedes Anselmi's residence in Parma. A traditional attribution to him of a *Visitation* in the church of the Fontegiusta in Siena is most

doubtful, and the date we should assign to this work (on grounds of the relation it bears to the development of Sodoma or Beccafumi in Siena), about 1530–5, is much after Anselmi's departure. What we do know as a work by Anselmi done in Parma of which the probable date is 1520[45] (at one time documented by a contract now lost), the grotesque decoration of the ribs of the nave vaults of S. Giovanni Evangelista, is in a style quite unlike the *Visitation*, and – perhaps because of the grotesque genre – more suggestive of an artist related to Pinturicchio's tradition than to the more recent Sienese. There is no trace yet in these grotesques, contemporary with Correggio's *Camera*, of his influence. But when, some time shortly after 1522, Anselmi painted a chapel in S. Giovanni Evangelista[46] with frescoes of Doctors of the Church, he had been converted wholly to the style of Correggio; all that indicates Anselmi's previous experience in any other manner is his mode of making more broken accents, linear and planar, with his brush.[47] By 1526–7 Anselmi had recovered somewhat from this Correggesque inundation. Though his altar for the Parma Duomo (with St Sebastian, St Roch, St Hilary, and St Blaise, *in situ*) depends liberally on Correggio's just preceding *St Sebastian* altar in design, the forms and mode of handling are more individual. Anselmi's figures and their physiognomies are more spare and ascetic than Correggio's, their angularity of action more pronounced, and the chiaroscuro more sharply accentuated. Moreover, the drawing with the brush is more constrained and fine and more literal in description, as if remembering an earlier Tuscan training. Only internal evidence exists to suggest that Anselmi may have revisited Siena about 1526, but it may be that renewed acquaintance with Sodoma and Beccafumi accounts partly for the still more Tuscan surface of Anselmi's *Madonna with St Sebastian and St Roch* (Parma, Gallery, c. 1530) [176]. But there is also, in this altar, a quality of rhyth-

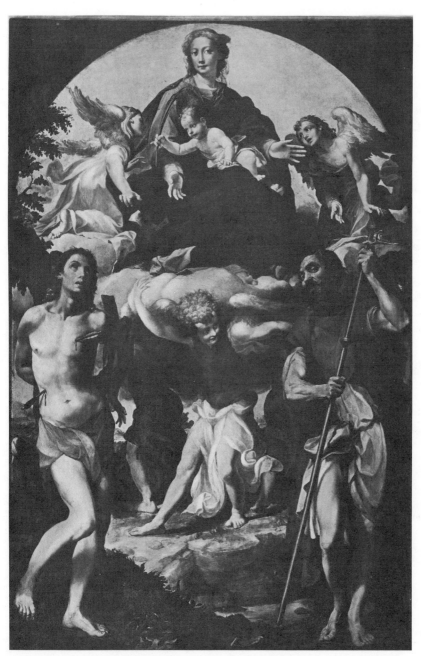

176. Michelangelo Anselmi: Madonna with St Sebastian and St Roch, *c.* 1530. *Parma, Gallery*

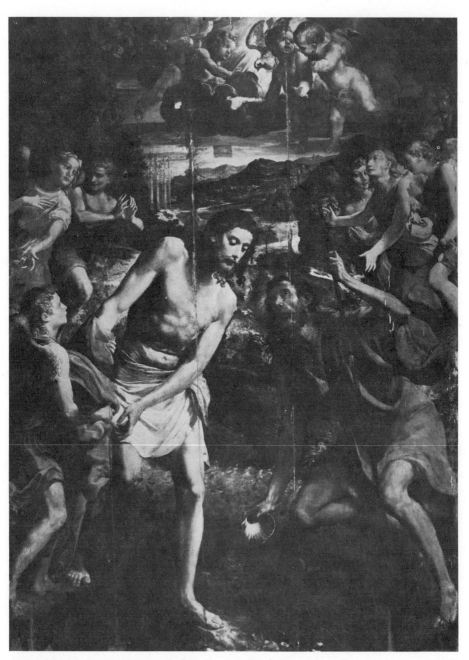

177. Michelangelo Anselmi: Baptism of Christ. *Reggio Emilia, S. Prospero*

mical elaboration that suggests – and this is the first time we can make the association clearly in Anselmi's work so far – the ornamentalism of Maniera. It is less likely that this should have been inspired by Sienese example of the middle twenties than by knowledge of Parmigianino's art, both what had been left behind since 1524 in Parma, and what he had done more recently in Bologna.

It is now, about 1530, that Anselmi emerges to the full measure of his capabilities as the author of a highly individual synthesis of Correggio's and Parmigianino's mature styles. The *Baptism of Christ* (Reggio Emilia, S. Prospero, shortly after 1530) [177][48] shows with what sensibility the fusion has been made – and with what fineness of hand and articulate discretion of emotion. But it has the fault that besets all compromises: it is a little timid, and is too equivocal between descriptive ends and the aestheticism that its fine manner makes. In the narrative fresco series of the history of the Virgin which Anselmi designed (and executed jointly with Rondani) for the Oratorio della Concezione in Parma (1532–5), the material of compromise is still much the same, but it is less cautiously manipulated. Later in the decade, accompanying Parmigianino's rising dominance in Parma, Anselmi made more complete concessions to him, as in his *Holy Family with St Barbara* (Parma, Gallery, towards 1540), rather exaggerating on the former's Bolognese *St Margaret* altar, and consulting his current *Madonna dal Collo Lungo* also. Anselmi's native emotional temper, earlier pressed towards a somewhat incoordinate febrility by Correggio's example, adapted itself easily to the excitements of Parmigianino's Mannerism.

It was Anselmi who was chosen to execute the decoration of the apse of the church of the Steccata for which Parmigianino had been commissioned, but for which he had done no more than supply a design. It was not Par-migianino's design that was given to Anselmi to execute, however, but one supplied by Giulio Romano from Mantua. First painted in 1541–2 according to Giulio's prescription, the finished product was felt to be unsatisfactory by the patrons, and in 1547 Anselmi was commissioned to 'reform' it.[49] His last work on a major scale was the fresco on the inner portal of the same church, an *Adoration of the Magi* (begun 1548), a handsome machine of vast extent, left unfinished and completed by Bernardino Gatti after Anselmi's death.

The fineness of temperament and hand that was at times almost a vice in Anselmi was conspicuously absent in his contemporary and occasional collaborator, Giovanni Maria Francesco Rondani (1490–1550). Like Anselmi, Rondani formed his style on the model of Correggio. We know him first not as an independent painter but as an executant for Correggio's designs, in the frescoes of the nave of S. Giovanni Evangelista (1522), and he was again Correggio's deputy, probably in the middle 1520s, for the execution of designs for the decoration of the vault in the Cappella del Bono in this church. His touch is rough, and his execution marks Correggio's ideas with an accent of vulgarity. The roughness is not just a matter of the hand but of Rondani's way of conceiving images: in his major surviving independent work in fresco, scenes of Christ's Passion and of the life of St Anthony Abbot in the Cappella Centoni in Parma Cathedral (1527–31), the forms and the tenor of the narrative have the crude exaggeration and directness of a comic strip. For the moment, his style in these frescoes reflects the influence – one which would have been temperamentally sympathetic to him – of the current Mantuan work of Giulio. Named as a collaborator with Anselmi in the decoration of the Parmesan Oratorio della Concezione, Rondani seems actually to have been rather an assistant there; again his brusqueness tends to deform what he executes.

As an altar painter Rondani was more cautious. A *Madonna in Glory with St Gregory and St Sebastian* (Parma, Gallery, before 1525) is in Correggio's technique but still conservative in its design, because at this date Correggio had provided no model of the type more advanced than his *S. Francesco* altarpiece. Considerably later, an *Assunta* (Naples, Capodimonte, of the late 1530s) is much more free and vigorous, making a spirited translation back into easel form of Correggio's fresco in the Duomo. Rondani is almost always formally or emotionally eccentric in some respect, and his deformation of Correggio's models gives them a peculiar cast, but he is persistently faithful to them in his fashion. Unlike Anselmi, Rondani made no compromise with the rising fashion for the Parmigianinesque Maniera.

One personality of greater talent, unhappily short-lived, worked briefly on the Parmesan scene in the post-Correggesque years. This was Giorgio Gandini del Grano (notices from 1532; died 1538), who was so much esteemed that it was he who was first selected, in 1535, to take up the decoration of the Duomo apse; his premature death prevented his fulfilling the commission. Alleged to have been a pupil of Correggio, his surviving works indeed reveal a basic training in Correggio's style, but it is also evident that he was much influenced by the Giulian school of Mantua. In smaller pictures that seem to be of c. 1530 (e.g. the *Holy Families*, Parma, Gallery, nos. 71 and 77) a Giulian accent characterizes Gandini's types and sharpens his Correggesque sfumato, darkening it also; it also seems a Giulian model that makes Gandini turn his drapery folds into sharpened edges, almost with the effect of lines. These works make a compromise between Correggio and a classicistic style. It seems to be the return of Parmigianino to his native town that drove Gandini one step farther, in the direction of a classicistic Mannerism. The major work he has left us, the *St Michael* altar (Parma, Gallery), should be of c. 1534-5; presumably it was this performance that won him the succession of Correggio's commission in the Duomo. Still based upon Correggio's and Giulio's vocabularies, it does not reflect Parmigianino in any explicit detail, and it may be due to Giulio rather than Francesco that the painting surfaces have become quite hard, abandoning Correggesque sfumato almost altogether, while every fold and contour has become a stressed line. But it is only Parmigianino's example that could give the figures their effect of preciousness and provoke the forms and lines into so highly charged a rhythmic activity. There are too many ideas entrapped within Gandini's driving and complex calligraphy to cope with quite effectively: the confluence – of the late Correggio, of Giulio, and of Parmigianino – is of disparate postclassical values that were, at this moment, each too strong to be reconciled. Still, it is not an eclectic object that results from Gandini's effort to assimilate them but a compression of rich formal, expressive, and intellectual energies. That his career should not have been fulfilled changed the subsequent complexion of the Parma school.

Unlike the painters we have discussed so far, Girolamo Mazzola Bedoli (c. 1500/5-1569)[50] was a follower of Parmigianino from his identifiable beginnings. Vasari (v, 220) tells us that in 1521 Bedoli, at that time 'putto e pittore' like Parmigianino, accompanied him to refuge in Viadana during the war then going on in Parma; apparently Bedoli was a fellow-pupil in the shop of Parmigianino's uncles. In 1529 he married the daughter of Pier Ilario Mazzola, and thus became a cousin by marriage of Francesco, adding the Mazzola surname to his own. It was jointly with his father-in-law that Bedoli received the first commission of which we have record for him, in 1533, for the altar (now Parma, Gallery) [178] of the *Immaculate Conception* for the Oratorio della Concezione

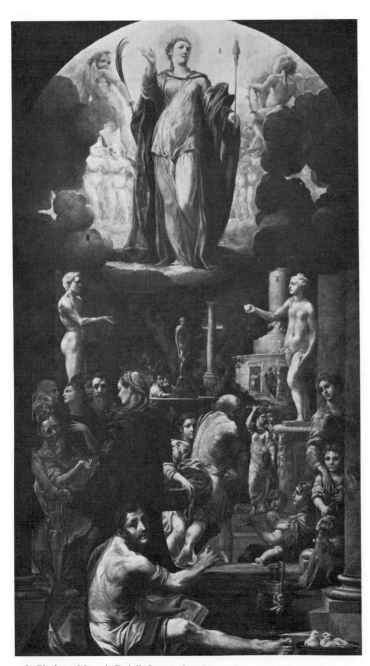

178. Girolamo Mazzola Bedoli: Immaculate Conception, commissioned 1533.
Parma, Gallery

(in which, the year before, Anselmi and Rondani had been employed as fresco decorators). But this altar, in the execution of which old Pier Ilario Mazzola could not have had the slightest part, is the work not only of a remarkably accomplished painter but of one who is entirely mature, with considerable prior experience. It has only recently been proposed[51] that Bedoli is the author of a picture that should precede the *Conception* altar by as much as a decade: the *Madonna Enthroned with St James and St John the Baptist* (Carate Brianza, Galli Collection, *c.* 1525). Its design is based closely on the altar, now at Bardi, which Parmigianino painted about 1521 at Viadana, and much of its vocabulary resembles Parmigianino's as it was towards 1524. This attribution is, however, doubtful, and perhaps can be proved incorrect; our present knowledge about Bedoli provides no bridge between this painting and the certain evidence of Bedoli's style that we discern later. The first such evidence may not much precede 1530 (or, less likely, follow Francesco Mazzola's return to Parma in 1531), when Bedoli discovered the example of Francesco's current mode, and set himself to imitate it. A group of works of which the *Adoration of the Child* (Naples, Capodimonte) and the *Madonna with St Sebastian and St Francis* (Dresden, Gallery) are examples, and the *Madonna with St Bruno* (Munich, Pinakothek) a more developed instance, antedates Bedoli's formation of the more personal and mature style he would employ in the *Conception* altar. The intimate relation to Parmigianino of this group does not obscure an essential difference between Bedoli and his model: Bedoli equivocates between Parmigianino's pervasive transformation of experience into aestheticized sensation and the more conventional mimetic purpose of the work of art.

The language of the *Conception* altarpiece (payments into 1539 but finished by the end of 1537) is not so overtly imitative as that of the preceding group, but it is notably more disciplined and exact in its control of techniques and of form. The refinement of touch and vision Bedoli has developed matches, and in places seems almost to exceed Francesco's. He rivals the subtlety with which Francesco can define the rhythm of a shape or purify a volume, and he transforms detail into ornament no less exquisitely. Yet none of the repertory assimilated from Francesco is used towards comparably arbitrary ends. Bedoli stands in this work in a relation to Parmigianino similar to that in which, in Florence at the time, Bronzino stands to Pontormo, in a realm of art equally refined but less abstracting and poetic; Bedoli's temper is more deliberate than Francesco's. He lingers on each form and its fine details, polishing it with lapidary effect. He sees and feels in parts, not in a compelling unity: he neither begins nor ends with the embracing impetus that in Parmigianino is at once an emotion and a form. From the same time as the *Conception* altar a *Madonna and Child* in a landscape (Cambridge, Mass., Fogg Art Museum), in small scale, and a full-scale altarpiece of *The Marriage of St Catherine* (Parma, S. Giovanni Evangelista, 1536–7) are no less compelling demonstrations of a quality of painting comparable to Francesco's own and of the difference in their kind. Still more marked in the individuality with which Bedoli has revised Francesco's style in it is an *Annunciation* (Milan, Ambrosiana, *c.* 1540) [179], despite the fact that its vocabulary derives from the *Madonna dal Collo Lungo* with a measure of dependence that requires to be described as daring. Bedoli outdoes even this model in sheer preciousness, making the whole picture surface a tissue of fine restless lines and shifting glazes, assembled out of elements of metal or tesserae of fragile stone; he makes

179. Girolamo Mazzola Bedoli: Annunciation, *c.* 1540. *Milan, Ambrosiana*

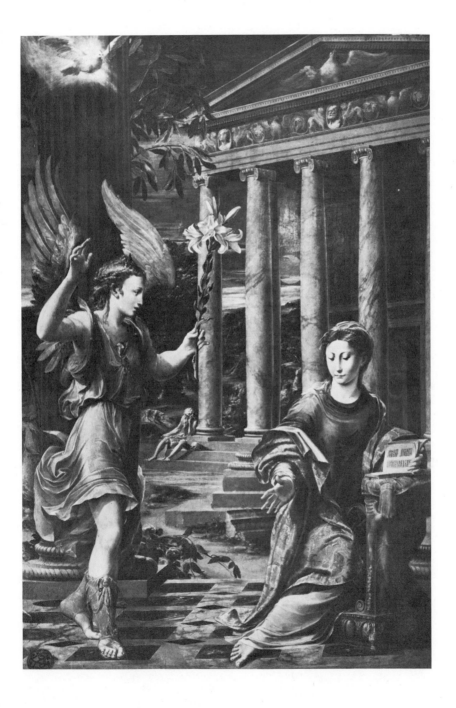

excess of ornament and artificiality. His vision is exaggeratedly precise and, now, disjunctive: his tesserae of form seem fragments, and his web of ornamental patterning congealed. It is not only preciousness but a brittle frangibility that, in this painting, he makes his forms convey.

The Milan *Annunciation* is the brilliant extreme of Bedoli's translation of Francesco's style. He recedes quickly from this mode, almost a goldsmith's or a lapidary's, towards one that is both technically less remarkable and representationally less arbitrary. A version of the Annunciation theme (Naples, Capodimonte), later by probably a half decade than that in the Ambrosiana, shows a suaver grace; its forms are, in comparison, of classicistic purity, though still caught in a fine, complex patterning of line and – now, as well, in consequence of Bedoli's readmission of Correggesque example – of light. The *Adoration of the Kings* (from the Parmesan Certosa, now Parma, Gallery, *c.* 1547) is a night scene in which the figures, in an extreme canon, act in swift and gracile attitudes, with the precious poise and the occasional extravagance of high Maniera notions of behaviour; the brittle tracery of line in which they are held extends and complicates the effect of pattern of the *Annunciation*. The setting of imposing architecture, as well as the lighting, suggest Bedoli's attention to the art of Giulio Romano. Bedoli's works of the forties are the apex of his exposition in Parma of a high Maniera.

After the mid-century Bedoli began gradually to retreat from this advanced position. Increasingly, he revived Correggio's old example and incorporated parts of it into his aesthetic, effecting a significant moderation in his style. In his *Marriage of St Catherine* (Parma, Gallery, 1556) or his *Madonna with St John and Angels* (Parma, S. Sepolcro, 1556–7) he tempered the agitation of design and made presences and expressions more accessible by adaptations of Correggesque devices. He lessened his Maniera in this way, but did not sacrifice it. Soon afterwards, however, it became evident that the intensity needed to sustain a high Maniera had diminished in the ageing Bedoli. In 1562 the musician figures with which he decorated the base of the organ in the Parma Duomo (now Parma, Gallery) have a touch of the vacancy that betrays a hardening of Maniera into formula.

On various occasions throughout his career Bedoli was employed as a *frescante*, though neither his temperament nor his fine-grained style were suited to the occupation. In 1538–44 he turned the choir vault of the Parma Duomo into an excellent demonstration of the Maniera's decorative principle of encrustation, and (taking up Correggio's old unfulfilled commission) painted a *Christ as Judge on the Last Day*, too full of Maniera calculation to be terrifying, in the apse. Between 1547 and 1552 he worked at the *Pentecost* in the south apse of the Steccata, of more Giulian than Correggesque inspiration; and between 1553 and 1567, delayed often by the endlessly obstructive nagging of the governors of the Steccata (notoriously difficult since their experience with Parmigianino), painted the north apse with an *Adoration of the Shepherds*, set in landscape and an architecture of imaginatively conceived ruins. He was a portrait artist also, producing works in this genre of a thin distinction, more interesting for their quality of painting than their record of personality. Unlike Parmigianino, he did not have the capacity to deal simultaneously with humanity and art.

CENTRAL ITALY 1535-1575

There is no suddenly-marked distinction in Florentine and Roman painting between the style into which the first generation of Mannerists matured towards 1530 and the dominating style of the years that followed. We have seen, in each of the innovators of the Mannerist style, the emergence – with varying degrees of swiftness and explicitness – of the qualities that constitute post-classical Maniera, and in general we have found that the maturing of these artists' styles coincides with their achievement of these qualities. Their continuing demonstration and refinement by artists of the first Mannerist generation is in its own right a major factor in the history of the first and even second decades of the period we are about to discuss; still more important, it is the principal factor in the forming of the style of the succeeding generation that matured at this time. The distinction between the kind and function of Maniera in the style of the first Mannerist generation and that of the younger men emerged gradually, as the latter matured. The change was due not to any wilful alteration of artistic doctrine by the younger men but to the action of a normal process. Experiment and invention in this style had been made by the first Mannerist generation, often at the cost of considerable creative travail; the formulation of Maniera they arrived at became the datum which the next generation was privileged to take as an established proposition to elaborate and refine. In different degrees – Pontormo most of all, Perino del Vaga least – the early Mannerists had been concerned with problems of emotion that were highly personal. Their expression, furthermore, carried – again in different degrees – the effect of dissent from the canons of High Renaissance classicism. Their

achievement of Maniera represented, as we have seen, a partial reconciliation with classicism, especially in vocabulary of form. For the next generation, maturing into a more stable, but also a more restrictive and reactionary cultural atmosphere, the Maniera formed by their predecessors was a visible novelty of artistic resource, but also one that seemed reintegrated with the authoritative classical tradition. What was difficult and private within its expression was set aside; what was agreeable and generalizable, formally explicit, and related to traditional authority could be sympathetically received by the younger generation. It was the ornamental attitude towards both form and feeling and the formal apparatus that was its vehicle which were, to this generation, the accessible and workable matter in the Maniera that the early Mannerists had achieved.

In the years that followed the religious and political turmoil of the third decade, a society of extreme sophistication learned to deal with spiritual urgencies by repression or by channelling their expression into controlled formulae. Evasive of unsettling emotion yet capable of the most complex response, interposing ritual and manner between themselves and their reality, contemporary society (and the artists who were not only its interpreters but part of its shaping force) found the first Maniera a style suitable for conveying complex sensation by aesthetic or by illustrative means, and at the same time for censoring aspects of being or feeling that were not *manieroso*. The ambitions of the early Mannerists were thus curtailed by their successors, and there is no counterpart in the high Maniera for their range, their power, and their freedom of invention, or for the intensities they made of form and meaning. The attitude of the high Maniera towards the possibilities of art is, by comparison, restrictive. It inherits more than it invents, and what it invents of its own lies in a rare and specialized province of the powers of art. It

crystallizes its inheritance from early Mannerism, and at the same time elaborates it, but narrowly, within this specialized realm. The liberty of profound question and wide search among the early Mannerists was promoted by their context of political and religious culture; so, obviously, was the restrictiveness of high Maniera owing in part to the political and religious context of its time.

The high Maniera, then, on the one hand restricts the range of accomplishment of its early Mannerist predecessors, but on the other develops the potential of what is explicitly Maniera in it.[1] In almost all its variants the high Maniera shows, more than the first Maniera, an evident effect of conscious artifice – indeed of artificiality – not only in form but in the character of content. The forms of high Maniera seem, even more than in the antecedent phase, to be commentary on appearance rather than a description of it. Smaller forms especially – drapery, hair, or anatomical details – are transmuted into fine-wrought ornament like jeweller's filigree, in a controlled technique that makes it clear that there is no place in this style for accidents. This technique works the surfaces of things as well as their shapes to smoothed, arbitrary perfection, so that figures seem more than earlier to be a compromise between flesh and tinted stone, or look like porcelain of which the glaze evokes, but only faintly, a quality like that of life. Forms are illumined by cool light, transmitted through an air so thin it seems unbreathable. In this atmosphere colour is distilled and made unnaturally lucid. The appearances the painter lends his actors are – often even in the figurative meaning of the word – aestheticized, and so in corresponding measure is their manner of behaviour. Posture and gesture take on an extreme deliberation, intending the effect of an exactly meditated grace, and expressions of countenance are no less fine, preciously rendered and extremely civilized. It becomes a signal differ-ence from the earlier Maniera that the communication of the quality, in the social sense, of 'manner' is by far precedent over the communication of any more urgent emotions for which the theme might be conceived to call.

The high Maniera image is, beyond its precedents, stylized and purposely artificial, yet it conveys its own kind of intense convincingness. The fine and insistent technique of a high Maniera picture, and the care taken with often seemingly indifferent detail, sharply affirm all but the substance of reality. Fragments of an unreal whole may be given with the precision and the plastic emphasis of *trompe l'œil*. The existence of the whole, essentially abstracting as it may be, is asserted by the extreme truth of fragments of it: we are baited with the small verity to swallow the whole poetic lie. The Maniera technique reinforces this result: the wiry strength of its delineation, the hard clarity of surface, and the lucid colour bound to plastic emphases of form contain a great force of aesthetic impact. Because this aesthetic force is bound to the simulacrum of a human presence, no matter how arbitrarily remade, the simulacrum partakes by association of this force. The validity of the aesthetic effect affirms a power of existence in the figures, whether that existence has been truthfully described or not.

The hard-surfaced, plastically emphatic form of many high Maniera pictures, which has so large a part in this effect, comes often from the deliberate imitation of a sculptural style. In both Rome and Florence (in the latter no less, since Michelangelo had left his main accumulation of statuary there in the third decade) Michelangelo's authority impressed a sculptural example on Maniera painters, not only by his works in stone but by his sculpturesque painting. Raphael, the other prime authority for mid-century painters – the first exponent, in their thinking, of *bella maniera* – had also, in his last and most influential years, taken a sculpturesque cast into his art: from his side,

too, example tended to dictate a stressed plasticity. But beyond these more immediate exemplars lay the more venerable authority of ancient art, visible chiefly in the guise of sculpture, which the artists of the high Maniera looked at with a concern stimulated by an increasing literary and historical pedantry in their culture. In a degree distinct from the tendency of the early Mannerists, and still more from the artists of the High Renaissance, high Maniera painters may use antique models not only as exemplars of a sculptural style, or for types and motifs, but as guides towards a mode of stylization – as exemplars, i.e., of 'maniera'.[2] The added measure of dependence upon ancient models does not result in an accretion of true classicism within high Maniera art, however; the antiquarianism of the high Maniera is no more than classicistic, and suggests more exactly than the parallel symptoms in early Mannerism the phenomenon art history defines as neo-classicism.

There is a duality between this emphasis on antique reference and the essentially unclassical character of the high Maniera work of art, and the same effect results from the painters' frequent habit of quotation from the classical High Renaissance, still more pronounced than in the early Mannerists. There is a duality also in the way in which high Maniera painting may appropriate the look and devices of the art of sculpture. But these are only some of the disparities that reside in the means employed by the high Maniera. In the painter's very mode of representation there is, in the first step he takes in the making of his image, a strong disjunction from the expectation we have of nature, in the degree of stylization he imposes on it; but even this stylization, dominantly of an abstracting kind, is not internally consistent. The painter may make contrasting episodes, within the stylization, of illusionistic realism, and there are many other stages – almost always disconnective, however – that he may make

between abstraction and illusion. From the first moments of our observation, high Maniera painting presents us not just with one duality but with an assortment of them, and with disparities of an extreme range in its representation. Within the Renaissance, the Maniera of the first Mannerist generation, and its development in high Maniera more so, is a phenomenon that exhibits both the admirable and the morbid characteristics of a cultural *fin de race*. Excessively sophisticated, the best high Maniera painters seem poignantly aware that there is no longer any virtue in a simple statement; indeed it is a circumstance of their contemporary history as well as in the nature of the situation of contemporary art that there are no longer any simple certitudes to state. Each facet of experience may contain not just an ambiguity but, more positively, an ambivalence, or multivalence; and when the variety of experience that is needed to create a work of art is gathered finally within one frame, the multiplicity of meaning in the high Maniera picture can exceed all precedent.

It is an unavoidable characteristic of a late phase of a cultural style that it should be retrospective. The high Maniera is more than that; it is oppressed by its genealogy. Its artists, furthermore, found it in the fashion of their time to have a relative excess of literary learning and to be antiquarian. They were thus prone to the habit of quotation, and their quotations come from what they recognized in the world of art as representing ultimate authority; antiquity, Michelangelo, and Raphael, and after that the masterworks of early Mannerism. But their quotations are only rarely apt insertions into the surrounding text. Usually high Maniera quotation consists in borrowing a form to be the vehicle of a meaning unlike that which it originally carried. The effect is like the use, in writing, of a metaphor of which the sense has been deliberately perverted or has slipped. There is indirection at the least, and a disjunc-

tion at the most, between the quoted image and its purpose in the painting, and this is another agency for ambivalent or multivalent sense. But more often, as is the nature of a perverse metaphor, it calls attention to itself, becoming notable not for the light it casts on either term of comparison but for its own extraordinary, salient effect of sheer art. The quotation is not only internally disjunctive in meaning but, as well, disjunctive from its context.

This kind of quotation is only an extreme symptom of the cast of mind that determines the high Maniera painter's relation in general to his sources of artistic style. Whether he is quoting literally from a precedent or only generally dependent on it, he looks at his source as in the main something to be regarded for its forms: its content is a separable or at least diminishable factor. He projects a kind of censorship upon the data given by his models which results, in his reading of them, in their petrifaction, and he may then use the substance which the vacated form becomes to build into any context. This suits not only the predisposition of the high Maniera to place first premium on the work of art as ornament; it also suits the disposition of the artist to evade emotions that are not ornamental in their kind. We have observed that feeling, too, requires to be stylized.

This style, on the one hand so formalist and on the other so disposed to make a complexity of meanings, received encouragement, and matter to exploit in both directions, from contemporary literature. The intellectual disposition of the high Maniera artist made for sympathy with the literary world and contact with it, and this was the sympathy in this time also of the artists' patrons. The role of the men of letters as a bridge between patron and painter seems, during this time, to be more overt and frequent than before. Towards the mid century the intercourse between art and literature sparked what was to become, as the century progressed, the most abundant body of writing about art up to this time, not only by men of letters but by artists who acquired their status. Often, this literature on art is itself a recognizable expression of a style of thought and exposition that belong to the visual Maniera. It is the artist's own inclination, as well as literary example and the patron's sympathy towards it, that results in the incorporation into the already complex visual matter of Maniera art of the development in contemporary literature of symbol, metaphor, and allegory. Compounded with the visual matter, the masking and the multiplicity of meaning given by a literary programme have produced, among the pictures of the high Maniera, some of the most difficult rebuses in the history of art.

This result may be apparent even in a painting of small compass, but the quota of abstruse complication tends, obviously, to increase with the extent of the work. In high Maniera fresco cycles the meaning of a narrative or a symbolic theme tends to be accompanied by multiple allusions, often implied rather than completely or explicitly defined in visual terms. These allusions or allegorical meanings are essentially literary, requiring verbal explanation or at least a verbal tag to understand them. They encrust the visual substance that makes the painting, but in their distinct possession of a verbal sense remain detached from it. Unlike the classical style's treatment of its literary programmes, which fused verbal meanings – or better subsumed them – into the formal texture of the work of art, in high Maniera painting the literary factors resist synthetic incorporation. But it does not seem that this is an unwanted result of the different nature of the literary ideas of the Maniera time: on the contrary, it may be that the Maniera painter preferred to keep the verbal meanings of his picture distinct from its visual sense, thus adding another level of complexity to his work.

The fresco cycles of the high Maniera, which best demonstrate this relation between verbal

and visible ideas, also illustrate most cogently some other principles of its aesthetic. One of the cardinal conceptions of the climactic phase of the classical style, and of the first Maniera following it, had been that of the identity of the picture plane – the acquisition, or rather re-acquisition, of the sense of pre-eminent importance of form articulated as if out of and upon the canvas, the panel, or the wall itself. Despite the excavations into space which the high Maniera painter may occasionally make, the design produced on the picture plane and its accompanying elaboration are almost always the prime stuff of his work of art. It is on this plane that he arranges his patternings of form, pointed and precious or calligraphically ornamental; it is in respect to it that he manipulates his statuary effects of relief; and when he penetrates it to describe a space, that space is bound into a continuity of pattern with the design made on the surface. This is no simple conception of planarity: the pictorial surface is a plane of reference rather than an absolute, in relation to which the painter contrives subdivisions and complications that elaborate it into a set of strata – levels of form as close-knit and multiple as the levels of meaning he makes in the work of art.

In combination with the painter's sense for formal beauty and his resources of technique, this acute sense of the picture surface invites its working like a precious substance. This is more true of the easel picture, but it often happens even on a monumental scale: a whole wall or ceiling may become an outsized precious ornament. Elaborating still farther than in the earlier Maniera the precedents given in the last moments of the High Renaissance, the high Maniera decorator works the whole extent of his given surface, encrusting the largest room in much the same spirit and with much the same devices that a goldsmith uses to encrust a box. He may have small regard for such logic as may be in the pre-existent architecture,

taking it rather as a free field for the projection of his ornamental wit. By formal processes of great control and complexity he creates upon the wall one great plane – or stratum – of ornamental form within which each subdivision has, in turn, its own stratified planarity.

One genre within high Maniera style, its religious art, requires special comment, because it presents a problem that seems to be contrary to the style's basic nature. If we take the requirements of religious painting in their customary sense, or as earlier periods took them – some among the painters of the first Mannerist generation included – then the artists of the high Maniera indeed did not meet them. We have noticed that the high Maniera had no sympathy with passion, and that it required 'unsocial' emotions to be evaded or controlled and replaced by feelings that were chastened and indicative of finer susceptibilities. It is amply clear that in most cases religious subject matter was taken by the high Maniera artist with small intention to illustrate a force of content in it of emotional experience. He preferred to crystallize this content – as he crystallized form – into something that would tend towards symbol rather than direct psychological or narrative communication. He then worked the forms required by his subject into an aesthetic construct of a complicated, precious kind, and the expression of the picture thus becomes, primarily, that of this construct. But this expression, though different in tonality and kind from the emotions normally implied by the subject matter, may be equal to it in intensity: an aesthetic surrogate has replaced the feelings of a human narrative or a human situation. The aesthetic form and the content that emerges from the form are quite consistent, but both are disjunctive from the subject matter. In this there is not only a duality of meanings but a dislocation made between them. The high-pitched, complex vibrance made by the Maniera forms and the tension that exists between

their content and the subject matter can produce an extraordinary excitement, and this, felt in the presence of the religious theme, could tell in the viewer's mind as a state equivalent to a religious inspiration. It is in this way that high Maniera religious painting works not just illustratively, but as an instrument of spiritual communication.

To understand the virtue as religious art of such Maniera pictures it may help to realize that their effect, and their intention also, is like those of the religious image we conventionally call an icon. In both, the subject matter is rigidified, translated from history towards symbol, and the form in which it is presented is made crystalline and tends towards the abstract. The formal construct, highly stylized, is the main agent of communication with the viewer's mind; and this form is the object of a precious working and elaboration. In front of a high Maniera altarpiece, as before an icon, the spectator sees an effulgence of abstracting beauty. But the viewer of the Maniera altarpiece does not see its subject matter as one with this effulgence. The precious and exalting emanation is suspended as if in a separable plane before the matter that identifies overt religious meaning. The spectator may associate his state of exaltation, produced by the aesthetic means, with the subject matter, but the artist has not made the identification for him.

There is a systematic scheme by which we can connect the multivalence of meaning we have found in high Maniera images with their immediate antecedents in the history of art. The classical style of the High Renaissance worked with meanings, of form and content, in such a way as to fuse them in a synthetic unity. The immediate successors of the classical generation, who were also the immediate predecessors of the high Maniera, fractured this synthetic unity, in some cases dedicating themselves to the development of separate strands deduced from it, in others seeking, deliberately,

the effects antithesis could achieve. The high Maniera pushed this process farther, to make an artistic principle of multiplicity and multivalence. In the same schematic vein, we may say that the most sophisticated examples of the high Maniera consist of accumulated strata of form and meaning, which sometimes intersect but are more often kept disjunctive, weaving among themselves a web of subtle tensions. The quality of tension is, most often, precious or even exquisite; it emanates a strained, finespun, unquiet grace. The multiple, disjunctive strands of meaning are presented to the spectator simultaneously, and it is for his swift and sophisticated response to make a single tissue of experience of the whole. It seems that the kind of matter in these pictures, and the kind of apprehension they require, are very like those of contemporary polyphonic music. In Maniera the spectator, not the artist, may be regarded as the agent who effects a synthesis. But like contemporary personalities in their portraits, all high Maniera art displays a fine aristocratic coldness towards the spectator. It is as if the picture were content to exist as a hieratic image, or as a decorative jewel, chill to the accident of being seen. Unless the viewer brings to the painting the refinement of sensibility, the wit, and the sophisticated resource that the work of art contains beneath its mask, it will not deign to make communication.

By no means all pictures painted in the vocabulary of the high Maniera achieve the effects we have described, or work at the high qualitative level that is required of this vocabulary to attain creative meaning. In the hands of lesser artists the style of Maniera, more easily than another, could become what was referred to even by contemporary critics[3] in a pejorative sense as merely 'di maniera', an art of repetition and facile formulae. The formalistic bias of the style itself encouraged this, and so in time did the contemporary theories of art. In their definition of what they called 'bella

maniera' they laid stress on a principle of ideal selection, more from the examples of *maniere* already set in art than from experience in nature, and gave counsel to re-use ideal formulae once they had been evolved. Less specialized and sophisticated styles than the Maniera are less likely than it to find technical and formal ingenuity a sufficient end, or wit at best and laboured intellectuality at worst adequate as content. The nature of Maniera and of the culture that supported it promoted such devaluation, and there is no preceding period of art when so much sophistication was exercised to satisfy a comparably diminished purpose. There is a sense in contemporary writing – usually only implicit, and infrequently confessed – that the style represented a decline, in respect not only to the High Renaissance but to the early Mannerist accomplishment.[4] Even the best of the Maniera of the second generation was felt to be (from what we have described as its restrictiveness, presumably) a lesser value in the scale of recent art. At the same time the mid-century Florentines and Romans held insistently to the proposition, part in fact still valid, part illusory, of their connexion with the early Cinquecento's apogee of classical style, from which contemporary style stood in the direct line of descent; but it could not be avoided that the idea of descent contained a double sense.

The roles of Florence and of Rome in the history of mid-century Maniera are distinguishable, but they are also inextricably interwoven. In Florence, the first Maniera represented by Pontormo's painting *c.* 1530 had a direct offshoot in the style generated from it by his pupil, Agnolo Bronzino, who in less than a decade effected the alterations that made his art one paradigm of high Maniera. Born in 1503 (and thus a contemporary of Francesco Parmigianino, but slower than he to mature), Bronzino belonged to a generation intermediate between Rosso and Pontormo and those young Florentines, Salviati and Vasari, both born about 1510, who would make a high Maniera paradigm of wider currency. Where Bronzino's high Maniera was formed mainly out of sources found in Florence, the two younger painters (and their colleague Jacopino del Conte also) formed their Maniera less in Florence than from sources found in Rome. They detached themselves from Florentine backgrounds that had not been in Pontormo's *avant-garde* but mostly in the conservative – and still strong – Sartesque tradition, and attached themselves in Rome to the example of the post-Raphaelesque school. Thus mostly indirectly, but also by direct reference and study, they effected a linkage with the first 'bella maniera' of the Cinquecento – that exemplified within Raphael's style. When the young Florentines first studied in Rome the creators of the post-Raphaelesque Maniera had long been dispersed in consequence of the Sack, but prime examples of their art were there; and before 1538 one of these protagonists, Perino del Vaga, returned. We have seen that he possessed, by the time of his return, as sophisticated an apparatus of Maniera as any painter working then in Italy: he had himself developed and elaborated his own propositions of Maniera style into high Maniera. His influence on the direction taken by the younger Florentines in Rome must have been conspicuous. As he, himself a Florentine by origin, had once reformed a conservative Tuscan style on Roman models of modernity, so now his younger compatriots accomplished the same process with his help, by which he served in part as intermediary between them and Raphaelism but also, more importantly, as Raphael's modern substitute. Salviati and Vasari practised subsequently in both Rome and Florence, as leading personalities in both, intermingling the histories of the two schools. As Rome regained its strength and, with it, its multiplicity and wealth of patronage, it regained its former pre-

eminence as a centre of contemporary art; but the main agents in the making and the practice of the high Maniera that dominated this contemporary scene were, or had been, Florentines. And what in mid-century Rome did not belong definitely to this style was in great part the effect of the residence there of another Florentine: Michelangelo. As had happened earlier in this century, and at times during the century before, Florentine genius infused creativity into the resources which Rome offered.

In Florence, Vasari's Maniera – always conditioned by his conservative early education and a temperament sympathetic to it – took a place beside Bronzino's in ascendancy on the local scene, and by sheer quantitative effect in time partly displaced it. With some modest effort the lesser and more backward Florentines could adjust their painting towards Vasari's mode, which, despite its Romanism, still had so much that was retrospective and Sartesque in it. Vasari did not effect conversions only among his contemporaries in age; because his activity as a decorative *régisseur* required an extensive school, he came to play a large role in shaping the style of a succeeding generation. As long as he and Bronzino lived (both into the first years of the seventies) they shared an authority that their distinct versions of a high Maniera imposed on Florentine painting. Before the ends of their long careers, however, this authority began to show signs of corrosion. By the mid seventies the complex stylizations of Maniera had ceased in most artists to represent the workings of a strong creative principle; in some painters this decline of creative pressure had occurred earlier. A generation's use had turned what once had been invention into the material of formula. No impelling new invention arose as yet, and painting was still bound to the prevailing formulae; nevertheless symptoms of a kind of thought distinct from that of the Maniera

appeared beside the formulae. Conditioned and constrained by them, these symptoms were no profound novelties, but they were at least the indices of search.

In Rome the history of this period is more complicated. The time of the formation there of high Maniera by the young visitors from Florence and the returned Perino coincided with the re-established residence in Rome of Michelangelo and with the painting of the Sistine *Last Judgement*. Though characteristics which appear within Maniera may be identified piecemeal in this, it is in more respects, and in profounder ones, antithetic to Maniera style. The elegance and subtlety which, in Michelangelo's previous Florentine productions, make his work akin to Maniera and an inspiration for it diminished rapidly in Rome. The causes were not only internal to the artist but in the altered climate of religion that he found in Rome, where the last but most developed currents of the Italian Reform and the incipient Counter-Reformation intersected. In the *Last Judgement* Michelangelo's style began to be, not as before gravely spiritual, but sombre, and would grow more so, discarding ornament and eventually abjuring beauty. His example had inevitable authority. No sooner had the high Maniera formed by his fellow-Florentines attained its full development than it found itself, at the middle of the century, in contest with the new pronouncements made by Michelangelo. His influence did not arrest the course of the Maniera, but it effected discernible alterations in the principles of some of the chief practitioners of the style. A group of painters attached themselves more directly to Michelangelo's model, but only a few among these were of measurable independent stature; the rest were the *epigoni* who began to multiply in Rome and spread elsewhere in these years. But even the converts to an apparent Michelangelism saw his art with preconceptions formed by the dominant Maniera. Evading the profound

sense of the master's art, they exploited its repertory of form to make what in the end was no more than another facet of Maniera. However, among some of these painters the sobering and chastening of both form and content on Michelangelo's example had the result of an expression enough distinct from the norms of high Maniera to require a label that articulates the distinction. A similar result of style, but one yet more distinct in structural mode and sobriety of temper from the high Maniera, had appeared contemporaneously, inspired less by the recent Michelangelo than by a purposeful recall of past Raphaelesque classicism.

Intending clarity in formal order and legibility in content, both the Raphaelesque and Michelangelesque variants of this dissenting style were contrary to the high Maniera in these large and basic respects. However, the practitioners of this new austerity of structure and expression did not insist that their mode require a significantly new way of representing nature, different from that of the Maniera: they continued to use the descriptive vocabulary of the Maniera, though not its syntax, to clothe their differing ideas. Much of the artificiality of Maniera and its abstractness may remain theirs, not only in description but in their affects of design and in the removed – chill, often – tenor of their illustration of human themes. Where the high Maniera evades strong emotion or deals with it obliquely, this style represses it, stating it in terms of symbols and conventions. This style, then, despite its differences from high Maniera, remains intrinsically connected with it, and may be thought of as the reverse face of the same spiritual and aesthetic coin. If we are careful to take the prefix 'counter' in an exact sense – as it is used, for example, especially in the conception of a counterpart (or further: counterproof, counterpoint, contrapposto), implying parallelism and relation between two terms at the same time as their opposition – then the term 'Counter-Maniera'

may serve us as a verbal handle that will help us grasp the nature of this style.

This Counter-Maniera is recognizable as an expression in a style of art of a temper we identify with the cultural and religious movement of the Counter-Reformation. As that temper was more clearly and pervasively defined from the mid century onward, it came to be a major force in strengthening a disposition towards art that found the high Maniera uncongenial; conversely, Counter-Maniera came to be an apposite expressive instrument for aspects of the thought and feeling of the Counter-Reformation. From the time of Pope Paul IV Carafa in the later fifties, then increasingly under Pius IV and the sainted Pius V, the tone of Roman culture became more austere. In a letter written from Rome in March 1567 Vasari gave his – Maniera – view of what life in Rome had become (in consequence, he asserts, of the puritanism imposed by the past Pope, Pius IV). He speaks of '. . . the grandeurs of this place reduced by stinginess of living, dullness of dress, and simplicity in so many things; Rome is fallen into much *miseria*, and if it is true that Christ loved poverty and the City wishes to follow in his steps she will quickly become beggarly . . .'.[5]

In such a milieu, the decrees issued specifically in regard to art by the Council of Trent[6] (only in its last session, 3-4 December 1563) were, rather than a new force to reshape the style of art in Rome, a codifying and official sanction of a temper that had come to be conspicuous in Roman culture. Counter-Maniera and the Counter-Reformation came to be reciprocal to one another, and a similarity of terms for them is thus informative, but the style of art must not be thought of as no more than a function of the movement in religion.

Counter-Maniera and the phenomenon that has acquired the designation 'anti-Maniera' are not the same. Starting significantly earlier, in the middle of the century, Counter-Maniera

took on prominence in the Roman scene along with its cultural and religious counterpart, but only after the last quarter of the century had begun did it provide the basis from which an 'anti-Maniera' style then developed. But despite its increasing role, the Counter-Maniera of the third quarter of the Cinquecento did not change the fact of the continuing pre-eminence of high Maniera in this time: high Maniera and Counter-Maniera prospered side by side. The choice between them was sometimes a temperamental one, but the same painter might find it practicable according to occasion to work in either mode – the best proof of the essential affinity between them which we have stressed. The determining occasions came to be – more or less generally, but without any rigid scheme – those of patronage and purpose. Secular subjects and painting of which the primary purpose was decorative (whether or not in a religious place) tended to follow the aesthetic of the high Maniera; works of devotion and some large-scale religious illustration tended towards the Counter-Maniera's more sober style. But the formulae of high Maniera endured well towards the end of the century in Rome, with not much adulteration.

THE FLORENTINES IN THE FORMATION
OF THE HIGH MANIERA

Bronzino

Agnolo Bronzino's high Maniera – not the most inclusive expression that the style took but one of its most eloquent – was, as much as possible in this time of cultural commerce between Rome and Florence, a native Florentine phenomenon. Its basis was, as we remarked, Pontormo's first Maniera, in which Bronzino had received the schooling that was to be decisive and essential to his future course. Born in 1503 (not quite ten years Pontormo's junior), Bronzino had a first training in the shop

of the conservative Raffaellino del Garbo, then came (by 1518/19 at the latest) to Pontormo. Their relationship became as close as that of a father and an adopted son, and endured on these terms through Pontormo's lifetime. Bronzino watched at first hand the whole creative travail by which his master evolved his first Maniera style in S. Felicita, and his own maturing of artistic personality coincided with it.

At the beginning, Bronzino's acquisition of the Maniera Pontormo had invented was evidently effortful. It was more than the habits he acquired in his adolescent time with Raffaellino that disposed the youthful Agnolo to describe more literally than Jacopo and to feel forms rather gracelessly. His first known works, preceding the time of S. Felicita, two small frescoed lunettes in the Certosa di Val d'Ema, done there in 1523-4 beside Pontormo, are only just enough preserved to recognize their conservatism as well as their awkwardness. By 1525-6, when he had the precedent of the early phase of the S. Felicita decoration (and had assisted in it himself),[7] he was able to construe it in his fresco *Temptation of St Benedict* (Florence, S. Salvi, detached from the Badia) in a mode that was technically highly skilled but still not fluent. In 1527-8, following Pontormo's own continuing development of his Maniera, Bronzino's *Holy Family* (Washington, National Gallery, Kress Collection; long erroneously considered to be by Pontormo himself) is a nearer paraphrase of his master's newest style. Yet even here it is apparent that Bronzino's accommodation is laboured. Within the borrowed stylization, he focuses upon elements of objective truth, which he sees fixed, still, and separate. Even his actors seem a form of still life, their emotions mask-like and no deeper than the visible skin. Pontormo's fusing of his vision and emotion of his subject matter, which he expresses in pulsating continuities of rhythm, is alien to Bronzino. Yet, aided by a sensibility as fine as Jacopo's, though of a very

different kind, and by a quick-ripened total mastery of hand, Bronzino continued to work towards the difficult goal of entire absorption of his master's style. In 1529–30 he came to achieve it, in the role of executant for Jacopo of his design for a *Pygmalion and Galatea* (Florence, Palazzo Vecchio).

Immersed in Pontormo's style to this degree, but none the less still different from Pontormo in his native tendencies, Bronzino embarked finally upon an essentially independent career.[8] From 1530 to 1532 he was at Pesaro, working in Duke Guidobaldo of Urbino's Villa Imperiale. His role at Pesaro still needs clarification, but in respect to what he may have learned while there it would appear that association with Genga, and with Raffaellino dal Colle (who seems to have worked directly with Bronzino), constituted an exposure at second-hand to the doctrines of Roman, and specifically Giulian, post-Raphaelesque style. The extent of their effect on Bronzino seems, however, minimal. A harpsichord cover with the story of *Apollo and Marsyas* (Leningrad, Hermitage), painted at Pesaro, remains quite like Pontormo's recent style. But most important among Bronzino's works at Pesaro, he painted a portrait of the young Duke Guidobaldo (Florence, Uffizi), the first step in his progress in this aspect of his career, in which he was to attain the first distinction among the portraitists of Central Italy. Based generally upon Pontormo's precedents, Bronzino's distinct disposition emerges in the *Guidobaldo* more positively than before. For reasons that are perhaps partly accidental, its armoured rigidity and discreet effect of aristocratic parade anticipate Bronzino's mature portraiture more than portraits that immediately follow.

The remaining years of the decade, after Bronzino's return to Florence in 1532, are mainly notable for his development of a portrait style. It may have been his renewed contact with Pontormo that summoned forth, in the portraits done soon after his return, a descriptive sensibility rivalling Jacopo's, and almost as charged with graphic and luministic vibrance. Yet the *Portrait of a Youth* (Milan, Castello Sforzesco, *c.* 1532) or the *Lutanist* (Florence, Uffizi, *c.* 1532–4) at the same time have a more literal intention than Jacopo's for what they describe. A graphic stylization is imposed on the whole picture pattern and pervasively touches the details; nevertheless, the human appearance within this stylization seems to remain, much more than in Pontormo's portraits, objectively intact. The quota of stylization increases rapidly, however; the native gift for observation that inclined Bronzino towards reality yields to the authority of the example set him not just by Pontormo but also by Michelangelo's sculptures, and Bronzino now begins to develop his personal and particular version of their Maniera stylizations.[9] The portrait of *Ugolino Martelli* (Berlin-Dahlem, *c.* 1536) [180] has a cursive elegance of shape seemingly as arbi-

180. Agnolo Bronzino: Ugolino Martelli, *c.* 1536. *Berlin-Dahlem*

trary as any in Pontormo, but sharper in effect of silhouette, and a contrapposto attitude derived from Michelangelo but more tautly set. Form has a lucidity appropriated from the art of sculpture, but even its most plastically assertive parts are bound into a pattern made by a still more assertive force of line, steely and fine-wrought both at once. It is by linear means that Bronzino styles his model into a large pattern of conspicuous elegance, and then elaborates it with rhythmical excitements of detail. The pattern almost adheres to the picture surface, set more against than into an oblique perspective of architecture which describes a space but does not feel like one; the setting is involved with the surface pattern in a subtle and equivocal dialogue. In the *Portrait of a Young Man* (New York, Metropolitan Museum), a little later than the *Martelli*, all its qualities are expressed in still more precisely articulated ways: the styled elegance of the whole design (and of the sitter's posture that is its vehicle and, in a sense, its partial cause) is higher, the smaller rhythmical refinements of more excitant effect, and the sense of pattern made upon the picture plane more dominant.

An extremely sophisticated sensibility has gone into the manipulations, of large design and of detail, that make up the aesthetic substance of these pictures, and in the process of its working this sensibility has been congealed, chilled into suspended fixity at its high pitch. This sensibility does not, from the beginning, involve passion, and, as if to ensure that its presence should not be mistakenly assumed, the effects of sensibility are set down coldly, explicitly with dispassion – given to us as objectified sensations from which the artist, having set them down, is now detached. This is a very different relation to the image from that of Pontormo, in whose paintings we are beset by the assimilation made between the matter of the work of art and his consuming

self. Bronzino's attitude affects not only the experience of formal values with which he so sophisticatedly deals, but equally and identically the human values, even of the portraits. Contact with the sitter is a confrontation only; communication is deliberately sealed off. The sensibility that excludes emotion makes a fine record of the surface of the countenance but goes no deeper, accepting – preferring, indeed – that it should have the fixity and the impenetrability of a mask. The very attitudes of body that the sitters take intensify the sense of a constraint: their behaviour is according to a precisely controlled, willed, personal *maniera*, of which the high artifice serves as a mask for passion or as an armour against it. At the same time this personal *maniera* affirms to the ultimate degree the qualities that pertain to it which are not different in the social personality, which has become a personality of art, from what they are in art itself. The refusal of involvement by the sitter is the reciprocal of the attitude of the artist.

We have seen how Bronzino detaches – objectifies – aesthetic sensation; the same relative objectivity exists in his confrontation not only with personalities but with the physical data they present, and with their environment. Bronzino alters the appearances of what he sees much less than Pontormo: his imposition of high style upon a form consists more nearly in arranging the objective facts until they almost of themselves begin to yield the effect of a styled pattern, then intensifying this effect by only restrained arbitrary means, including a brilliant yet measured exploitation of the possibilities a form may hold of complicating ornamental rhythm. Bronzino's experience of colour, too, is less subjective than the early Mannerists'. Bronzino's colour is most often tempered and discreet, and even at times repressed, as if it might be felt an unmannerly value. When colour is assertive or intense, as it

sometimes is, its tone (except in accents) is a cold intensity, high-keyed, in which sensuous value is distilled away, and the emotion that continues to attach to colour is made consonant with all the rest in its artificiality.

It is in the portrait of Bartolommeo Panciatichi [181] and the pendant portrait of his wife Lucrezia (Florence, Uffizi, *c.* 1540) that Bronzino realizes in full measure the special qualities of the portrait style he predicated in the *Martelli.* Of the family who were lords of Pistoia, but also vassals to the Medici, Panciatichi seems a paradigm of the neo-feudal aristocracy; he is of an almost skeletal refinement. Each preciously articulated effect of design conveys the quality of tight and precise elegance, yet at the same time gives the sense that this constrains a high-pitched, fine-wrought, complication. We cannot know if this last derives from Panciatichi's personality or from motives that originated rather in Bronzino,

181. Agnolo Bronzino:
Bartolommeo Panciatichi, *c.* 1540. *Florence, Uffizi*

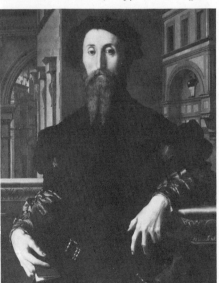

but the latter is the more likely source: the Panciatichi portrait probes the limits of complex expression of a high Maniera sensibility in portraiture from which Bronzino would afterwards recede.

We have no evidence that may much precede 1540 for Bronzino's conquest of a personal style effectively distinct from Pontormo's in his religious paintings. A small *Adoration of the Shepherds* (Budapest, Museum, towards 1540), however, is at once descriptively more normative – more like average expectation – and more classicist than anything within Bronzino's earlier, Pontormesque mode. It is also artificial in its tone of content and in the actors' manner of behaviour in a way that constitutes a novelty, and which pertains to high Maniera; no painter of the first Maniera had presumed to a preciosity disparate in this degree from the overt sense of the subject matter. As early as 1541, perhaps even during 1540,[10] Bronzino began the work in which he would mature a high Maniera in narrative and devotional art as he already had in portraiture: the fresco decoration in the Palazzo Vecchio of the chapel of the Duchess Eleonora of Toledo. In the ceiling fresco of the chapel, with four Saints in a partial *sotto-in-su,* Bronzino seems not yet to be quite clear about the direction of style that this (relatively) large-scale and public work should take. It is highly polished, but in general lays an unexpected stress upon effects of naturalism, as if Bronzino might be deliberately making a conservative counter-proposition to the extreme style of the recent Medicean decorations by Pontormo. This minimizing of the earlier Mannerist's distance between the image and the normative appearances of nature is carried into the style of the first wall fresco in the chapel, the *Passage of the Red Sea* (1541-2). The proportions of figures and descriptions of anatomy and drapery appear as 'correct' as they might be in a naturalistic and classicizing canon.

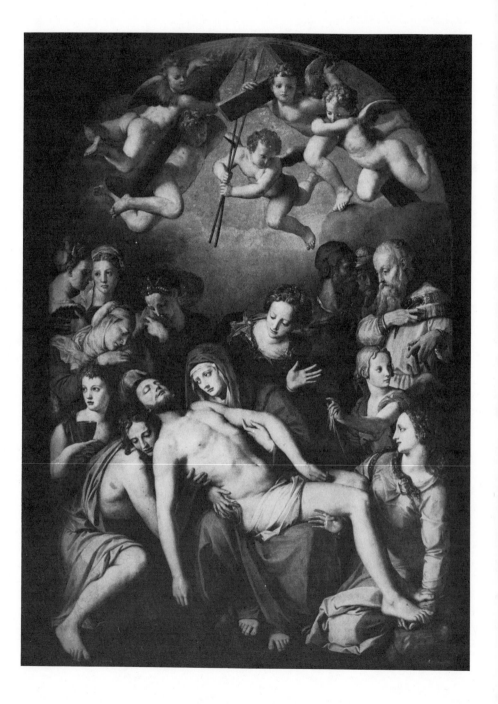

But on this basis that relates to nature and to classical precedent Bronzino imposes a repertory of devices for its stylization as aesthetically arbitrary as Pontormo's and (perhaps because they work as sharper contradictions of the 'naturalness' beneath) more extreme in their effect of artificiality. Bronzino's stylizations here are not, as Pontormo's tend to be, emotionally infused distortions of the forms, but cool, excessive purifyings of them, making unreal smoothness and regularities and a temper of precisely moderated, but obtrusive, grace. The figures turn into equivocations between nature and a neo-classic statuary of improbable perfection, posturing in attitudes that are meant to tell us primarily about their beauty and only incidentally or not at all about their meaning in the scene. In this scene, potentially dramatic, drama is relegated to the distance and there expressed only by objectively illustrated incident or a conventional vocabulary of response. The prime sense of the picture is in its accumulation of aesthetically remade beings, as untroubled by imperfections of emotion as of form. The higher realm in which they must exist is emphasized by a pure, pale tonality of light and by colour that makes the subtlest distinctions in degree of glaciality. In the second wall fresco of this time, the *Brazen Serpent* (begun in mid 1542), there is a possible reference to Michelangelo's design,[11] but it is difference, not similarity, that is notable. Along with episodes of naturalism more explicit than in the *Red Sea*, there are passages of statuary abstraction of still more transcendent and poetical effect, and a calligrapher's enlacements of design. It is the altarpiece of the *Pietà* (now Besançon, Museum) [182][12] that crowns Bronzino's progress into high Maniera. Bronzino imposes on the inescapable tragedy of the subject the discreet suppressions required by the

high Maniera's code, muting grief until its tenor is diminished and acceptable and endowing its bearers with such beauty of countenance, attitude, and ornament that it irradiates their paled residue of feeling, and then stands before it in our contemplation like a mask. An absolute technique asserts at the same time the intense plastic presence of the scene and the aesthetic factors that transform it. Colour, cold and luminous as ice, symbolizes what has been made of passion. Both this form and colour, in the intensity of sheer aesthetic sensation they produce, transcend illustrative meaning and in part displace it. Art does not narrate the tragedy but replaces it.

But where content jibes with the kind of feeling that is acceptable to the high Maniera, Bronzino exploits perfectly the sophistication of form that he had created to express it. The so-called *Venus, Cupid, Folly, and Time* (London, National Gallery) [183], which must be almost coincident in time of execution with the *Pietà*, demonstrates this to a consummate degree, Based upon a complex verbal allegory[13] of the Passions of Love, it pretends a moral demonstration of which its actual content is the reverse: the exposition of a sexuality so knowing as to be perverse, and so refined as to be at once explicit and oblique. Inverting Pygmalion's role, Bronzino has altered human presences into an improbably pure statuary; but he has retained, in transmuted form, a vibrance that those presences contained, distilling what conveyed their sexuality and quickfreezing their subtlest sensations. Glacé surfaces of flesh emanate a contrary excitation; the postures of the protagonists are frank and yet evade; cold grace is manipulated into attitudes that convey, by the effect of pattern, the finedrawn tension of the actors' states of mind. The whole pictorial patterning, a crystalline, eccentrically kinetic skein, is an elaboration upon this last effect. The colour, basically that of the enmarbled flesh and the ice-blue background,

182. Agnolo Bronzino: Pietà, before 1545.
Besançon, Museum

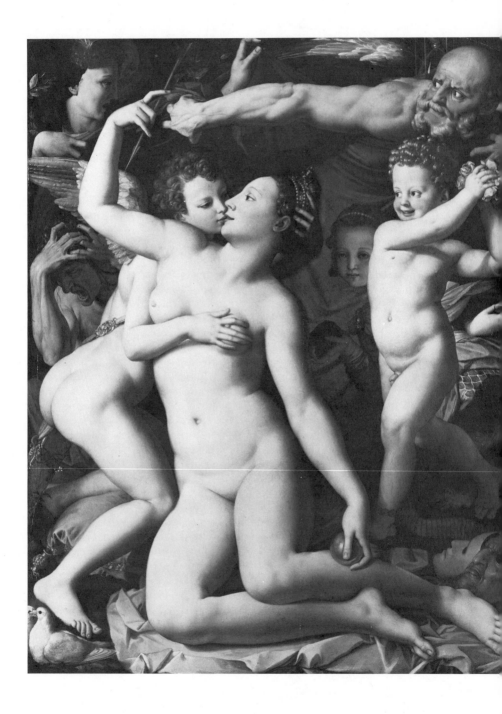

183. Agnolo Bronzino: Allegory,
called 'Venus, Cupid, Folly, and Time', c. 1545.
London, National Gallery

has the dual quality, by now characteristic for Bronzino, of intensity and abstracting cold. The extreme refinement of the execution defines the matter and the meaning of the image in consonant terms, but it also conveys the sense that whatever else it may be, the picture is a surpassingly wrought object of art: fiction, ornament, and jewel, and this is an index of the attitude with which, from the beginning, the artist has approached its essentially erotic content. Even this aspect of human experience must be aestheticized, its values transposed into those of art.

Salviati

With his achievement of the first half-decade of the forties Bronzino set one pattern in the history of the Florentine high Maniera. At approximately the same time the most gifted members of a slightly younger generation of Florentines – Francesco Salviati, Giorgio Vasari, and Jacopino del Conte – created an analogue of Bronzino's high Maniera style; we have observed that it was to have a wider currency than Bronzino's, and that its origins were distinct from his, in a conversion from conservative Florentine *Sartismo* to exemplars found, in the main, in the post-Raphaelesque style. In the case of Salviati this conversion was effected in Rome itself, as for Jacopino also; Vasari's style, as we shall see, underwent a more complex process of formation. Yet he, too, confirmed the significance for his art of experience in Rome. Of his visit there (January–June 1532) Vasari could say '. . . lo studio di questo tempo essere stato il mio vero e principal maestro in quest'arte' (*Autobiography*, VII, 653). Salviati had arrived in Rome only shortly before him, and unlike Vasari he was to remain uninter-

ruptedly throughout the decade. Jacopino migrated later than his contemporaries, late in 1536 or early in 1537,[14] but to stay permanently. Save for Sebastiano del Piombo, Rome at the beginning of the 1530s had no artistic luminaries; they had been dispersed by the recent Sack, and the reconstitution of the Roman school was at first slow. Michelangelo's presence was not as yet definitive; his final resettlement in Rome was not till 1534. One member of the great pre-*Sacco* constellation who came back to Rome, Perino, did so only about 1537. There was not much in the form of current artistic activity to obstruct the attention of the visitors from Florence to the most visible accomplished recent fact of style, the post-Raphaelesque Maniera, and to its source.

Francesco de' Rossi, called Il Salviati, born in Florence in 1510, was the earliest and the most convinced of the converts to a Roman ideal of Maniera. In Florence Salviati had been a pupil, in succession, of Bugiardini, of Bandinelli (in whose school he encountered his young contemporary, Vasari), and then briefly of Raffaelle Brescianino; and in 1529–30, until Sarto's death, he was in his shop. The Florentine experience was, as this list of teachers indicates, extensive, but it was not decisive.[15] In 1531 he was joined in Rome by his friend Vasari, who tells how avidly both devoted themselves to the study of the artistic riches that they found there. Francesco's gifts included a facility far in excess of Giorgio's and he was more precocious; but beyond this he was much nearer to possessing a creative genius. He very quickly found Roman patronage, especially from other Florentines then resident in Rome, such as Altoviti and Filippo Sergardi, but his early fresco works for them are lost. His first surviving Roman piece is an *Annunciation* (Rome, S. Francesco a Ripa) of c. 1533–5. The marks of his Florentine education are still clearly discernible in it, but it is more evident that Salviati is in rapid process of assimilation

of a Roman style. His primary model is one which represented now, only half a decade later than the Sack, post-Raphaelesque modernity: the mode formed before the Sack by Perino del Vaga. There is no direct approach to Raphael (and none to Michelangelo, despite a study of him we can document in drawings); Salviati grafted himself directly on to the post-Raphaelesque development of a Maniera.

In 1538 Salviati was engaged to join his recently arrived compatriot, Jacopino, in beginning a fresco decoration of the Oratory of S. Giovanni Decollato, a Florentine establishment in Rome of which the purpose was the charity of consoling prisoners condemned to execution. Despite its morbid purpose, the Confraternity chose to make their oratory a show-piece of modern decoration. This ambition provided a place and opportunity for Salviati and Jacopino to demonstrate a new style on a major scale. Later, over the course of more than a decade,

the oratory became the most important collective artistic manifestation of its time in Rome and the monument most representative of the emergence of Roman high Maniera style.[16] Salviati's initial contribution, the *Visitation* (dated 1538) [184], is visibly not yet entirely mature, but the high creative intelligence it shows and the symptoms in it of a new phase of Maniera mark a clear stage in the accomplishment in Rome of high Maniera style. Perino had by now returned, but as yet had made no major new work, and in the *Visitation* Salviati's chief model is still Perino's accomplishment of an earlier date, the Cappella Pucci of SS. Trinità in particular. Added to it is a demonstration of the results of some years of assiduous Roman study, in the form of borrowings not only from Perino but from masters of the classical style, namely Raphael and Peruzzi; but these two are transcribed by a formula that is Perino-based.[17] The tendency to make intellectual and aesthetic

184. Salviati: Visitation, 1538.
Rome, Oratory of S. Giovanni Decollato

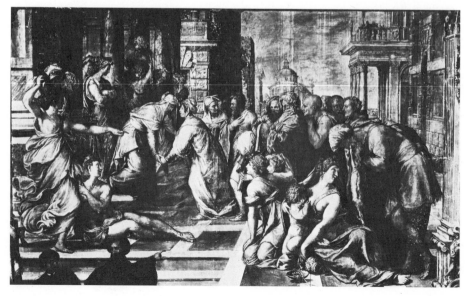

capital to this degree out of reference to high authority, and classical authority especially, is a symptom of an attitude of high Maniera. But more indicative of novelty is the measure – decisively more not only than in Perino but than in any other of the early Roman protagonists of the Maniera – of ornamental value given to the form. There are few extravagances of shape or proportion; ornament is made rather by an insistent, almost entirely pervasive calligraphy that invades every element that can, without a radical distortion, be made subject to it. This is no mere decorative exercise but a highly charged, excessively deliberate manipulation, inspired by a consuming aesthetic will. It makes the objects in the picture – and the whole design – seem as if they had been wrought, like goldsmith's work, rather than painted, and (despite the relatively normative appearance of things) as if they had been fabricated more than represented. The narration, too, is ornamentally elaborated, but none the less remains explicit; however, the attitude that disposes Salviati to intense concern with ornament affects the way in which he conceives content. That too becomes an ornamental occasion, taking the temper of the form. Finally, it is the form that assumes primacy. As Perino, building on the later Raphael, had specially developed one of his major propositions of style, so Salviati, building on that step by Perino, had in turn made a further and yet more specialized development on it – the basis, thus, of a high Maniera. The contemporary Perino, however, proceeded beyond his own previous accomplishment in much the same way.

Salviati departed from Rome late in 1538 or early in 1539 to return to Florence briefly, from which he travelled via Bologna (where he was for a while with Vasari, then working there) to Venice, remaining in Venice into 1541. He returned to Rome by way of Verona, Mantua, and the Romagna. In Venice his chief patrons were the Grimani, in whose palace he executed (in stucco frames by Giovanni da Udine) two small decorations *all'antica*.[18] They give evidence of an important experience, newly gained by Salviati outside Rome, of the Bolognese paintings of Parmigianino. The kind and quality of grace that Salviati observed in Parmigianino gave his strained calligraphy new fluency, while not diminishing its complexity or power. More important, Parmigianino's style did more than demonstrate a mode of ornament; it revealed that stylization could create high elegance. Two Roman years that followed the North Italian trip show Salviati's process of assimilation of what he had acquired. A series of Madonna paintings of the early forties illustrates the degree of his attraction to Parmigianino. Parmigianino's artistic licence, much more than Salviati hitherto had dared, infects these paintings, but only for a brief while. Like most of his contemporaries of the second Mannerist generation, Salviati had a classicistic preference for less arbitrary forms and soon returned to them, making his effects by revisions rather of detail than substance, and by appending ornamental values to forms that, relatively speaking, remained normative.

In 1543 Salviati returned to Florence, where he was to stay until 1548; Duke Cosimo's régime, now firmly controlled, autocratic, and relatively prosperous, offered opportunities of patronage almost comparable to those of Roman society. It was at the beginning of this time that Salviati's personality and style both came to full fruition. In close coincidence with Bronzino's whole attainment of a high Maniera, Salviati achieved the same, but in a variant that joined the draughtsmanship, the wit and elegance of a native Florentine to the tradition and the repertory of Rome. His first major exercise in Florence was the fresco decoration in the Palazzo Vecchio of the Sala dell'Udienza (October 1543–1545), where the theme supplied him was the celebration of Cosimo's régime in the guise of the history of a great –

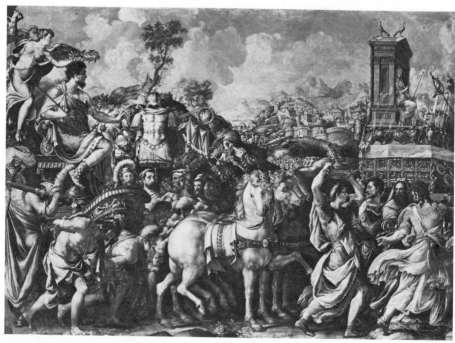

185. Salviati: Triumph of Camillus, 1543-5.
Florence, Palazzo Vecchio, Sala dell'Udienza

but unpopular – antique tyrant, the Roman Camillus [185].[19] The narrative scenes accumulate the most learned and elaborate battery of archaeological reminiscence, as if for the edification of the Florentines who had not the advantage of a Roman education, and they are framed by allegories, no less learned, of almost hieroglyphic abstruseness. High-keyed in colour and polished to an extreme degree, the single forms in the narratives take on the three-dimensionality of sculpture, while the whole design, by a further act of antique recollection, approximates late classical relief. Giulio Romano's precedent serves Salviati at least as much as antiquity itself. But working everywhere upon this sculpture-like substance,

insistently instilling it with life, is Salviati's line. It shapes forms now swiftly, now as if against resistance, and with an energy that is always at the same time intense and utterly controlled. Line makes ornament upon the forms and makes ornament of them, even while it helps define the seeming truth of their existence. The power of feeling involved in the making of the image is not less than in the Florentine early Mannerists (nor is the sense of its infusion in the draughtsman's hand), but it is bent chiefly towards a different end, to the extreme, almost infinitesimally probing exploitation of the image's ornamental sense. Rosso and Pontormo had made their artifice of form responsive to narrative or dramatic values;

here, however, intense feeling is an effect of the ornament alone. The temper of this affect may be disparate from the subject matter: among Salviati's scenes even the violence of battle is divorced from its ordinary content. Violence and passion may be illustrated in his fresco of the *Rout of the Volsci before Sutrius*, but they are not expressed.

Still as in the Roman *Visitation*, but now with a vastly different elegance and exact command, Salviati's images convey the sense of something wrought, a working on real visual and tactile matter until it yields what the artificer wills from it of ornament, while at the same time this matter's existential power is translated into a power of art. Not just imitation of antique relief but a more important motive, seeking strong presence and effects, makes forms crowd towards the picture surface. And to accumulate the energy and density of ornament that Salviati wants also requires it to be condensed, without dispersion into space, in a woven continuity close upon the picture plane. This artificer's will works not only all the major matter in a single picture's frame but the whole extent of the surface given him to decorate: the entire wall has the quality of a thing made by an incredible conjunction in the medium of paint of the sculptor's, goldsmith's, and lapidary's art.

Other court commissions came to Salviati, especially for the provision of cartoons for Cosimo's recently established *Arazzeria*. Salviati's finest and most elaborate designs for tapestries, probably of 1545-8, are an *Ecce Homo* and a *Resurrection* (Florence, Uffizi) and a *Joseph explains Pharaoh's Dream* (Florence, Palazzo Vecchio), the last of the set for which Bronzino and Pontormo supplied designs at the same time. It was appropriate to Salviati's gifts that, differently from Bronzino, his chief employment was more in decorative enterprises than in easel works. However, there are some easel paintings by him of this Florentine period

186. Salviati: Deposition, *c.* 1547-8.
Florence, Museo di S. Croce

that match his decorative pieces in quality and in significance for the definition of a high Maniera. Two of them, a small *Portacroce* and a *Caritas* (both Florence, Uffizi, *c.* 1543-5), reflect, despite their degree of Maniera, Salviati's sensibility to his earlier Florentine, Sartesque tradition. His most important easel painting of this time, the *Deposition* for the Dini Chapel of S. Croce (Florence, Museo di S. Croce, *c.* 1547-8) [186], refers in its descriptive mode still more to a conservative tradition, but at the same time makes an extreme artifice in figure postures and a patterning of pointed and refined complexity in the whole design. With Bronzino's closely contemporary *Pietà* for the Duchess Eleonora, this painting constitutes an

alternative paradigm in Florence of high Maniera. In 1548 Salviati returned to Rome, where, after his half-decade's absence, he encountered circumstances that would make him alter the complexion of his high Maniera style.

Jacopino del Conte

A different and much more drastic change occurred about the same time in the style of Jacopino del Conte, who had been Salviati's rival in the forming of the new phase of Maniera in the previous decade. Like Salviati, Jacopino (born c. 1510 in Florence) had apparently received his first important training under Sarto. In the years between 1530 and about 1535, when he arrived in Rome, Jacopino produced a series of easel paintings in which an initial close dependence on Andrea's style was quickly modified by a reference to Michelangelo's Medicean sculptures, and in less degree to Pontormo's painting; by the middle thirties he had evolved a style which (though its sources were openly apparent) made a personal contribution, to the aspect of contemporary Florentine Mannerism.[20] Jacopino was almost over-sensitive to influence (and also emotionally responsive in a measure quite unlike either Bronzino or Salviati), and his arrival in Rome provoked a considerable reorientation of his ideals of style, at first significantly classicistic. His first fresco in S. Giovanni Decollato, the *Annunciation to Zachariah* (possibly still within 1536, and the first to be done of the whole decoration), is a revision of his preceding style so thorough as to obscure their connexion: it is based upon a very restrained, even academically correct, interpretation of the mature Raphael. An unexecuted design for a second fresco, a *Birth of the Baptist* (1538?; preserved in an engraving by Bonasone), is not so dependently Raphaelesque but more overtly classicistic; its sources are not just in Raphael but in the – to the mentality of Jacopino's genera-

tion – more accessible doctrinaire translation of a classical style by another semi-Romanized Florentine, Bandinelli. These retrospective gestures, more extreme than any made by Salviati, were equivalent to a Roman counterbalance, mainly Raphaelesque and classical, to Jacopino's prior Florentine education, as if preparing his assimilation into the tradition of the Roman school.

Perino del Vaga seems to have been a major agent in completing this assimilation and bringing it up to date. It was Perino who supplied the design (Vienna, Albertina) which Jacopino used, still within 1538, for his second executed fresco in S. Giovanni, the *Preaching of the Baptist* [187]. As much as Salviati's *Visitation* of the same year, this is a landmark of high Maniera accomplishment; by no means wholly or even mainly on account of the role which Perino's design plays in it.[21] On the classicistic canon he had found in retrospective Raphaelesque study Jacopino has imposed the mannered *grazia* deduced, by Perino conspicuously, from Raphael; but further, recalling his earlier dedication to Michelangelo, Jacopino has turned to him again – not to the recent Florentine sculpture but (once more retrospectively) to the Sistine Ceiling. He has fused the two great Roman strains of classical example in the *Preaching* in a way more programmatic and more explicit in effect than any predecessor, in a binding medium that consists of Maniera ornament developed, more even than the contemporary Salviati's, to a complexity and elaboration that the first phase of Maniera had not known. Jacopino's aesthetic for a high Maniera is not different in its principles from Salviati's at this moment, but it is more matured and more probingly articulated, anticipating effects that Salviati was not to find to this degree until his Sala dell'Udienza decoration, after 1543. The last of the three frescoes that Jacopino conceived for the Oratorio, the *Baptism of Christ* (1541), is more painterly in

187. Jacopino del Conte: Preaching of the Baptist, 1538. *Rome, Oratory of S. Giovanni Decollato*

handling and in colour than its earlier companion piece, the *Preaching*, but it is also more overtly Michelangelesque; this was the year of the unveiling of the *Last Judgement*.

Some years afterwards, in 1547-8 at latest, Jacopino undertook (in company with Siciolante da Sermoneta) another fresco decoration, of the chapel of S. Remigio in S. Luigi dei Francesi, for which Perino del Vaga held the commission when he died. Here, as on a previous occasion in 1538, Jacopino may have been indebted to designs that Perino had prepared. A parallel case of likely obligation to another artist, in this case Daniele da Volterra, exists with the altarpiece, a *Deposition* [188], which Jacopino

188. Jacopino del Conte: Deposition, *c.* 1552.
Rome, Oratory of S. Giovanni Decollato

painted *c.* 1552 for the Oratorio where he had worked before. Commissioned, as newly-discovered documents attest, to Daniele in 1551,[21a] the work was passed to Jacopino, but the design he employed reveals Daniele's preceding role. The *Deposition* of *c.* 1545 in the Orsini Chapel is a precedent, and beyond this there may have been a specific model turned over by Daniele, which is recorded in a drawing – of uncertain attribution, however – in the Louvre. Elements of contemporary Roman Michelangelism appear in Jacopino's painting, not only *via* Daniele but from the Master himself, whose *Pietà* (now Florence, Duomo, begun after 1545) supplies the central motif of the altarpiece design. But even stronger than these effects of Jacopino's Roman environment are the evidences of a recently renewed affiliation with the art of Florence. A visit to Florence by Jacopino is recorded in 1547,[22] when it is likely that he would have seen the *Deposition* for S. Croce, then in progress or perhaps finished, by Salviati, his recent colleague in the Oratorio: its effect on Jacopino's picture is sensible, yet oblique rather than overt, as is the influence of Giorgio Vasari's less recent *Immaculata* (Florence, Ss. Apostoli). However, this experience of contemporary Maniera had no effect on Jacopino comparable to that of his re-seeing the work of Jacopo Pontormo. Pontormo's Maniera, which had meant much less to Jacopino in his early years, now took on a quite different exemplary value for the painter who had matured in the style.[23] Besides his evident adapting of Pontormesque mode and motifs, Jacopino has worked the design of his altar into an involved eurhythmy resembling Pontormo's. But Jacopino's patterning is distinct from Pontormo's in that its ornamental value in places has become gratuitous – precisely a characteristic of high Maniera. It is also indicative of the newer phase of style that (as in the contemporary Bronzino) forms are more classicistic or more naturalistic than

Pontormo's, and design more regular. The *Deposition* was yet another demonstration, and one of the most positive, of the repeated interaction between Roman and Florentine Maniera. But after this event, later into the mid century Jacopino's art began to move upon a path divergent from the high Maniera that his brilliant action in the Oratorio di S. Giovanni had helped to form. An account of this phase is best given in a later context, that of the Counter-Maniera – though even there his course seems special and aberrant.

Vasari

Giorgio Vasari's attainment of a high Maniera was not intrinsically a more complex process than Salviati's or Jacopino's, but far more extensive evidence survives to illustrate how it occurred. Born in 1511 in Arezzo, Vasari began his artistic education there under the *émigré* Frenchman Guillaume Marcillat. Disposed even as early as this to a literary culture, Giorgio had the substantial beginning of a humanistic education in Arezzo, and this, combined with his artistic talent, attracted the interest of Silvio Passerini, Cardinal of Cortona and tutor-governor of Alessandro and Ippolito de' Medici. In 1524, at the age of twelve, Giorgio was sent by Passerini to Florence, and while he pursued his literary education in the company of the two young Medici also had, for a brief time, the privilege of study under Michelangelo. In late 1524 and 1525 he passed to Sarto's shop; then, still under Medici protection, was put to study under Bandinelli. The temporary expulsion of the Medici put an end to this privileged education, but the Medicean association was to persist, to Giorgio's eventual great profit. Returned to Arezzo, Vasari was befriended by Rosso in 1528; it was Rosso who helped Giorgio 'di disegni e consiglio' (VII, 651) in his first major public work, a *Resurrection* (now lost without trace). In Florence again in 1529 Giorgio joined Salviati (whom he had known since early on his first Florentine visit) in Raffaele Brescianino's shop, and then studied goldsmithing with Vittorio Ghiberti and with other smiths. After wandering in Pisa, Bologna, and Arezzo again, this extraordinarily diverse education reached its climax in early 1532 in six months of study in Rome, again in Salviati's company; we have referred earlier to Vasari's estimate of the importance to his history of this event.

It is interesting to observe, however, how little of Rome there is in Vasari's early surviving paintings. His *Entombment* (Arezzo, Casa Vasari, 1532; the earliest known work by him) is essentially a translation into paint, part Sartesque, part Rosso-like in its technique, of Bandinelli's drawing style. It is uncertain whether the young Vasari explicitly shares in Bandinelli's acid and abstracting *jeu d'esprit* upon the classical aesthetic, but it is in general clear that his main orientation is post-classical – intellectual, formalistic, and abstracting. This orientation is clearer still in a portrait of *Duke Alessandro* (Florence, Museo Mediceo, 1534), based in motif on Michelangelo's *Duke Giuliano*. Vasari has given his sitter an extraordinary abstractness, putting forth a polished geometry of armour as a surrogate for human presence. Symbols that are half heraldry, half hieroglyph, convey all meaning that does not reside in form.[24] Successive works on a major scale, done in Arezzo (*Santa Conversazione*, Arezzo, Museum, 1535-7; *Deposition*, Arezzo, SS. Annunziata, 1536-7), display the extent of Vasari's education, but at the same time show the spirit in which he has taken it. He has assumed the translation already made by Bandinelli and by Rosso of the classical Sartesque style as a threshold for a further step, establishing a more consistent role for purely formal values in the work of art, and he has conceived these values with an almost impersonal intellectuality. His attitude removes the

painter from involvement with the qualities of form as such and from their possible inherent expressiveness. It also makes distance between the artist and the content that his subject bears, leaving it to be conveyed not by pressures on the form but by the means of illustration.[25] In terms of singular aridity, Vasari has made a deduction from the first Florentine post-classical style that prepares for an essential part of the aesthetic of the high Maniera.

As yet, however, because the strongest factors informing Giorgio's vocabulary have been Sarto and Bandinelli (more than Rosso, Pontormo not at all, nor Rome so far, despite his asseveration), there is small trace of *bella maniera* in Vasari's early style. A further visit to Rome in the first half of 1538 supplied this lack. Vasari must then not only have seen what was different from his recent style in the current modes of Salviati and Jacopino but, on their example, must also have looked at Raphael and post-Raphaelesque painting with a sympathy he had not displayed six years before. The effect of this response in Rome to Raphael and the extension in Maniera of his model was compounded with that of a working visit to Bologna (1539–early 1540), where Giorgio absorbed, beyond the Raphael *St Cecilia*, the mature painting and the graphic art of Parmigianino.[26] The change that these accumulated factors made in Giorgio's style was decisive: in sum, he acquired the elements, in Romanized guise, of *bella maniera*, which he then fused with his earlier proposition of a formalistic, illustrative art that we have seen already had in part a shared basis with the high Maniera. What in this earlier mode was not compatible with Maniera – its excessive dryness and abstractness – he now saw fit, as much as by nature he could, to shed.

Stylization in the temper of Maniera is incipient in the works Vasari did in that Bolognese stay (three large altarpieces, one now lost,

and a fresco decoration for the Camaldolite establishment of S. Michele in Bosco), but his achievement of a style that belongs not only wholly to Maniera but to the new, high phase of it occurred just following his return. Almost the most striking impression made by Giorgio's *Crucifixion* altar[27] (Camaldoli, Arcicenobio, 1540) [189] is that it is, by comparison with his harsh, abstracting early works, much more classicistic and related to the classicizing norms. What in the works preceding 1538 had been their aspect of attachment to Sartesque tradition (within an aesthetic stance that was essentially radical) becomes, in the *Crucifixion*, a more apparent and authentic linkage with the classical tradition, that of Raphael. The nature of the reference is not only more overt than in

189. Giorgio Vasari: Crucifixion, 1540.
Camaldoli, Arcicenobio

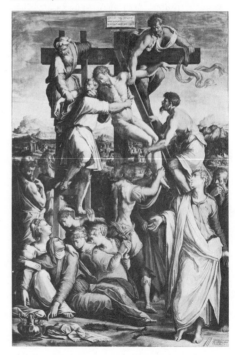

any of Vasari's contemporaries but seems more conservative in kind and in effect: Vasari borrows sanction for this new style from the relation that he now affirms it has with Raphaelesque classicism. But his interpretation of the classical example is visibly in the mentality we have defined in high Maniera style. A discreet coolness is imposed on the pathos, and equally upon the temper of the forms; attitudes conventionally illustrate a state of mind but mean a crystalline effect of ornament instead; Raphaelesque *grazia* is altered into frozen fineness. The plastic clarity of shapes does not denote reason ordering experience, as in the classical style, but an intellect disposed (still Bandinelli-like) to make abstracting geometry of form. The colour is lucid but manifestly arbitrary: it is as artificial and a-sensuous as Bronzino's, but opposite in that Vasari's hotter and more varied hues contain an effect of dead chill. The air of deliberate conservatism that the *Crucifixion* wears does not obscure the fact that it is no less than Bronzino's, Salviati's, or Jacopino's art of this moment essentially a novelty; we have observed that the kind of reference Vasari makes to classical authority is among the indices of high Maniera style. The wings of the altar exploit a classical connexion even more: with Sarto. The predelle, however, are full of the results of Giorgio's study of the Maniera he had seen in Parmigianino. Not only as a direct influence but indirectly by its effect on the art of Salviati, the arbitrary grace of Parmigianinesque Maniera was increasingly to invade Vasari's style.

In 1540-1 Vasari made the first public pronouncement to Florence of his new style on a major scale: an altar of the *Allegory of the Immaculate Conception* (Florence, Ss. Apostoli), more gracile in drawing and more fluent in the use of colour than the preceding *Crucifixion*, and of which the design is no less remarkably artificial than the verbal construction of iconography that Giorgio (in collaboration with the patron, Bindo Altoviti, and other learned friends) invented for it. In December 1541, on Aretino's solicitation, Vasari went (by way of Bologna, Mantua, and Parma) to Venice, to remain there throughout most of 1542. A sponge for new experiences, Giorgio shows, in what remains to document the appearance of his Venetian works,[28] his further immersion on his travels in the style of Parmigianino, the influence of Giulio Romano's Mantuan perspective systems, and the mark of Venetian modes of decoration. The reason he advanced for leaving Venice is an early symptom of what was shortly to become a major topic of dispute between Central Italian and Venetian art: 'he [Vasari] might have come to stay there for some years; but Cristofano [Gherardi, his principal assistant] always dissuaded him, saying that it was not good to stay in Venice, where they took no account of *disegno*, nor did the painters in that place use it' (VI, 226). It is uncertain whether the example of a novelty in Central Italian style that Giorgio gave to Venice on this visit was much more important for the future course of Venetian painting than Salviati's, on his recent stay, had been.[29]

In the early forties, which Vasari spent more outside Florence than in it – in Rome, mainly, but in Naples also (late 1544-mid 1545) and in the Marches – the influence of Salviati in particular, and perhaps that of Perino also, seemed to be among the factors that pressed him towards a maximum elaboration of effects of ornament in his style. Altars such as his *Presentation in the Temple* (Naples, Capodimonte) [190], done for Naples in 1544, represent an apex in Vasari of a sensibility that is peculiarly of the high Maniera, comparable in kind though not in quality to Salviati's manner of the same time. But this is not a native tenor of expression for Vasari. Unlike Salviati, Giorgio has no passion to infuse into his ornament,

nor does he feel form strongly as aesthetic sub-
stance; for him ornament is, almost in a merely
decorative sense, just that, and form the matter

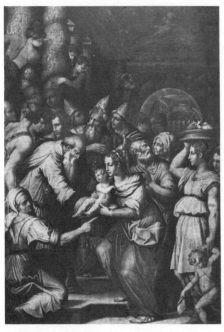

190. Giorgio Vasari:
Presentation in the Temple, 1544.
Naples, Capodimonte

of representation and illustration, to which
ornament may be attached. Within his painting
even of this period there are aspects of formula,
and the sense that Giorgio's Maniera is not
strong enough a principle to compel the matter
that he represents and illustrates into an essen-
tially aesthetic consistency. Nor is it strong
enough to transform wholly the residues of
hand and mind that persist from his first
Sartesque education. More than that of any
other painter of the high Maniera, and more
now in some ways than in his early works,
Giorgio's mature style betrays the links that

bind it to a conservative and specifically Flor-
entine tradition.

Even in the thirties and early forties Vasari
had been the most mobile personality in Italian
art. In the middle forties, still more peri-
patetic, his widespread demonstrations of his
mature style helped to shape the major course
of art-historical events in Rome and Florence,
and in lesser artistic places (as in Naples)
changed the history of the local school. In the
fifth decade Vasari became an exalted com-
mercial traveller in high Maniera style. The
brand of it that he offered was a relatively easy
one to sell because his art was the most recog-
nizably conservative and – no less important –
most nearly impersonal and thus imitable mani-
festation of this style. It was he who most
quickly translated the invention he had helped
to make into an art 'di maniera', in the sense in
which the phrase would be pejoratively used.
It was remarkable that it was in this extremely
active time that he composed and published[30]
the first edition of the *Lives*, which was destined
to be a contribution of more universal value to
the history of art than what Giorgio accom-
plished as a painter. This does not diminish
the significance, in our perspective of his own
time, of the history that he, as a painter, made
in it. In the *Vite* he attempted to define the
objectives of art as he saw them, and to indicate
in what a *bella maniera* consisted. He proved
himself, in the *Vite*, a brilliant historical intel-
lect and a critical sensibility of the highest
order, but he was an unsystematic theorist. The
verbal exposition that he gave of his ideals of
style was far less explicit and much less influen-
tial than the demonstrations that his wide-
spread pictures made. Their influence increased
as Giorgio became the artist who, save for the
aged Michelangelo, was most *in auge* in Central
Italy, and certainly the busiest. Inevitably, as
this occurred, he became more a *régisseur* of
artistic enterprises than a painter, accomplish-

191. Giorgio Vasari:
History of Pope Paul III, 1546. *Rome, Palazzo della
Cancelleria, Sala dei Cento Giorni*

ing his purposes largely through auxiliary
hands; the very number of assistants who
passed through his shop increased the semina-
tive effect of his style.

In Rome, in 1546, Vasari received his first
grand-scale decorative commission, compar-
able in extent to that which Perino had begun
the year before in the Castel S. Angelo. This
was the painting of the grand salon of the
Palazzo della Cancelleria, ordered by Cardinal
Alessandro Farnese to celebrate the life of Pope
Paul III. Pressed by the Cardinal for quick
completion, Vasari recruited a whole *bottega* of

assistants on the spot and finished the decora-
tion within one hundred days, so that the room
now bears the name *Sala dei Cento Giorni* [191].
Literary *invenzioni* were supplied by Paolo
Giovio, on which Vasari then conceived (in
what appears, from the results, to have been a
manic ferment) designs for histories that are
packed to the extreme limit with extravagant
Maniera attitudes, dense patternings of eccen-
tric movement, quotations (ancient, recent, and
contemporary), and specious illusionist device.
The histories take place within a scheme of
painted architecture no less extraordinary,

which transforms the motif of Michelangelo's *ricetto* in the Biblioteca Laurenziana into pure Maniera conceit.[31] Altarpieces from the later forties (*Adoration of the Magi*, Rimini, S. Fortunato, 1547-8; *Deposition*, Ravenna, Accademia, 1548) are somewhat less extravagant in temper than the frescoes of the Sala, but no less dense in their designs. Away from Rome, the Raphaelesque and classicistic accent in these paintings much diminishes, as if this were, for Giorgio, in some degree an incompletely convinced affectation, and the effect in them of continuity of Florentine and Sartesque techniques returns.

Vasari himself justly deplored the quality of execution in the Sala dei Cento Giorni. However, it is applicable to more than this extreme case that, as Vasari's career matured, the quality as painting of what he produced – whether through his own hands or his assistants' – became essentially irrelevant. Where it exists, significance resides in the idea that precedes the execution, or more accurately, as in the Sala dei Cento Giorni, in the conceit. This is much more the case with Giorgio's art than elsewhere in Maniera, because for him the motives of art lie in an intellect disposed mainly towards a-sensuous ideas, of verbal concepts or aesthetically abstracting forms. He had a sense for relations of abstract geometry like an architect's – which in fact he also became. Given an expanse of architecture on which to project decoration, he could make not only logic but elegance in his geometric subdivisions of it, and (as in the Cancelleria) he could invent a system of relation of his decoration to the extant architecture that worked as bold and ingenious conceit. But beyond these larger factors in the design of decorative schemes he had the gift for brilliant elaboration of them in detail. In the designs he gave for the decoration of the Cappella del Monte in S. Pietro in Montorio in Rome (1550; the sculpture executed by Ammanati), Giorgio's *concettismo* turns in the details into a subtle wit, manipulating abstract forms of ornament in patterns that divide and subdivide, always with more animating complication, in a process that seems both intellectual and organic. As he adapts the Raphaelesque tradition of grotesquerie, the abstract logic of larger forms of ornament, architectural in kind, is transmuted into images of living things; but these conversely have the use of ornament themselves. The formal texture of the decoration, as fine as it is rich, conveys the sophistication of its making intellect, turned to purposes of wit. This is, so to speak, a backdrop in the chapel for the more pretentious pronouncement made by its altar picture, a *Conversion of St Paul* (1551) – a good index that Vasari's power to manipulate the human stuff he must deal with in a picture is less than that with which he works upon the abstract matter of its decorative frame.

In 1556 Vasari was given the opportunity to exercise his decorator's skills on a vast scale in an enterprise in Florence more grand than any save for one (at Caprarola) then being undertaken in the neighbourhood of Rome. This was the refurbishing, architectural as well as decorative, of Duke Cosimo's state and living quarters in the Palazzo Vecchio. Until the latest years of his career the planning and execution of this decoration and the supervision of his corps of assistants working at it were major among Vasari's always multiple concerns – which even within the Palazzo Vecchio were multiple: he began the painting of two main apartments at the same time, the Quartiere degli Elementi (1556-9) and the Quartiere di Leone X (1556-62), one just below the other on closely matching plans. The programme for the decoration of these suites was conceived with the aid of learned *letterati* (Cosimo Bartoli in particular), and exposed in detail by Vasari himself in his *Ragionamenti*. In the Quartiere degli Elementi the various rooms treat in excessively sophisticated allegory of the gods who

regulate the cosmos, in an exposition of the idea of good government that is also a pun upon the Grand Duke's name. The suite of Leo X below deals with the history of Cosimo's family, but relates each ruler of the clan to the deity who presides in the room immediately above. It is not unusual that the rooms in each suite relate to a whole ideal scheme, nor that the parts of each room constitute a carefully worked out ideal relation; but as the *Ragionamenti* explain, each room contains multiple layers of allegorical meaning that extend accordion-wise, one behind the other, beneath the overt figurations on the walls. At the same time, not only are the central themes of the apartments on the separate storeys related, but each lower room is specifically joined in meaning to the one above. It does not count that the relations of ideas cannot be seen, nor that they are ideas which, either in the single allegorical picture or in the entire scheme, cannot by their nature be given direct visual expression. The verbal concepts, manipulated in a physical space and in an abstract intellectual dimension in the very pattern of a honeycomb, are more the essential substance of this art than the painting that we see. The same quality of mind that wittily manipulates conceits of ornament works here at a level more intellectualized, and with more pedantry than wit, to make manipulations of a verbal *concettismo*. The obscurity and elaborateness were not meant to be penetrated by mere visual inspection; they require exposition – even to Giorgio's very patrons – like that provided in the *Ragionamenti*. As Giorgio guides his interlocutor in the *Ragionamenti*, Cosimo's son, the Regent Francesco, through these rooms, Francesco exclaims (VIII, 22) 'Voi mi fate oggi, Giorgio, veder cose, che non pensai mai che sotto questi colori e con queste figure fussino queste significati . . .'. It almost suffices for the purposes of such an art that, apart from its efficiency of decorative effects, its quality as figuration be quite secondary, and in general it

is. There is an increasing heaviness and dryness in the figure scenes, and at times a pedestrian emphasis of illustration in the paintings of these two Quartieri.[32]

In 1563, while the painting of the Quartiere degli Elementi was still in progress, Vasari undertook the largest element of the decoration of the Palazzo, the Sala Grande (del Cinquecento), dedicated to the celebration of the Florentine dominion in Tuscany and to the illustration of the battles (with Pisa and Siena) that won it; counsel for the programme was sought from the *dotti* Vincenzo Borghini and G. B. Adriani.[33] In size and function this great public room was analogous to those in the Venetian Palazzo Ducale, which Vasari meant, by his own declaration, to surpass: his aim had a political as well as an artistic implication. His scheme was based upon the Venetian example, which he reworked with a Tuscan architectural consistency, but the paintings with which his corps of assistants, working from Vasari's designs, filled this frame were either inconsequential or machine-like works of art. Thirty-nine small paintings on the compartmented ceiling were completed by the end of 1565; six large battle paintings, compiling all the formulae of high Maniera into a busy tedium, were executed between 1568 and 1572. The battle paintings stand instead of what Leonardo and Michelangelo had been meant to accomplish in this room but never did, and Vasari's designs refer not only to the inventions they had made but, in the spirit of historical research that is one of the symptoms of his learning, to as many other precedents, both recent and quattrocentesque, as he could quote.

In 1570 Vasari designed an appendage to the Sala Grande, the Studiolo of Francesco I [192], contrastingly minuscule: not a study, as the name implies in English, but more accurately a vault-room, lined with cupboards, in which precious objects of small size – the typical contents of a Cinquecento *Kunstkammer* – might

192. Giorgio Vasari:
Studiolo of Francesco I, 1570-3.
Florence, Palazzo Vecchio

be kept. Appropriately Vasari conceived a decoration for it that has the character and the effect of an encrusted jewel box – inhabitable, with its ornament inside. A programme worked out with Vincenzo Borghini supplied the theme, the relation between art and nature, which was illustrated in a frescoed ceiling, thirty-four panel paintings of easel size and finish, and eight pieces of bronze statuary. Presiding over these, two tondo portraits of Cosimo and Eleonora, by Bronzino, were inset in the lunettes at each end of the room. A rich ingenuity dictated the topics of the single illustrations, which refer variously in contemporary, historical, or allegorical terms to the elements of nature or to what art makes of them. Vasari himself contributed but one panel, a *Perseus and Andromeda* (illustrating the mythology of coral); for the rest it seems he was content to leave the translation into design of Borghini's *invenzioni*, as well as their execution, to other artists, many but not all of them from his usual body of assistants. Some of the painters of the Studiolo were properly subservient or ageing followers of Vasari, but others were younger men whom Vasari's stiffened formulae no longer suited. The Studiolo thus became, in the years of its fitting out until 1573, a *Kunstkammer* that enclosed not just a treasury of precious objects but a set of paintings – jewel-like artefacts themselves – that crystallized the situation of the time in Florentine art. Under Vasari's eyes, the younger artists of the Studiolo revealed tendencies, divergent from his and from Bronzino's, that were to be significant in Florence for the span of the next generation, and which we shall examine later.

The vitality of Vasari's high Maniera style had long since begun to diminish, but his extraordinary pace of activity did not. It was in his later years especially that he worked also as an architect (e.g. on the building of the Uffizi, begun in 1560), and still as a historian; the much expanded second edition of the *Lives* was published in 1568. In 1566 he undertook an enterprise of considerable importance and extent, involving architectural supervision as well as painting: the modernization of the altars of the churches of S. Maria Novella and S. Croce. He himself (with the usual liberal assistance) supplied half a dozen altar paintings between 1566 and 1572, in a style which, in the altar form, is still more visibly ponderous than in the frescoes of corresponding date in the Palazzo. The heaviness, density, and lessened grace of these altarpieces is not, however, only of negative import in the history of Vasari's own style: these qualities are the symptoms of an incipient change in the character of the Maniera, in which, indeed, the ambition to Maniera in the strictest sense it has, of high artifice of formal effects and of emotion, has been diminished. Vasari gives evidence in these altars of a response to a changing taste, more grave, direct, and serious, especially in religious painting, that had already made its clearer mark in the Counter-Reformation atmosphere of Rome. The year in which the altars for the Florentine churches were begun was, after all, that of the publication of the Tridentine decrees. Commissions for the other new altarpieces in the two churches were distributed through Vasari while he lived. Like the paintings of the Studiolo, though in a less concentrated way, the altars of these churches document the state of Florentine painting of the time.[34] In these years Vasari still continued to commute to Rome. Between 1570 and 1573 he was the responsible agent in the decoration (with Jacopo Zucchi as his executant) of three chapels in St Peter's (S. Michele, S. Pietro Martire, and S. Stefano, all 1570-1) and in the long overdue completion of the Sala Regia in the Vatican (1572-3). Meanwhile he had accepted a gigantic task in Florence, the painting of the

dome of the cathedral (commissioned in 1571). Returned to Florence to complete this work in June 1573, death overtook him the next month.

Vasari has been too often characterized as a good writer and a bad painter (if Maniera style permits an architect, he was among its best), but it does not matter what his primary sphere of action was. His significance for art must be assessed by the quality, and perhaps still more by the extraordinary fecundity, of his ideas; it is less important that not all of them were ideas that were explicitly limited to the domain of painting.

Among the contemporaries of Vasari who served as his assistants one requires to be singled out: Cristofano Gherardi of Borgo S. Sepolcro (called Il Doceno; 1508–56), who was not only Vasari's exceptionally gifted aide but his close friend. At S. Sepolcro he had been a pupil of Raffaellino dal Colle, but he had encountered Rosso there and, at the same time, the young Giorgio Vasari. He had started on a decorator's career at S. Sepolcro and at Città di Castello (working in a style derived in the main from Raffaellino) when, in 1536, he was asked to Florence to help Vasari in the task, assigned to him in that year, of supervision of the *apparato* for the entry into the city of Charles V. The next year, after Duke Alessandro's death, Gherardi was banished from Florence for supposed anti-Medicean actions. This did not much impede his connexion with Vasari, given the latter's wide activity outside Florence, and Gherardi became Vasari's principal deputy in his extra-Florentine works (save for the Cancelleria decoration) throughout the forties. In the intervals of working for Vasari, Gherardi occupied himself with decorative works at S. Sepolcro and Città di Castello. Near S. Sepolcro he painted in the Villa Bufalini at S. Giustino on various occasions between 1537 and 1542, in a mode that reflects the Roman tradition of post-Raphaelesque grotesque decoration more than that of Florence. At Città di

Castello his principal enterprise was in the so-called Palazzina of the Vitelli family (a dependence of the Palazzo Vitelli a S. Egidio). There he left (towards 1550) a ceiling decoration that is one of the most luxuriant productions of Mannerist fantasy, a fictitious pergola heavy-laden with fruits, vegetables, and flowers, and swarming with birds, fish, and foreshortened putti in dizzying elaboration. Its ancestry in Raphael's Farnesina loggia is apparent, but the transformation, not the relation, is what counts. It is a transformation that might have pleased a Giulio Romano, but it is opposite in temper to the dry wit, and much more to the pedantry, of Vasari. In 1554, with Giorgio's intervention, Gherardi's banishment from Florence was revoked, and he worked with Vasari not only outside the city (as in the Compagnia di Gesù in Cortona, which he executed for Vasari almost in its entirety in 1554) but in Florence, on the first stages of the decoration of the Quartiere degli Elementi in the Palazzo Vecchio. The difference of Gherardi's temperament, sensible to the excitements of free draughtsmanship and the sensuous qualities of paint, and natively disposed to grace, emerges often enough even through the designs laid down for him by Giorgio. Vasari knew Gherardi's value and esteemed the qualities in him which he did not himself possess. Gherardi died in 1556, soon after the great enterprise in the Palazzo Vecchio had begun, and Vasari genuinely felt his loss.

To succeed Gherardi in his role as principal assistant Vasari had recourse for a time to a younger and less gifted painter, Giovanni Stradano (Jan van der Straat, born in Bruges *c.* 1523–died Florence 1605), Flemish in origin and in early training. He had arrived in Italy about 1545 and found employment in Florence as a designer of tapestry cartoons for Cosimo's recently founded *Arazzeria*; designing for this factory remained his principal occupation throughout his long career. A sojourn in Rome

beginning in 1550 (which lasted perhaps for a few years) brought Stradano into contact directly with Daniele da Volterra and with Salviati, and indirectly with Michelangelo's recent art. But this period of Roman study did not affect Stradano's style as much as the example of Vasari and his immediate association with him. About 1561 Stradano was recruited into the corps engaged in the decoration of the Palazzo. It was delegated in particular to him to execute a great part of the paintings in the Quartiere di Eleonora. Stradano's native Flemish accent is apparent, even in his works as Giorgio's executant; it takes the form of an inertness of hand quite the opposite of Gherardi's and exceeding Vasari's own, and more obviously in a tendency to demonstrate his mastery of genre incident and realist detail. One of his two panels in the Studiolo, *The Glass Factory* (1570), reverts, beneath its skin of Vasarian style, to the tradition of Pieter Aertsen, a master with whom Stradano had worked long ago in Flanders. Stradano was evidently prized in Florence for this specialized capacity for genre painting – to Florentine taste an accomplishment of exotic interest – and he was given an opportunity to exercise it on a large scale as well in tapestry designs. A fine set of tapestries of hunting scenes done for the decoration of Poggio a Cajano (now Florence, Palazzo Vecchio, 1567) makes a neat compromise between a Flemish and a Florentine Maniera mode. More of Stradano's tapestry designs, however, are of religious and mythological subjects, and in these his Vasarian conformity is the more apparent factor.

The Later Bronzino

While Vasari grew more effusive in the years of his maturity, Bronzino grew increasingly discreet. The attainment of his subtlest and highest sophistication of Maniera in his pic-

tures of the middle forties was a salient from which he then chose to retreat and find a more tempered, less extreme expression. The last demonstration that he may have made on the level of intensity that the London *Allegory* or the Besançon *Pietà* represent is in a portrait, *Eleonora of Toledo and her Son* (Giovanni?; Florence, Uffizi, *c*. 1546?) [193], of which the main sense is in the transcription of the Duchess's dress with such probing fineness and extreme detail that it acquires an effect more like hallucination than visual truth. An extraordinary work of art in itself to begin with, the garment makes a meaning of pure frozen ornament that seems separable from and more significant than the person it contains. But in a sense it is also a symbol for her, an appurtenance of station, as parade armour would be for an illustrious male, and no less a beautifully worked body-mask. A portrait of *Stefano Colonna* (Rome, Galleria Nazionale, dated

193. Agnolo Bronzino:
Eleonora of Toledo and her Son, *c*. 1546(?).
Florence, Uffizi

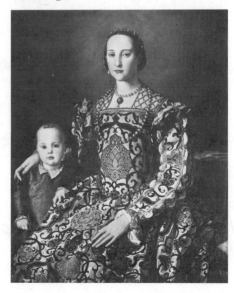

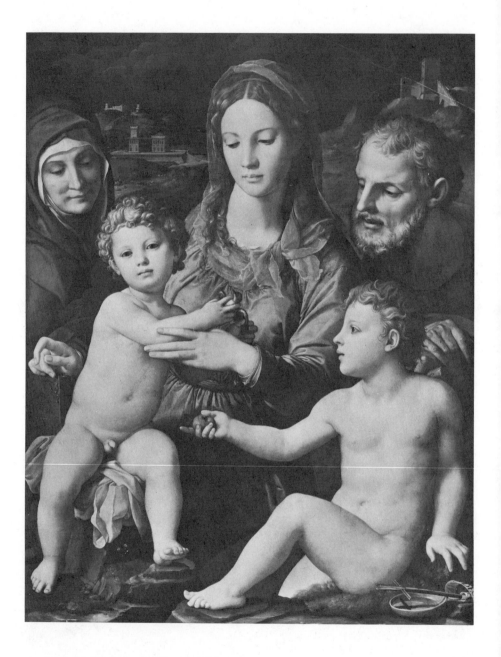

194. Agnolo Bronzino: Holy Family with St Elizabeth and St John, *c.* 1550. *Vienna, Kunsthistorisches Museum*

1546) is precisely so encased, yet its tenor of form and of expression is quite different, and not only because Bronzino is always more penetrating in his interpretation of male than female sitters. This is different from Bronzino's earlier male portraits also: grander and less finely tensed in attitude, not less aristocratic but less chilled. The Colonna portrait was painted in Rome, where Bronzino's presence is attested on occasions between 1546 and 1548, and the change of temper in it, and what is only relatively speaking a less extreme Maniera form, seem the result of the impression made on Agnolo by Roman art. The austere grandeur of Sebastiano del Piombo's later portraits seems reflected here, and there is a kind of poise that recollects the models of Raphael's classical style. Half a decade later, portraits done in Florence, like the *Portrait of a Gentleman* (Ottawa, National Gallery, from the Simon Collection) or the *Lodovico Capponi* (New York, Frick Collection), re-acquire part of Bronzino's earlier hardness and preciosity, but only part; their stronger emphasis is, as in the *Stefano Colonna*, on dignity and on simpler classicist clarities of form.

An altered temper of Bronzino's art is still more apparent elsewhere than in portraits: an *Allegory of Venus and Cupid* (Budapest, Museum) of the fifties employs most of the apparatus that was in the London *Allegory*, which is on a comparable theme, but it is much less subtle and high-keyed. Its forms and its expression are as artificial, but they are heavier and less complex. This seems more deliberated in its effect of a neo-classicism, and more cautiously constrained in emotion, almost academicizing its earlier counterpart. There is a graver air also in Agnolo's Madonna paintings that post-date his Roman stay. The sense of artifice in the *Panciatichi Madonna* (Florence, Uffizi) or the *Holy Family with St Elizabeth and St John* (Vienna, Kunsthistorisches Museum [194]; both *c*. 1550) is undiminished and still

more poignant in its sheer effect of art than it had been before, but this appears within a new suavity and breadth of form, and it is mingled with a delicate sobriety of feeling. But what in smaller compass makes consonance between artifice and sentiment does not operate in Bronzino's later large religious works. In 1552 he signed two altarpieces, a *Resurrection* for SS. Annunziata (*in situ*) and a *Christ in Limbo* for S. Croce (Florence, Museo di S. Croce) [195]. In these works for a public destination Bronzino's dominating motive comes to be the perfectly self-conscious demonstration of those resources of his art, which, in this climate, would command appreciation from his colleagues and his critical contemporaries of the Maniera. Nowhere else, not even in Bronzino's *Deposition* for Eleonora, seven years before, is there so

195. Agnolo Bronzino: Christ in Limbo, 1552. *Florence, Museo di S. Croce*

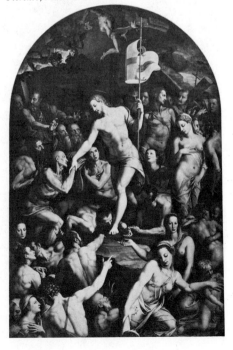

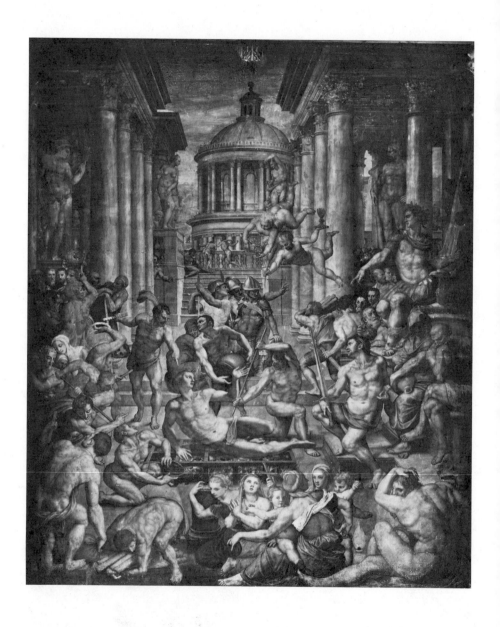

196. Agnolo Bronzino: Martyrdom of St Lawrence, 1565-9. *Florence, S. Lorenzo*

evident a dislocation between the picture's subject and its content, which consists of its effects of artifice. Both new altars are accumulations of fine attitudes, polished form, and wrought details, multiplied so that they impress still more by quantity; the principle by which the pictures are conceived is in fact that of accumulation. The acutest exploitation of the machinery of art builds up a whole that appropriately verges, in the end, on the character of *machine*. The sense of frozen passion that was in Bronzino's earlier productions is no longer here. Instead, this brilliant apparatus seems worked out with a detached intellectual and aesthetic deliberation, full of learning and of virtuoso rhetoric. The quality of thought is supreme in its kind, but the kind is incipiently academic. There are ostentatious quotations, like a literary humanist's, from ancient sources and an assortment of references to the modern art of Rome; here Bronzino finally concedes to the Michelangelesque proposition that the main burden of the painter's art is not only sculpturesque but anatomical. The tendency in public works to academic rhetoric and to a mannered Michelangelism, almost wholly in the spirit of the *epigoni*, increases in the next decade. The fresco *Martyrdom of St Lawrence* (Florence, S. Lorenzo, 1565–9) [196] transforms its violent and tragic theme into a beautifully artificial fusion of gymnasium and ballet, played upon an antique stage; the result is one of the most consistent demonstrations of the aesthetic of the high Maniera and one of the finest in its whole range of style.

A late portrait, of the poetess *Laura Battiferri Ammanati* (Florence, Palazzo Vecchio, Loeser Collection, 1555–60), is almost as much as the *S. Lorenzo* a surpassing index of the mind of high Maniera. In this depiction of a woman Bronzino himself defined as 'steel inside and ice without', stylization of pictorial form is accompanied by a stylization of physiognomy and personality still more extreme than in Bronzino's portraits of the forties. Yet there is a quality in both the personality and form of more arid and removed abstractness than in those earlier portrait works, as if the image had been touched by a seriousness and austerity that belong no longer to the high Maniera but to the mind of the incipient Counter-Reformation. Some among Bronzino's later portraits show this tendency more openly, subduing ornament, but also making the subject almost accessible to communication. Spare in form and quietly sympathetic in expression, the *Lady with a Statuette of Rachel* (Florence, Uffizi, c. 1555–60) is no longer high Maniera, but interchangeable with portraits in a Counter-Maniera style. The changing climate of his context thus finally affected the old Bronzino, and he yielded to it a little, but less evidently in his latest religious works (*Raising of the Daughter of Jairus*, Florence, S. Maria Novella, c. 1571–2, with Allori's assistance) than in his portraits. When he died in December 1572, not long before Vasari, Bronzino had become as much as Vasari the exponent of a style that required more than either of them could make in it of change.

The Later Pontormo

The great protagonist of the first Florentine Maniera lived into the time of full fruition of the high Maniera (he died on 1 January 1557), and in this time his contribution signified both participation in the newer style and dissent from it. Pontormo shared in the development of those aspects of the high Maniera of which his own inventions were a precedent, but did not yield the basic tenet that distinguished his attitude towards art from it. We have earlier defined the core of Pontormo's difference from the high Maniera, too summarily, as the fusion that he makes between form and an expressive value that is not just in the form but in the complex human psyche and in the matter the

form illustrates. As his descendants of the high
Maniera made more quantitative ornamental
value out of form, so in these later years did
Jacopo, but his ornament remained a value with
a different content in it of emotive poignance.
His art became almost as elaborate as theirs, as
arbitrary in its pattern-making and in the
canons of behaviour that he assumed for his
actors. His manner was more arbitrary in the
liberties that he now, as earlier, took with
nature: the high Maniera, after all, was an
aesthetic that had to do with a specialized con-
ception of propriety, in which there were
'correct' limits of representational licence, as
much as of emotional response, which should
not be trespassed. Pontormo's individuality,
which had created a vocabulary of Maniera as
an agency for personal expression, was not
disposed to accept the restrictions that the new
generation had invented for it. He remained,
throughout the years of Bronzino's and Vasari's
rise, the most formidable figure on the Floren-
tine scene, but a disquieting one, more worri-
some – and at times antipathetic – to his Mani-
era colleagues of the second generation than he
had been earlier to the classical establishment.

Neither this historical eccentricity nor his
personal eccentricity, more marked as the years
wore on, interfered with his public stature. He
continued to enjoy Medici patronage and pro-
tection. In 1537-43 he followed his decoration
of the Medicean villa at Careggi with another,
of a loggia in their villa at Castello (with Bron-
zino's help); between *c.* 1545 and 1549 he
supplied cartoons to Cosimo's *Arazzeria* for
the tapestries of the Sala del Dugento [197], in
company with Bronzino and Francesco Sal-
viati, and in 1546 began the large fresco decor-
ation of the choir of the Medici church of S.
Lorenzo on which he was to work for the ten
years until his death, and which he was to leave
incomplete. His way of working in these years
was perhaps still more than it had been before
a 'travagliare del cervello', self-questioning and

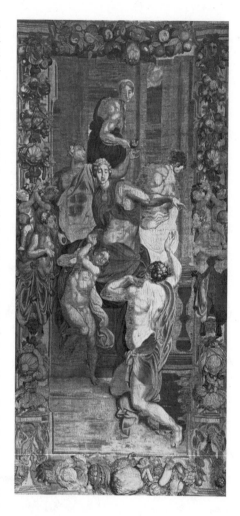

197. Pontormo:
The Cup of Joseph (tapestry), *c.* 1545-9.
Rome, Palazzo del Quirinale

THE LATER PONTORMO · 461

slow. The sources tell us of his reluctance to unveil the Careggi loggia and of his forbidding access to the S. Lorenzo frescoes altogether. It was not just creative privacy he sought; he must have felt how, in the climate of high Maniera, his individuality could give offence. It did; Vasari was to observe (VI, 286–7) of the S. Lorenzo paintings that they lacked 'ordine, misura, regola, proporzione, bontà e grazia' – the whole classicist catalogue of virtues. A few portraits, but almost no other easel works, complete the account of Pontormo's painting in his later years. Were it not for the survival of his drawings, however, we should have the smallest knowledge of his last two decades; the Castello decoration (like that of Careggi) has vanished from the wall, and the S. Lorenzo frescoes were destroyed when the choir of the church was rebuilt in 1742.

The drawings for the Castello loggia are of a beauty as subtle and difficult as the *Three Graces* study which they closely chronologically succeed: if there is a distinction to be made, it is in a still more tormenting insistence in them upon pyschological presence and on an articulation still more impossibly refined of the feeling that inhabits form. The Castello frescoes seem not to have been an inauguration of a new phase of style for Jacopo but rather a culmination of his first Maniera. An alteration that deflects towards high Maniera what is assimilable to it of Pontormo's art occurred just subsequently, perhaps in part from a response to a local experience of the new styles of Bronzino and Salviati. A more important factor in the change was a re-occurrence of the periodic trauma caused Pontormo by exposure to a new stage in the art of Michelangelo, in this case that of the Sistine *Last Judgement*, seen probably about 1543 in Rome. The indices of change appeared in Jacopo's designs for two of the Sala del Dugento tapestries (*Lamentation of Jacob, Benjamin at the Court of Pharaoh*; now Rome, Quirinale), not much misrepresented by

the weaver. Heavier, slow-moving, Michelangelesque anatomies are wound into a warping pattern that ascends the narrow panel; the figures seem to hang suspended in their space with an effect of levitation that may be inspired by the *Last Judgement*. In Pontormo the abstractness of idea that he perceived in Michelangelo's floating forms has become an abstractness, extraordinarily removed, of mood and of appearances. Jacopo has revised the anatomies into shapes more libertarian than he had ever before used – even in the early years at the Certosa – and which now have the smoothness and the excessive artificial grace of high Maniera style. The pattern into which these figures weave has not just a stress of ornamental value but an effect of clear primacy of meaning of ornament more entire than in the extreme of high Maniera practice. To compare Pontormo's tapestries with those of this set that Bronzino especially (but also Salviati) designed, is to recognize how Jacopo at the same time relates to and diverges from the high Maniera. Jacopo does not accept the proposition that his younger colleagues do, that expression can observe conventions, aesthetic or social. Feeling, even when, as here, it is the consequence of ornament much more than narrative and is exceedingly abstract, is wholly poignant, haunting, and introvert – somnambulistic.

The same vocabulary of form and the same disposition of expression were in the frescoes – stories from Genesis, and a combined *Resurrection* and *Last Judgement* – that Pontormo did not quite complete in S. Lorenzo. The drawing studies that survive to indicate what their appearance was are among the most eloquent of his career [198].[35] More than in the tapestry designs, for obvious reasons, the thought and style of Michelangelo are deeply in Pontormo's mind, to be at once revered and exorcized. Jacopo does not compete with the acknowledged master; rather he absorbs his art to its very essence and then no less essentially trans-

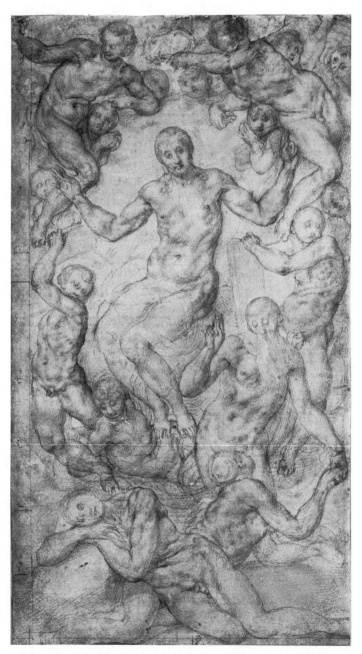

198. Pontormo: Christ in Glory, study for the (destroyed) S. Lorenzo choir, begun 1546. *Florence, Uffizi*

forms it. Jacopo's designs are abstract arabesques of high Maniera ornament, simultaneously rigid and involved. Within them the human shapes of which they are composed assume a spectral malleability, fluctuating endlessly; they are like a liquefaction of Michelangelo's images. The imaginings they represent, iconic or phantasmagoric, are lonelier and more private than Michelangelo's, and generated in another but no less elevated spiritual stratosphere. They penetrate the viewer with a power that is less than Michelangelo's, but more acutely. This is the same over-reaching in individuality – seeking a dimension of art that others, even Michelangelo, had not yet explored – which had made the early searchings into Mannerist style three decades before.

Lesser Florentines

It was a necessary consequence of the ascendancy that Vasari and Bronzino (and Salviati, also) had established for the high Maniera in Florence that lesser painters whose careers had begun in a conservative tradition should in some measure accommodate themselves to their styles. In general, the accommodation was a gradual one, and its results among the painters who were of Vasari's or Bronzino's generation, or older still, were not often inspired. The stretch between the habits to which they had been formed and the manner they attempted to acquire was, in most instances, very wide. An extreme case is that of Michele Tosini (Michele di Ridolfo, 1503–77), who had emerged towards 1525 as an assistant and collaborator of the most reactionary master on the Florentine scene, Ridolfo Ghirlandaio, painting in a style that could be credited, for its backwardness, to Ridolfo himself. As tardily as possible in respect to the developments he saw around him in contemporary art, Michele turned from an archaic mode towards one resembling Fra Bartolommeo's or Sogliani's,

carrying the aged Ridolfo with him; then, about 1540, he began to absorb the most legible surface features of Maniera. Subsequently he came to serve Vasari as an assistant in the Palazzo Vecchio, and thus his shift into a modern mode was finally confirmed. Pictures like his *Holy Family* (Florence, Museo Bandini, c. 1560?) or his late *Nativity* (Passignano, Badia) indicate the more than modest aptitude with which he worked in a Vasarian style. It is not surprising, however, that we can recognize the strong persistence, within the Vasarian vocabulary, of traits of form and conservative habits of composition from the Bartolommesque and Sartesque past. Michele acquired high skill as a portraitist in his later years, basing his portrait mode mainly on the example left in Florence in the fifth decade by Salviati. His finest example in this genre is a *Portrait of a Huntsman* (Florence, Marchese Antinori).[36]

Carlo Portelli da Loro (before 1510–1574), a pupil of the old Ridolfo, made a less facile accommodation with Maniera. He is on a level just distinguishable from the so-called 'Florentine Eccentrics' of a slightly older generation; like them he has idiosyncratic tendencies of form, but no style, in the sense of positive aesthetic principle. Fairly early in his career he seems to have been impressed by Rosso, Pontormo, and perhaps Beccafumi, and gleaned from them an inchoate set of notions which he stirred into a vaguely contemporary broth. By the mid century (*Immaculate Conception*, Florence, S. Croce, 1555) he had made the compromise that fashion at that moment asked between his weak, pointed, and eccentric forms and the vocabulary of Vasari and Bronzino. His most impressive work, the *Martyrdom of St Romulus* (Florence, S. Maria Maddalena dei Pazzi, c. 1555–60), is an eclectic compilation from the repertories of the present and past generations of Maniera (Rosso's idiom is still particularly apparent in it), but its busy composition is essentially in accordance with the

notions of Vasari's recent style. Because Portelli's eccentricities of form are a function of his instincts of expression, his images convey an effect of complicated, discoordinate emotional excitement; despite his borrowings of apparatus from the high Maniera, his mood remains more nearly akin to that of Mannerism's first phase.

Pier Francesco Foschi (1502-67)[37] had the advantage over Portelli of a less reactionary early education, in Sarto's atelier, and of a more consistent sense of form. But he was disposed to think in simple terms, both of form and expression, that were at variance not just with Sarto but even more with the Maniera. As quickly as he could he exchanged a first dependence upon Sarto for a smoothed and simplistic style, related to Sogliani's academicized and slightly mannered alteration of his classical exemplar, and perhaps in part based on it. However, Foschi came to respond to more modern influences, from Pontormo in particular (whom he assisted at Careggi in 1536), and his way of smoothing form and applying at least the simpler indices of artificial grace to it gave him an accent of Maniera; he came to accept Pontormo's attenuations also. In the later 1540s Foschi supplied three altar paintings for S. Spirito - an *Immaculate Conception* (*c.* 1545), a *Resurrection*, and a *Transfiguration* (this one the latest) - which indicate his process of assimilation of a variety of Maniera style. A *Christ carrying the Cross* (Rome, Borghese, *c.* 1550?) is further evidence of the kind of contemporaneity that he finally achieved. But these paintings are not ordinary instances of Florentine Maniera of the mid century: beneath their limited conformity to a contemporary taste they hold a differently direct, as well as simple, pietistic spirit, and the apparatus of Maniera in them is made flat and dry. Despite their accent of modernity they more essentially represent (like the provincial North Italian altars of iconic cast that began to appear

at the mid century) an archaic state of mind, more concerned with the purposes of piety than, as Maniera is, with art. This is an attitude that the Counter-Reformation will imminently resurrect within Maniera, so that Foschi's mode, even while it is an archaism, is also an anticipation of the future.[38]

There was a provincial echo, in Vasari's Arezzo, of these lesser careers that span the styles from High Renaissance to high Maniera. Giovanni Antonio Lappoli (1492-1552) had every advantage of education and association that could make him an advanced artist, but his was a case where opportunity and talent did not match. He began in Arezzo as a student of the local painter Domenico Pecori, but then, in Florence, apparently as early as *c.* 1514, became an assistant of the slightly younger Jacopo Pontormo. In Rome in 1524-7 he knew Perino del Vaga (whom he had already met on his trip to Florence) and was Parmigianino's close friend. From 1523 to 1528 he was frequently in contact with Il Rosso. In Arezzo and its neighbourhood, where most of his practice lay, his earlier works (*Visitation*, Badia di S. Fiore, *c.* 1524; *Adoration of the Magi*, S. Francesco, *c.* 1527-8) are based directly on designs supplied by Rosso, but Lappoli's translations of them are awkward and misunderstood. During the thirties his style was mainly a pastiche of Rosso's in that extreme version which he had left in Arezzo in the post-Sack years. In the forties, however, when Vasari established his style as the model for his native town, Lappoli fell in with it, as his *Allegory of Original Sin* (Montepulciano, Pinacoteca, dated 1545) proves. His career contained no contributions, but is a mirror, of poor quality, that shows how the course of artistic fashion looked to the Tuscan province.

These artists of conservative origin and older generation were only one part of the artistic environment which the action of Bronzino and Vasari formed in Florence and its neighbour-

hood. More important were the results of their example on the younger painters, men born in the span of years when the first Maniera style was formed, and whose education happened when high Maniera was becoming, or had already become, an accomplished fact. Their actual education need not have been with either of the *capomaestri*; the young painters gravitated in any case towards the example the *capomaestri* made. The economy of art in Florence that Vasari virtually controlled made his influence in particular almost unavoidable. In addition to his pupils and the regular assistants he needed in his large-scale works, he recruited artists for occasional activities, these too (like the public celebrations ordered for the Medici) sometimes on a large scale. During the 1560s the presence of a younger generation educated wholly in the period of the high Maniera became a factor of ponderable importance on the Florentine scene. It was, however, much more a quantitative than a qualitative one: for the most part the art of these young men who chose to work in the prevailing style was undistinguished. Indeed, the adequate approximation they made to the Vasarian or Bronzinesque vocabulary did not always hold a corresponding sense for the real principles of high Maniera style. Beside these relative conformists, however, there were other painters of the younger generation who, even in the sixties, showed symptoms of divergence from the context that Vasari and Bronzino dominated. The conformists and the authors of incipient change were all brought together, as we observed earlier, in the decoration of the Studiolo.

Two among the latter group, Mirabello Cavalori (da Salincorno, before 1520-1572) and Tommaso Manzuoli (Maso da S. Friano, 1531-71), did not live beyond that time, and we discuss them here as indices of difference among the younger generation from Vasarian and Bronzinesque authority in the seventh decade.

Their creative colleagues in the Studiolo shared some of their differences and conceived still others, which were to mature more fully in the succeeding years. The degree of recognizable individuality that both Maso and Mirabello possessed differentiates them in the beginning from the generality of Vasari's entourage; each, also, was markedly unlike the other. Their results are very different, yet they share two characteristics that are not normal to the high Maniera: an inclination towards elements of painterly naturalism, and the tendency to look back to and depend upon earlier phases of Florentine sixteenth-century art for precedents – not merely for motifs and quotations, as Vasari does, but genuinely for their sense of style. In Mirabello's case the intentions and effects that separate him from Vasarian convention were more decisive than in Maso, whose character and course were less consistent. His very inconsistencies, however, are significant: they are not just the vagaries of a personality without a clear aim, but an index of the uncertainty provoked in a talented and searching artist by the situation to which painting in Florence had come by this time.

Except for a double portrait dated 1556 (Rome, Palazzo Venezia) we have no certain works by Maso that precede 1560. In that year, a *Madonna with Four Saints* (Cortona, S. Trinita) suggests that his teacher is likely to have been Portelli (rather than Foschi, who is also said to have filled that role); but there is already in this picture evidence that Maso had been studying Andrea del Sarto, though as yet without determining effect. Within the same year, however, a dated *Visitation* (Cambridge, Fitzwilliam Museum, from S. Pier Maggiore) makes a surprising change from the vocabulary of Maniera. Still gracile, but only gently so, quiet in design and tenor of expression, and of a discreet shadowed naturalness, it creates, out of historical reaction, what in its context is a novelty of style. Sarto, and to a lesser degree Fra

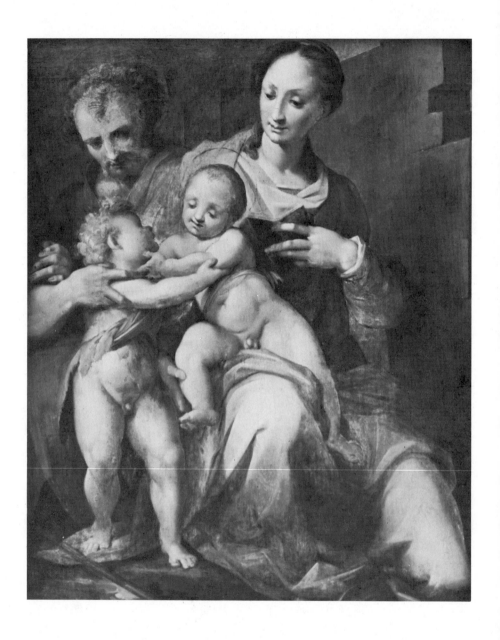

199. Maso da S. Friano: Holy Family, *c.* 1570. *Oxford, Ashmolean Museum*

Bartolommeo, were Maso's chief guides in this retreat from high Maniera, and this recession towards the style of the High Renaissance is an affirmation of a new position. Sarto is still more an overt model for Maso's *Nativity* (Florence, Ss. Apostoli, *c.* 1567). More than the *Visitation* this shows a near-consistent naturalism of appearance and a painterly sfumato that are contrary to the habits of the time of the high Maniera. Yet there is a more *agitato* temper in the later painting, which in this is more akin to the Maniera: Maso could affirm a new position, but not extricate himself entirely from the present one. In his last few years his Sartesque naturalism lessened and he came to paint more with the spirit and the accent of Maniera. But even in this more conformist guise Maso did not adhere to the conventions of Vasari's mode. Again, to help him find a different course, he sought older historical example, now not in Florentine classical style but in the first Maniera: in Pontormo particularly, and in Rosso. In his pictures for the Studiolo (*Fall of Icarus, The Diamond Mine*) Maso sought for forms that are not more but less 'correct' than in Vasari's style, and for a strain of delicate expressive fantasy. At the last Maso's naturalism became that kind of painterly conviction that infuses form even when it is extravagantly conceived, as in his Pontormesque *Holy Family* (Oxford, Ashmolean, *c.* 1570) [199]. Maso in effect creates – in part, re-creates – a mode which resembles that of early Mannerism, more relevant at the moment to his contemporary context than a resurrected *Sartismo*. This was his way of refounding and regenerating a style which, in this time of the high Maniera, had become in part congealed.

Less evidence survives of Cavalori's history. All that can be positively identified of his paintings is three or four works from the latest years of his career. It may be this accident of survival and chronology that gives us the impression of a consistency of style unlike Maso's

and of more decisive purpose. This consistency results from the union in these few paintings (two in the Studiolo, *The Sacrifice of Lavinia* and *The Wool Factory* [200]; a *Blessing of Isaac* in the Palazzo Vecchio, Loeser Collection)[39] of much the same tendencies that exist in Maso, but more pointedly expressed. Conspicuously, Mirabello's naturalism is much more explicit than Maso's, and given with a quality of eye and hand superior to his. Maso's naturalism had been acquired rather by following a Maniera procedure – i.e. by consultation of precedents in art – than by immediate reference to nature. But to a degree that has no parallel at this time Mirabello looked at nature directly, and his hand transcribed with brilliant flexibility what his eye perceived. He is startlingly responsive to the revelation of existence in a living light; to him, even space is something seen with the eyes, as well as felt. In this exercise on nature of the powers of sight Mirabello is at variance with high Maniera, and he, no less than Maso, required the support of precedents outside its scope. These are the same for Mirabello as for Maso – Sarto and the earlier Pontormo – though Mirabello interprets them in a different way and with another stress. His disengagement from the high Maniera involves not just their precedents of optical veracity but much of their vocabularies of form. In his *Blessing of Isaac* Mirabello remarkably evokes Pontormo's style as it had been half a century before at S. Felicita; in the Studiolo pictures he moves farther backward, making a vocabulary we could almost conceive to be the demonstration of another way in which the young Pontormo might have emerged beyond Sarto's art. This is as much a studied recollection of the past as Maso's, and its purpose of re-creating the first vital stage of a style that in a later, present, stage had grown lifeless is the same. Mirabello returns still more precisely to the very incipient moment of the first Maniera. Obviously the act of recollection bears the indices of its present

200. Mirabello Cavalori: The Wool Factory. *Florence, Palazzo Vecchio, Studiolo*

time, but the two clearest ones are of opposite significance: one is the crystalline and rather rigid patterning that Mirabello still employs, a residue of high Maniera which he does not eradicate; the other is a specificity of descriptive will that builds beyond the past examples of Andrea and the early Jacopo, seeking effects that suggest realism and genre. Suggest, but do not quite attain; the strong element of Maniera stylization that Mirabello retains in the end disciplines the working of his sight. His tendencies point the path into the future none the less.[40]

One of the expressions that the thinking of the high Maniera brought forth in Florence was the first organization of artists into an academy, the Accademia del Disegno. Its founder, naturally, was Giorgio Vasari, who in 1562 proposed to a select group within the old religious Company of St Luke that they create a new form of organization. A constitution was drafted by Vasari, Bronzino, Tosini, Foschi, the sculptor Montorsoli, and the architect Francesco da Sangallo, and approved by Duke Cosimo in January 1563. The intention of Vasari was to assure to artists a dignity and status comparable to that given to its members by the Florentine Academy of Letters, founded in 1540 (to which, for a time, artists had been permitted to belong), and, of equal importance and more practical effect, to make a sanctioned channel between the government and the artists the Academy saw fit to elect: thirty-six of the seventy members of the old religious company were thus chosen. The Academy was to take all the government's festival decorations in hand – an occasional but major charge – and one of its architects was ex officio to be connected with all public works, and even major private enterprises. A further purpose was to supervise (and thus in some measure to control) the standards of artistic education. Each year a painter, a sculptor, and an architect were designated *Visitatori*, with the responsibility of

instruction of their younger colleagues in *disegno*, and the duty of inspecting the instruction in *disegno* that others gave.

The intentions of the Academy were, however, much more than its effects. The purpose of design of public festivals was, for a time, the sole one it efficiently discharged. The organization of the funeral of Michelangelo in 1564 (and subsequently the design of his tomb) and in 1566 the elaborate machinery of decoration for the marriage of Francesco de' Medici were large affairs. However, the latter at least would not have been conducted much differently had Vasari been in charge without the academic masquerade, as he had been for similar festivities before. The educational practices of the Academy fell far short of its announced aims, and the programme soon fell into almost entire neglect. In 1574, after Vasari's death, Federico Zuccaro, who had come to Florence to complete the former's undone task in the Duomo, attempted to revitalize the programme for instruction, and characteristically, beyond what Giorgio had intended, to give it a theoretical foundation. He was as unsuccessful as his predecessors. Despite its petty record of accomplishment, the Florentine Academy begot successors elsewhere, and later Zuccaro was to try to do in Rome, not much more effectively, what he had failed to do with the institution he inherited from Vasari. But in the sense of its historical effects in Florence the Accademia del Disegno was not important: its significance was that of a social form which the artistic culture of the high Maniera had produced.

ROME

Michelangelo

In Rome from 1534 for thirty years until his death,[41] Michelangelo became still more the dominating figure of the world of art than he

had been earlier in his native Florence. We observed that even as the younger Florentines in Rome were evolving their new phase of a Maniera style in the course of the fourth decade, Michelangelo, painting again in the Sistine Chapel, was creating a kind of art which, however many elements of Maniera it contained, was in fundamental ways at variance with it. In his last work in painting, in the Pauline Chapel, these fundamental differences increased. The *Last Judgement* was the monument that most profoundly influenced the course of art in mid-century Rome. However, its influence could be taken in two ways. Because it held much of a formal repertory that had certainly to do with the Maniera it could be looked at as the model of a new variety of Maniera style; but those who were disposed, in the climate of the Italian Reform and the incipient Counter-Reformation in Rome, to respond to its more essential content saw a negation of Maniera in the *Last Judgement*, which the Pauline Chapel subsequently confirmed.

The giant fresco of the *Last Judgement* [201 and 202], covering the whole altar wall of the Sistine Chapel,[42] was a project which Clement VII had conceived in 1533. Initial designs that Michelangelo had made then were put aside when Clement died, but his successor Paul III commanded Michelangelo to proceed. Preparation of the wall was complete by April 1536 and the painting finished in November 1541. The subject chosen is an indication of a state of mind already strong within the Roman court: normal iconography and the context of the early decoration postulate a *Resurrection* on this wall, but the Reform spirit found it more important that Michelangelo should represent this differently involving and injunctive theme, to which he then chose to give a radical interpretation. In place of the actionless and hieratic scene of earlier *Last Judgement* illustrations, Michelangelo conceived an exalted drama,

moved in every part, which is enacted by a multitude of beings in their essential nudity,[43] still more superhuman in their breadth and muscularity of form than in the last stages of the ceiling, and as exaggerated in their grandeur as the figures of the Medicean tombs. A youthful beardless Christ, compounded from antique conceptions of Hercules, Apollo, and Jupiter Fulminator, turns *sinister* towards the Damned, and makes the awesome gesture of their condemnation. Gathered tensile against His side beneath the gesturing arm, the Virgin averts her gaze and looks down on the Blessed. She cannot intercede for those whom Christ damns, nor can the surrounding agitated assembly of Saints. Christ's gesture generates their complex responses, which are those of giant powers here made powerless, bound by racking spiritual anxiety. The force and meaning of His gesture pass through the Saints and through the tangled Damned, who fall towards a crowded nightmare bark of Charon just below. Underneath the Christ, but in some unmeasurable distance, angels summon the dead with trumpets, and they emerge and take on form as if from the very earth. Opposite the falling Damned, the Blessed levitate towards Heaven, most of them still numbed or half in sleep. In places wingless angels help them rise, and on the fringe of the ascending group one weightful, negroid pair are lifted by an angel on a rosary that denotes prayer. Christ's gesture sets in motion - not by its physical value but by its meaning - a gigantic slow rotation on the wall: descending, turning, and rising up to Him again. It is a motion subdivided almost endlessly into the convolutions of the densely grouped forms, but absolutely ineluctable: the great bodies are moved by and with it. The pattern of the whole movement and the way in which it functions in its parts appear to make a cosmic simile. Christ is seated in the heavens like a sun;[44] the heavenly host around Him seem dense clouds made of human forms.

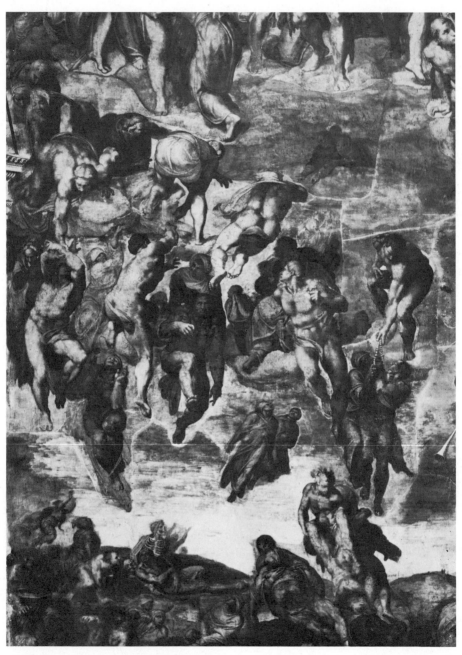

202. Michelangelo: Last Judgement (detail)

Below, in a luminous aether, bodies fall to one side towards the water like clouds dissolving into rain; on the other they rise from the earth like moisture gathering again into clouds.

The force of this simile in the image lends to the human event that it depicts the effect of inevitability that is in the processes of nature. What happens at the end of mortal time to all humanity, which we see here in the process of its happening, is unalterable. Christ will judge, and all is consequent upon His will: the titan Saints stand powerless; the muscled figures of the Damned can only writhe. The splendid bodies of the Saved neither help nor weigh in their ascent, nor does the judging Christ attend to them. Some work upward through the aether, straining; others ascend in somnolence, levitated by sheer faith, or rise on the current of the irresistible rotating force. It may be that the interpretation of the theme partakes in some ways of aspects of the thinking of the Italian Reform that are reflective of some influence from Protestantism, but this should not be over-estimated. The stress on faith as the instrument of salvation does not exclude working towards salvation also, and in this context of the Last Day the suspension of all human and saintly power of action in the flux of a finally unalterable Will does not imply predestination. Yet the emphasis in the temper of the new religious thought on faith and divine will are there, and with them is the sense, exceeding anything in Michelangelo's work before, of the profound sobriety of his religious thought and of its conviction, which he shares with the authors of the Reform. This is the image in which Michelangelo's own *terribilità* conjoins absolutely with the meaning and the stature of the theme, and it is his most awesome creation.

It is in this burden of profound ideal and human meaning and in the surpassing consonance between it and its form that the *Last Judgement* is essentially unlike the currently evolving high Maniera. At the same time, those very aspects of Michelangelo's style that had given sanction to the painters who conceived the first Maniera are in some ways more apparently developed here. Despite the force of the emotion that inhabits the idea, despite its content of an active drama, and regardless even of the magnitude of physical being in which it is expressed, Michelangelo's image represents, still more than the ceiling, a sphere of being greatly distant from our own, and the ideas underlying its embodiment in drama seem still more abstract: this bronzed and marbled turbulence that Michelangelo suspends within a nowhere sky pertains to an exalted place and level of idea. The sense of abstractness is as much apparent as the power and immediacy in which abstraction has been given form; more than in the ceiling, because Michelangelo works here in a different, more objective temper of deliberation. His emotion is authentic, but it is about the general idea more than the human images that he presents to specify it. We do not feel in them the vibrance which, in the figures of the ceiling, comes from the way in which Michelangelo there identified himself with the feelings of the beings he invented. This is a drier passion, and the products of it that take human shape are more separate from their author – more objectified. On this account we in turn may take them more nearly in the sense of objects: though illustrative meaning in them is entirely explicit they convey a value of form, as such, more emphatic than in the ceiling. This is not a value quite intended to be separate, but it is separately assertive none the less. There is a resurrection in the *Judgement* of an attitude that Michelangelo had displayed long ago in the Cascina cartoon (and the Doni Tondo also),[45] before his full development in the ceiling of a classical style, and his present formalism requires to be taken as an index of a converse happening. The vast repertory of anatomies that Michelangelo conceived for the *Last Judgement* seems often to have been

determined more by the requirements of art than by compelling needs of meaning, and the astonishing accomplishment they represent attains, and may well often be, a demonstration of absolute virtuosity. Some among the figures are in one way or another – intellectual, technical, or formal – *concetti*, but in Michelangelo's dimension, meant not just to entertain but to overpower us with their effects. Often, too, the figures assume attitudes of which a

major sense is one of ornament, and the dense enlacements of their plastic forms become convolutions of Maniera arabesque. Yet one quality of Maniera that Michelangelo had carried far in Florence earlier, the fine *affilature* and the elegances of shape of the S. Lorenzo statues or the *Victory*, has diminished here, perhaps not just by personal decision but from the action upon Michelangelo of the heavier sobriety of Rome. *Grazia*, and the kind of beauty that it

203. Michelangelo: Conversion of St Paul, 1542-5. *Vatican, Cappella Paolina*

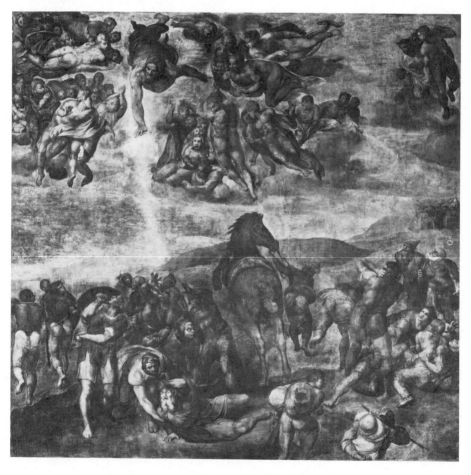

helps to generate, is less. The density of impact that Michelangelo can make with form – or in other instances, the concentration in it of its value of idea – has taken precedence for him above beauty that derives from musical proportion and from grace.

The *Last Judgement* had not even been completed when Pope Paul conceived that Michelangelo should go on to the decoration of his recently built adjoining private chapel, the Cappella Paolina. In November 1542 Michelangelo began work on the first of the two large lateral frescoes there, the *Conversion of St Paul* [203]; it was completed (with interruptions due to the ageing painter's ill health) in July 1545. The second fresco, the *Crucifixion of St Peter* [204], was begun in March 1546 and finished during the course of 1550; it was Michelangelo's last effort in the art of painting. Though no appreciable interval separates the comple-

204. Michelangelo: Crucifixion of St Peter, 1546–50. *Vatican, Cappella Paolina*

tion of the *Last Judgement* from the Pauline frescoes, the change in style that is at once perceptible in them is major, and apparent from their beginning. The earlier fresco, the *Conversion of St Paul*, displays clearly what the *Crucifixion of St Peter* shows still more: a stage of unconcern with *grazia* and the ideas of beauty of form that are associated with it that suddenly and drastically exceeds the symptoms in the *Judgement*. Figures are described as blunt, dense shapes, heavily direct in pose, and there is no trace in them of a virtuoso display of anatomy. In the *Conversion* even the angels who attend Christ are untouched by grace and the human actors are explicitly unbeautiful. In the *Crucifixion* the blockiness and bluntness of anatomy have gone farther. The figures seem rough-shaped from an inert clay; they carry their own weight as if it were a burden. A profound alteration in the attitudes that Michelangelo had previously entertained towards basic values is required to explain this change in his conception of the human form. Its substance is no longer the material of beauty or the instrument of spiritual states and powers, and its complex anatomy is no longer the virtuoso's vehicle of art. The human body is the earthen shell, the *carcer terreno* of a spirit that seems not to possess a private will or even specified identity. This is an abjuring of a whole life's history, and of the aspirations of the time in which it had been made: in the deepest possible sense an anti-classicism, and a negation of the Renaissance. More immediately, this graceless, sombre figure style is a negation of those qualities of Maniera which the actors of the *Last Judgement* had preserved.

In the *Conversion of St Paul*, as in the *Last Judgement*, the sole action of God initiates every response in the fresco, but the nature of response is different. A beam of light falls from the drastically foreshortened figure of God towards the fallen Paul; it cleaves his cortège and explodes it fanwise around his bolting horse. Violent in its pattern of action, the design is none the less schematically rigid, with the effect in it of an abstracting geometry and a symmetry that is deliberately difficult and disquieting. The figures it contains appear congealed, as if their heavy bodies had been flung into their attitudes of fear or flight and they were incapable of any other motion by an exercise of will. Paul lies enormous and inert, and his countenance – blinded, but with the look on it of a beginning revelation – conveys a meaning that may symbolize the reason for Michelangelo's withdrawal from his actors of their personal power: illumination comes from blind faith, so no other resource will avail.

In the *Crucifixion of St Peter* the figures act the tragedy as if they were automata. A circle laid obliquely back upon a barren hillside – a desolate, abstract place – determines the design. Within it, the cross upon which Peter is nailed upside down, now facing us, is being turned and pushed upright into its hole. The onlookers stand around the turning cross or move heavily with its direction. To the left and to the right rear, soldiers and civilians flow in tangents into the movement of the circle; at the front, the circle is left open and incomplete; and on one side the onlookers descend as if into our space while on the other soldiers rise as if from it. The spectator, standing before the picture between the figures who appear to descend or rise to either side of him, is compelled not only to be immediately involved inside the circle that includes the event but to feel himself as one of the slow-turning procession around it, sharing the dumb fear of the civilian onlookers and the guilt, equally dumb, of the soldiery. The circular and ineluctable movement of design recalls the *Judgement*, but once more the difference in character of form and quality of meaning is acute: this is a more rigid and terrible relentlessness, arid and hopeless. Art, so eminently present in the *Last Judgement*, denies itself any purpose here save

that of exposition of a meaning of inevitable tragic destiny and the resignation of the race of mankind to it. In both frescoes the atmosphere of tragic fatality is so strong that it seems more than an interpretation of these events only, and to imply an attitude much more generally meant. The abjuring in them of physical beauty and sensuous values indicates a sympathy with the most rigorous – and in respect of the ethos of the Renaissance, most reactionary – attitudes of the Counter-Reformation; but the sense of the powerlessness of man to contest fatality by works seems to reflect a view held by extreme elements of the Italian Reform, and one close to Michelangelo in Vittoria Colonna's circle, with which he had been in contact since his return to Rome. And in these frescoes Michelangelo conforms to the core of the doctrine of art that such Counter-Reformation theorists as Gilio da Fabriano later would articulate, though not to its small-mindedness: that the function of religious art is not aesthetic or poetic but only that of illustrating religious meaning. The negation of Maniera qualities in the Pauline frescoes results in an art which is related to the style of Counter-Maniera that would soon come into being – provoked in part by this example – to a degree like that in which, before, Michelangelo's art had been related to Maniera itself. With the Counter-Maniera, Michelangelo's frescoes share the generalization of descriptive vocabulary, the fixity of form, the schematic effect of design, and the abstractness of inhabiting idea; and, as in Counter-Maniera, these qualities are the off-shoot or the converse of the preceding style.

Michelangelo gave no subsequent expression to his thought in painting, but the few things he did in sculpture in the sixth decade and until his death in 1564, or even privately in drawing, had reverberations among painters. The religious dedication of his art in these years was so exclusive and profound that it could not easily be taken, as the *Last Judgement* still could be,

for its values of artistic form: motif and meaning had become so simply and evidently a fusion that imitators could not borrow one without effect from the other. Necessarily, however, the imitators diminished both. The last drawings and the last sculpture, the Rondanini *Pietà* – unfinished, but not needing to be complete – were unsuitable to imitate, conceived in a language so private and out of an experience so inward that they were not a convertible artistic currency. In one sense, like the barely articulated prayers they seem to be, they ascend into a sphere that transcends time, place, and concepts of historical styles; in some ways they transcend even the limits hitherto assigned to art. In another sense, they are the consequences that Michelangelo drew from his experience in just this time and place: the shape and quality his final spiritual affirmation took was the result of the history he had lived, and of what he had renounced of it.

The Moderation of Maniera and the Rise of Counter-Maniera. Daniele da Volterra and the Michelangeleschi

Among the Roman painters of the mid century who attached themselves closely to Michelangelo's example, Daniele da Volterra (Daniele Ricciarelli, *c.* 1509-1566) was the most gifted, and the least inhibited by contiguity with the master. Daniele had been educated probably more in Siena than in his native Volterra, in the main on the model of Sodoma. A damaged fresco fragment, an *Allegory of Justice* (Volterra, Pinacoteca) signed and dated by Daniele in 1532 and the sole certain work of pre-Roman date by him that survives, is provincial even in the light of Sodoma's contemporary style. Probably about 1536 Daniele came to Rome and proceeded, with intelligence and more flexibility than might have been expected, to adapt himself to the current Roman idiom. A

first independent Roman commission for fresco decoration (of which only one small part survives) in the villa at Salone of Cardinal Trivulzio was succeeded by a role as executant for Perino del Vaga, newly returned to Rome, in the Cappella Massimi in SS. Trinità. This work may have occupied Daniele from about 1538 to 1540-1; between 1540-1 and 1543 he was again Perino's executant for the designs he had made for the completion of his long-neglected (since before the Sack!) decoration of the Cappella del Crocefisso in S. Marcello. It is likely to have been during this same span of time, but beginning more likely near the earlier term, that Daniele undertook the painting of a frieze in the main salon of the Palazzo Massimo alle Colonne with the history of Fabius Maximus, a commission secured for him (according to Vasari) through the intervention of Perino; the likelihood of Perino's advice in Daniele's designs should not be discounted. From the time of this work on, Daniele was an artist of independent reputation in Rome. In December 1541 he had received a commission for a work of still greater importance than the Massimo frieze: the entire decoration of the Cappella Orsini in SS. Trinità. Not just the pressure of previous engagements but slow, labouring habits of invention and execution delayed major work on it until towards the middle of the decade. In the course of these efforts Daniele established himself as a figure in the Roman school of a stature similar to that of Salviati and Jacopino, the other young Romanized Tuscans who were his contemporaries, and as their equal in a modernity which, however, was of a rather different kind.

The order of these early works is not wholly sure, but it is likely that, of what survives in Rome itself, the frieze in the Palazzo Massimo may be the first.[46] There is no residue in it of the Sodomesque element in Daniele's past Sienese education, but traces of the painting style of Peruzzi indicate that the memory of Siena is relatively recent, and, yet more revealing, there are numerous references to the Maniera repertory that Beccafumi had devised, just before Daniele's departure from Tuscany, in the Sienese Palazzo Pubblico. These are fused with a strong influence from the current high development of Maniera in Rome, especially as Daniele learned it in his close contact with Perino. Beside this measure of assimilation of Maniera in the frieze, what is most significant in it for Daniele's future is its evidence of Michelangelism. Perino at this time was much conditioned by the Roman presence of Michelangelo; the designs he gave Daniele for the *St Luke and St Matthew* which he executed in the Cappella del Crocefisso are an instance of Perino's Michelangelesque concern at its extreme. In his frieze, however, Daniele seems still more involved with Michelangelo, obviously concerned with Michelangelesque models of anatomy but, more important, inspired – in places almost with the effect of impetuousness – by Michelangelo's idea of plastic energy that acts in space. The results, powerful though not quite coordinate, recognizably contain the seeds of Daniele's imminent mature style: a fusion of aesthetic energies generated as much out of Michelangelesque substance as from Perinesque Maniera line. When it matured, it was to constitute a new variant of a recognizably high Maniera, shortly subsequent in its emergence to Salviati's and Jacopino's, and resembling the latter's more.

The much damaged but still very eloquent fresco altar (now transferred) of the *Deposition* for the Orsini Chapel in SS. Trinità (commissioned initially in December 1541 but executed later)[47] is a completely articulate achievement in this novel style [205]; it has the magnitude not only of a mature but of a major accomplishment of art. It is all that remains of a chapel decoration which, like Perino's chapel for the Massimi in the same church, also lost, was a

205. Daniele da Volterra: Deposition, 1541/c. 1545. *Rome, SS. Trinità dei Monti, Cappella Orsini*

paradigm within its genre. Despite the pronounced Roman air of the altarpiece there are still Tuscan reminiscences in it – of Sodoma in motif only, and of the inevitable Rosso in Daniele's native Volterra; but it is the difference from Rosso, rather than the relation, that is significant. It may be more the palette than the motifs of Daniele's picture that recalls Rosso, and perhaps something in his wiry delineation of forms and silhouette. Yet the colour, even in its presently diminished state, has a quality of opulence and a flow among its singularities of hue that is more nearly consonant with classical ideals. By comparison with the master paintings from Mannerism's past experimental phase, Daniele's work seems classicizing. His conception of anatomy depends overtly upon Michelangelo, and even moderates the models he unveiled in the *Last Judgement* a moment before the *Deposition* was commissioned, making a compromise between them and the older canons of the Sistine Ceiling. Several of the figure motifs quote from Michelangelo specifically.[48] The power of human substance and the energy with which it moves in space, and, as important, the compelling emotions that inhabit it, are, as much as is in Daniele's command, made to be consonant with the classical component within Michelangelo's style. Daniele achieves a powerful and immediate consistency of form and content: some parts of his image, like the swooning Virgin, take on the pathos and the force of impact of high classical rhetoric. But at the same time that – under stimulus from Michelangelo – he regenerates elements of a classical style, Daniele works, even on these elements, in another, identifiably Maniera, temper. His rhetoric is to a perceptible degree more stylized and contrived than that of classicism. He has given his actors a linear elaboration in anatomy and drapery that is precisely and self-consciously refined, akin in kind and tenor to Perino and

to Tuscan contemporaries in Rome. And with all Daniele's emphasis of plastic power, this design that he contains it in has the effect of meditated artifice and of an ornament worked from the picture's surface that belong to the advanced Maniera style; so does the colour, even in its present state a bejewelled complexity. For all the deep intelligence with which Daniele has considered Michelangelo, his consideration has been in the rising temper of the generation to which he belonged, and he does with the style of Michelangelo what Michelangelo approached, but did not come to do himself: he makes Maniera of it.

The temper of Maniera is perhaps more sharply indicated in the *Madonna with St Peter and St Paul* for the church of Ulignano near Volterra (now Volterra, Seminario; only recently rediscovered), dated 1545 [206]. An invention by Perino has again served Daniele partly, for the Madonna's pose, but this is not what makes the heightened effect of Maniera – indeed, Perino's motif for the Madonna looks back to an early Roman work by Jacopo Sansovino, and Daniele's Paul and Peter have a look that comes from his consulting Raphael; the structure of the painting is rectilinear and simple, of a classicistic kind. Nevertheless all its parts are worked with a brittle complicating energy of line and a restless faceting of metallic surfaces of form that most identifiably pertain to Maniera; so does the high-keyed, sharp-edged poise of the Madonna, who seems a visible conjoining of Michelangelo with Rossesque fantasy. In the Madonna Daniele combines power with high preciosity to a degree that was never to be repeated in his art. The Ulignano altar seems in a temper interchangeable with that which, the drawings tell us, was in the lateral frescoes, illustrating the history of the True Cross, of the Orsini Chapel. In default of the accessory paintings of the chapel and the handsome *concetti* Daniele conceived

206. Daniele da Volterra: Madonna with St Peter and St Paul, 1545. *Volterra, Seminario*

207. Daniele da Volterra: Assumption, 1548/53. *Rome, SS. Trinità dei Monti, Cappella Rovere*

for the stucco enframement, we can get some sense of their effect in a decoration that, at the latest, closely succeeded the Orsini Chapel in time: a frieze of mythologies in the Palazzo Farnese.[49]

From the mid century a change occurred in the complexion of Daniele's style. It may be described, much too succinctly, as a chastening of his Maniera, diminishing its preciousness and rather forced effect of grace, and striving instead for a more ponderous, grave mode. Daniele's major decoration of the early fifties, of the Cappella Rovere, also in SS. Trinità (commissioned in 1548, executed, with the very liberal participation of assistants, by 1553), shows this change. The two lateral walls contain a *Massacre of the Innocents* and a *Presentation of the Virgin*; the altar wall, also entirely in fresco, an *Assumption* [207]. The ensemble is notable in that, like the Cappella Orsini but with a more impressive degree of success, it aims at a spatially consistent illusionistic scheme. Within the frescoes figures of clearer plastic definition are set into depths of space that are also clearly defined: this is an extension into a corollary dimension of Daniele's Michelangelesque concern with substance, and the extension is into the painter's realm that Michelangelo preferred not to explore. For precedents, Daniele turns to Peruzzi and to Raphael, and for all his continuing involvement with Michelangelo, Daniele's frescoes in the Cappella Rovere carry the moderating mark upon their style of those masters of a preceding and more classical time. The frescoes should be counted among the early incidents in mid-century Rome in which the symptoms appear of a classicistic Raphaelesque revival, which was to take increasing prominence among the features of the Counter-Maniera style. The Raphaelesque element was not only in Daniele's obvious geometry of pictorial structure in the frescoes; it was also in a mode (incipient earlier in the Farnese frieze) of smoothing, clarifying

indication of each separate form, also evidently classicistic. The result for Daniele's figure style, so strongly dependent on Michelangelo for its anatomies and canon, was to cast a further glaze of artificiality upon this Michelangelesque basis. It makes the effect of Maniera in Daniele's Michelangelism more discreet, but it also makes it look more academic.

Daniele had become the old Michelangelo's good friend, and when the master ceased to paint, Daniele in a sense became his surrogate, as Sebastiano del Piombo – only recently deceased – had been at an earlier time. *A Madonna with the Young St John and St Barbara* (Siena, d'Elci Collection, *c.* 1552?) [208] exceeds Michelangelo's gigantism, transcribing it into a Maniera speech, but one of swollen magniloquence; more assertively than it resembles Michelangelo, it is like a modernizing of Sebastiano. Probably in 1555-6 Daniele executed five pictures of assorted themes for Giovanni della Casa. Of these, two survive in the original and one in a copy; all are based on sketches supplied by Michelangelo. The most important as well as the most interesting of these pictures, the *David and Goliath* (Paris, Louvre), not only uses Michelangelo's design; it programmatically illustrates the definition of the *Paragone* – the comparison between painting and sculpture – that the master had laid down for Benedetto Varchi's inquiry on the subject a few years before. Daniele's panel (actually a slate) is painted on both front and back with opposite views (closely but not literally matching) of the same scene: it presents, almost in the extreme possible terms, the case Michelangelo had made for painting to be esteemed in the measure to which it approaches sculpture. By now, Daniele had in fact become so much involved with the problems posed by the *Paragone* and by Michelangelo's example that he turned for the last decade of his career, after 1556, to sculpture as the main field of his endeavour. He did not abandon painting

208. Daniele da Volterra: Madonna with the Young St John and St Barbara, *c.* 1552(?). *Siena, d'Elci Collection*

wholly, at least in the sense of the direction of his shop. The commission he had received about 1555-6 for the decoration of the Cappella Ricci in S. Pietro in Montorio engaged his atelier until 1562 or 1563; in the last year or so of Pope Paul IV's reign (about 1559?) Daniele accepted the task that is most symptomatic of the rising Counter-Reformation attitude in Rome towards art: the veiling (cautiously enough performed) of the most aggravated nakednesses in Michelangelo's *Last Judgement*. The job may have been done mostly after Michelangelo's death.

For Daniele, Michelangelo had been a model of art and of spiritual stature, but not of a religious attitude. Indeed, his action in the matter of the *Last Judgement* was that of a censor, mending what was not proper to the temper of the Counter-Reformation in Michelangelo's ways. But other artists came to look at Michelangelo's later art not so much in its aesthetic meaning as for the meanings it contained that were relevant to the new piety. This was a measurable trend, and the Roman painter in whom it was most explicitly identified is Marcello Venusti (1512/15-1579). Of North Italian origin, from Como, Venusti had become a helper in Perino's shop in Rome, but without much effect on his initial style. With the North Italian attitude he still possessed, simplistic and conservative in respect both to form and content, his response to Michelangelo was sympathetic in particular to the Counter-Maniera which, by the mid century, was overt in the master's style. In 1549 Venusti made a copy, in almost miniature reduction, of the *Last Judgement* (Naples, Capodimonte) which elicited Michelangelo's approval. Thereafter an important part of Venusti's activity consisted in small cabinet paintings that paraphrased models found in Michelangelo – in his painting, sculpture, or drawings, in general of recent date. By preference, the themes Venusti chose

to transpose were religious ones, and his pictures were evidently meant to serve the purpose of multiplying the images of piety that Michelangelo had conceived so that they could be disseminable private objects of devotion. It is not only a more literal North Italian tendency of mind but, obviously, a concept of piety in Venusti and his patrons which was more pedestrian than Michelangelo's that caused the painter, when he reproduced the master's themes, to shrink their inner scale and work them to the polish of a miniature, to labour details and append specific settings. What was awesome and abstracting religious thought in Michelangelo's inventions was deflated in Venusti's reproductions of them to a level of neat illustration, much more comfortable for the uses of an ordinary piety.

Not all Venusti's production from the mid century onward was of this essentially reproductive kind; he worked independently as well, but then too meaning less that his pictures be creations of formal beauty than that they be the vehicles of a religious sentiment or a narration legibly and simply defined. Venusti's style in these independent works avoids the apparatus of Maniera, and more than in the paraphrases stresses a mood of literal description that came from his North Italian origins, but which now was also welcome to the aims of a religious art that was intended to be less art than illustration. The atmosphere these works evoke is that of the restrictiveness – arid more than it is austere – of the Counter-Maniera which conveys, in images, the tenor of the Counter-Reformation.

Initially no less close an imitator of Michelangelo, but in a way assertively opposite – concerned with Michelangelo's demonstrations of form but disregarding what he meant to be its human content – was Battista Franco Veneziano (Il Semolei, before 1510-1561).[50] Franco appeared in Rome at the age of twenty and

dedicated himself for a span of years to the exclusive study of Michelangelo's art, but as a draughtsman only. It was not until 1535-6 that he began to apply the result of his study to painting – a small *Allegory of the Battle of Montemurlo* (Florence, Pitti), done in Florence for the young Cosimo de' Medici late in 1537 or in 1538, and a fresco of the *Arrest of the Baptist* in the Roman Oratorio of S. Giovanni Decollato, probably of 1541, indicate with what dubious effect. In these works Franco abstains, apparently deliberately, from any action of invention and takes it as a matter of principle that art can be made by compilation – regardless of thematic relevance – of forms and motifs aped respectfully from Michelangelo's repertory. The reception given in Rome to this naïve extreme of the cult of Michelangelo was unsympathetic, and Franco left to practise elsewhere. From about 1545 to 1551 he was mostly in Urbino, interrupting his work there for one more brief stay in Rome, where in 1550 he decorated a chapel in S. Maria sopra Minerva. This latter Roman work as well as the few paintings that survive from his activity in Urbino prove the degree to which his earlier exact imitation of Michelangelo had been a point of dogma: they are generically but by no means literally Michelangelesque, and exhibit a moderately accomplished and consistent personal style, not so different from Daniele's notion of a Michelangelesque Maniera. By *c.* 1552 Franco had returned finally to his native Venice, but even before this he had begun to yield, in Urbino, to influences from the Venetian school. Still, his first Venetian works made propaganda there for a mode of Romanism, though not at a level which, in the Venetian community of the time, could have carried much weight. The process that had begun before his return, of readjustment towards a Venetian style, accelerated rapidly. Franco was by no means the sole painter in Venice to pro-

fess a Romanist aesthetic. Nevertheless, the authenticity of his Roman experience, compared with that of Venetian colleagues of similar inclination, made him more distinct than they within a Venetian context and lent his production a measure of authority that theirs did not always have.

It is hard to know how to classify what Jacopino del Conte did in his later career. The alteration in his painting is extraordinary: it is eccentric in form and psychologically difficult of access, and it is sparse, though Jacopino lived until 1598. His religious works convey the effect of a conflict, which we have reason to believe was between art and piety. The later Michelangelo and Counter-Reformation religiosity – taken apparently as almost interpenetrating ideas – are major influences on Jacopino's course, though not the sole ones. A *Pietà* of late, uncertain date (Rome, Galleria Nazionale) relates very differently from Jacopino's earlier *Deposition* to the *Pietà* by Michelangelo (that now in Florence), finding a far greater urgency of spiritual meaning, and borrowing some of the sense, which in the late Michelangelo goes with it, of the physically unbeautiful. These Michelangelesque propositions have been read by Jacopino with a macabre pietistic seriousness, apparently inspired in him at least in part by direct contact with Ignatius Loyola. The religious impulse collides in Jacopino with his vocabulary of high Maniera, and his inner 'conversion' does not work quite effectively enough upon the habits of Maniera form but only warps them, with bizarre effect. It may be that Loyola's *Exercises* here find – a relatively short time after their first publication in Italy – their first result in a religious image. Later than his *Pietà*, Jacopino's *Magdalene* (Rome, S. Giovanni in Laterano) is a compound of laboured, halfdenatured, still insistent forms of the Maniera and of religious pathos which could occur with

this result only at this time: it is prime stuff for the making of a Counter-Maniera.

The Later Salviati

Salviati had achieved a climactic maturing of his high Maniera style in Florence. It is not certain that he could have made his point so brilliantly or pressed it so far in Rome in the latter 1540s. Even before he left Rome, in 1543, forces were at work there which could have operated as a brake upon the radical Maniera tendencies he realized in Florence; by the time of his return to Rome, in 1548, these forces had matured, stabilizing a situation which half a decade before had still been in flux. In the social and religious climate of Rome, the most important of these forces was its gathering conservatism; in the specific sphere of art the most important was the ever-rising concentration of authority in Michelangelo. These converged into one effect of disfavour for the extremes of Maniera, and it seems to be in a response to this that, following his return to Rome, Salviati's style showed indices of change and, in general, of moderation. They appear in his first important post-Florentine work, the decoration of the Cappella del Pallio in the Palazzo della Cancelleria (1548-c. 1550), for the most part of a differently classicist effect from the frescoes done in Florence. In these Salviati seeks strong development of plastic forms on Michelangelo's example, and a distribution of them into space by means that recall the mode of Raphael. In the main parts of Salviati's paintings in the Margrave Chapel of S. Maria dell'Anima (1549-50) he makes still more overt concessions to Michelangelo, and the altar painting there, a Pietà, goes so far as to imitate the pietistic tone as well as the specific motif and vocabulary of the latest Michelangelo. In 1551, returning to a former scene of operations in S. Giovanni Decollato, Salviati's Birth of St

John is in a similar vocabulary, stiffened, heavy, even turgid, seeming effortfully to restrict the painter's gifts as a draughtsmanly manipulator of Maniera rhythms.[51]

The restraints could not have been sympathetic; they were too much at variance with the Maniera that Salviati had previously achieved. About 1553 a great decorative exercise, the painting of a salon in the Palazzo Ricci-Sacchetti with the history of David [209 and 210], showed the kind of compromise that Salviati effected between Michelangelism and high Maniera; it turned out less a compromise than a warping of the Michelangelesque repertory to purposes connected with Maniera taste. There was a precedent for this, close in character as well as time, in the latest Perino, in the Sala del Consiglio of the Castel S. Angelo. Salviati consulted this: as in Perino's inventions there, Salviati's anatomies in the Palazzo Ricci take on Michelangelesque dimensions, but the patterns Salviati makes of them are no less Maniera ornament than his human forms had been before. More than Perino's figures do, and more like Michelangelo's, Salviati's move assertively in space; as they move, the ornamental arabesques they carry move with them. Differently from the quasi-relief design of Salviati's Florentine Sala dell'Udienza, in the David scenes the rhythmical structure works through a developed sculpturesque substance, and, where the artist wills it, in a painter's liberty of space. There has not been a basic change in the role assigned to ornament made by a Maniera calligraphy, but there is a tempering of its formal value and effect. The heaviness of sculpturesque form (which Salviati makes it apparent that he strongly feels) slows down the pace of the calligraphy, and the openings of space diffuse its effect; nevertheless it is still the working of Maniera rhythm that is the main, if no longer wholly dominating, determinant of the character of form and the tenor

of expression. It may represent a new conquest for Maniera style that Salviati can absorb so much of Michelangelo and reshape it to Maniera ends. There is a new *pondus* in the *David* frescoes which is not Michelangelesque but which in general belongs to the ideal of Romanità. This is a new inclination within high Maniera style, but no departure from it.

The scheme in which the *David* histories are contained is at once identifiable as a Mannerist *concetto*, and one of the most ingenious among them: Salviati plays in it with the idea of the *quadro riportato* to an extent which may be without precedent. In fictions generated out of paint he intermingles the effects of architecture, sculpture, easel picture, and tapestry. The other major decoration that Salviati left in the

sixth decade depends on a similarly inventive and not less elaborate *concettismo*. The Sala dei Fasti Farnesi in the palace of the family [211] engaged Salviati recurrently from about 1549 until his death in 1563. Here the painted simulations of other media of art are compounded with an equal mingling of varieties of meaning in the illustrated themes. These relate the glories of the family in war and peace by means of allegory and myth as well as history; as the formal vehicles that convey these different modes of illustration intersect and overlap, so do these kinds of meaning and their different levels of relation to reality. The source of Salviati's thinking here is in one of the earliest expositions of Roman Mannerism, the Sala di Costantino, and the open reference

209 (*opposite*). Salviati: Detail of decoration, *c.* 1553. *Rome, Palazzo Ricci-Sacchetti*

210 (*below*). Salviati: The Death of Saul and Jonathan, detail of decoration, *c.* 1553. *Rome, Palazzo Ricci-Sacchetti*

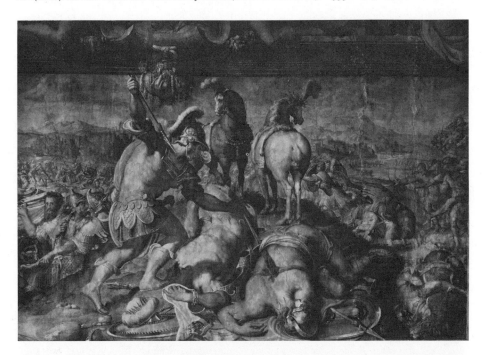

211. Salviati: Sala dei Fasti Farnesi, *c.* 1549–63, detail. *Rome, Palazzo Farnese*

Salviati makes to it reveals to what extent his recollection is not only that, but a development and a sophistication.

Salviati's work in Rome was interrupted in 1555-6 by a stay in France, where he was engaged chiefly in a scheme of decoration in the château of Dampierre. After his return to Rome his activity included further painting in the Farnese Sala[52] and the completion of the decoration of the Chigi Chapel in S. Maria del Popolo, begun long before by Raphael and more recently left unfinished by Sebastiano. A smaller-scale decoration in the Cappella della Vergine in S. Marcello al Corso (c. 1560?[53]) is not less plastically ambitious or complex than his frescoes of the first half of the decade, but achieves a lyric grade of elegance, *memore* his experience of France, of Primaticcio's painting in particular.[54] Despite the large effect on him of his mid-century Roman milieu, when he died in 1563 Salviati was still the most eloquent practitioner in the city of high Maniera style.

The Zuccari

The highly characterized Maniera accent of the later Salviati was rather the exception than the rule in Rome after the middle of the century. The younger painters who emerged at that time began to manifest a different taste, more moderate and in general more evidently classicistic. Of this younger generation the most gifted was Taddeo Zuccaro, unhappily short-lived (1529-66); he was also the least restrictive of the younger painters in this style and the one still most attuned to high Maniera. Born in the Marches, near Urbino, he came at the age of fourteen to Rome, where he received his training from painters of no consequence. His true education was self-won, in particular by study of Raphael and the models of the Raphaelesque school of the first Maniera. By 1548 Taddeo had won notice as a decorator of façades, in a manner reputed to have been superior to

Polidoro's. We cannot contest this judgement: no work by Taddeo exists that precedes the time, about 1553, when he collaborated with the Bolognese Prospero Fontana in the fresco decoration of the Villa di Papa Giulio. Taddeo's contribution there is notable at once for the degree to which it recalls the qualities of Raphaelesque style. The recollection is not just by outward imitation; there has been a re-creation of some part of classicism's essential sense. The same kind of reference to Raphael-esque style was in Taddeo's *Crucifixion* altar-piece (in fresco, severely damaged; cf. the copy, Rome, Galleria Pallavicini) for the Cappella Mattei in S. Maria della Consolazione (c. 1553-6). The specific accent of Maniera in these works diminishes as it yields to remade ele-ments of classicism – descriptive naturalism, normative proportion, clarity of form and space – but it by no means vanishes. Taddeo's retro-spective classicizing is entirely genuine, but so was his contemporary impulse towards the complicated structure and refined calligraphy that pertain to Maniera. He develops these, in the fresco histories of the Cappella Mattei, even as he quotes High Renaissance examples generously, not only from Raphael but from Michelangelo and Sebastiano del Piombo. The frescoes by Taddeo in the Cappella Frangipane in S. Marcello al Corso, Rome (commissioned in 1556 but mostly painted after 1560; finished after Taddeo's death by his brother Federico) make clear the meaning of this conjunction that he effected between mid-century Maniera and a restudied High Renaissance classicism. This is as close as a retrospective historical act can be to a reconquest of the situation in which art in Rome had been during the first post-Raphaelesque years. The altarpiece of this chapel, a famous *Conversion of St Paul* (c. 1563, *in situ* [212]; a replica in the Galleria Doria),

212. Taddeo Zuccaro: Conversion of St Paul.
Rome, S. Marcello al Corso, Cappella Frangipane

also looks towards earlier examples, among which the Michelangelo of the same theme is included: it is significant that the relation to the Michelangelo is of motif only, not of style.

It is not only the accent that Maniera had come to acquire in the mid century that distinguishes Taddeo's painting from what it resurrects, often with authentic effect, of High Renaissance classicism, for he exhibits, at the same time, a quality opposite to the Maniera: a descriptive naturalism which he may employ in episodes beside or within his Maniera stylization, and which in general exceeds Raphaelesque naturalism in its degree. It is sometimes so stressed that it may summon up a foretaste of the Baroque, of the Carracci, or even Caravaggio. On occasion, as in the small fresco *Histories of Alexander* in the Castello Orsini at Bracciano (*c.* 1560), Taddeo makes a balance, unique at this time, between what he has naturalistically observed and his effects of ornament. More rarely, as in the fresco *Death of the Virgin* that Taddeo contributed (1564–5) towards the completion of Perino del Vaga's Pucci Chapel in SS. Trinità dei Monti, he means mainly to describe an aspect of observed reality, and could sufficiently overcome the preventions of a Maniera education to give this aspect primacy. This naturalism is an important factor in the whole complex of Taddeo's art, but in sum it is a qualifying, not a dominating one. In the final analysis Taddeo remains a Maniera artist: but there are more modes in which he could manipulate Maniera style, and he had a wider range of intentions for it, than his colleagues in the Roman school. In part, his variety derived from a greater critical and historical awareness than his colleagues' of the accumulated resources that Cinquecento painting offered at the middle of the century. Despite the diversity with which he was able to endow his art, the most historically significant actions of his brief career did not consist in any major novelties but in a compromise – more properly,

perhaps, a reconciliation – between Maniera and the demands imposed on art by the beginning Counter-Reformation.

In a specifically religious image this reconciliation is represented by Taddeo's late *Dead Christ supported by Angels* (Urbino, Galleria Nazionale; a version in Rome, Galleria Borghese; 1564–5),[55] pietistic in an acceptably Tridentine vein yet not altogether stiffened into a Counter-Maniera. This painting was intended for the chapel of the great country palace of the Farnese family at Caprarola, where, in 1559, Taddeo had begun work on a fresco series that was to occupy him intermittently but regularly until his death; afterwards the responsibility descended for a short time to his brother. Illustrating an elaborate programme devised by Cardinal Alessandro Farnese himself, by Annibale Caro, and by lesser humanists, Taddeo gave a form and atmosphere of feeling to the decoration that also showed the effects of conjunction between Counter-Reformation and Maniera, operating here in the social rather than the religious sphere. The result of this enterprise, of which the most important as well as the earlier parts are Taddeo's (in design, but less in execution, since he employed considerable help), is the most extensive secular decoration in the region of Rome in the middle of the century, which rivals in dimension and exceeds in quality the Florentine Palazzo Vecchio. The temper of the Caprarola decoration, more than its iconography, is symptomatic of the states of mind in Rome's social and cultural élite that are the counterpart of the religious attitudes engendered by the incipient Counter-Reformation. There is no concession in the decoration to simplicity in thought or feeling, nor any lessening of richness of display, but there is a pervading atmosphere in it which at its best is cool austerity and at worst flat dryness; elegance and complication are expressed in a more rigid, restrictive vein. The mentality of iconographic

213. Taddeo Zuccaro: Sala dei Fasti Farnesi, 1565.
Caprarola, Villa Farnese

invention is Maniera, but it is prescribed to the painter by the inventing humanists with a controlling stringency of verbal matter that exceeds even the usual Maniera habit. Invention is allowed the artist only where his creativity cannot much affect the illustration he has been assigned. This control stifles, but it is also in some respects a goad. What Taddeo illustrates of his assigned subjects may be pedantically banal or coldly artificial, but the ornament he imposes on them can attain an extreme complexity. Yet, conversely, the tenor of the ornament is in itself taut and dry, as if expressing energy that is repressed or has been congealed.

The structure of the larger decorative schemes at Caprarola is similar in kind [213 and 214]. In the room that is the most important in the decoration both in theme and in

aesthetic substance, the Sala dei Fasti Farnesi of 1565, the exposition of Maniera formal *concettismo* and of a Maniera learning that makes visual quotations achieves the paradox of subtle ostentation. The vault consists in part of true illusionism, in part of *quadri riportati*; the walls are wholly the latter, except that the principal scenes are not *quadri* but *arazzi*, simulated by Taddeo's paint. The intellectual and visual play of the design is elaborate, but its rules are those of an abstractly elegant geometry – a geometry of planes, but not of substances. In the whole scheme as well as in the scenes that make its parts there is a constant sense of recall of the artistic past: Taddeo telescopes the whole tradition of the Raphaelesque *bella maniera* into his references, from the recent Salviati back into Perino, Giulio,

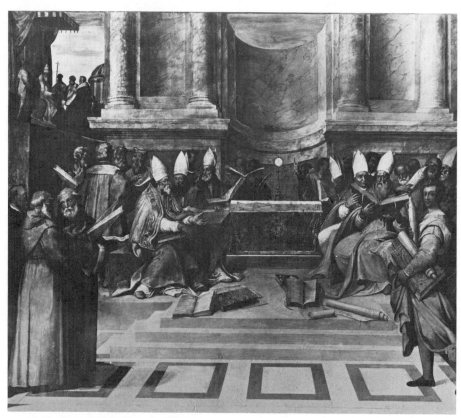

214. Taddeo Zuccaro: The Council of Trent,
detail from the Anticamera del Consiglio, 1565.
Caprarola, Villa Farnese

and Raphael himself – the last the most asser-
tively recalled. Taddeo's artistic forms and
aesthetic conceits try to summon from the past
an authority more than they intrinsically have:
the historicism is in accord with the thematic
burden of the room that justifies, by an account
of history, the present state of the Farnese
family. An altered manner, yet one as sophis-
ticated as ever in its new tone of dry restraint,
and pedantically assertive of its pedigree, has
at Caprarola been put in the service of a
corresponding attitude among the mid-century
aristocracy of Rome.

Federico Zuccaro inherited the commissions
which Taddeo left unfinished at his death in
1566. Some thirteen years Taddeo's junior
(born *c.* 1542), Federico had been brought up
by his brother and early became his helper. He
was also painting independently, however, well
before his twentieth year. In 1560, at eighteen,
he was the author of a decoration in the Casino
of Pius IV (of which the more important parts
are lost). In 1563 he went to Venice, where he
took over a commission in the Grimani Chapel
of S. Francesco della Vigna from Battista
Franco, recently deceased. He was occupied in

Venice until the spring of 1564, when, after a study trip through Lombardy (partly in company with the architect Palladio), he returned southward. In 1565 he was employed in Florence on works for the ceremonial entry of Giovanna d'Austria into the city. From Florence he was recalled to Rome by Taddeo, who hoped to use his help particularly in the task of finishing Perino's Pucci Chapel in the Trinità dei Monti. The renewed fraternal collaboration was quite brief: Federico returned in June 1566; Taddeo died in September. Federico went to work in his brother's place, seeming yet more ubiquitous and certainly more facile: at Caprarola, at the Trinità dei Monti, at S. Marcello, and in the Sala Regia of the Vatican. He assumed new commissions of his own as well, for example in the cathedral of Orvieto (1570) and in the Oratorio del Gonfalone (1573). In 1574 the peripatetic instinct that was to animate his whole career asserted itself once more, and he travelled to Lorraine, Holland, and England. In England, Elizabeth sat to him for a portrait (apparently only in drawing, however; British Museum). Within the year he returned to Italy, to Florence, where he spent five years completing the dome of the cathedral, which Vasari had left undone at his death. Federico's later career, spent in Rome, Urbino, Venice, Spain, Turin, and the Marches, and as notable for its contribution to art theory as to art, lasted until 1609 and belongs to a subsequent chapter of our history. He became quite literally a representative of what is often referred to as the International Late Mannerist style.

In the decade and a half of Federico's geographically diffuse and energetic activity before 1575 he demonstrated the efficiency with which he had absorbed his brother's lessons. The ingredients that constitute the bases of Federico's style, and much of his precise vocabulary, are more like Taddeo's than the normal connexion between pupil and master

would account for. Federico's skill of hand does not seem less than Taddeo's; however, the mentality that moves the hand does not inspire it in the same way. Federico's attitude towards what he represents seems more detached than Taddeo's, but he is more attached to habits of classicistic correctness and routine. The dryness that Taddeo adopted on occasion as a thematically indicated choice of mode seems, in Federico, a habitual disposition. But that Federico's version of Maniera in the later sixties and seventies is more routine and classicist than his brother's may be less a function of his private disposition than of a cultural sensibility we may suppose that he possessed, which continued the significant process Taddeo himself had begun of accommodation between Maniera and – now, still farther into the century – the ever more restrictive atmosphere of the Counter-Reformation.

Siciolante

Among the painters who came to their maturity in Rome about the middle of the century, Girolamo Siciolante da Sermoneta (1521–c. 1580) demonstrates best the alteration of Maniera into Counter-Maniera. The change was promoted in Siciolante (as a less radical one had been in Taddeo Zuccaro) by a tendency to refer to the past, which in Siciolante was accentuated much beyond the normal habit of painters of the Maniera. In Siciolante the backward references are more obvious and explicit than in Taddeo, and still more largely Raphaelesque. Siciolante is reputed to have been a pupil of the conservative Leonardo da Pistoia, but his first surviving work, of 1541, an altar once in Valvisciolo near his native town of Sermoneta (now Rome, Palazzo Caetani), indicates his effortful assimilation of an advanced, Romanized Maniera style. The years shortly following, spent partly in Rome and partly working in Emilia, brought diverse results, for

Siciolante visibly confessed in his paintings what he found interesting in his study of the past as well as in contemporary art. He came into the service of Perino, and so to learn how to handle fluently the vocabulary of Maniera. In Piacenza in 1545-6 he was touched specifically by the elaborate Parmesan Maniera of Mazzola-Bedoli. A *Holy Family with St Michael* (Parma, Gallery), done at this time in Emilia, makes a handsome union between the most recent Roman, Perinesque, Maniera and that of Parma. But this accomplished exercise in high Maniera contains a strong component of a contrary tendency, of monumental shape and heaviness of form, evoking Raphael and Michelangelo more than it quotes them. Despite the expertness that Siciolante had acquired in the Maniera, his inclination was neither to its form of speech nor to its tenor of emotion. The classicistic temper apparent in the Parma *Holy Family* is much more overt in an *Annunciation* for the Chiesa dei Cappuccini (perhaps earlier than the Parma *Holy Family*) on which Siciolante has imposed an almost Nazarene variety of Raphaelism. His classicist tendency operates on Michelangelesque material as well, as in a near-paraphrase (Poznań, Museum) of a *Pietà* by Sebastiano del Piombo.

Again in Emilia in 1548, this time in Bologna -where a conservative Raphaelesque tradition was stronger even than in Rome itself - Siciolante decisively committed himself to a classicist style, based upon ideas that refer to the past. His *Madonna with Six Saints* (Bologna, S. Martino Maggiore, dated 1548) [215] seems generated out of a reactionary aesthetic with archaizing means: in mid-century Italy it was of radical effect. The structure of the painting adopts a typical Emilian form, but casts it into a rectilinear geometry: it means to be logical, imposing, and severe, recreating the sense of a classical design, but is forced to the point of diagram, schematically abstract. Anatomies compound the models of Raphael, Michel-

angelo, and Giulio Romano, but by a principle that belongs mostly to the last, so that they seem stiff-jointed statuary without their own motive life. A degree of descriptive naturalism as extreme and non-Maniera as might be found in any of the current Lombards accompanies metallic surfaces that deny imitative truth. Despite the logic and the naturalism in it, both based on classical ideals, the first sense of this painting is its arbitrariness and artifice. Even as the altar deviates from Maniera and makes

215. Siciolante da Sermoneta: Madonna with Six Saints, 1548. *Bologna, S. Martino Maggiore*

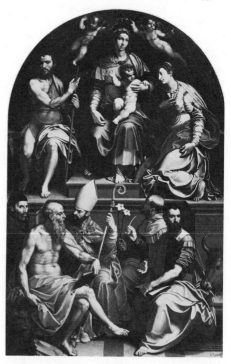

distinct differences from it, its temper of form and content remain of Maniera artificiality: this is Counter-Maniera, in a relatively early and emphatic version of the style. In Siciolante's generation of this style Raphael's art

was a major source and influence, and compositional ideals and a canon of appearance for the actors comes in the main from him; yet it must be realized that Siciolante's reading even of the classical Raphael is in the light of his appreciation of the much more recent, indeed contemporary, Michelangelo. Still more than the works Siciolante did after his return to Rome, the S. Martino altar indicates this deep debt to the Michelangelo of the forties, not just to the great frescoes but to the small works –

the Colonna *Pietà*, or the *Silenzio* – that had acquired an authority quite disparate from their size.

Siciolante's more evident relation to the precedents of Raphael and the conservative Raphaelesque tradition increased, however. Completing (with Jacopino del Conte) the chapel in S. Luigi dei Francesi that Perino del Vaga had left unfinished at his death, Siciolante almost plagiarized his *Baptism of Clovis* (*c.* 1548-9) [216] from the fresco of the *Donation*

216. Siciolante da Sermoneta: Baptism of Clovis, *c.* 1548-9. *Rome, S. Luigi dei Francesi*

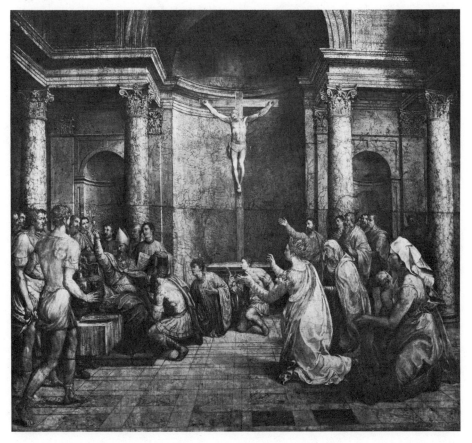

in the post-Raphaelesque Sala di Costantino, schematizing that design still further. A chapel for the Fuggers in S. Maria dell'Anima, illustrating the life of the Virgin (commissioned in 1549 but executed into the early fifties), is heavily dependent on Peruzzi as well as Raphael. Exact quotations from Raphael or generic references to his models persist in Siciolante's art throughout his subsequent career. If Taddeo Zuccaro seems at times to have recaptured a position like that of the first post-Raphaelesque Maniera, Siciolante seems often to have made an analogue for an even earlier moment in the history of sixteenth-century Roman style, as in his *Life of the Virgin* painted in S. Tommaso dei Cenci in 1565 [217].

It must not be forgotten that Siciolante's concern in the making of a classicistic, simplified, and naturalizing style was not merely formal: it was meant to support a kind of meaning and to establish a communication unlike that made by the conventions of the contemporary high Maniera. In the sixties Siciolante's devotional paintings (e.g. his *Crucifixion*, Rome, S. Giovanni in Laterano) could at times assume a simple immediacy of sentiment so strong and a description of appearances so naturally consistent as to overcome the Maniera quality of abstractness that is normal in his art; they then anticipate a succeeding stage of Counter-Reformation style that is represented by the imminent emergence in Rome of Scipione

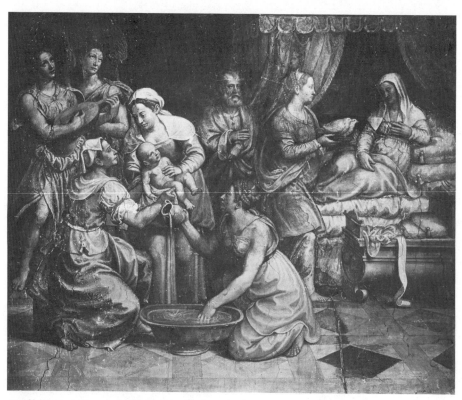

217. Siciolante da Sermoneta: Birth of the Virgin, 1565. *Rome, S. Tommaso dei Cenci*

Pulzone. However, it is not an attitude towards a problem of art that takes Siciolante's painting towards this forward reach; it is a view, already Counter-Reformational in spirit, of the subordination of style to the purpose of religious illustration. He is thus not stylistically consistent: the last decade and a half of his career produced works that range from a simplistic pseudo-Raphaelism to his still Raphaelesque but evidently mannered contribution to the completion of the Vatican Sala Regia, or his *Martyrdom of St Catherine* in S. Maria Maggiore (1568). If anything, the elements that confirm Siciolante's affiliation with Maniera tend to become more apparent in his later years.

Muziano

Siciolante's style is nevertheless in the main in harmony with the temper that was to assume still more importance in Rome in the later years of the century. Even what seems from the standpoint of aesthetic judgement to be a negative value of Siciolante's art, its effect of dullness and monotony, is historically positive. Because inspiration is individualistic and therefore, in the climate of the strict Counter-Reformation, suspect, it should be suppressed even where (as is not often Siciolante's case) it threatens to appear. Boredom is a requisite of the Roman Counter-Maniera style, invading even the art of the few painters whose inspiration may be too considerable and too authentic to be sealed off wholly. This is the case of Girolamo Muziano (1532–92), a decade Siciolante's junior, whose activity in Rome began in the middle of the century and extended almost to its end. A more overt *devôt* than Siciolante, Muziano more explicitly exemplifies the pietism that took root in Roman art at the middle of the century and then grew with the Counter-Reformation. Of Brescian origin, but trained in Padua (*c.* 1545–9), Muziano's first

orientation was decidedly Venetian. He came to Rome about 1549 and studied earnestly (and with much painful self-denial) for some five years, assimilating what to his serious temperament appeared to be the most compelling models of the Roman school: Michelangelo conspicuously, the late Sebastiano del Piombo hardly less, and, among his contemporaries, Taddeo Zuccaro. He did not forsake the Venetian elements with which his prior training had equipped him, however. Like Sebastiano del Piombo, Muziano never lost his sensibility to textures and effects of light: it was made secondary – as the Roman preference required – but then re-emerged as, in the course of the seventh and eighth decades, naturalism became an increasing interest generally within the Roman school. Muziano was also, more than any artist so soon as this in Rome, a practitioner of the art of landscape, in paintings of religious subjects in which the settings, generically Titianesque in derivation, are concordant in mood with the expression of dramatic piety that Muziano instils in his figures. Not only landscape settings but the backgrounds Muziano makes of architecture have the spatial extension that betrays an origin in Venetian experience. But equally indicative of a talent that originated in the north of Italy, and more essentially important, is Muziano's capacity to manipulate the actors, setting, and staging of religious narrative in a compelling, and if need be complex way.

Muziano's début in Rome was with a *Resurrection of Lazarus* for S. Maria Maggiore (1555; now Vatican Museum), of the dimensions of a Venetian *telero* [218]. Figures of Michelangelesque type and scale still bear a Venetian – even specifically Tintorettesque – accent, and their combination in a narrative design is Venetian in its union of explicitness and fluency. But the more important tenor of the work is Roman, and in the most advanced mode of the moment: pedantically rhetorical

218. Girolamo Muziano: Resurrection of Lazarus,
1555. *Rome, Vatican Museum*

and extremely serious. This mode recalls the art of Sebastiano del Piombo, but in a form regenerated by compromise with the Maniera. Muziano's result is strikingly like the exactly contemporary Taddeo Zuccaro's in principle, though it is distinguished from it in appearance by a dedication to Michelangelesque rather than Raphaelesque example. This weighty and emphatic style is also in the earlier of the altar-pieces (*Resurrection of Lazarus*, commissioned in 1555, and *Road to Calvary*, commissioned in 1556) that Muziano painted for the cathedral at Orvieto, and the paintings executed about 1557-60 (now lost) for the cathedral at Foligno. Within the rhetoric of these altars there are fine incidents of description, and in a *Raising of the Daughter of Jairus* done for Philip II of Spain (Escorial, *c.* 1560-5) the quality of optical response and the naturalism that accompanies

it for once exceed the rhetoric. But these effects diminish: more and more Muziano became the agent of his brand – grave, impressive, and exceedingly restricted – of the artistic formulae that illustrated Counter-Reformation piety. The impress his works make is not just a function of the grand scale of their forms nor of the evident power that inhabits their restraint but of the oppressive melancholy in Counter-Reformation spirituality that Muziano conveys to us. This is the emanation of his large altars with the *Preaching of St Jerome* and the *Giving of the Keys* (Rome, S. Maria degli Angeli, *c.* 1585) [219] and still more of his late high altar of the *Circumcision* for the church of the Gesù (1587-9). In the last quarter of the century Muziano was a favourite painter of the Papal court, employed in particular by Gregory XIII.[56] In these later years his art fitted still

219. Girolamo Muziano: Giving of the Keys, *c.* 1585. *Rome, S. Maria degli Angeli*

more accurately into its religious context than it had at the beginning.[57]

Two collective Roman enterprises on a large scale afford condensed images of the look of painting in the city as the third quarter of the sixteenth century moved towards its end. One, the Sala Regia in the Vatican, had church histories, mainly of a secular kind, for its subjects; the other, the Oratorio del Gonfalone, presented episodes from the Passion of Christ. The paintings in the Oratorio, begun in 1569 and completed by 1575, are half or more by artists whose principal activity falls into the last quarter of the century, and its decoration is more relevant to the course of art at that time, with which we shall discuss it. (A further collectively executed religious decoration, of the Oratorio del Crocefisso di S. Marcello, belongs to the turn of the century's last quarter and shortly beyond it; its significance is also for the later time.) However, the whole history of the Sala Regia, finished in 1573, belongs within the period of this chapter. The work had been begun three decades earlier, but the effective realization of the programme for its painting did not begin until 1563. This programme, complementary to the paintings in the adjoining Sistine and Pauline Chapels, was a celebration of the defence of the Faith by the monarchies. The large room, of which the building was begun about 1540 to the plans of Antonio da Sangallo the Younger, was entrusted first, in 1542, to Perino del Vaga to decorate. Before his death in 1547 he had seen to the execution of the stuccoed ceiling and designed the windows. When Perino died the Sala became an object of contest between Francesco Salviati and Daniele da Volterra. Daniele at first won, and held the commission between 1547 and 1550, working mainly on the stucchi (certainly those on the walls); he was then diverted to other decorations in the Vatican (in the apartments of Julius III and in the Stanza di Cleopatra), and work in the Sala was apparently

suspended until about 1559. Then Daniele had sole responsibility again until 1561, but from 1561 to 1563 was forced to share it equally with Salviati. It is not clear how much of the stucco decoration of the walls, around the framing elements that would contain the paintings, was accomplished by Daniele before Pope Paul's death in 1549, or executed when he returned to work about 1560. The question of their design – Perino's legacy or Daniele's invention – is also unresolved.

When Salviati was finally allowed to participate his behaviour was characteristically difficult and resulted in such conflict that it was decided, probably in 1563, on the suggestion of Pirro Ligorio, that the painting of the Sala should be shared out among younger artists. Salviati died before he could make any measurable contribution to the room, but Giuseppe Porta Salviati, his Venetianized ex-assistant, executed a large fresco that Francesco may have planned. Spaces were doled out to Taddeo Zuccaro, Siciolante, Livio Agresti da Forli, and to a few lesser exponents of the Maniera mode of history painting who were as conventional as Agresti and even less talented. The death of Pius IV stopped this charitable patronage, and it was not until 1572-3, after Gregory XIII's succession, that the aged Vasari (with Lorenzo Sabbatini as his principal assistant) was called to complete the job, still half undone. The tenor of the paintings done in Pius's time is dull enough: even Taddeo's and Siciolante's pieces seem to be noteworthy mostly for their classicistic pedantry. The old Vasari's contribution is more evidently in accordance with the conventions of Maniera, but even more than in the latest Vasarian demonstrations of the Palazzo Vecchio, the conventions as here recalled for their *nth* re-use are devoid of vitality. The decorative scheme – Perino's or Daniele's – handsome, imposing, and ingenious, but a little dry, is filled with images that reflect the rigidifying of a culture as well as of a style of painting.[58]

VENICE 1540-1600

The attitudes – not only towards aesthetic preferences but towards spiritual or religious values – that determined in Venice how art should be made may have offered less impediment to creativity than those of the Mannerists of Central Italy: by comparison with the high Maniera of Rome or Florence, and still more with the Counter-Maniera that came gradually to take a place beside it, the painting of the mid century in Venice seems libertarian and energetic, offering meanings and satisfactions that are far easier of access. Yet, from about 1540 onwards all the more important phenomena in Venetian painting – not just, as had been the case before, occasional events of note – carry the mark on them, in some degree, of contact with the Mannerism that had its origin in Central Italy. There had been a continuous diffusion of Florentine and Roman ideas towards Venice throughout the first four decades of the century, but in the main these ideas had their source in the Central Italian classical style. Only Pordenone, late in his career, reflected elements whose sources were in contemporary Mannerism. We have seen the effect of the conjunction in Venetian painting between native principle and imported classical ideas. It is a conjunction which is more often than not effortful, and conveys a sense of self-conscious intellectual demonstration foreign to the natural tenor of Venetian art. Nevertheless, the classical style of Central Italy was compatible with Venetian Cinquecento style at more points than the new Mannerism of Central Italy could be, or even its influential Emilian offshoot. The intellectuality and precise draughtsmanly articulation of emotion and of form that are yet more evident in Central Italian Mannerism than in its classical antecedent diverge by that much more from Venetian custom. By about 1540, when the new Maniera had achieved its own clear definition and its dominance in Central Italy, the contrast between it and the generality of contemporary painting style in Venice had become acute.

The contrast was illustrated by an accumulation of circumstances, important for their collective rather than their individual effect upon Venice. Among the most obvious are the brief stay of Francesco Salviati in 1539-40 and the longer, perhaps more influential, visit of Vasari in 1541-2. But perhaps more historically effective than either of these actual artistic presences in Venice was the import of prints, after Roman painters of the High Renaissance and the first Mannerist generation, and after the Emilio-Roman Parmigianino in particular. There was, of course, no acute distinction in the minds of Venetian contemporaries between the phases or varieties of Central Italian style, and Romanism of an earlier-sixteenth-century vintage, transcribed into the style of a post-classical printmaker, effectively reads as Mannerism. As important in preparing the intercourse of Venetian art with Mannerism were the concessions already made to Romanism by the major painters in Venice, by Titian frequently and by Pordenone constantly; we observed that in Pordenone's case his art came to involve contemporary Mannerism as well.[1] A more general cultural circumstance assisted also, at least in the sense of its effect on Venetian taste: as an aftermath of the political and religious disturbances that were more strongly felt in Central Italy in the later twenties, Venice in the next decade for a while became a centre of religious and intellectual activity of importance unusual for the city. For a time and incompletely, Venetian culture took on a cast that more nearly than before resembled that of Rome or Florence.

In the domain of painting the confluence upon Venice of these factors was sufficient to

effect a visible reaction in Venetian style. It was in the main affirmative, accepting much and often from the examples set by Central Italian Mannerism, but it was not consistent and, except at a very minimal level, not generalizable. The problem in the confrontation of the two schools – basically what it had been before but now more acute in its contrasting terms – remained that of a style of *disegno* (in its intellectual as well as mechanical sense) and one of *colore*. The painters of mid-century Venice, and more certainly the critics who spoke about and for them, saw the problem accurately,[2] and articulated it on occasion in a polemic tone, opposing their Venetian deity Titian to the Central Italian divinity of *disegno*, Michelangelo. But beyond the question of the different essential disposition of the Venetian and Central Italian schools towards the aesthetic matter from which art is made, there was the explicitly contemporary problem that the Central Italian Mannerist example posed: of its particular ways of shaping pictured forms and their environments and making compositions, and concomitant with this, its attitude of licence towards description. The identifiable look of the Maniera, not just of Romanism, makes itself extensively apparent in Venetian painting of the mid century. But it is only in the most pedestrian Venetian painters that this occurs as an evident adoption of a foreign style. The major Venetians who matured about the mid century took the poetic licence and vocabulary of Mannerism and transformed them – not by imitation but by creative synthesis – into the distinct language of Venetian style.

What is founded in the fifth decade in Venice or in the sixth endures as the basis of Venetian art until the latest years of the century and has an after-life into the early 1600s: there is less change and innovation than in Central Italy in the same span of time. But the diversity of modes in Venetian painting in the second half of the sixteenth century is not less than that

which we have observed in contemporary Central Italy; and Venetian painting only rarely shows the character of restrictiveness, either in form or expression, that is pervasive in Central Italian style of the time. Venetian painting seems more free, and the human energy in its creation more apparent. This is a function not only of Venetian style but of the circumstance, not altogether accidental, of the presence in Venice of the highest concentration of artistic power in later-sixteenth-century Italy. Neither Rome, Tuscany, nor any other region of the country could summon a group to match the stature of genius held by the old Titian, Tintoretto, and Veronese. They make a level of illumination in Venetian painting of the second half of the Cinquecento different from that of the other contemporary Italian schools.

Titian after 1540

By 1540 Titian had reigned over Venetian painting for thirty years since Giorgione's death, yet this was no more than the rough midpoint of his career. He continued to paint for three decades more, and at an age that was most probably a little over ninety finally let go of life, in 1576. This last half of his career – a span that would have sufficed a normal sixteenth-century creative life – was even more astonishingly vital than the first.

In the early forties the preoccupation that had been increasingly visible in Titian's art of the previous decade, with Central Italian ideas of style, became a factor that significantly affected – where it did not control – his most important paintings for some years. We have seen his competitive involvement in the later thirties with the art of Pordenone, and his exposure to the more authentic Romanist example in Mantua of Giulio Romano; he was in Mantua again late in 1540. The *Crowning with Thorns* (Paris, Louvre, 1542-4; painted for S. Maria delle Grazie in Milan) [220] is the revel-

ation of the extent to which his accumulated experience of Giulio affected Titian. Against an ashlar architecture that, like Giulio's real buildings, is both expressive and archaeological, Titian sets Romanized anatomies in poses of forced action. The self-consciously rhetorical exaggeration in these postures and the extreme stress of their plasticity is Giulio's, compounded with an element of Michelangelism and by a recall of the Laocoön. Twenty years before, two of these same factors had been instrumental in Titian's earlier confrontation of Venetian with Roman values, as in the *Resurrection* of Ss. Nazzaro e Celso. But now the confrontation is with Giulio's exaggeration of the proper-

220. Titian: Crowning with Thorns, 1542–4.
Paris, Louvre

ties of Roman painting style into post-classicism, and the will to convert its possibilities to his own use brings Titian nearer to the formal accent and expressive atmosphere of post-classical Roman style than he had ever ventured before – with the diminished but still saving factor of an optical technique that gives the foreign artifice of form at least the light and texture of existence in reality. This is the irreducible native constant not only in the *Crowning* but also in the other works of this short phase, within the early forties, of Titian's deepest probing towards *Romanità*. It is still more evident in the three great ceiling paintings, twice life-size – *Cain and Abel*, *David and Goliath*, and the *Sacrifice of Isaac* – which he executed for the church of S. Spirito (c. 1543; now Venice, S. Maria della Salute).[3] In these, anatomical *gigantismo* and dramatic action have a less artificial pathos than in the *Crowning*, and chiaroscuro and colour are as much the agencies of drama as the actors' forms. Not just Giulian example but Pordenone's and Correggio's, more nearly of the Venetian tradition, served Titian in the ceiling paintings, affecting both the motifs and the devices of illusionism he employs in them, and his way of dealing with his sources is, more evidently than ever before, an expropriation even more than it is an assimilation. By it, in this episode of Romanism, he finds a new and more rhetorical impressiveness for his actors and their settings and a higher energy not just for their forms but for the colours he clothes them in. The large *Ecce Homo* (Vienna, Kunsthistorisches Museum, dated 1543) has these effects of Titian's Romanism but less of forced *Romanità*, tempering artifice in its dramatic style with a pathos more closely dependent on observed truth. The extreme of Titian's Romanism passed before his actual experience of Rome itself.

In the autumn of 1545, responding to solicitations from the Farnese, Titian finally made an extended visit to Rome: he stayed from October

221. Titian: Paul III and his Nephews, 1546. *Naples, Capodimonte*

1545 to June of the succeeding year. He was lodged in the Belvedere and guided (by Vasari among others) through the city's monuments and works of art. He was commissioned to do paintings which were, mostly, portraits. Of other works he left in Rome, the most important that survives is the *Danaë* (Naples, Capodimonte), which Titian had begun on order from the Cardinal Alessandro Farnese the year before, but with its Roman destination then certainly in mind.[3a] The *Danaë* seems a programme piece, meant to display how much Titian had absorbed, even before his experience of Rome, of Romanism; equally, it demonstrated his Venetian differences from Rome. The nude form of the *Danaë* takes on a high classical character, partly from the study of antique examples, but more from a synthesis that Titian had not made to this degree before between grandeur of dimensions and regularizing harmony of shapes. Titian has grasped wholly the classical sense of Roman plastic style; the shape and posture of the *Danaë* have the plastic certainty of grand classic statuary. But as if to demonstrate to Rome – perhaps polemically – a power of Venetian classicism that Roman art did not possess, Titian has clothed the Danaë's nude form with a tactile lustre, which emanates a sensuousness of which the effect is of a grandeur not less high than that of the ideality of form. What is in the *Danaë* is more than the dialectic Titian had achieved at times before between plastic and optical style. To a Rome in which true classicism was no longer a living principle Titian showed, in the *Danaë*, that he had moved on to an exalted plane of that style, higher than he had achieved before, and of which he would never quite abandon the essential sense.[4]

The major portrait Titian did in Rome, of the aged *Paul III with his Nephews, Alessandro and Ottaviano* (Naples, Capodimonte) [221], is a very different but no less important matter. It

is unfinished, and this intensifies the effect it makes, almost startling, of the momentary and immediate, and of psychological experience so subtly nuanced as to seem evanescent. The painting is in these ways a virtuoso demonstration of Titian's most instinctive, rather than classical and cogitative, gifts. The picture's livingness is the antithesis of the congelations of contemporary Maniera portraiture, more rigid in Rome than elsewhere.[5] Was its virtuosity a contradiction offered to Maniera portraiture on its home ground, as the sensuous lustre of the *Danaë* was to the Maniera's sophistications and fragilities in painting of the nude?

Titian's return to Venice was followed fairly shortly by an invitation from Charles V to come to Augsburg. In January 1548 Titian was en route to Germany, and he remained in Augsburg until October of that year. He was engaged entirely in painting portraits,[6] among them some (such as the *Charles V Seated*, now in Munich) that make measured concessions to a German taste. One of the Augsburg portraits, depicting Charles as a mounted general at the recent victory of Mühlberg, was an image so immediate in both reference and presence and, at the same time, so stately that it founded an iconography within the portrait genre: its formula was destined to endure until generals and horses ceased to coexist. While Titian was in Augsburg, Mary of Hungary, Charles's sister, commissioned a set of what might best be called antique morality-paintings, which Titian executed after his return to Venice (three in 1549, one before 1553), sending them then to Mary's residence in Flanders. They illustrated four great ancient 'condannati': *Tityus, Sisyphus, Tantalus*, and *Ixion*. The last two have been lost, and the two remaining ones, now in the Prado, were very early damaged by fire (1554), and may not document much more than the idea that Titian had when he conceived them. Yet, in the *Tityus* especially

(sometimes improperly identified as a *Prometheus*), there is evidence of the maturing of a process that had been at work since the middle of the fifth decade, of which the Roman *Danaë* may mark the inception; a second version of the *Danaë* theme (Madrid, Prado, 1554) [222] may testify to its fulfilment. In the early forties Titian's response to Romanist ideas had consisted mainly in an aggrandizement of form in size and in effect of plastic substance. In the Roman *Danaë*, however, more in the *Tityus*, and quite evidently in the second *Danaë*, aggrandizement is not so much through physical effects as by the sense of scale Titian gives to the idea inhabiting the form. Substance is dense, but it is no longer plastically defined, and it is bound more closely to the surrounding light and air. Not only form but all sensuous and, specifically, optical values that the image holds are conceived on a larger scale, felt – and now set down by a rougher brush – with a power so grand that it endows them too with a character of idea. The later *Danaë* and the pictures that are coeval with it – the *Venus and Adonis* (Prado), *Venus with a Mirror* (Washington, National Gallery, *c.* 1555), or the *Perseus and Andromeda* (London, Wallace Collection, after 1553/6) – convey the sense that an extra-

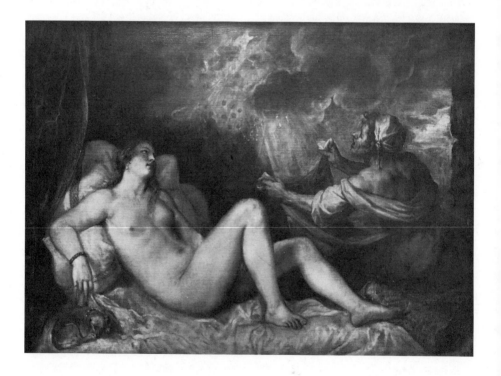

222 (*above*). Titian: Danaë, 1554. *Madrid, Prado*

223 (*opposite*). Titian: Diana and Actaeon, 1559 or earlier. *Edinburgh, National Gallery, Ellesmere Loan*

ordinary reach of classical expression has been achieved in them, as sensuous experience, as much as that of the spirit and the mind, assumes the stature of idea. This compares in many ways with what had happened in Michelangelo at an earlier time, but it contrasts with what the contemporary art of the Florentine had since increasingly become: an abjuring of the senses. As overt decorative virtue yields to depth of meaning in these works colour becomes quieter, but in compensation is infused by the rougher vibrance taken on by light. More than ever, what the paintings of the fifties and the years that follow tend to possess is less a colorism than a tonality: a tissue of restrained hues woven with a wonderfully diverse luminescence. In this tissue chiaroscuro is the agency of drama, not just of narrative but of visual experience. Within it the lights are radiance and coruscation, exalting what they touch.

At the end of the sixth decade and the beginning of the seventh this phase of Titian's style found a culmination in a set of large mythologies painted for the new monarch of Spain, Philip II; the *Diana and Callisto*, the *Diana and Actaeon* (Edinburgh, National Gallery, Ellesmere Loan [223]; both sent to Spain in 1559), the *Punishment of Actaeon* (London,

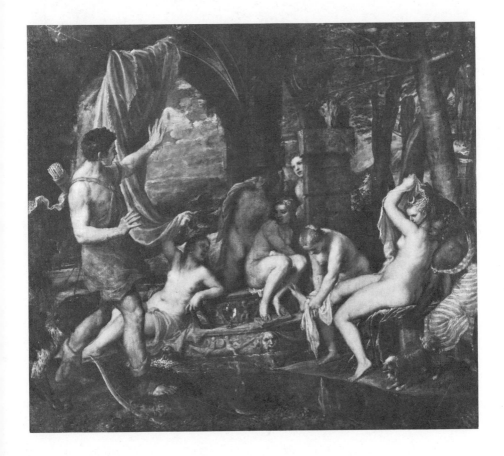

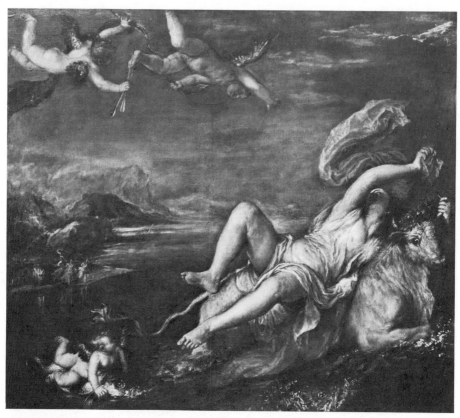

224. Titian: Rape of Europa, 1559–62.
Boston, Gardner Museum

National Gallery, formerly Earl of Harewood, *c.* 1560), and the *Rape of Europa* (Boston, Gardner Museum, 1559–62) [224]. Each is composed with regard to the structure of the others, making complementary relations of a characteristically classical kind,[7] but in which the variations are of an absolutely bold, commanding largeness. This largeness is the present scale of Titian's functioning in all respects. In each picture a humanity of superb sensuous presence, grand in proportion and in posture, and above concern with artifice of rhetoric or grace, enacts the theme: their appearance and their quality of action make drama actual, with the effect neither of theatre nor of ordinary reality, but of an event in the existence of Olympian beings. Their physicality seems a palpable, not just a visually demonstrated fact, and it is as if inspired, charged with vitality on a consonant grand scale. The power of their substance radiates through the flesh and beyond the contours of its form and

action, and on their surfaces the brush works with light and colour to give the effect (as in a Phidian statue) of a breathing porosity, mingling with the circumambient air. But this surrounding air is made to seem no less a textured, live, existence, as is the landscape that it fills. All the matter in the picture, its grandly physical humanity included, is woven into a purely pictorial unity, essentially optically determined. No new aesthetic principle has been invented to create these works. The difference between them and the work of Titian's past is in the magnitude with which the image is conceived and felt and with which the means of art are made to operate, and in a magisterial daring so perfectly controlled that it is consonant with classicism. In their scale of idea and artistic means and in their daring these works have an awesomeness that, without the pessimism or the melancholia, is akin to the *terribilità* of Michelangelo. But unlike the later Michelangelos, which deny all but spirit, these late Titians remain exemplars – almost the most encompassing in range and at the most exalted level – of classical style.

Obviously, the idea that inspires the magnitude and reach of this late style is generated by much more than the intellect. The power of spirit and emotion in it may be measured in the religious paintings that relate to the royal mythologies in time. In the *Entombment* (Madrid, Prado, 1559) an emotion that is as much love as it is tragedy is orchestrated, more than it is described, in a design of light-shot colour, expanding out of darkness like a firework in a night sky. Darkness sets the tone of tragedy in the late religious pictures, and against the dark the lights and forms conjoin intensity with scale to create emotion. In the *Crucifixion* (Ancona, S. Domenico, 1557–8) the forms are almost icon-like in their austerity; the *Martyrdom of St Lawrence* (Venice, Gesuiti) is contrastingly elaborate. Painted mostly about

1557, but begun in 1548, just after Titian's trip to Rome, the *Martyrdom* retains the Roman accent of rhetoric and archaeology of its first design; but almost more than by the overt action, drama is made in it by painted fire and nocturnal light.

In general, the paintings of the sixth decade convey an atmosphere which, while it exalts the senses, at the same time seems an exaltation of the power of reason. But there is the symptom in them of another power which need not violate reason but seems to transcend it. This emerges in the middle sixties, the cause, effect, or both, of an inspiration so overwhelming in force and scale that by it art exceeds what had hitherto, except for the latest Michelangelo, been its limits. The paintings of Titian's last ten years no longer seem just to describe, or paraphrase, or symbolize the factors that make physical or spiritual being work but to incorporate them absolutely. What Titian seems to deal with now are essences and powers, no more than ever as abstractions but as constituents of the visible and palpable world. It is as if he should have identified himself wholly and with passion with the matter of experience – otherwise said, with life and nature. This identification resembles a religious act, but in Titian's case it is not a spiritualizing, overt orthodoxy that promotes it. Titian's latest art contains the effects of a long life's dedication to what may be called, alternatively, humanism, paganism, or sheer sensuousness; the existence Titian now depicts as inhabited by vast immaterial powers is still sensuously grasped. But these powers now seem so profound as to be limitless. Where the paintings of the preceding decade induced awe by their mastery of art, these later works overwhelm. They possess, now, true *terribilità*, which, like Michelangelo's, resides not only in the power of idea but in a depth and authenticity of emotion that we fear. But there is another way, not in Michelangelo,

by which the *terribilità* of Titian reaches for us: by the imminence to us of the sensuous presences in which idea and emotion dwell. It remains nature that Titian paints, and it is not that he transcends it but that he is, more nearly than any painter before him, one with its essential stuff – with what is terrible as well as beautiful in it, and with the forces in it that are not amenable to reason. There is something Faustian in this – so far, ultimate – possession of the world by means of painter's knowledge: it has an element of the daemonic.

Unlike his Mannerist contemporaries, the late Titian does not have to abstract or reshape the appearances of nature to make expression; purely painterly devices suffice towards this end. Always able to create emotions out of handling of paint, Titian now gives this resource liberty on the scale that his present dimension and depth of meaning ask. His mode of notation, already bold enough in the preceding phase, takes on, from the mid sixties, and then yet more towards 1570, an abbreviation that cannot be explained mechanically as a function of economy of effort or of failing sight. Broad, rough-texturing, touching form with a rude, deft power that evokes the action of an old lion's paw, the brush makes strong and summary existences from light. As always in Titian, the stroke and the content that it bears of coloured light define existence optically, but in a way unparalleled in his art before the brush stroke expresses the subjective action Titian now imposes upon optical experience. He may alter or astonishingly transmute what objectively he may have been supposed to see, infusing *pneuma* into it, but this infusion in the image does not mean that it becomes a-sensuous. Substantial and tactile values are not dematerialized to become values of disembodied light; on the contrary, it is as if a purely optical value should be added like a transparent film to the substances that may be underneath. The surface of flesh may take dull fire, but the flesh

is not consumed; draperies may phosphoresce, but they lose none of their density or opulence of texture; atmosphere may glow or be invaded by a fitful darkness, but it remains palpable. Only landscape in these latest works seems evanescent, about to be consumed in a crepuscular atmosphere that is as if on fire. The human actors, very vehicles of sublimity, assert none the less their sensuous being, but the world in which they act may take on the semblance of dream: this is a new, dynamic, and aggrandized recrudescence of the Giorgionesque *sogno*.

An *Annunciation*, painted *alla prima* about 1565 as an altar-cover for the Venetian church of S. Salvatore (*in situ*), is among the first of Titian's transcendent late works. In it the descent of the Spirit is accompanied by an eruption of young angelic forms from a darkened heaven; below, an unexpectedly masculine Gabriel moves with bulking power towards Mary. Light makes brilliant saliences of form out of the dark, and within the darks makes restless crepitation: the image is dense with the accumulation in it of the energies of substances and lights, and vibrant with the grandeur and profundity of emotion that is equally idea. Two closely contemporary paintings are reworkings in this new stature of earlier ones: the *St Margaret* (Madrid, Prado, *c.* 1565-6) [225] of a theme of 1552 (Escorial); the *Martyrdom of St Lawrence* (Escorial, 1564-7) [226] of the picture in the Gesuiti. The *St Margaret* is much in the temper of the *Annunciation*, but still more gives the effect of expanding grandeur to the actor's form. She seems the image of a tragic goddess, of immeasurable dignity, rather than a Christian saint. Her figure shines in a landscape where, though it is night time, nothing rests. Across a lake, a city in the distance is mysteriously alight, as if it might be on fire, scattering sparks upon the water and up into a clouded sky. In the *St Lawrence* of the Escorial the light is less mys-

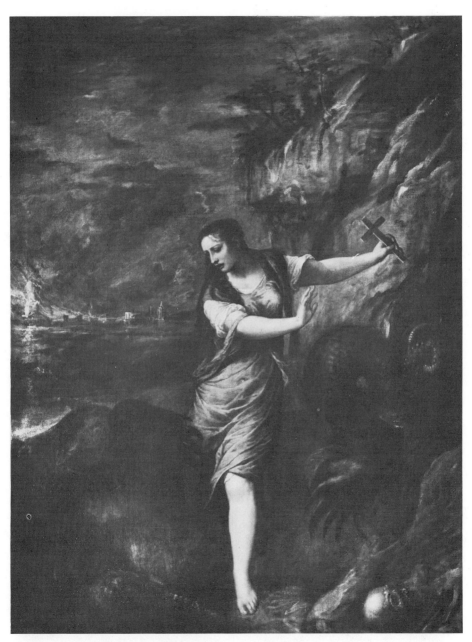

225. Titian: St Margaret, *c.* 1565–6. *Madrid, Prado*

226. Titian: Martyrdom of St Lawrence, 1564-7. *Escorial*

terious in origin but still more transforming and evasive of rationality in its effects. It is violent, agitating, and unbeautiful, and gives the cruel scene an atmosphere of unclear dream. The archaeological and theatrical apparatus of the earlier *St Lawrence* are quite gone. Titian envisions the image as torment and nightmare, and makes roughnesses and haunting ugliness replace the strong rhetoric he had used for the theme before. A work of *c.* 1570-1, the *Crowning with Thorns* (Munich, Pinakothek) [227], is a recasting of a still earlier painting, that in the Louvre [220]. Here, too, rhetoric has been abjured, and the image is given with a forthrightness that is close to harshness, even willing (as in the *Martyrdom*, too) a daemonic element of caricature. The setting is again a darkness, from which a single blazing chandelier calls forth dense and sombrely rich-coloured forms. The brush moves to express the force with which the image is conceived and optically evoked, and its very roughness generates, more than before, tactile and visual splendour. In these latest years Titian's art suggests the image of a setting sun, most marvellous just before it sets.

Most of the latest works cannot be put in a sure chronological order, and it is even more likely for them than for the pictures of preceding years that they were done over a span of time, some of them more or less concurrently. Of the *Tarquin and Lucretia* (Cambridge, Fitzwilliam Museum) it is known that it was despatched to Philip II in August 1571, and that it is thus contemporary with the Munich *Crowning*. Given the conjunction of theme and patron Titian is not so libertarian or subjective in the *Tarquin*, but he still engenders force in both the visual and dramatic matter of the image in a measure that exceeds his past. The different modes of touch that Titian uses in the two contemporary works should indicate how much his liberties of hand were purposeful; and there is a still further stage of freedom that he

could exercise at will. Several paintings, only loosely datable within Titian's last decade, are conceived with minimal concern for plastic forms or contours: instead, their surfaces are half-dissolved into soft-textured light, to which a running, broken brush stroke gives churning brilliance. The *Tarquin* theme, for example, was also treated on a smaller and informal scale in this mode (Vienna, Akademie); the different handling exactly means to elicit from the subject a differently private and more lyric pathos. A picture in large scale, the *Flaying of Marsyas* in the Archiepiscopal Palace at Kroměříz (Kremsier) of *c.* 1570 or later [228],[8] is painted in a compromise between this mode and that of the Munich *Crowning*. The result is a yet more extraordinary, emotion-generating vibrance. In

227. Titian: Crowning with Thorns, *c.* 1570-1.
Munich, Pinakothek

the *Marsyas* the surfaces of bodies make a silvered incandescence and the atmosphere, almost unbreathably dense, is like dulled fire. The image seems both palpable and limitless, depicting existences in landscape space but denoting that what we see here is a fraction of the cosmos. In this intensely present yet im-measurable world the enactment and the actors seem to make time as well as space coalesce, and it is uncertain whether they are beings conjured into now from mythical antiquity or persons from the present, almost caricatures, in antiquarian disguise. There is a wry comedy within the cruelty, ugliness and strangeness

228. Titian: Flaying of Marsyas, *c.* 1570 or later. *Kroměříž (Kremsier), Archiepiscopal Palace*

within the magisterial beauty, and terror accompanies the sense of the sublime. The daemon who inhabits Titian, making union between him and the cosmos, is old Pan.

The *Marsyas* seems Titian's most technically radical late work, and the most complex in its inhabiting idea. There are two other paintings of the last half-decade that are on the same transcendent level: the *Nymph and Shepherd* (Vienna, Kunsthistorisches Museum) and the *Pietà* (Venice, Accademia) [229], the latter finished posthumously, but not in any essentials, by Palma Giovane. In the pastoral the landscape catches fire from the last rays of a

229. Titian: Pietà, unfinished in 1576.
Venice, Accademia

setting sun, while light on the rough-hewn figures of the nymph and shepherd is opalescent, contrasting the descending dark. The sense of the picture is again panic, though in a quieter tone than in the *Marsyas*, and it makes a profound affirmation of the magnitude of meaning to Titian of sensuous life. And in the *Pietà*, where its explicitly Christian sense is forceful, serious, and distinct, it is not that content which is primary. The *Pietà* – at first meant by Titian to have gone into his burial chapel in the Frari – is less a painting about Christian death and tragedy than a splendid and impassioned affirmation of both art and life. Its true protagonist is the Magdalene, salient in a radiance of green against a gold-shot background, who walks out of the picture into the real world, shouting, palpable, magnificent, and one with us in life. She illustrates a cry of grief, but makes the effect of pronouncement of a victory. In the end Titian's destiny was thus opposite to Michelangelo's. Titian never abandoned the values that the classical ethos had inspired in him in his youth. In age, he only made them grander, and perfected the cohabitation that is in the essence of the classical style between nature and idea.[9]

Tintoretto

The style of the later Titian is at the same time adventurous and conservative. This is not a paradox; the matter he chose to treat with such coercive and exalting effect still belongs, as we observed, within the domain of a classical conception of artistic style. Counter to the old Titian, in these years it was Tintoretto who represented modernity in Venice and was the agent who converted much of Venetian painting to an aesthetic consonant with that of Mannerism. Born in Venice in 1518, and recorded as an independent painter by 1539, the education Tintoretto received in the years between is still not known. Bonifazio, and sometimes Paris Bordone, have been proposed as likely masters, and old tradition maintains he was for a brief while in Titian's shop. However, it may not matter much who taught Tintoretto the rudiments of painting, or even the bases of a style: his energy of invention transcended what any single master in the school of Venice could have taught him. He seems to have been essentially autodidact, possessed by a voracious appetite for anything he could gather that implied novelty or radicalism, which for him included everything accessible of contemporary non-Venetian styles. In the last years of the fourth decade and about 1540 he was a counterpart in Venice of the Florentines who twenty years before had wrought a major change in their city upon the prevalent artistic style.

In Tintoretto's Venetian context the change may perhaps, with more justice than in the case of the Florentines, be described as anti-classical. The naturalism that is so much more apparent a component of Venetian classical style seems more drastically violated by the inspired descriptive licence that Tintoretto takes from the beginning, and the atmosphere of Venetian painting, more often relaxed than dramatic, is counter to his temper of explosive energy. Unlike the Florentines of two decades before, Tintoretto did not invent the graphic vocabulary of his new style but through various agencies took over the vocabulary that they, and their Roman and Emilian Mannerist colleagues, had conceived. In Venice at the time that would have been decisive for the formation of Tintoretto's style, between 1535 and 1540, the aspect of Central Italian or Emilian Mannerism would have been present to him in the work of Pordenone and of Lotto, and possibly – the chronology remains uncertain – of Andrea Schiavone; and the impact of available graphic material, Roman and Parmesan, should not be discounted. These were the chief things with which, within Venice, he could have satisfied his radical's unrest. But beyond these is a

Michelangelism in Tintoretto's early style so strong that it seems unlikely that it could have been inspired by reflections in the work of others. Visual evidence suggests that, however briefly, Tintoretto may have visited Central Italy – Florence, and Rome also – as soon as 1540, and that the early indices of Michelangelism in his style were derived at first hand.[10]

What does not exist in Tintoretto's early art is any visible evidence of contact with what the Florentines who visited Venice – Salviati, his assistant Porta, and Vasari – left there. In this respect, indeed, only Salviati could qualify even on chronological grounds for relevance. It is as early as 1540, in a *Sacra Conversazione* (New York, Wildenstein), signed and dated,[11] that Tintoretto's first explicit demonstration of his novelty of style appears. The demonstration is on a major scale and gives the effect of Jacopo's entire assurance in a new vocabulary formed out of the sources, Michelangelesque and Mannerizing, which have been described above, to which he has given a commanding personal stamp. In this picture anatomies take on a proportion and quality of attitude that suggest Michelangelo in his closest convergence with Maniera, as in the *Victory* or in the Medicean tombs, and the tenor of the figures' action, grandiose and elegant, resembles his. Draperies are rhythmically charged, and weave together with the action of the figures into an elaborately cursive and pervasive pattern. This pattern does not quite override repeated plastic emphases, again Michelangelesque and Romanist, but it dominates them. In all these respects, the *Sacra Conversazione* is interchangeable in principles of style with recent or contemporary Mannerist painting in Central Italy or its offshoot in Emilia. These modern and foreign principles make the novelty of this Venetian work, but though they have displaced the classical component of the native style, they have by no means displaced more essential elements of the Venetian aesthetic. Tintoretto's borrowed Mannerism works in a dialectic with a colorism of which Titian had demonstrated the sense and use: the picture has the diversity of colour and the opulence of surface of its native school, and effects of Mannerist *disegno* are achieved with a free-moving painter's brush. But the colour, like the Mannerizing form, is libertarian, stressing that its prime sense is far more aesthetic and expressive than descriptive. Both the colour and the form are charged with an extraordinary energy that requires to be expressed in movement, expansive and intense, yet conforming to ideas of a Maniera grace.[12]

From this threshold of a new style Tintoretto moved with a rapidity that is a function of the energy the *Sacra Conversazione* so evidently holds, testing the possibilities of a Mannerism. About 1542 or 1543 a *Christ among the Doctors* [230], painted for the cathedral of Milan (Milan, Opera del Duomo), is brilliantly arbitrary in its descriptive mode, choosing to let form take shapes that seem determined by the pressures of propulsive rhythm. The recording of action has become arbitrary, too: the effect of energy that it conveys does not come from the physical process that is illustrated but from the imposition on it of the same impulse of rhythm. The image is a pattern of inspired convolutions, of which the liberty is again matched by Tintoretto's licence in the use of colour. Still more libertarian, the *Conversion of St Paul* (Washington, National Gallery, Kress Collection, *c.* 1544-5) takes a step that, except for Pontormo, Central Italian Mannerists had as yet not risked: that of creating painted forms as radically warped away from the appearances of nature as those in a private drawing study might be, and as swift in the draughtsman's impulse given to the brush. Still more than the figures, landscape is subjectively transformed, worked into an excitant, half-transparent filigree of lines and coloured lights. The colour is in general brilliant, aberrant, and magical, intending poetry achieved

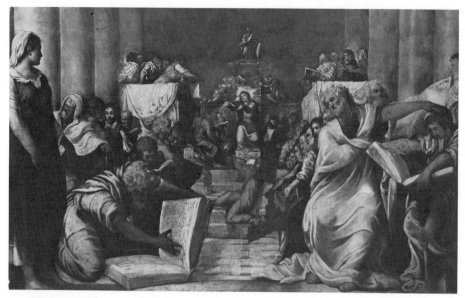

230. Tintoretto: Christ among the Doctors, *c.* 1542/3.
Milan, Opera del Duomo

by optical means, but not optical truth. Both the *Christ among the Doctors* and the *Conversion* are radical and experimental in a way that recalls the early stages, just two decades before, of the first Mannerists, and are equally assertive of their disconnexion from the values of a classical style.[13]

As had been the case in the invention of the style of Mannerism, the most extreme probes that Tintoretto made into the resources of his new style were among the earliest. About 1545 he settled towards a manner that was less radical, accepting some compromise and moderation from the native, Titianesque, classicism. An *Apollo and Marsyas* (Hartford, Atheneum), probably painted for Pietro Aretino in 1545, indicates this more controlled mode. However, the fact that appearances are no longer quite so radically rearranged does not mean that there is a halt in Tintoretto's quest for new effects that are not in the reper-

tory of classicism – effects that exploit more essential means than licence of description. Much of Tintoretto's art, for some years to come, was to be problematic in the sense of a concern in it to invent and develop cerebrally generated aesthetic devices; in this he may exceed the contemporary Florentines and Romans. Some of his problems were occasioned by the requirement, of his own making, that all the resources of Venetian style, not just its colorism, be converted to modern, i.e. Mannerist, uses. Major among these resources was the Venetian interest in setting and effects of space, for the handling of which in Mannerist terms the contemporary art of Central Italy provided no good guide, and Michelangelism none at all. Bonifazio de' Pitati and Paris Bordone had tried earlier to give structure, by perspective, to optical Venetian space; in this they may have pointed a direction to Tintoretto. But his use of perspective structuring of space was differ-

ent, intending that space be given impelling and eccentrically exciting life, like that which his mode of drawing and colour gives the figures. A group of paintings of 1546 and 1547 first indicates the means by which he could achieve this end. Such a picture as the *Christ and the Adulteress* (Rome, Galleria Nazionale) makes perspective and its handmaid architecture into strongly active agents, inventing ways by which the movement of orthogonals can be made to generate energy and tension which are transmuted instantly from effects of form into conditions of the picture's content.[14]

The assertion of an active space and the distribution of the figures in the pictorial depth made by perspective creates a further difference with the accustomed aesthetic of Central Italian Mannerism that must be resolved. Again, Bordone definably, Bonifazio less certainly, may have anticipated Tintoretto in the principle of his solution, which appears fully defined in *Christ washing the Apostles' Feet* (Madrid, Prado, 1547). We have seen that the rhythmically continuous patterning of Maniera painting tends to be bound close to the picture plane, and that interruptions in its continuity made by openings in space may be felt disruptively. Tintoretto here looses the Maniera pattern from the surface. He threads its sinuosities through the forms he has disposed in space: as forms recede in depth the shape of each is made to adjoin or even intersect with the preceding one in a continuity of silhouette and rhythmic impulse. The pattern flows without disconnexion into space; and where there may be a hiatus in the line it works with the effect, at once generative and propulsive, of a spark gap. Space does not intrude into the patterning, but as the Maniera line is woven into depth it takes on, as an added value, the energy and tension that Tintoretto has imposed on the perspective scheme. At the end of its course, no matter what its penetration into depth, the patterning line is bound again into

inescapable connexion with a form on the picture surface. In this invention of a mode of vital union between ornament and spatiality colour comes to play a part in respect to both that is also novel. Venetian in its luminosity, but drier than Titianesque colour, the quality of Tintoretto's colour betokens a growing element of intellectuality and abstractness: it is the Venetian optical response itself that reflects a Maniera stylization. Colour patterns are made out of sequences, alternations, and repetitions, plotted as a product of the Florentine *disegno* might be. They make ornamental value, which in episodes can create the purest visual enchantment. But in sum the effect of calculation made in colour is more apparent than its sensuousness, and there is often a dry energy in it which resembles that in the colour of the Florentines, as well as incidents of dissonance.

No single means makes the effect, almost the most pressing one in Tintoretto's style, of energy: the scale and vibrance of the energy his means convey is what distinguishes his art from most contemporary expressions of Maniera. By comparison, the states of mind that Central Italian high Maniera paintings deal in seem constrained, and the energy that is in their forms and feelings appears introvert and precious. Tintoretto's energy expands what it invests, magnifying the effects of form and, in the same process, carrying the expression of his actors and their themes towards resonance of meaning that the contemporary Maniera wills rather to evade. It is by virtue of this energy of feeling in and about the humanity he paints that Tintoretto seems to be in quality and scale of spirit more like the inventors of the Mannerist style, a generation past, than like his Maniera contemporaries. Yet the quality in Tintoretto's style that is explicitly Maniera is no less patent on this account. No matter how strong the emotion that inspires how a figure acts, or how excitant the pattern of his action, it is stylized to an extreme degree, seeking fusion

between power and grace (though often Tintoretto's expansiveness and energy, too urgent, can push grace into a disequilibrated swagger and drama into melodrama). The artifice of attitudes is at least as apparent as the force of emotion they convey, and it is soon clear to the observer that there is a repertory of attitudes which, once set, is almost endlessly re-used. Even as emotion is seen pressingly it is impressed into formal stereotypes: the pictures seem at times to take on a quality that is more of ballet than of styled drama or of rhetoric. This is a resemblance accentuated by the way Tintoretto makes emotional response involve not only his protagonists, or distinguishable secondary individuals, but whole choruses of stereotypes whom he invokes to populate his pictures with what seems at times too much fertility of mind and hand. In any case, the communication of content in his pictures is in great part according to a principle of Maniera: content comes less from the explicit interpretation by the actors of their parts (in the sense that it still does so strongly in the latest Titian) than from conjunction of the themes they obviously illustrate with the affect of the patterns into which they have been – sometimes violently – cast. There is often an ambivalence or a disparity in Tintoretto's paintings between his obvious authenticity of dramatic meaning and his insistence on manipulation of his actors in Maniera patternings. Of course, this insistence is no less authentically motivated. And no matter how powerful their vibrance or how grand their scale, the emotions Tintoretto communicates – like the forms that may not always consonantly express them – can take on, in repetition, the effect of stereotypes. Even his unavoidable and undeniable greatness of spirit at times can seem, in the pejorative sense, a greatness *di maniera*.

For Tintoretto the stereotypes of form or of expression seem to have been a kind of shorthand for notation of ideas (as his swift, summary handling is a shorthand for description and for his way of indicating optical effects). His vast facility depended in part on stereotypes, and it may even be that, like prefabricated elements of architecture, their use promoted Tintoretto's capacity to invent new ways of manipulating basic factors of design. At the same time that his repetitiveness in some respects may be obvious, his inventiveness is still more so. Yet his constant and evidently self-conscious effort to make novelty of effect is in itself – not altogether paradoxically – a kind of stereotype, even specifically of the Maniera mentality. However, even stereotypes in Tintoretto's art are vehicles of an extraordinary energy that has no contemporary equal, and of a velocity of statement and of impact in it that even Michelangelo did not possess. It is again, finally, a function of his energy that his production attains such abundance as no painter, Venetian or other, had attained before.

By the later forties, after less than a decade's experiment that we can trace, Tintoretto had forged the essentials of his novel style. Then the effect of mastery over new device displaces the sense, always apparent earlier, of straining search: this is a maturing of his style. By early 1548 Tintoretto had exhibited a picture, on a large scale, that signalled this point, the *Miracle of St Mark* ('*Miracle of the Slave*', Venice, Accademia) [231]. There is a commanding fluency in the picture's whole expression of which the most apparent symptom is its composition, a swift convolution that simultaneously carries the narration and the design. Fluency – more exactly, controlled energy moving at high speed – acts to fuse the diverse components that make up the picture's style: its Romanist plasticities and ostentation of foreshortenings with its Venetian shuttling of lights and colours, almost kaleidoscopic; the colour itself, intense and metallic, is in turn a fusion between Venetian resonance and Maniera brass. An impelled

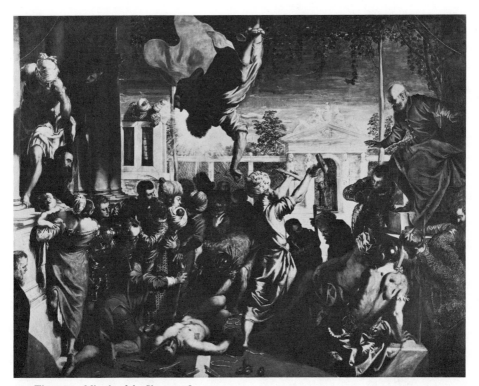

231. Tintoretto: Miracle of the Slave, 1548.
Venice, Accademia

and empowered grace exalts the drama of the scene, but lends it artificiality as well. It may have been the pace at which Tintoretto has made his image work, more than the apparent brio of its execution, that prompted the criticism of Aretino towards it, advising Tintoretto to convert 'la prestezza del fatto in la patientia de fare'.[15]

The *Miracle* established Tintoretto's stature in Venice. His place and reputation grew rapidly in the fifties, but what is more notable is his internal growth. A work of that decade on a major scale such as the *Presentation of the Virgin* (Venice, S. Maria dell'Orto, 1552–6; designed as organ shutters) is evidence of it.[16] Design in the *Presentation* makes a new meas-

ure of dramatic force, not only in the narrative but in terms of sheer visual effect. Illusionist foreshortenings, of great plastic power, engage the spectator with a steep perspective ascent of which the climax is a poignant contrasting of scales and silhouettes. In this demonstrative public picture Tintoretto aggrandizes his effects and forces them. But there is a measure of this same forcing spirit – it is partly willed, but also partly the effect of an almost ungovernable inventive energy – even in the smaller and private paintings of this time. In them it tends to seek a different end, conjoining eccentric brilliances with subtleties of form and feeling; the result is as poignant and refined in tenor and in the calculation with which it is achieved

as anything in Mannerism, but it is not, as in Maniera, precious. The *Susanna and the Elders* (Vienna, Kunsthistorisches Museum, 1555-6) [232] may stand for the height of what this state of mind attains, or almost as well the Old Testament illustrations of about contemporary

it is an opalescence that approximates the pattern of a female form.

In the early sixties, on a commission given him in 1562 by Tommaso Rangone, Tintoretto supplied two paintings, a *Finding of the Body of St Mark* (Milan, Brera) [233] and an *Abduction*

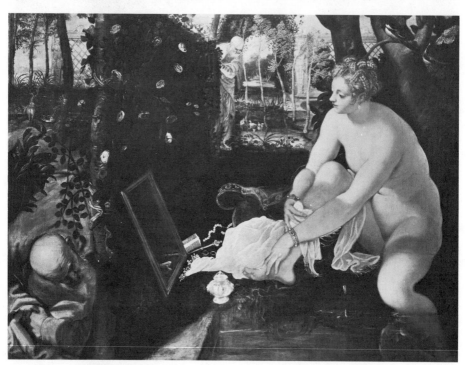

232. Tintoretto: Susanna and the Elders, 1555-6.
Vienna, Kunsthistorisches Museum

date, in frieze form, in the Prado. In works of the fifties such as these a quality that has grown to a new dimension is an ability to paint light with a brilliance that had not been seen in Venice since the early Titian; but as this optical effect in Tintoretto's style increases, so does his Maniera power to make light not a fact of record but a factor of abstraction. In the Vienna *Susanna* the painting of her flesh does not describe the experience of an objective eye;

of the Body of St Mark (Venice, Accademia),[17] to accompany his earlier *Miracle of the Slave*. They indicate how little, in the interval since 1548, Tintoretto had followed Aretino's public advice to him to change 'prestezza' into 'patientia', and to what great advantage: not just the virtuoso breadth of handling but the energy of the whole pictorial structure has increased, and now power of form is less compromised with a Maniera grace. Unlike the

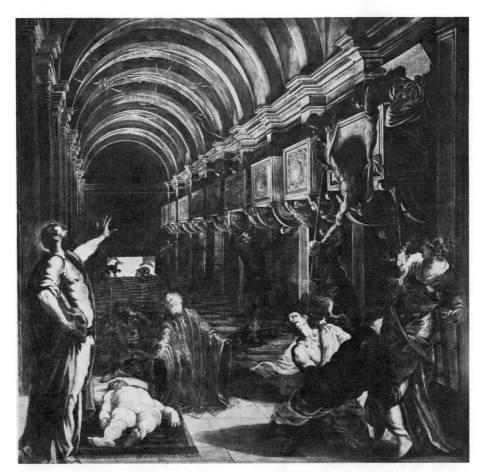

233. Tintoretto: Finding of the Body of St Mark, commissioned 1562. *Milan, Brera*

Miracle, which carries an effect of Romanizing declamation, these pictures work their drama with ideas – of action, attitude, and setting – that seem invented utterly *ad hoc*, and by an imagination that responds almost violently to the themes. In both pictures setting takes on a role of new urgency in the expression of the whole: deep space, in an aberrant charged perspective, is lit by an eccentric chiaroscuro for which each theme gives a pretext. More than it describes an environment for the drama, the space participates in it, reciprocally exchanging energies of shape and lighting with the figures. These, by a principle long since standard in Tintoretto's style, are set out in the deepened space, but on their one connecting taut and convoluted linear thread. Among the magnified powers of light, space, and line, colour seems much less than before to have a separately asserted value. It is as if the colour

should have been in part blotted up by other, more powerful elements of Tintoretto's repertory. But also it has become more identifiably a dependent function of the light, which in the extremes of chiaroscuro Tintoretto makes for it in works like these blanches colour or absorbs it. In the torch-lit setting of the *Finding of the Body* the colour is no more than a patterning of muted radiances.

In 1565 Tintoretto undertook what was to be a major and recurrent concern until almost the end of his career, the decoration of the Scuola of the Confraternity of St Roch.[18] When, more than twenty years later, the decoration was in effect complete it constituted the most extensive concentration in Venice of the efforts of a single painter, and it is the most abundant affirmation we possess of a Venetian artist's personality. The first large piece to be executed in the long series, the great *Crucifixion* (about 40 feet (12 m.) long; dated 1565) in the Albergo of the Scuola, was the most overwhelming [234]. It confirmed – as its eruptively creative author meant it to – that no artist then in

Venice was his match for technical facility and for variety of *invenzione*; but it also demonstrated how wholly a poetic sense informed these quantitative powers. The vast canvas teems not just with the multitude that Tintoretto has evoked to populate the hill of Golgotha but with the life their actions and appearances convey. Linear energies uncoil from one form into another, making tight arabesques across the whole extent of the canvas, and this effect is fused with the most complex possible activity of light, a subtle pyrotechnic. This whole pictorial vibration, so powerfully charged, is controlled by a simple scaffold of design, based on intersections of diagonal and triangular motifs; but even these simplified directions are laid out so as to generate an extreme energy. Normal perspective direction is inverted on the hill: lines that are the opposite of orthogonals converge forward from it, like a plough, towards the mourning group beneath Christ's cross and towards the spectator. Tintoretto commands the whole repertory of physical illusion in this painting

234. Tintoretto: Crucifixion, 1565.
Venice, Scuola di S. Rocco

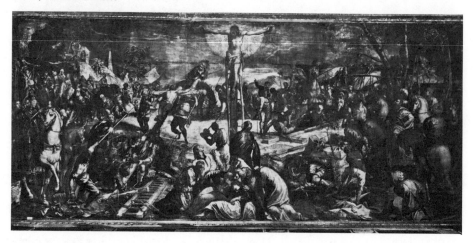

and employs it liberally, but to bring the spectator into a world he has poetically transformed.

The decoration of the Albergo, the smallest of the three rooms in the Scuola that Tintoretto was to paint, was completed in 1566-7 with three scenes from the Passion, *Christ before Pilate*, *The Way to Calvary*, and the *Pietà*, and with secondary paintings for the ceiling (complementing the competition piece Tintoretto had supplied earlier, in 1565). It was not until eight years later that Tintoretto returned to paint in the Scuola, but in the interval his more important commissions included paintings for the choir of the church of S. Rocco with histories of the Saint's life (1567),[19] and probably in 1568 the *Crucifixion* and *Christ in Limbo* of the sacristy of S. Cassiano. At S. Cassiano Tintoretto invents perspective situations that give the subjects an exceptional effect of novelty. The *Crucifixion* is seen as if from a level lower than the hill and from the side, where accident might place us as spectators (opposite us, we see the heads only of the painted spectators on the other side, at the same level Tintoretto has assigned to us). Very differently, Tintoretto describes the *Limbo* as a perspectiveless nowhere in which figures move as if there were no reference in their haunted space to gravity.

In 1575 Tintoretto began the painting of the main room on the upper storey of the Scuola di S. Rocco, where he worked until 1581. On the ceiling, in the opulently framed compartments customary in the Venetian decorative mode, thirteen Old Testament scenes are grouped so as to illustrate the charitable functions of the Confraternity, and at the same time to make concordance with events in Christ's history painted on the walls. The wall paintings carry the history up to the tragic episodes just before the *Crucifixion* in the adjoining room, the Albergo, and then illustrate the *Resurrection* and *Ascension*.[20] According to by now established Venetian habit, the ceiling paintings are projected in foreshortening of about forty-five degrees, which makes a working compromise between the requirements of illusion and of legibility; it also permits a preference (which, as Tintoretto exercises it, is both painterly and Mannerist) for strong definition of the picture surface. The central painting on the ceiling, a large *Brazen Serpent* (1576), echoes the Michelangelisms of Tintoretto's own *Last Judgement* for S. Maria dell'Orto of some fifteen years before, but it has a more decisive clarity and a more forcefully unifying structure and expression of dramatic content. Beside it, a smaller *Moses striking Water from the Rock* (1577) makes still more concentrated unity between form and meaning: the arching jet of water shapes the whole picture form, and the figures turn in it in a shadowed, sparkling flow. On the walls, the paintings are at a level like that of a high stage, and their situation does not objectively require perspective manipulations like those on the ceiling; but they are manipulated none the less. Landscapes pile up; architectural settings drastically recede; some structures that are compoundings of the two (the stable of the *Nativity* and the shelter of the *Christ tempted in the Wilderness*) rise obliquely over us, as if the onlookers were inside their perspective scheme. In all these restless spaces the figures move as if the law of gravity were not quite operative: they lean and thrust, in postures that are less determined by the action that they are supposed to represent than by a power the artist has imposed, gathering and impelling them. Forms are caught up in this force, which makes them bend in long, low, arching lines and link in curving patterns, eccentrically live and swift, which sweep the canvas on a simple armature. It is as if an electricity should have been put into the pictured world, charging it and realigning its forms. The analogy is heightened by the behaviour Tintoretto has assigned to light,

more than before a powerfully contrasting and complex chiaroscuro, in which the lights reverberate and silhouettes assume extreme dramatic force. As the chiaroscuro is intensified the darks absorb colour, making it a sombre, vibrant glow, and the lights transform it into bleached radiance. The chiaroscuro may lend forms an extraordinary plastic strength, but more often it dissolves substance, turning it into a half-transparent rhythmic tracery.

The world that Tintoretto projects in this room is alive to an extent and to a degree of intensity that exceeds anything in Cinquecento painting save only for the Sistine Chapel. This aliveness serves a different – a Mannerist – power of transforming fantasy, freer to reshape experience, freer to make emotion private and extreme, and freer in its range and novelty of artistic means. A private vision has been projected at the spectator with the urgency and the drastic affirmation of a grand public statement. It is as if Tintoretto had conceived a rhetoric in which to make confession. There is no way to assess the authenticity of belief that went into the expression of these visions; such biographical data as we possess indicate that Tintoretto was a thoroughly believing Catholic, who by this time may well have been touched by the mounting piety of the Counter-Reformation.[21] His paintings in the upper room of the Scuola convey, sometimes tenderly, sometimes with stunning force, the human and dramatic values of their themes and, often, an inspired conviction in the enactment of a supernatural event. The paintings are pregnant vehicles of religious experience, not just from their quality as illustration but from the presence in them of a power that infuses what is illustrated with spirituality. This religiosity may have to do with the currents of the Counter-Reformation; yet it is notable that intensified religious expression in Tintoretto's art assumes a form quite opposite to that which

Counter-Reformation style in painting takes in Rome. This is as demonstrative as the Roman style is restrictive, and individualistic where the Roman style tends towards anonymity and *ennui*. The extreme, demonstrative sense of self that Tintoretto must assert, and the awareness this creative self imposes on us of the effects of art may not be in conflict with authenticity of religious feeling, but they may compromise it.

In his mature paintings of antique themes – relatively infrequent – the effects of art become explicit effects of Maniera artifice. In his best-known mythologies, four canvases now in the Anticollegio of the Palazzo Ducale (from the Sala dell'Antipregadi, finished in 1578), Tintoretto sees the antique themes with a coolness that contrasts with the intensity of his religious art. His temper of response seems classicistic, seeking purities of feeling and forms and incorporating the sense of the subject as much as he can into ornament. The *Bacchus and Ariadne* makes the most elegantly arbitrary design in this set: three chaste neo-classic figures are manipulated so that they form a helix. Another mythology of the seventies, *The Origin of the Milky Way* (London, National Gallery), treats its subject matter as if not only ornament but heraldry could be made of it; yet at the same time Tintoretto reacts to the humour and the sensuality this theme contains. He is not unsympathetic to the antique inheritance, but it summons a different mode from him and involves him less.

In 1583 Tintoretto took up the decoration of S. Rocco once again, this time of the remaining large room on the ground storey, devoted to the history of the Virgin. He completed this room, with some help, in 1587, and a *Visitation* on the stairs between the two floors, perhaps slightly later, marked the end of the entire scheme. Where assistants intervened largely the results of this campaign are weak, but

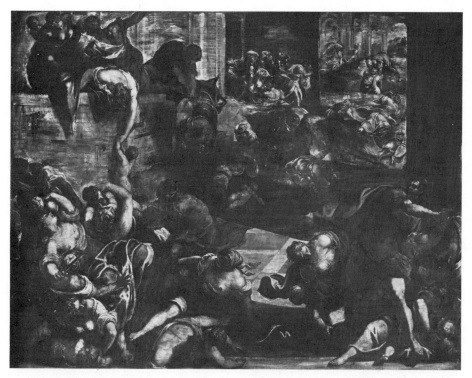

235. Tintoretto: Massacre of the Innocents, 1583/7.
Venice, Scuola di S. Rocco

where Tintoretto's own hand as well as inventive mind have worked, they are in a still more extraordinary reach of expression than before. The *Annunciation* of the lower room takes place in a near-genre setting, as if to insist that the depicted miracle was truth: both terms are heightened in effect by their conjunction, and the drama takes on an intense force. In the scene of the *Massacre of the Innocents* [235] emotion and form, indissoluble from one another, churn up a turbulence revealed to us by lightnings. But it must be remembered that while emotion and form are indissoluble, emotion in Tintoretto – even of this violence and power – is also indissoluble from art: feeling

in him, even at this level, itself partakes of the quality of an artistically invented thing.

Three scenes which, exceptionally for Tintoretto, are dominated by their landscape settings are the latest and most innovative paintings made by Tintoretto for this room: a *Flight into Egypt*, and two narrow pendant vertical panels with a *Magdalene* and a *Mary of Egypt in the Wilderness* [236]. In the *Flight*, energies of light and line interweave in a skein in which the landscape forms are made to live no less than the figures. In the pendant panels the single figures of the saints are almost *staffage*, but even then the landscape is not really the protagonist. That is the light: a moonlight,

236. Tintoretto: Mary of Egypt in the Wilderness,
1583/7. *Venice, Scuola di S. Rocco*

veiling more than it reveals, which Tintoretto
threads upon a pointed brush to pick out with
silver the shimmering edges of things seen; the
world he describes in this way seems private
and unmaterial.

Other commissions of importance coincided
in time with the last campaign of painting at
S. Rocco or shortly followed it: a gigantic
battle painting of the *Siege of Zara* (1584-7)
for the Sala dello Scrutinio in the Palazzo

Ducale, in which Tintoretto demonstrated, to
a degree no contemporary could match, his
power to invent and manipulate complex forms;
a *Paradise* (1588), no less vast, for the Sala del
Gran Consiglio in the palace; a set of canvases
of the history of St Catherine (Venice, Ac-
cademia, after 1584; from the church of S.
Caterina); and paintings for the altars and the
choir of Palladio's S. Giorgio Maggiore
(1592-4). Much help was enlisted for the exe-
cution of these large late works; nevertheless
some among them are based on ideas so highly
eloquent that the presence of assisting hands
cannot diminish them by much: this is the case
in the *Gathering of Manna* and the so-called
Last Supper in S. Giorgio. The latter [237] is
conceived in the same strain of magically
transforming night light as the recent land-
scapes of S. Rocco, and here, too, in the context
of a drama that is reserved in its action, the light
becomes the prime interpreter of meaning. It
causes us to see, beyond the institution of the
Eucharist which the scene overtly illustrates,
an apposite transubstantiation, by which light
turns substance and appearance into spirit. The
Pietà for S. Giorgio, painted in 1594, the year
Tintoretto died, is as exalted. The devices with
which Tintoretto had made artifice as strong as
emotion are still here, but used almost bluntly.
Finally, he has divested the Maniera formulae
of their interest as art, consuming the effects of
art not only in the intensity but in the purity of
his spiritual idea.

Christian subject matter, with its require-
ment for compassion, had always been the stuff
that most exercised Tintoretto's feeling and
imagination and summoned his exceptional
creativity. His bent for human sympathy
worked less often with comparable creative
results when he confronted real people, in his
role as a painter of portraits. For Tintoretto, so
restlessly energetic, emotion seems to have
been best generated out of a dramatic situation,
which the conventions of a portrait style do not

permit. He was rarely an inventive portraitist: Titian had anticipated too many of the possibilities in the genre, and for the most part Tintoretto was content to work with the devices Titian had created for Venetian portrait style. Especially in his earlier career, Tintoretto's practice as a portraitist was large, but his results not often memorable except in their technique, more dashing than the contemporary Titian's.

(Florence, Pitti, *c*. 1560), the sculptor-architect Sansovino (Florence, Uffizi, *c*. 1565), Vincenzo Morosini (London, National Gallery, *c*. 1580), or himself in great age (Paris, Louvre, *c*. 1587-8) there are a subtle strength and sympathy that makes us feel a likeness between Tintoretto's quality of humanity and Rembrandt's: less ideally grand than Titian's but more intimate and gentle.

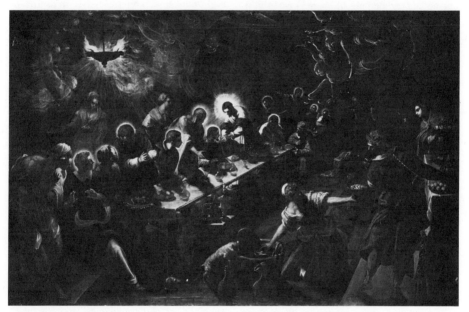

237. Tintoretto: Last Supper, 1592-4.
Venice, S. Giorgio Maggiore

In his mature years there are examples of high merit, almost challenging Titian's dignity and elegance (e.g. the *Young Man* dated 1553, Vienna, Kunsthistorisches Museum). But it is a special aspect of the portrait genre that best suits Tintoretto's sensibility: the portraiture of old or ageing men, whose faces wear the imprint of their humanity more deeply. In portraits like those of Jacopo Soranzo (Milan, Castello Sforzesco, *c*. 1550), Alvise Cornaro

Tintoretto's style became the dominant model of the Venetian school in the later sixteenth century. More than that of any other single painter his vocabulary infiltrated that of other artists, gradually displacing even the authority of Titian. The impress Tintoretto made in Venice was not in consequence of the quality of his art alone but of its quantity as well. Fertile as his creativity was, and almost miraculous as his efficiency of hand seems to

have been, he used assistants, in his later years especially, on a considerable scale. His active shop came to depend much (as frequently in Venice) on his family: his son Domenico (*c.* 1560–1635) in particular, by far the most gifted; Marco (d. 1637), Domenico's junior; and a daughter, Marietta (*c.* 1556?–90?). Domenico achieved a reasonable approximation of his father's later style and could execute Jacopo's designs without gross disfigurement, but he lacked not only his father's sensibility but his energy, and the forms he inherited from Jacopo tend to congeal within their attitudes of motion or become entirely inert. As his career progressed into the seventeenth century it was convenient to the general tendency of the time, as well as to his own temperament, to adapt the characteristic elements of his father's repertory to the uses of Seicento naturalism, though this contravened the essence of his father's style. Marco's role as an executant for his father, and after his father's death for Domenico, is less clear, and his independent work is only tentatively identifiable. What we assume is his seems to be of minor merit. And despite attributions that not infrequently appear, Marietta's style cannot be defined with any certainty.

Beyond the family, Jacopo's older assistants included Andrea Vicentino (Michieli; *c.* 1540–*c.* 1617), who worked with him on the acreage of battle paintings in the Palazzo Ducale in the 1580s, but in a style that tended to be more heavy-handed and Romanist than Tintoretto's own. Another helper, the Greek-born Antonio Vasilacchi, called L'Aliense (1556–1629), also worked in the Palazzo Ducale in the eighties, but had a more interesting prior and subsequent career. Before he came to Tintoretto, L'Aliense had been an assistant of Veronese; then, converted to a Tintorettesque style resembling Domenico Robusti's, he practised it with moderate fidelity and for almost as long into the seventeenth century.

Mannerizing Modes in Venice

Tintoretto's art is the most significant result of the intersection between Venetian style and Mannerism, but it is part of a more general phenomenon which, from about 1540 onward, looms large in our perspective of the Venetian scene. More painting done in Venice in the rough span of the mid-century years reflects the vocabulary of Mannerism than not. However, outside Tintoretto's style and that of painters who openly derived from him, there does not seem to be enough consistency among the others who were disposed towards ideas of Maniera to require that they be constrained into a category of Venetian Mannerism. Not only are their Mannerizing tendencies diverse, but even when they are quite evident they may not seem the most important in a painter's style. It is not only that the nature of Maniera changes in the process of accommodation with Venetian style but that it becomes diffuse and imprecise, as if by the actual action of Venetian modes of vision and techniques upon it.

If, however, there were a paradigm of what Maniera should look like in Venetian guise it would be in the work of Andrea Meldolla, called Schiavone [238].[22] More quickly than any other painter of the Venetian school, and more wholly, he absorbed a Maniera vocabulary – the Maniera vocabulary *par excellence* – from the art of Parmigianino, and with such fidelity that the assertion would be made (by Lomazzo) that he had been Francesco's pupil. Schiavone copied and paraphrased Francesco's prints, but knew more of his production than his graphic art: undoubtedly the paintings in Bologna, and possibly but less certainly those in Parma. At a time we have no evidence to specify but which seems to have been in the few years shortly after 1540 Schiavone acquired from Francesco's model the essentials of a Maniera aesthetic in its most assertive form.

238. Andrea Meldolla Schiavone:
Adoration of the Kings, *c*. 1550.
Milan, Ambrosiana

We do not know upon what prior Venetian basis this learned mode was imposed. The assertion (made often in the modern literature) that Schiavone's first Venetian training was with Bonifazio de' Pitati is unprovable, though it is surely Bonifazio's style that, in the course of the middle 1540s, Schiavone's came most nearly to resemble, partly through the presence in Bonifazio also of elements of Maniera form. Like Bonifazio's, one of Schiavone's special genres was the painting of furniture panels, and in the loose, cursive style that genre encourages the effect of a resemblance is increased. It is understandable that Schiavone's inclination should have taken him beyond Bonifazio towards the more Mannerist example of Tintoretto, as that emerged so strongly in the later forties. However, by this time Schiavone had no need to depend on others for models of form or of painterly technique; both were quite developed in him and, in the conjunction he had made of them, were of a notable individuality in Venice. He had translated the Parmigianinesque Maniera – essentially based on graphical manipulations of form – into the language of Venetian colorism, not only by sub-

stituting a painterly for a delineating brush, or by filling Maniera shapes with luxuries of colour, but by treating colour as if its first significance was that of ornament. Schiavone's handling of colour is still more arbitrary than that of the graphically fluent form with which it has been fused: the colour is a transformation of the classical Venetian model, departing from the Titianesque palette and exaggerating on it. In the special dialect of Venice Schiavone's colour is the corollary of his Maniera form. No other Venetian painter had gone so far in this direction by the mid century.

Schiavone was able to invent a Venetian Maniera mode, but he was strangely uncreative in the more ordinary workings of artistic invention. His early efforts had been based on Parmigianino not only in their general style but in specific figure motifs and in compositions; as he matured in Venice, the sources of his borrowings shifted, and they also spread. Models of motif and design from Tintoretto were quickly supplemented by borrowings from the Maniera phase of Jacopo Bassano, and from the middle fifties onward Schiavone relied frequently on Titian's images. Occasionally, the sensibility – too receptive, almost feminine – that inclined Schiavone towards imitation brought him to the verge of echo of the larger personality. Rarely (as in his two surviving tondi in the ceiling of the Library of S. Marco, 1556) he chose to paint in a Romanist, rhetorical mode native neither to his usual sources nor to himself, apparently to meet what he conceived to be the demands of a public style. But most often, no matter what measure of dependence in invention he may show, his work conveys a strikingly recognizable aesthetic personality, identifiable in its peculiar and extreme stylizing of the matter that it treats. Even in Schiavone's later years, when the old Titian's influence lent his paintings greater density of form and gravity of mood, they still spoke a dominantly mannered language. The effects of

artifice, as evident in colour as in form, outweigh all other aspects of his pictures' meaning, and this most of all pertains to the Maniera.

Another exponent in Venice of Maniera, of a kind that conforms still more recognizably than Schiavone's to the norms of the style outside Venice, is even less than he Venetian in origin: this is Lambert Sustris (Alberto de Olanda, c. 1515/20–after 1584), an Amsterdamer who came to Venice probably in the middle forties. We know nothing of his education. According to Ridolfi he was in Titian's atelier and much employed there in the North European speciality of landscape painting. He accompanied Titian on his Augsburg trips of 1548 and 1550-1, and remained briefly after Titian left, executing some portraits (e.g. *Wilhelm IV von Waldburg-Trauchburg*; Augsburg, Gallery) that make a skilful compromise between Titian's Augsburg models and a native North European style. On Sustris's return to Italy he shifted his allegiance, turning towards the Mannerizing current, by then thoroughly matured, that Tintoretto and Schiavone represented. Sustris was directly influenced by the graphic art of Parmigianino as well as by Schiavone's paraphrases of it, and revised his style to attain a comparable attenuated elegance (e.g. *Venus, Cupid and Mars*, Paris, Louvre, towards 1560). His Titianesque technique was also then revised, made less sensuous, achieving an effect peculiar to Sustris of dry, luminous transparency. Even in this wholly Italianized guise Sustris retained certain Netherlandish predilections (which he expressed with great skill in his acquired Venetian Maniera vocabulary), especially for small-figured narratives in extensive landscapes (e.g. *Baptism of Christ*, Caen, Museum, c. 1555; *Diana and Actaeon*, Oxford, Christ Church, c. 1560-70). The paintings of his later years are often sparkling and free in execution, and of a delicacy more precise than Schiavone's; they are more often than Schiavone's responsive to the meanings of their subject matter. For an

uncertain time in the sixth and early seventh decades Sustris worked in Padua rather than in Venice proper. From the late sixties at least into the middle eighties he was again in Venice, where the commissions he was called to carry out included his acting in the place of Tintoretto for official portraiture; the latest known of these portraits, which is also the last work we know by Sustris, is dated 1584.[23]

If Bonifazio de' Pitati was a factor in the early phase of the accommodation in Schiavone between Maniera and Venetian style, it was because his own art had been engaged still earlier with an at least related problem. We have seen how, in the thirties, Bonifazio had been one of the painters most responsive to the influence of Central Italian style, and seemed even to show some ideas of appearance and behaviour that suggested the Maniera. More important than his action upon Schiavone, it is likely that Bonifazio's more advanced notions may have been germinative for the youthful Tintoretto, but only at a very early stage. What had seemed inventive or suggestive of an imminence of Mannerism in the art of Bonifazio in the fourth decade was so swiftly overtaken after 1540 by the young Tintoretto that the novelties that we identified in Bonifazio lose much of their significance. In the fifth decade Bonifazio absorbed back-influence from Tintoretto, which increased the effect of kinship between Bonifazio's painting and Maniera. But in a context measured by the style of Tintoretto it is clear that Bonifazio's relationship to Mannerism is not close or profound. Considering his generation (he was Titian's contemporary), it is remarkable that he was as flexible as this. His major formal paintings of the mid forties are often explicitly more Romanist than those of the previous decade, but they are not much more strongly mannered. The *Massacre of the Innocents* (Venice, Accademia, 1545?; from the Palazzo Camerlenghi) is largely based on Raphaelesque prints and also on Titian's *Peter*

Martyr, itself an earlier incident of Romanism. A *Conversion of St Paul* (Florence, Uffizi, 1545–50) is so athletic and theatrical that it was once attributed to Pordenone. It was generated by Bonifazio from the Raphael Tapestry Cartoon then in the Grimani Collection in Venice, and from Francesco Salviati's painting of the theme (Rome, Galleria Doria), engraved in 1545. A companion painting in the Palazzo Camerlenghi to the *Massacre of the Innocents*, and close in date to it, *Christ among the Doctors* (Florence, Pitti, 1545–6), has a more native accent. In it a device of design, a funnelling diagonal perspective of interior space, which Bonifazio may once have made interesting to the young Tintoretto, is returned from him with rich interest.

It is also Tintoretto's ideas of design that inform *Lazarus and the Rich Man* (Venice, Accademia, after 1545),[24] not only in Bonifazio's exploitation of a deep colonnaded space but in the woven continuity of figure composition through it. This painting is as close as Bonifazio came not only to the style of Tintoretto but to Maniera. His translation of the Bible theme into domestic genre is accomplished with a refinement that suggests the tenor of Maniera, but the idea of assimilating Bible text and modern aristocratic reality was not new in Venice: we have seen that Bonifazio had earlier at times referred backward to Carpaccio's art. The same mentality is in a large *Finding of Moses* (Milan, Brera) [239], also of the middle forties, more conventional than the *Lazarus* in design, but more mannered-seeming in the fineness with which details are ordered and described. The painter ornaments the theme he treats as well as the persons and their settings, but he takes no liberties remotely comparable to those of the Maniera. His result is an elegant equivocation between conservatism and modernity, Palmesque tradition and Tintoretto's world, and it is a foretaste of the imminent Veronese. But, as

earlier in Bonifazio's career, there was not necessarily any consistency in this decade in his attitude towards style, or even any consistency in such a compromise as the *Finding of Moses* represents. He could design and paint in a simplistic and conservative mode, in which

seen that he was, probably in 1538, at Fontainebleau; he was in Augsburg close before or afterwards; and after his return from his transalpine trip he worked, probably from 1540 to 1543, in Milan. The foreign stimuli that were instigating change in Venice were experienced

239. Bonifazio de' Pitati: Finding of Moses.
Milan, Brera

assistance from his shop, often extensive, could accentuate the banality and dullness. A case in point, contemporary with the best of the Romanizing works we have mentioned, is an *Adoration of the Kings* (Venice, Accademia, from the Palazzo Camerlenghi, 1544?). It is this tendency, rather than Bonifazio's more progressive one, that increased till it came to dominate his latest works.

Paris Bordone's role in the school of Venice towards the middle of the century and later was differently assertive. In the crucial time about 1540 when the major change in the complexion of the Venetian style began, Paris was not resident in Venice, but was in the most mobile phase of his restless career. We have

by Paris elsewhere, in particular in the colony of expatriate Italians whom he found in France. The change this contact wrought upon his own style was decisive. Before, Paris had only sporadically used elements of a Romanist vocabulary (taken not from Central Italian sources but indirectly, mostly from the art of Pordenone); now Romanisms pervade his painting, and in whole thematic areas of his production dominate it. A *Mars, Venus, and Vulcan* (Munich, Trusteeship) and a *Bathsheba* (Cologne, Wallraf-Richartz Museum) [240], both apparently painted in Milan before 1543, are treated as classicistic illustrations of erotica, with plastically insistent nude anatomies, complex attitudes, and rhetorical expression; in the

Bathsheba a setting of elaborately pseudo-antique architecture is appropriated from the recent book of Serlio. The equivocation which Paris had displayed before between Venetian opticality and Lombard literalism is resolved within a classicistic guise, in a mode that smoothes the tactile surfaces and stresses their details. Tonality is blond and colour is high-keyed, sharp in places to the point of stridency. Optical effects are not discounted, but they compromise with the stress of plastic ones, and are chilled in the bleaching light. Light and

240. Paris Bordone: Bathsheba, before 1543(?).
Cologne, Wallraf-Richartz Museum

colour do not work in a continuum but instead make fragments of the visual experience: where light searches to describe in sharp detail, illusionistically, it dislocates a form, of anatomy or drapery, out of its context.

Precipitated by experience of a Maniera, this response of Paris's, classicistic as it may be, is not itself effectively Maniera. The conflicts between his past education and the modern ideas he has not quite absorbed are too many, and they obstruct the fluency that Maniera grace requires. There is more will to realism than to stylization, and each works against the other. When he returned to Venice, where he saw the novelty of the style in process of formation by the young Tintoretto, Paris made a more effective and convinced approximation to Maniera, with forms resembling Tintoretto's and adapted mainly from him (and perhaps in part on this account resembling the contemporary Bonifazio also). Paris's best instances of this mode are the earliest, from the half-decade 1545–50, e.g. his *Christ among the Doctors* (Boston, Gardner Museum) and, rather later, an *Annunciation* (Siena, Pinacoteca); he was rarely to attain a comparable fluency again. Working at the same time on themes that encouraged his Romanist labourings of anatomy, he accentuated the elements within his style that conflicted with the qualities of Maniera, as in the *Baptism of Christ* (Milan, Brera). But the very working of cross-purposes upon each other may generate strong effects, visually quite interesting, of silhouette, line, and, particularly, colour. The sense the pictures hold is mostly in these effects: the meaning that derives from consideration of the subject matter is rarely more than illustrational. It seems not to be deeply meditated purpose but a posture of suspense between tradition and modernity and, as well, some defect of intelligence that determined this phase of Bordone's style.

Paris became a kind of specialist in the painting of pictures in which his classicistic anatomical style had some appropriateness. Throughout the fifties and sixties he seems to have been the principal purveyor in Venice of figure groups which, in the guise of mythological subject matter or of allegory, or allegory and portraiture conjoined (e.g. *Two Lovers as Mars and Venus crowned by Victory*, Vienna, Kunsthistorisches Museum, *c.* 1560), satisfied a taste for literate and mildly prurient themes – not unlike Mannerist erotica in a temper that combines an arid brilliance, prurience, and chill. This genre intersected in Paris with another speciality, the portraiture of Venetian courtesans, usually in some unassertive allegorical disguise. This was the culmination (in the quantitative sense at least) of the peculiarly Venetian tradition that Titian had founded and Palma Vecchio conspicuously explored; and there is a strong element of likeness between the *glacé* – in a sense proto-Maniera – *belle* of the late Palma and the near-Maniera *belle* whom Paris paints. Lustre and rigidity, and an only occasional response to the individuality he is asked to paint, characterize almost all of Paris's portraits, of men as well as women; but the women give the greater impression that Paris paints them as if he saw them as still life.

As Paris aged, his style hardened, but it was not until his latest years that it lost its difficult, sharp brilliance. His late commissions on a large scale – for example the *Paradise* (Treviso, Museo Civico, *c.* 1560) and the *Nativity* (Treviso Cathedral, *c.* 1560–5) – attest the limits of Bordone's power to control extensive forms, and the *Last Supper* in S. Giovanni in Bragora, Venice (after 1566), has the polished vacancy of the most conventionally classicistic style, more Lombard than Venetian, of its time. Bordone died at the beginning of 1571.[25] Even at the end, he possessed a form of virtuosity, an exasperation of mechanical powers of the eye and hand; but when the mind did not guide it quite enough this virtuosity could turn into a brainless labouring, and too often did.

There were painters working in Venice at the mid century and later who were Romanist for the best of reasons, viz. that they were of Central Italian origin or had worked there at length. The latter fits the case of Battista Franco Veneziano (whose career after his return to Venice *c.* 1552 we have referred to earlier);[26] the former that óf Giuseppe Porta (*c.* 1520–1575), called Salviati after the greater Florentine as whose assistant he had come to Venice in 1539. The effect of Venice upon both Franco and Porta was stronger than their action on it – expectable for Franco, but much more pronounced in Porta. When he arrived in Venice Porta had barely acquired the elements of Maniera; he was less a Mannerist than a painter of classicistic disposition – and quite modest talents. But in this Venetian context he counted, as authentically as possible, as a Romanist. An early independent work in Venice, his *Resurrection of Lazarus* (Venice, Cini Foundation, *c.* 1545), is in a post-Raphaelesque style which, in Rome at this date, would seem retarded; and it has already reached a compromise with Venetian effects of handling and landscape setting. Porta's accommodation with Venetian example was quite swift. Ceiling paintings for S. Spirito in Isola (*c.* 1550), following Titian's paintings in the same church (and like them now transferred to the Salute), are influenced, still more than by Titian, by the early Veronese. By 1556, when Porta was assigned three tondi in the decoration of the Library of S. Marco, he had made a passable approximation of Veronese's current style. Later works extend his range of borrowings, increasingly from Tintoretto. In 1565 Porta was temporarily recalled to Rome; his function there was to succeed his old employer, Francesco Salviati (recently deceased), in the painting of a large work for the Sala Regia, the *Reconciliation of Pope Alexander III with Barbarossa*. Porta made some effort in this work to re-adapt himself to Roman, Salviati-like Maniera, but only

partly altered a Venetian style to which, in the course of a quarter century's residence, he had become so much acclimatized. He brought more of a Maniera accent back from Rome, but only as a factor to incorporate into Venetian style.

The decoration of the Biblioteca Marciana (known also as the Libreria Vecchia di S. Marco or Sansoviniana) was an enterprise that, pretending for still unknown reasons to a kind of democracy of patronage, reached perforce into the second rank of Venetian painting; it was in this stratum that the Romanist group lay. Of the seven painters chosen to execute tondi in the ceiling of the Sala, two (and possibly a third) had a Central Italian education – like the architect himself. In their tondi Porta and Battista Franco compromised more with the local style than Giovanni Demio (notices from 1537 to after 1563),[27] who was looser than they in his attachment to the Venetian school; he produced (also in 1556) the most laboriously polished, pseudo-statuary paintings in the entire scheme. Like his colleagues in the Marciana decoration generally (even the most gifted, such as Veronese and Schiavone), but to a more visible degree, Demio seems to have inclined to an academicizing 'correctness' of style in his tondi. It is from this academicizing tendency that the Sala, despite the spread of Venetian painters employed in it, is not quite representative of its moment in Venetian style.[28] Nor is this deficiency enough compensated by the presence of Tintoretto later, in the decoration of the walls.

Demio's work elsewhere – what survives, especially in painting, was not done in Venice – is on a different level of interest, far less constrained in style. Born in the neighbourhood of Vicenza, Demio seems to have been trained in a Mantuan or Bolognese Maniera, and perhaps knew the beginnings of the high Maniera style in Rome. But our first sure knowledge of him is in Venice, in 1537, when he was

listed as a mosaicist. In 1537-8, however, he was in Pisa, working there also as a mosaicist. In 1544-8, in Milan, he frescoed the Cappella Sauli in S. Maria delle Grazie: his style there is extremely accomplished as well as individual, containing – but not necessarily synthesizing – strong Maniera stylization, polished plastic form, episodes of realism (pressed in places to the point of caricature), and fantastic landscape. In its context in Milan this is one of the most interesting of contemporary events.[28a] The Lombard (and specifically Moretto-influenced) accent in these frescoes is no longer evident in the mythologies which Demio left, after 1553, in Palladio's Villa Thiene at Quinto near Vicenza. These are polished performances of classicist Maniera, comparable in style to the recent painting of the Roman Daniele da Volterra, and unspoiled by the difficult academicizing that besets his tondi, slightly later, in the Venice Library. In 1557 and 1558 Demio painted in Padua, leaving altarpieces that develop the new tack he had taken in the tondi to strong positive effect, fusing plastic force with powerfully convoluted line. He returned to his native Vicentine neighbourhood about 1560; in Vicenza he signed and dated an extravagantly mannered altarpiece of an *Adoration of the Kings* for S. Lorenzo in 1563. It is involved, cartaceous, and almost as eccentrically romantic as a Polidoro, and it is the last we know of this singular and gifted artist. Despite his years in Venice he resisted incorporation into the Venetian school, and his direction remained essentially consistent with that which he took when he first started, looking from Vicenza towards Emilia and its Mannerism, rather than to Venice.

The Bassani

The longest as well as the central phase of the career of Jacopo Bassano (dal Ponte, *c.* 1510-1592) is distinguished by its deep involvement with Maniera. What preceded that phase might be considered, with much historical correctness, as his process of acquiring Maniera; what followed it, as his liberation from Maniera and surpassing of it. Bassano's history is far from uniform, but it revolves around a core of Maniera not less identifiably such than in Schiavone's art, and much more complex, articulate, and extensive. This core is, furthermore, explicitly Maniera, to be distinguished on the one hand from the Venetian modes that carry the cast more than the essence of Maniera, and on the other from the more generic Mannerist style that Tintoretto practises, which exceeds Maniera. Nothing in Venetian painting of the mid century, save for the lesser phenomenon that Schiavone represents, is so sharply characterized in its Maniera, and on this account Bassano's style is salient from its context, somewhat disjunctive from the norms – even though they were fluid – of contemporary Venetian taste. His art was in fact not quite authentically Venetian, at least in the sense of the school fixed physically in the city: though Jacopo was usually in contact with the city and sporadically resided there, his main place of practice was the town, some thirty miles northwest of Venice, from which he takes his name.

The difference in his art from that of the metropolis was apparent in more than its acute Maniera phase. Even in that guise, and still more evidently before and after it, Bassano's painting conveyed the provincial's insistent concern – characteristic for provincial painting even in the Cinquecento – with the requirement that art illustrate reality, no matter what else it may do besides. It is not only that Bassano might incorporate realism of descriptive detail into commanding Maniera forms; except in the degree of his insistence on their truth, this is a commonplace of the Maniera. It is rather that he chose types to populate his works which derive from his own accustomed reality, and kept their idiomatic quality of appearance

and expression regardless of transforming contexts. Also, he invented motifs to insert into old themes that made them illustrations of the same small town or countryman's reality. In time he moved beyond the infusion of this kind of genre into standard themes to invent, instead, a new mode of bucolic genre: in this he inverted the former relation between religious subject matter and genre, giving genre primacy of meaning and the nominal subject a significance secondary to it. It is, then, what Bassano's paintings illustrate, more than the descriptive truth of illustration in them, that distinguishes their tenor of expression from that of the art of the Venetian metropolis.

His pictures incorporate elements that could make realist prose; however, these become the matter of a highly artificial poetry, of a bucolic cast. The sensibility that translates prose matter into artifice was as refined as any in the metropolis, but for long in Jacopo's career it remained the function of a provincial mentality, labouring too much, and drawing from the things it illustrates, for all their being so finespun, the qualities that stress effects of genre.

The process that turned a provincial, realist prose into Maniera took about a decade from the visible beginning of Jacopo Bassano's painting. He received his first training from his father, Francesco dal Ponte the elder (c. 1470/80–c. 1540), a retardataire painter of Bassano, in whose day, despite the fact that the town was part of the Venetian dominion, it was the habit to turn for artistic models rather to Vicenza or Verona. As a youth, Jacopo assisted his father, but this was hardly so decisive for his future as a short residence in Venice, before 1534, where he was in the shop of Bonifazio de' Pitati. In Venice Jacopo learned at least as much from looking at the art of Titian as from Bonifazio. In the middle thirties a set of Bible histories on themes of judgement, from the Sala dell'Udienza at Bassano (now Bassano, Museo Civico), show a labouring descriptive

literalness, at this date one of the indices of a provincial view of art and, as well, of archaism. But Jacopo's realism is no mere inherited habit of mind: it has an awkward strength and an effect of urgency that make it seem a stage towards new discovery rather than a persistence of the ideas of an archaic style. Bonifazio's technique, imperfectly imitated, and devices of design no less imperfectly adapted from both Bonifazio and Titian, give these paintings and others close to them in date, above their impact of description, some effect of modern style. Jacopo's sense of urgency about description resists change, but the awkwardness of his description lessened; at the same time his concern for style – more accurately, stylization, as a factor distinct from description – grew. By the end of the decade, as his *Adoration of the Magi* (Burghley House, c. 1539) and *Christ among the Doctors* (Oxford, Ashmolean, c. 1540) indicate, he came to approximate the fluency of single shapes and whole pictorial design he had observed in Bonifazio, and more recently in the more energetic work of Pordenone. Pordenone was, furthermore, an avenue of approach towards elements of visual culture that were extra-Venetian in origin. In 1538 Jacopo had decorated the façade of the Casa Michieli at Bassano; among the varied matter on it was a *Samson battling with the Philistines*, which he repeated in an easel work (Dresden, Gallery) a little later. The scene incorporates not only Pordenone's force of movement and foreshortening but his plastic stress, and beyond this, consulting Roman prints, refers to the anatomical style of Central Italy.[29]

By about 1542 Jacopo's concern with graphic material that could instruct him in the character of recent Romanizing art had become obsessive. A *Martyrdom of St Catherine* (Bassano, Museo Civico) has absorbed the most demonstrative and complicated Romanist vocabulary accessible through prints, and in addition it shows that Jacopo has been exposed

(apparently also through graphic works) to Parmigianinesque Maniera, and that the exposure has emphatically taken. As yet neither consistent nor mature, the print-formed style of this painting abruptly brings Bassano up to date. Its sharp-edged virtuosity of form and the chill brilliance Jacopo has imposed on what had been Venetian colour make it a surprising parallel to the exactly contemporary style in Florence of Bronzino. As in Bronzino, whose instinct to specify reality is not unlike Jacopo's, description is not sacrificed to style but made in a temper that the style determines; taut, probing, and acidly precise, etching the responses of a brilliant sensibility.

Neither the Romanism nor the lesser element of Parmigianinesque Maniera in the *Martyrdom* were (as we are by now amply aware) singular to Bassano at this moment in Venetian style, and from contact with contemporary events in the metropolis he could have received stimulus to move farther in the new direction. However, it seems that the more efficient cause of Jacopo's next step, by which he became an exponent of Maniera in a measure beyond the most avant-garde of his colleagues in the city, lay - once again - in prints. Sophistications of Maniera drawing style, identifiably Parmigianino-like, and revisions of appearance to approximate Parmigianinesque forms occur in Jacopo's *Road to Calvary* (Cambridge, Fitzwilliam Museum, *c.* 1542), almost taking precedence in interest over the Romanisms; in the *Rest on the Flight* (Norton Simon Collection, from Prinknash Abbey, 1542-3) the Parmigianinesque vocabulary is pervasive and conveys the effect of a whole design conceived in one continuity of rhythm. There is still no lessening of Jacopo's concern to describe what he has chosen to present of a genre-like reality and its details, but his mode of description is now, still more than before, highly stylized. A figure that illustrates a rural type deliberately equivocates between homeliness

and elegance, and each veristic detail of his form is drawn with fine-edged ornamental grace. By the middle of the fifth decade Jacopo commanded the means of this equivocation absolutely, and quite in the mentality of the Maniera. In such brilliant samples as his *Adoration of the Shepherds* (Hampton Court, *c.* 1545), and yet more in the later versions of the theme, the verism is not there just as imitation but as a demonstration of an explicit power of art, exhibited by a hand that utterly styles the detail it describes. Each veristic element is given us in part as truth, but more in the temper of an inspired artifice, and this is the case with the elements of genre also. The more Jacopo illustrates of genre, the more is the effect that he achieves - again in the mentality of Maniera -of a sophisticate's delight in the contrast of genre against artificiality and simultaneous transmutation by it.

However, this ability to deal with verity in the temper of Maniera and with its means became of secondary moment to Bassano even as he achieved it: his preoccupation with Maniera itself, and with the making of an art that is stylized to a degree without counterpart in Venice proper, became primary for him. In the context of the Venetian school, Jacopo's extremism in Maniera may be taken as an index of provincialism, and a symptom of the absence from his usual milieu of what we have referred to elsewhere as the influence towards restraint of metropolitan traditions. We owe to this liberty Jacopo's finally complete translation into Maniera, in his *Road to Calvary* of 1546-7 (Weston Park, Earl of Bradford) [241], of the *Spasimo* of Raphael that he had so long meditated as a print. The lapidary surface into which details are etched in this work was relaxed almost immediately after. The plastic lustre and the colour that inclines to chill (both tendencies akin to those of Central Italian Maniera, but related also to the provincial Lombard schools) yielded in the second half of

241. Jacopo Bassano: Road to Calvary, 1546–7. *Weston Park, Earl of Bradford*

the decade to renewed responsiveness to more properly Venetian ideas for the use of colour and to corollary ideas of optical experience of nature and painterly descriptive means. The *Last Supper* (Rome, Borghese, *c.* 1548) makes clear how much this redirection is dependent on the coming to maturity, barely earlier, of Tintoretto's style. The *Beheading of the Baptist* (Copenhagen, Museum, *c.* 1548–50) resembles the contemporary Tintoretto as well as Schiavone, but exceeds the Maniera tendencies of both; the loosening of Jacopo's technique promotes not only a Venetian effect but also an important quality of Maniera in that, for the first time, his descriptive means do not so labour that they obstruct fluency of form. As his command of painterly style developed,

Jacopo came to make extraordinary effects of combination of it with ornamental draughts-manship. Vibrance made by subtle and insistent energies of line is joined to a vibration made by light, and in crucial passages of his pictures the conjunction scintillates. Description has become so wholly stuff for the making of effects of art that Jacopo can manipulate even the most genre-laden of his themes, such as the *Adoration of the Shepherds* (Verona, Giusti Collection, *c.* 1548–50), and, still more, his *Rest on the Flight* (Milan, Ambrosiana, *c.* 1550) [242], into a high elegance.

For half a decade after 1550 Jacopo's was the most extreme Maniera position among his Venetian contemporaries, building more radically beyond the indices of Tintoretto and (now

242. Jacopo Bassano: Rest on the Flight, *c.* 1550.
Milan, Ambrosiana

more identifiably) of Schiavone. Still exploiting the vocabulary of Parmigianinesque Maniera, the style that Jacopo attained at this time is an extrapolation from it, as libertarian as Parmigianino's in description or sometimes more, and more impulsive in calligraphy. His arbitrariness in colour is inspired and extraordinary, seeking – with a more penetrating intelligence than Schiavone's – ways to translate the late Titian's light and colour into Mannerist singularities and poignances, and at times venturing a technique almost as bold. A series of major paintings done in this half-decade stands as a *summum* of the possibilities that Maniera style could realize in the Venetian school: among these are the *Lazarus and Dives* (Cleveland, Museum, *c.* 1550-3) and its pendant *Miracle of the Quail* (Florence, private collection, 1550-5), the *Road to Calvary* (Budapest, Museum, *c.* 1555), and two different interpretations of the *Adoration of the Shepherds* (Stockholm and Rome, Borghese, both *c.* 1555).

Jacopo receded from this extreme position, and once the change of style had started, it proceeded fairly quickly. In the later fifties and the earlier years of the next decade the essentially Maniera elements of style diminished, though Jacopo might recall them on demand. From the lyric fantasy of the extreme Maniera he turned towards a more sober and objective mood, which reasserts his pre-Maniera interest in illustration and description. His sympathies with art in the metropolis became less radically inclined, and the oldest authority in Venice – and still the highest – the late Titian, replaced that of Jacopo's still avant-garde but none the less ageing contemporaries. A work of which the date, 1558, is documented, a *St John the Baptist in the Wilderness* (Bassano, Museum), marks the pivot between Jacopo's Maniera phase and the tendencies of his later career. The *St Peter and St Paul* (Modena, Galleria Estense, 1560-2) tends farther from the vocabulary and temper of Maniera and more towards

Titianesque ideals. A *St James*, a little later (Munich, Pinakothek, *c.* 1563-5), depends frankly upon Titian. When, probably at the middle of the decade, Jacopo painted a monumental *Pentecost* for the church of S. Francesco at Bassano (now Bassano, Museum), it was on Titian's model of design and in a technique approximating that of Titian's contemporary style. For a while, however, where the tenor of a subject might encourage it, the residues of Maniera persisted, but wedded to a form-creating chiaroscuro and a luxury of colour that the late Titian had inspired. The *Adoration of the Magi* (Vienna, Kunsthistorisches Museum, *c.* 1563-4) [243], one of the most replicated works in all Jacopo Bassano's œuvre,[30] is the high example of this dialectic; the related theme, the *Adoration of the Shepherds* (Rome, Galleria Nazionale, *c.* 1563-5), is hardly less, even though it reaches into a region of descriptive verism more probing than Jacopo had sought since long before, and towards a new emphasis on genre content.

The graces and attenuations of Maniera diminished swiftly by the later sixties and in time vanished almost altogether from Jacopo's art, while the Maniera devices of design came to be employed as formulae, the unruminated conventions of a long-accustomed speech. Altars of the seventies, many of them elaborately populated and with extensive settings (executed most often with substantial help from Jacopo's large shop, and from his son Francesco in particular), such as the *Martyrdom of St Lawrence* (Belluno Cathedral, 1571), the *Preaching of St Paul* (Marostica, S. Antonio, 1574), and the *Baptism of St Lucilla* (Bassano, Museum, *c.* 1577), assemble figures as if out of pattern books, and are composed on almost interchangeable schemes. The pattern books seem actually to have existed, as did the arbitrary schema of design,[31] and to use both as bases for the invention of a series of resembling works of art seems an extreme of the Maniera

243. Jacopo Bassano: Adoration of the Magi,
c. 1563-4. *Vienna, Kunsthistorisches Museum*

disposition towards stereotypes. But now, in Jacopo's last years, when a larger demand for Bassanesque pictures had more than ever to be satisfied by the assistance of his shop, an economic more positively than an aesthetic principle may account for the use of stereotypes. These give an effect of repetition and monotony that is partly masked by the surfaces with which Jacopo and his assistants overlay them, scintillating with the textures of jewel-coloured garments glowing out of darks. The quality of light and colour resembles that of the latest Titian, but means much more than he does to convey the value of illusion. Verism, which in Jacopo's earlier art had been a function of what he could illustrate or draw, has also become a function of what he can achieve with light in paint. In these scenographic altars the effect of drama or of poetry is less in what they illustrate than in their quality of light in paint and, at the same time, in the enchantment of their episodes of illusion. A few late pieces, in which Jacopo's seems entirely the dominating hand, attain a more profound communication, not to be diminished by comparison with the latest Titian because it is inspired by it. In the *Entombment* of 1574 in S. Maria in Vanzo at Padua [244], light generates a reverberation which, in this subject matter, magnifies its tragic eloquence. In the *St Martin* (Bassano, Museum, c. 1580) the light still more attains a vibrance like the old Titian's, at once powerful and tender, by

244. Jacopo Bassano: Entombment, 1574. *Padua, S. Maria in Vanzo*

which the whole tenor of the subject is suffused. *Susanna and the Elders* (Nîmes, Museum, signed and dated 1585)[32] is as summary and inspired in touch, and as direct in its assessment of a human situation, as in the ancient Titian, almost as if this were a posthumous event in the history of Titian's art.[33]

Earlier in his career Jacopo had made an iconographic invention of importance for the history of Italian art, [34] which had grown out of his long habit of inserting elements of bucolic genre in his depictions of religious themes. Perhaps as early as the later 1550s he had begun to invert the importance in some of his pictures of the genre component in them and the overt religious subject. However, it was not until the next decade that the production of paintings of which the evident main theme was bucolic genre became an important enterprise of his. Still, the pretext of religious subject matter (or of cyclical themes such as the *Seasons* or the *Elements*) was retained: difficult to find as the moral or 'philosophical' subject may sometimes be, these paintings almost without exception are not pure genre. From the mid seventies onwards they appeared with increasing frequency in the Bassano œuvre, at first with intervention in their execution as well as their design by Jacopo; but in time execution was delegated almost altogether to the *bottega*, to Francesco Bassano especially. Their manufacture in what at times seems numberless repetitions, to satisfy a very wide market, engaged the shop not only while Jacopo lived but into the seventeenth century. The process of invention was based, yet more visibly than in the case of the late scenographic altarpieces, on the recombination of stereotypes from Jacopo's pattern books into standard Maniera formulae of composition. The intention to make effects of realism is in the parts of these paintings (and then not consistently), and never in the whole. As it had always been for Jacopo, the effects of verity or illusion that he created were not just mimesis but assertions of the painter's art. But it is certain in these overt genre pictures that there is a different weight in the relation in them between mimesis and art, and that the former has become more important. It is as if this strain which had been so strong in Jacopo's beginnings, and which it had taken long years of accommodation with a metropolitan culture to control, had pressed Jacopo to the conception of a new sphere of imagery in which it could re-emerge. But even then an equivocation between art and reality persists, in the genre subject matter itself as well as in the mode of painting it. It must be remembered that even if bucolic genre reproduced an aspect of reality, that reality was an exoticism to Bassano's patrons in the Serenissima, meant to appease the ancient nostalgia of Venetians for the *terra ferma*. Equivocation between the artificial and the real in genre would be resolved in Jacopo's lifetime, not by him or his Venetian successors, but by Caravaggio and the Carracci as they laid the foundations for the style of the next century.

The shop that helped Jacopo Bassano to multiply his efforts, in his later years on a scale like that of a minor industry, was staffed most importantly by his own sons. In order of age they were Francesco (named after his grandfather), born in 1549, who died a suicide in 1592, shortly after Jacopo's decease, Giovanni Battista (1553-1613), Leandro (1557-1622), and Gerolamo (1556-1621). Of the lot, Francesco was the only painter of distinct talent. He was formed in his father's mode of the 1560s and matured into Jacopo's less mannered, more veristic style of the seventies; he then began to work not only as a collaborator with Jacopo, signing pictures jointly with him, but independently as well. In 1579 Francesco moved to Venice, where his career included official state commissions for the Palazzo Ducale as well as pictures in his father's vein. He particularly pressed a development of chiaroscuro that Jacopo had made earlier, the painting of noc-

turnes – a much appreciated taste also elsewhere in North Italian painting of the time. He exaggerated Jacopo's late manner in general towards more obvious effects and towards a rougher touch, and the verism that had been a tendency in his father's style at the time Francesco matured grew to be a still more positive inclination in the son.

Leandro also had some claim to a distinguishable personality and at least a modest level of artistic gift. He collaborated young, still in the middle seventies, with his father and Francesco, but soon showed symptoms of a tendency distinct from theirs, more literal and less painterly. Some time in the 1580s he too moved to Venice permanently, where he acquired the duller characteristics of the late-sixteenth-century Venetian style, academicizing his father's mode and, in time, desiccating it. His latest works, portraits especially, are timidly realistic, yielding ground in the new century to the beginnings of a new style. Leandro's older brother, Giovanni Battista, almost evades definition as an independent personality, but what we can identify by him indicates no small ineptitude. The youngest brother, Gerolamo, was essentially a copyist, not only of his father's models but of Leandro's also.[35]

At Feltre, still more removed from the metropolis than Bassano, there was a more provincial variation of the Venetian mid-century style, for which the art of the Bassani served as a major intermediary. The painter worth remark at Feltre – the first since Morto – was Pietro de' Mariscalchi (sometimes called Spada; c. 1520–1589). The course of his style runs roughly parallel to Jacopo Bassano's, partly for the obvious reason of his influence, partly because their circumstances of place and culture were somewhat alike. Mariscalchi's art is like an extrapolation of Bassano's farther into provincialism. His early works (none we can identify seems to antedate the fifth decade) depend on locally available export merchandise of Titian's school (such as that of Francesco Vecellio) and are correspondingly conservative as well as of a similar indifferent merit. About 1550 this timid style yielded to one formed mainly on the modern example of Jacopo Bassano's Maniera. At least for a brief while Bassano's influence may have been reinforced by that of Giovanni Demio. Mariscalchi's response to these contemporary stimuli was profound, sympathetic, and (in view of the limitation of his earlier works) highly accomplished. An altar of the *Madonna della Misericordia* (Feltre Cathedral, c. 1560) combines Maniera calligraphy and Romanizing plastic form in a close-woven, mobile tissue. Flawed in the details of both execution and idea, the altar is nevertheless inspired to be an image of high style. Throughout the early years of the next decade Mariscalchi followed Jacopo Bassano's example ever more exactly. Like Jacopo, he diminished the specific accent of Maniera in his style; still more than Jacopo, he sought to make it painterly. An altarpiece of the mid sixties, the *Madonna with St James and St Prodoscimus* (New York, Chrysler Collection, dated 1564), of which the vocabulary is for the most part recognizably Bassanesque, outdoes Jacopo in the play of light on drapery. Another influence, not so unlike Bassano's as to be incompatible with it, appears in this altar: that of the late works left in the neighbourhood by Schiavone. Their careless brilliance provoked Mariscalchi to still more exaggerated tricks with coloured light and soft sfumato, as in his *St Peter in Prison* (Villabruna near Feltre, Pieve, c. 1570). A painting of this kind may suggest an aspect of the style of the contemporary Titian, though the relation is only indirect, through Bassano and Schiavone; however, an abrupt descent in quality of Mariscalchi's art makes comparison intolerable. Gauche in its exaggerations of technique and expression, and graceless in its shapes, this work marks the vanishing of Mani-

era from Mariscalchi's art and its re-absorption in provincialism. But in the end the results of this change are not negative: in Mariscalchi's last decade or so gracelessness and over-emphasis become part of a creative shaping force, wedded to a will to assert that the work of art can contain a presence like that of reality. A late portrait of an old nurse and her young charge (Leningrad, Hermitage) shows the force of this inclination in its simplest terms, but a far richer document is Mariscalchi's *Pietà with St Clare and St Scholastica* (Bassanello, S. Maria Assunta), equal to his *Madonna della Misericordia* of a quarter of a century before in stature as a work of art, yet the antithesis in style of its Maniera. The expressive directness of description in the *Pietà* and the immediacy with which light serves in it as a descriptive means link this, more than to contemporary Venetian art, to those tendencies in northern Italy from which a major current of the coming century, the exploration of reality, would flow.

Veronese and his Followers in Venice

The predominant style in Venice of the middle and later years of the century is a Mannerism mostly consequent on Tintoretto, but the action on the city of Titian until 1576 and of Paolo Caliari, called Veronese, from about 1550 till his death in 1588 almost makes a counter-balance of non-Maniera styles. Veronese's history is the converse of those we have considered recently. Born in 1528 in Verona, and educated there by the competent local painter Antonio Badile, Paolo grew to personal maturity in a climate and at a time that were favourable to Maniera, and his earlier works bear its accent. He moved to Venice (probably in 1551) when his style was still malleable and when the new Mannerism of Tintoretto and the grand classicism of the late Titian offered a clearly distinguishable choice; he opted for the latter, thus entering on a development that was coun-

ter to what, in the previous decade, had been the Venetian norm of accommodation with Maniera. Veronese's historical position in the Venetian scene may be compared – in an approximate way – to that of those artists of the same generation in Rome who chose to find, in their case in terms we have designated as those of Counter-Maniera, a renewed relation to the precedents of classical style.

Paolo's art had been influenced by Maniera in his first Verona years, but not permeated by it. His earliest known work, an altar for the Bevilacqua family (Verona, Museum, 1548),[36] engagingly but only superficially employs a vocabulary that reflects Maniera (in a Parmigianinesque or perhaps Salviati-like mode). The remains of fresco decoration once in the Villa Soranza (now mostly in Castelfranco Cathedral; dated 1551), also mannered, are less Parmigianinesque; their accent is more that of an offshoot of the Giulian school of Mantua, to which, by force of long tradition and geographical circumstance, Verona turned even more than to Venice. However, it is less the Mannerism in Giulio's style that is exemplary for Paolo than his classicistic tendency, and in this context of decoration, his illusionism. The concern to make illusion need not be related to a concern for literal description, but an un-Maniera inclination to insist on seen facts is evident in the Soranza fragments. It is possible that contact with contemporary Lombard painting, in Moretto's vein, provoked this tendency in Veronese, but it is more likely to be the result of native disposition and provincial taste, precedent in him to what he had come to learn of 'style'.

In Venice, when Veronese received his first metropolitan commission, for an altar painting with a *Sacra Conversazione* in S. Francesco della Vigna (*c.* 1552), it was this naturalistic taste that determined that he should seek a model in Titian's art: Veronese has referred openly to the Pesaro altar of a quarter of a

century before. The turn to Titian was of decisive and immediate importance. Beginning with this altarpiece, Veronese committed himself in his first Venetian work to Titian's essential proposition of a style that transcribes the look of nature. But in the climate of Venetian art in the sixth decade it would have been unlikely that a newly arrived painter, earlier disposed towards Mantuan and Parmesan ideas of style, should avoid the widespread current of imported Romanism. Romanist tendencies displaced Paolo's preceding likeness to Maniera, but he absorbed these at the same time as he did the art of Titian. Paolo's *Temptation of St Anthony*, painted in 1552 or early 1553 for the cathedral of Mantua (now Caen, Museum), is particularly Romanist in accent, incited by the presence of local Giulian example; but the combination of this with what Paolo had acquired of Titianesque technique results in a recollection of Titian's own conspicuous episode of Romanism about ten years before. In 1553 Paolo's first state commission in Venice, the ceiling paintings (in the accustomed Venetian oblique perspective) in the Sala del Consiglio dei Dieci and the adjoining Sala dei Tre Capi del Consiglio, remarkably combine a luministic power based on Titian and a plastic and illusionistic force for which, among the possible precedents, Giulio's remains the most important. Three years later, the Giulian debt in Paolo's most ambitious ceiling decoration yet, the three-part *History of Esther* in the nave of the Venetian church of S. Sebastiano, is still apparent. In two of the ceiling panels, *Esther led before Ahasuerus* and the *Triumph of Mordecai* [245], Paolo constructs a spatial scaffolding of foreshortened architecture on which the forms exist with the force of statuary. His intention to assert plasticity in this degree requires strong light and strong colour, which will sort forms out and make them salient. Though Paolo's mode of description is based on Titian's optical technique, and his concern

245. Veronese: Triumph of Mordecai, 1556.
Venice, S. Sebastiano

with luminosity and colour is Titian-inspired, their application to a Romanizing plastic style of this power results in a substantive alteration of what was Titianesque. Colour does not work in a fusing chiaroscuro (or in a 'tonality') but in high-keyed light that analytically searches forms. It takes on a variegated, high-pitched brilliance; in order to produce unity, it must, like the structural and plastic elements of form to which it is attached, be ordered in *disegno*: the principle is that of a Central Italian, more than just a Romanist style.

This alteration of Titianesque colour practice into a new mid-century mode was generated not just by the exigencies of the particular aesthetic problem Paolo had posed himself but by the instigation of Maniera taste – less that in contemporary Venice than what he had known in Mantua and, probably, in Emilia.

There is in the S. Sebastiano frescoes, and there remains afterwards, an arbitrariness in Veronese's choice of colour and a preference for coolness in it that relate to tendencies of Maniera. Soon he was to come to a way of making colour denote ornament, its value virtually separable from what it describes; he assigned it a role in his painting like that taken in Maniera by the manipulations of shape and line. But these affiliations with Maniera, genuine and important as they are, qualify but do not basically change the fact that, since Paolo's residence in Venice, the formal vocabulary of Maniera in which he had in part begun has been displaced by a vocabulary of Romanist style, much more classicistic; and the ideal and rhetorical conventions that that style prescribes have come to be inhabited not only by effects of illusionism but by a naturalism more particular in its scale and intention than that which had been normal in Venetian Cinquecento art.

Their difference in quality, more obviously than one of style, distinguishes Paolo's contributions to the decoration, in mainly Romanist company, of the ceiling of the Biblioteca Marciana (three tondi: *Honour*, *Music*, and *Arithmetic and Geometry*, 1556-7); yet in this company and by comparison with Paolo's own prior ceiling for S. Sebastiano the Library paintings seem less marked in their Romanism and more painterly, reflecting more from Paolo's increasing exposure to Titianesque ideas. Longer residence in Venice began to have a more pressing effect, disposing Paolo towards sympathy with what was native in Venetian taste. Very quickly, what was obviously foreign in his Romanism – the tendency to an emphatic rhetoric of content as well as over-emphatic form – began to yield and be replaced by elements adapted from Venetian style. The foreign accent and the emphases of Paolo's Romanism went, but much of its classicistic core remained – a substance he proceeded now to fuse with principles observed in

Titian's art and to grace with a fluently Venetian accent. The evidence of this change appears close on the time of the tondi, most dramatically as Paolo turned towards a Venetian genre which he would, in time, make his particular preserve. A kind of modern variety of the old *telero*, these are large biblical or classical histories, presented in long horizontal format as if on a stage, with an abundant scenographic architecture, splendid costuming, and an ennobled style of behaviour for the actors. For recent precedents – of staging, however, not of style – Paolo turned to Tintoretto, and perhaps to Bonifazio; ten years before, Tintoretto's *Miracle of the Slave* had included all the elements Paolo thought requisite to the genre. A fresco lateral in the choir of S. Sebastiano, *S. Sebastiano before the Emperor* (1558), proceeds from this obvious Tintoretto source, but is at once distinct from it, diminishing its qualities of Maniera. Paolo makes his figures normative in their proportions, nicely adjusts their mode of action between normality and grace, and opens intervals between the actors to create an ample space. The scene acquires the effect of plausibility in the appearances it represents, of clarity and order in design, and of a distension in emotional temper. Compared with Paolo's precedent in Tintoretto, this reverts in the direction of a classical style, or reasserts it. The grand *Presentation in the Temple* (Dresden, Gallery) may be somewhat earlier in its ambition towards such a style; the *Christ in the House of Simon* (Turin, Gallery) or the *Supper at Emmaus* (Paris, Louvre), both just before or into 1560, mark further advances towards its achievement. These works clarify differences from Maniera which Paolo has established but at the same time they make evident what stands between him and an essential classicism. Paolo's disposition to observe and paint reality is like that of a Lombard more than a Venetian; at times he seems a kind of displaced cousin of Moretto. His sloughing off

of what he possessed of Maniera is only partly because he felt an affinity for classical ideas of style; it is more because Maniera is less reconcilable with naturalism.

In the *Christ in the House of Simon* painted to *épater* an audience in Verona, and in the *Emmaus*, larded with portrait-figurants (to satisfy what may have been Paolo's inclination no less than the patron's), the contest between the urge to truth and the demands of style is not yet quite resolved. It was in 1560 that this resolution occurred, perhaps precipitated not just by an internal progress but by a trip to Rome which, according to Ridolfi, Paolo made in that year; it also may have been a motive towards defining his style that the largest chal-

lenge offered him so far came to him then, the decoration of Palladio's Villa Barbaro (later Giacomelli, now Volpi) at Maser. It occupied him apparently throughout 1561. The fresco decoration[37] extends through the main rooms of the *piano nobile*, of which the focus is a two-storeyed central hall [246]. Its subject matter consists of allegories (in the easy and apposite vein of elements, seasons, virtues, etc.) given customary antique form, pure landscape scenes, and unexpected intrusions, utterly illusionistic, of contemporary figures; the whole in frameworks of painted architecture which amplify the actual Palladian substance of the house. From the beginning this Palladian ordinance, with the residue in it – so like what

246. Veronese: Sala dell'Olimpo, 1560–1.
Maser, Villa ex-Barbaro

was apparent in the style of Paolo even before this – of Maniera coolness, fineness, and precision, creates the tenor of a classicism around the paintings it incorporates. The entire painted architectural system is illusionistic, and its conceits and some of its forms still recognizably depend on Giulio, but the way in which they have been used makes explicit the process by which Paolo reclassicizes the Maniera. The process would surely have been reinforced by an immediately preceding experience of Rome, and Raphael's decorative models seem in fact to have been relevant to Veronese – not only those in the Vatican but those in the Farnesina, and Peruzzi's also.[38]

The art of Raphael may well have been a guide for Paolo in more important respects than those of decorative order. It is at Maser that Paolo's figures assume shapes, proportions, and a mode of movement that make a close analogy with the Roman Raphael, as opulent and almost suave. The resemblance is trenchant, yet the end effect is evidently not the same. Paolo revises actual appearances rather less, describing more things with more particularity, and he makes generalizations just a little unconvincedly. He has achieved a compromise between his realist inclination and the ideals of classicism at the cost of diminishing their ideality. The result is less like Raphaelesque classicism than a Venetian precedent: Titian in a brief early episode about 1515, when his classicism subsided nearest towards prose and his idealizing was less a power of idea than a convention. The means of the compromise were not hard to find. Though he insisted on more particular detail than Titian, Paolo had learned, initially from him, that an effect of verity need not depend on drawn details but can derive from an optical effect achieved by the force of light. Paolo took the consequence of Titian's lesson farther: more brilliant light conveys a more insistent sense that in his semblances of ideal form Paolo has described a

seen truth. Yet this light that asserts verity and confirms illusion can also create, in pure painter's terms, effects of poetry, Parian shinings of nude flesh and coloured splendours in the draperies.

Important elements in Paolo's attitude towards the recording and transformation of reality – a transformation which employs both the formal means of classicizing style and those of painterly device – recall not just the younger Titian but Correggio, and like the latter's style Paolo's also contains elements that anticipate a baroque. However, Paolo is much farther than Correggio from that innovative end. What is in Correggio, and in Titian also, that Veronese conspicuously does not possess (or seem even to aspire to) is an emotional commitment to his subject matter, much less passion in his handling of it. Transcending even his concern with verity, Paolo's more essential concern is aesthetic, for the effects of art he can achieve with light, colour, composition, and staging. This is related to one of the major attitudes of the Maniera; and despite the classicizing apparatus of Paolo's art, the primacy of aesthetic concerns in it over those of emotional or dramatic sense make it more nearly only classicistic. Paolo's response towards subject matter is characteristically also classicistic: his actors take the attitudes which, in the visual rhetoric of classical style, denote ennobled feeling, but communicate little or nothing of its essence. They posture (as in the grand *Saints* of the organ shutters of 1558–61 from S. Gemignano in Venice; now Modena, Galleria Estense) with a dignity and handsomeness like that in high classical style, and may add to these a chastened elegance – but no preciosity – like that of the Maniera; but what their behaviour conveys is not emotion but the replacement of it by the social value that is called *maniera*.

The adjustment into a superb equilibrium of the complex matter of Veronese's art achieved at Maser was maintained throughout the fol-

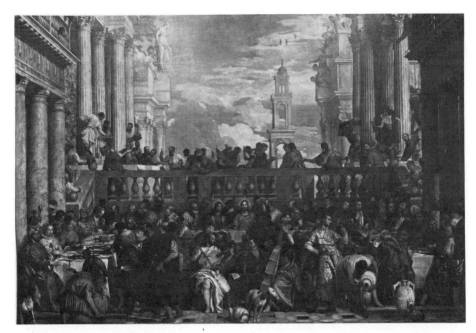

247. Veronese: Marriage at Cana, 1562–3.
Paris, Louvre

lowing decade. A *Marriage at Cana* (Paris, Louvre, 1562–3) [247], for the refectory of S. Giorgio Maggiore, of enormous size – over 30 feet (10 m.) in width – makes a panorama of opulence out of the Christian story, paraphrasing (and surely magnifying) the luxury of dress and setting which a grand patrician feast would have in contemporary Venice, and capturing its effects of movement and of visual brilliance.[39] The viewer is compelled to hunt for the illustration (and it is no more than that) of the religious theme, and in this sense Paolo's image may be taken as mundane reportage. But at the same time it is a *poesia* – about a quite contrary theme – celebrating sheer opulence, an orchestration in the grandest range of forms and colours, and a stage manager's masterpiece. From this time Paolo is most eloquent when he can transpose an assigned subject into terms

that let him deal primarily with the appearances and manners of Venetian society, as when he paints the confrontation, without a trace of tragedy, between *Alexander and the Family of Darius* (London, National Gallery, 1565–70) [248], all sumptuousness and fine courtier's elegance, in its setting and cool artificiality of action also like a tableau on a stage. His dissympathy with dramatic action, much less with the powerful emotions that impel it, is demonstrated when he must treat subjects such as *St Mary and St Marcellinus led to Martyrdom* (Venice, S. Sebastiano, choir, *c.* 1565) and the *Martyrdom of St George* (Verona, S. Giorgio, 1566?). Each device – of anecdote, costume, or pure painterly manipulation – by which Paolo multiplies distractions from the tragic theme relieves his preference for *maniera* in behaviour over deeper sentiment.

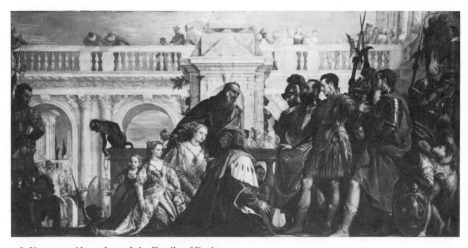

248. Veronese: Alexander and the Family of Darius, 1565–70. *London, National Gallery*

In the early seventies, some symptoms of a change in Paolo's temper of expression appeared, motivated by the unavoidable example not only of Tintoretto's but of the latest Titian's seriousness. The shift in tone of content is accompanied by a concomitant shift in painterly tonality, deepening colour and increasing chiaroscuro. The first index of this change occurred in 1571, in three New Testament paintings done for the Cuccina family (Dresden, Gallery), among which the *Adoration of the Kings* most clearly shows that Paolo has consulted Tintoretto. His study of Tintoretto is again confirmed by the deep-toned and pathetic *Crucifixion* (Paris, Louvre) of about this time. An *Adoration of the Kings* from S. Silvestro in Venice (London, National Gallery, 1573) is more than sumptuous parade: in it Paolo makes convincing drama out of the power of movement and contrasting light. It is partly an irony, but also understandable, that it should have been for a *Last Supper*, larger than the *Marriage at Cana* of ten years before,[40] but altogether the less ostentatious painting, that

Paolo was summoned to justify his illustrative licence to the Inquisition; the issue was resolved by renaming the picture *The Feast in the House of Levi* (Venice, Accademia, 1573) [249]. By contrast with the *Cana*, the *Levi* is meditative in content as well as in its form. The setting (here, too, conveying the impression of a stage) is tempered in its effect of illusion, and its architecture scans the picture field and orders space with a clarity and dignity that recall the classical Raphael. The figures in the setting are arranged no less classically: action, gesture, and expression in them carry an authentic eloquence, and the effect of conviction touches even episodes like those the Inquisition did not like, introduced as gratuitous effects of nature or of ornament.

This change in Paolo to a graver and more pondered mode affects the whole substance of his painting by the middle of the eighth decade. His *Marriage of St Catherine* (Venice, Accademia, *c.* 1576; a renovation now, more than a recollection of Titian's Pesaro Altar) gathers heavy forms into a dense design, and asserts,

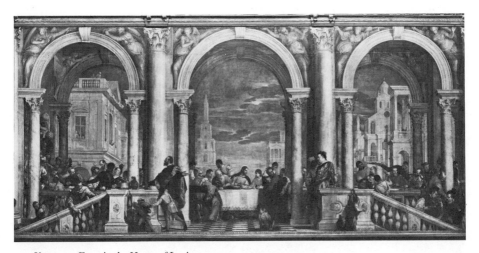

249. Veronese: Feast in the House of Levi, 1573.
Venice, Accademia

much more strongly than before, the splendour of their textured, almost illusionistic presence. The *Rape of Europa* (Venice, Palazzo Ducale, Sala dell'Anticollegio, *c*. 1576–8; also necessarily a commentary on the earlier Titian) has a similar effect of density and splendour of sheer visual substance, and, as in the altarpiece, it does not matter that the artist's feeling about paint seems more compelling than his feeling for the assigned subject. This is also the effect of the mythologies Paolo painted between 1576 and 1584 (owned by Rudolf II; New York, Frick Collection and Metropolitan Museum, and Cambridge, Fitzwilliam Museum), where grand form joins with power of paint to compensate quite richly for a trace of rhetorical inflation in Paolo's response to the subjects. But in these it is evident that the deep conviction Paolo feels about the handling of paint is of more than the commanding splendour he can make with it. He can manipulate its content of colour, light, and texture, and the quality of touch with which it is laid on, so that of itself the paint can make nuances of feeling more

subtly articulate and more moving than the face, the gesture, or the action that the paint has illustrated. The ceiling of the Sala del Collegio in the Palazzo Ducale, which Paolo decorated in 1576–7, solicits this capacity in almost its extreme degree.

In the pictures of the seventies there had been only occasional instances of overt dependence by Paolo on the style of Tintoretto or the latest Titian, even though, as we remarked, their examples seem to have precipitated the new temper of Paolo's art. But about 1580 he began to yield to their combined influence in major and obviously identifiable ways. Elements of Tintoretto's figure style and certain of his devices of design appear in Paolo, and from the late Titian he adapts – by no means consistently in either case – his excitant handling. Their combined models dictate a sudden strong accentuation of Paolo's chiaroscuro: the silvered, sometimes slightly melancholy modulation of light in the paintings of the seventies yields to extreme contrast – within which, however, colour still holds almost all its earlier

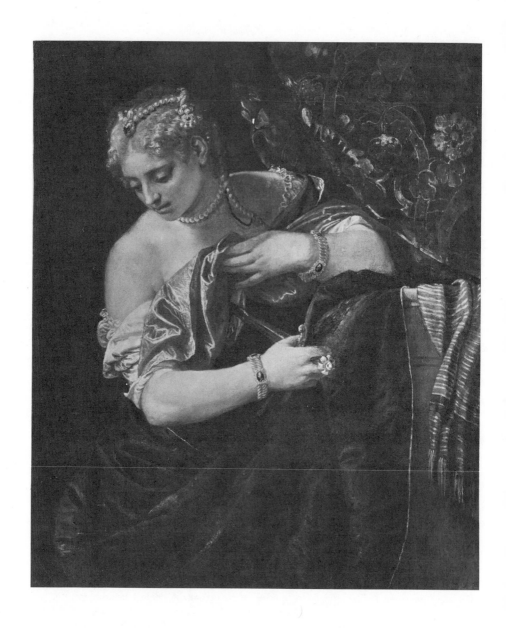

250. Veronese: Lucretia, 1580–5. *Vienna, Kunsthistorisches Museum*

strength, glowing now out of an encroaching dark or making a luminescence through it. Splendour is still an essential content of Paolo's art, but finally his illustration of human content has assumed not just a matching, but in some instances a higher value, corollary to the drama implied by the light. *The Agony in the Garden* (Milan, Brera, *c.* 1580) approximates the late Titian's pathos, and the *Lucretia* (Vienna, Kunsthistorisches Museum, 1580–5) [250] ascends to a tragic dignity that is almost in the old Titian's dimension. A late altarpiece, done shortly before 1584, a *Pietà with St Mark, St James, and St Jerome* (Venice, S. Giuliano), contains an image of the dead Christ borne by angels that is equally convincing of its depth of tragic feeling. In painting style, however, Paolo's acquiescence in the example of the other leaders of Venetian art (not only Titian and Tintoretto but, in this case, Jacopo Bassano also) is apparent to the point of gross compromise of his own painterly identity. Moved by the examples of his contemporaries, and probably as well by the increasing penetration into Venice of the temper of the Counter-Reformation, Paolo learned finally to feel about the humanity he painted. But he could not express feeling of this kind in the painting style he had evolved himself and practised for two decades past: that style had been conceived out of the crystalline detachment from all but aesthetic concerns that is Paolo's most essential link with the Maniera.[41]

Many of Paolo's later works are compromised in quality by concession not to his contemporaries but to his assistants' hands. Like Jacopo Bassano, Paolo ran a family *bottega*, a flourishing enterprise that helped him not only in the execution of larger works (as especially the grand *Apotheosis of Venice* in the Sala del Maggiore Consiglio of the Palazzo Ducale, before 1585) but in the repetition of smaller ones. In his later years Paolo's signature was meant to be taken as a trade-mark rather than a guarantee of his personal execution. Paolo's shop included his brother Benedetto (1538–98), his older but less able son Gabriele (1568–1631), and his younger son Carletto (1570–96), whom he had sent to school with Jacopo Bassano. A nephew, Alvise Benfatto, called del Friso (*c.* 1544–1609), completed the usual *équipe*. The shop was so dependent on Paolo's style and reputation that, after his death in 1588, they continued to produce works as a group, under the signature 'Haeredes Pauli'. Their collective work adds no new dimension to their inheritance from Paolo save for a tendency, native to the generation of his sons (as for Jacopo Bassano's), to incline more towards a pedestrian naturalism. As individuals, their manners tend to be devaluations of Paolo's later style in varying degrees of competence.

Veronese's classicist aesthetic was a minority position in Venice in the face of Tintoretto's Mannerism and yielded precedence to it in the city. Our account of Veronese's own career shows how he himself in time acknowledged the pre-eminence of Tintoretto's style. Apart from the *Haeredes Pauli*, his followers in Venice proper were relatively few; nor did he have an important following in the Veneto.[42] The independent artist who stood nearest Veronese in style was Giovanni Battista Zelotti (1526–78), who had been a co-worker with Paolo in decorative undertakings during their earlier careers in Venice. Zelotti was Paolo's close contemporary, and most probably like him a Veronese by birth. The two young men had similar educations: Antonio Badile had been master to both. Zelotti, however, seems also to have had a time of study under Titian. As early as 1551 Veronese and Zelotti shared work in the Villa Soranza near Castelfranco, and in 1553–4 they were employed (together with Ponchino) to paint the ceiling of the Sala del Consiglio dei Dieci in the Palazzo Ducale. Twice again in the

fifties they worked side by side, in 1556-7 in the Biblioteca Marciana and about 1557 in the Palazzo Trevisan at Murano. Their beginning styles were rather alike, perhaps more from their community of education than from interchange of influence. Zelotti had no talent comparable to Paolo's, and was heavier of hand: his decorations of the fifties that survive, while generally like Veronese in their style, are more laboured and self-consciously Romanist.

Zelotti found a career in the sixties as a *frescante*, specializing in the painting of the recently built great country houses in the area around Venice; he worked also as a façade painter in Vicenza. The general similarity of his style to that of Veronese persisted, and Zelotti's style, like Paolo's, became looser and less Romanist. However, it is by no means sure that the commonplace of the critical literature is quite correct when it asserts that Zelotti's mature art depends on imitation of Paolo's. Indeed, Zelotti's style in the seventh decade moved in a direction opposite to Paolo's, displacing Romanism not with a more Titianesque and classicizing mode but with a strong attachment to Emilian, and specifically Parmesan, Maniera. The detached fresco *Concert* (Verona, Museo Civico, *c.* 1562), his best-known piece, is a sample of this trend. At the Villa Emo at Fanzolo near Castelfranco, Zelotti's decoration of 1567-70 has an elegance and wit that match the temper of Maniera, as well as a Maniera fluency of form. At the Villa Obizzi at Catajo near Padua a major decoration (1570-3) celebrates the history of the family in a scheme of grand fictitious architectural enframements enclosing ceremonial and battle scenes. Zelotti's style here is more brisk and pointed, and no longer so attached to the temper of Maniera, but it still vacillates between Venetian loyalties and interest in the painting of Emilia. Zelotti spent his last years, after 1575, as prefect of buildings in the service of the Gonzaga at Mantua.

Palma Giovane

In the last two decades of the century there was almost no obstruction to the dominance in Venice of Tintoretto's style. It captured the vast majority of younger Venetian painters, most of them of rather mediocre talent, who found Tintoretto's model so obviously commanding as to be inescapable, and, better still, found in his formulae an apparatus that almost automatically amplified the small things they had to say. Many of them continued to paint on a basis that his style provided into the first decades of the next century. There was no convinced desire for change, but what little of it was sought had to work its way through the formulae Tintoretto left, and these proved too oppressive to allow invention of any significant kind. The climate of the last years of the century and the beginning of the next was mostly one of pedestrian conservatism, of gestures made by rote in an expiring style.

The only painter of this generation to exhibit the semblance of a creative vitality, even within formulae based mostly upon Tintorettesque style, was Jacopo Palma Il Giovane (1548/50–1628). He was the end product of a good artistic lineage: his great-uncle had been Palma Vecchio, and his father, Antonio Nigreti (1510/15–after 1575), had been a pupil of the older Palma's shop-foreman, Bonifazio. After Bonifazio's death, Antonio Palma inherited the shop, and worked ably in an extension of Bonifazio's style. Eventually, Antonio succumbed partly to the Tintorettesque fashion. The first training that the young Jacopo received included, beyond his father's example (not yet Tintorettesque), copying from works of Titian. Through the agency of Guidobaldo, Duke of Urbino, Jacopo went in 1567 to Rome to study for some years, returning to Venice *c.* 1572. Despite the long stay in Rome the specifically Roman facets of Palma's education rubbed off quickly, and soon after his return he re-assimilated a

thoroughly Venetian style. The adverb is explicit: the style Jacopo formed in the 1570s eclectically fused (in an adjustment that reflected accurately their current status on the Venetian scene) the Mannerist vocabulary of shapes, designs, and temper of action of Tintoretto (the predominant component); the sensuous response to surfaces and light of the older Titian; an occasional discursive opulence à la Veronese; and inclinations towards descriptive naturalism, often genre-like, à la Bassano. The amalgam thus ingeniously evolved was used by Palma throughout his long career for an enormous output, of which the size would not have been possible had it not appealed so effectively, by its very eclecticism, to a widespread and persistent taste.

Palma worked the components of his eclectic style with virtuoso skill and with a facile intelligence that varied stress among them to suit diverse occasions. Exceptionally his work may give the effect not just of great facility but of inspiration (e.g. in the scenes of Purgatory and Indulgence in the former Compagnia della Giustizia in Venice). Most often, however, his style seems formula of which the elements too obviously remind us that another artist had had the inspiration earlier. The élan of Palma's figures seems imposed, not really motivated, and the handling that pertains to qualities like Tintoretto's or Titian's may at times be dense, or worse, inert. All the symbols that denote vitality are there, but they seem too often to have coagulated. The style of this gifted and efficient painter is parallel to contemporary styles elsewhere: to the late Cinquecento academicizing of Maniera in Central Italy, and – though in only a superficial sense – to the so-called eclecticism of the contemporary Bolognese. The comparison with the Carracci's brand of eclecticism cannot stand because, unlike the young Palma's, which only mildly moderates an essentially Tintorettesque Maniera, theirs was a means to surmount the formulae of Maniera style.

Yet the tendency that most obviously distinguishes the new direction taken by the Carracci, their descriptive naturalism, is present in Palma Giovane as early as it is in them (e.g. in the *Martyrdom of St Lawrence*, Venice, S. Giacomo dell'Orio, before 1584; more fully and conspicuously in the histories of the Doge Cicogna in the Oratorio dei Crociferi, Venice, 1586-7). It appears at first in minor episodes, which seem intrusions borrowed from Bassano, but from about 1590 onwards Palma may choose, at will, to insert so many of these episodes into a painting (as in the Veronese-inclined *Venice receiving Subject Peoples*, Sala del Maggior Consiglio, Palazzo Ducale [251])

251. Palma Giovane:
Venice receiving Subject Peoples, *c.* 1600.
Venice, Palazzo Ducale, Sala del Maggior Consiglio

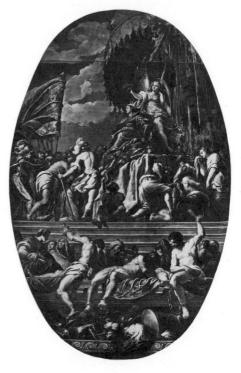

that they make a sensible change within a basic Maniera coloration. His means for making a more evident naturalism are the same as the Carracci's: more particular and exact delineation of form joined to a more exact reproduction of explicitly optical effects. Yet Palma's results are not equivalent. His intensity, and still more his consistency of naturalistic purpose, is much less, and his means, though like in kind, are not the same in quality. The sixteenth-century mentality that esteems idea above reality remains Palma's even as he works into the new century, and he does not permit what happens in the Seicento style to occur in his: that the simulated presences within a picture should assert an identity to the spectator stronger than the idea of the presence before him of a work of art.[43]

The prospect of painting in the chief provincial centres of North Italy in the second half of the sixteenth century is rather less diverse than earlier. We observed that in the first half of the century the North Italian local schools were formed by intersection of their local traditions with influences that came in varying proportions from Venice and from Central Italy. The lessening diversity of local styles is accounted for not only by the wide authority gained in North Italy after about 1550 by the Maniera, but by the fact that Venetian art itself succumbed in part to it. Thus, what emanated from Venice to the North Italian city-schools was less divergent from the influences that had an origin in Central Italy.

Models of style that were explicitly Venetian (with or without the accent of Maniera) continued to be influential in the areas near by, and within the Veneto won firmer attachments than before; but in compensation Venetian models lost importance in the centres of Veneto-Lombardy. There the influence of Maniera prevailed largely, at the expense of what had earlier been a distinct Venice-related tradition. Thanks to the spread of Maniera there was also a diminution of the measure of identity that each local school had possessed before. The urban, courtly, and aesthetically sophisticated models of Maniera represented an antithesis of provincial taste, and to aspire to one required the suppression of the other. It was a saving grace (or perhaps, more accurately, an innate lack of it) that local strains in the provincial centres were often stubborn and would not yield entirely to (what in this context paradoxically is) the levelling effect of Maniera's high style. Out of these strains that were

resistant to Maniera grew the seeds of what were to become, as early as the middle of the ninth decade, the recognizable bases for the next century's style.

VENETIAN DEPENDENCIES

It partly makes up for the secondary place that Veronese's models took in Venice proper that they became the major influences in his native Verona and in Vicenza. In Verona Antonio Badile (c. 1518-1560),[1] Paolo's former master, in his latest works became a limping imitator of his pupil. Earlier, however, Badile may have helped to shape Paolo's disposition in a way important to his mature style. Paolo's naturalism could have come to him by other routes, but Badile was the nearest source and the most obvious channel of communication for it. In Badile's early works his descriptive literalness came from the retardataire tradition in Verona of Caroto, still linked to the Quattrocento; in the 1540s (when Paolo was his pupil) it was Brescian influence, Moretto's in particular, that superficially modernized his old-fashioned realist taste.

Domenico Riccio, called Brusasorci (c. 1516-1567), was Badile's nearly exact contemporary, but of no comparably conservative disposition. Brusasorci's art indicates much more accurately than Badile's the nature of the artistic environment that produced Paolo Veronese. Our knowledge of Brusasorci's early style is inadequate, but in his maturity, at the middle of the century, his orientation was decisively towards Mantua and Parma, not towards Venice. A fresco decoration done at Trento (Casa Garavaglia, now Municipio, 1551) is in a facile compromise of Giulian and Parmesan maniere. Rather than the rising style of the younger Paolo Veronese it may be Brescian influence (which we have noticed already in Verona) that began to modify Brusasorci's attachment to Maniera: it seems perceptible in a fresco

decoration that he painted in the Palazzo Vescovile at Verona in 1556.[2]

The pressure of Paolo's models does appear, however, in Brusasorci's rather later frieze in the Palazzo Ridolfi-Lisca, depicting ceremonial cavalcades of Charles V and Clement VII. Brusasorci still insists here, more than the contemporary Paolo, on a specifically Maniera elegance, not only in form but in quality of handling. The *Cavalcades* show an almost fragile delicacy of touch, which Brusasorci expresses in manipulations which, despite his ingenuity of play with colour, seem more draughtsmanly than painterly. It was only towards the end of his career that Brusasorci took on a decisively Venetian cast of style (*Madonna in Glory and Two Saints*, Verona, S. Pietro Martire, 1566), and in his case it was an unfortunate concession.

Brusasorci's status in Verona was challenged, even before he vacated it, by Paolo Farinati (1525-1606), almost a decade younger, and more nearly Paolo Caliari's contemporary. If Farinati was (as Vasari says, VI, 374) a pupil of Giolfino, the most archaic painter of Verona, it had no visible effect. He seems to have responded early and strongly to Central Italian ideas of style, particularly as he found them in Giulian Mantua and also as he could study them, Vasari tells us, in reproductions after Michelangelo. Farinati was thus from the beginning more Romanist than Paolo Veronese, and when he chose about 1560 to adapt himself to the model Paolo's style offered it was with a yet more plastically emphatic as well as mannered accent (*Ecce Homo*, Verona, Museum, 1562). But a painterly mode, employing deeper chiaroscuro and less polished handling, came to succeed this Romanizing paraphrase on Veronese (e.g. *Deposition*, Grenoble, Museum, 1573); however, this was not an index of a clear accommodation with the art of Venice. On the contrary: Farinati's pictures of the later sixties and the seventies are less imitative even of Caliari's style, and partly replace his models by those of the twin deities of Parma, Correggio and Parmigianino. By the later seventies (*Madonna with Three Saints*, Frassino di Peschiera, Santuario di S. Maria, 1576) Farinati's style had become a late Maniera broth cooked up from ingredients found in near-by Emilian, Lombard, local Veronese, and (least of all) Venetian sources, and its place of origin could almost as well have been farther to the west or south. It was only in the last two decades or so of his very long career that Farinati turned towards Venice again, renewing his old dependence on Veronese (or rather upon his heritage), and incorporating aspects of Tintoretto's or the young Palma's style; but even at the end Farinati remained a mannered artist.

A large dependence on Emilian Mannerism is still more apparent in the painting of Bernardino India (1528-90), whose style just after the mid century (e.g. *Holy Family with St Catherine*, Verona, Museum) recasts Correggio's and Parmigianino's models in an effort to make them consonant with Giulio Romano's: the result is an academicism at once ponderous and mincing. It lightened the tone, but not the essential temper of Bernardino's work when he later added, to this Emilian-Lombard formula, a strong accent of Paolo Veronese (*Madonna with St Anne and Angels*, Verona, S. Bernardino, 1579). Orlando Flacco (b. *c.* 1530) finished Bernardino India's most extensive work, a votive *telero* in the Sala del Maggior Consiglio in Verona. He was as pedestrian as Bernardino, but more disposed towards Paolo Veronese.[3] Felice Brusasorci (*c.* 1540-1605), Domenico's moderately gifted son, carried the frequent Emilian inclination of the Veronese one step farther, for he went to Florence, probably after 1557, and worked there for some years. He did not settle permanently (as did his compatriot Jacopo Ligozzi)[4] but returned to Verona, possibly about 1570, and seems to have resided there until his death. We have no accurate

evidence of the work Felice did in Florence, but what he did following his resettlement in Verona is not original, nor is it even conspicuously Tuscanized. His paintings first tended to resemble his father's (to the point of frequent confusion), and later Paolo Farinati's as they were in the eighth and ninth decades. Felice's style is more fussily and mechanically ornamental than Farinati's: it is a busier and even less inspired aspect of the Maniera's expiring phase.

Neighbouring Vicenza, so distinguished in architecture in the second half of the century, achieved no parallel distinction in painting. It was intermittently the place of practice (and close to the birthplace) of the eccentrically gifted Giovanni Demio. Paolo Veronese had worked near by in the Palazzo Porto at Thiene, as had Zelotti; and Zelotti, though Verona-born, left more work in Vicenza than in his native town. The chief Vicentine painter of the time, Giovanni Antonio Fasolo (1530-72), was formed in the atelier of Paolo Veronese, of whom he is recorded as a helper in Venice (in the ceiling decorations of S. Sebastiano) in 1556. An altar painting of the *Pool at Bethesda* (Vicenza, Museum, from S. Rocco, *c.* 1565) reveals the skill with which Fasolo manipulated the style he learned from Veronese.

Fasolo was already working independently as a fresco decorator in 1557, and again in 1562, in Palladio's Teatro Olimpico, and the rest of his brief career was in the main that of a *frescante* who exercised a fine gift for Mannerist *capricci* in his schemes for decoration of Vicentine palaces. He employed a painting style in them which, though it deviated less than Zelotti's from the model set by Paolo Veronese's, diverged from it in like directions: on one hand towards more *maniera*, and on the other, conversely, towards more naturalism. Fasolo's handsomest and most expansive decorations survive in the Palazzo Porto-Colleoni at Thiene and in the Palazzo Coldogno, both near 1570.

In the field of religious painting in Vicenza the chief place belonged to Giovanni Battista Maganza (*c.* 1513-1586), whose disposition seemed to suit a local churchly taste exactly opposite, in its lack of fantasy, to that supplied by Fasolo or Zelotti for their secular patronage. Maganza (a reputed pupil of Titian) made a modest concession to the local fashion favouring Veronese, but in the course of time became an eclectic painter of the type of Palma Giovane. It is to the Palma syndrome that Giovanni Battista's son, Alessandro Maganza (b. 1556), still more openly belongs.[5]

EMILIAN CENTRES

By the middle of the century the process of conversion of Emilian painting to the Maniera was virtually complete. Parma had been a wellhead of the style for the north of Italy since Francisco Mazzola's return in 1531; Mantua (Lombard rather than Emilian only by an accident of boundary) had been a major source for the spread of Giulian Mannerism since the same time; Florentine example and influence pressed from the south. Bologna had housed the major carrier of Maniera, Parmigianino, for a brief sojourn, too early to have much effect on its conservative artistic climate, but finally even the Bolognese had yielded to the rising pressures on them of modernity. However, it was towards the Vasarian Maniera that they then turned, more than to the locally accessible example of Parmigianino. They thus adjusted themselves to the new style's most cautious variant, and carried their conservatism with them into it. The generality of painters in Bologna used Maniera make-up to give their retardataire styles a modern face of academicism, more nearly consistent with the mentality of Maniera. Among the Bolognese of the high Maniera generation only Pellegrino Tibaldi does not have this academic limitation (but his practice as a mature artist in Bologna was for

less than a decade), and in near-by Reggio there was a counterpart for Tibaldi in inventiveness and individuality in Lelio Orsi. Despite the general academicism, it was in the Bolognese milieu that, in the 1580s, the most vigorous symptoms in North Italy of a new and un-Maniera attitude towards art appeared, from which the pupils of the latest academic Mannerists laid, well within the limits of the sixteenth century, the perceptible foundations of the next century's style.

The first among the Bolognese to make close contact with Maniera other than that of Parmigianino was Prospero Fontana (1512–97). A pupil at first of the Raphaelesque Innocenzo da Imola, Fontana had gone off young to Genoa, where he was employed as an assistant to Perino del Vaga in his decoration of the Palazzo Doria. Fontana afterwards found work with Giorgio Vasari's rapidly expanding *équipe*, and assisted in Vasari's schemes both in Florence and in Rome. In 1551, in Rome, he worked beside the young Taddeo Zuccaro in the Villa di Papa Giulio. About 1560 he was called to Fontainebleau by Primaticcio, but remained only briefly. In 1565 he again worked for Vasari among the artists of the *apparato* for the wedding of Francesco de' Medici. Fontana was thus repeatedly involved with the Maniera, in its Vasarian form particularly, from a relatively early time. It is surprising that he was so long in making a successful adaptation of it: in 1545 a *Transfiguration with Saints* (Bologna, S. Domenico) is still an uncertain and mostly conservative work. It was only in the fifties that he turned his style into a near-counterfeit of the current Vasarian Maniera (as e.g. in the *Disputation of St Catherine*, Bologna, Madonna del Baraccano, only approximately datable *c.* 1560). He then maintained this style, with fair fidelity, throughout almost two decades. In the seventies an unexpected element of novelty appeared within his art, until then so thoroughly derivative. Though his style

remained within a Maniera, it became much less Vasarian, and it is strongly touched by a more natural mode of seeing and design, which seems to have been inspired in part from Venice and perhaps in part from Lombard art. The element of naturalism in description, and a conviction in expression that accompanies it, in such late altars as Fontana's *S. Alessio distributing Alms* (Bologna, S. Giacomo, 1576) is sufficient to identify a new, late, phase of Maniera, with tendencies within it that could grow into another and eventually non-Maniera style.

The oldest of the Bolognese Maniera painters thus became, towards the end of his career, an early agent of dissent within Maniera, and in this is more progressive than almost – but not quite – all of his younger Mannerist colleagues in Bologna. But it is true particularly of Lorenzo Sabatini (*c.* 1530–1576), who joined Fontana in his close following of Vasarian example. Sabatini was in contact with Vasari from the early sixties, and in 1565 was in Vasari's decorative corps in Florence; he was esteemed enough there to be elected a member of the Florentine Academy. Within the Vasarian formulae that he adopted, Sabatini held into the sixties to elements of a pedantic Raphaelism acquired from the pre-Mannerist Bologna school (*Assunta*, Bologna, Pinacoteca). In the fresco of *Four Church Fathers* (Bologna, S. Giacomo Maggiore, 1570) there is also a specifically Emilian accent but of a more modern kind, dependent on Parmesan Maniera. In the early seventies Sabatini moved to Rome, and there again worked for Vasari as his principal assistant in the campaign that finally completed the Sala Regia of the Vatican (1572–3); his concession there to Vasari's worn but still formidable authority is complete. But before he died in Rome, Sabatini painted at least one large religious work, a *Pietà* (Rome, St Peter's, sacristy), in which his Bolognese conservative and classicistic disposition re-emerged, solicited by the example of the Counter-Maniera

style of Rome; an exported tradition of Raphaelism and a native one thus converged.

Orazio Samacchini (1532–77), a close friend of Sabatini, was no less bound at the beginning to the conservative Raphaelesque tradition of his school, but he was an artist of much more energetic disposition. When Sabatini went to work in Florence for Giorgio Vasari, Samacchini instead went to Rome to study independently and work. In 1563 or 1564 he was employed in the most distinguished Roman artistic company of the time (including Taddeo Zuccaro) in Pius IV's programme of decoration in the Sala Regia. The Maniera he acquired in Rome was mainly on the Raphaelesque pattern of Taddeo's and of Siciolante's; to these he added, after his return to Bologna, a vigorous Michelangelesque condiment from his compatriot Tibaldi's style. The *Madonna with St James and St Anthony* (Bologna, S. Maria Maggiore, before 1570) is a sample of the compound he made then. But the artistic climate of Bologna began to exercise its chastening effect on Samacchini, making his style drier and more like Vasari's (*Purification*, Bologna, S. Giacomo Maggiore, 1575) and, at the end – also like an aspect of the late Vasari – athletically ponderous (*Coronation of the Virgin*, Bologna, Pinacoteca; *Annunciation*, Forlì, Pinacoteca).

There was a brief infusion of vitality into the academic climate of Bologna when, during the sixth decade, a former native son, Pellegrino Tibaldi (1527–96), returned from Rome, apparently after an intervening stage spent in the Marches, in Loreto and Ancona. He remained in Bologna for a few years only, but in this time he was responsible for the most significant events of mid-century Bolognese art. In the 1560s he moved on to Milan and its neighbourhood, where he did little painting but turned in the main to architecture instead, working especially on the Duomo of Milan under the high patronage of Carlo Borromeo. For eight years at least, from 1586 to 1594 (or perhaps 1595), Tibaldi resumed his painter's role for Philip II at the Escorial in Spain. He returned finally to Milan, dying there rich and ennobled.

This lively career had begun in Bologna, with exceptional precocity, before 1540. There is no indication in Tibaldi's *Marriage of St Catherine* (Bologna, Pinacoteca), done probably when he was fifteen or little more, of the painter's immaturity. Its style is based upon the local classicist precedent of Bagnacavallo and Innocenzo da Imola, which Tibaldi has modified with an elegance of draughtsmanship acquired from Maniera and a canon that is vaguely Michelangelesque. Form has an exceptional degree of clarity and an insistent plastic strength. Perhaps as soon as 1543, but by 1545 or 1546 at latest, Tibaldi had carried his precocious skills to Rome, and found employment for them in the atelier of Perino del Vaga, working in the decoration of the Sala del Consiglio of the Castel S. Angelo. With swift efficiency Tibaldi substituted for the retardataire model he had brought to Rome one closely modelled on Perino's. The brilliance of his adaptation of the master's style, distinguished beyond that of Perino's other helpers in the Sala del Consiglio, earned him the succession of the commission when Perino died. From late in 1547 into 1549 Tibaldi was engaged in the completion of this major decorative scheme, adding some elements of his own design (including the grand *St Michael* and at least one illusionistically painted doorway) to what he had executed for Perino earlier.

Perino's style in the *Alexander* frescoes of this room had been the farthest concession he had made to Michelangelism; since Perino's death – or, perhaps, beginning even before – Tibaldi had accelerated the strong tendency in this direction. His reworking of Perino's Michelangelesque Maniera exceeds the original in plastic power and in the fusion between muscular exaggerations and charged, elaborating grace. Moving in Michelangelo's direction beyond

Perino's lead, Tibaldi's disposition conforms to what we have recognized as the leading current of the mid century in Rome, consonant with the direction that Perino's older, shortly previous major helper, Daniele da Volterra, had taken. And as in Daniele at about the same moment, the specifically Perinesque element within Tibaldi's style decreased. An *Adoration of the Shepherds* (Rome, Borghese) signed and dated 1549 – the painter was then only twenty-two – is more overtly Michelangelesque than

the contemporary Daniele in temper as well as in motifs, and asserts more, at a higher pitch, of formal and psychological complexity. Yet it should be emphasized, despite these differences, how much Tibaldi's power of form, taut energy of space, and narrative conviction resemble the example of Daniele; they may owe something to it. About 1550 Tibaldi actually worked for Daniele, it would seem more as an associate and friend than in the role of an assistant, in the painting of the vault (now

252. Pellegrino Tibaldi:
Sala di Ulisse (detail), *c.* 1554/5(?).
Bologna, Palazzo Poggi

ruined; with Marco Pino also) of Daniele's Cappella Rovere in the Trinità.

Pellegrino continued to paint in Rome (in S. Luigi dei Francesi, in the Belvedere of the Vatican, in S. Andrea in Via Flaminia) until late in 1553, when he accepted a commission to decorate a chapel, at that time dedicated to St John the Baptist, in the basilica of the Santa Casa at Loreto. The frescoes he painted there are part destroyed and part removed; the *staccati*, preserved at Loreto, are in bad state. Payments for this decoration are recorded until December 1554, and for other, lesser painting at Loreto in July 1555; long lapses in the documentation, presumably indicating absences, exist for most of the latter half of 1554 and the first half of 1555. It seems more likely in these intervals, rather than after his whole work at Loreto, that Tibaldi undertook his most important decoration in Bologna, in the Palazzo Poggi (now the University; succeeding Niccolò dell'Abbate, who had left for France in 1552). Tibaldi's main work in the palace is in two rooms illustrating the story of Ulysses [252], at least as brilliant in the use of Maniera decorative conceits as the exactly contemporary Roman work of Salviati.[6] Tibaldi's scheme is full of Roman references: to Perino del Vaga's *Nikes* in the Sala dei Pontefici, to the fictive architecture in Raphael's Logge, and above all to the Ignudi of the Sistine Chapel. These last Tibaldi re-creates as vehicles of an astonishing illusion and in an entirely Maniera paraphrase, refining their extravagant posturings in a charged contour and a flexing modelling that give the sense of an expansion from within, as of an imminently bursting pod. In the narrative fields single forms and combinations of them are as if galvanized into exciting patterns, in relief against or moving into an expanding and elastic space. The communication of the affects made by form is at an intense pitch, and these are affects of a Maniera repertory: of experience made strong, quick, sharp, and precious, prob-

ing after excitement and surprise, and always mindful of the transformation of experience into artifice. The illustrations, full of wit, take their temper from the working in them of this artifice more than from their ingenuity of narrative device; and the largest fields of the decoration have, rather than a subject matter, a meaning that resides in a conceit of form.

Probably just following his decoration in the palace Tibaldi went on to a religious decoration for the same patron, in the Cappella Poggi in

253. Pellegrino Tibaldi: Conception of the Baptist, *c.* 1555. *Bologna, S. Giacomo Maggiore, Cappella Poggi*

S. Giacomo Maggiore (*c.* 1555).[7] There two fresco laterals (which, however, are of high arched shape) depict episodes from the life of St John the Baptist, the *Conception of the Baptist* [253] and the *Preaching to the Multitude*, in a confusingly elaborate iconography; like the

Ulysses scenes, they are full of Roman references made for reasons of art rather than of illustrative efficiency. Tibaldi makes a forcing demonstration of his virtuosity in both frescoes, packing them with figures of impressive density and – in the *Conception* especially – power of movement. In the *Conception*, however, the sense of seeking after grand effects seems too premeditated. Impressiveness shades into ponderousness, grand style into booming rhetoric. Even earlier Tibaldi's temper had inclined towards heaviness and over-emphasis; he had learned a saving grace in Rome. Now, after so short a time back in Bologna, even his genius began to yield to the climate of artistic pedantry.

The change that began in Bologna was accelerated in a much more provincial context to which Tibaldi moved, apparently in 1558. He seems to have been mostly in Ancona from that year to 1561. His chief effort there, a fresco decoration in the Loggia dei Mercanti, is ruined, but the laboured gigantism which it apparently showed appears in a secondary decoration that Tibaldi left, in the Palazzo Ferretti. An altarpiece for the church of S. Agostino, a *Baptism of Christ* (now Ancona, Pinacoteca), employs the formulae of the Palazzo Poggi in a chastened way in its predelle (Milan, Brera and elsewhere), but in the major panel shows a weighty and simplistic style, almost devoid of ornament and tending – perhaps from exposure in the Marches to Venetian influence – towards naturalism. An atmosphere of religious sobriety native to the provinces (and increasing under Counter-Reformation pressure), and Tibaldi's own native strain of ponderousness have converged to shape a work which, if it were somewhat more visibly charged with conviction, could be taken as a demonstration of Counter-Maniera. It is *post-facto*, but may be relevant, that in Ancona in 1561 Tibaldi met Cardinal Carlo Borromeo, and soon afterwards enlisted in his service as an

architect in Pavia and Milan. Until 1586, when Tibaldi began work in the Escorial, he did little painting. In Milan only his cartoons for windows in the Duomo remain (now Ambrosiana); and on one of his longer sporadic visits to Bologna he painted an *Allegory of Silence* in the Palazzo Accursio (now Bologna, Museo Civico, 1569) and a *Blinding of Polyphemus* in the Palazzo Sanguinetti (1570), both in a heavy, academicized Maniera.

What Tibaldi did when he resumed painting in Spain, in the last decade of his career, is more interesting as a phenomenon of art history, and some of it may even lay claim to interest as art. At the Escorial he followed Federico Zuccaro into Philip's employ by some months, and when Federico was relieved of his commission in 1588, replaced him. Tibaldi's first campaign of work in the monastery was in its great cloister, where (with extensive assistance) he illustrated, over life-size, the *Life of the Virgin* and the *Passion of Christ* [254]. His style in these (and in his altar paintings for the Escorial also) is based upon the ponderous and rather vacant mode he evolved in the rare paintings of his Milanese years, but moves beyond it in a new – though perhaps negative – direction. There are evident residues in the frescoes of the habits of Maniera, but it is more important that these and every other element that has gone into the making of the images have been converted to a dominating purpose of simplistic exposition. Even more than in his paintings of the recent past, in these frescoes Tibaldi over-generalizes form and employs a consonant colour, also over-generalized and high in key. His generalizing contains within it, and controls, a considerable descriptive naturalism; by stylizing the naturalism to a moderate degree the generalization makes it at the same time more simply legible and more reconcilable with classicistic – academic – taste. The means of art are used to serve the ends of an illustrative lucidity that on one hand is respectable and

254. Pellegrino Tibaldi and assistant: Ecce Homo, before 1589. *Escorial, Cloister*

'correct', and on the other deliberately pedestrian. This mode is not unique in this time to the aged Tibaldi, but it is more finely (and extensively) characterized by him at the Escorial than by either of his Italian predecessors there, rather similarly inclined, Luca Cambiaso and Federico Zuccaro. This is a major one among the kinds of illustrative art that the Counter-Reformation summoned forth – in this case, it must be remembered, from an artist long in S. Carlo Borromeo's service, and now in Philip II's – and which conservative and relatively well-bred piety would call to life again two centuries later. The parabola in Tibaldi from high Maniera into *arte sacra* is only more extreme than it is in some of the best of his contemporaries.[8]

Tibaldi's second major work at the Escorial was the decoration of the monastery's library (1591). Within a severe, rather arid, geometric scheme, the main elements of the decoration are great figures, foreshortened on the vault, who personify the Trivium and Quadrivium – close-gathered, bulking forms, hard-shining and largely generalized. What had become a nearly academic Maniera in Tibaldi's later art, or converted to the use of the *arte sacra*, has been transformed here into something more aesthetically positive, a grandiose abstracting neo-classicism, of disquieting impressiveness.

Tibaldi's span of authentic creativity in Bologna was a brief one and did not substantially alter the complexion that painting in the city had.[9] Prospero Fontana was little affected by Tibaldi, his companions Sabatini and Samacchini more so, but still not profoundly, and the conventionalized Maniera of this pair was very soon again Bologna's dominating style. It remained so for some years following their deaths, into the last quarter of the century, even as the stirrings of a significant new invention began to be apparent. Prospero Fontana, as we noted, painted till the latest years of the century. It was his late manner, responsive to an atmosphere of change, that laid the bases for the style of his painter-daughter Lavinia (1552–1614) but did not inspire it with any comparable interest.[10]

The example not only of Fontana but of Sabatini shaped the style of a Fleming who assumed great prominence in the city in the last quarter of the century, Denys Calvaert (Dionisio Fiammingo; 1540-1619). He came to Bologna from his native Antwerp about 1560, trained already as a painter, but set himself to learn the Italian style first with Prospero Fontana, then with Sabatini. He accompanied Sabatini to Rome in 1570, helped him in his painting in the Sala Regia, and studied Roman painting diligently. Returned to Bologna soon after 1573, he opened a school that in time

attracted pupils as distinguished as Domenichino, Reni, and Albani: the classicistic inclination that they share, their air of academicism, and their tendency towards sentiment may have to do with the effect on them of exposure to Calvaert's doctrine and practice. His own early Maniera (*Martyrdom of St Ursula*, Bologna, S. Maria della Vita) was excessively *léché*; gradually his form acquired breadth, and in the eighties an evident inclination towards naturalness. It is not certain what the order is of cause and effect, but Calvaert became a student of Correggio's art and a propagandist for it. Motifs, types, and quality of expression became openly dependent on Correggio's (*Virgin appearing to St Francis*, Bologna, Pinacoteca; Dresden, Gallery, the latter dated 1589), and his handling became that of a Correggio imitator, but it remained *léché*. Whatever style he espoused and on whatever scale he worked, Calvaert was a *maestro di maniera piccola*. He could change to a new mode, but he could not create in it. And his turning to Correggio, and his use of Correggesque style to displace his previous Maniera, was less likely his own invention than a following of the young Carracci.

Bartolommeo Passarotti (1529-92) made fewer gestures in the direction of Carraccesque modernity, but his art conveys a more convincing sense of search, invention, and directed growth – all, however, within limits still defined by the Maniera style. He let certain of his ideas strain these limits, verging upon the terrain of the young Carracci (of whom Agostino was among his pupils): a vision liberated in part by Passarotti's own inventions, and thus freer from traditional constraints than his, could turn some of the things he had implied into more radical, artistically novel facts. Passarotti had the early advantage of an education that removed him from Bologna, apparently for about fifteen years: probably on the invitation of the architect Vignola, he had gone to Rome and there become a pupil of Taddeo Zuccaro. He

worked in Rome from about 1551 nearly to 1565, gaining reputation chiefly as a portraitist, a field in which he would work all through his career with much distinction. On his return to Bologna, Passarotti's altar of the *Virgin Enthroned with Saints* (Bologna, S. Giacomo Maggiore, 1565) shows little that can be attributed precisely to his schooling with Taddeo. It is an aberration, even in terms of Passarotti's own history, in which for a moment he appears to join the school of Parma, making an enamelled transcription – not unlike the recent Bedoli's but more faithful – of Correggio's style; this long antedates Calvaert's Correggism. Fifteen years or so after it was painted, the altar may have been a bridge to the real Correggio for the Carracci. If so, aberrant as it was in 1565, the S. Giacomo altar stands as the *proto* in Bologna of the later, important, Correggio revival.

This was Passarotti's last extra-Bolognese gesture before the suffocating local marshals of the Maniera, Sabatini and Samacchini, claimed him. By 1570 (*Madonna in Glory with Dominican Saints*, Bologna, S. Petronio, dated) he was substantially their captive. He showed his own identity only within the bounds of their general formulae, in a more pointed energy of forms and in episodes of his portraitist's tendency towards naturalism. Too restless to endure this brand of academic tedium, Passarotti shifted allegiance, but still within the Maniera, to the models Tibaldi left in Bologna in his best years. Altars painted about 1575, such as *Crucifixion with St Francis and St Bartholomew* (Bologna, S. Giuseppe; destroyed in the Second World War) and an *Ecce Homo* (Bologna, S. Maria del Borgo) [255], may be the only paintings in the school that rival the merit of the style they imitate. An *Adoration of the Magi* (Bologna, Palazzo Arcivescovile) recedes towards a more conventional Maniera; by this time, at the end of the eighth decade, Tibaldi's fancy mode of the middle sixth had become too

The *maniera* of contemporary society, as well as his own aesthetic predisposition, informed Passarotti's portraits throughout his brilliant career in this field. Attitude and expression in his portraits have a conspicuous dry elegance, and form is attenuated and sharp in silhouette. A technique that records optical effects is used unsensuously, differing even more (until Passarotti's later years) from a Venetian optical style than does the contemporary portraiture of the Bergamasque Moroni. On this basis of a chastened optical naturalism, a Maniera draughtsman's sharp-accenting hand delineates detail and at once stylizes it. Late in his career Passarotti's portraits make more nearly assertive optical effects, but he still does not diminish his Maniera linearity of silhouette and accent.

Another more exceptional aspect of Passarotti's art deserves more consideration than our space permits. This is his work in a curious and special genre which combines still life and realist human caricature in scenes of butcher's shops. Only a few survive (e.g. Rome, Galleria Nazionale [256]; Florence, Longhi Collection). Their obvious source of inspiration is Flemish painting of the kind produced by Pieter Aertsen, and of which there had been a more pallid echo, earlier than in Passarotti, in the Cremonese Vincenzo Campi. Passarotti's first works in this genre may date from about 1575. The strident realism of both theme and (in the still life) descriptive technique, in places approximating a *trompe-l'œil*, is in one sense surely counter to the precepts of Maniera, and an index of the path the imminent redirection of artistic style was to take. But at the same time this foreign-inspired novelty, startling as it seems in the surrounding context of Maniera, is treated in still more essential ways according to the demands of a Mannerist mentality. Not just the low-life persons, but the still life even more, make vibrating equivocation between illusion and the power of ornament imposed by

255. Bartolommeo Passarotti: Ecce Homo, *c*. 1575. *Bologna, S. Maria del Borgo*

disparate from current taste. Passarotti did not just reassume the Bolognese academic formulae: certainly they are in his *Presentation of the Virgin in the Temple* (Bologna, Pinacoteca, *c*. 1583), but at the same time in this picture Passarotti seeks new ways in which to manifest his inclinations towards naturalism, in a simpler and more explicit way than he had done before. Perhaps no more than three or four years afterwards, a *Presentation of the Infant Christ* (Bologna, S. Maria della Purificazione) marks a decisive change, in which the roles of Maniera convention and naturalistic inclination are reversed. Maniera is a residue, visible but of far less importance than the conviction and immediacy of description – in a mode, however, that is no longer Passarotti's own but assimilated with quick intelligence from the Carracci.

256. Bartolommeo Passarotti: Butcher's Shop.
Rome, Galleria Nazionale

colour and by fine-edged line. More, the artist's subjective intrusion into the still life is not just aesthetic – it is, so to speak, moral: it is unquiet flesh that he describes, outraged by the butcher's hook and knife. The first look of these pictures is of a humorous genre, a little too startling and insistent in its effects, but its deeper aspect is of pain and pity; it is a moralizing Mannerist *concetto*, far from the tenor of genre painting which, inspired in part by Passarotti, Annibale Carracci would undertake.[11]

Whatever symptoms may have existed among Bolognese painters brought up in the Maniera of a significant redirection of style, it was only the Carracci who, in union but in distinguishable ways, achieved it. By the last years of the ninth decade their liberation from

Maniera was effectively complete, and the foundations had been laid of a style which, disseminated by Annibale in Rome after 1595 and in the north of Italy by Lodovico's school, was to be the major shaping force on painting in the century to come.[12]

In Ferrara, a painter only a little older than the Carracci negotiated the transition into the seventeenth-century style, in a way that is peculiarly instructive of the differences between it and its antecedent. Ippolito Scarsellino (Scarsella, *c.* 1550–1620) first emerged about 1570 in Ferrara in an artistic climate that had been undistinguished since the Dossi, Garofalo, and Girolamo da Carpi died. The interval had produced one painter of some interest, Sebastiano Filippi, called Bastianino (*c.* 1532–

1602), the ablest representative of a durable Ferrarese artistic family.[13] Though trained first by his father in the local style, Bastianino chose to find a less provincial mode in Rome, where he is supposed to have spent seven years. He returned to Ferrara about 1553, a complete epigone of Michelangelo. He tempered his Michelangelism somewhat in his decorative works, but in his religious paintings leaned upon the master with a fidelity more exact than anything in Rome itself. A *Last Judgement* altar in Rovello Porro (Arcipretale, *c.* 1565) and the same theme in a vast fresco in the apse of the cathedral of Ferrara (commissioned 1577) are dedicated re-creations, for the benefit of Bastianino's local audience, of what he could summon up for them of Michelangelo's late style. Even in these paintings, however, Bastianino gave evidence of attachment to a local taste for colour, in the final analysis dependent upon Venice. He had begun as soon as 1570-5 to expand the bases of his art towards Venice, referring explicitly to the latest Titian: Bastianino thus reasserted in its extremest form the conflict of allegiance that since the beginning had beset Ferrarese Cinquecento painting. Almost as if in reply to the setting off of Rome against Venice, in the specific persons of Michelangelo and Titian, that was a burden of contemporary art-literature, Bastianino tried to reconcile the two. Remarkably enough, there is a real sense in which this aspiration, at once heroic and provincially naïve, succeeded - not just in quantitative terms or in merely imitative ones. Works like his *Resurrection of Christ* (Ferrara, S. Paolo, *c.* 1580?) or the *Christ in Limbo* (in the same church but of later date) fuse rough power of large form with dark opulence of colour, and these means are at the service of a ponderous but strong emotion and imagination, with which Bastianino forges - out of his eclectic programme - an idiosyncratic style. He attains a pathos which in some ways seems clumsy and pretentious, but in others is grandiose and movingly sincere.

From about 1570 until Bastianino ceased to paint (perhaps in 1596, when he is said to have gone blind) he was increasingly required to share his local eminence with Scarsellino. Scarsellino was a painter of entirely different temperament, intimate and subtle, with much in him of the disposition of a *Kleinmeister*. Even when he was called upon to paint dramatic subjects, or on a public scale, it was a private sensibility that mainly prescribed the tenor of his art. He resurrected a strain in Ferrarese Cinquecento painting that had been important especially to both Dossi, of cabinet pictures meant for the taste of connoisseurs: rich in light and colour, sensuous in effects of handling, and informal in interpretation of their subject matter. These cabinet paintings, which had been only part of the Dossi's practice, became the main matter of Scarsella's.

It was essentially a regenerated Dossesque language with which Scarsellino started, and regardless of elements of artistic vocabulary which he eclectically adopted from elsewhere, his mode of seeing and emotion remained in that essential vein. The son of a painter, Sigismondo Scarsella (who later came to be a follower of his more gifted son), Scarsellino is known to have studied as a youth, in the later sixties, in Bologna and in Venice; and though it is not reported in the older sources, he certainly knew the art of Parma. But only some among his early pictures of the eighth decade are touched explicitly by Parmesan or Bolognese Maniera; where he reacts sympathetically to Maniera, it is rather in terms of its Venetian variant, in Jacopo Bassano and in Schiavone, and occasionally in Tintoretto. More than to any Maniera component of the contemporary Venetian art he knew, Scarsellino responded to examples and to values that perpetuated those of classicizing, nature-oriented, coloristic styles.

257. Ippolito Scarsellino: Venus Bathing.
Rome, Borghese

Titian was a major influence (as, later and in lesser measure, was Veronese), and it was in the light of this un-Maniera mode in Venice that Scarsellino reinterpreted – as it were, back towards the original – the Mannerizing colorism, and the emotional style also, of his basic Ferrarese model, Dosso. By the early eighties Scarsellino had quite found his personal vein, represented by such sensuously beautiful small pictures as the *Venus Bathing* of the Galleria Borghese in Rome [257]. In these there is no significant difference from the general vocabulary of form we might expect to find in a classical Venetian mode, in the descent of Titian: the shapes of represented things, the manner of arrangement, and the selection and design of colour are based, as in a Titian, on

processes of classicizing idealization. Yet the end effect is evidently not the same, but conveys a novel quality akin to that in the exactly contemporary Carracci – without influence between them; the similar element of novelty has been independently conceived, and by like means. The classically reformed shapes do not retain the classical effect of ideal distance: the way of seeing and feeling them that Scarsellino's handling of texture, light, and colouring conveys lends each form a new degree of sensuous immediacy and intimacy. Increasing the sensuous attraction and the opulence of pure optical device, and at the same time seeking fine and intimate sensation in this sensuousness, Scarsellino alters the complexion of Cinquecento ideality, accomplishing a result that seems out

of proportion to its means. As in the classicizing variants of the seventeenth-century Baroque style, he gives an idealized image the effect of poignantly felt sensuous presence. As with Annibale Carracci at this very moment, Scarsellino's independent action represents reaction from the Maniera towards alternative precedents of style that are optical and naturalistic; that they were classical as well (wholly in the case of Titian, less so in that of Correggio) was relevant but less important.

Annibale Carracci was by far a grander personality and more powerful inventor than Scarsellino; in his reformation and invention both the classical element, which is the reforming one, and the new naturalism, which is the innovation, were more powerfully – and not antithetically – assertive. Scarsellino conceived no grand ideas or grand forms, and the effect of nature he creates in his art insinuates more than it commands. Scarsella's paintings differ in an essential way from Annibale's (or Lodovico's) in that the assertion that the paintings make of a natural presence yields primacy to the sense of presence of a work of art. Despite his convincingness of optical and sensuous effect we continue, in Scarsellino – as in works in Cinquecento classicizing style – to identify the picture first as an art-object, possessing an autonomous existence as an aesthetic idea that tells more strongly than the link with nature its mimesis may make. It does not minimize the distinction in Scarsella's paintings in intention and degree of mimesis from his antecedents in Cinquecento classical style when we observe that, like them, he combines sensuous imminence with poetic distance; it is as if he – not unlike his Ferrarese predecessor Dosso – were bound not just to Titian but to the inheritance of Giorgione.

The Counter-Reformation climate had made itself felt increasingly in Ferrara, changing the taste of Scarsella's patrons more, perhaps, than his own. From about 1590 onwards, secular themes yielded place in Scarsella's work almost entirely to religious subject matter. Especially after 1598, when the city was ceded to the Church, Scarsella became its most active painter of large altarpieces; but he still conceived them in the disposition, in respect both to form and quality of emotion, of a *Kleinmeister*. Intimate and yielding pathos and a consonant soft loveliness of surface characterize such altars of the first decade of the seventeenth century as the *Martyrdom of St Margaret* (Ferrara, Istituto della Providenza, 1604) or the *Decapitation of St John the Baptist* (Ferrara, S. Giovanni Battista).[14] About 1600 Scarsellino began to recognize that the ambitions he had independently realized before converged with those of the Carracci, but that the Carracci expressed them with more authoritative means. Increasingly afterwards Scarsellino came to borrow from them, more from Lodovico than Annibale . His two decades of work in the seventeenth century attest his continuing modernity, but it had become modernity achieved no longer by invention but by derivation.

An inclination towards Venetian models was an expected part of the Cinquecento Ferrarese tradition. Elsewhere in Emilia, more distinct from Venice, artists whose interests might lie towards an optical and coloristic style found a pole of attraction in Correggio instead. More than Titian it was Correggio who served the Carracci as a guide. But earlier, in the years around the middle of the century, Correggio's influence was less than that of his successor Parmigianino, even within Parma itself. And in the other centres of Emilia too the atmosphere was so much permeated by the preference for Maniera that even artists disposed towards the painterly ambitions of Correggio's art rephrased them with the accent of Maniera – not necessarily just that of Parmigianino but of other models of Maniera also. Lelio Orsi of Novellara (1511–87) may have been the most optically oriented painter of the mid-century

span in Emilia, closer to Correggio than the native Parmesans in quality of vision and, for a time, in mode of handling; yet throughout his entire mature career he was unequivocally Mannerist in style. Orsi's native town of Novellara and the larger near-by town of Reggio, where he also worked at length, lay in a region where the sphere of influence of Parma intersected with that of Bologna, and which Giulio Romano's Mantuan domain adjoined. Orsi was late to form a distinctive style, but when he did, in the later 1540s, it was by a personal and strong fusion of the best this environment contained. To a mode not only of seeing but of feeling based on Correggio – vibrant in seeing, and inspired with fine-edged passion – Orsi joined Maniera graphisms resembling those in the contemporary Bedoli: a *Christ in the Garden of Gethsemane* (Zagreb, Strossmayer Gallery, *c.* 1545) represents an early phase of his accomplished style. It may be Bedoli's influence as much as that of the Giulian style that then caused Orsi to seek more polished, less overtly Correggesque effects of surface and plastic form, but not for any classicizing ends. His *St George and the Dragon* (Naples, Capodimonte, *c.* 1550) shows how his way of feeling had become a specifically Mannerist extrapolation from Correggio's, excitable, precious, and eccentric all at once: obviously not in Correggio's dimension. Orsi worked in both Novellara and Reggio as a secular decorator on a large scale, and in the former town especially as a painter of façades, some of them brilliantly appropriating Correggio's illusionist devices to domestic purposes. But his decorations survive in fragments or in studies only, and our evidence for the monumental aspects of his style is sadly incomplete. Except as a decorator, Orsi worked almost not at all on a large scale (there are no surviving altar paintings). It may distort our measure of his art that we know it almost entirely in the form of cabinet pictures, which more than large-scale decorations came to be

his speciality.[15] Yet even these paintings in small dimensions, labouring fine effects, work as if upon a large scale. A restless energy of form and force of feeling seem to expand them: there is a magnifying tension in the difference between their expressive reach and their precious, jewelled technique.

In 1555 Orsi spent almost the entire year in Rome. The consequences for his style of this contact with the contemporary art of Central Italy were, most of all, a profound contamination from Michelangelo, and in addition, what might be more accurately described as a confluence of thought with Daniele da Volterra rather than an influence from him about interpretation of the master's art. After his return northward Orsi was equipped to understand the brilliant Michelangelesque high Maniera which Tibaldi was demonstrating at this moment in Bologna; again, however, Orsi's relation to Tibaldi seems more of confluence than influence. His style of the next decade and a half is, in its essentials, that which he formed at this time. The elements in it that owed their eventual origin to Correggio persist, but the elements of classicist or Mannerizing kind that he earlier fused with them are now transposed into the language of Michelangelesque Maniera. Especially at the beginning of this phase (e.g. *Martyrdom of St Catherine*, Modena, Galleria Estense, towards 1560) [258] the results are extraordinary in quality and kind, the only painting in the near vicinity of Bologna to rival Tibaldi's, in a manner at once related to and perceptibly distinct from his. The distinction is increasingly affirmed: as the interval since Orsi's return from Rome increased, so did the old Correggesque component in his style (*Christ on the Road to Emmaus*, London, National Gallery, *c.* 1565; *Adoration of the Shepherds*, Berlin-Dahlem, *c.* 1565-70). Orsi's inspiration did not always keep to this high formal and expressive level. In no measure comparable to what happened to Tibaldi, Orsi in his religious

258. Lelio Orsi: Martyrdom of St Catherine, *c.* 1560. *Modena, Galleria Estense*

paintings began in the later sixties to reflect the chilly symptoms of the rising pietism and eventually to show the brittleness of a late, no longer vital phase of high Maniera style (*St Cecilia and St Valerian*, Rome, Borghese, of the 1570s).

In Parma itself, where the Maniera descended in direct line from Francesco Mazzola, a similar desiccation of the style might well have occurred. Its signs were apparent enough in the paintings of the ageing Bedoli of the sixties, the last decade of his career, but an historical aberration intervened in this expected process: the appearance of Giacomo Zanguidi, called Bertoia, much too short-lived (1544-74), who chose to turn himself into a posthumous *alter ego* of Parmigianino. Bertoia could, at will, assume Francesco's style as if it were a native skin, infusing it immediately with creative life. This creativity made far more than imitation: Bertoia was able to extend the Parmigianinesque Maniera into a region of fantasy which Parmigianino had not explored, more rarefied, more oblique, and more concettistic, but much slighter too. If it is conceivable that Maniera should have a phase resembling a rococo, then Bertoia's phoenix play upon Francesco's art is it.

Once established, this Parmigianinesque vein was as if natural to Bertoia's art; however, subject matter or surrounding cultural circumstance conditioned the degree to which he thought fit to work in it. Though born in Parma, Bertoia had studied in Bologna (apparently with Sabatini), and his first surviving large commission, a banner of the *Madonna della Misericordia*, painted in Parma in 1564 (Parma, Gallery), is mainly Bolognese in style. Only its painted border, simulating an elaborate frame, suggests the style of Parmigianino. But in the next year Bertoia was commissioned to paint a fresco of the *Coronation of the Virgin* (finished before mid 1566) on the façade of the old Palazzo del Comune: the fresco is now almost wholly lost, but the remnants reveal Bertoia's swift and remarkably exact assimilation of Francesco's style. Evidence indicates that the younger painter was asked to serve in this commission as executant for a design Parmigianino had prepared some thirty years before (the drawing still exists, Parma, Gallery); it seems to have been for the purpose of this undertaking that Bertoia determined to engraft himself on to that master's past Maniera.[16] The consequences were fully realized soon afterwards, when Bertoia passed from imitation into free creation in independently conceived large decorative works, most important in the Parmesan Palazzo del Giardino. There, at a time of which we can fix only the limits, 1566-73, he was the inventor and executant of what may be the most engaging fantasy in North Italian decoration of its period, the so-called Sala del Bacio [259], as well as of a smaller room, now dismantled, of which fragments exist in the Parma Gallery; and he was at least in part co-inventor and painter of a large room pendant to the Sala del Bacio, the Sala di Orfeo.[17] In the Sala del Bacio (probably the latest of the set), conceits of enframement based on Bolognese and Mantuan recollections are treated with disarming cavalier illogic. Luxuriant and restless landscapes mostly serve as backgrounds, but on one wall (from which the room takes its name) Bertoia evokes an incredible architecture, a hall of crystal columns, capitalled and roofed in chiselled gold, in which beings (whom we see partly through the crystal) dance and embrace. Fragile and exquisite in form, they seem creatures resurrected from some Tanagrene antiquity, but they are moved by a spirit that is bizarre as well as playful. The *concetto* of persons, situation, and setting is the doing of a fine virtuosity of wit, sensibility, and performing hand, and makes a poetry that is graceful and luxurious *divertissement* - of another order than the *poesia* of Parmigianino, which in retro-

259. Bertoia: Sala del Bacio (detail), 1566/71. *Parma, Palazzo del Giardino*

spective contrast is differently grand. In quality as well as kind, this is the nearest analogue within Italy to the Maniera of the Emilian immigrants at Fontainebleau, to Niccolò dell'Abbate in particular. But even in this contemporary comparison there is a difference: Bertoia's form and meaning in these frescoes are more febrile and oblique and less subjected to a classicist control.

But Bertoia also, as we observed, could work where context and occasion required it in a more chastened mode, tempering his extreme of Parmigianinesque Maniera with the classicist – or even academic – accent he had learned earlier in Bologna. Late in 1568 Bertoia began to divide his practice between Parma and Rome (he had already been to Rome for a brief stay earlier). Exposure to the Roman climate of this time invited the development of classical tendencies, as well as the tempering of a style that in Rome might seem extravagant. Bertoia's moderation of his style is evident even in the first major work he was given to do in Rome, the beginning of the decoration of the Oratorio del Gonfalone. It was Bertoia who (in two episodes of work, in 1568–9 and in 1572) laid down the scheme of decoration of what was to become, after his premature death, the most important collective enterprise of art in Rome; he actually executed one scene, an *Entry into Jerusalem* [260], and the elaborate enframements of two bays. His contribution could have been more, but demands were still being made on him from Parma, where he returned twice for parts of 1571 and 1572. But interruptions caused by Cardinal Alessandro Farnese were more decisive: he captured Bertoia first part-time, and then entirely in the year or so before his death in 1574 to paint at Caprarola. Bertoia had worked there first in mid 1569, joining Federico Zuccaro as a collaborator in the Sala di Ercole but soon replacing him. Bertoia made important contributions to the continuing decoration of Caprarola, painting the vaults of

260. Bertoia: Entry into Jerusalem, *c.* 1572. *Rome, Oratorio del Gonfalone*

the Sale del Giudizio, della Penitenza, and dei Sogni and of the Anticamera degli Angeli.[18] The elements – classicistic and occasionally conventional – which make Bertoia's style more like that of his Roman context of Maniera decoration increase in these rooms. His Parmesan accent yields considerably, and he takes on the more urbane but less personal intonation of contemporary Rome.

Bertoia's were the last genuinely creative manifestations of the Maniera in Parma – alternatively, of the Parmesan Maniera, that style which in a special sense pertained to the city. While he made his extraordinary gestures for his ducal patron in the Palazzo del Giardino, the burghers of the Duomo were paying for the pedantries the visiting Bernardino Gatti and Lattanzio Gambara displayed in the frescoes of

the nave (1568–72). Few of the native masters working after the mid century were even as distinguished as this. Prominent among them were the ungifted son of Correggio, Pomponio Allegri (1521–93), and Bedoli's offspring, Alessandro Mazzola (1533–1608), no better endowed. Giovanni Sons (1553–1611), a Netherlander who had settled in the city, achieved a turgid competence in his adopted style.[19] Giovanni Battista Tinti (1558–1604), whose talents are not notable, nevertheless assumed the role and status of a renovator in the Parma school. It was he who in the middle eighties first inverted in favour of Correggio the primacy as model that Parmigianino had held for more than four decades. The motives of his return to Correggio resembled those of the contemporary Bolognese. When, about 1590, Tinti observed the greater clarity of purpose with which the Carracci turned their study of Correggio to account, he accepted their lead. He developed a particular mode of schematizing Correggesque forms and light, which seems to have given direction to a more able painter, Giulio Cesare Amidano (c. 1560–1630), and then in turn to Bartolommeo Schidone, the master with whom the history of seventeenth-century style in Parma properly may be said to start.

LOMBARDY

In Cremona the history of painting in the second half of the Cinquecento is in the main a family affair, an account of the heirs and dependants of the old, enduring Giulio Campi. As earlier, the city was a natural point of confluence of Emilian and Lombard elements of style, and these external pressures seem to have increased after the middle of the century: it is thanks to the different responses that these pressures provoked among Giulio's successors that they display, despite their common heritage, a remarkable diversity of style. Man-

tuan and Parmesan Maniera, the former particularly a component of the ageing Giulio's style, early became important elements in the art of his successors; so, however, did a reflection of the verism of the schools of Brescia and Bergamo, quite contrary to the ideals of Maniera. The role this non-Maniera style played was reinforced by a moral, even more than an aesthetic influence, exercised upon the painters of Cremona by Milan, where the mentality of the Counter-Reformation, under Carlo Borromeo's guidance, rapidly took hold.

Antonio Campi (1522/3–1587), Giulio's much younger (half-?) brother, was the most various of the younger Campi in his ways of dealing with these pressures and also the most original. Admitting and at times seeming even to force the possibilities of differences of style, he was also able, when he wished, to force union on them, adapting Lombard verism to the stylizing processes of high Maniera. His example in this only moderately conditioned Bernardino Campi (1522–91, a distant relative at best), a gentler personality, less inquiring as well as less inventive than Antonio. He chose to react less strongly to influence from Brescia or Milan, and to remain not only more consistent in his style but more faithful to the first school in which he had been formed, of Maniera that was mostly Emilia-inclined. Vincenzo Campi (1530/5?–1591), Antonio's younger brother, took the contrary tack and achieved his main fame as an early painter of still life cum genre, inspired by North European sources. In addition to their long activity in Cremona, all the Campi worked extensively in Milan itself, Bernardino in particular. Despite the conditioning of their style by the atmosphere of Milan their art, especially in its Maniera aspects, helped lighten the ponderous complexion the school of Milan bore in this time.

Antonio's early inclination seems to have been to master the formulae of Maniera that

261. Antonio Campi: Pietà with Saints, 1566. *Cremona, Duomo*

his teacher, Giulio Campi, had deduced from Emilia, but to make them more explicitly Maniera and more up to date. A dry elegance, more accurately reflecting the late Mantuan Giulio in particular, invests Antonio's first recasting of his older brother's style. His goal went farther than this, however: to assimilate the learned and virtuoso language of the classicist Maniera observable in Mantua and in prints that had their origin in Rome. In 1564, working at his first major commission for the rich market in Milan, he exhibited his command of this style in frescoes for the church of S. Paolo, of a *Conversion* and a *Martyrdom* of the Saint. It is thus a revolutionary matter that, two years later, a *Pietà with Saints* (Cremona Cathedral, 1566) [261][20] is in a style that, in succession to the Maniera of the frescoes in Milan, must be defined as an anti-Maniera: almost unidealized (intending in part to be bluntly literal in description), simplistic in design, and utterly direct in the communication of its meaning. Almost wholly devoid of ornamental value, of form or emotion, this picture is, in its context, radical and reactionary both at once. The aesthetic matter out of which it has been fashioned was ready to Antonio's hand – in past, more than in contemporary painting in Brescia, in Milan, and in Cremona itself – and we are able to identify it,[21] but this does not diminish the fact that Antonio has given this matter a new complexion and effect. We can only speculate what extra-aesthetic motives occasioned this invention in artistic style, but in the context of Carlo Borromeo's Milan, and close on the conclusion of the Council of Trent, it is likely that some existed. In any case, Antonio's result is the most immediate fulfilment of the requirements of a Counter-Reformation style. Following by two years the publication of the polemical *Degli Errori dei Pittori* by Gilio da Fabriano, Antonio's *Pietà* fulfils its requirements more fully than any work of Counter-Reformation Rome, accepting that religious painting should be less art than illustration, and even denying beauty because that might be an impediment to a response of piety from the common spectator. We have discussed elsewhere the ways in which this art that rejects Maniera is still in profound ways none the less of Maniera's kind: its verities incorporated into abstracting forms; its simplicity too close to classicist rigidity; its legibility promoted by schematic means. Nowhere so conspicuously as in these earliest efforts of Antonio in a Counter-Reformation style, in the later 1560s, is the sense of relation to the Maniera context so acute, as well as the effect, so characteristic of *arte sacra*, that its asserted objectivity is specious.

The *Pietà* of 1566 was followed by a painting more explicit in the qualities that mark a Counter-Reformation mode: a *Visitation* (Cremona, Museo Civico, 1567) [262], smoother, harder, and more rigid than the *Pietà*, denying (on the optical pretext of a night illumination) the traces of Brescian optical atmosphere that the *Pietà* contains. The nocturne was inspired in Antonio more probably by Brescian and Bergamasque example than by precedents in Pordenone, Giulio Romano, or Correggio,[22] and as he uses it here to begin with its purpose and effects are still ambivalent. Seeking out an unexpected aspect of reality, the night light means to make conviction with it, but at the same time serves to schematize appearances and make a virtuoso effect of the painter's art. Like the other facets of his innovation of a Counter-Reformation style, this is as much revival as it is novelty, but in its aspect of revival it appears to have been vastly influential. It may have been a point of departure for the subsequent Milanese; and the line of succession that leads from the nocturnes of Milan into Caravaggio and the seventeenth century is by now well known.[23] The probe these two important paintings represent was not exclusive, and it must be taken as an ex-

262. Antonio Campi: Visitation, 1567. *Cremona, Museo Civico*

263. Antonio Campi:
Centurion kneeling before Christ, 1581.
Cremona, Duomo

perimental counter-proposition to Maniera but
one that by no means displaced it as a valid
style. In the same year as the *Visitation* Antonio
did his handsomest Maniera altarpiece, the
Holy Family with Saints ('*della Colomba*',
Cremona, S. Pietro al Po, 1567), redolent of the
idols of Emilian style in Parma and of Giulian
Mantua.

The seventies saw a phenomenon no less
important than the novelty of Antonio's anti-
Maniera: his attempt to fuse the ambitions of a
new verism with the stylizations of a high
Maniera; we have remarked earlier that the
attempt was remarkably successful. Its best
results that still survive are in Antonio's fres-
coes in S. Sigismondo (*Christ in the House of*

Simon, 1577; *Baptism of Christ*, 1581) and his
Centurion kneeling before Christ [263] in the
Cremona Duomo (1581). Antonio's verism in
these works consists not only (as it could also
within a purer, earlier Maniera) of draughts-
manly details and plastic stress but of convic-
tion in effects of lights and surfaces; of ele-
ments of ordinary environment observed
keenly and trenchantly described, as are a cast
of characters who seem resistant in both face
and figure to the processes of idealization. Yet
all these are drawn with a sharp-edged cursive
line, sometimes wiry, sometimes deliberately
dry, of which the sensibilities and complica-
tions are those of Maniera, and of which the
temper permeates and in part transmutes what

it defines. The actors resist idealization, but cannot withstand the pressures on them of artificiality and preciousness. The states of mind that they reveal – not only by their quality of action but in countenance – are intense but also improbably refined. The proposition of an art made by a dialectic between verity and Maniera that Antonio sets forth in works like these is akin to the one that somewhat later was given its initial testing by painters in Utrecht and Haarlem. However, once accomplished by Antonio at the beginning of the ninth decade the idea had no further consequence for him. At the same moment he had already turned to a renewed and more aggressive exploration of a veristic style which, in his Italian context, was a more pressing aesthetic novelty, as well as more consonant with the circumstances of the Lombard culture of this time. An *Adoration of the Shepherds* (Milan, S. Paolo, 1580), compromising still, but only slightly, with Maniera, leans towards a naturalism that is almost genre-like. In 1581 a *Beheading of the Baptist* (in the same church) is a nocturne as harsh in contrast and as rigid in design as those Antonio had done a decade and a half before, and more literal in what it describes. Now, however, the artificial light does much more than assert the reality: it is a device which Antonio employs as a metaphor, transferring the salience and depths its contrasts make to the emotions of the described drama; and, no less important, it is used in such a way as to make poetry of its specifically visual effects. The nocturne is not just an emphatic way of redirecting art towards observed reality; it is the vehicle of an emotion, at once powerful and poetic, about it.

Also in Milan, Antonio's large *St Catherine in Prison* of 1584 in S. Angelo is a drama of strong emotions, enacted by assertive presences in a concrete place, in which nocturnal light is even more the novel and commanding factor. As there was the rigidity of a classicist and restrictive Cinquecento style in the *Beheading*,

so there is elaborate evidence of Maniera artifice of design and behaviour in this more stagey work. These are not unwanted residues but values to which Antonio positively held, and they maintain the Cinquecento tenor of his style. But save for this coloration of Maniera in him, Antonio's concept of the relation of art to reality had now become that which a major current of the seventeenth century was to entertain. This is accurately described as a proto-Caravaggesque style, for it occurred in the very moment of young Michelangelo da Caravaggio's arrival in Milan. Yet it should be noted that the tenebrist mode, of which Antonio Campi's pictures were the most advanced and powerful of this time in Milan, was not that in which Caravaggio began his career as an independent artist in Rome, some six or seven years later; he re-evoked it to become his special and extraordinary instrument only when the new century began.

Vincenzo Campi moved in a direction like his brother's, but more single-mindedly. The early religious works by him we can identify (from the later sixties, when he must already have been practising for a time) are in an Emilia-oriented Maniera, derived from the other members of the clan. His early portraiture, however, imitates an opposite mode, Brescian in origin and prosily descriptive, and it was on this Lombard axis that Vincenzo's interest and gifts inclined. Encouraged by the experimental turn in this direction of Antonio's most recent art, Vincenzo then followed it in his religious painting also. Since he entertained less complicated purposes than Antonio, Vincenzo soon outstripped him in the development of an altar-painting style of veristic tendency, suppressing effects of Maniera almost altogether. Once formed, Vincenzo's verism became a factor of style more pervasive and determining for him than for Antonio. Vincenzo used the descriptive means he had re-won from older Brescian and Bergamasque example not so intellectually

as Antonio and with more directness, seeking a different, more entire consistency of visually apprehended truth. About 1580 Vincenzo joined a modern Venetian component to his Lombard repertory, adding further means of optical conviction. On occasions his painting of the eighties may be related, more pressingly than Antonio's, to the change that Caravaggio was so much more efficiently to mature (*Annunciation*, Busseto, S. Maria Annunciata, *c.* 1580; *St Matthew and the Angel*, Pavia, S. Francesco, perhaps inscribed later with the date 1588).

At an undetermined moment in his evolution, but certainly not earlier than the middle seventies, Vincenzo started to work in a genre that in the contemporary Italian context must be regarded as an innovation of strongly 'realist' tendency. The genre consists of still-life painting which seeks a 'human' thematic pretext, as for example in the guise of market scenes, so that the still life is accompanied by figures [264].

But the figures are the secondary and the still life the primary matter; further, it is still life treated as an end in itself, not as material to make effects of decoration or as a vehicle for literary conceits (as, e.g., in the contemporary Milanese Arcimboldo).[24] These works were popular and much copied, and sought after not only by Italian but by North European patronage: not surprisingly, since Vincenzo had found his model for the genre in Aertsen and Beuckelaer.[25] The novelty of these works began thus as a borrowed one, but this does not compromise the fact of their novelty in Italy: the same, or similar ideas were very soon – but afterwards – to occur to the Bolognese; in Venice a related idea occurred to the Bassani about the same time. Vincenzo's novelty is not just in the genre subject matter but in his objectivity of seeing it and in his demonstration that this sheer material existence, reproduced in painting, is a sufficient purpose of his art.

264. Vincenzo Campi: Still Life. *Milan, Brera*

By comparison with the brothers, Bernardino Campi was an unproblematic, and also an uninventive artist. Schooled first in Giulio Campi's shop, he then spent a long period of study in Mantua. He was not yet twenty when he returned to Cremona in 1541, to begin independent practice in an eclectic style (*Holy Family with St Benedict and St Francis*, Cremona, Museum, 1548) of which the main components were derived from Giulio Romano, Correggio, Parmigianino, and the native Camillo Boccaccino: even including the last, an essentially Emilian brew. Some years of painting in Milan

which followed (1550–6) did not much alter this un-Lombard inclination (e.g., from his Milanese stay, a large *Crucifixion* now in the Badia at Fiesole). Instead, Bernardino refined his style still farther in a Maniera sense, to achieve a dry, stiff, fragile elegance – a kind of calcifying, at the same time that it is an exaggeration, of the Parmigianinesque mode. In its more conventional aspects Bernardino's mature style (*Annunciation*, Cremona, S. Omobono, 1572) recalls that of the old Bedoli; in more fanciful works, such as his *Glory of Saints* [265], in the dome of S. Sigismondo at Cremona

265. Bernardino Campi: Glory of Saints, 1570.
Cremona, S. Sigismondo

(1570), he could make *divertissement* on Parmigianinesque themes that almost bears comparison with Bertoia. He could also summon up a delicate, mannered echo of Correggio's sentiment (*Pietà*, Milan, Brera, 1574) and a silvery sfumato to go with it. This and such occasional iconic images as his *Assunta* (Cremona, Museum, 1568) are the sole evidence of his concessions to the new piety; but until his later and declining years he made almost none to Antonio's or Vincenzo's Lombard verism. Beyond his early residence in Milan, Bernardino also worked much outside Cremona in his late career, in the region around Mantua and Parma and in Reggio; it was in Reggio that he died in 1591.

Bernardino was the first teacher, and Bernardo Gatti, Il Sojaro, the second, of a Cremonese phenomenon, the lady painter Sofonisba Anguissola (1527-1625). Sofonisba was still more wondered at and prized than the younger Bolognese Lavinia Fontana, whom she outlived. In 1559 Sofonisba accepted the invitation of Philip II to come to Spain, where (when she was not engaged with courtly duties as a maid of honour to the Queen) she did portraits, her principal occupation as a painter. Her portrait style, literal-minded and heavy-handed, seems to have been formed on Brescian models. The occasional charm her portraits exercised (her best subject was herself, e.g. Naples, Capodimonte, *c.* 1555) results from what they illustrate, not from any quality of execution or design.[26] The last considerable painter of the Cremona school who worked in part within the sixteenth century, Giovanni Battista Trotti (Il Malosso, 1555-1619), had also been Bernardino's pupil, and the traces of this Maniera origin are visible in his work in the 1580s. However, he was quickly caught up in the new currents of influence, now no longer Mannerist, that came to Cremona from Emilia. By the middle of the last decade of the sixteenth century he was working effectively in the repertory of the Carraccesque reform.

In Brescia the veristic tendency that had so strongly marked its painting in the second quarter of the Cinquecento yielded place, after Romanino and Moretto had died, to a more urbane fashion. Lattanzio Gambara (1530-74), Romanino's collaborator and son-in-law, the chief painter of the later Brescian school, had brought to Romanino when he joined him about 1550 the Emilian inclinations of a painter trained until then in the Cremonese school; his master apparently had been Giulio Campi. During the decade when Gambara worked for the ageing Romanino (as, e.g., in the middle fifties, in the decorations of the Palazzo Averoldi) he acceded only partly to the latter's lead of style, asserting his Mannerist affiliations instead. Indeed, Gambara seems to have helped to incline the older painter towards the Romanism he exhibited in his latest years. Gambara's Maniera in his secular fresco decorations of the later fifties and early sixties (e.g. the façade of the Casa del Gambero in Brescia, after 1557) is often spirited and occasionally even inventive. But a counter-effect on Gambara of the Brescian environment slowed his Maniera impetus: compromising between Brescian tradition and Maniera, his style turned after a while into a classicistic academicism, laboured, turgid, and correct. His last work was not in Brescia but in Parma, where he shared the task of decoration of the nave arcade of the cathedral (at intervals between 1567 and 1572) with the Cremonese Sojaro. Desiring not only the correctness of an academic style but its pretence to the grand manner also, he sought accessible examples from which to borrow it in Giulio Romano and Pordenone; we have had occasion to refer elsewhere to the effect that these Parmesan frescoes make.

The tradition of Romanino and Moretto had a less inspired but more faithful extension in the later sixteenth century in Brescia in Pietro Marone (1548-1625).[27] It was to Bergamo, however, in the person of Giovanni Battista

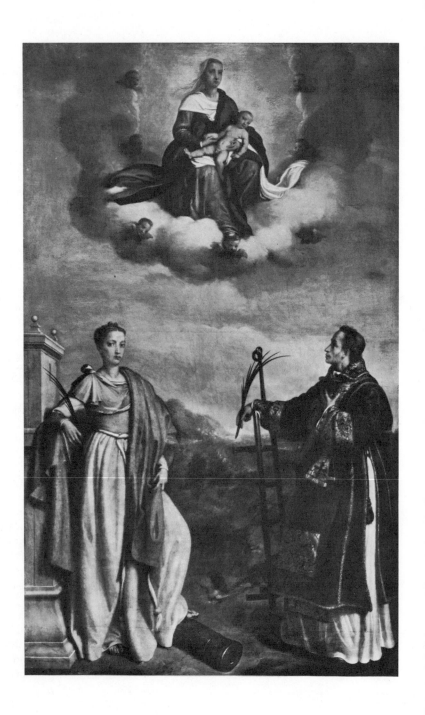

Moroni (*c.* 1523-1578), that the authentic local line of descent shifted. Born near Bergamo, Moroni had been trained in Brescia with Moretto, and was his pupil and assistant in the early 1540s. He returned to Bergamo to practise, but his earliest dated works, of 1546 and 1548, were done for Trento. Moroni quickly filled the vacuum in Bergamo of significant artistic production caused by the habit of Venetian residence of its best artists. By the early fifties he was heavily engaged as a religious painter, supplying altarpieces especially to the neighbouring towns, and had embarked on what was to be a still more active career as a portraitist, this mainly for the urban clientele.

The character of Moroni's religious painting was set almost from its beginning [266]. His return to Bergamo caused him to look not just with interest but with imitative attention at the precedents of verism, still more compelling than Moretto's, left there (or sent from Venice) by Savoldo. Moroni fused Moretto's and Savoldo's modes into a more particular, sharp-sighted, and sharp-edged descriptive style, smaller in scale of seeing and of mind. This was in one sense a development upon, but in another a diminution of, Moroni's precedents, for in this style the effect of verity of the whole image was reduced: the exact truth of parts nowhere added up, in his altar pictures, even to the semblance of credibility. What is so carefully described of faces, hands, and draperies is assembled as if upon lay figures, disarticulate and rigid, while design barely answers even to the needs of exposition. Vision and description are so extremely analytic that they almost exclude awareness of relations among things. Indeed, the relations among forms that make up composition or design are not, in any of Moroni's altar paintings, the outgrowth of the forms but a scheme imposed upon them, of an

266. G. B. Moroni:
Virgin in Glory with St Barbara and St Lawrence.
Milan, Brera

abstractness the exact converse of their verism. Not only that: these schematized designs are not the products of Moroni's thought but borrowings of compositions made by others – Moretto mainly, occasionally Savoldo – which Moroni has reduced to diagrams. The obvious explanation for such arbitrary and derivative design is an incapacity – quite counter to what is general among most good Cinquecento painters – to order forms synthetically, and it is supported by the extreme analytic vision which we have just observed. Despite the epidermis of modernity it wears, Moroni's result recalls a long-past style, realist and additive, of the late Quattrocento.

Yet the obvious explanation may be far from wholly right. The doubt is generated by Moroni's portraits, which share with the religious paintings their character of verism but are remarkably unlike in other basic factors of their style. The portraits seem intended to fulfil not only different – appropriately different – functions of illustration and communication, but different concepts of what reality and art might be. The simplistic and, in some respects, archaic-seeming tenor of the religious works, which persists without real alteration throughout Moroni's career, contrasts with the fluency and fine control of form of the portraits and with their sophistication – considerable elegance, often – of expression.[28] Where there may be constraint in the portraits it is not due, as in the religious images, to schematizing, but is the evidence in form and spirit of the meaning, more precisely even in the social than in the aesthetic sense, of Maniera. Moroni's portraits may often be of a temper more resembling Bronzino's than Moretto's, from whom in the beginning they derive, or Lotto's, from whom they also take much. His earlier portraiture especially, for some years after 1553 (e.g. *Cavalier with a Wounded Foot*, London, National Gallery, *c.* 1558; *Unknown Poet*, Brescia, Pinacoteca, dated 1560) suggests quali-

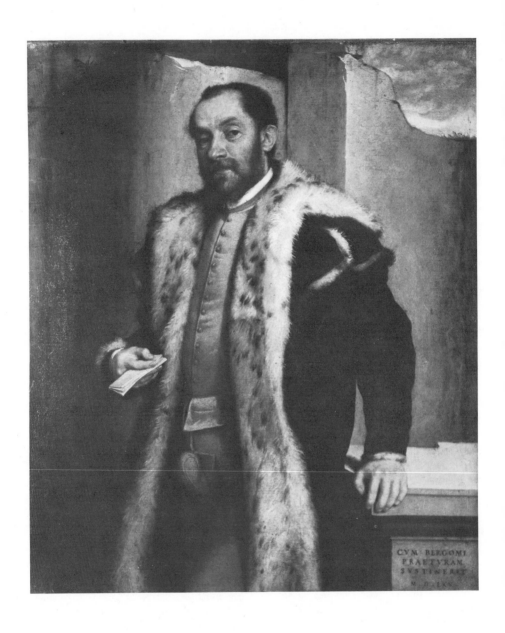

267. G. B. Moroni: Antonio Navagero, 1565. *Milan, Brera*

ties like those of Florentine Maniera: fine-drawn countenances of sharp but unwelcoming glance: slender, eccentrically active silhouettes, defined by an incisive line; passages of brilliantly illusionist detail. The likeness does not prejudice the factors of style that bind Moroni to his Lombard origins. He may see in the temper of Maniera, with a subtle acuity that makes fine distinctions in a narrow compass, but his mode of apprehending form remains basically optical. Line serves Moroni for a pattern-making or expressive purpose, but never primarily a descriptive one. No matter how skilfully it is conveyed, the sense of an aesthetic purpose of the portrait – its formal component of 'maniera' – is never so insistent as its purpose of establishing descriptive truth. From as early as 1560 the stylizations that are akin to the Maniera tend to decrease (e.g. *Portrait of a Magistrate*, Brescia, Pinacoteca, dated 1560; *Antonio Navagero* [267], Milan, Brera, dated 1565), and the sense of optical effect and of an objectivity that is both descriptive and psychological tends more and more strongly to emerge. Among his later portraits some (e.g. *Portrait of a Man in Black*, Boston, Gardner Museum, dated 1576) have a most imposing density of presence, in which the sitter seems to have been described as an object more than as a person: as elsewhere in Lombard painting of these years, there is the intimation of the way to Caravaggio.

The portraits challenge the simplistic answer that we gave to the problem of the style of Moroni's religious works. Their schematic and disjointed form and rigid artificiality – or vapidity, or entire vacancy – of expression may result from a conscious assessment by Moroni of his popular and usually provincially religious market, which he may have seen as the naïve antithesis to his sophisticated urban clientele for portraits. For his religious audiences Moroni made an *arte sacra*, combining over-simplification with insistent verity, simulating

naïveté in form and feeling, and often taking on – deliberately? – the look of an old-fashioned style. Moroni thus exaggerated enormously the iconic tendencies of Moretto's later religious art, from which he took the bases of his own. But the problem of religious art was in all likelihood considered by Moroni in the light of more than its market: he may have conceived – in sympathy with Counter-Reformation doctrine – that a combination of a schematic and veristic style best suited the didactic functions of religious art, and that its neutrality (or banality) of content made it a good vessel into which the believer could direct a simple piety. Whatever the explanation, the contrast remains between this congealed sacred puppetry and the intense life, of art as well as persons, of Moroni's portraiture; and the poignance of the contrast may be a symptom we cannot yet fathom accurately of the moral dilemma of the place and time.

None of the major painters of the first half of the Cinquecento in Milan or Piedmont lived on after the mid century. Gaudenzio Ferrari, whose presence in Milan in his later years effected a period of union between the Milanese and Vercelli schools, died in 1546. In his native school he left behind a following which, excepting only Bernardino Lanino, was at best modest in the quality of painting it achieved, and almost statically faithful to Gaudenzio's tradition.[29] In Milan itself Gaudenzio's death left a situation almost worse. The vacuum of talent in Milan which he for a while had helped to fill appeared again. The best remedy the native Milanese could manage was Luini's sons, Aurelio (1530-93) and Giovanni Pietro (most often Aurelio's assistant), who made minimal concessions in their father's style to suit more modern fashion. It was evidently a more effective solution to continue to import artists, and the years after the middle of the century in Milan were dominated by painters who were not Milanese. Most conspicuous among them

were the members of the Campi family of Cremona, Bernardino in particular; the brothers Andrea and Ottavio Semino from Genoa; and from Bologna, Pellegrino Tibaldi and Ercole Procaccini. These visitors represented diverse schools and tastes, but had in common that their cultures in the final analysis derived from the Maniera. Their example in Milan contributed to the formation of some native painters of fair merit, of whom the most interesting are Giovanni Paolo Lomazzo (1538-1600) and his pupil Ambrogio Figino, ten years younger (1548-1608). A Bergamasque, Simone Peterzano (notices from 1573 to 1590), shared their prominence and has posthumously acquired more, because he was the master of Caravaggio. However, a new style in Milan did not grow in a direction quite like that which the young Caravaggio took in Rome, or even quite resembling that of the Carracci. Artists of the generation that emerged in the mid 1590s – the chief among them Giovanni Battista Crespi (Il Cerano), Giulio Cesare Procaccini, and Pier Francesco Mazzuchelli, called Morazzone – established a mode which is without question an incipient Baroque, but marked by a degree of subjectivity that is exceptional for any seventeenth-century style. It is a style of which the form and expression may often seem extreme and artificial, and thus mannered, but it is not (as the recent tendency of critical literature asserts) on that account an extension of the Cinquecento style of Mannerism.

One of Mannerism's more curious aberrations is associated with the Milanese school, where, however, he actually worked relatively little. Giuseppe Arcimboldo (1527-93), born in Milan, is known to have worked there as a designer of stained glass and tapestries until 1562. He then left for Prague, where for twenty-five years he served Ferdinand I, Maximilian II, and then Rudolf II as court painter. He did not return to Milan until 1587, half a dozen years before he died. He painted portraits of commendable 'naturalness' which Lomazzo praised, but which we cannot now identify. But his contemporary fame rested on an invention which sprang from the improbable communion of Lombard realism with Mannerist conceit: still-life matter ingeniously assembled so that it makes grotesque and piquant semblances of human forms, illustrating both a visual and a verbal pun. The *Seasons* (Vienna, Kunsthistorisches Museum, dated 1563) or the *Elements* (*ibid.*) are favourite themes of these *bizarrie* which (when they are by Arcimboldo's own skilled hand, and not by one of his too many imitators) are fine – understandably, somewhat North European – in touch and pedantically clever in invention. They were esteemed as *scherzi*, and conformed to the eccentric aspect of Maniera taste that took delight in the *Wunderkammern*.

Even as *scherzi*, Arcimboldo's painted conceits reflect the academicizing, often laboured intellectuality that, perhaps in part by way of a debased inheritance from Leonardo, was an affliction of the later Milanese. In his role of theorist of art, Gian Paolo Lomazzo was to demonstrate this tendency at its extreme. When, still in his early thirties, he went blind (shortly after 1571), he turned his gifts for abstruse thought to the writing of the most extensive and complex of sixteenth-century treatises on art, the *Trattato della Pittura* (first printing of the first edition, 1584) and its generalization in terms of a Maniera conceit, the *Idea del Tempio della Pittura* (1590). Before then, he had displayed a talent for invention in paint as prolix as his literary gift, but authentically impressive in effect. A population of posturing Romanist figures inhabited Lomazzo's vast *Allegory of the Lenten Feast* (Piacenza, S. Agostino, dated 1567, now destroyed). The academic direction taken by the school of Gaudenzio in its late phase in Milan (from which, by way of his teacher, della Cerva, Lomazzo descends) is much accentuated and

makes an analogue – doubtfully so soon the result of influence – with the style of the recently arrived Tibaldi. About 1570, in the Cappella Foppa of the church of S. Marco in Milan, Lomazzo achieved a more concentrated and consistent but not less extraordinarily ambitious style. For the apsidal half-dome of the chapel he created an illusionistic glory of angels which, based eventually on Gaudenzio, translates his precedent into an extreme Romanist language [268]: Lomazzo encrusts the whole surface with bulking classicistic forms compressed together into dense, impenetrable relief. This style seems to synthesize the ambitions of the past Gaudenzio and the recent Tibaldi, and beyond that to intend to outdo both: the mere hyperbole creates an effect of

astonishment. The surviving lateral fresco, a *Fall of Simon Magus* (the facing lateral is almost obliterated), reveals the presence of another major source, not as evident in the dome, for Lomazzo's style. Another local deity, Bramantino, is a factor of importance in determining the effect in Lomazzo's forms of hollow and abstracting squared geometry: in the composition of the *Fall of Simon* the idea of rectilinearity is raised to the power of a dogma. The Bramantinesque features are translated into modern speech, not just classicistic but archaeological in accent, and they are made ponderous by sheer stress of bulk and by an equally stressed rhetoric of action. Lomazzo's ponderousness of form and content – impressive and tedious at once, in a way that is almost

268. Gian Paolo Lomazzo: Glory of Angels, *c.* 1570. *Milan, S. Marco, Cappella Foppa*

paradigmatic for an academic art – is less evident in the contemporary Tibaldi, but his chastened and regularized style in Milan (cf. his cartoons for windows in the Duomo; Ambrosiana, 1567–74) and that which Lomazzo finally achieved are much alike. Lomazzo's, too, might be defined in the terms of a Counter-Maniera. That he should have referred in making this style to the great classical personality of earlier Milanese Cinquecento art makes part of its process of invention like that of the first manifestations of Counter-Maniera in the school of Rome.

Lomazzo's actual span of work was brief, but his teaching determined the essentials of Ambrogio Figino's style. Figino's temper was as ponderous as his master's, and in general his paintings achieve a related effect – less inspired and more academic – of imposing tedium. For obvious reasons (the most obvious his much more extensive œuvre), Figino's formal vocabulary is more various than Lomazzo's. In place of his teacher's bulking and emphatic figure style, which only roughly and indirectly refers to Michelangelo, Figino came to display an overt Michelangelism, apparently acquired about 1580 at first hand in Rome. In addition to his Michelangelism, he would have found, in the Roman Counter-Maniera, support for the direction of style in which the teaching of Lomazzo and the Milanese mode of Tibaldi had initiated him. In Milan, furthermore, a similar direction would early have been deduced by Figino from the work of the visiting Antonio Campi, but with the special intonation in it of insistent, hard-edged verism. Figino's mature style makes a strong amalgam out of these accumulated resources, of which highly characteristic examples are his organ shutters for Milan Cathedral (*Passage of the Red Sea* and *Ascension of Christ*, 1590-5), and his *St Ambrose expelling the Arians* (Milan, Castello Sforzesco). His figures labour and make heavy rhetoric, and seem like congelations into a harsh metal of

the forms of the late, unbeautiful, severe Michelangelo. It is a style of deadly seriousness, considering feeling in terms of public and declamatory gesture only, and otherwise negating it. Even in drawing, at which he seems to have worked indefatigably, Figino could articulate only a formal and didactic speech. In character of content as well as in its criteria of form Figino's art is the antithesis of the new Milanese style which grew up as this one died.[30]

Despite his connexion with the apprentice Caravaggio, Simone Peterzano belongs almost as strictly as Figino within the terms of reference of late Maniera – perhaps more precisely, Counter-Maniera – style. Peterzano's initial orientation was different; he was Bergamasque in origin, and had studied in the atelier of the ageing Titian. While the effects of a Venetian training are often visible, especially in his earlier works, it is a Bergamasque tendency to hard-surfaced literalness that rapidly became more obvious. The character of his equipment, but not its quality, was that of a latter-day Savoldo. The influence of the verism demonstrated in Milan by Antonio, and perhaps Vincenzo, Campi was joined to Peterzano's Bergamasque inheritance, but for the most part appears in him as a labouring of descriptive detail. By far the most important influence of Milanese art on Peterzano was from the classicist tendency represented by Lomazzo and then by Peterzano's contemporary Figino: it is this affiliation, not that to the Campi's current, which is in general the more apparent in his art. It is in a heavy and assertive plastic style, classicistically 'correct', and visibly artificial and rhetorical, that his largest set of works, at the Certosa di Garegnano (1578-82), was done. The veristic effects he seeks at the same time are very relevant to the tenor of this style, but they are mostly incorporated within its larger artificiality and dominated by it. Only occasionally is there the effect of a just compromise between truth and artifice, and when it happens

it recalls an earlier naturalistic classicizing art, in particular Savoldo's. The paintings in which Peterzano aligns himself more wholly with the 'progressive' intentions of Antonio Campi are altogether the exceptions in his œuvre: the strongest of these and the most consistent in his application of Antonio's example is a *Pietà* (Milan, S. Fedele, for which datings range from 1583 to 1591). This picture, which seems demonstrably to have been remembered by Caravaggio, has the effect of a reforming work, almost – but not quite – acquiring the new purposefulness of an anti-Maniera. However, it is different in only slight degree and not much in kind from a variety of art in contemporary Rome which Caravaggio was to find on his arrival there, such as Scipione Pulzone's. At the same time, Peterzano's labouring classicistic vein – a late, inflated form of Counter-Maniera – also had its counterpart in the painting of contemporary Rome. But it is a false devaluation of the young Caravaggio's relation to Peterzano to assess it only in terms of what Caravaggio would have learned from him to convert into seventeenth-century realism. Not only the Bergamasque qualities but the Venetian inclination that mark Caravaggio's early painting may well have had their initial source in Peterzano. Another factor of connexion may be still more fundamental. In Caravaggio's art the character and effect of what is obviously new, his so-called realism, is inseparable from a classicizing sense of form: the precedent Peterzano offered, of verism imposed within classicizing form, could be the basis of the revolutionary transformation which Caravaggio made of it, into realism that invests classicizing form.

GENOA

The patronage of Andrea Doria had given Genoa a school of painting in the late 1520s and the 1530s, but by importation: he did not re-deem the native Genoese. The main native painters of the town, Antonio Semino (*c.* 1485/90-1555) and his partner Teramo Piaggia (1480/90-before 1572), were indeed so firmly set in habits that were still quattrocentesque that their rate of change towards modernity was all but imperceptible. Giulio Romano's altar painting of the 1520s, the *Stoning of St Stephen* (painted for the Saint's name church in Genoa), fairly soon had some superficial action on their style, but for the Maniera of Perino to affect Antonio Semino even slightly took far longer, while it never reached Teramo at all. Perino's style did in time form a native school, but among painters not older than himself, and more among men of the generation following, who matured at the mid century or later. In altar painting the effects of Perino's example were relatively conservative, but in decoration, where his efforts in general had been more important as well as inventive, he inspired an active and creditable school. Lazzaro Calvi (1502-1607; almost unbelievably durable) and his brother Pantaleone (d. 1595) were actually among Perino's pupils, but their reflection of his style both in altar paintings and in decoration is more than normally adulterated by their backwardness. Giovanni Battista Castello (*c.* 1510-*c.* 1569), called Il Bergamasco to indicate his origin,[31] brought a richer experience to Genoa to fuse with the example of Perino's mode. His fresco works (e.g. his decoration of the Palazzo Cataldi) show Cremonese and, occasionally, Parmesan elements of style beside those adapted from Perino. Ottavio Semino (1520-1604), son and pupil of the retardataire Antonio, could not entirely evade the effects of this inheritance, despite his study not only of Perino's style but of art in Rome. His sense of form – or habits of form acquired by association with his father – was not easily compatible with the ideals of Maniera. His altar paintings tended to be graceless and old-fashioned-looking, so that it was a favourable accident for him

that the course that style in religious painting took, towards Counter-Maniera, came to approximate what he was naturally equipped to do. As a decorator he forced a gelid and superficial approximation of Perinesque Maniera. In Milan (where, as we observed, local talent was inadequate to the demand) even this was welcome, and it was there that he spent the later years of his career, working mainly as a *frescante*. In Genoa his best decoration is in the Palazzo Cambiaso (now Banco di Napoli: *Banquet of Psyche, Rape of the Sabine Women*), and in Milan the grand salon of the Palazzo Marino. Ottavio's frequent collaborator in decorations, often on an equal basis, was his brother, Andrea (1525-95). Andrea had a similar education but proved to be more readily inclined to Maniera. However, his idea of what Maniera ought to be was interestingly conservative. Perhaps because he had been thoroughly conditioned by Perino's work, Andrea interpreted his experience of Roman art in such a way as to create a style that evokes, almost deceptively, the immediate post-Raphaelesque Roman manner of the 1520s. With his brother he spent some time in Milan, and the remarkably Raphaelesque vault of their salon in the Palazzo Marino there is his.

Of all the painters of the sixteenth-century school of Genoa only one ascends to an importance that is more than local: Luca Cambiaso (1527-85). Only he among the painters of the North Italian centres may lay claim to rival the genius of Pellegrino Tibaldi (his exact contemporary), whom he resembles not only in the dimension of his gifts but in their kind. Even the course of evolution of their styles is somewhat similar, though Luca's creative energy in painting seems, by comparison, unquenchable. Luca was the son of Giovanni Cambiaso (*c.* 1495-*c.* 1579), a painter of the elder Calvi's generation, to whose instruction Luca could not have been much obliged. He learned,

instead, from almost every importation he could find in Genoa, from Perino chiefly, but, almost equally important, from Pordenone and from Giulio Romano also. Further, there is the likelihood that just before the time of his first extant work, a fresco decoration of important scale in the Doria palace that is now the Prefettura (1544), he had been through Lombardy, and perhaps even visited Rome.

In 1544 Luca was seventeen, and in the Prefettura decoration (scenes of antique history and myth) his precocity, phenomenal as it is, is not so astonishing as his explosive *élan* of form and idea, or the sense of individuality of style with which he invests what he has learned.[32] It seems to be by synthesis of Perino's Genoese Maniera and Pordenone's plastic mode, more than by any needful reference to Roman art, that Luca conceived this style. However, the pressures under which he fused these main components produced a result of extreme modernity. In its large forms it extends the mode of Pordenone (classicized to reconcile it with Perino) into an abstractness and a play upon illusionist conceit that are more according to the intellectual disposition of Maniera, yet almost aggressively devoid of grace; conversely, the mode employed in smaller scenes is an extension of the ornamental style of Perino, closely analogous to what the avant-garde of high Maniera evolved in contemporary Rome. The violence of statement of these frescoes soon subsided, as did the extremism of their geometry of large form. From the mid century onward Luca began to moderate his large-scale mode with effects taken into it from his *maniera piccola*, and within the course of a decade the result was an approximate consistency of recognizable Maniera. The vault decoration of the Doria church of S. Matteo (before 1559, in collaboration with Il Bergamasco) is an indication of the thoroughness with which Luca could assimilate Maniera graces and sophistica-

tions, but yet not wholly sublimate his taste for arbitrary geometric form. However, he could at the same time manipulate these factors with an exactly inverse emphasis. His *Resurrection* (1559) and its companion altarpiece, a *Transfiguration* (1561, both Genoa, S. Bartolommeo degli Armeni), are basically demonstrations of a classicist, geometric form to which refinement of detail and drawing gives the accent of *grazia*. The geometry makes over-generalized and vacant volumes, of which the effect of intangibility is confirmed by thin, pale-shimmering light and veils of pastel colour. That Luca's geometry is an aspect of Maniera style is wholly clear; that its regularity prevails over rhythmic grace makes it a factor in an incipient Counter-Maniera. These are the interrelated faces of Cambiaso's style about 1560, and for a brief while it was possible to develop both of them side by side. The proper Maniera aspect, however, tended to congeal rapidly: as early as 1563 a major altar painting such as Luca's *Resurrection* (Montalto Ligure, S. Giovanni Battista, dated) gives, together with its fine Pieran elegance, an effect of labouring, academical and empty, as if the painter were no longer quite convinced not only of the mode of feeling but even of the formal sense of such a style. Nevertheless, the temper and devices of Maniera were so useful and appropriate to decoration that they continued there, even if in a stiffened form. The middle sixties were the time of Luca's finest efforts as a *frescante*, conspicuously in the Villa Imperiale at Genoa-Turalba (*c.* 1565) and in the Palazzo Meridiana (ex-Grimaldi, 1565). In both schemes, in the former especially, the academicizing of Maniera is a process that has been turned to positive much more than negative effect. Luca's geometric tendency of mind has been applied to the manipulation of volumes and spaces in a way which, while basically that of the Maniera conceit, endows the *concetto* with the force of a

high formal rhetoric. Nowhere else is the notion of the decorator's *quadro riportato* so ingeniously made the matter of illusionistic paradox. An illusionist intelligence almost as extraordinary is in a religious decorative scheme in the Cappella Lercari of the Duomo di S. Lorenzo, in which Luca was responsible for the painting of the lateral frescoes of the *Presentation* and *Marriage of the Virgin* (1569; the remainder of the decoration is by Il Bergamasco). More than is the norm for artists of the time, Luca's decorative works eclectically exploit every source he could have known, Central Italian as well as Emilian in the palace schemes, Brescian and Venetian in the Cappella Lercari. In the Cappella Lercari the Maniera aspect of the secular decorations gives place to a quieter, partly classicistic style, recalling both Romanino and Veronese.[33]

More rapidly than in his decorations, in his easel pictures Luca veered away from the obvious apparatus of Maniera. The change is now observable to us mainly in religious works, but it is by no means confined to them alone. By 1570 most of his religious pictures had assumed an explicit Counter-Reformation content, simply illustrating an obvious and sober popular piety, and the form and the descriptive mode devised to suit this content is a paradigm of Counter-Maniera. The potential to make such a style may have been part of Luca's aesthetic disposition since his beginnings; he had moved towards it even in the 1550s, apparently more in consequence of aesthetic than religious attitudes; but in the course of the seventh decade the latter came to be the determining factor. Until his departure for Spain in 1583 (where he preceded Federico Zuccaro and Tibaldi as chief painter in the Escorial) a large part of Luca's production consisted in the manufacture of simplistic works of *arte sacra* [269], almost perfectly exemplifying the conjunction only this genre could call for of

naturalism adequate to inspire belief, abstractness and extreme legibility. The degree of banality to which Luca aspires – so wholly antithetic to his earlier Maniera search for ingenuity of conceit – is, at least throughout most of the seventies, apparently in the painter's wholly self-aware control. Some among the altarpieces, destined for the use of public piety, attain the dubious but still noteworthy charac-

269. Luca Cambiaso: Martyrdom of St George. *Genoa, S. Giorgio*

ter of anti-art. But smaller devotional paintings, using a moderated version of the same vocabulary, still make witticisms and astonishments with play of the abstracting forms and evoke fine, oblique emotions, of a Maniera cast, from the persons and situations that they illustrate.

With another slightest shift in handling of shapes and surfaces, antique subjects, some of them quasi-erotica, recover still more of the aspect and effects of the Maniera [270]. Yet the basic formal matter Luca employs is, in all these cases, close to interchangeable, demonstrating perhaps more efficiently than in any of Luca's contemporaries what the relationship between Maniera and its counterpart style is.

Differently but not much less than the Maniera, the Counter-Maniera is an artificial style and almost as arbitrary. Nevertheless, it is one of the elements in Counter-Maniera's difference from Maniera that, just as it pretends to classicizing rationale (but achieves no more than classicistic formulae for it), so also it pretends to naturalism. But to a still essentially Mannerist mentality, as Luca's Counter-Maniera mind still is, naturalism means either an unfancy kind of narrative or psychological datum that can be illustrated (not necessarily, therefore, an effect of visual mimesis) or an aspect of visual experience that can be turned to use as a *concetto*. The first of these 'naturalisms' inclines Luca towards frequent and genuinely captivating incidents of genre-like intimacy, usually in smaller works; the second leads him to combine these with the theme of the nocturne. In both respects, and more especially the latter, his tendencies coincide with those of the Cremonese Campi, Antonio in particular. Antonio and Luca are so close in the time of their first essays in *notturni* that we cannot surely assign precedence to either, nor assess the possible direction of an influence between them. Luca's *notturni* may well have been an independent and coincidental growth, with one of its sources in a singular facet of the Genoese art of Perino. In any case, it is Luca who is by far the more frequent worker in the nocturnal genre, more subtle and capricious in his exploitation of its possibilities, and far more poetic in the effects that he achieves in it of

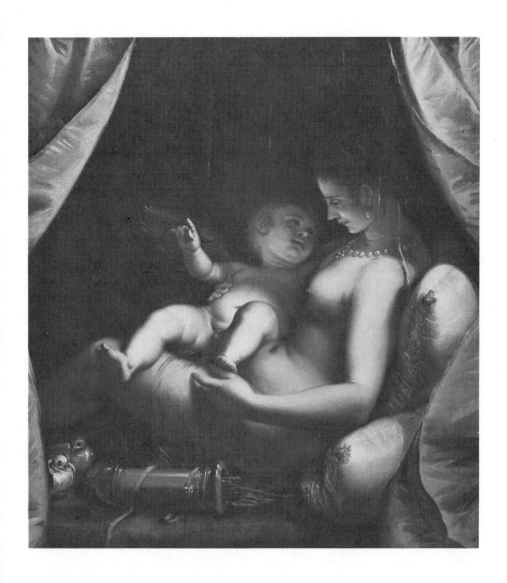

270. Luca Cambiaso: Venus and Amor. *Chicago, Art Institute*

visual as well as psychological sensation. Antonio Campi's nocturnes had some role in the formation of the seeing of Caravaggio, who turned them to account in his new search for reality. It may be significant for the qualities of Mannerism that persist more evidently in Luca's nocturnes that, by a route still unexplained, he seems to have been a source for Georges de La Tour, whose nocturnes so poetically transcend reality.

But Cambiaso is important not for what he may seem to anticipate of the Seicento but for his connexion with the Mannerism that is peculiar to his own time. The final confirmation of this may be in the peculiar drawing style he invented, sometimes referred to as 'cubistic', where geometrical abstraction of anatomy is carried to an extreme for the sixteenth century, in a spirit that is intellectual and capricious. These drawings (which began to appear perhaps as early as about 1565) are the freest, sometimes brilliantly bizarre expression of Luca's private fantasy. Yet in their extreme abstractness there is a bridge between them and his latest public thought, his many paintings (done obviously with extensive help) for the decoration of the Escorial (1583–5) [271], of which the character, compounded of icon, heraldry, and valentine, seems to exemplify not just Counter-Reformation *arte sacra* but an *arte bigota*. This is a death of style, impotent to generate a new beginning.[34]

271. Luca Cambiaso: Paradise, 1583/5.
Escorial, S. Lorenzo

CENTRAL ITALY 1570-1600

The last quarter of the sixteenth century in Central Italian painting was even more a period of diversity than the quarter-century before. At the beginning it was still a time of domination of artistic style by the Maniera, in Florence more pervasively than in Rome. Counter-Maniera, which reasons of religious circumstance, beyond those of aesthetic motivation, had caused to make widespread conversions in the art of Rome, had less popularity in Florence. However, neither in Florence nor in Rome of the seventies and eighties did Maniera proper remain what it had been in the decades nearer the mid century. Even in the sixties there were indices at times of kinds of change within Maniera style quite different from the inversions and the petrifyings of Counter-Maniera. The most important of them seem to be a relaxation of the tightness and the complication of high Maniera, a lessening insistence on effects of artificiality, and a tempering of draughtsmanship (and of draughtsman's arbitrary colour) by optical and painterly device. The consequence of these interrelated tendencies is a moderation of the high Maniera so that it is no longer quite so high – so arbitrary, precious, difficult, and extreme. To a mild but distinctly perceptible degree the Maniera descended a little, admitting a contamination of naturalness. Fantasy and even extravagance of idea, states of mind, and form need not be diminished, but none of them is projected with so insistent an effect, as with a galvanizing charge, as before. Once initiated, the processes of change accelerated in the eighties and in the last decade of the century. But then, what had begun as an alteration

within Maniera proper took incitement from the early manifestations of a new style which, opposite to Maniera, consciously made naturalness a prime requisite of art. The result for artists of the late Maniera may be an irreconcilable conflict of ambitions; it is an only verbal paradox that more often the increasing admission of naturalism into late Maniera effectively results in its denaturing. Even then, though the first *raison d'être* of Maniera, the assertion of the sense of 'style', is irremediably compromised, the Maniera formulae that superficially denote stylishness were only hesitantly put aside. In Rome, especially in decorative art, they had some currency until the second decade of the Seicento.

It may be difficult to accept the fact that painting in Florence in the last two decades of the Cinquecento was in general more 'advanced' than painting in Rome at the same time. We tend to see the Roman situation in a hindsight falsified by the intrusion into it, only in the last few years of the century, of the two great immigrants from North Italy whose actions would decisively make Mannerism obsolete. But until their advent, and for a time afterwards until their innovations took some general effect, Roman painting was bound more than that of Florence not only by Maniera formulae – more exactly, by Maniera become formula – but by the Counter-Maniera, of which the psychological rigidity still less invited change. It may have been the relative exemption of the Florentines from an atmosphere that sanctioned such a style as Counter-Maniera, as well as from the style itself, that permitted painters there to embark on a reformation of artistic style of which the aims essentially resemble those of Annibale Carracci. But the energy of reform, the measure of novelty achieved and its decisiveness, did not match Annibale's, so that in the succeeding century what the Florentine reformers made, before 1600, of a new

basis for art was displaced by Carracci's more explicit innovations and by Caravaggio's. Yet the Florentine reform shares their proposition that, before art is a vehicle of style, it must be an efficient mimesis, legible in form and explicit in its content. The Carracci sought means to promote these ends in non-Maniera and pre-Maniera styles of Venice and North Italy; the Florentines referred back to their comparable local precedents, particularly to Sarto, and they became receptive (in a degree exceptional for Florence) to Venetian influence. Among the Florentines, however, the measure in which optical and painterly device supports the search for naturalism is qualified by their draughtsmanly and sculptural tradition. Even reference to Sartesque style did not always suffice to diminish the persistence of a taste the Maniera had exalted, which confounded the aesthetic of statuary with that of painting. There is – not only in this – an evidently classicistic temper within most of the painting of the Florentine reform which also is at least as much a carryover from Maniera as it is the result of reference to the High Renaissance. Yet these qualifications do not very much lessen the most important affinity between the reformers of Florence and the innovators of Bologna, which is the effect made in the work of art of a descriptive truth more nearly entire, more consistent, and more quickly credible than is achieved in any earlier style. In this alone the art of the reformers is marked off as obviously from the style we define as Counter-Maniera as from the Maniera proper. Yet at least part of the motives that determined the direction the reformers took were those that helped shape Counter-Maniera, at least in religious art. Simplicity, legibility, and submission of aesthetic values to those of narrative or dogma are standards the two modes held in common. The reformers might have wished to promote a similar religious end, inspired by the requirements of the Counter-Reformation; but for all

their limitations – self-imposed and otherwise – they did not do so in that mixture of the puppeteer's and poster-maker's repertory that constitutes the Roman, or the North Italian, *arte sacra*. Their art effects a bridge from Mannerism into the seventeenth century, over which most of the reformers crossed.

To include the art of the Florentine reformers in the denomination 'anti-Maniera'[1] may be excessive. As we have indicated, they retained visible links to the Maniera or Counter-Maniera even at relatively evolved stages of their careers. Moreover, the temper of their art is in general so measured that it is difficult to conceive of it as 'anti' anything; it is neither passionate nor intellectually doctrinaire. Yet that they wished – and in time achieved – a reform of art upon a basic principle that inverts the aesthetic of Maniera is more apparent than the connexions they still show with it: the essential character and net effect of their action is thus anti-Manneristic, and on this final ground the denomination may be justifiable, but it distorts, imputing to the reformers' styles a programmatic purpose of both criticism and reconstruction, and an intensity in it, which they did not possess.

Looking to the Seicento, the style the Florentine reformers made is as distant from the seventeenth-century Baroque as it is from Cinquecento Mannerism. We have had repeated occasion to imply the origins in Northern Italy of Seicento Baroque style, immediately in the art of the Carracci and more distantly in the Titianesque and, particularly, the Correggesque examples the Carracci chose to observe in a crucial formative phase of their own style. There was another major link between Correggio's early Cinquecento intimations of Baroque style and the Seicento in the painting of Federico Barocci of Urbino. It was an earlier manifestation than that of the Carracci and won converts earlier not only in the Marches but in Tuscany (in Siena, not in

Florence) and, in a minor but perceptible degree, in Rome. Barocci's own mature and later art intensifies the qualities, formal and emotional, that in Correggio resemble Baroque style, and these include a heightening and specifying of effects of vision that imply reality. In terms of structure and descriptive apparatus there is small distinction to be made in the end, and perhaps none, between Barocci's and Seicento Baroque style. He outlived Annibale Carracci. Yet all this does not give Barocci's art historical importance for the seventeenth century comparable to Annibale's, nor does Barocci's art surpass, as Annibale's did, the effect of a profound affiliation with the sixteenth century. Barocci is almost morbidly a *raffinato*, in an aestheticism he gratifies with his almost incredible subtlety in the painter's art, and in feeling that is an exaggeratedly sentimental response to Counter-Reformation piety. More important than his measure of anticipation of a new style, he stands as the final product of an evolution only the sixteenth century could achieve, fusing – as Correggio before him only on occasion did – optical and emotional resources that Baroque style would exploit with the precious sensibilities of Maniera.

As the end of the century approached, Mannerism altogether lost the energy of a creative style, and gradually it also lost the power (usual on account of the inertia within cultural process) to condition by formula or habit new inventions rising by its side. In Central Italy the art of the reformers in Florence, of Barocci and, still more, of his followers in the Marches and Siena, assumed a complexion closer to that of the seventeenth century than the sixteenth; in Rome the force of Annibale Carracci's and the young Caravaggio's inventive acts outweighed their context of fatigued Maniera. The last stages of the meaningful history of Mannerism in this last decade of the Cinquecento require to be described; but rather than in this account of the passing of a cultural and artistic

style the grander import of this time is in the founding in it of the ideas of the Seicento style to come.

FLORENCE

The Late Maniera

Vasari's role in Florentine art history did not cease through the mere accident of death. In 1565-6 he had been entrusted with the most important and far-reaching project of religious art in Florence, a remodelling (with Grand Ducal sanction and, in part, financial support) of the interiors of the churches of S. Maria Novella and S. Croce. This involved the modernizing of the architecture (more extensively in S. Croce), not just for its own sake but with the particular purpose of accommodating it to be a setting for a nearly complete provision of new altarpieces in place of the existing ones, to be supplied by the Chosen of Vasari's Florentine Academy.[2] These projects became a focus of painterly activity in the latest years of Vasari's life, but still more following his death. Of twenty-eight altars in the two churches, Vasari personally had taken the commissions for six (executed between 1566 and 1572) and Bronzino for one; Bronzino and Salviati had each supplied an altar painting earlier, before the projects were invented, and these were retained. But it was the next generation that took on the great burden of the work: in the main the same group who served Vasari in the decoration of the Studiolo, partly a contemporary but mostly a previous enterprise. Sixteen altarpieces were supplied between 1569 and 1577, two more by the 1580s. On a larger scale and in a differently serious vein than in the Studiolo, these pictures offer a collective image of the state of art in Florence as the last quarter-century began. Save only for Santi di Tito's five contributions (all of them later than Vasari's death), the collective impression that

they make is still unequivocally Maniera; there seems less evidence in these religious paintings than in the fancy matter of the Studiolo of incipient dissent.[3]

The most faithfully Maniera painters in these projects are the lesser ones – faithful in the sense of their continuing in a way at best no more than a little changed from that of Vasari. It is the more gifted painters who give evidence of tendencies that diverge from Vasarian example, or from that of the alternative paradigm of Florentine mid-century Maniera, Bronzino. Bronzino's closest pupil, Alessandro Allori (1535–1607), is one of these.[4] His *Christ and the Samaritan Woman* of 1575 for S. Maria Novella [272], based mainly on Bronzino's classicistic Maniera, also shows the accent of Michelangelism, acquired not just from the late work of Allori's master but from some years' study (in the later 1550s) at the source in Rome. The *Pearl Fishers* painted by Allori for the Studiolo a few years before is, from an extravagant exploitation of the subject matter, a more obvious demonstration of the Michel-angelo-Bronzino combination. Allori seems more than ordinarily to illustrate that ideal of Maniera by which art (and style) are generated out of pre-existing art. In the altarpiece his main figures press resemblance to statuary to an extreme, more than is in either Michel-angelo or Bronzino, making regularities of shapes and exaggerating polish and an inor-ganic brittleness of form; the result is a resplendent petrifaction. Preciosity has been joined to a pedantry that embalms the styliza-tion of the high Maniera and renders it inert. Strangely, part of this deadening proceeds from a tendency which runs counter to the excessive artifice: a way of seeing and describing light and of indicating details that betrays a natur-alizing inclination at work. It casts a pall of

272. Alessandro Allori:
Christ and the Samaritan Woman, 1575.
Florence, S. Maria Novella

prose over whatever higher aspiration the abstractness of these forms denotes. Elsewhere than in the major figures the naturalizing ten-dency is given perceptibly more rein. It makes a stiff compromise with mannered stylization in the secondary figures; in the landscape, how-ever, a naturalistic prose quite dominates. Allori's brand of abstractness combines with his opposing naturalism (including the mode of lighting that especially supports it) in an effect that is un-Maniera: a slowing, and in places a complete stopping, of the rhythmic mobility that had been conspicuous in high Maniera design, and which was a prime factor of its functioning as ornament; in this facet of rela-tion to the ideas of Maniera Allori's style also emerges as a stiffened compromise. A principle of compromise invades his colour, too: it tends to keep the off-key, glassy hues of a Maniera taste, but shows them through sfumato and in-fuses them with rich, naturalizing light.

Allori's situation was defined in these essen-tial terms as soon as the post-Vasarian phase of Florentine art began. Throughout the rest of his career he showed no radical change. The relative weight within his style of Maniera and of naturalist components shifted often, and the character of each might be adjusted measur-ably; however, there was no strong tendency, much less an exclusive one, towards increased naturalism. Paintings of Allori's latest years (e.g. *Road to Calvary*, Rome, Doria, 1604) stress Maniera as much as some works of the eighties, and may be more fluent (because less insistently Michelangelesque) than works done in the seventies. But in some paintings from the middle nineties and afterwards (*Birth of the Virgin*, Cortona, S. Maria Nuova, 1595; and in Florence, SS. Annunziata, 1602) naturalism both of visual effects and tone of narrative became sufficiently important to Allori for him to try to fuse it pervasively, throughout the picture, with Maniera, instead of dealing with it as a separate, lesser aspect of the work of art.

The result is a hybrid that does not quite convince in either sense, but which is formally and (in the meaning of the conflict Allori has attempted to resolve) psychologically highly charged. More often, the elements of Allori's dilemma remain too clearly disparate. In the end his approach to nature was no less *di maniera* than his way of handling his inheritance from Bronzino. He had no deep response to the content of new natural experience; in the main it was for him, like the repertory of Maniera, a matter of aesthetic and formal concern.[5]

Bronzino's Maniera survived into the last quarter of the century more in the guise into which Allori had transformed it than in Bronzino's own. Giovanni Maria Butteri (*c.* 1540-1606) had been Bronzino's pupil, and had contributed meritoriously to the paintings of the Studiolo. Late in the seventies, however, he became Allori's collaborator, and from then on more rather than less his follower. Giovanni Bizzelli, somewhat younger (1556?-1607?), began as Allori's pupil and became his assistant, and even when he worked separately reflected his employer's style. Vasari was posthumously much more influential than Bronzino, as had been the case while both were alive. One major painter of the late Maniera, Battista Naldini (1537-91), drifted towards the Vasarian persuasion from a side of the Maniera still more distant from it than Bronzino's, from a juvenile apprenticeship, some eight years long (*c.* 1549-1557), with the old Pontormo. He followed this with a time of study in Rome (1560-*c.* 61), then returned to begin practice in Tuscany. About 1562 he was recruited into Vasari's quasi-industry, working for some four years in the Palazzo Vecchio as an executant and, it would appear, on occasion in a minor role as a designer. Then, in 1570, he painted two of the most accomplished pieces in Vasari's Studiolo, the *Allegory of Dreams* and the *Gathering of Ambergris* [273], and in 1570-1 the first of the four great altarpieces he was to supply for

Giorgio's projects in S. Maria Novella and S. Croce. In the later seventies he worked successfully in Rome, and then in Florence during the remaining years of his career was one of the city's most esteemed painters of religious works.

Like Allori, Naldini was essentially attached to the Maniera, but also like him tended to diverge from the form of Maniera he inherited. In Naldini's case, the inheritance was more complicated. The influence that mostly shaped the formal elements of his vocabulary was Vasari's, but his vein of feeling remained closer to Pontormo, to whom he owed his earliest example. Naldini softened Pontormo's emotional mode and conventionalized and feminized his grace, but he retained some of Pontormo's energy. Naldini infused these qualities into Vasari's forms, already half congealed, and gave them an altered but partly renewed life. It was surely a matter of disposition still more than education that caused Naldini to see, in both Pontormo and Vasari, their origin in a common master, Sarto. Painterly, colorist, intimist, and often sentimental, Sarto supplied Naldini with the precedent of style and the devices he required in order to recast Maniera so as to express a similarity in his temperament. What till then had been essentially a draughtsman's style thus became painterly in a change which Naldini invented for it. Rhythms of an explicitly Maniera kind are traced out by Naldini not in line but with a flexible, often loaded, brush. Contours take on a powdery sfumato, and his play of light and dark makes a new variety of saliences and depths; his colour, still in the pastel, slightly off-key taste of the Maniera, softens and takes on sensuous texture. Emotion is felt, as the forms that tell of it are seen, in a sfumato, with a result that falls somewhere between the past Sarto and the contemporary Barocci.

273. Battista Naldini:
Gathering of Ambergris, 1570.
Florence, Palazzo Vecchio, Studiolo

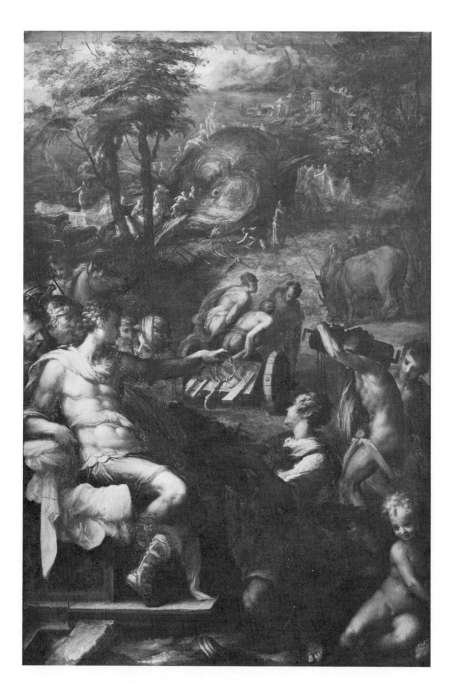

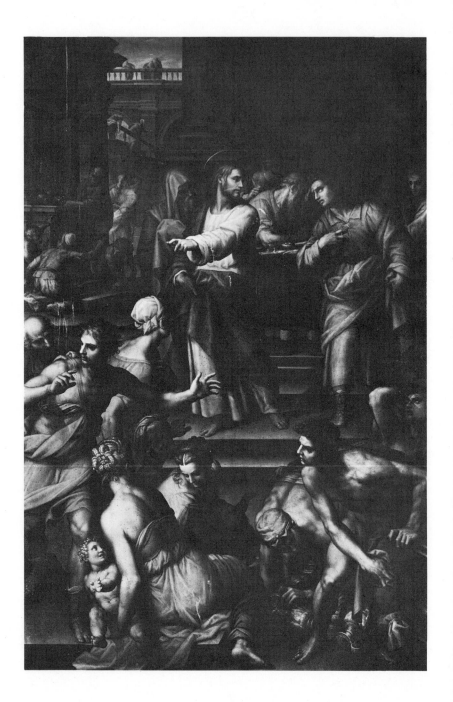

The painterly elements of Naldini's style are by definition in a measure optical, and on this account there may be reason to suggest that his style, like Allori's, thus contains an element of naturalism, divergent from the preceding norms of high Maniera. In these restricted terms it would be true; but it does not diminish the effect of Naldini's painterliness to recall the uninterrupted persistence in Florence of a subcurrent of Sartesque style, or the recent painterly inclinations of Cristofano Gherardi. It is more important to recognize that, much as the optical elements of Naldini's style may intend effects of naturalism, they intend effects of ornament more. In any case the natural effects are subsumed into the formal and expressive artificiality that finally (and with no equivocation like that in Allori's painting) dominates each one of Naldini's works.

Naldini's most painterly phase came in the late sixties and lasted until the middle seventies. In the later seventies his style tightened and took on a more conventional and academic cast (e.g. *Presentation in the Temple*, Florence, S. Maria Novella, 1577) as if, in the absence of Vasari, there was reason for his former helper to perpetuate Vasari's point of view. Naldini's Roman stay completed his reconversion towards the standard practices of late Maniera. Polished forms, even of Michelangelesque accent, and the conventionalized repertory of expression of a Counter-Reformation piety appear in his *Deposition* (Florence, S. Croce, finished 1583); his *Calling of St Matthew* (Florence, S. Marco, Cappella Salviati, 1584-8) [274] is more congealed, as accomplished a testimony as exists in Florence at the date of how to make art *di maniera*.[6]

By the middle of the eighties nothing could be done in Maniera style except *di maniera*. Partly, the Maniera's accumulation of sophis-

274. Battista Naldini:
Calling of St Matthew, 1584-8.
Florence, S. Marco, Cappella Salviati

tication in ideas and means had passed the tolerable limit, and it could no longer be a style in which invention, or even fresh creation, could be achieved. The post-Vasarian devotees of the Maniera worked creatively with their inheritance, and made some innovations in it in the eighth and early ninth decades; but what happened in their painting later is, as in Naldini's case, congealed formula, or as among other of his colleagues in the style, a translation of it into Counter-Maniera – as we noted earlier, much less widespread in Florence than in Rome, and of less importance as a cultural symptom. Where the Roman Counter-Maniera of the later Cinquecento conveys, even in its arid limitations, a positive religious purpose and aesthetic sense, the rarer Florentine phenomena of Counter-Maniera mainly convey the negative effect of the surrender of the values of Maniera, and a retreat from them.

Until this occurred, creativity even in the preceding phase was possible only by a forcing of the values taught these late Maniera painters by their collective master, Vasari. Naldini's innovations are not only formal but insist on an individuality of feeling that Vasari never willingly exhibited. Francesco Morandini, called Il Poppi (*c.* 1544-1597), a younger colleague of Naldini and early a pupil of Vasari, found novelty by courting eccentricity of feeling and form. In Naldini there is reference back to Sarto and Pontormo in his vein of feeling: what Poppi recalls of a past Cinquecento state of mind, perhaps more by affinity than explicit influence, is Rosso. Poppi had been Vasari's helper in the later parts of the Palazzo Vecchio decoration, and there and in the preparation of Vasari's huge ancona for Boscomarengo (1567-8) had worked close beside Naldini.[7] Naldini pointed the way for Poppi's divergence from Vasari, thoroughly contaminating Poppi's style with the example of a painterly and colorist mode that need not be used for a descriptive end. Pursuing this adopted point still farther,

FRAN·POPPI·

Poppi made Naldini's technique into the instrument of an extreme fantasy. Poppi shared with Naldini, perhaps partly owing to his guidance, his interest in the pre-Vasarian sixteenth-century generations, but where Naldini tended towards the earlier and more moderate examples that Pontormo offered and to the mature work of Sarto, Poppi looked to their extravagances: to the early, and as it were proto-Mannerist paintings of Andrea, and to Pontormo's more mature and extreme styles. The latter may have been the starting point for the shapes and movements that human forms surprisingly assume in Poppi's paintings of the 1570s, but on this inspiration Poppi has imposed the temper, very different from Pontormo's introverted *terribilità*, of an artist of the late Maniera. This, in Poppi's case, is a subtly berserk whimsy that is laboured and precious both at once: it works on form to make it as malleable as toffee, and evasive of any graspable proportion, patterning it with swift convolutions. Feeling proceeds not just from the strangeness and excitements of this form, but from what is illustrated of action and of facial expression, as eccentric as the form. Consulting Sarto on Naldini's lead, Poppi makes their painterly techniques still less sensuous – filmy, vaporous, and impalpable; the result resembles Rosso, and the resemblance is increased by Poppi's penchant for evading rationalizable relations among colours as he evades proportionality in form. Poppi is another instance in the post-Vasarian generation of Maniera – with Cavalori, who did not live to mature with his generation, as well as Naldini – of their search backward into the art of the pre-Vasari generations for ways to give renewed sense to Maniera style.

Poppi's inventive extension of Maniera lasted (as we observed in Naldini's case as well) only till the early eighties. Its products until then include, each in a somewhat different mode, the two pieces Poppi supplied for the walls of the Studiolo (*Alexander and Campaspe*, 1571 [275]; the *Foundry*, 1572), the most expressive among all the panels of artistic individuality;[8] the Sarto-derived *Tobias and the Angel* (Prato, Galleria Comunale); and the Rosso-inspired *Assunta* (Castelfiorentino, S. Chiara). About 1584-5 the altar which Poppi contributed to the Salviati Chapel in S. Marco (where Allori and Naldini also painted), a *Christ healing the Leper* [276], is a remarkable demonstration of a forcing of the worn Maniera conceits until they re-acquire an expressive sense. In his relationship to the first Mannerist generation (here he cites Beccafumi, too) Poppi

276. Francesco Morandini, Il Poppi: Christ healing the Leper, *c.* 1584-5. *Florence, S. Marco, Cappella Salviati*

275. Francesco Morandini, Il Poppi: Alexander and Campaspe, 1571. *Florence, Palazzo Vecchio, Studiolo*

aspires to their intensity of content, not just to their repertory of form. But all this is too evidently laboured, and so also – as much as in the purposely jewel-like pictures for the Studiolo – is the surface of the altarpiece, so that for all its forcing of expressiveness, it has an academic cast.

Poppi's straining is of a fabric already too much worn. The S. Marco altar was a last vital effort in Maniera style. Even earlier there had been episodes of slackness and apparent fatigue in Poppi's art, but in the later eighties his Maniera almost precipitously fell into a character of vacancy (e.g. *Presentation in the Temple*, Florence, Banca Toscana): he came to imitate his own past inventions, reducing them to formula. Subsequently, his Maniera lessened, invaded by an awkward naturalism borrowed from the Florentine reformers (*Last Supper*, Castiglion Fiorentino, Gesù, 1591); or, still more radically, he gave way altogether (as in the *Crucifixion with Saints*, Florence, S. Michele a S. Salvi, and in the *Crucifixion* of 1594 at Castel Fiorentino, S. Francesco) to a Counter-Maniera extraordinary in its deliberate effect of campanilistic archaism. Poppi may have meant, like the reformers, to recall the naturalist and classical Sarto or Fra Bartolommeo, but what he in fact disinterred more nearly resembled the dead style of Sogliani.

In Girolamo Macchietti (1535/41–1592) the congelation was still swifter. A pupil of Michele di Ridolfo in his Vasarian phase, Macchietti had then worked for six years (*c.* 1556–1562) in Vasari's *équipe* in the Palazzo Vecchio. For this experience he found a partially effective antidote in two years' independent study in Rome. Returned to Florence he formed a close but discontinuous connexion with the restless, brilliant Mirabello Cavalori, considerably older but destined to be shorter-lived. During this period Macchietti shared with Cavalori in the projects for which Vasari distributed commissions, such as the *Esequie* of Michelangelo and

the Studiolo. In 1573, a year after Mirabello's death, Macchietti supplied an altarpiece for the Vasarian redecoration of S. Maria Novella. The association with Vasari, an almost inescapable fact of the Florentine artistic economy of the time, should not disguise the difference from his brand of Maniera that Macchietti asserts in his early style. It is as marked as Cavalori's and somewhat influenced by it; and his effort to revivify Maniera and to redirect it is not less apparent than in the painting of Naldini and Poppi, his contemporaries from the Vasari shop. The nature of Macchietti's dissent is apparent on a major scale in his *Adoration of the Magi* (Florence, S. Lorenzo, 1568), in which he tries, with a remarkable degree of success, to aggrandize the Vasarian Maniera according to the models – some of them observed in Rome – of the first generation of Maniera, conspicuously Parmigianino's. Handsome fullnesses of form, defined by generously rounding rhythms, recall the descent of contemporary Maniera from Raphael. Colour is *changeant* and continuously surprising, in the best vein of Florentine Maniera, but it is given resonance in chiaroscuro. In his pictures for the Studiolo (*Medea and Jason, The Baths of Pozzuoli* [277], 1570–2) light takes on a more important role. These small panels show an elegance of shapes and rhythmic style that still more obviously depends on Parmigianino, but the forms exist in light – inspired, most probably, by Cavalori – that subtly and astonishingly conveys a truth of visual effect, surrounding artifice with credibility. Not just Parmigianino but the early Pontormo, who had sought similar effects, is recalled by Macchietti and exploited for this fine Mannerist ambivalence of purpose.

The concern with light as a means to regenerate or redirect Maniera is one that Macchietti shared with Poppi and Naldini; but only Macchietti's use of light suggests that his main purpose for it is, like that of the reforming Santi di Tito, naturalistic. In Macchietti's

277. Girolamo Macchietti: The Baths of Pozzuoli, 1570-2. *Florence, Palazzo Vecchio, Studiolo*

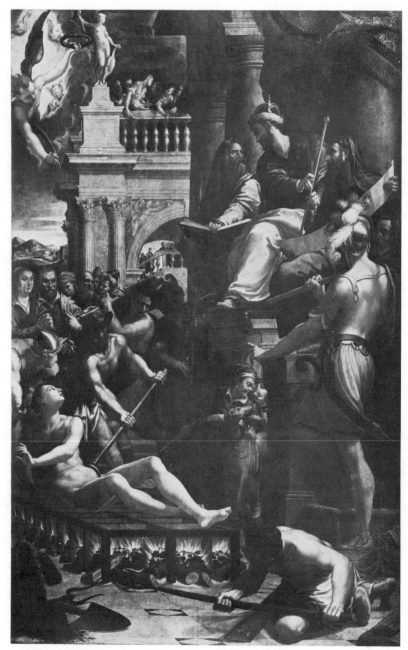

278. Girolamo Macchietti: Martyrdom of St Lawrence, 1573. *Florence, S. Maria Novella*

Martyrdom of St Lawrence (Florence, S. Maria Novella, 1573) [278] lighting takes on a Venetian cast; however, even more surprisingly, so do the composition and its spatial order (resembling Titianesque inventions), the setting (more Veronese-like), and many of the details. An experience of Venetian painting, gained in some way we cannot document, guided Macchietti nearer a naturalism which, in this painting, competes with its component of Maniera.[9] Macchietti here ventured on a path that only afterwards would be explored by the reformers, but he did not pursue it. Closely following on the altar for S. Maria Novella, his *Madonna della Cintola* (Florence, S. Agata) is in quality of content as much as in form a Maniera preciosity, made emblematically rigid. But in 1577 his *Gloria di S. Lorenzo* (Empoli Cathedral) is no more than academic late Maniera, unsatisfactorily conjoining a stiff artificiality with pedestrian naturalism of detail: a result so tedious that it suggests the action upon Macchietti of Federico Zuccaro, then in Florence.

After this time Macchietti ceased to be a major figure in Florence itself. For reasons that may have had more to do with conditions of patronage under Don Francesco than with a sense of crisis in his style or his insufficiency to meet it, Macchietti left to take work in South Italy, where he remained till about 1585. In Florence again only briefly, he was in Spain from 1587 to 1589 and died two years after his return. Of his late non-Tuscan work we have as yet identified nothing, but we possess an altar done in Florence almost in his last year (*Crucifixion*, Florence, S. Giovannino di Scopoli, 1590). It still shows strong residues of Maniera, but more essentially it illustrates a Counter-Reformation thought in a Counter-Maniera style.

The lesser painters of the generation born about 1535-40 whom Vasari gathered into his collaborative enterprises, the Studiolo in particular, were mostly adequate adherents of Maniera in their earlier careers, more often in his version of it than another. For most of these painters, whose activity extended into the last decade of the century or even into the next, we have little knowledge of their post-Vasarian careers; however, it appears that in them too there were symptoms, within the eighth decade, of an alteration of Maniera modes. Alessandro del Minga (after 1540-1596), author of the *Deucalion and Pyrrha* in the Studiolo and of an *Agony in the Garden* (1575-8) among the altarpieces of S. Croce, moved towards a heavier and darker style and a labouring of descriptive detail. Alessandro Fei (del Barbiere; 1543-92), the painter of the *Goldsmith's Shop* in the Studiolo and the *Flagellation* (1575) in S. Croce, followed a similar course, insisting still more upon description. Both painters contaminate Maniera, but do not basically compromise it. This is the posture also of an older Studiolo artist, Jacopo Coppi (del Meglio; 1523-91), of less conventional tendency and gifts. In the Studiolo his pieces are the *Powder Factory* and the *Family of Darius before Alexander*. One, partly Vasarian in cast, is also recollective of an older Cinquecento style like Bacchiacca's; it is a paradigm of the bizarre spirit and eccentric form in which the Maniera approached genre. The other, in a quite different mode, exaggerates Coppi's and Allori's models into precious nonsense. In 1574, an altar of the *Preaching of St Vincent* (Florence, S. Maria Novella) suggests still more than the *Powder Factory* a compound of Vasarian Maniera with the recall of an older style, descended from Fra Bartolommeo and Sarto. The recall may be more than a symptom of conservative disposition; it may be (as among other painters at this moment also) the result of a seeking for values different from those of the Vasarian Maniera. While Coppi's *Ecce Homo*, painted for the S. Croce altar series in 1576, is pretentious and academic and more akin to the late Vasarian style, it is at the same time influenced by the

most 'modern' tendencies of a naturalizing kind that his fellow artists in the altar schemes had displayed. An altar for Bologna, *The Miracle of the Crucifix of Soria* (Bologna, S. Salvatore, 1579), settles on a working compromise: a basis of Vasari-derived Maniera to which Coppi has applied a new efficiency and breadth of spatial logic and descriptive accent. Again in this later work there are repeated references to early Cinquecento style, surely calculated retrospective acts, to which, however, Coppi might have been more than ordinarily disposed by a taste and habits formed by his early education. We know of him that he studied with painters described only as 'various masters'; given their anonymity, they are likely to have been other than progressive.[10]

In the generation after Coppi's there is a productive painter of some reputation whose tendencies to backward reference are yet more obvious, and in his case it is clearer that his disposition proceeds at least partly from his early education. Francesco Brina (*c.* 1540–1586) was a pupil of Michele di Ridolfo, if not of the old Ridolfo Ghirlandaio himself. An education as conservative as good talent in Florence could provide about the middle of the century seems to have fixed Brina's interests even as they were being formed. Primarily a *madonnero*, he painted devotional pictures in a style dependent mainly on Tosini's mature mode, which in this genre was the most conservative adaptation of Vasarian Maniera. However, much more than Tosini, Brina made purposely overt paraphrases on Sarto's compositions, and managed to rephrase Tosini's handling so that, while remaining explicitly Maniera, it refers insistently to Sarto. Attesting the market for this mode – a Maniera that especially proclaimed a local flavour and asserted the best local ancestry – Francesco's brother, Giovanni (d. 1599), who had also been Tosini's pupil and afterwards one of Vasari's

hands in the Palazzo Vecchio, helped to multiply his brother's production, working in close imitation of him.

The Florentine Reformers

The interest in earlier Cinquecento art of the Florentine painters we have called 'reformers' is different in effect, and in real purpose also, from that exhibited by the persistent Mannerists. The reformers sought out the artists of the classical High Renaissance style – never the early Mannerists – to be guides towards naturalism in describing persons, things, and their environment of space, towards achieving clarity and logic of pictorial structure, and, equally important, towards attaining legibility of communication. The two latter aims coincide with those of the Counter-Maniera, but it is precisely the vital difference between the art of the Counter-Maniera and that of the reformers that they do not share the first. It is possible to show, in the case of Santi di Tito, the earliest – and also most important – of the Florentine reformers, that his style of reform was preceded by exposure to the Counter-Maniera and a strong disposition towards it; this does not predicate a necessary sequence between the two in his case or in general. The distinction between the making of a Counter-Maniera and a new naturalist style was evidently not always an offered choice: what was possible in the way of innovation and reform in Florence in the 1570s was not necessarily a possibility earlier, before the high Maniera had completed its creative course; and what was possible at that time in Florence may not have been in the atmosphere of contemporary Rome.

Santi di Tito (1536–1603), born in Borgo S. Sepolcro, was trained in Florence by a minor painter whose work is now unknown to us, though it is alleged that Santi was also a pupil of Bronzino and of Baccio Bandinelli. By 1554,

when he was not yet eighteen, Santi had been admitted to the Florentine Compagnia di S. Luca and at twenty-two had gone to Rome, where he is supposed to have been in Cellini's shop. At twenty-three, in 1559, he had already been commissioned independently, to decorate the chapel of the Roman Palazzo Salviati. The remains of this decoration reveal a quick assimilation to the Roman school, and to its most advanced contemporary currents – which at this time meant the moderate and reactionary ones. Siciolante and Taddeo Zuccaro (as, e.g., in his very recent Cappella Mattei) are Santi's immediate models, through whom (but only thus indirectly) he sees Michelangelo and Raphael. The latter, and Siciolante, who was his present advocate, were much the more congenial to Santi. When between 1561 and 1564 he came to paint in the Sala Grande of the Belvedere beside the Maniera decorators Giovanni de' Vecchi and Nicolò Circignani, Santi's Raphaelesque classicistic bent emerged still more obviously, contrasting with that of his associates. The frescoes in this suite that are unequivocally his (e.g. *Homage of the People*) suggest, more nearly than Siciolante ever does, the notion of Domenichino *avant la lettre*.

Returned in 1564 to Florence with this avantgarde-reactionary Roman mode, Santi had a difficult phase while, as he regained a Florentine vocabulary and accent, he sought at the same time not to succumb altogether to its dominating substance of Maniera. Bronzino (whether or not Santi earlier had learned from him) became his closest model, faithfully enough observed so that his Romanizing receded, displaced by a style dependent on Bronzino's polishing of forms and sharpness of draughtsmanly effect. Santi resisted Bronzino's ornamentalism, however, and by the same token Bronzino's – and the general Maniera's – disposition to idealize and refine appearances wherever possible. Even as early as the middle

sixties Santi began to convert Bronzino's controlled and incisive line, which suspends descriptive virtue within the sense of ornament, into an instrument for more evident and more objective description; at the same time he began to use light, very differently from Bronzino, to accentuate the verity of what he drew, conveying its existence in an atmosphere and space. Santi had already found the means to make pictorial existence legible in the Counter-Maniera style of Rome and its authentically classical antecedents in the High Renaissance. Now, in Florence, he found in the local classical past, in Sarto's art particularly, the example of a use of light that could add to legible existence an optical effect of truth. His first effective compounding of Bronzino and the Florentine High Renaissance is a *Sacra Conversazione* for the Ognissanti, painted between 1565 and 1568. In 1570-2, his two contributions to the Studiolo (*Hercules and Iole* and the *Origin of Amber*) have a Bronzinesque and classicistic air, but this is outweighed by the pressures Santi applies in them to achieve an effect of mimetic presence more compelling than in any of the other Studiolo panels, including those few (like Mirabello's) that work towards naturalism with subtler means.

As Santi was more deeply re-absorbed into the current Florentine climate – still essentially a Maniera one – that produced the Studiolo, it would seem he thought for a moment to make a working compromise between Bronzinesque Maniera and his developing naturalism. More than the Studiolo panels, the first of the altars Santi painted for the Vasarian projects in S. Croce and S. Maria Novella, a *Resurrection* (Florence, S. Croce, 1570-4) [279], is the indication of this moment: excessively deliberated stylizations of anatomy and attitude join with an almost pervasive, nearly *trompe l'œil* realism of details. The stylizations alter the meaning of this realism and temper its effect, but this work

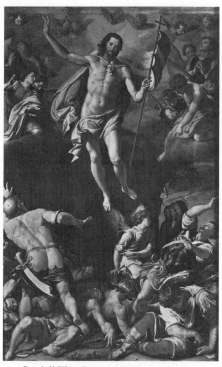

279. Santi di Tito: Resurrection, 1570–4.
Florence, S. Croce

still contains more trenchant re-creations of physical presence than any other painting within Central Italy at this date. Some passages could be taken to belong not to a quarter of a century before Caravaggio but in his following. What happens in Santi's next altarpiece for S. Croce, the *Supper at Emmaus* (1574) [280], indicates a truth about the preceding *Resurrection* altar that may seem a paradox: that the hard, sharp, fine-edged urgency with which things were described in it is a conversion to naturalist purpose of a Maniera state of mind. As soon as Santi abandons his intention to make naturalism and Maniera coexist, his realism becomes less trenchant; but it is more important that the general effect of naturalness then becomes more believable, consistent, and

complete. This is the effect of the *Supper at Emmaus*, which thus becomes the most radical accomplishment of naturalistic painting of the time. The precipitate may have been in an experience of Venetian painting (as, we presume, in Macchietti's case before); but this work of Santi's, if not less bound by residual ties to the Maniera than the contemporary art of Paolo Veronese, is more purposely pedestrian. Its conception of the relation of the work of art to actuality is not Venetian but strictly local, in Sarto's unrhetorical naturalism, and in its ancestry of Ghirlandaiesque prose. The conventions of design, differing as if by deliberate principle from the Maniera, have a more complex origin, studied partly from Sarto's classical manipulations of checks and balances, but also from Venetian style: the Pesaro altar is the archetype of Santi's use of a space-creating scaffold of diagonal motifs – excepting only Macchietti's *Martyrdom of St Lawrence* of the year before, also Venice-inspired, a drastic novelty in Florence. What is borrowed or derived not only supplies Santi with artistic means but helps him to define his ends. However, it is Santi's personality and purpose, as distinct from the recent and contemporary Venetians as from the Florentines of Sarto's time, that determines the way in which he uses what he borrows or revives, and the effect he makes with it. The degree of naturalism that he wills and finds was not a possibility of art in Florence earlier than this, and it is not only more, but of a different kind than the naturalism of contemporary Venice; it is more nearly like the incipient novelties – also a revival in part – of the current Lombard school, but more articulate of a novel purpose as well as more advanced, freer from Maniera.

During the seventies Santi pressed his naturalistic purpose farther. The *Resurrection of Lazarus* for S. Maria Novella (1576), comparable to the *Emmaus* in its scheme of composition, almost achieves the character of an

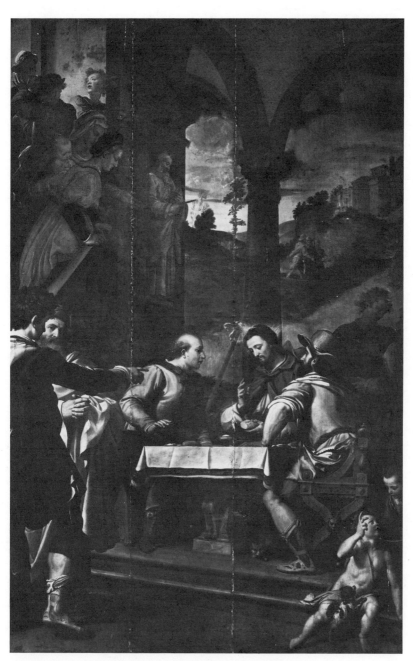

280. Santi di Tito: Supper at Emmaus, 1574. *Florence, S. Croce*

objectively descriptive prose. Smaller and less formal pictures of the later seventies (*Pietà with Saints and Military Donor*, Florence, Uffizi, deposit, or various *Holy Families*) come still closer to this end, remarkable in its time and place. Yet these works also indicate the limit to which Santi could – or would – go in his mimetic purpose. Maniera conventions now hardly apply, but conventions of a more classicizing kind do, academically rephrased from Sarto's and even Bartolommeo's models of the High Renaissance. Santi is content to have effected a decisive reform; he does not seek a revolution. There is an irreducible residue of idealism beneath his naturalizing. It affects human appearance, giving it a classicizing cast, and it conditions attitudes and modes of behaviour.

Having pressed his innovation in the later seventies as far as he desired it to go, Santi sought increasing sanction for it from past classical authority. In the 1580s he sought to reconcile naturalism with classicizing purities of shape and regularities of composition, the latter sometimes so simplistic that they may recall Perugino more than Sarto or the Frate (e.g. *Doubting Thomas*, Borgo S. Sepolcro Cathedral, before 1584). These classicizing elements do not denature Santi's naturalism by so very much, and certainly not to the degree where his descriptive mode approaches that of Counter-Maniera. Yet some of his schematic simplifyings after classical ideas resemble those of the Counter-Maniera; and it is understandable that he should respond, like some of his contemporaries, to the tone of un-fancy piety promoted by the Counter-Reformation. He is not one with them, however: it may be due to a remnant of Maniera in Santi's make-up that his quiet and sometimes astonishingly actual re-creations of religious scenes, such as the *Crucifixion* altar of S. Croce (1588),[11] convey more sense of his accomplishment of art in them and of his exercise of taste than of conviction of a Counter-Reformation belief.

The last decade of the century and the first years Santi lived into the next are perhaps fortunately less perfectly restrained and less classicistic. As most painters in Tuscany and elsewhere gained their liberation from Maniera and made a progress into naturalism similar to Santi's, he was willing to republish innovations he had made earlier, occasionally turning them to more forceful account. Two altarpieces of 1593, a *Marriage at Cana* (Colazzo, Villa Chierichetti) and a *Vision of St Thomas Aquinas* (Florence, S. Marco) [281], conspicuously stress diagonal space compositions, the former in a way that quite affirms Santi's experience of Venetian art. The latter uses his mimetic techniques, if anything now still more effective, to

281. Santi di Tito:
Vision of St Thomas Aquinas, 1593.
Florence, S. Marco

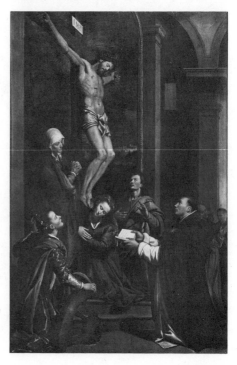

make an image which admits no boundary between the spectator's reality and that to which the painting, with nearly *trompe l'œil* effect, pretends, and within the painting there is no line between the real and the visionary. Most of Santi's apparatus as well as his intentions are not to be distinguished from those of the seventeenth century, and it is a difference of degree more than of kind that he requires of the reality he evokes that it achieve a compromise with a controlling classicistic taste. In almost all Santi's latest pieces (e.g. the quietly powerful *Annunciation* of 1602 in S. Maria Novella), this taste is expressed with an understated elegance: the last link in Santi's art with the temper of Maniera.

Santi was the earliest, and for a time the strongest, force in the redirection of Florentine painting that began in the last quarter of the century. In his quest for naturalism he certainly took cognizance of the means to achieve optical truth that he could find in Venetian style, of which he must have had (probably in the early 1570s) first-hand experience; but Venetian art (which, it must be recalled, offered more examples of its brand of Mannerism than of naturalism in these years) was by no means determining for Santi's style. It did play a significant part in the work of two somewhat younger painters, Ligozzi and Passignano, who participated – though much less inventively than Santi – in the process of reform. In the case of Jacopo Ligozzi (1547-1627) the Venetian tendency was one he brought to Florence from his place of birth and early practice, Verona; he did not appear in Florence until about 1577, to shoulder the restrictive and often artisan-like responsibilities of painter to the Medici court. This position seems to have isolated him somewhat, both as a giver and receiver, from the progressive circles of contemporary art. Until about 1590 his work in Florence seems not to have included commissions either on a large scale or of a public kind. However, Ligozzi had

earlier developed a peculiar kind of mimetic faculty in the painting of water-colour illustrations of birds, fish, and animals for 'scientific' clients, and the effects of this specialist imitative skill are apparent in Ligozzi's paintings of the nineties, when he finally came into public view. The naturalistic effects of a Venetan, if not explicitly a Venetian background, are also evident in these works (as, e.g., in such a characteristic picture as his *Visitation*, Lucca Cathedral, 1596) in their strong chiaroscuro and perspective openings of space, both of which help to assert existence for the painted forms. But traditional Tuscan values had come to impose their even more apparent effect on Ligozzi's style, stiffening and formalizing it and deadening his colour: this is a debased analogue of the past history of Sebastiano del Piombo. It is doubtful that Ligozzi's art, or the Venetian component in it, had much formative effect in the genesis of seventeenth-century Florentine style.[12]

This was not the case with the Tuscan Domenico Cresti (Il Passignano, c. 1558/60-1638), in whose style the Venetian factor was much stronger than in Ligozzi, and who used it with a different purposefulness and understanding of its powers. Passignano spent seven or eight years of residence in Venice, between 1581/2 and 1589. He had gone there from Rome in the company of Federico Zuccaro, whose assistant he had been since the middle seventies, when Zuccaro had come to Florence to complete the painting of Vasari's dome in the cathedral. Before that Passignano had studied with Naldini, and even earlier with Macchietti. The course of this education was one of exposure to advanced currents of the time in both Central Italian and Venetian art, among which Federico's academicism was by no means the least. Recalled to Florence in 1589 to participate in the festival decorations in honour of Christina of Lorraine, Passignano quickly secured a major commission, for the fresco

laterals (the *Translation* and *Funeral of St Antoninus*) in the Cappella Salviati in S. Marco, where the older Allori, Poppi, and Naldini painted the altars. The frescoes document an extensive artistic learning, from Florentine, Roman, and Venetian sources, but it may be on account of a deliberate accommodation to the Florentine taste (with its present strains of academicism and residual Maniera) that their chief effect is of a visually sharpened version of Federico's style. Shortly afterwards the *Preaching of the Baptist* (Florence, S. Michele Visdomini, *c.* 1590) [282] shares the disposition of the advanced Florentines to look back towards Sarto. However, it is not a Florentine but a

282. Domenico Passignano:
Preaching of the Baptist, *c.* 1590.
Florence, S. Michele Visdomini

Venetian reference that dominates this work, for it is the product of deep study of the art of Titian, though the consequences Passignano has drawn from it yield a result of which the closer analogue for density and richness of chiaroscuro (and probably, once, colour; it is now much darkened) and for trenchant handling of observed facts is in the contemporary Bassani. What the picture holds of Titian-like emotion is no less important, and is a still more extraordinary intrusion into the context of current Florentine art: it has to do with warmth and directness in describing and communicating feeling – an attitude the Maniera had effectively suppressed. This is the demonstration of what may be called a naturalism of content, which here is fused more effectively than hitherto in Florence with a new naturalism of form.

Passignano's Venetian education was allowed to show itself more openly in his succeeding paintings of the nineties. Some, such as his *Nativity* (Lucca Cathedral, 1594), take on a character like that of works of Palma Giovane's school. When the relation becomes so apparent, we realize that Passignano's contribution to the Florentine reform, at least within the limits of the sixteenth century, must be measured more in terms of a borrowing he was able to pass on to his native school than in those of any major innovation of his own. Yet in the first years of the new century he achieved a mode, combining Venetian mobility of forms and lights with a more literal descriptive naturalism, which was influential for the subsequent development of Florentine seventeenth-century style.[13]

Though his painting exhibited conspicuous elements of naturalism well before 1600, Bernardino Poccetti (1548–1612) does not have a comparable role in the process of detaching Florentine painting from the Maniera. Trained from the beginning as a decorator (as a painter first of grotesques and then of façades), he never lost his concern for the ornamental value

of forms or their quality of stylishness. Unlike his more pressingly reformist colleagues, Poccetti could not accept the proposition that elegance and truth could not be reconciled in art. His counter-proposition seems to have been: where else? He preserved the pointed and complex mobility of Maniera draughtsmanship especially, and according to Maniera habit stressed the role of rhythmic continuities in large design. Where he could, he touched his actors' looks with an air of ideality and gave their attitudes a slightly artificial grace. These qualities, persistencies from Poccetti's education in Maniera, should not obscure the measure to which he manipulates the blood tones of his habitual fresco medium to lend his forms the effect of optical truth and give the sense of their existence in an expanding, atmospheric space. His naturalism is partial, but it is compelling where it is crucial that it should be. Unlike his more dogmatic colleagues he did not equate naturalism with prose; however, the elements of artifice which Poccetti carried over from Maniera into his naturalizing style did not remain in that new context, in form or intonation, quite what they had been before.

Poccetti progressed from his métier of painter of grotesques and decorator of façades to the nobler forms of the art of the *frescante* only in 1580, when (after a probable period of study in Rome) he was commissioned to take part in the hagiographic decoration of the Chiostro Grande of S. Maria Novella. This enterprise, in which the participation of most of the post-Vasarian generation of painters had been enlisted since 1568, was the earliest, the most extensive, and artistically the least homogeneous of a series of didactic decorations in Florentine churches, instigated by the Counter-Reformation purpose to create a popular revival of religious enthusiasm. The kind of subject matter and its purpose referred almost of necessity to the older Florentine tradition, preceding the Maniera, of narrative fresco art. As yet,

Poccetti was too involved in the Maniera to observe the direction that this analogue and precedent implied. Furthermore, secular decoration, on which he also was engaged, encouraged the practice of the most concettistic mode of the late Maniera; Poccetti employed it brilliantly in the Florentine Palazzo Capponi (*c.* 1585). But further concern with the demands of popular religious narrative drew him towards a soberer and – observing the force of ancient precedents – a retrospective style: it appears in Poccetti's frescoes (late 1580s) in the cloister of the Confraternità di S. Pier Maggiore (S. Pierino), another of the didactic fresco cycles.[14] In the early 1590s Poccetti undertook what was to become a long, though sporadic, decorative enterprise at the Certosa di Val d'Ema. His chief piece there, the choir lunette with the *Funeral and Translation of St Bruno* (1592-3), is full of trenchant naturalism achieved by tensile draughtsmanship and sharply observed light. Space is ample, deep, and architecturally measured, and design is simply geometrical, almost to the point of symmetry. The fresco seems to make a double reference to pre-Maniera styles: one to the classicism of the High Renaissance – Raphael's as well as Sarto's – the other to the realism of the Ghirlandaiesque late Quattrocento. What has been retained of Maniera is hardly identifiable. Passignano's shortly previous frescoes of the Cappella Salviati, comparable in subject, are less avant-garde than this.

By the early nineties, Poccetti had control of all the apparatus needed to make art a vehicle of naturalism, and he employed it with interest and much consistency; yet he could not take the view that mimesis was the first end of art. For him, effects of naturalism remained matter to be incorporated with the effect of artistic style. Mimesis was a value concomitant with style, but one which he would without hesitation make subject to it. His fresco decoration of the Cappella Neri (Cappella del Giglio, finished

283. Bernardino Poccetti: Detail of decoration, 1599. *Florence, S. Maria Maddalena dei Pazzi, Cappella del Giglio*

1599) in S. Maria Maddalena dei Pazzi [283] is testimony of Poccetti's position in the last year of the century. The decoration is full of efficient devices of illusionism and of forms from which Poccetti's light and drawing have elicited a cogent sense of visible existence. But in this chapel, private and aristocratic by contrast with the Certosa or the public cloisters (and thus more akin in kind and purpose to a secular palace decoration), he re-evoked the finesses, the complexities, and even some of the arbitrary elegances of Maniera. In the Palazzo Usimbardi (now Acciaiuoli, 1603) his explicitly decorative frescoes seem translations into the present idiom of the art of Francesco Salviati. Even when Poccetti again confronted the demands of the popular didactic fresco (Florence, S. Marco, Cloister of S. Antonio, begun 1602) he could not always quite contain his sense of style within the simply natural and archaistic – Raphaelesque, Sartesque, and Ghirlandaiesque – mode which he deliberately affected there. Poccetti learned, partly from the example of his reforming colleagues, the variations of mode required to suit an assortment of contemporary purposes. But no matter what the quota of new or retrospective naturalistic style in it, his own way – as he demonstrated on a grand scale in his *Massacre of the Innocents* (Florence, Innocenti) as late as 1610 – retained much of the principle, as well as the intonation, of Maniera.

The artists whom we have so far characterized as taking part in the reform of painting in late Cinquecento Florence were, relatively, its more cautious agents. There were others, who, still within the confines of the century, disengaged themselves more thoroughly from Maniera, pressed more forcefully towards a new style, and achieved a more consistent formulation of it. Lodovico Cigoli and Jacopo Chimenti da Empoli are the most conspicuous as well as authentic *reformatori*; Andrea Boscoli and Gregorio Pagani, working in a different and less stringent vein, accomplished rather more

sensational but historically less durable novelties. The four artists were roughly of a common age, born during the sixth decade. Among the more tentative reformers, Passignano was the contemporary of the youngest of these, but Ligozzi and Poccetti were older by about a decade, and Santi di Tito by some twenty or more years. It is surely relevant that the present group made their choice of a direction for their styles when the demonstrations of the older 'reformers', however much more cautious, were already known to them. Pagani and Boscoli, indeed, were Santi's pupils, and thus oriented in his sense from the beginning. Santi's model was, however, not the operative stimulus for the development that carried Pagani (1558–1605) in a direction which Santi's classicism did not permit him to explore. Until the early eighties Pagani had been not only Santi's pupil but his assistant. When, about 1585, Pagani was commissioned independently for one of the frescoes in the cloister of S. Maria Novella, what he produced was substantially in Santi's mode. But shortly afterwards – according to Baldinucci, on a trip to Arezzo with Cigoli, who was his friend – Pagani discovered the art of Barocci and began to reshape his own style accordingly. Barocci's precedent equipped Pagani with the means to inspire forms and compositions with the effects of dramatic action and to charge his figures with emotion, and combined with the devices of description he had learned from Santi, made the bases for Pagani of an incipient Baroque style. But his hand had perhaps been too long schooled by Santi's precept: a tightness of technique – and mind – constrained the new directions of Pagani's art.

Boscoli (*c.* 1553/60–1606) was a more eccentric and more genuinely inventive personality than his fellow pupils under Santi. His eccentricity lay both in emotional disposition and in quality of seeing, and it was of the kind that the late Maniera characteristically spawned. But

Boscoli turned these singularities into channels that led away from the abstracting domain of Maniera and into nature. His first documented surviving work, the *Martyrdom of St Bartholomew* (1587) which he contributed to the series in the cloister of the Confraternità di S. Pier Maggiore, exceeds Santi's teaching in contrary directions. A light more energetic and more optical than Santi's is employed to give existence to forms in part more real but in general – despite the gruesome explicitness of illustration of the martyrdom – extravagantly febrile and more mannered. By 1593, in an *Annunciation* for the Carmine in Pisa, the energy and verity of light reveal figures that seem almost palpable and, rather than Mannerist, deliberately pedestrian. The febrility remains, but it is now much less than before a factor of Maniera aesthetic sensation; it is instead an agent that intensifies the tenor of description and communication. Like his former master, but in a very unlike temper, Boscoli studied Sarto's naturalism and his optical techniques, and his eccentric disposition led him (like some among the Studiolo group) to look at the still Sartesque Rosso and Pontormo also. A *Madonna and Child with St John* (formerly Berlin, art market, *c*. 1595) evokes Sartesque presences, but with a hallucinatory, almost disruptive brilliance of vision that recalls the first generation of Florentine Mannerists. However, reference to past Florentine art, though more important in determining the course of Boscoli's style than Santi's teaching was, was not so influential as the same non-Florentine force that had worked upon Pagani. Barocci's style, encountered at the latest in the transcriptions of his Sienese followers in 1589 (when Boscoli is known to have worked in Siena), is a major factor in his case as well. After 1600 the connexion was more closely sealed. In that year Boscoli went into the Marches for an extended stay. Then, not only Barocci's example but that of the Bolognese Lodovico Carracci in a short time

helped to complete the shaping into wholly Seicento terms of Boscoli's still powerfully idiosyncratic style.

The symptoms of what would become Seicento style – albeit with its Florentine accent of relative conservatism – can be identified in both Chimenti's and Cigoli's painting sooner and with less ambiguity than in any other of the Florentines. Jacopo Chimenti da Empoli (1554?-1640) had his first schooling under Maso da S. Friano, and chose to consider him a link backward to an earlier Sartesque style. Closer at hand, he found support for his tendencies to react from Maniera in the paintings which Santi published in the mid seventies. In 1579 Jacopo's *Madonna in Glory with St Luke and St Ives* (Paris, Louvre) had made Santi's naturalism more explicit, and re-emphasized the retrospective classicism of design that Santi, for this brief experimental period, forgot. Jacopo's subsequent development was almost rectilinear, proceeding mainly from the threshold Santi had supplied. He insisted more than Santi on an objective mode of seeing and on the techniques, of luminous colour and relieving chiaroscuro in particular, to describe it; at the same time he made the effect of his vision and description more legible by simplifying them. His simplification works not only in description but in whole designs, influenced in this certainly by Santi, and as in Santi also in some way by the intellectual abstractness of Maniera – or of Counter-Maniera; at the same time this tendency is at least as much allied to the models of lucidity and order which both master and pupil studied in the early Cinquecento classical style. Even when Jacopo insists too heavily on simplifying, making rigid schemata of design, they do not impede but rather work to dignify the existential virtue that he gives his forms. The conjunction between intellectualizing order and stressed naturalism that he makes in his style towards 1600 (*Susanna*, Vienna, Kunsthistorisches Museum, 1600) [284] is peculiarly

284. Jacopo Chimenti: Susanna, 1600. *Vienna, Kunsthistorisches Museum*

Florentine: at the end of the sixteenth century it seems that he is reviving, more than an early-sixteenth-century, a Florentine fifteenth-century point of view.

To begin with, Chimenti made his conservative but none the less authentic Seicento style out of essentially Florentine ingredients, but later, in the forty years that his career extended into the new century, his purity of Tuscan accent came to be much diminished. Ludovico Cardi (Il Cigoli, 1559-1613), who had begun as Alessandro Allori's pupil, sought less inhibited examples, and in his early twenties discovered that there were more signs of creative vitality from which he could take inspiration outside Florentine art than in it. At least as soon as Boscoli and Pagani, Cigoli recognized the indications of a future way that lay in the style of Barocci and in that of Barocci's antecedent, Correggio: as quickly as Passignano, and more intelligently, he absorbed the similar potential in Venetian art, in Titian's and in Veronese's examples; and still within the nineties he sought indices in the Bolognese inventions of Ludovico Carracci. Cigoli's eclecticism was often obvious in his works of these years of searching, but for him as well as for most of his inquiring contemporaries this was the normal means by which they achieved their liberation from Maniera and the basis for a modern style. By the later nineties Cigoli was as visibly advanced in the principles of the early Seicento style as Ludovico Carracci; in the first decade of the new century, which Cigoli spent in the main in Rome, he was an important and progressive member of its modern school.

BAROCCI AND HIS SCHOOL

We have seen that for more than one of the Florentine reformers experience of Federico Barocci's art was the precipitant for a new direction of their styles. Yet no Florentine was so much affected by Barocci's example as were the most important of the contemporary Sienese and, obviously, the painters of his own neighbourhood in the Marches. A group that worked in Rome, composed of a mingling of painters from these two schools, seems to have been a main switch through which Barocci's influence was passed from one geographically disjoined area to the other; but Barocci's influence was spread still more effectively by the mere sight of his paintings, exported by him from Urbino particularly to Rome, Perugia, and Arezzo. From the latter half of the eighth decade for about ten years, until he was outstripped by the younger Annibale Carracci's impetus, Barocci's style was the most radical novelty in Italian painting and the most impressive; and even after the maturity of the Carracci, Barocci's model for a time remained the most widespread. Before the Carracci, and long before the Florentines, Barocci incorporated Venetian idiom and principle into an education that had begun in the Maniera, exploiting the equivocal geographical and cultural situation of his native place. More decisive and much more important, he chose, without any measurable cause we can attach to training or environment – again, well before the Carracci – to look back across an intervening generation to Correggio, and, refounding Correggio's style in his own, to extend it farther still towards what we recognize as a baroque, forging another link between Correggio and the seventeenth century.

In his native Urbino Federico Barocci (c. 1535-1612) had early been a pupil of Battista Franco (while Franco, fresh from Rome, was in his most Romanizing phase) and then of Genga. Working as a youth in near-by Pesaro he had an initial significant experience of Titian in the ducal collection there. In the middle fifties he went for a period of study to Rome, where he observed Raphael particularly and became a

friend of Taddeo Zuccaro. Not immediately but somewhat later, on a second Roman visit to work on the decoration of the Casino of Pius IV (1560-3), Barocci demonstrated the sympathy he felt with Taddeo's style and the extent to which it shaped his idea of a Maniera. Barocci's second stay in Rome was interrupted by an alleged poisoning, engineered or performed by an unnamed rival. Whatever occurred had drastic consequences for Barocci's health. He returned to Urbino and for four years painted almost not at all; throughout his life - a long one despite the misadventure - he seems to have been often invalid and subject to depression. After his return he seems hardly to have travelled, but perhaps on his way home from Rome he may have experienced his revelation of Correggio, though old sources indicate, almost incredibly, that Barocci never went to Parma.[15] When he began to paint again, in 1567, he had remade his style on Correggio's example, and his progress from that point constitutes what is significant in his career for the history of sixteenth-century painting style.

A painting by Barocci, the *Martyrdom of St Sebastian* (Urbino, Duomo), done in 1557 (when he was about twenty-two), reveals the formidable intelligence of mind and hand which, apparently during that very year, he had learned to control exactly. It also shows the measure of his power to fuse into a personal consistency the elements of a visual culture of an unusually diverse kind. Barocci has exploited the environmental accident that put him in a place where Central Italy, Venice, and Emilia could exert almost equal forces of attraction on him, while fixing him to none of them. The *Martyrdom* depends not only on Roman and Emilian Maniera but on the equivalent Venetian style: *disegno* in it has the energy of the one but works upon a colorism and an optical sensibility that belong to the other. It is an exceedingly contemporary compound of the

two *maniere*, yet within it there are still the most apparent residues of study of the older great of both the Roman and Venetian schools - Raphael, Michelangelo, and Titian; and beneath the apparatus of Maniera it is Titian's model that has been most deeply felt.

Barocci's return to Rome in 1560 (his host there was Federico Zuccaro) drew him more closely towards a Romanized Maniera, aligned in some of its intentions with that propounded by the Zuccari, Raphaelesque in its bias. Like the Zuccari, starting just then at Caprarola, Barocci in the main salon of the Casino of Pius IV used this moderated Maniera for the figurative portions of a decorative scheme of the most elaborate and *artifizioso* kind. His description of appearances may be moderated, but this does not inhibit the brilliant artificiality of aesthetic effect that he achieves as he describes. He makes line work in a temper that is peculiarly Maniera, joining fineness with a flexing strength, and makes both line and form seem spatially active, inspired with propulsive energy. But neither these Maniera qualities nor the references to Raphaelesque tradition (or the likeness, partly in consequence, to Taddeo Zuccaro's current style) obscures Barocci's continuing concern with the kind of painting that depends on sensibilities that are peculiarly optical. To his manipulations of line and form Barocci welds a high-keyed yet complexly differentiated light and colour; the colour, swift-flickering, intensifies the movement of the forms but also casts a veil of insubstantiality on them, as if what we perceive might imminently evanesce. The painter's energy seems the product equally of passion and inspired play, and the latter makes a quality in Barocci's form as well as in the emotions he describes that suggests a spirit like that of a rococo style.

The four years following this Roman stay, during which Barocci worked so little, were none the less vital to his development: they

285. Federico Barocci: Madonna di S. Simone, *c.* 1567. *Urbino, Gallery*

contained the crucial experience and the medi-
tation on it that brought Barocci to re-create
Correggio's style. The *Madonna di S. Simone*
(Urbino, Gallery, *c.* 1567) [285] shows that the
measure of coincidence between Barocci's re-
creation and the original was, in its beginning,
extraordinary, perhaps unparalleled so far in
the history of art. It depends on no precise acts
of imitation, either of particular works or
particular aspects in Correggio's art. Barocci's
temperament and past Maniera history dictate
that he should incline towards the extremes of
refinement and the softest subtleties discernible
in Correggio's style. He makes Correggio's
emotion even more sfumato – oblique and un-
fixable – so that, in a temper like that of Mani-
era, feeling is less immediate and pressing. A
literal sfumato of visual effects absorbs form,
more than in Correggio, within delicately
coloured mists. Again even more than in Cor-
reggio, visual and emotional sensation verge on
the ineffable. In an altar of dramatic rather than
devotional theme, the *Deposition* for the
Duomo of Perugia (1567-9) [286], the Correg-
gesque mode which Barocci chooses to approach
is that of the late works that are, in both psy-
chological and painterly effect, *léché*. Emotion
is described by every possible overt sign. The
image moves as if caught in a high wind, but
this brings with it, despite the strength of
colour in the picture, an effect of chill: feeling
is pointed and bitter-sweet, but it is distant.
The altar was painted in Perugia, and perhaps
Barocci was recalled there to a renewed sense
of partial kinship with Central Italian style. His
image recalls not only Raphael's *Deposition*
design (as engraved by Marcantonio) and
Daniele da Volterra's famous painting but the
brittleness and stridency of the young Rosso's
altar on this theme. In Urbino again in 1570, a
Rest on the Flight (Rome, Pinacoteca Vaticana),
visibly paraphrasing Correggio's *Madonna
della Scodella*, makes a kind of play, not in
Correggio, of sharp, almost abstracting facet-

ings of form against powdery sfumati. But as if
to compensate for this excess of artificiality in
form, Barocci has made emotion obvious, a
prosy cuteness.

In the seventies Barocci attained a control
over the effects of the Correggesque repertory
that enabled him to manipulate them as his
independent tools and in a perfectly equili-
brated way. *Il Perdono* (a *Vision of St Francis*;
Urbino, S. Francesco) is early evidence of
Barocci's achievement of this stage. The ele-
ments of design are described in a softer, more
finely differentiated technique, which weaves
form into a close-textured optical and pictorial

286. Federico Barocci: Deposition, 1567-9.
Perugia, Duomo

287. Federico Barocci: Madonna del Popolo, 1575-9. *Florence, Uffizi*

unity, more veil-like, delicate, and imminently fragile in effect than even in Correggio himself. This texture is not disrupted by the emphasis, Correggio-derived, on motifs that employ illusionism to increase the sense of a connexion with the spectator. The famous *Madonna del Popolo* (Florence, Uffizi, 1575-9, dated in the latter year) [287], painted for the Misericordia of Arezzo, is the completer demonstration of a maturity that has moved beyond dependence on Correggio. From a theme that combines the Virgin's roles of *Madonna della Misericordia* and *Madonna Mediatrix* Barocci has evolved a design which links these functions, one earth-directed and the other heavenly, and which pulls the spectator into the union, too. Emerging from a rearward space (which depicts the actual piazza in front of the church of the confraternity at Arezzo), the impulse of design moves forward, round, and upward like a helix through the supplicants, gathering the spectator in as it sweeps by, and breaking on the blessing gesture of the heavenly Christ – a gesture meant for the spectator as much as for the population in the picture. Each element in the picture, not just the composition, works towards an effective unity which shall be not only internal but include the spectator. It is by extension from Correggio's precedent that a chief means to this end is the infusion of the work of art by movement, in Barocci more pervasive than Correggio's, and of more high-pitched, small-scale vibrance. It affects the painterly activity of surface and gives extraordinary life, as well as natural conviction, to optical effects; colour becomes brilliantly but also subtly diverse. Action is gesticulative and impelled but also ornamentally refined, and the linear rhythms that describe it are articulated in a temper close to febrility. The image vibrates in its every part and into the surrounding ambience: it makes an aura to engage the spectator, and then to convince him Barocci employs a measure of descriptive naturalism that

is generically like Correggio's and evidently dependent on him. However, Barocci's scale of description is smaller than Correggio's, and his detail thus more intimate. The distinction from the early Cinquecento precedent in this respect is the same the Carracci were soon to display, and the Florentine reformers also.

The differences from Correggio which this painting shares with the Carracci (Annibale, obviously, in particular) are less important than the precedence over the Bolognese that Barocci established in his resort to Correggio as a threshold for the making of a style that measurably departs from the Maniera to align itself with the historical course we recognize in hindsight as proto-Baroque and Baroque. Yet while Barocci's result, contrasted with the early stages of reconstruction taken by Annibale, has more of the brio of a seventeenth-century Baroque style, it has far less of its substance. It is not only the residue of evident Maniera artificiality, in form and emotion, that makes this in an essential sense less near to the Baroque. Barocci's difference from the Baroque lies still deeper: he remains far more concerned with art as a transmutation of existence than as an affirmation of it. Despite its play of optical and painterly effects and its degree of naturalism, the primary existence that this image has is a subjective one of art.

Like Correggio when he achieved his full creative stature in the later 1520s, Barocci in the 1580s proceeded to produce (again like Correggio, sometimes concurrently) altar works of surpassing eloquence in his new style. In two great dramatic altars, the *Entombment* (Sinigallia, S. Croce, 1580-2) and the *Martyrdom of S. Vitale* (Milan, Brera, 1580-3), Barocci developed the device used earlier in the *Madonna del Popolo* of a rotating, spectator-catching, motion of design and intensified its baroque-like brio. At the same time he sharpened – but also slightly feminized – the Correggesque emotional effect of complex poignance in these

288. Federico Barocci: Circumcision, 1590. *Paris, Louvre*

themes. In a different key, the *Calling of St Andrew* (Brussels, Musée des Beaux-Arts, 1580-3) is simple in form, grander, and less emotionally complicated also; simpler feeling, however, does not mean that it is less poignant. There is evidence that in the middle eighties Barocci sought to modify the tendencies we identify as related to baroque and to strengthen effects that suggest the dignity of classicism: the *Annunciation* (Rome, Pinacoteca Vaticana, 1582-4) and the *Visitation* painted for the Roman Chiesa Nuova (1583-6) are in this comparatively restrained vein, and would be still more imposing were it not that, at the same time, Barocci's feminine accent in feeling has increased. He has begun to probe more insistently into those too-soft, yielding regions of emotion that are morbid in both the English and Italian senses, touching on sentimentality or falling quite into it. By 1590 classicizing aspiration was quite displaced by a *vibrato* of sentiment, sometimes exquisite, sometimes intense, which is accompanied by a sharpened optical response that seems inhabited by this emotion even while it naturalistically describes it. The result in Barocci's *Circumcision* (Paris, Louvre, 1590) [288], where these factors work to an extreme degree, seems like a temporary trespass of historical limits, in the effect and method of description and in the quality of emotion anticipating the Italian late Baroque or Rococo. The subsequent more formal altars of the nineties are not so radical as this; nevertheless, the *Presentation of the Virgin* (Rome, Chiesa Nuova, 1593-4) and the still more complicated *Last Supper* (Urbino, Duomo, mainly executed in the later nineties) express the ferment that Barocci's fusion of emotional and visual sensibilities could produce.

Finally – but only after the Carracci had bypassed him – Barocci came to a style that is not distinguishable except in detail from a seventeenth-century Baroque. The first evidence of this stage may be the *Madonna del Rosario*

289. Federico Barocci:
Madonna del Rosario, finished 1593.
Sinigallia, Palazzo Vescovile

(Sinigallia, Palazzo Vescovile, finished 1593) [289], which invites comparison with the contemporary art of Lodovico, the most Baroque-minded of the Carracci, and suggests strongly the possibility that knowledge of the painting of the Bolognese may have precipitated this shift in character and meaning of Barocci's style. That this may be so is indicated by the fact that the *Rosario* is the strongest sensuously and emotionally the most nearly masculine of Barocci's late works. The religious paintings that follow, though no less fervently inspired (e.g. *Stigmatization of St Francis*, Urbino, Galleria Nazionale, *c.* 1594-5; *Crucifixion*, Genoa Cathedral, finished 1596), are touched again with Barocci's excessive fineness of form and with a sentimentalizing of emotion, which

now moves towards the precarious borderline between ecstatic sweetness and confectionary artifice. What these late works look forward to in seventeenth-century style is Guido Reni, within whose 'baroque' we have learned to identify the traces of a tradition that descends from the Maniera. And Barocci's *Beata Michelina* (Rome, Pinacoteca Vaticana, 1606) [290] is the expression in the feminine gender of the male vision of a female ecstasy that Bernini saw in his *St Teresa*. Almost from its inception in the nineties, the late style of Barocci was no longer in the forefront of invention. But earlier it had been, and among the historical meanings it had then, which this last style more openly brings out, is that of an alternative to the attitudes towards religious art of both the Maniera and the Counter-Maniera. This atti-

290. Federico Barocci:
Beata Michelina, 1606.
Vatican, Pinacoteca

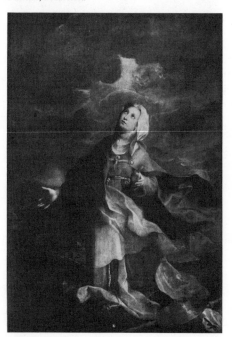

tude of Barocci's, more nearly than the others, was to be the mode of religious expression of the seventeenth century.

As far as the history of painting within the sixteenth century is concerned, Barocci's effect on his native school was of minimal importance. His more significant influence in Urbino and the Marches was on artists who worked well past the boundary of the Seicento. Of his actual pupils only one, Antonio Viviani (Il Sordo, 1560-1620), attained some measure of distinction before the end of the century. He was more than ordinarily dependent on Barocci for ideas, though not always for technique, and even a time of residence in Rome did not liberate him much. He worked in Rome as a *frescante* under Sixtus V, and was there again just past the turn of the century. His Seicento career lay mostly in the Marches. In Rome, in the eighties, he may have been a link in the dissemination of Barocci's style beyond the confines of the Marches.[16] Another painter of Marchigian origin, Andrea Lilio of Ancona (1555-1610), adopted Barocci's style; however, he seems to have come by it in Rome, where it appears he was artistically reared, not in the Marches. He was among the main painters whom Sixtus V engaged to work on his several and extensive decorative schemes; it may have been in the course of working in the Library of Sixtus that Lilio was first exposed at length to Barocci's idiom in the guise given it by Viviani. In his own painting in the library, however, Lilio's style is still distinctly Roman, and generally Zuccaresque. His subsequent adoption of Barocci's style was swift, and about 1590 it came to dominate the Roman component in his art (fresco scenes from the *Life of Christ*, Rome, S. Maria Maggiore; scenes from the *Life of the Virgin* in the nave, *ibid.*, finished 1593). In 1596 or shortly after Lilio returned to his native town: like Viviani, his seventeenth-century activity was mainly as an altar painter in the Marches.

Barocci's much more significant influence was neither in his native region nor in Rome but in Tuscany. We have already noticed how exported pictures by Barocci helped to reshape the course of style among some of the most advanced of the Florentine reformers. However, it was among the Sienese that Barocci's art became the main model for a qualitatively important school. The cause of this geographically eccentric event seems to have been an exercise of choice by a single gifted artist, Francesco Vanni (1563/5–1610). The stepson of a modest painter of Siena, Arcangelo Salimbeni, Francesco went elsewhere for his education, perhaps first to Bologna, then, c. 1578-80 (still, evidently, very young) to Giovanni de' Vecchi in Rome. His early independent pictures in Siena are based in the main on Roman study (*Baptism of Constantine*, Siena, S. Agostino, 1587), yet there are traces in them from about 1585 of experience (gained in the course of an early-founded habit of restless travelling) of Correggio and Barocci; and by 1588 (*Immacolata*, Montalcino, church) Vanni had reformed his style on Barocci's example. Vanni's response to Barocci was at first as if Barocci's painting summoned him to a similar Correggesque revival more than to dependence on Barocci himself. Very quickly, after Barocci's painting had served to point out a new way, divergent from the routines of the late Maniera, Vanni asserted a conspicuous individuality in his progress in this same direction. His tendencies were solider if less inspired than Barocci's, without the latter's febrile spirit and his almost excessive sensibility of eye and touch; furthermore, his Central Italian bias did not let him handle form as optically, with so diminished an effect of substance, as Barocci. In comparison, Vanni's painting of the nineties is pedestrian, but from this very quality of prose seems less bound than Barocci's to persistences of Maniera. Some of Vanni's habits formed in Cinquecento style were nevertheless not eradicable,

and their sixteenth-century character came to be more salient as Vanni worked into the first decade of the new century. But it is not comparison with his Tuscan milieu, even its avant-garde, that compels us to awareness of this, but only contrast with the great innovators of the seventeenth-century style.

Vanni had a natural if not inevitable follower in the person of his half-brother, Ventura Salimbeni (1567/8-1613). Like Vanni, Salimbeni had been formed in the main in Rome, where he went as a youth to work, first in the Logge of Gregory XIII and then in Sixtus's various decorations. His early Roman works were altogether in the current late Maniera decorators' idiom. However, towards 1590, perhaps with the encouragement of his half-brother in Siena, he joined the group of Sixtus's decorators who were attracted to the Barocci style: among these he was closest in his course of development and its results to Andrea Lilio. Lilio, the older artist, may have been the leader. In the early nineties Salimbeni worked in Rome, in a style thus only tangentially derived from Barocci, in S. Maria Maggiore and, in a minor role, in the Gesù. He left Rome only after 1593, and by 1595 was working in Siena on a major decorative scheme. He was then twenty-eight, and his style was much susceptible to influence from his half-brother, but a temperamental rather than a technical difference kept the two apart. Salimbeni had the lighter spirit and the more delicate touch, at times suggesting the quality of Barocci more than Vanni did; yet Salimbeni was no more dependently imitative of Barocci's style than was his brother. Like Vanni, Salimbeni came to approximate the tendencies of seventeenth-century Baroque style.

Vanni and his brother dominated the Sienese school of the last years of the century, but not to the exclusion of the vigorous but uninspired work there of a painter of rather different orientation, Alessandro Casolani (1552-1606).

Casolani owed his formation to the backward Arcangelo Salimbeni (Ventura's father) and to contact with the academizing Cristofano Roncalli when he was working about 1580 in Siena. Once Casolani had acquired a reformist mode, somewhat mechanical and often turgid, he used it as the principal basis of his art. He admitted some suggestion of Francesco Vanni, but without deep or lasting effect. As his career proceeded through the nineties and into the early years of the seventeenth century Casolani became Siena's representative of Tuscan 'modernism': an academic yet naturalizing style, in his case uncomplicated, but also undistinguished.[16a]

ROME

Two important decorative enterprises, each of them enlisting groups of artists in their painting, give an idea in condensed compass of the state of art in Rome about 1575. One, the Villa Farnese at Caprarola, is a secular decoration, the other, the Oratorio del Gonfalone, a religious one, but despite this apparently basic difference both give a general impression of community of style. Part of this quite naturally proceeds from the fact that three important painters among the several involved were engaged in both places: Federico Zuccaro, Giacomo Bertoia, and Raffaellino Motta da Reggio.[17] It may be more important, however, that, in both, the habit of Maniera lays strong stress on the value of each scheme as decoration, and on the apparatus of form that Maniera ingenuity had developed to suit decorative ends. Throughout both the oratory and the villa decorative purposes may or may not exceed didactic purposes or those of narrative in any single case – this is variable, and to some degree a matter of the specific painter's option – but since the narrative is embodied in Maniera forms it cannot but take on some part of their temper. The sense of a community of

style that this generates is stronger than the differences made by the purposes and kinds of subject matter; indeed, the responses we might expect at this date to religious as distinct from secular themes are, at Caprarola and the Gonfalone, at least in part transposed. We earlier noticed the considerable tendency at Caprarola towards a moderated and restrained mode, partaking of the character we have defined for Counter-Maniera. At the oratory, however, the painters who illustrate the Passion from the Entry into Jerusalem to the Resurrection do not use – as some of them already had done earlier in altarpieces or other devotional works – the means or temper of a Counter-Maniera; on the contrary, their response to the themes and to the stage-like idea given for their setting is highly *artifizioso*, and it is both aesthetically and dramatically energetic. Following the invention of Bertoia, apparently the author of the *mise-en-scène*, the painters promote communicative and didactic sense by use of devices of illusionism, which at Caprarola are in general restricted. The painters' aims may have been formed for them in some measure by the aims of the Confraternity, trying to revivify, as if in a dramatic re-enactment, the history of the Passion. In terms of the option between the Maniera and the Counter-Maniera proffered in contemporary art, the former might have seemed, at least initially, the more effective instrument to achieve this end, preferable to the restraint of the latter.

Some time soon after the inception of the decoration of the Gonfalone, but mostly later into Gregory XIII's reign, towards 1580, another oratory decoration, that of the Oratorio del Crocefisso di S. Marcello,[18] employed the services of a group of major Roman painters, the most important of them Giovanni de' Vecchi, Cesare Nebbia, Nicolò Circignani, and the younger Cristofano Roncalli; the first two had worked also at Caprarola and the Gonfalone respectively. The main theme of the

decoration in the later oratory was a history of the True Cross. The collective character of these paintings, in the sense of stress of decorative value and Maniera device, was much the same as at the Gonfalone; evidently creative energy was still to be found in the decorative tradition of Maniera. Nevertheless, the Maniera would come to be chastened and in instances displaced among these efficient, still inventive decorators. The force for change came not only from the cultural pressures that had already helped to generate the Counter-Maniera within Roman art but from a direction pointed by a leader among Maniera painters, perhaps first in a fresco in the Gonfalone. Federico Zuccaro, in his *Flagellation* there of 1573 [291], is the only major painter in the group of artists in the Gonfalone whose work evades the generalization about its style which was made above. His scene diminishes decor-

ative emphasis and effects of ornament, seeking a relative forthrightness in description and the simplicity and legibility of a classicistic scheme for his design. It would take some time for this early lead and Federico's subsequent reforms to make their mark, but in time he was to help form an orientation much divergent from the mid-century's high Maniera among his followers, and those he had inherited from his brother.

Federico Zuccaro

Federico was the most important personality of Roman painting in the last quarter of the century. It is an importance that comes less from claims that could be made for him of quality than from quantitative features: not just from the extent and the dissemination of his work (as we noticed earlier, throughout Italy and beyond its borders) but from its typicality – a typicality enhanced, obviously, by the fact that his influence was more conspicuous than that of any other Roman contemporary. His course of development in these years exemplified much of what was generalizable in the course of art in Rome, and in part shaped it. Federico returned to Rome in 1579 from Florence, where, as we have seen, he had been engaged for four years on the thankless task of completing the dome of the cathedral, which Vasari had left unfinished. This labour had been hostilely received but Federico's presence nevertheless left a discernible mark on the direction which Florentine painting took, increasing the element of academicism already present in the native situation. In Rome, Federico was given a less physically difficult – but more essentially impossible – assignment, also a completion of another's work: the decoration begun by Michelangelo in the Cappella Paolina. He did not finish it until 1583-4, however; his stay in Rome was interrupted by an incident which, however extraordinary its

291. Federico Zuccaro: Flagellation, 1573.
Rome, Oratorio del Gonfalone

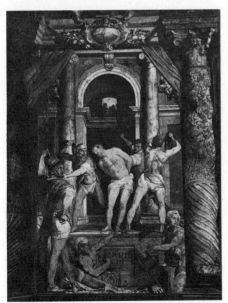

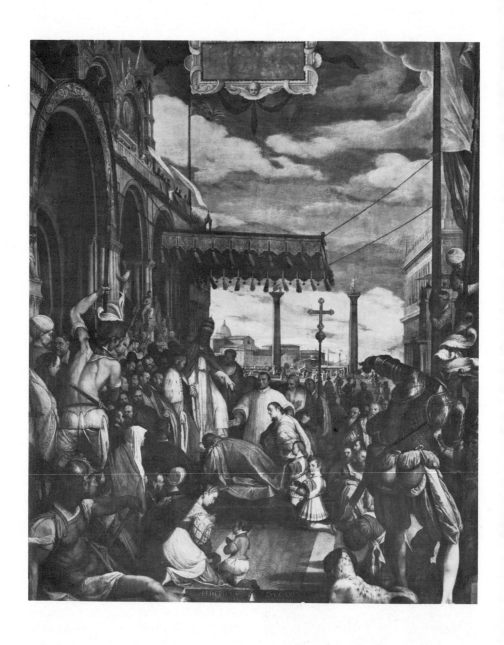

292. Federico Zuccaro: Barbarossa making Obeisance to the Pope, 1582.
Venice, Palazzo Ducale, Sala del Maggior Consiglio

circumstances, is representative of the workings of Federico's mentality, and through it of the important academic current of the late Maniera. In 1580 Federico took a commission for a *Procession of St Gregory* to be sent to Bologna for the church of S. Maria del Baraccano (still *in situ*). He produced a design more schematic than his normal habit and left its execution to his helpers, Bartolommeo Carducci and Domenico Passignano. The reception of the painting in Bologna was as hostile as that of the cathedral dome in Florence had been. Federico's retort was to paint an allegorical defence – more precisely, a counter-attack – the *Porta Virtutis*, including in it caricatured portraits of his detractors (1581; the painting is lost, but the preparatory drawing is in the Städelsches Institut in Frankfurt). The public exhibition of the *Porta Virtutis* in Rome provoked a scandal and Federico's temporary banishment until 1583 by Pope Gregory XIII.

In the interval while he was compelled to travel – no hardship for Federico – his services were sought by the Venetian State and by Federico Maria II, Duke of Urbino, whose chapel in S. Maria di Loreto he decorated (1582–3). The painting for Venice, *Barbarossa making Obeisance to the Pope*, in a place unusually honorific for a foreigner, the Sala del Maggior Consiglio of the Palazzo Ducale (1582) [292],[19] cleverly adapts, but also presumes to correct, Venetian ideas of design – design only; contrary to what had happened in his earlier Venetian experience, Federico's colour now yields nothing to Venetian example. Tintorettesque compositional devices are, with perverse effectiveness, altered in order to recollect honoured Roman precedents in Raphael and his school. Venetian elements of naturalism are counterbalanced by emphasis on stock motifs from the repertory of Maniera. The painting was a way of demonstrating to the current Venetian school, and to Tintoretto especially, how to make their native product better.

Federico made no secret of his distaste for Tintoretto's style; he expressed it unsparingly in the *Lamento della Pittura* which he published later, in Milan, in 1605. In his decoration at Loreto Federico reverted to his usual methods of design, insisting on the schematizing regularity that had recently provoked the Bolognese. The side panels of the chapel vault, a *Death of the Virgin* and an *Ascension*, are moderate in their intention of achieving clarity, but sufficiently expose the classicistic bent that had been growing in Federico's style throughout the last decade. The central panel, a *Coronation of the Virgin*, is a rigidly symmetrical, almost heraldically abstract design which, however, at the same time works in terms of an extreme illusionism and a Maniera intellectual conceit. In the way of describing things in the Loreto frescoes there is an indication that, at least in one important sense, Federico's renewed Venetian experience may – despite his homiletic posture towards the Venetians – have had some effect on him. He might choose not to regard Tintoretto, but the values of naturalism, and of the uses of painterly techniques – of chiaroscuro especially – to promote it, that Venetian art embodied in its Titianesque past and Veronese present seem to have infiltrated the Loretan works. An interest in increasing naturalism had been an early factor within Federico's style, inherited in the beginning from Taddeo's teaching. So far, however, the acuity of observation, a descriptive skill of hand, and the mood of pleasure in the things described that Federico on occasion showed had been required to coexist with a dominating apparatus of Maniera artificiality. For a moment after his return from Venice, Venetian stimuli worked to reverse this balance, as in the *Christ in Limbo* (Milan, Brera, 1585). But this result was momentary: it did not have the consequence that, had it continued, could have made Federico an equivalent in Rome of the contemporary Florentine reformers. In the next

decade he would often make effects of considerable naturalistic consistency, but they would be subsumed by larger ideas of a classicizing academicism, or on occasion by the schematizing and rigidity of a Counter-Maniera much related to it. This direction was not determined, but was probably reinforced, by two years (1586-8) in the service of King Philip at the Escorial, replacing Luca Cambiaso. Federico's work at the Escorial (on two of the side altars and on part of the great *retablo*) was cordially disliked[20] but generously paid for none the less. Soon after his return to Rome a commission to decorate the Cappella degli Angeli in the Gesù and to supply the chapel's altarpiece stimulated a response characteristic of this time in Federico's career: in the decorative parts an academic stiffening of Maniera; in the altarpiece a congealing of Maniera into an iconic emptiness [293].

By the middle nineties, however, Federico made a basic concession to the pressures towards naturalism that were increasingly apparent even in the Roman milieu. He did not relinquish his schematic turn of mind but he did moderate it, strengthening its classicistic implications by references backward towards early-sixteenth-century style – Raphael's especially – and admitting a canon of proportion and a standard of naturalism in description from it. The result, as in Federico's altarpiece for the cathedral of Lucca, an *Adoration of the Magi* (1594), is no longer definable as Mannerism but belongs to the recognizable contemporary species that, in Florence, is represented by the art of Santi. From now on throughout the remaining active years of his career this style, more allied than not to that of the Florentine reformers, was basic in Federico's production, but it did not exclude his recourse, when theme or occasion seemed to him to allow it, to stock motifs of Maniera or to Maniera conceits. And at his best Federico could still, in his latest years, approach some part of the liveliness of

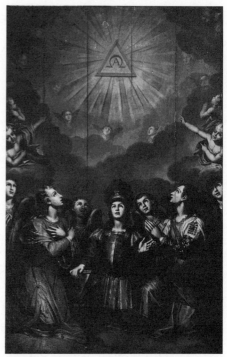

293. Federico Zuccaro: Angels worshipping the Trinity. *Rome, Gesù, Cappella degli Angeli*

his youthful Maniera *ductus*. The elaborate decoration of his own house (1598 and afterwards)[21] varies room by room in its emphasis among these modes that Federico could employ, but for all the resistant and occasionally still vital elements of Maniera in them, it is his newest mode – naturalistic, classicizing, and retrospectively Raphaelesque – that dominates. In good time, but not soon enough to count among its leaders, Federico aligned himself with the conservative reform that in the late Maniera context stood for progress. It could be said that even this conclusion was a continuation of his brother's work. Reform, however, was far from revolution, and it must be kept in mind that this was in the process of accomplishment at this very time in Rome.

Federico spent the early years of the new century mostly away from Rome, working in the main in Lombardy and Piedmont. Before then, from the early nineties on, he had played a large role in the founding in Rome of the Accademia di S. Luca, which was meant to fulfil for the Roman world of art – though more effectively – functions like those of the Florentine Accademia del Disegno. Federico was elected its first *principe*, but his efforts barely stirred the Academy to intellectual action, and only for a brief while; the hope that the artistic community could be provoked to regular and formal exercises of the mind was as fruitless in Rome as it had been in Florence. Federico's own deliberations on the theory of art were worked out by him *in extenso* during his late time of residence outside Rome and finally published, in Turin, in 1607. His *Idea de' scultori, pittori et architetti* was by now a posthumous exposition of the metaphysics, as well as the aesthetics, of Maniera, but it was the most systematic and the most lucid.[22]

Federico developed a following that his brother had only begun to attract. That Federico was a more academic painter made him an easier model; it also made him a more authoritative one. Beyond the younger painters who might be expected to reflect his style he influenced the course of older artists and contemporaries, sometimes deflecting a development already formed. The case of Cesare Nebbia (1536–1614), one of the busiest *praticanti* of the Roman late Maniera school, is one in point. An Orvietan by birth, he was a pupil of Muziano but came to prefer the Maniera demonstrated by both Zuccari. About 1573–5, when Nebbia was engaged on two frescoes in the Passion series in the Oratorio del Gonfalone (*Crowning with Thorns* and *Ecce Homo*), he was working in a formally and dramatically overburdened version of the Zuccaresque style of the later sixties, made ponderous by the residues of Nebbia's training under Muziano.

Nebbia's contributions to the decoration of another major oratory, that of the Crocefisso di S. Marcello, somewhat later, are more sober. In the eighties Cesare came progressively to follow Federico's reform. For years of busy practice in the reigns of Sixtus V and Clement VIII Nebbia covered a measureless expanse of wall, engaged in many of the more important Papal as well as private enterprises of fresco painting, as in the Biblioteca Vaticana and S. Giovanni in Laterano. Given the increasingly apparent example of a legible and non-rhetorical mode by Federico, Nebbia's contributions to these narrative cycles became in turn less mannered and less ponderous: effective illustration, sometimes almost mechanical in kind, but at other times distinguished by strict discipline of hand and clarity of thought. As with Federico, the change from rhetoric and Maniera to a legible and un-fancy style was more than a personal affair; it responded to an alteration within Roman culture.

Painters of the Late Maniera

The end products of Federico Zuccaro's career are four decades distant from the Maniera he had practised – adroit and often dryly brilliant – in his first large independent enterprise, the decoration at Caprarola in which he had succeeded Taddeo Zuccaro. We have seen that Federico's tenure at Caprarola was relatively brief and that he was followed by the Parmesan Bertoia.[23] Bertoia in turn was followed by another painter of similar gifts but no comparable efficiency in output, Giovanni de' Vecchi (from Borgo S. Sepolcro, 1536–1615); his helper Raffaellino Motta da Reggio was the most gifted of the youngest generation then at work in Rome. Alessandro Farnese's command of the best artistic talent in contemporary Rome was almost infallible. De' Vecchi's contribution to the decoration consisted of the figured scenes in the Sala di Mappamondo (1574) and

294. Giovanni de' Vecchi: St Helen orders the Search for the True Cross, *c.* 1580. *Rome, Oratorio del Crocefisso*

most of the painting of the walls of the Camera degli Angeli (1575).[24] His manner is livelier than Federico's and his seeing and technique less dry; parts of his work, particularly in contrast to Federico's, have a painterly and coloristic richness. The imagination that suits form to theme is also different in him: more spontaneous than Federico's, making effects of a sharper visual wit. More remarkable than their differences, however, is the degree to which the two men's styles are alike. The resemblance is not just in their decorative work at Caprarola (Federico's independent work there, it should be recalled, is earlier by five years or more); it may be still more marked in such a religious painting by Giovanni of this time as his fresco altar of the *Adoration of the Magi* (Rome, S. Eligio degli Orefici). But where Federico in the seventies began to dry and schematize his style Giovanni increased its warmth of emotional and painterly effects (three episodes from the story of the True Cross, Rome, Oratorio del Crocefisso, *c.* 1580) [294]. This difference persists within an evolution which, it turns out, carried Giovanni as far away from pure Maniera as Federico. In Giovanni's case his authenticity of feeling made him respond strongly to the new temper of religion generated in post-Tridentine Rome. In the course of the 1580s he came to adopt a mode in his religious works in Rome that, suppressing ornamentalism almost altogether, approached the simplicity of Counter-Maniera. However, unlike the Counter-Maniera, Giovanni's later style exhibits an extraordinary development, far beyond his earlier symptoms of a painterly disposition, in range of chiaroscuro and febrility of light. The light supports an illustration of overt and deep emotion; this also differs strongly from the conventionality or abstractness of expression of the Counter-Maniera. For his mode of feeling it may be Barocci who is de' Vecchi's analogue; perhaps more exactly, but retrospectively, it may be Correggio. Naturalism of form is a much weaker factor in Giovanni's later work than this authenticity – in another sense, naturalism – of content. But because the two naturalisms do not coincide in these works, Giovanni's art does not transcend the region that belongs to the Maniera.[25]

Another artist of roughly the same generation but whose activity in Rome extended over the last quarter century, Nicolò Circignani (1530/5?-1596?),[26] exhibits a third pattern of development, nevertheless more like Federico Zuccaro's than dissimilar. Circignani's early work in Rome, shortly after 1560, was in the fresco friezes of Old Testament histories in the Vatican Belvedere, where Giovanni de' Vecchi painted also and, in a different spirit, the young Santi di Tito. Circignani's paintings were certainly the most exaggeratedly mannered among these three, extreme in their canon of proportion and excessive in calligraphy. They are at an opposite pole within contemporary Roman style to the moderation of Maniera that Taddeo Zuccaro had introduced. This exaggeration of Maniera in the hands of a painter of much less than first-rate talent was in fact counter to the mainstream of current Roman taste, and Circignani's chief business came from altarpieces supplied for a provincial clientele, as e.g. at Orvieto (Duomo, 1570), Umbertide (1572), Città di Castello (1573-7), and especially in later years at Città della Pieve.

In the early 1580s Circignani found a peculiar specialized employment with the prime agents of the Counter-Reformation: the Jesuits made him their preferred painter of martyrologies, a didactic genre they found useful in the education of their missionaries, to fortify their souls against the fate they might expect. In 1581-4 Circignani, assisted by the landscape specialist Matteo da Siena, painted the grim illustrations of English martyr saints that once existed in the English Jesuit community in Rome of St Thomas of Canterbury; subsequently (with another collaborator for the

landscapes, Antonio Tempesta) Circignani painted the explicit records of torture that – the word seems inapt – decorate S. Stefano Rotondo. They are as deliberately simplistic in form and mode of communication as a comic strip, and, save for the deftness of drawing of the good Maniera *praticante* that Circignani was, they verge on anti-art. This is a possible and even an expected end to which the point of view of Counter-Maniera might be pressed. Art has only been required to serve a purpose of religious illustration more extreme than usual in Counter-Maniera painting; to do so quite so thoroughly as here is to combine the force of the injunctions of Gilio da Fabriano with those of Ignatius Loyola. But where place and purpose of a painting allowed or encouraged the exhibition of Maniera, Circignani preferred it, even at this late date, and even on Jesuit premises. His painting of the chapel of S. Francesco Borgia in the Gesù displays the whole apparatus of a late Maniera in its Roman and Federico Zuccaro-like vein: schematic and more than a little vacuous, with elements of laboured naturalism that do not redeem it.

Even a thorough prior formation in another school could not insure a painter working for any length of time in Rome against Zuccaresque infection, particularly in the decorative field. Jacopo Zucchi of Florence (1541/2-1589/90) had begun his career in Vasari's atelier and had risen to a place in it comparable to Naldini's, much engaged in the Salone del Cinquecento of the Palazzo Vecchio. Vasari chose him as executant for his late enterprises in Rome, and Zucchi worked there first in 1567-9 and 1570-1.[27] Probably in 1572 his relations with the ageing Giorgio turned sour, and he settled in Rome to work independently. He remained for more than fifteen years, returning to Florence only about 1589, very shortly before his death. He became a member of the Roman school; long before coming back to Florence he had lost even his Tuscan accent.

Zucchi's training in Vasari's school had fostered his facility as a *frescante* and equipped him with a full repertory of decorator's conceits. These were the initial bases for the first major decoration Zucchi undertook on his own account in Rome, still for a Florentine client, Cardinal Ferdinando de' Medici (later Grand Duke), in his Palazzo Firenze (*c.* 1574). To this Vasarian basis, however, Zucchi had by then added the results of Roman study, particularly of the line of Maniera that had its origin in Raphael, which he followed down as far as the recent Taddeo Zuccaro. Zucchi thereby enriched his Vasarian inheritance with forms of fuller roundness, depths of space, and greater ornamental opulence. His most important work of church decoration, commissioned in 1576, filled the apse wall and semi-dome of S. Spirito in Sassia with a swarming *Pentecost*. It is executed in a drier manner than the palace decoration, and perhaps on this account more clearly suggests likeness to the current Roman late Maniera norm of decorative style that Federico Zuccaro, or at a far lower level Nicolò Circignani, illustrates; but despite its handling this is more lively in design and more spirited in its pictorial conceits than anything that the authentically Roman contemporaries did. Probably in the middle eighties, again in the Roman palace of a Florentine family, the Rucellai (now the property of the Ruspoli), Zucchi painted a great *salone* with a genealogy of the antique gods [295]. Brilliantly eclectic, he pillaged the major precedents of ceiling painting that Rome offered and combined them with a measure that at this date is wholly radical, not just in Rome, of plastic richness and dense-woven rhythmical exuberance. And this plastic energy is carried by anatomies (and animal forms also) that have the look of natural existence in a degree not much less radical, and of which in the contemporary Roman context only Scipione Pulzone makes an equivalent (contrastingly un-exuberant, however). The

295. Jacopo Zucchi: Genealogy of the Gods (detail).
Rome, Palazzo ex-Rucellai

elements of a Seicento Baroque style of decoration are not only potential in this ceiling but half-realized: episodes in it invite comparison with Annibale Carracci or, still more surprisingly, with Pietro da Cortona. But what is in the end the more determining effect is that enough remains of a recognizable Maniera temper of pattern-making, both in single forms and in larger design, to hold the decoration within a stylistic confine that still belongs to Mannerism. It is in a dominant effect of Maniera that this ambivalence of Zucchi's later Roman style is resolved in his easel paintings also,[28] in a *maniera piccola* that is surely Flemish-influenced (*Fruits of the Sea*, Rome, Borghese). As late as 1589 an easel painting on a large scale, *Cupid and Psyche* (Rome, Borghese, dated), opts, despite genre and still-life detail, for Maniera artifice. More naturalism, but also of a more pedestrian kind, is in

Zucchi's paintings in the Sala delle Carte Geografiche in the Uffizi in Florence, his last work. In a Florentine context even this mild statement indicates that Zucchi belongs nearer to the reformers than to his former colleagues of the post-Vasari style: in the slower Roman context he had just left, his ideas verged upon the radical.

The generations of late Maniera painters merged almost imperceptibly into each other in late-sixteenth-century Rome, but this is because of the homogenizing action upon all of them of Zuccaresque style. The youngest group, born about 1550, included one painter of remarkable potential stature, Raffaellino da Reggio (1550-78), unfortunately very short-lived; but even in the brief half-dozen years of his Roman career he had time to turn into a follower of Federico. Raffaellino had come to Rome from his native Emilia about 1572 after

296. Raffaellino da Reggio: Christ before Caiaphas. *Rome, Oratorio del Gonfalone*

schooling under Lelio Orsi. At the beginning of his Roman career he showed tendencies, like those of his master or the Bolognese Tibaldi, to fluent swellings and pointings in the shaping of forms, and to complex lighting and charged brilliance in his drawing with the brush. Even the pressure of convention that he felt and responded to in Federico's style did not, however, quite suppress his individuality. He made a Roman reputation first as a façade painter (for which Orsi's training would have specially prepared him). About 1575 he went with Giovanni de' Vecchi to work at Caprarola, and seems to have assisted there in painting in the Sala del Mappamondo and on the walls of the Camera degli Angeli; probably just earlier he was among the painters of the Gonfalone. His single fresco in the oratory, *Christ before Caiaphas* [296], is the most spirited painting in the series, yet it is full of a young foreigner's concern to absorb novelties of Roman style. He reflects elements of Federico's fresco of 1573, but not its restrictiveness; he prefers to take Zuccaresque style in a more actively Maniera form, in a guise like that in which his other older colleague in the decoration, Nebbia, demonstrated it. But what has been absorbed from others cannot obscure an individuality that is much more evident than is usual among the later Mannerists of Rome. Raffaellino asserts physical presence and an energy of feeling and action in it with an expanding power that makes his forms tumescent; but at the same time he insists on their refinement, making draughtsman's ornament and elegance. He particularly exemplifies the possibility of coexistence in the best painters of the late Maniera of a stronger attachment to the elements of physical reality and a more arbitrary fantasy; a coexistence more difficult to conceive than to practise, and from which the late Maniera might have derived a double source of possible regeneration.

As Raffaellino approached the end of his short career, one aspect of his art, his fresco

painting on a large scale (*Martyrdom of the Quattro Santi Coronati*, Rome, Quattro Ss. Coronati, Cappella di S. Silvestro, towards 1578), became less unconventional and recognizably more Zuccaresque. However, his smaller works in fresco (e.g. *Christ in the House of Simon*, Logge of Gregory XIII, 1576-7) make a more spontaneous effect. But these are not so brilliant as his panel pictures, unfortunately too rare (*Tobias and the Angel*, Rome, Borghese; *Diana and Actaeon*, Rome, Patrizi Collection), where Raffaellino even more compellingly demonstrates how he makes a union between telling elements of descriptive truth and an extreme draughtsman's licence. The patterns he creates as he reshapes forms and weaves them in a whole design have a remarkable controlled power. His energy does not have only an aesthetic source: it derives from the vitality of Raffaellino's communion – episodic as it may be and in the end transcended – with nature. Even late in his Roman career there is the persistent sense of Raffaellino's connexion with an Emilian past, beyond Orsi, with Correggio, even more than there is the effect of relation in the present to his near, part-Romanized contemporary, Bertoia.

There is, however, a contemporary relationship of some importance, of which the scene is Roman but the *personae* conspicuously not, between Raffaellino and the North Europeans studying and painting in Rome about 1575. The most conspicuous of these was Bartolommaeus Spranger, who had earlier been in Parma and from 1566 to 1575 was resident in Rome;[29] also there were Karel van Mander, from about 1573 to 1577, and Otto van Veen, who came about 1574-5.[30] They learned Maniera, but brought to it their Flemish disposition towards verity of detail. There is thus a common ground between them and Raffaellino, but no necessary reason to explain it by an exchange, in either direction, of influence. Raffaellino's panel paintings (more pertinent to this point than his frescoes) in fact

less resemble the youthful works of his Flemish contemporaries than the subsequent paintings of full-blown Flemish Mannerists of the latest years of the century such as Wittewael, who are still more like Raffaellino in their way of drawing energy from their contact with nature to infuse into the arbitrary manipulations of Maniera art.[31]

While the painters of Raffaellino's generation in Rome who worked mainly at decoration or who for other reasons still preferred to hold to the Maniera observed, in general, the model set by Federico Zuccaro for the late and Roman version of the style, at least the better ones among them did so with some variation. As a fellow Marchigian, Pasquale Cati (*c.* 1550–*c.* 1620), who came to Rome from Jesi, was more than commonly disposed towards Federico's model. Early in his Roman career, in a *Martyrdom of St Lawrence* (Rome, S. Lorenzo in Panisperna, 1577?), he showed that he had mastered the Zuccaresque vocabulary, though hardly fluently. By 1588-9, when he decorated the Cappella Altemps in S. Maria in Trastevere, Federico's style was still Cati's model; however, he had by then acquired – from the study of sources that are certainly not in Federico, but perhaps in Muziano – a verity of light that partly redeems his stock apparatus of stiffened Zuccaresque late Maniera form. Giovanni Battista Poggi (1561-89), of Lombard origin, was one of the *frescanti* who made contributions to the major decorative enterprises particularly of Sixtus's reign. His manner, reformed in Rome on the models of both Zuccari, nevertheless retained the accent of a somewhat heavy and provincial speech. Giovanni Battista Ricci (1545-1620), who came late from his native Novara to share the decorative work available in Rome in Sixtus's time, also put on a Zuccaresque style but kept a still more identifiably Lombard accent. His facility has left its trace in many Roman churches, but his best-known and most extensive fresco works are in S. Mar-

cello al Corso. An inclination engendered in a native place also conditioned the style of another Zuccaro follower of some prominence, Nicolò Trometta (1550-*c.* 1620). From Pesaro, Trometta had had much opportunity to study Barocci, and he made some effort at compromise between Zuccaresque form and Barocci's variety of colour. The weight of the compromise remained heavily on the formal side. At his best (as in the vault paintings of the choir of S. Maria in Aracoeli), Trometta used the Zuccaresque vocabulary with rhetorical exaggeration and an effect of opulence which the contemporary Federico's taste would not willingly display. At worst, as in the decorations of his later career, Trometta ranges from unthinking, yet skilled *praticante* down to careless hack.

It was also possible to be a decorative painter in Rome in the latter years of the Cinquecento without being in some way a dependent of the Zuccari, but only in exceptional circumstances. Tommaso Laureti (*c.* 1530-1602) did this, making a modest mark on the Roman scene in the last two decades of the century not so much by the measure of his talent as by virtue of a curious gymnastic his career performed with time and place. Born in Palermo, he had come very young to Rome and studied under the old Sebastiano del Piombo, and this education had detached him from the dominating contemporary development of high Maniera. After Sebastiano's death Laureti carried his dogma, including its Michelangelism, to Bologna. There he developed special skills as a perspectivist and was infected with an academic variant of *Tibaldismo*; these fused with the style he had acquired in Rome. The longest extent of Laureti's practice was in Bologna, where altars by him survive (e.g. *Transportation of the Body of St Augustine*, Bologna, S. Giacomo Maggiore, 1577), but little of his decoration. In 1582 he was summoned by Gregory XIII to Rome to use his decorative gifts on the newly elevated

ceiling of the Sala di Costantino in the Vatican; he completed the painting in 1585. What Laureti brought back to Rome was a style of which the principal components were based not only on Roman painting of a generation past, about 1550, but on its then least mannered aspect. He was virtually exempt from the Zuccaresque influence that had been of such moment in the intervening years. What Laureti chose to regard instead on his return to Rome was older example, more suited to his early inclinations as well as to what he had since become: Michelangelo conspicuously, and, because of the locale in which he was now painting, Raphael and his school. The result for the Costantino ceiling is an assembly of forms of great plastic density and rhythmic vigour, of which an only secondary element is a Maniera accent. Laureti's second major Roman decoration, of the Sala dei Capitani in the Palazzo dei Conservatori (c. 1592), still more authentically displays the effect of his prolonged exposure in the Vatican to the immediate post-Raphael school. The accent of their moment is of course distinguishable in the Conservatori frescoes, but they recall the temper of form and rhetoric of Giulio Romano's Sala with an effect (and apparently a purpose) in the archaism that is ethical as well as artistic. Laureti's result has nothing to do in style with Federico Zuccaro, or indeed with much else in contemporary Italy; but it should be observed that it shares not only with Federico but with the younger painters who were to make new inventions a deep concern to learn, even by close imitation, from the early-sixteenth-century past.

The general rubric of a Zuccaresque late Maniera does not cover another case in the area of decorative painting, this time of a group among the younger generation, transients in the Roman school (though some were there for a considerable time), mostly in the years when Sixtus's enterprises offered good employment.

Coming from diverse places, these painters were at first drawn into the common orbit of Roman decorative late Maniera, generically Zuccaresque. But in the vicinity of 1590 they began to veer off towards a different style, into which they quickly and irreversibly matured, and of which the eventual source was in Barocci. Despite their diversity of origin, all these painters seem to have been associated in some way while in Rome. We observed that one among them, Antonio Viviani of Urbino, had actually been a Barocci pupil. In Rome when he worked on the enterprises of Sixtus V (though for no great length of time; then again, on a second visit, about 1600) he may be the obvious person to designate as the carrier of a Baroccesque virus. However, the Sienese Francesco Vanni, who had been in Rome somewhat earlier than Viviani, had already remade his style on Baroccesque example by 1588 – but in Siena after his return, not in Rome.[32] His half-brother, Salimbeni, was in Rome almost constantly from before 1585 to about 1593, and Vanni seems to have been in close communication with him; it is thus possible that Vanni's *Baroccismo*, formed in Tuscany, was one precipitant of the change of style among this group in Rome. Andrea Lilio – a native of Ancona, well within Barocci's native sphere of influence, but at the beginning of his Roman career not a follower – worked closely with Salimbeni in Rome on various Sistine commissions, and the two show a parallel development towards Baroccesque style.[33] The manner of the introduction of Barocci's idiom into the Roman school in the last decade of the century remains unclear, but that this phenomenon occurred changes the collective image that the Roman school presents, although not significantly. The novel tendencies in the Barocci style were very quickly to be represented to Rome in a more commanding, 'modern' way by Annibale Carracci; furthermore, the whole group in Rome of incipient *Barocceschi* dispersed in the

course of the decade to their native places, and only there matured their style fully; their practice of it falls chronologically into the succeeding century.

The merit of the Barocceschi is that they, more obviously than their colleagues in Rome who were more fixed within a Zuccaresque Maniera, relieve the general effect of uniformity and absent inspiration that prevails in the decorative enterprises of the reign of Sixtus V, of which we have mentioned some in passing. The largest of them were the Biblioteca Vaticana (or Sistina, finished in 1589) and the contemporary Scala Santa; the staircase and partial interior painting of the new Palazzo Laterano; and in S. Maria Maggiore, the Cappella Sistina (late 1580s) and the nave frescoes of the Life of the Virgin (finished *c.* 1593). We have already noticed the more important of the many artists who were employed in these works, of which the extent made them both a tedium and a bonanza to the painters. In terms of numbers of contributors – we can identify no less than twenty – and vast space covered these projects are important, but the number of painters does not result in variety, and the extent magnifies the effect its absence makes. The presence of the *praticante* is nowhere more tiresomely felt than in these decorations. The problem was not merely quantitative or mechanical. Some among the late Maniera frescoists of Sixtus's jobs (as, for example, Nebbia's pupil, Paris Nogari) had shortly earlier, in Gregory XIII's Logge in the Vatican, done work of quality in the same late Maniera style, but in the Sistine enterprises their Maniera formulae seem mostly to have grown stale. In an unhappy parody of the memory of Raphael's Stanza della Segnatura, the Biblioteca Vaticana (the deadest of the lot) expounds prosy humanistic subject matter in a flat-spirited academic style. Cesare Nebbia and a frequent associate, Giovanni Guerra of Modena, had direction of this work and are supposed to have supplied inventions and designs to the multiple executants.

Differently from Sixtus's enterprises, the Sala Clementina in the Vatican, the latest of the grand Papal decorations of the sixteenth century (1596-8), is stimulating and inventive. Its painting was given into the charge of the Alberti brothers from Borgo S. Sepolcro, a family of specialists in *quadrature*, of which the youngest, Giovanni (1558-1601), was the prime mover. No distinction attaches to the figure painting in the Sala Clementina, but the play with painted architecture on the walls and ceiling works with an effect of energy and conviction in its fictive mass and fictive excavated space that, while it may have precedents earlier in the sixteenth century, has no peers. It is the link between the *quadrature* of the Cinquecento and the great perspective constructions in painting of the Baroque style, and nearly belongs to the latter.

Another special genre, landscape painting, often – but in this case incorrectly – thought of as a link forward with seventeenth-century style, took on more importance in the decorative fresco painting of the last two decades of the century than it had earlier. Not in fresco works but in easel paintings (and more often in drawings meant to be engraved) Girolamo Muziano had begun, soon after the mid century, to give landscape painting in the Roman school its first new impetus since Polidoro. The sources of his landscape style lay in Titian, and he compounded with them some of the devices of composition (of surface organization as well as of perspective into space) of the Flemish school. His landscapes – always, of course, appended to a religious subject – retain the sense of a dramatic content that is almost invariably in Titian's, and add an effect of unreal mystic wildness, apparently religious in implication, that seems apposite to the temper of the Counter-Reformation. Their seriousness of intention and effect differentiates Muziano's

landscapes from those of the *frescanti*.[34] For them, landscape served a mainly decorative purpose; it might set an unassertive mood or might be illustrative or occasionally fantastic, but it was, in general, not more than a secondary element within a decorative whole. It was thought of as a piece of the decorator's quasi-standardized apparatus, not unlike the useful *grotesquerie*, and like it was part fantasy, part ornament, and part wallpaper – in which respects it fell naturally into a substratum of Maniera style.

Matteo da Siena (1553–88), who worked particularly in the Vatican (Sala Ducale, Logge of Gregory XIII), was the first extensive user of the formulae that make up this late Maniera landscape genre. Whatever his inclinations to refer to native, and especially Raphaelesque, precedents may have been, they were superseded by the mounting influence of Flemish specialists in Rome. Matthaeus Bril, who was born in Antwerp about 1550 and died in Rome in 1583, was an early one of these, who also painted in the Vatican in the eighth and early ninth decades (Sala Ducale, Logge of Gregory XIII, Torre dei Venti); at least in the Sala Ducale, Matthaeus worked in company with a countryman, Giovanni Sons, who earlier had been in the service of the Farnese in Parma, and in 1579 painted for them at Caprarola, decorating the Casino there. A Flemicized Italian, Antonio Tempesta (1555–1630), a pupil of Stradanus, Vasari's Flemish aide, was active in Rome as a decorator from about 1580, and worked among the landscape painters in the Vatican (Logge of Gregory XIII, Galleria) and almost certainly at Caprarola also (Camera del Torrione, 1579, vault and walls of the great spiral staircase, 1580). Most important of the group, however, was the younger brother of Matthaeus Bril, Paul (Paolo; b. Antwerp 1554, d. Rome 1626). Paolo came to Rome soon after 1570 to join his brother, though no document attests his presence before 1582. About 1583–4,

following Matthaeus, Paolo worked in the Torre dei Venti in the Vatican, in the late eighties on the Scala Santa, and about 1590 in the Lateran Palace.[35] These frescoes are not much different in their style, but are distinct in quality, from those of Paolo's close predecessors and contemporaries in the landscape mode. Their schemes of composition and their spatial structures are derived from Flemish style, but their handling tends to the Italian, absorbing thoroughly the breadth that is encouraged by the fresco medium and occasionally making brilliant *sprezzature*; the cursive action of Paolo's hand may coincide with Maniera ideas of ornament based on an inspired calligraphy. Paolo produced easel landscapes, too, most often in a tighter, less assimilated mode. As the end of the century approached Paolo's Maniera spiritedness subsided: his best-known landscape series, in S. Cecilia in Trastevere (1599), is in a weightier style, more suggesting Muziano's. It is still explicitly Maniera, however: Paolo has no more role in the invention of the landscape style of the seventeenth century than his less distinguished colleagues. Indeed, about 1606 Paolo began slowly but visibly to respond to inventions made by artists in the newer style, Elsheimer first; then, influenced by the Carracci and by Domenichino, he subsided into a gentle, only slightly mannered, classicistic style, waiting on the advent of the young Claude.

Late Counter-Maniera

None of the decorators of the youngest generation followed Federico Zuccaro into the reticences – classicistic or Counter-Maniera-like – of his later style. They preferred to hold to formulae he had deduced (as early as the seventies) from inventions that Taddeo had conceived even before. However, not only Federico but, as we have observed, the more important painters who were contemporary

with him or older, in the later years of the century espoused a principle of restriction of Maniera – in a sense a reform of the style; but it took on neither the dimensions nor the force of a significant artistic movement, and it was far from the consistency and strength of the reform initiated earlier in Florence. But what did occur in Rome in the way of constraining the temper of the late Maniera brought it at least into a distant concord with the other face of Roman art that wore the guise of Counter-Maniera, long since well established. In the last quarter of the century in Rome the same religious forces that had earlier helped to make a composition between Counter-Reformation and Counter-Maniera continued to be felt, but in circumstances no longer quite so austere. Counter-Reformation propaganda began to include in its requirements for art the capacity to satisfy an ordinary public taste – an inventive task, for it had hardly been conceived earlier than this by patrons of fine art that such a taste existed, much less that there was a reason for accommodation with it. Naturalism became a positive requirement of this – in effect – missionary art, and so did positive emotion, especially as it expressed the sentiments of piety. Where Counter-Maniera and Counter-Reformation continued to intersect, these requirements significantly lessened Counter-Maniera's earlier abstracting character. It was thus that, in the course of the eighties, the Roman version of what has been given the appellation *arte sacra* appeared, not earlier nor substantively different in its principles or aesthetic devices from its counterparts elsewhere in Italy that we have encountered and described before. In the nineties the youngest Roman perpetrator of the *arte sacra*, Scipione Pulzone, pressed the naturalist and simplifying components of that mode beyond the limits that a definition of the Counter-Maniera tolerates. Out of what had begun as Counter-Maniera

Scipione created an anti-Maniera style: it is a reform, paradoxically at once more forceful yet not quite so thorough as among the contemporary Florentines. The residues of the Counter-Maniera are more strongly felt in Scipione, and the new is asserted as if in an internal contest with the old. The retrospective factor in this not quite sufficiently revolutionary act of Scipione's is important to our understanding the character and meaning for art history of his style, and it throws into sharper relief the authentic revolutionary events that Caravaggio and Annibale Carracci contemporaneously achieved in Rome.

Until his death in 1592 Girolamo Muziano, who since the sixth decade had been a major agent of the confluence between Counter-Reformation and Counter-Maniera, remained the Roman painter who expressed most accurately the most stringent, as well as the deepest, kind of Counter-Reformation faith, that generated at the end of the Council and throughout the reign of Pius V. Impressive and intrinsically important as Muziano's later works (e.g. the *Circumcision* for the high altar of the Gesù, 1587) might be, his model was by then no longer quite so relevant to his successors in the field of pietistic painting. Muziano's style particularly reflected the dependence we tend too easily to overlook of the larger part of the pietistic art of the Counter-Maniera on the late Michelangelo and, as well, on the related inheritance that came from Sebastiano del Piombo. The same dependence characterized the early religious painting of Giuseppe Valeriano (1542–96), Muziano's successor and Scipione's predecessor in the Roman *arte sacra*. Valeriano was in a more precise sense than the others an agent in art of the Counter-Reformation: since 1572 he had been a member of the Society of Jesus and had served it in the capacity of architect as well as painter. Born in Aquila in the Abruzzi, Valeriano was a pupil of

Pompeo Cesura, a provincial Michelangelesque painter who worked mainly there, but in Rome also. Valeriano's *Ascension of Christ* (Rome S. Spirito in Sassia) of about 1570 is in a clumsily emphatic style, based on the laboured rhetoric of his master, into which he has compounded Sebastiano's models, Michelangelo, and a store of motifs taken from the similar theme in Raphael. The painting has no consistent style and an only partial component of Maniera, but it does convey an effect of dramatic and emotional conviction. It precedes Valeriano's joining of the Order, which occurred in Spain. There and in Portugal he spent the years 1572 to 1580. On his return he was extensively engaged by the Society as an architect, in Genoa, Naples, and Rome; and he was employed as a designer of paintings for two chapels in the first campaign of decoration of the Roman church of the Gesù, the Cappella della Madonna della Strada (after 1588) [297] and the subsequent Cappella della Passione (not finished until after Valeriano's death). Too busy to complete the work of execution, Valeriano extensively employed Scipione Pulzone as his executant in the former chapel and entrusted the latter wholly to Gaspare Celio. A late Maniera decorator of considerable skill, Celio's interpretations of Padre Valeriano's designs may be rather inexact; they seem to mingle too much *maniera* into piety. Scipione, however, seems to have made a sympathetic and precise accommodation to the Padre's thought. The illustrations in the Cappella della Strada of the Virgin's life are in a style which generically resembles Muziano's (or that of the late pietistic paintings of de' Vecchi), and are thus assimilable to the Counter-Maniera, but a Counter-Maniera now wholly detached from that form of it which descended from Michelangelo's and Sebastiano's examples. Instead it relates into the past to Raphael, taken in an aspect in which a nineteenth-century Nazarene

297. Scipione Pulzone (to designs by Valeriano): Marriage of the Virgin, after 1588.
Rome, Gesù, Cappella della Madonna della Strada

might see him, and with a similar false assumption of sentiment and simplicity. Where Raphael, Nazarenified, does not serve as touchstone, Leonardo, still more strangely, does. The affectation of simplicity is accompanied by an insistence which we observed before in *arte sacra*, but which is here more sharply pressed, upon naturalism so combined with generalization as to promote legibility and credibility at the same time. The mode of generalization retains, *pianissimo*, the echo of Maniera. The *clou* that appears here, but not elsewhere that we have seen in *arte sacra*, is that this slick, intentionally witless form illustrates a content that is deliberately made out of banality and sentiment. This is the most explicitly identifiable ancestor of the religious oleograph, intended for the delectation of the simple-minded; it is propaganda for the faith directed primarily to an audience oppositely unliterate to that to which the religious painting of the Maniera was intended to appeal. In the measure that this is for didactic piety of such a kind, it is anti-art; it is not altogether a hyperbole to suggest that the means of art are either debased to serve efficiency of piety, or turned into a demonstration of technique, or at best employed to manufacture *beaux morceaux*.[36]

Valeriano's membership in the Society of Jesus summons up the concept of a 'Jesuit style', usually considered in conjunction with the Baroque of the seventeenth century, but which should be considered here with at least equal relevance. The fact that Valeriano was a Jesuit does not mean that the images he designed for the Gesù are evidence of a recognized, sanctioned, or general prescription that the Order conceived for an artistic style. Certainly, Valeriano's notion that the content of a religious image be accommodated to the taste of a popular audience, and thus serve an evident missionary purpose, is in accord with Jesuit ideas. There is even reason to suggest that Jesuit policy sanctioned exploitation of emotions that are, in both the social and ethical senses, un-noble. But these elements of content do not in themselves determine style. Even within the two chapels he designed for the Gesù, Valeriano's propositions were interpreted with considerably different effects, of content as well as form, by his two excellent executants. Furthermore, what we may choose to isolate in Valeriano's images as a specifically Jesuit-determined content by no means represents a common denominator among paintings done for Jesuit patronage by other artists of the time: indeed, within the Gesù its first campaign of decoration (*c.* 1585–1595) embraces works that span almost the whole range of contemporary Roman modes of religious imagery. Conversely, it turns out that there is no distinction between what Muziano, Federico Zuccaro, or Scipione Pulzone paint in the same years for other churches. We thus cannot identify a specifically Jesuit style of painting in the later years of the Cinquecento. The role of the Society in respect to art is unspecific, but it is not for that reason any the less important: the Jesuits were among the chief agents in establishing the character of Counter-Reformation religious culture, and thus the state of mind which in general promoted Counter-Maniera art.[37]

Except in his collaboration with Valeriano, Scipione Pulzone (*c.* 1550–1598) does not seem overtly specious. As a craftsman he is conspicuously honest. In his religious pictures the emotions he describes are legible and satisfy what convention requires of the scene. But they are emotions without depth: Scipione illustrates the signs of feeling but, it would appear, being himself unconcerned or, less uncharitably, reticent, these signs carry no conviction. His earliest career was as a portrait painter, and he always exercised this aspect of his art successfully, but the portraits, too, are almost wholly noncommittal in expression, and at best conventional: it is as if they turned the Maniera

portrait's positive effect of a precise emotional constraint into something deliberately neutral. That the evasion of emotional commitment appears in both the portrait and the religious genre may be more than a result of Scipione's personality. It seems rather to express a major one among the psychological attitudes engendered by the latest-sixteenth-century phase of the Counter-Reformation, still restrictive but now less inspired.

Scipione had been the pupil of the old, artistically eccentric and *dévot* Jacopino del Conte, but apparently felt no great rapport with his personality or style. It may nevertheless have been the late Jacopino's model that first inclined Scipione towards Counter-Maniera. Though he soon showed that he preferred Siciolante's and Muziano's examples, Scipione never put aside the preference for abstractness and rigidity of form that was exceptionally strong in Jacopino's later art. With this preference, Scipione combined an antithetic concern for accurate description. To achieve this he at first used (as in his earliest dated portrait, *Cardinal Ricci*, Cambridge, Mass., Fogg Museum, 1569) the means he could garner from his observation of contemporary Roman painting, especially that of Siciolante. Soon, however, his will to describe became more specific, meaning to include not only detail that the draughtsman's point could probe but truth of optical effects as well. He studied Flemish and Venetian painting for examples. More important, following Siciolante's indication, he looked back to Raphael, and found in him what he looked for: sharp verity and schematically clear order. When Scipione transcribed Raphael, it was with much of the pre-Raphaelite effect which we noticed also in Valeriano. In a relatively early major altar, the *Immaculata* (once in the Roman church of the Concezione, now Ronciglione, Cappuccini, *c.* 1581), Scipione has transmogrified Raphael into Perugino or Ghirlandaio: the result almost suggests a

will to recall the aesthetic of the latest Quattrocento. The way in which the somewhat disconnective verity of surface that Scipione has achieved is imposed on rigid and abstracting form (of both small elements and the whole composition) promotes the pre-Raphael resemblance.

In 1584 Scipione was in Naples and in Florence, and in Florence had the chance to see the new directions instigated by the earlier reformers and appreciate that his inclinations were not unique. An *Assumption of the Virgin* (Rome, S. Silvestro al Quirinale), painted in 1585 following his return to Rome, is a fair approximation of contemporary ideas of the Florentine reform, which, in addition to the multiple references in it to preceding classic works of Roman sixteenth-century art, pays homage to Andrea del Sarto. As currently among the Florentines, Venetian painting guides Scipione towards a more controlled effect of visual truth and less arbitrary rigidity: the *Annunciation* painted in 1587 for Scipione's native town of Gaeta (now Naples, Capodimonte) may be the least schematic picture, in design, handling, and tenor of expression, of his whole career. In 1588 or shortly after Scipione undertook the collaboration in the Gesù with Padre Valeriano that I mentioned earlier, implying that it might have been the occasion for Scipione's learning to put on an unfelt face. His *Holy Family* (Rome, Borghese, *c.* 1588-90) [298] affects every sentimental cuteness that Valeriano's example had inspired. More than Valeriano, Scipione justifies his course by summoning the authority of Raphael, and makes a vacant parody of classical emotions as well as classical ideas of form.

It was only as late as this that Scipione finally conceived his definite personal vocabulary; it appears, without the falsity of archaistic accent of the *Holy Family*, in his fine *Crucifixion* (Rome, Chiesa Nuova, *c.* 1590) [299] and in the *Pietà* that was once on the altar of the Cappella

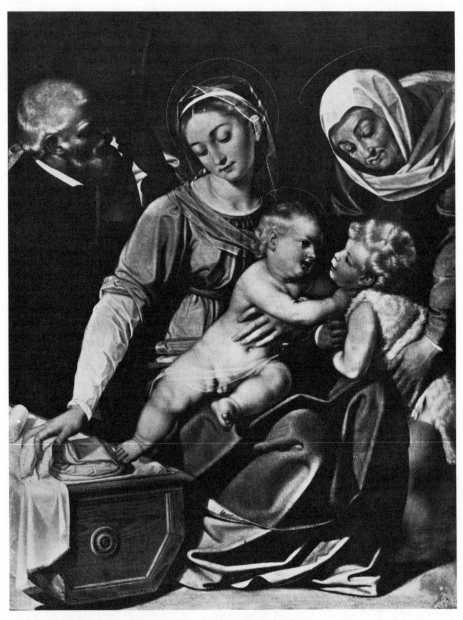

298 (*above*). Scipione Pulzone: Holy Family, *c.* 1588–90. *Rome, Borghese*

299 (*opposite*). Scipione Pulzone: Crucifixion, *c.* 1590. *Rome, Chiesa Nuova*

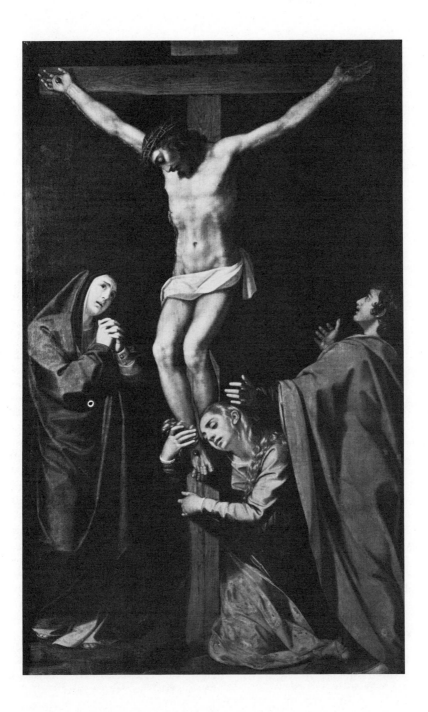

della Passione in the Gesù (1591; recently New York, art market). In these pictures verity is not made by labouring detail or by effortful optical effects; on the contrary the descriptive mode is simplified, and by this simplifying makes a more forceful and consistent impact of apparent existence than in Scipione's works before. But the simplifying comes from a mind grown up in the Counter-Maniera: it schematizes, conveying, after the first impact, a sense of vacancy. The world composed by Scipione with his simple, polished volumes – perhaps, with so much guidance taken from the High Renaissance, classically intended, but actually sub-classical – does not convince. Scipione's commitment to the verity of form is in the end almost as incomplete, and as much contained by convention, as his commitment to emotion. Anti-Maniera Scipione's developed mode may be, but it is bound nevertheless within the aesthetic of the sixteenth century. This is not a voice that proclaims, like Annibale or Caravaggio, the advent of a new style.

Roncalli and the Cavaliere d'Arpino

There may be some connexion with the shape of things to come in the style that two Roman painters conceived in the later eighties and nineties, the closest counterpart Rome offered to the results of the Florentine reformers. These painters were Cristofano Roncalli (1551/2-1626, called Il Pomarancio after his place of origin, as was his supposed master Circignani[37a]) and Giuseppe Cesari (1568-1640), more generally known by his title, Cavaliere d'Arpino. In his paintings of the last decade and a half of the century Roncalli combined more than was usual of optical as well as illustrative naturalism with effortfully plastic form. His actors sometimes resemble Muziano's, but they are inhabited by a contrastingly active and, in the beginning (*Histories of St Paul*, Rome, S. Maria in Aracoeli), often excessive energy. His style is thus not at all as restrictive as Muziano's and has no identifiable character of Counter-Maniera; at the same time it is more classicistic and reflects a deliberate accommodation with earlier-sixteenth-century art, Sebastiano del Piombo's especially, and to a less extent that of Michelangelo and of the later Raphael. His energy and ponderousness were a little moderated as he evolved (*Passion of Christ*, S. Maria in Aracoeli, *c.* 1588-90), and in time were turned to good account, simulating – for some time only rather awkwardly – the effects of the new style which Annibale Carracci had imported (Loreto, Casa Santa, Sala del Tesoro, 1609). Eventually Roncalli learned to imitate the newer style with much efficiency and became a respectable painter of the early-seventeenth-century Carraccesque school. He joined the new style, as many of the Florentine reformers did, but did relatively less than they to prepare the ground for its reception.

The Cavaliere d'Arpino was a more complicated personality. A prodigy, he had been invited at the age of fifteen by Circignani to join the painters, Roncalli among them, working on Gregory XIII's Logge; it is likely that Roncalli should have influenced him. The speed of the young Arpino's development was phenomenal, recalling Giulio Romano's in a former time. At twenty he was entrusted with a major church commission, two fresco histories (now lost) of the name saint in S. Lorenzo in Damaso. His success there was clamorous.[38] It was rewarded with a still more substantial commission to paint the vaults of the choir and sacristy of the Certosa di S. Martino in Naples. The first portion of this work, in the choir, was done in part in 1589, the sacristy not until 1596. From this extensive work it becomes clear that the impact Cesari made upon his public was not just by his prodigiousness or his facility. The earlier part of the decoration is already rich in indications of a new orientation, deviating from the accustomed ways of the Roman

late Maniera; the latter part affirms that Cesari had invented a way of grasping and presenting form distinct from that in the Maniera context. Between the two episodes of the Naples scheme Cesari, in Rome, began (with the vault, 1591–3) the painting of the Contarelli Chapel in S. Luigi dei Francesi, which Caravaggio (at some point in this time an assistant in Cesari's shop) was to complete in the latest years of the decade; and *c.* 1593–5 he executed a masterly decoration of the Cappella Olgiati in S. Prassede (*Ascension of Christ, Prophets, Saints* and *Sybils*) [300]. There Cesari demonstrated a sense for clarity and wholeness of form that may be more allied to the temper of the Carracci, if not to Caravaggio, than to the Maniera. Cesari's clarity of form does not come from an abstracting and restrictive schematizing, as in Counter-Maniera, nor is it arid and inert, as in the current art of Federico Zuccaro; it is a

clarity conjoined with energy and with effects that suggest convincing presence. Figure proportions tend towards the normative, and light and drawing are combined to make considerable truth of descriptive detail. The means Cesari uses to convey the effect of existence are strong, but they are subtle, too. The energy in this decoration is not expressed in terms of affirmation of existence only; it spills out into a regenerated ornamentalism, a calligraphy more muscular and spatial than that usual in late Maniera but otherwise exactly in its temper. Enough bound to Maniera to think that elegance and Maniera must be equated, Cesari has compromised reform, but nevertheless has made, in the Olgiati frescoes, a novel, dialectic step in style. This became one of the modes he would use subsequently, but only one among them; it tended to appear in small paintings, particularly of disguised erotic themes, Chris-

· 300. Cavaliere d'Arpino:
Cappella Olgiati (detail), *c.* 1593–5.
Rome, S. Prassede

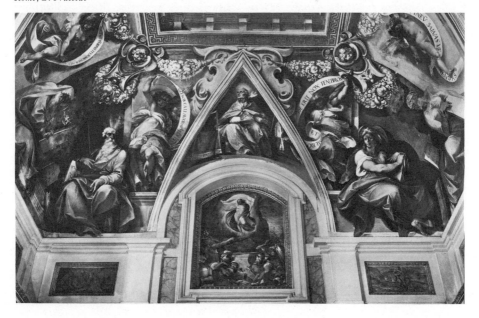

tian or mythological (*Expulsion from Paradise*, Paris, Louvre, *c.* 1597; *Perseus and Andromeda*, Vienna, Kunsthistorisches Museum, 1602) for private patrons rather than in works on large scale.

The frescoes of the sacristy vault at the Certosa di S. Martino, later than the Cappella Olgiati, are in a similar but more chastened vein. His compositions there are based on *contrapposti* and responsive ordering and tend to be set out measurably and clearly in a depth of space. The architectural framework Cesari conceived for the paintings works with a consonant effect of clarity and relative simplicity. The whole style conveys a character of classicism that would almost be authentic were it not, in its extraordinarily pervasive and explicit references to Raphael mainly, and to Michelangelo secondly, a kind of neo-classicism. It is made too much by recollection and by imitation to be enough personally felt. Nevertheless, what Cesari achieved requires to be taken as a style distinct from both the Maniera and the Counter-Maniera, and analogous in general to the action of the Florentine reformers. However, in the S. Martino frescoes there is too often a quality of slickness, or even of vacuity, that recalls the temper of a Maniera *praticante* or the abstractness of the Counter-Maniera; and Cesari retains a strong disposition towards the ornamental values of Maniera. His reformism is, at the date, equivocal.

In the later nineties Cesari's fresco style tended, for the most part, towards an increasing sobriety. As his public style evolved it became more academic, conforming to a prescription – so explicitly fulfilled that it must be his own – for hollow and ennobled boredom. The element of authenticity in his classicism receded, and by the first years of the new century Cesari's art came to resemble in principle, means, and some of its precise effects that of the aged Federico Zuccaro. Cesari challenged Federico's deanship of official art in the cen-

tury's last decade, and for a while displaced him. But by that time the point of view of either had become irrelevant to the meaningful problem of contemporary style. As the styles of the Carracci and Caravaggio came to dominance in Rome Cesari's style degenerated into vacancy, become the husk of the reform he did not quite accomplish years before.[39]

The relation between the emergence into the leading place in Florence and in Venice of a new artistic style and the opening of the sixteenth century is a coincidence which more than ordinarily serves the convenience of the historian. At the close of the century, the relation between it and the end of a tradition of style which Leonardo founded and which Michelangelo, Raphael, Giorgione, and Titian built is not quite so neat, but still a working historical approximation. What the Carracci and Caravaggio started in the 1580s and 1590s, and brought to maturity towards 1600, marked the advent of a style of which the common denominators were more clearly distinct from those of sixteenth-century painting than the varieties of sixteenth-century style were distinct from one another. It may be only by moving outside the confines of the Cinquecento that we can see its painting as belonging in a community of style – however broad, internally diverse, or loosely joined. From within, as our account sufficiently attests, the visage sixteenth-century Italian painting offers us appears Protean, various in time and place as the painting of no other century or country had been before: as it could be only in this country and this century, in the culminating and concluding stages of the Renaissance, when painters had at their disposal an accumulation of resource, cultural as well as specifically artistic, greater than at any time before.

The complexity of resources increased as the century advanced, arriving, with much variation of times and places, at a point of surfeit or

diminishing return, which eventually became pervasive. The earlier searchings towards a basis on which to refound artistic style were shaped too much by their matrix and too much bound in it to make significant progress, and could not (in the case of Counter-Maniera, even with a major external cultural support) contest the vitality which the existing style still possessed. As this diminished, however, the prospect of successful as well as significant invention widened. Two of the principal resources were drawn upon which the century possessed, but to which Maniera, while it was a dominating style, barred the direct way: one was naturalism, to which Maniera had opposed its code of artifice; the other classicism, before which the Maniera had interposed a deforming screen. Both were to be found in the models of the High Renaissance, which the painters who sought reform consulted. But to make a new style more than retrospection was required. In formulating the style – more accurately, the paired phenomena of style – which displaced its Cinquecento antecedents, the Carracci and Caravaggio were moved by a conception of reality and a will to represent it that were not only opposed to the Maniera but discernibly beyond the naturalism of the High Renaissance. This realist motive was accompanied, or tempered, or controlled in both the Carracci and Caravaggio by qualities of form and values of expression that resembled those of High Renaissance classicism and owed much to its study – not its imitation: because early-sixteenth-century classicism was looked at with a vision that established a new reality, it took on a different aspect for the viewers, conveying different values from those it had held for its High Renaissance contemporaries, and an altered sense. But this vision of early-sixteenth-century classicism by the young radicals of the last years of the century was truer to the underlying sense of classicism than much of what had come between, and restored clarity, unity, and force – nobility, too, for all the elements of realism – to classical values that had been, in both senses of the Italian word, *sofisticato*. The ratio of classical to realist ambitions seems opposite in Annibale and in Caravaggio, but this is only superficially true: the substance of Caravaggio's art may hold a deeper, more essential classicism than Annibale's, none the less authentic because it will not be antiquarian. Both men had gathered forces for a regeneration of style in their native North Italy – gathered retrospectively in great part, by Caravaggio in Lombard tradition and in Giorgione's Venice, by Annibale in Lombardy, in Titian's Venice, and in Correggio. Both brought their North Italian gatherings to Rome, and only there, fusing them with the sixteenth-century inheritance of classicism, gave full form to their historical invention. What they accomplished may be thought of as a new synthesis, which resolves the differences among schools and styles of Italian painting of the sixteenth century for the profit of the century to come.

Cambridge, Massachusetts
1 August 1968

LIST OF THE PRINCIPAL ABBREVIATIONS USED

IN THE NOTES AND BIBLIOGRAPHY

A.B.	*Art Bulletin*
Boll. d'A.	*Bollettino d'Arte*
Burl. Mag.	*Burlington Magazine*
G.B.A.	*Gazette des Beaux-Arts*
J.K.S.W.	*Jahrbuch der Kunstsammlungen in Wien*
J.P.K.	*Jahrbuch der preussischen Kunstsammlungen*
Mitt. K.H.I.F.	*Mitteilungen des Kunsthistorischen Institutes in Florenz*
Rep. K.W.	*Repertorium für Kunstwissenschaft*
Riv. d'A.	*Rivista d'Arte*
Vasari	Vasari, G., *Le Vite de' più eccellenti pittori, scultori ed architettori* (1568), G. Milanesi ed., Florence, 1878–85, repr. 1906.
Venturi, *Storia*	Venturi, A., *Storia dell'Arte Italiana*, Milan, 1901–39.
Warburg Journal	*Journal of the Warburg and Courtauld Institutes*
Z.b.K.	*Zeitschrift für bildende Kunst*
Z.K.	*Zeitschrift für Kunstgeschichte*

NOTES

Bold numbers indicate page references

14. 1. This chapter consists in the main of material condensed from my *Painting of the High Renaissance in Rome and Florence* (Cambridge, Mass., 1961). I have taken the opportunity to revise some of the views expressed there and to correct the judgements or information that I have since become convinced were incorrect. Attention will be called in these Notes to places where substantial changes of fact or opinion have been made.

19. 2. Usually also given to Leonardo's execution, if not invention, in the *Baptism* are the landscape to the left rear, part of the drapery of his angel, and some painting in the body of the Christ.

23. 3. See the much more extended explanation of the situation in Freedberg, *op. cit.*, I, 15 ff.

4. In Freedberg, *op. cit.*, I, 18, I characterized the version of this picture in the London National Gallery much too abruptly, stating that 'despite the possible reading of the documents, it was not by Leonardo'. I did not mean thereby to exclude Leonardo's intervention in the London version, which is visible in important places, though not to the degree that overcomes the dominating role of Leonardo's documented assistant, Ambrogio de Predis, in its execution. The London picture is with virtually complete certainty (see M. Davies, *The Earlier Italian Schools*, London, 1951, 204 ff.) the picture finally delivered by Leonardo in 1508 to the Confraternity of the Madonna della Concezione. No clear evidence exists to indicate why it was substituted for the first (Paris) version, nor to explain how that picture came to France.

The major changes in the London version – of design, as distinguished from details – seem mostly purposeful, not accidental alternatives, and are mainly in the sense of a developing classicism in Leonardo's style (e.g. larger and more fully modelled forms, more rounding curves, a more closed space). It may be supposed that Leonardo himself instigated these changes and indicated the main elements of design on the panel. In my estimation the principal labour of execution was then left to Ambrogio,

Leonardo (during this phase) intervening in the Virgin's head and in that of the angel. The style of these details suggests that this occurred in the mid nineties or soon afterwards, when this version apparently was begun. The unfinished painting may have been worked on by Ambrogio during Leonardo's absence in Florence until 1506. Then, however, a new set of stipulations was devised, which, since they involve Ambrogio as well as Leonardo, must have expected his continuing participation. Leonardo must again have intervened, in a style distinct from his (apparently) earlier touches and related to his more recent Florentine achievement. Such later intervention seems to me to be visible in the Christ child, in parts of the St John, and in the Virgin's foreshortened hand.

Since the above was written two new documents, dated 18 August 1508, have emerged from the Archivio Storico of Milan (at this date only informally published, as in the journal *La Repubblica* for 13 May 1980) which further confirm a role for Leonardo in the London version. The documents note that the original (Louvre) version may be removed from its normal location to a more private place within the church or convent for as much as four months at a time so that Leonardo and his helpers may copy from it. The fee for executing the second version was divided equally between Leonardo and de Predis.

24. 5. The medium, not conventional fresco but a kind of oil on a ground of pitch and mastic, characteristically experimental, deteriorated very rapidly. Signs of advanced damage were reported as early as 1517. Cf. L. Heydenreich, *Leonardo da Vinci* (Basel, 1954), I, 38–9. A careful (and relatively successful) cleaning and stabilizing of the remains of the original painting was undertaken in the years following the Second World War.

6. For evidence which supports very strongly the dating of the National Gallery cartoon within the first Milanese stay see J. Wasserman, *Art Bulletin*, LIII (1971), 312–26.

Another work surviving from Leonardo's first Milanese period that is certainly attributable to him (beyond the remade foliate decoration of the Sala

delle Asse in the Castello Sforzesco, *c.* 1491) is a portrait of Cecilia Gallerani (Cracow, Czartoryski Museum, of the mid eighties). The unfinished *Musician* of the Ambrosiana is generally accepted as Leonardo's, but I consider that it should be taken with much reserve. On the other hand, I should like to suggest that the *Belle Ferronnière* of the Louvre deserves more consideration than she has usually received in recent literature.

26. 7. For attempted reconstructions of the design of the picture beyond its central *Battle of the Standard* see G. Neufeld, *Art Bulletin*, XXXI (1949), 170 ff., J. Wilde, *Warburg Journal*, VII (1944), 65–81, and, less convincingly, C. Gould, *Art Bulletin*, XXXVI (1954), 117–29.

31. 8. But cf. Note 4 above for Leonardo's likely intervention between 1506 and 1508 in the London version of the *Madonna of the Rocks*. During this Milanese stay he may have touched up the old *Benois Madonna*, from his early Florentine time, and another Madonna also intended for delivery to Louis XII of France. He seems to have conceived a painting of a *Kneeling Leda*, but probably never even began its execution.

32. 9. The Medici collection of antiques, located in the gardens of S. Marco, was accessible for study by Bertoldo's pupils, apparently quite freely. Vasari, retrospectively imposing his contemporary point of view, and with the intention of flattering the Medici, magnified Bertoldo's school into a proper classicist academy; but cf. E. Gombrich, 'The Early Medici as Patrons of Art', in *Italian Renaissance Studies, a Tribute to the Late Cecilia M. Ady* (London, 1960), 279–81; reprinted in *Norm and Form* (London, 1966), 35–57.

10. The dating *c.* 1492, deduced from Vasari (VII, 144), does not seem to be supported by the evidence of style. See the discussion of dating (and of attribution also) by C. Eisler in *Stil und Überlieferung in der Kunst des Abendlandes* (Acts of the 21st International Congress for Art History, 1964) (Berlin, 1967), II, 115–21.

35. 11. This remains the case no matter what elaborate iconographic explanations may be devised: cf. M. Levi d'Ancona, *Art Bulletin*, L (1968), 43–50.

12. Cf. W. Koehler, *Kunstgeschichtliche Jahrb. der K. K. Zentral Komm.*, IV (1907), 115–72; J. Wilde, *op. cit.* and *Burl. Mag.*, XCV (1953), 65–77; C. Isenmeyer, 'Die Arbeiten Leonardos und Michelangelos für den grossen Ratssaal in Florenz', in *Studien zur Toskanischen Kunst, Festschrift für L. Heydenreich* (1964), 83–130. The above give differing reconstructions of the cartoons and the layout of the decorative scheme. Michelangelo's cartoon was cut up about 1512, and no part now survives. Our best information

about the Michelangelo cartoon is in a small copy (attributed to Aristotile da Sangallo) preserved in the collection of the Earl of Leicester, Holkham Hall.

37. 13. C. Justi, *Michelangelo* (Berlin, 1922), 15 ff. (first edition 1900), seems to have been the first to recognize this relation.

14. Documented in a drawing in the British Museum, 1859–6–25–567r.

15. Letter to Fattucci, December 1523; G. Milanesi, *Lettere* (Florence, 1875), 426–30.

38. 16. More recent efforts of iconographical exegesis of the ceiling that go beyond this quite overt and legible meaning may be found in E. Wind, *G.B.A.*, XXVI (1944), 211–46, F. Hartt, *Art Bulletin*, XXXII (1950), 115–45, 181–218, and K. Tolnay, *Michelangelo* (Princeton, 1945), 11.

39. 17. The most convenient summary of the results of scholarship on the ceiling's dating is in P. Barocchi, *La Vita di Michelangelo nelle redazioni del 1550 e del 1568* (Milan, 1962), II, 426, note 335. But see also the valuable, though much too summary, exposition of J. Wilde, 'The Decoration of the Sistine Chapel', in *Proceedings of the British Academy*, XLIV (1958), 61–81, and especially 78, note 2, where he disputes the generally held view (cf. Tolnay, *op. cit.*, II, 108–9, and Freedberg, *op. cit.*, I, 110) that the lunettes were painted at a later time than the curved portions of the vault. In *High Renaissance* I considered that the lunettes were designed in two episodes, but all executed following the uncovering of the unspecified portion of the work which was recorded in August 1511. Wilde (making more concrete an idea entertained by Steinmann) proposed instead that the lunettes were painted along with the bays above them on the vault, which makes a considerable difference in the arrangement of an internal chronology. Wilde's point of view, stated but not explained in the article quoted above, is more fully developed by J. Schulz, *Art Bulletin*, XLV (1963), 162–3, including some evidence for the chronology Wilde would prefer. I now find this proposal to associate the lunettes in time of execution with the vault above preferable in principle to my former view; however, I should prefer that flexibility be allowed in this association, and that it not be required that each lunette exactly follow in its time of painting on the bay above. No reason of style (nor any external indication) forbids that Michelangelo have done the four easternmost lunettes and the two on the east end wall, as well as the *Judith* and *David* pendentives, more or less as a group, following his completion of all the pictures in the corresponding vaults above; the same observation may apply to the four westernmost surviving lunettes. Only the four lunettes beneath the ceiling's central

bays seem inflexibly attached by style to the bay above each. In any case, the acceptance of Wilde's proposition, even in general terms, requires that we accept a revised chronology.

The critical element in Wilde's chronology is his deduction that at the 'unveiling' of August 1511 the ceiling was done to and including the bay containing the *Creation of Eve*. There is much to support this idea, but it also has the defect that it requires Michelangelo to have completed the whole remaining painting – four ceiling bays, two very complicated pendentive compositions, and eight lunettes – in the twelve further months in which we know he worked, while (by this same chronology) the previous five ceiling bays, two simple pendentives, and eight lunettes had taken him twenty-four or twenty-five working months. There is no firm reason to believe that what Wilde (*via* Schulz) refers to as the 'first unveiling' of August 1511 was 'first', since at the end of August 1510 Michelangelo writes (letter, see Tolnay, *op. cit.*, no. 36) that he will have finished the part he began, and has uncovered it ('l'ò schoperta'). It may have been to this happening that Michelangelo's biographer Condivi referred, rather than to that of 1511, when he stated (A. Condivi, *The Life of Michelangelo*, tr. Holroyd, London and New York, 1903, 47) that the 'first unveiling' took place when the decoration was half done, 'fin a mezzo la volta'. The place of demarcation remains at the boundary between the fifth and sixth bays (the *Creation of Eve* and the *Creation of Adam*), but the time is a year earlier than in Wilde's chronology, and as it is more usually proposed. Accepting that the 'middle of the vault' was reached by August 1510 the division of months of actual work (as distinguished from elapsed time; we can surmise the former adequately especially from Michelangelo's letters) between the five easterly bays and east end wall and the four westerly bays and west end wall is (fairly closely) eighteen to seventeen – a much more tenable ratio than Wilde's chronology requires. Our chronology results in an average rate of work per bay (or end-section) of about three months. The actual work period after August 1510 and before August 1511 was only about six months: Michelangelo began to paint again only in February 1511. The 'unveiling' of August 1511 would thus have brought Michelangelo only two bays farther on, to the end of the seventh bay (the *Separation of the Waters*). This seems a rather arbitrary place for an 'unveiling', but only if it is assumed (as the words of the reporter, Paris de Grassis, do not justify) that the occasion was really ceremonial. The problem cannot be considered as resolved, but the fewest difficulties result from the chronology that I prefer.

18. Assisted only by *garzoni* to do preparatory and menial work, but certainly no figurative painting. Michelangelo had originally brought an *équipe* of Florentine painters to help him, among whom were Granacci and Bugiardini, but let them go without using their work; see Vasari, VII, 175. The names of some of the *garzoni*, who were also Florentine by preference, are known; see Tolnay, *op. cit.*, II, 113–14.
41. 19. One of this pair of Ignudi was mostly obliterated in the only major damage suffered by the ceiling, an explosion in 1798.
50. 20. It is unlikely that Raphael's closest association with Perugino should post-date 1500, as is generally held in the older literature and in Freedberg, *op. cit.*, I, 62. See R. Wittkower in *Bulletin of the Allen Art Museum*, XX (1963), 150–68, and C. Gilbert in *Bulletin of the North Carolina Museum of Art*, VI, no. 1 (1965), 3–35, for the latest critical examinations of the problem of Raphael's education and the chronology of his work in the time preceding his transfer to Florence. I consider Gilbert's solutions in general the more convincing, and I hold with him that we cannot retard the date of the Vatican *Coronation of the Virgin* to 1500, as Wittkower does. In particular among Gilbert's arguments I find excellent his grounds for advancing the date of small panels such as the Chantilly *Three Graces* to *c.* 1504 or 1505.
51. 21. All for churches at Città di Castello. Both Wittkower, *op. cit.*, and Gilbert, *op. cit.*, propose that the actual locus of Raphael's practice between 1501 and 1504 was Città di Castello rather than Perugia. Of the early altarpieces, only the *Coronation of the Virgin* in the Vatican was painted for Perugia.
22. As originally by H. Wölfflin in *Classic Art* (London, 1952), 82–7 (original edition, 1899).
53. 23. The altar was left unfinished on Raphael's departure for Rome, and completed only after his death by his assistants and for another patron. The arguments of P. Riedel, *Mitt. K.H.I.F.*, VIII (1957–9), 223 ff., which try to establish that the architectural background was not in Raphael's original design are not in my opinion valid.
Shearman, in *Master Drawings*, XV (1977), 107–46, has adduced strong evidence which indicates Raphael had visited Rome, probably on more than one occasion, before 1508.
24. J. Shearman, 'Raphael's Unexecuted Projects for the Stanze', in *Walter Friedlaender zum 90. Geburtstag* (Berlin, 1965), 175, has added evidence, based on the interpretation of documents of 1508 and 1509, to support the thesis originally proposed by F. Wickhoff, *J.P.K.*, XIV (1893), 49 ff., that the Stanza della Segnatura was a library.
54. 25. The inventors of the programme of the

Stanza della Segnatura should most reasonably be pictured among the 'modern' poets, among whom we can certainly identify only Sannazzaro and Tebaldeo.

26. Like Shearman, *loc. cit.*, I now disclaim the possibility (cf. *vs.* Freedberg, *op. cit.*, I, 112–17) that either Sodoma or Peruzzi may have assisted Raphael in the *tondi* of the Segnatura's ceiling.

56. 27. Colour assumes an important function in design in the *School of Athens*, especially conditioning the effects of space. For a discussion of this colour function and a fuller exposition of the character and historical meaning of the conception of a space dependent upon substances, see Freedberg, *op. cit.*, I, 124–6.

57. 28. In the *Civil Law*, more likely through later loss than incompletion, all that remains is the preparation in *buon fresco*. The modelling and working of details *a secco*, usual for most of the figures of this Stanza, is almost altogether lacking.

The illusionism of these scenes perpetuates a quattrocentesque ambition. It is likely that Melozzo da Forlì's *Sixtus IV and his Court* in the Vatican was a particular model for the *Canon Law*.

58. 29. The recent research of Shearman, *op. cit.*, has satisfactorily demonstrated that the subjects of the wall frescoes were all invented at the same time and are 'prophetic', not topically conceived to refer to events of 1512. The older 'topical' view of the iconographic relation of the subjects to events within the first half of 1512, held by most authors, was the one I used in my account in Freedberg, *op. cit.*, I, 151 ff. I also held the view (*ibid.* and 148) that Peruzzi, rather than Raphael, was responsible for the invention and execution of the Old Testament analogues on the ceiling of the Stanza d'Eliodoro. However, evidence presented by Shearman and by K. Oberhuber, *Mitt. K.H.I.F.*, XII (1966), 225–44, including the discovery of two new preparatory studies, now proves sufficiently that only the subsidiary decoration (the borders, etc.) of the ceiling (of *c.* 1509) by Peruzzi (and others) survives, while the rest was replaced *c.* 1514 by Raphael, to his own designs. The iconographical concordances between ceiling and walls are thus *post-facto*.

59. 30. The story is that of a Eucharistic host which controverted the doubts of a priest concerning the doctrine of Transubstantiation by bleeding when it was elevated; the miracle occurred at Bolsena. The dogma and the particular relic were objects of special veneration by Pope Julius.

62. 31. The main helper here appears to be Francesco Penni, who would by now have finished his work on the accessory decoration of the Stanza della Segna-

tura. His participation in the *Repulse* seems to be extensive in its right half.

63. 32. An approximate *terminus ante* for completion of the Stanza d'Eliodoro is July 1514, when Raphael wrote to his uncle, Simone Ciarli (V. Golzio, *Raffaello nei documenti*, Città del Vaticano, 1936, 32), that he had begun another room (the Stanza dell'Incendio); see Note 38. Terminal payments for the Stanza d'Eliodoro were made in August 1514.

65. 33. But see the argument of K. Oberhuber, *J.K.S.W.*, LVIII (1962), 32–3, for a dating of the Sibyls slightly earlier, *c.* 1511–12.

The *Galatea* in the decoration of its room complements the *Polyphemus* painted *c.* 1512 by Sebastiano del Piombo.

34. Commissioned most likely by Pope Julius before he died, in honour of his uncle, Sixtus IV. The 'Sixtus' in the painting bears Pope Julius's features. It has recently been established by K. Oberhuber (*Burl. Mag.*, CXII (1971), 124–32) that the autograph version of Raphael's portrait of Pope Julius, of *c.* 1512, formerly most often assumed to be that in the Uffizi, is instead that in the National Gallery in London.

35. In the *Madonna dell'Impannata*, which in Freedberg, *op. cit.*, I, 172 ff., I thought altogether of Giulio's execution, I now discern the considerable presence of Raphael's own hand. Sent to Florence very soon after its completion, the *Madonna dell'Impannata* had some influence on painting there.

67. 36. From *c.* 1513–14 only one portrait survives that is certainly of Raphael's execution as well as invention: the *Donna Velata* (Florence, Pitti, *c.* 1514). The portrait of Tommaso Inghirami ('Il Fedra') in the Gardner Museum in Boston, which I formerly believed was an autograph by Raphael, has proved on cleaning (September 1982) to be a copy, derived from the *Fedra* in the Pitti (*c.* 1516?). This last seems in the main to be of Giulio Romano's execution, perhaps touched in the face and hands by Raphael himself. A further portrait of Giuliano de' Medici (late 1514?) is lost. A version in the Metropolitan Museum, for which Raphael's authorship has been claimed in the past, is a copy from the lost original rather than a replica of it from Raphael's shop.

37. Michiel, *Diaries*, 6–7 April 1520 (quoted in Golzio, *op. cit.*, 113).

69. 38. Golzio, *op. cit.*, 32. The phrasing indicates that the actual painting was still in the future; what was begun at this date was probably no more than early thinking of design. The frescoes of this room were not planned all at once (like those of the preceding Stanze) but successively; that this is true for this

once at least is quite explicit from the topical references made by the two later frescoes of the room. All four scenes treat, in historical analogy, the theme of the powers the Church, from its divine sanction, may exercise through the person of the Pope. However, there is no such coherence among the illustrations here as in the earlier Stanze, nor any comparable unity of aesthetic plan. The decoration was completed between March and July 1517.

39. I have shifted the order of events proposed in Freedberg, *op. cit.*, I, 293 ff., and returned to a sequence I earlier preferred in a paper read before the College Art Association in January 1952, *Crisis and Dissolution in the Painting of the High Renaissance*. I have also altered my belief that Giulio rather than Raphael was the dominating executant of the *Fire*. I am indebted to Oberhuber, *op. cit.* (1962), 23 ff., for his argument concerning the first point and both to his remarks and those of Shearman, *op. cit.* (1965), 175 ff., on the second.

The *Fire* shows how Pope Leo IV miraculously caused the extinction of a fire in the *borgo* around the Vatican; it is taken usually as an analogy for Leo X's extinction in June 1513 of the doctrinal 'conflagration' engendered by the Pisan schism. The *Battle of Ostia* was a victory against the Saracens off that port, also in Leo IV's reign.

71. 40. The character of this highest classicism deserves far more detailed analysis than there is room for here. An extended treatment of the aesthetic of the tapestry cartoons is in Freedberg, *op. cit.*, I, 273–93. For the most useful discussion of other highly relevant considerations, in particular the order of arrangement of the tapestries in the Sistine Chapel and their iconography, see J. White and J. Shearman, *Art Bulletin*, XL (1958), 193–221, 299–323, and in more detail, J. Shearman, *Raphael's Cartoons in the Collection of Her Majesty . . .* (London, 1972).

72. 41. The subject refers by analogy to the meeting between Leo X and François I in Bologna in November 1515, when François rendered homage to the Pope. Raphael's design was given over to Francesco Penni for preparation in detailed studies and for most of the execution.

73. 42. Drawings by Raphael are preserved at Lille and Oxford. For an extensive and precise examination of Raphael's entire project for the Chigi Chapel in S. Maria del Popolo, see J. Shearman, *Warburg Journal*, XXIV (1961), 129 ff. Shearman there explains, *inter alia*, the logical relation between the meaning and design of the dome and an intended but unexecuted *Assunta* altarpiece.

74. 43. The main antique source of the grotesque system in the Bibbiena apartment is the Domus Aurea. Giovanni da Udine, the North Italian helper in the shop who had hitherto apparently specialized in still-life details (e.g. the instruments of the *St Cecilia* altar), in this decoration acquired the status of a specialist of the grotesque style, preparing him for his larger role in the Logge.

44. The apparent pretext for the subject was the final legalization of Chigi's union with his mistress Francesca Andreosia; they were married by Pope Leo in 1518.

77. 45. A photograph, imperfectly legible, has come into my possession of a preparatory study, in pen and ink, for the *God separating Light and Darkness* in the first loggia bay, of which the style strongly suggests that it is by Raphael's own hand. I have not been able to locate the drawing itself or identify its owner.

For a succinct discussion of the problem of the Logge studies, in which more weight is given to the likelihood of Raphael's supplying all the first designs, see P. Pouncey and J. Gere, *Raphael and his Circle* (London, 1962), I, 53–5.

46. Following the completion of the Logge Giovanni da Udine and his assistants were given the task, apparently with no specific dictation from Raphael, of decorating the corresponding loggia on the first floor of the Cortile di S. Damaso (second half of 1519). A much less pretentious project, without figured compositions, the main interest of this lower loggia is in the illusionistic devices used to paint the vaults.

47. The date may be, on external grounds as well as on style, early 1516. The picture has been cut at the bottom; a drawing by Rembrandt, who saw the painting for sale in Holland, shows the sitter's hands.

78. 48. The double portrait is, however, by no means unique; though the precedents for it are in the main Venetian. See Freedberg, *op. cit.*, I, 337.

49. Careful reconsideration of the portrait of the young *Bindo Altoviti* (Washington, National Gallery), which in Freedberg, *op. cit.*, I, 338–9, I thought of Giulio's execution, has led me to be more cautious on this point. I now think it may be possible that it is by Raphael's hand, by analogy with the role in the execution of the *Fire in the Borgo* that I would now concede to him.

K. Oberhuber, *Burl. Mag.*, CXIII (1971), 436–43, has published the rediscovered original of a 'lost' portrait by Raphael of Lorenzino de' Medici (1518) in a painting in the New York art market. I concur in his conclusion (which I had reached independently) that this portrait is the autograph version.

81. 50. Cf. F. Hartt, *Giulio Romano* (New Haven, 1959), I, 27 ff., and J. Shearman, 'Maniera as an

Aesthetic Ideal', in *The Renaissance and Mannerism* (Acts of the Twentieth Congress of the History of Art) (Princeton, 1963), II, 214, note 48.

51. A third French royal picture, a *St Margaret* (Paris, Louvre, much damaged) in scale similar to the *Michael*, was probably done *c.* 1518–19 for Marguerite de Valois, François's sister; the execution seems by Giulio Romano. Another version of the *Margaret* theme, also done during Raphael's lifetime, is in the Kunsthistorisches Museum, Vienna: it is also a shop piece, by another hand than the painting in the Louvre.

None of the late devotional paintings on a smaller scale, of *Holy Family* or *Madonna* subjects, seems in the present state of our knowledge to be positively attributable to Raphael's execution. The *Madonna della Rosa* (Madrid, Prado) may be a likely candidate; otherwise, the best in quality among these pictures seem to show Giulio Romano's hand, by now developed to a phenomenal degree of skill. Among these the most interesting is the *Madonna della Perla* (Madrid, Prado, 1519–20), where, working still on a basis supplied by Raphael, Giulio makes a genuinely creative, and in some important ways unclassical, alteration in the Raphaelesque style. See Freedberg, *op. cit.*, I, 364–70, for discussion of some of these later productions of the Raphael shop.

52. See K. Oberhuber, *Jahrbuch der Berliner Museen*, IV (1962), 116 ff. Previous to the cleaning performed in 1972-6 Raphael's personal participation in the execution had been greatly obscured, and the consensus of opinion tended to assign most of the left lower group to Raphael's hand, the right lower group to Giulio, and the upper part to Penni, with allowance for Raphael's intervention in some measure in the Christ. It is now amply evident that the painting is in greatest part by Raphael's hand: all the upper portion and the group at lower left most certainly; only the group at lower right may show participation by assistants.

83. 52a. A justification for the inclusion of the lower scene could have been found in its reference to Christ's role as healer, which could be taken in the sense of *medicus* appropriate to the Medici commissioner. Cf. K. Posner, *Leonardo and Central Italian Art, 1515–1550* (1974), 43-7.

84. 53. Our first knowledge of Baccio's painting may date from shortly after 1494, when he assisted in the finishing of an altar of the Malatesta family at Rimini, left incomplete by Ghirlandaio at his death. See E. Fahy, *Burl. Mag.*, CVIII (1966), 456–63.

85. 54. The traditional history (e.g. Vasari, IV, 183-4) that makes Raphael learn during his Floren-

tine residence from Fra Bartolommeo may be correct only in respect to minor matters; the more important influence appears to go the other way.

88. 55. For Cardinal Ferry Carondolet. The Besançon altar originally had an upper section with a *Coronation of the Virgin*, which has been severed. It is partly preserved in the gallery at Stuttgart. Illustrated in Freedberg, *op. cit.*, II, figure 262. A full discussion of this altarpiece is by L. Borgo, *Burl. Mag.*, CXIII (1971), 362–71.

89. 56. S. McKillop, *Franciabigio* (unpublished MS., 1967), 22, reports that the date of the Certosa *Crucifixion*, usually read as 1505, properly reads 1506.

57. Commissioned 1506; G. Poggi, *Riv. d'A.*, IX (1916), 65, reports records of payment from 1506 to after 1510.

58. In Stockholm; O. Fischel, *Raphaels Zeichnungen*, V (1924), 21, dated by Fischel 1508.

59. The republication of the dated Volognano altar (Berenson, *Florentine School*, 1963, 2; L. Borgo, *Burl. Mag.*, CVIII, 1966, 468) disposes of the notion recurrent in the literature on Albertinelli (and which appears also in Freedberg, *op. cit.*, I, 200) that he quite retired from painting probably in 1513. The time of Albertinelli's temporary change of profession to innkeeping (reported by Vasari, IV, 222) is not clearly established.

90. 60. Sister Plautilla Nelli (1523–88), a pupil of Fra Paolino, gave Fra Bartolommeo's model (or at least Paolino's thin approximation of it) a long posthumous existence, adhering to the formula for reasons that had more to do with a conception of their religious fitness than their sense as art.

61. As J. Shearman, *Andrea del Sarto* (Oxford, 1965), I, 21 ff., has established.

92. 62. There is no provable indication in the *Birth of the Virgin* that requires it include an experience of Raphael's art up to this time in Rome, but it is not altogether to be excluded that the level of development of classical style that Andrea's fresco represents may depend in part on Roman stimulus. Vasari (V, 55) reports that Andrea made a journey to Rome, but with the implication that it was later in Andrea's career than this. The best supposition I am able to offer for a Roman voyage by Andrea is *c.* 1525; see Freedberg, *Andrea del Sarto* (Cambridge, Mass., 1963), II, 137.

95. 63. As J. Shearman, *Mitt. K.H.I.F.*, XI (1960), 206–20, was the first to demonstrate, the vaulted architecture of the *cortile* is an eighteenth-century addition; the painted lunette fields which now surmount the atticae date from that time.

96. 64. It is my present opinion that in Freedberg,

op. cit. (1961), I, 80–1, I dated these two works too early, *c.* 1508, as a consequence of imitation of the Florentine Raphael. The arguments of McKillop, *op. cit.*, 243 ff., in favour of a later date appear compelling. It should still be observed, nevertheless, that the paintings in question recall more of the Florentine Raphael than they imitate of his Roman style.

65. Documents (J. Shearman, *Burl. Mag.*, CII, 1960, 152–6) indicate that Franciabigio's fresco was finished by September 1513, when Andrea's *Birth of the Virgin* must only recently have been begun. This casts doubt on Vasari's famous account (V, 193) of Franciabigio's damaging his fresco in a rage when it was unveiled 'prematurely' on the same day as Andrea's, and compared unfavourably with it. But it is also documented that the author of the damage to the *Marriage of the Virgin*, still unrepaired and visible, was Franciabigio.

98. 66. Franciabigio enjoyed a role of some prominence as a portrait painter, more important than Andrea's in respect to quantity at least; Andrea's few portraits seem mostly to have been relatively private objects. As in other facets of his art, Franciabigio used Raphael's model, Leonardo-derived, for his earliest essays in portraiture; subsequently Andrea's painterly vocabulary and his style of feeling, altered into *Schwärmerei*, suffused Francesco's portraiture (Florence, Uffizi; London, National Gallery, both dated 1514). In the later teens he shed the eclecticisms in his portrait mode and instead put on a joyless objectivity, saying almost harshly what he saw as truth (*Portrait of Caradosso*, Stoneroyd, Lancs., P. Rosenberg Collection, dated 1516; *Fattore of the Medici*, Hampton Court, 1523?). Still more than his religious painting, Franciabigio's portraiture required a renewed experience of Rome to restore – and then only momentarily – a sense of style.

66a. The recognition in the *Liberation of Andromeda* of an allegory of the 'rescue' of Florence by the Medicean restoration of 1512 (L. Berti, *Il primato del disegno*, Florence, 1980, 27–8 and cat. no. 370: so also J. Cox Rearick, *Dynasty and Astrology in Medici Art*, MS., 1980, 21) requires that the dating of the picture, given in previous editions as *c.* 1510, should be advanced slightly, and the datings for the apparently succeeding events in Piero's career also be advanced accordingly.

100. 67. The Montemurlo altar is the latest datable work by Granacci we know. It may be that his later years were largely inactive, or devoted to painting perishable works such as banners; the account Vasari gives (V, 345) of him permits either or both to be true. The *Madonna with St John* I attributed in Freedberg,

op. cit. (1961), I, 495, to Granacci as a work of *c.* 1518–20 has since been properly assigned by F. Zeri, *Boll. d'Arte*, XLVII (1962), 227, to his 'Master of the Kress Landscapes'.

102. 68. Attesting to the wide disposition in contemporary Florence towards a conservative taste is the presence of artists who seem to have enjoyed at least an adequate patronage and whose styles are more persistently old-fashioned than Ridolfo's. Two products of Lorenzo di Credi's too-durable school are among them: Antonio del Ceraiolo (last mentioned 1524), so retardataire that one wonders if his manner may not be purposely archaic; and Tommaso di Stefano Lunetti (b. *c.* 1490). Yielding more to Bartolommeo's mode, Lunetti's works, especially in portraiture, may generically resemble those that issued from Ridolfo Ghirlandaio's studio.

104. 69. The so-called Master of the Manchester Madonna is an artist who stands between a personality of Berruguete's type and level and the minor masters whom Federico Zeri has dubbed the 'Florentine Eccentrics'. For a discussion of his curious œuvre, see F. Zeri, *Paragone*, no. 43 (1953), 15–27, and Freedberg, *op. cit.* (1961), I, 255–8.

70. Morto da Feltre (a near-Venetian whom we shall encounter in his native context), who is credited with the first significant resurrection of antique grotesquerie when he was an assistant of Pinturicchio in the nineties, carried the grotesque mode to Florence in the years 1504–7; Andrea di Cosimo Feltrini, the Florentine master of grotesque decoration, received his first instruction in the mode from Morto. In 1508 Morto, back in Venice and assisting Giorgione in the minor decoration of the Fondaco dei Tedeschi, may conceivably have contributed to the formation of an interest in grotesquerie by Giovanni da Udine (then already twenty-one years old). Cf. N. Dacos, *Paragone*, no. 219 (1968), 10.

105. 71. Cf. Note 29.

106. 72. A considerably damaged fresco altar of the *Adoration of the Child* (Rome, S. Rocco, 1515; so dated by documents; cf. C. Frommel, *Die Farnesina und Peruzzis architektonisches Frühwerk* (Berlin, 1961), 121–2, 172, 179) is an unusual concession, in its apparently softened style (in part the effect of damage?), to Raphaelism.

73. Peruzzi was, according to Vasari (IV, 600), the 'inventor' of the whole 'modern' genre of stage design, based on the deployment of his perspective skills. Cf. R. Krautheimer, *G.B.A.*, XXXIII (1948), 327–46.

111. 74. The problem of the relationship is viewed in diverse ways in the literature, but its solution seems to depend largely on the attribution of 'preparatory'

drawings for certain of Sebastiano's pictures to him or to Michelangelo. Since J. Wilde, *Michelangelo and His Studio* (London, 1953), the major current of opinion tends to take these sheets as Michelangelo's, thus giving him rather than Sebastiano the significant share in the invention of the relevant pictures. A contrary view is held by L. Dussler, *Die Zeichnungen des Michelangelo* (Berlin, 1959), and earlier by Berenson, *Drawings of the Florentine Painters* (1938), I, 238–50 (first edition, 1903). For an examination of these drawings that favours Sebastiano's authorship, see S. Freedberg, *Art Bulletin*, XLV (1963), 253–8. I should like to stress that this essay was meant to be exploratory, presenting the question for renewed debate, and not proposing that its conclusions be taken as definitive.

113. 74a. E. Safarik, *Arte Veneta*, XVII (1963), 65–77, publishes a triptych in the Archiepiscopal Palace at Olomouc (Czechoslovakia) of which the central part is a copy after the *Pietà* now in Leningrad, the left wing a *Christ Appearing to the Apostles* (Luke xxiv: 36–49) and the right a *Christ in Limbo*, identical in composition with the painting of that theme now in the Prado [95]. It would appear from the evidence this old copy offers that the Leningrad *Pietà* at one time served as the central portion of a triptych. There is no clear evidence, however, that this was its original condition when it was painted in 1516; and there are some positive indications that the triptych could have been made up some years later, fulfilling at that time an intention that may have existed from the beginning. This intention would (so to speak) justify the singular, and somewhat exceptional, asymmetry of the design of the *Pietà*, which is complemented and adjusted with fine intelligence by the composition of the laterals the Olomouc triptych shows. The iconography of the triptych (whether one calls the left wing *Christ Appearing to the Apostles* or, as M. Hirst, *Sebastiano del Piombo*, Oxford, 1981, 133 n45, a *Taking of Christ*) is not less justifiable than its whole design.

While he will countenance the idea that Sebastiano may have supplied wings for the 1516 *Pietà* at a later date, Hirst prefers to think that this was never Sebastiano's idea but rather an invention of the Olomouc copyist; Hirst names Ribalta as the likely agent who not only arbitrarily wed the *Limbo* to the *Pietà* (both of them early recorded in the Spanish Royal collections, though never described as being physically together) but also quite made up the left wing, the *Christ Appearing* (or *Taking of Christ*) as a contribution of his own in order to create a triptych. There are good arguments both for and against this notion. For it is the fact that the dimensions of the Prado *Limbo* and the Leningrad

Pietà are not reconcilable in a normal triptych form; the width of the *Limbo*, 114 cm., exceeds by 17.5 cm. the vertical centre axis of the *Pietà* (193 cm. wide), which (even without considering the necessary added dimension of a frame) would make closing of the wings upon the central panel quite impossible. Further, the height of the *Limbo* (220 cm.) exceeds that of the *Pietà* by 34 cm. It should be noted that in the Olomouc triptych the proportions and dimensions of the wings have been adjusted to make them fit exactly to close together on the central *Pietà*. To this objection on the grounds of size it may be argued that the combination hypothetically conceived by Sebastiano may not have been a literal triptych with hinged and exactly proportionate wings, but only a tripartite assembly into close physical conjunction of the *Pietà*, the *Limbo*, and the left lateral. The style of this last (which we shall call the *Christ Appearing to the Disciples*) seems to me to exclude the possibility of its invention by Ribalta or another Spanish artist: its vocabulary reflects no less (and no more) accurately than the other Olomouc panels Sebastiano's style. The reflection is not only of the repertory of the *Pietà* and *Limbo*, which a Spanish painter could have seen, but of the *Resurrection of Lazarus* also, which he most likely could not.

What must in any case be discarded is the notion (which seems consequent on Safarik's discovery of the Olomouc copy, but which even he advances only tentatively; but which M. Lauro, *L'opera completa di Sebastiano del Piombo*, Milan, 1980, 108, has accepted as conclusive) that on the evidence of the Olomouc triptych the *Christ in Limbo* of the Prado, universally dated so far in the literature to 1530 at the earliest, must be redated back to the time of the *Pietà* of 1516, which it accompanies in the triptych. A number of circumstances militates strongly against this, including the handling of surface and the emotional tonality of the *Limbo*. More conclusive is the discovery among the drawings in the *cantina* of the Sagrestia Nuova in S. Lorenzo of a sketch by Michelangelo for the figure of a Christ in Limbo which is almost exactly coincident with Sebastiano's figure, and which (far better than any Michelangelo study that has so far been adduced, e.g. no. 35F recto of the Casa Buonarroti) seems surely to have been the basis for the drawing supplied to Sebastiano by Michelangelo for this theme – the 'aiuto grafico' which we know Sebastiano had requested. The *cantina* drawings are datable (to my mind firmly; see P. dal Poggetto, *I Disegni murali di Michelangiolo e della sua scuola nella Sagrestia Nuova di San Lorenzo*, Florence, 1979, 130; the *Limbo* sketch illustrated as figures 174 and 176; Poggetto's summary of conclusions on dating, p. 256) in 1530.

75. K. Oberhuber, 'Raphael und Michelangelo', in *Stil und Überlieferung in der Kunst des Abendlandes* (Acts of the Twenty-First International Congress for Art History, 1964) (Berlin, 1967), 11, 162, suggests that the *Lazarus* 'competes' with the *Spasimo*, the last 'published' work by Raphael; Oberhuber repeats the observation I made initially in Freedberg, *op. cit.* (1961), 1, 383, of the resemblance between the two compositions. Oberhuber, however, prefers that the invention of the *Lazarus* design be Michelangelo's.

116. 76. In 1516 Sebastiano gave a Roman extension to a subdivision of the portrait genre that also was Venetian in origin, the group portrait, in his *Cardinal Bandinello Sauli and his Suite* (Washington, National Gallery, Kress Collection). It seems to have been relevant to Raphael in his invention of the *Leo X with the Cardinals Giulio de' Medici and Rossi*.

77. Though an independent work by a Roman pupil of Peruzzi's, Virgilio Romano, does survive: a *sgraffito* façade, much faded, on the Vicolo del Campanile in the Borgo. Illustrated in Freedberg, *op. cit.* (1961), 11, figure 477.

117. 78. The picture of activity in the Roman school of these two decades takes on a further dimension when it is realized how, above any other city in contemporary Italy and more than in any previous time, Rome was a destination for artistic visitors, some of them come only to study antiquity and the quickly-famous accomplishments of the contemporary school, others for some share of the rich Roman patronage. In the second decade the list of transients includes the old Leonardo, a pampered guest in the Vatican more or less continuously for three years from 1513, but only little occupied with art and apparently quite eccentric to the Roman scene. Among other Florentines were Fra Bartolommeo in 1514 and probably Franciabigio about 1512; a visit in this decade by Sarto is not certain. The Sienese Sodoma, returned to Rome for the years 1516 to 1518, stayed long enough to make a contribution of importance to the decoration of the Villa Farnesina; his compatriot Beccafumi was at least twice in Rome (before 1512 and *c.* 1519), as was Sodoma's one-time assistant, Vincenzo Tamagni, who stayed to join the shop of Raphael. So did the Ferrarese Garofalo and Battista Dosso. The greater Dosso Dossi may have made a visit at the end of the decade. Of the North Italians Correggio, probably in 1518, was the most important and impressionable visitor.

It might be recalled that Lotto remained in Rome, after his documented presence in the Vatican in 1509, at least until 1511, possibly into early 1512. All these were frankly transients, but it must be remembered that the established painters in the city were foreign too – no more than adoptive Romans. Now, as earlier (and as it was still to be in coming decades), the life of modern culture in the city was, even more than is the frequent case with capitals, made by a population – patrons, audience, and artists – that was imported.

118. 79. See A. Hayum, *Art Bulletin*, XLVIII (1966), 215–17, correcting the earlier dating of *c.* 1512 hitherto generally accepted, as by Freedberg, *op. cit.* (1961), 1, 140.

Sodoma's *Alexander and Roxane* is based upon a well-known drawing of which the lost original, by Raphael, illustrated a description in Lucian of an antique painting.

121. 80. A brother and assistant, Raffaello, died in Florence in 1545.

CHAPTER 2

123. 1. On the Venetian economy in the sixteenth century, see F. Braudel, 'La Vita economica di Venezia nel secolo XVI', in *La Civiltà veneziana nel Rinascimento* (Florence, 1958), 83–102.

124. 2. From the later fifteenth century, the diminution of Venetian sea-trade had driven Venetian capital (and politics) increasingly to development of landward interests. An inclination of art thus coincides with a patronage that was more and more concerned with land ownership – with its pleasures as well as its practical problems.

It ought to be observed that in Venice as in Florence the time of the invention and first formation of the vocabulary of the Cinquecento classical style coincides with a low point in the political and economic fortunes of the city.

3. Vasari, IV, 11, in the *Proemio* to part III. The partisans of Titian, seeking to magnify his deserved glory still more, sought to diminish not only Giorgione's stature but his precedence in the founding of Venetian sixteenth-century style. Dolce, *L'Aretino* (1557), is the first conspicuous representative of this Titian 'claque'.

4. The documents are given most conveniently in G. Richter, *Giorgio da Castelfranco* (Chicago, 1937), 303 ff.

125. 5. The inclusive position is best represented in the modern literature by H. Cook (1900) and L. Justi (1908); the exclusive position by G. Gronau (1908) and L. Venturi (1913). L. Hourticq's *Jeunesse de Titien* (Paris, 1930) introduced a new dimension into the problem of attribution of Giorgionesque pictures.

6. Though it should be noted that the documen-

tation is generic, and does not speak specifically of this figure; it could in theory be by a helper rather than by Giorgione himself.

7. Or less likely, late 1504.

8. And later in Bellini's career by Piero also.

127. 9. Indeed, Giorgione's perspective is significantly arbitrary, and there is no one commanding projection in this work; his attitude towards the authority of perspective is exactly what Leonardo's had been in the *Adoration of the Magi* years before.

10. A companion picture, the *Judgement of Solomon* (Florence, Uffizi), shows Giorgione's hand only in the landscape setting, while the figures are by a more conventional painter, who may perhaps be Giulio Campagnola.

128. 11. E.g., by Vasari in the first edition of the *Lives,* but not in the second. See Vasari, IV, 91, note 1.

12. In *Viatico per cinque secoli della pittura veneziana* (Florence, 1946), 20.

13. The works by Costa that seem relevant are the Ghedini Altar (Bologna, S. Giovanni in Monte), 1497; the *Adoration of the Magi* (Milan, Brera), 1499(?); and the *Madonna in Glory with Saints* (Bologna, S. Giovanni in Monte), 1501. L. Coletti, *Tutta la pittura di Giorgione* (Milan, 1955), 28 ff., attempts to invalidate Longhi's hypothesis, alleging that the Emilian evidences of likeness to Giorgione are too late to have been formative for him, but he does not trouble to search out such examples as we list here.

14. There were works by Perugino himself in Emilia (for example the altar of the *Madonna in Glory* of 1494 now in the Bologna Pinacoteca, originally in S. Giovanni in Monte); hypothetically Giorgione could have seen these. Perugino's visit to Venice of 1494 would seem to have had no effect in that city: the visit was too brief, and he left no works behind.

From Vasari (IV, 92) onward it has been asserted that Leonardo had a role in the formation of Giorgione's style; modern critics have estimated Leonardo's significance in divergent ways. Leonardo's own movements admit a remote possibility of contact with Giorgione in 1500 or in late 1499. The most objective examination of what appear to be Leonardesque elements in Giorgione's art yields a strongly negative result.

130. 15. Though a parallel interest in pastoral setting is present in contemporary literature; an analogy is frequently drawn to Bembo's *Asolani*.

131. 16. An eighteenth-century engraving by Larcher which shows the picture enlarged on both sides by a more extensive landscape has been taken to show the original form, but this is incorrect. See J. Bialo-

stocki, *Burl. Mag.,* XCIX (1957), 388. The physical history of the *Judith,* as it has been determined in the course of some very recent research, is discussed by I. Fornichova, *Burl. Mag.,* CXV (1973), 417–20.

17. It is the *Judith* which more often than any other of Giorgione's works provokes comparison with Leonardo, as with his *Leda* composition, but the resemblances here cannot be objectively explained by pointing to Leonardo as a 'source'. The *Leda* is at earliest only contemporary (1504–6) with the *Judith*.

It may be more nearly explicit that Giorgione is at this point still interested in North European art. The lower drapery of the *Judith* seems to indicate an influence from Dürer: cf. certain of the Dürer woodcuts of about 1503.

132. 18. The subject is best described as the 'Three Magi'. Though the word 'magus' is in effect interchangeable with 'philosopher', the common alternative title, the *Three Philosophers,* implies another interpretation of the subject than the primarily Christian one it has.

The date of the painting is not fixed; it may have been begun as early as 1505, or, more doubtfully, as late as 1507. Michiel asserts collaboration in the execution with Sebastiano del Piombo, but it is not possible to isolate his contribution if it in fact exists.

19. There is a likely return of influence upon Giorgione in this respect from Bellini's S. Zaccaria altar; the oldest Magus certainly refers to the *St Jerome* of Bellini's altarpiece.

133. 20. The scheme balances an approximate near right triangle of light against a farther approximate inverted right triangle of dark. It becomes an important compositional precedent for Titian, who uses it with brilliant variations. Compare the analogous compositional device used by Andrea del Sarto in his frescoes of 1510 and 1511 in SS. Annunziata, with an apparently similar intention.

21. Illustrated in Richter, *op. cit.,* 243.

22. For the precedents in Venice for such façade decoration, see L. Foscari, *Affreschi esterni a Venezia* (Milan, 1936). There are approximate analogies in Central Italy to Giorgione's decorative scheme for the Fondaco, but they are mostly later in date. The first Roman decorations that develop, in a degree comparable to the Fondaco, the conception of the single figure in an illusionist situation within a painted architectural frame are those of Peruzzi, roughly *c.* 1515.

The meaning of Giorgione's figures on the Fondaco was apparently quite early a puzzlement. Vasari (see IV, 96) speaks of them as if they were some kind of mystification.

23. A just conceivable knowledge by Giorgione of early drawings after Michelangelo's very recent *Cascina* might help explain the style of the Fondaco. But I should like to discount the often advanced notion that Fra Bartolommeo's visit of 1508 to Venice accounts for a transmission to Giorgione (and Titian) of Central Italian ideas of classical style. Fra Bartolommeo left no work of which we have any evidence in Venice; but in any case his own style in 1508 was not so advanced in classical manipulation of form as Giorgione's. The art of Venice, on the contrary, influenced Bartolommeo's style in the works he did after his return to Florence. See S. Freedberg, *Painting of the High Renaissance* (Cambridge, Mass., 1961), I, 58–9.

134. 24. J. Anderson, 'Giorgione, Titian and the Sleeping Venus', in *Tiziano e Venezia* (Vicenza, 1980), 337-42, adduces good evidence that the Venus may have been commissioned by Gerolamo Marcello as an epithalamium for his marriage in October 1507.

25. Michiel attests that the picture was completed by Titian. The landscape to the right and the drapery around the Venus are certainly his in invention as well as execution. There may be some intervention from him in the figure, but she is generally and correctly taken to be Giorgione's. The idea and the basic design are Giorgione's, and there seems no justification for the notion advanced by Hourticq, *op. cit.* (1930), 72, that would give the picture wholly to Titian. An *Amor* once at the right side of the composition has been so much abraded that it was painted out. See H. Posse, *J.P.K.*, LII (1931), 29-35. Other antique references may be operative here, to an Ariadne or to the Sleeping Maenad type.

135. 26. Abraded and cut down; the original dimension is preserved in an engraving by Hollar, illustrated by Richter, *op. cit.*, plate LVIII. The Brunswick portrait has often in the past been considered a copy, but X-rays taken in recent years help to assure its autograph character.

27. The following represent all the pictures I consider to be authentic works by Giorgione or copies after lost works by him. They are given in what I regard as their chronological sequence, with suppositions of their dates.

Trial of Moses (Florence, Uffizi), *Judgement of Solomon* (*ibid.*; landscape only, the figures perhaps by G. Campagnola?), 1500-1. Casa Pellizzari frescoes (Castelfranco; in part), 1501-2. *View of Castelfranco*, drawing (Rotterdam, Boymans Museum, Koenigs Collection), *c.* 1502. *Tempesta* (Venice, Accademia), 1503-4. *Finding of Paris* (pastiche by D. Teniers, Florence, Loeser Collection; fragment of a copy,

Budapest, Museum), 1504-5. *The Assault* (copy or pastiche by Teniers, formerly Florence, Gronau Collection), 1504-5. *Judith* (Leningrad, Hermitage), 1504-5. *Castelfranco Altar* (Castelfranco, S. Liberale), *c.* 1505. *Three Magi* (Vienna, Kunsthistorisches Museum), *c.* 1506. *Youth Holding an Arrow* (Vienna, Kunsthistorisches Museum; copy?), 1505-6. *Sleeping Venus* (Dresden, Gallery), 1507-8. *David and Goliath* (Vienna, Kunsthistorisches Museum; copy?), *c.* 1508. *Fondaco Frescoes*, documented 1508. Portraits: *Young Man* (Berlin-Dahlem), 1504-5. *Self-Portrait* (lost, copies by Palma, Budapest, Museum, and Teniers), 1505-6. *Portrait of an Old Lady, 'Col Tempo'* (Venice, Accademia), 1505-6. *Laura* (Vienna, Kunsthistorisches Museum), 1506. *Terris Portrait* (San Diego, Museum), 1506(?). *Warrior and Page* (Vienna, Kunsthistorisches Museum), *c.* 1507. *Self-Portrait as David* (Brunswick, Gallery), 1508-10.

Dr John Shearman informs me that X-ray photographs of the Hampton Court *Shepherd with a Pipe*, most often taken, on account of its wanting quality, to be a copy after Giorgione, is not a copy but an original picture – not, however, by Giorgione.

28. Born, probably, *c.* 1488 in the Alpine town of Cadore; but his birth date was long taken to be *c.* 1477, coetaneous with Giorgione. There is an extensive literature about Titian's birth date. See, e.g., H. Cook in *Nineteenth Century*, LV (1901), 123 ff.; G. Gronau, *Rep. K.W.*, XXIV (1901), 457-62; Cook, *Rep. K.W.*, XXV (1902), 98-100; Hourticq, *op. cit.* (1919), 64 ff., etc. Among the sixteenth-century sources the evidence in Vasari indicates the date of birth of Titian towards 1490, and so does Dolce, in *L'Aretino* of 1557.

137. 29. For the literature on the very extensive controversy about this picture, more frequently ascribed to Giorgione, and for an alternative proposal for its authorship, see E. Tietze-Conrat, *Art Bulletin*, XXXI (1949), 11 ff.

30. I discern the influence of Giorgione's *Three Magi* (for which, by my reckoning, a median date is 1506) in structure, and perhaps in some respects of vision and technique.

31. Though the small *Holy Family* from the Kress Collection (now Raleigh, North Carolina) might serve this purpose.

32. In a capacity said sometimes to be that of an assistant of Giorgione, but it is more likely that Titian worked here in a substantially independent role. Titian's frescoes also have been mostly lost. In 1967 fragments of a frieze of putti, over life-size, from the side façade of the Fondaco were uncovered and detached; they are taken to be Titian's (see F. Val-

canover, *Arte Veneta*, XXI (1967), 266–8). Seventeenth-century engravings by Jacopo Piccini and eighteenth-century engravings by Zanetti record the appearance of other parts of Titian's decoration.

138. 33. A second *Lucrezia* (last recorded in the art market in Munich) of 1508–9, contemporary with the Fondaco frescoes, makes an informative approximation of their character of style.

34. E. Tietze-Conrat, *G.B.A.*, XXVII (1945), 189 ff., attempts a different identification of the subject, and a connexion with a document of doubtful authenticity referring to Giorgione as of the year 1508. The documentary connexion at least is almost certainly invalid. Datings for the picture vary in the literature from *c.* 1508 to 1510, and the attribution is one that in the past has vacillated between Giorgione, Titian, and Sebastiano; the name of Domenico Mancini has also been suggested.

139. 35. The canvas has been cut down at the right so that its original balance of design has been falsified. A copy of the picture in its original extent exists in Bergamo, and a fragment of the amputated portion of the original, once in the collection of Arthur Sachs, is now on loan to the National Gallery, London.

36. Cf. Note 45.

37. The contrast of ideal typologies in the *Portacroce* seems Leonardesque, though only unsure connexions can be made with precise examples by Leonardo. A connexion in theme with Dürer and with Bosch has also been suggested. See Richter, *op. cit.*, 95.

37a. J. Anderson, *Arte Veneta*, XXXI (1977), 186–8, publishes a document from the archives of the Scuola di S. Rocco which gives evidence of the time of painting of the *Portacroce*, though none of its authorship: the commission must have been given after 25 March 1508 and the picture delivered before the end of 1509.

38. There is still wide difference of opinion on the authorship of this picture. It is given more generally to Giorgione than to Titian, and some critics propose Titian's collaboration after Giorgione's death. The latter is the opinion of R. Pallucchini, *Tiziano* (Bologna, 1953), I, 63 ff. Sebastiano has also been suggested as the painter, and at one time even the names of Giulio Campagnola and Palma were proposed. The picture has recently been relabelled in the Louvre as 'Titian'. It has suffered considerably, but not, in my opinion, in such a way as significantly to obscure its authorship.

For an examination of the problem of the iconography of the *Pastorale* see P. Egan, *Art Bulletin*, XLI (1959), 303–13.

39. On this evidence, which is the only evidence of authorship to which we have access in this case, we

must take the invention also as Titian's, and are not entitled to speculate that it may have been Giorgione's.

141. 40. The problematic relation between attributions to the young Titian and to Giorgione requires that I complement the list of pictures I assign to Giorgione with a list of pictures I believe are by Titian up to *c.* 1510. The list is necessarily controversial.

Allendale Nativity (Washington, National Gallery), *c.* 1506(?). Three furniture paintings: *Leda; Man, Woman, and Child in a Landscape* (both Padua, Museo Civico); *Lutanist and Old Man with an Hourglass* (Washington, D.C., Phillips Collection), *c.* 1506(?); *Pastorale ('The Ashburton Idyll')* (private collection, on loan to the Fogg Museum, Harvard University), *c.* 1506–7. The *Birth of Adonis*, the *Wood of Polydorus* (Padua), the *Holy Family* (Raleigh, North Carolina, from the Kress Collection), *Orpheus and Eurydice* (Bergamo), the *Circumcision* (Yale University Gallery), all 1507–8; but it is conceivable that the two Padua panels may be from somewhat later. *Fondaco frescoes*, 1508–9. *Lucrezia* (Munich), *Judgement of Paris* (copies only, e.g. Dresden and Chiavari, Lanfranchi Collection), *Madonna* (Bergamo), all 1508–9. *Portacroce* (Venice, S. Rocco), 1509. *St George* (Venice, Cini Collection), *Lucrezia* (Hampton Court), the *Flight into Egypt* (Leningrad, Hermitage), *c.* 1509; the last from the house of Andrea Loredan at S. Marcuola (Vasari, VII, 429) which was finished within 1509. (The painting later passed with the house to the Grimani.) *Holy Family* (Earl of Bath), *c.* 1509 (a version in Florence, Contini Collection, which I have not seen, seems from the photographs to be by another hand). *Adulteress* (Glasgow), 1509–10. *Madonna* (New York, Metropolitan Museum, Bache Collection; with reserve), 1509–10. *Madonna with Donor* (Munich), *c.* 1510. *Pastorale* (Paris, Louvre), late 1510–11. Portraits: *Lady*, much damaged (Norton Simon Foundation, formerly Duveen), *c.* 1509. *Man* (Washington, National Gallery, Kress Collection, formerly Goldmann Collection), *c.* 1509–10. *'Ariosto'* (London, National Gallery), *'La Schiavona'* (London, National Gallery), both *c.* 1510–11. *Knight of Malta* (Florence, Uffizi), *c.* 1511.

Adoration of the Kings (London, National Gallery), the *Benson Holy Family* (Washington, National Gallery), and two works which depend in attribution on the Benson picture, *Moses and the Burning Bush* (London, Courtauld Institute, Lord Lee Collection) and *Paris Exposed* (Princeton Museum, Mather Collection), all *c.* 1506–7, seem to be by the early Sebastiano, not by Titian or by Giorgione.

41. Vasari, V, 585, states that Sebastiano died in 1547 at the age of sixty-two. Sebastiano's actual date

of death was 21 June 1547; see R. Pallucchini, *Sebastiano Viniziano* (Milan, 1944), 136, note 178.

42. Cf. the *Madonna with Saints and Donor*, dated 1505 (Cornbury Park, Watney Collection). There is also an apparent study of North European models (Flemish rather than German), but this may be illusory. The source of the Flemicizing look may be Antonello.

43. It has been observed (as by Pallucchini, *op. cit.* (1953), I, 18) that the compositional motif may derive from Carpaccio.

44. R. Pallucchini, *op. cit.* (1944), 153, accepts the Accademia picture for Sebastiano without question and dates it *c.* 1506; L. Dussler, *Sebastiano* (Basel, 1942), is reserved about the attribution and would place it *c.* 1505. B. Berenson, *Arte Veneta*, VIII (1954), 146 ff., first perceived the identity of hand in the three pictures, but assigned the group unconvincingly to Cariani. The portrait called of Francesco Maria della Rovere (Vienna), assigned to Sebastiano by Pallucchini, *op. cit.*, 153, appears to be a work of the same moment as the Accademia picture. The *Portrait of a Woman* (Budapest, Rath Museum) given by Pallucchini (*ibid.*) and Dussler, *op. cit.*, 129, to Sebastiano seems rather, as Berenson proposed (*Lists*, 1936), to be by Licinio.

I should now prefer to assign to Sebastiano *c.* 1508 the *Warrior and Page* (Vienna, Kunsthistorisches Museum) which I formerly attributed to Giorgione, and confirm the attribution I made to Sebastiano (in Freedberg (1961), I, 337) of the double portrait of Verdelotti and Ubretto (formerly Berlin, Museums).

142. 45. Though it is susceptible neither to proof nor to disproof we must consider seriously the possibility the documentary material allows of a role for Giorgione – which, however, we cannot define clearly – in the invention, as well as the inspiration, of Sebastiano's picture. In August 1507 and January 1508 Giorgione received two payments for a 'teller' – a large canvas – intended for the Sala dell'Udienza in the Palazzo Ducale. In May 1508 a payment was made to one Zorzi Spavento, the *protho* in charge of this commission, '. . . per la tenda di la tella facta per camera de li autientia nuove', from which it on occasion has been deduced (extrapolating far more than the document says) that the picture was certainly finished and in place by this date. Were this the case, the Kingston Lacy picture, which is evidently not quite finished, could not be the work commissioned to Giorgione to which these documents refer. (For the documents see Richter, *op. cit.*, 303.) I do not consider that the phrase in the document, 'la tella facta', in which the order for the *tenda* is decreed, must be taken

literally, any more than it would be in an Italian business transaction of our present day: the order for the *tenda* could have been, literally, only in anticipation of the *facta*.

No further document exists for this transaction, and no subsequent account of the Palazzo Ducale mentions a painting by Giorgione in the Sala dell'Udienza; it would seem in fact not to have been delivered. (Had it been it would have been destroyed in the fire of 1574.) In size and subject the *Judgement of Solomon* accords with a destination such as the documents described; and it is unfinished. It is therefore conceivable that it is the picture contracted to Giorgione, and that he handed over its painting to Sebastiano. Its general idea at least would be Giorgione's, and perhaps part of its exact invention. The proposition is attractive, for it accounts for an event that otherwise might seem to take place almost *ex vacuo*. Even if the general invention were Giorgione's, its precise articulation must have been Sebastiano's. This is indicated by the quality of attitudes, more athletic than in Giorgione at this date (more, indeed, like the young Titian's), and also by the evidence of a surviving probable preparatory drawing by Sebastiano (London, British Museum, Sloane 5236; the attribution of the drawing was made by Mrs Barbara Knowles Debs in a paper delivered to the College Art Association, 1964). It is possible that the painting has been cut down at the (proper) right.

M. Hirst, *Sebastiano del Piombo* (Oxford, 1981), 13 ff., takes a different view of the genesis of the *Judgement*, insisting that it was quite unrelated to the commission for the Sala d'Udienza, and suggesting that it may instead have been intended from the beginning for the Casa Loredan. Hirst, p. 14, note 59 has somewhat overstated my view of Giorgione's possible role in the invention of the *Judgement*.

143. 46. The architecture is more purely 'antique' in vocabulary, too, than any in earlier Venetian paintings. Among the figures there is an antique reference, in the executioner on the right, which may be to the *Fighting Warrior* (Rome, Borghese), presumably via a cast, or to one of the figures of the Niobid group.

47. Commissioned (see Pallucchini, *op. cit.*, 1944, 7) by a canon who was in office from October 1507 and who died in 1509. The execution of the interior must be earlier than that of the exterior, which I should place in 1509.

48. According to recent documentary evidence. See R. Gallo, *Arte Veneta*, VII (1953), 152.

144. 49. Suida, *G.B.A.*, XIV (1935), 74-95, has observed that the framework of the composition of the Crisostomo altar reappears in Bellini's *St Jerome* altar,

in the same church, and suggests the influence of Sebastiano's design later, on the Pesaro altar of Titian.

Sebastiano's Roman function as a portraitist also depends on experience founded in his Venetian period. Note the attribution to Sebastiano of the double portrait formerly in Berlin made by Freedberg, op. cit., I, 337. Portrait-like Venetian pictures by Sebastiano are his dated *Salome* of 1510 (London, National Gallery) and the *Wise Virgin* (Washington, National Gallery, Kress Collection), close to it in time. In both these there may be influence from the kind of colourism Titian had displayed in his *Adulteress*.

50. Sometimes dated earlier in the older literature. More recently considered, in view of the saints who accompany Mark, to be an offering connected with the plague of 1510, which killed Giorgione.

51. There are two further identifiable references in the painting to precedents by Sebastiano: the St Mark derives partly from the Solomon of Sebastiano's *Judgement*; the asymmetric colonnade derives from the Crisostomo altar.

145. 52. The origin of the compositional idea is in Bellini, in his dated *Madonna* of 1509 in Detroit, affirming Titian's continuing sense of relation to the older tradition despite his profound alteration of it.

146. 53. It is repeatedly observed that the landscape on the right in the *Noli me Tangere* is a variant on that Titian used to complete Giorgione's *Sleeping Venus*.

54. This is also often still attributed to Giorgione. The picture could conceivably be dated earlier. A date within 1511 would seem to be required by the fact that its influence (see explicitly the right sleeve of the Madonna) is evident in the Lendinara altar by Mancini, which carries the date 1511.

55. The character of the drapery style may help to date the much disputed earlier Pesaro altar in Antwerp, for which the datings range from 1501 to c. 1515. I should hazard that the picture may have been begun c. 1511–12, but finished slightly later, towards 1515.

147. 56. Recent evidence, presented in H. Wethey, *The Paintings of Titian*, III (London, 1975), 175–9, has established that it is most likely that this picture was occasioned by the marriage in May 1514 of Nicolo Aurelio (then secretary of the Council of X) to the orphaned daughter of Bertuccio Bagarotti. The subject of the painting – the title it bears now goes back only to the later eighteenth century – should therefore be most reasonably interpreted in the sense of an epithalamium, as by C. Hope, *Titian* (London, Toronto, and New York, 1980), 36–7.

148. 57. The iconography has been subject to much and often complicated speculation, which is expertly summarized in Wethey, *loc. cit.*

149. 58. The *Laura Dianti* and the *Flora* may in fact be allegorized portraits. Given the iconographic association of the *Flora* especially with the courtesan, she may be the first sixteenth-century example in the long series of Venetian celebrations in paint of the city's famous prostitutes – a genre in which Paris Bordone was to become a kind of specialist.

This type of half-length female with allegorical attributes or narrative accessories has as antecedents Titian's own *Salome* (Rome, Doria, c. 1512–13), and before that Sebastiano's *Wise Virgin* (Washington, National Gallery) and *Salome* (London, National Gallery, 1510). The latter seems to have originated as a translation into the feminine gender of Giorgione's Brunswick self-portrait.

59. A probable precedent for this group portrait is the painting I attribute to Sebastiano del Piombo, the double portrait of Verdelotto and Ubretto (formerly Berlin, Museum); cf. Note 49. Titian's seems to be the earliest portrait in Italian painting with three figures within a single ambience.

60. The so-called *Violante* (Vienna, Kunsthistorisches Museum) is a portrait that recalls, by virtue of its subject matter, the allegorical female half-lengths. Its somewhat exceptional technique is that of the pictures we would put in the neighbourhood of 1514; the subject is the model for the St Catherine of the Balbi *Sacra Conversazione*.

61. F. Valcanover, *Tutta la pittura di Tiziano* (1960), I, 57, reports that the painting bears the date 1516, but this statement has since been described by Professor Valcanover as an editorial error. It is instead the frame that is dated.

The altarpiece is 6·9 m. (22 ft 6 in.) high.

151. 62. A non-Venetian example may have inspired Titian partly: Mantegna's *Assunta* in the Eremitani Chapel.

63. Compare the 'window-theory' of the location of Raphael's *Sistine Madonna*, then in Piacenza. We may only speculate that there may have been a connexion between Titian's *Assunta* and that picture.

64. Hourticq, *op. cit.* (1919), 180, accurately records that the perspective system is arbitrarily adjusted for each of the three registers in the picture; but this is normal practice even in the fifteenth century for paintings of this scale.

153. 65. The Pordenone frescoes are dated 1520. The chapel was endowed in 1519, and the frame of Titian's painting is dated 1523. The *Annunciation* is dated earlier by G. Gronau, *Titian* (London and New York, 1904), to 1516–18, but the consensus of opinion places it between 1520 and 1522; see Pallucchini, *op. cit.* (1953), I, 128. The view has also been proposed

(by Öttinger, *Münchner Jahrbuch*, VII, 1930, 319–37) that this is a composition by Titian adapted for its present place by Paris Bordone. My own view is that the picture is of late 1519 or 1520 and wholly by Titian.

66. The asymmetric disposition of the architecture recalls Titian's earlier *St Mark* altar, and Sebastiano's Crisostomo altar before it. More immediately, however, the idea of design develops from the first in the series of the Este Bacchanals, the *Worship of Venus* of 1518.

67. For an early instance of Titian's response to prints or drawings after Raphael (and Michelangelo?), see the discussion in F. Mauroner, *Le Incizioni di Tiziano* (Padua, 1943), 31 ff., of the *Triumph of Faith* woodcuts (of which the first edition is probably of 1511).

154. 68. The radical nature of this picture is somewhat obscured by its traditional format, almost certainly required by the terms of the commission. Titian's classical unification of mobile design through the limits imposed by the archaic compartmented frame is noteworthy.

69. V. Luzio, *La Galleria dei Gonzaga . . .* (Milan, 1913), 218, quoting·a letter addressed from Ferrara to Isabella d'Este.

156. 70. See R. Forster, *J. P. K.*, XLIII (1922), 134–5, and J. Walker, *Bellini and Titian at Ferrara* (London and New York, 1956), 40 ff. Titian's relationship with Alfonso of Ferrara had begun earlier, when he had completed (and altered) Bellini's *Feast of the Gods*, the first picture for Alfonso's *camerino*, probably in 1516. The *Tribute Money* (Dresden) was also almost certainly painted for Alfonso.

We know from letters that the *Worship of Venus* must have been begun after April 1518, and that it was delivered in October 1519. The information is summarized by Pallucchini, *op. cit.* (1953), I, 117 ff.

71. The resemblances of motif are too close to permit that they result mostly from separate inventions inspired by the assigned text in Philostratus, as E. Wind, *Bellini's Feast of the Gods* (Cambridge, Mass., 1948), 59, seems to require.

72. The compositional device anticipates the Pesaro Altar of the Frari. There is a near-contemporary Roman analogy of design, in Raphael's *St Paul preaching at Athens* among the Sistine tapestries.

73. The programme is discussed, with references to other literature, by Walker, *op. cit.*, 31 ff.

74. Letters between Alfonso d'Este and his agent in Venice, Tebaldi, indicate that the *Bacchus and Ariadne*, though apparently ordered from Titian within 1520, was not put into work in earnest until

after March of 1522 (to Alfonso's considerable exasperation); it was delivered to Ferrara in January 1523 and finished there in place. In regard to the *People of Andros* the usual assumption had been that it had intervened in time of execution between the *Worship* and the *Bacchus*, about 1520 (and this was the view taken in previous editions of this book). This view is one for which excellent stylistic grounds may be adduced, and if these were the only evidence the *Andrians* should remain in that chronological place. However, C. Gould, *Titian, Bacchus, and Ariadne* (London, n.d. [1969]), followed and further confirmed by C. Hope, *Burl. Mag.*, CXIII (1971), 641–50, 712–21, and CXV (1973), 809–10, has subjected the documentary evidence to new critical scrutiny, and correctly deduced that the *Andrians* cannot be referred to in any of the considerable surviving correspondence about the *camerino* pictures, and that the evidence excludes the possibility that the picture was executed in an interval between the delivery of the *Worship* and the beginning of the *Bacchus*. Neither is there any mention of the *Andrians* in the documentary material on Titian's relations with Alfonso d'Este following the completion of the *Bacchus*, but there is information about unspecified works that Titian undertook for Alfonso in the period 1523–5, and it is in this span that it would seem the painting of the *Andrians* should be placed. I have accepted this conclusion, though still with some misgiving.

75. See O. Brendel, *Art Bulletin*, XXXVII (1955), 113 ff. Of particular interest among the quotations in the *Andrians* is that of the *Borghese Warrior*, possibly already quoted by Sebastiano in the *Judgement of Solomon* a decade before.

158. 76. As always since the *Pastorale*, Titian differs in his system of geometric order from the Central Italian habit, creating enlivening effects of asymmetry, and exploiting intersecting, balancing diagonals, which move not only on the surface order but in space.

77. Though the contemporary Sebastiano, extending his Venetian origins, does something like this in his *Pietà* (Leningrad) of 1516.

160. 78. The signature, sometimes contested, is certainly genuine. A dating earlier than mine has been proposed (e.g. by G. Gombosi, *Palma Vecchio*, Stuttgart and Berlin, 1937, plate 1), but is unacceptable on grounds of comparison with Carpaccio's chronology. The Carpaccesque motif (but not the manner) appears also in the Oxford Ashmolean *Madonna* I give to Sebastiano, and date *c.* 1506–7.

The extreme paucity of dates and documents for Palma's paintings makes the establishment of a

chronology for him difficult, and the published conceptions of the order of his works betray exceptional critical confusion. My proposals for datings are to be taken with appropriate reserve.

79. Though much rigidity and some archaism in technique persist in Palma's large *Adam and Eve* (Brunswick, Gallery, probably before 1512), it is imitative of the monumental figure style of the Fondaco (more than of the Dürer print on which its composition has been based). The date of the *Adam and Eve* is generally based on a disputed passage in Michiel, which is not good evidence.

80. It is not certain that a group of pictures on bucolic themes, including the *Nymph and Shepherd* (London, National Gallery), the *Piper and the Shepherdess* (formerly Munich, von Nemes Collection), and the *Concert* (formerly in Lord Lansdowne's collection, now Ardencraig, Lady Crichton-Stuart), should be excluded from Palma's œuvre. J. Wilde, *J.K.S.W.*, N.F. VII (1933), 97–135, detached these, assigning them to a 'Master of the Idylls', and suggesting that this painter might be Domenico Mancini. Until further evidence is available the group should still be regarded as related more closely to Palma than to another painter. Their differences in style from the Frankfurt *Diana and Callisto* may be the result of shop work, or even more likely of different scale. They would be of roughly contemporary date.

The Munich *Faunetto* and the *Concert* in the Wilstach Collection in the Philadelphia Museum are, however, certainly to be detached from Palma.

161. 81. Palma's large production of these paintings is an index of the state of patronage in Venice, for these *Sacre Conversazioni* are in shape and tenor, and most often in size, evidently household pieces. It is likely that they were not always thought of chiefly in the role of objects of devotion, but as art objects, and they may have been a counterpart, in religious subject matter, of the Giorgionesque idyllic themes that were meant for the private delectation of the patron.

82. Sometimes assigned to Palma's school, and probably in part a shop piece.

162. 83. In a similar mode is the *Madonna with St Catherine and St John the Baptist* (Dresden, Gallery).

The best evidence seems to indicate that Palma was the inventor of the large *telero*, the *Miracle of St Mark* (now in the Accademia), which many earlier sources assigned instead to Giorgione. External evidence, as well as the internal style of the picture, suggests that it was painted by Palma some time after 1518, and that its manner reflects the same aspiration to a Central Italian-like pathos of form and content as are present in the Thyssen *Sacra Conversazione*. The

restored or added pieces of the large canvas are usually accurately attributed to Paris Bordone.

163. 84. If so, Paris Bordone's numerous portraits of these ladies have an antecedent in Palma and in Titian (and possibly in Giorgione's *Laura*) as well as in the famous Carpaccio. Cf. Note 58 above.

164. 85. This may be the same girl who earlier posed for the '*Violante*', also in Vienna, which is in my view Titian's, but has also been attributed to Palma (cf. Note 60).

This genre as Palma practises it suggests comparison with the *Fornarina* pictures by Raphael and his school.

86. The source literature offers a confusion of names for this painter. His history is clarified by C. Huelsen, in *Mitt. K.H.I.F.*, II (1912–17), 81–9. Morto's birth date is uncertain, but may be *c*. 1470. He died at the end of 1526 or in the first days of 1527, at Venice.

165. 87. Generally attributed to Torbido, and occasionally to Savoldo; it was restored to Morto by C. Gilbert, *Arte Veneta*, III (1949), 105–6.

88. For whose identity we lack completely any data beyond those provided by his few signed pieces and the date on the picture at Lendinara.

89. Note the relation of the painting of the right arm of the Madonna to that in Titian's Prado *Holy Family with St Francis and St Roch*. Cf. Note 54.

166. 90. This work is often still attributed to Sebastiano. Berenson's attribution to Mancini (*Venetian School*, 1957, 157) of the *Sacra Conversazione* formerly in the Duke of Cumberland's collection seems certain. This picture has also appeared elsewhere in the literature (e.g. Pallucchini, *op. cit.*, 1944, 156) as a work by Sebastiano.

91. Berenson, *Venetian School* (1957), 52, regards the Grafton version as the primary one. Most of the replicas bear the same signature and date as the 'original'. Wilde, *op. cit.*, 125, associates this picture with the group (to my view internally inconsistent) he assembles for his 'Master of the Self-Portraits', but of which certain key items seem certainly by Mancini (e.g. the *Lutanist* in Vienna).

The number of repetitions of the Grafton portrait tends to discount that it is a portrait of the painter himself. This would more likely be some personage of greater note.

92. Berenson, *ibid*. One of the 'signed' pictures appears, however, to be not more than a copy, including the signature, of the original now in Budapest.

93. Berenson's group is not related to that assembled by Wilde, *op. cit.*, under the rubric of the 'Master of the Idylls', whom he suggests may be Mancini. One of Wilde's attributions to a second *anonimo*, his

'Master of the Self-Portraits', Berenson takes into his corpus of Mancini, in my estimation correctly.

94. Born in Venice, but died in Treviso. He became the son-in-law of Pier Maria Pennacchi.

95. Into this category I should put, e.g., such *botteghe* as those of Francesco di Simone and Francesco Rizzo da Santacroce. Much of the production of this art trade appears to have been for provincial export.

170. 96. And also in the remarkable *Pietà* (Venice, Accademia, from the Donà dalle Rose Collection), which I should assign to this latest time.

171. 97. See F. Gibbons, *The Late Giovanni Bellini and his Workshop* (diss., Harvard University, 1961); and *Art Bulletin*, XLIV (1962), 127–31.

98. See the inscription on the dated *Christ on the Mount of Olives* (Milan, Brera): 'Andrea dipintor *in* Bergamo'.

172. 99. In the inscription on the rear of Giorgione's *Laura* (Vienna). A curious confirmation of the association may be in the underpainting of Giorgione's Brunswick self-portrait, which shows a part of a Madonna picture in a Bellinesque mode that might have been Catena's.

173. 100. The former picture in the art market, New York, from the Heseltine Collection; the latter picture formerly in the Brownlow Collection. The antecedent of the *Adoration* is in the *Allendale Nativity*, by our account Titian's rather than Giorgione's.

101. Catena died in 1531. In 1528 he had been a witness to the marriage in Venice of Sebastiano's sister, when Sebastiano was also present. This 'Roman' contact explains nothing in Catena's art, but it brings to mind the excessive instances of possible Central Italian influence, or actual Roman experience, that Robertson speculates on in his Catena monograph. One authentic instance of Romanism is in the *Holy Family with St Anne* (Dresden, Gallery) adapted from a model of Raphael's school (explicitly from a Raphaelesque drawing preserved to us in two versions, usually attributed to Giulio Romano, at Chatsworth and at one time at Wilton House). Unlike G. Robertson, *Catena* (Edinburgh, 1954), 29 ff., who dates this painting *c.* 1518–20, I believe it must be towards 1525.

CHAPTER 3

176. 1. The invention of the term is due to Walter Friedlaender, *Rep. K.W.*, [XLVI] (1925), 49–86; in English translation 'The Anti-Classical Style', in

Mannerism and Anti-Mannerism in Italian Painting (New York, 1957).

2. For summaries of the history of the use of the term 'maniera', in both its absolute and historical senses, see M. Treves, 'Maniera, the History of a Word', *Marsyas*, I (1941), 69–88; G. Wiese, 'Storia del termine "Manierismo" ', in *Manierismo, Barocco, Rococò* (Rome, 1960), 27–38; also 'La doppia origine del concetto di Manierismo', in *Studi Vasariani* (Florence, 1952), 181–5; C. Smyth, 'Mannerism and Maniera', in *The Renaissance and Mannerism* (Princeton, 1963), II, 199; J. Shearman, 'Maniera as an Aesthetic Ideal', in *The Renaissance and Mannerism* (1963), II, 200–21, and *Mannerism* (Harmondsworth and Baltimore, 1967).

3. The application of the term 'Mannerism' to the art that precedes the Maniera proper has most recently been contested, in particular in so far as it is required to include the experimental first decade in Florence. This view was first enunciated by L. Becherucci, 'Momenti dell'arte fiorentina nel Cinquecento', *Il Cinquecento* (Florence, 1955), 161–83, and repeated independently by Shearman, *opera cit.*, and with less emphasis by Smyth, *op. cit.* I suggest that this view is based upon incomplete reading of the character of the Florentine experiments, which has been excessively conditioned by the element in it of an (admitted) anti-classicism. I have made some summary remarks on this point in 'Observations on the Painting of the Maniera', *Art Bulletin*, XLVII (1965), 187–97.

It may be useful to indicate here the ways in which I shall use the terms 'Mannerism' and 'Maniera'. Within the term 'Mannerism' I include not only the phenomena of the Maniera proper (or 'high Maniera') of the mid century, but those in the decades that precede and follow which are visibly more related to it than to the classical style of the High Renaissance or to the nascent Baroque. It seems proper also to include within the generic term what I regard as an intrinsic and undisassociable step in the formation of the style it denotes: i.e. the phenomena of the style's first experimental phase, including even the so-called anti-classical aspects of this phase in Florence. The end of the experimental phase is marked by the achievement (even in the most radical of the experimenters) of *maniera*: a hallmark of the first maturing of the new style is the concession of a major role to the quality of *grazia*, and a stress upon the function of the work of art as ornament. The first generation of Mannerism, its inventors, thus could achieve *maniera*, but this requires to be distinguished not only chronologically but in degree and in some respects of

kind from the 'high Maniera' or Maniera proper. I shall refer to the *maniera* achieved by the artists of the first Mannerist generation as 'first' or 'early' Maniera. In some cases, the distinction of this first Maniera from the high Maniera is not much more than one of the refinement or elaboration the high Maniera may make on the preceding style. In these cases, the artist of the earlier generation may justifiably be called a Maniera painter. In other instances, while the qualities of grace and ornamental value that the painter of the earlier generation has achieved may be major and essential factors in his style, they may be far from his prime concern: he may at the same time have ambitions to intense emotional communication or meaningful decorative statement, or he may even charge his search for *grazia* with exceptional emotional intensity. Artists like these, who employ basic principles of the Maniera, but who do not share the high Maniera's restrictive conception of the function of a work of art, may more properly be defined Mannerist rather than 'Maniera' painters.

178. 4. The *Leda* for Duke Alfonso of Ferrara; the *Venus and Cupid* for Bartolommeo Bettini, *c.* 1532–3; the *Noli me Tangere* for the Marchese del Vasto, 1531. See K. Tolnay, *Michelangelo* (Princeton, 1948), III, 190, 194, 197.

181. 5. Another sculptor, Michelangelo's emulator Bandinelli, is involved to an important degree with the process of the formation of the Mannerist vocabulary in Florence especially, but also in Rome.

6. The predella for the altar reconstructed by S. Freedberg and J. Cox, *Burl. Mag.*, CIII (1961), 7–8. Cox's more recent investigations indicate that, while the essentials of design are Pontormo's, the execution is later and by another hand. See J. Cox Rearick, *Pontormo* (Cambridge, Mass., 1964), I, 137–45.

182. 7. A second effort by Pontormo to continue the Poggio decoration, in Clement VII's time, failed wholly; by then only Pontormo survived of the three painters who had begun the scheme. The work was not completed until 1578–82, by Pontormo's grand-pupil Alessandro Allori.

8. For a discussion of the complicated and difficult evolution of the design, see Freedberg, *High Renaissance* (Cambridge, Mass., 1961), I, 559; for a detailed study of the many preparatory studies, see Rearick, *op. cit.*, I, 172.

9. The inventor of the programme was, according to Vasari (V, 195), Paolo Giovio. An iconographical scheme of extraordinary complication underlies the overt subjects of the paintings in the Salone, referring to the politics, history, and astrology of the Medici. A precise and exhaustive exposition is given in the work of J. Cox Rearick, *Dynasty and Astrology in Medici Art: Pontormo, Leo X and the Two Cosimos* (MS.). See also for the iconography M. Winner, 'Pontormos Fresken in Poggio a Caiano: Hinweise zu seiner Deutung', *Z.K.*, XXXV (1972), 153–97.

184. 10. Gravely damaged by weathering, the frescoes have been detached and their remnants made secure. They are now housed in the museum of the Certosa.

11. Just behind Jacopo's self-portrait in this role is another portrait that seems to represent Michelangelo; cf. the head on the extreme left in Pontormo's roughly contemporary small picture of the *Adoration of the Magi* (Florence, Pitti). These identifications, and certain observations of style, are made from the reduced copies by Empoli preserved in the museum at S. Salvi; they are no longer legible in the ruined originals.

185. 12. This device had earlier been used by Domenico Ghirlandaio in the Sassetti Chapel, but there with the intention to create the illusion of physical connexion into an objective space.

13. The *occhio divino* above Christ's head in this picture is a later insertion.

187. 14. For Bronzino's role in the painting of these tondi, see Rearick, *op. cit.*, 257.

15. In this Pontormo anticipates the theories of later Mannerist writers (e.g. B. Varchi, *Libro della beltà e grazia*, written 1543, published 1590), who would see in *grazia* a source of beauty of actual persons, not only of their representation in art. See also V. Danti's ideas on *grazia*, *Il primo libro del trattato delle perfette proporzioni* (Florence, 1567), 20.

189. 16. The figure of Galatea herself may be by Pontormo's hand. The designs for the figures were Pontormo's, as a study (Uffizi) for at least the kneeling Pygmalion attests. The panel was originally a cover for a portrait, now lost, of Francesco Guardi.

17. The *Martyrdom* is exactly an illustration of a reversion by Pontormo to an earlier phase, for it re-uses for the middle distance and farthest groups of the painting a design Pontormo invented *c.* 1523. See Rearick, *op. cit.*, 277–8. A second, smaller version of the same theme, in the Uffizi, is Bronzino's.

18. For the relation of these cartoons by Michelangelo to the forming of Maniera style, see p. 178.

191. 19. In its format and general proportion the figure of the Lucca picture is indebted to Sebastiano del Piombo's *Albizzi*, which was finished at the end of April 1525, and is supposed soon afterwards to have arrived in Florence. See Sebastiano's letter to Michelangelo, 30 April 1525, and Vasari, V, 575.

20. The later date proposed by H. Keutner, *Mitt. K.H.I.F.*, IX (1959), 149–50, as well as the identification as Cosimo I that provokes this dating, is certainly erroneous. See Rearick, *op. cit.*, I, 270.

192. 21. We have no certain knowledge of works by Rosso earlier than 1516, though one lost early work is described by Vasari as a collaboration with Pontormo in the execution of a predella, now lost, for Sarto's *Annunciation* for S. Gallo, datable *c.* 1512–13. A body of alleged youthful works by Rosso, assembled on the basis of indications initially made by Longhi (cf. Freedberg, *op. cit.*, I, 248 ff.), has been proved by more recent research to belong to a lesser master, who has been baptized (by F. Zeri, 'Eccentrici fiorentini', *Boll. d'A.*, XLVII [1962], 216 ff.) 'Master of the Kress Landscapes'. The suggestion made by J. Shearman, *Andrea del Sarto* (Oxford, 1965), I, 166, that would identify a Madonna in Frankfurt (Städelsches Institut), long attributed only uncertainly to Rosso, as a sure early work by him is very likely correct. However, its style is so close to that of the *Assunta* of SS. Annunziata that it need not antedate it. This picture may still offer us a lever for discovery of other, earlier, attributions.

I should now place the Leningrad *Madonna*, which I once dated *c.* 1515 (Freedberg, *op. cit.*, I, 539), *c.* 1519 instead.

194. 22. There may be an identifiable Donatellesque element in this figure style; so at least the *St Jerome* specifically suggests.

23. Painted originally for the Compagnia della Croce in Volterra; subsequently shown in the cathedral.

197. 24. From S. Spirito, where it has been replaced by a copy to the original dimensions of the painting, which as it is now shown in the Pitti has been enlarged all round.

25. Rosso's picture was meant as a substitute for the *Madonna del Baldacchino* of Raphael, commissioned for this altar but never delivered. It may be that some consciousness of this relation to the Raphael commission, on the part of both the patron and the artist, served to influence Rosso in this work.

26. The Volterra *Deposition* reveals an earlier but differently oriented study of Michelangelo, probably of the *Cascina* cartoon. The element of Michelangelism in the *Marriage of the Virgin* does not of course derive as yet from the Medici sculptures but from Michelangelo's drawings.

That Vasari read the *Marriage of the Virgin* as a demonstration of the virtues of *grazia* is indicated clearly in the passage in the *Lives* (V, 159) that just follows his mention of the picture: '. . . in quella sua facilità del fare non è mai stato chi di pratica o di distrezza l'abbi potuto vincere ne a gran lungo accostarseli; per esser egli stato nel colorito si dolce e con tanta grazia cangiato i panni. . . . Sono le femmine graziosissime, e l'acconciature de'panni bizarre e capricciose . . . tutto conduceva con tanta facilità e grazia, che era una maraviglia.'

Though Perino del Vaga visited Florence in 1522–3, I should discount that his style, as yet not so formed as Rosso's, should have influenced the change we see in the *Marriage of the Virgin*.

199. 27. Pontormo's cartoon was never executed in this form. For its history, and the connexion with a pendant design by Perino del Vaga made during his Florentine visit of 1522–3, see Rearick, *op. cit.*, I, 210–12. It should be observed that Perino's design had no influence on Rosso's *Moses*.

28. Despite much argument, the relation between the anatomical style Rosso adopts in this picture and that which Bandinelli practises in drawing is still not clear. It is likely that the first suggestions came from Bandinelli, and their results may be apparent in Rosso's work from *c.* 1518. Bandinelli had gone to Rome in 1517, but was in Florence again between 1521 and 1523–4.

29. And a significant group of other non-Roman painters also: see S. Freedberg, *Parmigianino* (Cambridge, Mass., 1950), 63 ff.

201. 30. The two painters knew each other during their common time of residence in Rome. There must have been an interchange of influence between them, and I should read the evidence of it to assume that Rosso may have contributed significantly to the shaping of the style that Parmigianino achieved in the *Vision of St Jerome* (London).

31. There is a dense complex of references to Michelangelo in the Christ, but the most exact is to the drawing (Paris, Louvre), disputed in attribution between Michelangelo and Sebastiano del Piombo, which the latter used for his much later *Pietà* at Ubeda. The posture of the upper body of the Christ also closely recalls, however, that of the Christ in the *Deposition* at Volterra. The question of the relation of Rosso's Boston figure, but also of his Volterra Christ, to this Louvre sheet requires to be clarified.

32. Rosso's production of paintings during his Roman stay seems to have been relatively limited, but he had a considerable activity of designing for engravings, of mythological subjects mostly executed by Caraglio. The style of the prints is fully consonant with that of the *Dead Christ*; the majority date from 1525 and 1526. Their influence in the dissemination of Rosso's achieved Roman style, which, as we

observed, is effectively that of the Maniera, seems to have been considerable.

203. 33. The picture makes, again, references to classical antecedents which it quite transforms: to Raphael's *Entombment* (Rome, Borghese), re-seen by Rosso at Perugia on his return from Rome, to Sebastiano del Piombo's Viterbo *Pietà*, and to Fra Bartolommeo's *Pietà* (Florence, Pitti). Obvious are the recollections of Rosso's own painting in Volterra.

34. As the document of commission specifies (M. Hirst, *Burl. Mag.*, CVI, 1964, 121) the subject is a *Resurrection*, not (as the picture is usually entitled) a *Transfiguration*; and the anonymous population of figures below, which seems to have puzzled Vasari, who called them 'zingari e more' (V, 166), were required by the contract, as 'diversi figure che dinotino . . . el popolo'.

35. Preserved in the Louvre, G.C. 1575; despite general critical opinion to the contrary I think the sheet original, not a copy from the engraving by Caraglio after Rosso.

36. See A. Blunt, *Art and Architecture in France, 1500–1700* (Pelican History of Art), 2nd ed. (Harmondsworth and Baltimore, 1970), 31–2.

37. The *Pietà* by Rosso (Louvre), usually considered to be a late work of his French career, should in my opinion be placed instead at its inception. His *Madonna with St Elizabeth and St John* (Los Angeles, County Museum), usually assigned to the Florentine period, is instead from the period in France, and parodies a painting by Andrea del Sarto (Louvre no. 1515) that he would have found in François I's collection.

204. 38. See J. Shearman, 'Raphael's Unexecuted Projects for the Stanze', in *Walter Friedlaender zum 90. Geburtstag* (Berlin, 1965), 177–80. See also the excellent review of the evidence concerning the measure of Raphael's responsibility in L. Dussler, *Raffael* (Munich, 1966), 96–7.

39. The letter from Sebastiano reprinted in V. Golzio, *Raffaello nei documenti* (Rome, 1936), 132.

40. A document, first properly interpreted by Shearman, *loc. cit.*, informs us that a scaffolding was erected in some part of the Sala di Costantino before October 1519, presumably to prepare a portion of the wall with a *mistura* for painting on it in oil, which, Vasari also tells us, had been Raphael's first intention. Of drawings for the Sala di Costantino which survive, those with the most convincing claim to be autographs by Raphael are a model study for a seated *Virtue* (Oxford, Ashmolean) and a detailed nude study for a portion of the *Battle of Constantine* (also Oxford).

41. For a résumé of the chronology of the execution, see Freedberg, *op. cit.* (1961), I, 569–70.

42. Giulio's principal assistant in the first phase of the painting of the Sala di Costantino was Raffaellino dal Colle, and in the second, in 1524, Francesco Penni. Polidoro da Caravaggio worked at his speciality of monochrome decoration in the *basamenti* of the Sala, and there were other helpers in the painting also, whose hands we cannot specify.

205. 43. The drawings for the Sala di Costantino that we now tend to attribute to Raphael in fact differ basically in style from the paintings Giulio executed from them. However, the two 'trial' figures of *Virtues* executed in oil at the very beginning of the first campaign seem conspicuously to approximate Raphael's own manner.

207. 44. The altar is not precisely dated, but external evidence as well as the evidence of style indicate its likely invention *c.* 1521 and its completion before 1523. See F. Hartt, *Giulio Romano* (New Haven, 1958), I, 55–6.

208. 45. Cf. H. Hoffmann, *Hochrenaissance, Manierismus, Frühbarock* (Zürich-Leipzig, 1938), 19 ff.

210. 46. To explain the circumstances behind Giulio's designs of 1524 for the obscene series of engravings by Marcantonio, the *Pose*, would require more space than the problem is worth here, but it should be observed that the explanation should take into account the religious – or more precisely the irreligious – climate that made the tenor of the Anima altar (and Rosso's *Dead Christ*) possible.

While no set of Marcantonio's engravings now survives (in consequence of Pope Clement's rapid action of censorship), the fragments (of nine heads only) exist in the British Museum, and a set found in the early nineteenth century (but now also lost) was faithfully copied in lithograph by Baron Waldeck. A unique set of woodcut copies of *c.* 1527, in book form, has recently been discovered (New York, private collection); these are faithful except that they are not to the full width of the originals.

47. The lower (Assumption) half is from a design salvaged, apparently, from an unexecuted project for an altarpiece for the Chigi Chapel in S. Maria del Popolo; see J. Shearman, *Warburg Journal*, XXIV (1961), 143 ff. and 158 ff.

211. 48. Sometimes known as the *Arazzi della Scuola Nuova*. They were woven in Brussels, where the actual cartoons seem to have been prepared by Tommaso Vincidor and Francesco de Hollanda, with some adulterations in detail of Penni's designs. The finished tapestries were probably delivered *c.* 1531.

49. We may possess some evidence of Perino's work

in Florence under Ridolfo: a drawing in Stockholm for an *Adoration of the Shepherds* and a painting of similar subject in the Metropolitan Museum in New York may be by his hand. Cf. B. Davidson, *Master Drawings*, I (1963), no. 3, 5, and plate 1.

50. Recently cleaned and isolated from a surrounding landscape added in the later sixteenth century. See M. V. Brugnoli, *Boll. d'A.*, XLVII (1962), 340 and figure 23. In Freedberg, *op. cit.*, I, 417 the *Pietà* is dated 1517, but the discovery by Oberhuber (*Master Drawings*, IV, 1966, 175) of a preparatory study of more advanced style, as well as the evidence of the cleaned fresco, indicate that a date nearer 1520 is correct. I should now also deny Perino's authorship of the drawing (Louvre), more likely by Raphael, which I related (*ibid.*) to the S. Stefano *Pietà*.

212. 51. The dating of the angel-nikes into Clement VII's reign (rather than in 1521) proposed by Brugnoli, *op. cit.*, 343, in my opinion has no adequate foundation. They are wholly consistent in style with the other figures inserted by Perino into the Sala dei Pontefici, which is marked repeatedly with Leo's name.

I find convincing Davidson's suggestion (*op. cit.*, 20–1) of a date 1520 or shortly thereafter for the fragments (Hampton Court) of a *Crucifixion* painted for S. Maria sopra Minerva. Instead of a source in Sebastiano del Piombo for that picture I should prefer to suggest for it a relationship to designs by Michelangelo in the British Museum and in Haarlem.

214. 52. Virtually ruined, but important fragments still survive *in situ*, and have been recently restored. Two scenes of the former frieze of the room, detached, are now in the Uffizi.

The present state of the decoration of the salon as well as of the lesser rooms in the palazzo is recorded in R. Montini and R. Averini, *Palazzo Baldassini e l'arte di Giovanni da Udine* (Rome, 1957). Conclusions of this book as to authorship and dating are not reliable.

53. There is a remarkable analogy of style between these figures and Parmigianino's in his exactly contemporary decoration of the chapels in S. Giovanni Evangelista in Parma; this is an early instance of analogy that was later to repeat itself when the two painters came into actual contact in Rome.

54. In addition to Perino's salon there is another major room in the palazzo with a vaulted ceiling decorated in an advanced grotesque style, developed from that of the Loggetta of Cardinal Bibbiena. This vaulted room is attributed to Giovanni da Udine. See Montini and Averini, *op. cit.*

55. Vasari arrived in Florence only in 1524.

56. See Rearick, *op. cit.*, I, 211–12, for a discussion of Perino's design, related to one by Pontormo, for a *Martyrdom of the Theban Legion* (Perino's original modello, according to Davidson, *Master Drawings*, I, 1963, no. 4, 20 in the Albertina) for the convent of the Camaldoli; Perino's drawing freely exploits the precedent of the *Battle of Ostia*. The only other certain surviving Florentine piece is a large grisaille painting of a *Passage of the Red Sea* (Florence, Ugguccioni Collection) which paraphrases Giulio's newest manner. An unfinished *Holy Family* (London, Courtauld Institute), often assigned to the Florentine visit, may belong rather (cf. Davidson, *op. cit.*, no. 3, 4) to a later time, in Genoa.

57. Davidson, *op. cit.*, no. 3, 14, considers that the vault frescoes were begun *c.* 1521, but Brugnoli, *op. cit.*, 327, that they were most likely designed just before Perino's trip to Florence but not executed until after his return. Both scholars assign the paintings of the lunettes to 1524 and afterwards. The decoration was never finished by Perino; interrupted by his departure from Rome in 1528, it was taken up again only in 1562 by Taddeo Zuccaro, and completed after his death by Federico.

58. Two of them are now badly damaged. Preparatory designs for all four vault scenes are preserved; see Brugnoli, *op. cit.*, figures 9–11, and Davidson, *op. cit.*, no. 4, plate 7a.

216. 59. The set had been begun by Rosso before the Sack.

60. Giulio's *Pose* make an obvious precedent for Perino's *Loves*.

61. I should like to record here the suggestion that a portrait of a young man (Paris, Louvre, illustrated in Freedberg, *op. cit.*, 1950, figure 161), attributed in the older literature to Raphael or Parmigianino, may be by Perino. Mme Sylvie Beguin has informed me (letter, 22 April 1982) that she has independently, and before knowledge of this note, come to entertain the idea of Perino's authorship of the Louvre portrait and moreover believes that the sitter in it should be the young Francesco Parmigianino. I have myself long believed this to be the case, and shared my opinion with colleagues and students, but have not so far dared to assert it in print. The reinforcement given me by Mme Beguin's opinion has encouraged me to express my conviction here that the Louvre portrait does in fact represent Parmigianino, at the time when we know that he and Perino were in friendly contact in Rome, and to express the near-conviction that the author of the portrait is Perino.

217. 62. See Freedberg, *op. cit.* (1950), 36 ff., for a

discussion of Parmigianino's *Baptism of Christ* (Berlin, Museum, *c.* 1519).

63. Correggio was never directly Parmigianino's teacher. His initial instruction in art came from his uncles, both painters (as his father, Filippo Mazzola, had been; Filippo died when his son was three years old). Francesco's first training must have been in a very provincial Bellinesque mode.

218. 64. Cf. Freedberg, *op. cit.* (1950), 63 ff. It is possible that he had already encountered Rosso (perhaps also Perino del Vaga?) in Florence on his way to Rome.

65. Vasari reports (v, 224) that the completion of this picture was interrupted by the Sack, but there is no indication that it is unfinished. It remained in Rome (in S. Maria della Pace) until about the middle of the sixteenth century; later it was removed to Città di Castello. For a discussion of Parmigianino's other Roman paintings, see Freedberg, *op. cit.* (1950), 58 ff.

220. 66. Late in 1519 Polidoro assisted Giovanni da Udine in the painting of the lower loggia of the Vatican; and he may be the author of a panel of grotesque decoration, generally in Giovanni's style, in the Sala dell'Incendio.

221. 67. For the frescoes of the Cappella della Passione see R. Kultzen, *Zeitschrift für schweizerischen Archäologie und Kunstgeschichte*, XXI (1961), 19–30, which, however, leaves some questions of importance unanswered. Very likely in the Cappella della Passione and the Costantino *basamenti*, certainly in the Villa Lante, Polidoro was assisted by his inseparable companion, the Florentine-born Maturino. Maturino's manner conformed, as much as his ability allowed, to Polidoro's. Though Maturino was an adequate draughtsman, he was a far less able painter, and had no personal originality. His parts in the *basamenti* of the Sala di Costantino and the ceiling of the Villa Lante salon may be identified not only by their qualitative difference from Polidoro's but also by positive comparison with a painting of a *Crucifixion* initialled by him (Maturino) and dated 1523. Formerly in the Berlin Museum, this work has apparently been lost for many years, but it has been photographed. A drawing of a *Battle of Amazons* in the Rennes Museum (no. 45/3) bears an old inscription of Maturino's name and is by the same hand. We have no knowledge of Maturino's birth date, but he is supposed to have been another of the helpers in Raphael's Logge, and to have died in 1528, following the Sack.

225. 68. He had almost certainly been in Naples once before, in 1524, to escape the plague in Rome. There is no good evidence for the suggestion of

F. Bologna, in *Ruviale Spagnolo* (Naples, 1958), 82, that Polidoro returned to Rome for a visit after 1541 and then saw Michelangelo's *Last Judgement*.

69. The provincial schools of Naples (and Messina) can claim small distinction in the first half of the sixteenth century beyond that which Polidoro's presence lent them. The general level of native art in early-sixteenth-century Naples, before Polidoro's time, was not only low in quality but more archaizing than in any centre of fair size elsewhere in Italy. Foreigners, of Lombard origin at first, were the earliest to demonstrate some ideas of the modern style to Naples. Milanese by education, the so-called pseudo-Bramantino (Pietro Sardi?) left work in Naples in an eccentric version of the earlier Bramantino style, with some touches in it of the influence of Leonardo; then Cesare da Sesto (see Chapter 6), residing in Naples between *c.* 1514 and 1520, became the most important newer influence on the school.

Though the more nearly significant native Neapolitan painters are reported by old sources to have studied in Rome, the direct influence of the Roman school seems small in the first and second decades. One major work of Raphael, the *Madonna of the Fish*, had been sent there, but without perceptible effect. It was through the Lombard Cesare rather than by direct example that the Raphaelesque style made some progress in Naples. Penni was in Naples and left behind a variant of Raphael's *Transfiguration* (now in the Prado), but whatever mark he may have made locally has vanished. It was by Polidoro's presence, first in 1524 and then for a time following the Sack of 1527, that Naples became mainly dependent on the Roman school. The rising tide of Mannerism then spread gradually from Rome towards Naples, and in 1544 residence and work there by Vasari resulted in a more or less effective conversion of the Neapolitans, but this was in time for the matured Maniera; our account of the painters of that time and persuasion belongs in a later place. The process of getting Naples into step with the sixteenth-century development took a full half-century, and even then it was without conspicuous result in terms of the quality of local art.

Of the native Neapolitan painters of the first half-century the most able was Andrea Sabbatini da Salerno (*c.* 1484–1530). He is supposed to have had some Roman training (allegedly in Raphael's school, but this is almost certainly untrue), but it is Cesare da Sesto's indirect example of Raphaelism that was most apparently important for him. Andrea's debt to Cesare is such that his polyptych at Cava dei Terreni (Museo dell'Abbazia, *c.* 1518) seems to be in its

important parts from Cesare's designs, and other works of the same phase reveal an almost equal measure of dependence. Andrea's Raphaelism, even in this indirect and Lombard guise, was most superficial. Before his submission to Cesare, Andrea seems to have been influenced by the works left in Naples by the pseudo-Bramantino, and after Cesare's departure (*c.* 1519) he reverted to this influence again. An *Adoration of the Kings* (Naples, Capodimonte) is only loosely Raphaelesque; there is more in it of the hollow amplitude of a Bramantino-like construction. This is the character also of a still later work, a *St Benedict Enthroned* (*ibid.*). In this altar, the smoothed emptiness of form, its attenuation, and a stress on rhythmic patterning suggest the character of a post-classical style; in the predella panels a pointing eccentricity of shapes suggests the relation even more. But this effect is in the main fortuitous: it does not result from symptoms of modernity but from archaic tendencies which Andrea never overcame.

What we know of the painting of Marco Cardisco (*c.* 1486–1542) belongs to a stage of the Neapolitan school succeeding that which Andrea da Salerno represents. Though he was a contemporary of Andrea's and was visibly influenced by him, Cardisco became a follower of Polidoro when the latter came, after 1527, to represent modernity in Naples. A native painter whose least uninteresting work coincides in time with Andrea's is the long-lived Giovanni Filippo Criscuolo (1500–70/84?). His career consists of reflections first of an archaic Lombard style, then of the more nearly modern pseudo-Bramantino's or of Sabbatini's; in his late years he turned into a pasticheur of the post-Raphaelesque Maniera.

69a. The version of this theme (on slate, and in the reverse direction) in the Museo di Capodimonte in Naples has been convincingly demonstrated (by M. Hirst, *Sebastiano del Piombo*, Oxford, 1981, 84–5), on technical grounds as well as grounds of style, to be from the early 1530s, rather than the early 1520s, as it has been dated usually in the literature, including the previous editions of this book.

228. 70. 'Hora ... che siamo passati per acqua et per fuoco et che havemo provato cosse che mai si lo pensasemo, rengratiamo Dio di ogni cossa et questa pocca vita che ne resta, consumamola almanco in quella quiete che si po; che in vero è da far pochissimo conto de le acione de la fortuna, tanto è trista e dolorosa. ... Ancora non mi par esser quel Bastiano che io era inanti el sacco; non posso tornar in cervello ancora' (Milanesi, *Correspondants*, 36, 38; 24 February 1531).

70a. See Note 74a to Chapter 1 for discussion of the dating of the Prado *Limbo* and its possible relation to the *Pietà* of 1516 in Leningrad.
71. Painted in oils on the wall; Sebastiano was a conspicuous early experimenter in the technique of painting with oils on stone.
Sebastiano succeeded Raphael in the main commission for the decoration of the chapel. See Shearman, *op. cit.* (1961), for a convincing assignment of a project for an *Assunta* by Sebastiano (Amsterdam, Rijksmuseum, probably *c.* 1526) to this altarpiece. In 1530 Sebastiano received a contract to paint the present subject instead. Working slowly and sporadically, as had become his habit with his larger works especially, Sebastiano had apparently not yet begun to paint in 1532, when he asked Michelangelo for help with an invention which seems to be of this picture. It was not finished at Sebastiano's death. Its completion, in the upper zone, was left to Francesco Salviati.
231. 72. There is virtual certainty that Sebastiano based this picture not only on the early *Pietà* by Michelangelo in St Peter's but also on a drawing by him which he used for the figure of the Christ. A developed study for the Christ is in the Louvre, disputed in authorship between Sebastiano and Michelangelo. The relation of the Ubeda Christ to Michelangelo is one of the most difficult problems in the Michelangelo–Sebastiano connexion (which ceased, at least as far as direct communication was concerned, in 1533), and it cannot be solved without considering a third term, the earlier *Dead Christ* by Rosso in the Boston Museum of Fine Arts. Cf. Note 31.
The most recent consideration of the Ubeda picture is by M. Hirst, *Burl. Mag.*, CXIV (1972), 585–95.
232. 73. The subject is usually supposed to refer to Lorenzo il Magnifico as the recipient of such a gift, but J. Cox Rearick has demonstrated (*op. cit.*, Note 9) that the reference is rather to Leo X and recalls a gift made to him by the King of Portugal in 1514. The fresco was enlarged to the right by Alessandro Allori when he completed the decoration in the 1580s.
234. 74. So documented in the records of the convent. Cf. Freedberg, *Andrea del Sarto* (1963), II, 140–1. Andrea had contracted for this subject long before, in 1511, when he executed the saints in tondi and a *Trinity* on the arch-face before the wall on which the *Supper* is painted.
236. 75. Andrea di Cosimo Feltrini had already been at work on the (non-figurative) painting of the ceiling. Franciabigio's fresco has also been enlarged later by Alessandro Allori.

76. As he was slightly older than Pontormo, it might be expected that we could identify youthful pictures by Puligo in comparable quantity and beginning at a similarly early date, but recent criticism has established that there are in fact few extant works by Puligo that are surely from within the second decade. A body of small paintings formerly assigned to Puligo (e.g. Freedberg, *op. cit.*, 1961, I, 242, 497 ff., and in the *Lists* of Berenson, 1932 and 1936) has mostly been distributed among lesser hands, correctly, by Zeri, *Boll. d'A.*, XLVII (1962), 216 ff. and 314 ff. Collaboration with Sarto from Puligo's early time that has been suggested in the literature seems also to be unprovable.

237. 77. A change from a Sartesque allegiance to Pontormo is evident between *Portrait of the Courtesan Barbara* (Salisbury, Salmond Collection, *c.* 1523; also evidently influenced by Raphael's *Leo X*, already then in Florence) and the *Pietro Carnesecchi* (Florence, Pitti), which is of *c.* 1525–7. The *Young Man* (Bromfield, Earl of Plymouth, *c.* 1527), though also basically imitative of Pontormo, may be an innovation in the Florentine school in its three-quarter-length format. The original source for this format within the Florentine school is in an imported work by Sebastiano, the *Albizzi* portrait of 1525.

239. 78. Zeri, *op. cit.*

79. His early works have been wrongly assigned to Rosso (cf. Note 21). His later mode suggests Beccafumi's more extreme *maniera piccola*, but without its control or quality.

244. 80. We have only the lower (and thematically less important) part of the *Ascension of Christ*, the fresco decoration of the apse of Siena Cathedral which Beccafumi painted intermittently from 1535 to 1544, and the most extensive work of his later career. The main part of the fresco was destroyed by earthquake in 1798.

246. 81. Though one picture, a *Resurrection* (Siena, Palazzo Pubblico, *c.* 1532?), and another of the same theme (Naples, Capodimonte, *c.* 1534) exploit Sodoma's knowledge of Michelangelo's designs for this subject.

248. 82. The *Augustus and the Sibyl* (Siena, Church of the Fonteguista) is assigned to Peruzzi by tradition with an alleged date 1528, and bears a (later) inscription with his name. He may be responsible for the design, and even for a fraction of the execution (only the figure of the Sibyl seems to approach the quality of his hand), but the picture is largely by a lesser painter, much influenced by Rosso's manner and by the style of Beccafumi.

249. 82a. A documented account of Riccio's career

can be found in the entry by F. Sricchia Santoro in the exhibition catalogue *L'Arte a Siena sotto i Medici, 1555–1609* (Rome, 1980), 27–47.

250. 83. Giulio's personal role in the execution of the decoration was limited. Among his aides the chief were Benedetto Pagni and Rinaldo Mantovano. The young Primaticcio also served in the Palazzo del Te, in particular in the Sala dei Stucchi. For detailed information on the Mantuan works by Giulio, and for illustrations, see Hartt, *op. cit.*

252. 84. The measure of inspiration by Correggio of the illusionistic mode in the Sala dei Giganti, of its consistency in particular, is obvious; by the time of the invention of this room Giulio would have seen the completed dome of Parma Cathedral of which Giulio's room may be thought of as a parody and, literally, an inversion.

85. Besides Parmigianino's influence there is, in the Boschetta altarpiece, again a reference to Correggio, to both the *Notte* and the *Giorno* altars. Contact in Mantua with Correggio's painting after 1530 was closer than ever; it was in the period 1530 to 1534 that Correggio supplied the *Loves of Jupiter* to Federico Gonzaga for installation in the Palazzo del Te.

253. 86. The destroyed originals have been replaced by copies attributed to Bernardino Campi.

254. 87. Giulio inhabited a palace of his own, reconstructed by him in 1544 but not originally built by him (see Hartt, *op. cit.*, 236–40), which also contains an important frescoed room, done in a mannered style of strongly neo-classic aspect.

88. The vault bears the date 1530, applied later by the restorer on no sure evidence. Though restored, these frescoes are in general not significantly altered in style.

255. 89. Giulio's room was designed in 1532 and finished in 1534. There is no sure external evidence with which to fix the date of invention of Perino's ceiling, but it is most likely to have been completed in 1533, when the Emperor visited the palace. It is likely that the community of themes is occasioned by a reference to Charles V rather than to the families who owned either palace.

90. The principal executant for Perino's *stucchi* was Silvio Cosini of Fiesole. Originally, the decoration was completed (as may have been intended for the Farnesina) by tapestries, designed by Perino, which are now lost.

257. 91. A further major decoration by Perino survives in the Palazzo del Principe: the Loggia degli Eroi, a developed Mannerist translation of precedents in the Raphael Logge and in the *basamento* of

the Sala dell'Incendio. A pictorial decoration of the street façade (with the history of Camillus) was intended but never executed. A drawing, cut and divided between Chantilly and Amsterdam, survives for Perino's elaborate plan; cf. B. Davidson, *Art Bulletin*, XLI (1959), 322 ff.

About 1533 Pordenone worked briefly on the garden side of the palace. A visit by Beccafumi, probably in 1536 (see p. 244 above), did not result in any contribution to the decoration.

92. Among the recent discoveries for Perino's œuvre are a number of small predella panels, painted in a very cursive style and, in instances, with remarkable effects of artificial light. Six of these (of which five are in the Brera) have been suggested as being the predella of the *Pala Basadonne*; see B. S. Manning, *Art Quarterly*, XV (1952), 215. Their touch of realism is a strain in Perino that departs from the artifices of his Maniera, and may have been inspired by contact with Pordenone on his Genoese visit in 1532.

In the same year in which the *Pala Basadonne* is dated Perino had an unfruitful episode of employment for the cathedral of Pisa. A fragmentary frieze by him is there, and we have noticed (p. 238) the inferior translation by Sogliani of Perino's designs for an altar.

93. Cf. J. Gere, *Burl. Mag.*, CII (1960), 10, note 8; and see the same article *passim* for supporting evidence for the Cappella Massimi and Castel S. Angelo decorations.

94. Perino was commissioned to design a tapestry *basamento* for Michelangelo's *Last Judgement*. What remains of it, in the Galleria Spada, was identified by Voss, *op. cit.* (1920), I, 73–4. See also B. Davidson, *Perino del Vaga e la sua cerchia* (Florence, 1966), 51–2.

259. 95. An extensive team of executants was employed by Perino in the Castel S. Angelo, among whom the chief were Pellegrino Tibaldi, Siciolante da Sermoneta, and Marco Pino.

96. Gianfrancesco Penni was Perino's brother-in-law: Penni's younger brother, Luca (b. *c.* 1500), served as an assistant to Perino in Genoa. He also worked at Lucca and elsewhere in Italy, and then with Rosso at Fontainebleau. The principal activity by which he is known to us is as an engraver, of his own designs as well as others'. His later work is in the style of the developed Maniera.

263. 97. Parmigianino had a quite considerable practice as a portraitist, especially in his later years, though his portraits did not have so wide an influence as his other paintings. In his portraits Parmigianino exercises much less of the poetic licence he allows

himself in his religious works. Their formulae and their psychological atmosphere coincide remarkably with those in the portraits of Parmigianino's exact contemporary, Bronzino.

264. 98. Raffaellino was again in Pesaro, however, between 1539 and 1543.

99. Genga's impressive altar of the *Resurrection* in the Roman oratory of S. Caterina in Via Giulia (*c.* 1522) is a significant response to the earliest independent demonstrations of Giulio's style, and it is a major, though insufficiently regarded, event in the production of the post-Raphaelesque Roman school.

CHAPTER 4

268. 1. For the best summary of the discussion of Correggio's date of birth, see A. E. Popham, *Correggio's Drawings* (London, 1957), xv.

2. It is only suggestive that the central group of the Washington panel may reflect the earlier Leonardo *St Anne* schemes (and in particular the cartoon of 1501), but it may be more explicit that, in this context of Leonardesque *sfumato*, the foreshortened right hand of Correggio's St Anne should be accounted for by his knowledge of Leonardo's *Virgin of the Rocks* (rather than by derivation from Mantegna's *Madonna of Victory*, which Correggio obviously knew, and used elsewhere).

269. 3. There are elements in the *Adoration* that might suggest the possibility of Correggio's knowledge of Titian's *Allendale Nativity* (perhaps then in Ferrara?).

4. There is also a resemblance in the upper portion of the picture to the upper part of the *Madonna di Foligno* (this as an overlay upon Correggio's obvious reminiscence of Mantegna's *Madonna della Vittoria*).

271. 5. For the term 'naïve Mannerism', see S. Freedberg, *Parmigianino* (Cambridge, Mass., 1950), 126.

6. The similarities of exotic costume and of glowing colour, as well as the descriptive liberties, have suggested (e.g. R. Longhi, *Il Correggio e la Camera di S. Paolo*, Genoa, 1956, 28) that Correggio's *Adoration* has been influenced by Dosso. This assumption is based on a false reading of Dosso's chronology, in which effects of comparable fluency do not occur until somewhat later – *c.* 1518. If there is influence, it may go the other way.

7. A group of erroneous attributions to the early Correggio has been isolated independently by myself and Federico Zeri; also independently the essential items of this group have been assembled by M. Laskin,

Jr, *The Early Work of Correggio* (diss., New York University, 1964). From the painting in the Orombelli Collection, Milan, the one among the group most often improperly assigned to Correggio, I have given the author of these pictures the name 'Orombelli Master'. In addition to the items published by Laskin I wish in particular to propose the addition of the (damaged) *Holy Family* (Pavia, Museo Civico) which is usually taken for Correggio without question.

273. 8. See, e.g., Longhi, *op. cit.*, 30 ff.

9. E. Panofsky, *The Iconography of Correggio's Camera·di S. Paolo* (London, 1961).

10. Cf. not only the burial chapel of Mantegna in S. Andrea, in the decoration of which Correggio was engaged in 1511–12, but also the accounts of lost decoration by Mantegna in Rome in the Chapel of Innocent VIII in the Vatican (1490).

275. 11. By Cesare Aretusi mainly, after 1586. Fragments of the original fresco are preserved in Parma (the central group) and in London. Correggio also designed the nave frieze of S. Giovanni Evangelista, for which he signed a contract in November 1522 (documents of payment until January 1524); the execution of this frieze was for the most part by Rondani. The frieze continues into the bay containing the crossing vault before the choir; here the execution as well as the design seems mostly Correggio's own. This, and the decoration of the ribs of the vault in this bay, also by Correggio, has only recently been uncovered; published by A. G. Quintavalle, *Boll. d'A.*, L (1965), 193–9.

12. See Popham, *op. cit.*, 31 ff., Longhi, *op. cit.*, 34–5, and A. Foratti in *Manifestazioni . . . nel IV centenario della morte del Correggio* (1936), 121–5.

13. J. Shearman, 'Correggio's Illusionism', in M. Emiliani (ed.) *La Prospettiva rinascimentale: Codificazioni e Trasgressioni*, I (Florence, 1980), 281–94, has made the interesting speculation that the illusionist apparition that Correggio painted here (and later in the dome of the cathedral also) is influenced by actual spectacles presented in churches.

282. 14. The emotional acuity, but not the Manneristic formal appearance, of the *Placidus and Flavia* appears in the closely contemporary *Agony in the Garden* of 1526–7 (London, Apsley House).

15. He will replace the spectator (who is put into a voyeur's situation towards the Antiope) in the concavity her body makes.

Iconographic studies of the Louvre picture and its London pendant are in L. Soth, *Art Bulletin*, XLVI (1964), 539–44, and E. Verheyen, *G.B.A.*, LXV (1965), 321–40. Both come independently to the conclusion that the pair is meant to illustrate the theme of

the celestial and earthly Venus (cf. Titian's *Sacred and Profane Love*).

16. A fourth altar, the *Madonna of St George*, not later in date than 1530, is usually considered with the others in a group, but incorrectly, since it reveals an alteration in Correggio's tendencies of style and requires to be discussed separately.

285. 17. Commissioned first in 1523, but this design cannot have been conceived then. A drawing (Christ Church) identified by Popham, *op. cit.*, 86, plate 90b, as a design made at the time of the commission is in my opinion not earlier than 1526.

18. Also commissioned long before, in 1522, for S. Prospero in Reggio Emilia (where the original frame exists). A drawing of the same theme formerly in the Clark Collection, now in the Fitzwilliam (Popham, *op. cit.*, plate 86), is not, in my opinion, the modello supplied at the time of the first contract. That modello is more likely to have resembled the *Circumcision* by Parmigianino painted with a night lighting (a copy of the lost original is preserved in Detroit, Museum), of which the lighting and the design can only be explained by knowledge of Correggio's first scheme for the 'Notte'.

19. This too may have been commissioned earlier, c. 1524. It was not set up until 1530. The original frame (still on the picture) bears that date.

286. 20. The painting of the apse was finally executed after 1538 by Bedoli.

21. 'Un guazzetto di rane'; see C. Ricci, *Correggio* (London and New York, 1930), 110.

22. As the *Vision of St John* is to Raphael's *Transfiguration*, so Correggio's *Assunta* is to Titian's altar in the Frari.

289. 23. The spectator here is in a relation of response to an energized concavity of structure like that which Correggio tried to create also, as we have seen, even on the flat surface of his easel paintings of this time.

Giulio's later scheme in the Sala dei Giganti of the Palazzo del Te is similar in all essential respects of its intellectual devices to Correggio's, and certainly influenced by it, but it is, so to speak, earthbound and downward-directed; its intention is the opposite of a spiritual elevation and its mood the reverse. It might be thought of as a secular inversion of Correggio's idea. See Chapter 3, Note 84.

24. From S. Pietro Martire in Modena. Popham, *op. cit.*, 83, indicates that the altar should have been finished by 1530, since this date is on an 'adaptation' in the City Art Gallery, York, signed by Girolamo da Como. Lancilotti, however, asserts that the chapel in S. Pietro was not decorated until 1532.

290. 25. Usually dated somewhat earlier, but in my opinion incorrectly.

291. 26. See the discussion of this group of paintings, including a reconstruction of their likely original setting in the Palazzo del Te, by E. Verheyen, *Warburg Journal*, XXIX (1966), 160–92.

The Berlin picture was slashed by the son of the Régent d'Orléans in the eighteenth century; the head of Leda was destroyed altogether. The canvas was then restored by Coypel and a new head supplied for Leda by Schlesinger.

27. Parmigianino had returned to Parma in 1531 – close to the time when Correggio left. It is doubtful whether Correggio's relation to Maniera after 1530 depends at all significantly on his knowledge of Parmigianino's example.

28. Pordenone's earliest style seems to derive mainly from Gianfrancesco da Tolmezzo and Pellegrino da S. Daniele. It is not certain who his master was; Vasari reports that he was autodidact. The earliest surviving picture (painted when Pordenone would have been only sixteen or seventeen) is a *Madonna* (Springfield, Mass., Museum) which bears his signature and the date 1500; the next securely signed and dated work is a fresco altar at Valeriano, of 1506.

292. 29. The S. Giovanni Evangelista in the Susegana altar is derived from one of the apostles in Raphael's *Coronation of the Virgin* of 1503–4, then in S. Francesco in Perugia (now in the Vatican Museum). Pordenone's Baptist may be inspired by the *Madonna di Foligno*, but this is less certain. The architecture has a Roman accent, but this does not necessarily require any knowledge of Rome itself, nor does the quotation of an antique statue resembling a *Torso Belvedere* (propped up in the upper storey of the architecture) prove Roman experience. This torso appears in several drawings of certain Venetian origin, and its appearance in a *Portrait of an Artist and his Pupils* by Bernardino Licinio (Alnwick Castle) indicates that casts from it were a familiar studio property in Venice.

In the seventeenth century Scanelli reported the existence of works painted in Perugia by Pordenone. An *Entombment* by Pordenone (which now survives only in copies) depends closely on Raphael's Baglione *Entombment*, at that time in Perugia. See also remarks by A. Ballarin on a *Resurrection of Lazarus* by (?) Pordenone in Prague, *Arte Veneta*, XIX (1965), 60–2.

30. Apparently just previously (in February 1520) he had begun but not brought to completion the façade decoration of the Palazzo Cerisani in Mantua. It was wholly lost by the later nineteenth century, and no evidence now survives to indicate its appearance, but it is likely to have reflected what Pordenone saw of Peruzzi's façade decorations in Rome.

The decoration of the Cappella Malchiostro is discussed by J. Schulz, 'Pordenone's Cupolas', in *Studies in Renaissance and Baroque Art presented to Anthony Blunt* (London and New York, 1967), 44–50.

297. 31. The element of relation to the Quattrocento tradition in this form of perspective realism is evident from the connexion of Pordenone's Christ with Mantegna's late painting of the same theme (Milan, Brera) which Pordenone could have seen in Mantua.

298. 32. The analogy is thus with the 'inversion' of Correggio's Duomo fresco in Giulio's secular joke in the Sala dei Giganti of the Te. Giulio might well have known the Cortemaggiore chapel and taken inspiration from it for his different theme.

The daring and intellectual inventiveness of the fresco cycles of the twenties which we have discussed is in contrast, often very marked, with the deliberate conservatism that Pordenone most often exercised in his altar paintings. There are also fresco works of this decade that are quite reactionary in their style, and of which the character is not to be charged wholly to the participation in their execution by assistants. It seems that Pordenone made deliberate distinctions in style based not only on the kind of content, dramatic or devotional, that was desired in the picture, but on its function in respect to a specific setting; no less important, it appears, that he made distinctions according to the measure of sophistication – or lack of it – that he expected of his patrons.

302. 33. The exact date, despite Lotto's own testimony in a will of 1546, is uncertain. Older sources contest the place of Lotto's birth, some alleging Bergamo, and others, less unreasonably, Treviso, but the best evidence suggests that both are incorrect.

34. Lotto alone among the major masters of the Cinquecento generation reveals traits that suggest a relation with the Vivarini shop; cf. B. Berenson, *Lotto* (Milan, 1955), 8. It has also been suggested (cf. L. Coletti, *Lotto*, Bergamo, 1953, 30 ff.) that he may have been trained in the Marches.

303. 35. Common Dominican relationships – Lotto's commissions in his earliest years were frequently Dominican, and were to continue to be so through his lifetime – might have reinforced the likelihood of the connexion. Expressive demands that might be specifically Dominican in origin do not account for Lotto's brand of religiosity, however. In Fra Bartolommeo and in metropolitan Florence, where the authority of art was differently considered by the religious, the Frate's 'Dominican' art is very different

in temper as well as in form from that which Lotto produces for his provincial audiences.

36. The reference to Bramante's illusionistic choir of S. Satiro seems evident.

304. 37. Cf. in the S. Spirito altar the apparent dependence of Lotto's glory of angels on Titian's *Assunta* of the Frari.

306. 38. The *Marriage of St Catherine* was mutilated in the sixteenth century, during the French occupation of Bergamo, by a soldier who cut out the landscape background.

308. 39. The stage illusionism, very moderately employed at S. Michele, seems influenced by Pordenone, and the ceiling fresco of a descending God the Father must be explicitly Pordenone-derived, from the dome at Treviso.

40. It is difficult to generalize about Lotto's designs for the *tarsie* of S. Maria Maggiore at Bergamo, which he supplied at intervals extending over the period 1524 to 1533. They include the most varied aspects of Lotto's capacities, among them an inventive fantasy of landscape which extends that in the backgrounds of the frescoes at Trescore.

310. 41. There may in fact be a recollection by Lotto of Pordenone's *Crucifixion* fresco of ten years before at Cremona.

42. A replica of later date is in the Palazzo Apostolico, Loreto.

313. 43. Suggesting the manner of the Brescian Moretto in the forties and probably influenced by him.

315. 44. P. Della Pergola, *Arte Veneta*, VI (1952), 187–8, offers evidence that this may be a self-portrait.

45. Despite the reports of an earlier birth date *c.* 1474 (Vasari) or *c.* 1479 (Baruffaldi), R. Longhi, *Officina Ferrarese 1934 . . . Ampliamenti 1940 . . . Nuovi Ampliamenti 1940–55* (Florence, 1956), 80, hypothesized the later birth date. The source of the name Dosso is probably a country place in the Mantuan territory where the family held property.

46. There seems small support, however, for alleging (as Baruffaldi did) that the Mantuan Costa was Dosso's teacher.

47. From the 'early' group proposed by Longhi, *op. cit.*, 82 ff., I accept as works by Dosso from this phase the *Salome* (Milan, private collection) and the *Holy Family with Donor* (Philadelphia, Museum, Johnson Collection), both of which I should place *c.* 1511–12, and in 1513-14 the *Gigi and Candaule* (Rome, Borghese) and the *Holy Family* (Rome, Capitoline).

It must be emphasized that the chronology of Dosso's painting is difficult and far from definitely fixed. The datings given here which are not based on the rare documentation must be taken tentatively. A

good working chronology is in the recent book of A. Mazzetti, *Il Dosso e Battista Ferrarese* (Ferrara, 1965). See also the subsequent *Dosso and Battista Dossi*, by F. Gibbons (Princeton, 1968).

316. 48. It is now clear (cf. J. Walker, *Bellini and Titian at Ferrara*, New York, 1956, and Mazzetti, *op. cit.*, 10) that the painting of the same theme in the Castel S. Angelo, Rome, is a later work, not for the *camerino*.

318. 49. The Viterbo *Pietà* of Sebastiano del Piombo may be a model, as well as the Marcantonio print of the theme after Raphael's designs.

50. This is the conjecture of Mazzetti, *op. cit.*, 18, which she supports with good evidence.

320. 51. An interpretation of the astrological signs in this painting permit a dating for it as late as 1529.

52. I here follow Mazzetti's suggestion (*op. cit.*, 27) for chronological placing of this group of works. They have more often been dated late in Dosso's career.

53. Rather than in 1532, as is usually assumed; see Mazzetti, *op. cit.*, 30–1, based on information supplied by Professor C. H. Smyth.

321. 54. Recently restored; the restoration proves that Vasari's account (VI, 319) of the taking down of the Dossi's initial decoration of this room is untrue.

55. Dosso, it will be recalled, owned property in the Mantuan territory also. Giulio's Romanizing influence on Dosso was supported, though with less effect, by that of Dosso's Ferrarese compatriot, Garofalo.

322. 56. Between 1517 and 1520 certainly, and perhaps as late as 1524, when he is again documented at Ferrara. Cf. Mazzetti, *op. cit.*, 39 ff.

CHAPTER 5

323. 1. When the largest payments are recorded; see Venturi, *Storia*, IX/3, 121–2.

325. 2. The relation to the invention of design conceived for the *Venus Worship* of 1518 is obvious, and this seems an indication of connexion in time of the designs with the altarpiece. A Central Italian analogue, of date coincident with the mid-point of Titian's execution, is Giulio Romano's S. Maria dell'Anima altar.

326. 3. The influence of northern prints is secondary, and that of the *St Christopher* in Pordenone's *Misericordia* altar of 1515 should be discounted.

4. The original was burned in 1867. The copy *in situ* is attributed to Cigoli.

5. The modello is preserved in the Uffizi; illustrated in G. Fiocco, *Pordenone* (Padua, 1943), plate 135.

328. 6. Both the main group and the fleeing monk are deduced essentially from ancient classical *topoi*

which Titian (and Pordenone also) had used in other guises before.

7. The freedom of these pictures and the means of composition and motif that support it were not purely self-generated in Titian. In late 1529 or 1530 Titian was in Bologna (cf. R. Pallucchini, *Tiziano*, Bologna, 1952–3, I, 159), and there must have seen Parmigianino's *Madonna with St Margaret*; the basic motif and the brilliance of flat colour fields in Titian's London picture, as well as something of the colour scheme, seem to have been inspired by Parmigianino's painting. In the Louvre picture, the motif of the figure's coming into the painting from the left, as well as the pronounced diagonal form of the design, so much suggest a relation to Correggio's del Bono *Pietà* that it seems possible that Titian went on to Parma on this same trip. The libertarian mode of both Titian's paintings would thus derive in part from his experience of works that trespassed beyond classical style and which Titian exploits but, more importantly, does not follow in their radical directions.

8. The premises of the Scuola form part of the present Accademia, so the painting is *in situ*, altered only by the late cutting of a door at the lower left.

9. The topmost part of the altar, originally arched and showing a God the Father, has been removed. Datings in the literature range from 1523 (based on an incorrect reading of a passage in Sanudo's diary) to *c.* 1542 (Tietze). The painting must precede 1538, since the St Nicholas is imitated in an altar by Jacopo Bassano of that year. An elaborate examination of the time and circumstances of production of this altar, confirming a dating between 1532 and 1538, is in W. Hood and C. Hope, *Art Bulletin*, LIX (1977), 534–52.

329. 10. The model is the girl, presumably a courtesan, who is the subject of the portrait called '*La Bella*' (Florence, Pitti) and of the *Girl in a Fur* (Vienna, Kunsthistorisches Museum).

11. Overt and unidealized, and thus different from Correggio's late erotica for Mantua, Titian's *Venus* resembles the Mantuan portrait-nudes of Giulio in temper. It is possible that Titian took both Correggio's and Giulio's examples into account in his conception of his 'donna nuda'.

330. 12. Cf. J. Shearman, *Burl. Mag.*, CVII (1965), 174.

13. It was then sent by Titian (on Aretino's advice) to the Emperor, who rewarded him for it with 2,000 scudi (the price set for the church had been 500 scudi); cf. Pallucchini, *op. cit.*, I, 187. The painting was engraved by Caraglio.

14. Burned in 1577. The original commission was given to Titian in 1513. Repeated solicitations were required to get him to execute the work, and it was not begun until June 1537. It was finished in August 1538. A painted copy on a small scale is in the Uffizi [141]. Cf. E. Tietze-Conrat, *Art Bulletin*, XXVII (1945), 205–6, for a history of the picture.

15. The two most prominent motifs in Titian's picture in the left foreground and middle plane are lifted nearly literally from Pordenone's Venetian façade of the Casa d'Anna.

16. Compare the *Battaglia del Coltellino*, B. 212. Through Giulio's agency it is possible that Titian also knew drawings for (or after) the *Battle of Constantine* itself. The 'bridge' episode of that fresco may be relevant to Titian's design of his picture. There is also an expected borrowing from Michelangelo's *Battle of Cascina*. Tietze-Conrat, *op. cit.*, also alleges Titian's knowledge and exploitation of designs for Leonardo's *Anghiari*.

332. 17. The last of the set of twelve were actually painted by Giulio. They are reproduced in engraving by Sadeler and in painted copies, *in situ*, assigned to Bernardino Campi.

333. 18. Taking example from a portrait of Charles V that Titian had painted earlier, in 1533, on the basis of a German model.

334. 19. Titian was probably in Mantua in August 1538. In his publication of the portrait of Giulio (*op. cit.*, 172–6) Shearman implies the likelihood of a date in the late 1530s for it.

336. 20. Traditionally attributed also to Giorgione; restored and added to later by Bonifazio (and others).

337. 21. A related painting is in the collection of Count Seilern in London. See W. Suida, *Belvedere*, XII (1934–5), 90–1, for observations on the relation of pose to a Campagnola engraving dated 1514.

22. Some examples of female half-lengths of this time of special merit are: Alnwick Castle, *c.* 1520; Hampton Court, *c.* 1523; and Berlin, *c.* 1524–5 (this is the same sitter who was the model for the *Fitzwilliam Venus*). A portrait of a courtesan (Chicago, Art Institute) which post-dates 1525 indicates how soon Palma left off this demanding mode.

23. E.g. *Francesco Querini* (Venice, Querini-Stampalia), 1528; *Courtesan* (Milan, Poldi-Pezzoli); '*La Schiavona*' (formerly Rome, Barberini Collection).

338. 24. A painting, now lost, done for a church in the Valle Seriana in the Bergamasco, was dated 1514.

339. 25. Portraits that Cariani painted in the span of this decade show the same evolution, from the retardataire but strong style of the *Giovanni Benedetto da Caravaggio* (Bergamo, Accademia, *c.* 1518) and the group portrait of the Albani family (Bergamo, Count

Roncalli, dated 1519) or the *Nobleman* (London, National Gallery, *c.* 1522) to the more chiaroscuro manner of the *Gentleman with a Letter* (Ottawa, National Gallery, *c.* 1525) and the essentially dependent Palma–Titian mode of the signed and dated *Man* (Venice, Accademia) of 1526 and the so-called *Schiavona* (Bergamo, Accademia, towards 1530).

340. 26. Our first notice of Savoldo's presence in Venice is in documents of 1521, in which, however, he is paid for coming from Venice to work in Treviso. Cf. A. Boschetto, *G. G. Savoldo* (Milan, 1963), 60.

27. If there is a real and not a fortuitous affinity to Florentine example, it is to that of the latest Ghirlandaio and to the early Cinquecento products that depend on him, as, e.g., those of Granacci.

28. A remade *cartellino* carries the date 1570, which has been interpreted to mean 1510. It should be observed that the chronology of Savoldo is much argued: see the contrasts in dating between C. Gilbert, *Savoldo* (diss., New York University, 1955), and Boschetto, *op. cit.* The dates given here should be taken with due reserve.

341. 29. It is universally recognized that Savoldo's Louvre painting is a 'paragone' picture, related to the lost work of the same kind by Giorgione.

343. 30. The lighting and the theme originate in a painting of the early twenties by Romanino, to which Savoldo gives (despite the talk of 'proto-Caravaggism' in Savoldo's picture) a less popular-realist appearance.

31. Authentic replicas are in London, National Gallery, Florence, Contini Collection, and Berlin; the latter two do not in my opinion pre-date 1535. The London version, to my mind the best, is probably towards 1540.

344. 32. Letter of Pietro Aretino, *c.* 1548; cf. Boschetto, *op. cit.*, 63.

33. The relation to Pordenone does not occur earlier; there seems to be no justification for Berenson's description (*Venetian School*, 1957, 96) of Licinio as a 'pupil' of Pordenone.

345. 34. Licinio had a nephew, Giulio, who worked as his principal assistant, apparently as early as 1532, and in a style that is completely indistinguishable from his uncle's. After Bernardino's disappearance from the scene, Giulio had a long independent career as a mediocre painter, succumbing first to the Romanist influence in Venice (tondi in the library of S. Marco, 1556) and then to Veronese. In 1559 he went to Augsburg, and in 1565 was appointed painter to the Emperor Maximilian. Giulio worked for nearly a decade in Austria, returning to Venice in 1573. He then went back to the north, to the court of Rudolf II at Prague, where he was last heard of in 1591.

35. Despite the assertion in Ticozzi, *Vite dei pittori Vecelli* (1817), that he was born in 1475.

346. 36. It is likely that the *Miracle of the Miser's Heart* in the Scuola del Santo in Padua, adjoining Titian's fresco there of the *Speaking Babe*, is by Francesco at about the same time. Cf. G. Fiocco, *Arte Veneta*, IX (1955), 73.

37. Often dated as early as 1530, or (e.g. Berenson, *Venetian School*, 1957, 194) 1530–5, but the motifs in the organ shutters depend on inventions of Titian made as late as the middle forties.

347. 38. Fiocco, *Arte Veneta*, XI (1957), 2 ff., has assigned to Francesco a *Noli me Tangere* at Oriago (near Bassano) which is in fact by Jacopo Bassano, a replica of a picture at Onara.

39. It has been altered in the upper part, like the other pictures by Bonifazio from this place; the original shape conformed to the vaulted architecture of the room. It is possible that the date on this picture indicates its year of commission; the execution may be somewhat later, *c.* 1535.

349. 40. There is a still antecedent moment of Paris's painting that we may be able to identify, in the vein of Titianesque *Giorgionismo*, represented by the attribution to him of the *Apollo and Daphne* panel in the Venice Seminario, often falsely assigned in earlier literature to Giorgione. See G. Canova, *Paris Bordone* (Venice, 1964), 114–15, following a proposal made by Pallucchini.

351. 41. A portrait dated 1532, the so-called *Cavaliere Attaccabrighe* (formerly Vienna, Liechtenstein Collection), is strongly Lombard-influenced, with an illusionistic texture like that in a Romanino. However, the air of elegance that posture and design convey are not Brescian and may not even be Titianesque: it may be that Paris here reflects some knowledge of the early Mannerist portrait style of Central Italy or of Parmigianino.

42. See Canova, *op. cit.*, 17 ff., for her determination of the dating. Our interpretation of the importance of this picture depends on the accuracy of this date, which seems justified on both internal and external grounds.

43. On a lesser scale there had been something like this in Titian's Treviso *Annunciation* in particular, on which Bordone must often have meditated and which must have played a role in his idea of design for the *telero*.

44. Serlio was in Venice in 1534 and. before that in 1532; one small motif only can be linked to an illustration in Serlio's *Second Book*, which, however, was not published until 1545. Canova, *op. cit.*, 21, speculates that Bordone may have seen Serlio's drawings.

An influence for this kind of architectural setting could also have come from German pictures in the style of Altdorfer.

352. 45. Cf. Canova, *op. cit.*, 28 ff.

46. An artist who is rather mysterious to us appears in Venice before 1530: Sante Zago, mentioned by Pino and Dolce as a fresco painter, façade decorator, and student of the antique; all works of this kind by him have been lost. Boschini refers to him as a pupil of Titian, and C. Gilbert, in *Arte Veneta*, VI (1952), 126 ff., has proposed the attribution to Zago of a group of works of which the style, rather like that of the early Bonifazio or of Bordone in the earliest twenties, is closely dependent upon Titian. These include the *Tobias and the Angel* in the Accademia at Venice, from S. Caterina, which Boschini had assigned to Zago. Zago is last mentioned in 1557.

CHAPTER 6

355. 1. A curious and idiosyncratic device (apparent ever since the 1517 prints) by which Campagnola seems to seek to give forms energy and interest by means of disarticulating foreshortenings is very apparent in his Santo frescoes, and it is more so in the *Madonna with St Catherine and St George* (Philadelphia, Museum, Johnson Collection, of a near date to the Santo fresco), where it is conceivable that some justification like that of a high place originally intended for the picture may exist.

356. 2. Marcello Fogolino, a Friulian by origin, worked in Vicenza in his earlier career, in the late teens and twenties; see p. 357.

357. 3. Girolamo di Tommaso is to be distinguished from Girolamo Pennacchi da Treviso, called the Elder, who, however, seems not to be related.

Because he was of Friulian origin, mention should be made in this native context of Giovanni da Udine (Giovanni Nanni, 1485 Udine–1561 (?) Rome), a pupil of Giovanni Martino da Udine, whose career illustrates even more obviously the inclination (or necessity) of the best Friulian painters to work elsewhere. We encountered Giovanni earlier as a major helper in the Raphael shop in Rome, where he came to specialize in stucco-work (of which he had reinvented the antique technique) and grotesquerie. He afterwards worked mainly in the decorative mode which he helped to create in the Raphael Logge, in Rome for most of the 1520s and early 1530s, then in Florence *c.* 1532–3, where he did work, now lost, in Michelangelo's sacristy of S. Lorenzo. In the following years of his long career he was at least based on his native town (where he married in 1535, and in the

course of time fathered ten children), but worked much in Venice (e.g. in the Palazzo Grimani, 1536–40) and sporadically in Rome. He returned to Rome about 1560 to work in the west wing of the Vatican Logge, and died in that city, probably in 1561 (though some reports give the date 1564).

4. A group which R. Longhi, *Officina Ferrarese* . . . (1956 ed.), 162, re-assigned, in my opinion incorrectly, to Savoldo; he was contested in this by L. Coletti, *La Critica d'Arte*, I (1936), 172–80, but followed in the latest Savoldo monograph of A. Boschetto (Milan, 1963). F. Boccazzi, in *Arte Veneta*, XII (1958), 70–8, corrects this misconception; see also Berenson, *Venetian School* (1957). The last picture in this group, the *Noli me Tangere*, on account of its presence in Bologna, belongs most likely to the first moments of Girolamo's transfer there.

358. 5. One of the more curious incidents in Longhi's mistreatment of Girolamo (beyond his transfer of the early pictures to Savoldo) is the insertion (*op. cit.*, 84, figure 257) of a *Madonna Enthroned with Saints* (Glasgow, Gallery) into the corpus of the earliest Dosso Dossi: the Glasgow picture is, in my opinion, a fine work by Girolamo in his last, Maniera, phase.

359. 6. Previtali died in 1528, and his activity in Bergamo was thus about coincident with Lotto's. A useful index of Previtali's paintings done in Bergamo, with their dates, is in Berenson, *Venetian School* (1957), I, 147 ff.

7. See Chapters 2 and 5. Conspicuous among the Bergamasques in Venice were Palma, Cariani, and Francesco and Girolamo da Santacroce.

360. 8. Three artists of some ability who worked in Brescia in the earlier sixteenth century began in a position that was more or less dependent on the art of Foppa and held to it for much of their careers, yielding only slowly and uncertainly to the Cinquecento styles that displaced his. They are Vincenzo Civerchio, born in Crema near Milan in the 1460s, but who worked in Brescia mostly from *c.* 1490 until the last years of the fourth decade; Floriano Ferramola (*c.* 1480–1528), younger than Civerchio but still more resistant to essential change; and Foppa's nephew Paolo de Caylina the Younger (*c.* 1495–after 1545), in view of his age the most susceptible to a variety of newer influences, but still only superficially.

9. Cf. the quotations from Bellini's S. Zaccaria altar.

10. In 1512 conditions in Brescia were particularly disturbed by an unsuccessful revolt against the French, who temporarily, between 1509 and 1516, took the city from the Venetians.

362. 11. Cf. M. Gregori, *Paragone*, no. 69 (1955), 17 ff.

12. See, e.g., the very Bramantino-influenced fresco at Tavernola of *c.* 1515.

13. We have observed that Lotto's change in style *c.* 1520 may be partly indebted to Romanino; the S. Francesco altar is one of the likely vehicles of influence on Lotto's altarpieces of 1521.

364. 14. Despite questions raised in past literature, the documents and the visual evidence do not allow serious question of the division of responsibility between Romanino and Moretto in the Cappella del Sacramento. Romanino's responsibility was for the paintings (all canvases) on the west wall of the chapel, Moretto's for those on the east.

367. 15. Moretto's first definite notice as a painter is precocious, when he is described as 'magister' in 1516; in 1516–18, subcontracting for Ferramola, he painted the *St Faustinus and St Jovita* on the organ wings then in the Duomo Vecchio at Brescia (now Lovere, S. Maria in Valvendra).

368. 16. The usual association, based on Savoldo's age rather than our exact knowledge of his chronology, is that he influenced Moretto, which at first seems to have been true; however, there is a good likelihood that once Moretto had attained his precocious maturity the course of influence may have been reversed; cf., e.g., the date of the *Assunta* and the probable date, towards 1530, of the altar by Savoldo which most resembles it (Milan, Brera).

As a portraitist Moretto is in general dependent on the formulae of Romanino, which in turn had been derived from Titian. In 1526, however, Moretto was responsible for an invention in Italian portraiture, the first full-length Italian portrait that we know (London, National Gallery); apparently he was adapting precedents available to him in German models. But it is doubtful whether this picture had any effect outside Brescia, and Titian 're-invented' the format for Italy, again on the precedent of German models, in the early thirties.

373. 17. We have no knowledge of Altobello's birth date, but it is likely to have been towards 1490. We do not know when he died, and a most uncertain corpus of work has been assigned to his supposed later years. I know no acceptable attribution that can be dated beyond *c.* 1535.

375. 18. As in Boccaccino's frescoes in the Duomo, there is continuing Emilian influence in Altobello's, most probably from Aspertini and Mazzolino. The precedent of Bembo's frescoes in the Duomo is also relevant, though not to the same degree.

376. 19. Attributed, in my opinion incorrectly, to Altobello in *Mostra di Girolamo Romanino* (Brescia, 1965), 164 and figure 156.

377. 19a. G. Bora, *Paragone*, no. 295 (1974), 41–2, has established that the date on the Cistello altar, which now reads 1525 (and is so reported in the literature), should be 1527, and was so given in the older guides. The artist's presence in Venice is documented apparently throughout the year 1525.

379. 20. The possibility exists, and is suggested by the design of the *Adultera* fresco, that Camillo may have visited Florence or Rome, but prints (and knowledge of Mantua) could account for the seemingly specifiable Central Italian elements in this work.

21. A date on it, no longer legible, is alleged to have read 1530, but this would seem not to be admitted by the style of the picture.

382. 22. The attribution to Ambrogio of portraits that seem more nearly to penetrate the sense of Leonardo's style (e.g. *Francesco Brivio*, Milan, Poldi-Pezzoli) has been seriously contested in recent years. Cf. F. Russoli, *La Pinacoteca Poldi-Pezzoli* (Milan, 1955), 154–5.

23. The fragment of a late altar with a pair of donor portraits (Milan, Brera) is as much Bramantinesque as Leonardo-like in style. It has recently been reassigned by M. Gregori, *Paragone*, no. 69 (1955), 28, to Bembo, in my opinion incorrectly.

383. 24. It is uncertain whether this painter is to be identified with Gian Pietro Rizzi or Giovanni di Pietro di Como.

25. The sole signed work by Melzi, a portrait (Milan, Gallarotti-Scotti Collection, 1525), does not justify the reputation assigned to him by Lomazzo, and still less the attributions (W. Suida, *Leonardo und sein Kreis*, Munich, 1929, 230 ff.) of Leonardesque works of quality such as the *Vertumnus and Pomona* (Berlin, Museum).

26. The elaborate landscape in this picture, full of Flemish motifs and very fine in handling of detail, is (according to Lomazzo) the work of one Bernazzano, a collaborator of Cesare who may actually have been Flemish.

385. 27. The most enduring persistence of the Milanese tradition of Leonardism is in the work of Cesare Magni, a painter of minimal talent who was a follower of Cesare da Sesto, and who continued his manner, ever less faithfully and more ineptly, until the mid century.

390. 28. The later Foppa and Bergognone are the main sources of this style, but it also bears some resemblance to the late Quattrocento Veronese Girolamo dai Libri, and to Cima also.

392. 29. As is assumed of Defendente and the youth-

ful Sodoma, Gaudenzio's first education is most likely to have been in the shop of Spanzotti, in Vercelli.

30. It is not certain whether Gaudenzio was engaged at the Sacro Monte in an earlier and much less important campaign of decoration. The major work at this sanctuary began with the campaign of 1517, in which Gaudenzio was the principal artist, and probably the sole designer, of the terracotta sculptures as well as the paintings that accompany them.

393. 31. The apparent order of Gaudenzio's chapels (G. Testori, in *Mostra di Gaudenzio Ferrari*, Milan, 1956, 29 ff.) is: Pietà, *c.* 1517; Crucifixion, shortly after 1520; grotto of the Nativity, Adoration of the Shepherds, Visitation, all before 1526; Adoration of the Magi, 1526–8.

Rather than a life of Christ, the original intention at the Sacro Monte was the recreation of a New Jerusalem with its 'loci santi'. The change of emphasis occurred only in the 1560s.

397. 31a. Though Luini had made a beginning of some sort in the cupola: a cleaning in the 1950s uncovered sinopie and graffiti by Luini for some two dozen putti in the topmost range. There is no way of determining what Luini's contribution may have been to the invention of the scheme Gaudenzio developed here.

32. For an extended account of Gaudenzio's influence, see A. Griseri, in *Mostra di Gaudenzio Ferrari*, 121 ff.

398. 33. Nevertheless, there is no element of a Giorgionesque or Titianesque appearance in his art, nor of Bellinism either, that could not be explained as resulting from a study of Venetian imports to Ferrara. Vasari (VI, 468) described Garofalo as Giorgione's friend. Perhaps this friendship dated from a visit of Garofalo to Venice, but if the theory that we support of the Emilian origins of Giorgione's style is true, their friendship could have been formed earlier. The Giorgione-like qualities of Garofalo's early works do not require his knowledge of the former's art after the *Trial of Moses*.

401. 34. Two of the predella scenes of this altar are frequently attributed to Dosso, as by A. Neppi, *Garofalo* (Milan, 1959), 24.

402. 35. In a way that suggests full acquaintance not only with Giulio's Mantuan works to date, but with his painting in Rome; however, no old source speaks of any early Roman voyage by Girolamo.

404. 36. In addition to his other artistic activity, Girolamo was a busy portraitist. In a first moment his portraits show the influence of contact in Bologna with Parmigianino's models (*Archbishop Bartolini-*

Salimbeni, Florence, Pitti, 1532; *Portrait of a Lady,* Hampton Court). Longhi, *op. cit.,* 167 note, suggests that Girolamo may also be the author of a group of portraits long attributed to Parmigianino, of which the principal example is the so-called *Girolamo de' Vincenti* (Naples, Capodimonte). Girolamo's later portraits assume a more rigid and literally descriptive mode.

37. We have had occasion to observe before (cf. Chapter 4) that some of the motifs and effects of Mazzolino's and Aspertini's styles are like those that may appear in the first experimental phase of the new Mannerism, but that they should be historically distinguished, because the Cinquecento classical style is a prerequisite of the formation of true sixteenth-century Mannerism, and in the first two decades, when the art of Mazzolino and Aspertini seems most like an anticipation of things to come, Cinquecento classicism has no part in it.

405. 38. Though L. Grassi, *Arte Antica e Moderna,* XXV (1964), 54, prefers to date it later, *c.* 1512–15, on grounds of style only.

407. 39. The nearest analogy to the style of this painting is in Giovanni Francesco Bembo's fresco of the *Adoration of the Magi* (1515) at Cremona. Aspertini's influence on Bembo is a possibility.

40. The assumption in the older literature (e.g. C. Ricci, *L'Arte,* XVIII, 1915, 87) that Aspertini was in Rome between 1516 and 1525 is based on a mis-dating of two Roman sketchbooks by Aspertini in the British Museum. For a correct dating of these, see P. Bober, *Drawings after the Antique by Amico Aspertini* (London, 1957), 11 ff.

41. Cf. Bober, *op. cit.,* 15.

409. 42. Aspertini was a sculptor of some talent also, working especially in the decoration of S. Petronio. See Ricci, *op. cit.*

411. 43. For which see especially S. Béguin, 'Niccolò dell'Abbate en France', *Art de France,* II (1962), 112–44. Niccolò's later Italian career also includes distinguished contributions as a portraitist, but the literature has too frequently confused his works in this genre with those of Parmigianino, which they indeed resemble. Typical examples of Niccolò's developed portrait style (from his Bologna phase) are the *Young Man with a Dog* (Rome, Galleria Nazionale) and the *Young Man with a Parrot* (Vienna, Kunsthistorisches Museum), both recognized as Niccolò's, and the *Young Lady* (New York, art market) published by L. Fröhlich-Bum, *Pantheon,* XVIII (1960), 114, as a work by Parmigianino.

44. A moderately able native Parmesan, Cristoforo Caselli (d. 1521), worked mainly in Venice.

412. 45. Cf. A. G. Quintavalle, *Boll. d'Arte*, L (1965), 195.

46. The sixth on the left, assigned in the older literature to Parmigianino, is now more generally taken as Anselmi's.

47. A. G. Quintavalle, *Anselmi* (Parma, 1960), 23, publishes for *St Benedict Enthroned*, one of the frescoes in the transept semi-dome of S. Giovanni Evangelista, the discovery of a date of 1521, and concludes that this confirms the proposition (first put forward by Roberto Longhi) that Anselmi is the agent of transmission to Parmigianino of the vocabulary of the earlier Tuscan Mannerism; Anselmi thus becomes the 'cause' of the Maniera tendencies visible in Parmigianino's painting since his Bardi altarpiece of 1521. Were the date of this *St Benedict* in fact 1521, there would be some justification for this proposition. However, the style of the fresco is so radically disparate from the grotesques in S. Giovanni Èvangelista of (according to Signora Quintavalle's evidence) 1520 that it would seem most unlikely that it was painted in the next year. Furthermore, unless we are willing to concede that much not only of Parmigianino's repertory but of Correggio's as well is taken from Anselmi, we must recognize that major motifs in the *St Benedict* require the precedent of Correggio's finished cathedral dome (the flying putti) and the *Giorno* altar (the canopy behind the Saint). The date of 1521 – if it is in truth that, and not a mutilation or restoration – whatever it applies to, does not apply to the fresco; it would make sense for the *St Benedict* if it read 1531, but not 1521.

415. 48. In which the landscape is adapted from Parmigianino's *Madonna di S. Zaccaria* of *c.* 1530, and which may make reference in motifs to Parmigianino's earliest painting, his *Baptism* of 1519.

49. At that time Parmigianino received a partial posthumous revenge on Giulio, for Anselmi seems to have referred for what was 'reformed' to Parmigianino's old design (Parma, Gallery); cf. S. Freedberg, *Parmigianino* (Cambridge, Mass., 1950), plate 105a.

416. 50. We have no dependable information on the time of Bedoli's birth, which is usually stated, without evidence, to have been *c.* 1500.

418. 51. A. Popham, *Master Drawings*, II (1964), 245.

I am indebted to Miss Ann Millstein for clarifications in this edition of Bedoli's early chronology and for items of new documentary evidence on which some revisions have been based.

CHAPTER 7

422. 1. Some of the general remarks which follow are adapted from S. Freedberg, 'Observations on the Painting of the Maniera', *Art Bulletin*, XLVII (1965), 187–97.

423. 2. Cf. C. Smyth, 'Mannerism and Maniera', in *The Renaissance and Mannerism* (Princeton, 1963), II, 174 ff., and in book form, New York, 1963 (?).

426. 3. Cf. Dolce, *L'Aretino* (1685 ed.), 264.

427. 4. Cf. Vasari, dedication to the first edition of the *Lives* (1550), and in the second edition, I, 243 (in the *Proemio Generale*), and more important the tone of language in which he estimates his own Florentine Academy, VII, 593 ff.; also Dolce, *L'Aretino*, of 1557 (1685 ed., 304); Armenini, *Veri precetti* (1587), 12; Lomazzo, *Idea del Tempio*, of 1590 (1947 ed., 27 and 31).

429. 5. Letter to Bartolommeo Concino, VIII, 421.

6. The decrees of the Council in respect of art specified that the point of religious images is to instruct the faithful and confirm them in the practice of their faith; the use of images that may contain false doctrine or may encourage error is forbidden. It is further specified that images shall not encourage superstition; that they shall conform to the requirements of modesty as well as moderation; and that no image of an extraordinary or unaccustomed kind shall be exposed in church without the express permission of the Bishop.

430. 7. In two of the tondo panels of Evangelists in the vault. These are variously identified, but are best taken (see J. Cox Rearick, *Master Drawings*, II, 1964, 369) as the *Mark* and *Luke*.

431. 8. Though he was summoned by Pontormo in 1532 to assist him in the scheme for the second phase of the fresco decoration at Poggio a Cajano, then not executed; but in 1535–6 Bronzino did assist Pontormo intensively in the execution of his decoration, now lost, at the Medici Villa at Careggi and also helped him in his subsequent decoration at the villa of Castello.

9. The *Lutanist* (based on a figure design in a drawing in the Uffizi assigned to Pontormo as a self-portrait, but for which more recently Bronzino's own authorship has been suggested) had already quoted, in its figure posture, the Medici *Giuliano* – the first among a host of such Michelangelo quotations in Florentine Maniera portraiture. More obliquely derived from the tombs is the idea of an architectural setting of fine, nervous profiles to support the design and augment the pitch of content.

433. 10. Cf. A. Emiliani, *Bronzino* (Milan, 1960),

comments to tavole 33 ff., for an exposition of C. H. Smyth's and E. Sanchez' investigations concerning the chronology of the Eleonora Chapel, which in the older literature had been dated significantly later. Bronzino's preparatory studies for the chapel are discussed by J. Cox Rearick, *Revue de l'Art*, no. 14 (1971), 7–22.

435. 11. Which Bronzino would not at this time have known directly.

It is not certain that Bronzino's *Brazen Serpent* was completed during 1542. The third main fresco in the chapel, *Moses striking the Rock,* may be significantly later in date. Cf. Emiliani, *loc. cit.*

12. Sent to Cardinal Nicholas de Granvelle in France after its completion and before August 1545. The replica substituted by Bronzino in the chapel (*in situ*) was not painted until 1553.

13. The most nearly convincing iconographic explanation, based on Vasari's reading of the picture, is the recent one of M. Levey, in *Studies in Renaissance and Baroque Art presented to Anthony Blunt* (London and New York, 1967), 30–3.

Miss S. J. Finsten has observed that there is a recollection in the *Venus, Cupid, Folly, and Time* of Michelangelo's Doni Tondo, oblique yet sufficiently apparent to be evident not only in motifs and character of form but in the inversion of the Doni Tondo's content.

437. 14. Cf. F. Zeri, *Boll. d'A.*, XXXVI (1951), 140.

15. The sole painting of Florentine origin attributed to Salviati in this early period is a *Madonna and Child* (Hampton Court, no. 139) which is in effect a Sarto shop-piece, made from a stock design. Early drawings by Salviati indicate that Bandinelli's influence may have been more considerable and lasting than Andrea's. See I. H. Cheney, *Francesco Salviati* (Ann Arbor, University Microfilms, 1965), 2–3.

438. 16. The responsibility for the invention of the basic scheme of decoration is uncertain, but in view of Jacopino's earlier employment it is likely to be his. It is not noteworthy for its originality (though its details of elaboration are interesting). Its Florentine origin in (the original form of) Sarto's analogous decoration in the Chiostro dello Scalzo is obvious.

17. Cf. the Raphaelesque *Canephore* on the left of Salviati's fresco, who is modified according to the precept of Perino in the angel of the *Annunciation* in the Cappella Pucci. There is as yet no clear indication of the influence of Parmigianino. However, there are Florentine recollections: from Rosso, from Sarto, and, surprisingly, from Ghirlandaio.

439. 18. Cf. I. Cheney, *Art Bulletin*, XLV (1963), 337 ff., and M. Hirst, *Z.K.*, XXVIII (1963), 146 ff., for

two excellent though slightly divergent accounts of Salviati's Venetian stay. Cheney establishes with clarity that the consequences for Venetian painting of Salviati's stay were not significant; he was not, as the literature has assumed, a major factor in the introduction of Mannerism in Venice. Salviati's other surviving works done in Venice are in fact not consistent in their style: see the recently rediscovered *Pietà*, once in the church of Corpus Domini in Venice and now at Viggiù near Milan, which indicates the influence of Venice on Salviati rather than vice versa. Another work of more consequence, a *Madonna and Saints* done for S. Cristina in Bologna (*in situ*, but painted in Venice), is a compendium of influences from Parmigianino, the Florentine Rosso, and the conservative factors in current Bolognese painting.

440. 19. Only the east, long, wall of the room remains in good condition. The rest is either unfinished or disfiguringly overpainted or, in places, both.

442. 20. A tentative list follows of Jacopino's pre-Roman works (of which the basis was assembled by Zeri, *Proporzione*, 11 (1948), 180 ff.): *Foundling Madonna* (Florence, Innocenti), *c.* 1530–1; *Madonna with St John* (New York, art market), *c.* 1532–3; *Madonna with St John* (Florence, Uffizi, deposit), 1533–5; *Madonna with St Elizabeth and St John* (Florence, Contini), *c.* 1535–6 (and thus perhaps Roman). A *Madonna with Saints* (formerly Milan, private collection) similar in composition to the Florence pieces is more likely, as Zeri, *op. cit.* (1951), 142, points out, to be a Roman work. The famous *Three Fates* (Florence, Pitti), often attributed to Salviati, is proposed by Zeri to be Jacopino's; if so, its time of origin is not so surely still in Florence. The altar of S. Anna dei Palafrenieri, done in collaboration with Leonardo da Pistoia, must follow almost immediately on Jacopino's arrival in Rome.

21. Cf. Hirst, *Burl. Mag.*, CVIII (1966), 402, who makes the suggestion that Perino's study was not drawn *ad hoc* for Jacopino but was a cast-off from Perino's unexecuted project for the chapel of St George and St John the Baptist in Pisa Cathedral. It should be noted that the Sarto reminiscence (from the Scalzo frescoes) in Perino's design is made more explicit by Jacopino.

444. 21a. Cf. J. Weisz, *Burl. Mag.*, LXXIII (1981), 355–6.

22. Jacopino's famous portrait of Michelangelo (Paris, Chaix d'Estanges Collection) must pre-date the Florence visit, since their friendship ceased at that time. The break was caused by reports to Michelangelo of slanderous remarks that Jacopino had made about him in Florence, presumably about his work at

St Peter's, motivated by Jacopino's relationship (of a brother-in-law) to the architect Nanni di Baccio Bigio.

23. Not only the S. Felicita altar but even more expressly the Carmignano *Visitation* has been taken as a model for motif and style.

445. **24.** The written programme of Vasari's own invention for the picture's iconography survives; see P. Barocchi, *Vasari pittore* (Milan, 1964), 113.

This work is a very early instance in painting, perhaps second only to Parmigianino's *Charles V* (New York, art market, formerly Cook Collection), of the state portrait in which it is the effort of the artist to describe by symbols the station and the function of the ruler rather than his person and personality. Michelangelo's Medici Dukes are similar in a sense, but without no such current and topical meaning either as a proper portrait or as a 'state portrait'. In Parmigianino's case the negation of personality is part-accident (for the circumstances of Parmigianino's painting the Emperor, see Vasari, v, 229), but in Vasari the negation must be deliberate, since he knew Alessandro well.

446. **25.** Vasari has left a letter (see B. Davidson, *Art Bulletin*, XXXVI, 1954, 288–9) in which he explains the feelings (connected with Duke Alessandro's assassination) that the subject of his *Deposition* in Arezzo inspired in him. It is significant that what he felt is given poignantly enough in words but not in the picture.

26. The latter again apparently in response to Salviati's lead; Salviati was briefly with Vasari while en route to Venice.

27. Begun by his cousin and assistant, Stefano, on the basis of a design by Vasari before his definitive return from Bologna. The execution is, however, mostly Giorgio's own, following his return in June 1540.

447. **28.** Cf. J. Schulz, *Burl. Mag.*, CIII (1961), 500 ff., for the best account of Vasari's Venetian visit. In Venice Vasari created an important but ephemeral theatre decoration for a production of Aretino's *La Talanta*, painted a ceiling (now dismembered) for the Palazzo Corner-Spinelli, and was commissioned by the Florentine community to do another, for the church of S. Spirito; this latter work, left undone by Giorgio, was shortly to be taken in hand by Titian.

29. In Arezzo for a while in 1542, Vasari began the decoration of his own house there. His early gentlemanly education and the status he had recently acquired – which, in his writing, he was to strive later to justify for artists in general – promoted the idea that his own environment should not be less distinguished than that of his patrons. This decoration occupied him intermittently, mainly during this decade, and grew into a prime example of Maniera decorative devices and a rich compendium of allegories of the arts. Later, after 1557, Giorgio devised an equally handsome decoration for the *salone* of his Florentine house at Borgo S. Croce No. 8.

448. **30.** According to Vasari himself, the *Vite* were begun in 1546, but evidence suggests that he had been compiling his material since about 1540. The book was ready to be 'copied out' in 1547 or 1548 at the latest. The first edition was published in 1550; the second, much revised, in 1568.

450. **31.** Vasari somewhat confuses the logic of the *ricetto*, but also turns the interior space into a simulacrum of a piazza from which we mount by stairs into another space.

451. **32.** The Quartiere di Eleonora, decorated in 1561–2 (connected to the Quartiere degli Elementi on the same floor), completes the main set of apartments in the palazzo; its main executant was Giovanni Stradano.

33. When the programme was submitted to Duke Cosimo he felt compelled to ask that Vasari insert '. . . in ogni historia qualche motto o parole, per maggiore espressione del figurato' (letter, 14 March 1563); see A. Lensi, *Palazzo Vecchio* (Milan, 1929), 204.

453. **34.** After Vasari's death their manufacture continued until 1588. See M. B. Hall, *Art of the Counter-Maniera in Florence; the Renovation of S. Maria Novella and S. Croce* (diss., Harvard University, 1967), for a full treatment of this important subject.

461. **35.** See the analysis of the S. Lorenzo material in J. Cox Rearick, *Pontormo* (Cambridge, Mass., 1964), where the matter from Pontormo's late diary that is relevant to the frescoes is also presented.

463. **36.** Tosini may well be the author of a portrait of earlier date (*c.* 1545–50?) of a young man in the City Art Museum, St Louis, of which the attribution is disputed between him and Salviati.

464. **37.** Pier Francisco di Jacopo di Domenico, but also correctly called 'di Sandro', incorrectly known until recently by the surname Toschi. See D. Sanminatelli, *Paragone*, no. 91 (1957), 56 ff., for a clarification of the name.

38. Foschi also worked, apparently extensively, as a portraitist. A dated but unsigned painting of 1540, a *Man holding a Letter* (Florence, Corsini), is a key work in his portrait œuvre, and convincing attributions include several pictures earlier given to Sarto, Puligo, and Pontormo. For Foschi's portraiture, see C. Gamba, *Boll. d'A.*, IV (1924), 193, R. Longhi, *Paragone,* no. 43 (1953), 51–5, and H. Voss, *voce* in Thieme-Becker. I should like to suggest that the

Portrait of a Lady with a Basket of Spindles (Florence, Uffizi), often attributed to the early Pontormo or to Puligo, may be by Foschi in a still Sartesque phase.

Jacopo di Giovanni Francesco, called Jacone (d. 1533), was another of the lesser Sarto pupils of this generation whose work (or a small surviving part of it) we can identify. His principal remaining painting is an altar in S. Maria Nuova at Cortona, in a style that represents the slightly mannered form that Sarto's vocabulary took in the hands of his most faithful followers in the course of the fourth decade.

467. 39. Signed and dated by Mirabello in 1568 (cf. W. and E. Paatz, *Die Kirchen von Florenz*, Frankfurt, 1952–5, V, 252) is a *St Thomas Aquinas* altar for the Florentine Congregazione dei Contemplanti dei Nobili. The theme of this picture, in which the Saint is surrounded by portraits of the Congregation, gives it a peculiar Counter-Reformational effect.

469. 40. The 'genre' and 'realist' effects in Mirabello's Studiolo pictures should be distinguished from those in Stradano or his imitators there. What seems true in Mirabello is the result of his seeing truly, while Stradano's paintings do little more than illustrate genre themes with Maniera conventions.

41. Michelangelo had already revisited Rome twice since 1532 before finally settling there in September 1534. It was most likely in 1532 that he formed his attachment for Tommaso Cavalieri, for whom he did the series of drawings (*Ganymede, Tityus, Phaeton,* and the *Bacchanale of Putti*) now named after him. The *Archers* (Windsor Castle), usually considered one of the Cavalieri drawings, is not such; cf. A. Popham and J. Wilde, *Italian Drawings of the XV and XVI Centuries . . . at Windsor Castle* (London, 1949), no. 424.

471. 42. To gain this unbroken extent Michelangelo eradicated two of his own prior *Ancestor* lunettes from the ceiling decoration as well as Perugino's older altarpiece.

43. Masking draperies were applied by Daniele da Volterra between 1559 and 1565, in response to characteristic Counter-Reformation censure.

44. C. Tolnay, *Art Quarterly*, III (1940), 125 ff., and *Michelangelo*, V (Princeton, 1960), 37–8, finds the Christ of the fresco an analogue of Apollo–Helios.

473. 45. There are, in fact, self-quotations in the *Judgement* from the repertory of the cartoon.

478. 46. The most valuable contribution to our knowledge of the order of events in Daniele's earlier Roman career is the recent article of Hirst, in *Burl. Mag.*, CIX (1967), 458–509. My account depends on Hirst's researches, though our conclusions as to the order of events do not quite agree.

47. Cf. Hirst, *op. cit.* (1967), for arguments that place the altar *c.* 1545; and B. Davidson, *ibid.*, 553–61, for evidence that convincingly dates the fresco laterals *c.* 1545–8. Davidson publishes drawings that inform us excellently of the appearance of the lost paintings. It is my opinion that Hirst's chronological location of the altar may be slightly later than his evidence requires, and that it may have been done *c.* 1543/4 rather than *c.* 1545. Vasari's report that Daniele worked in the chapel for over seven years is accurate.

480. 48. The group of Maries derives from the motif Michelangelo invented in his *Crucifixion* drawings (e.g. Haarlem, Teyler Museum); the Christ is a modernization of the figure in the *Pietà* in St Peter's; the men lowering Him paraphrase figures in the *Judgement*. There is also a relation to Raphael in the design, to the well-known *Deposition* print engraved by Marcantonio.

483. 49. Among the decorative commissions that fell to Daniele in the late forties was his succession, following Perino del Vaga's death, to the supervision of the Sala Regia in the Vatican (1547–9); see p. 502.

485. 50. Franco's date of birth is given by many authors, probably erroneously, as 1498, for which there is no dependable evidence. Vasari's account of Franco's career indicates that it is more likely that he was born towards 1510 and belonged to the second Mannerist generation.

487. 51. Salviati is most often assigned, probably correctly, the responsibility for the figure composition of the *Beheading of the Baptist*, another of the frescoes of this campaign of *c.* 1550 in S. Giovanni Decollato (though not its actual execution; this is by an assistant so far not certainly identified); while the background is reasonably referred to Pirro Ligorio. Ligorio (Naples 1513/14-Ferrara 1583) is the author of the *Dance of Salome* in S. Giovanni. By this time an archaeologist and architect more than a painter, Ligorio in this fresco demonstrates a set of special interests that are not informative for the situation of painting in Rome about the middle of the century.

490. 52. Completed after Salviati's death by Taddeo Zuccaro.

53. Surely not, as asserted by L. Mortari in *Studies in the History of Art dedicated to W. Suida* (London and New York, 1959), 247, of *c.* 1542.

54. In 1562 Salviati received a commission he had long coveted, for half the decoration of the Sala Regia of the Vatican, but the commission evaporated soon after it was won, when he had executed only part of one fresco. In 1563 Giuseppe Porta Salviati, his former assistant, now a Venetian resident, was called to the Vatican to work in Francesco's stead.

492. 55. Again a retrospective painting, referring to the Rosso (Boston Museum of Fine Arts), to Sarto's lost Puccini *Pietà*, and to Michelangelo.

500. 56. It was Muziano's influence that persuaded Pope Gregory to issue the bull (1577) that permitted the founding of the Accademia di S. Luca.

502. 57. Visiting painters from the north of Europe, always in some measure a factor on the sixteenth-century Roman scene, are more than usually noticeable around the turn into the last quarter of the century. Two of them, Bartholommaeus Spranger (in Rome 1566–75) and Karel van Mander (in Rome *c.* 1573–7), were in the service of Cardinal Alessandro Farnese; Spranger was so expert in the contemporary Italian manner that he competed favourably for altar commissions with the native Romans. Only one of his altarpieces survives, however: a *Martyrdom of St John Evangelist* in S. Giovanni a Porta Latina. Otto van Veen, later to be Rubens's teacher, came to Rome *c.* 1574/5. See F. Baumgart, *Marburger Jahrbuch für Kunstwissenschaft*, XIII (1944), 187–250, for a detailed account.

58. Except by acts of intrusion, the Neapolitan school of painting did not rise any nearer to artistic distinction or identity in the middle years of the century than earlier. Only one painter of apparently native origin, Silvestro Buono (b. *c.* 1520?), of whom little is known (cf. F. Bologna, *Roviale Spagnuolo*, Naples, 1959, 69, note 23), seems to have attained the competence that would entitle him to more than craftsman's status in more northern schools. One of the foreigners who was long active in Naples was not much better: Leonardo Grazia da Pistoia (fl. *c.* 1520–*c.* 1550), by origin a Tuscan of Sartesque stamp, but later involved with the post-Raphaelesque milieu in Rome. In the late 1530s he seems to have moved permanently to Naples, where he practised first in a stiffened and eclectic variant of the post-Sartesque style, timidly mannered, and then in a congealed post-Raphaelism, almost as timid.

Maniera modernity and respectable artistic merit appear together in Naples for the first time after Vasari's important sojourn of 1544/5 in the person of a Spaniard, Pedro Roviale (Ruviale or de Ruviales, 1511?–82?), who in the first half of the fifth decade had been in Rome and exchanged a Spanish mode for one based on Salviati; he had also been one of Vasari's helpers in the painting of the Sala in the Cancelleria. He came to Naples in the later forties and remained till *c.* 1555. His work in Naples exhibits a complete high Maniera fluency formed out of what he had acquired from Salviati and Vasari. However, he was not immune to local influences, and at times recalls the models Polidoro left in Naples, doing so with a grace and power that are not just reflected from that greater master.

The most important representative of mid-century Maniera working in Naples for an extended time was the ex-Sienese Marco Pino da Siena (*c.* 1520–after 1579). Trained first under Beccafumi, he turned to a Roman high Maniera under the guidance chiefly of Perino del Vaga, for whom he worked in the Castel S. Angelo in 1546. He also worked for Daniele da Volterra in 1550 in the Cappella Rovere in SS. Trinità de' Monti, but without effect upon his dedication to Perino's style. Before 1557 he had taken residence in Naples, where he was to stay for the rest of his career (with occasional interruptions; returning, e.g., to Rome *c.* 1573–5 to paint in the Oratorio del Gonfalone). His art soon dominated the Neapolitan school, to which he contributed an extensive production especially of altarpieces that are notable for their facile rhythmical elaboration. A local cast, of suppressed religious fervour encased within hard-shelled forms (effects of Spanish contact?), came to intrude into the painting even of this high Maniera sophisticate. But in addition, his latest works became highly characterized expressions of Counter-Reformation religiosity, and excellent examples of the way in which the vocabulary of the high Maniera could be converted to the ends, at once analogous and opposite, of Counter-Maniera.

CHAPTER 8

503. 1. This commerce was not just of importation into Venice; Titian's travels in the Emilian territory, as well as Pordenone's, were a major factor in their Romanisms.

For an extended examination of the contacts between Venice and Central Italian art *c.* 1540, see especially R. Pallucchini, *Giovinezza del Tintoretto* (Milan, 1950), 36 ff., where the significance of these contacts is discussed; see also the earlier investigation of the problem by L. Coletti, *Convivium*, XIII (1941), 109 ff. Among the Central Italian intrusions into Venice those in the fields of sculpture and architecture should be mentioned, such as Jacopo Sansovino's settling in Venice in 1527, and his inviting Danese Cattaneo and Bartolommeo Ammanati, who became his assistants.

504. 2. E.g. P. Pino, *Dialogo di Pittura* (1548); A. F. Doni, *Disegno* (1549); L. Dolce, *L'Aretino* (1557); and Vasari in the *Vite* of both 1550 and 1568. The subtlest observations are the occasional ones in the letters of the venetianized Tuscan, Aretino.

505. 3. The commission was originally given to

Vasari. There is no indication, however, that any ideas Vasari had for this project may have influenced Titian, and Vasari himself is careful to make no such claim.

507. 3a. The account given by Vasari of the *Danaë* appears to indicate that it was executed during Titian's time of residence in Rome, and this has been the date assigned to it in the literature. However, a letter from Giovanni della Casa to Alessandro Farnese, dated 20 September 1544 (only recently recalled to notice by C. Hope, 'A Neglected Document about Titian's "Danae" in Naples', *Arte Veneta*, XXXI (1977), 188-9), refers with virtual certainty to this painting and describes it as 'presso che fornita' at the time of writing.

4. Michelangelo's comments on the *Danaë* are recorded by Vasari, certainly with some licence, in his life of Titian (VII, 447); Michelangelo makes the expected condemnation of the bad habits of Venetians in respect to *disegno*.

5. Compare especially the portrait by Jacopino del Conte of *Paul and Ottaviano* (formerly Rome, A. Barsanti Collection), illustrated in F. Zeri, *Pittura e Controriforma* (Turin, 1957), figure 2.

6. With help from his sons Orazio and Cesare as well as from the Netherlander Lambert Sustris. Titian soon made a second visit to Augsburg, in 1550-1.

510. 7. I assume their installation as a set, in which the *Diana and Callisto* and the *Diana and Actaeon* would have been opposite: both scenes in which the figures dominate the landscape, the composition of one inverting that of the other. The *Punishment* and the *Europa*, in which the landscapes play a major role, are complementary to the first two paintings in this respect, and to each other in the sense that their similar designs are inverted in direction.

The correspondence between Philip II and Titian in which the 'poesie' are referred to does not reveal that either the patron or the painter had a fixed literary programme for the set: furthermore, it would appear that Titian had no definite idea of where the pictures were to be installed. See A. Cloulas, 'Documents concernant Titian conservés aux Archives de Simancas', in *Mélanges de la Casa de Velasquez*, Madrid, III (1967), 197-288, esp. 233 ff.

515. 8. The theme and composition are based either on Giulio Romano's painting of the subject in the Sala dei Metamorfosi in the Palazzo del Te or on a common antique source.

518. 9. Over and above the vast exemplary value of his published production, the training younger painters received in Titian's shop was a factor of importance in Venetian painting in the third quarter

of the century. His atelier was allowed to participate increasingly in the production of his later years, and its role is often evident (though not in those later paintings we have selected for discussion), as it had not been earlier, when Titian seems not to have left unrevised any preparation or execution on the canvas done by his assistants. Repetitions or variants of works, demanded by Titian's large patronage, were often left entirely to assistants.

The following are some of the identifiable assistants in the large shop in the latter half or so of Titian's career:

Girolamo Dente (called Girolamo di Tiziano, *c.* 1511-after 1566), who was long in Titian's service and apparently specialized in underpainting for the master.

Orazio Vecellio (before 1525-1576), Titian's second son, a barely adequate and entirely dependent imitator of his father's style. He accompanied him on the Roman and German voyages in the forties.

Cesare Vecellio (1521-1601), a distant relative, who joined the shop on the occasion of the first Augsburg trip. After Titian's death his imitative style was influenced by Tintoretto in particular.

Marco Vecellio (*c.* 1545-1611), also a distant cousin. He was particularly useful in the latest years of the shop.

The shop seems to have been especially attractive to foreign painters studying in Venice. Among the northerners recorded as working there are:

The Fleming Giovanni Calcar (*c.* 1499-1550), in Titian's shop *c.* 1540 or somewhat earlier, a figure painter who separately distinguished himself as a portraitist. He worked for some time in Naples, where he died.

The German Emmanuel Amberger (called, in the Italian documents that refer to him, Emmanuele d'Augusta), who joined Titian in Augsburg and must have remained long in his service, since he is mentioned often in the years 1565 to 1570.

The Dutch Dirk Barendsz. (1534-94), in Titian's shop some time after 1555.

Lambert Sustris, also Dutch by birth, became a personality of some importance and requires to be discussed separately.

Not so far as we know an actual member of the shop, Polidoro Lanciano (1515-65) was an almost excessively dependent imitator, whose stature is somewhere between that of a *madonnero* and an artist. He was an Abruzzese who appeared in Venice before 1536 and became a dedicated Titian follower. In 1545 (at the age of thirty) he painted a *Pentecost* (Venice, Accademia) that is a good paraphrase of Titian's

recent style, and which is also responsive to some Romanist ideas. Later, however, he subsided into repetitive imitations of Madonna themes in Titian's mode – not Titian's contemporary mode, however, but one recollecting his models of the second and third decades.

519. 10. Hitherto, the earliest date ventured for this speculative trip to Rome has been Pallucchini's, *op. cit.* (1950), 38: *c.* 1545.

11. The signature reads 'Jacobus, 1540'. Between the name and the date is a device of which the form suggested to von Hadeln, *Burl. Mag.*, LIII (1928), 226–31, the form of a mill-wheel; von Hadeln invented a non-existent painter to fit his reading of the signature.

12. The union of the Venetian and the Central Italian aesthetic in Tintoretto's art was expressed by Ridolfi's famous account – well found if most likely historically untrue – of a slogan Tintoretto is supposed to have hung in his studio: 'Il disegno di Michelangelo ed il colorito di Tiziano'. The origin of this slogan is in a comment in Pino's *Dialogo di Pittura* of 1549.

520. 13. The dependence of the *Conversion* on Titian's *Battle of Cadore* and on Pordenone is obvious. It may also be that some of its motifs derive from the *Battle of Constantine* in the Vatican. This speculation is provoked by the multiple quotations of motifs from Roman sources in the *Christ among the Doctors*, so insistent that they give the effect of Tintoretto's having known the sources, again mainly in the Vatican (the Raphael rooms especially), at first hand.

521. 14. The specific means require some comment. Most important among them Tintoretto tends (not only in this picture) to displace the vanishing point asymmetrically and to raise it high. He imposes the perspective structure on the spectator's attention and gives its orthogonals an effect, at times precipitate, of funnelling. The movement into depth is not scanned but rather contested by the rectilinear stress of forms of architecture, thus making tension. Tension is created further by the repoussoirs that, Tintoretto insists, define the foremost picture plane, but against which the obliquely shifted movement of perspective pulls.

Tintoretto's working method (described best by Boschini; cf. von Hadeln, *J.P.K.*, XLII, 1921, 183–6) facilitates manipulations of this kind. His *concetto* seems to have been worked out less by drawings than by the use of an actual miniature stage, on which wax figures were disposed and appropriately lighted. A perspective floor of this stage could have been so shifted as to set up the desired eccentric movements of orthogonals.

523. 15. *Lettere sull'arte di Pietro Aretino*, ed. E. Camesasca (Milan, 1957), II, 205: April 1548.

16. Not necessarily related (as by S. Levie, *Arte Veneta*, VI/VII, 1952–3, 168–70) to Daniele da Volterra's painting in the Cappella Rovere in the Trinità de' Monti in Rome. Compare instead the well-known print by Marcantonio after the Raphaelesque design for the Cappella Massimi in the Trinità, or the Lotto in S. Michele in Pozzo Bianco, Bergamo.

524. 17. The latter mutilated at the proper right side; it was originally of approximately the same shape as the *Finding*. Compare the old copy illustrated in Venturi, *Storia*, IX, part IV, figure 365. A small sketchlike painting in Brussels is not, as has often been believed, a study for the *Abduction*, but represents another incident of the story. Opinions as to Tintoretto's authorship of it vary, but incline to consider it his, and similar to the executed paintings in date. A third painting, of St Mark's *Rescue of the Saracen* (Venice, Accademia), also belongs to this set.

526. 18. After a competition in the previous year, in which Tintoretto frustrated his rivals by supplying a complete painting for the competition space (a ceiling painting in the Albergo di S. Rocco) instead of the requested modello.

527. 19. The major one of this time is *St Roch in Prison*; its pendant, *St Roch among the Plague-Stricken*, is usually taken to be earlier, of 1549, despite the similarity of style between the two.

20. The iconography has been analysed in a classic article by H. Thode, *Rep. K.W.*, XXVII (1904), 34 ff.

528. 21. Too much has been made in the popular literature of the 'donation' of Tintoretto's paintings to the Scuola, as if they were a free religious offering. The actual arrangement Tintoretto made (only in 1577) with the Confraternity was that he supply three paintings annually to the Scuola until the whole decoration was complete, in exchange for a 'provision' of 100 ducats yearly: a significant discount but not quite a gift.

532. 22. Born at Sebenico. His birth date, according to Ridolfi, was 1522; his date of death has been established by document as December 1563. Since von Hadeln (Ridolfi, *Maraviglie*, ed. von Hadeln, 1914, I, 247, note 1), his birth date is most often set back earlier than by Ridolfi, into the first decade of the century. On internal evidence only it seems to me that Ridolfi may have been about correct, and that Schiavone was an approximate contemporary of Tintoretto. We do not know when he first came to Venice.

535. 23. A son, Federico Sustris, settled in Florence and became a member of Vasari's Academy there. In 1564 he assisted in the *Esequie* of Michelangelo.

24. Dated by D. Westphal, *Bonifazio Veronese* (Munich, 1931), 46, at the end of the thirties or 1540 at the latest; by R. Pallucchini, *La Pittura veneziana del Cinquecento* (Novara, 1944), vii, more reasonably, in the fifth decade. I find it contains too many identifiable Tintorettesque elements to pre-date 1545 at the earliest.

538. 25. There is the possibility that Bordone made a trip to France late in life, *c.* 1559, in addition to the earlier voyage. A *Combat of Gladiators* (Vienna, Kunsthistorisches Museum) seems close in manner to contemporary paintings in France – Caron's, for example. Cf. G. Canova, *Bordone* (Venice, 1963), 61 ff.

539. 26. See Chapter 7, p. 486.

27. Known also as De Mio, Del Mio, and Fratino or Frattini.

28. It should be noted that Giulio Licinio, whom we have met earlier as an imitator of Bernardino Licinio's style, and later as an indifferent Veronese follower, also worked in a pronounced Romanist manner in his tondi of 1556 in the Marciana.

540. 28a. The fresco decorations of the Cappella Sauli were almost altogether destroyed in the Second World War. The altar painting in the chapel, a *Crucifixion*, probably *c.* 1545, remains (illustrated in the exhibition catalogue *Da Tiziano a El Greco*, 1981, no. 27).

541. 29. In particular, A. Veneziano's print after Raphael's *Spasimo di Sicilia* is quoted repeatedly by Jacopo from about this time for some five years.

545. 30. Of the several versions, only the Vienna one seems certainly by Jacopo's own hand. Two small paintings of the same theme, which employ a closely related set of actors and motifs (both Rome, Borghese, nos. 234 and 565), are also Jacopo's own, almost contemporary with the Vienna painting, and more overtly mannered. These were at one time misassigned to Greco.

31. See Verci, the well-informed eighteenth-century writer on the Bassani, and the discussion in W. Arslan, *I Bassano* (Milan, 1960), I, 126–8.

548. 32. The date reads 1585 (as against the previous generally accepted reading of 1581) after cleaning; published by A. Ballarin, *Arte Veneta*, XX (1966), 114.

33. The technique is not the effect of accident, even though Francesco Bassano in 1581 reports in a letter that Jacopo is too old and his sight too bad to paint much. Ballarin, *op. cit.*, diminishes the force of Francesco Bassano's statement, which hitherto had been taken rather too literally. Ballarin assigns a group of pictures to Jacopo's late dramatic vein to dates throughout the ninth decade, correctly finding the old painter's hand dominant in them.

34. Perhaps, more accurately, Bassano adapted it from the general example in North European painting; see the discussion of this point in Arslan, *op. cit.*, 135–6. For a further clarification of Jacopo's inventive role in respect to 'genre' paintings, see W. Rearick, *Burl. Mag.*, CX (1968), 241–9.

549. 35. To the extent that El Greco was at the beginning of his career a painter of the Venetian school and a Mannerist in style he could well be discussed at this point in our narrative; but his Italian years have been described in the volume in this series by Kubler and Soria (1959), 210. However, the reader may also wish to see a more recent and restrictive view of Greco's Venetian career in H. Wethey, *El Greco* (Princeton, 1962), and by Arslan, in *Commentari*, XV (1964), 213–31.

550. 36. The assignment, by M. Levey, *Burl. Mag.*, CVII (1965), 111, of a *Christ in the Temple* (Madrid, Prado) to 1548 on the basis of the reading of an apparent date seems difficult to reconcile with the evidence of the picture's style, which is usually (and correctly) taken to be of the 1560s.

553. 37. Assistants were employed by Veronese in less important parts of this extensive decoration. Its condition is not so impeccable as now appears: the landscape views in particular were 'revived' by Lochoff in 1939.

554. 38. Peruzzi's views into landscape through the columns of the Sala delle Prospettive may be the source for the more extensive use by Paolo of the idea of opening vistas as if through the walls of the villa into the surrounding countryside.

The relevance of a Venetian model for Veronese's architectural illusionism in the villa should not be discounted: Rosa's ceiling for the Biblioteca Marciana (1559) was a closely contemporary precedent.

555. 39. The musical quartet at the wedding party is traditionally identified as Veronese, Tintoretto, Titian, and Jacopo Bassano.

556. 40. 12·8 m. wide by 5·55 m. high (42 by 18 ft); from Ss. Giovanni e Paolo, where it replaced a Titian destroyed by fire in 1571. The scheme of the *Levi* refines and elaborates Paolo's 8-m. (26-ft)-long *Supper of St Gregory the Great*, painted for the sanctuary of Monte Berico at Vicenza in 1572.

559. 41. Veronese was only occasionally engaged as a portraitist. His most individual contributions in that genre are in a larger format, three-quarter or full-length, such as the so-called *Bella Nani* (Paris, Louvre, *c.* 1560) or the portraits of Giuseppe and Lucia da Porto with their children (Florence, Contini, and Baltimore, Walters, *c.* 1556). Moretto's influence may account for the resemblance to Brescian style of the latter.

42. In Venice certain lesser painters came to take Veronese as their primary model. Among these were Ponchino, called Bozzato da Castelfranco (d. 1570?), who had long been an assistant of Vasari, especially in Rome, and who then naturally formed a part of the Romanist group when, towards 1550, he returned to Venice. Associated with Veronese in the decoration of the ceiling of the Sala del Consiglio dei Dieci in 1553–4, Ponchino accommodated his foreign style to Paolo's brand of Romanism of that moment, and subsequently held without great variation to this compromise. Francesco Montemezzano (c. 1540?–1600?) seems to have formed himself on Paolo, probably as an assistant, and worked much on church and government commissions in Venice. Parrasio Micheli (c. 1525–78) is one of the most obvious of Veronese's imitators, but also the most inept.

562. 43. Ridolfi characterized Palma Giovane's career too unkindly but in part accurately (Maraviglie, ed. von Hadeln, 1914, II, 176) '. . . datosi dopo la morte del Tintoretto e del Bassano ad una buona pratica, attese poscia a far opere in gran quantità, havendo per solo fine in molte di quelle di trarne più l'utilità, che la lode.'

Tintoretto's inheritance mingled in the last years of the Cinquecento and the first decades of the Seicento with the adulterations of it made by Palma Giovane in particular, and also by the late Bassani. Among the mediocrities in Venice who worked this vein to its end the least insignificant were Giovanni Contarini (1549–1604), Leonardo Corona (1561–1605), Pietro Malombra (1556–1618), and Sante Peranda (1566–1638).

In the last quarter of the century in Venice the colony of resident northerners, some of them effectively naturalized Venetians, included a few who attained at least modest stature (though none compares remotely in achievement to the older Lambert Sustris). Paolo Fiammingo (Paolo de' Franceschi, identifiable as the Antwerp-born Pauwels Frank, notices from 1561 to 1596) was an adequate figure painter, but better known as a specialist in landscape. Pozzoserrato (Lodewyck Toeput, fl. Venice from at least 1577 till his death in 1605) was also in the main a landscape painter, working in decorative landscapes in the fresco medium. Pietro Mera, Brussels-born, first emigrated to Florence, then came to Venice, where he flourished from 1579 to 1639. His œuvre includes much tedious altar painting in a debased version of Tintoretto's tradition, but he also worked, apparently earlier in his Venetian career, in a maniera piccola related to that of some late-sixteenth-century Florentines such as Jacopo Zucchi.

CHAPTER 9

563. 1. Paolo Veronese married Antonio's daughter Elena, but only in 1566, six years after Badile died. According to Ridolfi, Maraviglie, ed. von Hadeln (1914), I, 298, Paolo was Antonio's nephew, but no proof of this assertion has been found.

564. 2. The scheme of this decoration, at least partly dictated, is unusual: an illusionist architectural enframement with landscape views below (comparable to Paolo Veronese's later landscape scenes at Maser), and in the upper portion 'portraits' of the entire line of bishops of Verona.

3. Another academically inclined painter, of a somewhat earlier generation, was Battista del Moro (1514–before 1575). His son, Giulio del Moro (b. 1555), joined the late-sixteenth-century eclectic group in Venice, where his presence is recorded between 1584 and 1615.

4. Ligozzi was born in 1543, and was therefore slightly Felice Brusasorci's junior; it is not likely (as Venturi, Storia, IX, part 7, 1073, says) that Ligozzi was Felice's teacher.

565. 5. In Padua the principal painter of the later years of the century was Veronese by origin: Dario Varotari (1539–96) was described by Ridolfi as a pupil of Paolo Veronese and son-in-law of Battista Ponchino. In Padua Varotari put aside an indifferent imitation of Paolo's style in favour of a more vigorous imitation of Tintoretto's. Varotari did not take the role of caposcuola in the town until the seventies. Stefano dell'Arzere (c. 1520–1573), a long-time associate of the older caposcuola, Domenico Campagnola (d. 1564), and his follower, held the place for the decade by which he survived Campagnola.

569. 6. The chronology given here for Tibaldi's earlier career depends mainly on research Dr Bernice Davidson has undertaken but not yet published fully; but see her Perino del Vaga e la sua cerchia (Florence, 1966), 66 ff.

7. A second lesser decoration in Tibaldi's style in the Palazzo Poggi is a frieze with histories of St Paul, assigned to Tibaldi by Lamo in his Graticola di Bologna (1560).

The allegation of influence from Salviati's decoration in the Roman Palazzo Sacchetti on Tibaldi's Ulysses rooms (made by G. Briganti, Tibaldi, Rome, 1945, 76) must be incorrect, since the Palazzo Sacchetti decoration was not begun until c. 1553, interrupted in 1554, and not finished until after 1555.

The altarpiece in the Cappella Poggi, a Baptism of Christ, perhaps in part to Tibaldi's design, is by Prospero Fontana, 1561.

571. 8. The conception of 'arte senza tempo' which F. Zeri entertains (*Pittura e Controriforma*, Turin, 1957) for 'arte sacra' of this kind is not strictly accurate, because this kind of *bondieuserie* occurs only in the aftermath of classicizing styles and by deduction from them. In its 'noble' form it is represented by Ingres' religious painting or that of Puvis de Chavannes.

9. Malvasia's allegation in the *Felsina Pittrice* that all painters in Bologna after Tibaldi were his followers is far from being correct. In the 1580s Pellegrino's art (the Palazzo Poggi decoration in particular) exerted discernible influence on the Carracci, but his close following was relatively small.

Malvasia names as Tibaldi's 'effetivi scolari' Girolamo Miruoli (Mirola) and Giovanni Francesco Bezzi, called Nosadella (d. 1571). The former is known to us less in a Bolognese context than in his association with the Parmesan Bertoia, where his connexion with Tibaldi's style is not to be distinguished. The latter is said to have been a *frescante* mostly, but no work by him in fresco survives, and he is now certainly identified as the author only of two altarpieces in Bologna, in S. Maria della Vita and in S. Maria Maggiore. The earlier altar, in S. Maria della Vita, is a conservative painting of startlingly Sartesque accent, yet related to Tibaldi's style; the latter work, a *Circumcision*, was finished after Bezzi's death by Prospero Fontana, and is a conventional work of academic Maniera, still, however, with a stronger than ordinary trace of Tuscan style. H. Voss, in *Mitt. K.H.I.F.*, III (1932), 449 ff., has attributed a group of what he thought to be imitations of Tibaldi's mature *Holy Family* or *Madonna* paintings (of the type of which the one in the Capodimonte Gallery, Naples, may be the best) to Bezzi, but these attributions, suggested by Malvasia's verbal account of Bezzi's style, do not seem to be confirmed by any good evidence. They have in fact been mostly restored to Tibaldi by later criticism. For a discussion of Nosadella, especially in reference to his relation to Tibaldi, see L. Winkelmann, *Paragone*, no. 317-19 (1976), 101-15.

10. Ercole Procaccini the Elder (1515-95) was supposed by Lomazzo to have been Prospero Fontana's pupil, but this is doubtful in view of their close age. Ercole was a heavy-handed painter who came in time to make adequate essays in the academic Bolognese Maniera style, of which a signal instance is his *Conversion of St Paul* (Bologna, S. Giacomo Maggiore, dated 1579). He changed his residence to Milan in 1585 or 1586 and was responsible for the presence there of his much more distinguished sons, Camillo (*c*. 1550/5-1629) and Giulio Cesare (1574-1625). Also

worth mention among the Bolognese of the last quarter of the century, but for an event in the history of Parmesan rather than Bolognese art, is Cesare Aretusi (d. 1612), who in 1586 painted the copy-reconstruction of Correggio's destroyed apse in S. Giovanni Evangelista.

574. 11. It may be that the still-life-cum-genre paintings of this kind mean to make more than a general moralizing point and have a specific iconological content also.

Bartolommeo Passarotti was the founder of a minor artistic dynasty. His son Tiburzio (d. *c*. 1612), generally an imitator of his father, introduced an added but specious energy into most of his compositions. Tiburzio had two artist sons, Gaspare and Archangelo, the one a painter, the other a worker in intarsia and embroidery.

12. For the history of the Carracci and the significance of their inventions, see, in this series, R. Wittkower, *Art and Architecture in Italy: 1600–1750*, 3rd ed. (Harmondsworth, 1973), chapter 3.

575. 13. His father Camillo (fl. 1530–d. 1574), of whom Sebastiano was first the pupil, then for many years the collaborator, had been a lesser member of the group that worked under the Dossi and Garofalo in the Este *delizie*. Camillo worked in a debased variant of the Ferrarese classicistic style. A son younger than Sebastiano, Cesare, followed Camillo's style closely.

577. 14. Many of these late altars seem anticipations of the early-eighteenth-century Bolognese Giuseppe Maria Crespi.

578. 15. This genre seems to have been in part inspired by strong Ferrarese example. There is some analogy to Dosso's smaller works in the brilliance of colour as well as the eccentric emotional intensity of Orsi's cabinet pictures.

580. 16. There is no more complete demonstration of the so-called *Grossvatergesetz* in Italian painting of the Cinquecento. It should be noted that Bertoia's resurrection of the precedent of the first Maniera is not isolated, though it is extreme in its exactness. About this same time, in Florence, there is a visible Pontormo 'revival' in the art, e.g., of Macchietti and Mirabello Cavalori.

It should be observed that there was a curious, as it were, para-genealogical connexion between Bertoia and Parmigianino. Bertoia's father had been a loyal friend of Parmigianino in his late years of adversity and was one of his heirs. The woman who commissioned Parmigianino's *Madonna dal Collo Lungo*, Elena Bajardi, was Bertoia's godmother.

17. The collaborator whose traces we think identifiable in the Sala di Orfeo is the Bolognese Girolamo

Mirola (Miruoli; see Note 9), of whom Vasari states that he worked in the Palazzo del Giardino. Documents indicate that Mirola was in the Farnese service off and on from 1557 until 1570. A. G. Quintavalle, *Bertoia* (Parma, 1963), posits what seems to be too close an interdependence between Bertoia and Mirola, and gives the latter more credit towards the invention of alleged joint productions than he may deserve. It is Mirola who seems the dependent – and significantly less gifted – personality.

582. 18. See L. Partridge, *The Frescoes of the Villa Farnesina at Caprarola* (diss., Harvard, 1969).

583. 19. It may be recalled that part of Bartholomaeus Spranger's Italian education was in Parma, where he was an assistant to Gatti in the Duomo.

585. 20. Assigned incorrectly, only by Venturi, *Storia*, IX, part 6, 888, to Vincenzo.

21. The sources on which Antonio must have drawn include: in Brescia, beyond the contemporary Moroni, Moretto and Civerchio; in Milan, besides the late Gaudenzio, the late style of Luini – this perhaps a more important influence than is now realized; in Cremona, obviously, Pordenone.

22. There is also the possibility that North European models may have helped to precipitate Antonio's interest in nocturnes, but no available source from Northern Europe can be specified.

23. See R. Longhi's ground-breaking research, 'Quesiti Caravaggeschi', *Pinacotheca*, I (1928–9), 17–33.

589. 24. Several pictures by Vincenzo on such 'still-life' themes survive, of which the most important group are five in the Fugger Schloss Kirchheim in Bavaria. Four of these carry signatures, and three are dated, two legibly, 1580 and 1581. See S. Zamboni, *Arte Antica e Moderna*, no. 30 (1965), 134–5.

25. Cremona had a particular commercial connexion with Holland through the family of Giancarlo Affaitati, resident in Holland since his youth, who in 1561 built the palace in Cremona that now serves as the museum. Zamboni, *op. cit.*, 137, suggests the likelihood of Vincenzo's direct experience of a series of paintings by Beuckelaer which the Farnese Inventory of 1680 recorded in the Palazzo del Giardino in Parma; these pictures (like much of the former Farnese collection) are in Naples in the custody of the Galleria Nazionale di Capodimonte.

591. 26. Yet, in the vein of naturalizing exploration that is important to the character of the Cremonese school, Sofonisba too may have been the author of an innovation; cf. R. Longhi, *Paragone*, no. 157 (1963), 50 ff. This is the idea of a portrait group of figures in a genre relation to each other – specifically, playing chess. There are two such works at least, one (of Sofonisba's sister and their maid; Poznań, Museum) dated 1555.

Sofonisba's sisters Elena, Lucia, Europa, and Anna Maria were also lady painters. Sofonisba returned from Spain to Italy only in 1580, to settle in 1584 in Genoa. Van Dyck painted her in her extreme age, in 1623.

27. The Brescian brothers Rosa made a reputation outside Brescia, in Venice especially, for their work in the perspective art of *quadratura*, of which the most famous surviving example is that in the vestibule of the Biblioteca Marciana (1559–60). Cristoforo Rosa's son, Pietro Rosa (b. *c.* 1541), became a student of Titian in Venice and his mediocre follower. Camillo Ballini, a Brescian who signed works dated 1574 and 1578 as a pupil of Titian, was still less notable.

593. 28. The distinction is made extremely sharp in a single frame in a curious picture that displays a portrait figure in prayer before an image, as if materialized, of the Virgin (Washington, National Gallery, Kress Collection).

595. 29. The school of Vercelli includes Giovanni Battista della Cerva, Gaudenzio's other principal assistant, on whom, however, we have no sure information after the middle of the century; the sons of Bernardino Lanino, Pier Francesco (b. *c.* 1552) and Gerolamo (b. 1555); and the sons of Gerolamo Giovenone, Giovanni Battista (fl. from 1547) and Giuseppe Giovenone the Younger (b. 1524).

598. 30. Lomazzo's model seems to have been the dominant influence on Giuseppe Meda (notices from 1550, d. 1599), even though he was first taught by Bernardino Campi. Meda was the author of four paintings for organ shutters in the Duomo (first commissioned in 1565, paid for only in 1581); the Campi manner is more evident in the first of these, a *Procession of the Ark,* but yields in the successive shutters to the heavy style of Lomazzo.

A set of illustrations of the life of St John the Baptist in the cathedral of Monza, often attributed to Meda, are instead by Giovanni Battista della Rovere, called Il Fiamminghino; one of the set is signed and dated by him 1586. These are no longer in the Lomazzo mode but in a more conventional, ornamental, and pedestrian late Maniera.

599. 31. Il Bergamasco seems to have come to Genoa as a youth, but throughout his career returned sporadically to paint in Bergamo and its vicinity. He was active as an architect as well as a painter. His latest years, from 1567 at least, were spent in Spain.

600. 32. Luca's father seems to have been his collaborator in this room, but not as an inventor. The areas

of coarser execution in the frescoes may indicate Giovanni's presence.

601. 33. Cambiaso's travels very probably included a visit to Venice *c*. 1565. In 1575 he is reported to have been in Florence and Rome, and his presence in Rome is documented in 1583. Venetian influence on Cambiaso's art becomes significant in the middle sixties, but it should not be forgotten that the optical character of some aspects of his work is still more related to Lombard than to Venetian sources.

604. 34. The anti-art Cambiaso generated in the Escorial must have influenced Tibaldi's *arte sacra* there, which we have discussed earlier; Tibaldi's sacred narratives are less bold and doctrinaire.

Cambiaso brought to Spain as his principal assistant Lazzaro Tavarone (1556–1641), who returned to Genoa to practise only in 1594. Giovanni Battista Paggi (1554–1627), also formed by Cambiaso's example, practised only briefly in Genoa before he was banished. He then worked mainly in Tuscany, and was not permitted to return to Genoa until 1599. The chief painter of the generation after Cambiaso actually working in Genoa was Bernardo Castello (1557–1629), who became Cambiaso's most able follower, and was particularly accomplished in secular decorations.

CHAPTER 10

606. 1. As is done at least for Cigoli by W. Friedlaender, 'The Anti-Mannerist Style', in *Mannerism and Anti-Mannerism in Italian Painting* (1957); in the original form in *Vorträge der Bibliothek Warburg*, XIII (1929), 214–43.

607. 2. See M. B. Hall, *Art of the Counter-Maniera in Florence*; *The Renovation of S. M. Novella and S. Croce, 1565–76* (diss., Harvard, 1967).

609. 3. For the view contemporary criticism took of these altarpieces, both aesthetic and in terms of their religious function, see R. Borghini, *Il Riposo* (1584).

4. Bronzino took Allori into his house at the age of five, when his father, who had been Bronzino's friend, died. After Bronzino's death Allori, on Vasari's advice, took his master's name.

610. 5. Mention should be made of Allori's extensive activity in portraiture, in which he inherited Bronzino's popularity. Allori received one major decorative commission, to complete the painting (begun by Sarto, Franciabigio, and Pontormo) of the great salon at Poggio a Cajano; his work there is dated 1582.

613. 6. As a draughtsman Naldini is one of the most remarkable phenomena the sixteenth century offers, not necessarily in terms of quality. He learned from Pontormo to imitate his style nearly to the point of counterfeit, and copied Sarto's drawings frequently. However, he was not just an imitative draughtsman but the inventor of a mode of drawing corresponding to that of his painting, but which he could turn in drawing to freer and more brilliant effect.

Some of the paintings of Naldini's later years are made more academic than they might have been by the intervention in them of his pupil and assistant, Giovanni Balducci (Cosci, *c*. 1560?–after 1631). After Naldini's death Balducci worked in Florence for a time (e.g. fresco series in S. Jacopo in Via S. Gallo, 1590) in a very pedestrian version of Naldini's style; then (*c*. 1592) he moved to Rome and thence (*c*. 1600) to Naples, where he was an active practitioner of late Maniera.

7. Both Naldini and Poppi had been, as youths, under the protection of Vasari's friend and adviser, Vincenzo Borghini, prior of the Innocenti.

615. 8. The fresco ceiling of the Studiolo is also by Poppi, but earlier than the programme begun in 1571 of panel paintings for the walls, and in a more dependently conventional Vasarian style.

619. 9. Macchietti's Venetian experience may not have been so recent, but previous to 1568: in his S. Lorenzo *Adoration* there are two heads on the left in the second plane that seem to demand knowledge of the work of Veronese.

620. 10. Other Studiolo painters of the generation coinciding with Macchietti's (b. *c*. 1535–40), whom we have not had occasion to mention earlier and whose careers, except for their work there, are wholly or virtually unknown to us, include:

(a) Pupils of Vasari or of Michele di Ridolfo since his Vasarian conversion: Niccolò Betti (d. after 1617), Domenico Buti (d. 1590), Vittore Casini (matriculated in the *Speziali* 1567), Bartolommeo Traballesi (d. 1585).

(b) Bronzinesque painters: Lorenzo della Sciorna (*c*. 1535–1598), Sebastiano Marsili (dates unknown). Francesco Coscia and Giovanni Fedini should probably be assigned to this category, but they verge on artisanry rather than fine art.

Jacopo Zucchi, the remaining Studiolo painter of this generation, was active mainly in Rome, and he is treated in our discussion of the Roman school.

624. 11. The date previously misread as 1568; read correctly by Hall, *op. cit.*

625. 12. About 1600 Ligozzi's style for a moment assumed peculiar interest. Apparently almost simultaneously he painted (a) devotional altars (e.g. *Three Archangels*, Florence, S. Giovannino degli Scolopi; *Pietà*, Florence, SS. Annunziata, dependent in design

on Sarto), in a style essentially Counter-Maniera, of an iconic or pietistic accent and in a luminist technique, which together make them look like slightly later Spanish work; and (b) prosy and naturalist, quasi-Ghirlandaiesque narratives (*Life of St Francis*, Cloister of Ognissanti). He subsequently developed into an adequate representative of the conservative Florentine Early Baroque school, to which category his well-known *Martyrdom of St Lawrence* (Florence, S. Croce, *c.* 1611) and *Miracle of St Raymond* (Florence, S. Maria Novella, *c.* 1620–3) belong.

626. 13. Passignano's later career, much of it in Rome, passed through various phases of early-seventeenth-century fashion, from an academic naturalism to a fair approximation of the Caravaggesque mode.

627. 14. Purpose and subject matter – determined by the patron, not the painters – in these late-sixteenth-century Florentine religious fresco cycles may have had a role of some importance in the redirection not only of Poccetti's style but also of that of other artists who participated in their painting. The hagiographical cycles required narrative legibility and believableness (thus naturalism) of form and corresponding effects in the handling of content.

633. 15. It need not necessarily have been at Parma that Barocci acquired the distinct effect of Parmigianino's influence that may be discerned in his earlier drawings and in his earliest known painting, the (otherwise Raphaelesque) *St Cecilia* of the Duomo at Urbino (1556).

640. 16. See the discussion of the problem of the spread of Barocci's style via Rome under our treatment of that school, pp. 665–6.

A considerably less able artist, Filippo Bellini (*c.* 1550/5–*c.* 1603), whom Voss, *Malerei der Spätrenaissance* (1920), 500, describes as an Urbinate follower of Barocci, is rather an offshoot of Battista Franco and influenced by the Venetians.

642. 16a. Recent researches, incorporated in the catalogue *L'Arte a Siena sotto i Medici 1555-1609* (Rome, 1980), have exhumed some still more modest artists of the late-sixteenth- and early-seventeenth-century Siena school. The least uninteresting of them is Pietro Soria (1556?-1622), a most peripatetic painter who worked variously in Tuscany, and also in Genoa and Rome. The son-in-law of Domenico Passignano, he came in time to be assimilated to the latter's style.

17. The other identifiable painters working before 1575-6 at the Gonfalone, besides Jacopo Bertoia (1569 and 1572), are Livio Agresti, Cesare Nebbia, Marco Pino (on a return visit from Naples at this time, *not* earlier), Matteo da Lecce, and Marcantonio del

Forno. See K. Oberhuber, *Römische Historische Mitteilungen*, III (1959-60), 239-54.

18. Under the protection of Cardinals Alessandro and Ranuccio Farnese. The present building was begun in 1560 and completed in 1568. The architect is reported by the more authoritative sources to be Giacomo della Porta. For the time of the decoration see R. Roli, *Arte Antica e Moderna*, nos. 31–2 (1965), 326–7, and I. Faldi, *Tutela e valorizzazione del patrimonio artistico di Roma e del Lazio* (Rome, 1964), 92. A recent monograph on the Oratorio, with new and extensive documentation, is J. von Henneberg, *L'oratorio dell' Arciconfraternità del Santissimo Crocefisso di S. Marcello* (Rome, 1974).

645. 19. On a subsequent visit to Venice, in 1603, Federico retouched the *Barbarossa*.

646. 20. Federico also began the series of frescoes in the Cloister of the Evangelists at the Escorial, painting the first six illustrations of the *Life of the Virgin*, but these were shortly later removed and replaced by Tibaldi.

Federico's assistant, Bartolommeo Carducci (1560–1608), had more success, and remained (with his brother, Vincenzo, 1578–1638) to become court painter to the Spanish king. Bartolommeo subsequently worked in Madrid and Valladolid. The name was hispanicized to Carducho.

21. On the triangular site where the Via Gregoriana and the Via Sistina join; now the seat of the Biblioteca Hertziana. It was used by the Roman Accademia di S. Luca as their meeting place.

647. 22. The substance of *L'Idea* is taken usually, and probably mostly correctly, in this sense. Yet to do so implies a divergence between Federico's late theory and his practice of the same time, which as we observed no longer pertains to the Maniera. It is probable that the divergence exists, but it might nevertheless be useful to re-read *L'Idea* from the point of view of an exposition of Federico's post-Maniera style and see if this might result in a different emphasis for some of its content.

23. The extent of Bertoia's role in the decoration seems to be larger than has hitherto been supposed, as e.g. by I. Faldi, *Gli Affreschi del Palazzo Farnese a Caprarola* (Milan, 1962). The evidence has been gathered by L. Partridge in his dissertation, *The Frescoes of the Villa Farnesina at Caprarola* (Harvard, 1969).

649. 24. See Partridge, *op. cit.*, for the documentary evidence of attribution and dating. The ceiling of the Camera degli Angeli, painted before November 1573, is by Bertoia rather than (as is usually assumed) by de' Vecchi.

25. Among de' Vecchi's later paintings were the original decoration in fresco of the dome of the Gesù in Rome, replaced in the late seventeenth century by Bacciccio.

26. Known, from his place of birth near Volterra, as Il Pomarancio, a nickname he shares with his countryman, Cristofano Roncalli. Circignani's date of birth is placed by older sources as early as 1516, but there is other evidence to suggest a much later date.

650. 27. The execution of the three chapels in the Torre Pia of the Vatican is largely Zucchi's.

Zucchi is also almost beyond doubt the author of the panel in the Florence Studiolo depicting *Goldmining*. It could as well have been sent from Rome as painted during a brief stay in Florence.

651. 28. Zucchi's allegories of the *Ages of History* (Florence, Uffizi), probably before 1580, relate to Federico Zuccaro in style and show little 'naturalist' concern.

653. 29. There is no documentary evidence to support the idea, frequent in the literature, that Spranger was employed *c.* 1569–70 as a painter of landscapes at Caprarola. By 1572–3 (*Martyrdom of St John Evangelist*, Rome, S. Giovanni a Porta Latina), he was a master of the apparatus of contemporary Maniera.

30. Antonie Blocklandt, in Rome in 1572, was another member of this circle.

Among the foreigners in Rome *c.* 1575 there was, of course, also the young Greco. F. Zeri, *Pittura e Controriforma* (Turin, 1957), 47 ff., makes more than I think justifiable of a hypothetical encounter between Blocklandt, Greco, and de' Vecchi as a source for the pictorial mysticism of the late Cinquecento.

654. 31. Despite the brevity of his career Raffaellino's example attracted an older painter, Paris Nogari (1535–1600), who encountered it in the Logge of Gregory XIII, to adopt the fresco manner that Raffaellino had demonstrated there. A facile *praticante*, Nogari was employed in almost all the busy collaborative enterprises of the later sixteenth century in Rome – besides Gregory's Logge, in the Biblioteca Vaticana, S. Maria Maggiore, S. Susanna, and S. Giovanni in Laterano.

655. 32. Vanni did not go to Rome again till 1592 and then only briefly, and too late to account for the other artists' change.

33. It is certain that Ferrau Fenzoni of Faenza (1562–1645), who worked in some contact with this group, and on the same Sistine decorative jobs, had only a reflective role (and not a thoroughly convinced one) in the Baroccesque tendency in Rome.

657. 34. Nevertheless Muziano had the responsibility, important to these frescoists and, perhaps, at least formally generative for them, of supervising the decoration with fresco landscape of the Villa d'Este in Tivoli (1563–6).

35. Documents examined by Partridge, *op. cit.*, indicate that there is no support for the repeated assertion (as most recently by H. Hahn, *Römische Forschungen der Biblioteca Hertziana*, XVI, 1960, 308–23) of Paolo Bril's participation in the later decoration at Caprarola.

660. 36. The *beau morceau* is related, as a source of specious appeal, to the appeal in the picture's content of sentimentality. One of the remarkable characteristics of *arte sacra* in its latest-sixteenth-century form is its analogy not only to the *bondieuserie* of the middle and later nineteenth century but to the Salon art of that period.

37. The same conclusion, of an unspecific and indirect role in the formation of an artistic style, applies also to the seventeenth century. If we choose to take Valeriano's style as a consequence of reading the *Spiritual Exercises*, we should realize that Bernini later also took them regularly: content is hardly related in the two artists, and form not at all. The Jesuit text thus cannot be taken as a major determinant of style. Furthermore, we might observe the profound change from Counter-Maniera taste to maximum Baroque that the Order sanctioned in the later seventeenth century redecoration of the Gesù.

664. 37a. W. Kerwin, *Paragone*, no. 335 (1978), 21 contests the account in Baglione's *Vita* that describes Roncalli as having been, after his arrival in Rome *c.* 1578, apprenticed to Circignani.

38. A bozzetto exists (London, Dr E. Schapiro) for one of these histories, and there are rather unsatisfactory copies after both (Rome, Ludovisi-Rospigliosi). See the exhibition catalogue *Il Cavaliere d'Arpino* (Rome, 1973), nos. 1, 3, and 4.

666. 39. Painting in Naples in the last quarter of the sixteenth century continued without important alteration on the path established for it in the preceding years. Marco Pino remained the leading painter of the school until his death in the late eighties, always the facile Maniera *praticante* but in his later years not frequently inspired. More than either of his teachers, Criscuolo or Leonardo da Pistoia, Pino helped to form the style of Francesco Curia (1538–*c.* 1610), the one native Neapolitan who attained a measure of distinction in a late Maniera mode (*Annunciation*, Naples, Capodimonte; *Archangel Michael*, Naples, S. Maria la Nova). It is reported that Curia spent a time working in Milan, and that experience seems to have made some change in him, but only about or after the beginning of the new century. His works that may be

dated at that time (e.g. the *Symbolic Apotheosis of the Virgin*, S. Maria la Nova) suggest that he had assimilated the style of the current Lombards, as, for example, Procaccini.

The chief painters of the generation following Curia's, Girolamo Imparato (1550–*c.* 1621) and Fabrizio Santafede (1560–1634), were trained elsewhere than in Naples, and exposed to influences that inclined them early towards reform movements. From there they moved on, early in the new century, to an easy sympathy with the swift emergence in the Neapolitan school of Carraccesque and Caravaggesque styles. Giovanni Balducci of Florence, who settled in Naples *c.* 1600 for what was to be a long career, also after a while went over to the modern style. The work of Belisario Corenzio (b. Morea 1558–after 1646), the most prolific decorative painter of this generation, also belongs mainly to the seventeenth century.

BIBLIOGRAPHY

This bibliography is obviously a very limited one. It emphasizes the more recent literature, but gives older works wherever they still may be considered standard, or contain more extensive, useful bibliographies of their own. I have omitted encyclopedia articles, guide books, and book reviews; doctoral dissertations that are not in published form (but for U.S. dissertations I have considered the existence of a xerox copy made by University Microfilms as equivalent to publication); literature on artists who may be touched on in this book but whose careers fall mostly outside the limits of the sixteenth century. Entries have been carried to the end of 1977.

The bibliography is arranged under the following headings:

I. Art History and Theory of the Sixteenth to the Eighteenth Centuries
II. General Works
III. Studies of Periods or Styles
IV. Studies of Regional Schools
V. Studies of Periods or Styles within a Regional School
VI. Artists

Entries in the first five categories are arranged alphabetically by author; in the sixth category, alphabetically by artist.

I. ART HISTORY AND THEORY OF THE SIXTEENTH TO EIGHTEENTH CENTURIES

ARMENINI, G. *De' veri precetti della pittura libri III.* Ravenna, 1587.

BOCCHI, F. *Le Bellezze della città di Fiorenza.* Florence, 1581. Ed. (rev. and amplified) G. Cinelli, Florence, 1677.

BORGHINI, R. *Il Riposo.* Florence, 1584. Ed. *Classici italiani,* 3 vols., Milan, 1807.

CONDIVI, A. *Vita di Michelagnolo Buonarroti.* Rome, 1553. Ed. K. Frey, Berlin, 1887.

DANTI, V. *Il primo libro del trattato delle perfette proporzioni* . . . Florence, 1567.

DOLCE, L. *Dialogo della pittura intitolato L'Aretino.* Venice, 1557. Ed. M. Roskill, Princeton, 1968.

GILIO, G. *Due dialoghi* . . . *nel secondo si ragiona degli errori de' Pittori* . . . Camerino, 1564.

HOLLANDA, F. DE. *Tractato de pintura antiqua.* 1548. Ed. A. Aurelj, *Dialoghi michelangioleschi di Francesco d'Olanda,* Rome, 1926.

LOMAZZO, G. *Idea del Tempio della Pittura.* Milan, 1590.

LOMAZZO, G. *Trattato dell'arte della pittura* . . . Milan, 1584.

MOLANUS, J. *De picturis et imaginibus sacris.* Louvain, 1570.

PALEOTTI, G. (Cardinal). *Discorso intorno le immagini sacre e profane* . . . Bologna, 1582.

PINO, P. *Dialogo di pittura.* Venice, 1548. Ed. R. and A. Pallucchini, Venice, 1946.

POSSEVINO, A. *Tractatio de poesi et pictura* . . . Rome, 1593.

RIDOLFI, C. *Maraviglie dell'arte.* Venice, 1648. Ed. D. v. Hadeln, Berlin, 1914.

SANSOVINO, F. (pseud. A. Guisconi). *Dialogo di tutte le cose notabili che sono in Venetia.* Venice, 1556, 1561, etc.

SANSOVINO, F. *Venetia città nobilissima* . . . Venice, 1581.

VARCHI, B. *Due lezzioni* . . . Florence, 1549.

VASARI, G. *Le Vite de' più eccellenti architetti, pittori e scultori italiani* . . . 2 vols. Florence, 1550; 2nd ed. 1568. (References in the present book are to the edition of G. Milanesi, 9 vols., Florence, 1878-85, reprinted 1906.)

ZUCCARO, F. *L'Idea de' scultori, pittori e architetti* . . . Turin, 1607. Ed. D. Heikamp, *Scritti d'arte di Federico Zuccaro,* Florence, 1961.

II. GENERAL WORKS

BACOU, R., et al. *Le seizième siècle européen: Peintures et dessins dans les collections publiques françaises.* Paris, 1965.

BAROCCHI, P. (ed.). *Trattati d'arte del Cinquecento.* 3 vols. Bari, 1960-2.

BAUMGART, F. *Renaissance und Kunst der Manierismus.* Cologne, 1963.

BERENSON, B. *Drawings of the Florentine Painters.* 2 vols. London, 1903; 2nd rev. ed., 3 vols., Chicago, 1938; *I Disegni dei pittori fiorentini* (3rd rev. ed.), 3 vols., Milan, 1961.

BERENSON, B. *Italian Painters of the Renaissance.* Original eds., with separate vols. for the Venetian, Florentine, Central Italian, and North Italian Schools, 1894-1907. One-vol. ed. under the present title, Oxford, 1930; London and New York, 1952.

BERENSON, B. *Italian Pictures of the Renaissance.* (Originally with the essays on the separate schools, 1894-1907; in one vol., rev., Oxford, 1932. Further rev. and expanded ed., in separate vols., by schools): *Venetian School,* 2 vols., London and New York, 1957; *Florentine School,* 2 vols., London and New York, 1963; *Central Italian and North Italian Schools,* 3 vols., London and New York, 1968.

CARLI, E., GNUDI, C., et al. *Pittura italiana,* III, *Il Cinquecento.* Milan, 1963.

CHASTEL, A. *The Crisis of the Renaissance.* Geneva, 1968.

CROWE, J. A., and CAVALCASELLE, G. B. *A New History of Painting in Italy.* 1st ed., 3 vols., London, 1864-6; 2nd ed., 6 vols., New York, 1903-14 (vol. VI ed. T. Borenius, 1914).

DVORÁK, M. *Geschichte der italienischen Kunst im Zeitalter der Renaissance,* 2 vols. Munich, 1927, 1929.

HOFFMANN, H. *Hochrenaissance, Manierismus, Frühbarock.* Zürich-Leipzig, 1938.

HOOGEWERFF, G. *Nederlandsche Schilders in Italie in de XVIᵉeeuw.* Utrecht, 1912.

KAUFFMANN, G. *Die Kunst des 16 Jahrhunderts* (Propyläen Kunstgeschichte, n.f. VIII). Berlin, 1970.

MEISS, M., et al. (eds.). *The Renaissance and Mannerism* (Acts of the Twentieth International Congress of the History of Art, II). Princeton, 1963.

POPE-HENNESSY, J. *The Portrait in the Renaissance.* New York, 1966.

SCHLOSSER, J. V. *Die Kunstliteratur.* Vienna, 1924. Trans. *La Letteratura artistica,* Florence, n.d. [1937].

VENTURI, A. *Storia dell'arte italiana,* IX, *La Pittura del Cinquecento,* parts 1-7. Milan, 1925-34.

WÖLFFLIN, H. *Kunstgeschichtliche Grundbegriffe.* Munich, 1915. Trans. *Principles of Art History,* New York, various eds.

III. STUDIES OF PERIODS OR STYLES

BAUMGART, F. 'Zusammenhänge der niederländischen mit der italienischen Malerei in der zweiten Hälfte des 16. Jahrhunderts', *Marburger Jahrb. für K.W.,* XIII (1944), 187-250.

BECHERUCCI, L. *Manieristi toscani.* Bergamo, 1944.

BRIGANTI, G. *Il Manierismo e Pellegrino Tibaldi.* Rome, 1945.

BRIGANTI, G. *La Maniera italiana.* Rome, 1961. Trans. *Italian Mannerism,* Leipzig, 1962.

DACOS, N. *La Découverte de la Domus Aurea et la formation des grotesques à la Renaissance* (Studies of the Warburg Institute, XXXI). Leiden, 1969.

DEJOB, C. *De l'influence du concile de Trente sur la littérature et les beaux-arts chez les peuples catholiques.* Paris, 1884.

FASOLA, G. 'Storiografia del Manierismo', in *Scritti di storia dell'arte in onore di Lionello Venturi,* 429-667. Rome, 1956.

FREEDBERG, S. 'Observations on the Painting of the Maniera', *A.B.,* XLVII (1965), 187-97.

FREEDBERG, S. '*Disegno* versus *Colore* in Florentine and Venetian Painting of the Cinquecento', in *Florence and Venice: Comparisons and Relations,* II, *Cinquecento.* Florence, 1980.

FREY, D. *Manierismus als europäische Stilerscheinung.* Ed. G. Frey. Stuttgart, 1964.

FREY, D. 'Tizian und Michelangelo, zum Problem des Manierismus', in *Museion, Studien aus Kunst und Geschichte für Otto H. Förster.* Cologne, 1960.

FRIEDLAENDER, W. 'Der Antimanieristische Stil um 1590 und sein Verhältnis zum Ubersinnlichen', *Vorträge der Bibliothek Warburg,* VIII (1928-9), 214-43. Trans. 'The Anti-Mannerist Style', in *Mannerism and Anti-Mannerism in Italian Painting.* New York, 1957.

FRIEDLAENDER, W. 'Die Entstehung des antiklassischen Stiles in der italienischen Malerei um 1520', *Rep. K.W.,* XLVI (1925), 49-86. Trans. 'The Anti-Classical Style', in *Mannerism and Anti-Mannerism in Italian Painting.* New York, 1957.

Manierismo, Barocco e Rococò, concetti e termini (Accademia Nazionale dei Lincei, Quaderno no. 52). Rome, 1962.

NYHOLM, E. *Arte e Teoria del Manierismo,* I. *Ars Naturans.* Odense, 1977.

PEVSNER, N., and GRAUTOFF, O. *Barockmalerei in den romanischen Ländern.* Wildpark-Potsdam, 1928.

PEVSNER, N. 'Gegenreformation und Manierismus', *Rep. K.W.,* XLVI (1925), 243-62.

SHEARMAN, J. '"Maniera" as an Aesthetic Ideal', in *The Renaissance and Mannerism,* 200-21. Princeton, 1963.

SHEARMAN, J. *Mannerism.* Harmondsworth, 1967.

SMYTH, C. 'Mannerism and Maniera', in *The Renaissance and Mannerism,* 174-99. Princeton, 1963. In book form, New York, 1962.

SUMMERS, D. 'Contrapposto: Style and Meaning in Renaissance Art', *A.B.,* LIX (1977), 336-61.

WEISBACH, W. V. 'Gegenreformation – Manierismus – Barock', *Rep. K.W.*, XLIX (1928), 16–28.

WEISBACH, W. V. 'Der Manierismus', *Z.B.K.*, XXX (1918–19), 161–83.

WEISE, G. 'La doppia origine del concetto di Manierismo', *Studi Vasariani* (1950), 181–5.

WÖLFFLIN, H. *Die klassische Kunst.* Munich, 1899. Trans. *Classic Art*, London, 1952.

WÜRTEMBERGER, F. *Der Manierismus.* Vienna and Munich, 1962.

IV. STUDIES OF REGIONAL SCHOOLS

ACQUA, G. DELL', et al. *I Pittori bergamaschi dal XIII al XIX secolo. Il Cinquecento.* 2 vols. Bergamo, 1975.

BERTOLOTTI, A. *Artisti belgi ed olandesi a Roma nei secoli XVI e XVII.* Florence, 1880.

BODMER, H. *Correggio und die Malerei der Emilia.* Vienna, 1942.

BOLOGNA, F. *Roviale Spagnuolo e la pittura napolitana del Cinquecento.* Naples, 1959.

BORENIUS, T. *The Painters of Vicenza, 1480–1550.* London, 1909.

BOSSAGLIA, R. 'La Pittura bresciana del Cinquecento', in *Storia di Brescia*, II (1963), 1011–1101.

CROWE, J., and CAVALCASELLE, G. *A History of Painting in North Italy.* 2 vols. London, 1871.

DUFOUR, C. et al. *La Pittura a Genova e in Liguria dagli inizi al Cinquecento.* Genoa, 1971.

GROSSATO, L. *Affreschi del Cinquecento in Padova.* Milan, 1966.

LONGHI, R. *Officina ferrarese.* Rome, 1934. 2nd ed., Florence, 1956.

LONGHI, R. *Viatico per cinque secoli della pittura veneziana.* Florence, 1946.

NICOLINI, F. *L'Arte napoletana del Rinascimento e la lettera di Pietro Summonte a Marcantonio Michiel.* Naples, 1925.

ORTOLANI, S. 'Le Origini della critica d'arte a Venezia', *L'Arte*, XXVI (1923), 1–17.

PAATZ, W. and E. *Die Kirchen von Florenz.* 6 vols. Frankfurt am Main, 1952–5.

PALLUCCHINI, R. *La Critica d'arte a Venezia nel Cinquecento.* Venice, 1963.

PALLUCCHINI, R. *La Pittura veneziana del Cinquecento.* Novara, 1944.

POPHAM, A. *Italian Drawings in the Department of Prints and Drawings in the British Museum: Artists Working in Parma in the Sixteenth Century.* 2 vols. London, 1967.

PREVITALI, G. *La Pittura del Cinquecento a Napoli e nel Vicereame.* Turin, 1978.

RICCI, C. *La Pittura del Cinquecento nell'Alta Italia.*

Bologna, 1928. Trans. *North Italian Painting of the Cinquecento*, Florence and New York, 1929.

ROLFS, W. *Geschichte der Malerei Neapels.* Leipzig, 1910.

ROTILI, M. *L'Arte del Cinquecento nel Regno di Napoli.* Naples, 1972.

SCHULZ, J. *Venetian Painted Ceilings of the Renaissance.* Berkeley and Los Angeles, 1968.

SCHWEITZER, E. 'La Scuola pittorica cremonese', *L'Arte*, III (1900), 41–71.

SMYTH, C. 'Venice and the Emergence of the High Renaissance in Florence: Observations and Questions', in *Florence and Venice: Comparisons and Relations*, I, *Quattrocento.* Florence, 1979.

TIETZE, H., and TIETZE-CONRAT, E. *The Drawings of the Venetian Painters in the Fifteenth and Sixteenth Centuries.* New York, 1944.

Venezia e l'Europa (Atti del XVIII Congresso Internazionale di Storia dell'Arte). Venice, 1956.

V. STUDIES OF PERIODS OR STYLES WITHIN A REGIONAL SCHOOL

ACQUA, G. DELL'. 'La Pittura a Milano dalla metà del sec XVI al 1630', in *Storia di Milano*, X (1957), 673–721.

ACQUA, G. DELL', et al. *I Pittori Bergamaschi dal xiii al xix secolo. Il Cinquecento.* 2 vols. Bergamo, 1975.

ANCONA, P. D'. *Gli Affreschi della Farnesina in Roma.* Milan, 1955.

ARSLAN, E. *Le Pitture del duomo di Milano.* Milan, 1960.

BAROCCHI, P., et al. *Mostra di disegni dei fondatori dell'Accademia delle Arti del Disegno.* Florence, 1963.

BAUMGART, F. 'La Caprarola di Amadeo Orti', *Studi Romanzi della Società Filologica Romana*, XXV (1935), 77–179.

BECHERUCCI, L. 'Momenti dell'arte fiorentina nel Cinquecento', in *Il Cinquecento* (Libera Cattedra di Storia della Civiltà Fiorentina), 161–83. Florence, 1955.

BERTI, L. *Il Principe dello Studiolo.* Florence, 1967.

BRAHAM, A. 'The Bed of Pierfrancesco Borgherini', *Burl. Mag.*, CXXI (1979), 754–65.

BUCCI, M. *Lo Studiolo di Francesco I* (Forma e Colore, X). Florence, 1965.

CIARDI, R. 'Giovanni Antonio Figino e la cultura milanese tra il 1550 e il 1580', *Arte Lombarda*, VII (1962), 73–84.

COLETTI, L. 'La Crisi manieristica nella pittura veneziana', *Convivium*, XIII (1941), 109–26.

DUPRONT, A. 'Art et Contre-Réforme: Les Fresques de la bibliothèque de Sixte-Quint', *Mélanges*

d'Archéologie et d'Histoire de l'École Française de Rome, XLVIII (1931), 282-307.

FALDI, I. *Gli Affreschi del Palazzo Farnese a Caprarola*. Milan, 1962.

FASOLA, G. 'Il Manierismo e l'arte veneziana del Cinquecento', in *Venezia e l'Europa* (Atti del XVIII Congresso Internazionale di Storia dell'Arte, 1955), 291-3. Venice, 1956.

FREEDBERG, S. *Painting of the High Renaissance in Rome and Florence*. 2 vols. Cambridge, Mass., 1961.

FRIEDLAENDER, W. *Das Kasino Pius des Vierten*. Leipzig, 1912.

GAUDIOSO, E. 'I lavori farnesiani e Castel Sant' Angelo', *Boll. d'A.*, LXI (1976), 228-61.

GAVAZZA, E. 'Note sulla pittura del "Manierismo" a Genova', *Critica d'Arte*, III (1965), 96-102.

GEROLA, G. *Il Castello di Buonconsiglio*. Rome, 1934.

GHIDIGLIA QUINTAVALLE, A. 'L'Oratorio del Concezione a Parma', *Paragone*, no. 103 (1958), 24-38.

GRAZZINI CACCO, E. 'Pittori cinquecenteschi padovani', *Bollettino del Museo Civico*, Padua, XX (1927), 89-117.

GREGORI, M. 'Avant propos sulla pittura fiorentina del Seicento', *Paragone*, no. 145 (1962), 21-40.

KELLER, R. *Das Oratorium von San Giovanni Decollato in Rom*. Rome, 1976.

LAVAGNINO. E. *La Chiesa di S. Spirito in Sassia e il mutare del gusto a Roma al tempo del Concilio di Trento*. Turin, 1962.

LENSI, A. *Palazzo Vecchio*. Milan, 1929.

LONGHI, R. 'Comprimarj spagnuoli della maniera italiana', *Paragone*, no. 43 (1953), 3-15.

LONGHI, R. 'Cose bresciane del Cinquecento', *L'Arte*, XX (1917), 99-114.

LONGHI, R. 'Quesiti caravaggeschi', *Pinacotheca*, I (1928), 17-33; (1929), 258-320.

MAZZINI, F. 'La Pittura del Primo Cinquecento', in *Storia di Milano*, VIII (1957), 567-654.

MOLFINO, A. *L'Oratorio del Gonfalone*. Rome, 1964.

MONTEVERDI, M. 'Lungo percorso di un manierismo lombardo disceso dal Bramantino', *Arte Lombarda*, II (1956), 94-111.

MORASSI, A. 'I Pittori alla corte di Bernardo Clesio a Trento', *Boll. d'A.*, IX (1929-30), 241-64, 311-34, 355-75.

PALLUCCHINI, R. *La Giovinezza del Tintoretto*. Milan, 1950.

PALLUCCHINI, R. et al. *Da Tiziano a El Greco*. Milan, 1981.

PATZAK, B. *Die Villa Imperiale in Pesaro*. Leipzig, 1908.

POSNER (WEIL GARRIS), K. *Leonardo and Central Italian Art, 1515-1550*. New York, 1974.

POUNCEY, P., and GERE, J. *Italian Drawings in the Department of Prints and Drawings in the British Museum: Raphael and his Circle*. 2 vols. London, 1962.

REDONA BEGNI, P. 'La Pittura manieristica', in *Storia di Brescia*, III (1964), 529-88.

SGARBI, V. 'Aspetti della Maniera nel Veneto', *Paragone*, no. 369 (1980), 28-51.

SUIDA, W. *Leonardo und sein Kreis*. Munich, 1929.

VOSS, H. *Die Malerei der Spätrenaissance in Rom und Florenz*. 2 vols. Berlin, 1920.

ZERI, F. 'Eccentrici fiorentini', *Boll. d'A.*, XLVII (1962), 216-36, 314-26.

ZERI, F. *Pittura e Controriforma: L'Arte senza tempo di Scipione da Gaeta*. Turin, 1957.

VI. ARTISTS

ABBATE, DELL'

Béguin, S. *Mostra di Nicolo dell'Abate*. Bologna, 1969.

Bodmer, H. 'Die Landschaften des Niccolò dell'Abbate', *Z.K.*, IV (1951), 106-12.

Bombe, W. 'Gli Affreschi dell'Eneide di Niccolò dell'Abbate nel Palazzo di Scandiano', *Boll. d'A.*, X (1931), 529-53.

ALBERTINELLI

Bodmer, H. 'Opere giovanili e tarde di Mariotto Albertinelli', *Dedalo*, IX (1929), 598-620.

ALTOBELLO

Bologna, F. 'Altobello Melone', *Burl. Mag.*, XCVII (1955), 240-50.

Grassi, L. 'Ingegno di Altobello Meloni', *Proporzione*, III (1950), 143-61.

Gregori, M. 'Altobello e Gian Francesco Bembo', *Paragone*, no. 93 (1957), 16-40.

Gregori, M. 'Altobello, il Romanino e il Cinquecento cremonese', *Paragone*, no. 69 (1955), 3-28.

ANSELMI

Ghidiglia Quintavalle, A. *Michelangelo Anselmi*. Parma, 1960.

ARCIMBOLDO

Legrand, F., and Sluys, F. *Arcimboldo et les Arcimboldesques*. Aalten, 1955.

ARPINO, D'

Faldi, I. 'Gli Affreschi della Cappella Contarelli e l'opera giovanile del Cavalier d'Arpino', *Boll. d'A.*, XXXVIII (1953), 45-55.

Röttgen, H. 'Giuseppe Cesaris Fresken in der Loggia Orsini', *Storia dell'Arte*, III (1969), 279-95.

ASPERTINI

Grassi, L. 'Considerazioni e novità su Amico Aspertini e Jacopo Ripanda', *Arte Antica e Moderna*, no. 25 (1964), 47-65.

Ricci, C. 'Gli Aspertini', *L'Arte*, XVIII (1915), 80-119.

Scaglietti, D. 'La Maturità di Amico Aspertini e i suoi rapporti con la "Maniera" ', *Paragone*, no. 233 (1969), 21-45.

BACCHIACCA, IL

Marcucci, L. 'Contributo al Bacchiacca', *Boll. d'A.*, XLIII (1958), 26-39.

McComb, A. 'Francesco Ubertini', *A.B.*, VIII (1926), 141-68.

Nikolenko, L. *Francesco Ubertini, called Il Bacchiacca*. New York, 1966.

BAROCCI

Olsen, H. *Federico Barocci*. Copenhagen, 1962.

Schmarsow, A. 'Federigo Baroccis Zeichnungen', *Abhandlungen der Sächsische Akademie der Wissenschaften*, XXVI (1909), no. 5; XXVIII (1910), no. 3; XXX (1914), no. 1.

BARTOLOMMEO, FRA

Borgo, L. 'Fra Bartolommeo, Albertinelli, and the Pietà for the Certosa di Pavia', *Burl. Mag.*, CVIII (1966), 463-8.

Fahy, E. 'The Beginnings of Fra Bartolommeo', *Burl. Mag.*, CVIII (1966), 456-63.

Gabelentz, H. v. *Fra Bartolommeo und die Florentiner Renaissance*. 2 vols. Leipzig, 1922.

Knapp, F. *Fra Bartolommeo und die Schule von S. Marco*. Halle an der Saale, 1903.

BASSANO, THE

Arslan, W. *I. Bassano*. Bologna, 1931.

Arslan, E. [W.] *I Bassano*. 2 vols. Milan, 1960.

Ballarin, A. 'Chirurgia bassanesca, 1', *Arte Veneta*, XX (1966), 112-36.

Ballarin, A. 'Osservazioni sui dipinti veneziani del Cinquecento nella Galleria del Castello di Praga', *Arte Veneta*, XIX (1965), 59-82.

Ballarin, A. 'Jacopo Bassano e lo studio di Raffaello e dei Salviati', *Arte Veneta*, XXI (1967), 77-101.

Bettini, S. *L'Arte di Jacopo Bassano*. Bologna, 1933.

Furlan, I. 'La Componente tizianesca nella formazione di Jacopo Bassano', *Arte Veneta*, XIII-XIV (1959-60), 72-8.

Longhi, R. 'Suggerimenti per Jacopo Bassano', *Arte Veneta*, II (1948), 43-55.

Pallucchini, R. 'Jacopo Bassano ed il Manierismo', in *Studies in the History of Art dedicated to William E. Suida*, 258-66. London, 1959.

Rearick, W. 'Jacopo Bassano's Later Genre Paintings', *Burl. Mag.*, CX (1968), 241-9.

Smirnova, I. 'Due serie delle "Stagioni" Bassanesche e alcune considerazioni sulla genesi del quadro di genere nella bottega di Jacopo da Ponte', *Studi di Storia dell'Arte in onore di Antonio Morassi*, n.d. (1972?), 129-37.

Zampetti, P. (Mostra di) *Jacopo Bassano*. Venice, 1957.

BASTIANINO, IL

Arcangeli, F. *Il Bastianino*. Milan, 1963.

BECCAFUMI, D.

Ciaranfi, A. *Domenico Beccafumi*. Florence, 1966.

Sanmimatelli, D. *Domenico Beccafumi*. Milan, 1967.

BEDOLI, MAZZOLA-

Ghidiglia Quintavalle, A. 'Il "Cenacolo" recuperato del Bedoli', *Paragone*, no. 219 (1968), 30-8.

Popham, A. 'The Drawings of Girolamo Bedoli', *Master Drawings*, II (1964), 243-67.

Testi, L. 'Una grande pala di Girolamo Mazzola alias Bedoli detto anche Mazzolino', *Boll. d'A.*, II (1908), 369-95.

BERTOIA, IL

Baumgart, F. 'Giovanni Bertoia pittore di Parma', *Boll. d'A.*, XXV (1931-2), 454-64.

Borea, E. 'Lelio Orsi, Il Bertoia e l'Oratorio del Gonfalone', *Paragone*, no. 141 (1961), 37-9.

Ghidiglia Quintavalle, A. *Il Bertoia*. Parma, 1963.

Oberhuber, K. 'Jacopo Bertoia im Oratorium von S. Lucia del Gonfalone in Rom', *Römische Historische Mitteilungen*, III (1958-60), 239-54.

Quintavalle, A. O. 'Il Bertoja', *Aurea Parma*, XXXV (1951), 74-88.

BOCCACCINO, B.

Puerari, A. *Boccaccino*. Milan, 1958.

BOCCACCINO, C.

Bora, G. 'Note cremonesi, I, Camillo Boccaccino, le proposte', *Paragone*, no. 295 (1974), 40-70; 'II, L'eredità di Camillo e i Campi', *Paragone*, no. 311 (1976), 49-74; 'III, L'eredità di Camillo e i Campi (continuazione)', *Paragone*, no. 327 (1977), 54-88.

Gregori, M. 'Traccia per Camillo Boccaccino', *Paragone*, no. 37 (1953), 3-18.

BONIFAZIO DE' PITATI

Westphal, D. *Bonifazio Veronese*. Munich, 1931.

BORDONE

Bonicatti, M. 'Per la formazione di Paris Bordone', *Boll. d'A.*, XLIX (1964), 249-50.

Canova, G. *Paris Bordone*. Venice, 1963.

Canova, G. 'I Viaggi di Paris Bordone', *Arte Veneta*, XV (1961), 77-88.

BOSCOLI

Forlani, A. 'Andrea Boscoli', *Proporzione*, IV (1963), 85-208.

BRAMANTE

Ferrari, M. 'L'ampio raggio degli affreschi di Bramante in Bergamo', *Paragone*, no. 171 (1964), 3-12.

Suida, W. *Bramante pittore e il Bramantino*. Milan, 1953.

BRAMANTINO
Suida, W. *See* BRAMANTE.

BRONZINO, IL
Emiliani, A. *Il Bronzino*. Busto Arsizio, 1960.
Rearick, J. C. 'Some Early Drawings by Bronzino', *Master Drawings*, II (1964), 363-82.
Rearick, J. C. 'Dessins de Bronzino pour la chapelle d'Eleonora au Palazzo Vecchio', *Revue de l'Art*, no. 14 (1971), 6-22.
Smyth, C. 'The Earliest Works of Bronzino', *A.B.*, XXXI (1949), 184-210.
Smyth, C. *Bronzino as Draughtsman*. New York, 1971.

BRUSASORCI, F.
Boccazzi, F. 'Profilo di Felice Brusasorci', *Arte Veneta*, XXI (1967), 125-43.

BUGIARDINI
Sirén, O. 'Alcuni quadri sconosciuti di Giuliano Bugiardini', *Dedalo*, III (1926), 773-83.

CALLISTO PIAZZA
Ferrari, M.-L. 'Callisto de la Piaza', *Paragone*, no. 183 (1965), 17-49.

CALVAERT
Bergmans, S. *Denis Calvaert* (Academie Royale de Belgique, *Mémoires*, ser. 2, vol. 3, fasc. 2). Antwerp, 1931.

CAMBIASO
Frabetti, G. 'Aggiunte a Luca Cambiaso', in *Studies in the History of Art dedicated to William E. Suida*, 267-75. London, 1959.
Rotondi, P. 'Ipotesi sui rapporti Cambiaso-Tibaldi', *Boll. d'A.*, XLIII (1958), 164-70.
Suida Manning, B., and Suida, W. *Luca Cambiaso*. Milan, 1958.

CAMPAGNOLA, D.
Colpi, R. 'Domenico Campagnola', *Bollettino del Museo Civico di Padova*, XXXI-XLIII (1942-54), 81-110.

CAMPI, THE
Bora, G. 'Note cremonesi, II, L'eredità di Camillo e i Campi', *Paragone*, no. 311 (1976), 49-74; 'III, L'eredità di Camillo e i Campi (continuazione)', *Paragone*, no. 327 (1977), 54-88.
Godi, G., and Cirello, G. *Studi su Giulio Campi*. Milan, 1978.
Perotti, A. *I Pittori Campi da Cremona*. Milan, n.d. (193?).
Puerari, A. 'Due dipinti di Vincenzo Campi', *Paragone*, no. 37 (1953), 41-5.
Zamboni, S. 'Vincenzo Campi', *Arte Antica e Moderna*, no. 30 (1965), 124-47.
Zeri, F. 'Bernardino Campi: Una "Crocefissione" ', *Paragone*, no. 37 (1957), 36-41.

CARIANI
Gallina, L. *Giovanni Cariani*. Bergamo, 1954.

CAROTO
Bravo, C. del. 'Per G. F. Caroto', *Paragone*, no. 173 (1964), 3-16.

CATENA
Robertson, G. *Vincenzo Catena*. Edinburgh, 1954.

CAVALORI
Marcucci, L. 'Appunti per Mirabello Cavalori disegnatore', *Riv. d'A.*, XXVIII (1953), 77-98.

CESARE DA SESTO
Nicodemi, G. *L'Opere e l'arte di Cesare da Sesto*. Milan, 1932.

CHIMENTI
Vries, S. de. 'Jacopo Chimenti da Empoli', *Riv. d'A.*, XV (1933), 329-98.

CIGOLI, IL
Bucci, M., et al. *Mostra del Cigoli*. San Miniato, 1959.
Busse, K. *Manierismus und Barockstil: Lodovico Cardi da Cigoli*. Leipzig, 1911.
Pittaluga, M. 'The Exhibition of Cigoli and His Circle', *Burl. Mag.*, CI (1959), 444-5.

CORREGGIO
Bianconi, P. *Tutta la pittura del Correggio*. Milan, 1953. 2nd rev. ed., 1960.
Bodmer, H. *Correggio und die Malerei der Emilia*. Vienna, 1942.
Bottari, S. *Correggio*. Milan, 1961.
Copertini, G. *Note sul Correggio*. Parma, 1925.
Ghidiglia Quintavalle, A. *Gli Affreschi del Correggio in S. Giovanni Evangelista a Parma*. Milan, 1962.
Ghidiglia Quintavalle, A. 'Ignorati affreschi del Correggio in S. Giovanni Evangelista a Parma', *Boll. d'A.*, L (1965), 193-9.
Gould, C. *The Paintings of Correggio*. Ithaca, 1976.
Gronau, G. *Correggio*. Stuttgart and Leipzig, 1907.
Laskin, M. *The Early Work of Correggio*. Ann Arbor (University Microfilms), 1965.
Longhi, R. 'Le Fasi del Correggio giovane e l'esigenza del suo viaggio Romano', *Paragone*, no. 101 (1958), 34-53.
Manifestazioni parmensi nel IV centenario della morte del Correggio. Parma, 1936.
Popham, A. *Correggio's Drawings*. London, 1957.
Ricci, C. *Correggio*. Rome, 1930. Trans. London and New York, 1930.
Shearman, J. 'Correggio's Illusionism', in M. Emiliani (ed.), *La Prospettiva rinascimentale: Codificazioni e Trasgressioni*, I (Florence, 1980), 281-94.
Vito Battaglia, S. de. *Correggio, Bibliografia*. Rome, 1934.

DANIELE DA VOLTERRA
Barolsky, P. *Daniele da Volterra*. New York, 1979.

Canedy, N. 'The Decoration of the Stanza della Cleopatra', *Essays in the History of Art presented to Rudolf Wittkower*, II, 110-18. London, 1967.
Chiarini, M. 'Una Pala datata di Daniele da Volterra', *Boll. d'A.*, L (1965), 219-20.
Davidson, B. 'Daniele da Volterra and the Orsini Chapel, II', *Burl. Mag.*, CIX (1967), 553-61.
Davidson, B. 'The Decoration of the Sala Regia under Pope Paul III', *A.B.*, LVIII (1976), 395-423.
Hirst, M. 'Daniele da Volterra and the Orsini Chapel, I', *Burl. Mag.*, CIX (1967), 498-509.
Levie, S. *Der Maler Daniele da Volterra.* Cologne, 1962.
Mez, M. 'Una Decorazione di Daniele da Volterra nel Palazzo Farnese a Roma', *Riv. d'A.*, XVI (1934), 276-91.
Sricchia Santoro, F. 'Daniele da Volterra', *Paragone*, no. 213 (1967), 3-34.
Weisz, J. 'Daniele da Volterra and the Oratory of S. Giovanni Decollato', *Burl. Mag.*, CXXIII (1981), 355-6.

DEMIO
Fiocco, G. 'L'Eredità di Giovanni Demio', *Riv. d'A.*, XX (1938), 158-73.
Guglielmi, G. 'Profilo di Giovanni Demio', *Arte Veneta*, XX (1966), 98-111.

DIANA
Paolucci, A. 'Benedetto Diana', *Paragone*, no. 199 (1966), 3-20.

DOSSI, THE
Gibbons, F. *Dosso and Battista Dossi.* Princeton, 1968.
Mendelsohn, H. *Das Werk der Dossi.* Munich, 1914.
Mezzetti, A. *Il Dosso e Battista Ferraresi.* Ferrara, 1965.
Puppi, L. 'Dosso al Buonconsiglio', *Arte Veneta*, XVIII (1964), 19-36.

FERRARI, G.
Brizio, A., et al. *Mostra di Gaudenzio Ferrari.* Milan, 1956.
Mallé, L. *Incontri con Gaudenzio. Raccolta di studi e note su problemi gaudenziani.* Turin, n.d. [1969].

FIGINO
Ciardi, R. *Giovan Ambrogio Figino.* Florence, 1968.
Ciardi, R. 'Addenda Figiniana', *Arte Lombarda*, XVI (1971), 267-74.

FOGOLINO
Zampetti, P. 'Affreschi inediti di Marcello Fogolino', *Arte Veneta*, I (1947), 217-22.

FOSCHI
Longhi, R. 'Avvio a P. F. Toschi [Foschi]', *Paragone*, no. 43 (1953), 53-5.
Pinelli, A. 'Pier Francesco di Jacopo Foschi', *G.B.A.*, LXIX (1967), 87-108.

Sanminiatelli, D. 'Foschi e non Toschi', *Paragone*, no. 91 (1957), 55-7.

FRANCO
Rearick, W. 'Battista Franco and the Grimani Chapel', *Saggi e Memorie di Storia dell'arte*, II (1959), 107-39.

GAMBARA
Redona, P., and Vezzoli, G. *Lattanzio Gambara, Pittore.* Brescia, 1978.

GAROFALO, IL
Mazzariol, G. *Il Garofalo.* Venice, 1960.
Neppi, A. *Il Garofalo.* Milan, 1959.

GENGA
Petrioli Tofani, A. 'Per Girolamo Genga', *Paragone*, no. 229 (1969), 18-36; no. 231 (1969), 39-56.

GIORGIONE
Baldass, L., and Heinz, G. *Giorgione.* Venice, 1964.
Coletti, L. *Tutta la pittura di Giorgione.* Milan, 1955.
Fiocco, G. *Giorgione.* Rome, 1941. 2nd ed., Bergamo, 1948.
Hourticq, L. *Le Problème de Giorgione.* Paris, 1930.
Morassi, A. *Giorgione.* Milan, 1942.
Pergola, P. della. *Giorgione.* Milan, n.d. [1954?].
Pignatti, T. *Giorgione.* Venice, 1969. 2nd ed. Milan, 1978.
Pignatti, T. 'Giorgione e Tiziano', in *Tiziano ed il Manierismo Europeo.* Florence, 1978.
Richter, G. *Giorgione.* Chicago, 1937.
Zampetti, P. (Mostra di) *Giorgione e i Giorgioneschi.* Venice, 1955.

GIOVANNI DA UDINE
Averini, R., and Montini, R. *Palazzo Baldassini e l'arte di Giovanni da Udine.* Rome, 1957.
Dacos, N. 'Il Trastullo di Raffaello', *Paragone*, no. 219 (1968), 3-29.

GIROLAMO DA CARPI
Antal, F. 'Observations on Girolamo da Carpi', *A.B.*, XXX (1948), 81-103.
Serafini, A. *Girolamo da Carpi.* Rome, 1915.

GIROLAMO DA TREVISO
Coletti, L. 'Girolamo da Treviso il Giovane', *Critica d'Arte*, I (1936), 172-80.
Pouncey, P. 'Aggiunte a Girolamo da Treviso', *Arte Antica e Moderna*, nos. 13-16 (1961), 209-10.

GIULIO ROMANO
Gombrich, E. 'Zum Werke Giulio Romanos', *J.K.S.W.*, VIII (1934), 79-104; IX (1935), 121-50.
Hartt, F. *Giulio Romano.* 2 vols. New Haven, 1958.
Nicco Fasola, G. 'Giulio Romano e il Manierismo', *Commentari*, XI (1960), 60-73.
Vogel, J. 'Giulio Romanos Jugend und Lehrzeit', *Monatshefte für Kunstwissenschaft*, XIII (1920), 52-66.

INNOCENZO DA IMOLA
Buscaroli, R., and Galli, R. *Innocenzo da Imola.* Bologna, 1951.
Pouncey, P. 'Drawings by Innocenzo da Imola', *Master Drawings*, VII (1969), 287-92.

JACOPINO DEL CONTE
Cheney, I. 'Notes on Jacopino del Conte', *A.B.*, LII (1970), 32-40.
Henneberg, J. v. 'An Unknown Portrait of St Ignatius', *A.B.*, XLIX (1967), 140-2.
Zeri, F. 'Intorno a Gerolamo Siciolante', *Boll. d'A.*, XXXVI (1951), 139-49.
Zeri, F. 'Salviati e Jacopino del Conte', *Proporzione*, II (1948), 180-2.
Zeri, F. 'Rivedendo Jacopo del Conte', *Antologia di Belle Arti*, II (1978), 114-20.

LEONARDO
Beenken, H. 'Zum Entstehungsgeschichte der Felsgrottenmadonna in der Londoner National Gallery', in *Festschrift für Hans Jantzen*, 132-40. Berlin, 1951.
Beltrami, L. *Documenti e memorie riguardanti la vita e le opere di Leonardo da Vinci.* Milan, 1919.
Castelfranco, G. 'Momenti della recente critica vinciana', in Marazza, *Leonardo*, 417-77. Rome, 1954.
Castelfranco, G. *La Pittura di Leonardo da Vinci.* Milan, 1956.
Clark, K. *Leonardo da Vinci.* Cambridge, 1939.
Heydenreich, L. 'Leonardo-Bibliographie', *Z.K.*, XV (1952), 195-200. (Bibliography from 1939 to 1952.)
Heydenreich, L. *Leonardo da Vinci.* Berlin, 1943. 2nd rev. ed., Basel, 1953; trans. Basel, 1954.
Isermeyer, C. 'Die Arbeiten Leonardos und Michelangelos für den Grossen Ratsaal in Florenz', in *Studien zur Toskanischen Kunst* (Festschrift L. H. Heydenreich), 83-130. Munich, 1964.
Marazza, A. (ed.), et al. *Leonardo, Saggi e ricerche.* Rome, 1954.
Möller, E. *Das Abendmahl des Leonardo da Vinci.* Baden-Baden, 1952.
Pedretti, C. *Studi vinciani.* Geneva, 1957.
Popham, A. *The Drawings of Leonardo da Vinci.* London, 1946.
Posner (Weil Garris), K. *Leonardo and Central Italian Art, 1515-1550.* New York, 1974.
Raccolta Vinciana, XIV (1930/4), XV/XVI (1935/9). (Bibliography from 1930 to 1939.)
Richter, J. P. *The Literary Works of Leonardo da Vinci.* London and New York, 1939.
Shearman, J. 'Leonardo's Colour and Chiaroscuro', *Z.K.*, XXV (1962), 13-47.
Suida, W. *Leonardo und sein Kreis.* Munich, 1929.

Varga, E. *Bibliografia vinciana.* Bologna, 1931. (Bibliography to 1930.)
Wasserman, J. 'The Dating and Patronage of Leonardo's Burlington House Cartoons', *A.B.*, LIII (1971), 312-26.
Wilde, J. 'Michelangelo and Leonardo', *Burl. Mag.*, XCV (1953), 65-77.

LIGOZZI
Bacci, M. 'Jacopo Ligozzi e la sua posizione nella pittura fiorentina', *Proporzione*, IV (1963), 46-84.

LILIO
Emiliani, A. 'Andrea Lilli', *Arte Antica e Moderna*, no. 1 (1958), 65-80.
Olivari, T. 'Per Andrea Lilli', *Commentari*, XXII (1971), 337-42.
Scavizzi, G. 'Note sull'attività romana del Lilio e del Salimbeni', *Boll. d'A.*, LXIV (1959), 33-40.

LOTTO
Banti, A., and Boschetto, A. *Lorenzo Lotto.* Florence, n.d. [c. 1953].
Berenson, B. *Lorenzo Lotto.* New York and London, 1895. Rev. ed., London, 1901. Third rev. ed., Milan, 1955; in English, London and New York, 1956.
Bianconi, P. *Tutta la pittura di Lorenzo Lotto.* Milan, 1955.
Brizio, A. 'Il Percorso dell'arte di Lorenzo Lotto', *Arte Veneta*, VII (1953), 7-24.
Coletti, L. *Lotto.* Bergamo, 1953.
Pallucchini, R. *Profilo di Lorenzo Lotto* (Lezioni tenute alla facoltà ... di Bologna, 1953-4). Bologna, n.d.
Zampetti, P. *Mostra di Lorenzo Lotto.* Venice, 1953.

LUINI
Ottino della Chiesa, A. *Bernardino Luini.* Milan, 1960.

MACCHIETTI
Marcucci, L. 'Girolamo Macchietti disegnatore', *Mitt. K.H.I.F.*, VII (1953-6), 121-32.
Pouncey, P. 'Contributo a Girolamo Macchietti', *Boll. d'A.*, XLVII (1962), 237-40.

MANCINI
Gamba, C. 'Contributo alla conoscenza di Domenico Mancini', *Critica d'Arte*, XXIV (1949), 211-17.
Wilde, J. 'Die Probleme um Domenico Mancini', *J.K.S.W.*, VII (1933), 97-135.

MARESCALCHI
Fiocco, G. 'Il Pittore Pietro de Marescalchi da Feltre', *Arte Veneta*, I (1947), 37-41, 97-107.

MASO DA S. FRIANO
Berti, L. 'Nota a Maso da San Friano', in *Scritti di storia dell'arte in onore di Mario Salmi*, III, 77-88. Rome, 1963.

Brookes, P. C. 'Three Notes on Maso da San Friano', *Burl. Mag.*, CVII (1965), 192-6.
Brookes, P. C. 'The Portraits of Maso da San Friano', *Burl. Mag.*, CVIII (1966), 560-8.
Pace, V. 'Maso da San Friano', *Boll. d'A.*, LXI (1976), 74-99.
MAZZOLINO
Zamboni, S. *Ludovico Mazzolino*. Milan, 1965.
MICHELANGELO
Barocchi, P. *La Vita di Michelangelo nelle redazioni del 1550 e del 1568*. 5 vols. Milan, 1962.
Barocchi, P. 'Michelangelo e il Manierismo', *Arte Antica e Moderna*, no. 27 (1964), 260-80.
Bertini, A. *Michelangelo fino alla Sistina*. Turin, 1942. 2nd rev. ed., 1945.
Cherubelli, P. 'Supplemento alla bibliografia michelangiolesca (1931-42)', in *Michelangiolo Buonarroti nel IV centenario del Giudizio Universale*, 270 ff. Florence, 1942. (Bibliography for 1931-42.)
Dussler, L. *Die Zeichnungen des Michelangelo*. Berlin, 1959.
Einem, H. v. *Michelangelo*. Stuttgart, 1959.
Hall, M. 'Michelangelo's "Last Judgement": Resurrection of the Body and Predestination', *A.B.*, LVIII (1976), 85-92.
Hartt, F. 'Lignum Vitae in Medio Paradisi: The Stanza d'Eliodoro and the Sistine Ceiling', *A.B.*, XXXII (1950), 115-45, 181-218.
Hartt, F. *Michelangelo*. New York, 1964.
Isermeyer, C. 'Die Arbeiten Leonardos und Michelangelos für den Grossen Ratsaal in Florenz', in *Studien zur Toskanischen Kunst (Festschrift L. H. Heydenreich)*, 83-130. Munich, 1964.
Isermeyer, C. A. 'Das Michelangelo-Jahr 1964 und die Forschungen zu Michelangelo als Maler und Bildhauer von 1959 bis 1965', *Z.K.*, XXVIII (1965), 307-52.
Justi, C. *Michelangelo*. Leipzig, 1900. 2nd ed., Berlin, 1922.
Justi, C. *Michelangelo, Neue Beiträge zur Erklärung seiner Werke*. Berlin, 1909.
Knapp, F. *Michelangelo*. Stuttgart and Leipzig, 1906.
Oberhuber, K. 'Raphael und Michelangelo', in *Stil und Überlieferung in der Kunst des Abendlandes*, II, *Michelangelo*, 156-63. Bonn, 1964.
Steinmann, E. *Michelangelo im Spiegel seiner Zeit*. Leipzig, 1930. (Bibliography for 1927-30.)
Steinmann, E. *Die sixtinische Kapelle*. Munich, 1901-5.
Steinmann, E., and Wittkower, R. *Michelangelo Bibliographie, 1510-1926*. Leipzig, 1927. (Bibliography to 1926.)

Stil und Überlieferung in der Kunst des Abendlandes (Acts of the 21st International Congress for Art History), II, *Michelangelo*. Bonn, 1964.
Summers, D. *Michelangelo and the Language of Art*. Princeton, 1981.
Thode, H. *Michelangelo und das Ende der Renaissance*. Berlin, 1902-12.
Thode, H. *Michelangelo, Kritische Untersuchungen*. Berlin, 1908-12.
Tolnay, K. *Michelangelo*. 5 vols. Princeton, 1943-60.
Tolnay, K. *Michelangiolo*. Florence, 1951. In French, *Michel-Ange*, Paris, 1951.
Wilde, J. 'The Decoration of the Sistine Chapel', *Proceedings of the British Academy*, XLIV (1958), 61-81.
Wilde, J. *Michelangelo and His Studio*. London, 1953.
Wilde, J. 'Michelangelo and Leonardo', *Burl. Mag.*, XCV (1953), 65-77.
MORANDINI
Barocchi, P. 'Appunti su Francesco Morandini da Poppi', *Mitt. K.H.I.F.*, XI (1964), 117-48.
MORETTO
Boselli, C. 'Asterischi morettiani', *Arte Veneta*, II (1948), 85-98.
Boselli, C. *Il Moretto*. Brescia, 1964.
Gombosi, G. *Moretto da Brescia*. Basel, 1943.
MORONI
Cugini, D. *Moroni pittore*. Bergamo, 1939.
Gregori, M. 'Giovanni Battista Moroni', in *I pittori bergamaschi dal xiii al xix secolo. Il Cinquecento*, III (Bergamo, 1979), 95-377.
Lendorff, G. *Giovanni Battista Moroni*. Winterthur, 1933, and Bergamo, 1939.
Rossi, F., and Gregori, M. *Giovanni Battista Moroni* (mostra). Bergamo, 1979.
MORTO DA FELTRE
Hülsen, C. 'Morto da Feltre', *Mitt. K.H.I.F.*, II (1912-17), 81-9.
MUZIANO
Como, U. da. *Girolamo Muziano*. Bergamo, 1930.
Gere, J. 'Girolamo Muziano and Taddeo Zuccaro', *Burl Mag.*, CXVIII (1966), 417.
Mack, R. 'Girolamo Muziano and Cesare Nebbia at Orvieto', *A.B.*, LVI (1974), 410-13.
Procacci, U. 'Una "vita" inedita del Muziano', *Arte Veneta*, VIII (1954), 242-64.
NALDINI
Barocchi, P. 'Itinerario di Giovambattista Naldini', *Arte Antica e Moderna*, no. 31 (1965), 244-87.
NEBBIA
Mack, R. 'Girolamo Muziano and Cesare Nebbia at Orvieto', *A.B.*, LVI (1974), 410-13.

Moccagatta, V. 'Ancora su Cesare Nebbia', *Scritti di Storia dell'Arte in onore di Edoardo Arslan*, I, 609-27. Milan, 1960.

ORSI
Gregori, M. 'Una Madonna di Lelio Orsi', *Paragone*, no. 43 (1953), 55-6.
Hoffman, J. *Lelio Orsi da Novellara, 1511-87: A Stylistic Chronology*. Univ. of Wisconsin (University Microfilms), 1975.
Salvini, R., and Chiodi, A. *Mostra di Lelio Orsi*. Reggio Emilia, 1950.
Salvini, R. 'Su Lelio Orsi e la mostra di Reggio Emilia', *Boll. d'A.*, XXXVI (1951), 79-83.

PALMA GIOVANE
Ivanoff, N., and Zampetti, P. 'Giacomo Negretti detto Palma il giovane', in *I pittori bergamaschi dal xiii al xix secolo. Il Cinquecento*, III (Bergamo, 1979), 401-739.
Rosand, D. *Palma Giovane and Venetian Mannerism*. Ann Arbor (University Microfilms), 1967.

PALMA VECCHIO
Ballarin, A. *Palma Il Vecchio*. Milan, 1968.
Gombosi, G. *Palma Vecchio*. Stuttgart and Berlin, 1937.
Mariacher, G. *Palma Il Vecchio*. Milan, 1968.
Spahn, A. *Palma Vecchio*. Leipzig, 1932.
Suida, W. 'Studien zu Palma', *Belvedere*, XII (1934-5), 85-101.

PAOLO FIAMMINGO
Rinaldi, S. 'Appunti per Paolo Fiammingo', *Arte Veneta*, XIX (1965), 95-107.

PARMIGIANINO
Bologna, F. 'Il Carlo V del Parmigianino', *Paragone*, no. 73 (1956), 3-16.
Copertini, G. *Il Parmigianino*. 2 vols. Parma, 1932.
Copertini, G. 'Nuovo contributo di studi e ricerche sul Parmigianino', *Comitato per le onoranze al Parmigianino*. Parma, 1954.
Freedberg, S. *Parmigianino, His Works in Painting*. Cambridge, Mass., 1950.
Fröhlich-Bum, L. 'Latest Literature on Parmigianino', *G.B.A.*, XLII (1953), 327-30.
Fröhlich-Bum, L. *Parmigianino und der Manierismus*. Vienna, 1921.
Ghidiglia Quintavalle, A. 'Il "Boudoir" di Paola Gonzaga Signora di Fontanellato', *Paragone*, no. 209 (1967), 3-18.
Popham, A. *The Drawings of Parmigianino*. London and New York, 1953.
Popham, A. *Catalogue of Drawings by Parmigianino*. 3 vols. New Haven and London, 1971.
Quintavalle, A. O. *Il Parmigianino*. Milan, 1948.

PASSAROTTI
Bodmer, H. 'Die Kunst des Bartolomeo Passarotti', *Belvedere*, XIII (1938-9), 66-73.

PELLEGRINO DA MODENA
Davidson, B. 'Pellegrino da Modena', *Burl. Mag.*, CXII (1970), 78-86.

PERINO DEL VAGA
Averini, R., and Montini, R. *Palazzo Baldassini e l'Arte di Giovanni da Udine*. Rome, 1957.
Brugnoli, M. 'Gli Affreschi di Perino del Vaga nella Cappella Pucci', *Boll. d'A.*, XLVII (1962), 327-50.
Davidson, B. 'Drawings by Perino del Vaga for the Palazzo Doria, Genoa', *A.B.*, XLI (1959), 315-26.
Davidson, B. 'Early Drawings by Perino del Vaga', I, *Master Drawings*, I, no. 3 (1963), 3-16; II, *Master Drawings*, I, no. 4 (1963), 19-26.
Davidson, B. *Mostra di disegni del Perino del Vaga e la sua cerchia*. Florence, 1966.
Davidson, B. 'The Decoration of the Sala Regia under Pope Paul III', *A.B.*, LVIII (1976), 395-423.
Gere, J. 'Two Late Fresco Cycles by Perino del Vaga: The Massimi Chapel and the Sala Paolina', *Burl. Mag.*, CII (1960), 8-19.
Hirst, M. 'Perino del Vaga and His Circle', *Burl. Mag.*, CVIII (1960), 388-405.
Oberhuber, K. 'Observations on Perino del Vaga as a Draughtsman', *Master Drawings*, IV (1966), 170-82.
Parma Armani, E. 'Il Palazzo del Principe Andrea Doria a Fasolo in Genova', *L'Arte*, no. 10 (1970), 12-63.
Poggi, G. 'Due affreschi di Perino del Vaga nella galleria degli Uffizi', *Boll. d'A.*, III (1909), 270-3.
Popham, A. 'On Some Works by Perino del Vaga', *Burl. Mag.*, LXXXVI (1945), 56-66.
Torriti, P. 'Dipinti inediti o poco conosciuti di Perino del Vaga a Genova', in *Studies in the History of Art dedicated to William E. Suida*, 196-204. London, 1959.

PERUZZI
Frommel, C. *Baldassare Peruzzi als Maler und Zeichner* (Beiheft zum Römischer Jahrbuch für Kunstgeschichte, Bd 1, 1967-8). Vienna, 1967-8.
Martini, L. 'Le Fonti storiche per la vita e le opere di Baldassare Peruzzi', *La Diana*, IV (1929), 127-58.
Pope-Hennessy, J. 'A Painting by Peruzzi', *Burl. Mag.*, LXXXVIII (1946), 237-41.

PIAZZA
Novasconi, A. *I Piazza*. Lodi, 1971.

PIERO DI COSIMO
Bacci, M. *Piero di Cosimo*. Milan, 1966.
Fahy, E. 'Some Later Works of Piero di Cosimo', *G.B.A.*, LXV (1965), 201-12.

Morselli, P. 'Piero di Cosimo, Saggio di un catalogo delle opere', *L'Arte*, XXIII (1958), 67-92.

Zeri, F. 'Rivedendo Piero di Cosimo', *Paragone*, no. 115 (1959), 36-50.

PINO

Borea, E. 'Grazia e furia in Marco Pino', *Paragone*, no. 151 (1962), 24-52.

POCCETTI

Frey, D. 'Wandfresken Bernardino Poccettis im Palazzo Acciauoli zu Florenz', *Scritti di storia dell'arte in onore di M. Salmi*, III, 63-76. Rome, 1963.

Tinti, M. 'Bernardino Poccetti', *Dedalo*, IX (1928-9), 406-30.

POLIDORO DA CARAVAGGIO

Borea, E. 'Vicende di Polidoro da Caravaggio', *Arte Antica e Moderna*, no. 13-16 (1961), 211-27.

Kultzen, R. 'Bemerkungen zu einer Fassadenmalerei Polidoros da Caravaggio in der Piazza Madama in Rom', *Römische Forschungen der Biblioteca Hertziana*, XVI (1960), 207-12.

Kultzen, R. 'Der Freskenzyklus in der ehemaligen Kapelle der Schweizergarde in Rom', *Zeitschrift für schweizerische Archäologie und Kunstgeschichte*, XXI (1961), 19-30.

Kultzen, R. 'Die Malereien Polidoro da Caravaggio im Giardino del Bufalo in Rom', *Mitt. K.H.I.F.*, IX (1960), 99-120.

Marabottini, A. *Polidoro da Caravaggio*. 2 vols. Rome, 1969(?).

Ravelli, L. *Polidoro da Caravaggio*. Bergamo, 1978.

PONTORMO

Berti, L., et al. *Mostra del Pontormo e del primo Manierismo fiorentino*. Florence, 1956.

Berti, L. *Pontormo*. Florence, 1966.

Berti, L. *Pontormo, Disegni*. Florence, 1965.

Braham, A. 'The Bed of Pierfrancesco Borgherini', *Burl. Mag.*, CXXI (1979), 754-65.

Clapp, F. *Pontormo, His Life and Work*. New Haven, 1916.

Forster, K. *Pontormo*. Munich, 1966.

Maurer, E. 'Pontormo und Michelangelo', in *Stil und Überlieferung in der Kunst des Abendlandes*, II, *Michelangelo*, 141-8. Bonn, 1964.

Rearick, J. C. *The Drawings of Pontormo*. 2 vols. Cambridge, Mass., 1964.

Shearman, J. 'Pontormo and Andrea del Sarto, 1513', *Burl. Mag.*, CIV (1962), 478-83.

Shearman, J. 'Rosso, Pontormo, Bandinelli, and Others at SS. Annunziata', *Burl. Mag.*, CII (1960), 152-6.

PORDENONE

Fiocco, G. *Giovanni Antonio Pordenone*. Udine, 1939. 2nd ed., Padua, 1943.

Friedlaender, W. 'Titian and Pordenone', *A.B.*, XLVII (1965), 118-21.

Molajoli, B. *Mostra del Pordenone e della pittura friulana del rinascimento*. Udine, 1939.

Schulz, J. 'Pordenone's Cupolas', *Studies in Renaissance and Baroque Art presented to Anthony Blunt on his 60th Birthday*, 44-50. London and New York, 1967.

PORTELLI

Barocchi, P. 'Proposte per Carlo Portelli', *Festschrift Ulrich Middeldorf*, 283-9. Berlin, 1968.

PULZONE

Zeri, F. *Pittura e Controriforma: L'Arte senza tempo di Scipione da Gaeta*. Turin, 1957.

RAFFAELLINO DA REGGIO

Collobi, L. 'Raffaellino Motta detto Raffaellino da Reggio', *Riv. del R. Istituto d'Archeologia e Storia dell'Arte*, VI (1938), 266-82.

Faldi, I. 'Contributi a Raffaellino da Reggio', *Boll. d'A.*, XXXVI (1951), 324-33.

RAPHAEL

Ancona, P. d'. *Gli Affreschi della Farnesina in Roma*. Milan, 1955.

Baumgart, F. 'Beiträge zu Raffael und seiner Werkstatt', *Münchner Jahrbuch der bildenden Künste*, VIII (1931), 49-68.

Biermann, H. *Die Stanzen Raffaels*. Munich, 1957.

Dacos, N. 'Il Trastullo di Raffaello', *Paragone*, no. 219 (1968), 3-29.

Dacos, N. *Le Logge di Raffaello*. Rome, 1977.

Dussler, L. *Raffael, Kritisches Verzeichnis der Gemälde, Wandbilder und Bildteppiche*. Munich, 1966.

Fischel, O. *Raphael*. 2 vols. London, 1948.

Fischel, O. 'Raphael's Auxiliary Cartoons', *Burl. Mag.*, LXXXI (1937), 166-8.

Fischel, O. *Raphaels Zeichnungen*. Parts 1-8. Berlin, 1913-14. Part 9, by K. Oberhuber. Berlin, 1972.

Gilbert, C. 'A Miracle by Raphael', *Bulletin of the North Carolina Museum of Art*, VI, no. 1 (1965), 3-35.

Golzio, V. *Raffaello nei documenti, nelle testimonianze dei contemporanei, e nella letteratura del suo secolo*. Rome, 1936.

Hetzer, T. *Die Sixtinische Madonna*. Frankfurt am Main, 1932.

Müntz, E. *Raphael: Sa vie, son œuvre, et son temps*. Paris, 1881. Trans. W. Armstrong, London, 1882.

Oberhuber, K. 'Die Fresken der Stanza dell'Incendio im Werk Raffaels', *J.K.S.W.*, LVIII (1962), 23-72.

Oberhuber, K. 'Raphael und Michelangelo', in *Stil*

und Überlieferung in der Kunst des Abendlandes, II, *Michelangelo*, 156–63. Bonn, 1964.

Oberhuber, K. 'Raphael and the State Portrait. (1) The portrait of Julius II', '(2) The portrait of Lorenzo de' Medici', *Burl. Mag.*, CXIII (1971), 124–32, 436–43.

Oberhuber, K. 'Vorzeichnungen zu Raffaels "Transfiguration"', *Jahrbuch der Berliner Museen*, IV (1962), 116–49.

Ortolani, S. *Raffaello*. Bergamo, 1942.

Passavant, J. *Rafael von Urbino und sein Vater Giovanni Santi*. 2 vols. Leipzig, 1839. 2nd rev. ed. (trans.), Paris, 1860.

Pope-Hennessy, J. *The Raphael Cartoons*. London, 1950.

Posner, K. Weil-Garris. 'Raphael's Transfiguration and the Legacy of Leonardo', *Art Quarterly*, XXXV (1972), 343–74.

Pouncey, P., and Gere, J. *Italian Drawings in the Department of Prints and Drawings in the British Museum: Raphael and his Circle*. 2 vols. London, 1962.

Putscher, M. *Raffaels sixtinische Madonna*. Tübingen, 1955.

Rosenberg, A., and Gronau, G. *Raffael*. Stuttgart and Leipzig, 1905.

Salmi, M. et al. *The Complete Work of Raphael*. Novara, 1969.

Shearman, J. 'The Chigi Chapel in S. Maria del Popolo', *Journal of the Warburg and Courtauld Institutes*, XXIV (1961), 129–85.

Shearman, J. 'Die Loggia der Psyche in der Villa Farnesina und die Probleme der letzten Phase von Raffaels graphischem Stil', *J.K.S.W.*, N.F. XXIV (1964), 59–100.

Shearman, J. 'Raphael's Unexecuted Projects for the Stanze', in *Walter Friedlaender zum 90. Geburtstag*, 158–80. Berlin, 1965.

Shearman, J. *Raphael's Cartoons in the Collection of Her Majesty the Queen and the Tapestries for the Sistine Chapel*. London and New York, 1972.

Shearman, J. 'Raphael, Rome and the Codex Escurialensis', *Master Drawings*, XV (1977), 107–46.

Stridbeck, C. 'Raphael Studies I, A Puzzling Passage in Vasari's Vite', *Stockholm Studies in History of Art*, IV (1960).

Stridbeck, C. 'Raphael Studies II, Raphael and Tradition', *Stockholm Studies in History of Art*, VIII (1963).

White, J., and Shearman, J. 'Raphael's Tapestries and Their Cartoons', *A.B.*, XL (1958), 193–221, 299–323.

Wittkower, R. 'The Young Raphael', *Allen Memorial Art Museum Bulletin*, XX (1963), 150–68.

Wölfflin, H. 'Das Problem der Umkehrung in Raffaels Teppichkartons', *Belvedere*, IX (1930), 63–5.

Wülfingen, O. B. v. *Die Verklärung Christi von Raffael*. Berlin, 1946.

ROMANINO, IL

Bossaglia, R. 'Il Romanino: bilancio di una mostra', *Arte Lombarda*, X (1965), 167–72.

Ferrari, M. *Il Romanino*. Milan, 1961.

Gilbert, C. 'Portraits by and near Romanino', *Arte Lombarda*, IV (1959), 261–7.

Gregori, M. 'Altobello, il Romanino e il Cinquecento cremonese', *Paragone*, no. 69 (1955), 3–28.

Morassi, A. 'I Pittori alla corte di Bernardo Clesio a Trento', *Boll. d'A.*, IX (1929–30), 241–64, 311–34, 355–75.

Panazza, G. et al. *Mostra di Girolamo Romanino*. Brescia, 1965.

RONCALLI

Heideman, J. 'The Cappella della Pietra in S.M. in Aracoeli in Rome', *Paragone*, no. 369 (1980), 28–51.

Kirwin, W. 'The Life and Drawing Style of Cristofano Roncalli', *Paragone*, no. 335 (1978), 18–62.

ROSSO, IL

Barocchi, P. *Il Rosso Fiorentino*. Rome, 1950.

Carroll, E. 'Lappoli, Alfani, Vasari, and Rosso Fiorentino', *A.B.*, XLIX (1967), 297–304.

Kusenberg, K. 'Autour du Rosso', *G.B.A.*, X (1963), 158–72.

Kusenberg, K. *Le Rosso*. Paris, 1931.

Shearman, J. 'The "Dead Christ" by Rosso Fiorentino', *Boston Museum Bulletin*, LXIV (1966), 148–72.

Shearman, J. 'Rosso, Pontormo, Bandinelli, and Others at SS. Annunziata', *Burl. Mag.*, CII (1960), 152–6.

SALIMBENI

Mirelli, E. 'Gli ultimi sprazzi del Cinquecento a Siena: I, Francesco Vanni; II, Ventura Salimbeni', *La Diana*, VII (1932), 59–71, 111–24.

Riedl, P. 'Zum Œuvre des Ventura Salimbeni', *Mitt. K.H.I.F.*, IX (1960), 221–48.

Scavizzi, G. 'Note sull'attività romana del Lilio e del Salimbeni', *Boll. d'A.*, LXIV (1959), 33–40.

Scavizzi, G. 'Su Ventura Salimbeni', *Commentari*, X (1959), 115–36.

SALVIATI

Cheney, I. *Francesco Salviati*. Ann Arbor (University Microfilms), 1963.

Cheney, I. 'Francesco Salviati's North Italian Journey', *A.B.*, XLV (1963), 337–49.

Dumont, C. *Francesco Salviati au Palais Sacchetti de Rome et la décoration murale italienne (1520-1560).* Rome, 1973.

Hirst, M. 'Francesco Salviati's "Visitation"', *Burl. Mag.*, CIII (1961), 236-40.

Hirst, M. 'Three Ceiling Decorations of Francesco Salviati', *Z.K.*, XXVI (1963), 146-65.

Mortari, L. 'Alcuni inediti del Francesco Salviati', *Studies in the History of Art dedicated to William E. Suida*, 247-52. London, 1959.

Zeri, F. 'Salviati e Jacopino del Conte', *Proporzione*, II (1948), 180-2.

SANTI DI TITO

Arnolds, G. *Santi di Tito.* Arezzo, 1934.

SARTO, A. DEL

Braham, A. 'The Bed of Pierfrancesco Borgherini', *Burl. Mag.*, CXXI (1979), 754-65.

Fraenckel, I. *Andrea del Sarto.* Strasbourg, 1935.

Freedberg, S. *Andrea del Sarto.* 2 vols. Cambridge, Mass., 1963.

Monti, R. *Andrea del Sarto.* Milan, 1965.

Shearman, J. *Andrea del Sarto.* 2 vols. Oxford, 1965.

Shearman, J. 'Pontormo and Andrea del Sarto, 1513', *Burl. Mag.*, CIV (1962), 478-83.

SAVOLDO

Boschetto, A. *Giovan Gerolamo Savoldo.* Milan, 1963.

Gamba, C. 'Savoldo', *Emporium*, LXXXIX (1939), 373-88.

Gilbert, C. *The Works of Girolamo Savoldo.* Ann Arbor (University Microfilms), 1962.

Nicco Fasola, G. 'Lineamenti del Savoldo', *L'Arte*, XLIII (1940), 51-81.

SCARSELLINO

Novelli, M. *Lo Scarsellino.* Milan, 1964.

SCHIAVONE

Fiocco, G. 'Nuovi aspetti dell'arte di Andrea Schiavone', *Arte Veneta*, IV (1950), 33-62.

Fröhlich-Bum, L. 'Andrea Meldolla gennant Schiavone', *J.K.S.W.*, XXXI (1913), 137-220.

Moschini, V. 'Capolavori di Andrea Schiavone', *Emporium*, XLIX (1943), 237-42.

Richardson, F. *Andrea Schiavone.* Oxford, 1980.

SEBASTIANO

Dussler, L. *Sebastiano del Piombo.* Basel, 1942.

Hirst, M. 'A Late Work of Sebastiano del Piombo', *Burl. Mag.*, CVII (1965), 177-85.

Hirst, M. 'Sebastiano's Pietà for the Commendador Mayor', *Burl. Mag.*, CXIV (1972), 585-95.

Hirst, M. *Sebastiano del Piombo.* Oxford, 1981.

Pallucchini, R. *Sebastiano Viniziano.* Milan, 1944.

Safarik, F. 'Contributo all'opera di Sebastiano del Piombo', *Arte Veneta*, XVII (1963), 64-78.

SICIOLANTE DA SERMONETA

Davidson, B. 'Some Early Works of Girolamo Siciolante da Sermoneta', *A.B.*, XLVIII (1966), 55-64.

Waterhouse, E. 'Some Frescoes and an Altarpiece by Gerolamo Siciolante da Sermoneta', *Burl Mag.*, CXII (1970), 103-7.

Zeri, F. 'Intorno a Gerolamo Siciolante', *Boll. d'A.*, XXXVI (1951), 139-49.

SODOMA, IL

Carli, E. *Il Sodoma.* Milan, 1979.

Gielly, L. *Giovanni-Antonio Bazzi dit Le Sodoma.* Paris, 1911.

Hayum, A. 'A New Dating for Sodoma's Frescoes in the Villa Farnesina', *A.B.*, XLVIII (1960), 215-17.

STRADANO

Thiem, G. 'Studien zu Jan van der Straet, genannt Stradanus', *Mitt. K.H.I.F.*, VIII (1958), 88-111.

SUSTRIS, L.

Ballarin, A. 'Profilo di Lamberto d'Amsterdam', *Arte Veneta*, XVI (1962), 61-81.

Peltzer, R. 'Lambert Sustris von Amsterdam', *J.K.S.W.*, XXXI (1913), 221-45.

TIBALDI

Barolsky, P. 'A Fresco Decoration by Pellegrino Tibaldi', *Paragone*, no. 237 (1969), 54-9.

Briganti, G. *Il Manierismo e Pellegrino Tibaldi.* Rome, 1945.

TINTORETTO

Arcangeli, F. 'La Disputa del Tintoretto a Milano', *Paragone*, no. 61 (1955), 21-34.

Barbantini, N., et al. *La Mostra del Tintoretto.* Venice, 1937.

Bercken, E. v. d. *Die Gemälde des Jacopo Tintoretto.* Munich, 1942.

Bercken, E. v. d., and Mayer, A. *Jacopo Tintoretto.* 2 vols. Munich, 1923.

Coletti, L. *Il Tintoretto.* Bergamo, 1941.

Hadeln, D. v. 'Zeichnungen des Tintoretto', *J.P.K.*, XLII (1921), 82-103, 169-89.

Newton, E. *Tintoretto.* London and New York, 1952.

Pallucchini, R. *La Giovinezza del Tintoretto.* Milan, 1950.

Pallucchini, R. 'Giunte alla giovinezza del Tintoretto', *Arte Veneta*, V (1951), 111-15.

Pittaluga, M. *Il Tintoretto.* Bologna, 1925.

Thode, H. 'Tintoretto: Kritische Studien über des Meisters Werke', *Rep. K.W.*, XXIII (1900), 427-42; XXIV (1901), 7-35, 426-47; XXVII (1904), 24-45.

Tietze, H. *Tintoretto.* London, 1948.

TITIAN

Ballarin, A. 'Tiziano prima del Fondaco dei Ted-

eschi', in *Tiziano e Venezia* (Vicenza, 1980), 493-9.

Cloulas, A. 'Documents concernant Titien conservés aux archives de Simancas', *Mélanges de la casa de Velázquez*, III (1967), 197-288.

Crowe, J., and Cavalcaselle, G. *Titian: His Life and Times*. 2 vols. London, 1877. 2nd ed., 1881.

Fischel, O. *Tizian*. Stuttgart and Leipzig, 1904.

Friedlaender, W. 'Titian and Pordenone', *A.B.*, XLVII (1965), 118-21.

Gioseffi, D. *Tiziano*. Bergamo, 1959.

Gould, D. *Titian's Bacchus and Ariadne*. London, n.d. [1969].

Gronau, G. *Titian*. London and New York, 1904.

Hetzer, T. *Tizian, Geschichte seiner Farbe*. Frankfurt am Main, 1935.

Hetzer, T. *Tizians Bildnisse, Aufsätze und Vorträge*. Leipzig, 1957.

Hood, W., and Hope, C. 'Titian's Vatican Altarpiece and the Pictures Underneath', *A.B.*, LIX (1977), 534-52.

Hope, C. *Titian*. London, Toronto, and New York, 1980.

Hope C. 'Problems of Interpretation in Titian's Erotic Paintings', in *Tiziano e Venezia* (Vicenza, 1980), 111-24.

Hourticq, L. *La Jeunesse de Titien*. Paris, 1919.

Kennedy, R. 'Tiziano in Roma', in *Il Mondo Antico nel Rinascimento* (Atti del V Convegno Internazionale di Studi sul Rinascimento, Florence, 1956), 237-43. 1958.

Longhi, R. 'Cartella tizianesca', *Vita Artistica*, II (1927), 216-26.

Morassi, A. 'Esordi di Tiziano', *Arte Veneta*, VIII (1954), 178-98.

Neumann, J. *Tizian: Die Schindung des Marsyas* (also in French, *Titian: Marsyas écorché vif*). Prague, 1962.

Pallucchini, R. 'Studi tizianeschi', *Arte Veneta*, XV (1961), 286-95.

Pallucchini, R. *Tiziano* (Lezioni tenute alla Facoltà . . . di Bologna, 1952-3). 2 vols. Bologna, 1953-4.

Pallucchini, R. *Tiziano*. 2 vols. Florence, 1969.

Pallucchini, R., ed. *Tiziano e il Manierismo Europeo*. Florence, 1978.

Pignatti, T. 'Giorgione e Tiziano', in *Tiziano e il Manierismo Europeo*, 29-41. Florence, 1978.

Pozza, N., ed. *Tiziano e Venezia. Convegno Internazionale di Studi, Venezia, 1976*. Vicenza, 1980.

Shearman, J. 'Titian's Portrait of Giulio Romano', *Burl. Mag.*, CVII (1965), 172-7.

Suida, W. *Tiziano*. Rome, 1933.

Tietze, H. *Titian*. Vienna and London, 1937.

Tietze, H. *Tizian*. 2 vols. Vienna, 1936.

Tietze, H., and Tietze-Conrat, E. 'The Allendale Nativity in the National Gallery', *A.B.*, XXXI (1949), 11-20.

Valcanover, F. *Tutta la pittura di Tiziano*. 2 vols. Milan, 1960.

Walker, J. *Bellini and Titian at Ferrara*. New York, 1956.

Wethey, H. *Titian*. 3 vols. London, 1969, 1971, and 1975.

TOSINI

Gamba, C. 'Ridolfo e Michele di Ridolfo del Ghirlandaio', *Dedalo*, IX (1928/9), 465.

VANNI

Brandi, C. 'Francesco Vanni', *Art in America*, XIX (1931), 63-85.

Mirelli, E. 'Gli ultimi sprazzi del Cinquecento a Siena: I, Francesco Vanni; II, Ventura Salimbeni', *La Diana*, VII (1932), 59-71, 111-24.

VASARI

Barocchi, P. *Mostra di disegni di Giorgio Vasari e della sua cerchia*. Florence, 1964.

Barocchi, P. 'Il Vasari pittore', *Rinascimento*, VII (1956), 187-217.

Barocchi, P. 'Sul Vasari pittore', *Studi Vasariani*, 186-91. Florence, 1952.

Barocchi, P. *Vasari pittore*. Milan, 1964.

Bombe, G. 'Giorgio Vasaris Häuser in Florenz und Arezzo', *Belvedere*, XIII (1928), 55-9.

Carroll, E. 'Lappoli, Alfani, Vasari, and Rosso Fiorentino', *A.B.*, XLIX (1967), 297-304.

Davidson, B. 'Vasari's Deposition at Arezzo', *A.B.*, XXXVI (1954), 228-31.

Hall, M. 'The Operation of Vasari's Workshop and the designs for S. Maria Novella and S. Croce', *Burl. Mag.*, CXV (1973), 204-8.

Kallab, W. *Vasaristudien*. Vienna and Leipzig, 1908.

Monbeig-Goguel, C. 'Giorgio Vasari et son temps', *Revue de l'Art*, no. 14 (1971), 105-11.

Schulz, J. 'Vasari at Venice', *Burl. Mag.*, CIII (1961), 500-11.

VECCHI, G. DE'

Roli, R. 'Giovanni de' Vecchi', *Arte Antica e Moderna*, no. 29 (1965), 45-56; no. 31-2 (1965), 324-34.

VECELLIO

Fiocco, G. 'Profilo di Francesco Vecellio', I, *Arte Veneta*, VII (1953), 39-48; II, *Arte Veneta*, IX (1955), 71-9.

VENUSTI

Davidson, B. 'Drawings by Marcello Venusti', *Master Drawings*, XI (1973), 3-19.

VERONESE

Ballarin, A. 'Osservazioni sui dipinti veneziani del

Cinquecento nella Galleria del Castello di Praga', *Arte Veneta*, XIX (1965), 59-82.

Fiocco, G. *Paolo Veronese*. Bologna, [*c.* 1928].

Hetzer, T. 'Paolo Veronese', *Römische Jahrbuch für Kunstgeschichte*, IV (1940), 1-58.

Pallucchini, R. *Mostra di Paolo Veronese*. Venice, 1939.

Pallucchini, R. *Veronese*. Bergamo, 1939. 2nd rev. ed., 1943.

Pignatti, T. *Veronese*. 2 vols. Venice, 1976.

Vertova, L. *Veronese*. Milan, 1959.

ZUCCARI, THE

Collobi, L. 'Taddeo e Federico Zuccari nel Palazzo Farnese a Caprarola', *La Critica d'Arte*, III (1938), 70-4.

Gere, J. 'The Decoration of the Villa Giulia', *Burl. Mag.*, CVII (1965), 199-206.

Gere, J. *Mostra di disegni degli Zuccari*. Florence, 1966.

Gere, J. 'Two of Taddeo Zuccaro's Commissions, Completed by Federico Zuccaro. I, The Pucci Chapel in S. Trinità dei Monti'; II, 'The High Altarpiece in S. Lorenzo in Damaso', *Burl. Mag.*, CVIII (1966), 286-93, 341-5.

Gere, J., *Taddeo Zuccaro, His Development Studied in His Drawings*. Chicago, 1969.

Heikamp, D. 'Federico Zuccaro a Firenze', I, *Paragone*, no. 205 (1967), 44-68; II, no. 207 (1967), 3-34.

Heikamp, D. 'Vicende di Federico Zuccari', *Riv. d'A.*, XXXII (1959), 175-232.

Korte, W. *Der Palazzo Zuccari in Rom*. Leipzig, 1935.

Partridge, L. 'The Sala d'Ercole in the Villa Farnese at Caprarola', *A.B.*, LIII (1971), 487-92; LIV (1972), 50-62.

Perotti, M. 'Federico Zuccari', *L'Arte*, XIV (1911), 381-90, 427-37.

ZUCCHI

Calcagno, A. 'Jacopo Zucchi e le sue opere in Roma', *Il Vasari*, V (1932), 39-56.

Voss, H. 'Jacopo Zucchi: Ein vergessener Meister der Florentinisch-Römischen Spätrenaissance', *Z.B.K.*, XXVI (1912-13), 151-62.

LIST OF ILLUSTRATIONS

Where not otherwise acknowledged, copyright in photographs belongs to the museum, gallery, or owner cited as location, and photographs of paintings in the Florence Accademia, the Palazzo Pitti, and the Uffizi are reproduced by permission of the Soprintendenza alle Gallerie, Florence, from photographs supplied by them.

187. Jacopino del Conte: Preaching of the Baptist, 1538. *Rome, Oratory of S. Giovanni Decollato* (Gabinetto Fotografico Nazionale)

188. Jacopino del Conte: Deposition, *c.* 1552. *Rome, Oratory of S. Giovanni Decollato* (Anderson)

189. Giorgio Vasari: Crucifixion, 1540. *Camaldoli, Arcicenobio* (Scala, Florence)

190. Giorgio Vasari: Presentation in the Temple, 1544. *Naples, Capodimonte* (Soprintendenza alle Gallerie, Naples)

191. Giorgio Vasari: History of Pope Paul III, 1546. *Rome, Palazzo della Cancelleria, Sala dei Cento Giorni* (Alinari)

192. Giorgio Vasari: Studiolo of Francesco I, 1570-3. *Florence, Palazzo Vecchio* (Alinari)

193. Agnolo Bronzino: Eleonora of Toledo and her Son, *c.* 1546(?). *Florence, Uffizi* (Anderson)

194. Agnolo Bronzino: Holy Family with St Elizabeth and St John, *c.* 1550. *Vienna, Kunsthistorisches Museum*

195. Agnolo Bronzino: Christ in Limbo, 1552. *Florence, Museo di S. Croce* (Anderson)

196. Agnolo Bronzino: Martyrdom of St Lawrence, 1565-9. *Florence, S. Lorenzo* (Alinari)

197. Pontormo: The Cup of Joseph (tapestry), *c.* 1545-9. *Rome, Palazzo del Quirinale* (Soprintendenza alle Gallerie, Florence)

198. Pontormo: Christ in Glory, study for the (destroyed) S. Lorenzo choir, begun 1546. *Florence, Uffizi*

199. Maso da S. Friano: Holy Family, *c.* 1570. *Oxford, Ashmolean Museum* (By courtesy of the Ashmolean Museum)

200. Mirabello Cavalori: The Wool Factory. *Florence, Palazzo Vecchio, Studiolo* (Alinari)

201. Michelangelo: Last Judgement, 1536-41. *Vatican, Sistine Chapel* (Anderson)

202. Michelangelo: Last Judgement (detail) (Anderson)

203. Michelangelo: Conversion of St Paul, 1542-5. *Vatican, Cappella Paolina* (Anderson)

204. Michelangelo: Crucifixion of St Peter, 1546-50. *Vatican, Cappella Paolina* (Alinari)

205. Daniele da Volterra: Deposition, 1541/*c.* 1545. *Rome, SS. Trinità dei Monti, Cappella Orsini* (Gabinetto Fotografico Nazionale)

206. Daniele da Volterra: Madonna with St Peter and St Paul, 1545. *Volterra, Seminario* (Soprintendenza, Pisa)

207. Daniele da Volterra: Assumption, 1548/53. *Rome, SS. Trinità dei Monti, Cappella Rovere* (Gabinetto Fotografico Nazionale)

208. Daniele da Volterra: Madonna with the Young St John and St Barbara, *c.* 1552(?). *Siena, d'Elci Collection* (Gabinetto Fotografico Nazionale)

209. Salviati: Detail of decoration, *c.* 1553. *Rome, Palazzo Ricci-Sacchetti* (Foto Luce)

210. Salviati: The Death of Saul and Jonathan, detail of decoration, *c.* 1553. *Rome, Palazzo Ricci-Sacchetti* (Gabinetto Fotografico Nazionale)

211. Salviati: Sala dei Fasti Farnesi, *c.* 1549-63, detail. *Rome, Palazzo Farnese* (Anderson)

212. Taddeo Zuccaro: Conversion of St Paul. *Rome, S. Marcello al Corso, Cappella Frangipane* (Gabinetto Fotografico Nazionale)

213. Taddeo Zuccaro: Sala dei Fasti Farnesi, 1565. *Caprarola, Villa Farnese* (Alinari)

214. Taddeo Zuccaro: The Council of Trent, detail from the Anticamera del Consiglio, 1565. *Caprarola, Villa Farnese* (Gabinetto Fotografico Nazionale)

215. Siciolante da Sermoneta: Madonna with Six Saints, 1548. *Bologna, S. Martino Maggiore* (Foto Villani, Bologna)

216. Siciolante da Sermoneta: Baptism of Clovis, *c.* 1548-9. *Rome, S. Luigi dei Francesi* (Gabinetto Fotografico Nazionale)

217. Siciolante da Sermoneta: Birth of the Virgin, 1565. *Rome, S. Tommaso dei Cenci* (Gabinetto Fotografico Nazionale)

218. Girolamo Muziano: Resurrection of Lazarus, 1555. *Rome, Vatican Museum* (Gall. Mus. Vaticani)

219. Girolamo Muziano: Giving of the Keys, *c.* 1585. *Rome, S. Maria degli Angeli* (Alinari)

220. Titian: Crowning with Thorns, 1542-4. *Paris, Louvre* (Cliché des Musées Nationaux)

221. Titian: Paul III and his Nephews, 1546. *Naples, Capodimonte* (Anderson)

222. Titian: Danaë, 1554. *Madrid, Prado*

223. Titian: Diana and Actaeon, 1559 or earlier. *Edinburgh, National Gallery, Ellesmere Loan* (Annan, Glasgow)

224. Titian: Rape of Europa, 1559-62. *Boston, Gardner Museum*

225. Titian: St Margaret, *c.* 1565-6. *Madrid, Prado* (Anderson)

226. Titian: Martyrdom of St Lawrence, 1564-7. *Escorial* (Foto Mas)

227. Titian: Crowning with Thorns, *c.* 1570-1. *Munich, Pinakothek* (Bayerische Staatsgemäldesammlungen, Munich)

228. Titian: Flaying of Marsyas, *c.* 1570 or later. *Kromeríz (Kremsier), Archiepiscopal Palace* (Otakar Klepš, Kromeríz)

229. Titian: Pietà, unfinished in 1576. *Venice, Accademia* (Cameraphoto, Venice)

230. Tintoretto: Christ among the Doctors, *c.* 1542/3. *Milan, Opera del Duomo* (Fabbrica del Duomo, Milan)

INDEX

THE PELICAN HISTORY OF ART

COMPLETE LIST OF TITLES

* Also published in an integrated edition.
† Published only in an integrated edition.
‡ Not yet published.

* Also published in an integrated edition.
‡ Not yet published.